The Encyclopedia of New Zealand
RUGBY

The Encyclopedia of New Zealand
RUGBY

Rod Chester **Ron Palenski** **Neville McMillan**

Hodder Moa Beckett

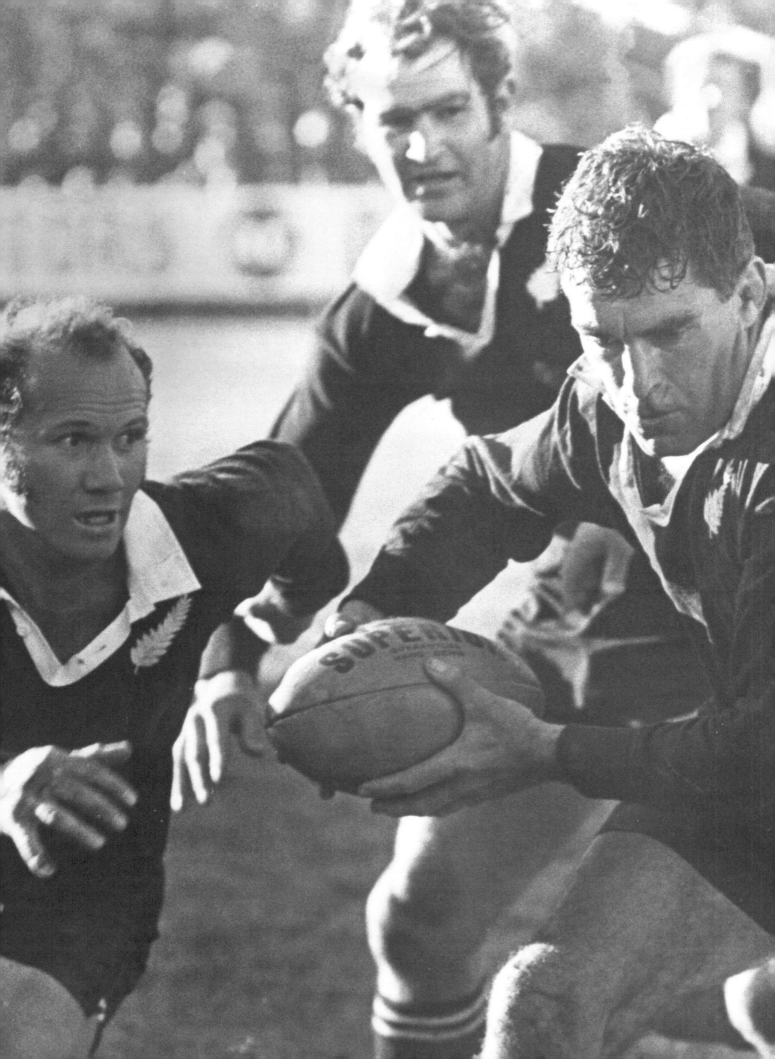

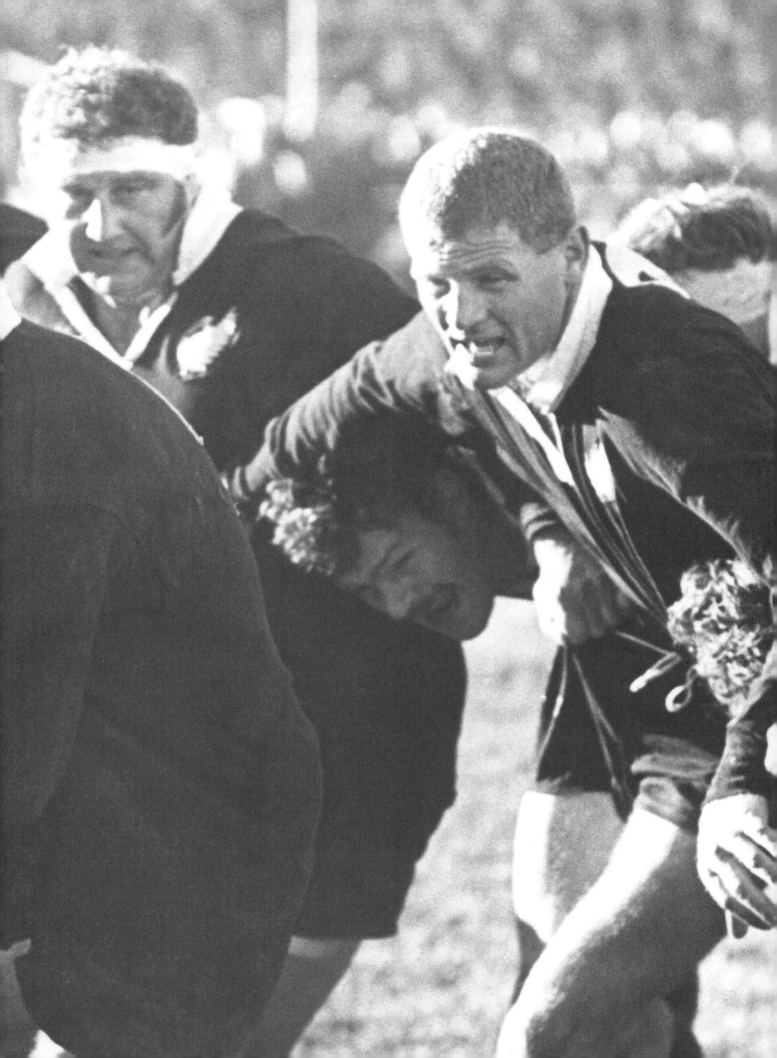

ACKNOWLEDGEMENTS

The authors and publisher acknowledge the invaluable assistance of the News Media Auckland group and the New Zealand Rugby Museum (Palmerston North). Both organisations provided access to their extensive photographic libraries and were always happy to co-operate with the sometimes demanding, and often time consuming requests of the publishers.

Thanks also to Photosport (Auckland) for the colour photographs which appear on the cover and to Peter Bush, the doyen of rugby lensmen.

Cover photos:	Black and white – News Media Auckland
	Colour – Photosport (Auckland)
Text photos:	News Media Auckland, New Zealand Rugby Museum (Palmerston North),
	Peter Bush (Wellington) and Photosport (Auckland)
Pages 4–5:	Colin Meads against the Lions, Carisbrook, 1971. Supporting Meads are Sid Going,
	Ian Kirkpatrick, Brian Muller and Richie Guy (Peter Bush)
Pages 8–9:	Zinzan Brooke against the Springboks, Carisbrook, 1994
	(Andrew Cornaga, Photosport)
Pages 384–385:	South Africa versus Canterbury, Lancaster Park, 1937 (News Media Auckland)
Pages 386–387:	Auckland versus Canterbury, Eden Park, 1964 (Peter Bush)

First published 1981
Second edition 1987
This third edition published by Hodder Moa Beckett Publishers Ltd, 1998

ISBN 1-86958-630-1

Published by Hodder Moa Beckett Publishers Limited
[a member of the Hodder Headline Group]
4 Whetu Place, Mairangi Bay, Auckland, New Zealand

Designed and produced by Hodder Moa Beckett Publishers Limited
Typeset by TTS Jazz, Auckland
Scanning and film produced by Microdot
Printed by Kyodo Printing Company Ltd, Singapore

CONTENTS

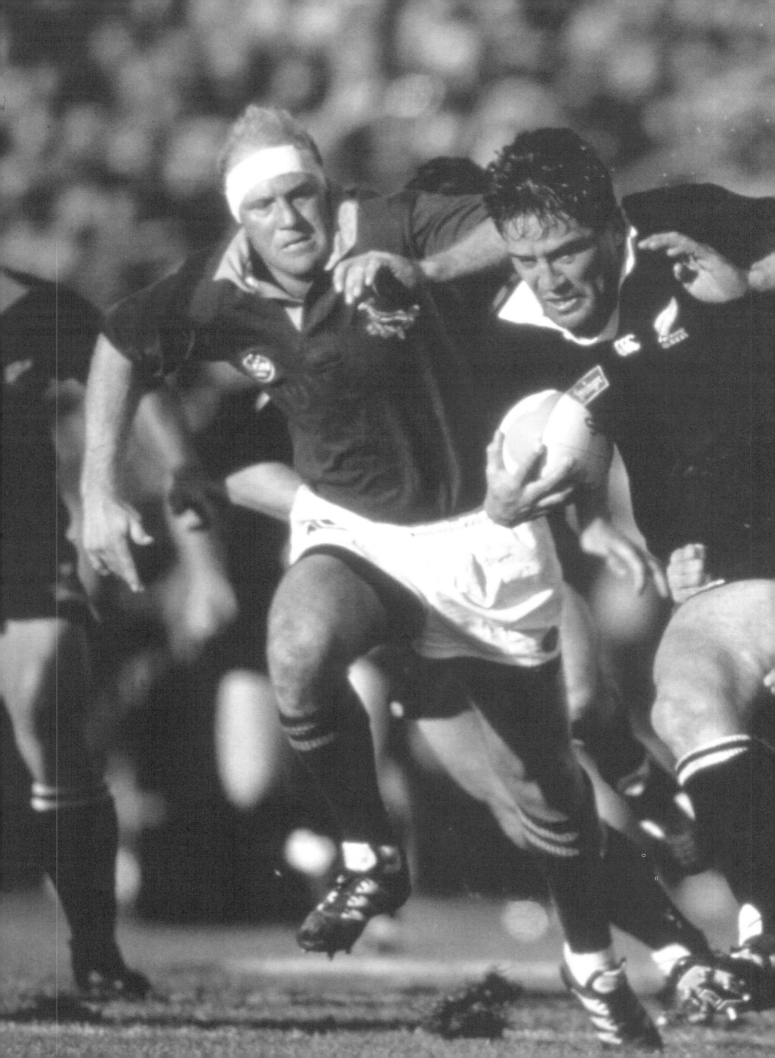

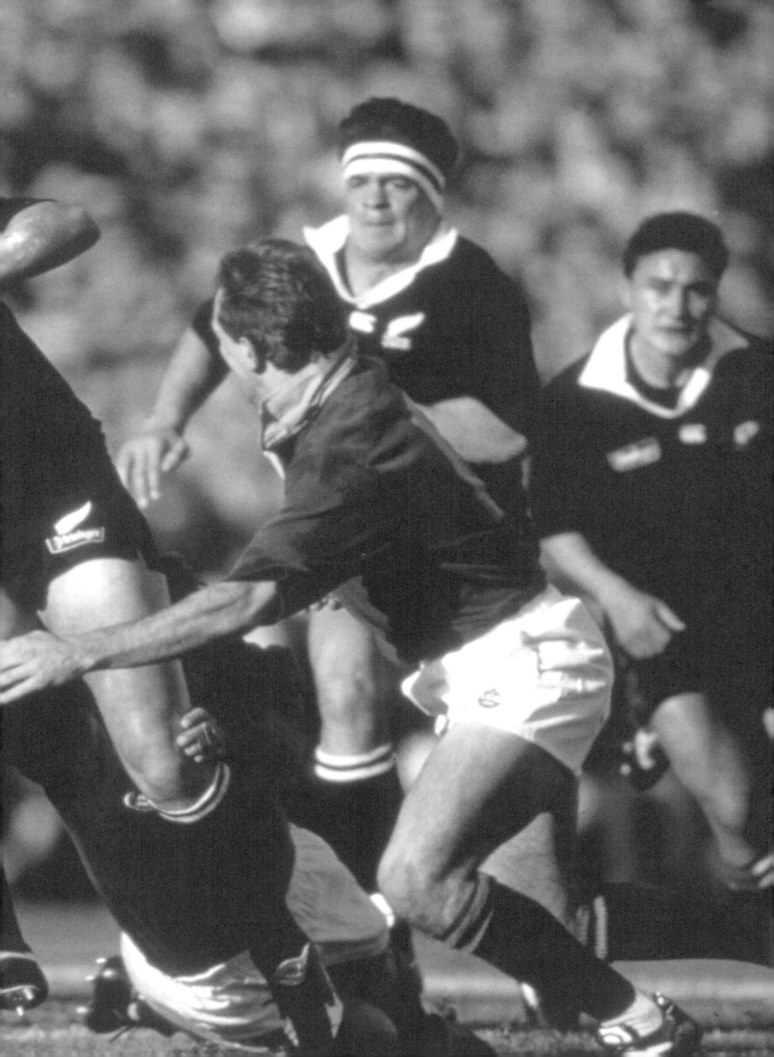

Preface

The first edition of the *Encyclopedia of New Zealand Rugby* was compiled by those indefatigable recorders of rugby's past and present, R H Chester and N A C McMillan, and published in 1981. For the second edition, published in 1987, they were joined by, to follow the initial precedent, R A Palenski. R A was sought because R H and N A C were, at roughly the same time, updating *Men In Black* and continuing to research the third volume of their monumental trilogy, *The Visitors*.

Alas, neither R H nor N A C lived to see the third edition. Rod Chester died in 1994 and Neville McMillan late in 1997, but the substance of this book – and the others they wrote – remains their enduring legacy. Neville and I had one meeting about the third edition before he died and I took up his allotment of duties, hoping I could give the facts and statistics of New Zealand rugby the same loving care and attention that he and Rod had. Since they were unable to argue against it anymore, I took the liberty of including them in the 'Writers, Broadcasters' chapter. I shall remain grateful to Neville's widow, Val, for pursuing what must have been an emotionally painful task and joining me on New Year's Eve going through Neville's substantial collection of papers and books looking for *Encyclopedia* material.

Much has changed in New Zealand rugby since the second edition of the *Encyclopedia* yet the staff at Hodder Moa Beckett and I have tried to keep as close to the original format as we could or deemed practical. The clubs of All Blacks continue to be listed, though many All Blacks have not played club rugby for some years and, in the future, none may play at all. Similarly, the first-class appearances of All Blacks continue to be listed even though what some people perceive as the demands of the modern game demean that status. I join Clive Akers, co-editor of the *New Zealand Rugby Almanack*, in his belief that first-class status should be something to aspire to, and not a convenient match to try out some player who may be returning from injury. This practice has led to such statistical absurdities as Andrew Mehrtens playing for Bay of Plenty or North Islanders playing for sides conveniently labelled 'South Island Invitation XVs'. There is an increasing case for the New Zealand Rugby Football Union to re-examine the status of first-class matches and confine them to NZRFU games such as internationals, trials and tour matches (though the latter are increasingly infrequent), Super 12 and NPC matches, matches for trophies such as the Ranfurly, Hanan and Seddon Shields, and certain specified "traditional" fixtures between unions.

The changing face of rugby has led to the introduction of chapters on the World Cup, Super 12 and the NPC, plus a separate chapter on nationally-selected teams such as New Zealand A, New Zealand B (spot the difference!), New Zealand XV and other temporary amalgams. Chapters on teams that are no more, such as the New Zealand Juniors, or of increasingly less significance, such as New Zealand Universities, are retained for their historical value.

The chapter on unions and clubs has been fairly extensively overhauled and while the essential details of unions are retained, only senior clubs and their colours are now listed. The 11-year period since the previous *Encyclopedia* saw many club mergers and the total disappearance of many, and this is a process that is likely to continue and eventually also encompass some of the provincial unions. It seems anachronistic that boundaries drawn for the most part in the 19th century, when difficulty of transport was a significant factor, remain almost as they were in the closing years of the 20th century, when transport is easy but expensive. A rationalisation of provincial boundaries is an economic inevitability.

The greatly increased number of matches, plus the additional chapters, meant something had to go if the *Encyclopedia* was still to be within reach of all rugby supporters, and not just the affluent. The chapter that was called 'Players unlucky not to represent New Zealand' in the first edition and 'Prominent Players' in the second is one casualty. It listed, for example, All Black reserves who had not taken the field; now, with tactical substitutions and enlarged All Black squads, there is not the same need for such a chapter.

I have remained faithful, for the most part, to the style and terminology originated by Rod and Neville in 1981. Metrication applies only to those players whose careers were after the introduction of the metric system in 1975. Points values given are those applying during a player's career; to do otherwise would lead to some bizarre, and reversed, match results. The word 'forward' is given for early All Blacks when none had a designated forward position yet other outdated position names, such as breakaway, have not been retained. Modern journalistic affectations such as "touchdown" (for try), "winger" (for wing), "outfit" (for team), "mentor" (for coach), "second rower" (for lock) and even "field goal" (for dropped goal; the rugby field goal was a long-outlawed entirely different kick) find no place in this book.

It should not be necessary to point out, though I will, that a book such as this can only be as good as its source material. The base source material was the excellent *Rugby Almanack*, but many readers of the previous editions wrote letters pointing out factual errors or omissions. The provincial unions generally

were obliging and helpful when asked, though some had to be asked more than once. Many individuals gave of their knowledge, their enthusiasm and their time and they are all thanked; they will recognise their contributions in these pages. If mistakes have crept in, the fault will be mine, not theirs.

The publisher, Hodder Moa Beckett, is to be commended for continuing to want to publish the *Encyclopedia* and specifically within that organisation, Sarah Beresford and Warren Adler are thanked for their forbearance and the extra duties they undertook.

I thank also my family for once again putting up with a husband and father whose physical presence was not always in their midst and whose mental presence was often further away. I thank also the families of Rod Chester and Neville McMillan for their support in the first place. I hope they are as proud of this edition as they were of the first two.

Ron Palenski
Akatawara Valley and Taieri Mouth
March 1998

Rugby – The Origins of the Game

The most enduring and widely known tale of the origins of rugby was that a pupil at Rugby School in Warwickshire in England, William Webb Ellis, disregarded the rules of football as it was played at the time and picked up the ball and ran with it.

A plaque at the school and numerous books on the history of the game perpetuate the tale, even though Ellis's run was purported to have occurred in 1823 yet rugby recognisable as the forerunner of the game played today was not common until about 30 years later. The only historical evidence to support the Ellis story is contained in an article written in *The Meteor* (the Rugby School magazine) on 22 December, 1880, 57 years after the alleged event. The author, Matthew H. Bloxham, although an old boy of the school, was not a witness to Ellis's effort, having left school in 1820, three years before. His testimony was reliant on the evidence of unidentified observers. It was refuted by a contemporary of Ellis's, who wrote: "I remember William Webb Ellis perfectly. He was an admirable cricketer, but was generally regarded as inclined to take unfair advantages of football. I should not quote him in any way as an authority."

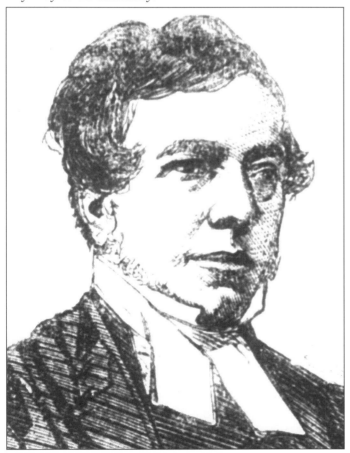

The man that tradition says began it all, William Webb Ellis.

Ellis probably did pick up the ball and run with it, but what is in contention is that, by so doing, he originated rugby.

Football in some form or other had been played in England long before the advent of William Webb Ellis and indeed long before the founding of Rugby School. It is generally believed that the Romans introduced a rough-and-tumble game played with a pig's bladder in which any number of players could take part. English townsmen adopted this pastime and games involving hundreds of people were played in the streets, resulting in much damage to person and property.

Gradually rules of a sort evolved, especially in the public schools. In some cases, where there was a shortage of grass fields, a dribbling game akin to soccer developed. At schools like Rugby, set among acres of green fields, a game involving bodily contact was favoured.

The main feature of the game as played at Rugby before 1823 was the maul. The object of the game was to drive the maul over the opposing team's goal line and so be given the opportunity to kick a goal. Handling the ball was in vogue at Rugby before Ellis's time but running with it was not.

The handling game spread to the universities and a number of clubs began to take it up. By the 1860s it was quite widespread but there was still no set of uniform rules. However, most teams consisted of 20 players and scoring was by goals. The scoring of a try did not count for points. It simply gave a team the right to 'try' to kick a goal, which counted one point. A team could therefore cross its opponents' line 10 times and end up with no points if no goals were kicked. On the other hand, the opposition could cross the line once and, if successful in kicking the goal, win the match.

THE FIRST UNION

The Football Association was formed in 1863 to administer the game popularly known as soccer but it was not until 1871 that the adherents of the handling code formed the Rugby Football Union. The first international rugby match was played in the same year between England and Scotland, although the Scots did not form their union until 1873. Played with teams of 20, the game took place in Edinburgh and was won by the home team. Both sides scored a try but the Scots goaled theirs to give them the victory.

EARLY RUGBY IN NEW ZEALAND

The first game of rugby played in New Zealand took place before the Rugby Football Union was formed. From early European times football in various forms had been played but from the description of the game

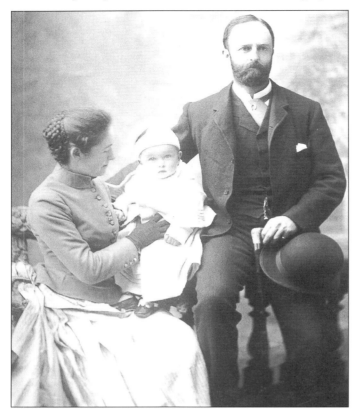

Charles John Monro, in about 1886, with his wife and oldest son, David.

in local papers, it is certain that the match between Nelson College and Nelson Football Club, played on 14 May, 1870, was played under rugby rules.

Credit for the introduction of rugby to New Zealand goes to Charles John Monro, son of Sir David Monro, Speaker in the House of Representatives from 1860 to 1870. Charles Monro, who was born at Waimea West, was sent to Christ's College, Finchley, in England to complete his education and while there he learned the rugby game. On his return to Nelson he suggested that the local football club try out the rugby rules. The game must have appealed to the club members for they decided to adopt it.

Nelson College also chose to adopt rugby and a game was arranged between town and school. It took place at the Botanical Reserve on Saturday, 11 May, 1870, the club side winning by two goals to nil. As far as is known, this was the first football match in New Zealand to be played under rugby rules.

A visit to Wellington by Monro later in 1870 resulted in a game being arranged between Nelson and Wellington. This match was played at Petone on 12

The first match is remembered in the Botannical Reserve, Nelson.

September and was won by Nelson by two goals to one.

In 1871 the game became organised in Wellington and it had spread to Wanganui by the following year. Auckland adopted rugby in 1873 while Hamilton followed suit in 1874. By 1875 the game had become established all over the colony and a team representing Auckland clubs undertook a two-week southern tour. Matches were played (and lost) against teams from Wellington, Dunedin, Christchurch, Nelson and Taranaki.

FIRST NEW ZEALAND UNIONS

In 1879, unions were formed in Canterbury and Wellington, indicating that the game was becoming more formally organised. Other unions soon followed but it was not until 1892 that the New Zealand Rugby Football Union was formed to administer the game at national level.

Even before the New Zealand Rugby Union came into being overseas tours had been arranged. In 1882 the first rugby team from overseas visited New Zealand when New South Wales toured both islands late in the season. In 1884, a New Zealand team, wearing blue jerseys with a gold fern, returned the visit, winning all its matches in New South Wales. New South Wales sent another side to New Zealand in 1886 and the first British team to visit arrived in 1888.

The New Zealand Native Team became the first from the colony to visit Britain when it undertook the longest tour ever in 1888-89. The first national side to take the field under the auspices of the New Zealand Rugby Football Union did so in 1893, when 10 games were played on a tour of Australia.

Since 1893, New Zealand has sent teams to every major rugby country and to some countries where the game is very minor. At the same time, the NZRFU has been host to players from all corners of the world. The game is spreading all the time and although rugby players in some countries may not be too sure where New Zealand is, it is certain would have heard of the All Blacks.

Rugby historically had been an amateur sport and as recently as the 1980s, players were banned for accepting proceeds from books they had written and others were investigated by various national unions for alleged breaches of the amateur regulations. The advent of the World Cup tournament and increasing demands on players' time led to calls for some form of compensation or a limited form of professionalism and attempts in the 1970s and 1980s to begin a professional arm of the game failed.

By 1995, however, realities caught up with rugby and after New Zealand, Australia and South Africa sold television rights to their games to News Corporation, and after the newly-acquired funds were used to fend off an Australian-based attempt to set up a professional rugby competition, the International Rugby Board wiped the amateur regulations and declared the game "open". In New Zealand, the leading players were contracted to the NZRFU and paid varying amounts,

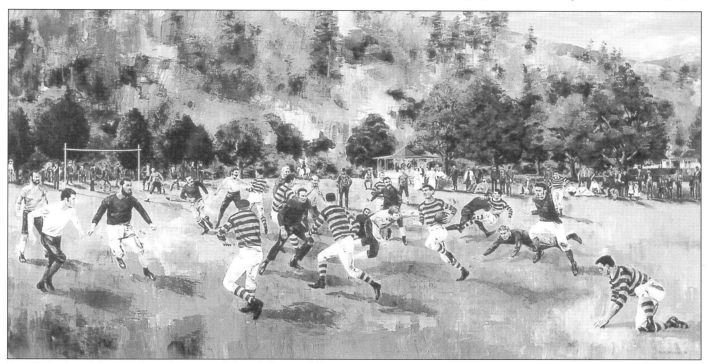

An artist's view of the 1870 match between Nelson College and Town.

but the reality is that only a tiny percentage of rugby players in New Zealand or anywhere else are paid. Though the game is now "open", for the vast majority of the players it is as amateur as it ever was, just as most sports are.

A parallel development has been the expansion of the International Rugby Board, which for years was based in London, moved to Bristol in 1993 and to Dublin in 1996. It now has more than 60 member countries, with its main policy-making body a 12-country executive council. Rugby World Cup Ltd is a subsidiary of the IRB.

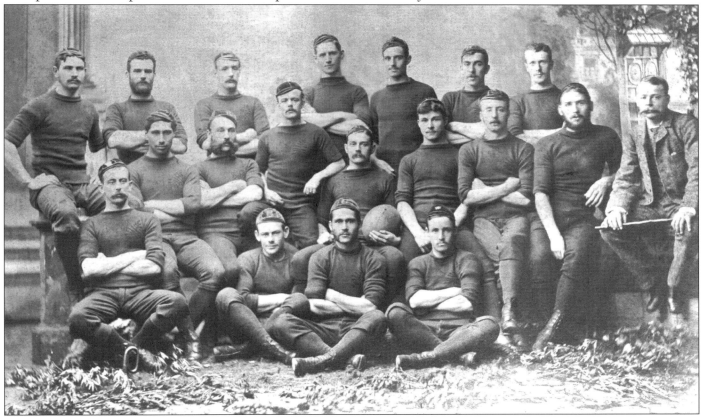

The 1884 New Zealand team to Australia
Back row: J. O'Donnell, H. Udy, G.S. Robertson, J. Allan, E.B. Millton, T. Ryan, R.J. Wilson.
Second row: J.G. Taiaroa, G. Carter, J.T. Dumbell, W.V. Millton (captain), H.Y. Braddon, G.H.N. Helmore, P.P. Webb, S.E. Sleigh (manager).
Front row: E. Davy, J. Lecky, J.A. Warbrick, H. Roberts.
Absent: T.B. O'Connor.

A Chronology of New Zealand Rugby

A brief summary of important dates in the history of New Zealand rugby.

1870 First rugby match in New Zealand at Nelson

1875 First tour of New Zealand by a provincial team (Auckland) and the first inter-provincial match (Auckland Clubs v Dunedin Clubs at Dunedin, 22 September)

1876 First inter-collegiate match (Nelson College v Wellington College, 20 June)

1879 First unions (Canterbury and Wellington) founded

1882 First visit to New Zealand by an overseas team (New South Wales)

1884 The use of the whistle by referees became generally accepted in New Zealand

First New Zealand team assembled (toured New South Wales)

Points system of scoring adopted: try 1 point, conversion 2, other goals 3

1887 First New Zealand representative died when William Millton, who captained the 1884 team in Australia, contracted typhoid

1888 First visit to New Zealand by a British team

1888-89 New Zealand 'Native' team toured New Zealand, Australia and Great Britain

1892 New Zealand Rugby Football Union founded

Scoring values revised: try 2 points, conversion 3, penalty goal 3, dropped goal 4

1893 First New Zealand team selected under the auspices of the NZRFU (toured Australia)

1894 First match against overseas team played by a New Zealand representative team in New Zealand (v New South Wales at Christchurch, 15 September)

Further revision of points system: try 3 points, conversion 2, penalty goal 3, dropped goal and goal from a mark 4

1896 First visit to New Zealand by Queensland

1897 First interisland game (at Wellington, 26 June)

1902 Ranfurly Shield presented to the NZRFU by the Governor of New Zealand, Earl of Ranfurly (Auckland was the first holder)

1903 First full-scale international match played by New Zealand (v Australia at Sydney, 15 August)

1904 First full-scale international match played by New Zealand at home (v Great Britain at Wellington, 13 August)

1905 First visit to New Zealand by a fully

An early rugby programme.

representative Australian team

Value of the goal from a mark reduced to 3 points

1905-06 First visit to the British Isles, France and North America by a fully representative New Zealand team

1907 First encounter in New Zealand with professionalism when a national team, to be dubbed the 'All Golds', left for matches in Australia and England

1908 First NZ Universities team toured Australia

1910 First NZ Maoris team visited Australia

First American team (American Universities) toured New Zealand

1913 First full-scale tour of California and British Columbia by the All Blacks

1919 NZ Services team won the King's Cup tournament in Britain

Tour of South Africa by the NZ Services team

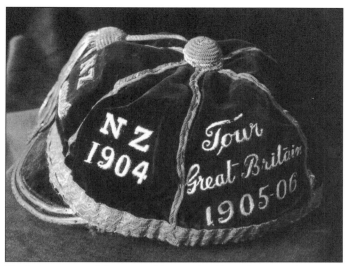

The test cap awarded to one of New Zealand's early greats, Charlie Seeling.

1921 Visit of the first South African team

 The NZRFU elected its first life member (George Dixon)

1924-25 The 'Invincibles' won every match on tour of Britain, France and British Columbia – the only team to do so on full-scale tour

1926 First visit to Victoria by the All Blacks (the 1888 Native team and the 1910 Maori side had played at Melbourne)

 First radio commentary on a rugby match in New Zealand (and probably in the world) made by Alan Allardyce at Christchurch when he gave a commentary on the Christchurch v High School Old Boys game, 29 May

1926-27 Tour of France, England, Wales and Canada by NZ Maoris

1928 First All Black tour of South Africa

1929 New Zealand lost all matches in an international series for the first time (defeated in all three tests in Australia)

1930 New Zealand wore white jerseys in tests against Great Britain to avoid clashing with dark blue worn by the visitors

1931 Bledisloe Cup presented by Lord Bledisloe, Governor-General of New Zealand, for competition between Australia and New Zealand

 The last season for New Zealand's traditional 2-3-2 scrum and the wing forward when the two-fronted scrum was outlawed by the International Board

1934 New Zealand lost the Bledisloe Cup for the first time

1937 South Africa won a test series against New Zealand for the first time. Two previous series (1921 and 1928) were drawn

1939 First visit to New Zealand by Fiji

1945-46 2nd NZEF army team (the 'Kiwis') toured Britain and France at the conclusion of the Second World War

1948 Value of the dropped goal reduced from 4 to 3 points

 New Zealand admitted to International Rugby Board

1949 New Zealand played six tests and lost them all – four against South Africa and two against Australia

1956 New Zealand won a test series against South Africa for the first time

1961 First visit to New Zealand by France

1963 First visit to New Zealand by England

1969 First visit to New Zealand by Wales

 First visit to New Zealand by Tonga

 NZ Rugby Museum Society established by enthusiasts in Palmerston North

1971 British Isles won a test series in New Zealand for the first time

1972 Value of a try increased from 3 to 4 points

 First direct telecast of test match in New Zealand (v Australia at Auckland)

 First direct telecast by satellite of test match (New Zealand v Wales at Cardiff)

1973 Scheduled South African tour of New Zealand cancelled after Government intervention

 First visit to New Zealand by Victoria

1975 First visit to New Zealand by Scotland

 First visit to New Zealand by Romania

1976 First visit to New Zealand by Ireland

 First visit to New Zealand by Western Samoa

 First visit to New Zealand by Cook Islands

 New Zealand toured Argentina for first time

 National Provincial Championship established

1977 All Blacks played in Italy for first time

1978 NZ Rugby Museum moved into permanent quarters in Palmerston North

 All Blacks achieve 'grand slam' for first time by beating Ireland, Wales, England and Scotland (the 'Invincibles' did not play Scotland)

1979 First visit to New Zealand by Argentina

1980 First visit to New Zealand by Italy

1981 Two South African tour matches in New Zealand cancelled on police advice

 All Blacks play in Romania for the first time

1982 NZ Maoris tour Wales and Spain

1984 New Zealand made first separate tour of Fiji

1985 New Zealand tour of South Africa cancelled after legal action; replacement tour to Argentina

1986 All Blacks named in 1985 team for South Africa make unauthorised tour there; declared ineligible for test against France and suspended from first test against Australia

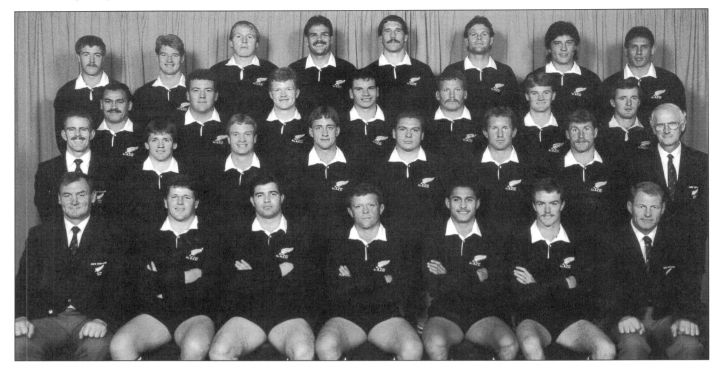

The 1987 All Blacks – winners of the inaugural World Cup
Back row: Andy Earl, John Kirwan, Albert Anderson, Gary Whetton, Murray Pierce, Alan Whetton, Zinzan Brooke, Wayne Shelford.
Third row: Joe Stanley, John Drake, John Gallagher, Michael Jones, Richard Loe, Bernie McCahill, Kieran Crowley.
Second row: Neil Familton (physiotherapist), David Kirk, Grant Fox, Warwick Taylor, Mark Brooke-Cowden, Bruce Deans, Craig Green, David Laing (doctor).
Front row: Brian Lochore (coach), Sean Fitzpatrick, Steve McDowell, Andy Dalton (captain), Frano Botica, Terry Wright, Richie Guy (manager).

1987 First Rugby World Cup played in New Zealand and Australia. Sixteen countries competed and the Webb Ellis Trophy won by New Zealand with France as runner-up

1991 New Zealand eliminated by Australia in Dublin in semifinal of World Cup; Australia beat England in the final at Twickenham

1992 NZRFU marked its centenary with three official tests between the All Blacks and a World XV.

Political changes made possible a resumption of links with South Africa; New Zealand toured there for the first time since 1976, winning the only test

Value of a try increased from 4 to 5 points; other law changes included a "use it or lose it" provision applying to mauls

Semifinals-finals format introduced to the National Provincial Championship

1993 Auckland's record Ranfurly Shield tenure of eight years and 61 defences ended by Waikato

1994 South Africa toured New Zealand for the first time since 1981, the All Blacks winning the first two tests and the third drawn

1995 New Zealand played first test outside of World Cup against Canada

New Zealand beaten 15-12 in World Cup final in Johannesburg by South Africa

New Zealand, Australia and South Africa combine to sell television rights for all southern hemisphere test matches, a new international

provincial competition (later named the Super 12) and domestic provincial competitions in each of the three countries for 10 years to News Corporation for $828 million

Privately-promoted World Rugby Corporation organised by former Australian prop and administrator Ross Turnbull gained indications of intent from leading players, including most All Blacks. Former All Black captains Jock Hobbs and Brian Lochore negotiate with players on behalf of NZRFU, signing the majority to contracts and warding off the threat

International Rugby Board repealed all regulations relating to amateurism, declaring the game "open"

All Blacks' match against Italy A in Sicily the first international of the professional era; the match against Italy three days later was the first test of the new era

1996 All Blacks won inaugural tri-nations series against Australia and South Africa and won a series in South Africa for the first time.

John Hart became the first All Black coach to be appointed for more than a year

1997 New Zealand played first test outside World Cup against Fiji

New Zealand played Wales at Wembley Stadium in London because of redevelopment of Cardiff Arms Park. The All Blacks also played England at Old Trafford in Manchester

New Zealand Representatives

1884-31 December 1997

Although this section of the *Encyclopedia* is self explanatory, some definition is needed.

All players who have taken the field for New Zealand in official, first-class matches from the 1884 tour of Australia to the end of 1997.

If a player was known by a name other than his first given names, that is included in the text, but nicknames are not given. Where it has not been possible, despite extensive research, to give dates of birth or death a question mark is shown. When the year of a player's birth or death is known but not the exact date, the letter 'c' (for *circa*, Latin for about) is given.

The playing positions given are those in which the player usually represented New Zealand. The term 'forward' is used for the early periods of rugby when set forward positions were not assigned. 'Loose forward' covers those who played off the side of the scrum or at number eight.

The sub-heading, 'First-class record' does not purport to cover every team for which a player may have appeared in a first-class match. It covers his principal teams such as provinces, island sides and trials but does not include all invitation sides that have proliferated and have been deemed to be of first-class status.

The years of representation for New Zealand and other teams are shown with a dash between years if the period is continuous and a comma to show broken years.

Heights and weights given for some players were taken from official records, usually supplied by provincial unions to the NZRFU or the editors of the *Rugby Almanack*. Metric measurements are given for those players whose careers were either wholly or mostly after 1975, the year of the introduction of metrication in New Zealand.

Points values given are those applicable at the time, e.g., the points value of a try was increased from three to four at the beginning of the 1972 season in New Zealand.

ABBOTT Harold Louis
b: 17.6.1882, Camerontown *d:* 17.1.1972, Palmerston North
Wing threequarter

Represented NZ: 1905,06; 11 matches – 1 test, 47 points – 15 tries

First-class record: Taranaki 1904 (Inglewood), 1906,14 (Clifton); Wanganui 1907-09 (Pirates); Wellington Province 1907; Taranaki-Wanganui-Manawatu 1904; British Columbia 1906

A very fast and strong wing, 'Bunny' Abbott began his rugby career in army matches in South Africa while serving in the Boer War. Along with Bill Cunningham, he was added to the 1905-06 'Originals' after the preliminary tour of New South Wales. His statistics for this tour were given as 5' 10½" and 13 stone.

A poisoned leg restricted his appearances on the British tour but he played in the French international, scoring two tries (one from inside his own 25) and a conversion. Played against British Columbia at San Francisco on the way home from Britain but in the return match the Canadians were short because of injuries and Abbott took the field against the All Blacks, scoring a try for his adopted team. Also played against the 1907 New Zealand team for Wellington Province.

Abbott captained Wanganui against the 1908 Anglo-Welsh tourists but retired from first-class football after the 1909 season. He returned to Taranaki and represented that union again in

'Bunny' Abbott

1914 before giving up the game. He was also a noted professional sprinter. His son, Lionel, represented Wellington 1944-46,49-52,54 and a New Zealand XV 1944.

ADKINS George Thomas Augustus
b: 21.8.1910, Timaru *d:* 24.5.1976, Timaru
Prop

Represented NZ: 1935,36; 11 matches, 6 points – 2 tries

First-class record: South Canterbury 1929-34, 36-39 (Star), South Island 1934; NZ Trials 1934,35; Rest of New Zealand 1934

Educated Timaru Main Primary and Timaru Boys' High School. As a 14½ stone prop, standing almost six feet, Adkins played extremely well in the early matches of the 1935-36 British tour and was seriously considered as a test candidate. He appeared 51 times for his union over a decade.

South Canterbury RFU president 1974.

AITKEN George Gothard
b: 2.7.1898, Westport *d:* 8.7.1952, Wellington
Centre threequarter

Represented NZ: 1921; 2 matches – 2 tests

First-class record: Buller 1914,15 (Westport); Wellington 1917-22 (University); North Island 1921; NZ Trials 1921; NZ Universities 1921, Scotland 1924,25,29; Oxford University 1922,24; Barbarians (UK) 1922-25

Educated Westport High School, 1st XV 1916. First played for Buller as a 16-year-old. A speedy and resourceful threequarter usually playing at centre, Aitken stood 5' 9" and weighed 12st 4lb.

Made his debut for New Zealand and captained the team in the first two inter-nationals against South Africa 1921 – the youngest NZ captain in an international until 1929.

Awarded a Rhodes Scholarship 1922, studying at Oxford and winning blues there, also eight caps for Scotland playing against England, Ireland and Wales 1924,25 and v France 1925,29. Won Wellington and NZ Universities 440yd hurdles titles and runner-up in that event at the 1919 NZAAA championships.

ALGAR Beethoven

b: 28.5.1894, Wellington *d:* 28.11.1989, Levin
Five-eighth and threequarter

Represented NZ: 1920,21; 6 matches, 9 points – 3 tries

First-class record: Wellington 1914,15,19-22 (Poneke); North Island 1919-21

A versatile midfield back whose first-class rugby career was interrupted by war service. Selected as a threequarter for the 1920 tour of Australia, he appeared only twice in that country but played in the three matches at home before and after the tour. Captained the All Blacks v Manawatu-Horowhenua-Wanganui. Next year he played at second five-eighth against New South Wales at Christchurch. Served on the Poneke club committee 1919-27,34,35; club captain 1925,27. His brother, Doug, represented Wellington 1920-22,24.

ALLAN James

b: 11.9.1860, Taieri *d:* 2.9.1934, Hawera
Forward

Represented NZ: 1884; 8 matches, 6 points – 3 tries

First-class record: Otago 1881,82 (Dunedin), 1883,84,86 (Taieri)

Educated Otago Boys' High School. Known as the 'Taieri Giant', Allan weighed 14 stone. Visited Australia with the 1884 New Zealand team, playing three times against New South Wales. Described by the team manager, S.E. Sleigh, as "hard as nails, very fast and always on the ball". One of four brothers who represented Otago.

ALLEN Frederick Richard

b: 9.2.1920, Oamaru
Five-eighth

Represented NZ: 1946,47,49; 21 matches – 6 tests, 21 points – 7 tries

First-class record: Canterbury 1939-41 (Linwood); Marlborough 1944 (RNZAF); Waikato 1944 (Army); Auckland 1946-48 (Grammar); North Island 1946-48; NZ Trials 1947,48; 2nd NZEF 1945,46; Barbarians (UK) 1946

Educated Phillipstown School, Canterbury Primary Schools rep 1933. Showed considerable promise for Canterbury before enlisting in the Army. Served as a lieutenant in the 30th and 27th Battalions during WWII.
Allen made his name as a brilliant five-eighth for the 'Kiwis' in Britain. Captained New Zealand in the two-test series against Australia 1946; led his country to Australia 1947 and South Africa 1949, appearing in two tests in each series. Also captained Auckland and the North Island 1946-48.
Weighing 12st 6lb and standing 5' 10", Fred Allen was one of the greatest post-war All Black

backs playing equally well at either first or second five-eighth. Allen had an outstanding record: as selector-coach of the Auckland team 1957-63, including that province's 26-match tenure of the Ranfurly Shield, and of New Zealand 1966-68, during which time the All Blacks won all 14 tests played. Also served on the New Zealand selection panel 1964,65. Co-author of a rugby coaching book *Fred Allen on Rugby* (Cassell, 1970).

Fred Allen

ALLEN Lewis

b: 30.10.1870, New Plymouth *d:* ?
Centre threequarter and five-eighth

Represented NZ: 1896,97,1901; 11 matches – 32 points – 10 tries, 1 conversion

First-class record: Taranaki 1893-99,1901,03 (Star), Manawatu 1905 (Palmerston North); North Island 1897

Played at centre for New Zealand against Queensland at Wellington 1896, scoring a try. Selected for the 1897 Australian tour on which he scored 23 points. Made his final appearances for New Zealand v Wellington and New South Wales 1901 at second five-eighth. 'Snip' Allen was understood to have later lived in Wellington and Nelson.

ALLEN Mark Richard

b: 27.7.1967, Stratford
Prop

Represented NZ: 1993,95-97; 26 matches – 8 tests, 5 points – 1 try

First-class record: Taranaki 1988-96 (Stratford); Central Vikings 1997; Wellington Hurricanes 1996,97; NZ Development 1990,94; NZ XV 1991,92,94; NZ Divisional 1996; NZ Trials 1991-97; NZRFU President's XV 1995

Allen built up a folk following first in Taranaki and then in the rest of New Zealand based on his rampaging runs with ball in hand, when

Mark Allen

crowds boomed out his nickname, "Bull". It was a catchcry taken up on grounds around the world, whether playing for the All Blacks or leading the Wellington Hurricanes in the Super 12. Shaven-headed and with long shorts, he was an instantly recognisable figure on the field and the modern rugby marketer's dream off it. Rugby Park in New Plymouth became known as "The Bullring" in tribute to him, a name that was retained after his move to the Central Vikings.
Allen was first chosen in the reserves for the All Blacks against Western Samoa in 1993 and made his test debut when he went on as a temporary replacement, which became another hallmark of his All Black career. He toured England and Scotland at the end of the year and played in seven matches. Allen was not required in 1994 or for the World Cup in 1995, but returned to the All Blacks for the tour of Italy and France, playing in four matches. He played another four in South Africa in 1996 and added to his test replacement role in 1997, but by the end of the year he had earned his first run-on place in a test team, against England at Twickenham.

ALLEN Nicholas Houghton

b: 30.8.1958, Auckland *d:* 7.10.1984, Woollongong, NSW, Australia
First five-eighth

Represented NZ: 1980; 9 matches – 2 tests, 28 points – 4 tries, 4 dropped goals

First-class record: Auckland 1978-80 (University), 1983 (College Rifles); Counties 1980 (Manurewa); NZ Juniors 1980; NZ Colts 1978; NZ Universities 1979,80

Educated Remuera Primary, Remuera Intermediate and Auckland Grammar School, 1st XV 1975,76, Auckland Under 16 1974 and Auckland Secondary Schools representative 1975,76.
Included in the 1977 North Auckland squad but played his first representative game the next season for Auckland. Made internal tours with the NZ Colts 1978 and the Juniors 1980 – playing once for the latter team before flying to Australia to replace the injured Wayne Smith in

Nicky Allen

the All Blacks. Allen appeared in three of the last four games in Australia, including the third test, and two in Fiji.

A leg muscle injury kept him out of action for the rest of the domestic season but he was named in the team to tour Wales at the end of the year. Scored a try in the centenary test. Nicky Allen developed into a fine all round first five-eighth.

He represented Auckland in Brabin Cup cricket. Weighed 79kg and was 1.80m.

Allen died from head injuries received in a club match in Australia, where he had lived since 1981.

ALLEY Geoffrey Thomas
b: 4.2.1903, Amberley *d:* 25.9.1986, Upper Hutt
Lock

Represented NZ: 1926,28; 19 matches – 3 tests, 3 points – 1 try

First-class record: Southland 1925,26 (Lumsden); Canterbury 1927,30 (University); South Island 1926,27; NZ Universities 1927; NZ Trials 1927; Otago-Southland 1925

Educated Christchurch Boys' High School, 1st XV 1919-21. Went farming in Southland and entered first-class rugby from that province before attending Canterbury University College. Standing 6' 3" and weighing about 16 stone, Alley normally played as lock in the 2-3-2 scrum.

Toured Australia 1926 and South Africa 1928.

One of the biggest and strongest forwards on the South African tour, he played in the first three tests.

Alley was the author of the tour book *With the British Rugby Team in New Zealand, 1930.*

Won the NZ Universities shot put title 1928 and the Canterbury title 1929. Brother of Rewi Alley of China fame.

ANDERSON Albert
b: 5.2.1961, Christchurch
Lock

Represented NZ: 1983-85,87,88; 25 matches – 6 tests

First-class record: Canterbury 1981,82 (Lincoln College), 1983-90 (Southbridge); South Island 1983,85; NZ Trials 1982,84,87-90; NZ Colts 1980,81; NZ Juniors 1982; South Zone 1987-89; NZ Universities 1982

Educated Southbridge DHS and St Andrews College, 1st XV 1977,78. Played for South Island Under 18 before moving to Lincoln College, from where he made his Canterbury debut.

A principal member of Canterbury's Ranfurly Shield team of 1982-85, Anderson was first chosen for the All Blacks for the tour of England and Scotland at the end of 1983. He played in both tests and in all three tests on the 1984 tour of Australia. He toured Fiji in 1984 and in 1985 toured Argentina. He also went on the rebel Cavaliers' tour of South Africa in 1986. He played against Fiji in the 1987 World Cup and toured Australia the following year.

ANDERSON Brent Leslie
b: 10.3.1960, Lower Hutt
Lock

Represented NZ: 1986,87; 3 matches – 1 test, 4 points – 1 try

First-class record: Wairarapa-Bush 1983-88 (Masterton); Waikato 1989,90 (Frankton), 1991-93 (Marist); North Island 1986; NZ Trials 1986,87; NZ Emerging Players 1986; NZ Divisional XV

Brent Anderson

1988; Central Zone 1987,88; Barbarians 1987
Educated Viard College in Porirua, Anderson played three years' senior rugby for the University club in Dunedin before moving to Auckland in 1980 and not playing any further rugby until beginning with the Masterton club in 1983.

After a trial, the interisland match and the

Emerging Players tour in 1986, Anderson was a reserve for the test against France and played in the first test against Australia when Gordon Macpherson and Brett Harvey were forced out because of injury.

Anderson played in the final trial for the World Cup squad the following year but was not selected, the third lock's position going to his taller namesake from Canterbury, Albert Anderson.

Brent Anderson toured Japan at the end of the year, playing both unofficial tests. He transferred to Waikato at the end of 1988 and was one of the dominant forward pack in Waikato for the next five years when the province won the national provincial championship in 1992 and the Ranfurly Shield from Auckland in 1993.

ANDERSON Eric James
b: 4.4.1931, Whakatane
Prop

Represented NZ: 1960; 10 matches, 6 points – 2 tries

First-class record: Bay of Plenty 1956-59,61 (Rotorua HSOB); NZ Trials 1959-61; Bay of Plenty-Thames Valley 1959

Educated Te Puke Primary and Te Puke District High School, 1st XV 1946,47. A strong, hard working prop, weighing 14st 12lb and standing almost six feet, who gave valuable service to his union over a number of years. Selected for the 1960 South African tour at the age of 29.

Bay of Plenty selector-coach 1974-78 when that province won the inaugural National Championship 1976.

ARCHER James Albert
b: 31.5.1900, Invercargill *d:* 15.7.1979, Oamaru
Wing forward

Represented NZ: 1925; 2 matches

First-class record: Southland 1924,26 (Pirates)

Educated Waimahake School. A fast wing forward who received favourable comment playing for Southland in 1924 when he caught the speedy Canterbury wing, 'Jockey' Ford, from behind.

Played for the 1925 All Blacks against Wellington but a knee injury in the first match of the Australian tour affected the rest of his rugby career. Stood six feet and weighed 13st 11lb.

A professional middle-distance runner and Southland representative rifle shooter.

ARCHER William Roberts
b: 19.9.1930, Gore
Five-eighth

Represented NZ: 1955-57; 12 matches – 4 tests, 15 points – 5 tries

First-class record: Otago 1953,54 (University), 1955 (Pirates); Southland 1956-63,65,66 (Pioneer); South Island 1955,57,59; NZ Trials 1956-61; New Zealand XV 1954,55; Rest of New Zealand 1954,55; NZ Universities 1954

Educated Gore High School, 1st XV 1946-48. 'Robin' Archer was a clever first five-eighth with good hands and a sound defence; weighed 11st 8lb and stood 5' 8". Played in the first two tests

'Robin' Archer

v Australia 1955 and brought back for the first and third internationals against the 1956 Springboks, missing the second test with a rib injury and left the field with a shoulder injury in the third test. Toured Australia 1957 but did not make the test side.

Coached Southland 1973-75,80,81 and Eastern Southland sub-union selector 1971,72 and coach 1976-79. His father, Bill (1927), and a brother, Watson (1957-63), were also Southland representatives. His uncle, Jim Archer, was a 1925 All Black.

ARGUS Walter Garland
b: 29.5.1921, Auckland
Wing threequarter

Represented NZ: 1946,47; 10 matches – 4 tests, 42 points – 14 tries

First-class record: Canterbury 1941,42,46-49 (Linwood); South Island 1946; NZ Trials 1947,48; 2nd NZEF 1945,46; NZ XV 1949

Educated Pleasant Point District High School. Argus was one of the star wings in the 'Kiwis' army team. A powerfully built (13st 5lb and 6' 1"), strong-running wing whose prolific try-scoring made him a great favourite with rugby crowds.

Played in the two tests v Australia at home 1946 and in the two in Australia the following year. His debut international, in New Zealand's 31-8 victory at Dunedin, was marked by two tries. He scored in both the 1947 tests and recorded a further 10 tries in five other matches in Australia.

Selected for the 1949 All Black team to South Africa but forced to withdraw – a significant blow to New Zealand's hopes on that tour. Also missed both home tests against the 1949 Wallabies through injury.

ARMIT Alexander McNaughton
b: 1874, Inverkeithing, Scotland d: 12.11.1899, Dunedin
Wing threequarter

Represented NZ: 1897; 9 matches, 18 points – 6 tries

First-class record: Otago 1893,96-99 (Kaikorai); South Island 1897

Described as "a dangerous man in his opponent's quarter being difficult to stop". An 11$^{1}/_{2}$ stone wing, he toured Australia with the 1897 New Zealand team.

'Barney' Armit died as the result of injury during the second half of the Otago v Taranaki match August 26, 1899. Armit tried to hurdle Taranaki's Alf Bayly but was tackled and landed on the back of his head. The resultant broken neck paralysed him and he died in Dunedin Hospital eleven weeks later. The Otago v Auckland match played the week after the accident was a benefit for him.

ARMSTRONG Adam Loftus
b: 13.4.1878, Carterton d: 30.1.1959, Hastings
Wing forward

Represented NZ: 1903; 5 matches, 3 points – 1 try

First-class record: Wairarapa 1899 (Thursday Union), 1900-05 (Carterton); North Island 1902,03

Toured Australia 1903 playing mostly in minor matches but appeared against New South Wales and Queensland. Weighed nearly 14 stone. Later refereed at first-class level.

ARNOLD Derek Austin
b: 10.1.1941, Balclutha
Second five-eighth

Represented NZ: 1963,64; 15 matches – 4 tests, 24 points – 7 tries, 1 dropped goal

First-class record: Canterbury 1961-70 (Christchurch); South Island 1963-66,69; NZ Trials 1962,63,65-67

Educated Rai Valley Primary, Harewood Airport School and Christchurch West High School, 1st XV 1956-58.

Toured Great Britain, France, and British

Derek Arnold

Columbia with the 1963-64 All Blacks appearing in 15 matches including internationals against Ireland, Wales, England and France, missing the Scottish game with his leg in plaster.

An elusive runner and determined tackler 'Bluey' Arnold weighed 10$^{1}/_{2}$ stone and stood 5' 8". This dynamic but erratic second five-eighth was surprisingly discarded by the All Black selectors after this tour although he continued to represent his province throughout the 1960s.

Player-coach of the Suburbs club in Christchurch 1973, coach 1974. Canterbury selector 1975,76.

ARNOLD Keith Dawson
b: 1.3.1920, Feilding
Flanker

Represented NZ: 1947; 8 matches – 2 tests, 6 points – 2 tries

First-class record: Waikato 1941 (Matamata), 1947,48 (Hautapu); NZ Trials 1947,48; 2nd NZEF 1945,46

Educated Cambridge School. Served in WWII as a private in the 21st Infantry Battalion and made 25 appearances for the 'Kiwis' army team. Exceptionally fast and a deadly tackler, hence his nickname, 'Killer'. Arnold stood 5' 11" and weighed 13$^{1}/_{2}$ stone.

He was omitted from the 1946 home series although many regarded Arnold as the best loose forward in New Zealand. Toured Australia 1947 playing in both tests and scored a try in his international debut. His early retirement from major rugby robbed the game of one of its finest exponents. His brother, A.J. Arnold, represented Waikato 1947-50.

ASHBY David Lloyd
b: 15.2.1931, Mataura
Fullback

Represented NZ: 1958; 1 match – 1 test

First-class record: Southland 1951,55-59 (Mataura); South Island 1957-59; NZ Trials 1957-60

Educated Mataura Primary School and Southland Technical College. A lightweight fullback at 12st 9lb and standing six feet, Ashby's sole game for New Zealand was in the second test v Australia 1958 when Don Clarke was injured. Unfortunate to be a contemporary of Clarke as Lloyd was a competent fullback of the orthodox type and a consistent goalkicker who always played soundly.

Coached the Kaikorai club (Dunedin) 1979. Selector of the Eastern sub-union in Southland 1961.

ASHER Albert Arapeha
b: 3.12.1879, Tauranga d: 8.1.1965, Auckland
Wing threequarter

Represented NZ: 1903; 11 matches – 1 test, 51 points – 17 tries

First-class record: Auckland 1898,1900-04,07 (City); North Island 1902

Educated Tauranga School. Reputed to have played for Tauranga v Auckland in a sub-union match at the age of 13 but this cannot be substantiated.

A player of slight stature, standing less than

5' 6", his nickname of 'Opai' was derived from a racehorse of that name which won the 1898 Great Northern Hurdles – Asher perfected the ploy of jumping over intending tacklers early in his career.

His 17 tries for New Zealand on the 1903 tour remained a record for an All Black in Australia until equalled by Russell Watt in 1957. During this tour Asher was hailed as 'The India Rubber Man' because of his ability to bounce up after being tackled and carry on an attack. Suffered a leg injury as a fire brigadesman in 1904 which forced him to abandon the game for two years. Turned to rugby league 1908 and represented New Zealand 1910,13.

'Opai' Asher

ASHWORTH Barry Graeme

b: 23.9.1949, Waiuku
Flanker

Represented NZ: 1978; 8 matches – 2 tests, 8 points – 2 tries

First-class record: Auckland 1972,74-79,81 (Otahuhu); North Island 1976; NZ Trials 1976,77,79,81

Educated Otahuhu College. Ashworth gave valuable service to Auckland before being selected for New Zealand. Played in the first two tests v Australia 1978, missing the third because of injury.

Toured Britain later in that season and played in six games but did not win a place in the internationals. A rugged flanker with good rugby skills, Ashworth weighed 92kg and was 1.88m. He was not considered for Auckland selection from early in the 1979 season until 1981 because of boundary qualification problems.

ASHWORTH John Colin

b: 15.9.1949, Waikari
Prop

Represented NZ: 1977-85; 52 matches – 24 tests, 4 points – 1 try

John Ashworth

First-class record: Canterbury 1972-76 (Linwood), 1977-84 (Kaiapoi); Hawke's Bay 1985 (Dannevirke HSOB); South Island 1977-82,84; NZ Trials 1975-77,79,80,84

Educated Sefton, Rangiora High and Riccarton High Schools. A loosehead prop weighing 102kg and standing 1.87m, Ashworth toured France 1977 and made his international debut against Australia in the 1978 home series. He replaced Rod Ketels, an original selection, for the tour of Britain and Ireland later that year. Played in both unofficial 1979 internationals against Argentina but was not available for the tour of England and Scotland. Toured Australia and North America and Wales in 1980. From 1981 until 1985, Ashworth when available was a first-choice selection for the All Blacks and he and hooker Andy Dalton and tighthead Gary Knight formed a formidable front row in 24 internationals together.

Ashworth was an integral member of the Canterbury Ranfurly Shield side of 1982-84 but with his move to Hawke's Bay in 1985 it was widely expected that he would retire. Despite little first-class rugby that year, he was chosen for the two domestic tests against England and one against Australia and was retained for the aborted tour of South Africa. He was unavailable for the replacement tour of Argentina but toured South Africa in 1986 with the Cavaliers.

Ashworth was regarded as one of the bulwarks of the All Black scrum and had a reputation as a hard, uncompromising player, gaining much publicity for incidents against Bridgend in 1978 and against Argentina in Dunedin in 1979. He combined with Dalton and Knight in a 1986 biography, *The Geriatrics* (Moa, 1986).

ATKINSON Henry

b: 17.7.1888, Greymouth *d:* 21.7.1949, Dunedin
Lock

Represented NZ: 1913; 10 matches – 1 test, 3 points – 1 try

First-class record: West Coast 1911-13 (Kohinoor); Otago 1914,15 (Southern); South Island 1913

Represented New Zealand against the 1913 Australian tourists and against Wellington prior to touring the Pacific coast of North America.

The biggest man in the 1913 All Blacks, weighing 14st 10lb, Atkinson was described as "distinctly disappointing and having a lot to learn". Prior to the tour he was the centre of a storm when a bogus letter, claiming that he was unavailable to tour North America, was received by the NZRFU.

AVERY Henry Esau

b: 3.10.1885, Wellington *d:* 22.3.1961, Wellington
Wing forward

Represented NZ: 1910; 6 matches – 3 tests

First-class record: Wellington 1905,06,08-10 (Wellington College OB); North Island 1910

Educated Mt Cook School and Wellington College. Sent to Australia to join the 1910 touring team as a reinforcement after captaining Wellington against the All Blacks prior to their departure. Played in all three tests in Australia. Life member Wellington College OB club 1911.

Awarded the DSO 1916 while serving as a lieutenant-colonel with the NZEF. Graduated from Imperial Staff College after WWI and was QMG at army headquarters with rank of brigadier. Honoured with the CMG, CBE and the American Legion of Merit.

BACHOP Graeme Thomas Miro

b: 11.6.1967, Christchurch
Halfback

Represented NZ: 1987-92;94,95; 54 matches – 31 tests, 79 points – 19 tries

First-class record: Canterbury 1988-93 (Linwood), 94,95 (HSOB); NZ XV 1992,93; NZ Colts 1987; South Island 1995; NZ Trials 1988-95; South Zone 1988,89

Graeme Bachop achieved the rare distinction of playing for New Zealand before he had played for his province. Bachop was introduced to the All Blacks at the end of 1987 for the tour of Japan, filling the spot left vacant by David Kirk. Bachop played in three of the matches, including one as a replacement first five-eighth. He played only one game for Canterbury in 1988, but was still required by the All Black selectors, touring Australia as the understudy to the Canterbury and test halfback, Bruce Deans.

Coach Alex Wyllie promoted Bachop to the No 1 position for the test against Wales in November 1989 and he retained his place for the other test of that tour, against Ireland. He consolidated his position in the ensuing seasons, playing series against Scotland, Australia, France, Argentina and in the 1991 World Cup.

With the change of coach to Laurie Mains in 1992, however, Bachop was chosen for only the first of the centenary tests against a World XV and was not required until called to Australia as a temporary replacement. He played in one game. Bachop was brought back for the 1994 series against South Africa and was generally regarded as the outstanding halfback at the 1995 World Cup.

Bachop took up a contract in Japan after the

Stephen and Graeme Bachop

cup and thus became unavailable to New Zealand though a measure of his standing was that coach John Hart, when he took over in 1996, unsuccessfully sought approval from the NZRFU to get Bachop back. Another move, also unsuccessful, was made to secure Bachop for the Otago Highlanders in the 1998 Super 12.

Brother Stephen Bachop also played test rugby, the two appearing together in four tests in 1994.

BACHOP Stephen John
b: 2.4.1966, Christchurch
First five-eighth

Represented NZ: 1992-94; 18 matches – 5 tests, 15 points – 3 tries

First-class record: Canterbury 1986-90 (Linwood); Otago 1992-96 (Southern); Central Vikings 1997; Otago Highlanders 1996; Wellington Hurricanes 1997; NZ Colts 1986,87; NZ XV 1993; Southern Zone 1987-89; NZ Trials 1990,92,93,95; Barbarians 1987; Saracens 1992; Western Samoa 1991

The older brother of halfback Graeme Bachop, Stephen Bachop played international rugby for Western Samoa, on tour in New Zealand and at the World Cup in 1991, before he was chosen for New Zealand. He was selected for the All Blacks' tour of Australia and South Africa in 1992 and played in seven of the matches. He was not required again until the tour of England and Scotland in October and November 1993, when utility back Marc Ellis was chosen to play the tests at first five-eighth.

Bachop finally played his first test for the All Blacks in 1994, being called in for the second match against France after the first had been lost (so was the second). He was retained for the three matches against South Africa that year and one against Australia but was not selected again.

Bachop played four tests for Western Samoa in the 1991 World Cup and for the British Barbarians in 1996.

BADELEY Cecil Edward Oliver
b: 7.11.1896, Auckland *d:* 10.11.1986, Auckland
Five-eighth

Represented NZ: 1920,21,24; 15 matches – 2 tests, 27 points – 9 tries

Ces Badeley

First-class record: Auckland 1916,17,19-21,25,27,28 (Grammar), North Auckland 1926 (Whangarei HSOB); North Island 1919-21; South Island 1922; NZ Trials 1921,24,27

Educated Remuera Primary and Auckland Grammar School, 1st XV 1915. Served overseas with the New Zealand Rifle Brigade in WWI. Toured Australia with the 1920 All Blacks, and appeared in the first two tests against the 1921 Springboks. Captain of the 1924 New Zealand

team to Australia. Stood 5' 7" and weighed 10st 9lb.

Badeley's recurring knee injury was thought to be the reason the captaincy for the 1924-25 tour to Great Britain and France was transferred to Cliff Porter before the team sailed. Competition from Nicholls, Cooke and McGregor, and his knee injury restricted his appearances on this tour to two games.

A brilliant cricketer at school, Badeley scored 189 against Sacred Heart College – an Auckland Grammar 1st XI record for many years. His brother, Victor, was a 1922 All Black.

BADELEY Victor Ivan Roskill
b: 22.11.1898, Auckland *d:* 19.2.1971, Auckland
Threequarter

Represented NZ: 1922; 5 matches, 13 points – 3 tries, 2 conversions

First-class record: Auckland 1917,20-23 (Grammar); North Island 1922; Auckland-North Auckland 1921,23; NZ Trials 1924

Educated Remuera Primary and Auckland Grammar School, 1st XV 1915-18. Described as "a finished player, fast, a good line kicker and a good tackler. Equally reliable on attack and defence and utterly unselfish" . . . and by another critic as "the player with perfect hands".

Toured Australia 1922 when no tests were played. A head injury suffered in the 1924 All Black trials ended his rugby career. His brother, Cecil, represented New Zealand 1920,21,24.

BAGLEY Keith Parker
b: 10.2.1931, Gisborne
Lock

Represented NZ: 1953,54; 20 matches, 3 points – 1 try

First-class record: Poverty Bay 1951,54 (Gisborne HSOB); Waikato 1951 (Hinuera); Manawatu 1952 (University), 1953,54 (Kia Toa); East Coast 1957 (Tauwhareparae), North Island 1952,54; NZ Trials 1953

Educated Gisborne Boys' High School, 1st XV 1947,48. Selected for the 1953-54 All Black tour after playing in three of the 10 trials and the interisland B match. Although he did not displace 'Tiny' White or Nelson Dalzell from the test team, Bagley played in 20 games on the tour and was unlucky not to win All Black selection again.

A hard-working tight forward (15st 6lb and 6' 3½") and an excellent lineout jumper, he earned high praise from the critics for his consistent play.

BAIRD David Lindsay
b: 26.7.1894, Gore *d:* 11.12.1947, Invercargill
Loose forward

Represented NZ: 1920; 9 matches, 17 points – 4 tries, 1 conversion, 1 penalty goal

First-class record: Southland 1913-15 (Star), 1919,20 (Union), 1921 (Nightcaps); South Island 1920

Played eight games for the 1920 All Blacks in New Zealand and Australia as a forward and one at centre against Wellington on the team's

return. Big and fast (he was a noted track sprinter), 'Scotty' Baird had all the attributes of an outstanding loose forward. Captained Southland from the wing forward position when his team won the Ranfurly Shield for the first time, against Wellington in 1920. Baird's effectiveness in keeping the opposition inside backs in check was a decisive factor in Southland's win.

Baird died from injuries received in a mine accident.

BAIRD James Alexander Steenson
b: 17.12.1893, Dunedin *d:* 7.6.1917, France
Centre threequarter

Represented NZ: 1913; 1 match – 1 test

First-class record: Otago 1913 (Zingari-Richmond)

Educated Caversham School. First played senior rugby 1912 then appeared in his three first-class matches in the following year; two for Otago and one test against the touring Australians at Dunedin. He was chosen for the third test in 1913 but an injured hand kept him from playing, and illness prevented him playing in the 1914 season.

Served as a private with the Otago Infantry Regiment in WWI. Died as a result of wounds received in action in France.

BALCH William
b: 17.10.1871, Kaiapoi *d:* 4.4.1949, Christchurch
Wing threequarter

Represented NZ: 1894; 1 match

First-class record: Canterbury 1890-92 (University), 1894,98,99 (Kaiapoi)

Balch, who weighed 12st 3lb, was described by J.K. Maloney in his book *Rugby Football in Canterbury 1929-1954*, as "a great three quarter, a flyer both on the track and on the football field". Also a noted goalkicker. His sole match for New Zealand was against New South Wales at Christchurch 1894.

BALL Nelson
b: 11.10.1908, Foxton *d:* 9.5.1986, Durban, South Africa
Wing threequarter

Represented NZ: 1931,32,35,36; 22 matches – 5 tests, 37 points – 11 tries, 1 dropped goal

First-class record: Wanganui 1927-29 (Wanganui OB); Wellington 1930-32 (Hutt), 1934 (Poneke); North Island 1932; NZ Trials 1930,35

Educated Foxton Public School and Feilding Agricultural High School. A brilliant attacking player, he scored a try in his All Black debut (v Australia at Auckland 1931). Stood 5' 9" and weighed 10st 11lb.

Included in the 1932 New Zealand team to Australia when Ray Williams withdrew. 'Kelly' Ball played in four of the 10 tour matches, including two internationals. Selected for the 1935-36 New Zealand touring team, scoring seven tries in his 17 matches, including the Welsh and English internationals. Retired after a season for Feilding Old Boys and then coached that club 1937.

Nelson Ball

Emigrated to Australia 1947 then South Africa 1948. His brothers, Rex (1931,35) and Ernest (1931) also represented Wellington. His son, Murray (the *Footrot Flats* cartoonist), represented Manawatu 1958-62, Wellington 1963 and NZ Juniors 1959, and appeared in All Black Trials 1959,60. Bill Francis, the 1913,14 All Black, was a cousin.

BARBER Robert John
b: 14.1.1945, Oamaru
Utility forward

Represented NZ: 1974; 5 matches, 16 points – 4 tries

First-class record: North Otago 1963-65 (Excelsior); Canterbury 1967 (Christchurch); Southland 1968-70,72-76,78 (Star); NZ Trials 1967,68,74,75; NZ Maoris 1972-74,76; New Zealand XV 1974

Educated Oamaru North Primary and Waitaki Boys' High Schools. After playing for the NZ Maoris v the Californian 'Grizzlies' 1972 and touring the Pacific 1973, Barber was selected for the 1974 All Black team to Australia and Fiji.

A big flanker (1.90m and 96kg) who could also play at number eight or prop, Barber was described as "a strong, bruising runner, surprisingly fast." His brother, Ian, represented North Otago 1958-60,62-65.

BARRELL Connan Keith
b: 15.4.67, Whangarei
Prop

Represented NZ: 1996,97; 4 matches

First-class record: North Auckland 1990-94, Northland 1995 (Kamo); Canterbury 1995-97 (Sydenham); Canterbury Crusaders 1996,97; Poverty Bay Selection 1996; Hawke's Bay Invitation XV 1996; Northland Invitation XV 1996; Harlequins 1996; North Island XV 1996; Divisional XV 1993,95; NZ A 1997

Con Barrell, a prop who played his first season of first-class rugby as a hooker, had played for seven seasons before first being chosen for the All Blacks, in the first of the expanded tour

groups for the tour of South Africa in 1996. Barrell's elevation coincided with a move from his native Northland to Christchurch, where he played for the Crusaders in the Super 12 and in 1997 was a key member of the Canterbury team that won the NPC.

He played two matches for New Zealand in 1996 and two the following year on the tour of Britain and Ireland.

BARRETT James
b: 8.10.1888, Auckland *d:* 31.8.1971, Hamilton
Loose forward

Represented NZ: 1913,14; 3 matches – 2 tests

First-class record: Auckland 1911-14 (Marist)

Originally played for the City club in Auckland before accompanying Ponsonby on a visit to Australia 1910, then joined Marist on their formation 1911.

Represented New Zealand in the second and third tests against the 1913 Australian tourists. Replaced Mick Carroll who withdrew from the All Black team to Australia 1914 but 'Buster' Barrett played only once on that tour.

BARRY Edward Fitzgerald
b: 3.9.1905, Temuka *d:* 12.12.1993, Auckland
Loose forward

Represented NZ: 1932,34; 10 matches – 1 test, 6 points – 2 tries

First-class record: Wellington 1926-30 (Marist), 1931-36 (Hutt); Wanganui 1940 (Marist); NZ Trials 1934,35

Educated Seadown and Monavale Schools, Pleasant Point District High School and Wellington Technical College. A hard-working forward who enjoyed a long first-class career representing Wellington through 11 seasons and then played for Wanganui in one match.

Ned Barry toured Australia with the 1932 and 1934 All Blacks, appearing in four of 10 matches on the earlier tour and six of nine, including the second test and a match against the Rest of New Zealand, in 1934.

Served on the Bush RFU committee 1948-52; selector 1952. Coached the Silverdale club 1957-60, Thames Valley 1955,56 and Thames Valley-Counties-Bay of Plenty 1955,56. His son, Kevin Barry, represented New Zealand 1962-64 and his grandson, Liam, represented New Zealand 1993,95.

BARRY Kevin Edward
b: 22.4.1936, Lower Hutt
Utility forward

Represented NZ: 1962-64; 23 matches, 26 points – 8 tries (inc. 1 penalty try), 1 conversion

First-class record: Thames Valley 1954 (Mercury Bay), 1962-68 (Paeroa West); Counties 1955 (Ardmore Teachers College), 1956-59 (Papakura), 1960 (Pukekohe); Auckland 1961 (Marist); North Island 1959,62; NZ Trials 1957-63,65,66; Rest of New Zealand 1965, NZ Under 23 1958; Thames Valley-Counties 1966; Bay of Plenty-Thames Valley-Counties 1956

Educated St Joseph's College (Masterton) and Sacred Heart College (Auckland), 1st XV 1953.

Ned Barry

Kevin Barry

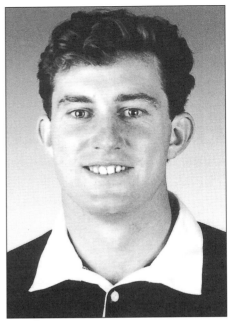
Liam Barry

Toured Japan with the New Zealand Under 23 team 1958 and appeared in All Black trials in nine years.

At 6' 2" and almost 16 stone, Barry was big, rugged and fast. An excellent all-round forward, he played for New Zealand at flanker, number eight and lock, in Australia 1962 and on the 1963-64 British tour.

Barry played in the era of such great All Black forwards as Nathan, Tremain, Graham and the Meads brothers and his 23 appearances in the All Black jersey did not include any internationals.

A son of Ned Barry who represented New Zealand 1932,34. His son, Liam Barry, represented New Zealand 1993,95 and his brother, P.T. Barry represented Counties 1963-66.

BARRY Liam John
b: 15.3.71, Takapuna
Loose forward

Represented NZ: 1993,1995; 10 matches –1 test, 5 points – 1 try

First-class record: North Harbour 1991-96 (East Coast Bays); NZ Colts 1991,92; NZ Trial 1995; NZ Development XV 1994

Liam Barry became the first third-generation All Black when he made his debut on the tour of England and Scotland in 1993. His grandfather, Edward Fitzgerald (Ned) Barry, played 10 matches in 1932 and 1934 and his father, Kevin Edward Barry, played 23 matches for New Zealand from 1962 to 1964. All three Barrys were loose forwards.

Liam Barry was unwillingly involved in controversy on his first tour when Mike Brewer, who was in Britain on business, was drafted into the All Blacks in the final week of the tour and added to the reserves for the England test and the finale, against the Barbarians, ahead of Barry and another touring loose forward, John Mitchell. Brewer took the field against the Barbarians.

Barry's one test appearance was against France in the second test at Paris in 1995. He took up a contract in Japan after the 1996 season.

BATTY Grant Bernard
b: 31.8.1951, Greytown
Wing threequarter

Represented NZ: 1972-77; 55 matches – 15 tests, 180 points – 45 tries

First-class record: Wellington 1970 (University), 1971-75 (Marist-St Pat's); North Island 1973-75; NZ Trials 1970-75; NZ Under 21 1972; NZ Juniors 1972; NZ Universities 1970

Educated St Mary's Convent School (Carterton), Greytown School and Kuranui College, 1st XV

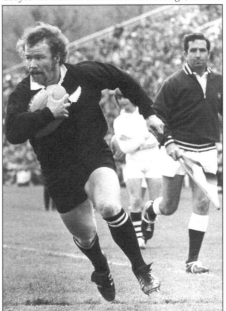
Grant Batty

1967-69. Highly regarded as a schoolboy capable of performing well in every backline position and a Wairarapa junior representative before shifting to Wellington. Played most of his early club rugby as a midfield back but later moved to the wing where he established himself as one of New Zealand's finest threequarters.

Toured Australia 1972 with the NZ Juniors and appeared in 23 matches on the 1972-73 British tour including all five internationals scoring 21 tries (the next best total being eight). His subsequent All Black career included the test v England 1973; nine games, including two tests in Australia and Fiji 1974 (13 tries); v Ireland 1974, the home test v Scotland 1975; 10 matches including all four tests in South Africa 1976, a tour in which he was plagued by a knee injury; the first test v the 1977 Lions in which he scored a brilliant try after an interception 60 metres from the line.

Selected for the second test of that series but withdrew because of his knee injury and announced his retirement from the game. Although Batty moved to Tauranga 1975 and had two more seasons playing for New Zealand, he did not appear in a match for Bay of Plenty.

Grant Batty stood only 5' 5½" and weighed 11 stone. His speed, cleverness and determination made him a favourite with rugby crowds. His biography *Grant Batty* (Rugby Press, 1977) was written by Bob Howitt.

BATTY Walter
b: 1.1.1905, Tonga *d:* 10.5.1979, Auckland
Loose forward

Represented NZ: 1928,30,31; 6 matches – 4 tests, 3 points – 1 try

First-class record: Auckland 1923-32 (Grammar); North Island 1928,29,31; NZ Trials 1930

Educated Auckland Grammar School, 1st XV 1920. Described as "tireless in the loose and lively in the tight, his dribbling rushes being a feature of his play", Batty played in the first game of the 1928 home series against New South Wales and in three tests against the 1930 Lions. Ended his international career as vice-captain of the All Blacks in the 1931 test v Australia. Stood 5' 6" and weighed 12st 12lb.

Served with the 6th Field Regiment during WWII, winning the DCM in Libya. Batty's five brothers were prominent club players in Auckland with Eric representing the union 1934,35.

BAYLY Alfred

b: 20.5.1866, Waitara *d:* 14.12.1907, Wanganui
Centre threequarter

Represented NZ: 1893,94,97; 19 matches, 22
points – 6 tries, 1 goal from a mark

First-class record: West Coast (North Island)
1882 (Hawera); Taranaki 1883,87-89 (Waitara),
1890-92 (Manganui), 1893,94,99,1901
(Stratford), 1895 (Clifton), 1896,97 (Hawera),
1898 (Tukapa); Egmont 1885 (Waitara); North
Island 1894,97

Educated New Plymouth Boys' High School. An
outstanding centre who could play equally well
on the wing or at five-eighth. His provincial
record is remarkable as he represented Taranaki
from six different clubs.
 Leading try scorer on the 1893 Australian tour
with five tries; captain New Zealand v New South
Wales 1894 and led his country on the 1897 tour
of Australia. Captained the North Island in the
first interisland game played in 1897.
 Bayly played only one more season for
Taranaki after the Otago match 1899 when
'Barney' Armit's neck was broken as he
attempted to leap over Bayly's tackle.
 Taranaki RFU president 1899-1906; selector
1891-98,1901,1906. NZRFU president 1907
(died in office); New Zealand selector 1901,05.
Five brothers also represented Taranaki (see
next entry) and Walter played for New Zealand
1894. An older brother, George, also served as
president of the New Zealand Rugby Football
Union 1898.

BAYLY Walter

b: 18.11.1869, Waitara *d:* 20.8.1950, Auckland
Wing forward

Represented NZ: 1894; 1 match

First-class record: Taranaki 1889-94 (Clifton);
North Island 1894

Educated New Plymouth Boys' High School.
Transferred from the Clifton club to Stratford
1894. Represented both New Zealand and North
Island against the visiting New South Wales
team 1894.
 His brother, Alfred, represented his country
1893,94,97 (captain 1894,97) before becoming a
New Zealand selector and president of NZRFU.
Four other brothers, Charles (1889-93), Frank
(1891,92,98-1900), Harry 1883 and George 1883,
represented Taranaki while the latter was
NZRFU president 1898.

BEATTY George Edward

b: 29.3.1925, New Plymouth
First five-eighth

Represented NZ: 1950; 1 match – 1 test

First-class record: Taranaki 1947-50 (New
Plymouth HSOB); North Island 1949; NZ
Trials 1948,50

Educated Fitzroy School and New Plymouth
Boys' High School, 1st XV 1942. His sole match
for New Zealand was the first test against the
1950 Lions. His weight was given as 11st 8lb
and his height 5' 7".
 Accepted an offer to play rugby league in
England for the Leigh club 1950-52 then
transferred to Bellvue Rangers 1953-55 before
returning to Taranaki. Represented his province
at cricket.

BELL James Raymond

b: c 1900, Invercargill *d:* 7.5.1963, Invercargill
Five-eighth

Represented NZ: 1923; 1 match

First-class record: Southland 1919,21-
25,27,29,30 (Star); South Island 1923,25; NZ
Trials 1924,30; NZ Maoris 1922,23,26,27,30,31;
Otago-Southland 1925

Educated Southland Boys' High School. First
represented his province 1919 as a forward but
appeared in most positions, especially five-
eighth and wing forward, during his career of
123 first-class matches. His sole match for New
Zealand was at first five-eighth against New
South Wales 1923. Selected for the 1925 All
Blacks but withdrew. Vice-captain of the 1926-
27 NZ Maoris touring team.
 'Wampy' Bell then gave long service to the
Southland RRA, life member; Star club committee
member, secretary, president, patron, historian
and co-author of the club's jubilee history.
Manager of South Island Maoris 1954 and selector
of South Island Railways teams 1949-54.

BELL Raymond Henry

b: 31.12.1925, Dunedin
Wing threequarter and fullback

Represented NZ: 1951,52; 9 matches – 3 tests,
29 points – 4 tries, 7 conversions, 1 penalty goal

First-class record: Otago 1945,49-52 (Pirates);
South Island 1950-52; NZ Trials 1950,51; New
Zealand XV 1952

Educated Macandrew Road School (Dunedin),
and King's High School. Played one match for
Otago before serving with J Force at the end of
WWII. A strong, hard runner and a useful place
kicker, standing six feet and weighing 13½ stone.
 Toured Australia 1951 and made his
international debut (and scored a try) in the third
test, playing in place of the injured Ron Jarden.
Appeared as fullback in the first test of the 1952
home series v Australia and on the right wing in
the second test. Suffered a severe knee injury
after 10 minutes of this match which finished his
rugby career. Otago selector 1968-71.

BELL Reginald Clive

b: c 1893, Birnie, Tasmania, Australia
d: 19.11.1960, Taieri
Fullback

Represented NZ: 1922; 8 matches, 5 points – 1
try, 1 conversion

First-class record: Otago 1921,22 (Pirates);
South Island 1922

Bell's brief representative career commenced in
Otago's match against South Africa 1921. Toured
Australia 1922 and played for New Zealand
against Wairarapa, Manawatu-Wellington XV
and NZ Maoris in the same season.
 Bell was drowned in the Taieri River on a
fishing expedition.

BELLISS Ernest Arthur

b: 1.4.1894, Palmerston North *d:* 22.4.1974,
Taihape
Wing forward and loose forward

Represented NZ: 1920-23; 20 matches –
3 tests, 27 points – 9 tries

First-class record: Wangnui 1914,20
(Moawhanga Huia), 1921-29,31 (Hautapu);
North Island 1920-22; NZ Trials 1921,24; NZ
Services 1918-20

An outstanding wing forward of the early 1920s,
'Moke' Belliss was an automatic All Black
selection. Listed as 5' 11" and 14st 4lb, he was
regarded as a big man in the positions in which

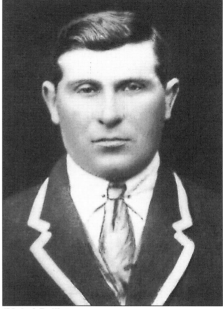

'Moke' Belliss

he played during his era.
 Toured Australia 1920; played in all three
tests against the 1921 Springboks; captained the
1922 All Blacks in Australia and appeared
against the touring New South Wales team 1923.
 His son, E.V. Belliss, represented Auckland
(1937) and Wanganui (1939-41) and a grandson,
Peter Belliss, a champion lawn bowler, also
played for Wanganui.

BENNET Robert

b: 23.7.1879, Dunedin *d:* 9.4.1962, Dunedin
Centre threequarter

Represented NZ: 1905; 1 match – 1 test

First-class record: Otago 1899-1906,08,09,11
(Alhambra); South Island 1904; Otago-
Southland 1904,05

Educated Albany Street School, Dunedin.
Appeared with Colin Gilray and Donald
McPherson in the all-Otago threequarter line
which played for New Zealand v Australia at
Dunedin after the 1905-06 All Blacks had
embarked upon their tour.

BERGHAN Trevor

b: 13.7.1914, Houhora
First five-eighth

Represented NZ: 1938; 6 matches – 3 tests

First-class record: Otago 1937-40 (University);
South Island 1938; NZ Universities 1939

Educated Rawene District High and Rotorua
High Schools, 1st XV 1931,32. Played
for Rotorua and the University club in
Auckland before studying in Dunedin and
representing Otago.

Standing 5' 7¹/₂" and weighing 11st 10lb, Berghan was named as one of the five promising players of the year in the *1937 Rugby Almanack of New Zealand.* Described as "impressing with his sound and steady play". Toured Australia 1938 and played in all three tests. Was one of the outstanding successes of the 1938 tour, making a great impression on the Australian press and rugby public with his incisive running and immaculate passing.

Assistant selector for North Island Services 1944 and coached the University club in Auckland 1947-51.

BERRY Martin Joseph
b: 13.7.1966, Wellington
Utility back

Represented NZ: 1986,1993; 10 matches – 1 test, 9 points – 2 tries

First-class record: Wairarapa-Bush 1985-88 (Greytown), 1991,92,95 (Featherston); Wellington 1989,90,93,94 (Upper Hutt); Manawatu 1996 (HSOB); NZ Trials 1987,93; NZ XV 1992; Divisional XV 1992,93; NZRFU President's XV 1995; Wellington Hurricanes 1996

For a time early in his career, Marty Berry became known as the 18-second All Black, going on in a 1986 test against Australia at Eden Park within the last minute as a replacement first five-eighth. He toured France at the end of that season, but did not play in either test.

Berry, a versatile player who could fit into most backline positions, flitted between Wairarapa-Bush and Wellington and was recalled to the All Blacks in 1993 for the tour of England and Scotland as a late replacement for Walter Little. He played in five of the matches on that tour, hampered by an ankle injury. He moved to Manawatu for the 1996 season and played for the Wellington Hurricanes in the first year of the Super 12. His brief foray onto Eden Park in 1986 remained his only test appearance.

BEST John Jeffries
b: 19.3.1914, Blenheim *d:* 25.5.1994, Blenheim
Loose forward

Represented NZ: 1935,36; 6 matches

First-class record: Marlborough 1933,34,36 (Opawa); Waikato 1937 (Marist); Bay of Plenty 1938,39 (Whakatane City); South Island 1934; NZ Trials 1934,35,37,39; Waikato-King Country-Thames Valley 1937; 2nd NZEF 1941; North Island Smaller Unions 1939; Rest of New Zealand 1934

Educated St Patrick's College (Wellington), 1st XV 1929,30 then transferred to St Patrick's (Silverstream) when that college opened, 1st XV 1931,32. Entered first-class rugby as a 19-year-old.

One of the first 10 players chosen for the 1935-36 British tour, Best was a very fast forward for his size (standing six feet and weighing 14¹/₂ stone) but was unable to find his top form on tour. Played a fine game for Waikato-King Country-Thames Valley against 1937 Springboks.

His father, E.H. Best, represented Wellington 1903,04 and Marlborough 1905-08. His uncle, J.E. Best, played for Nelson and also the South Island in 1911. Best's son, Mark, played for NZ Colts 1974, NZ Juniors 1976 and Marlborough from 1972-79.

BEVAN Vincent David
b: 24.12.1921, Wellington *d:* 26.5.1996, Wellington
Halfback

Represented NZ: 1947,49,50,53,54; 25 matches – 6 tests, 3 points – 1 try

First-class record: Wellington 1943 (Wellington College OB), 1946-49 (Athletic), 1950,51 (Tawa), 1953,54 (Athletic); North Island 1947-49,53; NZ Trials 1947,50,53; New Zealand XV 1949

Educated Otaki Convent School. Served in the North African and Italian campaigns during WWII. Played for the 22nd Battalion team (winners of the Freyberg Cup), 9th Brigade and 8th Army XVs and the 7th Brigade Group.

A nuggety halfback, standing just 5' 5" and weighing about 11 stone, Bevan had an exceptionally long and accurate pass. Toured Australia 1947 but despite excellent form did not play a test. As a part-Maori he was barred from the 1949 tour to South Africa but played in the home series v Australia and in the four tests against the 1950 Lions. Injuries prevented him touring with the 1951 All Blacks to Australia.

Recalled to the All Blacks at the age of 31 for the 1953-54 tour of the British Isles, France and Canada, but kept out of the test sides by Keith Davis.

BIRTWISTLE William Murray
b: 4.7.1939, Auckland
Wing threequarter

Represented NZ: 1965,67; 12 matches – 7 tests, 33 points – 11 tries

First-class record: Auckland 1961 (College Rifles); Canterbury 1962-66 (Christchurch); Waikato 1967 (St Pat's OB), 1968-70 (Hamilton City); South Island 1964-66; North Island 1967; NZ Trials 1963,65-68

Bill Birtwistle

Educated Belmont, Richmond Road and Dominion Road Primary Schools, Balmoral Intermediate and Mt Roskill Grammar School.

Played in all four tests against the 1965 Springboks, scoring two tries during the series. Injuries limited his appearances in 1966 but he

won selection for the 1967 British tour; appeared in eight games including internationals against England, Wales and Scotland. Top try scorer on tour with nine tries, including one against England and one against Wales.

A fast wing (5' 11¹/₂" and 11st 8lb) with a baffling sidestep and capable of scoring some thrilling tries.

A nephew, Mark, represented Counties 1986.

BLACK John Edwin
b: 25.7.1951, Timaru
Hooker

Represented NZ: 1976-80; 26 matches – 3 tests, 12 points – 3 tries

First-class record: Canterbury 1972-74,76-79 (University); South Island 1976-79; NZ Trials 1974,77-80; NZ Juniors 1973,74; NZ Universities 1975-79

Educated Timaru Boys' High School. Canterbury's second string hooker to Tane Norton until the All Black captain retired 1977. A member of the NZ Juniors team which beat the All Blacks on the 1973 internal tour and then visited North America, Ireland and Japan with the 1976 NZ Universities team.

Selected for the 1976 All Blacks to Argentina, Black played in four of the nine games. Appeared in the first test on the 1977 tour of France but Andy Dalton was preferred for the second test and the internationals on the 1978 visit to Britain. Black returned to the test scrum in Australia 1979 and in the final international in that country 1980. An injured back forced him out of the Fijian portion of the tour. Stood 1.83m and weighed 92kg.

BLACK Neville Wyatt
b: 25.4.1925, Kawakawa
First five-eighth and halfback

Represented NZ: 1949; 11 matches – 1 test, 3 points – 1 try

First-class record: Auckland 1948,50,51 (Ponsonby); NZ Trials 1948

Educated Ngongotaha Primary and Rotorua High School. Toured South Africa with the 1949 All Blacks and showed good form as an attacking five-eighth; also appeared at halfback in the third test. His statistics were given as 5' 6¹/₂" and 11 stone.

Accepted an offer from the English rugby league club Wigan 1952; transferred to Keighley 1957. On his return to New Zealand, Black played league for Ngongotaha 1957-60.

BLACK Robert Stanley
b: 23.8.1893, Arrowtown *d:* 21.9.1916, France
First five-eighth

Represented NZ: 1914; 6 matches – 1 test, 9 points – 3 tries

First-class record: Otago 1911,13 (Pirates), 1915 (University); Buller 1914 (White Star); South Island 1912,14

Educated Otago Boys' High School, 1st XV 1909,10. Impressed with his speed and acceleration. Injured in the interisland match 1912 and prevented from playing for the rest of the season. Toured Australia 1914, playing in the first test. Killed in action during WWI.

BLACKADDER Todd Julian
b: 20.9.71, Rangiora
Loose forward and lock

Represented NZ: 1995-97; 12 matches, 10 points – 2 tries

First-class record: Nelson Bays 1990 (Collingwood); Canterbury 1991-93 (Belfast), 1994-97 (Glenmark); NZ Colts 1991,92; NZ Divisional XV 1991; NZ Development 1994; NZ trials 1993,94,96; NZ A 1997; NZ XV 1993; Canterbury XV 1995; Canterbury Crusaders 1996,97; Hawke's Bay Invitation XV 1996

Todd Blackadder

Todd Blackadder was introduced to the All Blacks by coach Laurie Mains for the tour of Italy and France in 1995, the first professional tour by New Zealand, and he played in four of the matches. When Mains's successor, John Hart, introduced an enlarged 36-man party for the tour of South Africa the following year, Blackadder again played four matches.

Adept at either No 8 or the blindside flank, Blackadder led the Canterbury Crusaders and Canterbury with such success in 1997, using the lead-by-example technique, that Hart made him captain of the midweek All Blacks on the tour of Britain and Ireland in November and December.

BLAIR John Alexander
b: c 1872 *d:* 12.4.1911, Porirua
Hooker

Represented NZ: 1897; 9 matches, 5 points – 1 try, 1 conversion

First-class record: Wanganui 1890 (Wanganui), 1891,93-1900 (Kaierau); Wanganui-Manawatu 1894; North Island 1897

Educated Wanganui College, 1st XV 1886. A long-serving forward for Wanganui in the 1890s, Blair was described as "not an outstanding player but a very reliable one who does good work in the scrummages and collars low". Toured Australia 1897 playing in eight of the 10 matches as well as against Auckland after team's return.

BLAKE Alan Walter
b: 3.11.1922, Carterton
Flanker

Represented NZ: 1949; 1 match – 1 test

First-class record: Wairarapa 1941,44,46-55,57-60 (Carterton); North Island 1948,50,52; NZ Trials 1950,53; NZ Maoris 1948-50,52; New Zealand XV 1949; 2nd NZEF 1945,46; Wairarapa-Bush 1948-50,55,59

Educated Wairarapa High School. Represented his province over 20 years in a career interrupted by WWII. An outstanding forward in the 'Kiwis' army team (after serving as a trooper in Italy with the 20th Armoured Regiment), playing 24 games including all five 'internationals'.

Normally a loose forward, standing 6' 2" and weighing 14st 2lb, he also performed well at lock. His sole appearance for New Zealand was in the first test v Australia 1949, but he missed the second encounter because of a family bereavement. Although he played in later trial matches he did not play again for the All Blacks.

Wairarapa selector 1967,68. His brother, Rex, represented Wairarapa 1954-63 and Hawke's Bay 1965-67 and was also an All Black trialist 1957-59. His son, Ian, played for Wairarapa-Bush 1973,75,77,78.

BLAKE John Muldoon
b: 21.6.1902, Hastings *d:* 11.5.1988, Hastings
Threequarter

Represented NZ: 1925,26; 13 matches, 15 points – 5 tries

First-class record: Hawke's Bay 1921,22,24-28 (Celtic); Hawke's Bay-Poverty Bay 1921; North Island 1925,26; NZ Maoris 1921,22; NZ Trials 1924

Educated Hastings Convent School and St Patrick's College (Wellington),1st XV 1918-20. A beautifully balanced runner, normally playing at centre, Jack Blake stood 5' 9" and weighed 10st 9lb.

During Hawke's Bay's tenure of the Ranfurly Shield 1922-27, Blake appeared in 18 challenges and scored 22 tries including five against Wairarapa 1926 when his province reached a record 77 points. Toured Australia 1925 and 1926 – no tests were played on either tour.

His brothers, Bill, Phil and Maurice, all represented Hawke's Bay with the latter two also playing for NZ Maoris.

BLIGH Samuel
b: 8.1.1887, Blacks Point *d:* 25.3.1955, Christchurch
Hooker

Represented NZ: 1910; 5 matches

First-class record: Buller 1907,08,11,13 (Westport); West Coast 1909 (Greymouth); South Island 1909; West Coast-Buller 1908

Toured Australia 1910 appearing in four of the seven matches after earlier playing against Wellington. After captaining Buller, 1913, Bligh transferred to rugby league and played for the Blackball club 1915-21.

BLOWERS Andrew Francis
b: 23.3.75, Auckland
Flanker

Represented NZ: 1996,97; 11 matches – 5 tests, 5 points – 1 try

Andrew Blowers

First-class record: Auckland 1995-97 (Suburbs); Auckland Blues 1996,97; Barbarians 1996; NZ Colts 1995,96; NZ Trials 1996,97

Marked out early in his career as a likely All Black, Blowers was first chosen in the extended party for the tour of South Africa in 1996, where his first two tests were as replacements. He had an injury-hampered 1997 season, missing Super 12 and NPC matches, but was again in the All Blacks for the tour of Britain and Ireland in November and December and was chosen for the first test, against Ireland, ahead of incumbent Josh Kronfeld.

Kronfeld forced his way back into the test team, but Blowers played twice more in internationals as a replacement.

BLOXHAM Kenneth Charles
b: 4.1.1954, Milton
Hooker

Represented NZ: 1980; 2 matches

First-class record: Otago 1974-81 (Tokomairiro), 1982-86 (Taieri); South Island 1980; NZ Trials 1975,77,79,80; NZ Colts 1974; NZ Juniors 1975,76

Educated St Mary's School (Milton) and Tokomairiro High School where he played in the local club's senior team. Represented South Otago and Otago Country 1973 before winning a place in the full provincial side.

Called into the 1980 All Blacks to replace the injured John Black and appeared in two of the three remaining games including the match against Fiji. Bloxham impressed with his quick hooking and good all-round play. Stood 1.83m and weighed 88kg.

BOE John William
b: 23.11.1955, Auckland
First five-eighth

Represented NZ: 1981; 2 matches

First-class record: Waikato 1979-86 (Hamilton Old Boys); NZ Trials 1981,82

Educated Parnell Primary and Auckland Grammar, 1st XV 1973. Boe later moved to the Waikato where he had a long, distinguished career as first five-eighth and, for a period, as the provincial captain.

He was called into the 1981 All Black side touring Romania and France after Doug Rollerson was injured and played in two tour matches.

An adept reader of the game, Boe was also an accomplished goalkicker and scored a record 147 points for Waikato in the 1984 season.

BOGGS Eric George

b: 28.3.1922, Whangarei
Wing threequarter

Represented NZ: 1946,49; 9 matches – 2 tests, 3 points – 1 try

First-class record: Auckland 1941 (Training College), 1942 (Countess of Ranfurly's Own), 1943 (Army), 1944,46-48,50 (Ponsonby); Wellington 1943 (Army); North Island 1943,48; 2nd NZEF 1945,46; NZ Trials 1947,48; Barbarians (UK) 1946

Educated Horahora and Papatoetoe Primary Schools and Otahuhu Technical High School. Came into prominence in the early war years as a powerful, hard-running wing in club, representative and Services teams. Played 22 matches for the 'Kiwis', scoring 15 tries.

First represented New Zealand in the second test v Australia 1946 then returned to the All Blacks for the 1949 South African tour. Injuries limited his appearances to seven provincial games and the first test. Listed as 5' 10" and 12st 12lb for this tour.

Selector-coach 1953 and 1973-77 when Auckland held the Ranfurly Shield 1974-76 and selector of the NZ Teachers' team 1972. QSM 1980.

BOND Jack Garth Parker

b: 24.5.1920, Carterton
Prop

Represented NZ: 1949; 1 match – 1 test

First-class record: Canterbury 1940-43, 1946-52 (Albion); South Island 1949; 2nd NZEF 1945,46; NZ Trials 1947,48

Educated Hornby School. Served as a private with the 26th Battalion during WWII and played 19 games for the 'Kiwis', scoring two tries.

His sole All Black appearance was in the second test v Australia 1949. Standing six feet and weighing 14st 2lb, Bond was a very competent forward, especially with ball at toe.

His father, Percy, represented Wairarapa 1910-12 and the famous McKenzie brothers, Norman and Ted, were his great-uncles.

BOON Roger John

b: 23.2.1935, New Plymouth
Hooker

Represented NZ: 1960; 6 matches

First-class record: Taranaki 1956-60 (New Plymouth HSOB); NZ Colts 1955; NZ Juniors 1958; NZ Trials 1956-60

Educated Central School (New Plymouth) and Wanganui Collegiate, 1st XV 1951,52. Toured Ceylon 1955 with the NZ Colts and Japan 1958

with the Junior All Blacks.

Went to South Africa 1960 as a replacement for the injured Ron Hemi (who recovered to play again later in the tour), Boon had six provincial games. His statistics were given as 14$\frac{1}{2}$ stone and 5' 10$\frac{1}{2}$".

Waverley club coach 1966-69,79. Wanganui selector 1982-84.

BOOTH Ernest Edward

b: 24.2.1876, Teschemakers *d:* 18.10.1935, Christchurch
Fullback and threequarter

Represented NZ: 1905-07; 24 matches – 3 tests, 19 points – 5 tries, 2 conversions

First-class record: Otago 1896 (Athletic), 1900-02,04,06,07 (Kaikorai); South Island 1902,04,07; Otago-Southland 1905; New South Wales 1908,09

Educated Willis Street, The Terrace and Clyde Quay Schools in Wellington. Toured Australia 1905 before departing on the 1905-06 tour to the British Isles, France and Canada where he played in the French international. Appeared in the first and third tests in Australia 1907. Stood 5' 7$\frac{1}{2}$" and weighed 11st 10lb.

Moved to Sydney and represented New South Wales for two seasons and captained the Newtown club against the touring Ponsonby side in what was billed as "the Australasian club championship" (won by Ponsonby 14-6).

'General' Booth accompanied the 1908-09 Australian touring team to Britain as a newspaper correspondent.

BOROEVICH Kevin Grant

b: 4.10.1960, Te Kuiti
Prop

Represented NZ: 1983,84,86; 20 matches – 3 tests

First-class record: King Country 1978-85 (Waitete); Wellington 1986 (Wellington College Old Boys), 1987 (Upper Hutt); North Harbour 1988,89 (Silverdale), 1990,91 (Takapuna); North Island 1983,86; NZ Trials 1983,84,88; North Zone 1988; NZ Juniors 1980; NZ Colts 1978,79; NZ Maoris 1980,82,83,85,86,88

Educated Te Kuiti Primary and High Schools, he came under the early tutelage of All Black great Colin Meads. Boroevich was already an experienced first-class player when chosen, at the age of 23, for the All Blacks' tour of England and Scotland at the end of 1983.

He played in neither of the internationals on that tour nor on the tours of Australia and Fiji in 1984 but he was regarded as an invaluable, hard-working member of the touring parties. Boroevich's big year came in 1986 when he moved to Wellington, which already had established props Brian McGrattan and Scott Crichton. He forced his way into the side with such dynamic play that coach Earle Kirton also made him captain. With the enforced absence of players involved in the unofficial Cavaliers' tour of South Africa, Boroevich made his test debut against France that year and also played in the first test against Australia, losing his place in the return of the Cavaliers. He toured France at the end of the year, going on in the second test as a replacement. Weighed 104.5kg and stood 1.91m.

Two uncles, Percy Erceg and Joe Murray, were Maori All Blacks while Erceg was also an All Black 1951,52 and a Maoris' selector and coach.

BOTICA Frano Michael

b: 3.8.1963, Mangakino
First five-eighth

Represented NZ: 1986-89; 27 matches – 7 tests, 123 points – 13 tries, 19 conversions, 9 penalties, 2 dropped goals

First-class record: North Harbour 1985-89 (North Shore); NZ Trials 1987-89; North Island 1986; North Zone 1987; NZ Colts 1984; NZ Emerging Players 1985,86; NZ Maoris 1985,86,88

Frano Botica, who was educated at Westlake Boys High School, had played for Auckland Colts before joining North Harbour in 1985, its formation year. With the unavailability for two tests of players who had gone on the unauthorised Cavaliers' tour of South Africa, Botica made his test debut against France in 1986, played in the next against Australia in Wellington, and was retained for the remaining four tests that year.

The emergence of Grant Fox, however, meant

Frano Botica

Botica played only one more test after 1986 – in 1989 as a replacement second five-eighth. He was in the World Cup squad in 1987 but did not play a game, and went on the end-of-year tour of Japan, on which one of his three matches was at second five-eighth.

He was a perennial reserve to Fox – against Wales and in Australia in 1988, against Argentina and in Canada, Britain and Ireland in 1989 – despite being acclaimed as one of the best two first five-eighths in New Zealand and a player any other country would have been proud to own. Botica was a gifted goalkicker, as was Fox, but appeared to suffer in the selectors' eyes from an individual flair compared with Fox's steadier play to a team pattern.

He also played for an Anzac XV against the British Isles in Brisbane in 1989 and in 1997 played a World Cup qualifying match for Croatia against Latvia.

Botica switched to league after the 1989 tour and embarked on an illustrious career with Wigan and a season with the Auckland Warriors before the abolition of rugby's amateur regulations allowed him to play for Llanelli. At the end of 1997, Botica was ready to return to New Zealand rugby and signed a contract with North Harbour.

BOTTING Ian James
b: 18.5.1922, Dunedin *d:* 9.7.1980, Christchurch
Wing threequarter

Represented NZ: 1949; 9 matches, 6 points – 2 tries

First-class record: Ashburton County 1942 (Army Service Corps); Otago 1946-48 (University); South Island 1948; NZ Trials 1948; NZ Services 1945,46; Royal Air Force 1945; NZ Universities 1947; England 1950; Oxford University 1949,50; Nottinghamshire, Lincolnshire and Derbyshire 1952,53; Barbarians (UK) 1950

Educated John McGlashan and Christ's Colleges. Established a fine reputation in services teams during WWII while first in the Army and then a pilot in the RNZAF with the rank of flying-officer.

Played for Otago on his return and selected for the 1949 South African tour when Wally Argus withdrew. His statistics were given as 12st 3lb and almost six feet. Won a rugby blue at Oxford University and two caps for England (v Wales and Ireland 1950).

Returned to New Zealand after graduating and took holy orders in the Church of England. A noted track athlete, Botting won triple blues in athletics, cricket and rugby at Otago University 1948.

BOWDEN Noel James Gordon
b: 19.3.1926, Whangarei
Fullback

Represented NZ: 1952; 1 match – 1 test, 3 points – 1 penalty goal

First-class record: Auckland 1947 (Training College), 1954 (Ponsonby); Waikato 1948 (Cambridge United); Taranaki 1950-53 (New Plymouth HSOB); North Island 1952; NZ Trials 1948,53

Educated Ponsonby Primary and Auckland Grammar School, 1st XV 1941-44. Recognised as a brilliant centre at school. Joined the Navy then entered Auckland Teachers' Training College on his return from service.

Played representative rugby at centre, wing and fullback, settling in the latter position. His sole All Black appearance was in the second test v Australia 1952 after a good performance for Taranaki against the tourists. Stood 5' 10" and weighed 12st 2lb. Bowden was a good fielder of the ball with a powerful boot and a good goalkicker. Teachers' club coach 1968-72.

An all-round sportsman, his long-jump record of 22' 6", established in 1944, still stands at Auckland Grammar. Played in the national tennis championships 1949.

BOWERS Richard Guy
b: 5.11.1932, Rawhiti
First five-eighth

Represented NZ: 1953,54; 15 matches – 2 tests, 6 points – 2 tries

First-class record: Wellington 1951-54 (Athletic); Golden Bay-Motueka 1955-58,60,62 (Motueka Huia); South Island 1956; NZ Trials 1953,56; Nelson-Marlborough-Golden Bay-Motueka 1955,56

Educated Nelson College, 1st XV 1949,50. Selected for the 1953-54 tour of Britain, France and North America as a 20-year-old. Weighed 11 stone and stood 5' 7".

After appearing in just three of the first 15 tour matches Guy Bowers was chosen for the international against Ireland after a brilliant display v Combined Services. Despite this, he was dropped for the English and Scottish games but played the final international v France.

Rugby supporters were puzzled when the national selectors discarded Bowers because it was thought he had been chosen initially with an eye to the future. Came into prominence again and appeared to have a chance of making the test side to play the 1956 Springboks.

Golden Bay-Motueka selector 1966-68; South Island Under 16 selector 1972,73. Played 1st XI cricket and shared athletic championship at college 1950. His father, R. Bowers, represented Wellington 1917,18 and Nelson-Golden Bay Motueka against the 1921 Springboks.

BOWMAN Albert William
b: 5.5.1915, Auckland *d:* 20.1.1992, Waipukurau
Flanker

Represented NZ: 1938; 6 matches – 3 tests, 6 points – 2 tries

First-class record: Hawke's Bay 1936-39,47 (Napier Technical College OB); Wellington 1941 (Hutt Army), 1945 (Wellington); Nelson 1946 (Nelson College OB); North Island 1937-39,45; NZ Trials 1939; Seddon Shield Districts 1946; New Zealand XV 1945

Educated Richmond Road, Woodhill and New Lynn Schools and Napier Technical College.

In his book *On With the Game* Norman McKenzie compared Bowman on his 1937 form to Maurice Brownlie and described him as having "everything so far as size is concerned and a very good idea of the requirements of lineout play, in addition to the everyday work of a forward". Toured Australia 1938 appearing in the three tests. His statistics were recorded as 6' 2" and 14st 10lb.

BRADANOVICH Nicholas Martin
b: 13.9.1907, Auckland *d:* 14.4.1961, Pukekohe
Five-eighth

Represented NZ: 1928; 2 matches, 19 points – 2 conversions, 5 penalty goals

First-class record: Auckland 1926 (Marist), 1927 (University); Otago 1928-30 (University); South Island 1928; NZ Universities 1927

Educated Sacred Heart College (Auckland), 1st XV 1924,25. Originally a centre, he moved in to first five-eighth after a few club games and became an immediate success as a quick player who backed up well and was an accurate goalkicker. While studying in Dunedin, Bradanovich played in the first two matches for New Zealand against the touring 1928 New South Wales team.

BRADDON Henry Yule
b: 27.4.1863, Calcutta, India *d:* 7.9.1955, Sydney, Australia
Fullback

Represented NZ: 1884; 7 matches

First-class record: Otago 1883 (Invercargill); New South Wales 1888-90,92

Son of Sir Edward Braddon, the premier of Tasmania, Henry Braddon came to Invercargill 1882 on transfer with the Bank of Australasia.

Selected for the first New Zealand touring team, appearing in seven of the eight games played in Australia 1884. Remained in Sydney after the tour and represented New South Wales including a match against the 1888 British tourists.

New South Wales RFU president 1916-25. Also rowed in the NSW eight in a national carnival. KBE 1920.

BRAID Gary John
b: 25.7.1960, Tauranga
Lock

Represented NZ: 1983,84; 13 matches – 2 tests

First-class record: Bay of Plenty 1981-85,87-88 (Otumoetai Cadets), 1989-91 (Tauranga Sports); North Harbour 1986 (North Shore); NZ Trials 1984,86

Educated Pillans Point Primary and Otumoetai College, Braid was a soccer player at school until 1977 when he switched to rugby, making an immediate impression and playing in the 1st XV and gaining selection for the provincial under 18 side. He also played for Bay of Plenty Under 21 before gaining a regular place in the first-class side.

Gary Braid

Braid was chosen for the 1983 All Black tour of England and Scotland and played in both internationals. He also toured Australia with the 1984 All Blacks, but was not selected for any of the test matches. A front-of-the-lineout jumper, Braid switched to the middle when he moved to North Harbour in 1986 and was one of that side's outstanding players. Weighed 101kg and stood 1.93m.

An uncle, George Wyman, played for Counties in 1961,62 and captained Eastern Canada against the 1967 All Blacks.

BRAKE Leonard John
b: 3.7.1952, Rotorua
First five-eighth

Represented NZ: 1976; 5 matches, 8 points – 2 tries

First-class record: Bay of Plenty 1973-81 (Ngongotaha); NZ Trials 1977

Educated Ngongotaha Primary, Sunset Intermediate and Western Heights High School. A reliable five-eighth who played in five of the nine matches on the 1976 Argentina tour. Standing 5' 8" and weighing 11st 3lb, Brake was an accurate goalkicker and dropkick exponent.

BREMNER Selwyn George
b: 2.8.1930, Otorohanga
Five-eighth

Represented NZ: 1952,56,60; 18 matches –
2 tests

First-class record: Auckland 1952,53 (Grammar); Wellington 1954 (University); Manawatu 1955 (University); Canterbury 1955-59 (University); NZ Trials 1953,60; New Zealand XV 1954-56; NZ Universities 1955-57

Educated Tauranga College and Mt Albert Grammar School, 1st XV 1947. A big, rugged five-eighth, standing 5' 11" and weighing 12st 10lb, 'Mick' Bremner excelled at setting up second phase play.

Introduced into the New Zealand team at second five-eighth for the second test v Australia 1952 but not called upon again until he played at first five-eighth in the second test against the 1956 Springboks. Another four years passed before he was chosen again; toured South Africa 1960 as vice-captain; appearing in 13 games plus three in Australia en route but not selected for the test sides.

Coached the Victoria University club 1963-65,71,72. Represented Auckland in Brabin Cup cricket 1949-51.

BREWER Michael Robert
b: 6.11.1964, Pukekohe
Loose forward

Represented NZ: 1986-95; 61 matches – 32 tests, 49 points – 12 tries

First-class record: Otago 1985,86 (University), 1987-92 (Kaikorai); Canterbury 1993 (Leeston), 1994,95 (Christchurch); South Island 1986; NZ Trials 1986-89,94,95; NZ Colts 1985; NZ Universities 1984,85; NZ XV 1992

Mike Brewer, who was educated at Pukekohe High School, was earmarked early in his career as captaincy material. After playing for NZ Secondary Schools, he moved to Dunedin to attend Otago University. He played no rugby in 1982, but played for Otago Colts in 1983 and by 1985 had been made Otago captain by coach Laurie Mains.

In 1986, he was made South Island captain and leader of a trial team and made his test debut against France for the "Baby Blacks", the side chosen when the Cavaliers were unavailable. He retained his place for the rest of the year.

Injury, a recurring theme in the Brewer career, kept him out of the 1987 World Cup but he went on the tour of Japan at the end of the year. He toured Australia in 1988 but played only the first test when Michael Jones was unavailable because the match was on a Sunday. By 1989, he was a test regular when available, showing marked versatility by playing at No 8, and either side of the scrum.

He was chosen in the World Cup squad in 1991, but forced out when he failed a fitness test

Mike Brewer

on the team's assembly in Auckland. He was soon back playing for Otago, however, and led it to its only national championship title that year.

When Mains took over as All Black coach in 1992, it was no secret he wanted Brewer as his captain but he was injured in a trial match in Napier and the leadership instead went to Sean Fitzpatrick. Injury continued to limit Brewer's appearances in 1992 and 1993 but he was controversially added to the touring party in England and Scotland in 1993 when there on business, and went on as a replacement in the final match.

Brewer had an injury-free year in 1994 and was one of only seven All Blacks to play in each of the six tests that year. He finally played in a World Cup, in 1995, and played his last match for New Zealand against Australia in Sydney that year – the 100th test between the two.

His leadership and organisational qualities were largely held responsible for a resurgence in Canterbury, to where he moved in 1994 to take up a position as marketing manager for Canterbury International, the All Blacks' apparel sponsors, and he achieved one of his dearest ambitions – other than to play in a World Cup – when he led Canterbury in a successful Ranfurly Shield challenge.

Brewer later in 1995 moved to Ireland for business reasons and he played and coached successfully there and in Britain. He played for the British Barbarians in 1996. His biography, *Mike Brewer* – written in conjunction with Phil Gifford – was published in 1995 (Rugby Publishing).

BRISCOE Kevin Charles
b: 20.8.1936, New Plymouth
Halfback

Represented NZ: 1959,60,62-64; 43 matches – 9 tests, 55 points – 10 tries, 8 conversions, 3 penalty goals

First-class record: Taranaki 1957-65 (Tukapa); North Island 1959,63,65; NZ Trials 1959,63,65; New Zealand XV 1958,65; NZ Under 23 1958; SARB Jubilee matches 1964

Educated Fitzroy Primary and New Plymouth Boys' High School. After touring Japan with the 1958 Juniors, he replaced his Taranaki rival Roger Urbahn at halfback for the second test against the 1959 Lions.

Injured his ankle before the third test and Urbahn regained his place for the rest of the series.

Chosen as second-string halfback (to Urbahn) for the 1960 South African tour but because of his fine play earned a place in all four tests. Toured Australia in 1962 but was deposed by Des Connor as test halfback until the 1963-64 tour of the British Isles where he appeared in the first four internationals, before finally giving way to Chris Laidlaw in France.

A stocky, powerful player whose playing weight varied from 11st 10lb to 12½ stone and whose height was given as 5' 3" in statistics for the 1959 and 1960 teams but who had 'grown' to 5' 7" by 1963.

'Monkey' Briscoe was described by Terry McLean as "tough, courageous, pugnacious and incessantly energetic". A useful goalkicker when required to deputise.

BROOKE Robin Matthew
b: 10.12.1966, Warkworth
Lock

Represented NZ: 1992-97; 50 matches – 44 tests, 20 points – 4 tries

First-class record: Auckland 1987,89-97 (Marist); Auckland Blues 1996,97; New Zealand B 1991; NZ XV 1991; NZ Colts 1987; NZ Maoris 1987,89-92; NZ Development 1990; NZ Trials 1991,95-97; North Island 1995; North Zone 1989; Northern Zone Maoris 1988-92

Robin Brooke was educated at Mahurangi College where he played in the first XV for four years, for North Island Under 16 and 18, New Zealand Under 17 and New Zealand Secondary Schools. He made his debut for Auckland in

Robin Brooke

1987 against Queensland and in the same year he played for the New Zealand Colts and Maoris.

It took longer than expected for him to be chosen for the All Blacks, however, and he made his debut against Ireland in 1992, when he

partnered Ian Jones for the first time, and was retained for each of the tests on the tour of Australia and South Africa. He played in each of the five domestic tests in 1993 (against the British Isles and Western Samoa) but because of injury didn't play a match on the tour of England and Scotland. Injury also restricted him to two tests in 1994 and it may be indicative that of the six tests he missed in 1993-94 four were lost. His absences from Auckland also made that side look more vulnerable.

He played in four of the World Cup matches in 1995 and had an unbroken test run after that, he and Jones forming a formidable lineout combination and being integral members of the All Black tight five. Brooke's innate ball skills made him an added asset in the loose.

Brother Zinzan was an All Black fixture for all of Brooke's career and another brother, Marty, also played for Auckland and Southland, with a sojourn in Japan in between.

BROOKE Zinzan Valentine

b: 14.2.65, Waiuku
Loose forward

Represented NZ: 1987-97; 100 games – 58 tests, 190 points – 41 tries (24 worth 4 points), 3 dropped goals

First-class record: Auckland 1986-97 (Marist); NZ Trials 1989,91,93,94,96; NZ Colts 1985,86; NZ Maoris 1986,88,92-94; North Island 1995; North Zone 1988,89; Barbarians club 1986; Auckland Blues 1996,97

One of the most skilful forwards to have played for the All Blacks and one of the most versatile

Zinzan Brooke

and durable. He entered first-class rugby in 1986 as Murray Zinzan Brooke but changed his names by deed poll to take family history into account. Brooke, who was educated at Mahurangi College, impressed with the national Colts side but it was playing for the New Zealand sevens team in 1987 that established his reputation as a player with the build of a forward but the skills and flair of a back. He was chosen for the 1987 World Cup squad after the unavailability because of injury of Mike Brewer and played in the pool match against Argentina on the openside flank, scoring the first of his 41 tries for New Zealand.

Brooke toured Japan at the end of 1987 and Australia in 1988 but didn't play another test until 1989 when he replaced Michael Jones – as he'd done in his first test, against Argentina at Athletic Park. He was then seen as the deputy to captain Wayne Shelford at No 8 and when Shelford was dropped after the two-test series against Scotland in 1990, Brooke took over. His test appearances continued to be spasmodic, however, partly because of injury and partly because of the caprices of selectors. It was only relatively late in his career that he became the regular first-choice No 8 after being played on occasions there or either of the flanker positions.

He played in five of the matches in the 1991 World Cup and four in the 1995 cup, during which he kicked a dropped goal against England, the first of three in tests.

Brooke became Auckland captain after Sean Fitzpatrick was made captain of the All Blacks and he also led the Auckland Blues in the first two years of the Super 12, winning the title both years.

For all Brooke's standing in rugby, he also had a touch of wanderlust and evidently signed a contract with the Sydney league club, Manly, before changing his mind and later was on the verge of going to play in Japan before commercial deals were struck to keep him in New Zealand. Brooke signed with the London club, Harlequins, during 1997 and the All Blacks' tour of Britain and Ireland in November and December was his swansong – though it may pay to be wary about writing finis to Brooke's career.

Brooke received the ultimate compliment from All Black coach John Hart when he said there would never be another player like him.

His 17 tries in tests were a world record for a forward. Many of his more than 150 tries in his first-class career came from pushover tries at the base of the dominant Auckland pack, but the nature of the tries don't detract from the skill and competitiveness of one of the All Black giants of the 1990s, and one to live with the giants of the past.

Brooke's biography, *Zinny* (Rugby Publishing, 1995), was written in collaboration with Alex Veysey.

BROOKE-COWDEN Mark

b: 12.6.1963, Auckland
Flanker

Represented NZ: 1986,87; 7 matches – 4 tests, 16 points – 4 tries

First-class record: Auckland 1984-87 (Ponsonby); North Island 1986; NZ Maoris 1985,86; NZ Trial 1987; North Zone 1987

Brooke-Cowden, who was educated at Mt Albert Grammar, made his Auckland debut in 1984 and established his place in the side in the following year. He was first chosen for the All Blacks in 1986 to play France and the first test against Australia while the Cavaliers were unavailable because of their unauthorised tour of South Africa. Brooke-Cowden lost his test place but was retained for the tour of France at the end of 1986.

He was in the 1987 World Cup squad and played in the semifinal against Wales, in which he scored a try. That was the end of his rugby career because soon after the cup he signed for the English league club, Leeds.

Three uncles, Leon (1977-79), Ness (1970-71) and James Toki (1963-64), played for New Zealand Maoris and a great-grandfather, Wiri Nehua, was a member of the 1888-89 Native team that toured Britain and Australia.

BROOKER Frank Jenner

b: 11.10.1876, Christchurch *d:* 25.7.1939, Wellington
Flanker

Represented NZ: 1897; 4 matches

First-class record: Canterbury 1897 (Merivale); South Island 1897

An exceptionally tall player (at 6' 4") for his era, Brooker had not played in a representative match when called upon to replace an original selection who withdrew from the South Island team which contested the first interisland match 1897.

Included in the New Zealand team to tour Australia in the same year when Francis Young was unable to travel. His selection was a major surprise and attracted much criticism at the time. Played his sole match for Canterbury after the tour.

BROWN Charles

b: 19.12.1887, New Plymouth *d:* 2.4.1966, New Plymouth
Halfback

Represented NZ: 1913,20; 11 matches – 2 tests, 5 points – 1 try, 1 conversion

First-class record: Taranaki 1909,10 (Star), 1911-14,20,22 (Tukapa); North Island 1911,20; NZ Services 1919,20

Educated Central School (New Plymouth). Brown enjoyed a long first-class career for his province and was one of the few All Blacks to represent his country both before and after WWI. Appeared in the second and third tests against the 1913 Australians and also appeared as a guest player for a Maori XV against Australia in a benefit match.

Served as a corporal with the Field Engineers and played rugby for the NZ Division team which won the Somme Cup in France then took part in the King's Cup competition in Britain before captaining the NZ Army side which visited South Africa 1919. Toured Australia with the 1920 All Blacks.

After his retirement from playing Brown served as Tukapa club coach 1922-39, life member 1924. Taranaki RFU selector 1925,32-46; management committee 1940-50. North Island selector 1947,48. New Zealand selector 1944. His brother, Claude, represented Taranaki 1928-41 and was an All Black trialist 1935.

BROWN Handley Welbourne

b: 29.8.1904, Inglewood *d:* 5.12.1973, New Plymouth
Centre threequarter

Represented NZ: 1924-26; 20 matches, 35 points – 8 tries, 4 conversions, 1 penalty goal

First-class record: Taranaki 1923 (New Plymouth Boys' High School), 1925-30 (New Plymouth HSOB); NZ Trials 1924,27; Taranaki-Wanganui 1925

Educated New Plymouth Boys' High School, 1st XV 1921-23 from where he represented Taranaki on three occasions.

Regarded as a brilliant centre he was selected for the brief tour of Australia 1924 at the age of 19, when playing with the Hawera club, and later that season was included in the British tour. Called in to the 1926 team to Australia when Fred Lucas withdrew. His playing weight

was 11½ stone and he stood almost 5' 10".

Brown's son, Ross, represented New Zealand 1955-59,61,62 and another son, Donald, played for Taranaki 1954 and King Country 1957. A younger brother, Henry, was a member of the 1935-36 All Black team.

BROWN Henry Mackay

b: 14.6.1910, New Plymouth *d:* 1.6.1965, New Plymouth
Wing threequarter

Represented NZ: 1935,36; 8 matches, 15 points – 5 tries

First-class record: King Country 1930 (Taumarunui); Auckland 1933 (College Rifles), 1935 (Otahuhu); Poverty Bay 1938 (Gisborne HSOB); NZ Trials 1935

Educated New Plymouth Boys' High School. After three trial matches he was included in the 1935-36 All Blacks as a 5' 8", 10st 11lb winger. The team's vice-captain, C.J. Oliver, commented in his tour book that Brown "was not good enough to displace other wings and hardly came up to the recognised New Zealand standard. Towards the end of the tour he played with more confidence and his try at Aberdare (v Welsh Mid-Districts) was one of the best scored on tour."

An older brother, Handley, represented New Zealand 1924-26.

BROWN Olo Max

b: 24.10.1967, Apia, Western Samoa
Prop

Represented NZ: 1990,92-97; 63 matches – 50 tests, 20 points – 4 tries

First-class record: Auckland 1989-97 (Ponsonby); NZ Trials 1990-95,97; NZ XV 1991; NZ Development 1990; Auckland Blues 1996,97; North Island 1995; Barbarians 1997

Olo Brown came to New Zealand at an early age and was educated at Mt Albert Grammar School. He played for Auckland and North Island under 18 and New Zealand Secondary Schools in 1985 and for Auckland Colts in 1987

Olo Brown

before making his Auckland debut in 1989.

He first played for the All Blacks in France in 1990 when he was added to the side in the last stages of the tour because of an injury to Graham Purvis. He had been with the New Zealand Development team in Canada.

He wasn't required in 1991 but made the breakthrough in 1992 when coach Laurie Mains chose him for the second test against Ireland after Richard Loe had been injured in the first. On the following tour of Australia and South Africa, Brown gained a regular test place at the expense of Steve McDowell and has played in each test since for which he has been available.

The All Black front row of tighthead Brown, Sean Fitzpatrick and Craig Dowd from 1995 was a formidable combination not just for New Zealand, but also for Auckland and the Auckland Blues. Brown has also played occasional games for Auckland at hooker.

After rugby turned professional, Brown, who is an accountant, was one of the few elite players to continue a parallel career.

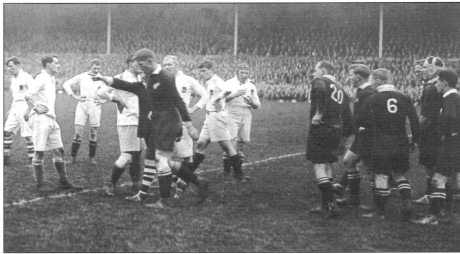

Cyril Brownlie is sent off by referee Albert Freethy in the 1925 England test.

BROWN Ross Handley

b: 8.9.1934, New Plymouth
Five-eighth and centre threequarter

Represented NZ: 1955-59,61,62; 25 matches – 16 tests, 27 points – 7 tries, 2 dropped goals

First-class record: Taranaki 1953-68 (New Plymouth HSOB); North Island 1954,56,58,61,62; NZ Trials 1956-59,61,62,65; New Zealand XV 1956,58; Rest of NZ 1955; NZ Under 23 1958

Educated Central School (New Plymouth) and King's College, 1st XV 1951,52, also captained 1st cricket XI and athletic champion. First represented Taranaki as an 18-year-old and selected for the North Island the following year, making his All Black debut in the third test v Australia 1955.

Played all four tests against the 1956 Springboks, three at centre and the fourth at first five-eighth. Toured Hong Kong and Japan with the 1958 Juniors as a first five-eighth and played in that position for the 1957 All Blacks in Australia.

Against the 1958 Wallabies he played two tests at first five-eighth and the third at second five-eighth. Dropped after playing at first five-eighth against the 1959 Lions but recalled as centre for the third test. Brown was not available for the 1960 South African tour but selected in four later tests, all at second five-eighth, three against France 1961 and the first test in Australia 1962 – his last international.

A brilliant runner with the ball and an excellent dropkicker, the versatile Ross Brown stood 5' 9" and weighed between 11½ stone and 12st 3lb during his playing career.

When he retired from the game in 1968, he had appeared in 207 first-class matches. Taranaki selector 1971,72. Son of the 1920s All Black Handley Brown and nephew of Henry Brown, a 1935 All Black. His brother, Don, represented Taranaki 1954 and King Country 1957. A son, Andrew, played for Manawatu 1985 and Taranaki 1986.

BROWNLIE Cyril James

b: 6.8.1895, Wanganui *d:* 7.5.1954, Wairoa
Loose forward

Represented NZ: 1924-26,28; 31 matches – 3 tests, 33 points – 11 tries

First-class record: Hawke's Bay 1922-26 (Hastings), 1927 (Waiau), 1930 (Wairoa Pirates); North Island 1924,25,27; NZ Trials 1924,27; Hawke's Bay-Poverty Bay-East Coast 1923

Educated Sacred Heart College (Auckland), 1st XV 1911,12.

Standing 6' 3" and weighing 15 stone, Cyril Brownlie was a huge forward for his era. His career spanned nine years and included 90 first-class matches. Toured Australia 1924 and 1926; the British Isles, France and Canada 1924-25 (including internationals against Wales, England and France) and South Africa 1928.

During the 1925 English match Brownlie became the first player to be ordered off in an international when he was sent off by the referee following an altercation, although he was perhaps unfortunate in being singled out as the prime offender.

Elder brother of Maurice and Laurence Brownlie, both of whom represented New Zealand in the 1920s.

BROWNLIE Jack Laurence

b: 25.11.1899, Makirikiri *d:* 8.10.1972, Napier
Loose forward

Represented NZ: 1921; 1 match

First-class record: Hawke's Bay 1921 (Hastings)

Educated Sacred Heart College (Auckland), and St Patrick's College (Wellington). A knee injury

forced him to give up the game after a short first-class career of six matches for Hawke's Bay and one appearance for New Zealand v New South Wales 1921.

The youngest of the three Brownlie brothers, Laurence was the first to win All Black honours.

BROWNLIE Maurice John
b: 10.8.1897, Wanganui *d:* 21.1.1957, Gisborne
Loose forward

Represented NZ: 1922-26,28; 61 matches – 8 tests, 63 points – 21 tries

First-class record: Hawke's Bay 1921-27 (Hastings), 1929,30 (Wairoa OB); North Island 1922-25,27; NZ Trials 1924,27; Hawke's Bay-Poverty Bay 1921; Hawke's Bay-Poverty Bay-East Coast 1923

Educated Hereworth School, Sacred Heart College (Auckland) and St Patrick's College (Wellington), 1st XV 1912,13. After serving in WWI he made his first-class debut for Hawke's Bay and the following year was appointed captain of that union and represented the North Island and New Zealand.

One of the most outstanding loose forwards of all time, Brownlie was an automatic choice for his province during its long Ranfurly Shield tenure and for the All Blacks over much of the decade.

He toured Australia 1922,24 and 26; played in all four internationals for the 1924-25 'Invincibles' and then captained the 1928 All Blacks to South Africa, leading the team in all four tests.

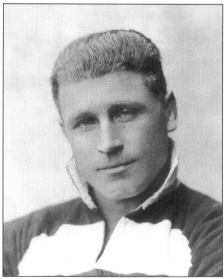

Maurice Brownlie

In his book *On With the Game*, the Hawke's Bay selector of the 1920s, Norman McKenzie, described Maurice Brownlie as "the greatest man I have ever seen as a side-row forward because he was great in every aspect of forward play. He could handle the ball like a back, he could take the ball in the lineout and burst clear, he could stimulate movements and, greatest of all, he had the ability to lead his forwards out of a tight corner, yard by yard, along the touchline. For sheer tenacity I have seen nothing to equal Maurice Brownlie. His outstanding qualities were strength and resolution. He was in every respect a remarkable man and one of the finest physical specimens of manhood I have ever seen." Brownlie stood six feet and weighed around 14 stone.

Some critics are of the opinion that he played

his finest match after his brother Cyril was ordered off in the 1925 English international. He was said to play like a man possessed. The try he scored in this game was described by the English captain, W.W. Wakefield, in his book *Rugger:* "I could see him going straight down the touchline, though it seemed impossible for him to score. Somehow he went on, giving me the impression of a moving tree-trunk, so solid did he appear to be and so little effect did various attempted tackles have upon him. He crashed through without swerving to right or left and went over for one of the most surprising tries I have ever seen."

The second of the three All Black Brownlie brothers, Maurice was also a noted boxer, reaching the NZ amateur heavyweight final 1921 where he was beaten by Brian McCleary, who was to join Brownlie in the 'Invincibles' scrum.

BRUCE John Alexander
b: 11.11.1887, Wellington *d:* 20.10.1970, Wellington
Loose forward

Represented NZ: 1913,14; 10 matches – 2 tests, 6 points – 2 tries

First-class record: Wellington 1909,10 (St James), 1921 (Athletic); Auckland 1911-15 (City); North Island 1909,12-14; NZ Services 1918,19

Educated Te Aro School. Toured North America with the 1913 All Blacks but a poisoned leg restricted his appearances. Played in the first and second tests on the 1914 Australian tour.

Served in WWI with the Field Engineers and was selected for the NZ Army team which contested the King's Cup and then toured South Africa.

Represented Wellington at cricket on eight occasions and scored a double century in club play.

BRUCE Oliver Douglas
b: 23.5.1947, Dunedin
First five-eighth

Represented NZ: 1974,76-78; 41 matches – 15 tests, 51 points – 6 tries, 2 penalty goals, 7 dropped goals

First-class record: Mid Canterbury 1967-69 (Ashburton HSOB); Canterbury 1970 (Christchurch), 1971-75,77,78 (Oxford), 1976 (Ohoka); South Island 1970,73,74,77; NZ Trials 1971,73-78; NZ Juniors 1970

Educated Leeston Primary, Southbridge District High, Ashburton High School, 1st XV 1965,66. Played senior rugby in his first year out of school and represented Mid Canterbury, for whom he played 26 games in three seasons. Moved to Canterbury 1970 and was that union's regular first five-eighth for nine years.

Toured Australia 1974, playing eight games but kept out of the test side by Duncan Robertson. Included in the short British tour 1974 but did not make his international debut until 1976 when he played three tests among 13 matches in South Africa.

Doug Bruce established himself as New Zealand's top first five-eighth and went on to play three tests against the 1977 Lions, two in France 1977, two against the 1978 Wallabies and four in the British Isles 1978.

A sound, reliable player, standing 1.78m and

Doug Bruce

weighing 74kg, Bruce was a prolific kicker of dropped goals – his two v Ireland 1978 were a record for a New Zealander in a test match. One of the "Five Players of the Year" in the *1977 DB Rugby Annual* and described as a "cool, commanding footballer . . . possessing flawless hands and a polished boot." He was assistant coach to Alex Wyllie during Canterbury's Ranfurly Shield era of 1982-85 and coach in 1987 and 1988.

BRYERS Ronald Frederick
b: 14.11.1919, Raetihi *d:* 20.8.1987
Lock

Represented NZ: 1949; 1 match – 1 test

First-class record: King Country 1941 (Raetihi), 1946,49 (Taumarunui Athletic); NZ Maoris 1945,46,49; North Island Services 1945; Taranaki-King Country 1946; New Zealand XV 1949

Educated Ohakune District High School, 1st XV 1934-37. Played much of his early football both in the backs and as a loose forward but settled into the lock position 1941.

Served with the 34th Infantry Battalion and established a reputation as a forward of great ability in service games. Represented NZ Maoris v Australia 1946 and captained King Country in that season. Injuries kept him out of rugby 1947,48 then he was chosen for his sole All Black match in the first test v Australia 1949.

Standing 6' 2" and weighing 17$\frac{1}{2}$ stone, Bryers was a strong rucking forward and a surprisingly fast runner with the ball in the loose.

Served as selector for Bay of Plenty 1962-73 and NZ Maoris 1957,58.

BUCHAN John Alexander Shepherd
b: 17.6.1961, Auckland
Hooker

Represented NZ: 1987; 2 matches

First-class record: Canterbury 1985-88 (University), 1989-91 (Ashley); South Island 1986; NZ Emerging Players 1986; South Zone 1987-89; NZ Universities 1985,86; South Island Universities 1985; Barbarians 1987

John Buchan was chosen for the All Blacks' tour of Japan at the end of 1987, a team that was a mixture of the victorious World Cup players and others.

Buchan played two of the games, against Japan B and Asian Barbarians, but was not again required by the national selectors.

BUDD Alfred
b: 22.1.1880, Timaru *d:* 7.11.1962, Melbourne
Loose forward

Represented NZ: 1910; 3 matches

First-class record: South Canterbury 1903,04,06,08 (Star)

Educated Timaru Main School. Replaced Alf Mitchell who withdrew from the 1910 New Zealand team to Australia. Budd remained in Australia after the tour and settled in Melbourne.

BUDD Thomas Alfred
b: 1.8.1922, Bluff *d:* 8.3.1989, Whangarei
Lock

Represented NZ: 1946,49; 2 matches – 2 tests

First-class record: Southland 1946-52 (Bluff); South Island 1946,49; NZ Trials 1947,48,50

Served in the Southland Regiment of the 1st Battalion and began his first-class career playing service rugby. Selected for his province and the South Island in his first post-war season.

Reserve for the first test v Australia 1946 then won his cap in the second encounter, but was not called upon again until the second test v Australia 1949.

At 6' 1" and 14 stone, Budd matured into a rugged lock who was among the most capable in the country towards the end of his career. His brother, H.G. Budd, represented Southland 1945.

BULLOCK-DOUGLAS George Arthur Hardy
b: 4.6.1911, Wanganui *d:* 24.8.1958, Wanganui
Wing threequarter

Represented NZ: 1932,34; 15 matches – 5 tests, 45 points – 15 tries

First-class record: Wanganui 1931 (Wanganui), 1932-36 (Wanganui and OB); North Island 1931-33; NZ Trials 1934,35

Educated Gonville School, Auckland Grammar School and Wanganui Collegiate, 1st XV 1927,28. A speedy wing and prolific try scorer whose best-remembered game was the 1932 interisland fixture when he scored five tries in the North's winning total of 28 points. He recorded tries in each of his other two appearances for the North Island.

Toured Australia 1932 playing in the three tests and again in 1934 appearing in both tests. His All Black statistics were given as 5' 9" and 11st 5lb.

His father George Bullock was a foundation member and the first secretary of the Kaierau club in Wanganui, while an uncle played for Taranaki and Wanganui.

BUNCE Frank Eneri
b: 4.2.1962, Auckland
Centre threequarter and second five-eighth

Represented NZ: 1992-97; 69 matches – 55 tests, 131 points – 27 tries

Frank Bunce

First-class record: Auckland 1986-90 (Manukau); Auckland B 1984; North Harbour 1991-97 (Helensville); North Island 1986,95; NZ Trials 1988,92-97; NZ XV 1992; Western Samoa 1991

Frank Bunce has had one of the most remarkable All Black careers, not being chosen until at an age when other players may have given up, then being an automatic choice, raising the question of why he had not been picked earlier.

Bunce, a product of Mangere College, first played for Auckland B in 1984 and did not make the A side until 1986 and even then, he played only one game that year though he also played for the North Island in the last of the regular interisland matches. He played only once for Auckland in 1987 though he had more games in 1988 as well as an All Black trial. He moved to North Harbour in 1991, the year that brought about a rapid change in his fortunes. Though of Niuean ancestry, Bunce toured New Zealand with Western Samoa in 1991 and attracted world-wide notice with his play for the Samoans in the World Cup. It caused him to be noticed in New Zealand too and at the start of 1992, new All Black coach Laurie Mains included him in his plans.

Bunce's first match for the All Blacks was at second five-eighth in the first of the centenary tests, but he swapped with longtime partner Walter Little in the second, and he has been the regular test centre since then, the first choice of both Mains and his successor, John Hart. Ironically, Hart was the Auckland coach during Bunce's wilderness years there.

Bunce has most often been compared to his regular test centre predecessor, Joe Stanley, for his ability to read a game and run his outsides into good positions, for his distribution and for his strength in the tackle, both giving and receiving.

Bunce is a direct descendant of George Rex, one of three sons borne by a Yorkshire draper, Hannah Lightfoot, by King George III before he married Queen Charlotte. A British television documentary team in 1997 "discovered" the King's secret marriage, but it and its relevance to the Rexes of Niue were all old hat to Bunce and the several hundred other descendants living in New Zealand.

BURGESS George Francis
b: 20.9.1883, Invercargill *d:* 2.7.1961, Auckland
Halfback

Represented NZ: 1905; 1 match – 1 test

First-class record: Southland 1902-07 (Pirates); South Island 1904; Otago-Southland 1905

'Jerry' Burgess captained the South Island 1904 and played in the 1905 test against Australia in Dunedin. Began his career as a five-eighth but made his name as a quick-passing halfback who gave good service to his backs. A reliable player who was adept at making openings.

BURGESS Gregory Alexander John
b: 6.7.1953, Auckland
Prop

Represented NZ: 1980,81; 2 matches – 1 test

First-class record: Auckland 1977-79 (Ponsonby), 1980-83 (Takapuna); NZ Trials 1978,81,82; NZ XV 1982; North Island 1981,82

Educated St Joseph's Convent School (Onehunga) and Marcellin College, Auckland. While studying in Dunedin, Burgess played for the University club as a wing and for Union at number eight before becoming a prop. A powerful forward (1.98m and 108.5kg) with exceptional speed, he appeared for the New Zealand XV which met Fiji at Auckland 1980 and replaced Gary Knight against South Africa for the second test in 1981.

Coached the Onehunga High School 1st XV 1976-79. Runner-up in the 100kg class in the 1978 national power lifting championships and won the 125kg class in 1985. Recorded 11 secs for the 100 metres sprint. Silver medallist national shot put championship 1984 and 1985.

BURGESS Robert Edward
b: 26.3.1949, New Plymouth
First five-eighth

Bob Burgess

Represented NZ: 1971-73; 30 matches –
7 tests, 50 points – 13 tries

First-class record: Manawatu 1967,68,71-73
(University); Southland 1970 (Southland
HSOB); North Island 1972; NZ Trials 1971,72;
NZ Juniors 1968; NZ Universities 1970,71

Educated Westown School, Palmerston North
and Hastings Boys' High Schools. First
represented Manawatu at the age of 18 then
chosen for NZ Juniors v Japan 1968. Missed the
1969 season with injury but toured Japan 1971
with the Universities team.

Played the first three tests against the 1971
Lions, scoring two brilliant tries in the second
and suffering a severe injury in the third.
Included in the All Blacks' internal tour 1972
and, after flu prevented him playing in the first
two tests, regained his place for the third v
Australia. Appeared in the Welsh, Irish and
French internationals on the 1972-73 tour,
playing a total of 19 games and scoring seven
tries. Had three more matches for Manawatu
before leaving to study in France where he
played with the Lyon club 1974.

BURGOYNE Michael Martin
b: 27.3.1949, Kaitaia
Flanker

Represented NZ: 1979; 6 matches, 4 points –
1 try

First-class record: North Auckland
1975,78,79,81 (Awanui); NZ Maoris 1975,79

Educated Kaingaroa Primary School and Kaitaia
College. Represented NZ Maoris v Tonga 1975
and toured Australia and the Pacific 1979.

Selected for the New Zealand XV in the second
'test' v Argentina 1979 before touring England and
Scotland later in that year, where injury restricted
his appearances to five of the 11 matches.

A fast loose forward, standing 1.88m and weigh-
ing 85kg, Burgoyne had a good sense of anticipation.

BURKE Peter Standish
b: 22.9.1927, Tauranga
Lock and number eight

Represented NZ: 1951,55,57; 12 matches –
3 tests, 6 points – 2 tries

First-class record: Bay of Plenty 1946
(Edgecumbe); Auckland 1947 (Marist);
Taranaki 1948-51 (Stratford), 1952-54
(Tukapa), 1955-59 (Hawera); North Island
1951-54,57; NZ Trials 1951,53,56,57; NZ XV
1955,56; Rest of New Zealand 1954,55

Educated Edgecumbe School and Tauranga
College, 1st XV 1941,42.

Played in six matches on the 1951 All Black
tour of Australia but did not make his test debut
until 1955 when he was called into the first test
side as a lock against Australia when Bob Duff
was unavailable. Played two tests in Australia
1957 at number eight.

A versatile 6' 2" and 14 stone forward, Burke
was a surprise omission from the 1953-54
touring team to Britain. Captained Taranaki in
many of his 117 games for that province.
Taranaki selector 1960-68; North Island selector
1970-75; New Zealand selector 1978-82;
NZRFU president in 1994.

Represented Bay of Plenty at tennis 1945 and
with his sister, Judy, won the Taranaki mixed
doubles title.

'Jake' Burns

BURNS John Francis
b: 17.2.1941, Christchurch
Lock

Represented NZ: 1970; 9 matches

First-class record: Canterbury 1962-72
(Marist); South Island 1968,69,71; NZ Trials
1967,68,70,71

Educated St Therese's School and St Bede's
College, 1st XV 1957,58. After long service for
Canterbury 'Jake' Burns won selection for the
1970 All Black tour to South Africa, playing eight
provincial games plus one in Perth en route.

At 15 stone and 6' 2" Burns was rated among
New Zealand's top locks over a number of years
and was probably unlucky not to win All Black
honours more often.

Coached the Marist club in Christchurch after
his retirement.

BURNS Patrick James
b: 10.3.1881, Lyttelton *d:* 24.2.1943, Lyttelton
Halfback and threequarter

Represented NZ: 1908,10,13; 9 matches – 5
tests, 15 points – 5 tries

First-class record: Canterbury 1904-13
(Albion); South Island 1906-09,11,12

Played at halfback in the second test against the
1908 Anglo-Welsh tourists, with Fred Roberts
appearing in the first and third. On the 1910
visit to Australia, Roberts captained the team
from halfback and Burns was selected as a
threequarter, playing on the wing in the first test
and centre in the two other internationals.
Again played at centre in the third test v
Australia 1913.

Paddy Burns represented his province over a
period of 10 years and with 'Doddy' Gray and
Joe Weston formed a formidable inside back
combination which contributed to the success
of the Albion club 1903-11.

BURROWS James Thomas
b: 14.7.1904, Prebbleton *d:* 10.6.1991,
Christchurch
Hooker

Represented NZ: 1928; 9 matches, 6 points –
2 tries

First-class record: Canterbury 1923
(Christchurch HSOB), 1925,27,29,30
(University); South Island 1925,27,29; NZ Trials
1927,30; Canterbury-South Canterbury 1925

Educated Waiau North Primary and
Christchurch Boys' High School, 1st XV 1920-
22. Originally a back-row forward he became a
hooker in the 2-3-2 scrum. Weighed 12½ stone
and stood almost six feet.

Toured South Africa 1928 but a rib injury
suffered in the game against Transvaal
prevented his appearance until the final six
provincial matches. His last game for
Canterbury was against the 1930 British tourists
after which he retired with a leg injury.
Canterbury selector 1932,33; New Zealand
selector 1936,37.

A fine all-round sportsman, Burrows
represented Canterbury at cricket 1926-34 as a
medium-pace bowler and won New Zealand
university blues for boxing 1924-26. His
biography, *Pathway Among Men*, was
published 1974.

Served in WWII rising to the rank of brigadier
winning the DSO 1942, Bar 1944 and Order of
Valour (Greece). He commanded K Force in
Korea 1954. CBE 1959.

BURRY Hugh Cameron
b: 29.10.1930, Christchurch
Number eight

Represented NZ: 1960; 11 matches, 24 points
– 8 tries

First-class record: Canterbury 1955,56
(University), 1957-60,62 (New Brighton); NZ
Universities 1956; NZ Trials 1957,59,60

Educated Christ's College, 1st XV 1948. An
intelligent, strong-running loose forward
standing six feet and weighing 14 stone, Burry
excelled at second phase play and was a prolific
try scorer.

Qualified as a general practitioner before
touring South Africa 1960 where his medical
training was an added bonus to his lively play.
Affected by a groin injury he played only eight
matches in South Africa plus three in Australia
en route but scored a try nearly every time he
took the field.

Retired from the game on his return from the
tour but did play for Canterbury 1962 and
coached Canterbury B 1963. Settled in England
where he practised medicine and coached Guy's
Hospital team 1966-75; staff coach to the Rugby
Football Union 1972,73. Chairman NZRFU
medical advisory committee since 1981. Two
uncles, R.D. and W.D. Cameron, represented
North Otago.

BURT John Robert
b: 27.8.1874, Dunedin *d:* 16.1.1933,
Christchurch
Loose forward

Represented NZ: 1901; 1 match

First-class record: Otago 1896,97,1900,01
(Pirates)

Educated Otago Boys' High School, 1st XV 1890. Replaced Walter Drake in the New Zealand team which played Wellington 1901, when the Canterbury man failed to arrive in time for the match. Life member Pirates R.F.C.

BUSH Ronald George
b: 3.5.1909, Nelson *d:* 10.5.1996, Auckland
Fullback

Represented NZ: 1931; 1 match – 1 test, 14 points – 1 conversion, 4 penalty goals

First-class record: Auckland 1928-30,32-37 (University); Otago 1931 (University); South Island 1931; North Island 1934; NZ Trials 1935; NZ Universities 1929,31,33,36

Educated Stanley Bay Primary and Mt Albert Grammar School, 1st XV 1926,27. Standing just over six feet and weighing 14st 6lb, Bush was a versatile player who appeared in the threequarter line, occasionally at five-eighth and, for Auckland and the North Island 1934, as a loose forward.

His sole match for New Zealand was at fullback in the test v Australia 1931 when his goalkicking proved vital in a 20-13 victory.

With Hugh McLean, Bush was a co-founder of the Barbarian club in New Zealand 1937. Auckland RFU president 1966-68. NZ Universities selector 1947-57. North Island selector 1959-64. New Zealand selector 1961,63,64. Assistant manager of the 1962 All Blacks in Australia.

Represented Auckland at cricket 1933. His father, George, played rugby for Canterbury 1898,99,1901.

BUSH William Kingita Te Pohe
b: 24.1.1949, Napier
Prop

Represented NZ: 1974-79; 37 matches – 11 tests, 4 points – 1 try

First-class record: Canterbury 1971-82 (Belfast); South Island 1973-75,78,81,82; NZ Trials 1972-79; NZ Maoris 1973-75,77-79,81,82; World XV 1982

Billy Bush and friend in South Africa in 1976.

Educated Rukokore and Apanui Primary Schools and Whakatane High School. Played for the City club in Whangarei, Horohoro in the Bay of Plenty and Suburbs in Christchurch before joining Belfast. Stood 1.85m and weighed over 100kg.

Toured Australia with the 1974 All Blacks, appearing in the first two tests, and Ireland later that year, playing twice in minor matches. Returned to the test scrum for the home internationals v Scotland 1975 and Ireland 1976 and then toured South Africa. With Kerry Tanner and Brad Johnstone out of action Bush was called upon to play nine games in succession. Appeared in the second and fourth tests but an ankle injury prevented his playing in the third.

Played the second and third tests against the 1977 Lions and replaced John McEldowney during the fourth. Visited Britain 1978 but after playing in the Irish and Welsh internationals he suffered a hamstring injury which put him out of action for the rest of the tour. In 1979 he played Queensland B and in the international against Australia on the two-match tour. Toured Wales with the NZ Maoris team in 1982.

BUTLAND Henry
b: 11.2.1872, Westport *d:* 2.12.1956, Hokitika
Halfback

Represented NZ: 1893,94; 9 matches, 6 points – 2 tries

First-class record: West Coast 1894,95 (Hokitika); NZ Trial 1893

Butland was one of the few players who have appeared for New Zealand before representing a union. Toured Australia 1893 and played against New South Wales at Christchurch the following year.

Weighed 12st 2lb and stood 5' 8". Described as "well-built and as game as a pebble . . . possessed a quick, low, sure pass; a splendid tackler and a good kicker, not particularly fast but a grand stopper of rushes."

Prominent businessman Sir Jack Butland was his son.

BUTLER Victor Claude
b: 11.7.1907, Auckland *d:* 1.2.1971, Auckland
Fullback

Represented NZ: 1928; 1 match

First-class record: Auckland 1926,27 (University), 1928,29 (Training College), 1930,31 (University); NZ Trials 1927

Educated Mt Albert Grammar School, 1st XV 1923-25. Won selection in the Auckland team in his first year out of school and made his sole appearance as an All Black two years later against New South Wales at Wellington 1928. Butler was named in the team for the second match of the series but was unavailable.

Served in WWII as a major in the 21st Infantry Battalion. A selector and assistant manager of the 'Kiwis' army team in Britain 1945-46. Auckland selector 1947,48. A triple blue in rugby, cricket and athletics while at university.

BUXTON John Burns
b: 31.10.1933, Auckland
Flanker

Represented NZ: 1955,56; 2 matches – 2 tests

First-class record: Manawatu 1954 (University); Canterbury 1955,56 (Lincoln College); Otago 1957 (University); Auckland 1958 (Takapuna); South Island 1956,57; NZ Trials 1956,57; NZ Universities 1955-57

Educated Takapuna Grammar School, 1st XV 1950,51. A fast flanker standing 6' 1" and weighing around 14 stone.

Won his cap in the third test v Australia 1955 and played in the first test against the 1956 Springboks but did not retain his place in the New Zealand team.

Captained the NZ Universities team which defeated South Africa 1956. Coached Hawke's Bay during their Ranfurly Shield era in the late 1960s.

CABOT Phillippe Sidney de Quetteville
b: 18.7.1900, Rough Ridge
Wing forward

Represented NZ: 1921; 1 match

First-class record: South Canterbury 1920 (Timaru HSOB); Otago 1921 (University); South Island 1921; NZ Trials 1921; NZ Universities 1922,25

Educated Timaru Boys' High School, 1st XV 1918. Foundation member and first secretary of the Timaru HSOB club. Selected for South Canterbury's unofficial representative match 1919 (v Ashburton) and played for the province the following year before attending Otago University.

In 1921 Cabot toured Australia with the NZ Universities team, was selected for the South Island, appeared in the NZ Trials, played his sole match for Otago (v South Africa) and for his country against the touring New South Wales team. He continued to play for the University club in Dunedin until 1926.

CAIN Michael Joseph
b: 7.7.1885, Waitara *d:* 27.8.1951, New Plymouth
Hooker

Represented NZ: 1913,14; 24 matches – 4 tests, 14 points – 4 tries, 1 conversion

First-class record: Taranaki 1908-14,20,21 (Clifton); North Island 1913,14,20; NZ Services 1919,20

Cain did not play rugby until aged 21 when he was enticed to replace an injured player in a club game. In his subsequent career of 104 first-class matches he toured North America 1913 and Australia 1914 (appearing against All America and all three tests) with the All Blacks, represented Taranaki when they won the Ranfurly Shield 1912 and was a member of the NZ Services team which won the King's Cup 1919. Selected for the 1920 All Blacks to tour Australia but withdrew.

CALCINAI Umberto Primo
b: 2.2.1892, Wellington *d:* 26.7.1963, Wellington
Hooker

Represented NZ: 1922; 5 matches

First-class record: Wellington 1919,20,22,23 (Poneke); North Island 1922

Normally a wing forward but selected for the 1922 New Zealand team to Australia as a hooker. Played four matches on tour, including all three against New South Wales. Played against New Zealand Maoris at Wellington after the All Blacks' return. His son, Vic, represented Wellington 1936-45 and North Island 1943 and a brother, 'Dooley', represented Wellington 1906-08.

CALLESEN John Arthur
b: 24.5.1950, Palmerston North
Lock

Represented NZ: 1974-76; 16 matches – 4 tests, 4 points – 1 try

First-class record: Manawatu 1970-78 (Palmerston North HSOB); North Island 1972,74,75,77; NZ Trials 1971,75,77; NZ Juniors 1972,73; Manawatu-Horowhenua 1971,77

Educated Nelson College, 1st XV 1967. Toured Australia with the Junior All Blacks 1972 and showed remarkable form then gained full All Black status on the 1974 Australian tour, playing eight games including all three tests. Also toured Ireland later that year and played in the Scottish test at Auckland 1975. Not available for the 1976 South African tour but was in the team that went to Argentina. Stood 1.96m and weighed 98kg.

Callesen was undoubtedly one of the best locks to play for New Zealand in his era, both as a lineout jumper and in general play.

CALNAN Joseph John
b: 24.6.1876, Wellington *d:* 31.12.1947, Wellington
Loose forward

Represented NZ: 1897; 9 matches, 8 points – 2 tries, 1 conversion

First-class record: Wellington 1895-97, 99,1900,03,04,06 (Melrose); North Island 1897

A 12st 5lb forward, Calnan played 49 first-class matches in a career interrupted by a two-year

suspension for alleged drunkenness and bad language after playing for New Zealand v Auckland 1897.

Withdrew from rugby when he was omitted from the 1905-06 touring party after being named in the original 53 players under consideration, although he played one further match for Wellington in 1906.

CAMERON Dennis Hugh
b: 17.11.1938, Ashburton
Wing threequarter

Represented NZ: 1960; 8 matches, 6 points – 2 tries

First-class record: Mid Canterbury 1959 (Rakaia); Counties 1961-63 (Papakura); NZ Trials 1959,60; South Canterbury-North Otago-Mid Canterbury 1959

Educated Ashburton High School, 1st XV 1954-56. Showed potential in his first representative game scoring two tries against a Canterbury XV 1959 and ended that season with nine tries from seven matches for his union and scored a thrilling try for South Canterbury-North Otago-Mid Canterbury against the Lions when he intercepted a pass in his own 25 and sprinted to the visitors' line. Also scored three tries in the All Black trials.

Selected for the 1960 South African tour but injured his hand during the preliminary short tour of Australia. His appearances in South Africa were limited to six matches and he never reached his best form on tour. Moved to Counties 1961 and played 13 games for that union before switching to rugby league with the Southern Districts club 1964.

At six feet and 14 stone Cameron was a fast and powerful wing. An administrator with the Te Awamutu club 1968-70. Coached the Tauranga OB club 1978-80. Competed at national swimming championships 1956,57.

CAMERON Donald
b: 15.7.1887, Waitara *d:* 25.8.1947, New Plymouth
Wing threequarter

Represented NZ: 1908; 3 matches – 3 tests, 3 points – 1 try

First-class record: Taranaki 1906-14 (Stratford); North Island 1908,09

Educated Stratford High School. Apart from his usual position of wing threequarter, he also played for Taranaki as a centre, fullback and five-eighth; scoring 146 points (31 tries, 18 conversions, one penalty goal, two dropped goals and two goals from marks) from 59 first-class matches. Scored four tries for Taranaki v Manawatu 1906.

An elusive runner weighing just over 10 stone, Cameron earned high praise for his displays against the 1908 Anglo-Welsh tourists. Selected for the 1910 New Zealand team to Australia but withdrew and was replaced by Frank Wilson. His father, R.H. Cameron, represented Taranaki 1885.

CAMERON Lachlan Murray
b: 12.4.1959, Hamilton
Second five-eighth and centre threequarter

Represented NZ: 1979-81; 17 matches – 5 tests, 16 points – 4 tries

First-class record: Manawatu 1978-82 (University); Counties 1983-85 (Te Kauwhata); NZ Trials 1980,81; NZ Juniors 1979; NZ Colts 1978; NZ Universities 1979,80,82

Educated Maungaturoto and Rangiriri Primary Schools, Te Kauwhata College and Hamilton Boys' High School, 1st XV 1975,76 from where he represented Waikato and North Island under 16 teams 1975 and Waikato Secondary Schools 1976. Played for the Te Kauwhata club 1977 and represented Counties in under 21 and under 18 grades before moving to Palmerston North to continue his studies.

Made his All Black debut in the first match against the 1979 Argentine tourists and the next year toured Australia and Fiji playing his first

Lachlan Cameron

international in the third test. Played in the second test against the 1981 Springboks at second five-eighth and in the third at centre. Toured Romania and France with the 1981 All Blacks, playing five games including the first French test. A strongly built midfield back weighing about 85kg and standing 1.83m. A thrustful runner and good passer of the ball.

CARLETON Sydney Russell
b: 22.2.1904, Christchurch *d:* 23.10.1973, Christchurch
Utility back

Represented NZ: 1928,29; 21 matches – 6 tests, 6 points – 2 tries

First-class record: Canterbury 1923-27,29,30 (Christchurch HSOB); South Island 1927; NZ Trials 1927; Canterbury-South Canterbury 1925

Educated Riccarton Primary and Christchurch Boys' High School, 1st XV 1920,21. Carleton was included in the 1928 New Zealand team to South Africa after Bert Cooke withdrew; appeared in the first three internationals, missing the final test through injury.

Toured Australia with the 1929 All Blacks playing the first test at centre, the second at fullback and the final encounter at second five-eighth.

The 1930 Canterbury team which defeated the British tourists 14-8 included the remarkable Christchurch HSOB inside back

Syd Carleton

combination of Dalley, Dave Hay, Innes and Carleton. On his death Carleton's club, provincial and All Black team-mate, Bill Dalley, said: "Syd was one of the toughest centres we had. He never missed a tackle on defence and on attack he was a master at setting up his winger for a try."

CARRINGTON Kenneth Roy
b: 3.9.1950, Whakatane
Wing threequarter

Represented NZ: 1971,72; 9 matches – 3 tests, 20 points – 5 tries

First-class record: Auckland 1969-74 (Waitemata); Bay of Plenty 1978 (Edgecumbe); North Island 1973; NZ Trials 1970-73; NZ Maoris 1970,71

Educated Opotiki College, 1st XV 1964-66, and Rutherford High Schools, 1st XV 1967,68. An outstanding schoolboy player who appeared in representative football in his first year out of school.
Selected for the first, third and fourth tests against the 1971 Lions and for the All Blacks' internal tour 1972, on which he played six matches and scored five tries. Stood 5' 10" and weighed 12st 1lb.
Played for the Casale club in Italy 1975-78. Champion sprinter at school.

CARROLL Alphonsus John
b: 20.4.1895, Mataura *d:* 1.12.1974, Palmerston North
Hooker

Represented NZ: 1920,21; 8 matches, 13 points – 3 tries, 2 conversions

First-class record: Manawatu 1919 (Rangioto Huia), 1920 (Pirates), 1921 (Jackeytown), 1922-24 (Palmerston North HSOB); North Island 1919-21; NZ Trials 1921,24; Manawatu-Horowhenua 1921,24; Manawatu-Wellington 1922

Toured Australia with the 1920 All Blacks and played against New South Wales at Christchurch 1921. A stockily built player weighing about 14 stone, Phonse Carroll was unfortunate not to gain selection in the 1924-25 'Invincibles' after playing well in the trials. Turned to rugby league 1925 and toured England with the 1926-27 New Zealand team.
Two sons also represented Manawatu. Jim appeared in the NZ Trials 1979 and was an All Black reserve, 1978,79. Joe also played for Wairarapa-Bush. Four of Carroll's brothers, Frank (1906,07); William 'Chum' (1908-10,12,14); Mick (1908-11) and Vince (1911,12,14) appeared for Manawatu. Mick was selected for the 1914 New Zealand team to Australia but withdrew.

CARSON William Nicol
b: 16.7.1916, Gisborne *d:* 8.10.1944, at sea
Flanker

Represented NZ: 1938; 3 matches, 3 points – 1 try

First-class record: Auckland 1936,38,39 (Ponsonby); North Island 1938,39; NZ Trials 1939

Educated Kaiti Primary and Gisborne Boys' High School, 1st XV 1933 from where he represented Poverty Bay Juniors as a midfield back.
A flanker, he weighed 14st 3lb and stood just under six feet when he was selected for the North Island and New Zealand 1938 but injury restricted his appearances on the Australian tour. Carson continued his fine form in 1939 and after playing for the North Island and in the All Black trials, it was expected that he would have gained a place in the New Zealand team scheduled to visit South Africa 1940. His last serious football was for Central Military Districts when based in Trentham Camp after he joined the army in February 1940.
Carson was one of the fine batsmen of New Zealand cricket, representing his country 1937-39 and scoring 714 runs in 22 matches. In the 1936-37 season he shared a world record third wicket partnership of 445 runs with Paul Whitelaw playing for Auckland against Otago.
In a distinguished military career he was promoted to the rank of major and won the MC at the Battle of Mareth. Wounded in Italy 1944 and contracted jaundice whilst recovering. Died on board a hospital ship and was buried in the Heliopolis Military Cemetery, Egypt.
His uncle, Jim Carson, represented New South Wales 1893,99 and Australia 1899 against the touring British rugby team.

CARTER George
b: 9.4.1854, Auckland *d:* 1.4.1922, Auckland
Forward

Represented NZ: 1884; 7 matches

First-class record: Auckland 1875-77,80,82,83 (Auckland)

Weighing only 11 stone, Carter was described by the 1884 team manager, S.E. Sleigh, as "a pocket Hercules". No amount of knocking around seemed to have the slightest effect on this hard-

working forward." Came into the New Zealand team for the Australian tour after Bob Whiteside and then Frank Clayton withdrew.

CARTER Mark Peter
b: 7.11.1968, Auckland
Flanker

Represented NZ: 1991,97; 8 matches – 5 tests, 5 points – 1 try

First-class record: Auckland 1989-95,97 (Suburbs); Auckland Blues 1997; NZ Colts 1989; NZ Trials 1990-93; NZ Development 1990; NZ B 1991; NZ XV 1991,92; NZ A 1997; Thames Valley XV 1997

Mark Carter was selected for the All Blacks' second test against Australia in 1991, won 6-3 by New Zealand, and was then included in the squad for the World Cup, in which he played against Italy and in the losing semifinal against Australia.
Though selected for trials and a New Zealand XV in 1992, the first year of All Black coach Laurie Mains's era, he was not required for New Zealand, even though nine flankers were used on the 1992 tour of Australia and South Africa. Carter at the end of the 1995 season joined the Auckland Warriors league team but returned to rugby in 1997, gaining All Black reserve status. He went on in two tests, against Fiji and Australia, and played three midweek matches on the tour of Britain and Ireland at the end of the year.
A brother, John, played for Auckland 1990-92 and North Harbour 1993,94.

CARTWRIGHT Scott Calvert
b: 7.1.1954, Christchurch
Wing threequarter

Represented NZ: 1976; 7 matches, 28 points – 7 tries

First-class record: Canterbury 1973,75-77,79 (Christchurch); South Island 1976; NZ Trials 1977; NZ Juniors 1976

Educated St Andrew's College. Toured Argentina with the 1976 All Blacks playing seven matches including both unofficial "tests". Finished that tour as top try scorer. Although on the light side at 69kg and 1.78m, Cartwright was a fast and nimble wing.

CASEY Stephen Timothy
b: 24.12.1882, Dunedin *d:* 10.8.1960, Dunedin
Hooker

Represented NZ: 1905-08; 38 matches – 8 tests

First-class record: Otago 1903,04,06-13 (Southern); South Island 1904-07

Educated Christian Brothers' School, Dunedin. A brilliant hooker who formed a most effective combination with George Tyler on the 1905-06 tour – this pair playing in the Scottish, Irish, English and Welsh internationals – then Casey also partnered 'Ned' Hughes against Australia 1907 and in the first test v Anglo-Welsh 1908. His brother, Mick, represented Otago 1901,02,06,08.

CASHMORE Adrian Richard
b: 25.7.1973, Tokoroa
Fullback and wing

Represented NZ: 1996,97; 2 matches — 2 tests

First-class record: Bay of Plenty 1992,93 (Tauranga Sports); Auckland 1994-97 (Grammar); Auckland Blues 1996,97; NZ Colts 1993,94; NZ Maoris 1996; NZ Trial 1996; NZ A 1997; Barbarians 1996; Northern Maoris 1993

Cashmore, a member of the enlarged All Black squad in 1996 and 1997, played two tests as a replacement, both for Jeff Wilson – the first was against Scotland in Auckland in 1996 and the second against Australia in Melbourne in 1997. He was selected for the tour of South Africa in 1996, but had to return home because of injury before the first match.

Adrian Cashmore

CATLEY Evelyn Haswell
b: 23.9.1915, Hamilton *d:* 23.3.1975, Hamilton
Hooker

Represented NZ: 1946,47,49; 21 matches – 7 tests, 3 points – 1 try

First-class record: Waikato 1935-41 (Taupiri), 1943-45 (Hamilton OB), 1946-48 (Taupiri United), 1950-52 (Huntly), 1953-55 (Taupiri); North Island 1944-48; NZ Trials 1935,39,47,48; Waikato-King Country-Thames Valley 1937; New Zealand XV 1944,45

Educated Orini School and King's College, 1st XV 1931,32. Played for Waikato before, during and after WWII and had a remarkable first-class career spanning more than 20 years; a total of 174 matches including 126 for his province.

Has Catley was rated as one of the great hookers of all time. He made his international debut at the age of 30, in the first test of the 1946 series v Australia, but was dropped for the second although he had won 23 scrums to two at Dunedin. Included in the 1947 Australian tour, playing both tests, and the 1949 team to South Africa – 13 matches including all four tests. On that tour Winston McCarthy singled out the front-row combination of Simpson, Catley and Skinner as "the real strength of the New Zealand scrum . . . that combination will be talked about as long as rugby exists". Catley's success as a hooker was due to his great strength

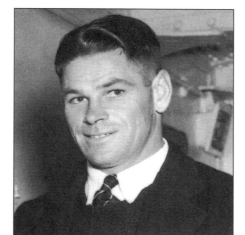

Has Catley

– he was six feet and 14st 2lb – and he had an excellent technique.

Continued to represent Waikato during that union's tenure of the Ranfurly Shield, finally giving way to the new All Black hooker, Ron Hemi. His last first-class appearance was for the Harlequins v Waikato 1956, at the age of 41. Co-coach of the team which beat the 1956 Springboks and sole selector 1961-65. His son, Gary, represented Waikato 1962-65,67.

CAUGHEY Thomas Harcourt Clarke
b: 4.7.1911, Auckland *d:* 4.8.1993, Auckland
Threequarter and second five-eighth

Represented NZ: 1932,34-37; 39 matches – 9 tests, 106 points – 34 tries, 1 dropped goal

First-class record: Auckland 1931-37 (University); North Island 1932,33; NZ Trials 1934,35; NZ Universities 1933

Educated Mt Albert Primary School and King's College, 1st XV 1927-30. The year after leaving school this brilliant, speedy player went straight into the Auckland team. Selected as a centre for the 1932 Australian tour, playing two tests and ending the tour as leading try scorer with Hugh McLean, both scoring 10 tries. Toured Australia again in 1934, playing both tests.

Although selected as a centre for the 1935-36 tour of Britain, 'Pat' Caughey played all his matches at second five-eighth. He was again leading try scorer with 18, including three in the international against Scotland. Also played against Ireland and England but missed the Welsh match through injury. Oliver and Tindill described him in their tour book as "a temperamental player. He was a real world beater on his day and was in the match-winner class but liable to be inconsistent. His dashing attack and wonderful sense of anticipation were features of the team's play. His defence however was not up to the same standard".

Played at centre against the 1936 Wallabies in the first test and selected as left wing in the third test against the 1937 Springboks but moved to centre during the game.

A fine all-rounder at school – 1st XI, athletics, boxing and swimming champion – Caughey played senior club cricket in Auckland 1931-36.

Two cousins, Brian (Auckland) and David Caughey (Otago, Auckland and NZ Universities), also played representative rugby.

Caughey was knighted 1972 for his services to the Auckland Hospital Board and was also made an OBE.

CAULTON Ralph Walter
b: 10.1.1937, Wellington
Wing threequarter

Represented NZ: 1959-61,63,64; 50 matches – 16 tests, 93 points – 31 tries

First-class record: Wellington 1957-65 (Poneke); North Island 1962-64; NZ Trials 1958-60,62,63,65

Educated Te Aro Primary School and Wellington College. Caulton made a spectacular beginning to his All Black career by scoring two tries in each of his first two appearances – in the second and third tests against the 1959 Lions.

Toured South Africa 1960 playing in the first and fourth tests, giving way to Frank McMullen for the other two tests. Appeared in the second test v France 1961. When Rod Heeps withdrew from the first test v England 1963 Caulton was called in and, after scoring two tries, held his place for the second test. On the 1963-64 tour of Britain and France he played in 21 of the 36 matches including all five internationals. On

Thomas Caughey

Ralph Caulton

this tour he scored 14 tries. His All Black career ended with the three-match series against the 1964 Wallabies.

In his 16 tests Caulton scored eight tries. He was a speedy and well-balanced runner always alert for scoring opportunities. Weighed 12 stone and stood six feet.

Coached the Poneke club 1967,68. Marlborough selector 1970-75, NZ Under 17 coach 1985. Served on the Wellington RFU committee 1977-79 and the NZRFU coaching committee 1978-86.

CHERRINGTON Nau Paora
b: 5.3.1924, Otiria *d:* 26.6.1979, Whangarei
Wing threequarter

Represented NZ: 1950,51; 7 matches – 1 test, 27 points – 9 tries

First-class record: North Auckland 1946-56 (Otiria); North Island 1947,50; NZ Trials 1950,51,53; NZ Maoris 1947-52,54

Educated Kawakawa District High School. A big powerful wing, standing six feet and weighing about 14 stone, who had the advantage of playing outside the great Johnny Smith, 'Brownie' Cherrington played outstanding rugby for North Auckland and the Maori All Blacks in the early post-war years.

Selected for the first test against the 1950 Lions when Peter Henderson was unavailable and toured Australia 1951. Also visited Fiji and Australia with Maori teams. A hard man to stop, Cherrington scored some thrilling tries during his long provincial career.

CHRISTIAN Desmond Lawrence
b: 9.9.1923, Auckland *d:* 30.8.1977, Auckland
Number eight, prop

Represented NZ: 1949; 11 matches – 1 test

First-class record: Auckland 1943-48,50 (Otahuhu); North Island 1944,45,47,48,50; NZ Trials 1947,48,50; New Zealand XV 1944,45

While serving with the army during WWII Christian played for the 1st Brigade Group and 1st NZ Division and was close to All Black honours for some time before being selected for

the 1949 South African tour where he appeared in the fourth test at number eight although chosen for the tour as a prop. Stood 5' 11" and weighed 13st 10lb.

Played 83 first-class matches including 50 for Auckland. After retirement from active rugby, he became a prominent administrator, Horowhenua selector 1962; North Island selector 1963-69; New Zealand selector 1964,66.

CLAMP Michael
b: 26.12.1961, Wellington
Wing threequarter

Represented NZ: 1984,85; 15 matches – 2 tests, 72 points – 18 tries

First-class record: Wellington 1981-88 (Petone); NZ Trials 1982-84; NZ Juniors 1982; NZ Colts 1981; NZ Maoris 1981-85,88; Central Zone 1987

While at Hutt Valley High School 1975-79 (the last three years in the 1st XV) Clamp had a keen interest in track and field and the speed developed then was to prove a boon in his later rugby. He played age-grade rugby for Wellington as a second five-eighth or centre.

Although he made his first-class debut for Wellington in 1980, Clamp's appearances over the next few years were restricted because of the presence in Wellington of All Black wings Bernie Fraser and Stu Wilson. He was a regular wing for New Zealand Maoris, including that side's 1982 tour of Wales and Spain. He later gained a regular Wellington place on his own merits, however, and won selection for the All Blacks' tour of Australia in 1984, when he was highest try scorer and played in the second and third tests. He toured Fiji later that year and in 1985 toured Argentina, although playing in neither test. He weighed 84kg and stood 1.85m.

Clamp went to South Africa in 1986 with the unofficial Cavaliers side.

CLARK Donald William
b: 22.2.1940, Cromwell
Flanker

Represented NZ: 1964; 2 matches – 2 tests

First-class record: Otago 1960-67 (Cromwell); South Island 1961,64-66; NZ Trials 1961,63,65,66

Educated Tarras Primary and Timaru Boys' High School. An energetic loose forward, standing six feet and weighing 14st 2lb, who played equally well as flanker and number eight. An experienced player at top level when selected for the All Blacks against Australia 1964 in the first two tests. He was relegated to the reserves for the third international. A very fast forward who excelled on attack, Clark suffered a severe injury in a farm accident which ended his rugby career in 1967.

CLARK Francis Leslie
b: 25.9.1902, Smithfield (Timaru) *d:* 12.11.1972, Auckland
Hooker

Represented NZ: 1928; 4 matches

First-class record: Canterbury 1925,27,28 (Christchurch HSOB); South Island 1928; NZ Trials 1927

Educated Christchurch Boys' High School, 1st

XV 1920. Played all three matches for New Zealand against New South Wales 1928 and appeared against West Coast-Buller as a replacement.

CLARK Lindsay Allan
b: 1.5.1944, Dunedin
Prop

Represented NZ: 1972,73; 7 matches

First-class record: Otago 1965-78 (Southern); South Island 1973,76; NZ Trials 1972-74

Educated Riselaw Road Primary, Macandrew Intermediate (Dunedin) and King's High School. Initially played for Otago as number eight, later as a flanker, before switching to prop 1971. Chosen as a replacement in the 1972-73 All Blacks in the British Isles when Keith Murdoch was sent home after the Welsh international. Appeared in seven of the final 14 matches on tour. A hard-working and mobile prop who weighed 15½ stone and stood six feet. Played in 157 first-class matches.

CLARK William Henry
b: 16.11.1929, Motueka
Flanker

Represented NZ: 1953-56; 24 matches – 9 tests, 21 points – 7 tries

First-class record: Wellington 1950-58 (University); North Island 1953-56; NZ Trials 1953,56; New Zealand XV 1954,55; NZ Universities 1951-56

Educated Nelson College, 1st XV 1948. Bill Clark began a long and fruitful association with Ron Jarden when both played for Victoria University 1950. As an extremely fast loose forward with uncanny anticipation, Clark was able to capitalise upon Jarden's precise centre kicks – a combination which often resulted in tries in the 230 games the pair played together.

Clark was selected for the 1953-54 tour of Britain, France and North America where he played 19 matches including the four British internationals. Described by Terry McLean as "the outstanding loose forward of the team by virtue of exceptional pace, a singularly alert mind . . . and an extraordinary gift of being in the right place at the right time". Clark's playing weight was given as 13 stone but it is claimed that this was a stone above his true weight; he stood 6' 1½".

Played the first two tests v Australia 1955 and was recalled after the first test against the 1956 Springboks for the rest of the series. Injuries curtailed his rugby after that season and he retired 1958. His father captained Golden Bay-Motueka and played for the South Island 1926 while his brother, Tony, represented Wellington and NZ Universities.

CLARKE Adrian Hipkins
b: 23.2.1938, Christchurch
Five-eighth

Represented NZ: 1958-60; 14 matches – 3 tests, 9 points – 3 tries

First-class record: Auckland 1958,59,61-66 (Waitemata); NZ Trials 1958-63

Educated Avondale College, 1st XV 1954. Selected for the third test v Australia 1958 after showing outstanding form for Auckland in his

first season of representative rugby. Standing 5' 8" and weighing 11st 2lb, Clarke played mostly at first five-eighth but was selected at second five-eighth in the fourth test against the 1959 Lions.

After showing impressive form in trial matches he won selection for the 1960 South African tour and played in 12 games including the first test. Continued to give good service to Auckland during that union's record-breaking Ranfurly Shield era of the 1960s.

His brother, Philip, represented New Zealand 1967 while his father, Vernon, was one of New Zealand's leading photographers of sports teams for many years.

CLARKE Donald Barry
b: 10.11.1933, Pihama
Fullback

Represented NZ: 1956-64; 89 matches – 31 tests, 781 points – 8 tries, 173 conversions, 120 penalty goals, 15 dropped goals, 2 goals from a mark

First-class record: Waikato 1951,53,54,56-64 (Kereone); North Island 1956-59,61-64; NZ Trials 1953,56-63; New Zealand XV 1958

Educated Te Aroha College. Came into the team as a 17-year-old and in his first representative year kicked two fine penalty goals on a heavy ground to help take the Ranfurly Shield from North Auckland. A knee injury kept him out of rugby in the 1952 and 1955 seasons.

Don Clarke made his All Black debut in the third test against the 1956 Springboks, scoring eight points in New Zealand's 17-10 victory. Don and Ian Clarke were the first brothers to appear in an international for New Zealand since the Brownlies played against France 1925.

Clarke continued to be the first choice test fullback until 1964, missing only the second test against the 1964 Wallabies with a recurring knee injury which finally ended his career. In the season he retired he was invited to play in the South African RFU jubilee matches.

In Australia 1957 his total of 163 points was a record for an All Black tour of that country. His six penalty goals in the first test against the 1959 Lions was a world record for an international. With 781 points for New Zealand, Clarke is the second highest scoring All Black behind Grant

Fox (1067). In 226 first-class appearances he scored 1851 points. On six occasions Clarke scored more than 100 points in a domestic season.

Colin Meads said: "There was a staggering tendency to disregard Clarke's ability as a player and to regard him merely as a kicking machine. He was a fine field player at his best with good positional sense, unworldly hands and a very difficult man to beat. There was a shrewdness in him, too; more than once I have seen him trick forwards standing on the mark into charging early and so gaining a charge-free kick."

Clarke stood 6' 2" and weighed 15½ stone when first selected and 17½ stone in 1962.

A fine cricketer, he appeared as a medium pace bowler for Auckland in the 1950/51,52/53 seasons and Northern Districts 1956/57,57/58. Also represented the North Island 1952/53. Four of his brothers, Ian, Doug, Brian and Graeme, played rugby for Waikato with all five Clarkes appearing in a game v Thames Valley 1961. Ian represented New Zealand 1953-64. With Pat Booth, Don Clarke wrote his biography *The Boot* (Reed, 1966) and, with Roger Urbahn, was co-author of *The Fourth Springbok Tour of New Zealand* (Hicks Smith, 1965).

CLARKE Eroni
b: 31.7.1968, Apia
Midfield back and wing

Represented NZ: 1992,93; 22 matches – 8 tests, 50 points – 11 tries

First-class record: Auckland 1991-97 (Suburbs); Auckland Blues 1996,97; NZ Trials 1991-93,96; NZ XV 1991,93; NZ Development 1994; NZ President's XV 1995; NZ A 1997; NZ Samoa 1992; Saracens 1992; Hawke's Bay Invitation XV 1996

Clarke, who moved to New Zealand at an early age and whose secondary education was at Henderson High School, was regarded as a highly promising player early in his career. After playing for Auckland and North Island age teams and the Auckland Colts in 1989 and 1990, he made his debut for Auckland in 1991 and for the All Blacks the following year.

His All Black career did not fulfil the early promise, however. He played the second and third centenary tests in 1992 at second five-

Eroni Clarke

eighth and the two following tests against Ireland, but he was not required for any of the tests on the tour of Australia and South Africa. He played two tests against the Lions in 1993, the first on the wing, and on the tour of England and Scotland at the end of that year, he replaced Matthew Cooper in the test against Scotland and played the full England test that was lost.

Though he continued as a robust defender and strong attacker for Auckland and the Auckland Blues, he was seldom seen again at national level.

CLARKE Ian James
b: 5.3.1931, Kaponga *d:* 29.6.1997, Morrinsville
Prop and number eight

Represented NZ: 1953-64; 83 matches – 24 tests, 16 points – 4 tries, 2 conversions

First-class record: Waikato 1951-59,61-63 (Kereone); North Island 1953-57,59,61; NZ Trials 1953,56,57,59,60,62,63; The Rest of New Zealand 1955,56; Black XV 1957; New Zealand XV 1954-56; Barbarians (UK) 1964

Educated Pihama and Otakeho Primary Schools and Hawera Technical College and made his international debut at Cardiff Arms Park during the 1953-54 All Black tour (although replaced by 'Snow' White for the other internationals). Captained the All Blacks in the 1955 home series against Australia from the number eight position but returned to prop for the rest of his long international career.

Toured Australia 1957 and 1962, South Africa 1960 and the British Isles, France and Canada 1963-64. His "swansong" on this tour was an appearance for the Barbarians (UK) against the All Blacks when he scored the only points – a dropped goal from a mark – for his team. One of the mainstays of the victorious forward pack against the 1956 Springboks, Clarke also played in home series v Australia 1958, the British Isles 1959, France 1961 and England 1963.

Ian Clarke stood 5' 10½" and his playing weight varied from 14st 3lb to 15st 5lb. Described by Terry McLean as "especially gifted in having a most unusual degree of speed . . . astonishing durability and inexhaustible energy

Don and Ian Clarke during an unceasing All Black chore, signing autographs.

built upon consistent physical fitness." Noted for his lineout skills, his ability to charge down kicks and enthusiasm in following up.

Reached representative level as a referee. One of five brothers (including Don Clarke, New Zealand 1956-64) who played for Waikato during the 1950s. President NZRFU 1993.

CLARKE Philip Hipkins
b: 23.1.1942
Wing threequarter

Represented NZ: 1967; 4 matches

First-class record: Canterbury 1962,63 (Albion); Marlborough 1965,66 (Woodbourne), 1967,68 (Opawa); NZ Trials 1965,67,68; NZ Combined Services 1960,61,63,64; Newcastle (Australia) 1969; Marlborough-Nelson-Golden Bay-Motueka 1965,66

Educated Oratia Primary and Henderson High School, 1st XV 1955-58. Clarke established himself as a high-scoring wing in service football before selection for Canterbury 1963. Scored three tries in All Black trial 1967 and won selection for the British tour but did not strike his best form overseas.

Returned to play another season of representative rugby in Marlborough before leaving the air force and spending some time in Australia where he played for Newcastle. Coached the Opawa club 1976. Brother of Adrian Clarke, the 1958-60 All Black, and son of team photographer Vernon Clarke.

RNZAF and Combined Services sprint champion.

CLARKE Ray Lancelot
b: 7.7.1908, Wairea *d:* 3.6.1972, New Plymouth
Lock

Represented NZ: 1932; 9 matches – 2 tests

First-class record: Taranaki 1928-34 (Okaiawa), 1935-37 (Stratford); Waikato 1938 (Te Awamutu); North Island 1932-34; NZ Trials 1934,35

Educated Okaiawa School. Toured Australia with the 1932 All Blacks playing against Wellington before the team departed and in eight of the 10 tour matches including the second and third tests. A powerful lock standing 6 feet and weighing 14½ stone, Ray Clarke was considered unlucky to miss selection for the 1934 Australian tour and the 1935-36 visit to Britain. His son, R.L. Clarke, represented Wellington 1962 and Taranaki 1964-66.

COBDEN Donald Gordon
b: 11.8.1914, Christchurch *d:* 11.8.1940, English Channel
Wing threequarter

Represented NZ: 1937; 1 match – 1 test

First-class record: Canterbury 1935-37 (Christchurch HSOB); South Island 1937; NZ Trials 1937; Barbarians (UK) 1939

Educated Christchurch Boys' High School. A tall player, standing over six feet and weighing 13st 4lb, Cobden also had great pace as a wing.

His sole All Black appearance came after three games for Canterbury, three trials and the 1937 interisland game. Retired with a leg injury

after 25 minutes of the first test against the 1937 Springboks.

Cobden joined the Royal Air Force 1938 and played for Catford Bridge, Kent, the RAF and the Barbarians (UK) while in England. He was reported missing during the Battle of Britain, and his body was later washed up at Ostend and buried by the Germans in the communal cemetery there. His brother, Alf (also a war casualty), represented Canterbury 1933,35.

COCKERILL Maurice Stanley
b: 8.12.1928, Hawera
Fullback

Represented NZ: 1951; 11 matches – 3 tests, 50 points – 1 try, 16 conversions, 5 penalty goals

First-class record: Taranaki 1949-51 (Hawera Athletic); NZ Trials 1951

Educated Hawera School and Hawera Technical College, 1st XV 1943-46. An outstanding schoolboy footballer who showed very good form from the start of his representative career – named one of the year's promising players by the *1950 Rugby Almanack of New Zealand*. Bob Scott's temporary retirement at the end of the 1950 season gave 'Snow' Cockerill his chance and after playing well in the 1951 trials he won selection for the Australian tour. Reached great heights in Australia, scoring 50 points, but a severe knee injury received in the Taranaki v Waikato game after his return home ended his career. His statistics were recorded as 5' 11" and 12st 2lb. Taranaki cricket representative.

COCKROFT Eric Arthur Percy
b: 10.9.1890, Clinton *d:* 2.4.1973, Ashburton
Threequarter and fullback

Represented NZ: 1913,14; 7 matches – 3 tests, 7 points – 1 penalty goal, 1 dropped goal

First-class record: Otago 1911,12 (University); South Canterbury 1913,14 (Pirates), 1920 (Timaru HSOB); South Island 1914; NZ Services 1919

Educated Southland Boys' High School, 1st XV 1906. Played for the Mataura club 1908-10 before going to Dunedin. Selected on the wing in the third test v Australia 1913 and then had two internationals at fullback in Australia 1914 after being sent to replace George Loveridge, who was injured.

Author of *The Modern Method in New Zealand Football* (W.H. Foden, 1924). Nephew of Samuel Cockroft (New Zealand 1893,94), older brother of Les Cockroft (South Canterbury and NZ Services), grandfather of John Greenslade (Mid Canterbury and South Island 1969). Eric Cockroft represented New Zealand at bowls 1953 and South Canterbury at cricket 1920,21.

COCKROFT Samuel George
b: 13.5.1864, Invercargill *d:* 1.1.1955, Wellington
Hooker

Represented NZ: 1893,94; 12 matches, 3 points – 1 try

First-class record: Wellington 1887,88 (Union), 1889,90 (Athletic), 1891,92 (Wellington); Manawatu 1893 (Palmerston

North); Hawke's Bay 1894 (Napier); North Island 1894; NZ Trials 1893; Queensland 1895,96

After touring Australia 1893 and appearing in the match against New South Wales 1894, Cockroft moved to Australia and captained the Queensland team on their 1896 tour of New Zealand. Weighed 12st 10lb. Uncle of Eric Cockroft (New Zealand 1913,14).

CODLIN Brett William
b: 29.11.1956, Pukekohe
Fullback

Represented NZ: 1980; 13 matches – 3 tests, 127 points – 1 try, 30 conversions, 21 penalty goals

First-class record: Canterbury 1979 (Lincoln College); Counties 1980-82,84 (Ardmore); North Island 1980; NZ Trials 1980,81; NZ Universities 1980

Educated Tehihi Primary School and King's College, 1st XV 1973,74. Represented Poverty Bay Colts 1975 from the Ngatapa club before studying at Lincoln College and then returning to the Counties area. Replaced Brian McKechnie who withdrew from the 1980 trials and subsequently won a place in the All Black team to tour Australia and Fiji. He played in 10 of the 16 games, including all three tests, and headed the point scorers with 95. Later that season he toured Wales appearing in three matches.

Brett Codlin

His father, M.C. Codlin, represented Waikato 1944 while his brother, Mark, played for Counties 1976-79 and NZ Juniors 1976 and had an All Black trial 1979.

COFFIN Phillip Hone
b: 24.7.1964, Otorohanga
Prop

Represented NZ: 1996; 3 matches

First-class record: King Country 1985-92 (Waitete), 1993-96 (Otorohanga); Wellington 1997 (Oriental-Rongotai); Wellington Hurricanes 1996,97; Coronation Shield XV 1994; Manawatu Invitation XV 1996; Southern Maori 1990-94; Central Maori 1995,96; NZ

Maoris 1991-97; Divisional XV 1991,92; NZ Colts 1985; NZ Trials 1987,88,91-93,96; NZ XV 1992

Phil Coffin became one of the limited number of players to make their debut for the All Blacks beyond the age of 30 when he was chosen in the first enlarged touring squad for the tour of South Africa in 1996. He played in two of the midweek matches and went on as a replacement in a third.

Coffin, who had been drafted into the Wellington Hurricanes for the first year of the Super 12, moved to Wellington for the NPC the following year after more than a decade of service to King Country.

Two brothers, Hutana and Pita, also played for King Country, as did two uncles, Ray and Waka, with Ray Coffin also playing for New Zealand Maoris in 1961 and 1963. Hutana Coffin also played for New Zealand Maoris in 1992. Phil Coffin's grandfather, Charlie, also played for King Country.

COLLING George Lindsay
b: 27.8.1946, Cromwell
Halfback

Represented NZ: 1972,73; 21 matches, 24 points – 6 tries

First-class record: Otago 1967 (Wakatipu), 1968-73 (Pirates); Auckland 1974-76 (Ponsonby); South Island 1969,72,73; NZ Trials 1970-76

Educated Cromwell District High School. First played for the All Blacks on the internal tour 1972 then selected for the tour of British Isles and France as second-string halfback to Sid Going, appearing in 15 games. Also played for the All Blacks on the 1973 internal tour and in Scottish RFU Centenary matches.

After his transfer to Auckland Lindsay Colling captained that union for three seasons then coached the Ponsonby club after his retirement from active rugby.

Lin Colling was an All Black selector in 1994, joining his 1968-69 Otago team-mates, Laurie Mains and Earle Kirton, on the national panel. He was coach of the New Zealand Colts in Australia for three wins from three and of the Development team in Argentina for seven from nine.

Two brothers, Don and John, also played rugby for Otago as did a son of Don Colling's, Michael. Michael Colling's sister, Belinda, captained the New Zealand netball team in England in 1997.

COLLINS Arthur Harold
b: 19.7.1906, Stratford *d:* 11.1.1988, Waitara
Fullback

Represented NZ: 1932,34; 15 matches – 3 tests, 110 points – 1 try, 35 conversions, 11 penalty goals, 1 dropped goal

First-class record: Taranaki 1927-32 (Stratford), 1933-37 (Clifton); North Island 1932; NZ Trials 1934,35

Educated Stratford Primary School. A slightly built fullback standing 5' 7" and weighing 11$\frac{1}{2}$ stone, Collins was a sound, consistent player and an accurate goal kicker. Toured Australia with the 1932 All Blacks, playing in eight of the 10 matches including two internationals. Led the point scorers on tour with 43.

In 1934 Collins again toured Australia, playing in five of the eight matches including the first test; not available for the second test owing to injury. Headed point scorers for this tour with 43 and recorded a further 13 against the Rest of New Zealand after the team's return home.

Retired from active play 1940 but remained a stalwart of the Clifton club as coach, club captain and committee member. He was made a life member in 1970. His son, B.A. Collins, represented Taranaki 1962,63.

COLLINS John Law
b: 1.2.1939, Tokomaru Bay
Second five-eighth

Represented NZ: 1964,65; 3 matches – 3 tests

First-class record: Poverty Bay 1958-61,64-68 (Marist); North Island 1964,65; NZ Trials 1959,65-67; NZ Maoris 1964-66; Poverty Bay-East Coast 1965,66

Educated Tokomaru Bay District High School. Moved to Gisborne and represented Poverty Bay

John Collins

for four seasons and had an All Black trial before going on active service to Malaya. Returned to New Zealand 1964 and was selected for the first test against Australia. Injury kept him out of the rest of the series, but he won selection again for the first and fourth tests against the 1965 Springboks.

Continued to play representative football until his retirement 1968. At 5' 10" and 12$\frac{1}{2}$ stone, Collins was a solid and dependable midfield back.

COLLINS William Reuben
b: 18.10.1910, Makuri *d:* 9.9.1993, Auckland
Lock

Represented NZ: 1935; 7 matches

First-class record: Poverty Bay 1931 (Gisborne HSOB); East Coast 1932,33 (Tokomaru Bay United); Hawke's Bay 1934,35 (Wairoa HSOB); NZ Trials 1935

Educated Tikokino School. A lock forward standing 6' 2" and weighing 15$\frac{1}{2}$ stone, Collins was the heaviest forward selected for the 1935-

36 All Blacks. He was unable to reproduce his best form on tour after suffering a back injury in the Bradford match. Halfway through the tour Collins had what was described as heart strain and did not play again.

Coached grade teams for the Mt Roskill club in Auckland. Eric Dunn, North Auckland 1948-51, is a nephew.

COLMAN John Thomas Henry
b: 14.1.1887, Hawera *d:* 28.9.1965, Hawera
Utility back and wing forward

Represented NZ: 1907,08; 6 matches – 4 tests, 8 points – 2 tries, 1 conversion

First-class record: Taranaki 1905-08,11 (Hawera), 1912,14 (Waimate), 1915,20-22 (Hawera); North Island 1907,08,11; Wanganui-Taranaki 1905

Educated St Joseph's School (Hawera). First played for Taranaki at the age of 18 and in 49 games for his province appeared at halfback, five-eighth, fullback and wing forward. For New Zealand – in Australia 1907 and against the 1908 Anglo-Welsh tourists – 'Ginger' Colman played at fullback, wing threequarter and wing forward.

CONN Stuart Bruce
b: 11.3.1953, Whakatane
Flanker

Represented NZ: 1976,80; 6 matches

First-class record: Auckland 1973-75 (Northcote), 1976,77 (Grammar), 1979-81 (Takapuna); Hawke's Bay 1982 (Wairakei); North Island 1976; NZ Trials 1976-80; NZ Juniors 1975; NZ Services 1981

Educated Oropi Primary School and Tauranga Boys' College, 1st XV 1969,70. A fine utility forward who played equally well at number eight, flanker or lock, Conn weighed 94kg and stood 1.91m. He toured Argentina 1976 playing in five of nine games but a knee injury kept him out of rugby 1977-79. Returning to top form in the 1980 season he was selected for the New Zealand XV which met Fiji at Auckland.

CONNOLLY Leo Stephen
b: 2.12.1921, Invercargill
Prop

Represented NZ: 1947; 5 matches

First-class record: Southland 1940-42,47,49,50,52 (Marist); Otago 1943,44,46 (Dunedin); Waikato 1953,54 (Marist); South Island 1943,44,47; NZ Trials 1947; New Zealand XV 1944

Educated Southland Boys' High School, 1st XV 1937. Toured Australia with the 1947 All Blacks and revealed first-rate form but could not win a place in the tests ahead of Ray Dalton and Johnny Simpson. Missed the 1948 season through injury so was not considered for the 1949 South African tour.

Connolly was one of the heaviest forwards in the 1947 All Blacks at 15st 2lb but his height of 5' 10" made him the shortest member of the pack. Coached the St Pat's (Wellington) club 1964, Marist (Hutt Valley) 1966 and schoolboy teams from 1976. Refereed in Wellington 1968,69. His brother, Ken, represented Southland 1926.

CONNOR Desmond Michael

b: 9.9.1935, Ashgrove, Queensland
Halfback

Represented NZ: 1961-64; 15 matches – 12
tests, 3 points – 1 try

First-class record: Auckland 1960-66 (Marist);
Queensland 1954-59; Australia 1957-59; North
Island 1960-62,64,65; NZ Trials 1961-63,65;
Rest of New Zealand 1960,65

Educated Marist Brothers' College (Brisbane).
Connor won his first international cap when
selected for the 1957 Australian tour of Britain
and France. Played in all tests on that tour and
came to New Zealand with the 1958 Wallabies,
again appearing in all tests. Also represented
Australia against the 1959 Lions.

Moved to Auckland 1960 and was one of the
key players during that union's long tenure of
the Ranfurly Shield. Selected for the All Blacks
against France in the three tests 1961 then
toured Australia 1962 and played both tests,
appearing in three more internationals against
his native country when the Wallabies returned
the All Blacks' visit later in the season. Connor
was the All Black halfback in the two tests
against the 1963 English team but was a surprise
omission from the British tour at the end of the
season. He ended his international career with
two tests against Australia 1964. After another
two seasons he returned to Brisbane and became
an Australian selector. Stood 5' 11" and
weighed 12st 4lb during his playing career.

Terry McLean described Connor as having "a
long, clumping breakaway from the scrum, a long
and fast pass, long and prodigiously powerful
punt, a reverse pass which no opponent could
possibly foresee, a character so fine that players
were attracted to him and inspired by him."

As vice-captain of Auckland, North Island
and New Zealand, and captain of Australia, he
showed himself to be an astute tactician. A
shrewd coach of Australian teams after his
active rugby career was over.

CONRAD William John McKeown

b: 10.5.1925, Taumarunui *d:* 14.8.1972,
Auckland
Halfback

Represented NZ: 1949; 10 matches, 3 points –
1 try

First-class record: King Country 1946,47
(Taumarunui); Waikato 1948,50 (Marist); NZ
Trials 1948

Educated Taumarunui High School. Played 10
matches for King Country before moving to
Hamilton. Represented Waikato in four games
during the 1948 season and took part in All
Black trials, gaining selection for the 1949 tour
to South Africa. At 5' 9" and 12st 13lb Conrad
was solid and strong with the ability to vary his
play but his slow pass prevented him from
reaching true international class. Played one
game for Waikato 1950 before retiring.

CONWAY Richard James

b: 22.4.1935, Whakatane
Flanker

Represented NZ: 1959,60,65; 25 matches –
10 tests, 12 points – 4 tries

First-class record: Otago 1957-59 (Zingari-
Richmond); Waikato 1961 (Hamilton

Technical College OB); Bay of Plenty 1962-68
(Whakatane United); North Island 1961; NZ
Trials 1958-63,65,66; Rest of New Zealand
1965,66; Bay of Plenty-Counties-Thames
Valley 1965

Educated Edgecumbe Primary and Whakatane
High School. Played club rugby in his home
town and in Taumarunui before travelling to
Dunedin each winter for several years to play for
Otago.

Brought into the All Blacks for the second test
against the 1959 Lions when Peter Jones was
injured, retained his place for that series and
played three tests in South Africa 1960. Did not
appear for the All Blacks again until he was
chosen for all four internationals against the
1965 Springboks. Captained combined Bay of
Plenty-Counties-Thames Valley team against the
tourists.

'Red' Conway played 157 first-class games in
a career spanning ten seasons. Although
comparatively small (5' 9" and 13½ stone), he
was an energetic, bustling loose forward whose
dynamic tackling was a feature of his play.
Coached the Whakatane United club 1975-78.
Represented Rotorua at softball 1956.

'Red' Conway

COOKE Albert Edward

b: 5.10.1901, Auckland *d:* 29.9.1977,
Auckland
Second five-eighth and centre threequarter

Represented NZ: 1924-26,28,30; 44 matches –
8 tests, 120 points – 38 tries, 3 conversions

First-class record: Auckland 1923,25
(Grafton); Hawke's Bay 1926 (Napier Technical
College OB); Wairarapa 1927 (Masterton),
1928,29 (Masterton OB); Wellington 1930
(Hutt); Hawke's Bay 1931,32 (Hastings); North
Island 1924-26,28,29,31; NZ Trials 1924,27,30;
Auckland-North Auckland 1923

Educated Hamilton East Primary and Hamilton
Boys' High School. Played rugby league for a
Post and Telegraph team after leaving school.

Bert Cooke

Joined the Grafton club and represented
Auckland 4th grade 1919. Graduated to senior
club rugby 1923, represented Auckland and was
a reserve for the All Blacks against New South
Wales in that season.

On the 1924-25 tour he played magnificently,
scoring 23 tries (the highest tally) in 25
appearances for the 'Invincibles'. In 1925 he
contributed two of the eight tries scored by New
Zealand in a 36-10 victory over New South
Wales, and then toured Australia with the 1926
All Blacks.

Following the 1927 trials, Cooke was selected
to tour South Africa the following year but
withdrew for business reasons and was replaced
by Syd Carleton. However, he did play twice for
New Zealand in 1928, against a New South
Wales touring side. His last appearances for his
country were the four tests against the 1930
British Isles team, finishing with two tries in the
fourth test characteristically both scored as a
result of his speed in following his own kicks
over the line.

Cooke played in the 1931 interisland game
but was not selected to play against Australia.
His last first-class game of rugby was for
Hawke's Bay v Wairarapa, June 3, 1932, before
joining the Richmond rugby league club in
Auckland. Represented New Zealand in league
against the 1932 British team and the 1935
Australians. After the outbreak of WWII, he
joined the air force and again played rugby for
that service in the 1940 Auckland club
competition.

In his first-class career Cooke scored 121 tries
in 131 matches.

Bert Cooke's great pace off the mark, his
accurate punting and ability to recover a short
kick ahead, as well as his remarkable capacity to
turn the slightest vestige of a chance into a try
made his name a household word during his
career. Although slightly built, weighing 9st
12lb and standing 5' 9", he was also a fine
defensive player.

R.A. Byers-Barr in a 1924 tour booklet
described him as "the most brilliant back in the
All Black team. As swift as a hare; as elusive as
a shadow; strikes like lightning, flashes with
brilliancy, Cooke is the shining star of the side.
He is meteoric in method; penetrates like a
bayonet-point, and thrusts like steel. Cooke is
Eclipse! . . . He is faster and more elusive than
any back in England or Wales today."

COOKE Alfred Ernest

b: c 1870 *d:* 3.6.1900, Lake Ellesmere
Halfback

Represented NZ: 1894, 1 match

First-class record: Canterbury 1893-95
(Merivale)

Alfred Cooke's sole match for New Zealand was against New South Wales at Christchurch 1894. In his union history, *Rugby Football in Canterbury 1929-54*, J.K. Moloney described Cooke as "a fine halfback, exceptionally quick at getting the ball away from the scrum and also a powerful and accurate line kicker". His brother, Reuben, represented New Zealand 1903.

COOKE Reuben James

b: c 1880 *d:* 10.5.1940, Melbourne
Loose forward

Represented NZ: 1903; 10 matches – 1 test, 3 points – 1 try

First-class record: Canterbury 1899,1901-03 (Merivale); South Canterbury 1904,05 (Star); South Island 1902,03

In the first match of the 1903 tour of Australia, against New South Wales, Cooke was involved in an incident with Harold Judd and was ordered off by the referee, former New Zealand player Tom Pauling. An inquiry exonerated Cooke but he was greatly affected by the affair and did not play again after this tour.

Moved to Melbourne 1913 and was coach and an administrator for the Kiwi club. Brother of Alfred Cooke (New Zealand 1894).

COOKSLEY Mark Stephen Bill

b: 11.4.1971, Auckland
Lock

Represented NZ: 1992-95,97; 21 matches – 9 tests, 5 points – 1 try

First-class record: Counties 1990-93 (Manurewa); Waikato 1994-97 (Fraser Tech); Waikato Chiefs 1996; Wellington Hurricanes 1997; NZ Trials 1991-94,96; NZ Maoris 1992-94,96,97; NZ Colts 1991; Saracens 1992; NZ Development 1994; NZ Divisional XV 1993; Northern Maori 1994,96; Crusaders 1995; South Canterbury Invitation 1995; Manawatu Invitation 1995; North Otago Invitation 1995; NZ A 1997

Mark Cooksley, regarded as a lock of high promise in the early 1990s, had something of a chequered career in the All Blacks, with whom he could never guarantee a place. There were times when he seemed to play better and make more of an impression for lesser sides than he did when playing for New Zealand.

He was first chosen for the first of the centenary tests in 1992 but was not wanted for another test that year. It was not coincidental that 1992 was also Robin Brooke's debut test year. Cooksley played three tests in the following year, and was controversially replaced against the Lions in Wellington, and had his best year in 1994 when Brooke was injured. His only appearance in 1995 was when he was called into the team in France as a replacement. He played the second-last match, in Nancy, and created a footnote in history after he had punched French Selection hooker Herve Guiraud and became the first All Black to be

shown a yellow card. Irish referee Gordon Black appeared not to know that the red and yellow card system did not then apply to international rugby.

Cooksley was not required in 1996 but after a strong Super 12 season for the Wellington Hurricanes and then for Waikato, who regained the Ranfurly Shield from Auckland, he went on the tour of Britain and Ireland in November and December 1997.

COOPER Gregory John Luke

b: 10.6.1965, Gisborne
Fullback

Represented NZ: 1986,92; 7 matches – 7 tests, 63 points – 2 tries, 14 conversions, 7 penalty goals, 2 dropped goals

First-class record: Hawke's Bay 1984,87 (Marist); Otago 1984,85,88-93, 96 (Green Island); Auckland 1986,87 (Marist); Auckland Blues 1996; South Island 1985; North Island 1986; NZ Colts 1984,85; NZ Trial 1992; NZ XV 1992; North Zone 1987; South Zone 1988-89

Greg Cooper played for New Zealand Secondary Schools from St John's College in Hastings and made his first-class debut for Hawke's Bay in his first year out of school. He moved to Otago after

Greg Cooper

one game for the Bay and gained national recognition on tour with the Barbarians club. He moved to Auckland in 1986, was the first-choice fullback for the Ranfurly Shield team and was chosen for the first two tests in 1986 when players who had made an unauthorised tour of South Africa were unavailable. He was retained for the second test against Australia when the Cavaliers were back, but not wanted thereafter.

He moved back to Otago in 1988 and despite a string of strong performances, was not wanted nationally. He was recalled to act as an All Black reserve in 1991 then finally regained an All Black place for the three centenary tests in 1992. He stayed there for the first test against Ireland, but was replaced by his brother Matthew for the second.

That was the end of Cooper's All Black career though he continued as a leading light in Otago for another year and ended with a record 1534 points for the province. He came back from a two-year retirement in 1996 to play for Otago

and was drafted into the Auckland Blues for the first Super 12.

Cooper's father Pat played a New Zealand trial in 1957 and for Hawke's Bay (1956-60) and Poverty Bay (1963). A cousin, Ivan Ujdur, was a fullback for Hawke's Bay and toured Australia and Sri Lanka with the New Zealand Colts in 1955.

Greg Cooper also played Hawke Cup cricket for Hawke's Bay in 1983,84.

COOPER Matthew James Andrew

b: 10.10.1966, Gisborne
Second five-eighth and fullback

Represented NZ: 1987,92-94,96; 26 matches – 8 tests, 224 points – 12 tries, 35 conversions, 33 penalty goals

First-class record: Hawke's Bay 1985,86 (Napier Technical COB), 1987,88 (Napier Marist OB),1989 (Hastings HSOB); Waikato 1990-97 (Marist); Otago Highlanders 1996; Waikato Chiefs 1997; NZ Colts 1987; Divisional XV 1988,89; NZ Trials 1989,90,93,94; Central Zone 1988,89; Saracens 1992

Like older brother Greg, Matthew Cooper was educated at St John's College and played for Hawke's Bay in age group teams as well as the national secondary schools side. He made his first-class debut in 1985 – at centre – and after playing for New Zealand Colts in 1987, was chosen for the All Blacks for the tour of Japan in October and November of that year.

He did not make his test debut, however, until five years later when he was chosen ahead of his brother at fullback for the second test against Ireland. He scored 23 points for a record on debut, which was beaten by Andrew Mehrtens' 28 points against Canada in 1995. Despite that, he played in only one test on the ensuing tour of Australia and South Africa, going on as a replacement for Va'aiga Tuigamala against South Africa. His next three tests were also as replacements (against the Lions and Western Samoa) but he gained a test spot in his own right against Scotland at Murrayfield in 1993, at second five-eighth. He was injured in that match, however, and could not play the following week against England, a test that was lost.

Cooper played in the two lost tests against France in 1994, again at second five-eighth, was not required in 1995 and gained a surprise recall in 1996 when he replaced the injured Adrian Cashmore in South Africa.

Cooper has had an outstanding career for Waikato after moving there in 1990 from Hawke's Bay and by the end of the 1997 season, he had scored 2120 points in all first-class matches, putting him fourth on the alltime points-scoring list (behind brother Greg, Kieran Crowley and Grant Fox). He is also among a select group of seven players who have been involved in three successful Ranfurly Shield challenges. The record is four, held by Bryan Williams.

CORBETT John

b: c 1880, Reefton *d:* 11.4.1945, Ratapiko
Forward

Represented NZ: 1905; 15 matches

First-class record: West Coast 1906,07 (Reefton); Buller 1908-10 (White Star); South Island 1904-06,09; Canterbury-South

Canterbury-West Coast 1904; West Coast-Buller 1908

Played for combined Canterbury-West Coast team against the 1904 British team. Selected for 1905 All Blacks and went on the preliminary tour of New South Wales, before departing for Europe.

On the British tour Corbett took the field in 12 matches, his appearances being restricted by injuries. Played well enough to win South Island honours twice after his return from Britain but did not gain New Zealand selection again. Played for West Coast-Buller against the 1908 Anglo-Welsh team. Buller selector, 1915.

CORKILL Thomas George
b: 9.7.1901, Wairoa *d:* 9.5.1966, Wellington
Halfback and five-eighth

Represented NZ: 1925; 4 matches

First-class record: Hawke's Bay 1923 (Wairoa City), 1924-27 (Wairoa Pirates); Wairarapa 1929,30 (Red Star); NZ Trials 1927; Wairarapa-Bush 1930

Educated St Patrick's College (Wellington), 1st XV 1918. Represented Hawke's Bay during its tenure of the Ranfurly Shield, playing in 10 of the 24 challenges. Basically a halfback, Corkill was forced by the presence of All Black halfback Jimmy Mill to play in a variety of positions including fullback, wing and five-eighth.

Included in the 1925 New Zealand team to Australia. A cool and steady player, standing 5' 10" and weighing 11 stone, Corkill had two matches on tour as halfback and two as a five-eighth.

CORNER Mervyn Miles Nelson
b: 5.7.1908, Auckland *d:* 2.2.1992, Auckland
Halfback

Represented NZ: 1930-32,34-36; 25 matches – 6 tests, 25 points – 1 try, 11 conversions

First-class record: Auckland 1929-35 (Grammar); NZ Trials 1930,34,35

Educated Auckland Grammar School. After a fine All Black trial he won selection for the All Black team to play the second test against the 1930 Lions as a replacement for Jimmy Mill and enjoyed a faultless game. Held his place for the rest of that series and the sole test against Australia 1931. Standing only 5' 5" and weighing 9½ stone, Corner was one of the smallest men to play for New Zealand.

Toured Australia 1932 but was kept out of the internationals by the team captain, Frank Kilby. Again in Australia 1934 he played in one test and Kilby the other. Appeared in 13 matches, including the English international, during the 1935-36 British tour.

Corner retired from first-class rugby after this tour but continued to play at club level and was a member of the newly-formed Takapuna club's senior team which won the Gallaher Shield 1940.

Auckland RFU president 1959-61; selector 1949,54-56, North Island selector 1949-53. New Zealand selector 1950-53. Won MC while serving in WWII. OBE.

COSSEY Raymond Reginald
b: 21.1.1935, Papakura *d:* 24.5.1986, Drury
Wing threequarter

Represented NZ: 1958; 1 match – 1 test

First-class record: Auckland 1953,54 (Ardmore College); Poverty Bay 1956,57 (Gisborne HSOB); Counties 1958-62 (Pukekohe); North Island 1958; NZ Trials 1957-59; NZ Under 23 1958; Poverty Bay-East Coast 1956; King Country-Counties 1959

Educated Wainui Primary, Helensville District High School, 1st XV 1948,49, and Otahuhu College, 1st XV 1950-52. Played for Auckland as an 18-year-old student at Ardmore Training College before the formation of Counties union.

Toured Japan with the 1958 Under 23 team and selected for the first test against Australia in the same year. Did not appear for All Blacks again but played representative football until 1960. A big, powerful wing, standing 5' 10" and weighing 13st 2lb, Cossey was a prolific try scorer at provincial level.

COTTRELL Anthony Ian
b: 10.2.1907, Westport *d:* 10.12.1988, Christchurch
Hooker and prop

Represented NZ: 1929-32; 22 matches – 11 tests, 12 points – 4 tries

First-class record: Canterbury 1928-34 (Christchurch); South Island 1929,31-33; NZ Trials 1929,30; Rest of New Zealand 1934

Educated Christ's College, 1st XV 1923-25. Standing 5' 10" and weighing 12st 12lb 'Beau' Cottrell was described as "a good all-round forward and an ideal hooker". Beginning his All Black career in Australia 1929, he played in 11 consecutive internationals, including all four against the 1930 Lions appearing in New Zealand's last 2-3-2 scrum against Australia 1931 and as a prop in the three tests in Australia 1932.

Cottrell served on the Canterbury RFU management committee 1930-39. CBE.

COTTRELL Wayne David
b: 30.9.1943, Christchurch
Five-eighth

Represented NZ: 1967,68,70,71; 37 matches – 7 tests, 33 points – 9 tries, 2 dropped goals

Wayne Cottrell

First-class record: Canterbury 1964-72 (Suburbs); South Island 1967-69,71; NZ Trials 1966-71; NZ Juniors 1966

Educated Halswell Primary and West Christchurch High School, 1st XV 1959,60. Captained the Canterbury Under 20 team 1963 and played for the NZ Juniors against the 1966 Lions before winning selection in the 1967 All Blacks to visit Britain and France where he appeared in eight of the 17 matches.

'Baker' Cottrell made his international debut at second five-eighth in the two tests in Australia 1968 and played the final two against France in the home series of that year. Ian MacRae returned for the two tests v Wales 1969 and then Cottrell played inside the Hawke's Bay man in the first test in South Africa 1970. Was unlucky to miss the next two tests and was not considered for the final international because of injury. Returned to second five-eighth for three of the tests against the 1971 Lions but when Burgess was injured he moved in to first five-eighth for his last international appearance. Played in RFU centenary matches, 1971. Weighed 12st 12lb and stood 5' 11".

COUCH Manuera Ben Riwai
b: 27.6.1925, Christchurch *d:* 3.6.1996, Masterton
First five-eighth

Represented NZ: 1947-49; 7 matches – 3 tests, 3 points – 1 try

First-class record: Wairarapa 1945-47 (Greytown), 1948-50 (Gladstone), 1951-54 (Martinborough); North Island 1947; NZ Trials 1947; NZ Maoris 1948-50; New Zealand XV 1949; Wairarapa-Bush 1946,48-50

Educated Pirinoa School and Christchurch Technical School, 1st XV 1940-42. Made his debut in representative football as a wing for Wairarapa against Hawke's Bay 1945.

Selected for the 1947 Australian tour playing five games including the first test. Played both the 1949 tests against the visiting Australians. Couch could play in various back positions but was best suited to first five-eighth where his excellent handling and steady all-round play were invaluable assets. Stood 5' 7" and weighed 13½ stone.

Ben Couch was a Wairarapa selector 1954,62-64 and served as chairman and president of the Wairarapa RFU. Member of the NZRFU council 1972-79. M.P. 1975-1984.

COUGHLAN Thomas Desmond
b: 9.4.1934, Temuka
Flanker

Represented NZ: 1958; 1 match – 1 test

First-class record: South Canterbury 1952-60 (Temuka); King Country 1961 (Aria-Mokauiti); South Island 1955,57,58,60; NZ Trials 1953,55-61; Rest of New Zealand 1960

Educated St Joseph's (Temuka) and St Mary's (Mosgiel) Convent Schools and St Kevin's College. After six seasons of first-class rugby he won selection for the first test v Australia 1958. Played well in his only international and his omission from the rest of the series was hard to understand.

A strong, forceful forward and a good pack leader, Coughlan played at 6' 1" and 14st 9lb. Mid Canterbury selector 1973,74. A son, Tom, represented NZ Colts 1984, NZ Universities 1985.

CREIGHTON John Neville

b: 10.3.1937, Rotherham
Hooker

Represented NZ: 1962; 6 matches — 1 test, 12 points — 4 tries

First-class record: Canterbury 1956-68 (University); South Island 1960-64; NZ Trials 1959-63,65,66; NZ Universities 1959,60,62-64,66,67; NZ Juniors 1959; NZ Under 23 1958; New Zealand XV 1960; Rest of New Zealand 1960

Educated East Christchurch Primary and Christchurch Boys' High School, 1st XV 1953,54. Toured Australia with the 1962 All Blacks then played his only international in the

John Creighton

second test when Australia paid a return visit later in the 1962 season. Appeared in 100 matches for Canterbury even though part of his career coincided with that of Dennis Young.

At 5' 11" and 14st 6lb, Creighton was a strongly built, quick-striking hooker who gave valuable service to the game over a long period. Coached the University club in Christchurch 1969-78 and Merivale-Papanui 1979.

CRICHTON Scott

b: 18.2.1954, Wanganui
Prop

Represented NZ: 1983-85; 7 matches — 2 tests

First-class record: Wellington 1980-82 (Athletic), 83-87 (Western Suburbs); NZ Trials 1985; NZ Maoris 1982,84,85,87

Educated Wanganui Boys' College where he was judged too heavy for the 1st XV.

Crichton was first chosen for the All Blacks for the 1983 tour of England and Scotland and played in both test matches, retiring injured against England.

He was not chosen for the 1984 tour of Australia but went to Fiji later that year. Named in the 1985 team to tour South Africa, Crichton went on the replacement tour to Argentina but

was injured in his first game and returned home. He toured South Africa with the unofficial Cavaliers in 1986. Weighed 111kg and stood 1.83m.

CRON Stewart Edward George

b: 7.7.1946, Hokitika
Flanker

Represented NZ: 1976; 6 matches, 8 points — 2 tries

First-class record: Canterbury 1967-70,74-76 (Suburbs), 1971 (Kaikoura), 1972,73 (Waiau); South Island 1970,72,75,76; NZ Trials 1970-73,76

Educated Wharenui Primary and Christchurch West High School. A very fit and fast loose forward who was on the verge of All Black honours throughout the early 1970s. He toured Argentina 1976 appearing in both matches against the Pumas. Stood 1.83m and weighed 90kg. His brother, Michael, represented Canterbury 1976,77, captained the NZ Colts 1974,75 and the NZ Services team in Australia 1978.

Stu Cron

CROSS Thomas

b: 21.1.1876, Dunedin *d:* ?
Loose forward

Represented NZ: 1901,04,05; 3 matches — 2 tests, 3 points — 1 try

First-class record: Otago 1898-1900 (Kaikorai); Canterbury 1901,02 (Linwood); Wellington 1903 (Poneke), 1904-07 (Petone); South Island 1902; North Island 1904,06; Wellington-Wairarapa-Horowhenua 1905; Wellington Province 1903,05,07

A leading forward of his day whose playing weight was given as 14st 5lb. After playing for New Zealand v Wellington and New South Wales 1901 and v Great Britain 1904, his omission from the 1905-06 All Black team was a major surprise although he did play against Australia after the touring party left. Ordered off

in a club match 1907 and suspended for the season. Turned to league that year and toured with the 'All Golds'.

CROSSMAN Graeme Murray

b: 30.11.1945, New Plymouth
Hooker

Graeme Crossman

Represented NZ: 1974,76; 19 matches, 12 points — 3 tries

First-class record: Bay of Plenty 1972-76 (Eastern Districts); North Island 1974,75; NZ Trials 1974-76

Educated New Plymouth Boys' High School and Tamaki College, 1st XV 1962,63. Played for the Teachers club in Auckland 1963-70 before moving to the Bay of Plenty, captaining that province 1973-76.

Crossman toured Australia with the 1974 All Blacks and captained the team in two of his five games. Visited Ireland that year, playing twice, and South Africa 1976 where he again captained the All Blacks in two of his 12 appearances.

A useful hooker and vigorous about the field, Graeme Crossman was described by the *1974 DB Rugby Annual* as "a mature and inspiring leader". He was perhaps unlucky to have his All Black career coincide with that of Tane Norton. Stood 1.78m and weighed 85kg.

Eastern Districts club coach 1977,78 and committee member 1971-76. Bay of Plenty selector 1979-84. His uncle, Cliff, played for King Country and was a reserve for the test series against the 1937 Springboks. His brother, Kevin, represented Taranaki 1968,70.

CROWLEY Kieran James

b: 31.8.1961, Kaponga
Fullback

Represented NZ: 1983-87,90,91; 36 matches — 20 tests, 320 points — 14 tries, 36 conversions, 61 penalty goals, 3 dropped goals

First-class record: Taranaki 1980-94 (Kaponga); North Island 1983; NZ Trials

Kieran Crowley

1982,84,85,87-89,91; NZ Colts 1980-82; Central Zone 1987,88

Educated at Kaponga Convent and Sacred Heart College in Auckland, Crowley played for the New Zealand Colts for three years before he was selected for the All Blacks' tour of England and Scotland in 1983, as a replacement for Allan Hewson. Crowley missed the 1984 tour of Australia but was recalled for the tour of Fiji later that year. He made his test debut against England in 1985, when he scored all of the All Blacks' 18 points. He played in both tests on the tour of Argentina and in 1986 was a member of the unauthorised Cavaliers' tour of South Africa.

He regained his test place for the deciding test against Australia and played in both tests on the tour of France later in the year. Crowley was the backup fullback to John Gallagher in the 1987 World Cup and played in the pool match against Argentina. Gallagher kept Crowley out of the All Blacks for the next two years, and was recalled in 1990 when both Gallagher and the up-and-coming fullback, Matthew Ridge, had switched to league. He played in all five domestic tests plus the two on the tour of France at the end of the year. Crowley toured Argentina in 1991 but was not an original choice for the World Cup squad. He was called up after injury to Terry Wright, however, and played in the semifinal against Australia.

Crowley also played for an Anzac XV against the British Isles in Brisbane in 1989.

Crowley was one of the most dependable of fullbacks but was said to have lacked the attacking flair of others, and suffered through the presence of Robbie Deans, Hewson, Gallagher and Ridge, then again in 1991 when the selectors chose a specialist wing, Wright, as fullback for the World Cup. Crowley gave years of service to Taranaki and scored a record 1723 points for the province.

A younger brother, Alan, also played for Taranaki, the Central Zone, New Zealand trials and the New Zealand sevens team.

Crowley also played cricket for Taranaki and Brabin Shield cricket for Central Districts.

CROWLEY Patrick Joseph Bourke

b: 20.10.1923, Wanganui *d:* 9.6.1981, Auckland
Flanker

Represented NZ: 1949,50; 21 matches – 6 tests, 6 points – 2 tries

First-class record: Auckland 1946-48,50 (Marist); North Island 1946-48,50; NZ Trials 1948,50

Educated Marist Brothers' School (Wanganui), Wanganui Technical College and St Patrick's College (Silverstream), 1st XV 1940. Toured South Africa 1949 playing in 16 matches

Pat Crowley

including the third and fourth tests. Selected for all four tests against the 1950 Lions and acclaimed as one of New Zealand's best post-war flankers.

A big man, at 6' 2" and 14st 12lb, Crowley was also very fast and a deadly tackler having a devastating effect on opposing inside backs.

CULHANE Simon David

b: 10.3.1968, Invercargill
First five-eighth

Represented NZ: 1995,96; 9 matches – 6 tests, 150 points – 1 try, 38 conversions, 22 penalties, 1 dropped goal

First-class record: Southland 1988-97 (Invercargill); Otago Invitation 1997; NZ Trials 1993,95; NZ XV 1995; NZ Divisional 1992,93,95; Otago Highlanders 1996,97; South Island XV 1995; Northland Invitation XV 1996; Manawatu Invitation XV 1996

Simon Culhane, whose secondary education was at Kingswell High School, Invercargill, played age grade rugby for Southland before making his first-class debut in 1988. Despite his early promise, he was not selected for an All

Simon Culhane

Black trial until 1993 and not chosen for the All Blacks until he was included in the World Cup squad in 1995. He played in the pool match against Japan, in which he scored a World Cup and New Zealand record 45 points.

Culhane played in the three tests on the tour of Italy and France in October and November in 1995 after the first-choice first five-eighth, Andrew Mehrtens, had returned home injured. Culhane also toured South Africa in 1996 and played in two of the tests when Mehrtens was again injured.

Culhane also played U-Bix Cup (formerly Hawke Cup) cricket for Southland.

CULLEN Christian Mathias

b: 12.2.1976, Paraparaumu
Fullback

Represented NZ: 1996,97; 23 matches – 22 tests, 140 points – 28 tries (24 in tests)

First-class record: Horowhenua 1994 (Paraparaumu); Manawatu 1995,96 (KiaToa); Central Vikings 1997; Wellington Hurricanes 1996,97; Barbarians 1996,97; NZ Colts 1995; NZ Trial 1996

Cullen, who was educated at Kapiti College at Paraparaumu, gave notice early that he was one of the most sensational attacking backs seen in New Zealand rugby. He made his debut for Horowhenua as an 18-year-old against Transvaal in which he scored a try that was to be his trademark – receiving the ball on defence and making a characteristic gliding run to the other end of the field. He seemed to make an impact in every game he played, whether for Horowhenua, Manawatu, New Zealand Under 19, the Colts or the national sevens teams. At the Hong Kong sevens tournament in 1996, he scored a record 18 tries.

He scored seven tries in the 1996 Super 12 and after another three in the All Black trial, his test selection became automatic. On his debut against Western Samoa in Napier, he scored three tries, followed by another four in his next test, against Scotland.

Cullen has played each test since then, his tries (24) just outnumbering his tests (22). In his only appearance for New Zealand that wasn't a test, against Llanelli on the 1997 tour of Britain and Ireland, he scored four tries.

Cullen completed the most formidable attacking lineup in world rugby with team-mates such as Jonah Lomu, Jeff Wilson and Glen Osborne. Toward the end of 1997, there was some muted criticism of Cullen for counter-attacking too often, for not being strong on defence and for not passing often enough, but such criticisms seemed to be outweighed by the dividend he could provide.

After the combined Manawatu-Hawke's Bay team, the Central Vikings, was confirmed for another year in second division in 1998, Cullen signed with Wellington.

Cullen is a great-nephew of 1951 All Black halfback Brian Steele.

CUMMINGS William
b: 13.3.1889, Timaru *d:* 28.5.1955, Christchurch
Loose forward

Represented NZ: 1913,21; 3 matches – 2 tests, 3 points 1 try

First-class record: Canterbury 1912-15,18,21 (Linwood)

Educated Marist Brothers' and Waltham Schools. After playing in the second and third tests against the 1913 Australians, Cummings appeared once more for the All Blacks v New South Wales 1921.

His brother, Ernie, represented Canterbury 1913,21 and the South Island 1919.

CUNDY Rawi Tama
b: 15.8.1901, Featherston *d:* 9.2.1955, Hinakura
Utility back

Represented NZ: 1929; 6 matches – 1 test, 31 points – 2 tries, 11 conversions, 1 penalty goal

First-class record: Wairarapa 1921 (Featherston United), 1922-27 (Featherston), 1928 (Southern United), 1929 (Greytown); NZ Trials 1927,29

Educated Nelson College, 1st XV 1918,19. Standing 5' 9" and weighing 12st 8lb, Cundy was normally a five-eighth but also played at fullback and wing threequarter and, in his first match for New Zealand, made one appearance as wing forward.

Toured Australia 1929, appearing in six of the 10 matches including an appearance in the second test when he replaced the injured Charlie Oliver.

An outstanding goal-kicker, Cundy became the first player to exceed 100 points in first-class rugby during a domestic season – totalling 110 points in 1927 from four tries, 31 conversions and 12 penalty goals. Four of these penalty goals helped Wairarapa beat Hawke's Bay 15-11 in their Ranfurly Shield challenge.

CUNNINGHAM Gary Richard
b: 12.5.1955, Auckland
Threequarter and second five-eighth

Represented NZ: 1979,80; 17 matches – 5 tests, 12 points – 3 tries

First-class record: Auckland 1976,78-84 (North Shore); North Harbour 1985,86 (North Shore); North Island 1979; NZ Trials 1979,81; NZ Juniors 1978

Educated Takapuna Grammar School, 1st XV 1971,72. Described by the *1978 DB Rugby Annual* as "the find of the NZ Juniors tour of Australia, an immediate All Black prospect," Gary Cunningham won selection for New Zealand in the next season for the brief Australian tour, making his test debut as a wing.

Appeared at centre in both matches against the 1979 Argentine tourists and then toured England and Scotland, playing at centre and second five-eighth in the internationals. In Australia 1980 he appeared again at centre and as a five-eighth in the first two tests but a thigh injury kept him out of the later tour matches. Named in the team to visit Wales at the end of that year, but withdrew because of knee injury. Cunningham's first-class career gained a new lease of life with the formation of North Harbour in 1985. Stood 1.83m and weighed 76.5kg.

CUNNINGHAM William
b: 8.7.1874, Rangiaohia *d:* 3.9.1927, Auckland
Lock

Represented NZ: 1901,05-08; 39 matches – 9 tests, 22 points – 2 tries, 8 conversions

First-class record: Auckland 1899-1901 (Waihi West), 1902 (City), 1904,05 (Waitete), 1906-13 (Ponsonby); North Island 1902,08; NZ Maoris 1910,12

A rotund, cheerful and durable player whose strength and technique made him the leading lock forward of his era, Bill Cunningham first represented New Zealand against New South Wales 1901.

Brought into the 1905-06 team to tour the British Isles when the preliminary tour of New South Wales revealed the team was short of a specialist lock. In his tour book, team manager George Dixon wrote "there being no man in the colony more eligible for this position than Cunningham, he was added to the team".

Joined the All Blacks in time to play against Wellington Province prior to leaving the country then played in 23 of the 33 matches in Europe including the Scottish, Irish and French internationals. At the time of this tour his

Christian Cullen . . . 24 tries in 22 tests.

weight was recorded as 14st 6lb and he stood 5' 11".

Toured Australia with the 1907 All Blacks, playing in all eight games and ended his All Black career at the age of 34 with the three test series against the Anglo-Welsh 1908. He retired after 103 first-class games five years later. Auckland selector 1920.

CUPPLES Leslie Frank
b: 8.2.1898, Otautau *d:* 10.8.1972, Hamilton
Loose forward

Represented NZ: 1922-25; 29 matches – 2 tests, 18 points – 6 tries

First-class record: Bay of Plenty 1920-23 (Tokaanu); North Island 1922; NZ Trials 1924

Educated Otautau School. A very strong and fit loose forward, standing 6' 2½" and weighing 13st 12lb. After serving with the Field Ambulance and winning the Military Medal in WWI, represented East Taupo sub-union 1920,22 and Bay of Plenty for three years, playing against the 1921 Springboks and in the Ranfurly Shield challenge 1922 when his union went within a point of defeating Hawke's Bay.

Cupples toured Australia 1922, played for New Zealand against the 1923 New South Wales touring side, visited Australia again 1924 and then played 18 games including the internationals against Ireland and Wales for the 1924-25 'Invincibles'.

CURREY William Douglas Roy
b: 2.6.1944, Auckland
Wing threequarter

Represented NZ: 1968; 7 matches, 24 points – 8 tries

First-class record: Auckland 1966 (Grammar); Taranaki 1967-69 (Opunake), 1970-72 (New Plymouth HSOB); NZ Trials 1967,68; NZ Under 23 1967

Educated Auckland Grammar School, 1st XV 1960,61. Played for Grammar Old Boys on leaving school and represented Auckland Colts and Auckland B before transferring to Taranaki 1967.

Selected for the 1968 Australian tour and showed good form as a fast, elusive wing. Played 67 matches for Taranaki, appearing at second five-eighth, centre and wing. Weighed 12 stone and stood 5' 9½". Won Taranaki 100 and 220yd sprint titles 1967.

His father, L.R. Currey, played for Auckland 1934,35.

CURRIE Clive James
b: 25.12.1955, Wellington
Fullback

Represented NZ: 1978; 4 matches – 2 tests, 18 points – 6 conversions, 2 penalty goals

First-class record: Wellington 1974-77 (Oriental-Rongotai); Canterbury 1978 (Christchurch HSOB); North Island 1977; South Island 1978; NZ Trials 1977; NZ Juniors 1978; NZ Colts 1976

Educated Rongotai College, 1st XV 1972,73. Top scorer on the Juniors 1978 tour of Queensland with 64 points. Impressed with his cool taking of the high ball, line and goalkicking and his

entry in to the backline.

Selected for the British tour with the All Blacks later in the season and appeared in the Irish and Welsh internationals but suffered a broken jaw and concussion against Wales which put him out of the rest of the tour. Stood 1.83m and weighed 85kg.

A New Zealand Secondary Schools representative at cricket. Appointed Wellington Rugby Union director of coaching 1986.

CUTHILL John Elliot
b: 24.8.1892, Inverleithen, Scotland
d: 22.4.1970, Invercargill
Fullback and threequarter

Represented NZ: 1913; 16 matches – 2 tests, 3 points – 7 tries, 5 conversions

First-class record: Otago 1911 (Taieri), 1912-14 (University); South Island 1913; NZ Universities 1913

Came to New Zealand 1896 and educated Otago Boys' High School, 1st XV 1907-09. Played in the first test v Australia 1913 then left for the tour of North America, appearing in the Berkeley international. Cuthill was asked to captain the 1914 All Blacks to Australia but withdrew from the team to concentrate upon his studies.

DALLEY William Charles
b: 18.11.1901, Lyttelton *d:* 9.2.1989, Christchurch
Halfback

Represented NZ: 1924-26,28,29; 35 matches – 5 tests, 15 points – 5 tries

First-class record: Canterbury 1921 (Leeston), 1923-27,30 (Christchurch HSOB); South Island 1924-27; NZ Trials 1924,27,29,30

Educated West Lyttelton Primary and Christchurch Boys' High School, 1st XV 1917-19. First represented Canterbury as a five-eighth then played for Ellesmere sub-union 1921,22.

Bill Dalley

On his return to Christchurch he became a regular member of the Canterbury team, playing in most backline positions before settling into halfback.

A rugged, reliable player who stood only 5' 4½" and weighed a pound or two over 10 stone. Described as "a courageous tackler and quick thinker with an ability to turn defence into attack".

Earned a place in the 1924 team to Australia then toured with the 'Invincibles' appearing in the Irish international, Jimmy Mill displacing him for the others. Dalley played in all four tests in South Africa 1928 and was picked out by newspaper correspondent F.M. Howard as one of the stars of that tour. He went to Australia with the 1929 team but was injured in the second match. Played his last game for Canterbury 1930 leading his province to victory over the British tourists.

After he retired Dalley served on the Canterbury RFU management committee 1932-52, chairman 1953-55; selector 1935 when Canterbury lifted the Ranfurly Shield from Auckland. Represented his province at bowls and Canterbury B at cricket. His brother, H.G. Dalley, played rugby for Canterbury 1921,22 and a nephew, B.H. Dalley, played for Canterbury and Nelson.

DALTON Andrew Grant
b: 16.11.1951, Dunedin
Hooker

Represented NZ: 1977-85; 58 matches – 35 tests, 12 points – 3 tries

First-class record: Counties 1975-85 (Bombay); North Island 1976-82; NZ Trials 1978,81-84; Counties-Thames Valley 1977; IRB Centenary 1986

Educated Andersons Bay and Kohimarama Primary Schools and Selwyn College, 1st XV 1968,69. Moved to Pukekohe from Auckland in 1975 when he was first chosen for Counties and took over the side's captaincy the following season.

Toured France in 1977 and made his international debut in the second test. Played all three tests against Australia in 1978 and in all four on the 1978 Grand Slam tour of Britain and Ireland, scoring the All Blacks' only try in the first of the tests, against Ireland. He played internationals against France and Scotland in 1979 but lost his place for matches against Australia and England. He was unavailable for the 1980 tour of Australia but went to North America and Wales later in the year.

Dalton took over the New Zealand captaincy in 1981 against South Africa when Graham Mourie was unavailable. He had become the regular All Black hooker and took over the captaincy after Mourie's 1982 retirement. He led New Zealand in successful series against the Lions, France, Australia and England. Dalton was chosen as captain for the aborted 1985 tour of South Africa but was not available for the replacement tour of Argentina, when the captaincy went to Jock Hobbs. Captain of World Cup squad.

Dalton said in his biography with John Ashworth and Gary Knight, *The Geriatrics,* that he was one of the principal New Zealand contacts for the unofficial Cavaliers' tour of South Africa in 1986. Dalton's jaw was broken in the second match of that tour by a Northern Transvaal flanker, Burger Geldenhuys, and he played no more rugby that year.

Dalton gained a reputation as one of the best

Andy Dalton and 1983 Lions captain Ciaran Fitzgerald.

hookers in world rugby and was the first All Black hooker to throw regularly into lineouts, an element of the game at which he was considered without peer. He also gained considerable stature as a captain, particularly in the difficult series against South Africa and two years later in the four-nil victory over the Lions.

Dalton was unable to play in the 1987 World Cup because of injury but remained with the squad and, except for on-field purposes, remained captain. He retired from all rugby soon after the cup.

Dalton stood 1.78m and weighed 93kg. His father, Ray, first played for New Zealand in 1947 and in 1949 was vice-captain of the All Blacks in South Africa.

Dalton coached Counties 1989-91.

DALTON Douglas
b: 18.1.1913, Napier *d:* 28.7.1995, Napier
Prop and hooker

Represented NZ: 1935-38; 21 matches – 9 tests, 3 points – 1 try

First-class record: Hawke's Bay 1933-40 (Napier Technical College OB); Wellington 1941 (Trentham Army); North Island 1936-38; NZ Trials 1935,37

Educated Nelson Park Primary School and Napier Technical College. Selected for the 1935-36 New Zealand team to Great Britain and Ireland. He suffered an injury in the second tour match and did not play again until the 17th game, finally appearing in nine of the 30 matches including internationals against Ireland and Wales.

Played both tests v Australia 1936 and all three against the 1937 Springboks then toured Australia 1938 and appeared in six of the nine matches including the first two tests.

Oliver and Tindill's 1936 tour book said: "Dalton proved himself a dashing player in the loose." His statistics were given as 5' 9" and 13st 6lb.

Napier Technical College OB club coach and management committee; Hawke's Bay selector 1946-56; North Island selector 1946.

Foundation member and president of the Saracens club. Napier Golf Club president; Hawke's Bay Squash Club patron. Gave valuable service to the St John Ambulance Assn, and was awarded the OStJ and QSO.

DALTON Raymond Alfred
b: 14.7.1919, Te Awamutu *d:* 2.2.1997, Auckland
Prop

Represented NZ: 1947,49; 20 matches – 2 tests, 3 points – 1 try

First-class record: Wellington 1946-48 (Wellington); Otago 1948,50 (Pirates); South Island 1948; NZ Trials 1947,48; NZ Services 1943-46; Combined Dominions 1943,44

Educated Te Awamutu Primary School and Te Awamutu College. Served as a flight-lieutenant in the RNZAF during WWII and was prominent in the NZ Services team in England 1944-46 as a number eight. On his return to New Zealand he commenced playing as a prop.

Toured Australia 1947 playing in both tests and then chosen as vice-captain of the 1949 All Blacks in South Africa. Played in 12 tour matches but a groin injury affected his form and restricted his appearances.

Standing almost six feet and weighing 14½ stone, Dalton was a well-built prop with good scrummaging technique and energetic in loose play. Retired from rugby after the 1950 season. Coached Pirates (Dunedin) 1952-54. Father of Andy Dalton, the 1977-85 All Black.

DALZELL George Nelson
b: 26.4.1921, Rotherham *d:* 30.4.1989, Christchurch
Lock

Represented NZ: 1953,54; 22 matches – 5 tests, 15 points – 5 tries

First-class record: Canterbury 1948-53 (Culverden); South Island 1950-52; NZ Trials 1951,53; NZ XV 1948,52

Educated Culverden School. While serving with the 3rd NZ Division in the Pacific during WWII he was severely wounded in the leg and back but recovered to play representative rugby – and have an All Black trial – by 1948.

Played in all five internationals on the 1953-54 tour of Britain and France, forming with 'Tiny' White one of the great locking combinations of the post-war era. At 6' 2" and 16st 1lb (his selection weight although he was nearly 17 stone by the end of the tour), Nelson Dalzell was immensely powerful. His try against England, which helped New Zealand win 5-nil, was scored with sheer strength from 10 yards out by "bunting forward as violently as an enraged bull" according to a match report.

The 1953-54 tour ended his representative career. Father-in-law of the 1980-83 All Black, Graeme Higginson and brother-in-law of Allan Elsom, 1952-55 All Black.

D'ARCY Archibald Edgar
b: 18.9.1870, Masterton *d:* 22.6.1919, Sydney
Fullback

Represented NZ: 1893,94; 7 matches

First-class record: Wairarapa 1887-90 (Red Star), 1891-94 (Masterton)

D'Arcy was the first player to score a penalty goal in an inter-union game in New Zealand (for Wairarapa v Wellington 1889). Toured Australia 1893 and played against New South Wales at Christchurch 1894. Transferred to Auckland 1897 and was nominated for the New Zealand team while playing for the Parnell club.

Represented Wairarapa at the meeting in Wellington to consider forming the New Zealand Rugby Football Union. Wairarapa RFU secretary 1894,95 and selector 1891,92,94,96 and representative referee.

DAVIE Murray Geoffrey
b: 19.9.1955, Christchurch
Prop

Murray Davie

Represented NZ: 1983; 5 matches – 1 test, 4 points – 1 try

First-class record: Canterbury 1977-88 (Albion); NZ Trials 1981,83,86,87; South Island 1983-85

Educated at Burnside High School, Davie's emergence as a major rugby player coincided with an era of abundant propping talent in Canterbury. For his first few years in the Canterbury squad, he had only intermittent games because of the prior claims of John Ashworth, Billy Bush and Barry Thompson. An indication of this was that he reached 100 games for Canterbury during 1986.

By 1982, however, he was claiming a regular place and his solid tight work was rewarded with selection in the All Blacks to tour England and Scotland at the end of 1983. He went on in the test against England as a replacement for Scott Crichton. Weighed 108kg and stood 1.88m.

Davie also represented New Zealand at water polo.

DAVIES William Anthony

b: 16.9.1939, Auckland
Fullback and five-eighth

Represented NZ: 1960,62; 17 matches – 3 tests, 94 points – 3 tries, 20 conversions, 11 penalty goals, 4 dropped goals

First-class record: Auckland 1958-60,65-67 (University); Otago 1961-64 (University); NZ Trials 1959-61,63,65; NZ Juniors 1959; NZ Universities 1959,61,63,64,66; Rest of New Zealand 1965

Educated Te Aroha Primary School and King's College, 1st XV 1955-57. Chosen while studying at Otago University, as the youngest member of

Tony Davies

1960 All Blacks to visit South Africa, Davies was second-string fullback to Don Clarke although he played as a midfield back during the tour and at first five-eighth in the fourth test. Scored 47 points in three matches in Australia

Lyn Davis against the Lions, 1977.

en route to South Africa where he scored another 47 points in 12 matches.

Chosen at second five-eighth for the second and third tests in the 1962 home series against Australia. Very fast and strong, Davies was a fine utility back. Standing 5' 9" and weighing 13 stone he had a rather chunky appearance.

Went to England to further his medical studies and completed a long rugby career by playing for Blackheath (1971,72) and London Irish (1972-74) clubs. Coached club and representative teams in Canberra. Two uncles, Maurice Davies (Auckland, Waikato and Bay of Plenty) and Leslie Davies (North Auckland) were representative players.

DAVIS Chresten Scott

b: 16.9.1975, Hamilton
Loose forward

Represented NZ: 1996; 2 matches

First-class record: Manawatu 1994-96 (University); Wellington Hurricanes 1996,97; NZ Universities 1994; NZ Divisional 1995; North Island XV 1995; NZ Colts 1994-96; NZ XV 1995

Educated at Morrinsville College and a member of the Waikato and New Zealand Secondary School sides, Davis went to Massey University and was selected for Manawatu as a flanker after two club games in his hitherto regular position of lock. He adapted readily to blindside flanker and was especially adept at the tail of lineouts.

After three years in the Colts and other national teams, he was chosen in the enlarged All Black party for the tour of South Africa in 1996.

Injury sustained in the Super 12 curtailed much of his rugby in 1997.

DAVIS Keith

b: 21.5.1930, Whakatane
Halfback

Represented NZ: 1952-55,58; 25 matches – 10 tests, 12 points – 4 tries

First-class record: Auckland 1951-59 (Marist);

North Island 1954,55,58; NZ Trials 1953,57,58; NZ Maoris 1952,54-56,58,59

Educated Sacred Heart College (Auckland), 1st XV 1947-49. Made his representative debut and was chosen for New Zealand in the following year, replacing 'Ponty' Reid in the team which lost the first test v Australia 1952.

Toured Britain and France with the 1953-54 All Blacks and played 20 matches on tour including all five internationals. Appeared in the second of the three tests against the 1955 Wallabies but was then discarded by the selectors until recalled to play all three tests v Australia 1958.

Davis stood 5' 6" and his playing weight varied from 10st to 11st 10lb. He possessed a useful pass but his great asset was his ability to run with speed and agility from both set and broken play. NZ Maoris selector 1967. His brother, Morris Davis, represented Waikato and NZ Maoris and a half brother, Mita Johnson, represented Manawhenua and NZ Maoris.

DAVIS Lyndon John

b: 22.12.1943, Christchurch
Halfback

Represented NZ: 1976,77; 16 matches – 3 tests, 12 points – 3 tries

First-class record: Canterbury 1964-77 (Suburbs); South Island 1965,67,70,71,75,77; NZ Trials 1965-69,71-73,76,77; NZ Juniors 1965,66

Educated Beckenham Primary and Cashmere High School. After a long representative career, nine All Blacks trials and being named as a reserve 16 times, Davis played his first game for New Zealand as a 32-year-old against the 1976 Irish tourists but had the misfortune to suffer a leg injury and retired at halftime.

Toured South Africa 1976 as second-string halfback to Sid Going and ended his All Black career with the third and fourth tests against the 1977 Lions.

Played 167 games for Canterbury with the distinction of opposing the 1966,1971 and 1977

Lions. Standing 1.73m and weighing 69kg Davis was a skilful, quick-thinking halfback with a good pass. He was unlucky to remain in the shadow of Going for so long. Coached the Suburbs club in Christchurch after his retirement from active football.

DAVIS William Leslie
b: 15.12.1942, Hastings
Threequarter

Represented NZ: 1963,64,67-70; 53 matches – 11 tests, 75 points – 25 tries (including 1 penalty try)

First-class record: Hawke's Bay 1961 (Hastings HSOB), 1962-71 (Taradale); North Island 1964,65; NZ Trials 1961-63,65-71; NZ Colts 1964

Educated Parkvale Primary, Hastings Intermediate and Hastings Boys' High School, 1st XV 1958-60. Chosen for the 1963-64 All Blacks to tour Britain and France as a wing and scored seven tries in 15 matches. Then a regular member of the Hawke's Bay Ranfurly Shield team in the mid-1960s.

Bill Davis

Played his first test at centre in the 1967 Jubilee game against Australia. His brilliant form in this match was highlighted by a fine try scored from a kick ahead from Hawke's Bay team-mate Ian MacRae. Toured Britain 1967 as a centre and partnered MacRae in all four internationals.

Appeared in both tests in Australia 1968 and the first test v France, injury keeping him out of the other two tests. After both games v Wales 1969, Davis went to South Africa 1970 making his final international appearance in the second test.

One of the best centres to play for New Zealand, Bill Davis had the ideal build for the position at just under six feet and around 13 stone. An incisive runner with excellent acceleration Davis combined extremely well with Ian MacRae inside him and had the ability to run wings into scoring positions. Also represented New Zealand at softball 1973,76

and was a Hawke's Bay athletic representative in sprint events 1960-63.

DAVY Edwin
b: 9.9.1850, Wellington *d:* 22.5.1935, Wellington
Halfback

Represented NZ: 1884; 3 matches, 2 points, – 1 try

First-class record: Wellington 1877-80,83,84 (Athletic)

A member of the first New Zealand touring team which won all eight games on a visit to New South Wales 1884. 'Ned' Davy was described by the team manager S.E. Sleigh as "a wiry halfback possessed of a good turn of speed and a capital collarer." Wellington RFU secretary treasurer 1884-87; management committee 1888,94,98.

DEANS Ian Bruce
b: 25.11.1960, Cheviot
Halfback

Represented NZ: 1987-89; 23 matches – 10 tests, 56 points – 14 tries

First-class record: Canterbury 1981 (Lincoln College), 1982-90 (Glenmark); South Island 1985,86; South Zone 1987-89; Emerging Players 1985; NZ Trials 1987,89,90

Educated at Cheviot District High School and Christ's College, Deans quickly established himself in the Canterbury team and became a key figure in the early-80s Ranfurly Shield era.

Deans was first chosen for New Zealand for the World Cup in 1987 but because halfback David Kirk assumed the captaincy, Deans sat through the tournament without playing a game. He finally made it onto the field for the All Blacks on the tour of Japan at the end of 1987.

He made his test debut against Wales in 1988 and was the first-choice halfback for the rest of the

Bruce Deans

year and for the domestic tests in 1989. On the tour of Wales and Ireland at the end of the year, however, he was supplanted as the test halfback by his provincial understudy, Graeme Bachop.

Younger brother of the 1983,84 All Black, Robbie Deans, and great-nephew of 1905-08 All Black, Bob Deans. Bruce and Robbie Deans are brothers-in-law of the 1984 and 1986 All Black captain, Jock Hobbs.

DEANS Robert George
b: 19.2.1884, Christchurch *d:* 30.9.1908, Christchurch
Centre threequarter

Represented NZ: 1905,06,08; 24 matches – 5 tests, 63 points – 21 tries

First-class record: Canterbury 1903,04,06-08 (Christchurch HSOB); South Island 1904,05,07; Canterbury-South Canterbury-West Coast 1904

Educated Christchurch Boys' High School, 1st XV 1898-1901. A robust threequarter standing six feet and weighing 13st 4lb, Deans quickly established himself as an outstanding player on his entry to representative rugby. The youngest member of the 1905-06 touring party, he played 20 games in Britain, including all four internationals, and two in North America.

Best remembered for his disputed "try" in the Welsh international. Deans and the rest of the New Zealand team were convinced that he had crossed the goal-line following a movement late in the match and scored, only to be pulled back into the field of play by the opposition. The referee disallowed the try leaving the result Wales 3, New Zealand 0 and controversy has raged ever since.

Deans sent a telegram to the *Daily Mail* the next day, stating: "Grounded ball six inches over line some of the Welsh players admit try. Hunter and Glasgow can confirm was pulled back by Welshman before referee arrived." According to Billy Wallace, Deans rolled off the ball after crossing the line and the Welsh halfback, Owen, put the ball infield and claimed that Deans had not reached the goal-line. He was not available for the 1907 tour of Australia and a knee injury kept him out of the first two tests against the Anglo-Welsh in 1908.

Two months after playing in the third test, Deans died of complications following an appendix operation. His memory is perpetuated at Christchurch Boys' High School by a plaque and the Robert Deans Scholarship, awarded annually to the boy who "exhibits the highest degree of qualities of intellect, athletic ability, leadership and character."

DEANS Robert Maxwell
b: 4.9.1959, Cheviot
Fullback

Represented NZ: 1983,85; 19 matches – 5 tests, 252 points – 8 tries, 59 conversions, 34 penalty goals

First-class record: Canterbury 1979-82 (Christchurch), 1983-87,89,90 (Glenmark); NZ Colts 1980; NZ Juniors 1982; South Island 1982-84; NZ Trials 1982,83

Educated Christ's College, 1st XV 1976,77. Deans also played for Canterbury and South Island Under 18 and for Canterbury Colts.

He became one of the mainstays of the Canterbury Ranfurly Shield era and scored a

Robbie Deans . . . 252 points for New Zealand and 1641 points for Canterbury.

record number of shield points (332) as well as creating records for most conversions, most penalty goals, most points in a match. During much of Deans' record-breaking spree, Allan Hewson was the incumbent All Black fullback and there was much agitation, particularly in Canterbury, for Deans to supplant him.

Deans was chosen with Hewson for the All Black tour of England and Scotland in 1983 but Hewson had to withdraw because of injury and Deans played both tests. The pair were again chosen for the 1984 tour of Australia. Hewson played the first test (with Deans going on for injured wing Bruce Smith) but Deans gained the fullback's job for the second and third. He had to withdraw from the Fijian tour at the end of the year because of a serious knee injury. This was still bothering him in 1985 but after missing selection against England and Australia, he was chosen for the cancelled tour of South Africa. He went to Argentina instead but could not regain his test place from the man who had taken over against England earlier in the year, Kieran Crowley.

Deans went on the unofficial Cavaliers tour of South Africa in 1986 but was not wanted by the All Black selectors.

Apart from his kicking powers, Deans, who weighed 78kg and stood 1.80m, was a safe defensive fullback and a quick, elusive runner on attack.

A brother, Bruce, played for Canterbury 1981-90. Bob Deans, the 1905,06,08 All Black, was a great-uncle.

When Deans retired at the end of the 1990 season, he had played 146 times for Canterbury and scored 1641 points.

He took over as coach of Canterbury in 1997 and had immediate success, winning the NPC first division. He was also manager of the Canterbury Crusaders in the Super 12.

DELAMORE Graham Wallace
b: 3.4.1920, Thames
Five-eighth

Represented NZ: 1949; 9 matches – 1 test

First-class record: Hawke's Bay 1941 (Napier Technical College OB); Manawatu 1943,44 (Air Force); Wellington 1948 (Hutt); North Island 1943,44,48; RNZAF 1943; Combined Services 1944; NZ Trials 1948

Educated Thames High School. Served in the RNZAF during WWII as a physical training instructor with the rank of flying-officer. Played rugby for the Air Force and services teams and the North Island before an ankle injury interrupted his career 1945-47.

Selected for the 1949 All Blacks to South Africa and played as a midfield back on tour although he was chosen at first five-eighth for the fourth test – his only international.

Although fairly small (5' 6" and 10st 12lb) 'Red' Delamore made up for a lack of size by his skill and fitness. Coached Takapuna Grammar 1st XV 1950-61. Played Hawke Cup cricket for Hutt Valley.

DEWAR Henry
b: 13.10.1883, Wellington *d:* 19.8.1915, Gallipoli
Loose forward

Represented NZ: 1913; 16 matches – 2 tests, 3 points – 1 try

First-class record: Wellington 1907,08 (Melrose); Taranaki 1910 (Hawera), 1911,12 (Star), 1913,14 (Stratford); North Island 1913

Educated Newtown and Berhampore Schools. 'Norkey' Dewar weighed 13 stone and stood 5' 10½", and was described as a most consistent player. Normally appeared as a hooker but capable of performing well in any scrum position.

Represented New Zealand in the first test v Australia 1913 before departing with the All Black touring team to North America where he played in the international v All-America. Selected for the 1914 tour to Australia but was unable to obtain leave.

Joined the NZ Expeditionary Force 1914.

Captained the Wellington Mounted Rifles team in several rugby matches in Egypt before embarking for the Gallipoli campaign where he fell in the offensive on Chunuk Bair.

DIACK Ernest Sinclair
b: 22.7.1932, Invercargill
Wing threequarter

Represented NZ: 1959; 1 match – 1 test

First-class record: Otago 1951-53,55-60 (University), 1962-64 (Zingari-Richmond); Southland 1954 (Pukerau-Maitland); South Island 1957-59; NZ Trials 1953,57,58-60; New Zealand XV 1958; NZ Universities 1955-60

Educated Napier Boys' High and Gore High School, 1st XV 1948,49. A big, strong wing who stood six feet and weighed 12st 12lb, 'Tuppy' Diack was a versatile footballer, an enterprising attacker and an accurate goalkicker. Scored more than 100 points in each of the 1958,59 and

'Tuppy' Diack

1960 seasons. Made his one appearance for New Zealand in the second test against the 1959 Lions after withdrawing from the first test through injury.

Gave great service at representative level and for NZ Universities playing particularly well when the students beat the 1956 Springboks. Played Brabin Cup cricket for Otago 1947-49. His father, Charlie, played for NZ Universities 1923, Otago 1923 and Marlborough 1931,32,34.

DICK John
b: 3.10.1912, Auckland
Wing threequarter

Represented NZ: 1937,38; 5 matches – 3 tests, 6 points – 2 tries

First-class record: Auckland 1935-39 (Grafton); Canterbury 1943 (Air Force); North Island 1936,38; South Island 1943; NZ Trials 1937; RNZAF 1943

Educated Ponsonby and Curran Street Primary Schools and Auckland Grammar School. A

speedy and tricky wing who scored six tries in one of the 1937 trial matches, Dick won selection for the first two tests against the Springboks in that year, scoring a try in his All Black debut.

Chosen to tour Australia 1938, he was forced to withdraw after he caught measles and was replaced by Alan Wright. When he recovered, his fare to Australia to join the team was paid by supporters. He arrived in time to play in three games including the final test.

Grafton club delegate to the Auckland RFU management committee, life member Auckland. His son, Malcolm, represented New Zealand 1963-70.

DICK Malcolm John
b: 3.1.1941, Auckland
Wing threequarter

Represented NZ: 1963-67,69,70; 54 matches – 15 tests, 120 points – 40 tries

First-class record: Auckland 1961-63,65-70 (Ponsonby); North Island 1963,66,67; NZ Trials 1961,63,65-67,69,70

Educated Bayfield School and Auckland Grammar School. Played most of his early rugby at second five-eighth but developed into a great wing – pacy, determined and also a reliable tackler with a solid build at 5' 9" and 12st 9lb. Would have played many more games for New Zealand but his career was interrupted with recurring injuries.

Top try scorer on the 1963-64 British tour with 19 tries in 24 matches including all five internationals. Injury kept him out of rugby in the 1964 season and much of 1965 apart from the third test against the Springboks. Played in the fourth test against the 1966 Lions scoring a try and scored seven tries in 10 games including all four internationals in Britain 1967. Returned for both tests v Wales 1969 and retired after the 1970 tour to South Africa where he played in the first and fourth tests. Scored a remarkable 40 tries in his 54 All Black appearances.

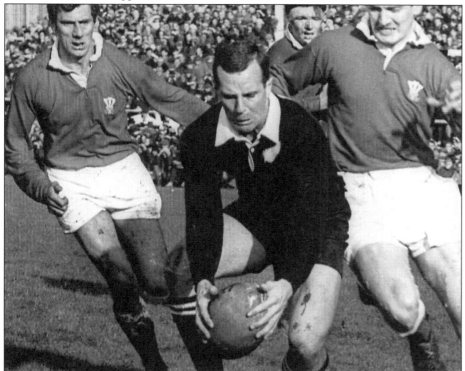

Malcolm Dick against Wales, 1969.

President ARU 1983; chairman 1984-86. NZRFU Council 1986-91. Son of All Black John Dick.

DICKINSON George Ritchie
b: 11.3.1903, Dunedin *d:* 17.3.1978, Lower Hutt
Five-eighth

Represented NZ: 1922; 5 matches, 6 points – 2 tries

First-class record: Otago 1922-24 (Kaikorai); South Island 1922

Educated Otago Boys' High School, 1st XV 1918-21. At the age of 19, Dickinson made his first-class debut for the South Island and was selected for the 1922 All Black team to Australia prior to playing for Otago. Appeared in four of the five matches including all three v New South Wales. Dropped out of first-class rugby at the age of 21.

An outstanding cricketer, Dickinson became the first so-called "double All Black" when he represented New Zealand at cricket against Victoria in the 1924/25 season and then played v Australia 1927/28, v England 1929/30 and South Africa 1931/32. A fast bowler, his best performance was 7-58 for Otago v Australia 1927/28. His last representative cricket was played for Wellington in the 1943/44 season.

DICKSON David McKee
b: 25.9.1900, Temuka *d:* 19.4.1978, Christchurch
Loose forward

Represented NZ: 1925; 7 matches, 13 points – 2 tries, 2 conversions, 1 penalty goal

First-class record: Otago 1922-25 (University); Canterbury 1926 (Christchurch HSOB)

Represented Canterbury Primary Schools 1914 before attending Christchurch Boys' High School, 1st XV 1918,19.

After a season of club rugby in Christchurch he went to Dunedin to study medicine and represented NZ Universities then Otago. Because of his studies he was unable to take part in the trials for the 1924 New Zealand team to Australia although he did tour Australia 1925.

Dickson weighed 13½ stone and stood six feet. He had a fine turn of speed, was a useful lineout forward and a competent goalkicker. Retired from the game after an outstanding display for Canterbury in the Ranfurly Shield match v Hawke's Bay 1926.

Began refereeing in the 1930s; controlled South Africa v Manawatu 1937.

DIXON Maurice James
b: 6.2.1929, Christchurch
Wing threequarter

Represented NZ: 1953,54,56,57; 28 matches – 10 tests, 51 points – 17 tries

First-class record: Canterbury 1948,51-56,58 (Sydenham); South Island 1953,54,56; NZ Trials 1953,56,57

Educated Sydenham School and Christchurch Technical College. Played in four internationals on the 1953-54 British tour and scored seven

Morrie Dixon

tries in 15 matches. Selected for all four tests against the 1956 Springboks and both on the 1957 Australian tour.

In his book, Winston McCarthy wrote: "To Dixon I hand the palm for being the best wing on the tour. He had the heart of a lion, never giving up, always looking for business on defence and attack." Stood 5' 8" and weighed 11st 8lb.

Canterbury selector 1963-65,68-71 and South Island selector 1976-80.

DOBSON Ronald Leslie
b: 26.3.1923, Auckland *d:* 26.10.1994, Auckland
Second five-eighth

Represented NZ: 1949; 1 match – 1 test



First-class record: Auckland 1946-48 (Ponsonby), 1949 (Northcote); NZ Trials 1948; 2nd NZEF 1945,46; NZ Services 1945,46; Barbarians (UK) 1946; Swansea 1946; New Zealand XV 1949

Educated Wellesley Street School. Played outstanding football in service matches during WWII and selected for the 'Kiwis' for whom he played 18 matches and scored eight tries. Close to All Black selection in the immediate post-war years and finally won his cap in the first test v Australia 1949. Dobson's main assets were his sure hands, a devastating sidestep, and a great ability to back up. Stood 5' 11" and weighed 11st 10lb.

Retired comparatively early and later coached the Northcote, Christchurch (during a sojourn in Canterbury) and Glenfield clubs.

DODD Ernest Henry
b: 21.3.1880, Wellington *d:* 11.9.1918, France
Hooker

Represented NZ: 1901,05; 3 matches – 1 test

First-class record: Wellington 1900-05 (Wellington College OB); North Island 1902; Wellington Province 1905; Wellington-Wairarapa-Horowhenua 1905

Educated Wellington College. The youngest member of the 1901 New Zealand team which played Wellington and New South Wales, Dodd also appeared against Australia at Dunedin 1905. His weight was given as 12st 4lb. Life member of the Wellington College OB club 1907.

He served with the NZ Rifle Brigade during WWI and was killed in action in France.

DONALD Andrew John
b: 11.5.1957, Wanganui
Halfback

Represented NZ: 1981,83,84; 20 matches – 7 tests, 20 points – 5 tries

First-class record: Wanganui 1976-83 (Ohakune), 1984-86 (Ohakune-Karioi); NZ Colts 1978; NZ Juniors 1979,80; North Island 1981,83,84; NZ Trials 1981-83,87; Central Zone 1987

Andrew Donald

Educated Wanganui Collegiate, 1st XV for two years. Donald was a contemporary of one of New Zealand's greatest halfbacks, Dave Loveridge, and his great rival, Mark Donaldson. The pair toured together from 1978 to 1980 and it was Donald who split them up after he was chosen for the 1981 tour of Romania and France. He was reserve to Loveridge in the three tests and didn't appear again until the 1983 tour of England and Scotland, for which Loveridge was unavailable. He played in both tests and kept his place the following year for two home matches against France and a tour of Australia (Loveridge was out with injury). He toured Fiji at the end of 1984.

A shoulder injury hampered his chances of regaining a place in the All Blacks in 1985, when Loveridge and Kirk were chosen. Donald went on the unofficial Cavaliers tour as a replacement for Kirk, who withdrew.

Donald, who stood 1.78m and weighed 82kg, was regarded as a tidy distributor of the ball and was strong on breaks from the base of the scrum.

DONALD James George
b: 4.6.1898, Featherston *d:* 29.8.1981, Greytown
Wing forward

Represented NZ: 1920-22,25; 22 matches – 2 tests, 20 points – 6 tries, 1 conversion

First-class record: Wairarapa 1917-19 (Gladstone), 1920 (Featherston Liberal), 1921 (Featherston United), 1922-27 (Masterton), 1928 (Southern United), 1929,30 (Greytown); North Island 1920,21; NZ Trials 1921,24,27; Wairarapa-Bush 1921,23,25,30

Educated Wellington College, 1st XV 1915. A strong, raw-boned player weighing 13½ stone and standing just over six feet, Donald had a remarkable first-class career playing 104 games, including 73 for his province, over 14 seasons and from six different clubs.

First played for New Zealand on the 1920 tour of New South Wales then appeared in the first two tests against the 1921 Springboks. Toured Australia again the following year but strangely missed selection in 1923 and 1924 before captaining the All Blacks in Australia 1925 where he played in all eight matches.

His younger brother, Quentin, represented New Zealand 1923-25.

DONALD Quentin
b: 13.3.1900, Featherston *d:* 27.12.1965, Greytown
Hooker

Represented NZ: 1923-25; 23 matches – 4 tests, 18 points – 6 tries

First-class record: Wairarapa 1918,19 (Gladstone), 1921 (Featherston United), 1922-24,27 (Featherston), 1928 (Southern United); North Island 1919,24; NZ Trials 1924; Wairarapa-Bush 1921,23

Educated Wellington College, 1st XV 1917. Represented Wairarapa in his first year out of school and selected for the North Island at the age of 19. Playing weight given as 12st 6lb and height 5' 10".

First won New Zealand honours in the second of the three-match series v New South Wales 1923. After three trial matches in the next year he was selected to tour Great Britain and France 1924-25. Struck top form on tour

Quentin Donald

appearing in 22 matches including all four internationals, forming a highly successful hooking combination with Bill Irvine.

Donald continued to play for his province until his retirement 1928. Wairarapa selector 1935. His brother, Jim, represented New Zealand 1920-22,25.

DONALDSON Mark William
b: 6.11.1955, Palmerston North
Halfback

Represented NZ: 1977-81; 34 matches – 13 tests, 20 points – 5 tries

First-class record: Manawatu 1974,76-83 (Palmerston North HSOB), 1985 (Te Kawau); Hawke's Bay 1975 (Celtic); North Island 1980-82; NZ Trials 1977,79-81; NZ Colts 1974,76; Manawatu-Horowhenua 1977; NZ Juniors 1977

Mark Donaldson

Educated College Street Primary (Palmerston North) and New Plymouth Boys' High School, 1st XV 1972,73. Donaldson played once for Manawatu in his first year out of school and represented NZ Colts before having a season in Hawke's Bay.

Selected for the 1977 tour of France, he played in five of the nine matches including both tests. Continued his international career in all three tests against the 1978 Wallabies and in Britain later that year, playing in three internationals, missing only the Welsh international with an ankle injury.

Donaldson held his place for the 1979 series v France and the brief tour of Australia but gave way to Dave Loveridge for the internationals on the visit to England and Scotland, although he appeared as a second-half replacement against Scotland. A broken jaw forced him out of the 1980 tour of Australia after two games but he recovered to play against Fiji at Auckland and to travel to Wales where his three appearances included the Newport match as captain. Had one further test, replacing Loveridge in the third 1981 international against South Africa.

A strongly built (73kg, 1.75m), energetic and competitive halfback. His father, William, represented Manawatu 1951-57 and Manawatu-Horowhenua against the 1956 Springboks.

DOUGAN John Patrick
b: 22.12.1946, Lower Hutt
First five-eighth

Represented NZ: 1972,73; 12 matches – 2 tests, 11 points – 2 tries, 1 dropped goal

First-class record: Wellington 1966,67,70-74,76,77 (Petone); Hawke's Bay 1968 (Taradale), 1969 (Havelock North); North Island 1972,74; NZ Trials 1967,68,70-74,76; NZ Juniors 1968; NZ Under 23 1967

Educated St Michael's School (Taita) and St Bernard's College, 1st XV 1962,63. After a long representative career, Dougan first played for the All Blacks on the 1972 internal tour. Also played in the first test against the touring Wallabies later that season. Again selected for the 1973 internal tour and for the test against England.

Weighing 12 stone and standing just over 5' 7", Dougan was noted for his enterprise, safe hands and his passing ability. Player-coach of the Taita club 1978,79. Represented Hutt Valley 1965-67 and Hawke's Bay 1969 at cricket. His uncles, Jackie and Bill, represented Wellington at rugby.

DOUGLAS James Burt
b: 11.7.1890, Shag Point *d:* 21.12.1964, Dunedin
Loose forward

Represented NZ: 1913; 9 matches, 24 points – 8 tries

First-class record: Otago 1912,13,15 (Southern); South Island 1913; NZ Services 1919

After touring North America 1913 and scoring eight tries in nine games for the All Blacks, Douglas was suspended by the Otago RFU in 1915 for allegedly receiving a bribe in connection with a club match.

He played overseas while serving in WWI, including an appearance in the King's Cup competition and his 1922 application for reinstatement was successful.

Craig Dowd

DOWD Craig William
b: 26.10.1969, Auckland
Prop

Represented NZ: 1993-97; 47 matches – 40 tests, 15 points – 3 tries

First-class record: Auckland 1991-97 (Suburbs); Auckland Blues 1996,97; NZ Colts 1989,90; NZ XV 1992,94; NZ Trials 1993,94,96; North Island 1995; Harlequins 1995

Despite an early recognition as a prop of promise, Dowd had been playing first-class rugby for four seasons before he was called up by the national selectors, and then only as a replacement in a New Zealand XV. It was the enforced absence of Richard Loe in 1993 that gave Dowd his chance, and he made his test debut in the first test against the British Isles – which was also Sean Fitzpatrick's 50th – and retained his place for the rest of the year.

With Loe back the following year, Dowd went into the reserves and played one test in 1994, going on against South Africa in Dunedin as a loose forward.

By 1995, however, Dowd's star was in the ascendant and he gained a permanent place in the test team, Loe going back to the reserves. At the World Cup, Dowd missed only the quarterfinal against Scotland and he played in each of the three tests on the tour of Italy and France at the end of the year. He was replaced by Loe late in the second test against France in Paris – ostensibly a bloodbin replacement – and, as the match ended, he distributed to the crowd tapes of music that was opposed to French nuclear testing.

Dowd continued to be a regular selection under new coach John Hart and missed only the second test against England in 1997 because of injury.

Dowd, hooker Fitzpatrick and tighthead prop Olo Brown formed a formidable front row for Auckland, the Auckland Blues and New Zealand and continued the effective recent New Zealand trend of keeping together established front rows – the Dowd-Fitzpatrick-Brown trio taking over from Loe-Fitzpatrick-Steve

McDowell who had followed "the geriatrics" of Gary Knight, Andy Dalton and John Ashworth.

DOWD Graham William
b: 17.12.1963, Takapuna
Hooker

Represented NZ: 1992; 8 matches – 1 test

First-class record: North Harbour 1985-94 (Takapuna); NZ Trials 1991-93; New Zealand B 1991; NZ XV 1991; Barbarians 1989

Educated at Rosmini College, Graham Dowd was one of the original North Harbour players in 1985 and had given unstinting service to the union by the time he was recognised by the national selectors in 1991. He was chosen for the World Cup squad but, as the deputy hooker to Sean Fitzpatrick, he did not play.

Graham Dowd

He did not make his All Black debut until the following year, when he went on as a prop in the first test against Ireland as a replacement for Richard Loe. It was his only test.

Dowd toured Australia and South Africa in 1992, playing in seven of the matches.

He continued playing for North Harbour until 1994, and played out his final year as a prop.

He and Craig Dowd are not related.

DOWNING Albert Joseph
b: 12.7.1886, Napier *d:* 8.8.1915, Gallipoli
Loose forward and lock

Represented NZ: 1913,14; 26 matches – 5 tests, 21 points – 7 tries

First-class record: Hawke's Bay 1909-11 (Napier Old Boys), 1912 (Marist); Auckland 1913 (Marist); North Island 1911,12,14; North Island Country 1911,12

Played against Australia in the first test before the 1913 tour to North America where he played in 14 of the 16 matches including the international and scored six tries on tour. Appeared in all three tests in Australia 1914.

Described as "an outstanding lineout forward

with a wonderful pair of hands." Norman McKenzie said that Downing was one of the finest players with whom he had played.

'Doolan' Downing was killed in action at Gallipoli during the landing at Suvla Bay – the first New Zealand rugby representative war casualty.

DRAKE John Alan
b: 22.1.1959
Prop

Represented NZ: 1985-87; 12 matches – 8 tests, 4 points – 1 try

First-class record: Auckland 1981-87 (University); NZ Universities 1980-82; NZ Trials 1984,87; North Zone 1987

Educated Auckland Grammar School but played his first club rugby in Dunedin and played for Otago Juniors. On his return to Auckland, he played for the under 23 and B provincial teams before becoming a regular member of the senior side.

John Drake

He played three seasons in France and it was the third of them, 1985-86, that gave him his first All Black appearance when he was called from France to reinforce the team touring Argentina. After his return from France in 1986, he immediately regained his Auckland place and was chosen for the All Blacks' tour of France, on which he played at tighthead in both tests.

Drake was a key member of the 1987 World Cup squad, playing in five of the six matches (missing the opener against Italy), and he played in the Sydney test in which the All Blacks regained the Bledisloe Cup. He retired at the end of 1987.

He also played for a Southern Hemisphere team that beat the Northern Hemisphere 39-4 in Hong Kong in 1991.

His father, L.S. Drake, played for Auckland 1932-34, 36-38.

DRAKE Walter Augustus
b: 21.2.1879, Christchurch *d:* 27.1.1941, Christchurch
Loose forward

Represented NZ: 1901; 1 match

First-class record: Canterbury 1898,1900-02 (Merivale)

Educated Christchurch Boys' High School, 1st XV 1894. A tall forward especially useful in the lineout, Drake represented Canterbury on 27 occasions. Played for New Zealand v New South Wales 1901 after arriving too late to take part in the earlier match against Wellington. Canterbury selector and New Zealand selector 1923.

Three of his brothers, Reginald (1918), Victor (1907) and Frank (1905) represented Canterbury at rugby. Frank Drake was also a national sprint champion 1905,06.

DUFF Robert Hamilton
b: 5.8.1925, Lyttelton
Lock

Represented NZ: 1951,52,55,56; 18 matches – 11 tests

First-class record: Canterbury 1945-53,55-57 (Christchurch); South Island 1951-53,55-57; NZ Trials 1951,56; New Zealand XV 1955

Educated Lyttelton District High and Christchurch Boys' High School, 1st XV 1942,43. Toured Australia with the 1951 All Blacks and played in all three tests. Represented New Zealand the following year in both tests against the Wallabies but was not available for 1953-54 tour to the northern hemisphere.

Retired temporarily 1954 but turned out again 1955 to regain his place in two tests against Australia. Played all four internationals against 1956 Springboks – the third and fourth as captain. At 6' 3" and 16½ stone, Duff was a big, powerful lock who excelled in the lineout and scrum.

Canterbury selector 1963-66, South Island selector 1967-72 and All Black selector 1971-73. Assistant manager and coach of the 1972-73 All Blacks in North America, British Isles and France.

DUMBELL John Thomas
b: 1859, Liverpool, England *d:* 31.12.1936, New Plymouth
Utility back and forward

Represented NZ: 1884; 5 matches, 7 points – 1 conversion, 1 dropped goal

First-class record: Wellington 1877,82,83 (Athletic)

Dumbell came to New Zealand with his family 1872 and settled in New Plymouth.

Appeared as a halfback for New Zealand v a Wellington XV 1884 then toured Australia playing twice on the wing and twice as a forward. Tour manager Samuel Sleigh described Dumbell as "a fast player and a capital pot at goal . . . can tackle the biggest man on the field". Of light physique (some accounts describing him as less than eight stone) he held his place with his pace and courage.

Wellington RFU management committee 1882-84; selector 1886,89 and a representative referee.

DUNCAN James
b: 12.11.1869, Dunedin *d:* 19.10.1953, Dunedin
Five-eighth and wing forward

Represented NZ: 1897,1901,03; 10 matches – 1 test, 9 points – 3 tries

First-class record: Otago 1889-93,95-1903 (Kaikorai); South Island 1897

Recognised as a brilliant tactician, Jimmy Duncan appeared in 50 matches for Otago over 14 seasons, captaining his union for six seasons and the South Island in the inaugural inter-

Bob Duff and Springbok captain Basie Viviers lead their teams onto Eden Park.

island match 1897. Believed to have originated the five-eighth system of back alignment.

Toured Australia 1897, captained New Zealand 1901 and led his country on the visit to Australia two years later, captaining New Zealand in the first officially recognised test match.

Amidst some controversy, he was appointed coach to the 1905-06 All Blacks. Served on the Otago RFU management committee 1906-11 and coached teams at Otago Boys' High School during the 1920s and 30s. Refereed the first test v the 1908 Anglo-Welsh team at Dunedin.

DUNCAN Michael Gordon
b: 8.8.1947, Waipawa
Centre threequarter and second five-eighth

Mick Duncan

Represented NZ: 1971; 2 matches – 2 tests

First-class record: Hawke's Bay 1966-73 (Hastings HSOB); North Island 1969; NZ Trials 1970,71,73; NZ Juniors 1969,70

Educated Elsthorpe School and Lindisfarne College, 1st XV 1962-64. Named as one of the season's promising players by the *1966 Rugby Almanack of New Zealand*. Played for the North Island 1969 at wing threequarter.

Made his All Black debut as a replacement for Bob Burgess in the third test against the 1971 Lions, going on at second five-eighth with Wayne Cottrell moving in to first. Then played in the fourth test at centre. At six feet and 13$^1/_2$ stone, Duncan alternated between centre and wing for Hawke's Bay and showed good form in both positions.

DUNCAN William Dow
b: 11.6.1892, Port Chalmers *d:* 14.12.1961, Dunedin
Hooker

Represented NZ: 1920,21; 11 matches – 3 tests, 3 points – 1 try

First-class record: Otago 1914,15,18-24 (Kaikorai); South Island 1920,21; NZ Trials 1921

A fine hooker standing 5' 9$^1/_2$" and weighing 13 stone, Bill Duncan toured New South Wales with the 1920 All Blacks and appeared in all three tests against the 1921 Springboks. Captained Otago against the South Africans and was praised by the critics for his fine play.

Otago selector 1946-50. His son, Bert, represented Otago 1941.

DUNN Edward James
b: 19.1.1955, Te Kopuru
First five-eighth

Represented NZ: 1978,79,81; 20 matches – 2 tests, 22 points – 4 tries, 2 dropped goals

First-class record: North Auckland 1973 (Te Kopuru Southern), 1977-84,87 (Whangarei OB); Auckland 1974,76 (Northcote); North Island 1977-79,81; NZ Trials 1974,75,79; NZ Maoris 1976,77,81,82; NZ Colts 1974,75

Educated Dargaville High School, from where he represented North Island Under 18 and North Auckland. Transferred to Auckland 1974 to attend Teachers' College and joined the Northcote club. Chosen for the 1975 All Black trials although he was not a member of Auckland team.

Dunn toured Britain 1978 playing nine games including the Barbarians match in which he dropped a goal in the last minute to give the All Blacks a win. Played for the All Blacks in both

Eddie Dunn

matches against the Argentina team 1979 and went to England and Scotland later in the year, making his international debut against Scotland. Recalled two years later for the first test against Scotland.

A chunky 1.70m and 71kg, Dunn was something of an individualist with an accurate boot and the ability to dominate a game. Winner of the Tom French Cup as the outstanding Maori player in the 1978 season.

Brother of Ian Dunn, 1983,84 All Black, and Richard Dunn, Auckland 1978-85.

DUNN Ian Thomas Wayne
b: 11.6.1960, Te Kopuru
First five-eighth

Ian Dunn

Represented NZ: 1983,84; 13 matches – 3 tests, 8 points – 2 tries

First-class record: North Auckland 1980,82,83,87-90 (Dargaville Southern), 1984-86 (Hora Hora); NZ Colts 1980; NZ Trials 1983,84; NZ Maoris 1980,83,84

Educated Dargaville High School, 1st XV 1974-77. A neat first five-eighth, Dunn had only the 1980 Colts tour to his credit nationally when he was chosen in place of the injured Wayne Smith for the first test against the 1983 Lions. Smith played the second test but went off injured in the third and Dunn played in the fourth. He also played in the test against Australia that year. He toured England and Scotland at the end of 1983 and Australia in 1984 without playing an international.

Dunn, who stood 1.77m and weighed about 69kg, continued to give North Auckland good service until 1990.

A brother of All Black Eddie; another brother, Richard, played for Auckland and NZ Maoris.

DUNN John Markham
b: 17.11.1918, Auckland
Wing threequarter

Represented NZ: 1946; 1 match – 1 test

First-class record: Auckland 1943-46 (Manukau Rovers), 1947 (Drury), 1948 (Grafton); North Island 1944,45; New Zealand XV 1944,45

Educated Ararimu School. Played for the Drury, Papakura and Pukekohe clubs before joining Manukau in 1943. Dunn was the subject of a boundary dispute between the Auckland RFU and the South Auckland sub-union. Established himself as one of New Zealand's leading wings during the war years. Selected for the first post-war test v Australia 1946 but found the brilliant Wallaby left wing Charlie Eastes rather a handful and was dropped in favour of Eric Boggs for the second test.

Chosen for the 1947 All Blacks but injury prevented his taking part. At six feet and 14 stone, Dunn was a comparatively big wing in his era. Coached Drury and Papakura clubs.

EARL Andrew Thomas
b: 12.9.1961, Christchurch
Utility forward

Represented NZ: 1986-89,91,92; 45 matches –
13 tests, 57 points – 14 tries

First-class record: Wairarapa-Bush 1979-82
(Tuhitangi); Canterbury 1983-92 (Glenmark),
1993 (Culverden/Waiau); NZ Colts 1982; NZ
Juniors 1984; South Island 1985,86; NZ Trials
1984,86,87,90,91; NZ Emerging Players 1985;
South Zone 1987,89

Born and educated a Cantabrian (Hawarden and
St Bede's), Earl played his first first-class rugby
as a 17-year-old for Wairarapa-Bush. He moved
back to Canterbury after four years and was a
regular member of the early 1980s Ranfurly
Shield team.
 The ineligibility of the Cavaliers for the first
two tests of 1986 gave Earl his All Black chance,
playing at lock in the first (against France) and
flanker in the second (against Australia). He was
not chosen for the next two tests, but toured
France at the end of the year, going on in the
second test as a replacement lock.
 He was in the 1987 World Cup squad and
played in the pool match against Argentina as
No 8 and toured Japan later in the season.

Andy Earl

 Earl played eight games on the tour of
Australia in 1988 but could not break into a
settled test team but in the following year, in
Wales and Ireland, he played in both tests after
regular blindside flanker Alan Whetton was
injured. Earl again took over from Whetton on
the 1991 tour of Argentina, played one test
against Australia, and played three matches in
the 1991 World Cup.
 His last season for New Zealand was in 1992,
when he was summoned to Australia as a
replacement and he played in one of the tests.
 Earl was regarded as the ultimate backup
player on tour, strong in the All Blacks'
midweek matches and never out of place when
required for tests.
 A brother, Chris, played for Canterbury 1984-
91, and for New Zealand Colts, Emerging
Players and the South Zone.

EASTGATE Barry Peter
b: 10.7.1927, Nelson
Prop

Represented NZ: 1952-54; 17 matches – 3
tests, 3 points – 1 try

First-class record: West Coast 1947,48
(Hokitika Kiwi); Canterbury 1949-54
(Linwood); South Island 1953,54; NZ Trials
1953; New Zealand XV 1954

Educated Richmond School and Hokitika High
School. Played both tests against the touring
Australians 1952 and then selected for the 1953-
54 British tour where he appeared in 15

Peter Eastgate

matches, including the Scottish international.
Not big compared with modern international
props, standing 5' 10" and weighing 14½ stone,
Peter Eastgate was nevertheless described by
Terry McLean in *Bob Stuart's All Blacks* as
"extremely rugged and powerful".
 Acting on medical advice, he retired from the
game at the end of the 1954 season. His brother,
R.R. Eastgate, represented West Coast 1947-
54,56 and Auckland 1955.

ECKHOLD Alfred George
b: 28.12.1885, Adelaide, Australia *d:*
24.10.1931, Dunedin
Five-eighth

Represented NZ: 1907; 3 matches

First-class record: Otago 1905-13,15
(Southern); South Island 1907,08

Educated in Australia and came to New Zealand
as a teenager. A dependable if unspectacular
five-eighth, Eckhold represented his union on
53 occasions over 11 years and toured Australia
with the 1907 All Blacks. Later took up
refereeing and controlled numerous major
matches during the 1920s including New
Zealand v New South Wales 1923 and four
Ranfurly Shield challenges.
 Represented Otago at cricket and also a rifle
marksman of note. Father-in-law of Harold
Simon, a 1937 All Black.

ELIASON Ian Matheson
b: 6.6.1945, Kaponga
Lock

Represented NZ: 1972,73; 19 matches, 8
points – 2 tries

First-class record: Taranaki 1964-81
(Kaponga); North Island 1970-72,74; NZ Trials
1966,67,70-74,76,77; NZ Juniors 1966,68

Educated Kaponga Primary and Opunake High
School. Selected for the All Black internal tour
of 1972, playing eight games and scoring two
tries then toured Britain 1972-73 but did not
play any internationals.
 Although not selected for the All Blacks again
Eliason continued to render outstanding service
to Taranaki, seeming to improve each season. A
big, powerful lock (6' 3", 16st 2lb) whose lineout
work and scrummaging were of a very high
standard. He played 258 first-class matches
including 222 for Taranaki.

Ian Eliason

ELLIOTT Kenneth George
b: 3.3.1922, Wellington
Lock and number eight

Represented NZ: 1946; 2 matches – 2 tests

First-class record: Wellington 1944-46
(Wellington College OB); Manawatu 1947
(University); Waikato 1949 (Hamilton OB);
North Island 1946; NZ Trials 1947; NZ
Services 1944,45

Educated Clyde Quay School and Wellington
College. Established a fine reputation in service
rugby, representing 1st NZ Division and the 4th
Brigade Group, before playing for Wellington
1944. Played both tests against 1946 Wallabies,
one at lock and the other at number eight. Rather
surprisingly, he did not wear the All Black
jersey again despite sound displays in these
games.
 At 6' 2" and 15st 4lb, Elliott was the ideal
build for the tight-loose game at which he
excelled. After retirement from active play he
was a Hamilton sub-union selector.

ELLIS Marc Christopher Gwynne
b: 8.10.1971, Wellington
Utility back

Represented NZ: 1992,93,95; 20 matches – 8 tests, 98 points – 19 tries, 1 dropped goal

First-class record: Otago 1991-95 (University); NZ Colts 1991; South Island 1995; President's XV 1992; NZ XV 1994; NZ Universities 1991,94; NZ Trials 1992,93,95; Saracens 1992; Harlequins 1995

Though a Wellingtonian born and bred, Ellis made his mark in Otago. Educated at Wellington College, he played for Wellington age teams and by 1990, was a member of both the New Zealand Under 19 team and the New Zealand Secondary Schools on tours of Australia.

Marc Ellis

He made his first-class debut at centre for New Zealand Universities in 1991 and his debut for Otago later the same year. Ellis was chosen in the All Black squad for the centenary tests in 1992 but did not play a match. He toured Australia and South Africa and made his New Zealand debut in Adelaide, playing against a South Australian Invitation XV.

Ellis was chosen at first five-eighth, a position he had played for Wellington College, on the tour of England and Scotland at the end of 1993 and made his test debut in the No 10 jersey, scoring two tries against Scotland. He also played against England the following week.

Ellis was affected by injury in 1994 and didn't again play for the All Blacks until the test against Canada early in 1995, when he was on a wing. He played in five of the World Cup matches, two of them as replacements, and scored a New Zealand record six tries against Japan.

He was not eligible for the tour of Italy and France at the end of 1995 because the New Zealand union decided only players who had contracted to the union could be chosen. By the end of the year, he signed with the Auckland Warriors league team and later represented New Zealand at league. In addition to his sporting prowess, Ellis developed a tandem career as a television personality, usually in partnership with his Warriors captain (and former All Black fullback) Matthew Ridge.

A brilliant schoolboy athlete, Ellis also played cricket for Wellington Schools and North Island under 16 and he was the Wellington schools 200 metres champion in 1990.

Ellis's father, Chris, played for Auckland Maoris and an uncle, Mick Williment, played nine tests for the All Blacks in the mid-60s.

ELLISON Thomas Rangiwahia
b: 11.11.1867, Otakou *d:* 2.10.1904, Wellington
Forward

Represented NZ: 1893; 7 matches, 20 points – 2 tries, 5 conversions, 1 goal from a mark

First-class record: Wellington 1885-89,91,92 (Poneke); NZ Trial 1893; NZ Native team 1888,89

Educated Otakou Native School and Te Aute College. Weighed 12st 3lb and described by a contemporary writer as "a magnificent forward".

Scored 113 points, including 43 tries, for the 1888-89 Native team during their lengthy tour, playing in the 'internationals' against Ireland, Wales and England. Captained the 1893 New Zealand team to Australia.

Wellington RFU management committee 1892,94,98; selector 1892,97,98,1902. Took a leading role at the New Zealand Rugby Football Union's first annual meeting 1893 and it was his motion that adopted the black jersey with a silver fern leaf as New Zealand's playing uniform (appropriately he captained the first team to display these colours).

Refereed several provincial matches and published an early coaching manual, *The Art of Rugby Football* (1902). His cousin, Jack Taiaroa, represented New Zealand 1884. It is believed that Ellison was the first Maori to enter the legal profession when he was admitted as a solicitor 1891.

ELSOM Allan Edwin George
b: 18.7.1925, Christchurch
Threequarter

Represented NZ: 1952-55; 22 matches – 6 tests, 42 points – 13 tries, 1 dropped goal

First-class record: Canterbury 1951-58 (Albion); South Island 1953,55-57; NZ Trials 1953,56-58; New Zealand XV 1955,56; Rest of New Zealand 1955,56

Educated North Linwood School and Christchurch Boys' High School. Chosen at centre in

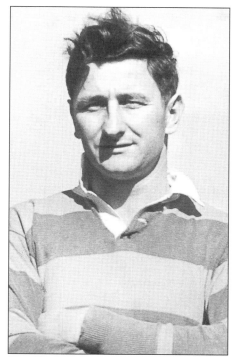

Allan Elsom

both tests against Australia 1952 then toured with the 1953-54 All Blacks, playing 17 matches – 14 on the wing (including the Welsh international) and three at centre.

Selected for all three tests against the 1955 Wallabies playing the first two at centre and the third on the right wing. Dropped a goal in the second test. Although he played three more seasons for Canterbury, Elsom did not gain All Black selection again even though he appeared in the final trial 1957 and showed he had lost little of his top form.

A rangy six-footer who weighed 12½ stone, Elsom was speedy and determined and a deadly tackler. Brother-in-law of Nelson Dalzell, 1953,54 All Black

ELVIDGE Ronald Rutherford
b: 2.3.1923, Timaru
Second five-eighth and centre threequarter

Represented NZ: 1946,49,50; 19 matches – 9 tests, 15 points – 5 tries

Ron Elvidge is led from the field in the first test against the Lions at Athletic Park in 1950.

First-class record: Otago 1942-48 (University), 1950 (Union); South Island 1943,45-48; NZ Trials 1948-50; NZ Universities 1945,46

Educated John McGlashan College, 1st XV 1937-40. Played both tests against the 1946 Wallabies at second five-eighth, but was not available for the 1947 Australian tour.

Played 14 matches in South Africa 1949, including all tests – two at centre and two at second five-eighth. Played centre in all but four of the tour matches. Captained the All Blacks in the third and fourth tests, taking over from Fred Allen.

Captain in the first three internationals against 1950 Lions but was badly injured in the third test match in which he scored a memorable try when he had returned to the field after having a head gash stitched.

Elvidge, who played at 5' 11" and 13 stone, was a brilliant tactician and an extremely rugged midfield back who excelled at setting up second-phase play. At school he was athletics champion 1938-40, 1st XI at cricket 1937-40.

ELVY William Lister

b: 2.12.1901, Christchurch *d:* 29.7.1977, New Plymouth
Wing threequarter

Represented NZ: 1925,26; 12 matches, 36 points – 12 tries

First-class record: Canterbury 1923-26 (Linwood); Wellington 1927,29 (Petone); South Island 1926; North Island 1929; NZ Trials 1924,30; New Zealand XV 1929

Educated Waltham School. Entered representative rugby as a five-eighth for Canterbury B

Bill Elvy

1923; switched to the wing and selected for Canterbury 1924. Appeared in three trial matches in that season but did not represent New Zealand until 1925.

Toured Australia 1925 and 1926 scoring 12

tries in as many games for the All Blacks. In his first-class career of 45 matches, Elvy scored a remarkable 42 tries including six for Canterbury v His Majesty's Fleet XV 1924.

In his book, *Haka! The All Black Story*, Winston McCarthy described Elvy as "the most amazing sidestepper of all time. Elvy was not fast for a wing but his tricky feet got him many tries". Stood 5' 7" and weighed 11½ stone.

Won the Canterbury Boxing Assn welter-weight title 1925 and the Andrew Fairburn Cup for the most scientific boxer.

ERCEG Charles Percy

b: 28.11.1928, Waipapakauri
Wing threequarter

Represented NZ: 1951,52; 9 matches – 4 tests, 9 points – 3 tries

First-class record: North Auckland 1948 (Aupouri), 1954,55 (Awanui), 1956 (Kaitaia Pirates); Auckland 1950-53 (Grafton); North Island 1951; NZ Trials 1951; NZ Maoris 1950-52

Educated Sacred Heart College (Auckland). Toured Australia with the 1951 All Blacks and played all three tests. Selected for the first test against the 1952 Wallabies but was dropped for the second encounter.

At 5' 10" and 12st 6lb, Percy Erceg was a well-built, determined and speedy wing who scored some spectacular tries during his first-class career. Won the Tom French Cup as the outstanding Maori player of the 1951 season. NZ Maori selector 1972-83 and manager of the Maori team which toured Australia, Fiji and Tonga 1979. Coach of the side that toured Wales and Spain 1982.

EVANS Cyril Edward

b: 10.1.1896, Christchurch *d:* 13.5.1975, Christchurch
Fullback

Represented NZ: 1921; 1 match

First-class record: Canterbury 1920,21 (Christchurch HSOB); South Island 1920

Educated Christchurch Boys' High School. In a brief first-class career, 'Scrum' Evans represented Canterbury seven times in the 1920 season, being selected for the South Island one week after his first game. Played for Canterbury v South Africa 1921 – the only loss suffered by the Springboks to a provincial team. Evans' only other match that season was his All Black appearance v New South Wales. Represented Canterbury at cricket 1919-29.

EVANS David Alexander

b: 4.10.1886, Napier *d:* 12.10.1940, Napier
Lock

Represented NZ: 1910; 4 matches – 1 test, 3 points – 1 try

First-class record: Hawke's Bay 1906 (City), 1907 (Scinde District), 1908,09 (Napier), 1910 (Napier HSOB)

Toured Australia 1910 playing in three of the seven matches including the third test. Weighed 13 stone.

Turned to rugby league the following year and represented New Zealand at that code 1911,12.

His son, Eric, represented Hawke's Bay 1934.

EVELEIGH Kevin Alfred

b: 8.11.1947, Palmerston North
Flanker

Represented NZ: 1974,76,77; 30 matches – 4 tests, 4 points – 1 try

First-class record: Manawatu 1969 (Palmerston North Technical College OB), 1970-78 (Feilding); Bay of Plenty 1981 (Eastern Suburbs), 1982 (Eastern Districts); Manawatu-Horowhenua 1971; North Island 1973-75,78; NZ Trials 1973-77; Rhodesia 1979; Zimbabwe 1980

Educated Otorohanga College. Toured Australia with the 1974 All Blacks and made his test debut on the 1976 South African tour. Named one of the five players of the year by the *1976 DB Rugby Annual*. Bob Howitt described Eveleigh as "a huge success, giving consistently dynamic performances". Played two tests against the 1977 Lions and toured Italy and France at the end of that year.

Standing 1.82m and weighing 88kg, Eveleigh proved himself a fearless tackler on the hard South African grounds. Eveleigh settled in Zimbabwe but returned to New Zealand in 1981 and played two seasons for Bay of Plenty. Appointed Manawatu coach 1987.

FANNING Alfred Henry Netherwood

b: 31.3.1890, Christchurch *d:* 11.3.1963, Christchurch
Lock

Represented NZ: 1913; 1 match – 1 test, 3 points – 1 try

First-class record: Canterbury 1913-15 (Linwood)

Educated Marist Brothers' School (Christchurch). Founder member of the Marist club in that city. A fine lock with great ability at the lineout who played only 12 matches for Canterbury and one for New Zealand in the third test v Australia 1913.

Served on the Junior Advisory Board of the Canterbury RFU. His brother, Bernie, represented New Zealand 1903,04. Another brother, Leo, wrote a popular 1910 rugby book *Players and Slayers*. His nephew, Louis Peterson played for New Zealand 1921-23.

FANNING Bernard John

b: 11.11.1874, Christchurch *d:* 9.7.1946, Christchurch
Lock

Represented NZ: 1903,04; 9 matches – 2 tests

First-class record: Canterbury 1895,97-1904 (Linwood); Wellington 1896 (Poneke); South Island 1897,1902,03; South Canterbury-Canterbury-West Coast 1904

First played senior club rugby for Kaiapoi 1894 as a 19-year-old; shifted to Christchurch the following year and, apart from one year in Wellington, represented Canterbury during the next 10 seasons.

Toured Australia 1903 and appeared in eight of the 10 matches including the first officially recognised test match. Played again for New Zealand v Great Britain the following season.

Bernie Fanning was regarded by his contemporaries as the best lock of his time.

Weighing 14 stone and of a powerful physique he was said to have held the scrum together as if it were in a vice.

Brother of the 1913 All Black Alfred Fanning and the journalist Leo Fanning.

FARRELL Colin Paul
b: 19.3.1956, Auckland
Fullback

Represented NZ: 1977; 2 matches – 2 tests

First-class record: Auckland 1974-81 (Suburbs); NZ Colts 1976

Educated St Paul's College (Auckland), 1st XV 1971,72. Entered club rugby 1973 for the Suburbs 3rd grade team progressing to the senior side and represented Auckland the following season as an 18-year-old.

Colin Farrell

Became the first All Black from the Suburbs club when he played in the first and second tests against the 1977 Lions. A strong-running fullback with a flair for counter-attack, he stood 1.77m and weighed 76.2kg.

FAWCETT Christopher Louis
b: 28.10.1954, Matamata
Fullback and threequarter

Represented NZ: 1976; 13 matches – 2 tests, 44 points – 4 tries, 8 conversions, 4 penalty goals

First-class record: Otago 1975 (University); Waikato 1977,78 (University); South Island 1975; NZ Trials 1974,76; NZ Juniors 1975; NZ Universities 1974-76,78

Educated Matamata College, 1st XV and North Island Under 18 1972. An unorthodox player who created an impression on the Juniors' internal tour 1975 and on the Universities world tour 1976 (scoring six tries, 24 conversions and 13 penalty goals in eight games on the latter tour).

After a good trial 'Kit' Fawcett was included in

Kit Fawcett

the 1976 All Black team to South Africa. Standing 1.85m and weighing 86kg, he was playing for the University club in Auckland at the time of his selection but did not represent that province. Appeared in 13 matches, including the second and third tests, but failed to reproduce his best attacking or goalkicking form.

Also played for the University of Natal 1979 and later for the Wasps club in England.

FEA William Rognvald
b: 5.10.1898, Dunedin *d:* 22.12.1988, Hamilton
Five-eighth

Represented NZ: 1921; 1 match – 1 test

First-class record: Otago 1920-23 (University); South Island 1920,22; NZ Services 1918,19; NZ Universities 1921

Educated Otago Boys' High School, 1st XV 1914-16. After leaving school he joined the army and served in Europe. Played for the NZ Services team which won the King's Cup and later toured South Africa, the youngest member of that team.

First represented Otago 1920 while studying medicine in Dunedin. His sole match for New Zealand was at first five-eighth in the third test against the 1921 Springboks. Weight recorded as 12st 4lb and height 5' 8".

The following season Fea had the distinction of captaining his club side, Otago, NZ Universities and the South Island but was not available for the New Zealand team owing to his studies. Retired from the game 1923 to concentrate upon medicine.

Coached the Timaru HSOB club 1926-30. Served as lieutenant-colonel with the 8th Field Ambulance during WWII. Selector of the 7th Brigade Group team 1942. New Zealand squash champion 1936,37.

FINLAY Brian Edward Louis
b: 7.11.1927, Cromwell *d:* 9.3.1982, Auckland
Flanker

Represented NZ: 1959; 1 match – 1 test

First-class record: Manawatu 1949,50,57,58 (University), 1951-54,56,59,60 (Marist); North Island 1952,59; NZ Trials 1959,60; Manawatu-Horowhenua 1950,56,59

Educated Marist Brothers' School (Miramar) and St Patrick's College. Appeared as a wing for a Manawatu XV v Horowhenua 1949 then played at centre, five-eighth and occasionally

Brian Finlay

fullback for his union until changing to the side of the scrum 1958 in which position he immediately attracted attention.

Selected for the first test against the 1959 Lions but suffered a leg injury making a tackle after 10 minutes of play. Aged 31 at the time of his sole All Black match, weighed 13st 12lb and stood 5' 11".

Coached the Marist and Ashhurst clubs. Cousin of Jack Finlay, a 1946 All Black.

FINLAY Jack
b: 31.1.1916, Normanby
Number eight

Represented NZ: 1946; 1 match – 1 test, 3 points – 1 try

First-class record: Manawatu 1934-39 (Feilding OB); Wellington 1941 (Hutt Army); North Island 1946; NZ Trials 1937; 2nd NZEF 1945,46

Educated Christchurch Boy's High School and Feilding Agricultural College, 1st XV 1933. First played for Manawatu as a five-eighth and was leading pointscorer in his debut season with three tries, 12 conversions and five penalty goals. Alternated between five-eighths and loose forward but appeared as prop and hooker in three All Black trials 1937.

Served as a major with the 25th Infantry Battalion during WWII winning the MC. Played rugby for service selections in New Zealand and the Middle East before becoming vice-captain of the 'Kiwis', appearing in the three 'internationals in Britain and 23 of the team's 38 games.

Standing 5' 10" and weighing 13½ stone, Finlay was described as "fit and tireless, adept at linking with backs or forwards and a great rucking forward". Selected for New Zealand in the first post-war test v Australia 1946. An injury prevented him taking the field in the second test and he retired at the end of the season.

Served as a selector for Manawatu 1949, North Island 1949-63; New Zealand 1961-63. Cousin of the 1959 All Black Brian Finlay.

FINLAY Mark Clayton
b: 10.5.1963, Palmerston North
Fullback

Represented NZ: 1984; 2 matches, 18 points – 2 tries, 5 conversions

First-class record: Manawatu 1981-86 (HSOB); NZ Trials 1984,85; NZ Colts 1982-84

Finlay was still a student at Palmerston North Boys' High School, 1st XV 1979-81, when he was first chosen for Manawatu, and became a regular and valuable member of the provincial side for many years. Represented North Island Under 16 1979 and New Zealand Under 17 1980; New Zealand Secondary Schools, 1981.

He was chosen for the All Blacks' tour of Fiji at the end of 1984 after Robbie Deans had to withdraw because of injury. He played in two of the four matches on the tour, but not in the unofficial international against Fiji. Weighed 90kg and stood 1.83m.

FINLAYSON Innes
b: 4.7.1899, Maungaturoto *d:* 29.1.1980, Whangarei
Flanker

Represented NZ: 1925,26,28,30; 36 matches – 6 tests, 35 points – 11 tries, 1 conversion

First-class record: North Auckland 1920,23-27,29 (Kamo), 1921 (Maungakaramea); North Island 1926,27; NZ Trials 1927,30; Auckland-North Auckland 1921

Educated Maungaturoto School. Made his first-class debut in North Auckland's first match (v South Island Country 1920) and scored his

union's first try in that game playing as a threequarter.

Selected as a loose forward for the 1925 New Zealand team to Australia. His weight was listed as 15 stone and his height 6' 2". Showing tremendous form, he played in all six tour matches and appeared later in the season against New South Wales at Auckland (the only other member of the touring team to be selected for this game was 'Mick' Lomas). Toured Australia again 1926 and played in all six games.

Toured South Africa 1928, playing in all four tests. Ordered off in the match against Transvaal. Played in the first two tests against the 1930 Lions with injury preventing his appearance in the rest of the series.

'Bunny' Finlayson served as a North Auckland selector 1933-35,39,40. He was a member of a remarkable rugby family. Three of his brothers, 'Bain', 'Tote' and Angus represented North Auckland in the 1920s; Jack was North Auckland RFU president 1950 while another brother, Callum, played for Otago 1927-30. Angus also represented Auckland 1924-34.

FISHER Thomas
b: 27.5.1891, Brunnerton *d:* 20.3.1968, Wellington
Loose forward

Represented NZ: 1914; 5 matches, 3 points – 1 try

First-class record: Buller 1913-15 (White Star), 1919 (Hill United); Marlborough 1920-22 (Awatere); South Island 1914,19; South Island Country 1912

Buller's second All Black, Fisher toured Australia 1914. His five tour matches included appearances against New South Wales and Queensland but he was kept out of the tests by outstanding loose forwards such as 'Ranji' Wilson, 'Doolan' Downing, Alex Bruce, Jim McNeece and Jim Graham. Prominent racehorse owner whose horses included Kentucky, The Rip, Vitesse and Darius.

FITZGERALD Charles James
b: 6.6.1899, Fairhall *d:* 8.5.1961, Awatere Valley
Centre threequarter and second five-eighth

Represented NZ: 1922; 5 matches, 3 points – 1 penalty goal

First-class record: Marlborough 1917-21 (Awatere); South Island 1922; Nelson-Marlborough-Golden Bay-Motueka 1921

Selected for the 1922 New Zealand team to tour Australia after scoring a try for the South Island in a 9-8 victory over the North Island earlier that season. A very versatile player, Fitzgerald appeared in first-class matches at halfback, first and second five-eighth, centre and wing.

Later changed to rugby league and represented New Zealand at that code v Great Britain 1924.

FITZGERALD James Train
b: 6.8.1928, Petone *d:* 13.5.1993, Christchurch
Centre threequarter and second five-eighth

Represented NZ: 1952-54; 17 matches – 1 test, 46 points – 11 tries, 5 conversions, 1 penalty goal

First-class record: Otago 1948,49 (University); Wellington 1952-54,56 (University); North Island 1953,54,56; NZ Trials 1953,56; NZ Universities 1949,52,54

Educated Hutt Valley High School, 1st XV 1943-47. Studied in Dunedin then returned to Wellington and was selected at second five-eighth for the first test v Australia 1952.

Jim Fitzgerald

Although Fitzgerald scored a try within minutes of his All Black debut he was one of many players dropped after the test loss.

Appeared in three trial matches and the interisland fixture 1953 and was chosen for the British tour. Scored 10 tries in 16 matches but was unable to reproduce his best form in early games and was omitted from the internationals. A brilliant and inventive attacker, described as "investing a backline with gaiety and zest"; weighed 12½ stone and stood 5' 9".

Captained North Island 1956 and retired from first-class play in that year. University (Christchurch) club coach 1965-69; Canterbury Under 19 selector 1970-72.

FITZPATRICK Brian Bernard James
b: 5.3.1931, Opotiki
Second five-eighth

Represented NZ: 1951,53,54; 22 matches – 3 tests, 15 points – 5 tries

First-class record: Poverty Bay 1949-51 (Gisborne HSOB); Wellington 1952,53 (University); Auckland 1954-56 (University); North Island 1951,52; NZ Trials 1951,53; NZ Universities 1952,54,56; New Zealand XV 1952; Poverty Bay-East Coast 1949; Poverty Bay-East Coast-Bay of Plenty 1950

Educated Gisborne Boys' High School, 1st XV 1946-48. Strongly built, standing 5' 10" and weighing 13st 8lb. Fitzpatrick was a punishing tackler and a powerful runner. Selected in the 1951 All Blacks to tour Australia as a 20-year-old, playing in four of the 12 tour matches.

'Bunny' Finlayson

Brian Fitzpatrick

In 1953 he was selected to tour Britain and appeared in 18 matches including internationals against Wales, Ireland and France as well as in a match against the Barbarians.

Made seven appearances for Auckland over the next three seasons before dropping out of first-class rugby. His son, Sean, represented New Zealand 1986-97.

FITZPATRICK Sean Brian Thomas
b: 4.6.1963, Auckland
Hooker

Represented NZ: 1986-97; 128 matches – 92 tests, 90 points – 20 tries

First-class record: Auckland 1984-97 (University); Auckland Blues 1996,97; NZ Colts 1983; NZ XV 1992; North Island 1995; North Island Universities 1984; NZ Universities 1984,85; NZ Trials 1986,87,89-95; North Zone 1988; Barbarians 1985,87,94,96,97; Harlequins 1995

The most-capped All Black and one of the most durable rugby players New Zealand or any other country has seen. Fitzpatrick was educated at Sacred Heart College in Auckland and played for New Zealand Secondary Schools in 1981. He made his debut for Auckland in 1984, but could not gain a regular place until 1986, evidently because of wayward throwing into lineouts.

Despite still not being the Auckland No 1, he was chosen as the reserve hooker for the 1986 test against France, and was elevated to the team when the first choice, Bruce Hemara, had to withdraw because of injury. Fitzpatrick played the first test against Australia while the Cavaliers were still ineligible but lost his place for the remaining domestic tests. He forced his way back into the test team in France at the end of the year, beginning an unbroken sequence of 63 tests – a sequence that only ended when he stood down from the World Cup pool match against Japan in 1995.

Injury to the captain, Andy Dalton, allowed Fitzpatrick to play in each of the World Cup matches in 1987 and it was another injury that opened the door for Fitzpatrick to take over the New Zealand captaincy five years later. Coach Laurie Mains had made no secret that Mike Brewer was his preferred captain, but when Brewer was injured in the 1992 trial in Napier, Mains turned to Fitzpatrick.

Fitzpatrick grew in stature with each lucky break though he may not have thought so the following year when he led the All Blacks in a loss to the Lions at Athletic Park. It was, he admitted, his worst game, and such was the criticism of him that Mains felt compelled to speak out on his behalf. Wellington has provided Fitzpatrick with the best and the worst. If the worst in a playing sense was the Lions in 1993, the worst in a personal sense was the following year when he was bitten on his left ear by the South African prop, Johan le Roux. The best at Athletic Park was in 1996 when the All Blacks beat Australia in what many people regarded as the closest thing to a perfect game any rugby team could ever reach.

Mains's successor as All Black coach, John Hart – who had coached Auckland when Fitzpatrick couldn't get in the team – echoed Mains in his unstinting praise of Fitzpatrick and hinted he would still like him for the 1999 World Cup. That seemed an increasingly distant prospect as the latter half of 1997 unfolded, however, and Fitzpatrick was so troubled by injury to his right knee that he missed most of the national provincial championship and then had a miserable tour of Britain and Ireland, going on as a replacement in two matches. When Fitzpatrick missed the first test of the tour, against Ireland, it was the first time in his career he could not be considered for a test because of injury – a remarkable testimony to not only his durability, but also his preparation and professionalism.

His career spanned vast changes in the game both on and off the field – from strictly enforced days of amateurism to days of great wealth, from pre-World Cup days to playing in the first three to be staged, and changes in the laws and playing attitude that took rugby into the forefront of the sports entertainment business. He made his All Black debut on the same day as Joe Stanley and, in 1997, Fitzpatrick could count among his team-mates Stanley's son Jeremy.

Though Fitzpatrick was criticised from time to time, and even in his younger days by Hart, for sometimes over-aggressive play and for gamesmanship, his mark on New Zealand rugby has been immense.

He also played for a Southern Hemisphere team that beat the Northern Hemisphere 39-4 in Hong Kong in 1991.

His father, Brian Fitzpatrick, played 22 times for the All Blacks between 1951 and 1954.

Fitzpatrick's biography *Fronting Up* was published in 1994 (Moa Beckett).

FITZPATRICK'S TESTS	
Argentina	7
Australia	24
British Isles	3
Canada	2
England	3
Fiji	2
France	12
Ireland	4
Italy	3
Scotland	8
South Africa	12
United States	1
Wales	6
Western Samoa	2
World XV	3

FLEMING John Kingsley
b: 2.5.1953, Auckland
Lock

Represented NZ: 1978-80; 35 matches – 5 tests, 16 points – 4 tries

First-class record: Auckland 1972 (Grammar); Wellington 1974-79 (Marist-St Pat's); Waikato 1980-83 (Marist); North Island 1978,79; NZ Trials 1977-81; NZ Juniors 1976; NZ Colts 1973,74

Educated Auckland Grammar School, 1st XV 1970. Selected for Auckland Colts and NZ Colts while playing for Grammar Old Boys' club. Moved to Wellington 1974 and included in the representative team.

Sean Fitzpatrick tries to get past Jean-Luc Sadourny of France.

Selected for the 1978 British tour, playing in 10 of the 18 matches including the Barbarians game at number eight. Appeared in the Queensland B game on the two-match Australian tour 1979 and then played in both 'tests' against Argentina in the home series and against England and Scotland on the 1979 tour where he impressed in 10 matches with consistently fine play. Toured Australia and Fiji 1980 playing in 12 of the 16 matches including all three internationals against Australia.

Fleming's build — 1.96m and 101kg — was valuable in the lineout. Moved to Waikato during the 1980 season but broke an ankle after five minutes in his first match for that province.

FLETCHER Charles John Compton
b: 9.5.1894, Rewiti *d:* 9.9.1973, Auckland
Loose forward

Represented NZ: 1920,21; 2 matches — 1 test

First-class record: Auckland 1919,20 (College Rifles); North Auckland 1921-24,26 (Waimauku); North Island 1920; Auckland-North Auckland 1921,23

Educated Waimauku School and King's College, 1st XV 1912. While farming at Waimauku he travelled to Auckland to play for the College Rifles club and the representative team.

A rugged player, weighing 13½ stone and standing six feet, Fletcher toured with the 1920 All Blacks to Australia but was unable to play because of an injury suffered in New Zealand before departing.

With the formation of the North Auckland RFU 1920, the Waimauku club joined the Kaipara sub-union and Fletcher played for the new union until his retirement 1926.

Appeared for the All Blacks v New South Wales 1921 then included in the third test team to play the Springboks two weeks later. His brother, Bert, also represented North Auckland 1921-30.

FOGARTY Richard
b: 12.12.1891, Matakanui *d:* 9.9.1980, Dunedin
Loose forward and hooker

Represented NZ: 1921; 2 matches — 2 tests

First-class record: Otago 1914 (Union); Taranaki 1920-22 (Hawera); Auckland 1923,24 (College Rifles); NZ Trials 1921; NZ Services 1918-20

Served with the NZ Rifle Brigade in WWI winning the MM. Played for the NZ Army team in the King's Cup series and then toured South Africa 1919.

His two games for New Zealand were against the 1921 Springboks, appearing in his usual position as a loose forward in the first test and surprisingly brought back as a hooker for the final test. Stood 5' 10" and weighed 13st 3lb.

When his playing career ended 1924, Fogarty had played in 67 first-class matches having represented three provinces over 11 years with the war intervening after one season for Otago. Manukau club coach 1936.

FORD Brian Robert
b: 10.7.1951, Kaikoura
Wing threequarter

Represented NZ: 1977-79; 20 matches — 4 tests, 32 points — 8 tries

First-class record: Canterbury 1970 (Kaikoura), 1971 (Shirley); Marlborough 1972-83 (Kaikoura); South Island 1972,74-81; NZ Trials 1972,74-79; NZ Colts 1972; Marlborough-Nelson-Bays 1977

Educated Kaikoura Primary and Rangiora High School. A strong, fast and determined runner,

Brian Ford

standing 1.83m and weighing 88kg, Ford appeared in his first interisland and trial matches 1972 but it was not until 1977 that he won All Black honours in the final two tests against the Lions.

Played six matches in France 1977 and four during an injury-restricted tour of Britain 1978. Injured in the Irish international and replaced by Bryan Williams. Appeared in both unofficial 'tests' v Argentina 1979 then toured England and Scotland, playing in the English international.

As an athlete Ford finished third in the national junior 100 and 200 metres 1971 and fourth in the senior 200m 1973. Recorded 10.7s for 100m, 21.9s for 200m and 49s for 400m.

FORD William August
b: 25.8.1895, Christchurch *d:* 7.7.1959, Christchurch
Wing threequarter

Represented NZ: 1921-23; 9 matches, 21 points — 7 tries

First-class record: Canterbury 1920-26 (Merivale); South Island 1921; NZ Trials 1921; NZ Services 1918-20

Educated Papanui Primary School. Played his early football as a halfback. After war service he was selected for the NZ Services team in the King's Cup series and the South African tour.

'Jockey' Ford made his provincial debut 1920 and the following season scored a memorable try for Canterbury enabling his team to defeat the 1921 Springboks.

Chosen for New Zealand to play against New South Wales 1921 then toured Australia in the next season and played against New South Wales at Christchurch 1923.

FORSTER Stuart Thomas
b: 12.2.1969, Pahiatua
Halfback

Represented NZ: 1993-95; 12 matches — 6 tests

First-class record: Hawke's Bay 1988,89 (Napier OB); Otago 1990 (Green Island), 1991-97 (Southern); Otago Highlanders 1996,97; NZ Colts 1990; Southern Zone Maoris 1990,92-94; NZ Maoris 1990,92-96; NZ Trials 1992-95; NZ XV 1992,95

"Imported" by Otago, Forster became a mainstay of Otago rugby through the 1990s and was celebrated as a nuggety, combative halfback who revelled in the nickname of "The Bear". "Bear Park" was even temporarily located in the street outside Carisbrook.

Forster benefited when his former Otago coach, Laurie Mains, became the All Black coach and he first played for New Zealand on the 1993 tour of England and Scotland, playing in both tests.

He was retained for the first two tests of the following year, against France, but was then replaced by Graeme Bachop.

With Bachop unavailable after the 1995 World Cup, Ofisa Tonu'u and Justin Marshall were the two halfbacks chosen for the tour of Italy and France, but Forster got another chance when Tonu'u had to withdraw because of injury. He played in the first two tests, against Italy and France, but was then dropped, some critics arguing that he paid the price for an inadequate forward performance in the loss in Toulouse.

Forster was hampered by injury in 1996 and 1997 and not again required by the national selectors.

Stu Forster

FOX Grant James
b: 16.6.1962, New Plymouth
First five-eighth

Represented NZ: 1984-93; 78 matches — 46 tests, 1067 points — 2 tries, 225 conversions, 192 penalty goals, 11 dropped goals

First-class record: Auckland 1982-93 (University); NZ Universities 1982; North Island 1983-85; NZ Juniors 1984; NZ Colts 1982,83; North Zone 1987-89; NZ XV 1992; NZ Trials 1987,89-93; Crusaders XV 1995

record 207 points in tests, came on the 1988 tour of Australia in only his second season as a regular choice.

It could be argued, and was, that much of Fox's success was due to the dominance of the All Blacks between 1987 and 1990, when they played 23 tests without defeat and that he couldn't have kicked conversions if his teammates had not scored tries. That was true, but matches were also won, or saved, because of Fox's prowess both as a kicker, whether for goal or position, and his ability to read a game and organise the other backs.

His Ranfurly Shield, Auckland, New Zealand and international scoring were all records, as was his tally of 46 tests at first five-eighth. His 433 points in first-class rugby during the 1989 domestic season was also a record.

Fox was still at his best in the domestic tests of 1993, was unavailable for the tour of England and Scotland because of his work for a sports marketing company, and he retired early in 1994.

Fox also played for a Southern Hemisphere team that beat the Northern Hemisphere 39-4 in Hong Kong in 1991.

Fox's biography *The Game The Goal* (Rugby Press), written by Alex Veysey, was published in 1992.

FRANCIS Arthur Reginald Howe
b: 8.6.1882, Wanganui d: 15.6.1957, Auckland
Loose forward

Represented NZ: 1905,07,08,10; 18 matches – 10 tests, 31 points – 8 tries, 2 conversions, 1 penalty goal

First-class record: Auckland 1904-10 (Ponsonby); North Island 1906,08-10

Educated Auckland Grammar School. A tall (6' 3"), strongly built player who was also a powerful goalkicker, 'Bolla' Francis was considered unlucky to miss selection for the 1905-06 'Originals' but did play for New Zealand v Australia at Dunedin 1905. Toured Australia 1907 appearing in all three tests. Played in all three internationals against the 1908 Anglo-Welsh side and again in Australia 1910.

Transferred to rugby league and joined the Newton Rangers club 1911, touring Britain at the end of that season as a member of an Australasian team. The following year Francis captained New Zealand before accepting an offer to play the professional game for the Wigan club in England; later transferred to Hull with whom he won a Rugby League Cup final medal.

Returned to New Zealand when his playing days were over and was reinstated to rugby. Coached the Grammar club in Auckland 1930-35. Dave Gallaher, the All Black captain, was his brother-in-law.

FRANCIS William Charles
b: 4.2.1894, New Plymouth d: 28.11.1981, Pukekohe
Hooker

Represented NZ: 1913,14; 12 matches – 5 tests, 9 points – 3 tries

First-class record: Wellington 1913-15,21 (Wellington); North Island 1914

Educated at New Plymouth Convent and West End Primary Schools. Played senior football as a 17-year-old for the Tukapa club under the

Grant Fox, New Zealand's highest points-scorer.

FOX'S FIRST-CLASS CAREER						
	Matches	*Tries*	*Conversions*	*Penalties*	*DG*	*Total*
Auckland	189	25	613	441	31	2746
NZ (tests)	46	1	118	128	7	645
NZ (other)	32	1	107	64	4	422
Others	34	2	60	50	5	293
	301	29	898	683	47	4106

Fox's test partners
17 **Graeme Bachop** (Australia 6, Scotland 2, France 2, Argentina 2, Ireland, England, Canada, Wales, World XV).
10 **Bruce Deans** (Australia 4, Wales 2, France 2, Argentina 2)
8 **David Kirk** (Argentina 2, Italy, Fiji, Scotland, Wales, France, Australia)
6 **Ant Strachan** (Australia 3, World XV, South Africa, British Isles)
4 **Jon Preston** (British Isles 2, Australia, Western Samoa)
1 **Jason Hewett** (Italy)

Fox was the most prolific points-scorer New Zealand rugby had seen and such was his high success rate it often obscured his valuable qualities as a first five-eighth and as a strategist. Many matches were won because of his kicking, but equally many were won because of his tactical understanding.

Fox was educated at Auckland Grammar School, was in the school's champion first XV in 1979 and 1980 and captained the New Zealand Secondary Schools side that toured Australia in 1980. He made his debut for Auckland in 1982 and was first chosen for New Zealand for a tour of Fiji at the end of 1984, but he did not become the regular goalkicker for New Zealand until the World Cup in 1987.

Fox was chosen for the abandoned tour of South Africa in 1985 and made his test debut on the replacement tour of Argentina, playing in

the first test but not in the second. He went on the Cavaliers' unauthorised tour of South Africa in 1986 and later in the year regained an All Black place on the tour of France, but he was not chosen for either of the tests.

His first home game for the All Blacks was in the opening match of the World Cup and he was one of the dominant players in New Zealand – and world – rugby from then until his retirement in 1993. He played an unbroken run of tests from 1987 to the World Cup in 1991. It was a measure of Fox's value that two coaches chose not to select him – John Hart in Japan in 1987 and Laurie Mains in the centenary series in 1992 – only to realise that he was too valuable to be left out.

Fox's extraordinary success brought him any number of test and first-class records and one of the most significant, surpassing Don Clarke's

captaincy of All Black 'Simon' Mynott.

Shifted to Wellington 1912 joining the Oriental club. The following year he transferred to the Wellington club and won selection for the New Zealand team to play the Australians in the second and third tests. He was five months short of his 20th birthday and the youngest forward to play test rugby for New Zealand. Toured Australia 1914 and appeared in all three tests, scoring two tries in the third encounter.

FRASER Bernard Gabriel

b: 21.7.1953, Lautoka, Fiji
Wing threequarter

Represented NZ: 1979-84; 55 matches – 23 tests, 184 points – 46 tries

First-class record: Wellington 1975-86 (Hutt Valley Marist); North Island 1979-82,84; NZ Trials 1979-84

Educated St Paul's College (Auckland), 1st XV and a member of Auckland Secondary Schools

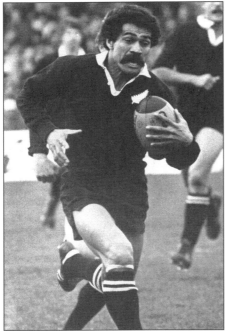

Bernie Fraser

team 1972. He was also a promising hurdler during his school days.

First selected for New Zealand in the two unofficial internationals against Argentina in 1979 and retained for the tour of England and Scotland later that year when he played in both tests. Toured Australia and Fiji in 1980 and played in the third test while at the end of the year he toured North America and Wales and played in the centenary test at Cardiff. At that stage, he had scored in each of his previous eight appearances for New Zealand. With the 1981 season, the Wellington back three partnership of Fraser on the left wing, Stu Wilson on the right and Allan Hewson at fullback began. This was retained for three seasons except for three tests when Wilson was at centre. Fraser was unchallenged for his position until the end of the 1983 season. He was not required for the two domestic tests against France in 1984 or for the tour of Australia but he joined the All Blacks in Australia as a replacement and played in the first international.

Fraser at 1.80m and 81kg was a strong, hard

runner and so difficult to stop when close to the tryline that a corner of Athletic Park in Wellington became unofficially and widely known as 'Bernie's corner'. Although troubled with injury towards the end of his career, Fraser continued to play for Wellington and in 1986 he went on the unofficial Cavaliers' tour of South Africa, after John Kirwan had refused his invitation.

Fraser in 1984 combined with Stu Wilson in a biography, *Ebony and Ivory* (Moa, 1984).

FRAZER Harry Frederick

b: 21.4.1916, Wanganui
Lock and prop

Represented NZ: 1946,47,49; 15 matches – 5 tests, 6 points – 2 tries (including 1 penalty try)

First-class record: Hawke's Bay 1937-41,46-48,50 (Pirates); Auckland 1943 (Army); Waikato 1944 (RNZAF); North Island 1943,46-48; NZ Trials 1947,48; NZ Combined Services 1944; RNZAF 1943; Hawke's Bay-Poverty Bay 1946

Educated Napier Central Primary and Napier Boys' High School, 1st XV 1933,34. Represented Hawke's Bay Colts 1936 and played for service teams during WWII.

Played in both tests v Australia 1946 as a prop, injured in the first test and replaced by Jack McRae. Toured Australia 1947 where injuries restricted his appearances to four matches including both tests. Brought down in full flight chasing the ball over the goal-line in the first test and awarded a penalty try. Toured South Africa 1949 playing in nine matches including the second test where he was included in place of the injured Charlie Willocks.

A hard-working forward, standing 6' 1" and weighing 15 stone, Frazer captained Hawke's Bay 1950 – his final season in a first-class career spanning 14 years. President and coach of the Pirates club in Napier; chairman of the combined clubs' committee.

FREEBAIRN William Stuart Scott

b: 12.1.1932, New Plymouth
Wing threequarter

Represented NZ: 1953,54; 14 matches, 27 points – 9 tries

First-class record: Manawatu 1952,53,55-61 (Feilding); North Island 1953,57,60; NZ Trials 1953,56,57,59-61; Manawatu-Horowhenua 1956,59

Educated Lytton Street Primary and Feilding Agricultural High School. A slight but speedy and determined wing standing 5' 9" and weighing 11st 6lb, Freebairn scored three tries in the main North Island trial 1953, subsequently representing North Island and being selected in the All Black team to go to Europe.

Although described by critics as a player showing a lot of promise he was not again selected to represent New Zealand. During his career he scored 53 tries for Manawatu including 19 in the 1959 season. Vice-president and coach of the Feilding club. Represented West Coast North Island at national athletic championships in long jump and relays.

FREITAS David Frank Errol

b: 23.2.1901, Hokitika *d:* 10.4.1968, Wellington
Loose forward

Represented NZ: 1928; 4 matches, 3 points – 1 try

First-class record: West Coast 1924,26-35 (Hokitika Excelsior); South Island 1928,29; NZ Trials 1927,29; West Coast-Buller 1930; South Island Minor Unions 1928

First played for West Coast as a centre but thereafter appeared as a loose forward.

Selected for New Zealand for all three games against New South Wales in the 1928 home season as well as v West Coast-Buller.

Died in the *Wahine* disaster in Wellington harbour.

FROMONT Richard Trevor

b: 17.9.1969, Papakura
Lock

Represented NZ: 1993,95; 10 matches

First-class record: Auckland B 1991;

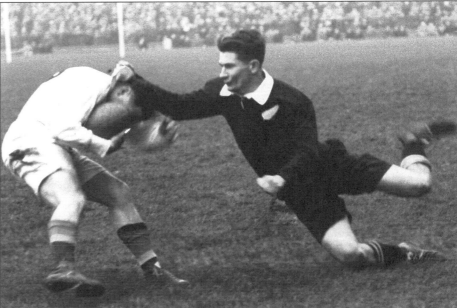

Stu Freebairn . . . nine tries for New Zealand on the 1953-54 tour of the British Isles and France.

Auckland 1993-97 (Suburbs); Auckland Blues 1996,97; NZ Trials 1993-95; NZ XV 1993-95; Coronation Shield Districts 1994; Poverty Bay Selection 1996

Educated at Avondale College, Fromont did not play rugby until he was 18 when he joined the Suburbs club. By 1990, he was in the club's under 21 side and played for Auckland Colts and B.

His first game for Auckland was in 1993 against Natal and in the same year he played for a New Zealand XV and in October was chosen in the All Black team to tour England and Scotland, on which he played in the midweek matches.

Two more New Zealand XV matches and trials intervened before he was picked for the All Blacks again, for the tour of Italy and France in 1995. Again, he played in the midweek matches.

FROST Harry
b: 27.2.1869, Riccarton *d:* 6.7.1954, Auckland
Forward

Represented NZ: 1896; 1 match

First-class record: Canterbury 1890,93,97,99-1901 (Christchurch)

Educated Riccarton and Bromsgrove House Schools. Frost's sole match for New Zealand was against Queensland at Wellington 1896 when he was called in to replace the injured James Swindley. Played most of his rugby as a hooker in the 2-3-2 scrum.

Devoted much of his life to administration of rugby and other sports. Christchurch club delegate to the Canterbury RFU 1893-1902 when he moved to Auckland. Active in the local referees' association and when a split occurred in that body in 1911, Frost was instrumental in forming the Auckland RRA of which he became the inaugural president.

Auckland RFU executive 1915-45; president 1935-44; life member 1929; NZRFU Appeal Council 1909,12,18,44-50; president 1924. First New Zealand representative to become a life member of the NZRFU 1939.

Frost's activity in other sports included club cricket, rowing and swimming; served as president and secretary of the Auckland Athletic Assn.

FRYER Frank Cunningham
b: 2.11.1886, Riccarton *d:* 22.9.1958, Hastings
Wing threequarter

Represented NZ: 1907,08; 8 matches – 4 tests, 33 points – 11 tries

First-class record: Canterbury 1905-10 (Christchurch); South Island 1906-09; Canterbury-South Canterbury 1905

Educated Christ's College, 1st XV 1902-04. A speedy and prolific try scorer, Fryer was the first player to score five tries in a provincial match in New Zealand (for Canterbury v South Canterbury 1905), a feat he repeated for New Zealand v Queensland 1907 on a tour of Australia where he played in all three tests. Recalled for the second test against the Anglo-Welsh 1908.

Shifted to Auckland and played for the University club and for Auckland in a sub-union game. Represented Canterbury Colts at cricket 1905-06 and appeared in Hawke Cup fixtures for Hawke's Bay 1917-23. Won the New

Zealand Golf Assn amateur foursomes title with Kapi Tareha 1927; NZ Golf Assn president 1954.

FULLER William Bennett
b: 9.4.1883, Christchurch *d:* 25.7.1957, Christchurch
Five-eighth and threequarter

Represented NZ: 1910; 6 matches – 2 tests, 15 points – 5 tries

First-class record: Canterbury 1907-13 (Merivale); South Island 1908,09

Began his playing career as a threequarter but selected as a five-eighth for the 1910 tour to Australia. Scored three tries against Wellington before the team departed and recorded a try in his test debut but did not appear again for New Zealand after the second test was lost 11-nil.

Canterbury RFU management committee 1916-20,30. Refereed the Wellington v Great Britain match 1930.

FURLONG Blair Donald Marie
b: 10.3.1945, Dannevirke
First five-eighth and fullback

Represented NZ: 1970; 11 matches – 1 test, 32 points – 10 conversions, 3 penalty goals, 1 dropped goal

First-class record: Hawke's Bay 1963-65,67-71 (Marist); Wellington 1966 (Marist); Bay of Plenty 1967 (Kawerau United); NZ Trials 1970,71

Educated Dannevirke North Primary and Dannevirke High School. Became a regular member of the Hawke's Bay team in his first season out of school. A well-built part-Maori

Blair Furlong

player standing six feet tall and weighing 13½ stone, Furlong established a fine reputation as a cool, steady, tactical player in the province's Ranfurly Shield defences 1967-69. His dropped goal against Wellington in the final moments of the 1967 Ranfurly shield match enabled

Hawke's Bay to draw the match.

After two All Black trials 1970 (one at fullback) he was selected to tour South Africa. Played one match en route in Western Australia, where he landed seven conversions and a penalty goal and 10 games in South Africa including the final test. Captained Hawke's Bay 1971.

Hawke's Bay RFU management committee 1975-80; member of the NZ Regional Coaching Committee 1978. As a cricketer represented Central Districts in 1965,68-70 and played for the New Zealand Under 23 team 1965. Achieved the hat-trick for New Zealand Under 23 v Canterbury 1965.

GAGE David Richmond
b: 11.1.1868, Kihikihi *d:* 12.10.1916, Wellington
Utility back

Represented NZ: 1893,96; 8 matches, 6 points – 2 tries

First-class record: Wellington 1887-89,91,92,94,96,1901 (Poneke); Hawke's Bay 1890,93,97 (Pirates); Auckland 1895 (North Shore); NZ Native Team 1888,89; North Island 1894; NZ Trial 1893

Educated Waiomatatini Primary School and St John's and St Stephen's (Auckland) Colleges winning a Makarini Scholarship to Te Aute College 1882. Selected for the Native team's tour 1888-89 (he weighed 11st 6lb) where he played a remarkable 68 of the side's 74 matches in Britain after missing the Australian part of the tour.

Chosen for the 1893 New Zealand team to Australia and the 1896 team which played Queensland. Also appeared for the North Island v New South Wales 1894.

During his long career Gage played a total of 131 first-class matches. The Poneke club raised money for a memorial stone and support for his family after his death.

GALLAGHER John Anthony
b: 29.1.1964, London, England
Fullback and centre

Represented NZ: 1986-89; 41 matches – 18 tests, 251 points – 35 tries, 39 conversions, 11 penalty goals

First-class record: Wellington 1984-90 (Oriental Rongotai); NZ Trials 1987,89; Central Zone 1987,88; Centurions 1987; NZ Combined Services 1985,86

Gallagher, who was educated at St Joseph's Academy in London and played for London Irish and Metropolitan Police, came to New Zealand in 1984 to gain rugby experience. He achieved it. He gained a place immediately in the Wellington team, usually at centre, and when Allan Hewson was unavailable, he played at fullback.

Consistent performances for unbeaten Wellington in 1986 gained Gallagher a place in the All Black team that toured France at the end of the year and he played two matches at fullback and two at centre.

Gallagher was the first-choice fullback for the All Blacks in the winning World Cup campaign in 1987, his attacking style fitting ideally into the game plan devised by coach Brian Lochore which took international rugby to a higher plane.

He scored five tries in the tournament, including four against Fiji. He also played in the Sydney test that regained the Bledisloe Cup and in each of the five matches in Japan at the end of the year.

Gallagher had no contenders for the fullback job for the next two years, playing series against Wales, Australia, France and Argentina. In addition to his counter-attacking speed and a reliable defence, Gallagher was also an accomplished goalkicker and kicked in matches in Wales and Ireland in 1989 ahead of two players later seen as specialist kickers, Matthew Ridge and Frano Botica.

Gallagher, who was captain of Wellington in 1990, was voted by the British press as international rugby player of the year for 1989 and while he was in London to receive the award early in 1990, he met officials of the Leeds league club and, a month later, signed with the club. With All Blacks Ridge, Botica, John Schuster and Paul Simonsson also switching to league in 1990, as well as leading provincial players such as Daryl Halligan and Clarry and Brett Iti, it was the biggest New Zealand loss to league in a single year since league's foundation year of 1907.

Gallagher was widely known as 'Kipper', a nickname that evidently grew out of a team session the night of Gallagher's first match for Wellington, against Southland in Invercargill. The Wellington masseur, Les Hall, had told a joke in which the name 'Kipper' figured prominently. Gallagher was required to tell a joke after Hall and, he recalled, failed miserably. Hall then suggested Gallagher be nicknamed 'Kipper' because he would then remember at least one good joke. The name stuck.

He played for the British Barbarians in 1996 and was captain of the Blackheath club in London when able to return from league.

GALLAHER David

b: 30.10.1873, Ramelton, Ulster *d:* 4.10.1917, Belgium
Hooker and wing forward

Represented NZ: 1903-06; 36 matches – 6 tests, 14 points – 4 tries, 1 conversion

First-class record: Auckland 1896,97,99, 1900,03-05,09 (Ponsonby); North Island 1903,05

Came to New Zealand with his family 1878 when his father took up land at Katikati; educated at the local school where his mother was the teacher. Moved to Auckland and played junior football for the Parnell club before transferring to Ponsonby. Served in the Boer War as a corporal in the 6th Contingent 1901.

Selected for the 1903 New Zealand team which won all its 20 matches in Australia. Gallaher began the tour as a hooker ending it as a wing forward – a position he occupied only occasionally for Auckland but in which he was to achieve fame. Played against the 1904 British team at Athletic Park and was appointed captain of the 1905 'Original' All Blacks. His statistics were recorded as 13 stone and six feet.

Played for Auckland against New Zealand on the preliminary tour of Australasia before assuming the captaincy. In Britain Gallaher's tactics as wing forward received much criticism with frequent complaints that he was off-side or obstructing play but his team of 'Colonials' earned respect for their dazzling style and magnificent record.

Gallaher retired at the conclusion of this tour and served as sole Auckland selector 1906-16 and New Zealand selector 1907-14. Co-author with Billy Stead of *The Complete Rugby Footballer* (Methven 1906). Died of wounds

Dave Gallaher

received in battle at Passchendaele and buried in the Nine Elms cemetery, Poperinghe.

A member of the 'Originals', Ernest Booth wrote of Gallaher: "Dave was a man of sterling worth . . . girded by great self-determination and self-control he was a valuable friend and could be, I think, a remorseless foe. To us All Blacks his words would often be 'Give nothing away: take no chances'. As a skipper he was something of a disciplinarian."

In 1922, the Auckland RFU presented the Gallaher Shield for the club championship in his memory.

Phil Gard

GARD Philip Charles

b: 20.11.1947, Kurow *d:* 3.6.1990, Kurow
Second five-eighth and centre threequarter

Represented NZ: 1971,72; 7 matches – 1 test

First-class record: North Otago 1966-77 (Kurow); South Island 1969-72; NZ Trials 1970-72; South Canterbury-Mid Canterbury-North Otago 1971

John Gallagher . . . voted international player of the year, 1989.

Educated Kurow District High School. Played 85 matches for North Otago over 12 consecutive seasons. Selected for the All Blacks for the final test against the 1971 Lions and included in the 1972 internal tour, playing six of nine matches.

Served on the Kurow club committee for 10 years; president 1979. A brother, Neville, represented North Otago 1962. A cousin, Ross Gard, represented Otago and NZ Universities and another cousin, Ian Gard, played for North Otago.

GARDINER Ashley John
b: 10.12.1946, New Plymouth
Prop

Represented NZ: 1974; 11 matches – 1 test, 8 points – 2 tries

First-class record: Taranaki 1966-75 (Tukapa); North Island 1974; NZ Trials 1974,75; NZ Juniors 1968

Educated Welbourne Primary and New Plymouth Boys' High School. Captained the Juniors against Japan 1968. Selected for the All Blacks to tour Australia 1974 playing in nine of the 12 matches in Australia including final international. Later in that season he toured Ireland, appearing in two of the eight matches. Weighed 101kg and stood 1.85m at time of tour. Active in administration for the Tukapa club.

GARDNER John Henry
b: 30.1.1870, Oamaru *d:* March, 1909, Victoria
Forward

Represented NZ: 1893; 4 matches

First-class record: South Canterbury 1893-95 (Union)

Selected for the 1893 tour of Australia before he had played any first-class rugby. His four matches in Australia included an appearance in the second New South Wales match.

GATLAND Warren David
b: 17.9.1963, Hamilton
Hooker

Represented NZ: 1988-91; 17 matches, 8 points – 2 tries

First-class record: Waikato 1986-88 (Hamilton OB), 1989-94 (Taupiri); NZ Trials 1988-91,93; Saracens 1992; NZ XV 1992; North Zone 1989; Maunsell Sports Trust Invitation XV 1987.

As a hooker, Warren Gatland suffered – if that's the right word – for playing at the same time as Sean Fitzpatrick. As other hookers found, being in the same team as Fitzpatrick meant a string of midweek matches and tests only when Fitzpatrick was injured, which was rare.

Gatland consequently played in no tests on the four All Black tours of which he was a part, Australia in 1988, Canada, Wales and Ireland in 1989, France in 1990 and Argentina in 1991. He was regarded as a strong tight forward and an able deputy and perhaps it was an acknowledgement of his role that he was made captain of a New Zealand XV in 1992.

Gatland had another string to his bow, however. During the tour of Australia in 1988, he introduced to the All Blacks' warm-up sessions at training a version of a game that was part Australian rules and part Gaelic football. It proved popular with the players, to whom variety is the spice of training, and continued as part of their routine for several years.

Warren Gatland

Gatland later coached in Scotland and Ireland and early in 1998 was named coach of the Irish national side.

GEDDES John Herbert
b: 9.1.1907, Invercargill *d:* 16.8.1990, Invercargill
Wing threequarter

Represented NZ: 1929; 6 matches – 1 test, 23 points – 7 tries, 1 conversion

First-class record: Southland 1926-34 (Pirates); South Island 1931; NZ Trials 1929,30

Educated Southland Boys' High School, 1st XV 1923. A speedy wing, standing 5' 8" and weighing 10st 10lb, Ben Geddes toured Australia 1929 playing six of the 10 matches including the first test, his only international as he was replaced by Bert Grenside for the rest of the series. Geddes was top try scorer with seven on this tour.

Coached grade teams for the Pirates (Invercargill) club after retirement. An Otago sprint champion with a recorded best time for 100 yards of 10 secs. Served in the RNZAF during WWII as a physical training instructor. His father, Arthur Geddes, was a prominent rugby administrator (see listing under *Administrators*)

GEDDES William McKail
b: 13.5.1893, Auckland *d:* 1.7.1950, Auckland
First five-eighth

Represented NZ: 1913; 1 match – 1 test

First-class record: Auckland 1911,13,14 (University); North Island 1913

Educated Auckland Grammar School, 1st XV 1910. Selected for the New Zealand team to tour North America 1913 was unable to accept but played for the All Blacks v Australia in the second test in that year.

Served in the NZ Field Artillery during WWI rising to the rank of major and winning the MC. A lieutenant-colonel in the territorial Artillery between the wars and Auckland fortress commander 1940,41.

GEMMELL Bruce McLeod
b: 12.5.1950, Auckland
Halfback

Represented NZ: 1974; 5 matches – 2 tests, 4 points – 1 try

First-class record: Auckland 1969-78 (Grammar); NZ XV 1974; NZ Trials 1971,74,75; NZ Juniors 1970,73

Educated Auckland Grammar School, 1st XV 1966-68. Captained the NZ Juniors team which defeated the All Blacks 14-10 in 1973 then selected for the tour of Australia 1974, playing in the first two internationals. Surprisingly, Gemmell was unable to hold a regular position in the Auckland team during the 1975,76 seasons. Retired from rugby 1979 on medical advice because of recurring head injury. Represented Auckland in Brabin Cup cricket.

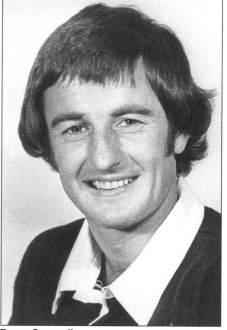
Bruce Gemmell

GEMMELL Samuel William
b: 28.8.1896, Mohaka *d:* 28.6.1970, Wairoa
Hooker

Represented NZ: 1923; 1 match

First-class record: Hawke's Bay 1921 (Te Aute College), 1922 (M.A.C.), 1923-25 (Marist), 1926 (Hastings), 1927 (Wairoa Pirates), 1928 (Mohaka), 1929,30 (Waipapa), 1931 (Tapuae); North Island 1923; NZ Trials 1924; NZ Maoris 1922,23,26-29; Hawke's Bay-Poverty Bay 1921

Educated Mohaka School and Maori Agricultural College, 1st XV 1915-17. Served in WWI with the 29th Reinforcements and played for the Maori Pioneer Battalion team in Britain 1919. Returned to New Zealand and attended Te Aute College from where he was selected for Hawke's Bay 1921.

Played his sole match for the All Blacks v New South Wales 1923 as a hooker although his usual position was loose forward. Toured with NZ Maoris to Europe, Ceylon and Australia 1926-27. Appeared in his last match for Hawke's Bay 1931. Played his final first-class match (for the Centurions 1941) when aged 45. His total of 145 first-class matches was a New Zealand record until after WWII. Stood 5' 10" and weighed 13 stone.

Coached the Johnsonville club. His uncle, Ben Gemmell, was a NZ Maoris representative 1914,21.

GEORGE Victor Leslie
b: 5.6.1908, Invercargill *d:* 10.8.1996, Wanaka
Prop

Represented NZ: 1938; 7 matches – 3 tests

First-class record: Southland 1929,30,32-39 (Invercargill); South Island 1933,35,38,39; NZ Trials 1934,35,37

Educated Otago Boys' High School. Had a long career in the Southland team and several All Black trials before touring Australia 1938 as a rugged prop standing just under six feet and weighing 14st 4lb. Played in all three internationals.

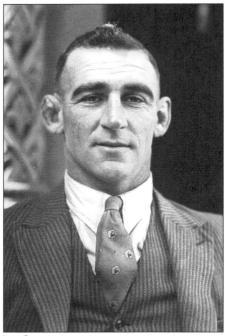

Les George

Included by Winston McCarthy in his speculative Team That Never Was – the touring party due to tour South Africa but denied the opportunity by the outbreak of WWII. Described as "hard as they come despite his 30 years".

After the war Les George served on the Southland RFU executive 1949-75; president 1956,57, coach 1946-54, selector 1952-60. South Island selector 1961-70. NZRFU council 1966-72; New Zealand selector 1964-70. Life member Invercargill club 1969 and Southland RFU 1976. His brother, Cyril, represented Southland 1929-38 and was an All Black trialist 1934.

GILBERT Graham Duncan McMillan
b: 11.3.1911, Rothesay, Scotland
Fullback

Represented NZ: 1935,36; 27 matches – 4 tests, 125 points – 31 conversions, 17 penalty goals, 3 dropped goals

First-class record: Buller 1930 (Westport OB); West Coast 1932-37 (Greymouth United); South Island 1936; NZ Trials 1934,35,37; West Coast-Buller 1930

Educated Westport Technical College. Came into the Buller team as a 19-year-old 1930 also appearing in the West Coast-Buller team v the British team as a centre threequarter although he later turned to fullback position. After playing in the three trial matches 1935 Gilbert was selected for the New Zealand team's British tour playing in all four internationals. Top points-scorer on the tour with 125 points from 27 of the 30 games.

The All Black vice-captain, Charlie Oliver, in the book on the tour written in conjunction with Eric Tindill, said of Gilbert: "In his first game, he was the equal of Nepia at his best, but as the tour progressed his positional play became a little uncertain. His line kicking and fielding of the ball were a treat to watch. I will never forget his magnificent kick from the sideline, with a greasy ball, which won for us the game against Oxford University; nor will I forget the wonderful dropkick from halfway in the match against Wales. He was a little slow for fast grounds, but was well suited to heavy going. A complete success on tour, 'Mike' was a player we could not have done without."

Joined the Bradford Northern Rugby League club 1937 and toured France with an unbeaten British Empire team 1938. Captain of that club before returning to New Zealand 1940.

GILLESPIE Charles Theodore
b: 24.6.1883, Masterton *d:* 22.1.1964, Masterton
Lock

Represented NZ: 1913; 1 match – 1 test

First-class record: Wellington 1905,11-13; (Oriental); Wanganui 1907,08 (Wanganui); North Island 1913; Wellington-Wairarapa-Horowhenua 1905

A 13st 6lb forward who usually played at lock or on the side of the scrum. His sole match for New Zealand was the second test v Australia 1913. Life member of the Oriental club 1931.

Joined the New Zealand Artillery 1904 and left with the Main Body to serve in WWI as a farrier-sergeant. Fought at Gallipoli. Commissioned in the field and awarded the Military Cross. Severely gassed and wounded at Passchendaele.

GILLESPIE William David
b: 6.8.1934, Cromwell
Flanker

Represented NZ: 1957,58,60; 23 matches – 1 test, 3 points – 1 try

First-class record: Otago 1954-59,61 (Pirates); Wellington 1962,63 (Onslow); South Island 1956,58,59; NZ Trials 1956-62

Educated Fruitlands and Alexandra Primary Schools and Waimate District High School. Did not play rugby until aged 16. Developed into a solid type of loose forward, at 6' 6" and 14st 2lb, well suited to the rucking type of game. Chosen for seven consecutive All Black trials.

Toured Australia 1957 and played his only international when called into the third test team against the 1958 Wallabies after the second test loss. Captained Otago to victory over the 1959 Lions and then toured South Africa 1960.

Dave Gillespie's father-in-law was Charlie Oliver, the 1928,29,34-36 All Black.

GILLETT George Arthur
b: 23.4.1877, Leeston *d:* 27.9.1956, Auckland
Wing forward and fullback

Represented NZ: 1905-08; 38 matches – 8 tests, 41 points – 4 tries, 13 conversions, 1 goal from a mark

First-class record: Auckland 1899,1906 (Karangahake), 1907-09 (Ponsonby); South Island 1905; North Island 1906

Educated Hamilton East School. Played for Thames and Auckland before leaving for Kalgoorlie where it was reported he represented Western Australia at Australian rules. Returned to New Zealand 1905, lived in Christchurch and played for the Merivale club winning selection for the South Island and the New Zealand touring team without appearing for Canterbury. His statistics were given as six feet and 13 stone.

Played 24 matches on the 1905-06 British tour, including four internationals at fullback. Relieved Dave Gallaher at wing forward occasionally on this tour, but occupied this position in two tests in Australia 1907 and two against the 1908 Anglo-Welsh.

Transferred to rugby league 1911 and toured England with an Australasian team. Retired after captaining Auckland 1912 and became a fulltime organiser for the code in the North Island, establishing league in Wellington and Thames. Reinstated to rugby; Poverty Bay selector 1917,18. His brother Jack represented Auckland at rugby 1897-99.

GILLIES Colin Cuthbert
b: 8.10.1912, Oamaru *d:* 2.7.1996, Timaru
First five-eighth

Represented NZ: 1936; 2 matches – 1 test

First-class record: North Otago 1931 (Waitaki BHS); Otago 1932,33,35,36 (University), 1938 (Matakanui); South Island 1936; NZ Universities 1936; NZ Trials 1934

Educated Waitaki Boys' High School, 1st XV 1929-31 from where he represented North Otago. Selected for the 1936 All Blacks to play South Canterbury and Australia in the second test of the series.

A fine first five-eighth who gave his backline thrust and often imparted brilliance in his play. A good punter of the ball and sound in cover defence.

North Otago sub-unions selector-coach 1954-56; North Otago selector 1956. Two brothers, A.J. and D.H. Gillies, also played rugby for North Otago. Represented North Otago at cricket 1931 from his school 1st XI.

GILRAY Colin MacDonald
b: 17.3.1885, Broughty Ferry, Scotland
d: 15.7.1974, Melbourne, Australia
Wing threequarter

Represented NZ: 1905; 1 match – 1 test

First-class record: Otago 1904-06 (University); South Island 1904; Scotland 1908,09,12; Oxford University 1908,09; Otago-Southland 1904,05

Came to New Zealand 1889. Educated Otago Boys' High School, 1st XV 1901-03. Selected for the South Island. Owing to his studies Gilray was not available for the 1905-06 tour but played against Australia in Dunedin.

Awarded a Rhodes Scholarship 1907 and won two Oxford blues. In 1909 he played left centre to Ronnie Poulton who scored five tries from the left wing to create an inter-university record. Capped four times for Scotland (v England 1908; England and Wales 1909; Ireland 1912). In his book *Rugger – The Man's Game*, E.H.D. Sewell described Gilray as "very close to inclusion in my super class of centres".

Served in WWI as a captain with the British Rifle Brigade winning the MC. Awarded OBE.

GIVEN Frederick James
b: 21.5.1876, Oamaru *d:* 12.6.1921, Hawera
Flanker

Represented NZ: 1903; 9 matches, 3 points – 1 try

First-class record: Otago 1895-99,1901-03,05 (Alhambra); South Island 1903; Otago-Southland 1905

Given was a fine lineout forward who played 34 matches for Otago, captaining the province 1898.

He toured Australia 1903 appearing in both New South Wales games and against Queensland but not in the international.

GLASGOW Francis Turnbull
b: 17.8.1880, Dunedin *d:* 20.2.1939, Wellington
Loose forward

Represented NZ: 1905,06,08; 35 matches – 6 tests, 43 points – 10 tries, 5 conversions, 1 penalty goal

First-class record: Wellington 1899,1900 (Athletic); Taranaki 1901,02 (Hawera), 1903,04 (Eltham); Hawke's Bay 1906 (Waipawa); Southland 1908,09 (Star); North Island 1905; Taranaki-Wanganui-Manawatu 1904

Educated Newtown Primary School and Wellington College. An intelligent and industrious loose forward standing 5' 10" and weighing 13st 3lb.

Glasgow was included in the preliminary Australasian tour before leaving with the 1905-06 team to Britain where he maintained a high standard. Played in 27 of the 35 matches including all five internationals. Recalled for the final test v Anglo-Welsh 1908 as a hooker. His last first-class rugby was for Trentham Army 1918.

Served on the NZRFU management committee 1931-36 and was on the executive from 1937 until his death. Liaison officer for the 1937 Springboks.

GLENN William Spiers
b: 21.2.1887, Greymouth *d:* 5.10.1953, Wanganui
Loose forward

Represented NZ: 1904-06; 19 matches – 2 tests

First-class record: Taranaki 1901-04 (Waimate),1912 unattached; North Island 1904,05; Taranaki-Wanganui-Manawatu 1904

Educated Manaia School. A regular member of the Taranaki team from 1901 earning selection for New Zealand against the touring 1904 British team. Toured Australia, New Zealand and Britain with the 1905-06 New Zealand team. His tour statistics were recorded at 5' 11" and 12st 12lb. Injury prevented his playing until the sixth game in Britain but appeared in 13 matches including the French international. Returned via Suez with Eric Harper rather than continue with the team to America. Glenn's only other first-class game was as a replacement for Taranaki v Wanganui 1912 while farming near Wanganui. NZRFU management committee 1922,23.

Served with the Royal Field Artillery as a major winning the Military Cross in WWI. Glenn was the first ex-All Black to enter Parliament, winning the Rangitikei seat 1919 and retaining it until 1928. A prominent racehorse breeder and owner, steward and trustee of the Wanganui Jockey Club.

GLENNIE Ernest
b: c 1871 *d:* ?
Halfback, five-eighth and wing forward

Represented NZ: 1897; 6 matches, 9 points – 3 tries

First-class record: Canterbury 1896,97 (Linwood); South Island 1897

Selected for the 1897 tour of Australia, appearing in minor matches and against Auckland on the team's return. Described as a "speedy wing forward".

GODDARD John Wood
b: 31.1.1920, Timaru *d:* 22.10.1996, Timaru
Fullback

Represented NZ: 1949; 8 matches, 32 points – 10 conversions, 4 penalty goals

First-class record: South Canterbury 1941 (Celtic), 1944 (Zingari), 1945-48,50,51 (Celtic); South Island 1948; NZ Trials 1947,48; Hanan Shield Districts 1946

A sound fullback and a good goalkicker, weighing 11st 3lb and standing 5' 9", who showed good form in the 1948 All Black trials, scoring 13 points in the final trial.

Played eight games on the 1949 South Africa tour but was kept out of the test team by Bob Scott. Older brother of Maurice Goddard, the 1946-49 All Black, with whom he toured.

GODDARD Maurice Patrick
b: 28.9.1921, Timaru *d:* 19.6.1974, Christchurch
Centre threequarter

Represented NZ: 1946,47,49; 20 matches – 5 tests, 27 points – 9 tries

First-class record: Ashburton County 1942 (Army); South Canterbury 1946-48,50,51,54 (Zingari); South Island 1946-48; NZ Trials 1947,48; Hanan Shield Districts 1946; NZ Services 1944-46; England Services 1945; Combined Dominions 1945; RAF 1945

Educated Marist Brothers' School (Timaru) and

Timaru Boys' High School. A strong, pacy runner with a devastating swerve. Stood 5' 9" and played around 12 stone. Goddard came into prominence with the NZ Services team in Britain, also played twice for England v Scotland in war-time service internationals and a member of the RAF team that played the 'Kiwis'.

Maurie Goddard

Selected for the second test v Australia 1946 when Johnnie Smith was unavailable, then toured Australia playing in both the 1947 tests. Broke his wrist in the fourth game of the 1949 South African tour and did not appear again until the 18th match but played the last seven fixtures including the third and fourth tests.

Goddard continued to play for South Canterbury until 1954. His brother, Jack, also toured with the 1949 All Blacks and his son, Tony, represented South Canterbury 1966,68, 69,76-78; Wellington 1970 and Marlborough 1971-75.

GOING Kenneth Tautohe
b: 18.2.1942, Kawakawa
Fullback

Ken Going

75

Represented NZ: 1974; 3 matches, 11 points – 1 conversion, 3 penalty goals

First-class record: North Auckland 1963-75 (Mid-Northern); North Island 1968; NZ Trials 1966-71,75; NZ Maoris 1966,68-75

Educated Maromaku Primary School, Northland and Church Colleges. A strongly-built, aggressive and enterprising fullback and reliable goalkicker, standing 1.75m tall and weighing 82kg, Ken Going played a record 130 matches for North Auckland over 13 consecutive seasons and scored 714 points. He also had a number of All Black trials and a long record of representing NZ Maoris.

Toured Ireland 1974 but a knee injury restricted him to three matches. Mid-Northern club coach 1977-79 and committee member. Brother of Sid (New Zealand 1967-77) and Brian (North Auckland 1967-78); the three Going brothers produced many extraordinary moves with uncanny combinations for their province and the NZ Maoris. A son, Darrell, represented North Auckland 1986. North Auckland selector-coach 1985,86.

GOING Sidney Milton
b: 19.8.1943, Kawakawa
Halfback

Represented NZ: 1967-77; 86 matches – 29 tests, 164 points – 33 tries, 18 conversions, 5 penalty goals, 1 dropped goal

First-class record: North Auckland 1962, 65-78 (Mid-Northern); North Island 1966-69,71,73,75,77; NZ Trials 1966,67,69-73,75,77; NZ Maoris 1965,66,68,69,71,72,74,75,77; New Zealand XV 1968

Educated Maromaku Primary School, Northland and Church Colleges, 1st XV 1959,60. Played one match for North Auckland 1962 as a replacement. Spent two years in Canada with the Mormon church. From 1965 Going was North Auckland's halfback for 14 seasons.

Made his All Black debut in the 1967 jubilee test v Australia and then toured Britain but displaced Chris Laidlaw only in the French international. Described by Terry McLean in his tour book *All Black Magic* as introducing a "singular quality" in the team's play; "the swift penetrative break around the scrummage or from the lineout through the first defensive line and into open spaces. The series of rapid, violent attacks Going initiated were the most remarkable features of the tour."

Toured Australia 1968 again as second-string to Laidlaw but when that player was injured later on that season, Going played in the third test v France when he scored two typically brilliant tries with solo breaks around the blindside. After both tests against Wales 1969, he toured South Africa, coming on for the injured Laidlaw in the first test and playing in the final encounter. From 1971 Going was regarded as the first choice halfback until 1974 when he was not chosen for the trials prior to the Australian tour. Although he declared himself unavailable for the 1974 trials to pick a team to visit Ireland he was included in the touring party. Retained his place in the 1975 and 1976 seasons (although relegated to reserves for the international against Ireland, but coming on as a replacement for Lyn Davis). Dropped after the first two tests against the 1977 Lions and retired from first-class rugby 1978.

A strong, stocky player, weighing 12st 10lb and standing 5' 7", Sid Going was undoubtedly among the greatest halfbacks seen in rugby. He possessed a flair for the unorthodox, his particular genius being his incisive and courageous running close to the forwards. Going was criticised for his less-than-perfect passing and his tendency to "go it alone" – often the All Blacks' display was too dependent upon his form – but his match-winning capabilities were undeniable.

Won the Tom French Cup for the outstanding Maori player of the year 1967-72. The subject of Bob Howitt's biography *Super Sid* (Rugby Press, 1978). Made an MBE for his contribution to rugby. Brother of Ken (a 1974 All Black) and Brian Going who represented North Auckland, North Island and NZ Maoris.

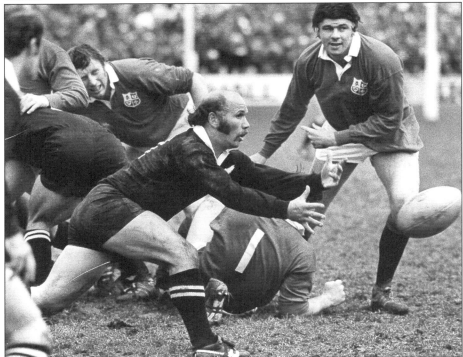

Sid Going . . . a flair for the unorthodox.

GOLDSMITH Jasin Alex
b: 24.7.1969, Tokoroa
Utility back

Represented NZ: 1988; 8 matches, 20 points – 5 tries

First-class record: Waikato 1987,88 (Fraser Tech); Auckland 1989-91 (Ponsonby); Bay of Plenty 1993 (Mt Maunganui); NZ Colts 1990; NZ Development 1990; NZ XV 1991; NZ Maoris 1988,91; Northern Maoris 1991; NZ Trials 1988,91; Maunsell Sports Trust Invitation XV 1987

Educated at Forest View High School, Goldsmith was hailed as one of the finest young prospects in years and played for North Island and New Zealand age teams as well as the national secondary schools team. A fortnight after his 18th birthday, he played for New Zealand Under 19 that beat Wales 56-9 in the curtainraiser to a Waikato-Counties match at Pukekohe and was among the try-scorers. He then went on as a replacement for Waikato and scored the final try that won Waikato the match.

When he made his debut for the All Blacks in Perth on June 19, 1988, aged 18 years and 330 days, he became the third-youngest player (after Lui Paewai, 1923, and Craig Wickes, 1980) to take the field for New Zealand. Goldsmith appeared at fullback, on a wing and at centre in his eight games on the tour.

He broke a leg playing for Auckland early the following year and missed the rest of the season and though he later played in trials and other national teams (including the Colts, despite having been an All Black), he never played for New Zealand again.

GOOD Alan
b: 12.7.1867, Urenui *d:* 30.4.1938, Hawera
Wing threequarter

Represented NZ: 1893; 4 matches

First-class record: Combined Taranaki Clubs 1887,88 (Pihama); Taranaki 1889-96 (Waimate), 1897 (Hawera), 1899 (Waimate); NZ Trials 1893

Educated Wanganui Collegiate. A strong and effective runner, weighing about 12½ stone, Good represented Taranaki on 38 occasions over a 13-year period. Toured Australia 1893 with the first team selected by the newly formed NZRFU.

Won the national long jump title with a leap of 19' 9½" at the 1898 amateur athletic championships. His brothers Hugh and Harry also represented Taranaki with Hugh Good also playing for New Zealand v New South Wales 1894. An accomplished Maori linguist, Alan Good gave much assistance to the Maori people of south Taranaki.

GOOD Hugh Maurice
b: 29.9.1871, Urenui *d:* 3.7.1941, Stratford
Wing threequarter

Represented NZ: 1894; 1 match

First-class record: Taranaki 1889-96 (Waimate); NZ Trials 1893

Educated Wanganui Collegiate and represented Taranaki in his final year at school. A burly 14½ stone wing capable of running 100 yards in a fraction over 10 seconds. Forced to decline an

invitation to join the 1893 New Zealand team in Australia as a replacement but played against New South Wales 1894.

National champion 1898 in the high jump and shot put. Brother of Alan (New Zealand 1893) and Harry, both Taranaki representatives.

GORDON Steven Bryan
b: 16.5.1967, Te Awamutu
Lock

Represented NZ: 1989-91,93; 19 matches – 2 tests

First-class record: Waikato 1987,88 (Hamilton OB), 1989-97 (Taupiri); Waikato Chiefs 1996; Otago Highlanders 1997; NZ Trials 1990,91,93; NZ XV 1992-94; NZ Development 1994; NZ Colts 1987,88; North Zone 1988; NZRFU President's XV 1995; South Canterbury Invitation XV 1995; Maunsell Sports Trust Invitation XV 1987

Steve Gordon was educated at Te Awamutu College and played his early club rugby for Pirongia. He played for Waikato, North Island and New Zealand age grade sides and New Zealand Secondary Schools. He played for Waikato Colts and North Island Universities in

Steve Gordon

1986 and made his first-class debut for Waikato in the first match of 1987.

Gordon spent most of his All Black career as a back-up lock, having first been selected for the tour of Wales and Ireland in 1989. He toured France in 1990 and Argentina in 1991 and was in the 1991 World Cup squad, though didn't play a match. He finally got his test chance on the 1993 tour of England and Scotland when Robin Brooke was injured and didn't play a match on tour. Gordon played in both tests.

A Waikato stalwart, in 1997 he became one of seven players to have been in teams that have won the Ranfurly Shield three times and he became the only player to have been in eight challenges for the shield.

He and Rob Gordon are brothers and when they and the Whettons toured France in 1990, it was the first double set of brothers in an All Black touring party since the Clarkes and the Meadses in 1963-64.

Rob Gordon

GORDON William Robert
b: 7.8.1965, Te Awamutu
Loose forward

Represented NZ: 1990; 3 games

First-class record: Otago 1986,87 (University); Waikato 1988 (University), 1990,91 (Marist); NZ Colts 1986; NZ Universities 1986; North Zone 1988; NZ Trial 1988; NZ XV 1991; NZ B 1991

Though Waikato born and bred, being educated at Te Awamutu College (and playing for New Zealand Secondary Schools in 1983,84), Rob Gordon played provincial rugby for Otago before he did for his home province, returning there in 1988.

With his younger brother Steve, he was selected for the All Blacks' tour of France at the end of 1990 and played in three matches. He and his brother played in one match together for New Zealand.

Gordon returned to live and play in France after the 1991 New Zealand season.

Gordon also played for a Southern Hemisphere team that beat the Northern Hemisphere 39-4 in Hong Kong in 1991.

GRAHAM David John
b: 1.1.1935, Stratford
Flanker and number eight

Represented NZ: 1958,60-64; 53 matches – 22 tests, 33 points – 11 tries

First-class record: Auckland 1955-57 (University); Canterbury 1958-65 (Christchurch HSOB); South Island 1958,61-65; NZ Trials 1958,60-63,65; NZ Universities 1957; New Zealand XV 1958; Rest of New Zealand 1965

Educated New Plymouth Boys' High School, 1st XV 1951,52. Played several seasons in Auckland before moving to Christchurch. Selected as a 5' 10", 13st 2lb number eight for the first two tests v Australia 1958. Withdrew from the 1959 trials but selected to tour South

Africa 1960 playing in 10 of the 26 matches (several as captain) including the second and third tests.

A.C. Parker, in his tour book *The All Blacks Juggernaut in South Africa*, wrote that John Graham "developed into one of the cleverest and quickest loose forwards in the side and the Springboks made no secret of their relief at his omission from the fourth test."

Appeared in all internationals, mostly on the side of the scrum, in the 1961-64 seasons, taking over the captaincy when Whineray stepped down after the 1963-64 British tour. Retired after the 1965 season. Terry McLean described Graham, the All Black captain, as "a man of strong opinions" who "goaded and scourged his men in demands for new life and greater vigour. 'The ball! the ball!' he used to bellow whenever there was a melee." Although a relatively slight man, Graham's intelligence and speed were valuable assets for New Zealand rugby.

Auckland assistant coach 1974-76 and 1991-93; deputy chairman NZ Secondary Schools Council 1983-86; president Auckland Rugby Union 1996-97; NZ cricket team manager from 1996.

Two brothers, Tim (Waikato, North Island and NZ Trials) and Bob (Auckland, North Island and NZ Trials), could be considered unlucky to have missed All Black honours.

GRAHAM James Buchan
b: 23.4.1884, Dunedin *d:* 15.5.1941, Auckland
Loose forward

Represented NZ: 1913,14; 19 matches – 3 tests, 74 points – 4 tries, 28 conversions, 2 penalty goals

First-class record: Otago 1908,10 (Zingari-Richmond), 1911-15 (Southern); South Island 1910,14

Educated Lawrence High School. A very good loose forward and fine goalkicker. Leading points-scorer on the 1913 New Zealand tour of America with 66 points from 11 matches. Played in the All-America international then toured Australia 1914 appearing in the first and third tests. Represented Otago at cricket. His son, J.G. Graham, represented Otago 1945,49,50.

GRAHAM Maurice Gordon
b: 20.12.1931, Blayney, New South Wales
Fullback

Represented NZ: 1960; 1 match

First-class record: New South Wales Country 1950-54; New South Wales 1954 (Wagga Wagga); Riverina 1957 (Gordon); Australian Colts 1953

Educated Grafton High School. Played for Armidale Teachers College 1950,51, Wagga Wagga City and Riverina 1952-54 and the Gordon Club (Sydney) 1955,68. Toured New Zealand with the NSW Country team 1954 playing in 10 of the 11 matches and scoring 19 points.

With Eddie Stapleton, Graham was invited to play for the All Blacks when the 1960 touring team was left with two players short owing to injury for its matches against Queensland and New South Wales played on the same day. Both invited players appeared in the side that played Queensland in the earlier match.

Manager of the Australian Schools team 1974,75. Foundation secretary of the NSW Schools Rugby Union and Australian Schools Rugby Union 1971-76.

GRAHAM Wayne Geoffrey

b: 13.4.1957, Tauranga
Flanker and number eight

Represented NZ: 1978,79; 8 matches – 1 test

First-class record: Otago 1976,77 (University), 1978,80-82 (Clinton), 1979 (Ranfurly), 1983,84 (Roxburgh), 1986 (Dunedin); South Island 1978,79; NZ Trials 1978,79; NZ Universities 1976,77; NZ Colts 1976; NZ Juniors 1977,78

Educated Tauranga Primary and Intermediate Schools and Tauranga Boys' College. Selected to tour with the New Zealand team to the British Isles 1978, playing six of the 18 matches on tour. Made his international debut 1979 when he replaced Frank Oliver at halftime in the first test v France. Played in the first unofficial test v Argentina later in 1979, replacing Ross Fraser, an original selection who was forced to withdraw after breaking a leg.

A versatile player who played equally well as a loose or tight forward, weighed 94.5kg and stood 1.88m. Represented NZ Secondary Schools at cricket 1973,75.

GRANGER Kenneth William

b: 20.3.1951, Wellington
Wing threequarter

Represented NZ: 1976; 6 matches, 20 points – 5 tries

First-class record: Manawatu 1971-79,81-84 (Freyberg OB); North Island 1976; NZ Trials 1976,77; Manawatu-Horowhenua 1977

Ken Granger

Educated Queen Charlotte College and Freyberg High School. A determined, hard-running wing who stood 1.83m and weighed 82kg. Apart from 1974 when he played frequently at fullback was a consistent try scorer for Manawatu playing 128 matches and scoring 66 tries. Selected for the North Island 1976 scoring two tries in the interisland match, then toured Argentina, playing in six of the nine matches. Played for the Harlequins club in England 1980.

GRANT Lachlan Ashwell

b: 4.10.1923, Temuka
Flanker and lock

Represented NZ: 1947,49,51; 23 matches – 4 tests, 12 points – 4 tries

First-class record: South Canterbury 1941,46-48,50-53 (Temuka); South Island 1947,48,51; NZ Trials 1947,48,51,53; 2nd NZEF 1945,46; NZ Services 1945; Hanan Shield Districts 1946

Lachie Grant

Educated Clandeboye School and Timaru Boys' High School. Played three games for South Canterbury 1941 as a 17-year-old. In a season interrupted by a knee injury, he played 13 matches for the 'Kiwis' after serving in the Italian campaign.

Toured Australia 1947 appearing in both internationals and South Africa 1949 playing in the first two tests. Visited Australia again with the 1951 All Blacks and continued to play until 1953.

Standing 6' 2" and weighing 14 stone, Grant was a lineout specialist. Hennie Muller, writing of the 1949 tour in his book *Tot Siens to Test Rugby* (Howard B. Timmins, 1953), said, "How

the New Zealanders came to drop Lachie Grant for the third and fourth tests is a mystery. Barring Roy John of Wales he ranks as the finest lineout forward I've seen, and what a fiery all-round forward."

Temuka club management committee; South Canterbury RFU president 1976. Grant's father, two brothers and three nephews also represented South Canterbury.

GRAY George Donaldson

b: 1880 *d:* 16.4.1961, Christchurch
Five-eighth

Represented NZ: 1908,13; 14 matches – 3 tests, 12 points – 4 tries

First-class record: Canterbury 1900,02,05-08,1910-15 (Albion); Wellington 1903,04 (Poneke); South Island 1908-13; Wellington Province 1903; Canterbury-South Canterbury 1905

One of the greatest of New Zealand's first five-eighths, 'Doddy' Gray represented Canterbury on 56 occasions and had 14 games for Wellington as well as six consecutive appearances for the South Island.

His first match for New Zealand was the second test against the 1908 Anglo-Welsh tourists then playing against Australia 1913 before leaving for the North American tour where he appeared in the international. Returned to play another season for Canterbury from the Albion club where he was a key member of the famous inside back combination of Burns, Gray and Weston.

Described by W.H. Atack as "a constant sense of anxiety to the opposition, ever ready to spring something unorthodox, keen witted, never flurried, always menacing, a gem in the position". In an obituary S.C. Mullins recalled Gray's stocky build and noted that he seldom kicked the ball and was never guilty of giving a bad pass.

GRAY Kenneth Francis

b: 24.6.1938, Porirua *d:* 18.11.1992, Plimmerton
Prop

Ken Gray . . . "durable, vigorous, supremely intelligent".

Represented NZ: 1963-69; 50 matches – 24 tests, 27 points – 9 tries

First-class record: Wellington 1958-69 (Petone); North Island 1963,64,66-69; NZ Trials 1961-63,65,66,68,69

Educated Plimmerton Primary School and Wellington College. Played for a Wellington XV from the Paremata club before joining Petone 1959 and regularly representing Wellington for the next decade. Standing 6' 2" and weighing around 16 stone, he played at lock until 1961.

Gray appeared in the front row of every All Black test series from 1963 until 1969 apart from those missed because of injury. He toured Britain 1963-64,67, Australia 1968 and played in home series against Australia 1964, South Africa 1965, the British Isles 1966, France 1968 and Wales 1969.

During the mid-1960s the All Black scrum was based on the skill, strength and experience of Gray and Whineray at prop and Denis Young or Bruce McLeod hooking. Terry McLean described Gray as "a great forward – durable, vigorous, relentlessly pursuing and supremely intelligent". He performed a valuable role at number two in the lineout and was surprisingly mobile about the field for a big tight-forward.

GRAY Roderick

b: 22.10.1870, Masterton *d:* 27.5.1951, Taratahi
Forward

Represented NZ: 1893; 2 matches, 6 points – 2 tries

First-class record: Wairarapa 1891-96 (Masterton), 1897,98 (Masterton Union); NZ Trials 1893

Educated Masterton School. Sent to Australia 1893 as a reinforcement after the first tour match was lost 25-3. Gray, 'Rab' McKenzie, Bob Oliphant and Bill Watson arrived in time to participate in the last two games. Gray scored two tries in the vital third encounter with New South Wales and played an outstanding game.

Described as "a splendid specimen of the fearless, dashing type of forward that any side can do with". An excellent athlete, said to be the best miler in Wairarapa.

GRAY William Ngataiawhio

b: 23.12.1932, Te Puke *d:* 10.1.1993, Rotorua
Second five-eighth

Represented NZ: 1955-57; 11 matches – 6 tests, 6 points – 2 tries

First-class record: Bay of Plenty 1950 (Te Puke HSOB), 1951 (Rotorua HSOB), 1953-57,59,62 (Whakarewarewa), 1964-66 (Ngongotaha); North Island 1956,57; NZ Trials 1956,57,59; NZ Maoris 1954-58; Bay of Plenty-Thames Valley 1955,59

Educated Te Matai Primary and Te Puke High School, 1st XV 1945-49. A strong, lively and courageous player standing 5' 11" and weighing 12st 10lb, Bill Gray was first selected for New Zealand in the second test v Australia 1955 holding his place for the final test of the series.

Played all four tests against the 1956 Springboks then toured Australia 1957, playing in five of the 13 matches. Toured Australia again with the NZ Maoris 1958 but suffered a broken leg in the second match and didn't play for the rest of that season.

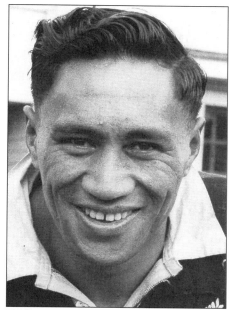

Bill Gray

In 1960,61 Gray played in Sydney for the Northern Suburbs club. Returned home 1962 and continued to play for Bay of Plenty until 1966. NZ Maori junior tennis champion 1950.

GREEN Craig Ivan

b: 23.3.1961, Christchurch
Second five-eighth and wing threequarter

Represented NZ: 1983-87; 39 matches – 20 tests, 108 points – 27 tries

First-class record: Mid-Canterbury 1979,80 (Rakaia); Canterbury 1981,83 (Lincoln), 1982 (Christchurch), 1984-86 (Glenmark), 1987

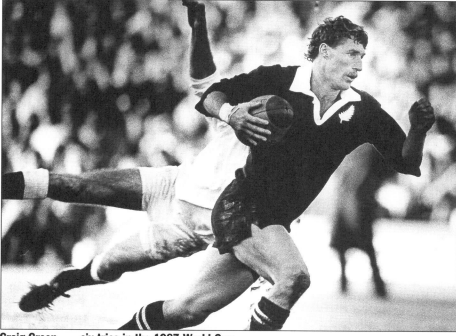

Craig Green . . . six tries in the 1987 World Cup.

(Shirley); NZ Colts 1982; NZ Universities 1983; South Island 1983-85; South Zone 1987; NZ Trials 1984,87

Though educated at Shirley Boys High School in Christchurch, Green made his first-class debut for Mid Canterbury and returned to Christchurch after two seasons. He became an integral member of Canterbury's Ranfurly Shield team of the early 1980s and he was first chosen for New Zealand for the tour of England and Scotland in 1983. He made his test debut when he went on against Scotland at second five-eighth as a replacement for his Canterbury team-mate, Warwick Taylor. He retained the position for the England test.

He played one test at centre and two on the wing in Australia in 1984 but by 1985, when he played in all the domestic tests, wing had become his regular position. He was selected for the All Black tour of South Africa and went on the replacement tour of Argentina, as well as the Cavaliers' tour the following year.

He regained his All Black place as soon as the Cavaliers were eligible and played in four tests in 1986. His selection in the World Cup squad for 1987 was a foregone conclusion. He played in five of the six cup matches and scored six tries, four of them against Fiji.

His last test was in the month after the World Cup, when the All Blacks regained the Bledisloe Cup in Sydney.

GREENE Kevin Michael

b: 31.12.1949, Hamilton
Halfback

Represented NZ: 1976,77; 8 matches

First-class record: Waikato 1969,72-77,79,80 (Fraser Technical OB), 1978 (Huntly College OB); NZ Trials 1974,78; NZ Juniors 1972

Educated St Joseph's Primary and Hamilton Boys' High School, 1st XV 1965-67. Captained the North Island Secondary Schools team in a curtainraiser to the 1967 jubilee test. Played for the 1972 Juniors against the All Blacks and in Australia.

Toured Argentina 1976 playing in four of the nine matches then played another four matches in France 1977. A compact, quick-moving halfback, standing 1.70m and weighing 79kg, Greene developed into a fine leader as Waikato's captain.

He coached Waikato 1992-94, during which it

won the Ranfurly Shield and NPC division one (1992).

His father, P. Greene, was a Waikato halfback 1952-54 and his brothers, Larry (1975,77) and Leo (1977), also represented the province.

GRENSIDE Bertram Arthur

b: 9.4.1899, Hastings *d:* 2.10.1989, Waipukurau
Wing threequarter

Represented NZ: 1928,29; 21 matches – 6 tests, 42 points – 14 tries

First-class record: Hawke's Bay 1918,19,21-27,29-31 (Hastings); North Island 1923,27; NZ Trials 1924,27; Hawke's Bay-Poverty Bay 1921; Hawke's Bay-Poverty Bay-East Coast 1923

Educated Taradale, Pukehou and Mohaka

Bert Grenside

schools. Bert Grenside appeared in 24 of the 27 matches played by Hawke's Bay during its Ranfurly Shield tenure 1922-27 and was leading scorer with 141 points from 30 tries, 21 conversions and three penalty goals.

After the 1927 All Black trials he was included in the 1928 team to tour South Africa, where he played in all four tests. Recalled after the first test v Australia 1929 and scored tries in the two remaining internationals. A tall (six feet and 13½ stone) and strong wing, Grenside was also a good goalkicker.

GRIFFITHS Jack Lester

b: 9.9.1912, Wellington
Five-eighth and centre threequarter

Represented NZ: 1934-36,38; 30 matches – 7 tests, 50 points – 3 tries, 14 conversions, 3 penalty goals, 1 dropped goal

First-class record: Wellington 1931-34,36-38 (Poneke); North Island 1934,36; NZ Trials 1934,35,37

Educated Khandallah Primary School and Wellington College, 1st XV 1928. Had his first All Black trial 1934 and toured Australia that

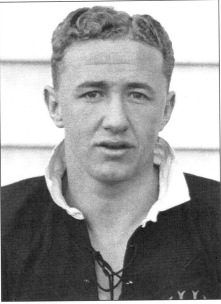

Jack Griffiths

year having one test at second five-eighth. After playing in two of the 10 trials held in the next season, Griffiths was named in the 1935-36 touring team appearing in 16 matches (10 at first five-eighth, five at second and one at centre), being replaced as the test first five-eighth by Eric Tindill only for the English international. Captained the All Blacks against the 1936 Wallabies playing at both first and second five-eighth.

Although Griffiths had gone to Britain as second-string five-eighth to 'Rusty' Page he proved a more than adequate substitute when Page badly injured his knee. Charlie Oliver wrote of him as "a god-send to us especially on defence. Without him we would have been hopelessly in trouble on many occasions". A small man, Griffiths stood 5' 8" and weighed just over 10 stone.

He had a distinguished war career rising to the rank of major, winning the MC and being mentioned in despatches; served as ADC to General Freyberg. While in North Africa he captained the 19th Infantry Battalion to win the Freyberg Cup 1940 and the 2nd NZEF team to beat Combined Services 1940. Played Hawke Cup cricket for Wanganui 1938-39.

Served as Poverty Bay selector 1939; Manawatu and Wanganui management committees; NZRFU council 1961-65; executive committee 1965-72. His father, A.J. Griffiths, represented Wellington 1904,05 and was an All Black selector 1920-23. His uncles, Jim (1913,20) and Fred Tilyard (1923), were All Blacks.

GUDSELL Keith Eric

b: 19.10.1924, Wanganui
Second five-eighth and centre threequarter

Represented NZ: 1949; 6 matches

First-class record: Manawatu 1945-47 (University); Wanganui 1948,53 (Technical College OB); Waikato 1956 (Patetere); NZ Trials 1948; NZ Universities 1945,47; Australia 1951; New South Wales 1951; Australian Universities 1951

Educated Wanganui Technical College. After taking part in the comprehensive series of 16 trial matches 1948, Gudsell was named in the 1949 team to South Africa where he played in

only six matches. A lively but individualistic player, he stood 5' 9" and weighed 12st 12lb at the time of his selection.

Went to Sydney to study veterinary science and was chosen for Australia to play in all three tests against New Zealand 1951.

GUY Richard Alan

b: 6.4.1941, Lower Hutt
Prop

Represented NZ: 1971,72; 9 matches – 4 tests, 8 points – 2 tries

First-class record: North Auckland 1966-74 (Waipu); North Island 1970,71; NZ Trials 1970,71

Educated Swanson Primary School, Henderson High and Waipu District High Schools. A very mobile forward weighing 15 stone and standing 6' 2" Guy was a stalwart of North Auckland teams for nine seasons.

Selected to play against the 1971 Lions when Keith Murdoch was not available and held his place for the series. Included in the All Black internal tour in the next season.

Chairman North Auckland 1981-86. NZRFU council 1984-96; chairman 1995. NZRFU Board 1996,97; chairman 1996.

Manager NZ Colts 1984, Emerging Players 1985, New Zealand 1986, World Cup team 1987. His father, R.E. Guy, represented Wellington 1939.

Guy was last chairman of the New Zealand Rugby Football Union council (1995,96), and the first chairman of the NZRFU board (1996,97). He was one of the key figures in negotiating the sale of New Zealand, Australian and South African broadcasting rights to News Corporation, one of the moves that precipitated the abolition of the amateur regulations.

HADEN Andrew Maxwell

b: 26.9.1950, Wanganui
Lock

Represented NZ: 1972,73,76-85; 117 matches – 41 tests, 32 points – 8 tries

First-class record: Auckland 1971-74,76-86 (Ponsonby); NZ Juniors 1972; North Island 1973,76,79-84; NZ Trials 1972-74,76,77,79,81-83; IRB Centenary 1986

Educated Okoia Primary, Wanganui Intermediate and Wanganui Boys' College, 1st XV 1967,69. At about 113kg and 1.98m, Haden was one of the biggest players to represent the All Blacks.

He toured Australia with the New Zealand Juniors in 1972 and was one of five from that side to be selected for the All Blacks' 1972-73 tour of Britain, Ireland and France. He played for the Tarbes club in France 1974-76 and returned to New Zealand for the 1976 season. Although he failed to make the side for the tour of South Africa, he was one of the dominant figures on the secondary All Blacks' ground-breaking tour of Argentina.

He made his international debut against the Lions in 1977 and thereafter was an automatic choice for New Zealand sides. He had played in 22 consecutive tests before a suspension for fighting in a club match forced him to miss the first test against Scotland in 1981. Haden was a permanent fixture in New Zealand sides, when available, until the end of 1985. He was unavailable for the tours of England and Scotland in 1983 and of Australia in 1984, the

Andy Haden . . . one of the game's outstanding forwards and personalities.

former because he was promoting his book, *Boots 'n all!* (Rugby Press Ltd) and the latter because he was under investigation by the NZRFU for alleged breaches of the amateur laws. He was chosen for the aborted 1985 tour of South Africa and went on the replacement tour of Argentina and in 1986 was one of the major instigators of the unofficial tour of South Africa by the players chosen in 1985.

The dominant rugby player of his era and one of the game's outstanding forwards and personalities, Haden stamped his mark on rugby. For pioneering off-season play in European clubs (for a period, Haden played Saturdays for the London club Harlequins and Sundays for a club in Italy) and for chiding officialdom, he became known as a rebel and in later years, as the senior All Black, he was seen as the players' 'shop steward'. He featured in moves by an Australian, David Lord, in 1983, to begin professional rugby and it was this involvement and making television commercials that led to his being investigated by the NZRFU. The union cleared him of all charges and later the same year appointed the company he had established, Sporting Contacts, to the new position of marketing adviser to the union.

For all his off-field activities, Haden's playing contributions to the game were immense, whether for Ponsonby, Auckland or New Zealand. At his peak, he was unequalled in the world as a front-of-the-lineout jumper, his technique in scrummaging allied with his vast experience in all facets of the game assisted many All Black sides, and he was deceptively quick around the field.

HADLEY Swinbourne
b: 19.9.1904, Wangaroa *d:* 30.4.1970, Auckland
Hooker

Represented NZ: 1928; 11 matches – 4 tests

First-class record: Auckland 1926,27,29-33,35 (Marist); North Island 1927,31; NZ Trials 1927

Educated Marist Brothers' School (Vermont St, Auckland). Weighing less than 13 stone and standing 5' 10", Hadley was a fast-striking hooker who joined 'Tuna' Swain in the front row of the scrum in all four tests in South Africa 1928. Injured his right shoulder in the second test and missed the next five tour matches. Played 57 matches for Auckland and was widely regarded as one of the best players in his position in New Zealand. His failure to win All Black honours again after 1928 was a mystery to rugby journalists and followers of the game.

Coached the Manukau club in the late 1930s. Invalided home after spending part of WWII in a POW camp. His younger brother, Bill, also represented New Zealand 1934-36.

HADLEY William Edward
b: 11.3.1910, Auckland *d:* 30.9.1992, Auckland
Hooker

Represented NZ: 1934-36; 25 matches – 8 tests, 6 points – 2 tries

First-class record: Bay of Plenty 1932 (Te Puke); Auckland 1933-37 (Marist); North Island 1933,36; NZ Trials 1934,35,37

Educated Marist Brothers' School (Vermont St, Auckland). Played a season for the Marist club before spending a year in Te Puke and representing Bay of Plenty. Returned to Auckland and rejoined his old club and gained Auckland honours.

As a 13 stone, 5' 10" hooker Hadley toured Australia 1934, playing in both tests, before departing with the 1935-36 All Blacks to Britain. Despite suffering a broken jaw in the opening match he was fit enough to play in the 11th tour match and appeared in all four internationals. Played two more tests against the 1936 Wallabies and for Auckland v South Africa 1937. Retired from first-class play after the trials in that year although he continued to play club rugby and was a member of the Takapuna team which won the 1940 Auckland club championship.

Vice-captain of the 1935-36 All Blacks, Charlie Oliver in the tour book described Hadley as "a great hooker, and beyond argument the master of them all. He won the advantage in every match in which he played and we sadly missed him during the six weeks he was out of action." Brother of the 1928 All Black Swin Hadley.

HAIG James Scott
b: 7.12.1924, Prestonpans, Scotland *d:* 28.10.1996, Dunedin
Halfback

Represented NZ: 1946; 2 matches – 2 tests, 3 points – 1 try

First-class record: Otago 1945 (Kaitangata Crescent), 1946 (Kaikorai); South Island 1945,46; New Zealand XV 1945

Educated Kaitangata School after coming to New Zealand at an early age. Represented South Otago sub-union 1944 before his brief career for Otago.

A strongly built halfback, standing 5' 7" and weighing 11st 11lb, Haig delivered a swift and accurate pass. Played both tests v Australia 1946, scoring a try in his first appearance.

Transferred to rugby league in the next year and represented New Zealand at this code 1947,48,50-54. His brothers, Laurie and Bert, also represented Otago with the former also playing for New Zealand 1950,51,53,54. A son, Barry, played for NZ Colts 1979.

HAIG Laurence Stokes
b: 18.10.1922, Prestonpans, Scotland *d:* 10.7.1992, Dunedin
First five-eighth

Laurie Haig, right, with 1905 All Black coach Jimmy Duncan.

Represented NZ: 1950,51,53,54; 29 matches – 9 tests, 15 points – 2 tries, 3 conversions, 1 dropped goal

First-class record: Otago 1944,45,47,48,50-53 (Kaitangata Crescent); South Island 1950,51,53; NZ Trials 1948,50,51,53; New Zealand XV 1945

Educated Kaitangata School. Represented South Otago sub-union before gaining full provincial honours. Standing 5' 10" and weighing 13½ stone, Haig was of solid build but established a reputation as a reliable five-eighth with a masterful tactical approach to his play.

Had an All Black trial 1948 but did not represent New Zealand until he was called into the second test against the 1950 Lions. Kept his place for the rest of the series and in Australia 1951. Named as vice-captain of the 1953-54 touring party. Appeared in 19 of the 36 games in the British Isles, France and North America, including internationals against Wales, England and Scotland, giving way to Guy Bowers against Ireland and France.

In his tour book *Bob Stuart's All Blacks*, Terry McLean said that Haig was the victim of the fickleness of public opinion, unjustly criticised for selection failings after being acclaimed by Winston McCarthy in the 1953 trials as "The Old Maestro".

Brother of Jim and Bert Haig, both of whom played for Otago while Jim also represented New Zealand 1946.

HALES Duncan Alister
b: 22.11.1947, Dannevirke
Threequarter

Represented NZ: 1972,73; 27 matches – 4 tests, 48 points – 12 tries

First-class record: Hawke's Bay 1969 (Dannevirke OB); Canterbury 1971-73 (Lincoln College); Manawatu 1974-76 (Palmerston North HSOB); South Island 1971,72; NZ Trials 1972-74; NZ Universities 1972

Educated Dannevirke High School. Played in seven matches and scored five tries for the All Blacks on the 1972 internal tour then included as a wing in the three tests against the 1972 Wallabies.

Duncan Hales

Appeared in 17 of 32 matches on the 1972-73 tour of Britain and France, playing at wing or centre threequarter occupying the latter position in the Welsh international.

Standing 5' 10" and weighing 13 stone Hales lacked the pace for an international threequarter but he was a courageous and resourceful player who later performed well for Manawatu at second five-eighth and centre.

HAMILTON Donald Cameron
b: 19.1.1883, Invercargill *d:* 14.4.1925, Invercargill
Wing forward

Represented NZ: 1908; 1 match – 1 test

First-class record: Southland 1906-08 (Pirates); South Island 1908

Educated Southland Boys' High School, 1st XV 1897,98. Played his sole match for New Zealand when the selectors introduced several new players into the second test against the 1908 Anglo-Welsh tourists. When this match was drawn, George Gillett was called in again to play as wing forward in the final test.

Hamilton was described by R.A. Barr in his tour book as the best forward on the ground in the Anglo-Welsh match with Southland. He participated in an exhibition match of rugby league 1909 while the Pirates and Britannia clubs were under suspension by the Southland RFU for refusing to play a competition fixture on a flooded ground. As a result players of both teams were declared professional and Hamilton's rugby career was at an end.

An outstanding cricketer, he led Southland to victory in the first Hawke Cup match in the 1910/11 season, scoring 110 against Rangitikei. Nominated for the New Zealand cricket team 1914.

HAMMOND Ian Arthur
b: 25.10.1925, Blenheim
Hooker

Represented NZ: 1951,52; 8 matches – 1 test, 3 points – 1 try

First-class record: Marlborough 1945,47-53 (Blenheim Central); NZ Trials 1948,50,51,53; Marlborough-Nelson-Golden Bay-Motueka 1949,50

Educated Marlborough College and first played for his province as a 19-year-old. Selected for the New Zealand touring team to Australia 1951, playing in seven of the 12 tour matches. Replaced Ian Irvine as hooker in the second test against the 1952 Wallabies after the first test was lost.

Served on the Marlborough RFU management committee for 13 years and has been president of his club.

HANDCOCK Robert Alexander
b: 6.4.1874, Auckland *d:* 27.1.1956, Auckland
Forward

Represented NZ: 1897; 8 matches, 9 points – 3 tries

First-class record: Auckland 1896,1903 (Parnell); North Island 1897

A 12-stone forward usually appearing in the front row of the 2-3-2 scrum. First played for the

Grafton club 1895 before transferring to Parnell. Toured Australia with the 1897 New Zealand team.

HARDCASTLE William Robert
b: 30.8.1874, Wellington *d:* 11.7.1944, Sydney
Forward

Represented NZ: 1897; 7 matches, 3 points – 1 try

First-class record: Wellington 1895 (Petone), 1896,97 (Melrose); North Island 1897; Australia 1899,1903; New South Wales 1898

Educated Petone High School. Called into the 1897 team to Australia when Barney O'Dowda was not available. Returned to live in Sydney after the tour and represented Australia 1899 and 1903 from the Glebe club. Later switched to rugby league and represented his adopted country in this code 1908 and on the 1908-09 tour to England. Served with the AIF in WWI and was involved in the organising of Services rugby.

HARPER Eric Tristram
b: 1.12.1877, Christchurch *d:* 30.4.1918, Palestine
Threequarter

Represented NZ: 1904-06; 11 matches – 2 tests, 24 points – 6 tries, 3 conversions

First-class record: Canterbury 1900-02,04,05 (Christchurch); South Island 1902,05; Canterbury-South Canterbury-West Coast 1904

Educated St Patrick's College (Wellington) and Christchurch Boys' High School. Selected at centre threequarter against the 1904 British team where his play was described as patchy in the beginning but improved later.

Joined the 1905-06 touring team after the preliminary visit to Australia. His statistics were recorded as 5' 11" and 12½ stone. His form at the start of the tour was disappointing; he played in only four of the first 17 games. As a wing in the French international he scored two of New Zealand's 10 tries. Harper returned home direct from England with Bill Glenn, missing the North American part of the tour. He did not play first-class rugby again.

Served on the Canterbury RFU management committee 1910,11. A leading athlete, Harper won national titles in the 440yd hurdles (62.6 secs) 1901 and 880yd (2m 2 secs) 1902.

Played cricket for Canterbury 1907. A keen mountaineer, he discovered a pass to the West Coast at the head of the Rangitata River with James Dennistoun 1908. His brother, Cuthbert, was also a noted athlete and played rugby for Canterbury 1906. Killed in action during WWI.

HARPER George
b: 19.8.1867, Nelson *d:* 7.6.1937, Paeroa
Threequarter

Represented NZ: 1893; 3 matches, 7 points – 1 penalty goal, 1 goal from a mark

First-class record: Nelson 1886,88-95 (Nelson); South Island 1888; Nelson Combined Clubs 1884

Educated Nelson College, 1st XV 1883,84. Made his debut in first-class rugby while still at school. Played twice for the South Island against the 1888 British team.

Although rough weather prevented him arriving in Wellington to participate in the 1893 trial match he was selected for the tour to Australia. His statistics were given as 5' 9" and 13 stone.

HARRIS Jack Hardy
b: 26.7.1903, Christchurch *d:* 19.5.1944, Italy
Fullback

Represented NZ: 1925; 8 matches, 4 points – 1 dropped goal

First-class record: Canterbury 1923-29 (Christchurch HSOB); South Island 1925,29; NZ Trials 1924,30; Canterbury-South Canterbury 1925

Educated Christchurch Boys' High School. After several seasons of outstanding performances at fullback for Canterbury Harris was selected in the 1925 All Blacks who played two matches at

Jack Harris

home and six in New South Wales. His only points for New Zealand – a dropped goal in the second game against New South Wales – won the game 4-0. Stood 5' 10" and weighed 11st 4lb.

After he retired he coached the High School Old Boys club, winners of the Christchurch championship 1935.

He was killed in action while serving as a corporal with the 23rd Battalion in Italy.

HARRIS Perry Colin
b: 11.1.1946, Feilding
Prop

Represented NZ: 1976; 4 matches – 1 test

First-class record: Manawatu 1970-79 (Te Kawau); NZ Trials 1977; Manawatu-Horowhenua 1971,77

Educated Feilding Agricultural High School. Began playing club rugby 1964 becoming a regular member of the Manawatu side 1970.

A 6' 1" 15st 8lb prop, he was a surprise replacement for the 1976 All Blacks when Brad Johnstone was injured in South Africa and returned home. Won an international cap in the third test when Kerry Tanner was ill and Bill Bush injured.

His father, Rex (1935), and his brother, Graham (1957-64), also played for Manawatu.

HARRIS William Albert
b: 30.6.1876, Christchurch *d:* 15.6.1950, Dunedin
Hooker

Represented NZ: 1897; 9 matches

First-class record: Otago 1894-96 (Union); South Island 1897

A fine forward of his day who played eight of the 1897 New Zealand team's 10 matches in Australia. Although small he was a hard, vigorous forward who excelled at dribbling. Following the team's match with Auckland on its return to this country, 'Pat' Harris was suspended for two years for alleged drunkenness and bad language and did not play first-class rugby again.

HART Augustine Henry
b: 28.3.1897, Auckland *d:* 1.2.1965, Auckland
Wing threequarter

Represented NZ: 1924,25; 17 matches – 1 test, 69 points – 23 tries

First-class record: Taranaki 1921,23 (Tukapa); North Island 1924; NZ Trials 1924

Educated Marist Brothers' School (Vermont St, Auckland), Sacred Heart College (Auckland) and New Plymouth Technical College, 1st XV 1916,17. After playing his early rugby as a five-eighth, Gus Hart switched to the wing when playing for the Tukapa club.

A diminutive player, standing only 5' 6½" and weighing 9st 12lb, he performed impressively in the 1924 All Black trials and cemented his place in the 1924-25 touring team

Gus Hart

by scoring three tries and a dropped goal in North's 39-8 victory over the South Island. Although Hart top-scored with 20 tries on the British tour (including four each in the games against Cheshire, Yorkshire and Cumberland), he appeared in only one international, against Ireland. Probably his finest try on this tour was against Llanelli when he gathered an opponent's kick and ran 60 yards to score between the posts for Nepia to convert, giving the All Blacks victory 8-3.

It is perhaps an indication of the quality of the 'Invincibles' that Gus Hart could not find a regular place in the All Black test team despite his record of 23 tries in 17 appearances. A leg injury ended his remarkable career in 1926.

HART George Fletcher
b: 10.2.1909, Christchurch *d:* 3.6.1944, Sora, Italy
Wing threequarter

Represented NZ: 1930-32,34-36; 35 matches – 11 tests, 84 points – 28 tries

First-class record: Canterbury 1927-36 (Christchurch); South Island 1931-34,36; NZ Trials 1930,34,35

Educated Elmwood Primary School, Canterbury Primary Schools rep 1922, and Waitaki Boys' High School, 1st XV 1924,25. Represented Canterbury B 1927 and the full representative team from the next season. Scored 42 tries for his province and 80 in club games, including 21 in the 1930 season.

Won a place as an 11½ stone, 5' 9" wing threequarter in all four tests against the 1930 Lions, scoring tries in each of his first two internationals. Played against Australia in the one test 1931 but a broken collarbone restricted his appearances on the 1932 tour of Australia and he took the field once, against Darling Downs.

After the two tests in Australia 1934 Hart toured the British Isles and Canada playing 19 games including internationals against Scotland, Ireland and Wales. He retired after the two tests in the home series against the 1936 Wallabies although he did play some rugby for the 4th Brigade while serving with the army in North Africa.

A very fast and deceptive runner who scored some brilliant tries, Hart was acclaimed as the "star" wing by the 1935-36 vice-captain Charlie Oliver who lamented that he "lost his dash" at the end of the tour and was dropped for the English international. Oliver recalled Hart's spectacular try against Leicester: "He controlled a wet ball with his feet for half the length of the field, gathered it on the bounce on reaching the fullback, punted it over the head of his opponent, and regained possession to score under the posts."

As an athlete he won the New Zealand 100yd title 1931, finishing second in 10.4 secs to the American sprinter George Simpson. A captain in the 20th Armoured Regt he died of wounds during the advance from Cassino to Avezzano.

HARVEY Brett Andrew
b: 6.10.1959, Palmerston North
Flanker

Represented NZ: 1986; 1 match – 1 test

First-class record: Wairarapa-Bush 1983-85 (Tiraumea), 1986-88 (Featherston); NZ Emerging Players 1985; North Island 1986; NZ Trials 1983,86,87; Central Zone 1987

Educated Palmerston North Boys' High School, Harvey represented Manawatu Colts in 1981 before moving south to Wairarapa-Bush, which he first represented in 1983. He was chosen for the Emerging Players touring team in 1985 and when regular All Blacks were unavailable early in 1986 because of their involvement with the unofficial Cavaliers' tour of South Africa, Harvey, who stood 1.94m and weighed 92kg, was chosen for the test against France.

He was retained as blindside flanker for the first test against Australia but was forced to withdraw because of a leg injury. He was not selected for the All Blacks again that year.

His father Neil played for Manawatu 1954-56 and for Manawatu-Horowhenua v South Africa, 1956.

HARVEY Ian Hamilton
b: 1.1.1903, Masterton *d:* 22.10.1966, Wellington
Lock

Represented NZ: 1924-26,28; 18 matches – 1 test

First-class record: Wairarapa 1922 (Tinui), 1923,24,26,27,29,30 (Masterton); North Island 1924,26,27; NZ Trials 1924,27,30; Wairarapa-Bush 1923,25,30

Had a disastrous debut in representative rugby at fullback but was recruited into the Wairarapa scrum for the next season because of injuries amongst the regular forwards. From this point his career blossomed and he developed into a powerful lock forward, weighing a little over 15

Ian Harvey

stone and standing 6' 1½".

With a fine performance for the North Island 1924, Harvey won selection for the 1924-25 touring team. Illness prevented his playing on the preliminary Australian visit and complications with tonsilitis ruled him out of contention from the fifth to the 19th game in Britain.

Enjoyed a good tour of Australia 1926 but again suffered from illness in South Africa 1928 losing 16lb at one stage of the tour. His sole international, the fourth test, was only his fourth appearance in South Africa.

Ian Harvey was surely a most unlucky player. With good health he could have represented his country on many more occasions.

HARVEY Lester Robert
b: 14.4.1919, Dunedin *d:* 3.6.1993, Clyde
Lock

Represented NZ: 1949,50; 22 matches – 8 tests

First-class record: Otago 1947,48,50 (Matakanui); South Island 1948; NZ Trials 1948,50

Educated Waitaki Boys' High School. Played for the Vincent sub-union from 1938. A strong rucking forward, standing 6' 3" and weighing 15st 6lb who became a regular member of the Otago Ranfurly Shield team 1947.

Selected for the New Zealand team to tour South Africa 1949 appearing in 18 matches of the 25 including an unofficial match against Cape Town Clubs at the end of the tour and all four internationals. Played in all four tests against the 1950 Lions.

HARVEY Patrick
b: 3.4.1880, South Rakaia *d:* 29.10.1949, Christchurch
Halfback

Represented NZ: 1904; 1 match – 1 test

First-class record: Canterbury 1900-04 (Christchurch); South Island 1902,03; Canterbury-South Canterbury-West Coast 1904; NZ Trials 1904

'Peter' Harvey played his early rugby with the Rakaia club before shifting to Christchurch where he earned a grand reputation in five seasons behind the Canterbury scrum.

Described by J.K. Maloney in Rugby Football in Canterbury 1929-54 as "a small nuggety man whose forte was defence. He used the line repeatedly, saved his forwards all the time and possessed cover-defence of rare quality."

Selected for the 1903 tour to Australia but was not available and replaced by the Taranaki halfback 'Skinny' Humphries. Had his sole game for New Zealand against the 1904 British tourists. Also named in the 1905-06 touring party but was unable to obtain leave from his job as a lip-reading teacher at the Sumner School for the Deaf. The matter was taken to the Government and Premier Seddon announced in the House of Representatives that Harvey could not be spared as he was the only such teacher in the country. Canterbury and South Island selector.

HASELL Edward William
b: 26.4.1889, Christchurch *d:* 7.4.1966, Christchurch
Hooker

Represented NZ: 1913,20; 7 matches – 2 tests, 21 points – 3 tries, 6 conversions

First-class record: Canterbury 1909-15,20 (Merivale); South Island 1911,20; NZ Services 1919,20

Educated Normal School (Christchurch). Played for New Zealand in the second and third tests against Australia 1913, scoring a try in his debut, and toured that country 1920 when no internationals were played. Described as "an excellent all-round player and a dependable goal kicker from marks close to the posts." After serving in WWI as a bombardier with the Field Artillery, 'Nut' Hasell represented NZ Services in the King's Cup competition in Britain and then visited South Africa with the team.

HAY-MacKENZIE William Edward
b: 2.7.1874, Oamaru *d:* 1.12.1946, Wellington
Fullback

Represented NZ: 1901; 2 matches

First-class record: Otago 1894-96,98,1900

(Dunedin); Auckland 1901-06,10 (Grafton); North Island 1905

Educated Oamaru and Milton High Schools. During his long rugby career 'Scobie' Hay-MacKenzie appeared as fullback, wing and centre threequarter. His two matches for New Zealand (against Wellington and New South Wales) were as fullback.

Considered unlucky not to be chosen for the 1905-06 touring team – the only back from the 1905 North Island team to miss selection after their 26-0 victory over the South Island.

A keen bowler with the Kelburn club in Wellington, playing in the national championships on numerous occasions, also a foundation member of the Miramar Golf Club. Life member Grafton RFC.

HAYWARD Harold Owen
b: 23.5.1883, Blenheim *d:* 25.7.1970, Thames
Loose forward

Represented NZ: 1908; 1 match – 1 test, 3 points – 1 try

First-class record: Auckland 1903-11 (Thames City); North Island 1908

An excellent forward who was unlucky not to represent New Zealand on more than his one appearance – in the third test against the 1908 Anglo-Welsh tourists when he scored one of the All Blacks' nine tries.

'Circus' Hayward turned to rugby league 1911 and played for New Zealand 1912,13 being captain in the latter year. Reinstated to rugby after WWI and continued to play at club level until 1924. His brother, Morgan, also represented New Zealand at league 1912,13 and then played rugby for Auckland 1920,23.

'Circus' Hayward

HAZLETT Edward John
b: 21.7.1938, Invercargill
Prop

Represented NZ: 1966,67; 12 matches – 6 tests, 3 points – 1 try

First-class record: Southland 1960-68 (Drummond); South Island 1964-67; NZ Trials 1965-68; Rest of New Zealand 1965,66

Jack Hazlett

Educated Waihopai and Winchester (Waihi) Schools and Christ's College. Played for the Mossburn club 1955-57 before transferring to Drummond. Had a magnificent match captaining Southland to victory over the 1966 Lions in their first tour match and subsequently included in all four tests of that series as a prop.

Played in the 1967 jubilee test v Australia and then toured the British Isles appearing in seven of the 17 matches including the English international giving way to Ken Gray for the remaining tests.

At 6' 2" and 15½ stone, Hazlett was a strong scrummager at loosehead prop and a fine lineout player. Described as "definite, vigorous and shrewd" in the loose with the ball in hand. Continued to play for and coach the Drummond club. His brother, D.L. Hazlett, played for Southland 1966. An uncle, Bill Hazlett, represented New Zealand 1926,28,30 and another uncle, J.S. Hazlett, had an All Black trial in 1924 while playing for Southland.

HAZLETT William Edgar
b: 8.11.1905, Invercargill *d:* 13.4.1978, Gore
Loose forward

Bill Hazlett

Represented NZ: 1926,28,30; 26 matches – 8 tests, 18 points – 6 tries

First-class record: Southland 1925-27,30 (Pirates), 1929 (Lumsden); South Island 1926,27,29; NZ Trials 1927,30

Educated Waihopai School and Waitaki Boys' High School. Joined the Southland team as a 19-year-old. Possessing great speed for a 15 stone six-feet forward, Hazlett quickly made an impression.

Toured Australia 1926 and South Africa 1928 where he played in all four tests. He missed the 1929 Australian tour but was recalled for the series against the 1930 British team. Along with a host of great All Blacks of the 1920s, Hazlett's international career ended with the fourth test.

His brother, J.S. Hazlett, was a Southland representative 1919-26 and an All Black trialist 1924 while his nephew, Jack, was an All Black 1966,67. A high country sheep farmer, Bill Hazlett was a well-known sheep dog trialist and owner of thoroughbreds. His racehorses earned over $900,000 and he headed the leading owners' list in New Zealand 1965-69.

HEEPS Thomas Roderick
b: 7.3.1938, Hamilton
Wing threequarter

Rod Heeps . . . eight tries against Northern New South Wales in 1962.

Represented NZ: 1962; 10 matches – 5 tests, 47 points – 15 tries, 1 conversion

First-class record: Wellington 1958,60-63 (Athletic), 1964,65 (Petone); North Island 1962; NZ Trials 1961-63

Educated Takapuna and Mt Albert Grammar Schools. Rod Heeps was an extremely fast wing

who stood 5' 11" and weighed 12 stone. Played all five tests against Australia on tour and in the home series 1962. His 14 tries scored on the Australian tour included a record eight against Northern New South Wales (won by the All Blacks 103-0) and four against South Australia (77-0)

National champion in the 100 yards 1961-63 with a best time of 9.8 secs.

HEKE Wiremu Rika
Played under the name Wiremu Rika
b: 3.9.1894 *d:* 30.11.1989, Rotorua
Loose forward

Represented NZ: 1929; 6 matches – 3 tests

First-class record: North Auckland 1924,25 (Tangowahine), 1928-30 (Mangakahia); NZ Trials 1929; NZ Maoris 1926-28

Although he played in the Maniopoto sub-union 1913 Heke did not play rugby again until 1923 owing to his farming in the remote areas of North Auckland. Appeared in 17 matches for North Auckland 1924-30 and toured with the 1926 NZ Maoris team under Wattie Barclay to Europe, Ceylon, Australia and Canada. Proved an outstanding player on this tour and in the book on the tour, written by Dave Pringle from team member T.P. Robinson's diary, Heke was described as "a colossal chap, who plays aggressively. Dangerous near the goal posts through his enormous strength".

Heke toured Australia 1929 with the All Blacks and played in all three internationals and was still playing good rugby the following year when he retired. His brother, Mundy, also represented North Auckland (1926,28,30,31) as did his son Kea (1940,47).

HELMORE George Henry Noble

b: 15.6.1862, Christchurch *d:* 28.6.1922, England
Utility back

Represented NZ: 1884; 7 matches, 16 points – 4 tries, 2 dropped goals

First-class record: Canterbury 1880-84 (Christchurch), 1885-88 (North Canterbury)

Educated Christ's College, 1st XV 1879,80. A member of the 1884 New Zealand team in Australia, Helmore was a versatile player who appeared as a wing and a centre as well as occasionally in the forward pack. Described by the team manager, S.E. Sleigh, as "a changeable man – at times he would play brilliantly and on others quite the reverse."

He also represented Canterbury at cricket 1884,90,92 and was captain of the Rangiora Rifles 1889,99.

HEMARA Bruce Stephen

b: 19.10.1957, Palmerston North
Hooker

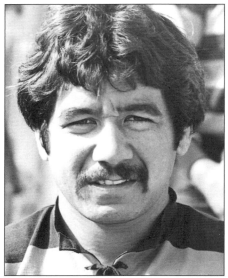

Bruce Hemara

Represented NZ: 1985; 3 matches

First-class record: Manawatu 1978-88,90 (Freyberg Old Boys); North Island 1985,86; NZ Trials 1984,85,87; NZ Emerging Players 1985; NZ Maoris 1982,85,86,88; Central Zone 1987

Educated Palmerston North Boys' High School, 1st XV 1973-75. Hemara began playing senior rugby for his Freyberg club the first year out of school.

Hemara suffered, like most other hookers in New Zealand, from playing at the same time as the country's two outstanding hookers, Andy Dalton and Hika Reid. He received his chance, however, in 1985 when Dalton withdrew from the All Blacks' tour of Argentina. He played three matches on that tour. In the absence of Dalton and Reid because of the Cavaliers' tour of South Africa in 1986, Hemara, who weighed 88kg and stood 1.88m, was chosen for the test against France but had to withdraw because of injury. (He had also declined an invitation to join the Cavaliers after Dalton was injured.) He was not picked for New Zealand again that year.

A grandfather, Moses Mete, was a five-eighth on the New Zealand Maoris' world tour in 1926-27.

HEMI Ronald Courtney

b: 15.5.1933, Whangarei
Hooker

Represented NZ: 1953-57,59,60; 46 matches – 16 tests, 18 points – 6 tries

First-class record: Waikato 1953-56,58-60 (Frankton); North Island 1953-56,59; NZ Trials 1953,56,57,59,60; New Zealand XV 1955,56,58

Educated Frankton Primary School, representing Waikato as a fullback in the Roller Mills Shield team, and Hamilton Boys' High School, 1st XV 1948-50. Joined the Frankton club 1951 and represented Waikato juniors as a three-quarter but moved into the front row on reaching his club's senior team next season.

Hemi had a meteoric rise in rugby. First chosen as a replacement for his province against Wellington, August 1, 1953, he made excellent progress in three further matches for Waikato and the trials to be named in the All Black touring team after the final trial on September 15. An outstanding success on this tour, he appeared in 22 of the 36 matches including all five internationals. Held his test place against Australia 1955, South Africa 1956 (displaced by Dennis Young for the second test) and in Australia 1957. Injuries and accountancy studies restricted his appearances 1957,58 but he played in three of the four tests against the 1959 Lions. Toured South Africa 1960 but suffered torn rib cartilages in the fifth match and as a result he was sidelined until late in the tour. An achilles tendon injury forced his retirement from the game 1961.

An excellent hooker, standing six feet and weighing 13½ stone, Hemi was an expert dribbler of the ball at toe and possessed speed in the loose. As the 20-year-old 'baby' of the 1953-54 team, his hooking performances were hailed as astounding – on one occasion he took eight tightheads off the experienced Englishman, Eric Evans.

Represented Auckland at cricket in the 1950-51 season as a left-hand opening bat.

HENDERSON Paul William

b: 21.9.1964, Bluff
Flanker

Represented NZ: 1989-91,93,95; 25 matches – 7 tests, 21 points – 5 tries

First-class record: Southland 1983-86 (Invercargill), 92-97 (Marist); Otago 1987-91 (Dunedin); Otago Highlanders 1996; NZ Colts 1983,84; Colts Trial 1984; South Zone 1987,89; NZ Trials 1990-93,95; South Island 1995; NZ Divisional XV 1993,95; NZ B 1991

A durable forward, Paul ('Ginge') Henderson was educated at Southland Boys High School, played for the New Zealand Secondary Schools team in 1980 and 1982 and made his debut for Southland against the British Isles in 1983.

Henderson had already been playing first-class rugby for seven seasons when he was chosen for the All Blacks' tour of Wales and Ireland in 1989. His tour was short-lived, however, because after the opening game in Canada and two in Wales he was injured and had to return home. Injury was a constant companion in Henderson's All Black career – either to him or someone else. Injury also cut short his role in the tour of Australia and South Africa in 1992, but he had also gained from others' misfortunes. He replaced original selection Mike Brewer (an Otago team-mate) in the 1991 World Cup squad and he was added to the team for the 1993 tour of England and Scotland after Michael Jones was forced out because of injury before the team left. He'd also toured France in 1990 and Argentina in 1991 and played in the three centenary tests in 1992 as well as the first against Ireland.

Henderson had the distinction of captaining New Zealand in the 145-17 win over Japan in Bloemfontein in the 1995 World Cup.

A twin brother, David, played for Southland, a South Island XV and the Divisional XV and an older brother, Peter, also played for Southland and the Divisional XV. Their father, D.B.

Ron Hemi in England on the 1953-54 tour.

Paul Henderson

Henderson, also played for Southland and was a reserve when Southland won the Ranfurly Shield from Taranaki in 1959.

HENDERSON Peter
b: 18.4.1926, Gisborne
Wing threequarter

Represented NZ: 1949,50; 19 matches – 7 tests, 24 points – 8 tries

First-class record: Hawke's Bay 1944,45 (Wairoa Celtic); Wanganui 1946-48,50 (Kaierau); North Island 1948; NZ Trials 1948

Peter Henderson

Educated Gisborne Boys' High School. First represented Hawke's Bay as an 18-year-old, scored 17 tries in 14 first-class appearances 1948.

Top try scorer with seven on the 1949 South African tour where he played in 16 of the 24 matches including all four internationals. 'Sammy' Henderson was unavailable for the first test against the 1950 Lions but played in the

other three. He scored a fine try at Eden Park, gathering a kick through and outpacing the defence including outstanding Welsh wing Ken Jones to reach the line with a spectacular dive. Later in this game he saved a certain Lions' try by cutting down Bleddyn Williams in full cry for the line.

Signed with the Huddersfield rugby league club at the end of that season and scored 214 tries from 258 league matches 1950-57. A compact winger, standing 5' 7¹/₂" and weighing 12¹/₂ stone, Henderson used his great speed equally well on attack and defence. He was national athletics champion in the 100 yards 1949 with a time of 10.0 secs. A finalist in that event at the 1950 Empire Games after winning a heat in 9.9 secs.

His brother, Ron, represented Poverty Bay 1935,36 and Southland 1937.

HENDRIE James Malcolm
b: 12.6.1951, Singapore
Halfback

Represented NZ: 1970; 1 match

Jamie Hendrie

Educated Clifton Hall and Merchiston Castle Schools in Scotland. Played for University of Western Australia for four years. Appeared as a guest player for the All Blacks in their match against a President's XV at Perth while en route to South Africa 1970. Two games against Western Australian teams were held on a Sunday, Sid Going was unavailable for religious reasons, and Hendrie wore the All Black jersey in the earlier match.

HEREWINI MacFarlane Alexander
b: 17.10.1940, Mokai
Five-eighth and fullback

Represented NZ: 1962-67; 32 matches – 10 tests, 92 points – 2 tries, 13 conversions, 10 penalty goals, 10 dropped goals

First-class record: Auckland 1958-66 (Otahuhu), 1967-70 (Manukau); North Island 1963-68; NZ Trials 1960-63,65-68,70; NZ Maoris 1960,61,64-66,70,71; Rest of New Zealand 1960

Educated Otahuhu Primary School, Wesley Prep and Otahuhu College, 1st XV 1955-58. First played for Auckland from school as a 17-

Mac Herewini

year-old fullback, switched to first five-eighth after two seasons and became a vital member of his province's Ranfurly Shield team 1960-63. Included in the Rest of New Zealand XV which played the 1960 All Blacks on their return from South Africa – others to appear for the Rest were Fergie McCormick, Des Connor, Waka Nathan and Stan Meads.

Herewini's international debut was in the third test against the 1962 Wallabies when he played outside his Auckland team-mate Connor. Scored a try after a typical jinking run and dropped goal in his first All Black appearance. Played in 19 matches on the 1963-64 British tour including Irish, Scottish (at second five-eighth) and French internationals. Scored 74 points on tour – second to Don Clarke. Played six games as fullback on this tour.

Did not play for New Zealand again until the final test against the 1965 Springboks but then included in all four against the 1966 Lions and the 1967 jubilee test v Australia. Toured the British Isles 1967 where he suffered a loss of form and was displaced in the internationals by Earle Kirton and appeared in only six of the 17 games.

Mac Herewini's expert tactical kicking was well suited to the All Blacks' concentration on forward play in the mid-1960s. A 5' 6" and 11¹/₂ stone five-eighth and a well-balanced and elusive runner, he was perhaps restricted in his play by the prevailing style of New Zealand rugby but his accurate drop kicks contributed much to the successes of that era.

Coached the Manukau club and a Northern NZ Maoris selector since 1975. His son, Mackie, represented North Island Under 16 1979, New Zealand Under 17 1980, New Zealand Secondary Schools on the 1980 Australian tour and Northern Zone Maoris 1985.

HERROLD Maurice
b: ?.6.1869, Calcutta, India *d:* ?/?/1950, Buenos Aires, Argentina
Halfback

Represented NZ: 1893; 2 matches

First-class record: Hawke's Bay 1886,87 (Napier Boys' HS); Auckland 1888,89 (Gordon), 1891 (Suburbs)

Arrived in New Zealand with his family 1880. Educated Napier High and Auckland Grammar Schools. Toured Australia 1893 but was troubled by injury and appeared in only two games.

HEWETT Jason Alexander

b: 17.10.1968, Clyde
Halfback

Represented NZ: 1991; 1 match – 1 test, 4 points – 1 try

First-class record: Manawatu 1988-90 (University); Auckland 1991-94 (University); NZ Colts 1989; NZ Universities 1992,93; NZ Colts Trial 1989; North Island Universities 1988; NZ Trials 1990,91; Central Zone 1989; NZ Divisional XV 1990; NZ Development 1990; NZ B 1991; NZ XV 1991

Jason Hewett was educated at Kelston Boys High School and played for the New Zealand Secondary Schools in 1986.

He went to Massey University and made his debut for Manawatu in 1988 and was selected for the New Zealand Colts the following year.

Hewett was chosen for the All Black squad for the World Cup in 1991 and played in one match, against Italy. Hewett, who had returned to Auckland for the 1991 season, was one of 12 Aucklanders in the All Blacks that day, the highest representation for one union in a test.

HEWITT Norman Jason

b: 11.11.1968, Hastings
Hooker

Represented NZ: 1993,96,97; 22 matches – 8 tests, 35 points – 7 tries

First-class record: Hawke's Bay 1988-94 (Taradale); Southland 1995-97 (Albion); Wellington Hurricanes 1996,97; NZ Colts 1989; NZ Development 1990,94; NZ Maoris 1990,91,93,94,97; Southern Zone Maoris 1991-94; NZ Trials 1990-95; NZ Divisional 1991,95,96; NZ XV 1991,93,94; NZRFU President's XV 1995; Manawatu Invitation XV 1996; Northland Invitation XV 1996

A product of Te Aute College in Hawke's Bay, Hewitt made his first-class debut in 1988 and soon came face to face with an All Black who played a major part in his career – Sean Fitzpatrick. The two were opposing hookers when Auckland took the Ranfurly Shield to McLean Park in 1988.

Hewitt first donned an All Black jersey in 1993 when he was the hooker reserve to Fitzpatrick in the Bledisloe Cup test in Dunedin, the first of 38 tests in which Fitzpatrick was on the field and Hewitt on the bench. Hewitt toured England and Scotland at the end of 1993 and played in six matches but didn't play his first test till the World Cup in 1995 when he went on for Fitzpatrick against Ireland. The first test in which he was chosen as hooker was the 145-17 win against Japan in Bloemfontein.

Hewitt toured Italy and France in October and November 1995, playing in four matches, and played his next test in 1996 when he replaced Fitzpatrick against Australia at Athletic Park.

Hewitt again went on for Fitzpatrick against

Norm Hewitt

South Africa in Johannesburg in 1997. By then, Fitzpatrick was sorely troubled by an injury to his right knee and on the tour of Britain and Ireland in November and December of 1997, Hewitt was chosen for each of the tests though, irony of ironies, was substituted by Fitzpatrick in the match against Wales at Wembley.

HEWSON Allan Roy

b: 6.6.1954, Lower Hutt
Fullback

Represented NZ: 1979,81-84; 34 matches – 19 tests, 357 points – 6 tries, 66 conversions, 61 penalty goals, 6 dropped goals

First-class record: Wellington 1973,74,77-86 (Petone); North Island 1981,82; NZ Trials 1981

Hewson's first regular first-class season was in 1978 when he played 11 matches for Wellington, turning out as a five-eighth, threequarter and fullback.

He was picked for the New Zealand team that toured England and Scotland in 1979 but was not wanted again by the All Black selectors until two days before the first test against Scotland in

1981, when he was called to Dunedin as a replacement for the injured David Halligan. He retained his place for the rest of that season kicking a winning penalty goal in the third test against South Africa to give the All Blacks the series win.

In 1982 against Australia at Eden Park, Hewson scored a world record 26 points (one try, two conversions, five penalty goals and one dropped goal). Hewson was a major figure in the 1983 series win over the British Isles but was forced to pull out of the tour of England and Scotland at the end of that year because of injury. He regained his place for the All Blacks' 1984 tour of Australia and played in eight games but was chosen for only the first international.

Slightly built by All Black standards (1.80m and about 76kg) Hewson was weak on defence and often the target of critics, particularly after he retired from an interisland match suffering from exposure. But even his critics acknowledged his attacking talent and his ball skills. Hewson finished his international career with 201 points.

Hewson also played first-class cricket for Wellington and a brother, Kevin, played rugby for Wellington. His biography, *For the Record* (Rugby Press), appeared in 1984.

After his playing career ended, Hewson embarked on a successful coaching career with Petone and Wellington age-grade sides.

HICKEY Percy Hubert

b: 28.4.1899, Rahotu *d:* c 1942
Wing threequarter

Represented NZ: 1922; 2 matches

First-class record: Taranaki 1919,20 (Waimate), 1921,22 (Clifton); Wellington 1925 (Poneke); North Island 1922; Wellington-Manawatu-Horowhenua 1925

After scoring a try in the 1922 interisland game, Hickey went on the short Australian tour 1922. In the second match with New South Wales (lost 8-14) a penalty try was awarded against Hickey for alleged shepherding.

A short, stocky wing, he was dangerous near the goal-line. Shifted to Wellington and represented that province before moving to Dunedin.

Allan Hewson about to kick the winning penalty goal against South Africa in 1981.

HIGGINSON Graeme

b: 14.12.1954, Rangiora
Lock

Represented NZ: 1980-83; 20 matches – 6 tests, 12 points – 3 tries

First-class record: Canterbury 1976-78 (Glenmark), 1979-81; (Culverden); Hawke's Bay 1982-84,88 (Takapau); South Island 1978,80,81; NZ Trials 1979,80,82,83

Educated Rangiora High School. A fine lock forward, aggressive and mobile, who stood 1.93m and weighed 104kg. Toured Australia and Fiji with the 1980 All Blacks playing in nine of the 16 matches and played for a New Zealand

Graeme Higginson

XV v Fiji at the end of the domestic season. Made his international debut against Wales in the centenary test later that year. Injury restricted his test appearances in the following three years. His brother, Bryan, played for Canterbury 1975,76 and his father-in law, Nelson Dalzell, toured with the 1953-54 All Blacks.

HILL Stanley Frank

b: 9.4.1927, New Plymouth
Lock and flanker

Represented NZ: 1955-59; 19 matches – 11 tests, 2 points – 1 conversion

First-class record: Canterbury 1951-53,58-60 (Christchurch), 1954-57 (Burnham Army); Counties 1961,62 (Papakura Army); South Island 1954,56-60; NZ Trials 1953,56,57,59; NZ Maoris 1956; New Zealand XV 1956; Rest of NZ 1954; NZ Services 1952,53,55-57,59-61; NZ Army 1949,50,52-54

Educated Okato Primary School. Joined the NZ Army and served with J Force in Japan 1948. Played for the army and Combined Services, and was a member of the strong Canterbury Ranfurly Shield team of the mid-1950s.

'Tiny' Hill developed into a hard, uncompromising forward, standing 6' 2" and weighing around $15^1/_2$ stone, usually appearing on the side of the scrum until changing to the lock position 1957. Came in to the All Blacks in

Stan Hill

place of the injured Peter Jones for the third test against the 1955 Wallabies; had three tests v South Africa 1956, two in Australia 1957; recalled for the third test v Australia 1958 and kept his place for the series against the 1959 Lions.

Hill selected teams for NZ Army 1964 and Canterbury 1975-79 and coached in rugby clinics in California and Texas 1977-79. NZRFU selector 1981-86. His sons, Stan and John, have represented New Zealand at basketball while a brother, Brian, played rugby for Taranaki 1954,55.

HINES Geoffrey Robert

b: 10.10.1960, Tokoroa
Flanker

Represented NZ: 1980; 12 matches – 1 test, 16 points – 4 tries

First-class record: Waikato 1979-82 (Tokoroa), 1984 (Leamington); NZ Trials 1980; NZ Colts 1979

Geoff Hines

Educated Tokoroa North Primary, Tokoroa Intermediate School and St Paul's Collegiate (Hamilton), Waikato and North Island Under 16 rep 1976, Under 18 rep 1977,78. Included in the 1979 NZ Colts internal tour after a dynamic performance in the 1980 All Black trials, Hines was selected for the tour of Australia and Fiji. Made his international debut in the third test. Also visited Wales on the 1980 centenary tour, playing in three of the seven games. An exceptionally fast flanker who weighed 91kg and was 1.91m. NZ Secondary Schools 110m hurdles champion 1977.

HOBBS Frederick George

b: 18.3.1920, Christchurch *d:* 15.10.1985, Christchurch
Flanker

Represented NZ: 1947; 6 matches, 9 points – 3 tries

First-class record: Canterbury 1940,46,47 (Linwood); South Island 1946,47; NZ Trials 1947; Middle East Army 1942

A tireless loose forward, standing 6' 2" and weighing $14^1/_2$ stone, Hobbs excelled in the lineout. After taking part in army matches in Egypt he was named as vice-captain of the 1947 All Blacks in Australia but although playing in six of the nine matches was troubled by a knee injury and unable to find top form.

HOBBS Michael James Bowie

b: 15.2.1960, Christchurch
Flanker

Represented NZ: 1983-86; 39 matches – 21 tests, 52 points – 13 tries

First-class record: Canterbury 1979-86 (Christchurch); Wellington 1987 (University); NZ Trials 1983; South Island 1984,85; Centurions 1987

Jock Hobbs was educated at Christ's College and played for Canterbury and South Island Under 18.

A key member of Canterbury's Ranfurly Shield team of the early 1980s, he was first chosen for the All Blacks in 1983, stepping into the openside flanker's position that had been Graham Mourie's since 1977. He played in all four tests against the Lions, a test against Australia and, later in the year, against Scotland and England. He played in the two 1984 tests against France then toured Australia, playing in each of the three tests. With regular captain Andy Dalton unavailable, Hobbs led the All Blacks on a tour of Fiji in 1984 and in 1985 was chosen for the aborted tour of South Africa. He went with the unauthorised Cavaliers, regained his test place against Australia and at the end of the year captained the All Blacks on the tour of France. Hobbs retired from international rugby early in 1987 and, after two games for Wellington, from all rugby.

He was a member of the New Zealand Rugby Football Union council in 1995 and bore the brunt of negotiating with players in the face of a threat from the Australian-based World Rugby Corporation. He was successful and generally regarded as the man who saved the All Blacks though when a board replaced the council at the beginning of 1996 Hobbs was not elected. Hobbs was also the New Zealand representative of the Japanese company Mizuno, contracted boots supplier to the NZRFU.

Hobbs was a successful coach in Wellington and coached New Zealand Universities in 1992, 1994 and 1995.

Hobbs is a brother-in-law of the Canterbury All Blacks, Bruce and Robbie Deans.

Jock Hobbs

HOGAN John
b: 3.9.1881, Wanganui *d:* 15.11.1945, Wanganui
Forward

Represented NZ: 1907; 2 matches

First-class record: Wanganui 1903,06-08 (Kaierau); North Island 1907

Educated Marist Brothers' School (Wanganui). Played two games on the 1907 tour of Australia. Broke a leg playing for Wanganui v Hawke's Bay the next season. Hogan turned to rugby league and represented New Zealand 1913. A prominent swimmer and a member of the Wanganui water polo team that won the 1905 national title.

HOLDEN Arthur William
b: 8.4.1907, Christchurch *d:* 27.7.1970, Invercargill
Halfback

Represented NZ: 1928; 3 matches

First-class record: Otago 1926-28 (University); Southland 1929,30,32 (Star); South Island 1928,29; NZ Trials 1927,30; NZ Universities 1927

Educated Kaikorai School and Otago Boys' High School, 1st XV 1923,24. Described as a fine halfback in attack and defence. He passed well from any position and varied his play well.

'Tubby' Holden was considered a little unlucky to miss selection for the New Zealand team that toured South Africa 1928 but he won his national cap in two matches against New South Wales in that season (with his clubmate Nick Bradanovich playing at first five-eighth) followed by a match against West Coast-Buller.

HOLDER Edward Catchpole
b: 26.7.1908, Seddonville *d:* 2.7.1974, Christchurch
Wing threequarter

Represented NZ: 1932,34; 10 matches – 1 test, 29 points – 9 tries, 1 conversion

First-class record: Buller 1929-35 (Westport OB), 1942 (Westport Territorials); South Island 1932,33; NZ Trials 1934,35; Seddon Shield Districts 1931

Educated Nelson College. A well-built player at 13 stone and just under six feet. Holder toured Australia in 1932 and 1934 playing five matches in each year, making his sole international appearance in the second test 1934.

Although he headed the season's list of points-scorers in New Zealand first-class rugby and had four trial matches 1935 he was omitted from the 1935-36 touring team. Transferred to rugby league and signed with the Streatham and Mitcham club in England, later playing for Wigan.

Returned at the outbreak of WWII, was reinstated to rugby union and had two games for Buller 1942 before leaving with the armed forces. Also represented Buller at cricket and athletics. An uncle, Arthur Holder, was an outstanding athlete in the 1890s.

HOLMES Bevan
b: 7.4.1946, Christchurch
Flanker, number eight

Represented NZ: 1970,72,73; 31 matches, 31 points – 9 tries

First-class record: North Auckland 1966 (Kaikohe), 1967-73,77,78 (Kamo); North Island 1968,69,71; NZ Trials 1968,70,72,73; NZ Juniors 1968,69

Educated Northland College. Played for the Teachers (1964) and Northcote (1968) clubs while at training college in Auckland. Captained NZ Juniors v Tonga 1969 and then toured South Africa 1970 where he was troubled by injuries and ailments and appeared in only seven of the 24 games. One of the three players of the 30-strong party who did not play in an international.

Bevan Holmes

Holmes appeared twice for the All Blacks in one day in Perth, en route to South Africa, when he went on as a replacement in the second game (v Western Australia) after playing against the President's XV.

Appeared in seven matches on the 1972 All Blacks' internal tour and two matches of the 1973 internal tour. Between times Holmes toured Britain and France with the 1972-73 All Blacks.

Kept out of rugby in the 1974 season with a broken leg and resumed playing for North Auckland 1977. A strong and fast loose forward standing 6' 2" and weighing 15 stone.

HOOK Llewellyn Simpkin
b: 4.5.1905, Puni *d:* 4.8.1979, Auckland
Threequarter

Represented NZ: 1928,29; 12 matches – 3 tests, 5 points – 1 try, 1 conversion

Lew Hook

First-class record: Auckland 1925-30 (Ponsonby); Waikato 1931,32 (Hamilton Technical OB); North Island 1927; NZ Trials 1927-29; Waikato-King Country 1931

Educated Thames High School. A speedy player, weighing a bare 10 stone and standing 5' 7". Hook played in his normal threequarter position against the touring 1928 New South Wales team but was used as a wing forward in the first test in Australia in the next year. Appeared in all but the first game of this 10 match tour and captained the All Blacks against NSW Country.

After retiring he coached the Hamilton Tech OB club. His brother, L.R. Hook, played for Auckland 1928,29,35 and was a provincial sprint champion. A younger brother, Glen, also represented Auckland, North Auckland and Wanganui.

HOOPER John Alan
b: 10.9.1913, Christchurch *d:* 21.4.1976, Sydney, Australia
Second five-eighth

Represented NZ: 1937,38; 7 matches – 3 tests, 9 points – 3 tries

First-class record: Canterbury 1934 (Merivale); West Coast 1935 (Greymouth United); Canterbury 1936 (Merivale), 1937,38 (Sunnyside); South Island 1937; NZ Trials 1935,37

Educated Belfast and St Albans Primaries and Christchurch Technical High School. A clever attacking five-eighth (5' 10" and 11 stone) who made an impression in the 1937 interisland match followed by a good match in the final trials. Won a place in the New Zealand team that played South Africa in the first test. He retained his place for the series and again played for the 1938 All Blacks in Australia, though in this year he did not play in the internationals.

Unable to play in the next season owing to injuries, Hooper was in Nelson 1940 and restricted his play to club level. A member of the 1941 NZ Infantry Battalion team that defeated a Fijian Battalion in Fiji by 32-9.

HOPA Aaron Remana
b: 13.11.1971, Hamilton
Loose forward

Represented NZ: 1997; 4 matches, 5 points – 1 try

First-class record: Waikato 1995-97 (Taupiri); Waikato Chiefs 1997; South Island Invitation XV 1997

Aaron Hopa had a remarkably quick rise to the All Blacks. He played in only three matches for Waikato in 1995 and was restricted to one in 1996 because of a broken bone in a wrist, but became one of the outstanding loose forwards in New Zealand in 1997.

After strong performances for the Chiefs and for Ranfurly Shield winners and NPC semifinalists Waikato, he was added to the expanded New Zealand squad that toured Britain and Ireland in November and December 1997, playing in four matches — three of them as replacements. Hopa also played for Ikaroa in the revamped Maori trials but was not chosen for New Zealand Maoris.

HOPKINSON Alister Ernest
b: 30.5.1941, Mosgiel
Prop

Represented NZ: 1967-70; 35 matches – 9 tests, 12 points – 4 tries

First-class record: South Canterbury 1962 (Timaru HSOB); Canterbury 1963 (Darfield), 1964-71 (Cheviot), 1972 (Amberley); South Island 1966-69; NZ Trials 1966-70; New Zealand XV 1968

Educated Tokomairiro District and South Otago High Schools. Following an outstanding match for South Island 1967 Hopkinson was chosen in the team to tour British Isles and France where he played in eight of 17 matches including the Scottish international.

Toured Australia with the 1968 All Blacks playing seven of the 11 matches including the second test. Later in that season he played all three internationals against the French touring team and in 1969 played in the second test against the visiting Welsh team. Appeared in the first three tests in South Africa 1970.

Alister Hopkinson

Hopkinson was a strong 16st 4lb, 6' 2½" prop who won his way into the test front row over some formidable rivals. Canterbury sub-unions selector and coach 1975-79. His father, C.D. Hopkinson, played for South Canterbury 1937.

HORE John
b: 9.8.1907, Dunedin *d:* 7.7.1979, Dunedin
Hooker, prop

Represented NZ: 1928,30,32,34-36; 45 matches – 10 tests, 33 points – 11 tries

First-class record: Otago 1926,27,29-34,36 (Southern); South Island 1927,31-34; NZ Trials 1927,30,34,35

Educated Macandrew Road School and King Edward Technical College. A very fit and hard-working forward, Hore played a total of 113 first-class matches including 51 for Otago during a long rugby career spanning a decade. Captained his province 1931-33,36.

Toured South Africa 1928 but won his first international cap in the second test against the 1930 Lions, replacing the first test hooker Bill Irvine. Retained his place for the rest of the series and appeared in New Zealand's first 3-4-1 scrum as a prop in Australia 1932. Also toured Australia 1934 playing in both tests. Broke his hand in the Scottish international on the 1935-36 British tour but recovered to play against England. His statistics were given as 5' 10" and 12st 10lb.

HORSLEY Ronald Hugh
b: 4.7.1932, Wellington
Lock

Represented NZ: 1960,63,64; 31 matches – 3 tests, 3 points – 1 try

First-class record: Wellington 1954-61 (Wellington); Manawatu 1962-64 (Kia Toa); North Island 1961; NZ Trials 1958-63

Educated Miramar South Primary School and Rongotai College.

Played for a Wellington XV 1954,55 before gaining a place in the Wellington team 1956. A 16-stone lock who stood 6' 4½" tall, Horsley was selected in the team to tour South Africa 1960. Improved greatly on tour playing in 14 of the 26 matches in South Africa including the

final three internationals as well as in three matches in Australia.

Described as an honest and determined player, Horsley made his only All Black appearance in New Zealand against the Rest of New Zealand after the team's return home. Included in the 1963-64 team to tour the British Isles and France but after showing good form early in the tour playing in 12 of the first 20 matches, Horsley had his appendix removed which kept him out of action until a match in British Columbia on the journey home.

Captain and coach of the Kia Toa club in Palmerston North 1963-65. Nelson selector and coach of Nelson-Marlborough-Golden Bay combined 1966. Golden Bay-Motueka selector 1967,68; Nelson Bays selector 1969,70. Wellington Junior Advisory Board and Under 19 selector 1974,75. Wellington RFC chairman 1975.

Ron Horsley

HOTOP John
b: 7.12.1929, Alexandra
First five-eighth

Represented NZ: 1952,55; 3 matches – 3 tests, 6 points – 1 try, 1 dropped goal

First-class record: Bush 1948 (Coast); Manawatu 1950 (University); Canterbury 1951,52 (Lincoln College), 1953,55 (Christchurch), 1960,61 (Darfield); Otago 1956,57 (Clutha), 1959 (Cromwell); South Island 1952,55,60; NZ Trials 1953,56; NZ Universities 1950-52; New Zealand XV 1952,55; Manawatu-Horowhenua 1950

Educated Cromwell District, King's and Waitaki Boys' High Schools, 1st XV Waitaki 1946,47. Played for Bush in his first year out of school aged 18. Selected for Southland 1949 but injury kept him out. A speedy and brilliant player, Hotop stood 5' 7" and weighed 11½ stone.

Selected for the New Zealand team in both tests against the 1952 Wallabies. Scored a try and landed a dropped goal in the second test. Missed the 1954 season owing to injuries but called into the third test v Australia 1955. Selector-coach of the Canterbury Country sub-union 1966-69.

Shane Howarth in action against South Africa, 1994.

HOWARTH Shane Paul
b: 8.7.1968
Fullback

Represented NZ: 1993,94; 10 matches – 4 tests, 151 points – 5 tries, 18 conversions, 30 penalty goals

First-class record: Auckland 1990-95 (Marist); NZ Trials 1990,93-95; Auckland Blues 1997; NZ Development 1990,94; NZ XV 1993-95; NZ Maoris 1994; Northern Zone Maoris 1994; Coronation Shield Districts XV 1994; Crusaders XV 1995

Educated at Auckland Grammar School and St Peter's College, Shane Howarth played for Auckland age grade teams and, remarkably, had 1987 out of rugby because of a broken neck while diving. He returned in 1988 to play for the Auckland Colts and by 1990, he was selected straight from club play to an All Black trial.

He was not to play for New Zealand, however, until the tour of England and Scotland in 1993, when he played six matches. He scored 34 points against the South of Scotland, breaking Billy Wallace's record of 28 against Devon in 1905 for most points by a New Zealander in a match in Britain.

Howarth made his test debut in 1994 against South Africa in Dunedin (scoring 17 points) and was retained for the remaining three tests, scoring all of New Zealand's 16 points in their loss to Australia in Sydney.

Howarth was wanted for nothing more than trials and a New Zealand XV in 1995 and mid-season he switched to league in Australia.

Available for rugby again, he was added to the Auckland Blues for two matches in the 1997 Super 12. While in Britain for the Sale club, Howarth was asked to play for England against New Zealand, but he refused.

HOWDEN James
b: c 1905 *d:* 12.3.1978, Waimate
Hooker

Represented NZ: 1928; 1 match

First-class record: Southland 1926-28 (Star); South Island 1928

Played for the All Blacks against West Coast-Buller in the week between the second and third matches against the touring New South Wales team. Injured during the game and replaced by F.L. Clark.

HUGHES Arthur Maitland
b: 11.10.1924, Auckland
Hooker

Represented NZ: 1947,49,50; 7 matches – 6 tests

First-class record: Auckland 1947-50 (Grammar); North Island 1948,49; NZ Trials 1948,50; New Zealand XV 1949

Educated Nelson College, 1st XV 1942. Invited to play for the All Blacks v Auckland on their return from Australia 1947 as both of the hookers in the touring party were injured. Hughes had not represented Auckland at the time.

A good all-round forward and a consistent hooker, he stood 5' 10" and weighed 13st 9lb. Played in both tests v Australia 1949 and retained his place for the series against the 1950 Lions.

Committee member of the Auckland Racing Club for 10 years and president of the NZ Racing Conference 1974-84.

HUGHES Daniel John
b: 19.9.1869, Patea *d:* 11.2.1951, Hawera
Hooker

Represented NZ: 1894; 1 match

First-class record: Taranaki 1892-95,98 (Waimate), 1897 (Tukapa)

Educated Manaia School. Played for New Zealand in the one match against New South Wales 1894. Regarded as a great forward and a dominant lineout player.

Renowned as a Cumberland-style wrestler and the undisputed champion of Taranaki fairground bouts.

HUGHES Edward
b: 26.4.1881, Invercargill *d:* 1.5.1928, New South Wales
Hooker

Represented NZ: 1907,08,21; 9 matches – 6 tests, 3 points – 1 try

First-class record: Southland 1903-08 (Britannia); Wellington 1920,21 (Poneke); South Island 1907; North Island 1921; Southland-Otago 1904

Educated Christian Brothers School, Invercargill. Reputed to be the oldest player to appear in a rugby international. His date of birth does not appear to have been registered but his army registration records give April 26, 1881. By this reckoning he was 40 years, 123 days when he took the field in the second test v South Africa 1921.

His previous internationals included three in Australia 1907, the first test against the Anglo-Welsh 1908 and the first test against the 1921 Springboks. Normally a 12-stone front row forward he played as a wing forward for the South Island 1907 and, 14 years later, represented the North Island. In the meantime Ned Hughes was declared professional for participating in the same rugby league exhibition match that saw Don Hamilton banned by the Southland RFU. A member of the 1910 New Zealand league team.

After serving with the NZ Rifle Brigade during WWI he was reinstated to rugby, playing for Wellington, North Island and New Zealand.

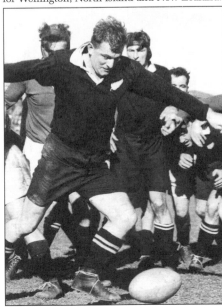

Arthur Hughes

HULLENA Laurence Clifford
b: 24.8.1965, Masterton
Prop

Represented NZ: 1990-91; 9 matches

First-class record: Wellington 1987-89 (Petone), 1990-91 (Poneke), 1992 (Petone); Central Zone 1988,89; NZ Trials 1990-92; NZ XV 1992; NZ B 1991; NZRFU President's XV 1992

Laurence Hullena, who was educated at Wairarapa College and played for New Zealand Secondary Schools in 1982, was chosen for the All Black tour of France in 1990 and played in five matches without playing in a test.

He played in another four on the tour of Argentina in 1991 but was not wanted for the World Cup squad that followed. He was chosen in the All Black squad for the centenary tests in 1992, but did not play a game.

Hullena, with Craig Innes and Ian Jones, also played for the British Barbarians against Argentina in Cardiff in 1990.

HUMPHREYS George William
b: 15.3.1870, Wolverhampton, England
d: 11.5.1933, Rotorua
Loose forward

Represented NZ: 1894; 1 match, 3 points – 1 try

First-class record: Canterbury 1891,92,94 (Christchurch)

Came to New Zealand at the age of 17. Played for New Zealand against New South Wales 1894. A son, F.E. Humphreys, represented Poverty Bay 1919,20.

HUMPHRIES Arthur Larwill
b: 15.2.1874, New Plymouth *d:* 13.4.1953, Wanganui
Halfback

Represented NZ: 1897,1901,03; 15 matches, 47 points – 3 tries, 18 conversions, 1 penalty goal

First-class record: Taranaki 1893-99,1901-03 (Star); North Island 1897,1903

Educated Central School (New Plymouth). A slightly built man weighing only 9½ stone, 'Skinny' Humphries usually played at halfback but also appeared as a five-eighth and wing during a long career representing Taranaki and also gave an excellent exhibition from fullback in the 1903 interisland game.

Toured Australia 1897 with the New Zealand team, played two matches against Wellington and New South Wales 1901 and was called in to replace Peter Harvey when that player was unable to tour Australia 1903. A useful goalkicker he recorded 18 conversions on the 1897 tour as well as a penalty goal.

Manager of the 1908 New Zealand team in the series against the Anglo-Welsh. Taranaki selector and president 1923. Life member Taranaki RFC.

HUNTER Bruce Anthony
b: 16.9.1950, Oamaru
Wing threequarter

Represented NZ: 1970,71; 10 matches – 3 tests, 24 points – 8 tries

First-class record: Otago 1969,71,73 (Pirates); South Island 1969,71,73; NZ Trials 1970,71,73

Educated Waitaki Boys' High School, 1st XV 1967,68, South Island Secondary Schools rep 1967. Hunter was a speedy, lightweight winger standing 5' 9" and weighing 11st 3lb. In his second match for Otago 1969 he scored five tries against Marlborough.

Bruce Hunter

Selected for the tour to South Africa 1970 as a 19-year-old. Became the first player to have two full matches for the All Blacks on one day when he appeared in both games in Western Australia en route to South Africa. Played in only five of the 24 matches in South Africa. Suffered numerous injuries and finished only two games.

After playing in the first three tests against the 1971 Lions, Hunter took a break from rugby to concentrate upon his athletic career but returned for one more season 1973. NZ title holder in the 800 metres 1970,71,75 with best winning time of 1m 51secs.

HUNTER James
b: 6.3.1879, Hawera *d:* 14.12.1962, Wanganui
Second five-eighth

Represented NZ: 1905-08; 36 matches – 11 tests, 147 points – 49 tries

First-class record: Taranaki 1898, 1900-04,06-08 (Hawera); North Island 1904-08; Taranaki-Wanganui-Manawatu 1904

Educated Hawera School and Wanganui Collegiate. First played for Taranaki as halfback (he stood 5' 6" and weighed 11st 8lb) and appeared as a wing and fullback before settling into the second five-eighth position where he performed spectacularly.

Captained the first 1905 team in Australia before leaving with the 'Original' All Blacks. From 24 games, including all five internationals in the British Isles and France, Hunter scored an extraordinary 44 tries. Appointed captain of the 1907 All Blacks to Australia and also led the New Zealanders in the second test against the Anglo-Welsh 1908 when Billy Stead was rested in favour of new blood.

Jimmy Hunter was described by E.H.D. Sewell as "one of the most sinuous runners I have ever seen. He seemed to glide rather than to run, and to go through the opposition as might a snake." Another critic spoke of his "zig-zag, eel-like bursts for the goal-line. His relentless passage through a thick sea of surging opponents is weird, uncanny. He might be covered with soap from the ease with which he eludes the grasp of one strong, fleet man after another." Life member of the Hawera club 1913.

HURST Ian Archibald
b: 27.8.1951, Oamaru
Second five-eighth and centre threequarter

Represented NZ: 1972-74; 32 matches – 5 tests, 44 points – 11 tries

First-class record: North Otago 1970,75,76,78-80 (Oamaru OB); Canterbury 1971-74 (Lincoln College); South Island 1973; NZ Trials 1972-76,79; NZ Universities 1972,73; New Zealand XV 1974

Educated Waitaki Boys' High School, 1st XV 1969,70 from where he first played representative rugby. A surprise inclusion in the 1972 trials, he won selection for the 1972-73 team to Britain as a 5' 11", 13 stone midfield back.

Despite injuries he appeared in 16 matches on tour including the Irish and French internationals. Played against England 1973 after the All Black internal tour and visited Australia the following year appearing in the first two tests and against Fiji. Toured Ireland 1974 playing in four matches including those against the Welsh XV and the Barbarians.

Ian Hurst

IEREMIA Alama
b: 27.10.1970, Apia, Western Samoa
Second five-eighth and centre threequarter

Represented NZ: 1994-97; 21 matches – 12 tests, 35 points – 7 tries

First-class record: Wellington 1992-97 (Western Suburbs); Wellington Hurricanes 1996,97; NZ Trials 1994-96; NZ Development 1994; NZ XV 1994,95; Barbarians 1996; Poverty Bay Selection 1996

Ieremia played for Western Samoa for two years before switching his allegiance to the All Blacks

Alama Ieremia

and in 1993 played in the first test between New Zealand and Western Samoa.

He made his All Black debut the following year, playing in each of the three tests against South Africa and in 1995 he was a member of the World Cup squad, playing in the 145-17 win against Japan.

He toured Italy and France at the end of 1995 without playing in a test and his next three appearances were all as replacements and all against South Africa – two in 1996 and one in 1997.

Ieremia's selection depended on the availability of Walter Little and when Little was injured during the tri nations series in 1997, he played in three successive tests. He also played against Ireland and England (in Manchester) on the tour of Britain and Ireland at the end of 1997, but was replaced by Little for the test against Wales and the second against England.

Ieremia was selected at centre only once for New Zealand, against the French Barbarians in Toulon in 1995.

IFWERSEN Karl Donald
b: 6.1.1893, Auckland *d:* 19.5.1967, Auckland
Second five-eighth

Represented NZ: 1921; 1 match – 1 test

First-class record: Auckland 1912 (College Rifles), 1921-24 (Grammar); NZ Trials 1924; Auckland-North Auckland 1921

Educated St John's College (Auckland) and Auckland Grammar School. After representing Auckland for a season, he switched to rugby league and played for New Zealand 1913,14,19,20.

Reinstated to rugby at the beginning of the 1921 season. Captained the combined Auckland-North Auckland team against the Springboks and created a sensation when he was called into the third test at second five-eighth in place of All Black captain George Aitken in a backline re-shuffle. Unavailable for selection in the 1922 team which toured Australia. Although Ifwersen was ineligible to visit Britain with the 1924-25 All Blacks owing to stipulations laid down by the RFU, and was

not listed in the reserves for the 1924 trial at Auckland, he went on as a replacement for Vic Badeley and was the key behind his team coming from 0-6 to win by 19-9.

Continued to play club rugby for several years. Auckland selector 1926; North Auckland selector 1936-38. His brother, Neil, represented Auckland 1924,26.

A master tactician who deserved far more All Black honours than his sole appearance, Ifwersen had speed off the mark, a baffling swerve, a beautifully controlled grubber kick and was also a fine goalkicker. Weighed 12 stone and stood 5' 10". For Auckland v a Wellington XV 1924 he scored 24 points (a try, a penalty goal and nine conversions) and v Wanganui 1925 scored 19 points (a try and eight conversions).

INNES Craig Ross
b: 20.9.1969, New Plymouth
Centre and wing

Represented NZ: 1989-91; 30 matches – 17 tests, 60 points – 15 tries

First-class record: Auckland 1988,89 (Marist), 1990,91 (Ponsonby); NZ Trials 1988,90,91; NZ Colts 1988,89

Innes, who was educated at Sacred Heart College, had a brilliant youth career, playing for New Zealand age grade sides and the national secondary schools team. Unusually, he made his first-class debut in an All Black trial in 1988 but could not gain a regular place in the Auckland team until later in the year.

He was chosen for the All Black tour of Canada, Wales and Ireland the following year

Craig Innes

and made his test debut against Wales, playing on the wing. He also played against Ireland in that position but in 1990, against Australia, he was at centre, a position to which his natural flair and ability to make a break was better suited.

He played both tests against France later in 1990 and in 1991 he was firmly established as the regular All Black centre, playing in all 10 tests – two in Argentina, two against Australia and six in the World Cup.

Innes also played for the British Barbarians against Argentina in Cardiff in 1990.

At the age of 22, with a long All Black career seemingly assured, he took up a league contract in England.

Innes returned to rugby early in 1998, the NZRFU securing his transfer from Sydney league club Manly to Auckland.

INNES Gordon Donald
b: 8.9.1910, Dunedin *d:* 6.11.1992, Christchurch
Second five-eighth

Represented NZ: 1932; 7 matches – 1 test, 6 points – 2 tries

First-class record: Canterbury 1928-31 (Christchurch HSOB), 1932 (Sydenham); NZ Trials 1930

Educated Waltham School and Christchurch Boys' High School, 1st XV 1927,28 from where he represented Canterbury. Won selection as a 5' 11", 13st 5lb five-eighth to tour Australia 1932 where he played in the second test.

Signed with the Wigan rugby league club 1933 with whom he played until 1938 when he transferred to Castleford for a season. Represented England against France 1935 and is believed to be the only All Black to play rugby league for England.

Returned to New Zealand and coached a schoolboy team for the Karori club and later assisted in coaching the Sydenham club. Also served as a Wellington selector.

IRVINE Ian Bruce
b: 6.3.1929, Carterton
Hooker

Represented NZ: 1952; 1 match – 1 test

First-class record: North Auckland 1949-53 (Whangarei HSOB); North Island 1952; New Zealand XV 1952

Educated Purua Primary and Whangarei Boys' High School. A 5' 9", 13st 6lb hooker, Irvine played his only game for the All Blacks in the first test against the 1952 Wallabies after earlier in the season representing the North Island and a New Zealand XV (v NZ Maoris).

Replaced by Ian Hammond after the first test was lost, but Hammond too was to play only one international for New Zealand. Irvine's father, Bill, represented his country 1923-26,30 and his brother, Bob, was a rugby commentator for Radio NZ.

IRVINE John Gilbert
b: 1.7.1888, Dunedin *d:* 10.6.1939, Queenstown
Lock

Represented NZ: 1914; 10 matches – 3 tests

First-class record: Otago 1912-14,18,19 (Southern); South Island 1914

A capable lock, weighing 15$\frac{1}{2}$ stone, who toured Australia 1914 appearing in the three internationals and missing only one game. Regarded as a great scrummaging forward whose strength was a tremendous asset, Irvine would no doubt have played many more games for New Zealand had his career not been interrupted by WWI.

IRVINE William Richard

b: 2.12.1898, Auckland *d:* 26.4.1952,
Whangarei
Hooker

Represented NZ: 1923-26,30; 41 matches – 5
tests, 24 points – 8 tries

First-class record: Wairarapa 1920
(Featherston Liberal), 1927-30 (Carterton);
Hawke's Bay 1922-26 (Waipukurau Rovers);
North Island 1923-26; NZ Trials 1924,30;
Hawke's Bay-Poverty Bay-East Coast 1923;
Wairarapa-Bush 1930

Educated Terrace School (Wellington). A
member of the Hawke's Bay Ranfurly Shield
team throughout its 1920s tenure, Irvine stood 5'
7½" and weighed about 13 stone. Described as
a powerful and hard working forward– and one
of the best exponents of the two-man front-row
hooking that played for New Zealand.

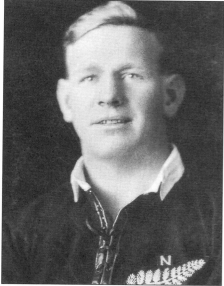

'Bull' Irvine

Made his All Black debut against New South
Wales 1923 with fellow hooker Quentin Donald
with whom he established a formidable
partnership on the 1924-25 tour. Appeared in 27
of the 30 matches played by the 'Invincibles',
including all four internationals. Played against
New South Wales at Auckland 1925 then toured
Australia 1926. Recalled for the first test against
the 1930 Lions.
A son, Ian, appeared for the 1952 All Blacks a
few months after his father's death while
another son, Bob, was a radio commentator on
the game.

IRWIN Mark William

b: 10.2.1935, Gisborne
Prop

Represented NZ: 1955,56,58-60; 25 matches –
7 tests

First-class record: Otago 1953,55-59
(University); Poverty Bay 1961 (Gisborne
HSOB); Bay of Plenty 1962 (Rotorua HSOB);
South Island 1954-56,58,59; NZ Trials
1953,56,59; Rest of New Zealand 1955,56;
New Zealand XV 1955,56,58,59; NZ
Universities 1954,55,58,59

Educated Wanganui Collegiate, 1st XV 1950-52.
Irwin made an immediate impact while

Mark Irwin

studying in Dunedin and was included in the
1953 trials as an 18-year-old. Missed much of
the 1954 season due to injury but played two
tests against Australia 1955.
Retired with damaged ribs at halftime in the
first test against the 1956 Springboks and did
not play again in the series. After playing little
rugby in 1957 he reappeared for the All Blacks
in the second test v Australia 1958. Had two
tests against the 1959 Lions and played his last
international in South Africa 1960 where his
form was partly affected by a car accident.
A 6' 1½" 16st 4lb tighthead prop, Irwin had a
magnificent physique. In his tour book, *The All
Blacks Juggernaut in South Africa*, A.C. Parker
said of him, "South African props who packed
against Irwin considered him the strongest of
the New Zealand front-row men, and it was
something of a surprise when he was dropped
after the first test." Terry McLean reported that
Whineray considered Irwin to be the strongest
tighthead prop in the world.
Vice-president of the Ngongotaha club 1979.
A member of the New Zealand rowing eight
1956 and a NZ Universities rowing blue.

IVIMEY Frederick Elder Birbeck

b: 28.3.1880, London, England *d:* 6.12.1961,
Christchurch
Loose forward

Represented NZ: 1910; 1 match

First-class record: Otago 1907,08 (Dunedin),
1909,10 (Union); Southland 1911 (Gore
Albion), 1913 (Invercargill); South Island 1908

A nimble and wiry type of forward who
normally played on the side or back-row of the
scrum. He first came to notice with a fine match
for Otago against the 1908 Anglo-Welsh team
and won selection in the South Island team of
that year. Injuries restricted his appearances to
one on the 1910 tour of Australia.

JACKSON Everard Stanley

b: 12.1.1914, Hastings *d:* 20.9.1975, Hastings
Prop

Represented NZ: 1936-38; 11 matches – 6
tests, 3 points – 1 try

First-class record: East Coast 1932 (Tolaga Bay
Country), 1933 (Hikurangi); Hawke's Bay 1934
(Whakaki), 1935 (Wairoa OB & Nuhaka), 1936-
40 (MAC); Wellington 1941 (Hutt Army);
North Island 1935-39; NZ Trials 1937; NZ
Maoris 1936,39

Educated Te Araroa Native School and
Rerekohu District High School. Played his early
club rugby as a wing and retained a good turn of
speed during his later career as a 14 stone, 5' 11"
prop.
First selected for New Zealand in the 1936
series against Australia, he held his place for the
three tests v South Africa 1937 and toured
Australia the following year, appearing in the
final international.
Served in WWII in the Maori Battalion with
the rank of captain and was severely wounded
in the Western Desert campaign, losing a leg. His
father, Frederick, played for Leicester against
the 1905-06 'Originals', toured New Zealand
with the 1908 Anglo-Welsh team and then
settled in this country later representing New
Zealand at rugby league 1910. His brother,
Sidney (Selwyn), played rugby for Hawke's Bay
and NZ Maoris 1938.

JACOB Hohepa

b: 16.11.1894, Levin *d:* 30.5.1955, Palmerston
North
Wing forward and loose forward

Represented NZ: 1920; 8 matches, 25 points –
7 tries, 2 conversions

First-class record: Horowhenua 1911,13,14,19-
25 (Levin Wanderers); Manawhenua 1925-27;
Manawatu-Horowhenua 1921,22-24; North
Island 1919-21,23; NZ Trials 1924; NZ Maoris
1913,14,22,23; Wellington-Manawatu-
Horowhenua 1925

Came into the Horowhenua side as a 16-year-old
and continued when that union was combined
with Manawatu 1925. His career spanned 16
years and 100 first-class matches, a total that
could have been higher if not interrupted by
service with the Pioneer Battalion in WWI when
he won the MM.
Toured Australia 1920, where no
internationals were played, but was not
available to travel with the 1922 team and
could not accept selection for the 1923 series
against New South Wales. During his rugby
career 'Harry' Jacob captained the North Island
1923, Horowhenua, Manawhenua (including
the Ranfurly Shield victory over Wairarapa
1927), NZ Maoris 1922 and Manawatu-
Horowhenua. Played for the Pioneer Maori
Battalion 1919.
Jacob's son, Ranfurly, represented Wellington,
NZ Universities and NZ Maoris in the years
immediately after WWII.

JACOB John Phillip le Grande

b: 19.5.1877, Marton *d:* 3.11.1909, Stratford
Wing threequarter

Represented NZ: 1901; 2 matches, 6 points – 2
tries

First-class record: Wanganui 1894 (Fordell);
Taranaki 1898 (Tukapa); Wellington 1901
(Wellington); Southland 1901,02 (Pirates)

Educated Wanganui Collegiate, 1st XV 1892.
Played for New Zealand 1901 against
Wellington and New South Wales. Described as

"a big man who showed extraordinary agility together with a dead stop prop and bruising hips." An itinerant character, Phil Jacob played rugby throughout New Zealand and in New South Wales.

JAFFRAY John Lyndon
b: 17.4.1950, Dunedin
Five-eighth

Represented NZ: 1972,75-79; 23 matches – 7 tests, 28 points – 7 tries

First-class record: Otago 1970-73 (Green Island), 1974,75,77,78 (Eastern); South Canterbury 1979 (Timaru HSOB); South Island 1975,77,78; NZ Trials 1972,74,75,77-79

Educated Concord Primary and Kaikorai Valley High School. Played initially as a first five-eighth winning a place in the All Blacks for the second test v Australia 1972. Next played for New Zealand as a second five-eighth against Scotland on a waterlogged Eden Park 1975. Toured South Africa 1976 after playing against Ireland early in the season. Played 11 of the 24 matches on tour including the first test.

Lyn Jaffray

Appeared in the second test against the 1977 Lions and toured with the 1978 All Blacks to the British Isles, playing in six of the 18 matches. Included in both tests v France 1979 before retiring.

Standing 5' 7" and weighing 12st 7lb, Lyn Jaffray was a reliable five-eighth with an incisive break. Described by Barry Glasspool in the 1976 tour book *One in the Eye* as "a most dependable player . . . but lost favour after the Durban defeat. Seldom again recaptured that balanced running and sheer opportunism that earned him five tries in his first five games." His brother, Mervyn, toured Argentina 1976 with the All Blacks.

JAFFRAY Mervyn William Rutherford
b: 18.1.1949, Dunedin
Flanker and number eight

Represented NZ: 1976; 4 matches, 12 points – 3 tries

First-class record: Otago 1969,71-78 (Green Island); South Island 1975-77; NZ Trials 1973,74,76,77

Educated Concord Primary and Kaikorai Valley High School. A tireless and intelligent player, who stood 1.83m and weighed 88kg, he played equally well as a flanker or number eight.

Selected for the All Blacks to tour Argentina 1976, playing four of the nine matches including both matches against the Pumas. A neck injury forced his retirement 1978. Coach of the Stoke club 1979 and selector coach of Nelson Bays 1980-82. His brother, Lyn, represented New Zealand 1972,75-79.

JARDEN Ronald Alexander
b: 14.12.1929, Lower Hutt *d:* 18.2.1977, Wellington
Wing threequarter

Represented NZ: 1951-56; 37 matches – 16 tests, 213 points – 35 tries, 36 conversions, 12 penalty goals

First-class record: Wellington 1949-56 (University); North Island 1950,52-56; NZ Trials 1953,55,56; New Zealand XV 1952,54,55; NZ Universities 1951-56

Educated Waikari Primary and Hutt Valley High School, 1st XV 1947 where he scored 105 points while his school team enjoyed an unbeaten season.

While in Australia with the NZ Universities team Jarden was selected for the 1951 All Blacks and remained there to join the New Zealand team. Played in six of the 12 tour matches, including the first two tests, missing the third with an ankle injury. With 38 points (six tries, 10 conversions) against Central West Jarden beat Wallace's New Zealand record of 28 points set in 1905 and his total of 88 points (15 tries, 17 conversions, three penalty goals) on the tour beat Wallace's 1903 record of 85. Played in both tests against Australia in the 1952 home series and then all five internationals among his 22 appearances on the 1953-54 tour of the British Isles, France and North America where he scored a total of 94 points. After three tests against the 1955 Wallabies and four against the South Africans in the next year, Jarden's

international career ended at the early age of 26. After a match for the Centurions club 1957 he retired after 134 first-class games in which he scored 945 points (145 tries, 141 conversions, 76 penalty goals).

Jarden was one of New Zealand's greatest wing threequarters and most prolific points-scorers. He combined pace with great acceleration, anticipation and intelligence. He was an accurate left-footed placekicker and his finely judged centering kicks presented many scoring opportunities to those familiar with his play. He stood 5' 8" and his playing weight varied from 12st 3lb to 13st 5lb.

Author of the book *Rugby on Attack* (Whitcombe & Tombs, 1961). National junior 440yds champion 1949. Represented New Zealand in the Admiral's Cup at Cowes 1975 in his yacht *Barnacle Bill.*

JEFFERD Andrew Charles Reeves
b: 13.6.1953, Gisborne
Second five-eighth

Represented NZ: 1980,81; 5 matches – 3 tests

First-class record: Canterbury 1974-76 (Lincoln College), 1977,78 (Glenmark); East Coast 1978-81 (Tokomaru United); North Island 1981; NZ Trials 1979-81; NZ Universities 1976; NZ Juniors 1976

Educated Tokomaru Bay Primary, Huntly Preparatory School and Wanganui Collegiate, 1st XV 1969-71. Visited North America, Ireland and Japan with the 1976 NZ Universities team.

Jefferd became the second All Black from the East Coast union when he was sent as a reinforcement to join the New Zealand team in Fiji after Tim Twigden was injured in Australia. Played against Suva and Fiji and proved to be a strong runner and a hard tackler. Played in both tests against Scotland 1981 and the first against South Africa. Stood 1.79m and weighed 79kg.

JENNINGS Arthur Grahn
b: c 1939, Lautoka, Fiji
Lock

Represented NZ: 1967; 6 matches

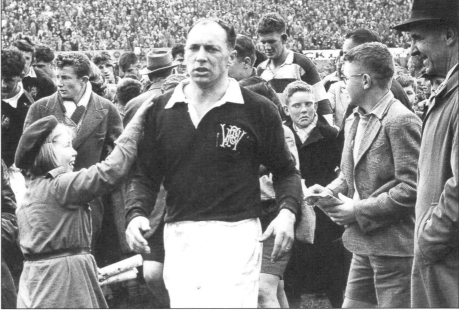

Ron Jarden . . . pace, acceleration, anticipation and intelligence.

Arthur Jennings

First-class record: Bay of Plenty 1962,63 (Te Puke Rovers), 1964 (Tauranga Cadet OB), 1965,66 (Ngongotaha), 1967,68 (Kahukura), 1969,70 (Eastern Suburbs); NZ Trials 1963,65,67,68,70

Arrived in New Zealand at the age of 12. Educated Northcote College. Played for Auckland Colts before settling in the Bay of Plenty. A strong lock standing 6' 4" and weighing 15 stone, Jennings was a powerful runner with the ball and a good lineout forward.

Toured British Isles and France with the 1967 All Blacks, playing in six of the 17 matches. Later returned to his home country where he served on the Fiji RFU executive.

JERVIS Francis Mahon
b: ?.1.1870, Auckland *d:* 20.12.1952, Lower Hutt
Wing threequarter

Represented NZ: 1893; 10 matches, 38 points – 5 tries, 6 conversions, 1 dropped goal, 2 goals from a mark

First-class record: Auckland 1889 (Gordon), 1890-92,94 (Parnell)

Educated Newton School and Auckland Grammar School. First played for Auckland as a 19-year-old. Leading scorer on the 1893 tour to Australia. Described as "a dodgy runner and a splendid goalkicker". Became a referee after moving to Dargaville 1895.

JESSEP Evan Morgan
b: 11.10.1904, Sydney, Australia *d:* 10.1.1983, Sydney, Australia
Hooker and prop

Represented NZ: 1931,32; 8 matches – 2 tests

First-class record: Wellington 1926-32 (Poneke); Australia 1934; North Island 1932; NZ Trials 1930; Victoria (Australia) 1933-37

Came to New Zealand 1908 and educated Newtown and South Wellington Schools. A rugged forward weighing 14 stone and standing 5' 10", Jessep was selected to partner 'Beau' Cottrell in the only test against the 1931 Wallabies.

Toured Australia 1932 and played in the first test, having the distinction of being New Zealand's first international hooker in a three fronted scrum. Moved to Melbourne in 1933 and represented Victoria. Vice-captain of the Australian team in two tests against the 1934 All Blacks thus becoming the first New Zealand representative to play both for and against his country in international rugby.

A broken ankle ended his career 1937 but he coached the Eastern Suburbs club (Sydney) 1940-55.

JOHNS Peter Arthur
b: 16.3.1944, New Plymouth
Five-eighth and fullback

Represented NZ: 1968; 6 matches, 6 points – 1 try, 1 dropped goal

First-class record: Wanganui 1966-68 (Waiouru Army); Bay of Plenty 1970 (Mt Maunganui); NZ Trials 1968-70; NZ Juniors 1966; Wanganui-King Country 1966; NZ Army 1967

Educated Fitzroy Primary and Highlands Intermediate Schools and New Plymouth Boys' High School. A strong-running back standing 5' 11" and weighing 13st 2lb who played mostly as a centre threequarter. Johns was adept at making breaks and was a sound defender. Selected to tour with the All Blacks to Australia 1968 playing three matches at second five-eighth and two at fullback, going on once as a replacement.

In Taranaki he played for the Fitzroy club 1968-70 and Okato 1974,75 and coached the Tukapa and Fitzroy senior teams. President of the Fitzroy club 1979. His father, Reg, represented Waikato 1938, Taranaki 1939 and a brother, Roy, played for Taranaki 1960,63.

JOHNSON Launcelot Matthew
b: 9.8.1897, Lumsden *d:* 11.1.1983, Christchurch
Five-eighth

Represented NZ: 1925,28,30; 25 matches – 4 tests, 19 points – 3 tries, 5 conversions

First-class record: Wellington 1923-25,27,29,30,32 (Wellington); Hawke's Bay 1926 (Celtic); North Island 1927,29; NZ Trials 1927,30; Wellington-Manawatu-Horowhenua 1925

Educated Lumsden School and Southland Boys' High School, 1st XV 1915. First represented New Zealand on the 1925 tour of New South Wales where he appeared in all three matches against the state side. Toured South Africa with the 1928 All Blacks, appearing in three tests at first five-eighth and one at second five-eighth. His final match for the All Blacks was against North Otago before the series against the 1930 Lions. Described as "swift and elusive", Lance Johnson stood 5' 8" and weighed around 12 stone. Played three Ranfurly Shield games for Hawke's Bay 1926, including the 58-8 drubbing of Wellington, the team he represented over seven seasons. Canterbury selector 1949,50.

JOHNSTON David
b: 24.3.1903, Okaiawa *d:* 5.7.1938, New Plymouth
Five-eighth

Represented NZ: 1925; 2 matches – 4 points, 2 conversions

First-class record: Taranaki 1922-30,32 (Okaiawa); North Island 1923; NZ Trials 1924,27,29; Taranaki-Wanganui 1925

One of Taranaki's best inside backs in a long career between the two wars, Johnston replaced an original selection, J.R. 'Wampy' Bell who withdrew from the 1925 New Zealand team that toured New South Wales. His statistics were given as 5' 8" and 10st 10lb. Taranaki selector 1936 and a coach of the Okaiawa club for a number of years.

David Johnston

JOHNSTON William
b: 13.9.1881, Dunedin *d:* 9.1.1951, Sydney, Australia
Loose forward

Represented NZ: 1905,07; 27 matches – 3 tests, 12 points – 4 tries

First-class record: Otago 1904 (Alhambra); South Island 1905,07

'Massa' Johnston played only six games for Otago before winning selection as a six foot, 13½ stone forward for the 1905-06 New Zealand touring party. Visited Australia before leaving with the 'Original' All Blacks. Played in only 13 matches owing to illness. A throat infection forced him to be left behind in London when the team went on to North America. He returned home with Charles Seeling.

After touring Australia 1907 and playing in both tests, Johnston turned to rugby league and toured with the 'All Golds'. He joined the Wigan club in England 1908, transferred to Warrington 1910. Played for a 'Colonial' team v England 1910.

JOHNSTONE Bradley Ronald
b: 30.7.1950, Auckland
Prop

Represented NZ: 1976-80; 45 matches – 13 tests, 28 points – 7 tries

First-class record: Auckland 1971-81 (North Shore); North Island 1975,79; NZ Trials 1971,74,76,77,79-81; NZ Juniors 1972,73

Educated Belmont Primary and Takapuna Grammar School, 1st XV 1965,66. A strong, mobile prop, standing 1.88m and weighing

104kg, Johnstone excelled at the front of the lineout. Captained Auckland 1977-81.

Visited Australia with the NZ Juniors 1972. Invalided home from South Africa 1976 with a chest injury after making his international debut in the second test. Played in the first two tests against the 1977 Lions then regained his place as a test prop in France 1977, the British Isles 1978, in England and Scotland 1979 and Australia 1980 and, at home, against the 1979 French tourists.

Johnstone, who had coached North Shore, became the coach of the Fiji national side in 1994.

Brad Johnstone

His father, Ron, was a member of the 'Kiwis' army team and represented Auckland 1948-52 and had All Black trials 1948,50.

JOHNSTONE Peter
b: 9.8.1922, Mosgiel *d:* 18.10.1997, Wanaka
Flanker and number eight

Peter Johnstone

Represented NZ: 1949-51; 26 matches – 9 tests, 12 points – 4 tries

First-class record: Ashburton County 1943 (Canterbury Cavalry); Otago 1946-48,50,51 (Taieri); South Island 1948,51; NZ Trials 1948,50,51

Educated Mosgiel District High School. Played soccer at school and represented Otago schoolboys before turning to rugby. Played one match for Ashburton County while serving in the army 1943. Had one match for Otago 1946 as a replacement before becoming a regular member of the team 1947.

A versatile forward who weighed 13½ stone and was six feet tall, Johnstone toured South Africa 1949 playing in 12 of the 24 tour matches including the second and fourth tests. Appeared in all four internationals against the 1950 Lions before captaining the All Blacks to Australia 1951 where he played in eight of the 12 matches including all three internationals.

Otago selector 1959-61 and president Otago RFU. Senior club coach, selector, committee man, president and life member of the Taieri club.

The Taieri RFC ground is named in his honour. His brother, Jim, represented Wellington 1955-57.

JONES Ian Donald
b: 17.4.1969, Whangarei
Lock

Represented NZ: 1989-97; 95 matches – 70 tests, 60 points – 13 tries

First-class record: North Auckland 1988-93 (Kamo); North Harbour 1994-97 (East Coast Bays); Waikato Chiefs 1996,97; NZ Trials 1990,93,94,96; NZ XV 1992; North Island 1995; North Zone 1989; Barbarians 1989,94,96,97; Harlequins 1995

Ian Jones, educated at Kamo High School, couldn't make the trials for the New Zealand Colts in 1988 but he made significant impact anyway to set him on his way to one of rugby's most illustrious careers. While at school, he had played in North Auckland age grade sides and for North Island Under 18.

He made his first-class debut against Counties in 1988 and played a Ranfurly Shield challenge against Auckland the following week, creating an immediate impression with his ball-winning capabilities and athleticism.

Jones, nicknamed 'Kamo' for the club he had joined when he was eight, was first chosen for the All Blacks' tour of Canada, Wales and Ireland in 1989 where Gary Whetton and Murray Pierce played in the tests. Pierce went to South Africa in 1990 and that led directly to Jones making his test debut in the first test against Scotland, in Dunedin. He was to be an almost automatic choice for the next seven years.

An indication of Jones's enduring value to New Zealand came in the 1993 series against the British Isles when Jones sat as a reserve for the first half of the second test in Wellington. The Lions had won so much lineout ball that Jones was put on at halftime in place of Mark Cooksley – a tactical substitution four years before such things were legal. He missed the Australian test that year because of injury but was not left out again, except for the World Cup pool match against Japan.

Jones played his 50th test during the domestic season in 1996 and, appropriately, it was at the same ground and against the same opponents as his first – Carisbrook against Scotland.

Ian Jones

By the end of 1997, Jones's 70 tests were easily a record for an All Black lock (Gary Whetton 58, Colin Meads 47) and just 10 short of the world record held by Willie-John McBride of Ireland.

Jones was the epitome of the modern breed of lock: still doing the vital ball-winning role in the middle of the lineout and still providing the pushing power required in scrums, but showing a variety of skills in the loose as well.

Jones also played for the British Barbarians against England, Wales and Argentina in 1990 and against Australia in 1992 and 1997.

JONES Michael Niko
b: 8.4.1965, Auckland
Flanker and number eight

Represented NZ: 1987-97; 70 matches – 51 tests, 69 points – 16 tries

First-class record: Auckland 1985-96 (Waitemata); Auckland Blues 1996,97; NZ Colts 1986; NZ Trials 1987,89,91,93; North Zone 1987-89; North Island 1995; NZ XV 1994,95; Barbarians 1987,96,97

An assessment in 1997 that Michael Jones was the greatest All Black to pull on the jersey could be faulted only because of the impossibility of comparing players from different eras playing different types of games. What cannot be faulted is that Jones was one of the greatest, one of a small few, to have played rugby for New Zealand.

Educated in west Auckland, Jones played for Auckland age grade sides and for Auckland and New Zealand Under 18, and made a spectacular debut for Auckland in 1985 when he scored two tries, against South Canterbury. He also scored two tries in Levin in a Colts trial but, mysteriously, did not make the national Colts team until the following year.

Jones was added to All Black trials and the interzone series early in 1987 and it was no surprise when he was named in the World Cup squad. He marked his New Zealand debut with

The word exceptional inescapably applies to Michael Jones.

a try – the first by a player in a World Cup (the first was a penalty try). Jones was a key element in the All Blacks' game plan to win the cup and he missed only the pool match against Argentina and the semifinal against Wales in Brisbane because it was on a Sunday.

Jones's adherence to his religious principles and his refusal to play on Sundays has been respected by all coaches and selectors throughout his career, though it's cost him many test matches. He would no doubt say it is a price he has gladly paid. Any lesser player with such principles may have been selected less frequently, but Jones was no lesser player. When he went with the All Blacks to Australia in 1988, it was made clear that Mike Brewer was playing in the first test only because it was on a Sunday.

Aside from speed, vision, ball skills and athleticism that few players have possessed in such abundance, Jones also exhibited an extraordinary will – such as his determination to continue with a university career at the same time as rugby was taking so much time (he finished with two degrees) and his determination to resume playing after a serious knee injury sustained against Argentina in 1989. It was suggested then that he may never play again; just over a year later he was back in the All Blacks for the 1990 tour of France. A year after that he played in his second World Cup and, like the first, he scored the tournament's first try in the All Blacks' 18-12 overture against England.

Jones has suffered other injuries that have limited his appearances. He was unavailable for the tour of England and Scotland in 1993 because of a broken jaw and he suffered another serious knee injury in the first test of 1997, against Fiji. His no-Sundays play almost certainly cost him a place in the 1995 World Cup.

For all his competitiveness on the field, Jones had a gentleness of character off it that is owned by few top-class sports people. On the field, he was just as likely to apologise to an opponent after a bone-jarring tackle as he would if he'd spilt someone's beer at an after-match function while he was drinking orange juice.

The word exceptional inescapably applies to

Jones, both on and off the field.

Jones also played a test for Western Samoa in 1986.

Michael Jones' biography *Iceman – The Michael Jones Story* was written by Robin McConnell (Rugby Press, 1994).

JONES Murray Gordon
b: 26.10.1942, Warkworth *d:* 12.2.1975, Auckland
Prop

Represented NZ: 1973; 5 matches – 1 test

First-class record: Auckland 1964-69 (North Shore); North Auckland 1970-74 (Omaha); North Island 1970,73; NZ Trials 1966,70,71,73; NZ Juniors 1965

Educated Takapuna Grammar School. A red-headed prop standing 6' 1" and weighing 15 stone who was a fiery, vigorous and consistent player. Included in all four matches on the 1973 All Blacks internal tour and later in the season played against England in the Eden Park test. Had a total of 128 first-class matches during his career.

His brother, Rod, represented North Auckland 1968-75. Drowned in Auckland Harbour when endeavouring to rescue his two-year-old son who had fallen overboard from a yacht.

JONES Peter Frederick
Family name: Hilton-Jones
b: 24.3.1932, Kaitaia *d:* 7.6.1994, Waipapakauri
Flanker and number eight

Represented NZ: 1953-56,58-60; 37 matches – 11 tests, 60 points – 20 tries

First-class record: North Auckland 1950-61 (Awanui); North Island 1953-55,57,58; NZ Trials 1951,53,56,58,60; New Zealand XV 1954,55

Educated Paparore Primary School (North Auckland Roller Mills team) and Kaitaia

College, 1st XV 1946,47. A strong, fast and vigorous loose forward, he was named as a North Island reserve in his first year of first-class rugby as an 18-year-old.

Scored 10 tries – the highest total of any forward – on the 1953-54 British tour when he played in 15 of the 36 matches, including the English and Scottish internationals. His statistics for this tour were given as 6' 2" and 15 stone.

Had two tests against the 1955 Wallabies and the final two in the series against the 1956 Springboks. Scored a memorable try at Eden Park gathering the ball 40 yards out after Ron Hemi had kicked the ball away from the Springbok halfback. Unavailable for the 1957 tour of Australia but played in all three tests against the 1958 Wallabies. Injured in the first test against the 1959 Lions and did not play again in that series. Toured South Africa 1960 but suffered a groin injury after the first test and his appearances were limited to 11 of the 26 games. His weight for this tour was recorded as 17st 2lb.

Terry McLean reported in 1954 that Jones was capable of running 100 yards in less than 11 seconds and said that "with the ball in hand he was the most dangerous man in the team, for he went through obstacles that other men had to go round."

Peter Jones' biography *I'ts Me, Tiger* (A.H & A.W Reed, 1965) was written by Norman Harris. He served as a selector for the Mangonui club and was a member of the North Auckland RFU.

Peter Jones

JOSEPH Howard Thornton
b: 25.8.1949, Christchurch
Centre threequarter

Represented NZ: 1971; 2 matches – 2 tests

First-class record: Canterbury 1968-71 (University); NZ Trials 1970,71; NZ Universities 1968,70,71

Educated Christchurch Boys' High School, 1st XV 1966,67. South Island Secondary Schools rep 1967. Represented his province in his first year out of secondary school aged 18.

After being reserve for the first test against the 1971 Lions Joseph played in both the second and third tests. Described as a good all-round midfield back; weighed 12st 10lb and stood 5' 11" tall. Torn ligaments of the knee suffered in the 1971 season ended his playing career.

JOSEPH James Whitinui

b: 21.11.1969, Blenheim
Loose forward and lock

Represented NZ: 1992-95; 30 matches – 20 tests, 15 points – 3 tries

First-class record: Otago 1989,90 (University), 1991-95 (Southern); NZ Colts 1989; NZ Trials 1992,93,95; South Island 1995; Saracens 1992; Harlequins 1995; NZ Maoris 1991-94; Southern Zone Maoris 1991,93,94

Joseph, a Marlborough product, was one of 15 new All Blacks in 1992, the first year of Laurie Mains as the New Zealand coach. He played in two of the centenary tests and the first against Ireland before touring Australia and South Africa, where he played nine matches, three of them tests.

Joseph, whose early playing days were at lock, was used as a blindside flanker in the All Blacks aside from some replacement appearances. He played in each of the five domestic tests in 1993 and in both tests on the tour of England and Scotland late in 1993 and gained some notoriety when television showed he stepped on England halfback Kyran Bracken during the test at Twickenham. The All Black management said it disciplined Joseph "in house" but did not say what form the discipline took.

Joseph played in only one test in 1994, going on as a replacement against South Africa, but played in five of the six matches at the World Cup in 1995, going on in the final for Mike Brewer.

Joseph took up a contract in Japan shortly after the World Cup and the New Zealand union made an unsuccessful attempt to bring him back for the 1997 Super 12.

Joseph's father Jim was a long-serving prop for Marlborough in the late 1960s and early 70s and played for New Zealand Maoris 1968-72.

Jamie Joseph

KANE Gregory Norman

b: 12.10.1952, Tauranga
Threequarter and second five-eighth

Represented NZ: 1974; 7 matches, 16 points – 4 tries

Greg Kane

First-class record: Waikato 1971-75 (University); Wellington 1976 (University); Bay of Plenty 1979,80 (Tauranga OB); North Island 1974; NZ Trials 1972,74-76; NZ Universities 1972,76; NZ Juniors 1973; NZ Under 21 1972,73

Educated Tauranga Boys' College. First played rugby for Waikato as an 18-year-old. Selected to tour Australia with the 1974 All Blacks, playing five of the 12 matches and later in that year appeared in two games in Ireland.

A strongly built player, weighing 82kg and standing 1.83m, Kane played for the Lyon Olympique Universitaire team in France 1977 but did not play 1978 owing to an injured ankle. Played cricket for Tauranga in the 1970-71 season and represented Waikato at the 1972 NZAAA championships in the javelin. His father, Norman, played rugby for Poverty Bay 1949,50 and a brother, Tony, represented NZ Universities 1979,80.

KANE (Father) Paul

See MARKHAM Paul Francis

KARAM Joseph Francis

b: 21.11.1951, Taumarunui
Fullback

Represented NZ: 1972-75; 41 matches – 10 tests, 343 points – 6 tries, 80 conversions, 51 penalty goals, 2 dropped goals

First-class record: Wellington 1969,70 (Marist), 1972-74 (Marist-St Pat's); Horowhenua 1971 (Horowhenua College OB), 1975 (Paraparaumu); North Island 1973,75; NZ Trials 1972-75; NZ Juniors 1972; NZ Under 21 1972; Manawatu-Horowhenua 1971

Educated St Patrick's College (Silverstream), 1st XV 1966-68 and North Island Secondary Schools 1967. First played for Wellington as a 17-year-old and in the next season scored 108 points in first-class matches. Played as a wing for the Manawatu-Horowhenua combined team against the 1971 Lions.

Selected to tour British Isles and France with the 1972-73 New Zealand team. Owing to injury to the first-string fullback Trevor Morris, Karam played in seven of the first nine games. Made his international debut against Wales and had a fine game showing a magnificent temperament and landing five penalty goals during this match. Played 20 of the 32 matches on the 1972-73 tour including all five internationals.

Appeared in all four matches on the 1973 internal tour and 11 of the 12 games in Australia 1974 completing the tour with 137 points including a record 41 (two tries, 15 conversions, one penalty goal) against South Australia. Scored all of New Zealand's 15 points v Ireland later in 1974 and had his final international against Scotland 1975, converting all of New Zealand's four tries on a heavily flooded Eden Park.

Karam joined the Glenora Rugby League Club 1976 and represented Auckland 1976,77 and the North Island. He was a loss to All Black rugby as he had established a reputation as a reliable fullback with an impressive goalkicking record.

Joe Karam

KATENE Thomas

b: 14.8.1929, Okaiawa *d:* 6.6.1992, Auckland
Wing threequarter

Represented NZ: 1955; 1 match – 1 test

First-class record: King Country 1947,48,54,57,58 (Karioi), 1949,50,52 (Hikurangi); Wellington 1955,56 (Petone); North Island 1955,56; NZ Maoris 1950,52,55-57; NZ Trials 1955,56; Waikato-King Country-Thames Valley 1950

Educated Matapu School. A stocky, hard running wing who could use the hip bump with effective results, also a good goalkicker. Stood 5' 9" and weighed 14 stone. Katene's sole appearance for New Zealand was against Australia in the second test of the 1955 series when he came in for the injured Ross Smith on the right wing.

KEANE Kieran James

b: 9.2.1953, Christchurch
Second five-eighth

Represented NZ: 1979; 6 matches

First-class record: Canterbury 1977-80 (University), 1981-85 (Belfast); South Island 1979; NZ Universities 1978

Educated St Bede's College. First played for Canterbury B 1977, graduating to the A team 1978 mainly as a first five-eighth when Doug Bruce was injured.

His first All Black game was against Argentina at Wellington 1979 and he was later included in the team to tour England and Scotland. Played four of the 10 matches in Britain and against Italy on the journey home. An incisive runner in broken play Keane weighed 74kg and stood 1.73m. His father, David, represented South Canterbury 1948.

KEARNEY James Charles
b: 4.4.1920, Naseby
First five-eighth

Represented NZ: 1947,49; 22 matches – 4 tests, 30 points – 6 tries, 4 dropped goals

First-class record: Otago 1939,41,47,48 (Ranfurly); Canterbury 1942 (Brigade); Ashburton County 1943 (Canterbury Yeomanry Cavalry); South Island 1947,48; NZ Trials 1947,48; 2nd NZEF 1945,46

Educated Ranfurly Public School and St Kevin's College, 1st XV 1935. Progressed from club rugby for Ranfurly through sub-union and country teams to represent Otago.

Selected for the 'Kiwis' army team, he suffered a hip injury and played only 11 of the 38 matches, including the Scottish 'international'. After missing the 1946 season owing to injury, he toured Australia with the 1947 All Blacks, appearing in the second test, and South Africa 1949 playing in the first three internationals and kicking dropped goals in the first two.

A snowy headed five-eighth, standing 5' 8" and weighing 11¹⁄₂ stone, Kearney was noted for his fine handling, anticipation and constant backing up.

Jim Kearney

KELLY John Wallace
b: 7.12.1926, Ashburton
Fullback and wing threequarter

Represented NZ: 1949,53,54; 16 matches – 2 tests, 86 points – 5 tries, 22 conversions, 7 penalty goals, 2 dropped goals

First-class record: Canterbury 1945-48 (University), Auckland 1949 (Training College), 1950-54 (Grammar); South Island 1947; North Island 1954; New Zealand XV 1949,54; Rest of New Zealand 1954; NZ Universities 1946-48

Educated Ashburton High School, 1st XV 1941-44. Selected for Canterbury in his first year out of school as an 18-year-old university student. First appeared for New Zealand in both tests v Australia 1949, playing the first test as a wing and the second at fullback – injured in the latter game and retired after 27 minutes.

Kelly was included in the 1953-54 team to tour the British Isles and France and appeared in 14 of the 36 matches. Although he had to play a supporting role to Bob Scott who was in magnificent form, Winston McCarthy in his tour book *Round the World with the All Blacks* commented: "Kelly had a good tour. In fact next to Scott he was the best fullback I saw on the tour." Standing six feet and weighing 13st 4lb, he was a pacy and effective runner with the ball, particularly adept at joining backline movements and a fine kicker of the ball.

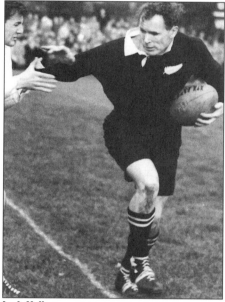
Jack Kelly

A coach of school teams 1950-68 he also coached the Ruawai club and Northern Wairoa Junior team 1958-61. Runner up in the 1945 NZAAA junior shot put and discus titles and South Island junior champion in both events 1944. A Canterbury and Auckland University athletic blue. A brother, G.A.K. Kelly, represented Ashburton County 1938,39,46 and played for South Island Minor Unions 1939 and Hanan Shield Districts 1946.

KEMBER Gerald Francis
b: 15.11.1945, Wellington
Fullback and second five-eighth

Represented NZ: 1967,70; 19 matches – 1 test, 158 points – 43 conversions, 24 penalty goals

First-class record: Wellington 1964,67,69,70 (University); North Island 1966,67; NZ Trials 1966,67,69; NZ Under 23 1967; NZ Juniors 1966; NZ Universities 1965-71

Educated Nelson College, 1st XV 1959-63. A reserve in the first, third and fourth tests during the 1966 series against the British Isles, Kember

Gerald Kember

won selection to tour the British Isles and France 1967. Played in seven of the 17 matches on tour, five times at fullback and twice as second five-eighth.

Reserve again in both internationals against Wales 1969 and in 1970 selected to tour South Africa where he played in 11 matches including the final test. In this international Kember played a fine game and scored 14 of New Zealand's 17 points with a conversion and four penalty goals. Earlier in the tour, he had scored 34 points in the All Blacks' 85-0 win over North Eastern Cape, including 14 conversions in the tally. Two matches for NZ Universities 1971, including the game against the Lions, completed his career.

A reliable player and a consistent goalkicker who weighed 12st 12lb and stood 5' 11". Coached Victoria University junior teams 1974. Played cricket for NZ Universities 1966 and was a Wellington Brabin Cup and Rothmans representative in the 1964/65 season.

KENNY Dean Julian
b: 22.5.1961, Woodville
Halfback

Dean Kenny

Represented NZ: 1986; 3 matches

First-class record: Otago 1981,83-89 (Southern); NZ Colts 1981; NZ Trials 1984,87; NZ Juniors 1984; NZ Emerging Players 1985,86; NZ Maoris 1985,86,88; Maunsell Sports Trust Invitation XV 1987

Educated at Westlake Boys' High School in Auckland and Palmerston North Boys' High, Kenny played for North Island age group teams and the national secondary schools side, and one year of club rugby in Manawatu before moving to Dunedin.

Otago coach Laurie Mains preferred Kenny to future All Black captain David Kirk, though on some occasions Kirk was at halfback and Kenny at first five-eighth.

Kenny was named reserve to Kirk for the four domestic tests in 1986 and was chosen for the tour of France at the end of that year, playing three matches. Strong running and kicking were notable features of Kenny's play.

His father, Merv, played for Auckland B and Combined Services.

KERR Alexander

b: 3.5.1871, Christchurch *d:* 18.6.1936, Christchurch
Loose forward

Represented NZ: 1896; 1 match, 3 points – 1 try

First-class record: Canterbury 1895-97 (Linwood)

Educated Abbotsford School and played rugby for Kaikorai in Dunedin before shifting to Christchurch. Played for New Zealand, and scored a try, against Queensland at Wellington, 1896. Described as "a good lineout forward and works like a Trojan in the scrums", 'Sandy' Kerr weighed 14st 5lb and stood six feet. After selection withdrew from the 1897 team to tour Australia. Coached junior teams for Linwood.

KETELS Rodney Clive

b: 11.11.1954, Papakura
Prop

Represented NZ: 1979-81; 16 matches – 5 tests

Rod Ketels

First-class record: Counties 1974-86 (Pukekohe); North Island 1978-82; NZ Trials 1979,81,82,85; NZ Juniors 1976,77; NZ Colts 1975

Educated Pukekohe East Primary and Pukekohe High School. Made his debut for Counties 1974 as a 19-year-old. Selected for the New Zealand team to tour the British Isles 1978 but was forced to withdraw with a leg injury and was replaced by John Ashworth. Toured England and Italy with the 1979 All Blacks, playing in four of the 11 matches. After playing against Fiji in Auckland 1980 he was chosen for the tour to Wales. Played in four of the seven matches including the centenary test as a loosehead prop. Stood 1.84m and weighed 104kg. In 1981, Ketels played in the first two tests of the year, against Scotland, and toured Romania and France at the end of the year, playing in the Romanian and first French tests.

KIERNAN Henry Arthur Douglas

b: 24.7.1876, Wanganui *d:* 15.1.1947, Otahuhu
Halfback

Represented NZ: 1903; 8 matches – 1 test, 9 points – 3 tries

First-class record: Wanganui 1894,96-99 (Kaierau); Auckland 1900-02,04-08 (Grafton); North Island 1902,03,06

After captaining New Zealand against Wellington Province, 'Mickey' Kiernan went on the 1903 tour to Australia (led by Jimmy Duncan) and played in the first official test match at Sydney. Also captained Auckland in its successful Ranfurly Shield challenge v Wellington 1905.

Described by R.A. Stone in his book *Rugby Players Who Have Made New Zealand Famous* as "a brilliant halfback. He was, on attack, equal to any player this country has produced." Stone ventured the opinion that Kiernan was equal, if not superior to Jimmy Mill. He specialised in blindside tries and was conspicuous on the field, usually wearing white boots.

KILBY Francis David

b: 24.4.1906, Invercargill *d:* 3.9.1985, Wellington
Halfback

Represented NZ: 1928,32,34; 18 matches – 4 tests, 10 points – 2 tries, 1 dropped goal

First-class record: Southland 1925,26 (Star); Wellington 1927,30-36 (Wellington); Wanganui 1929 (Pirates); Taranaki 1929 (Star); North Island 1927,31-33,35; South Island 1926; NZ Trials 1927,30,35

Educated Southland Boys' High School, 1st XV 1921,22. Joined the Southland team 1925 as a 19-year-old and in the following season played for the South Island. Moving to Wellington he was chosen for the North Island 1927. Following this interisland match he was named in the team to tour South Africa 1928. A broken ankle-bone restricted his appearances on this tour to five.

Captained the 1932 and 1934 All Blacks on tours to Australia, playing in all three tests on the first visit while an injury prevented him taking the field in the first test of the latter tour. Also led the North Island 1932,33,35 after which he announced his retirement.

Described as "showing up brilliantly,

especially when playing behind heavy forwards. In defence he has a wonderful sense of anticipation." Kilby stood 5' 6" and his playing weight was around 11 stone. He was considered unlucky by some critics to have missed out on selection for the 1935-36 touring team.

In subsequent years he built up an impressive record in rugby administration including: Wairarapa RFU management committee 1944,45, Auckland selector 1951,52; NZRFU executive 1955-74, manager of the NZ Maoris to Australia 1958 and the 1963-64 New Zealand team in Britain. Elected a life member of the NZRFU 1976. Also represented Southland at cricket.

KILLEEN Brian Alexander

b: 13.4.1911, Wellington *d:* 9.3.1993, Auckland
Second five-eighth and threequarter

Represented NZ: 1936; 2 matches – 1 test, 3 points – 1 try

First-class record: Wellington 1930-34 (Hutt); Auckland 1935-38 (Grafton); Taranaki 1939 (New Plymouth HSOB); Golden Bay-Motueka 1940,41 (Motueka United); North Island 1933,36; NZ Trials 1934,37

Educated Wellington College. First played for Wellington as a 19-year-old and captained Auckland in the mid-1930s and the North Island 1936.

Brian Killeen

A brilliant runner who stood 5' 11" and weighed just over 12 stone, Killeen played at second five-eighth against Australia in the 1936 home series and had a game against South Canterbury as a wing but was dropped for the second international.

Coached the Motueka United club during his last year of rugby 1941 and later coached Gisborne Marist 1949-51 and Grafton 1955,56. Served as secretary of the Motueka sub-union and Golden Bay-Motueka 1941.

KING Ronald Russell

b: 19.8.1909, Waiuta *d:* 10.1.1988, Greymouth
Lock

Represented NZ: 1934-38; 42 matches – 13 tests, 21 points – 7 tries

Ron King

First-class record: West Coast 1928,29,31-39 (Hokitika Excelsior), 1940-45 (Cobden); South Island 1934,36-39; NZ Trials 1934,35,37; West Coast-Buller 1937

Educated Hokitika District High School, 1st XV 1924-28. In his final year at school he represented West Coast as a wing – his first appearance in a provincial career spanning 18 years.

Switched to the forwards in the 1931 season and first won All Black honours on the 1934 tour of Australia. The second test on this tour began an unbroken sequence of 13 international appearances for New Zealand until the outbreak of WWII.

Oliver and Tindill's book on the 1935-36 tour of Great Britain described King as "the best of our forwards for general play. Always fit, he proved an excellent lock and excelled in every department of the game. We could not have done without him". He stood 6' 2" and weighed around 14 stone.

Led New Zealand in the series against the 1937 Springboks and toured Australia 1938. Continued to play provincial rugby during WWII and retired 1945 becoming selector-coach for West Coast 1946-52,64,66 and served on the South Island selection panel 1952-60 and was a New Zealand selector 1957-60. A brother, A. King, also played for West Coast.

KINGI Taituha Peina
See TAITUHA Peina

KINGSTONE Charles Napoleon
b: 2.7.1895, Auckland *d:* 6.5.1960, New Plymouth
Fullback

Represented NZ: 1921; 3 matches – 3 tests

First-class record: Auckland 1920 (Grafton); Taranaki 1921 (Clifton); North Island 1921; NZ Trials 1921

Educated Grafton School. A relatively small fullback (5' 8" and 11 stone), 'Nap' Kingstone had a brief first-class career – a total of 13 games in two seasons due to injuries received in a motor accident in 1922.

He played for New Zealand in all three tests against the 1921 Springboks and his performance in the final, scoreless match on a wet Athletic Park, was rated outstanding. Winston McCarthy described him as "a 'stay-at-home' fullback, always dependable, a good taker of the ball, a safe if not a big kicker, a good tackler and courageous in defence."

Represented Taranaki at cricket captaining that team in the 1926/27 season. His nephew Colin played rugby for Auckland 1941,42,45-47 and for Wellington and Canterbury 1942.

KIRK David Edward
b: 5.10.1960, Wellington
Halfback

Represented NZ: 1983-87; 34 matches – 17 tests, 68 points – 17 tries

First-class record: Otago 1982-84 (University); Auckland 1985,86 (University); South Island 1982-84; North Island 1986; NZ Trials 1983,85

Educated Wanganui Collegiate, 1st XV 1977,78. He studied medicine at Otago University, played for Otago Colts in 1980,81 and for Otago from 1982. He gained national prominence when he played for the winning South Island side against North at Wanganui in 1982. The following year he made his All Black debut on the tour of England and Scotland. He toured Australia and Fiji in 1984.

Kirk, standing 1.73m and weighing 72kg, moved to Auckland for the 1985 season and made his test debut against England, retaining his place for the second test against England and one against Australia. He was selected for the tour of South Africa and on the replacement tour of Argentina he played in the first international but lost his place to the former test halfback, Dave Loveridge, in the second. Kirk was one of only two members of the 1985 side chosen to tour South Africa who did not join the Cavaliers' unofficial tour (the other was John Kirwan). In the absence of the Cavaliers in 1986, Kirk was named All Black captain and led the side in the victory over France and in the lost series to Australia. He lost the captaincy for the end of year tour of France to Jock Hobbs but retained his test place. Kirk had also gained the Auckland captaincy during 1986.

Kirk was named a Rhodes Scholar but delayed taking the scholarship up by a year so he could play on the All Blacks' tour of France.

Kirk became on-field captain of the 1987 World Cup team after the named captain, Andy Dalton, injured a hamstring two days before the first match. Kirk led the All Blacks in each of the six cup games and scored a try in the final against France. His last match for New Zealand was in Sydney a month after the World Cup when the All Blacks regained the Bledisloe Cup.

Kirk took up his Rhodes Scholarship and captained Oxford University.

He coached Wellington 1993-94 while he was working as a policy advisor in the Prime Minister's Department.

Kirk's biography *Black & Blue* was published in 1997 (Hodder Moa Beckett).

KIRKPATRICK Alexander
b: 4.10.1898, Northern Ireland *d:* 25.8.1971, Hastings
Hooker

Represented NZ: 1925,26; 12 matches, 6 points – 2 tries

First-class record: Hawke's Bay 1918-26 (Hastings); North Island 1925; NZ Trials 1924; Hawke's Bay-Poverty Bay 1921; Hawke's Bay-Poverty Bay-East Coast 1923

Came to New Zealand at an early age and educated Woodville District High School. Foundation member of the Hastings club 1918, Kirkpatrick captained Hawke's Bay to take the Ranfurly Shield from Wellington 1922 and appeared in 22 of the 24 successful defences – more than any other player.

A lightweight (12 stone, 5' 11") hooker in the two-fronted scrum, he toured Australia 1925,26 – no internationals were played in either year. Served on the NZRFU council 1952-56 and appeal council 1957-71; president 1956. Deputy mayor of Hastings for 18 years; chairman of the Hawke's Bay Harbour Board; chancellor of the NZ Red Cross 1967-71. OBE and KStJ.

Sweet success . . . David Kirk and the World Cup.

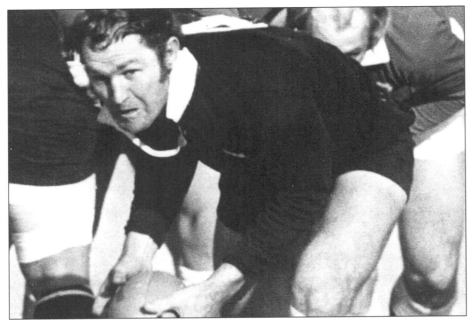

Ian Kirkpatrick . . . 38 consecutive internationals.

KIRKPATRICK Ian Andrew

b: 24.5.1946, Gisborne
Flanker

Represented NZ: 1967-77; 113 matches – 39 tests, 180 points – 50 tries

First-class record: Poverty Bay 1966,70-79 (Ngatapa); Canterbury 1967-69 (Rangiora); South Island 1968,69; North Island 1971-75; NZ Trials 1967-76; NZ Under 23 1967; Poverty Bay-East Coast 1966,71,72,77,78

Educated King's College, 1st XV 1962-64, Auckland Secondary Schools rep 1963,64. Standing 1.90m and weighing 101kg, Kirkpatrick developed into one of New Zealand's finest loose forwards with an extraordinary appetite for scoring tries – his total of 16 in internationals (until 1983) and he scored 115 in a career of 289 first-class matches.

First selected for the All Blacks on the 1967 tour of Britain, France and Canada, winning his international cap against France when he displaced Kel Tremain after 21 consecutive tests on the side of the All Black scrum.

After going on at number eight when Brian Lochore was injured in the 22nd minute of the first test v Australia 1968, Kirkpatrick scored three tries – the first time this had been achieved by an All Black test player since 1935. From this point he played in a then record 38 consecutive internationals, captaining New Zealand in the series against Australia 1972, Britain and France 1972-73 and England 1973 until Andy Leslie was chosen to lead the All Blacks in Australia 1974. Also had the distinction of being the first to captain both the North and South Island teams.

Kirkpatrick was manager of the 1986 tour of South Africa by the unofficial Cavaliers.

Acclaimed by Terry McLean on the 1967 tour as a potential All Black captain: "one born to the purple". Kirkpatrick had great pace and strength and was devastating when running with the ball. A biography, *Kirky* (Rugby Press, 1979), was written by Lindsay Knight. His brothers, David, Colin and John, also represented Poverty Bay with David also playing for Hawke's Bay, having one All Black trial and representing New Zealand at polo. MBE 1980.

KIRTON Earle Weston

b: 29.12.1940, Taumarunui
First five-eighth

Represented NZ: 1963,64,67-70; 48 matches – 13 tests, 42 points – 13 tries, 1 dropped goal

First-class record: Otago 1960-69 (University); South Island 1963,65,68,69; NZ Trials 1963,65-70; NZ Universities 1963-67,69,70; Barbarians (UK) 1971,72; Middlesex 1971,72

Educated St Joseph's Convent School (Upper Hutt) and St Patrick's College (Silverstream), 1st XV 1957. Played for the Upper Hutt club before studying in Dunedin and earning a place in the Otago representative team.

Replaced Bruce Watt for the 1963 interisland match and after a fine display he was included in the trials and was selected to tour the British Isles and France 1963-64 where he played in 13 games. He did not win All Black honours again until he toured Britain and France in 1967 and this time appeared in all four internationals.

Kirton maintained his test position against

Australia and France 1968, Wales 1969, and in two tests in South Africa 1970.

A stocky player, weighing 13 stone and standing 5' 10", Earle Kirton was a reliable five-eighth who ran well and was adept at doubling around an outside back to create an overlap. An accurate tactical kicker, he combined well with his clubmate Chris Laidlaw.

Left New Zealand 1971 to take a post-graduate course in dentistry in England and played for the Harlequins, Middlesex and Barbarians, later becoming selector-coach of the two former teams.

Kirton coached Wellington for two years, 1986 and 1987, and they were unbeaten and won the national championship in his first year.

He was a national selector in 1988 and again from 1992 to 1995, when he sometimes doubled as assistant to coach Laurie Mains.

KIRWAN John James

b: 16.12.1964, Auckland
Wing threequarter

Represented NZ: 1984-94; 96 matches – 63 tests, 275 points – 67 tries (35 in tests)

First-class record: Auckland 1983-94 (Marist); NZ Colts 1983; NZ Trials 1984,87,91,92,94; North Island 1983-85; North Zone 1987,88; Saracens 1992; Barbarians 1984,85,87,94; Marist President's XV 1985; Coronation Shield Districts XV 1994

One of the most devastating wings to play for New Zealand who when in top form was an irresistible try-scorer, as his record of 35 tries in tests and 67 in all matches for New Zealand testifies. At 1.90m and about 90kg, Kirwan was a fearsome runner with the ball, his ferocity on attack complemented by effective sidesteps off either foot.

Kirwan was educated at De La Salle College in Auckland where he played at halfback in the 1st XV in 1980. He played for Auckland Under 18 in 1981-82 and was playing for the Marist third grade when he was first chosen for Auckland. He made an immediate impression for Auckland, the New Zealand Colts and the North Island, prompting comparisons with an earlier young wing of great promise, Bryan Williams.

Kirwan first played for the All Blacks at the age of 18 in two tests against France in 1984 and

John Kirwan . . . 35 tries in 63 tests.

went on the tour of Australia, but his tour was cut short because of a shoulder injury that kept him out for the rest of the year. He returned in 1985 and played in each of the five tests that year, scoring his first test try against England in Wellington. He was chosen for the cancelled tour of South Africa and went on the replacement tour of Argentina, and he and halfback David Kirk were the only players chosen for South Africa who did not join the unauthorised tour in 1986.

Kirwan was an automatic selection for the All Blacks whenever he was fit, as he was throughout 1986 and he made a striking impact on the inaugural World Cup in 1987 when he scored an end-to-end try in the opening match against Italy. Kirwan played in each of the cup matches and scored six tries, including one in the final. He continued to be a headliner for the All Blacks through the late 1980s. In Australia in 1988 he passed Stu Wilson's record of 19 test tries in the first test and by the third test he had scored a try in eight successive tests.

KIRWAN'S TEST TRIES		
1985	1	v England
	4	v Argentina
1987	2	v Italy
	1	v Fiji
	2	v Wales
	1	v France
	1	v Australia
1988	6	v Wales
	4	v Australia
1989	3	v Argentina
1990	2	v Scotland
	1	v Australia
1991	1	v Argentina
	1	v Canada
1992	1	v World XV
	1	v Ireland
	1	v Australia
	1	v South Africa
1994	1	v South Africa
	35	
	8	v Wales, Argentina
	7	v Australia
	2	v Italy, Scotland, South Africa
	1	v Canada, England, Fiji, France, Ireland, World XV

He added another five tests (and three tries) in 1989 before he suffered an achilles tendon injury against Pontypool on the tour of Wales and Ireland and his tour came to an early end. He was back in 1990 doing what he did best, getting two tries in the two domestic tests against Scotland, and he played in each of the tests that year but missed one of the two in Argentina in 1991 because of injury. He played in five of the six tests in his second World Cup, in 1991.

Kirwan's fortunes started to wane in 1992 when, for the first time since his debut, he was not chosen for a test for which he was available – the second of the centenary tests against the World XV. He still got on the field though, as a replacement for fullback Greg Cooper. Kirwan played the two tests against Ireland and in each of the tests on the tour of Australia and South Africa, but increasing questions were being asked about his form, especially early each season when he'd returned from a season in Italy.

In 1993, Kirwan played in two of the three tests against the British Isles and against Australia and Western Samoa, but he was not chosen by coach Laurie Mains for the tour of England and Scotland in October and November. He made it back into the test team for the 1994 series against France and South Africa, but was dropped for the test in Sydney.

Kirwan retired soon after, saying that Mains had "lost the plot". He captained the New Zealand Barbarians in a match against the Australian Barbarians at Mt Smart in a match designed as a farewell to him. He joined the Auckland Warriors league club for two seasons before moving to Japan to play rugby.

Kirwan had also played in two International Rugby Board centennial matches in Britain in 1986 and for the Southern Hemisphere in a 39-4 win over the Northern Hemisphere in Hong Kong in 1991.

A grandfather, Jack Kirwan, played for Hawke's Bay 1921-23 and was an All Black trialist before taking up league.

Kirwan's biography *Running on Instinct* was written by Paul Thomas (Moa Beckett, 1992).

KIVELL Alfred Louis

b: 12.4.1897, Thames *d:* 13.2.1987, Christchurch
Loose forward

Represented NZ: 1929; 5 matches – 2 tests

First-class record: Taranaki 1920,21,23-30 (Stratford); Taranaki-Wanganui 1925; North Island 1926; NZ Trials 1929

Educated Stratford Primary and High Schools. Joined the Stratford club after returning from service in WWI and began his long career representing Taranaki the following year.

Selected as a 5' 9", 13-stone loose forward for the New Zealand team to Australia 1929, at the age of 32. After missing the first part of the tour through injury he played in the last five matches which included the final two internationals.

KNIGHT Arthur

b: 26.1.1906, Auckland *d:* 26.4.1990, Auckland
Loose forward and lock

Represented NZ: 1926,28,34; 14 matches – 1 test, 12 points – 4 tries

First-class record: Auckland 1925-32,34-36 (Grammar); North Island 1928; NZ Trials 1927,30,34,35

Educated Ellerslie School. Joined the Auckland team as a 19-year-old and a year later selected for the tour to Australia, playing in four of the six matches including two of the three encounters with New South Wales.

A hard, uncompromising forward, weighing 15 stone and standing 6' 2", 'Bubs' Knight appeared in all four matches for the All Blacks during the 1928 domestic season but did not play again for New Zealand until the 1934 tour of Australia where he had his only international in the first test.

Younger brother of L.A.G. Knight, the 1925 All Black, and uncle of Lawrie Knight (New Zealand 1974,76,77). A cousin of Wally Knight, Auckland 1937,39; Manawatu 1940,43; Canterbury 1944; NZ Services 1941,42; England Services 1942.

KNIGHT Gary Albert

b: 26.8.1951, Wellington
Prop

Represented NZ: 1977-86; 66 matches – 36 tests, 12 points – 3 tries

Gary Knight

First-class record: Horowhenua 1972 (Paraparaumu); Wellington 1973 (Wellington); Manawatu 1975,76 (Freyberg HSOB), 1977-86 (Palmerston North HSOB); North Island 1977,84,85; Manawatu-Horowhenua 1977; NZ Trials 1978-83; IRB Centenary 1986

Educated Mana College. Regarded as one of the best tightheads to play for New Zealand, Knight stood 1.87m and weighed about 107kg and was a first choice for New Zealand teams from when he was first chosen, on the 1977 tour of France where he played in both tests. Commitments to his farm made him unavailable for some tours and also for the second international against South Africa in 1981.

On the 1978 Grand Slam tour, Knight missed the first two internationals (Ireland and Wales) through suffering from facial herpes, contracted in the All Blacks' opening tour match against Cambridge University. Other misfortunes to come Knight's way in his long test career were being eye-gouged in his first test (against France),hit by a piece of timber during a crowd riot in Fiji, and hit by a flour bomb dropped from the protest aircraft over Eden Park in the third test against South Africa in 1981.

From the 1978 tour by Australia, Knight forged a front row combination with John Ashworth and Andy Dalton that became known as the best front row in world rugby. Knight was a member of the 1986 unofficial side to South Africa and was recalled to the All Blacks for the second and third internationals against Australia.

He combined with Ashworth and Dalton in a 1986 biography, *The Geriatrics* (Moa).

Knight won a national wrestling title in 1973 and the following year won a bronze medal in the over-100kg wrestling class at the Christchurch Commonwealth Games.

KNIGHT Laurence Alfred George

b: 16.7.1901, Auckland *d:* 24.12.1973, Auckland
Loose forward

Represented NZ: 1925; 5 matches, 6 points – 2 tries

First-class record: Auckland 1920-25,28-30 (Grammar); NZ Trials 1924; Auckland-North Auckland 1923

Educated Ellerslie Primary and Auckland Grammar School. First represented his province as a 19-year-old. The same height and weight as his younger brother 'Bubs' (6' 2", 15 stone), Knight was also an uncompromising forward.

Played in three of the trials to select the 1924-25 All Blacks but missed selection for the British tour although he visited New South Wales the next season. Knight's final year in first-class rugby saw him ordered off when playing for Auckland against the 1930 Lions after a difference of opinion with referee Joe Moffitt.

Died just four months before his son Lawrie was named in the 1974 All Blacks. His younger brother, Arthur, played for New Zealand 1926,28,34 and a cousin, Wally, was an Auckland, Manawatu and Canterbury representative and played for New Zealand and England Services during WWII.

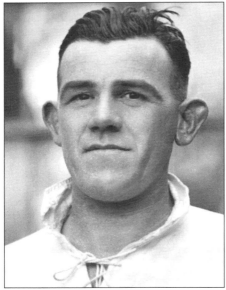

Laurie Knight

KNIGHT Lawrence Gibb
b: 24.9.1949, Auckland
Lock and loose forward

Represented NZ: 1974,76,77; 35 matches – 6 tests, 52 points – 13 tries

First-class record: Auckland 1970,72-74 (Grammar); Poverty Bay 1975-77 (Ngatapa); North Island 1973-75; NZ Trials 1972-77; Poverty Bay-East Coast 1977

Educated Auckland Grammar School, 1st XV 1965-67, Auckland Secondary Schools rep 1966, North Island Secondary Schools rep 1967. Knight toured Australia and Ireland 1974 and South Africa 1976 with All Black teams before making his international debut in the 1977 home series against the Lions. His try in the fourth test won the series for New Zealand. Appeared on the side of the scrum in both tests on the French tour later that year and spent the 1977-78 season playing for the Paris University club, later moving to Johannesburg, South Africa.

Standing 1.91m and weighing 100kg, Knight was described in the *1974 DB Rugby Annual* as "a huge success. Used as lock, number eight and flanker and gave classy displays from all positions. Surprisingly effective at the front of the lineout and second only to Kirkpatrick for driveability with the ball in his hand."

Represented his school at sprinting and cricket. His father, Laurie (1925), and uncle 'Bubs' (1925,28,34), both represented New Zealand.

KNIGHT Michael Orton
b: 20.5.1945, Auckland
Wing threequarter

Represented NZ: 1968; 8 matches, 18 points – 6 tries

First-class record: Hawke's Bay 1964 (Hastings HSOB); Counties 1965-68 (Manurewa); Wellington 1969,70 (Wellington); NZ Trials 1967,68; New Zealand XV 1968; NZ Under 23 Trials 1967; Counties-Thames Valley 1966

Educated Paeroa, Papakura and Hawera primary schools and Hawera Technical College. A fast wing who won selection for the 1968 tour of Australia where he played seven of 11 matches. His statistics were recorded as 5' 11" and 13st 3lb. Also played rugby for Singapore 1971-73 from the Singapore Cricket Club.

National junior 100 yard (10.4 secs) titleholder 1964. Played senior club cricket in South Taranaki 1963. A son of Wally Knight (Auckland 1937-39; Manawatu 1940,43; Canterbury 1944; NZ Services 1941,42; England Services 1947; RAF 1941,42).

KOTEKA Tohoa Tauroa
b: 30.9.1956, Tokoroa
Prop

Represented NZ: 1981,82; 6 matches – 2 tests, 4 points – 1 try

First-class record: Waikato 1978 (Tokoroa HSOB), 1979-84 (Tokoroa Pirates); NZ Trials 1980-83; NZ Juniors 1978,79; NZ Maoris 1980-84

Educated Tokoroa High School, two years in the 1st XV. 'Paul' Koteka was chosen for the 1981 tour of Romania and France and played in the second test against France.

His only other appearance for New Zealand was in the third test against Australia in 1982, when he took the place of John Ashworth, who was unavailable.

A strong scrummager, who weighed 105kg and stood 1.85m. He gave years of service to national and Prince of Wales Cup Maori sides, including the 1982 tour of Wales and Spain.

Lawrie Knight

KREFT Anthony John
b: 27.3.1945, Milton
Prop

Represented NZ: 1968; 4 matches – 1 test, 6 points – 2 tries

First-class record: Otago 1966-71 (Ranfurly); South Island 1968,70; NZ Trials 1967-70

Educated St John's School (Cromwell), Sacred Heart School (Ranfurly), and Ranfurly District High School. Sent to Australia as a reinforcement for the 1968 All Blacks after the touring team had suffered several forward injuries and arrived in time to play against Australian Capital Territory in the fifth match of the tour. Appeared in the final test at Brisbane. A fast and vigorous prop, at the time of the tour he weighed 15st 6lb and stood 6' 1½".

Maniototo sub-union coach 1972-74; sole selector 1975,76; selector 1977,78.

KRONFELD Joshua Adrian
b: 20.6.1971, Hastings
Flanker

Represented NZ: 1995-97; 32 matches – 30 tests, 55 points – 11 tries

Josh Kronfield

First-class record: Otago 1992,93 (University), 1994-97 (Alhambra-Union); Otago Highlanders 1996,97; Otago XV 1992; NZ Trial 1995; Otago Invitation XV 1992; Harlequins 1995; NZ Universities 1993; South Island Invitation XV 1997; NZ President's XV 1996; Barbarians 1997

Josh Kronfeld's early rugby was as a halfback or first five-eighth, though he had become a flanker by the time he was at Hastings Boys' High School, for which he played in the first XV 1987-89. He also played for Hawke's Bay under 16 and 18.

He moved to Dunedin to attend Otago University and though he played in Colts trials for two years he was not selected for the national team. He made his debut for Otago in 1992 and by the following year was the regular openside flanker.

His consistent, committed play earned him selection in the 1995 World Cup training squad and though he broke his jaw in the Super 10 at

the beginning of the 1995 season, he made his test debut against Canada in Auckland.

He was one of the standout players in the cup campaign in South Africa, missing only the match against Japan, and a feature of his play was his close support of the outside backs. He also played in the test against Australia in Auckland but, strangely, was replaced by Michael Jones for the match in Sydney. He went on as a replacement, however.

Kronfeld and his New Zealand and Otago team-mate, Jeff Wilson, were the first All Blacks in 1995 to sign contracts with the New Zealand Rugby Union in the face of the buy-up threat by the Sydney-based World Rugby Corporation.

Kronfeld toured Italy and France at the end of 1995, but an ankle injury sustained in the NPC final against Auckland prevented him from playing in early matches. Fit and ready to play in Bayonne, he rolled the ankle before the match and did not play on tour. The following year, he played in each of the 10 tests and in each of the eight domestic tests of 1997. Surprisingly, he was dropped for the test against Ireland in November 1997, replaced by Andrew Blowers, but he substituted Blowers for the last 20 minutes and regained his test place for the following matches against England and Wales.

He is a distinctive figure on the rugby field for both his speed and commitment in the classic role of the openside flanker, and also for headgear that he made fashionable. As with openside flankers before him, Kronfeld's career has been followed by injury, but that is an occupational hazard in such a high-risk position.

In 1995, when France was continuing to test nuclear weapons in the South Pacific, he drew a Campaign for Nuclear Disarmament logo on his headgear. That was also the year that the All Blacks in France wrote public letters to French President Jacques Chirac deploring the testing programme (which ended in 1996).

Two grand-uncles, David and Frank Solomon, also played for New Zealand. Frank, who played three tests in 1931,32, was the last All Black wing forward.

KURURANGI Robert

b: 4.7.1957, Gisborne
Wing threequarter

Represented NZ: 1978; 8 matches, 16 points – 4 tries

First-class record: Counties 1977-79,81-84 (Ardmore); North Island 1978,82; NZ Trials 1978,79; NZ Juniors 1978; NZ Maoris 1982

Educated Rerekohu Primary and District High Schools before going to Gisborne Boys' High School, 1st XV 1973,74, North Island Under 16 team 1973 and Under 18 team 1974. Played for Wanganui Colts 1975,76 from the Waiouru club.

Selected to tour the British Isles 1978 where he played in eight of the 18 matches. A strong-running wing, he stood 1.78m and weighed 82kg. His father, 'Bo' Kururangi, represented East Coast 1957-62 and was an All Black trialist 1959.

LAIDLAW Christopher Robert

b: 16.11.1943, Dunedin
Halfback

Represented NZ: 1963-68,70; 57 matches – 20 tests, 48 points – 11 tries, 5 dropped goals

First-class record: Otago 1962-67 (University); Canterbury 1968 (Shirley); South Island 1962-

Chris Laidlaw

66,68; NZ Trials 1963,65-68,70; NZ Colts 1964; NZ Universities 1962-67; Oxford University 1968-70

Educated Macandrew Primary and Intermediate Schools and King's High School (Dunedin), 1st XV 1957-61. As an 18-year-old Laidlaw represented Otago, NZ Universities and the South Island then was selected next season for the 1963-64 All Blacks to tour the British Isles and France.

The youngest member of the touring party, Laidlaw stood 5' 9" and weighed 12st 5lb at the time of his selection. Created a fine impression with his cool, mature play and long, accurate passing. His 19 tour games included the French international when he deposed Kevin Briscoe. Played the first test against Australia 1964 and captained the NZ Colts to Australia.

Laidlaw played all four tests against South Africa 1965 and against the 1966 Lions, and three internationals in Britain and France 1967. When Brian Lochore was injured in the first test in Australia 1968, Laidlaw led the All Blacks in the second test. A broken thumb kept him out of the third test v France 1968.

Took up a Rhodes Scholarship at Oxford University and captained the students to a victory over the 1969-70 Springboks in Britain. Returned to New Zealand 1970 and won a place in the All Black team to South Africa that year, playing the first three tests, but an appendix operation forced him to miss the last four games on tour. Returned to Oxford 1971 and later played for Lyon University in France.

Chris Laidlaw was a magnificent passing halfback, supplying his first five-eighth with consistently good ball. He also mastered the controlled kick over his forward pack.

Laidlaw wrote a controversial book, *Mud In Your Eye* (A.H. & A.W. Reed, 1973), after he had finished playing.

He continued in the public eye in senior quasi-government positions in Paris and London, was New Zealand's high commissioner to Zimbabwe in the late 1980s and in 1992 he won a parliamentary by-election in Wellington Central to become the sixth former All Black to become an MP. He was later the Race Relations Conciliator and head in New Zealand of the World Wildlife Fund.

LAIDLAW Kevin Francis

b: 9.8.1934, Nightcaps
Centre threequarter

Represented NZ: 1960; 17 matches – 3 tests, 21 points – 7 tries

First-class record: Southland 1956 (Marist), 1957-59,61,62 (Nightcaps); NZ Trials 1959,60,62

Educated Nightcaps Convent and St Kevin's College. Played with the Collegiate club in Invercargill before joining Marist. A strong-running, hard-tackling centre who weighed 12st 2lb and was 5' 10" tall, Laidlaw was selected for 1960 tour of South Africa.

Played in 14 of the 26 matches in South Africa as well as in two matches in Australia en route and in a match against the Rest of New Zealand after the team's return home. Generally acknowledged as the most improved back on tour, he won a place in each of the final three internationals. Laidlaw made the break and placed the kick for Frank McMullen to score his try late in the third test which enabled New Zealand to draw the match after the conversion had been goaled.

Southland selector 1969-72,82-85 and coach of the Southland Colts 1971,72. His son, Paul, was a threequarter for Southland 1980-86 and for the South Island 1985. He won two national gundog championships.

LAM Patrick Richard

b: 29.9.1968, Auckland
Loose forward

Represented NZ: 1992; 1 match

First-class record: Auckland 1990-94 (Marist); North Harbour 1995,96 (Marist); Canterbury Crusaders 1996; NZ Colts 1989; Western Samoa 1991,94-97; NZ Trial 1992; NZ Samoans 1992

Educated at St Mary's Convent in Avondale, Auckland, and at St Peter's College, Pat Lam was marked out early as a player of great promise. He played for Auckland, the North Island and New Zealand in age grade sides and captained the national secondary schools team on its tour of Japan in 1987. He also captained the New Zealand Colts in 1989 and played sevens for New Zealand.

Despite the early promise, Lam played only one game for New Zealand, in the 40-17 loss to Sydney in 1992. He had been called to the tour as a replacement and was himself replaced in the Sydney match.

Lam played for Western Samoa in the 1991 and 1995 World Cups and was captain in the second.

LAMBERT Kent King

b: 23.3.1952, Wairoa
Prop

Represented NZ: 1972-74,76,77; 40 matches – 11 tests, 6 points – 1 try, 1 conversion

First-class record: Manawatu 1971-74 (University), 1975-77 (Queen Elizabeth College OB); North Island 1973-75; NZ Trials 1972-77; NZ Juniors 1972; NZ Under 21 1972; NZ Maoris 1973,74; Manawatu-Horowhenua 1977

Educated Te Aute College. Created a favourable impression with the 1972 Juniors team in Australia and later that season won a place in the All Black team to visit Britain and France

making his test debut as a replacement for Jeff Matheson during the Scottish international.

Played for the All Blacks on the 1973 internal tour, and against them as a member of the NZ Maoris team; also included in the test against England that season. A surprise omission from the 1974 team to Australia, he was included in the tour to Ireland later that year and appeared in the three major games (v Ireland, the Welsh XV and Barbarians) played in the space of eight days.

A reserve for the 1975 Scottish test, Lambert went to South Africa 1976 playing 13 matches including three tests despite a hamstring injury. He missed the second and third tests against the 1977 Lions while recovering from an appendectomy.

Standing just under six feet and weighing 16st 4lb, Lambert was a very strong prop. He signed with the Penrith rugby league club in Sydney in 1978 but retired from the game after suffering a serious knee injury.

Kent Lambert

LAMBIE James Taylor
b: 9.4.1870, Christchurch *d:* 15.4.1905, Manaia
Forward

Represented NZ: 1893,94; 12 matches, 12 points – 4 tries

First-class record: Taranaki Combined Clubs 1888; Taranaki 1889-94 (Waimate); North Island 1894; NZ Trials 1893

A short, stocky and tremendously powerful man, Lambie was heavily built around the waist and inclined to be bandy. Toured Australia 1893 and played for New Zealand v New South Wales 1894. While representing Taranaki against the touring NSW team he scored three tries. Died from injuries received when his horse kicked him in the head while he was on the way home from watching Taranaki play the 1904 British team. His brother, W. Lambie, represented Taranaki 1895-99.

LAMBOURN Arthur
b: 11.1.1910, Maryborough, Queensland
Hooker and prop

Represented NZ: 1934-38; 40 matches – 10 tests, 9 points – 3 tries

Arthur Lambourn

First-class record: Wellington 1932-34,36-39 (Petone); North Island 1934,37,39; NZ Trials 1934,35,37,39; Middle East Army 1942

Educated Petone Central School and Petone High School. Toured Australia 1934 playing in seven of the eight games including both tests. The following year he was selected for the 1935-36 All Black touring party and appeared in all the internationals among his 22 matches, seven of these as hooker and the rest as a prop.

Missed the 1936 series against Australia but was recalled as hooker for all three tests v South Africa 1937. In Australia the next year he appeared in six of nine matches including the third test – his final game for New Zealand.

In their 1935-36 tour book, Oliver and Tindill commented: "Lambourn played good, solid football in all his games, and must be classed, along with King, as the best forward on the tour." His statistics for this tour were recorded as 5' 10" and 13st 2lb.

Played for the Middle East Army team during WWII and after his retirement from active play Lambourn coached the Petone club.

LARSEN Blair Peter
b: 20.1.1969, Takapuna
Lock and flanker

Represented NZ: 1992-96; 40 matches – 17 tests, 14 points – 3 tries

First-class record: North Harbour 1991-97 (Takapuna); Waikato Chiefs 1996,97; NZ Trials 1991-95; NZ XV 1992,93; North Island 1995; NZRFU President's XV 1995; NZ Colts 1990; NZ Combined Services 1990

Larsen developed rapidly as a rugby player after leaving Rosmini College and was in the North Harbour Colts for two years before being chosen for the New Zealand Colts in 1990.

He was first chosen as a lock in the New Zealand squad for the centenary series in 1992 and played in the second and third tests against the World XV, followed by the first test against Ireland. It was significant to Larsen's career that he made way for the second test against Ireland to Robin Brooke, who thereafter formed with Ian Jones a durable New Zealand locking partnership.

Larsen played eight games on the following tour of Australia and South Africa but without playing a test. He was called into the 1993 tour

of England and Scotland because of injury to Brooke but again did not play in either test. He was chosen as the blindside flanker for the 1994 series against France and South Africa.

He played four matches at the 1995 World Cup – initially, when Brooke was injured – and on the tour later that year of Italy and France played as a flanker in the test against Italy and the first against France.

Larsen filled a reserve role in 1996, going on against Scotland, and played in five matches in South Africa, including one test as a replacement.

Though Larsen began his career as a lock, he was more a standby in that position for the All Blacks and his greatest value was in his being able to cover lock or blindside flanker or even, on occasion, No 8.

Blair Larsen

LAW Arthur Douglas
b: 8.5.1904, Palmerston North *d:* 4.9.1961, Dannevirke
Wing threequarter

Represented NZ: 1925; 4 matches, 3 points – 1 try

First-class record: Manawatu 1924 (Palmerston North HSOB); Manawhenua 1925,26 (Palmerston North HSOB); Hawke's Bay 1928 (Dannevirke OB); Manawatu-Horowhenua 1924

Educated Palmerston North Boys' High School. Came into the Manawatu team as a 20-year-old and continued to play the following two seasons for the combined Manawatu-Horowhenua unions.

A 5' 11", 12st 10lb wing, Law toured New South Wales 1925 playing in four of the six games including two against the state side. Had one match for Hawke's Bay after moving to Dannevirke.

LAWSON Gordon Pirie
b: 15.9.1899, Timaru *d:* 13.9.1985, Timaru
First five-eighth

Represented NZ: 1925; 2 matches

First-class record: South Canterbury 1921-28,30 (Timaru HSOB); NZ Trials 1924; Canterbury-South Canterbury 1925

Educated Timaru Main School and Timaru Boys' High School. He won selection in the New Zealand team to tour New South Wales 1925 and played in two of the team's six matches; listed as standing 5' 9" and weighing 11st 4lb.

After he retired Lawson took an active part in rugby administration, being president of the Timaru HSOB club 1940-47 and a South Canterbury selector 1947. His three brothers, Douglas, Allan and William, also played for South Canterbury.

LECKY John Gage

b: 4.11.1863, Auckland *d:* 6.4.1917, Auckland
Forward

Represented NZ: 1884; 7 matches, 8 points – 4 tries

First-class record: Auckland 1883,86-89 (Grafton)

Lecky was called into the 1884 New Zealand team to visit Australia when J.C. Webster withdrew. He played four matches in the forwards, two as a halfback and appeared as wing forward in the preliminary game against Wellington.

Weighing only 11st 12lb he was one of the lightest forwards in the side. Described by team manager S.E. Sleigh as "a plucky player".

LEESON John

b: 15.11.1909, Morrinsville *d:* 11.3.1960, Morrinsville
Prop

Represented NZ: 1934; 5 matches

First-class record: Waikato 1929-37,42-44 (Kereone); North Island 1933-35; NZ Trials 1934,35; Waikato-King Country-Thames Valley 1930,37; Waikato-King Country 1931

Educated Morrinsville District High School. Remained in the Kereone club's senior team for 30 years and became the club's first All Black when he was selected for the 1934 tour to Australia. Played four matches on tour and went on as a replacement against the Rest of New Zealand on the team's return home.

Standing 5' 9" and weighing only 13 stone, Leeson was a little light to play as a prop at the highest level of rugby but he continued to represent Waikato for a number of years and had his last first-class match for the Harlequins club when a month short of his 45th birthday. Kereone club secretary 1944-59; senior coach and life member 1957. His brothers, George and Ted, also represented Waikato.

LE LIEVRE Jules Mathew

b: 17.8.1933, Akaroa
Prop

Represented NZ: 1962-64; 25 matches – 1 test, 8 points – 2 tries, 1 conversion

First-class record: Canterbury 1954-60 (Marist), 1961-65 (Culverden); South Island 1960-65; NZ Trials 1959-63,65; Rest of New Zealand 1960; New Zealand XV 1960

Educated Akaroa Convent School and St Bede's College (Christchurch). Played for the Akaroa club before joining Marist in Christchurch.

A reliable and tireless tighthead prop standing six feet and weighing around 15 stone,

Le Lievre played six matches on the 1962 tour of Australia but was kept out of the tests by Wilson Whineray and Ian Clarke. Later that season he played his only international, replacing Clarke for the second test against Australia in the home series.

On the 1963-64 tour to Britain and France, he appeared in 18 of the 36 matches but although he displayed consistent form throughout, Whineray, Clarke and then Ken Gray were preferred for the internationals.

Le Lievre played for the South Island in six successive years. Coach of the Culverden club 1961-65 and later president. Selected and coached Hurunui sub-union 1966-68 and Canterbury sub-unions 1969-74.

LENDRUM Robert Noel

b: 22.3.1948, Waiuku
Fullback

Represented NZ: 1973; 3 matches – 1 test, 32 points – 1 try, 5 conversions, 5 penalty goals, 1 dropped goal

First-class record: Counties 1968-79 (Papakura); North Island 1969-72,74,78; NZ Trials 1971-74; NZ Juniors 1969,70; Counties-Thames Valley 1971,77

Educated Papakura South Primary and Papakura High School. An enterprising player and fine goalkicker who began his first-class rugby as a second five-eighth before switching to fullback. Stood 5' 11" and weighed 12st 10lb.

Scored 16 points for the NZ Juniors v Tonga 1969 and 22 points out of his side's 31 in the 1971 interisland. He was included in the 1973 internal tour and the test against England that year.

LESLIE Andrew Roy

b: 10.11.1944, Lower Hutt
Number eight

Represented NZ: 1974-76; 34 matches – 10 tests, 28 points – 7 tries

First-class record: Wellington 1964-77 (Petone); North Island 1977; NZ Trials 1970-72,74-76

Educated Wilford Primary School and Hutt Valley Memorial Technical College, 1st XV 1959,60. After 10 years playing for Wellington, including 96 consecutive appearances 1968-73, Andy Leslie was appointed captain of the 1974 All Blacks to Australia although he had yet to play for New Zealand and was named ahead of the established captain Ian Kirkpatrick who was included in the party.

Leslie's team was unbeaten in Australia (although the second test was drawn) and in Ireland later that year (with a 13-13 draw against the Barbarians). In the next two seasons he led New Zealand to home victories over Scotland and Ireland before the 1976 tour of South Africa where he appeared in 14 of the 24 matches, including all four tests.

The *1976 DB Rugby Annual* said that Leslie was "one of the finest ambassadors New Zealand has ever sent overseas . . . a man of exceptional patience and understanding, traits which helped account for the All Blacks' several sensational comebacks . . . his own number eight play scaled great heights, his leadership was inspiring, sportsmanship always came first in his book." Weighed 14st 2lb and stood 6' 2".

Also represented New Zealand at softball 1966 and was a national water polo player at colts level.

Leslie coached Wellington 1990-92 and also coached extensively in Ireland, including a spell as the Irish union's director of coaching.

One son, Martin, played for Wellington and the Wellington Hurricanes and another, John, played for Otago, the Otago Highlanders, New Zealand Universities and the New Zealand Development team that toured Argentina in 1994.

LEVIEN Howard Joseph

b: 6.9.1935, Taumarunui
Second five-eighth and threequarter

Represented NZ: 1957; 7 matches, 30 points – 9 tries, 1 dropped goal

Andy Leslie scores in South Africa in 1976.

First-class record: Otago 1955-57 (University); South Island 1957; NZ Trials 1957

Educated Taumarunui District High School, 1st XV 1950-52 from where he played for King Country Juniors 1951,52. King Country Roller Mills primary school team 1946,47. A clever attacking midfield back who possessed a deceptive sidestep, Levien weighed 12st 3lb and stood 5' 9".

Appearing in seven of the 13 matches in Australia for the 1957 All Blacks, he finished the tour as equal leading tryscorer with Maurice Dixon. Chosen to visit Japan with the 1958 NZ Juniors, but was involved in a motorcycle accident 1957 and had a leg amputated below the knee.

Levien coached the Otago University Colts 1958-60 and was later secretary of the Thames Valley Primary Schools' RFU. A New Zealand disabled golf champion.

LEYS Eric Tiki

b: 25.5.1907, Wellington *d:* 21.1.1989, Gisborne
Halfback

Represented NZ: 1929; 5 matches – 1 test

First-class record: Wellington 1926,28,29 (University); NZ Trials 1929; NZ Universities 1929

Educated Wellington College. First represented his province as a 19-year-old and was sent to Australia as a replacement after Bill Dalley was injured on the 1929 tour and the first-named replacement, Ivan Bramwell, was unable to travel.

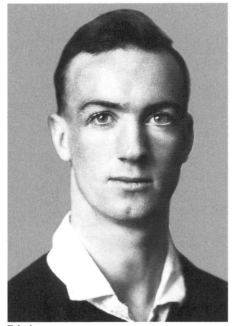
Eric Leys

Arrived in time to play in the fourth tour match and appeared in four others including his sole international, the third test. An injury in a club match on his return virtually ended his playing career although he did appear for the University club after moving to Auckland 1931. Played cricket for the Wellington Town side 1927, won Auckland B grade tennis titles 1936 and represented Auckland at lawn bowls 1959. His father, R.R. Leys, played rugby for Wanganui 1888-91 and Manawatu 1892,93.

LILBURNE Herbert Theodore

b: 16.3.1908, Burnham *d:* 12.7.1976, Dunedin
Five-eighth and fullback

Represented NZ: 1928-32,34; 40 matches – 10 tests, 65 points – 6 tries, 12 conversions, 5 penalty goals, 2 dropped goals

First-class record: Canterbury 1926,27,29,30 (Albion); Wellington 1931-35 (Hutt); South Island 1927,29; North Island 1931-33; NZ Trials 1927,29,30,34,35

Educated Woolston School, Canterbury Primary Schools rep 1921,22. Played in the Albion club's senior team at the age of 16 and two years later represented Canterbury. The following season he played for the South Island, appeared as a replacement in the final trials and was selected in 1928 All Black team to tour South Africa.

Lilburne's statistics for this tour were given as 5' 8" and 12st 1lb. He played 14 of the 22 matches including the third test at first five-eighth and the fourth at fullback. Returned to the five-eighth position for the three tests in Australia 1929 – captaining New Zealand in the first international because of injuries to Cliff Porter and Bill Dalley. At 21 years and 112 days Lilburne was the youngest ever All Black captain in an international. Leading points-scorer with 40 from eight games on the 1929 tour.

Played the first test against the 1930 Lions but then gave way to Mark Nicholls, regaining his place when Nicholls was not available for the fourth test. After appearing in tests against Australia 1931,32,34, Lilburne was a surprise omission from the 1935-36 All Black touring team. Switched to rugby league shortly after playing in the 1935 trials and represented New Zealand v Australia in the same year. Reinstated to rugby after WWII and coached the Zingari-Richmond club.

LINDSAY David Frederick

b: 9.12.1906, Studholm *d:* 7.3.1978, Timaru
Threequarter and fullback

Represented NZ: 1928; 14 matches – 3 tests, 63 points – 22 conversions, 5 penalty goals, 1 dropped goal

First-class record: Otago 1927,30 (University); NZ Trials 1927; NZ Universities 1927

Educated Waimate District High School and Timaru Boys' High School, 1st XV 1922-25. Played his early rugby as a five-eighth but later moved out to the threequarters and fullback. Selected for the South Island in the same season as he made his provincial debut and although injury forced him to miss the interisland match he was named among the 13 certainties to tour South Africa 1928.

Standing 5' 9" and weighing 13½ stone, Lindsay was selected as threequarter for the All Blacks but played all but one of his 14 games at fullback – the position he occupied in the first three tests while an injury prevented him appearing in the final international. Leading pointscorer with 63 on the 1928 tour.

One critic named Lindsay as the man of the match in the first test (lost 0-17 by New Zealand) because of the work he was required to do and described his display as "complete and without blemish in all respects". A shoulder injury restricted his appearances during the next season but he represented Otago again 1930 including the game against Great Britain. Retired after a few club matches in the following year. South Canterbury selector 1945,46.

LINDSAY William George

b: 29.12.1879, Waikouaiti *d:* 15.5.1965, Dunedin
Hooker

Represented NZ: 1914; 4 matches, 3 points – 1 try

First-class record: Southland 1912-15 (Winton), 1918 (Athletic); South Island 1914

First represented Southland at the age of 32 and two years later was called into the 1914 All Black team to tour Australia when an original selection, Peter Williams, was unavailable.

Captained the Invercargill club Athletic (later Marist) when they won the club championship 1918. Shifted to Dunedin and played for the Pirates club until he was 42 and then coached the Taieri and Dunedin clubs and Christian Brothers' School teams. Until three years before his death 'Dad' Lindsay was involved in coaching St Edmond's schoolboys.

Terry Lineen

LINEEN Terence Raymond

b: 5.1.1936, Auckland
Second five-eighth and centre threequarter

Represented NZ: 1957-60; 35 matches – 12 tests, 48 points – 16 tries

First-class record: Auckland 1954-59 (Marist); North Island 1955,58,59; NZ Trials 1957-60; New Zealand XV 1958; NZ Under 23 1958

Educated Vermont Street Marist Brothers' School and Sacred Heart College (Auckland), 1st XV 1950-52. A brilliant midfield back, standing six feet and weighing 12½ stone, Lineen possessed considerable pace and quick acceleration.

Played in both tests on his first All Black tour, to Australia 1957, and all three when the Wallabies visited New Zealand the following year. After appearing in the four tests against the 1959 Lions, Lineen toured South Africa 1960 playing in two matches in Australia and 16 in South Africa missing the fourth test with a dislocated shoulder. Leading try scorer in South Africa with 10 tries.

In his book *Beaten by the 'Boks*, Terry McLean said of Lineen: "as a runner through the broken field he was unsurpassed and because of his speed of foot, his courage and his hardihood he could exert a magnetic effect upon a game". After his retirement he coached a third grade team for the Marist club in Auckland.

A son, Sean, played for Counties in the late 1980s and 29 tests for Scotland between 1989 and 1992.

LISTER Thomas Norman
b: 27.10.1943, Ashburton
Flanker

Represented NZ: 1968-71; 26 matches – 8 tests, 33 points – 11 tries

First-class record: South Canterbury 1962-64,68-71,73,74 (High School OB); Wellington 1965-67 (Athletic); South Island 1968,69,71,74; NZ Trials 1965,67-71; NZ Colts 1964; NZ Juniors 1965,66; South Canterbury-Mid Canterbury-North Otago 1971

Educated Temuka Primary and Waitaki Boys' High School, 1st XV 1960. Selected for the South Canterbury team in his first year playing senior club rugby. A strong, fast and intelligent loose forward, Tom Lister stood 6' 2½" and weighed 15 stone.

Appeared in both tests in his first All Black tour – to Australia 1968. Played in the first test v France 1968, the two against Wales 1969, two in South Africa 1970 and had his final international in the fourth test against the 1971 Lions, ending his All Black career with a try.

Retired from first-class rugby 1972 but returned to represent his province again in the next two seasons; later coaching the South Canterbury Under 18 side. His brother, John, is a professional golfer.

LITTLE Paul Francis
b: 14.9.1934, Auckland *d:* 7.8.1993
Centre threequarter

Represented NZ: 1961-64; 29 matches – 10 tests, 27 points – 9 tries

First-class record: Auckland 1959-63 (Marist); North Island 1962; NZ Trials 1961-63

Educated St Michael's Convent School and Vermont Street Marist Brothers' School. Played for the Marist club in Auckland from 1947 until

Paul Little

his retirement 1964. Represented Auckland Colts 1956-58.

First selected for New Zealand to play in the second test v France 1961 when Terry O'Sullivan withdrew with a sprained ankle. Retained his place for the final test then played in three of the five tests in the home and away series against Australia 1962. Injury prevented him playing against the 1963 English tourists but he appeared in all five internationals on the 1963-64 tour of the British Isles and France.

Standing 5' 11" and weighing 12st 3lb during his All Black career, he was an incisive runner valuable both on attack and defence. In his biography, Colin Meads said: "Paul Little was the best centre in my experience for setting up his wings. Obviously Dick and Caulton capitalised on this. On the rare occasions he went for the gap himself, Little surged through and I will never forget his tackling in the 1963 Welsh test. Shattering stuff!" An Auckland Under 16 selector 1972-76.

LITTLE Walter Kenneth
b: 14.10.1969, Tokoroa
Five-eighth and centre

Represented NZ: 1989-97; 71 matches – 46 tests, 71 points – 15 tries

First-class record: North Harbour 1988-97 (Glenfield); Waikato Chiefs 1996,97; North Zone 1989; Barbarians 1989; NZ Trials 1990-93,95; NZ XV 1993,94

Walter Little had a brilliant schoolboy career, playing for North Island and New Zealand age grade sides, culminating in the New Zealand Under 19 team's 54-9 win against Wales at Pukekohe in 1987. Five of the seven backs in that team became All Blacks.

Within two years and a year after his first-class debut, Little was chosen for New Zealand's tour of Wales and Ireland in 1989 and played in the first match of the tour, against British Columbia in Vancouver, at first five-eighth.

He made his test debut the following year, against Scotland in Dunedin, and played in all seven tests that year. He seemed to be becoming the regular test second-five but after the first of two tests in 1991 against Australia, in Sydney, he was dropped and replaced by Bernie McCahill, who also played the majority of World Cup matches that year. Little returned, however, for the playoff match against Scotland and scored the try that confirmed New Zealand's third place.

Walter Little

In 1992, under new coach Laurie Mains, Little was at centre for the first of the centenary tests against the World XV and then he played at first five-eighth in the two tests against Ireland while Grant Fox was left in the reserves. The normal order of things was restored for the following tour of Australia and South Africa, with Fox at first-five and Little at second.

Injury often disrupted Little's career and he played in only two tests in each of 1993 and 1994 and he missed the 1993 tour of England and Scotland. By 1995, however, he was back as a major factor in the World Cup campaign and played in five of the matches for what was regarded as the dominant team in the competition.

He played in eight of the 10 tests in 1996, including the winning series in South Africa, but injury again sidelined him in 1997. He was back for the tour of Britain and Ireland in November and December, however, and regained his test place for the match against Wales and the second against England, re-establishing his midfield liaison with his North Harbour team-mate, centre Frank Bunce.

An entertaining and elusive player, Little showed the type of flair that could often turn a match, but he also had the solidity required of a second five-eighth and he was a strong defender. But for injury and occasional selectorial caprices, Little's test record could have been much more substantial than it is.

LOADER Colin James
b: 10.3.1931, Dannevirke
Second five-eighth and centre threequarter

Represented NZ: 1953,54; 16 matches – 4 tests, 12 points – 4 tries

First-class record: Wellington 1951 (University), 1952-55 (Hutt); NZ Trials 1953; New Zealand XV 1954,55

Educated Queen's Park (Wanganui) and Eastern (Hutt) Schools and Hutt Valley High School, 1st XV 1948-50. Selected as a second five-eighth for the 1953-54 tour but played in that position in only three of his 16 matches, appearing at centre in the rest including four internationals.

Colin Loader

Standing 5' 10" and weighing 11st 2lb, he was a strong tackler and a penetrating runner. In his tour book Winston McCarthy wrote: "Loader learned much on tour, chief among the lot being that he is more effective at 'second' than centre. A speedy player with a quick chop, he should be of great assistance to New Zealand in the next few years." This prediction was not borne out as he did not win All Black honours again.

Coached the Hutt club after his retirement.

LOCHORE Brian James

b: 3.9.1940, Masterton
Number eight and lock

Represented NZ: 1963-71; 68 matches – 24 tests, 21 points – 7 tries

First-class record: Wairarapa 1959-70 (Masterton); Wairarapa-Bush 1971 (Masterton); Wairarapa-Bush (combined) 1959,65,66; North Island 1964-69; NZ Trials 1961,63,65-70

Educated Opaki Primary School and Wairarapa College, 1st XV 1956. Made his debut for Wairarapa as an 18-year-old flanker. Named as a reserve for the home series v England 1963 and then selected for the 1963-64 British tour where he played in the English and Scottish internationals.

Appeared in all four tests against the 1965 Springboks and, after the retirement of Wilson Whineray, named All Black captain for the series against the 1966 Lions. Led New Zealand in the 1967 jubilee test v Australia and on the British tour later that season. A broken thumb in the first test in Australia 1968 saw Tremain and Laidlaw take over the captaincy until Lochore was pronounced fit enough to play the second and third tests against the 1968 French tourists.

Captained New Zealand against Wales 1969 and in South Africa 1970 – the three test losses in this series were the only international defeats suffered by the All Blacks under Lochore's leadership. Surprisingly recalled by the selectors from semi-retirement to partner Colin Meads as a lock in the third test against the 1971 Lions after a training injury to Peter Whiting.

Lochore captained New Zealand in 18 internationals as a 15½ stone, 6' 3" back-row forward. Terry McLean remarked upon his "dignity" as a leader and wrote: "His physical

fitness was inexhaustible, his anticipation was hawklike, his resolution was impenetrable. Add to this his catching at the lineout, his total engagement in the tight-loose, his serviceability on defence and you have the picture of a great back-row forward. New Zealand has fielded none better, that's for sure."

In his biography Colin Meads said of Lochore: "At the peak of his career, from 1966 through till 1969, he was everything I would want in a number eight. He spared himself not an ounce working away in the tight-loose, covering, covering, winning us great lineout ball in the deep, backing and filling and playing his part in the rolling drive-and-feed. As a captain he could be self-effacing – for this was the very nature of the man – yet in his way was as effective as Whineray had been."

Coach of the Masterton club 1966,67,75-78; club president 1977,78. Wairarapa-Bush coach 1980-82. NZRFU selector 1983-87, coach 1985-87 (World Cup winners). Coached overseas invitation teams celebrating IRB centenary 1986. Honorary member of the Barbarians (UK). Wairarapa tennis representative 1957-61,79,80. OBE.

Lochore retired from coaching after winning the 1987 World Cup, but continued to be in great demand for ad hoc rugby positions, among others. He was a co-selector and manager of the World XV that played three tests against the All Blacks in 1992 to mark the New Zealand union's centenary.

Lochore played a crucial role in the 1995 World Cup after being appointed campaign manager to work with manager Colin Meads and Laurie Mains and, after the cup, worked with a New Zealand union councillor, Jock Hobbs, to contract All Blacks in the face of the threat from the World Rugby Corporation.

He has been in demand from other sports as well. Netball New Zealand co-opted him onto a committee to choose a new coach and in 1997 he became chairman of the Sports Foundation's high performance funding committee, the body responsible for allocating the major New Zealand sports grants.

Three journalists – Alex Veysey, Gary Caffell and Ron Palenski – combined to produce his biography *Lochore* which was published in 1996 (Hodder Moa Beckett).

LOCKINGTON Terence McClatchey

b: 26.3.1913, Waihi
Flanker

Represented NZ: 1936; 1 match, 3 points – 1 try

First-class record: Auckland 1933-38 (Grammar); North Island 1936,38

Educated Waihi High School and Auckland Grammar School, 1st XV 1929. Played in the first Roller Mills Shield primary schools' tournament 1925 as a member of the Goldfields team.

Standing 6' 2" and weighing around 14 stone, he was described as "a typical hunting forward, fast, tall and with good hands." His sole game for the All Blacks was against South Canterbury between the two tests against the 1936 Wallabies. Injuries prevented his appearance in that series and kept him out of the 1937 trials.

Coached a grade team for the Grammar club 1935-37 and served on that club's committee.

LOE Richard Wyllie

b: 6.4.1960, Christchurch
Prop

Represented NZ: 1986-92,94,95; 78 matches – 49 tests, 44 points – 10 tries

First-class record: Canterbury 1980,81 (Glenmark); Marlborough 1982-85 (Awatere); Waikato 1986-93 (Fraser Technical); Canterbury 1994,95 (HSOB), 1996 (Ashley); Canterbury Crusaders 1996; Waikato Chiefs 1997; NZ Trials 1987,89-91,94,95; NZ XV 1992; North Zone 1987-89; South Island 1995; NZRFU President's XV 1995; UK Barbarians 1990; NZ Juniors 1982; NZ Emerging Players 1985; Nelson Bays Invitation XV 1985

One of the most controversial players to have been an All Black, but also one of the most durable and effective props. Loe was educated at Christchurch Boys' High School and after five years of first-class rugby was regarded as being close to national selection in 1986. He did play

Brian Lochore and Mike Campbell-Lamerton lead their sides out for the first test of the 1966 series.

for the All Blacks that year, but entered through the back door by being called up from the French club Lyon to reinforce the All Blacks on their tour of France.

He first gained orthodox selection the following year for the inaugural World Cup, playing in the pool matches against Italy and Argentina. He toured Japan later that year and became a regular test prop after the retirement of Aucklander John Drake. Loe's ability to play on either side of the scrum also counted greatly in his favour.

Richard Loe

Loe, Steve McDowell and Sean Fitzpatrick formed a formidable front row through the late 1980s and early 1990s when the All Blacks went on an unbeaten test streak of 23 matches, Loe's status as an automatic test selection continuing through 1992.

He was found guilty of eye-gouging the Otago fullback, Greg Cooper, in the national provincial championship final in Hamilton in 1992 and was banned for nine months, reduced to six months on appeal. It effectively kept him out of rugby in 1993, though he did play late in the season for Waikato.

By 1994, Loe was back in his home province of Canterbury and regained his test status for each of the six internationals that year. He made the World Cup squad in 1995, joining Fitzpatrick and Zinzan Brooke as the only All Blacks to play in each of the three cup tournaments, but his test spot by then had gone to Craig Dowd. Loe played in two of the early matches and went on in the final for Dowd.

The 1995 tour of Italy and France marked Loe's last days with the All Blacks and coach Laurie Mains gave him the captaincy for midweek matches in Bayonne and Nancy. His last match was as a brief replacement in the test in Paris.

The eye-gouging incident was not the only time Loe was cited for ill-discipline, but it was the most notorious and it gave him an unwanted cachet in New Zealand rugby. It sometimes overshadowed his value as a prop, especially his immense strength in scrummaging and mauling, and his value off the field as a team man.

Loe captained the Canterbury Crusaders in the first year of the Super 12, played for the Waikato Chiefs in 1997, then announced his retirement because of a neck injury.

LOMAS Arthur Robert

b: 15.11.1894, Thames *d:* 24.3.1975, Thames
Hooker

Represented NZ: 1925,26; 15 matches, 9 points – 3 tries

First-class record: Auckland 1920 (Thames RSA), 1924,25,28 (Thames City); North Island 1926; NZ Trials 1924; Auckland-North Auckland 1921

Served with the Auckland Mounted Rifles during WWI. A leading member of the Thames sub-union side which held the Peace Cup in the early 1920s, 'Mick' Lomas also appeared occasionally for the Auckland provincial team, including the Auckland-North Auckland combination against the 1921 Springboks, but travel difficulties prevented his playing regular representative rugby. Weighed 13st 12lb and stood 5' 10".

Performed well in the 1924 trials and was considered unlucky to miss selection for the 'Invincibles'. Scored a try for Auckland in their 14-3 defeat of the touring team. Played in all eight matches for the 1925 All Blacks in Australia and New Zealand and, with 'Bunny' Finlayson, was selected in the side, which included 13 of the 1924-25 team, to play New South Wales later in season. Toured Australia again 1926 appearing in the three encounters with New South Wales.

'Mick' Lomas

LOMU Jonah Tali

b: 12.5.1975, Auckland
Wing

Represented NZ: 1994-97; 29 matches – 20 tests, 100 points – 20 tries

First-class record: Counties 1994-97 (Weymouth); Auckland Blues 1996; NZ Trials 1994,95; North Island 1995; President's XV 1995,96; Barbarians 1994,96; Harlequins 1995; Coronation Shield Districts XV 1994; NZ Colts 1994

A sporting phenomenon, Lomu's rise and the coincidental introduction of professionalism in rugby took him to superstar status, a world celebrity beyond anything New Zealand rugby had experienced.

It was evident from his days at Wesley

College in Pukekohe that Lomu, then a loose forward and towering over his team-mates, was something special. Just how special, or rare, was beyond imagination. He was in the college's first XV for five years and was a regular in Counties schools and age grade sides. He was a lock for the New Zealand Under 17 team in 1991 and 1992, No 8 for the national secondary schools side in 1992 and 1993, and in the national Colts in 1994.

Even before his first-class debut, as a wing for Counties in May 1994, he had gained national attention with his astonishing play at the national sevens tournament in Palmerston North and for the New Zealand team at the annual Hong Kong tournament.

His second first-class game was an All Black trial in 1994, and he was chosen for the two lost tests against France, in which he displayed his astonishing power and speed, but also his tactical naivete and he was dropped for the following series against South Africa. At 19 years and 45 days, he had become the youngest All Black to play a test and, at just under two metres and weighing 112kg, the biggest back.

Lomu, whose ancestry is Tongan, was included in the All Black training squad for the World Cup and questions were raised publicly over his fitness and commitment and, for all his power and skill, there were doubts he would be included in the squad for the cup. Coach Laurie Mains had been joined by Brian Lochore as a campaign manager and together they talked to Lomu about what he needed to do if he was going to be more than a two-test All Black. The transformation was startling.

After the first cup match, with Ireland beaten 43-19 and Lomu scoring two tries, he was the talk of the tournament. He also played in the pool game against Wales and the quarterfinal against Scotland, but it was the semifinal against England in which Lomu was at his most devastating and gave him a fame beyond rugby. He scored four tries, a feat in itself, but it was the manner in which he scored them, particularly one in which he ran through England fullback Mike Catt, that made him the most celebrated rugby player in the world.

His name had been linked with league clubs in Australia and Britain and even with the Dallas Cowboys American football team, but when the dust settled after the acrimonious battle for contracts between the New Zealand union and the World Rugby Corporation, Lomu said he was staying with rugby. He was reported as being the highest-paid player on the NZRFU books, in addition to personal endorsements with multinational companies. Unusually, his fame transcended the normal bounds of New Zealand rugby interests and the first television commercial he made was one for pizzas in Britain, in which he featured with two of the beaten England players, Rory and Tony Underwood. He gained a jetsetter's celebrity status, stories and pictures of him appearing in magazines in countries in which rugby is a barely-noticed pursuit.

The fame also led to unwanted publicity, such as being booked for speeding and driving without a licence in Taranaki and not inviting his parents to his wedding to a woman he met during the World Cup, Tanya Rutter. A replica wedding was later held in South Africa, to which both sets of parents – and television – were invited.

Amid the publicity, Lomu continued to be a rugby player and he toured Italy and France in 1995, playing in each of the three tests. His form in 1996 was not of the same quality as it had been the year before and, after playing in five domestic tests, he did not play in any of the

Jonah Lomu . . . a star quality that almost defies definition.

winning series in South Africa. He had also been injured.

He said in early 1997 that he was withdrawing from all rugby so that he could be treated for a rare kidney disease and there were concerns that he might not play rugby again. But after an intensive course of treatment with what doctors called powerful drugs, he reappeared for Counties-Manukau late in the season and was, to no one's surprise, chosen for the All Blacks' tour of Britain and Ireland. He was not selected for the first test, against Ireland, but played against Wales and in both tests against England.

Lomu would have been a rugby phenomenon in any era but his rise coinciding with the new environment of professional rugby took him and the game to unprecedented heights of publicity and income-generating attraction. He is not the perfect rugby player and other All Blacks of his and other eras have been more skilful, but none in New Zealand, or anywhere else, has been able to match his combination of strength and speed and a star quality that almost defies definition. In purely rugby terms, Lomu's strength and speed with the ball in hand not only made him almost unstoppable at times but it meant too that more space and time was created for his team-mates. In purely commercial terms, Lomu is a goldmine.

LONG A.J.
b: ? *d:* ?
Forward

Represented NZ: 1903; 10 matches – 1 test, 12 points – 4 tries

First-class record: Auckland 1902,03 (Newton); North Island 1902,03

Little is known of 'Paddy' Long who toured Australia with the 1903 New Zealand team, playing in the first official test match. He was described by R.A. Stone as a great forward who put every ounce into the scrum at the right time and excelled in the loose.

Long was suspended by the Auckland RFU 1904 for his involvement in offering a bribe to a player from the City club – the suspension was lifted in 1911.

LOVEDAY John Kelman
b: 1.5.1949, Palmerston North
Lock

Represented NZ: 1978; 7 matches

First-class record: Manawatu 1969,74-79 (Palmerston North HSOB); North Island 1978; NZ Trials 1976-79; Manawatu-Horowhenua 1977

Educated Palmerston North Boys' High School, 1st XV 1964-66. Played two matches for Manawatu before spending the next four years at Palmer College of Chiropractic in the USA.

Selected for the 1978 tour of the British Isles where he played seven of the 18 matches after missing some of the early games with back trouble. Weighed 102.1kg and stood 1.93m.

In his tour book *Grand Slam All Blacks* (Methuen, 1979) Keith Quinn commented: "Loveday's back caused early problems but he returned to play a role that was more significant than the list of mid-week appearances suggests.

His games against the Welsh teams of Monmouthshire and Bridgend were of the highest quality."

LOVERIDGE David Steven
b: 22.4.1952, Stratford
Halfback

Represented NZ: 1978-83,85; 54 matches – 24 tests, 36 points – 9 tries

First-class record: Auckland 1973 (University); Taranaki 1974-86 (Inglewood); NZ Juniors 1975; North Island 1978,79,85; NZ Trials 1977-82,85; IRB Centenary 1986

Educated at Inglewood High School, 1st XV 1969, Loveridge played third and fourth grade for Taranaki before transferring to Auckland where he made his first-class debut. He returned to Taranaki in 1974 and the following year was chosen for the Junior All Blacks, playing in that team's 'test' against Romania.

He was the reserve All Black halfback in the 1978 series against Australia and was chosen for the Grand Slam tour at the end of that year, playing in the Welsh test after his great rival, Mark Donaldson, was forced out by injury. In 1979, Loveridge captained a second-string New Zealand team in two wins over Argentina and on the end of year tour of England and Scotland he gained test selection ahead of Donaldson.

With Graham Mourie unavailable, Loveridge captained the All Blacks on their 1980 tour of Australia and Fiji and later that year toured North America and Wales, playing in the one test against Wales. By then established as the number one halfback, Loveridge was an automatic choice for the next three years but was unavailable for the 1983 tour of England and Scotland. Early in the 1984 season, Loveridge tore the medial ligament in his left knee and missed the rest of the season, raising doubts whether he would ever play again. But he returned to first-class play in 1985, was reserve for the three domestic tests (two against England and one against Australia) and named in the side to tour South Africa. He went on the replacement tour of Argentina, playing in the second test, and in 1986 went on the unofficial tour of South Africa. He announced his retirement from test rugby after that tour and later that year went to England to play for the Harlequins club.

Dave Loveridge . . . one of the finest halfbacks to play for New Zealand.

'Trapper' Loveridge, who was regarded as one of the finest halfbacks to play for New Zealand, combining a long, swift and accurate pass with deceptive strength and fast, elusive running, stood 1.75m and weighed 75kg.

LOVERIDGE George

b: 15.10.1890, New Plymouth *d:* 28.11.1970, New Plymouth
Wing threequarter

Represented NZ: 1913,14; 11 matches, 20 points – 6 tries, 1 conversion

First-class record: Taranaki 1912-15 (Tukapa); North Island 1913

Educated Central School (New Plymouth). Began his rugby career as a halfback but played most of his football as a threequarter.

On the 1913 tour of North America Loveridge appeared once at halfback, second five-eighth and centre and four times on the wing. Owing to injury he played only twice on the 1914 Australian tour. Scored five tries for Taranaki v Wanganui 1914. President of the Tukapa club 1958,59.

LUCAS Frederlck William

b: 30.1.1902, Auckland *d:* 17.9.1957, Auckland
Threequarter

Represented NZ: 1923-25,28,30; 41 matches – 7 tests, 75 points – 25 tries

First-class record: Auckland 1920-23,25-27,29,30 (Ponsonby); Auckland-North Auckland 1923; North Island 1924,26,29; NZ Trials 1924,27,30

Educated Remuera Primary School and Seddon Memorial Technical College. While playing for the Ponsonby third grade team he made his debut for Auckland as an 18-year-old in a 1920 Ranfurly Shield challenge although he did not become a regular member of the provincial side until 1923.

In that year he appeared for the All Blacks in two of the three games against New South Wales. Standing 5' 10" and weighing 10st 4lb, Lucas was described as "fast, elusive and clever with a superb stop, swerve and sidestep". He was also highly regarded as a defensive player and was equally at home at either centre or wing threequarter.

Top scorer with six tries on the 1924 tour of New South Wales before leaving with the 'Invincibles', playing in the Irish and French internationals. Played for New Zealand against New South Wales at Auckland in 1925 and was selected for the 1926 Australian tour but withdrew. Played in the fourth test in South Africa 1928 when Syd Carleton, the centre for the other tests, was injured. Appeared in two other tests on the wing and two at centre against the 1930 British team and captained Auckland to a 19-6 victory over the tourists.

A popular figure in rugby circles, Fred Lucas was well known for his immaculate appearance. A foundation member of the Barbarians club, coached the Ponsonby club during the 1930s. Auckland selector 1938-46; North Island selector 1939-46 and an All Black selector 1945,46.

Lucas was also prominent in other sports representing the Piha Surf Club at national lifesaving championships and winning the Auckland B grade tennis singles. His older brother, 'Snow', also played rugby for Auckland

Fred Lucas

and was a member of the 1919 NZ Army team. His son, 'Buddy', was a national swimming champion who represented New Zealand at Empire Games 1950,54; winning a gold medal in the 1950 4 x 220yd relay and a silver in the 1954 330yd medley relay.

LUNN William Albert

b: 17.9.1926, Alexandra *d:* 22.12.1996, Alexandra
Flanker

Represented NZ: 1949; 2 matches – 2 tests

First-class record: Otago 1949,50 (Alexandra), 1952,53,56 (Pirates); NZ Trials 1950,53; New Zealand XV 1949

Educated Alexandra District High School. Played for Lincoln College 1943,44 and represented the Ellesmere, Vincent and

Bert Lunn

New Zealand Representatives

Maniototo sub-unions during the 1940s and 50s.

A 14-stone flanker, standing just over six feet, Bert Lunn played in both tests against the 1949 Wallabies in his first season of first-class rugby. Described as "a good honest lineout forward, a fierce rucker and hard tackler in the best Otago tradition".

Coached the Alexandra and Ranfurly clubs and the Maniototo sub-union.

LYNCH Thomas William

b: 6.3.1892, Milton *d:* 6.5.1950, Clyde
Wing threequarter

Represented NZ: 1913,14; 23 matches – 4 tests, 113 points – 37 tries, 1 conversion

First-class record: South Canterbury 1911-14 (Celtic); Southland 1921,22 (Northern); South Island 1911-14

Educated St Patrick's College (Wellington), 1st XV 1907. A brilliant threequarter and prolific try scorer, he played in the first test against Australia, scoring three tries, and recorded another three v Wellington, before touring North America with the 1913 New Zealand team. Leading try scorer on tour with 16 from 13 games.

In Australia 1914 Lynch appeared in all three tests and scored a further 16 tries in 10 matches. Played for Trentham Military Forces during WWI and Southland after the war. His father, T.W. Lynch, represented Otago 1888-90 and the South Island against the 1888 British tourists. His son, Tommy, was a 1951 All Black.

LYNCH Thomas William

b: 20.7.1927, Naseby
Second five-eighth

Represented NZ: 1951; 10 matches – 3 tests, 27 points – 8 tries, 1 dropped goal

First-class record: Otago 1947,49 (Southern); Canterbury 1950,51 (Marist); South Island 1950,51; NZ Trials 1951

Educated St Gerard's School (Alexandra) and Alexandra District High School. Toured Australia with the 1951 All Blacks playing in all three tests as a 13st 2lb, 5' 10" second five-eighth. Scored tries in the second and third tests and won praise for his all-round play.

Played rugby league for the English club Halifax 1952-56. A member of Otago's Brabin Cup (1945-46) and colts (1947) cricket teams. Lynch's father, Tom, was an All Black 1913,14 and his grandfather, also named Tom, played for Otago 1888-90 and the South Island 1888. Tom Coughlan, a 1958 All Black, was a cousin while his brother-in-law, J.F. Anderson, represented Otago and the South Island 1958.

MABER George

b: 2.11.1869, Kaiapoi *d:* ?
Forward

Represented NZ: 1894; 1 match

First-class record: Wellington 1893,94 (Petone)

A loose forward who weighed 11st 12lb, Maber was described as being of "wiry build, any amount of dash and a good collarer." Played for New Zealand against New South Wales at Christchurch 1894.

McATAMNEY Francis Stevens

b: 15.5.1934, Middlemarch
Prop

Represented NZ: 1956,57; 9 matches – 1 test, 6 points – 2 tries

First-class record: Otago 1954-57 (Strath Taieri); South Island 1956; NZ Trials 1956,57; New Zealand XV 1955

Educated Middlemarch Primary, Strath Taieri High School and St Kevin's College, 1st XV 1949,50. Played his early rugby for the Maniototo sub-union and Otago as a lock but was selected for the second test against the 1956 Springboks as loosehead prop.

Toured Australia with the 1957 All Blacks when his statistics were recorded as 14st 9lb and 5' 11". Coached the Ranfurly club 1960-62 and Geraldine 1971-79. South Canterbury selector 1983.

A son, Steven, played for South Canterbury 1984,85.

Frank McAtamney

McCAHILL Bernard Joseph

b: 28.6.1964, Auckland
Second five-eighth and centre

Represented NZ: 1987-91; 32 matches – 10 tests, 16 points – 4 tries

First-class record: Auckland 1984-93 (Marist); NZ Colts 1984,85; NZ Trials 1987,89,90,92; North Zone 1987-89; NZ XV 1991; NZ B 1991; NZ Barbarians 1987

Educated at St Peter's College in Auckland, McCahill showed early promise but found it difficult to break into an established Auckland team, a problem he also had when he became an All Black.

He was first chosen for New Zealand for the first World Cup and played in the pool match against Argentina and was a replacement in the quarterfinal against Scotland and the semifinal against Wales. McCahill was called into the 1988 tour of Australia as a replacement and in 1989 also went on in tests against France and Argentina.

His role was as a midweek player, either at second five-eighth or centre, in Wales and Ireland in 1989, France in 1990 and Argentina in 1991, though he was a first choice for four of the World Cup matches in 1991, including the semifinal against Australia, which turned out to be his last match for the All Blacks.

Bernie McCahill

A workmanlike midfielder who was also tried on the wing, McCahill's early progress was blocked by test incumbents Joe Stanley and Warwick Taylor and later by John Schuster and Craig Innes.

McCARTHY Patrick

b: 28.6.1893, Wellington *d:* 1.7.1976, Brisbane
Halfback

Represented NZ: 1923; 1 match

First-class record: Canterbury 1923 (Marist); South Island 1923

Educated Napier Boys' High School and St Patrick's College (Wellington). In a brief rugby career he played one match for Canterbury 1923 before winning selection in the South Island team. His match for the All Blacks against New South Wales at Christchurch completed his first-class career.

McCASHIN Terence Michael

b: 18.1.1944, Palmerston North
Hooker

Represented NZ: 1968; 7 matches, 3 points – 1 try

First-class record: Horowhenua 1963,64,68,69 (Horowhenua College OB); Wellington 1965-67,70 (Athletic); King Country 1972 (Pio Pio); Marlborough 1977 (Waitohi); NZ Trials 1967-69; NZ Juniors 1966; NZ Colts 1964

Educated Dannevirke and Levin Convent Schools and Horowhenua College. A reliable hooker who gained All Black honours when he toured Australia 1968, playing in seven of the 12 matches on tour. Weighed 13st 10lb and stood 5' 10".

After playing for King Country 1972 McCashin had a five-year gap before making three appearances for Marlborough. Coached Horowhenua OB club 1969, Pio Pio 1972 and Waitohi 1975,76. His father, B.L. McCashin, represented Manawatu 1938,39, King Country 1944 and Horowhenua 1946-48. A brother, B.J. McCashin, represented Horowhenua 1964,65.

McCAW William Alexander

b: 26.8.1927, Gore
Number eight and flanker

Represented NZ: 1951,53,54; 32 matches – 5 tests, 18 points – 6 tries

First-class record: Southland 1949-55 (Marist); South Island 1950-54; NZ Trials 1950,51,53; New Zealand XV 1952,54,55

Educated Marist Brothers' High School (Invercargill) and St Kevin's College, 1st XV 1944,45. After two years at Training College in Dunedin he returned to Invercargill and won a place in the provincial side as a 13st 9lb loose forward standing 5' 11".

Toured Australia 1951 and appeared in all three tests, the first two on the side of the scrum and the third at number eight. Injury restricted his rugby in the next season but he was selected for the 1953-54 British tour and played in 22 of 36 matches including the Welsh and French internationals and captained the All Blacks against North of Scotland.

Described by Terry McLean as "the Johnny-on-the-spot man of the team", while tour commentator Winston McCarthy praised McCaw as the unobtrusive worker. "A great success at number eight, whether it was on attack or defence. An intelligent player who was always there when wanted".

Coach, club captain and president of the Marist club in Invercargill 1956-58. A Southland and South Island softball representative.

McCLEARY Brian Verdon

b: 17.1.1897, Dunedin *d:* 2.7.1978, Martinborough
Hooker

Represented NZ: 1924,25; 12 matches

First-class record: Canterbury 1920,23 (Marist), 1924 (Culverden); South Island 1923,24; NZ Trials 1924

McCleary made his first-class debut with five games for Canterbury 1920 but did not appear again until 1923 when he played against NZ Maoris and in the interisland match. The following season he was selected for the All

Terry McCashin

Black trials and was named among the certainties for the 1924-25 tour after the interisland fixture. He was then playing for the Culverden club.

Played in Australia and at home for the All Blacks before departing for Britain where he appeared only nine times, being kept out of the major games by the front-row combination of Quentin Donald and Bill Irvine. Stood 5' 9" and weighed around 13 stone.

A fine boxer, McCleary was New Zealand and Australasian amateur heavyweight champion 1920 and 1921 (beating another future All Black, Maurice Brownlie, to win the national title). Turned professional 1922 after an unbeaten amateur record of 32 bouts, and was New Zealand heavy and light-heavyweight champion in that year. Lost both titles 1923, the former to future world title challenger Tom Heeney. His father, Jim, played rugby for Wellington 1888 and Otago 1890,91.

McCLYMONT William Graham

b: 22.6.1905, Lawrence *d:* 21.5.1970, Waitati
Wing threequarter

Represented NZ: 1928; 3 matches, 3 points – 1 try

First-class record: Otago 1927-29 (University); South Island 1928,29; NZ Trials 1927,30; NZ Universities 1929

Educated Tokomairiro District High School. Played his early rugby as a wing forward before switching to the left wing and occasionally appearing as a five-eighth. Had played only three games for Otago when he was named in the 1927 South Island team.

Described as "handling the ball well, fast and determined, and could beat the defence with a tricky run or sidestep", 'Monty' McClymont played in all three matches for New Zealand against the 1928 New South Wales tourists. Transferred to the Southern club 1930 but was injured in the All Black trials in that year and did not play again.

Coached the Southern club 1931-33 and Otago University 1935. Author of the official war history, *To Greece.*

McCOOL Michael John

b: 15.9.1951, Hastings
Lock

Represented NZ: 1979; 2 matches – 1 test

First-class record: Hawke's Bay 1972-78 (Celtic); Wairarapa-Bush 1979-83 (Pongoroa United); NZ Trials 1979; NZ Juniors 1974

Educated Kereru School and St Patrick's College (Silverstream), 1st XV 1968. A 107kg, 1.93m lock, McCool came to notice with a stirring game for Wairarapa-Bush against Wellington in 1979. He subsequently played a good All Black trial and was named in the 1979 team to Australia when Frank Oliver was unavailable to tour with an injury suffered in the earlier series against France. McCool appeared in both tour games, against Queensland B and Australia.

McCORMICK Archibald George

b: 23.2.1899, Christchurch *d:* 8.2.1969, Christchurch
Hooker

Represented NZ: 1925; 1 match

First-class record: Canterbury 1924-26 (Hinds), Ashburton County 1927 (Hinds), 1929,30 (Methven); South Island 1925; Canterbury-South Canterbury 1925; South Canterbury-Ashburton County-North Otago 1930

After two games for Canterbury 1924 McCormick was named in the All Black team which visited New South Wales the next season but played only in the final match (v E.J. Thorn's XV). On his return he represented Canterbury again and appeared in the 1925 interisland game. Played for the Ashburton County union from its formation in 1927.

A powerfully built man, standing 5' 10" and weighing 14 stone, he was New Zealand amateur heavyweight boxing champion 1922,23. Father of Fergie McCormick who represented New Zealand 1965-71.

McCORMICK James

b: 15.10.1923, Waipukurau
Hooker

Represented NZ: 1947; 3 matches

First-class record: Wairarapa 1944 (Featherston Army); Wellington 1945 (Army); Hawke's Bay 1946 (Waipukurau), 1947-49 (Waipukurau HSOB); NZ Trials 1947,48; Hawke's Bay-Poverty Bay 1946

Educated Scot's College. After representing several Combined Services teams during WWII, McCormick toured Australia with the 1947 All Blacks, appearing in three of the nine matches. Weighed 14 stone and stood six feet. Served on the Junior Advisory Board of the Central Hawke's Bay sub-union.

McCORMICK William Fergus

b: 24.4.1939, Ashburton
Fullback

Represented NZ: 1965,67-71; 43 matches – 16 tests, 453 points – 10 tries, 112 conversions, 62 penalty goals, 1 dropped goal

First-class record: Canterbury 1958-75 (Linwood); South Island 1960-69; NZ Trials 1961-63,65-73; New Zealand XV 1960,65; Rest of New Zealand 1960,66

Educated Papanui Primary, Papanui High School and Christchurch Boys' High School. Played his early club football as a five-eighth until turning to fullback during the 1959 season. A strongly-built player, standing just over 5' 7" and weighing 13 stone, Fergie McCormick was an aggressive, powerful runner, a devastating tackler and an accurate goalkicker.

Although he first played in All Black trials 1961, his international debut was not until 1965 when Mick Williment was not available for the fourth test against the Springboks because of injury. Surprisingly chosen ahead of Williment for the 1967 British tour where he appeared in all four internationals and top scored with 118 points. His subsequent All Black career included tours to Australia 1968 (110 points) and South Africa 1970 (132 points). In New Zealand he appeared in test series against France 1968 and Wales 1969. His last appearance was in the first test against the 1971 Lions.

In the second test against the 1969 Welsh tourists McCormick created an individual record in international rugby by scoring 24 points – three conversions, five penalty goals and a dropped goal. (The record was bettered by Allan Hewson in 1982.) In 16 tests he totalled 121 points and his first-class tally from 310 games was 2065 points.

McCormick was described by Colin Meads as "a rock, a fullback who could do the basic job with complete efficiency but who could set the game alight when he ran. His game was based on total involvement. His determination in times of crisis was unbelievable, a determination which seemed at times to lend him yards in pace". Terry McLean compared McCormick's reliability, his "resolution in the face of the enemy", to that of George Nepia.

Continued to play for Canterbury until 1975 and toured Europe 1979 with the Cantabrians club. Represented the South Island at softball. His father, Archie, had one game for the 1925 All Blacks and his mother, Helen, was a national

Fergie McCormick . . . "resolution in the face of the enemy".

hockey representative. McCormick's biography *Fergie* (Whitcoulls, 1976) was written by Alex Veysey.

McCULLOUGH John Francis
b: 8.1.1936, Stratford
First five-eighth

Represented NZ: 1959; 3 matches – 3 tests

First-class record: Taranaki 1955,56 (Stratford), 1957 (Clifton), 1958-60 (Tukapa), 1961,63,65,66 (Stratford); North Island 1957,59,60,63; NZ Trials 1956-61,63; New Zealand XV 1960

Educated Stratford Primary and Stratford Technical High School, 1st XV 1952-54. A steady and capable player who weighed 11st 4lb and stood almost 5' 9", McCullough began his long career as Taranaki's second five-eighth in his first year out of school. His three All Black appearances, however, were at first five-eighth replacing a Taranaki team-mate, Ross Brown, after the first test against the 1959 Lions. In the remaining three tests McCullough played outside two Taranaki halfbacks, Kevin Briscoe and Roger Urbahn.

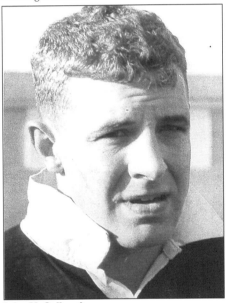

John McCullough

Continued to appear in interisland and trials until 1963 and played for Taranaki until 1966. Coached the Stratford club 1974,75. His father, W. McCullough, represented Taranaki 1931,32.

McDONALD Alexander
b: 23.4.1883, Dunedin *d:* 4.5.1967, Wellington
Loose forward

Represented NZ: 1905,08,13; 41 matches – 8 tests, 50 points – 16 tries, 1 conversion

First-class record: Otago 1904,06-09,11-14,19 (Kaikorai); South Island 1904-07,13; Otago-Southland 1904

Educated George St School. Began a 20-year club career with Kaikorai 1900 and captained Otago 1906-09,11-14,19.
Standing 5' 10" and weighing 13 stone, McDonald toured with the 1905-06 'Originals' after going to Australia on the preliminary visit. Appeared in internationals against Scotland and

Ireland on the side of the scrum and in the English and Welsh games in the back row. Toured Australia 1907, playing one test, and appeared in the first test against the 1908 Anglo-Welsh tourists. After missing the 1910 visit to Australia he captained the All Blacks in the first test v Australia 1913 before leading the New Zealanders on the tour of North America.
Served on the Otago RFU management committee 1914,15,20-28; vice-president 1928-32. New Zealand selector 1929-32. Moved to Wellington and coached the Wellington College OB club to a championship win 1933. NZRFU management committee 1935,36; council 1937-50. New Zealand selector again 1944-48; co-manager of the 1938 All Blacks in Australia and assistant manager of the 1949 team in South Africa. Elected a life member of the NZRFU 1951.

MACDONALD Hamish Hugh
b: 11.1.1947, Rawene
Lock

Represented NZ: 1972-76; 48 matches – 12 tests, 8 points – 2 tries

First-class record: Poverty Bay 1966 (Ngatapa); Canterbury 1967-69 (Rangiora), 1970 (Lincoln College), 1971-74 (Oxford); North Auckland 1975-78 (Kaikohe); South Island 1971-74; North Island 1975; NZ Trials 1972-76; Poverty Bay-East Coast 1966

Educated King's College, 1st XV 1963,64, Auckland Secondary Schools rep 1964. After playing in Poverty Bay Macdonald moved to Canterbury and made his All Black debut on the 1972 internal tour.

Hamish Macdonald

Toured with the 1972-73 team, appearing in all four internationals in Britain and France. After the home test against England 1973 he was a surprise omission from the 1974 team to tour Australia but regained his place for the Irish visit and played in the Dublin test. After appearances against Scotland and Ireland in the next two seasons, he played in 14 of the 24 games in South Africa 1976 including the first three tests, losing his place to Frank Oliver in the fourth test.
Standing 6' 3" and weighing 16 stone, Macdonald was regarded as a strong, driving lock, especially effective near the front of the

lineout. In 10 of his 12 internationals he formed a fine partnership with Peter Whiting. His father, H.J. Macdonald, played for North Auckland 1932-35 and his brother, Rod, represented that province 1975,76 and Southland 1970. Doug Bruce (New Zealand 1974,76-78) is his brother-in-law.

McDONNELL Peter
b: c 1874, Wanganui *d:* 24.5.1950, Wanganui
Wing threequarter

Represented NZ: 1896; 1 match

First-class record: Hawke's Bay 1893 (Te Aute), 1895 (Caledonian); Wanganui 1894,96,98,1900 (Wanganui)

Educated Wanganui High School and Te Aute College. Played his only game for New Zealand against Queensland at Wellington 1896 replacing original selection A.E. White who withdrew. In that season he became the first player to score four tries in an inter-union match in New Zealand, achieving this feat for Wanganui v Manawatu. Was described as "tricky and clever".

McDOWELL Steven Clark
b: 27.8.1961, Rotorua
Prop

Represented NZ: 1985-92; 81 matches – 46 tests, 28 points – 7 tries

First-class record: Bay of Plenty 1982 (St Michaels), 1983,84,89 (Kahukura); Auckland 1985,86 (Pakuranga), 1987-93 (Suburbs); Wellington 1994 (Tawa); NZ Colts 1982; NZ Juniors 1984; NZ Emerging Players 1985; NZ Trials 1985,87,89,90-93; North Zone 1987-89; Northern Zone Maoris 1985,89,90,92; NZ Maoris 1988-92; Invitation XV 1994; Saracens 1992; Wasps 1985; Barbarians 1987

Educated at Western Heights High School in Rotorua, McDowell played for Bay of Plenty age group teams until his first-class debut in 1982. Though he played for the New Zealand Colts and Juniors from the Bay, it wasn't until he moved to Auckland that his career took off.
In his first year for Auckland, he was selected for the New Zealand team to tour South Africa and when the tour was abandoned he went on the replacement tour of Argentina. He played in both tests, though his quick elevation was doubtless due in part to injuries to test prop Gary Knight and to Scott Crichton.
McDowell went on the unauthorised Cavaliers tour of South Africa in 1986 and when those players became eligible again he went straight into the All Blacks for the second and third tests against Australia, and followed that by playing in each of the two tests against France at the end of the season.
For the next five years, McDowell was virtually an automatic selection for the All Blacks and was regarded as one of the best props to have worn the black jersey. Aside from his strength and technique in scrummaging, driving and mauling, McDowell's attributes also included remarkable speed for such a big man and his game was characterised by powerful runs in broken play.
At the World Cup in Britain, Ireland and France in 1991, only McDowell and hooker Sean Fitzpatrick of the forwards played in each of the six matches. Craig Innes was the only back to play in all six.

Steve McDowell . . . his game was characterised by powerful runs in broken play.

McDowell was also one of the permanent features of the all-conquering Auckland Ranfurly Shield team of the late 1980s, though he briefly returned to Bay of Plenty for one match in 1989.

He began the 1992 season in accustomed fashion, playing in each of the five domestic tests, but he failed to gain selection on the following tour of Australia and South Africa and was not chosen for New Zealand again.

McDowell moved to Wellington for his last domestic season in 1994 after a stint in Ireland and he later also played and coached in Wales.

In addition to his New Zealand first-class appearances, McDowell also played for a World XV against Australia in 1988 in a game celebrating Australia's bicentenary, he played for an Anzac Selection against the British Isles in 1989 and for the Southern Hemisphere against the Northern in Hong Kong in 1991.

McDowell represented New Zealand in judo from 1974 until 1981, won an Oceania title in 1979 and was a member of the 1980 New Zealand Olympic team before judo officials withdrew their sport from the Moscow games for political reasons.

Throughout his career, McDowell's name was spelt with an "e", but his passport and birth certificate lists him as "McDowall".

McELDOWNEY John Thompson
b: 26.10.1947, New Plymouth
Prop

Represented NZ: 1976,77; 10 matches – 2 tests

First-class record: Taranaki 1967,69-80 (New Plymouth HSOB); North Island 1976,77; NZ Trials 1976,77

Educated New Plymouth Boys' High School. A strong prop who weighed 102kg and stood 1.83m, McEldowney represented Taranaki from 1967 and played 125 matches for his province.

Toured Argentina with the 1976 All Blacks playing in six of the nine matches including both matches against Argentina. Appeared in the third and fourth tests against the 1977 Lions, retiring with an injury in the latter game. Toured France at the conclusion of the 1977 season as a replacement for an original selection, Vance Stewart, who was injured before the team departed. His brother, Bryce, also played for Taranaki, 1972-80.

MacEWAN Ian Neven
b: 1.5.1934, Auckland
Lock and number eight

Represented NZ: 1956-62; 52 matches – 20 tests, 27 points – 9 tries

First-class record: Wellington 1954-63,65-67 (Athletic); North Island 1956-59,62; NZ Trials 1956-63,65

Nev MacEwan

Educated Nelson College, 1st XV 1951,52. Made his All Black debut in the second test against the 1956 Springboks playing at number eight but lost his place for the remainder of the series to Peter Jones.

Became a regular member of the All Black scrum on the 1957 tour of Australia. Played in the series against the 1958 Wallabies and the 1959 Lions although an attack of measles prevented his appearance in the final test. In

South Africa 1960 he played in all four tests including the third in the unusual position of prop. His career continued against the 1961 French tourists and in Australia the next year. After appearing in the first two tests against the Wallabies on the 1962 return visit, he was dropped when Colin Meads was recalled to partner his brother Stan. Played for the Blackheath club in England in the 1963-64 season.

Weighing 16$^{1}/_{2}$ stone and standing 6' 3" Nev MacEwan was a magnificent jumper at number three in the lineout, timing his leap to perfection and rarely missing a clean catch. By the time of his retirement he had played 133 games for Wellington in a first-class tally of 214. President of the NZ Rugby Museum 1978.

McGAHAN Paul William
b: 12.10.1964, Pukekohe
Halfback

Represented NZ: 1990-91; 6 matches, 4 points – 1 try

First-class record: Counties 1985 (Pukekohe); North Harbour 1986-92 (North Shore); NZ Trials 1990-92; NZ Colts Trial 1984; NZ Colts 1985

Though McGahan was prominent early in his career as one of New Zealand's most promising halfbacks, he was never required for anything more than a backup role for New Zealand.

He toured France in 1990 and played three of the midweek matches while Graeme Bachop played the tests and filled the same role the following year in Argentina, where he also played three matches.

He seemed unlucky not to have been chosen for the 1991 World Cup squad.

McGRATTAN Brian
b: 31.12.1959, Wellington
Prop

Represented NZ: 1983-86; 23 matches – 6 tests, 16 points – 4 tries

First-class record: Wellington 1980-86 (Marist St Pats); North Island 1983-85; NZ Trials 1985; Central Zone 1987

Brian McGrattan

Educated Rongotai College. McGrattan had only two appearances for Wellington in 1980 but began to establish himself as a regular member of the side the following year. He was chosen for the NZ Juniors team in 1982 but was forced to withdraw because of injury.

He was first chosen for the All Blacks for the 1983 tour of England and Scotland and played in both test matches. He toured Australia in 1984 but with regular props Gary Knight and John Ashworth available, he did not play in any of the tests. McGrattan, who weighed 105kg and stood 1.90m, was not selected for the South African touring party in 1985 but went on the replacement tour to Argentina after Ashworth withdrew.

In 1986 McGrattan was chosen for the domestic tests against France and Australia but lost his place when the players who had toured South Africa unofficially became re-eligible.

McGREGOR Alwin John

b: 16.12.1889, Thames *d:* 15.4.1963, Auckland
Wing threequarter

Represented NZ: 1913; 11 matches – 2 tests, 45 points – 15 tries

First-class record: Auckland 1909-14 (Ponsonby); North Island 1909,12

After good displays for Karangahake when that team won the Goldfields Cup 1908, 'Dougie' McGregor moved to Auckland 1909 and represented Auckland and the North Island. Played against Australia before leaving with the 1913 All Blacks to North America where he appeared in the international and scored 15 tries in 10 tour matches.

Turned to rugby league 1915 but played union again for military teams during WWI. Rejoined the league code at the end of the war and represented New Zealand 1919,20. Coached league teams in Otago and Auckland during the 1920s and 30s.

'Dick' McGregor (New Zealand 1901,03,04) was his uncle and the prominent league player and administrator, Ron McGregor, was a nephew.

McGREGOR Ashley Alton

b: 3.9.1953, Gore
Loose forward

Represented NZ: 1978; 3 matches

First-class record: Southland 1976-80 (Waikaia); Otago 1981 (Tapanui); South Island 1978; NZ Trials 1978

Educated Balfour Primary School and Southland College. Played for the Balfour club 1969,70, Waikaia 1971, Cromwell 1973 (from where he represented Otago Juniors) and Strath Taieri 1974 before rejoining the Waikaia club and winning a place in the Southland team.

After a fine display for his province when the 1978 Wallabies were beaten 10-7 and appearances in the interisland match and All Black trials, McGregor was named in the team to tour Britain late in that year but played in only three of the 18 matches.

Injuries hampered his play in the next year. Stood 1.83m and weighed 94.5kg. Coached the Waikaia club 1980.

McGREGOR Duncan

b: 16.7.1881, Kaiapoi *d:* 11.3.1947, Timaru
Wing threequarter

Represented NZ: 1903-06; 31 matches – 4 tests, 106 points – 34 tries, 2 conversions

First-class record: Canterbury 1900 (Kaiapoi), 1902,03,06 (Linwood); Wellington 1904,06 (Petone); South Island 1902,03,06; North Island 1904

A brilliant attacking wing and a prolific try scorer who stood 5' 9" and weighed 11st 3lb, Duncan McGregor scored a total of 66 tries in 59 first-class games. His 19 tries from 10 matches in the 1902 domestic season created a record which stood for 52 years. His 17 tries for Canterbury in the same season (in nine games) was that union's record until 1985.

Toured Australia with the 1903 New Zealand team and appeared in the first officially recognised test. The following year he scored New Zealand's two tries against the British tourists. After the brief Australian tour and games at home he left with the 1905-06 'Originals'. In 14 appearances, including the English and Welsh internationals, he scored 16 tries – the four against England remains an international record for a New Zealander.

Switched to rugby league and toured with New Zealand's first team playing that code, the 1907 'All Golds'. Remained in Wales and joined the Merthyr Tidfyl club. An ankle injury ended his playing career but on his return to New Zealand 1913 he became a league referee and national selector.

McGREGOR Neil Perriam

b: 29.12.1901, Lowburn *d:* 12.7.1973, Hokitika
Five-eighth

Represented NZ: 1924,25,28; 27 matches – 2 tests, 21 points – 7 tries

First-class record: Wellington 1923 (Wellington); Canterbury 1925-27 (Christchurch); South Island 1924-27; NZ Trials 1924,27,30; Canterbury-South Canterbury 1925

Neil McGregor

Educated Gore High School, 1st XV 1918,19. Played for the Pirates club in Invercargill before moving to Wellington where he made his first-class debut. The following season he transferred to Christchurch and appeared in three All Black trials, the interisland match and for New

Zealand against New South Wales and Auckland before touring with the 1924-25 'Invincibles'.

His 20 tour games included the Welsh and French internationals in which he played at first five-eighth inside Mark Nicholls and Bert Cooke. He appeared against New South Wales 1925, captained Canterbury and the South Island 1927 and then toured South Africa 1928 where he was troubled with injuries and played only four times. His last first-class match was an All Black trial 1930.

Despite his small stature (5' 7" and 10½ stone), Neil McGregor combined resolute defence with an astute tactical approach. In the 1924 Welsh international he was called upon to go down on the ball in the face of numerous forward dribbling rushes but never shirked his task and finished the game covered in bruises. Norman McKenzie wrote that McGregor "would stop a train, or try to".

Nelson selector 1961-63 and South Island selector 1964-68.

McGREGOR Robert Wylie

b: 31.12.1874, Thames *d:* 22.11.1925, Sydney
Centre threequarter and fullback

Represented NZ: 1901,03,04; 10 matches – 2 tests, 12 points – 4 tries

First-class record: Auckland 1898-1901 (Thames), 1902-04 (Grafton); North Island 1902,03

The youngest of six brothers, most of whom were well-known players in the Thames area, 'Dick' McGregor was a sturdily built centre threequarter whom R.A. Stone described as being "splendid on attack or defence".

Played for New Zealand against Wellington and New South Wales in the 1901 season and toured Australia 1903, scoring a controversial try in the first officially recognised test match. Called in to play at fullback in the 1904 match v Great Britain when 'Peter' Gerrard was forced to withdraw.

His nephew, 'Dougie' McGregor, was a 1913 All Black. 'Dick' McGregor was in ill health for much of his later life and a benefit match involving old representative players was arranged in 1918 before he moved to Australia.

McHUGH Maurice James

b: 19.2.1917, Auckland
Loose forward and lock

Represented NZ: 1946,49; 14 matches – 3 tests, 3 points – 1 try

First-class record: Auckland 1936,37,44-48 (Marist); North Island 1944-46,48; NZ Trials 1947,48; New Zealand XV 1944,45

Educated Sacred Heart College (Auckland), 1st XV 1932,34. Played once for Auckland before WWII and twice for a New Zealand XV v Combined Services 1944,45 before appearing in both tests against the 1946 Wallabies as a flanker.

Toured South Africa 1949 playing in the third test at number eight. A mobile and hardworking forward who weighed 14st 2lb and stood 6' 1", he retired from first-class rugby after the tour but continued to play appearing for the Barbarians in the early 1950s and the City club in Hamilton 1955-57.

New Zealand amateur heavyweight boxing champion 1938 and runner-up in the 1946 championships. His father, Andy, played rugby for Auckland 1915,21.

MACINTOSH Charles Nicholson

b: 6.4.1869, Timaru *d:* ?.12.1918, Rio de
Janeiro
Forward

Represented NZ: 1893; 4 matches, 3 points – 1
try

First-class record: South Canterbury 1888
(Waihi), 1889,90,95 (Timaru), 1891-94 (Union),
1896 (Star)

Educated Wai-iti School and Timaru Boys' High
School. Toured Australia 1893 with the New
Zealand team playing in four matches including
the New South Wales and Queensland games.
Mayor of Timaru 1901,02.

McINTOSH Donald Neil

b: 1.4.1931, Lower Hutt
Flanker

Represented NZ: 1956,57; 13 matches – 4
tests, 9 points – 3 tries

First-class record: Wellington 1951-60
(Petone); North Island 1957; NZ Trials
1951,53,56-59; Rest of New Zealand 1954,55

Educated Randwick and Featherston Primary
Schools and Featherston District High School. A
fine flanker noted for his rucking and lineout
abilities, McIntosh stood 6' 2" and weighed 14st
12lb. Played 120 games for Wellington and
captained that province 1955-60.
 On the verge of All Black selection for some
time before winning a place in the first test
against the 1956 Springboks. Dropped from the
team in a number of changes made after the
second test was lost, but selected again for the
tour of Australia in the following season and
appeared in both internationals. Played in All
Black trials for two more years but did not gain
New Zealand honours again.
 Coached the Petone club 1963-65 and
Featherston 1967-70,76-78. Believed to be the
only non-member of a referees' association to
control a representative match when he refereed
Wairarapa v East Coast 1968.

McKAY Donald William

b: 7.8.1937, Auckland
Wing threequarter

Don McKay

Represented NZ: 1961-63; 12 matches – 5
tests, 54 points – 18 tries

First-class record: Auckland 1958,60-66
(North Shore); North Island 1960,61,65; NZ
Trials 1958,61-63,65; New Zealand XV 1960;
Rest of New Zealand 1960

Educated Takapuna Grammar School, 1st XV
1954. A fast and enterprising wing, standing 5'
8" and weighing between 11st and 12st, Don
McKay was a regular member of the Auckland
team during its Ranfurly Shield tenure of the
early 1960s.
 Made his All Black debut in the first test
against the 1961 French tourists scoring a try the
first time he touched the ball two minutes into
the game. Although he did not play in either
international he scored five tries against

Brian McKechnie

Northern New South Wales and three each v
Southern NSW and Victoria on the 1962
Australian tour. Included in both tests against
England the following year but was surprisingly
omitted from the 1963-64 touring team.
Appeared again in All Black trials and the
interisland fixture 1965.
 Auckland third grade selector 1973-76. Sprint
and swimming champion at Takapuna
Grammar.

MACKAY James Douglas

b: 21.9.1905, New Plymouth *d:* ?.? 1985
Wing threequarter

Represented NZ: 1928; 2 matches, 12 points –
4 tries

First-class record: Wellington 1926,28-31
(University); NZ Trials 1930; NZ University
1929,31

Educated New Plymouth Boys' High School, 1st
XV 1922-24. Played for the All Blacks against
West Coast-Buller 1928, scoring four tries in a
40-3 victory, and three days later appeared
against New South Wales in the final game of
the three-match series.
 Coached the University club in Wellington
1931-36, RNZAF Wigram 1938-42 and Lincoln
College 1947-52. Member of the Canterbury
RFU Junior Advisory Board 1940-45; president
1942. RNZAF selector 1942,44. NZ Services and

Canterbury selector 1944. NZ Universities
selector 1947. President of the Ellesmere sub-
union 1953,54. MBE.

McKECHNIE Brian John

b: 6.11.1953, Gore
First five-eighth and fullback

Represented NZ: 1977-79,81; 26 matches – 9
tests, 148 points – 2 tries, 22 conversions, 28
penalty goals, 4 dropped goals

First-class record: Southland 1976-83 (Star);
South Island 1979,80; NZ Trials 1978,81

Educated Southland Boys' High School. An
accurate kicker and sound on defence,
McKechnie was a sound, reliable player who
preferred to play at first five-eighth but made his
international debut at fullback in the two tests in
France 1977 because of an injury to Bevan
Wilson.
 After a mediocre performance in the
unfamiliar position in the first test he showed
remarkable improvement in the second test. In
this match he landed a dropped goal after
retrieving the ball inches from touch. Had his
first test as a five-eighth in the third match
against the 1978 Wallabies then toured Britain
later that year.
 Played at fullback in the Welsh, English and
Scottish internationals. As a replacement for
Clive Currie at Cardiff, he landed three penalty
goals including the vital kick to give New
Zealand a 13-12 win. Played the test in
Australia 1979 at first five-eighth. Captained
the South Island 1980. Weighed 77kg and stood
1.73m.
 A fine all-round cricketer Brian McKechnie
was a NZ Secondary Schools rep 1971 and
played for Otago. Represented New Zealand at
cricket 1975,79,81. A book *Brian McKechnie
Double All Black* (Craigs Publishers) was
published in 1983.

McKELLAR Gerald Forbes

b: 9.1.1884, Cromwell *d:* 16.1.1960, Dunedin
Wing and loose forward

Represented NZ: 1910; 5 matches – 3 tests; 3
points – 1 try

First-class record: Hawke's Bay 1905 (Scinde); Wellington 1908-10 (Wellington); Otago 1911,12 (Pirates)

Educated Otago Boys' High School. Volunteered from school for service in the Boer War. Played his early representative rugby as a wing threequarter.

Came into the 1910 All Black team to Australia when 'Circus' Hayward was unable to travel and played at wing forward in the first test and in the back row of the scrum the next two. Life member Pirates RFC.

McKENZIE Richard John

b: 15.3.1892, Lyttelton *d:* 25.9.1968, Mt Maunganui
Five-eighth

Represented NZ: 1913,14; 20 matches – 4 tests, 57 points – 17 tries, 1 conversion, 1 dropped goal

First-class record: Wellington 1909-13 (Petone); Auckland 1914 (Marist); North Island 1912-14

Educated St Patrick's College (Wellington). First played representative rugby at the age of 17 and regarded as a fast and brilliant five-eighth.

Scored two tries in his All Black debut against Australia 1913 after moving in to first five-eighth when Henry Taylor retired hurt at halftime and 'Doddy' Gray took up the halfback duties. On the tour of North America Jock McKenzie again scored two tries in his international appearance. Missed the first test in Australia 1914 but was recalled at first five-eighth for the remainder of the series.

Serious wounds suffered in WWI ended his rugby career but he was reported to have later represented Waikato at hockey. Waikato RFU selector 1937,38.

MACKENZIE Robert Henry Craig

b: 17.2.1904, Wellington *d:* 19.7.1993, Wellington
First five-eighth

Represented NZ: 1928; 2 matches

First-class record: Wellington 1925-29 (University); NZ Trials 1930; NZ Universities 1929

Educated Terrace School and Wellington College, 1st XV 1920-22. Craig Mackenzie played for the All Blacks v West Coast-Buller and was then included in the final match of the 1928 series against New South Wales.

Led the NZ Universities team to victory over Australian Universities 1929 and played in the 1930 trials but did not win All Black honours again.

Represented Wellington at cricket in one match 1929. Author of the biography *Walter Nash: Pioneer and Prophet* (Dunmore Press 1975).

McKENZIE Robert Hugh

b: 1.6.1869, Auckland *d:* 24.6.1940, Hamilton
Forward

Represented NZ: 1893; 2 matches

First-class record: Auckland 1888-91 (Parnell), 1894,96-98 (Suburbs); Taranaki 1892 (Manganui); North Island 1894

Educated Auckland Grammar School. Made his provincial debut as an 18-year-old when he

scored Auckland's only try in their first match against the 1888 British team.

After originally declining an invitation to tour Australia with the 1893 New Zealand team, 'Rab' McKenzie was sent with three other reinforcements and played in the final two matches.

McKENZIE Roderick McCulloch

b: 16.9.1909, Rakaia
Flanker and lock

Represented NZ: 1934-38; 35 matches – 9 tests, 36 points – 11 tries, 1 goal from a mark

First-class record: Manawhenua 1930-32 (Kia Toa); Manawatu 1933-39 (Kia Toa); North Island 1933,34,37-39; NZ Trials 1934,35,37,39; NZ Services 1944,45; Scotland 1945; Combined Dominions 1945

Educated Kakariki School and Feilding Convent Schools. Played junior club rugby for St Pat's OB in Palmerston North then represented Manawhenua Juniors 1928 from the Waikanae club

Rod McKenzie

and the Manawatu sub-union 1929 from Woodville before returning to Palmerston North and gaining full representative honours from the Kia Toa club.

Toured Australia with the 1934 All Blacks, appearing in the first test as a 15 stone, six feet lock. On the 1935-36 British tour McKenzie played 15 games including the Scottish international on the side of the scrum. This position he occupied in the first test against the 1936 Wallabies, throughout the series against the 1937 Springboks and in the 1938 tests in Australia. Described by All Black vice-captain Charlie Oliver on the 1935-36 tour as "a fine loose forward . . . always in the picture and played harder football than anyone".

McKenzie's rugby career continued in the United Kingdom during WWII when he played for NZ Services, Combined Dominions and twice for Scotland in service internationals. His brother, Jack, also represented Manawatu 1937-39.

McKENZIE William

b: 12.6.1871, Greytown *d:* 1.7.1943, Melbourne, Australia
Wing forward

Represented NZ: 1893,94,96,97; 20 matches, 24 points – 8 tries

First-class record: Wairarapa 1889 (Carterton), 1890 (Carterton Rivals), 1891 (Greytown), 1892 (Greytown Rivals); Wellington 1893-97 (Petone); North Island 1897; NZ Trials 1893

Educated Clareville School. The eldest son of the remarkable McKenzie family (William, Edward, Bert, Jack and Norman) who were well-known in rugby circles throughout New Zealand, William McKenzie is credited with developing the wing forward role into a specialised position during the 1890s – his fringing play earned him his nickname of 'Offside Mac'.

Toured Australia with New Zealand teams 1893,97 and played against New South Wales 1894 and Queensland 1896 in domestic matches. A great personality who gave rise to many anecdotes including the story of his ordering off in the third encounter with New South Wales on the 1893 tour when he left the field with an affected limp and was sympathetically applauded by the spectators.

Rheumatism cut short his playing career and a charity match was played 1901 to send him to Rotorua for treatment. Wairarapa selector 1902,03. He later moved to Australia for health reasons.

MACKRELL William Henry Clifton

b: 20.7.1881, Milton, NSW, Australia *d:* 15.7.1917, Auckland
Hooker

Represented NZ: 1905,06; 7 matches – 1 test, 3 points – 1 try

First-class record: Auckland 1904,05 (Newton); North Island 1905

After fine displays as a hooker with All Black George Tyler for Auckland against the 1904 British team and in the 1905 interisland match, Mackrell won selection in the 1905-06 'Originals' but illness prevented his playing until the 23rd tour game.

Joined Tyler for his only international (v France). His statistics were given as 5' 10" and 12½ stone. Turned to rugby league and toured with the 'All Golds' 1907 and represented New Zealand again at this code 1911. A kick to the head ended his career 1912 and may have contributed to his death – a paralytic seizure at the age of 35.

MACKY John Victor

b: 3.3.1887, Auckland *d:* 15.9.1951, Auckland
Wing threequarter

Represented NZ: 1913; 1 match – 1 test

First-class record: Auckland 1911-14 (University)

Educated Bayfield School and Auckland Grammar School, 1st XV 1902. A brilliant wing scoring nine tries for Auckland in seven Ranfurly Shield games including four in a 12-0 win over Wellington 1912 and one which saved his team in a 5-5 draw with Otago.

His sole All Black match was the second test against Australia 1913. Victor Macky declined an invitation to play with the 1918 NZ Army side.

McLACHLAN Jon Stanley

b: 23.6.1949, Auckland
Wing threequarter

Represented NZ: 1974; 8 matches – 1 test, 32 points – 8 tries

First-class record: Auckland 1970-76 (College Rifles), 1977,78 (Eastern); NZ Trials 1974-77; NZ Juniors 1970

Educated Orakei School and Selwyn College. A wing possessing explosive pace, a deceptive swerve and a sound tackle, McLachlan stood 1.80m and weighed 77kg at the time of his selection in the 1974 All Black team to tour Australia.

Jon McLachlan

Appeared in eight of the 12 matches including his only international – the second test, when Grant Batty withdrew because of injury. Scored four tries against South Australia.

McLAREN Hugh Campbell

b: 8.6.1926, Auckland *d:* 9.5.1992, Tauranga
Number eight

Represented NZ: 1952; 1 match – 1 test

First-class record: Auckland 1947-49 (Grammar); Waikato 1950-54 (Matamata); North Island 1952,53; NZ Trials 1950,53; New Zealand XV 1952

Educated Auckland Grammar School, 1st XV 1943. After moving to Matamata 1950 he captained Waikato until his retirement 1954. A versatile forward, at 5' 11" and 13st 10lb, McLaren appeared in every scrum position during his career but had his sole All Black game at number eight in the first test against the 1952 Wallabies. Forced to withdraw from the team for the second test with a nose injury.

McLEAN Andrew Leslie

b: 31.10.1898, Auckland *d:* 18.1.1964, Auckland
Flanker and fullback

Represented NZ: 1921,23; 3 matches – 2 tests, 17 points – 1 try, 4 conversions, 2 penalty goals

First-class record: Auckland 1917 (Grammar), 1918 (College Rifles); Bay of Plenty 1922 (Whakatane), 1923 (Te Puke Rovers); North Island 1921; NZ Trials 1921

Educated Auckland Grammar School, 1st XV 1914,15. First represented Auckland against the 17th Reinforcements as a 17-year-old in a team which was restricted for war reasons to players under 20 years of age. After occasional appearances for his province in the next two seasons, he went farming in the Bay of Plenty and did not play first-class rugby again until he was selected for the 1921 North Island and All Black trial teams.

Missed the first test against the 1921 Springboks owing to an injury suffered after his selection but played in the rest of the series scoring New Zealand's only try in his debut. After playing in these tests as a 6' 2", 14 stone forward, McLean was recalled for the third game v New South Wales 1923 as fullback and kicked 14 points in a 38-11 victory.

His brother, Neil, represented Auckland 1918,20,21,24.

McLEAN Charles

b: 20.9.1892, Cape Foulwind *d:* 7.3.1965, Christchurch
Loose forward

Represented NZ: 1920; 5 matches, 21 points – 7 tries

First-class record: Buller 1919-23 (Westport); South Island 1920,21

Awarded the MM during WWI after taking part in the Gallipoli landings. Represented Buller 15 times over five seasons and had five games for the 1920 New Zealand team in Australia and at home. Playing in the forward pack, Charles McLean scored seven tries in his five All Black appearances.

McLEAN Hugh Foster

b: 18.7.1907, Wanganui *d:* 24.4.1997, Auckland
Loose forward

Represented NZ: 1930,32,34-36; 29 matches – 9 tests, 50 points – 16 tries, 1 conversion

First-class record: Wellington 1928,30-33 (Wellington); Taranaki 1929 (Star); Auckland 1934-39 (Grafton), 1941 (Papakura Army); North Island 1929-31,33; NZ Trials 1930,34,35

Educated Hastings Boys' High School and Napier Boys' High School, 1st XV 1923. Represented Hawke's Bay Juniors 1925 from the Hastings club before moving to Wellington where he made his first-class debut, then entering the North Island team during the following year from Taranaki.

He made his All Black debut in the third test against the 1930 British team scoring two tries in the match. Played in the final test of that series and toured Australia 1932,34 missing only the second test on the latter visit. His 14 games with the 1935-36 All Blacks included the Irish, Welsh and English internationals.

A tall player, at 6' 2½" and 14 stone, McLean was generally an excellent loose forward whose early form on the British tour was said to be disappointing but redeemed by good performances later.

With another ex-All Black, Ron Bush, he established the Barbarian club in New Zealand

1937 and captained the team in its first game (v Auckland 1938). His father, Jack McLean, and four uncles represented Wanganui around the turn of the century. Two brothers, Gordon (Taranaki and Wellington), and Bob (Taranaki and Wanganui), also played representative rugby. Another brother, Terry, is a noted sporting journalist and author of numerous rugby books.

Selected in the New Zealand rowing eight which was unable to travel to the 1928 Olympic Games because of a lack of funds. North Shore Golf Club captain 1948,49.

McLEAN John Kenneth

b: 3.10.1923, Thames
Wing threequarter

Represented NZ: 1947,49; 5 matches – 2 tests, 21 points – 7 tries

First-class record: Auckland 1943,46 (Training College), 1948,49 (Thames United); Canterbury 1944 (RNZAF); Waikato 1944 (RNZAF); King Country 1946,47 (Taumarunui); North Island 1947; NZ Trials 1947,48; NZ Combined Services 1944

Educated Thames High School, 1st XV 1938-40. A strong, fast and determined wing who began his representative career during WWII, playing for several provinces and in service teams. Stood 5' 10½" and weighed 13 stone during his rugby career.

Toured Australia with the 1947 New Zealand team, scoring four tries in his first game (v Australian Capital Territory) and playing in the first test. After a brilliant display for Auckland against a strong Barbarians team 1948 in which he scored four tries, McLean was widely expected to replace Wally Argus, who had announced his unavailability, in the 1949 All Black side to South Africa but in a major selection surprise Ian Botting was named in the touring party.

Chosen in the team for the first test against the 1949 Wallabies, he was unable to play owing to injury but took the field in the second test. Joined the Bradford Northern rugby league club in England and scored 274 tries from 1950 to 1956; leading try scorer in the 1955-56 English league season with 65 and runner-up on three occasions.

An accomplished athlete, Jack McLean was Auckland long jump champion 1943 leaping a record 22' 9", Waikato 100yd and long jump champion 1947, runner-up to future All Black Peter Henderson in the 1948 national 100yd championship and third in the 1949 decathlon. His best time over 100 yards was 10 seconds. He was New Zealand veteran 100m champion 1979 and long jump 1980.

Coached Thames High School 1957-67 and Thames Valley Secondary Schools selector 1973-76. His brother, Gilbert, played for Thames Valley 1957 and his son, John, represented that union 1973.

McLEAN Robert John

b: 23.5.1960, Hawera
Prop

Represented NZ: 1987; 2 matches

First-class record: Wairarapa-Bush 1987-89 (Woodville); Central Zone 1988,89; NZ Divisional XV 1988,90

McLean left the national rugby scene almost as quickly as he had arrived on it. His first year of

first-class rugby was in 1987 at the age of 27 and by the end of the year, after 14 matches for Wairarapa-Bush, he was a surprise choice in the New Zealand team that toured Japan.

He played in two of the tour matches, against Japan B and Asian Barbarians.

He was chosen for the Central Zone in the following two years and was in the New Zealand Divisional XV in 1988 and 1990, but was not required again by the national selectors. He played for the Divisional team early in 1990, but did not play for his province.

McLEOD Bruce Edward

b: 30.1.1940, Auckland *d:* 18.5.1996, Foxton Beach
Hooker

Represented NZ: 1964-70; 46 matches – 24 tests, 21 points – 7 tries

First-class record: Counties 1962-70 (Manurewa); Hawke's Bay 1971 (Colenso-Pirates); North Island 1965,66,68,69; NZ Trials 1963,65-70; New Zealand XV 1966; Bay of Plenty-Counties-Thames Valley 1965; Counties-Thames Valley 1966

Educated Manurewa Primary School and Otahuhu College. A burly, powerful and skilful hooker, who stood just under six feet and weighed around 14½ stone during a long All Black career, McLeod made his debut in the 1964 series against the Wallabies, marking his arrival in international rugby with a try scored with typical follow-up enthusiasm.

His subsequent test career continued against the 1965 Springboks and the 1966 Lions but he missed the 1967 jubilee test while suspended by his union after being ordered off in a club game. Toured Britain later in that season, Australia 1968 and South Africa 1970 and played against France 1968 and Wales 1969, finally losing his test place to Ron Urlich in the middle of the South African tour. During his 24 internationals McLeod formed the basis of a strong and efficient front row in the All Black scrum. He was partnered by a succession of experienced props including Wilson Whineray and Ken Gray. Described in David Frost's 1967 tour book as "a quick breaker from the front of the lineout both in attack and in spoiling". Life member Manurewa RFC.

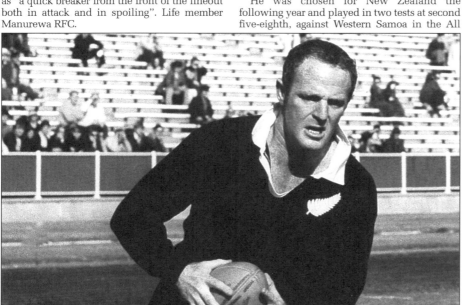

Bruce McLeod . . . powerful and skilful hooker.

McLEOD Scott James

b: 28.2.1973, Brisbane, Australia
Second five-eighth and centre

Represented NZ: 1996,97; 15 matches – 8 tests, 30 points – 6 tries

First-class record: Waikato 1995-97 (Hamilton OB); Waikato Chiefs 1996,97; NZ Trial 1996; North Otago Invitation XV 1996; Northland Invitation XV 1996; Harlequins 1996; South Island Invitation XV 1997

Scott McLeod

Australian-born McLeod was raised in the Thames Valley and went to Hamilton Boys High School, where he played in the first XV in 1990 and 1991. He played for Waikato Colts for three years and though sent to the Colts trials in 1994, was not chosen for the national team.

He made his first-class debut in 1995 and, remarkably, played in each of Waikato's 19 matches and made such an impression that he was named as a standby player for the All Blacks' tour of Italy and France.

He was chosen for New Zealand the following year and played in two tests at second five-eighth, against Western Samoa in the All

Blacks' first home night test, and in the first test against Scotland, after which he was replaced by Walter Little. He played in three matches on the tour of South Africa, two at centre and one at second five-eighth.

In 1997, he again played in the early domestic tests, against Fiji and one against Argentina, and on the tour of Britain and Ireland in November and December he played in eight of the nine matches, going on as a replacement in each of the four tests.

McLeod at 100kg is a strong midfield player, capable on defence and with a flair for the midfield break.

McMEEKING David Thomas McLaggan

b: 30.1.1896, Alexandra *d:* 30.8.1976, Dunedin
Hooker

Represented NZ: 1923; 2 matches, 3 points – 1 try

First-class record: Otago 1922-25,28 (Kaikorai); South Island 1923; Otago-Southland 1925

In a brief first-class rugby career McMeeking played spasmodically for Otago and appeared in two of the three All Black games against New South Wales 1923 and in the interisland match in that season. His son, R. McMeeking, represented Otago 1951.

McMINN Archibald Forbes

b: 14.8.1880, Marton *d:* 23.4.1919, Porirua
Loose forward

Represented NZ: 1903,05; 10 matches – 2 tests, 9 points – 3 tries

First-class record: Wairarapa 1903 (Carterton); Manawatu 1904,05 (Palmerston North Institute), 1908,09 (Kia Toa); North Island 1903; Manawatu-Horowhenua 1908

Described as a "broad shouldered giant" who stood 6' 3", Archie McMinn usually played as a back-row or wing forward but also appeared for Manawatu as a five-eighth and wing.

Toured Australia with the 1903 New Zealand team and played in the Sydney test. His other international was against Australia at Dunedin after the 1905-06 'Originals' had departed for Europe. Scored two tries in this match.

Brother of 'Paddy' McMinn who had one game for New Zealand 1904. Refereed provincial games 1910,11 and was later a Manawatu selector.

McMINN Francis Alexander

b: 10.11.1874, Turakina *d:* 8.8.1947, Auckland
Hooker

Represented NZ: 1904; 1 match – 1 test

First-class record: Manawatu 1895,96 (Pirates), 1898,99 (Alhambra), 1903-05,07,08 (College St OB); Hawke's Bay 1900 (Napier); Wellington 1902 (Wellington); Taranaki-Wanganui-Manawatu 1904; Manawatu-Horowhenua 1908; Manawatu-Hawke's Bay 1905

First played senior rugby at the age of 14 for the Albion club. A rugged, 5' 9" player, 'Paddy' McMinn began his representative career at fullback but had his one match for New Zealand

in the front row with George Tyler against the 1904 British tourists. Later appeared in combined provincial teams against the 1905 Australians and the 1908 Anglo-Welsh.

His brother, Archie, represented New Zealand 1903,05 and two older brothers, Gordon and Garnet, also played for Manawatu.

McMULLEN Raymond Frank
b: 18.1.1933, Auckland
Threequarter

Represented NZ: 1957-60; 29 matches – 11 tests, 45 points – 15 tries

First-class record: Auckland 1953-60 (Otahuhu); North Island 1958,59; NZ Trials 1956-60; New Zealand XV 1958

Educated Grey Lynn Primary, Pasadena Intermediate Schools and Seddon Memorial Technical College. Played lower grade football for the Eden club before transferring to Otahuhu.

Frank McMullen

Named as a reserve for the fourth test against the 1956 Springboks, Frank McMullen had his first game for the All Blacks on the 1957 tour of Australia. Scored a try from centre in each test. Played on the left wing in all three tests against the 1958 Wallabies, at centre in the first two against the 1959 Lions, on the wing in the third test and missed the final match with a shoulder injury.

After showing indifferent form early on the 1960 tour of South Africa, McMullen returned to the test side for the last three internationals and was described as the All Blacks' most brilliant attacking back, scoring a try to enable his team to draw the third test. Retired after one more appearance for Auckland in a Ranfurly Shield game.

Standing 5' 9" and weighing 11$\frac{1}{2}$ stone when first selected and 12$\frac{1}{2}$ stone in South Africa, Frank McMullen was fast and elusive with a devastating sidestep.

Took up refereeing and controlled the 1973 England-New Zealand international.

McNAB John Alexander
b: 14.12.1895, Hastings *d:* 23.7.1979, Hastings
Loose forward

Represented NZ: 1925; 1 match

First-class record: Hawke's Bay 1920-24 (Celtic); North Island 1922,24; NZ Trials 1924; Hawke's Bay-Poverty Bay 1921

Educated Hastings High School. Began his representative rugby after serving in WWI and played in 12 Ranfurly Shield matches for Hawke's Bay during the 1920s.

A tall (6' 1", 13$\frac{1}{2}$ stone) back-row forward with a good turn of speed, McNab travelled to Australia with the 1925 All Blacks but appeared only in the first tour match, against New South Wales, because of illness.

McNAB John Ronald
b: 26.3.1924, Owaka
Flanker

Represented NZ: 1949,50; 18 matches – 6 tests, 3 points – 1 try

First-class record: Otago 1945-48,50,53 (Owaka); South Island 1947,48,52; NZ Trials 1948,50

Educated Owaka District High School. A fit and vigorous flanker, standing six feet and weighing around 14 stone, he was a regular member of Otago's Ranfurly Shield team 1947,48 before winning selection in the 1949 All Black team to South Africa.

Jack McNab played the first three tests on that tour and the following season missed only the fourth test against the Lions because of injury. The 1952 interisland match and six appearances for Otago in the next year completed his first-class career

Committee member, secretary, president and coach of the Owaka club and delegate to the South Otago sub-union. Selector and coach for Otago Country and coach of the South Otago Colts team in Australia. Otago RFU president 1980,81. President Otago RFU 1981.

McNAUGHTON Alan Murray
b: 20.9.1947, Christchurch
Flanker

Represented NZ: 1971,72; 9 matches – 3 tests, 12 points – 3 tries

First-class record: Bay of Plenty 1968-80 (Kahukura); North Island 1969-71; NZ Trials 1970-73; NZ Juniors 1969,70

Educated Rotorua Boys' High School. A fast and wide-ranging loose forward who played for New Zealand in the first three tests against the 1971 Lions and in six of the nine matches on the 1972 internal tour.

Although he continued to display good form at provincial level he was not selected for the All Blacks again. Stood 6' 2" and weighed 14$\frac{1}{2}$ stone at the time of his international appearances.

McNEECE James
b: 24.12.1885, Invercargill *d:* 21.6.1917, Messines, Belgium
Forward

Represented NZ: 1913,14; 11 matches – 5 tests, 6 points – 2 tries

First-class record: 1905,07,08,12,13 (Waikiwi); South Island 1913,14

Educated Middle School (Invercargill). Developed into a 6' 2", 14$\frac{1}{2}$ stone forward who could play in any position in the pack and occasionally as a wing. Noted for his lineout prowess and powerful goalkicking.

Played in two tests v Australia after the 1913 All Blacks had departed for North America and then toured Australia the following year appearing in all three tests.

Represented Southland at cricket. A brother, A.M. McNeece, played rugby for that province 1905,07-13. Died of wounds during WWI.

McNICOL Alasdair Lindsay Robert
b: 15.6.1944, Lower Hutt
Prop

Represented NZ: 1973; 5 matches

First-class record: Wanganui 1970,71 (Waiouru Army), 1972,73 (Wanganui & HSOB); North Island 1972; NZ Trials 1971,72; NZ Combined Services 1970,71; Wanganui-King Country 1971

Educated Onslow College and Whangarei Boys' High School, 1st XV 1961,62. Represented Wellington Colts and Manawatu B before moving to Waiouru where he played for Wanganui and Combined Services.

Called on to join the 1972-73 team in Britain when Jeff Matheson was invalided home, 'Sandy' McNicol appeared in five of the last 10 tour matches. While playing for the Tarbes club 1973-76 he earned a reputation as one of the leading props in France. At 6' 2" and 16st 12lb he was remarkably mobile and effective in the front of the lineout.

McNicol's father, Stew, represented Wellington 1936,38-40; King Country 1937,41; NZ Universities 1938-40; NZ Services in the United Kingdom 1944 and Wanganui 1946.

McPHAIL Bruce Eric
b: 26.1.1937, Ashburton
Wing threequarter

Represented NZ: 1959; 2 matches – 2 tests

First-class record: Mid Canterbury 1956 (Ashburton HSOB); Canterbury 1957-59 (Christchurch); Nelson 1960-63 (Nelson

Bruce McPhail

College & OB); South Island 1958-61; NZ Trials 1958-62; Rest of New Zealand 1960; Nelson-Marlborough-Golden Bay-Motueka 1961

Educated Ashburton Borough School and Ashburton High School. A very fast wing who established a reputation as a prolific try scorer with 14 for Canterbury in the 1959 season including seven against Combined Services – a New Zealand first-class record. Replaced 'Tuppy' Diack when the Otago wing was injured before the first test against the 1959 Lions and then came in for Frank McMullen who suffered an injury in training for the fourth test. His statistics were given as 5' 10" and 12 stone.

Coached grade teams for the Nelson College OB club and assistant coach of the provincial team 1966. A referee in Mid Canterbury 1972-76. A Canterbury sprint finalist and national veteran sprint champion 1979-86.

MACPHERSON Donald Gregory
b: 23.7.1882, Waimate *d:* 26.11.1956, Waimate
Wing threequarter

Represented NZ: 1905; 1 match – 1 test

First-class record: Otago 1905-07 (University); Scotland 1910

A slightly built but swift and intelligent wing, Macpherson played for New Zealand against Australia at Dunedin after the 1905-06 'Originals' had departed.

While continuing his medical studies in London he won two caps for Scotland against England and Ireland 1910.

MACPHERSON Gordon
b: 9.10.1962, Gisborne
Lock

Represented NZ: 1986; 1 match – 1 test

First-class record: Poverty Bay 1983,84 (Ngatapa); Otago 1985,86 (Union), 1987-93 (Green Island); NZ Juniors 1984; NZ Emerging Players 1985; South Island 1985; NZ Trials 1986-88,92; South Zone 1988,89

Gordon Macpherson was educated at Gisborne Boys' High School, where he played in the first XV for two years and was considered unlucky in 1983 not to gain a place in the New Zealand Colts. He was chosen for the Juniors the following year and in 1985 moved to Dunedin.

With the leading players in South Africa on the unauthorised Cavaliers tour and ineligible for selection for two tests, Macpherson played his only game for New Zealand in the so-called "Baby Blacks" against France. He was retained for the following test against Australia in Wellington, but had to withdraw because of a leg injury.

Macpherson, 101kg and just over two metres, was never again chosen for the All Blacks though he played in All Black trials for the next two years and again in 1992, his second-last year of first-class rugby for Otago.

Two brothers, Ken (1979,80,82,84) and Willie (1984,85) also played for Poverty Bay.

MacRAE Ian Robert
b: 6.4.1943, Christchurch
Second five-eighth and centre threequarter

Represented NZ: 1963,64,66-70; 45 matches – 17 tests, 42 points – 14 tries

First-class record: West Coast 1961 (Marist); Bay of Plenty 1962 (St Michael's OB); Hawke's Bay 1963-71 (Marist); North Island 1964,67,69; NZ Trials 1963,65-67,69,70; NZ Colts 1964

Educated Rangiora High School, 1st XV 1958,59. Ian MacRae came into prominence when he scored three tries for Hawke's Bay in their 20-5 victory over the 1963 English tourists. Selected for the 1963-64 tour of Britain and France, playing in 17 matches as a centre.

Ian MacRae

In 1966 he made his test debut in the home series against the Lions as a second five-eighth and retained this position in the internationals in Britain 1967 after appearing in the jubilee test v Australia.

Unavailable for the 1968 tour of Australia but played in the first two tests against the French later that year. Aggravated a back injury and unable to appear in the third test. MacRae returned for both matches against Wales 1969 and the following year visited South Africa, playing in all four tests. His weight and height were given as 13½ stone and 6' 2". A strong runner, he was frequently used to set up second phase play.

In his biography Colin Meads commented: "People may never appreciate what MacRae meant to the All Blacks. He was, for instance, a most potent force in the clean sweep against the Lions in 1966 . . . anyone who saw the test against France in 1967 would realise just how fine a player he could be."

Assistant coach for the Hawke's Bay team 1976,78. Chairman, Hawke's Bay union 1997.

McRAE John Alexander
b: 29.4.1914, Springhills *d:* 24.2.1977, Invercargill
Hooker and prop

Represented NZ: 1946; 2 matches – 2 tests

First-class record: Southland 1940,41 (Marist), 1943,44 (Marist-Bluff), 1945-48 (Marist); South Island 1945-47; NZ Trials 1947,48

A hooker who first appeared for the All Blacks in the first test against the 1946 Wallabies as a replacement for prop Harry Frazer who had left the field at halftime. In the second test McRae played in his usual position of hooker. A fine all-round forward as well as a quick striker for the ball, he was listed as 5' 10" and 13st 6lb. Southland selector 1959.

McROBIE Nisbet
b: 1873, Invercargill *d:* 27.9.1929, Auckland
Hooker

Represented NZ: 1896; 1 match

First-class record: Southland 1889,90 (Star), 1891-96 (Pirates)

Regarded as a speedy forward, McRobie represented New Zealand against the 1896 Queensland tourists. NZRFU management committee 1900-01. A brother, David, played for Southland 1893-97 while another brother, Alex, was president of the province's first referees' association.

Remuera Bowling Club president 1924,25 and Maungakiekie Golf Club captain 1927,28.

McWILLIAMS Ruben George
b: 12.6.1901, Paeroa *d:* 27.1.1984, Auckland
Loose forward

Represented NZ: 1928-30; 27 matches – 10 tests, 25 points – 7 tries, 2 conversions

First-class record: Auckland 1922-27,29,30 (Ponsonby); North Island 1927; NZ Trials 1927,29,30

Educated Eureka School (Waikato). Selected for the 1928 New Zealand team to South Africa, McWilliams performed extremely well in his 13 tour matches, including the last three tests. His subsequent All Black career saw him play all three internationals in Australia 1929 and throughout the series against the British in the following season.

Ruben McWilliams

A tall and rangy forward (6' 1" and 14st 5lb) he had considerable speed around the field. After his retirement McWilliams was assistant coach for the Ponsonby club 1936,37,47,48.

MAGUIRE James Richard
b: 6.2.1886, Auckland *d:* 1.12.1966, Lower Hutt
Hooker

Represented NZ: 1910; 6 matches – 3 tests

First-class record: Auckland 1905,06 (City), 1907-10 (Grafton)

Although Maguire normally played in the back row, he appeared as a hooker in the 2-3-2 scrum in five of six games, including the three tests, for the 1910 All Blacks in Australia. A member of the Waitemata rowing crew which won the 1909 national fours title.

MAHONEY Atholstan
b: 15.7.1908, Woodville *d:* 13.7.1979, Pahiatua
Loose forward

Represented NZ: 1929,34-36; 26 matches – 4 tests, 6 points – 2 tries

First-class record: Bush Districts 1927-36,39 (Konini); North Island 1933; NZ Trials 1929,30,34,35; Wairarapa-Bush 1930,36; 2nd NZEF 1941,42

Educated St Anne's Convent and Marist Brothers' (Newtown) Schools, Sacred Heart College (Auckland) and St Patrick's College (Wellington). Made two tours of Australia with New Zealand teams 1929,34 without appearing in a test match but was included in all four internationals on the 1935-36 British tour.

Standing 6' 2" and weighing 14st 3lb, 'Tonk' Mahoney was described by his fellow All Black Charlie Oliver in his 1935-36 tour book as "a great wet-weather forward who excelled at holding and wheeling the scrum . . . has never played better football and was our best lineout man."

Mahoney retired after an injury in the 1936 season but returned to lead Bush on a southern tour 1939 and played for the 2nd NZEF team in Egypt. His son, Peter, represented Wairarapa-Bush 1976,77 and a cousin, Charlie Quaid, was a 1938 All Black.

MAINS Laurence William
b: 16.2.1946, Dunedin
Fullback

Represented NZ: 1971,76; 15 matches – 4 tests, 153 points – 2 tries, 31 conversions, 28 penalty goals

First-class record: Otago 1967-75 (Southern); South Island 1970,71,75; NZ Trials 1970,71,73,74,76; NZ Juniors 1968

Educated King's High School, 1st XV 1964. Played his early rugby as a five-eighth switching to fullback 1966 and representing Otago Juniors that year.

An accurate left-footed goalkicker who scored over 100 points in a first-class season on seven occasions, his best tally was 157 in the 1975 season. Introduced for the rest of the series against the 1971 Lions when Fergie McCormick was dropped after the first test, Mains scored New Zealand's only points, a try, in the third test.

Not selected again until the international against Ireland in Wellington 1976 then toured South Africa. Despite his total of 132 points – the third highest for a touring player in that country – and the All Blacks' lack of a consistent fullback and goalkicker, Mains was not called upon to play in any of the tests. His tour statistics were listed at 5' 11" and 12st 6lb.

Mains coached Southern, the Dunedin club for which he had played, and then Otago from 1983 to 1991, winning the national provincial championship first division in his final year. He had also coached the South Zone in the three-year interzonal series and All Black trial teams at various times.

He was chosen convenor of the New Zealand selection panel and therefore All Black coach late in 1991 and remained in charge until after the tour of Italy and France in 1995. The high point of Mains's All Black coaching career was the 1995 World Cup, in which New Zealand were the standout team but were beaten in the final by South Africa.

MAJOR John
b: 8.8.1940, Whakatane
Hooker

Represented NZ: 1963,64,67; 24 matches – 1 test

First-class record: Taranaki 1961-68 (Inglewood); North Island 1963,67; NZ Trials 1963,65-68

Educated Huirangi Primary School and Waitara High School, 1st XV 1954,55. Toured Britain with the 1963-64 All Blacks as understudy to Dennis Young, playing in 16 of the 36 matches.

John Major

When Bruce McLeod became the first-choice hooker Major acted as reserve for three home test series over the next two years, winning his only international cap in the 1967 jubilee test against Australia when McLeod was suspended. On the 1967 British tour Major again played mainly mid-week games while McLeod hooked in the international scrums.

A good all-round forward who weighed 14st 4lb, stood 5' 10" and played a total of 110 first-class matches during his career.

MANCHESTER John Eaton
b: 29.1.1908, Waimate *d:* 6.9.1983, Dunedin
Flanker

Represented NZ: 1932,34-36; 36 matches – 9 tests, 23 points – 7 tries, 1 conversion

First-class record: Canterbury 1928-36 (Christchurch); South Island 1931-33; NZ Trials 1930,34,35

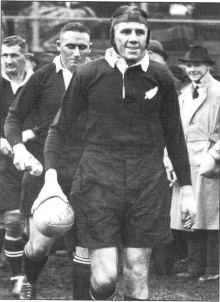

Jack Manchester

Educated Timaru Boys' High School, 1st XV 1924-26. Selected for the 1932 tour of Australia he made his debut as a replacement in the preliminary game against Wellington, scoring a try. Won a place in all three tests on tour and appeared in both internationals on the 1934 visit to Australia.

Chosen as captain for the 1935-36 All Blacks, he led his team in 20 of the 30 games in Britain and Canada including all four internationals. Standing 6' 1" and weighing 14st 3lb, Jack Manchester was described as "a great lineout forward, a tireless worker in the rucks and very fast in the loose".

Coached the Otago University team 1947-52. Christchurch club life member.

MANNIX Simon James
b: 10.8.1971, Lower Hutt
First five-eighth

Represented NZ: 1990,91,94; 9 matches – 1 test, 70 points – 2 tries, 19 conversions, 8 penalty goals

First-class record: Wellington 1990-96 (Petone); NZ Colts 1990; NZ Trials 1991,93,94; New Zealand XV 1992; NZ Development 1994

Mannix was marked out while at St Patrick's College, Silverstream, as a player with a promising future, but it was never really fulfilled. After playing for New Zealand Secondary Schools in 1989 and Wellington age grade teams, Mannix was introduced into the Wellington team in 1990 when still 18 and into the All Blacks later the same year.

He played in four matches on the tour of France at the end of 1990 and another four on the tour of Argentina in 1991, but was not wanted for the World Cup squad that followed.

Though he continued to be an asset for Wellington, he was not again required by the New Zealand selectors until the first test against France in 1994, after which he was promptly dropped. Mannix was regarded as technically proficient and mature for his age, but never developed as his early promise indicated he might.

Mannix was also chosen for a New Zealand XV in 1993, but did not play. He later continued his rugby career in Britain and played for the

British Barbarians in 1997.

A brother, Tim Mannix, played hooker for Wellington 1990-95.

Simon Mannix

MARKHAM Paul Francis
Also known as Father Paul Kane
b: 27.11.1891, Timaru *d:* 11.8.1953, Auckland
Second five-eighth

Represented NZ: 1921; 1 match

First-class record: West Coast 1919,20 (Cronadun); Wellington 1921 (Marist)

Educated Marist Brothers' School (Timaru) and St Patrick's College (Wellington).

Played three games for West Coast, seven for Wellington and had one All Black appearance against the New South Wales team touring at the same time as the 1921 Springboks, retiring at the end of the season.

MARSHALL Justin Warren
b: 5.8.1973, Gore
Halfback

Represented NZ: 1995-97; 29 matches – 23 tests, 70 points – 14 tries

First-class record: Southland 1992-94 (Woodlands); Canterbury 1995-97 (HSOB); Canterbury Crusaders 1996,97; NZ Colts 1993; NZ Divisional 1993; NZ Development 1994; NZRFU President's XV 1996; Harlequins 1996; NZ Barbarians 1996

Justin Marshall attended Gore High School and from 1986 to 1990 represented various Southland age group teams. He made his debut for Southland in 1992 at the age of 18 and also played for New Zealand Under 19 that year, followed by the New Zealand Colts in 1993 and 1994. He also played for the New Zealand Divisional team in 1993 and toured Argentina with the New Zealand Development team in 1994.

Southland gained promotion to the first division for 1995 but Marshall moved to Canterbury, where his career blossomed. Though he wasn't chosen for any trials that year, he was selected for the All Blacks' tour of Italy and France in October and November and replaced Stu Forster for the second test against France.

Under new coach John Hart, he became the regular New Zealand test halfback in 1996, playing in each of the 10 tests that year and in all 12 in 1997.

With Sean Fitzpatrick unavailable because of injury, Marshall first captained the All Blacks in the opening match against Llanelli on the November-December tour of Britain and Ireland, and retained the captaincy for each of the four tests.

Marshall, who was voted first division player of the year for 1996, was also a major contributor to Canterbury's success, which culminated in the division one title in 1997.

Strongly built, Marshall is a combative halfback and strong on the break, especially close to the line, but excels in the defensive and cover-defending demands of his role as well.

He is a nephew of 1958 All Black fullback Lloyd Ashby.

Justin Marshall

MASON David Frank
b: 21.11.1923, Wellington *d:* 3.7.1981, Johannesburg, South Africa
Wing threequarter

Represented NZ: 1947; 6 matches – 1 test, 9 points – 3 tries

First-class record: Wellington 1946,47 (Wellington College OB); NZ Trials 1947; Western Province 1950

Educated Takapuna Primary School and Wellington College, 1st XV 1939-41. Played his early rugby as a five-eighth.

Toured Australia with the 1947 All Blacks and appeared in the second test as a replacement for Wally Argus who retired with an injury late in the first half. Mason scored a try in this, his only international.

A fast and penetrating runner who handled well. His tour statistics were given as 5' 9" and 11st 8lb. Injured in a provincial match during the 1947 season and later that year moved to South Africa. Represented Western Province 1950.

MASTERS Frederick Harold
b: 20.12.1893, Brunnerton *d:* 27.5.1980, Sydney
Lock

Represented NZ: 1922; 4 matches

First-class record: Taranaki 1919-22 (Stratford); North Island 1919,22; NZ Trials 1921

Educated Stratford High School, Taranaki Schools rep 1908. Played for the Stratford club 1911 and Tukapa 1912 before moving to Auckland where he had two seasons with the College Rifles club.

Left to serve in WWI with the Main Body and won the MM at Messines. Returning to his home town he represented Taranaki and the North Island in the same year and then toured Australia with the 1922 All Blacks. A huge player for his time, Masters weighed 15st 6lb.

Served as a Taranaki selector after his retirement and was co-opted as an All Black selector 1936,37. Moved to Australia 1938 and coached teams from Sydney Grammar School and Sydney University. Enjoyed the unique distinction of serving as a national rugby selector in two countries when he joined the New South Wales and Australian panel 1946,47.

MASTERS Robin Read
b: 19.10.1900, Picton *d:* 24.8.1967, Christchurch
Lock

Represented NZ: 1923-25; 31 matches – 4 tests, 18 points – 6 tries

First-class record: Canterbury 1921-25 (Albion); South Island 1924,25; NZ Trials 1924; Canterbury-South Canterbury 1925

Played his early rugby for the Awatere club in Marlborough and the Oriental club in Wellington before moving to Christchurch.

Made his All Black debut in the third match against New South Wales at Wellington 1923 and then toured Australia the following season.

Selected for the 1924-25 'Invincibles', Read Masters was called upon to play frequently throughout the tour owing to the illness of the other lock, Ian Harvey. His 22 appearances included all four internationals. Illness forced his retirement from rugby after playing against New South Wales at Auckland 1925. Standing just short of six feet, his playing weight was given as 14st 5lb.

Masters then gave great service in rugby administration. Albion club secretary and delegate to the Canterbury RFU, president of that union 1950-52, life member 1956 and a Canterbury selector 1928-31. South Island selector 1938,39,47-50, New Zealand selector 1949 and NZRFU president 1955. From his tour diary he compiled *With the All Blacks in Great Britain, France, Canada and Australia, 1924-25* (Christchurch Press, 1928). One of the editors of the *Rugby Almanack of New Zealand* from its inception 1935 until his death.

MATAIRA Hawea Karepa
b: 3.12.1910, Nuhaka *d:* 15.11.1979, Wairoa
Loose forward

Represented NZ: 1934; 5 matches – 1 test, 3 points – 1 try

First-class record: Hawke's Bay 1932-35 (Nuhaka), 1936 (Napier Technical College OB); NZ Trials 1934,35; NZ Maoris 1932,35,36

Educated Nuhaka Native School and Maori Agricultural College, 1st XV 1928. Played for the

Nuhaka club in the Wairoa sub-union before gaining full representative honours and making 35 appearances for Hawke's Bay.

An energetic loose forward standing 5' 11" and weighing 14st 2lb, Mataira toured Australia with the 1934 All Blacks playing his only international at number eight in the second test.

Considered unlucky to miss selection for the 1935-36 team after displaying good form in the trials. Switched to rugby league 1937 and joined the City Rovers Club in Auckland and left with the 1939 New Zealand league team scheduled to tour England but which returned home after two matches owing to the outbreak of WWII. Played rugby in Egypt during the war but returned to league and was a member of the NZ Maoris side which played England 1947.

MATHESON Jeffrey David

b: 30.3.1948, Palmerston
Prop

Represented NZ: 1972; 13 matches – 5 tests

First-class record: Otago 1970-72 (Pirates); North Otago 1974,75 (Maheno); South Island 1972; NZ Trials 1972,74

Educated Waitaki Boys' High School, 1st XV 1964,65. Played for Lincoln College 1968 and Otago sub-unions from the Taras club before representing Otago as a 15st 9lb prop or lock standing just under six feet.

Jeff Matheson

Played in all three tests against the 1972 Wallabies and was selected for the British tour later that season. After appearing in 10 of the first 17 games including the Welsh and Scottish internationals he was invalided out of the tour with a rib injury suffered in the latter game and replaced in the touring party by 'Sandy' McNicol.

Did not play in the 1973 season but captained North Otago 1974,75 and coached the representative team 1977-80.

MATHIESON Robert George

b: 11.1.1899, Chatham Islands *d:* 16.4.1966, Oamaru
First five-eighth and halfback

Represented NZ: 1922; 4 matches

First-class record: Otago 1918,22 (Pirates); South Island 1922

Educated High St School and Otago Boys' High School. Selected for the 1922 New Zealand team to tour New South Wales, he played against Wairarapa before the side left, two of the five matches in Australia and had a further appearance against Wellington-Manawatu on the team's return.

Coached primary school teams in Oamaru.

MATSON John Tabaiwalu Fakavale

b: 14.5.1973, Nausori, Fiji
Threequarter

Represented NZ: 1995,96; 5 matches, 5 points – 1 try

First-class record: Canterbury 1994-97 (Marist-Albion); Canterbury Crusaders 1996,97; Canterbury XV 1995; NZRFU President's XV 1995; South Island 1995; NZ Trial 1995; New Zealand XV 1995; Barbarians 1994; Harlequins 1996; Air New Zealand Invitation 1996; Manawatu Invitation XV 1996; North Otago Invitation XV 1996; South Island Invitation XV 1997

Tabai Matson, born of a Canterbury father and a Fijian mother, and Christchurch-educated (Christ's College), played for Canterbury age grade sides, New Zealand Secondary Schools and New Zealand under 19 before making his Canterbury debut in 1994.

After playing in an All Black trial in 1995 and for a New Zealand XV against Canada, Matson gained full New Zealand selection in unusual circumstances. He was following the All Blacks' tour of Italy and France as a sponsor's representative when he was called into the team by coach Laurie Mains as cover for injured backs. He played three matches, one on the wing and two at centre. Matson became the second sponsor's representative to be called on to play. Mike Brewer filled a similar role in England and Wales in 1993.

Matson gained more orthodox selection the following year when he was chosen in the enlarged squad for the tour of South Africa, where he played in two of the midweek matches.

MATTSON Herman Alfred

b: 4.11.1900, Auckland *d:* 6.7.1980, Auckland
Second five-eighth and threequarter

Represented NZ: 1925; 5 matches, 3 points – 1 try

First-class record: Auckland 1922,25 (Ponsonby)

Educated Ellerslie School and Seddon Memorial Technical College. Entered the Auckland team 1922 as a threequarter but was unable to play representative rugby for the next two seasons because of a knee injury 1923 and a broken jaw 1924. In Australia with the 1925 All Blacks Mattson appeared in all but one of his five matches as a second five-eighth. A compact (5' 9" and 11st 5lb) and strong-running back, he was again troubled by a knee injury on this tour. A broken collarbone ended his rugby career 1926.

Ponsonby club treasurer and first president of the Old Boys' Assn. Also coached the Parnell club.

MAX Donald Stanfield

b: 7.3.1906, Nelson *d:* 4.3.1972, Brightwater
Loose forward and lock

Represented NZ: 1931,32,34; 8 matches – 3 tests, 3 points -- 1 try

First-class record: Nelson 1924,26 (Nelson College OB), 1927-31,33-35 (Brightwater Pirates); South Island 1931-33; NZ Trials 1929,34,35; Nelson-Marlborough-Golden Bay 1930; Seddon Shield Districts 1931

Educated Hope School and Nelson College. First played for Nelson as an 18-year-old. Made his New Zealand debut on the side of the All Blacks' last 2-3-2 scrum v Australia 1931.

Chosen for the tour of Australia the next year, Max appeared in the pre-tour game against Wellington but broke an ankle in the first fixture in Australia and did not play again in that season. Again Australia visited Australia 1934 appearing as a flanker in the first test and a lock in the second. Another broken ankle ended his rugby during the 1935 season.

Nelson selector 1951 and president of that union. NZRFU president 1949. Represented Nelson at cricket and golf. A brother, L. Max, also played rugby for the province.

MEADS Colin Earl

b: 3.6.1936, Cambridge
Lock and loose forward

Represented NZ: 1957-71; 133 matches – 55 tests, 86 points – 28 tries, 1 conversion

First-class record: King Country 1955-72 (Waitete); North Island 1956-59,62,63,65-69; NZ Trials 1956-61,63,65-71; New Zealand XV 1958,68; NZ Colts 1955; NZ Under 23 1958; Wanganui-King Country 1956,65,66,71; King Country-Counties 1959

Educated Te Kuiti Primary School, King Country Primary Schools rep 1947,48, and Te Kuiti High School, 1st XV 1950. Represented King Country Juniors 1953 and toured Australia and Ceylon with the 1955 New Zealand Colts team in his first year of provincial rugby.

Colin Meads made his All Black debut on the 1957 tour to Australia, winning his test cap as a flanker in the first international and moving to lock in the third test. Played all three tests against the Wallabies and was recalled after missing the first test against the Lions in the following year. On overseas tours Meads appeared throughout the series in South Africa 1960, Australia 1962, the British Isles and France 1963-64 and 1967, Australia 1968 and in two internationals in South Africa 1970 after breaking his arm.

In home series he played against France 1961, two tests against Australia 1962 (losing his place to his brother Stan for the second), England 1963, Australia 1964, South Africa 1965, the Lions 1966, Australia 1967, France 1968, Wales 1969. His final season for New Zealand was as captain for the series against the 1971 Lions.

A legend in New Zealand rugby, Colin Meads had a record 55 internationals for New Zealand, 47 of these as a lock, five on the side of the scrum and two at number eight. Standing 6' 4", Meads weighed around 16 stone. He was consistently fit, mobile, aggressive and determined. Described by Fergie McCormick in his biography as "a terrible man with the silver fern on. He regarded the All Black jersey as pure gold. He could do so many things so much better than anyone else in a match that he stood

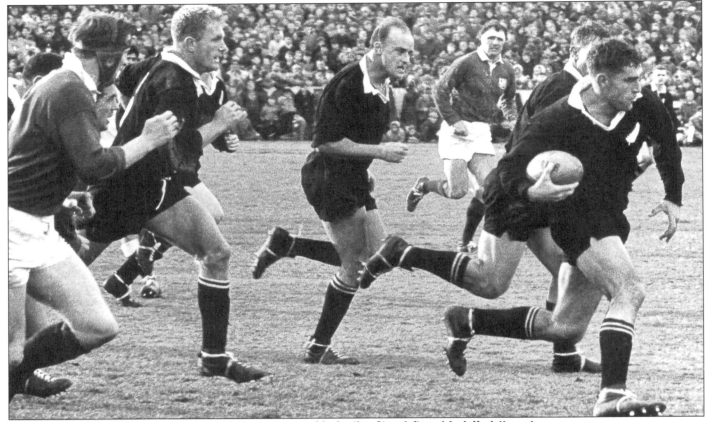

Colin Meads on the rampage against the 1966 Lions, supported by brother Stan, left, and Jack Hazlett, centre.

alone as the greatest player I have ever known". His total of 361 first-class matches (including 139 for King Country) is the highest by any New Zealander.

In the 1967 Scottish international he became the second player to be ordered off in a test match (the first was Cyril Brownlie, v England 1925) when he was sent from the field by Kevin Kelleher for allegedly kicking the ball as the Scottish fly-half reached to gather it.

Colin Meads was highly regarded throughout the rugby world. He was invited to play in a series of games celebrating the South African Rugby Board's 75th jubilee in 1964 and took part in a series as part of the Rugby Football Union's centenary celebrations 1971. He captained the President's XV and an Invitation XV against the All Blacks 1973.

His brother, Stan, made his All Black debut against the 1961 French tourists although the two Meadses did not regularly lock a test scrum until 1964. A biography, *Colin Meads All Black* (Collins, 1974), was written by Alex Veysey and sold 57,000 copies. MBE 1971.

After his retirement, Meads successfully coached King Country and was a North Island selector 1982-85. He was elected to the national selection panel in 1986 but at the beginning of that season he coached the unofficial Cavaliers in South Africa and was subsequently 'severely reprimanded' by the NZRFU council. He was voted off the national panel at the end of 1986. President King Country RFU, 1987.

Six years later, in 1992, Meads was elected to the New Zealand Rugby Football Union council and in 1994 and 1995 he was manager of the All Blacks, his tenure including the World Cup in South Africa. At the previous cup, in Britain in 1991, he had represented New Zealand at the formal opening ceremony at Twickenham.

Meads stood down from administration when the NZRFU council was replaced by a board at the beginning of 1996.

MEADS Stanley Thomas
b: 12.7.1938, Arapuni
Lock and loose forward

Represented NZ: 1961-66; 30 matches – 15 tests, 17 points – 5 tries, 1 conversion

First-class record: King Country 1957-66 (Waitete); North Island 1960,61,63-66; NZ Trials 1958,60-63,65,66; Rest of New Zealand 1960; Wanganui-King Country 1965,66

Educated Te Kuiti Primary School, King Country Primary Schools rep 1950, and Te Kuiti High School, 1st XV 1952,53 as a hooker. First represented New Zealand on the side of the scrum in the first test v France 1961 but did not play again in the series.

Toured Australia 1962 and appeared again in test rugby when the Wallabies visited later that season, replacing Colin Meads as lock in the second test and joining his brother as a lock in the third.

Played in only nine games on the 1963-64 British tour, requiring an appendix operation after the Irish international. Played in home series against the 1964 Wallabies and the 1965 Springboks, retiring after four tests against the 1966 Lions.

In his biography, Colin Meads said: "Without being parochial, biased or unduly moved by brotherly love, l would say that Stan was the best partner of all the great ones I had. He was strong, mobile, a fine lineout man, unremitting in his endeavours. He gave himself to every game; total effort almost above and beyond his actual weight."

Standing 6' 2½" and weighing 15st 8lb, Stan Meads played a total of 126 first-class matches. He locked the All Black scrum with his brother Colin Meads (New Zealand 1957-71) in 11 of his 15 tests. King Country coach 1994-96.

MEATES Kevin Francis
b: 20.2.1930, Greymouth
Flanker

Represented NZ: 1952; 2 matches – 2 tests

First-class record: Canterbury 1951-57 (Marist); South Island 1952; NZ Trials 1953,57; New Zealand XV 1952

Educated Marist Brothers' School (Greymouth) and St Bede's College. A flanker weighing 14st 12lb and standing 6' 2", Meates played both tests against the touring Australian team 1952, the first as a flanker and the second at number eight. A broken leg ended his rugby career after

Kevin Meates

the 1957 All Black trials. A foundation member of the Cantabrian club. A brother, Bill, represented New Zealand in 1949,50.

MEATES William Anthony
b: 26.5.1923, Greymouth
Wing threequarter

Represented NZ: 1949,50; 20 matches – 7 tests, 9 points – 3 tries

First-class record: Canterbury 1943 (Athletic-University), 1944 (Teachers College), 1947 (University); Otago 1948,50 (Ranfurly); South Island 1948,50; NZ Trials 1947,48,50; 2nd NZEF 1945,46; NZ Services (UK) 1945; Barbarians (UK) 1946

Educated Marist Brothers' School and St Bede's College, 1st XV 1942. Played 13 games for the 'Kiwis' army team on their tour of the British Isles and Europe and after some fine displays for Otago's Ranfurly Shield side, Meates was selected for the 1949 All Black tour to South Africa. Appeared in the final three tests in that series and in all four internationals against the Lions the following year, retiring at the end of that season.

A strongly built (12st 10lb, six feet), hard running wing described by Winston McCarthy in *Rugby in my Time* as "a great-hearted player. Never particularly fast, one of the best defensive players that I've seen in his covering up, and a heart – oh, as big as a house. He would give everything a go."

His brother, Kevin, was a 1952 All Black.

MEHRTENS Andrew Philip
b: 28.4.1973, Durban
First five-eighth

Represented NZ: 1995-97; 24 matches – 22 tests, 391 points — 6 tries, 71 conversions, 67 penalty goals, 6 dropped goals

First-class record: Canterbury 1993-97 (HSOB); Canterbury Crusaders 1997; Bay of Plenty 1997; NZ Colts 1993,94; NZ Trial 1995; Harlequins 1995,96; Air New Zealand Invitation XV 1996; NZ Barbarians 1994,96,97.

After education at Christchurch Boys' High School, where he was in the first XV in 1990, Andrew Mehrtens played age grade rugby for Canterbury before making his first-class debut in 1993. Though he'd been a first five-eighth throughout his school days, he also played at fullback in his first year for Canterbury.

Strong performances for Canterbury in the NPC and Ranfurly Shield matches in 1994 put him in contention for the All Blacks in 1995, and he made his New Zealand debut against Canada in Auckland, scoring 28 points, which set a world record for a player on debut, beating the 23 scored by Matthew Cooper against Ireland in 1992. The record was beaten during the World Cup by Simon Culhane, who scored 45 points against Japan.

Mehrtens became the first-choice first five-eighth at the cup tournament in South Africa, playing in five of the six matches and scoring 84 points. He was one of the standout players in the New Zealand effort that so nearly earned them the cup. A dropped goal attempt that could have won the final for New Zealand just missed. He also played in the two tests against Australia after the cup.

Mehrtens went on the tour of Italy and France in late 1995, but injured knee ligaments in the

first match, against Italy A in Sicily, and had to return home.

The injury forced him to miss the inaugural Super 12 competition, but he regained his All Black place for the first six tests of the year, against Western Samoa, Scotland and in the inaugural tri nations series. Injury struck again in South Africa, however, and he played in only two of the tests in the winning series.

For all Mehrtens' record and temperament, Carlos Spencer was chosen ahead of him initially in 1997 and he played only in the first test of the year, against Fiji, and when he went on as a replacement against South Africa in Auckland. By the time of the tour of Britain and Ireland, however, Mehrtens was restored to the No 1 position and he played in each of the four tests.

Mehrtens is a prodigious goalkicker, as his collection of points testifies, but he is also a fine first five-eighth with strong vision and tactical sense, and speed on the break.

His father, Terry, played for Canterbury, New Zealand Juniors and Natal (hence the Durban birthplace), and he is a grandson of 1928 All Black George Mehrtens.

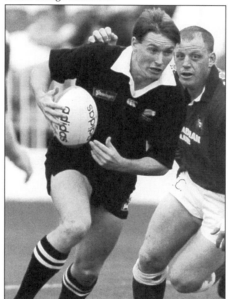

Andrew Mehrtens

MEHRTENS George Martin
b: 5.2.1907, Rangiora *d:* 30.8.1954, Rangiora
Fullback

Represented NZ: 1928; 3 matches

First-class record: Canterbury 1927 (Rangiora), 1928 (Christchurch HSOB)

Educated Christchurch Boys' High School. Represented Canterbury B from the Rangiora club 1927 before appearing in four matches for Canterbury.

Called into the All Blacks for the second match of the series against New South Wales 1928 after Vic Butler had withdrawn. Held his place for the final match of the series after playing in the intervening game against West Coast-Buller. A son, Terry, played for Canterbury, NZ Juniors and Natal. Grandfather of 1995-97 All Black Andrew Mehrtens.

METCALFE Thomas Charles
b: 13.5.1909, Invercargill *d:* 26.5.1969, Dunedin
Loose forward and lock

Represented NZ: 1931,32; 7 matches – 2 tests, 6 points – 2 tries

First-class record: Southland 1928-36,38 (Pirates); South Island 1931-34; NZ Trials 1934,35

First played for Southland as a 19-year-old and was a member of that province's 1929,30 Ranfurly Shield side, captaining the team in 1931 in an unsuccessful attempt to regain the shield from Wellington.

The following season he played in the back row of New Zealand's last international 2-3-2 scrum (v Australia 1931). On tour with the All Blacks in Australia in 1932 he became New Zealand's first number eight forward when he took the field in that position for the first test. Stood 5' 11" and weighed around 13½ stone.

Continued to represent Southland until 1938 with the exception of the 1937 season and had four first-class service games 1940, including a match for Combined Services.

MEXTED Graham George
b: 3.2.1927, Greytown
Number eight

Represented NZ: 1950,51; 6 matches – 1 test, 15 points – 5 tries

First-class record: Wellington 1950-52 (Tawa), 1953,54 (Athletic); North Island 1950,51; NZ Trials 1951,53

Educated Tawa Primary School and Wellington College. Represented Wellington Under 18 1944 from the Wellington College OB club before joining Tawa.

A fine all-round number eight forward he was called into the New Zealand team for the final test of the 1950 series against the Lions and then played five games on the 1951 tour of Australia. Listed at 14st 8lb and 6' 1".

Coach of the Tawa club seniors 1960-64 and president 1966-68. Wellington College tennis champion 1953 and provincial junior title holder 1944. His son, Murray, represented New Zealand at rugby 1979-85.

Graham Mexted

MEXTED Murray Graham

b: 5.9.1953, Wellington
Number eight
Represented NZ: 1979-85; 72 matches – 34 tests, 76 points – 19 tries

First-class record: Wellington 1975 (Tawa), 1976-85 (Wellington); North Island 1978,80,84; NZ Trials 1977,79,80,83,84; IRB Centenary 1986

Educated Tawa Primary, Wellington primary representative 1966, and Tawa College, 1st XV 1971. Wellington secondary school representative. Mexted was chosen for the second-string New Zealand side against Argentina in 1979 and toured at the end of the year with the full team on the tour of England and Scotland, making his test debut against Scotland (scoring a try) and beginning a remarkable sequence of 34 successive internationals.

Murray Mexted

Mexted made the All Black number eight position his own and during his 1979-85 tenure had few serious challengers. Wherever the All Blacks went in the first half of the 1980s, Mexted was sure to go. In an era when many All Blacks were complaining of too much rugby, Mexted seemed to thrive on it and in between New Zealand and Wellington commitments, he played club rugby in France and in South Africa.

As a member of the All Blacks named for the aborted 1985 tour of South Africa, Mexted toured in 1986 with the unofficial Cavaliers and made himself unavailable for the rest of the season. Standing 1.93m and weighing 97kg, Mexted was regarded as having the ideal number eight's build (although both his successors in the All Blacks were shorter). He was particularly effective running off the back of the lineout and was an unobtrusive but extremely effective defender.

In 1986 his autobiography, *Pieces of Eight* (Rugby Press) was published. That year he also married a former Miss Universe, Lorraine Downes.

Mexted's father, Graham, played for New Zealand in 1950 and 1951.

MILL James Joseph

b: 19.11.1899, Tokomaru Bay *d:* 29.3.1950, Gisborne
Halfback

Represented NZ: 1923-26,30; 33 matches – 4 tests, 53 points – 15 tries, 4 conversions

First-class record: Poverty Bay 1921 (Tokomaru Bay Wanderers); Hawke's Bay 1923-26,29 (Marist); East Coast 1928 (Tokomaru Bay Wanderers); Wairarapa 1929 (Masterton), 1930 (Masterton OB); North Island 1923-26,29; NZ Trials 1924,30; NZ Maoris 1921-23; Hawke's Bay-Poverty Bay 1921; Hawke's Bay-Poverty Bay-East Coast 1923; Wairarapa-Bush 1930

Educated Napier Boys' High School and Nelson College, 1st XV 1916-18 from where he played for Nelson in a second-class fixture.

Made his first-class debut for Poverty Bay 1921 and had two games against the Springboks when his union combined with Hawke's Bay and for NZ Maoris. Made the first of his 32 appearances for Hawke's Bay 1923 and was chosen for the All Blacks to play New South Wales at Dunedin.

Toured Australia 1924 before departing for Europe with the 'Invincibles'. Showing brilliant form on this tour he took over as the test halfback from Bill Dalley after the Irish game. On the team's return he played against New South Wales at Auckland and in all six matches on the 1926 tour of Australia, including one appearance at first five-eighth outside Dalley. Ineligible for the 1928 tour to South Africa because he was Maori, he had his final match for New Zealand in the first test against the 1930 British team.

Jimmy Mill

Standing 5' 7" and weighing 10st 12lb, Jimmy Mill was a clever player with a lightning break particularly on the blindside of the scrum. He scored a number of spectacular tries including one solo effort against Cambridge University to help the 'Invincibles' win by 5-nil and maintain their unbeaten record.

Member of the Poverty Bay cricket team which won the Hawke Cup in the 1918-19 season.

MILLER Todd James

b: 2.12.1974, Whangarei
Fullback

Represented NZ: 1997; 4 matches, 20 points – 4 tries

First-class record: Waikato 1993,94 (Hamilton Marist), 1997 (Hautapu); NZ Colts 1994

Todd Miller, who was educated at Kamo High School, played for three years in the New Zealand Secondary Schools team and for Northland age grade sides. He moved to Hamilton in 1993 and made an immediate impression, playing for Waikato Colts and making his first-class debut for Waikato. He was a member of the 1993 Waikato team that won the Ranfurly Shield from Auckland.

After a full season with Waikato in 1994, and selection in the New Zealand Colts, Miller was out of all rugby for 1995 and 1996 while he was engaged in church missionary work.

He made an impressive return to Waikato in 1997 and was chosen for the All Blacks for the November-December tour of Britain and Ireland, during which he played in four matches.

Miller is a strong, elusive runner with the ball and a solid defender.

He is a nephew of All Blacks Sid and Ken Going, and of Brian Going, and first-class players Vaughan, Charles, Troy, Adrian and Quinten Going are all cousins.

MILLIKEN Harold Maurice

b: 27.2.1914, Christchurch *d:* 10.1.1993, Auckland
Lock

Represented NZ: 1938; 7 matches – 3 tests, 6 points – 2 tries

First-class record: Canterbury 1933,35 (Springfield), 1936-38 (Sunnyside); South Island 1936-38; NZ Trials 1937

Educated St Andrew's College. A powerful lock weighing 15st 4lb and standing just under six feet, Milliken played in seven of the nine matches on the 1938 All Black tour to Australia. Formed an effective combination with Ron King in the three tests.

Transferred to rugby league 1939 playing with the Papakura club. Departed with the New Zealand league team which played only two games in England before the outbreak of WWII brought an early end to the tour. Served in the Pacific during the war. Reinstated to rugby union 1950 and appeared for the Clevedon club and Grafton before becoming player-coach of the Leamington club in the Waikato 1952-55.

MILLS Hugh Parsons

b: 6.6.1873, Timaru *d:* 26.3.1905, New Plymouth
Forward

Represented NZ: 1897; 8 matches, 12 points – 4 tries

First-class record: Taranaki 1896-99 (Tukapa); North Island 1897

An all-round forward who preferred to play as a wing forward. He toured Australia with the 1897 New Zealand side playing eight games including two against New South Wales, two against Queensland and v Auckland on the team's return.

MILLS John Gordon
b: 23.2.1960, Auckland
Hooker

Represented NZ: 1984; 2 matches, 4 points – 1 try

First-class record: Canterbury 1982,83,86-88 (Linwood); Auckland 1984 (Ponsonby); NZ Juniors 1982

Educated at Auckland Grammar School, where he was a flanker in the 1st XV 1977. Mills switched to hooker in 1979 when he played for Auckland third grade and in 1981 he played for Auckland Colts. He moved to Canterbury in 1982 and was in the Ranfurly Shield-winning team against Wellington.

Mills moved back to Auckland in 1984 and gained selection for the All Blacks' tour of Fiji at the end of that year. He missed most of 1985 through injury and subsequently returned to Canterbury. He was not again chosen for the All Blacks. He joined the Cavaliers in South Africa 1986 when captain Andy Dalton was injured. His playing weight was 85kg and he stood 1.78m.

MILLTON Edward Bowler
b: 7.3.1861, Christchurch *d:* 11.3.1942, Loburn
Forward

Represented NZ: 1884; 7 matches, 2 points – 1 try

First-class record: Canterbury 1883-86 (Christchurch); Wellington 1884

Educated Christ's College. A member of the 1884 team. Played only seven times for Canterbury during the four seasons he was in the representative squad. Named in the 1884 New Zealand party to tour Australia, he played against the tourists for a Wellington XV before the team sailed. Played seven of the eight matches in Australia and was described by the tour manager S.E. Sleigh as "one of the best dribblers in the team".

His brother, William, was captain of the 1884 team.

MILLTON William Varnham
b: 10.2.1858, Christchurch *d:* 22.6.1887, Christchurch
Forward

Represented NZ: 1884; 8 matches, 35 points – 4 tries, 9 conversions

First-class record: Canterbury Clubs 1876-78; Canterbury 1879-84 (Christchurch)

Educated Christ's College. After seven years playing for Canterbury William Millton was named as the captain of New Zealand's first touring team, a party of 19 players from the Auckland, Wellington, Canterbury and Otago unions which had eight games in Australia 1884.

Millton's first game on tour was at fullback and thereafter he played in the forward pack. He was leading pointscorer with 35. Team manager S.E. Sleigh described him as "the right man in the right place. A steady, dribbling forward, always near the leather. His good-natured, unselfish play tended in no small degree to make the games pleasant and at the same time successful."

Christchurch club secretary 1882 and delegate to the Canterbury RFU 1881-86, secretary of that union 1883-87. Played cricket for Canterbury 1878-86, captaining the side against the 1886 Australian tourists. His brother Edward was also a member of the 1884 New Zealand rugby team.

The hero of a passenger rescue from the vessel *Melrose* which was wrecked off Timaru 1878. Died of typhoid at the age of 29.

MILNER Henare Pawhara
b: 12.2.1946, Tokomaru Bay *d:* 2.3.1996, London, England
Utility back

Represented NZ: 1970; 16 matches – 1 test, 27 points – 9 tries

First-class record: East Coast 1963-65 (Tokomaru Bay United); Wanganui 1966-68,70-73 (Waiouru Army); Counties 1973-78 (Papakura Army); NZ Trials 1965-67,70,71; NZ Juniors 1965; NZ Colts 1964; NZ Maoris 1971,73-75; NZ Services 1967,69,71,73; Poverty Bay-East Coast 1965; Wanganui-King Country 1971; Counties-Thames Valley 1977

Educated Tokomaru Bay High School, 1st XV 1959-63 from where he represented East Coast. Toured Australia with the 1964 Colts. An elusive runner who stood 5' 10" and weighed 12st 5lb, 'Buff' Milner could fill most backline positions competently.

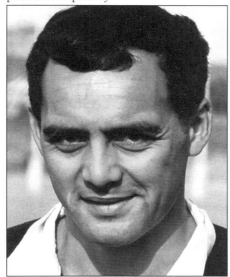
'Buff' Milner

In his 14 appearances on the 1970 South African tour he played at second five-eighth, centre and wing threequarter and fullback. His only international match, the third test, saw him on the wing with Bryan Williams moving in to centre.

Milner had a first-class career of 157 games over 16 seasons.

MITCHELL John Eric Paul
b: 23.3.1964, Hawera
No 8

Represented NZ: 1993; 6 matches, 10 points – 2 tries

First-class record: Waikato 1985-94 (Fraser-Tech); NZ Trial 1994; New Zealand XV 1994; NZ Development 1994; Air New Zealand Invitation XV 1996

John Mitchell

Mitchell was a classic example of a provincial forward who toiled for years without being noticed by the national selectors – in his case, almost too late. Remarkably, Mitchell had played nine years for Waikato and was never chosen for any form of national team until his sudden elevation to the All Blacks for the 1993 tour of England and Scotland. Mitchell was captain of Waikato and led them to the first division title in 1992 and in their successful Ranfurly Shield challenge in 1993.

Mitchell played six matches in England and Scotland in 1993 and coach Laurie Mains acknowledged his qualities by having him take over as captain for the final three midweek matches.

In Mitchell's last year of first-class rugby, he led teams in All Black trials, a New Zealand XV against France and a New Zealand Development team that toured Argentina.

Mitchell had coached for a season in Ireland and, after a brief stint in Hamilton, he took over as coach of Sale, a first division club in England. Within two years, he had been made assistant coach of England – and among the opponents in his first season on the job, 1997-98, were the All Blacks.

Mitchell also played for the British Barbarians.

MITCHELL Neville Alfred
b: 22.11.1913, Invercargill *d:* 21.5.1981, Auckland
Threequarter

Represented NZ: 1935-38; 32 matches – 8 tests, 60 points – 20 tries

First-class record: Southland 1932-34,36,37 (Old Boys); Otago 1938,39 (Alhambra); South Island 1934,37,38; NZ Trials 1934,35,37

Educated Waihopai and St George Schools and Southland Boys' High School, 1st XV 1928,29. Played for Southland Juniors 1930 and made his full representative debut two years later. After good displays in the 1934 interisland match and 1934,35 All Black trials he was selected for the 1935-36 British tour.

Played in 22 games in Britain including all four internationals. Unavailable for the first test against Australia 1936 owing to injury though

able to play in the second encounter. Also withdrew from the interisland fixture in that year after being named as South Island captain.

Hampered again by injuries in the 1937 season after outstanding form in the trial matches he was kept out of consideration until he appeared heavily bandaged and well below his top form in the third test against the Springboks. Captained the 1938 All Blacks in Australia but after appearing in six of the first seven games including two internationals he suffered another injury which kept him out for the rest of the tour.

Showed outstanding form for Otago but did not appear in the 1939 trials and transferred to Timaru where he played club football for the High School OB club. His last first-class match was for the Harlequins club 1946.

'Brushy' Mitchell's form on the 1935-36 tour was praised by Eric Tindill: "Right from the first game he played really outstanding football on the wing. He was unimpressive, I thought, as a centre, but as a wing he was a different player altogether, showing speed, clever sidestepping and determination in going for the line. Many a time I have seen him emerge triumphant with the ball when as many as six or seven of the opposition have confronted him. He possessed a deceptive swerve, dummied well and had a good body wiggle."

Mitchell served as a South Canterbury selector 1950,51. Represented Southland at cricket. His father, Alf, played rugby for Otago 1908-10 and Southland 1911,12. He was chosen for the 1910 All Blacks to tour Australia but was unable to travel. One of the selectors and tour manager that year, Vin Meredith, was also a selector and tour manager 25 years later when 'Brushy' Mitchell made his New Zealand debut. An uncle, Jack Mitchell, also represented Otago and was a guest player for the North Island 1904.

MITCHELL Terry William
b: 11.9.1950, Takaka
Wing threequarter

Represented NZ: 1974,76; 17 matches – 1 test, 36 points – 9 tries

First-class record: Golden Bay-Motueka 1968 (Takaka); Nelson Bays 1969,70 (Takaka), 1971,72 (Celtic); Canterbury 1973-78

Terry Mitchell

(Linwood); South Island 1974; NZ Trials 1971,73-77; NZ Juniors 1973; NZ Maoris 1971,74,75; Marlborough-Nelson Bays 1971

Educated Takaka District High School. First represented Golden Bay-Motueka as a 17-year-old. Mitchell was a strong-running wing who proved difficult to stop when in full cry. Moved to Christchurch 1973 and became the country's leading try scorer in that season with 17 from 23 games and again in 1974 with 21 from 20 appearances, including five for Canterbury v West Coast.

Played in three of the eight matches on the 1974 All Black tour of Ireland and in 14 games in South Africa 1976 including an appearance as a replacement for Grant Batty who retired in the second half of the final test. His last minute try against the Quagga-Barbarians, after a thrilling All Black revival, gave his team a 32-31 victory.

His father, M.D.I. Mitchell, played for Golden Bay-Motueka 1949,51.

MITCHELL William James
b: 28.11.1890, Melbourne, Australia d: 2.6.1959, Christchurch
Wing threequarter

Represented NZ: 1910; 5 matches – 2 tests, 6 points – 2 tries

First-class record: Canterbury 1909,10 (Merivale)

A strongly built wing who weighed 13 stone, Mitchell had a meteoric rise from a third grade club player to representative status 1909 and appeared in two internationals in the next season when he was sent as a reinforcement to join the 1910 All Blacks in Australia.

Joined the rugby league code 1911, represented New Zealand 1913 and captained the league team 1919. His son, Murray, played rugby for Canterbury 1944,45.

MITCHINSON Frank Edwin
b: 3.9.1884, Lawrence d: 27.3.1978, Wanganui
Threequarter and second five-eighth

Represented NZ: 1907,08,10,13; 31 matches – 11 tests, 80 points – 22 tries, 2 conversions, 2 penalty goals, 1 dropped goal

First-class record: Wellington 1905 (Southern), 1906-11,13 (Poneke); Wanganui 1912 (Raetihi); North Island 1906-10

Educated Berhampore and Newtown Schools, Wellington Primary Schools rep 1898-1900. A brilliant back who began his international career with three tries from centre in the first test in Australia with the 1907 All Blacks.

Appeared in the two other tests on that tour, scoring New Zealand's only try in the third, and in all three against the 1908 Anglo-Welsh tourists, with two tries in the first and three from the wing in the third. His 10 tries in international matches for New Zealand remained a record until bettered by Ian Kirkpatrick in 1973. In two of his three tests in Australia 1910 Mitchinson appeared at second five-eighth. As vice-captain of the 1913 team in North America, he played on the wing in the Berkeley international.

His brother, Charles, played for Hawke's Bay 1905; his son, Neil, played for King Country 1940-47 and Manawatu and Hawke's Bay 1941 while two of his grandsons, Grant (Wanganui

1974-78 and Hawke's Bay 1979,80) and Bruce (Wairarapa-Bush 1978), have also played representative rugby.

MOFFITT James Edward
b: 3.6.1889, Waikaia d: 16.3.1964, Auckland
Lock

Represented NZ: 1920,21; 12 matches – 3 tests, 14 points – 4 tries, 1 conversion

First-class record: Wellington 1910-12 (St James), 1914,15,20-24,26 (Oriental); North Island 1920,21; NZ Services 1918-20

A powerful scrummager who weighed 15 stone and stood just under six feet, Jim Moffitt played 42 games for Wellington over 17 seasons.

His rugby career was interrupted by service with the Auckland Infantry Regt in WWI during which he rose to the rank of 2nd lieutenant and played for the NZ Division in the Somme Cup tournament in France 1917 before representing NZ Services in the King's Cup competition in Britain. Toured South Africa 1919 with the army team.

Played in every match for the 1920 All Blacks in Australia and at home and was then included in all three tests against the 1921 Springboks.

His brother, Joe, was a prominent referee.

MOLLOY Brian Peter John
b: 12.8.1931, Wellington
Halfback

Brian Molloy

Represented NZ: 1957; 5 matches, 3 points – 1 try

First-class record: Manawatu 1950 (University), 1951 (Marist); Canterbury 1955-58 (University); South Island 1957,58; NZ Trials 1957,58; NZ Universities 1956,57

Educated Marist Brothers' High School (Palmerston North). A fine halfback who was skilful at making play on the blindside. After an impressive match for NZ Universities against the 1956 Springboks, Molloy was chosen to tour Australia the next year. Played in five of the 13 matches giving way to the team captain 'Ponty'

Reid for the main fixtures. At the time of the tour his weight was given as 12st 1lb and height 5' 8''.

Coached the University club in Christchurch 1959-64. NZ Universities selector 1975-78.

MOORE Graham John Tarr
b: 18.3.1923, Wellington *d:* 27.1.1991, Masterton
Wing threequarter

Represented NZ: 1949; 1 match – 1 test, 3 points – 1 try

First-class record: Hawke's Bay 1941 (Dannevirke High School), 1945 (Dannevirke Combined); Otago 1946-50 (University); South Island 1949; NZ Trials 1947,48,50; New Zealand XV 1949; NZ Universities 1946-50

Educated Dannevirke North Primary School and Dannevirke High School, 1st XV 1938-41 from where he represented Hawke's Bay. Played for Otago, initially as a threequarter then at fullback, while studying medicine in Dunedin.

Named as fullback for New Zealand in the first test against the 1949 Wallabies but when Jack McLean was forced to withdraw, Moore took his place on the wing with Rex Orr being called in to take the fullback berth. Scored New Zealand's only try in an 11-6 loss. A reliable and versatile player he stood 5' 10'' and weighed 13st 4lb.

Honorary doctor for the Wairarapa and Wairarapa-Bush unions from 1955. His brother, Colin, represented Otago 1949,50, Southland 1952,53 and NZ Universities 1949-51.

MORETON Raymond Claude
b: 30.1.1942, Invercargill
Second five-eighth and centre threequarter

Represented NZ: 1962,64,65; 12 matches – 7 tests, 24 points – 7 tries, 1 dropped goal

First-class record: Southland 1961 (Southland HSOB); Canterbury 1962-65 (University); South Island 1962,64; NZ Trials 1962,63,65; NZ Colts 1964; NZ Universities 1962,64,65

Educated Surrey Park Primary and Tweedsmuir Intermediate Schools and Southland Boys' High

Ray Moreton

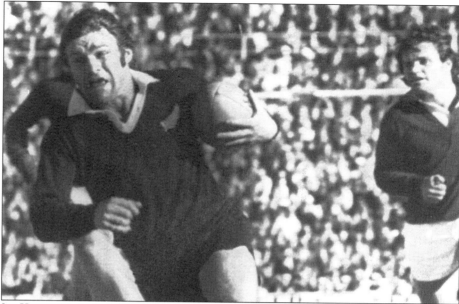
Joe Morgan heads for the goal-line against South Africa, 1976.

School, 1st XV 1956-59. Described as "a lively and enterprising player" he scored eight tries in seven appearances for Southland 1961 before going to Christchurch to further his education.

Played five matches for the All Blacks in Australia 1962 and then appeared in the first two tests against the Wallabies in the home series later that season. Considered unlucky to miss selection for the 1963-64 British tour, he was recalled for the three tests v Australia in 1964, scoring a fine try in the second. Reappeared for the All Blacks in the second and third tests against the 1965 Springboks. His statistics at that time were given as 5' 9'' and 12st 5lb.

Co-coach of the University club in Christchurch and South Island Universities selector 1974.

MORGAN Herman David
b: 13.6.1902, Milton *d:* 19.1.1969, Dunedin
Wing threequarter

Represented NZ: 1923; 1 match, 3 points, – 1 try

First-class record: Otago 1923,24,26 (Pirates)

Educated Otago Boys' High School, 1st XV 1917-19. In a brief rugby career he played four matches for Otago 1923 and one for New Zealand against New South Wales in the final game of a three-match series. Appeared once for his province 1924 and had three further games 1926. Morgan was not available to tour with the 1924 All Blacks.

National 440yd hurdles champion 1926 (58.6s) and was selected for national athletic teams 1923,26 but could not travel on either occasion.

MORGAN Joseph Edmund
b: 7.8.1945, Whangarei
Second five-eighth

Represented NZ: 1974,76; 22 matches – 5 tests, 20 points – 5 tries

First-class record: North Auckland 1967-81 (Mid-Northern); North Island 1970,74,75; NZ Trials 1970,74-77

Educated Hukerenui Primary and District High Schools and Whangarei Boys' High School. A strongly built (77kg, 1.78m) midfield back who gave great service to North Auckland for 14 consecutive seasons.

Made his international debut in the final test of the 1974 Australian tour and kept his place in Ireland later that year. Gave way as test second five-eighth to Lyn Jaffray against Scotland and Ireland in home internationals but his 13 games on the 1976 South African tour included the final three tests after showing disappointing form early on.

Scored a brilliant try in the second test running untouched from the South African 22 through a nonplussed defence. The *1976 DB Rugby Annual* said that Morgan "played like a champion after that sensational try, showing a rare capacity to punch through the defence from set play and maintaining his high reputation as a tackler."

Morgan played a record 165 matches for North Auckland.

MORRIS Trevor James
b: 3.1.1942, Nelson
Fullback

Represented NZ: 1972,73; 23 matches – 3 tests, 175 points – 1 try, 39 conversions, 25 penalty goals, 6 dropped goals

First-class record: Canterbury 1962,63 (University); Golden Bay-Motueka 1966-68 (Motueka Huia); Nelson Bays 1969-72 (Motueka Huia); South Island 1972; NZ Trials 1967,68,72; Marlborough-Nelson-Golden Bay-Motueka 1966

Educated Nelson College. After a playing career in Canterbury, Auckland and Motueka Morris was chosen at the age of 30 for the All Blacks' 1972 internal tour when he appeared in all nine matches and scored 88 points. Later in that season he played in all three tests against the Wallabies, scoring 33 points – the most by any New Zealand player in a three-match series until Allan Hewson's 41 points against Australia in 1982.

Chosen to tour with the 1972-73 All Blacks, he injured his leg in a match played in New York en route to Britain and although he played

in 10 more matches on tour was unable to recapture his form. An adventuresome fullback and exciting counter-attacker. A prodigious if sometimes an erratic goalkicker, standing 5' 10½" and weighing 12½ stone.

Trevor Morris

MORRISON Terry Geoffrey
b: 16.6.1951, Hamilton
Wing threequarter

Represented NZ: 1973; 5 matches – 1 test, 4 points – 1 try

First-class record: Otago 1972,73 (University); Auckland 1974-78 (Ponsonby); South Island 1973; NZ Trials 1974; NZ Universities 1972,73; Middlesex 1978,79

Educated Matamata College, 1st XV 1967-69. Scored 12 tries in 14 matches for Otago 1972 while studying in Dunedin and was selected for the 1973 internal tour made by the All Blacks. Later in that season he went on as a replacement in the home international v England when Mike Parkinson was injured.

Represented Auckland for five seasons before leaving for England where he played for the London New Zealand and Harlequins clubs as well as Middlesex county. One of the fastest players to appear for New Zealand, Terry Morrison stood 5' 10" and weighed 13 stone. NZ Universities sprint champion, national junior 200 metre titleholder 1970 and senior champion in that event 1976 with a time of 21.95 secs.

MORRISON Thomas Clarence
b: 28.7.1913, Gisborne *d:* 31.8.1985, Wellington
Wing threequarter

Represented NZ: 1938; 5 matches – 3 tests, 14 points – 2 tries, 2 dropped goals

First-class record: South Canterbury 1931-39 (Star); Wellington 1944 (Trentham Army), 1945,46 (Onslow); South Island 1935,37-39; North Island 1944,45; NZ Trials 1935,37,39; New Zealand XV 1945; NZ Services 1944

Educated Central School (Gisborne) and Main School (Timaru), South Canterbury Primary Schools rep. First played for his province as an 18-year-old.

In 1935 he scored 10 tries in seven games for South Canterbury, played in the first of his six interisland matches and appeared in three All Black trials but did not win selection for the British tour. Also took part unsuccessfully in the 1937 trials. Finally won New Zealand honours on the 1938 Australian tour, playing in all three tests.

A hard, determined runner and a fierce tackler as well as a capable goalkicker, Tom Morrison stood six feet and weighed 12½ stone at the time of his selection. While serving in WWII he played for the Middle East Army team and NZ Services before returning home to represent Wellington and appear in two more interisland games.

In his last year of representative rugby he secured a place on the NZRFU executive, serving on this body 1946-68, chairman from 1962. An All Black selector 1950-56 and on the Referees Appointment Board 1957-59. Elected a life member of the NZRFU 1969 and served on the Appeal Council 1971-85. Represented South Canterbury at athletics and swimming. CBE.

MORRISSEY Brian Lewis
b: 14.9.1952, Putaruru
Loose forward

Represented NZ: 1981; 3 matches, 4 points – 1 try

First-class record: Waikato 1975-77,80-82 (Tokoroa); NZ Trials 1981

Educated Tokoroa High School, 1st XV for two years as a fullback. Morrissey, who stood 1.88m and weighed 94.5kg, was a hard-working number eight or flanker who was dispatched to join the 1981 All Blacks in France when Murray Mexted was injured. His three matches for New Zealand comprised two at number eight and one at flanker.

Injuries restricted his first-class appearances the following year. Captained New Zealand Junior basketball team, 1968.

MORRISSEY Peter John
b: 18.7.1939, Christchurch
Wing threequarter

Represented NZ: 1962; 3 matches – 3 tests, 6 points – 2 tries

First-class record: Canterbury 1959-62 (Christchurch HSOB); Otago 1963 (Pirates), 1964 (Kaikorai); South Island 1962,63; NZ Trials 1961-63

Educated West Spreydon Primary and South Intermediate Schools and Christchurch Boys' High School, 1st XV 1956,57. A fast, strong and tenacious winger who represented New Zealand in all three home tests v Australia 1962, scoring tries in the first and third.

Coached lower grade teams for the Kaikorai and Christchurch HSOB clubs. A track athlete of note, John Morrissey was Canterbury 440 yards champion 1961 with 48.7 seconds and represented his province at the national championships on two occasions. He had a recorded best time for the 100 yards of 10.4 secs.

MOURIE Graham Neil Kenneth
b: 8.9.1952, Opunake
Flanker

Represented NZ: 1976-82; 61 matches – 21 tests, 64 points – 16 tries

First-class record: Wellington 1972-74 (University); Taranaki 1975-82 (Opunake); North Island 1976-80,82; NZ Trials 1974,75,77-79,81; NZ Juniors 1973-75; NZ Colts 1972; NZ Universities 1972,73

Educated Opunake High School, 1st XV 1968, and New Plymouth Boys' High School, 1st XV and Taranaki Secondary Schools rep 1969,70. Represented Wellington, New Zealand Colts, New Zealand Juniors and New Zealand Universities while studying at Victoria University. Captained the Juniors against the 1975 Romanian tourists, scoring his team's two tries in a 10-10 draw.

Mourie led the 1976 All Blacks on an unbeaten tour of Argentina and in 1977 played in the final two tests against the British Isles. Appointed captain of the New Zealand team to tour France 1977. After appearing in seven of the nine matches, including both tests, Mourie returned to France for the northern season and

One of the All Blacks' most respected captains, Graham Mourie.

played for the Paris University club.

Because of a back injury he was not available for the home series against the 1978 Wallabies although he was a reserve in the final test.

Resumed the captaincy for the tour of Britain late in that year when his team became the first New Zealand side to make the 'Grand Slam', defeating all four Home Unions. Continued his international career v France, Australia, England and Scotland 1979. Not available for the 1980 tour of Australia and Fiji but later that season captained the New Zealand XV against Fiji at Auckland and led the All Blacks on an undefeated tour of North America, where the USA and Canada were beaten, and Wales. Scored New Zealand's first try in the centenary test.

Mourie again led New Zealand against Scotland in 1981 but was not available for selection against South Africa because he opposed that tour. He returned to lead the All Blacks in Romania and France at the end of 1981 and captained New Zealand when it regained the Bledisloe Cup from Australia in 1982, after which he returned to France for another club season.

His autobiography, *Graham Mourie – Captain* (Moa), was published in 1982 and he declared himself professional by saying he accepted payment for the book.

He retained contact with rugby, however, through working for West Nally, the marketing body for the first Rugby World Cup.

Graham Mourie was a fast and constructive flanker and an intelligent, inspiring captain. His dynamic play and fine leadership on the 1978 Grand Slam tour earned him the title 'Player of the Year' in Britain's 1979-80 *Rothmans Rugby Yearbook*. Weighed 89kg and was 1.83m tall.

Mourie coached the Opunake (later renamed Coastal) club in Taranaki and in 1994 stood unsuccessfully to be a New Zealand selector.

In late 1997, he was appointed coach of Wellington.

MOWLEM John
b: 9.8.1870, Wainuiomata *d:* 12.10.1951, Tauranga
Forward

Represented NZ: 1893; 4 matches

First-class record: Manawatu 1890-93 (Palmerston North); Wairarapa 1894 (Greytown United); NZ Trials 1893

A fine all-round forward, Mowlem was called upon to change sides at halftime in the 1893 trial match and became the first player to appear for both teams in a New Zealand first-class game. Toured Australia later that season, appearing four times.

MULLER Brian Leo
b: 11.6.1942, Eltham
Prop

Represented NZ: 1967-71; 34 matches – 14 tests, 9 points – 3 tries

First-class record: Taranaki 1963,65-72 (Eltham); North Island 1967-69; NZ Trials 1967-71

Educated Matapu Primary and Eltham Convent Schools. First represented New Zealand in the jubilee test v Australia 1967 and was then included in the British tour later that season. His nine matches included internationals against England, Wales and France.

An injury restricted his appearances on the 1968 Australian tour to four matches including the first test and he was again troubled by injury the next year having to withdraw from the second encounter with the Welsh tourists. On the 1970 South African tour he played in the first three tests but was surprisingly dropped for Neil Thimbleby in the fourth. Regained his place for the series against the 1971 Lions and retired after three appearances for Taranaki in the next season.

Brian Muller

A strong tighthead prop who stood 6' 1" and weighed between 17 and 18 stone, 'Jas' Muller was described by the South African author Fred Labuschagne as "exceptionally fast for his weight . . . no prop around the country ever troubled this powerhouse."

MUMM William John
b: 26.3.1922, Mokihunui *d:* 11.12.1993, Westport
Prop

Represented NZ: 1949; 1 match – 1 test

First-class record: Buller 1942-55 (Ngakawau); South Island 1945-47,49; NZ Trials 1947,48; New Zealand XV 1945,49; Seddon Shield Districts 1946; West Coast-Buller 1945-47,49,55; Nelson-Buller 1948

Educated Summerlea Primary School, Buller Primary Schools rep 1934. From 1942 he played 104 first-class games including 85 for Buller in 14 consecutive seasons.

Played for a New Zealand XV 1945, in four interisland matches and All Black trials in two seasons but his sole appearance for New Zealand was in the first test v Australia 1949, an injury preventing him playing in the second. A Buller selector 1960-63,71-74.

A national champion sawyer winning various titles 1956-71. His father, W.J. Mumm senior, played rugby for Buller 1919,21 as did a brother, Peter (1952-57), and a nephew, Rex (1978-86).

MUNRO Henry Gordon
b: 8.12.1896, Invercargill *d:* 26.11.1974, Clyde
Hooker

Represented NZ: 1924,25; 9 matches, 9 points – 3 tries

First-class record: Canterbury 1920,21 (University); Otago 1922,23 (University); South Island 1924; NZ Trials 1924; NZ Universities 1921,23

Played his early rugby for the Invercargill club before leaving to serve in WWI. Played for both Canterbury and Otago as a university student.

Showed good form in the 1924 All Black trials and the interisland game and was chosen for the tour to Australia, appearing in all three encounters with New South Wales, and then departed with the 'Invincibles' to Europe. In his fifth appearance in England he seriously injured a knee against Leicester and did not play again until he had one match in Canada on the way home. A further injury in a club match ended his career 1925.

Standing 5' 9" and weighing 11st 12lb, 'Abe' Munro was one of the lightest forwards to play in an All Black pack. He was an extremely quick hooker in the two-fronted scrum and was also a skilled dribbler of the ball. After his retirement he coached the University club in Dunedin and served as delegate to the Otago RFU. President of that union 1949,50. NZ Universities selector.

MURDOCH Keith
b: 9.9.1943, Dunedin
Prop

Represented NZ: 1970,72; 27 matches – 3 tests, 20 points – 6 tries

First-class record: Otago 1964,67,69,71,72 (Zingari-Richmond); Hawke's Bay 1965 (Marist); Auckland 1966 (Ponsonby); South Island 1969,71; NZ Trials 1965,70-72

Keith Murdoch

Educated Ravensbourne Primary School and King Edward Technical College. An extremely strong prop who weighed 17st 4lb and stood six feet. Troubled by injury on the 1970 South African tour, Murdoch played in only eight of the 24 matches but recovered to win a place in the final test.

Named in the New Zealand team for two internationals against the 1971 Lions but forced to withdraw. After appearing in eight games on the 1972 internal tour he also played in the third test v Australia in the home series of that year.

Murdoch scored the All Blacks' only try in the 19-16 victory over Wales in 1972 and was involved in an incident the night of the match and sent home by the New Zealand tour management.

MURDOCH Peter Henry
b: 17.6.1941, Auckland *d:* 16.10.1995, Auckland
First five-eighth

Represented NZ: 1964,65; 5 matches – 5 tests, 6 points – 2 tries

First-class record: Auckland 1964-71 (Otahuhu); North Island 1965; NZ Trials 1965,66,68; NZ Colts 1964

Educated Mangere Bridge Primary School and Otahuhu College, 1st XV 1957,58. After touring Australia with the 1964 NZ Colts team Murdoch acted as a reserve in the interisland match and then was called into the second test v Australia, scoring a try in his All Black debut and another when New Zealand was beaten 20-5 in the third test.

Peter Murdoch

He played in the first three tests against the 1965 Springboks but was dropped in the fourth for Mac Herewini – who also kept Murdoch out of a regular place in the Auckland side until 1971.

A neat first five-eighth who possessed a quick burst of speed and a good tactical boot, Murdoch weighed 11½ stone and stood 5' 7".

He continued to play lower grade club rugby for several years after his retirement from first-class play. His father, 'Doc', represented Auckland 1934-36 and was a masseur and baggage man for numerous touring teams in New Zealand until 1977.

MURRAY Frederick Steele Miller
b: 20.8.1871, Mahurangi *d:* 5.8.1952, Auckland
Forward

Represented NZ: 1893,97; 20 matches, 16 points – 4 tries, 1 goal from a mark

First-class record: Auckland 1887,89,91 (Ponsonby), 1892,93 (Newton), 1894 (City and Hamilton), 1895-97,99 (Parnell); North Island 1894,97

Educated Hamilton East School. Like many of his contemporaries, Murray could play in any scrum position with equal ability. He toured Australia with the 1893 New Zealand team and was selected for the 1896 side to play Queensland but withdrew because of a family bereavement. Joined the 1897 New Zealand team to Australia when Donald Watson could not travel.

Auckland selector 1901,05; treasurer of that union 1906,08 and committee member 1910. Auckland RFU life member 1905. Also represented his province at cricket.

MURRAY Harold Vivian
b: 9.2.1888, Christchurch *d:* 4.7.1971, Amberley
Wing forward

Represented NZ: 1913,14; 22 matches – 4 tests, 36 points – 12 tries

First-class record: Canterbury 1909-13 (Irwell), 1914 (Springfield); South Island 1910,11,13,14; NZ Services 1919

Educated Christ's College, 1st XV 1904. Initially played for Canterbury as a threequarter before adopting the wing forward position. Played for New Zealand in the first test v Australia before touring North America with the 1913 All Blacks where he appeared in the All American international and scored two tries.

After appearing as a wing threequarter against Wellington 1914 'Toby' Murray returned to the forwards for the tour of Australia where he played in the second and third tests. Represented NZ Services in the King's Cup competition in Britain 1919 after serving in WWI.

MURRAY Peter Chapman
b: 23.1.1884, Southern Grove *d:* 6.2.1968, Auckland
Hooker

Represented NZ: 1908; 1 match – 1 test

First-class record: Wanganui 1901,03-09 (Wanganui College OB); North Island 1904,08; Taranaki-Wanganui 1905

Educated Wanganui Collegiate. Came into the representative side as an 18-year-old, usually playing as a hooker in the 2-3-2 scrum. When the New Zealand selectors made a number of changes for the second test against the 1908 Anglo-Welsh tourists (despite the 32-5 margin in the first), Murray made his one All Black appearance. Frank Glasgow was recalled to replace him when that game was drawn.

MYERS Richard George
b: 6.7.1950, Hamilton
Loose forward

Represented NZ: 1977,78; 5 matches – 1 test, 4 points – 1 try

First-class record: Manawatu 1971-73 (University); Waikato 1974-80 (Leamington); NZ Trials 1973-75,78,79; NZ Juniors 1973; NZ Universities 1972,73; Manawatu-Horowhenua 1971

Educated Leamington Primary School and Cambridge High Schools, Waikato Secondary Schools rep 1968. Standing 1.91m and weighing

Dick Myers

94.5kg, Dick Myers normally played at number eight. He was a surprise selection for the team to tour France 1977 where he appeared in four of the nine games. Recalled to the All Blacks for the third test v Australia 1978 when Barry Ashworth withdrew.

MYNOTT Harry Jonas
b: 4.6.1876, Auckland *d:* 2.1.1924, New Plymouth
First five-eighth

Represented NZ: 1905-07,10; 39 matches – 8 tests, 55 points – 17 tries, 2 conversions

First-class record: Taranaki 1899-1904,06-11 (Tukapa); North Island 1904-08; Taranaki-Manawatu-Wanganui 1904

Educated Central School (New Plymouth). Played senior rugby for the Tukapa club before spending the 1897 season with Newton in Auckland.

Made the preliminary tour to Australia 1905 before leaving for Europe with the 'Original' All Blacks. Usually a first five-eighth, Mynott made his international debut against Ireland as a wing threequarter. His normally reliable hands deserted him in the Welsh game – the only loss on the tour – when he appeared in his preferred position. However, he retained his place for the French test.

Toured Australia 1907, playing outside Fred Roberts in all three tests. Until Frank Bunce overtook his record in 1996, he was the oldest back to represent New Zealand. He was 34 years and 28 days old when he took the field for his final international, the third test on the 1910 tour of Australia.

A brilliant attacking player and also sound on defence, 'Simon' Mynott was regarded as a splendid sportsman. With Jimmy Hunter he formed a formidable five-eighth combination known as 'the Taranaki Twins'. Taranaki selector 1910-14 and an All Black selector 1913.

NATHAN Waka Joseph

b: 8.7.1940, Auckland
Flanker

Represented NZ: 1962-64,66,67; 37 matches –
14 tests, 69 points – 23 tries

First-class record: Auckland 1959-63,65-67
(Otahuhu); North Island 1960,61,63,65-67; NZ
Trials 1961-63,65-67; New Zealand XV
1960,66; Rest of New Zealand 1960; NZ
Maoris 1959-61,65,66

Educated Mangere Central Primary School,
Auckland East Roller Mills team, and Otahuhu
College, 1st XV 1956,57. Made his debut for
Auckland just before turning 19 and toured the
Pacific with the NZ Maoris that year. Late in the
1960 season he scored a dramatic last-minute
try for his province against Canterbury which
Cormack converted to retain the Ranfurly
Shield with a 19-18 win.

Nathan was selected for the 1962 All Black
tour of Australia and appeared in both tests
there and in all three when the Wallabies
returned the visit later that season. Early in 1963
he played in both tests v England. After
appearances against Ireland and Wales on the
1963-64 British tour he broke his jaw in the
Llanelli game and was restricted to 15 matches.
Despite this injury he scored 11 tries – the third
highest total on the tour.

A leg injury kept him out of rugby in the 1964
season and continued to plague him the
following year. Forced to withdraw from the
team selected to play the first test against the
1965 Springboks. Fully fit, he appeared in the
whole series against the 1966 Lions, scoring two
tries in the third test.

Toured Britain again after the 1967 jubilee test
v Australia but suffered another broken jaw and
played only six times. Retired after two more
seasons of club rugby.

In his 14 internationals for the All Blacks
Nathan never played in a losing side. He was
described by Colin Meads as "that most virile
runner with the ball in hand, great at exerting
pressure close to the forwards." During his All
Black career he weighed around 14½ stone and
stood 5' 11". NZ Maoris selector 1971-77.
Manager of Maori tour of Wales, 1982.

NELSON Keith Alister

b: 26.11.1938, Auckland
Loose forward

Keith Nelson

Represented NZ: 1962-64; 18 matches – 2
tests, 6 points – 2 tries

First-class record: Otago 1959,62 (University),
1963 (Clutha); Auckland 1964-67,69,70
(Ponsonby); South Island 1963; North Island
1964; NZ Trials 1962,63,65-67,70; NZ Juniors
1959; NZ Universities 1959,60,62

Educated Bayfield Primary School and
Auckland Grammar School, 1st XV 1955,56.
Represented Auckland Colts 1958 before going
to Dunedin to study dentistry and winning a
place in the Otago team.

Injuries suffered on the 1961 NZ Universities
tour of North America kept him out of top rugby
until 1962 when he made his All Black debut as
a number eight in the final two tests against the
Wallabies. Played 16 of the 36 matches for the
1963-64 New Zealand team and was considered

unlucky not to win selection for at least one
international. Stood 6' 1" and weighed 15 stone
at the time of this tour.

Later captained Auckland, representing that
province until 1970. Served on the Auckland
RFU management committee from 1978. His
father, Jack, played for Auckland 1931,32.

NEPIA George

b: 25.4.1905, Wairoa *d:* 27.8.1986, Ruatoria
Fullback

Represented NZ: 1924,25,29,30; 46 matches –
9 tests, 99 points – 1 try, 39 conversions, 6
penalty goals

First-class record: Hawke's Bay 1922-24
(MAC), 1925 (Dannevirke Aotea), 1926
(Nuhaka); East Coast 1927-33,47 (Rangitukia
Rangers); North Island 1924,25,33; NZ Trials
1924,29,30,35; Hawke's Bay-Poverty Bay-East
Coast 1923; Poverty Bay-Bay of Plenty-East
Coast 1930; NZ Maoris 1928-30,35

Educated Wairoa and Nuhaka Native Schools
and Maori Agricultural College 1921-23. Made
his first-class debut as a wing in a 1921 trial
match to select a NZ Maoris side to tour
Australia.

Became a regular member of the Hawke's Bay
Ranfurly Shield team 1923 as a five-eighth.
After an impressive display in the unfamiliar
position of fullback in the 1924 Northern v
Southern Maori game, he was considered a
definite prospect for the 1924-25 tour of Britain
and France in this position. Selected in this
team after two All Black trials and the
interisland match. His tour statistics were given
as 5' 9" and 13st 1lb.

Nepia's form for the 'Invincibles' was
outstanding. He appeared in all four matches in
Australia and the two in New Zealand before
the team departed for Europe where he played
in each of the 30 games plus two in Canada on
the way home. Still a 19-year-old, he won lavish
praise for his faultless displays of kicking,
tackling and fielding the ball. Named as one of
the "Five Players of the Year" by the English
publication, the *Wisden Rugby Almanack*.

Thirteen months after his debut for New
Zealand, Nepia completed 39 consecutive All
Black appearances when he played against New
South Wales at Auckland 1925. Not eligible for
the 1928 South African tour because of his
Maori blood and surprisingly did not play in the
home series v New South Wales. He was able to
play in only two matches in Australia 1929. He
injured his back and left the field in the first test
and then withdrew after selection from the final
test with influenza.

After taking part in all four tests against the
1930 British team he confined his play to a few
matches for East Coast and an interisland
appearance in 1933. He appeared again in the
1935 All Black trials in an unsuccessful
endeavour to win selection for another tour to
Britain. Led a NZ Maoris team to Australia in
that season and then accepted an offer to play
rugby league for the Streatham and Mitcham
club in England. Transferred to Halifax during
the 1936-37 season.

Returning to New Zealand in 1937 he played
for the Manukau league club and represented
New Zealand v Australia.

After a further year in club league he was not
seen again on a football field until he was
reinstated to rugby and played twice for East
Coast 1947 at the age of 42. Three years later he
became the oldest New Zealander to play in a
first-class match when he captained the

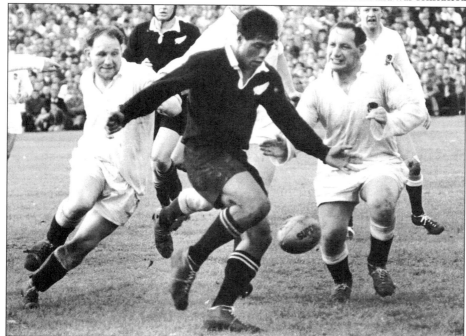
Waka Nathan . . . never played in a losing international.

George Nepia and Wellington captain Frank Kilby before the Maoris played Wellington in 1935.

Olympian club against Poverty Bay, led by his son George jnr (who represented that union 1950,51 and Manawatu 1953). This is the only occasion that a father and son have appeared on opposite sides in a first-class match in New Zealand.

After his retirement from active play, George Nepia spent several years refereeing.

The above date of birth is generally accepted and used in his biography *I, George Nepia* (AH & AW Reed, 1963), however school records show his date of birth as 4.4.1904.

NESBIT Steven Roberto
b: 13.2.1936, Auckland
First five-eighth

Represented NZ: 1960; 13 matches – 2 tests, 6 points – 2 tries

First-class record: Auckland 1958-61 (Marist); NZ Trials 1960

Educated St Peter's College (Auckland). Showed impressive form for Auckland before his selection for the 1960 tour of South Africa. Won his test cap at first five-eighth when Adrian Clarke was not available for the second international but was surprisingly dropped from this position for his Auckland team-mate Tony Davies (usually a fullback), in the final test.

A slight player at 5' 6" and just 10 stone, Nesbit was described by Fred Boshier in *All Blacks in South Africa* as "a mercurial first five-eighth who was expected to be the spark of the backline. He was neglected after being used freely in the early games and then came back to show the original estimate was correct. His neat handling and swift, straight running distinguished him among the inside backs."

Later went to the USA and toured New Zealand with a Californian Universities team.

NEVILLE Wayne Ronald
b: 10.12.1954, Waipukurau
Prop

Represented NZ: 1981; 4 matches

First-class record: North Auckland 1976 (Kaitaia Pirates), 1977 (Awanui), 1978 (Kaitaia), 1979 (Awanui), 1981,82 (Kaitaia)

Educated at Dannevirke High School, Neville was one of the surprise choices for the 1981 All Black team that toured Romania and France.

He appeared to leave the national scene as suddenly as he entered it. Neville had missed the 1980 season because of farm commitments but returned to play a full part in the 1981 season, missing only North Auckland's match in Wellington.

He was described as a hard worker and strong, solid scrummager by the *Rugby Almanack*. He weighed 108kg and stood 1.88m.

NEWTON Frederick
b: 7.5.1881, Christchurch *d:* 10.12.1955, Christchurch
Lock and loose forward

Represented NZ: 1905,06; 19 matches – 3 tests, 3 points – 1 try

First-class record: Canterbury 1901,04 (Linwood); Buller 1908 (White Star); South Island 1905; Canterbury-South Canterbury-West Coast 1904

Weighing 15 stone and standing six feet, Newton was the heaviest forward on the 1905-06 tour. Usually playing as a lock in the 2-3-2 scrum he was selected for internationals against England, Wales and France, winning his test caps when Bill Cunningham was injured before the English game, had a cold before the Welsh game, and was played on the side of the scrum against France.

NICHOLLS Harold Garwood
b: 19.11.1897, Wellington *d:* 10.8.1977, Whakatane
Second five-eighth

Represented NZ: 1923; 1 match, 3 points – 1 try

First-class record: Wellington 1915,19,22,23 (Petone); Wellington-Manawatu 1923

Educated Petone West School. After representing Wellington he changed to rugby league in 1919 and played in Wellington until he was reinstated to rugby 1922 and appeared again for Wellington.

Selected to play for the All Blacks against New South Wales at Wellington in 1923 he scored one of his side's eight tries. The older brother of All Blacks Mark and 'Ginger' Nicholls, the latter captaining New Zealand in 'Doc' Nicholls' sole appearance.

NICHOLLS Harry Edgar
b: 21.1.1900, Wellington *d:* 1.4.1978, Wellington
Halfback

Represented NZ: 1921-23; 7 matches – 1 test, 3 points – 1 try

First-class record: Wellington 1917,18,20-23,26 (Petone); North Island 1919,22; NZ Trials 1921,24; Wellington-Manawatu 1923

Educated Petone West School and Wellington College. Made his debut in the provincial side as a 17-year-old but was later kept out by the 1913,14,20,21 All Black halfback, Teddy Roberts.

Although he did not play for Wellington 1919 he was selected in the North Island team with Roberts appearing at first five-eighth and captain. 'Ginger' Nicholls was a controversial choice ahead of Roberts as All Black halfback in the first test against the 1921 Springboks.

At 5' 5" and 9st 6lb, he was one of the smallest All Blacks but showed outstanding form and was awarded a gold medal by the NZRFU as the outstanding New Zealand back in this match but was then omitted in favour of Roberts for the rest of the series.

Toured New South Wales with the 1922 All Blacks and had one more game for New Zealand as captain in the third encounter with New South Wales at Wellington in the next season. Missed selection for the 1924-25 touring team but accompanied the side as a correspondent for the *Free Lance*.

Had one further season playing for Wellington before retiring 1926. His father, Syd Nicholls, represented Wellington 1889 while two of his brothers, Mark (1921,22,24-26,28,30) and 'Doc' (1923) were All Blacks. Another brother, Guy, played for North Auckland 1929,30.

NICHOLLS Marcus Frederick
b: 13.7.1901, Greytown *d:* 10.6.1972, Tauranga
Five-eighth

Represented NZ: 1921,22,24-26,28,30; 51 matches – 10 tests, 284 points – 5 tries, 93 conversions, 20 penalty goals, 5 dropped goals, 1 goal from a mark

First-class record: Wellington 1920-23,25-27,29-31 (Petone); Auckland 1922 (Grafton); North Island 1922,24,26,27,31; NZ Trials 1921,24,27,30; Wellington-Manawatu 1923

Educated Petone West and Petone High Schools and Wellington College, 1st XV 1917-19. Making his debut for Wellington in his first year

out of school, he scored in four separate ways against Taranaki – a try, conversion, penalty goal and a goal from a mark taken by another player.

Appeared in all three tests against the 1921 Springboks, two at second five-eighth and one at centre (playing with his brother 'Ginger' in the first) and then led the points-scorers with 34 on the 1922 tour of New South Wales. Played latter part of 1922 season in Auckland and partnered Karl Ifwersen in the five-eighths for Auckland against a Wellington XV. Surprisingly overlooked by the selectors for the 1923 series against New South Wales and was denied the chance of joining his two brothers on the field in the third match.

One of the 16 "certainties" chosen for the 1924-25 touring team after the interisland match, Mark Nicholls had three games in Australia then 16 in Britain including all four internationals. The leading points-scorer for the 'Invincibles' with 103 he was named one of the "Five Players of the Year" in the *Wisden Rugby Almanack*, which praised his clear-headed leadership, judgment and development of attacks as well as his all-round abilities as a runner, passer and kicker.

Landed six conversions against New South Wales at Auckland 1925 and again was leading points-scorer with 41 on the 1926 Australian tour. As vice-captain of the 1928 All Blacks in South Africa he was at the centre of controversy when he played only 11 times and was selected for only the final test of the series. Played brilliantly on this occasion and was largely responsible for New Zealand's 13-5 win by kicking 10 points. Bennie Osler, the outstanding Springbok flyhalf, said that Nicholls was the best back he ever opposed.

Mark Nicholls appeared in the second and third tests against the 1930 British team, scoring seven points in a 13-10 victory in the second but was not available for the final match in this series. His first-class career ended the next season when he made his fifth interisland appearance. Nicholls was equally at home in either the first or second five-eighth positions.

A Wellington selector 1934-38, North Island selector 1948 and on the New Zealand panel 1936,37. Author of the tour book *With The All Blacks in Springbokland* (L.F. Watkins, 1928). Both his father, Syd (1889), and his son M.S.H. (1950), represented Wellington. Two of his brothers, 'Ginger' and 'Doc', were All Blacks in the early 1920s and another brother, Guy, played for North Auckland at the end of the decade.

NICHOLSON George William
b: 3.8.1878, Auckland *d:* 13.9.1968, Auckland
Loose forward

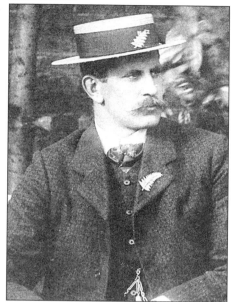
George Nicholson

Represented NZ: 1903-07; 39 matches – 4 tests, 24 points – 8 tries

First-class record: Auckland 1901-04,06 (City), 1907-09 (Ponsonby); North Island 1902,03

Educated Newton East School. Played his early football as a threequarter but developed into a tall (6' 3", 13st 10lb) loose forward, often referred to as 'Long Nick'.

After playing in the first official test match in Sydney on New Zealand's 1903 tour and appearing in the 1904 match against Great Britain when Reuben Cooke could not play, Nicholson surprisingly did not win selection for any of the internationals on the 1905-06 tour. Won fame with his winning try after a lone follow-up on a miskick by Percy Bush against Cardiff, a game won 10-8.

While on holiday in Australia he was called upon to join the 1907 All Blacks there and won two further test caps. After he retired he became a referee and controlled the third test New Zealand v Australia 1913.

Took over as Auckland selector when Dave Gallaher joined the army and served 1916-19,22-24,30,31 in that role. An All Black selector 1920,21,29,30,36,37. Life member of the Ponsonby club, the Auckland RRA and RFU.

NORTON Rangitane Will
b: 30.3.1942, Waikari
Hooker

Represented NZ: 1971-77; 61 matches – 27 tests, 4 points – 1 try

First-class record: Mid Canterbury 1961 (Methven); Canterbury 1969-77 (Linwood); South Island 1971-75; NZ Trials 1970-72,74-77; NZ Maoris 1969-75,77

Educated Methven Convent School and Methven District High School. Played three matches for Mid Canterbury 1961 but did not appear in representative rugby again until 1969. In that season he also appeared twice for NZ Maoris against Tonga.

Tane Norton

Made his debut for New Zealand in the series against the 1971 Lions, beginning a sequence of 27 consecutive internationals. His All Black career included the internal tour and the series against the Wallabies 1972, 15 appearances on the 1972-73 British tour, another internal tour and the English test 1973, the 1974 tours of Australia and Ireland, home matches against Scotland and Ireland in the next two seasons, the 1976 South African tour and he then captained the All Blacks to a 3-1 series win against the 1977 Lions.

His 197 first-class games included 82 for Canterbury and three for a World Invitation XV in South Africa 1977.

A model of consistency, Tane Norton was a fine hooker and all-round forward. He captained the NZ Maoris team on a Pacific tour and against the All Blacks 1973, Fiji 1974, Tonga 1975 and the 1977 Lions. Awarded the Tom French Cup 1973,74 as outstanding Maori player of the year. Stood six feet and weighed 13st 10lb during his playing career.

Mark Nicholls . . . leading points-scorer for the 'Invincibles'.

O'BRIEN Andrew James

b: 22.9.1897, Auckland *d:* 9.5.1969, Auckland
Loose forward

Represented NZ: 1922; 3 matches, 3 points –
1 try

First-class record: Marlborough 1919-21
(Opawa); Nelson-Marlborough-Golden Bay-
Motueka 1921; Auckland 1922,23 (Grafton);
North Island 1922

Played in the 1922 interisland game and was
included in the All Black team which toured
New South Wales before he represented
Auckland in one match late in that season.

After five further appearances for his
province next year Jim O'Brien turned to rugby
league and represented New Zealand 1924,
25,28.

O'BRIEN John

b: 28.10.1871, Greymouth *d:* 26.4.1946,
Auckland
Forward

Represented NZ: 1901; 1 match

First-class record: West Coast 1896 (Oriental);
Wellington 1898-1901 (Athletic)

Played for New Zealand against Wellington
1901 when Tom Cross failed to arrive in time for
the match.

O'BRIEN John Gerald

b: 9.12.1889, Wellington *d:* 9.1.1958, Kiwitahi
Fullback

Represented NZ: 1914,20; 12 matches – 1 test,
5 points – 1 try, 1 conversion

First-class record: Auckland 1910-13,20
(Marist); North Island 1920; NZ Services
1919,20

Educated at Roman Catholic schools in
Taranaki, Jack O'Brien became a member of
Auckland Marist's first senior team. On the 1914
tour of Australia he broke his leg against New
England after playing in the three previous
matches including the first test. He was
described as "a master of positional play to the
point of wizardry".

A fullback of average build, weighing about
11 stone, he performed exceptionally well for
the NZ Services team in the 1919 King's Cup
competition, attracting the attention of the
Prince of Wales who was reported as saying: "If
I dropped my kitbag from the dome of St Paul's,
O'Brien would catch it."

Toured South Africa with the 1919 army side,
played in the 1920 interisland game and then
visited Australia again with the first post-war
All Black team, appearing in two of the three
encounters with New South Wales.

O'CALLAGHAN Michael William

b: 27.4.1946, Culverden
Wing threequarter

Represented NZ: 1968; 3 matches – 3 tests

First-class record: Manawatu 1966-69,78-80
(University); Waikato 1970 (Matamata); North
Island 1968-70; NZ Trials 1968-70; NZ
Universities 1967,68,70; NZ Juniors 1968;
Barbarians (UK) 1977

Mick O'Callaghan

Educated Culverden District High School and
Christchurch Boys' High School. Played for
Lincoln College before transferring to Massey
University.

Fast and intelligent, he developed into a
reliable and experienced centre weighing 11st
4lb and standing 5' 9". After scoring two tries for
NZ Juniors against Japan he was selected as a
wing for all three tests against the French
tourists later that year.

Left for France to study for a veterinary degree
and played rugby there for Stade Poitevin 1970-
71 and Stade Toulousain 1971-73 before
winning four blues at Cambridge University.
Returned to New Zealand and regained a place
in the Manawatu team.

O'CALLAGHAN Thomas Raymond

b: 19.1.1925, Wellington
Second five-eighth

Represented NZ: 1949; 1 match – 1 test, 3
points – 1 penalty goal

First-class record: Canterbury 1943,44 (Air
Force); West Coast 1946 (Celtic); Auckland
1947 (Marist); Wellington 1948-50,53,54
(Marist); South Island 1944; North Island
1947,49; NZ Trials 1953; NZ Combined
Services 1944; Seddon Shield Districts 1946;
West Coast-Buller 1946

Educated St Joseph's Convent School (Nelson)
and Marist Brothers' High School (Greymouth).
First represented Canterbury as an 18-year-old
and the next year was selected for the South
Island and Combined Services. Injuries
prevented him from appearing in the 1948 All
Black trials. He played his one game for New
Zealand against the 1949 Wallabies in the
second test.

A solid and reliable type of five-eighth
weighing 13$\frac{1}{2}$ stone and standing 5' 11", Ray
O'Callaghan later appeared as fullback. An
accurate goal kicker, he was included in the
1953 trials but was not selected for the touring
team. Served on the Wellington Marist club
executive 1949 and coached its senior team
1964-66. Represented West Coast at cricket and
hockey.

O'CONNOR Timothy Beehane

b: 1860, Kilenenan, Ireland *d:* 5.2.1936,
Auckland
Forward

Represented NZ: 1884; 7 matches, 4 points –
2 tries

First-class record: Auckland Combined Clubs
1881,82 (North Shore), 1883,86-89 (Auckland),
1892 (Ponsonby)

Played seven games for the 1884 New Zealand
team including three against New South Wales.
Weighing over 14 stone, O'Connor was
described by the tour manager S.E. Sleigh as
"the heaviest man in the team, yet one of the
fastest forwards. Never far away from the ball
and seldom left the field without greatly helping
to add to the score."

Captained Auckland against the 1888 British
tourists after Whiteside retired hurt.

A noted field events exponent, O'Connor
won three national shot put titles with a best
heave of 37' 8" in the 1889-90 championships.
He was also the Australasian champion 1893
(38' 4$\frac{3}{4}$") and the hammer throw titleholder (86'
8").

O'DEA Robert John

b: 27.1.1930, Gisborne *d:* 16.7.1986, Te Puna
Flanker

Represented NZ: 1953,54; 5 matches

First-class record: Thames Valley 1951-53,55
(Patetonga); NZ Trials 1953; Thames Valley
Bay of Plenty 1955

Educated Patetonga Primary School and
Morrinsville District High School, 1st XV 1944-
47. A surprise selection for the 1953-54 All
Blacks, O'Dea suffered a knee injury in the game
against Pontypool and Cross Keys which put
him out for the tour and prevented him from
playing in the 1954 domestic season.

Standing 6' 3" and weighing 14st 10lb, he was
useful in the lineout. Captained Thames Valley
1952,53,55 and played for the Waharoa Walton
club 1958,59 after retiring from representative
rugby.

Also played cricket for Thames Valley 1951-
55.

O'DONNELL Desmond Hillary

b: 7.10.1921, Palmerston North *d:* 18.1.1992,
Wellington
Prop

Represented NZ: 1949; 1 match – 1 test

First-class record: Wellington 1945 (Army),
1946-51 (St Patrick's College OB); North Island
1949; NZ Trials 1948; NZ Combined Services
1945

Educated St Patrick's College (Silverstream), 1st
XV 1938-40. A hard-working prop, weighing
14st 2lb and standing six feet, who represented
New Zealand once – in the second test v
Australia 1949.

Played his last game for Raetihi 1964 at the
age of 43, having coached the club 1952-58 and
served as treasurer 1952-56.

Coached the Marist St Pat's club in
Wellington 1971. O'Donnell's nephews,
Patrick (Horowhenua and Manawatu) and
Kevin (Horowhenua), have also played
representative rugby.

O'DONNELL James

b: ? d: ?
Forward

Represented NZ: 1884; 7 matches, 8 points – 4 tries

First-class record: Canterbury 1882 (Christchurch); Otago 1883 (Invercargill); New South Wales 1884-86,88; Australia 1899

Described by S.E. Sleigh, manager of the 1884 New Zealand touring side, as a "fast wing forward", O'Donnell was regarded as the speediest man in the team. Remained in Australia, represented New South Wales 1884-86,88 including an appearance against the 1888 British tourists and played for Australia against Great Britain, 1899.

Prior to his departure for the 1884 tour a sensation arose when he was arrested at Clinton and returned to Invercargill under a fugitive warrant, apparently indebted to several tradespeople who had a strong suspicion he did not intend returning to New Zealand.

He was a well-known athlete in the region. A son, J.B. O'Donnell, played for NSW 1928,29.

O'DOWDA Bernard Clement

b: 23.3.1874, India d: 26.7.1954, New Plymouth
Forward

Represented NZ: 1901; 2 matches

First-class record: Taranaki 1895 (Kaitake), 1896,97,99-1902 (Tukapa); Sussex 1894,95

Educated Christ College (Finchley, London). Played rugby for the Brighton club in England and represented Sussex twice before coming to New Zealand 1895 and farming at Oakura in Taranaki.

Helped form the junior club Kaitake and represented Taranaki, transferring to the Tukapa club the next year. Barney O'Dowda was named in the 1897 New Zealand team but could not travel to Australia, but four years later played against Wellington and New South Wales. Weighed 14st 3lb.

His son Clem also represented Taranaki 1931-39. His son-in-law was All Black Ces Badeley.

OLD Geoffrey Haldane

b: 22.1.1956, Eltham
Loose forward

Represented NZ: 1980-83; 17 matches – 3 tests, 4 points – 1 try

First-class record: Taranaki 1974 (Eltham); Manawatu 1975-83 (Palmerston North HSOB), 1984,85 (Te Kawau); NZ Trials 1979,81,82; North Island 1982; NZ Juniors 1976,78; Manawatu-Horowhenua 1977; NZ Services 1984

Educated Eltham Primary, Taranaki Primary Schools rep 1967,68, and New Plymouth Boys' High School, 1st XV, Taranaki Secondary Schools rep and Taranaki Under 18 rep 1972,73.

Played for Taranaki in the year after leaving school and then moved to Palmerston North. Made his All Black debut against Fiji at Auckland and then made three appearances on the 1980 Welsh centenary tour. Played the third test against the 1981 Springboks and played his second test as a replacement against Romania

on the tour of Romania and France later that year. Replaced Andy Haden in the first test against Australia 1982. Toured England and Scotland 1983. A strong and versatile loose forward, a back-of-the-lineout specialist jumper. Stood 1.89m and weighed 94.5kg.

Geoff Old

O'LEARY Michael Joseph

b: 29.9.1883, Masterton d: 12.12.1963, Masterton
Utility back

Represented NZ: 1910,13; 8 matches – 4 tests, 33 points – 13 conversions, 1 penalty goal, 1 dropped goal

First-class record: Wairarapa 1900,04-08 (Masterton); Auckland 1909-13 (Ponsonby); North Island 1907-10-12; Wellington Province 1905; Wellington-Wairarapa-Horowhenua 1905; Wairarapa-Bush 1908

A fine player in most backline positions and an excellent goal kicker, Joe O'Leary captained Wairarapa-Bush against the 1908 Anglo-Welsh tourists then visited Australia with the Ponsonby club 1909 and played in the so-called "Australasian club championship" match against Newtown in Sydney where his powerful and well-directed line kicking was reported to have completely crumpled the opposition.

Toured Australia with the 1910 All Blacks appearing in the first and third tests as fullback and leading the tour point scorers with 19. Declined selection in the New Zealand team to tour North America 1913 but in the second and third tests against Australia in that year he became the only player to captain New Zealand from fullback in a test.

His consistency was commented on by the *Sportsman* journal: "One will grow old and hoary waiting for O'Leary to play a bad game." Wairarapa selector 1922-25. His brother, Humphrey, captained NZ Universities 1908,09 and later became Chief Justice.

OLIPHANT Robert

b: ?.1.1870 County Tyrone, Ireland d: 18.1.1956, Auckland
Wing forward

Represented NZ: 1893,96; 3 matches, 3 points – 1 try

First-class record: Manawatu 1887,88,90,91 (Palmerston North); Wellington 1892,93 (Poneke); Auckland 1894 (Grafton), 1896 (City); Hawke's Bay 1900 (Pirates), 1902 (Napier City); North Island 1894; NZ Trial 1893

Came to New Zealand with his family 1883. A very fast player who normally played as a wing forward but could perform equally well in the backline, he weighed 12st 8lb.

Sent to Australia with three other forwards as reinforcements for the 1893 New Zealand team and appeared in the last two games. Also played against Queensland 1896.

Oliphant was a noted professional runner and after his reinstatement as an amateur he won the 440 yards at the 1898 national championships in a time of 53.4 secs, finished second in the 440yd hurdles 1899 and third in the 100 yards 1897,99. His best time for the sprint was 10.4 and for the hurdle event, 62.4 secs.

Awarded the Royal Humane Society's Certificate of Merit after rescuing a boy from heavy surf 1902.

OLIVER Anton David

b: 9.9.1975, Invercargill
Hooker

Represented NZ: 1996,97; 7 matches – 1 test, 10 points – 2 tries

First-class record: Marlborough 1993 (Opawa); Otago 1994-97 (University); Otago Highlanders 1996,97; NZ Colts 1994-96; NZ Colts Black 1995; South Island 1995; NZ Trial 1996; New Zealand A 1997; Barbarians 1996

Educated at Marlborough Boys' High School, Oliver captained the New Zealand Secondary Schools side in 1993, the year in which he made his first-class debut, and also captained the New Zealand Under 19 team in 1993 and 1994.

Anton Oliver

He moved to Otago to attend university, played one game for his new province in 1994, and established himself in 1995 as the longterm replacement for long-serving David Latta.

Oliver was first chosen as a reserve for New Zealand in 1995 and made the expanded squad that toured South Africa in 1996, playing in two matches, and he made his single test appearance

the following year when he replaced Sean Fitzpatrick against Fiji. Oliver played in four matches on the tour of Britain and Ireland in 1997.

His father, Frank Oliver, played 17 tests between 1976 and 1981 and was All Black captain in 1978 and an uncle, Paul, played for Otago, South Island, New Zealand Juniors and Colts, and New Zealand Universities. A brother, Brent, played for Otago B, Central Vikings and New Zealand Universities.

OLIVER Charles Joshua
b: 1.11.1905, Wanganui *d:* 25.9.1977, Brisbane, Australia
Threequarter and second five-eighth

Represented NZ: 1928,29,34-36; 33 matches – 7 tests, 69 points – 16 tries, 9 conversions, 1 penalty goal

First-class record: Canterbury 1924-26,28-35 (Merivale); South Island 1926,28,31-34; NZ Trials 1929,30,34,35

Educated Waltham School (Christchurch). Began playing senior club rugby at the age of 16 and made his debut for Canterbury two years later, representing that province over the next 12 years (excepting 1927 when he toured England with the New Zealand cricket team).

First appeared in the All Blacks as a wing against New South Wales and West Coast-Buller 1928 when Percy Minns could not play. Appeared at second five-eighth in the third match of the series. Toured Australia the following year and played in the first two tests but a serious injury in the second put him out for the rest of the tour.

Played well in the 1930 trials but missed selection and then was forced to withdraw from the 1931 team to play Australia with blood poisoning caused by having his hand bitten in a provincial game. He was not chosen for the 1932 tour of Australia but was included in the 1934 team and appeared in the first test at Sydney at second five-eighth.

Oliver was appointed vice-captain of the 1935-36 New Zealand team and appeared in 21 matches including all four internationals despite receiving a leg muscle injury early on which affected his play throughout the tour. All his appearances on this tour were at centre with the exception of the Welsh international, in which he played as second five-eighth. Retired with a groin injury in the next season but appeared twice for the Centurion club in Wellington 1946.

Charlie Oliver stood 5' 10" and weighed just over 12 stone on the 1935-36 tour. The *Free Lance* correspondent said his form had "never been better . . . without his steadying influence, genius, quickness in seizing the smallest opening, and magnificent defence, our backs would have been lost."

In conjunction with his fellow All Black Eric Tindill, Oliver wrote *The Tour of the Third All Blacks* (Sporting Publications, 1936).

As a cricketer he represented Canterbury 16 times 1923-27, scoring an unbeaten 95 v Victoria. Toured Australia with the New Zealand team in the 1925/26 season and England 1927. A son-in-law, Dave Gillespie, was an All Black 1957,58,60.

OLIVER Desmond Oswald
Christened Oswald Desmond Oliver but with common usage has reversed his forenames
b: 26.10.1930, Palmerston North *d:* 25.10.1997, Oxford, England
Flanker

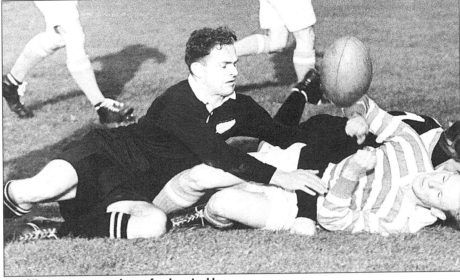

Des Oliver . . . renowned as a fearless tackler.

Represented NZ: 1953,54; 20 matches – 2 tests, 12 points – 4 tries

First-class record: Otago 1952,53 (University); Wellington 1954 (University); South Island 1953; NZ Trials 1953; NZ Universities 1954

Educated Marist Brothers' School (Palmerston North) and Palmerston North Boys' High School, 1st XV 1948. Attended Victoria and Otago Universities but did not resume playing rugby until 1952 when he was included in the Otago team.

His 20 appearances on the 1953-54 British tour included internationals against Ireland and France, in the former being called upon to substitute for the injured Ron Jarden on the right wing. Winston McCarthy's tour book commented: "Fast, good hands and a fearless tackler; this trip will be of untold value to Oliver." Stood 6' 2" and weighed 14½ stone.

Retired after playing twice for Wellington 1954.

OLIVER Donald Joseph
b: 29.4.1909, Dunedin *d:* 25.6.1990, Hastings
Wing threequarter

Represented NZ: 1930; 3 matches – 2 tests, 6 points – 2 tries

First-class record: Otago 1929 (Kaikorai); Wellington 1930 (Wellington); Wairarapa 1931 (Carterton); Waikato 1933,34 (Waikeria); Southland 1935 (Pirates); South Island 1929; NZ Trials 1930,35; New Zealand XV 1929

Educated Heriot School. Represented five separate unions in six seasons. Played for New Zealand against North Otago in a preliminary match before the 1930 British tour and appeared in the first two tests of that series. Despite a fine try in the second test he was dropped in a reshuffle of the backline.

Described as "a very solid type of wing . . . defence excellent and plenty of pace when he gets going." His statistics were given as 5' 10" and 12st 4lb. Served as a Horowhenua selector 1948-50; Manawatu-Horowhenua 1949,50.

OLIVER Francis James
b: 24.12.1948, Dunedin
Lock

Represented NZ: 1976-81; 43 matches – 17 tests, 8 points – 2 tries

First-class record: Southland 1969-76 (Marist), 1977 (Waiau); Otago 1978,79 (Tokomairiro); Manawatu 1980-83 (Marist); South Island 1972,74,75,77,79; North Island 1980,81; NZ Trials 1970-72,74-77,79,80; NZ Juniors 1969,70; NZ Services 1968,72

Educated Lawrence District High School, 1st XV 1963-65. Oliver impressed from the outset of his first-class career as an All Black prospect and appeared in trials in 1970 but was not selected for a New Zealand team until the 1976 tour of South Africa.

Frank Oliver

Displaced Hamish Macdonald to partner Peter Whiting as the locking combination in the final test on that tour and then retained his position in the home series against the 1977 Lions and in France later that year. With Graham Mourie injured, Frank Oliver captained New Zealand against the 1978 Wallabies and then, under Mourie's leadership, played in all four internationals in the British Isles. Appeared in both tests v France 1979 although a back injury forced him to retire during the first match.

Oliver's play was affected by this injury and he missed selection for the 1979 tours to Australia and England, Scotland and 1980 Australian tour but returned to his best form for Manawatu and the North Island. Appeared in the match against Fiji at Auckland and then visited Wales, playing three games on the 1980 centenary tour, and recalled from Australia where he was on tour for one test against South Africa in 1981.

Standing 1.91m and weighing 106kg, Oliver was credited by the *1976 DB Rugby Annual* with supplying "the basic, low driving, hard rucking approach," while the *1978 Annual* praised his leadership and consistently good rugby against the Wallabies. His brother, Paul, represented Otago 1974-76,78-80; South Island 1976; NZ Juniors 1975,76; NZ Colts 1973; NZ Universities 1975-77.

Oliver coached the New Zealand under 19 team in 1994, of which his son Anton was captain, and coached Manawatu 1995-97 and the Central Vikings in 1997.

He also coached the Wellington Hurricanes 1996-97 and had been reappointed for 1998.

Another son, Brent, played for Otago B, the Central Vikings and New Zealand Universities.

ORCHARD Sydney Arthur
b: 1875, Elmore, Australia *d:* 19.4.1947, Christchurch
Fullback

Represented NZ: 1896,97; 9 matches

First-class record: Manawatu 1893 (Palmerston North); Canterbury 1894-99 (Linwood); South Island 1897

Arrived in New Zealand 1886. Educated East Christchurch School. Normally appeared as fullback but also played on the wing. Represented New Zealand v Queensland 1896 then toured Australia in the following year.

Orchard served on the Canterbury RFU management committee 1901-03. Also a prominent referee, he controlled West Coast-Buller's game against the 1908 Anglo-Welsh tourists. Represented Canterbury at cricket 1898-1913, twice achieving the hat-trick. Played for the South Island v Lord Hawke's England XI 1903 and was selector and manager for the 1913/14 New Zealand cricket team in Australia.

ORMOND Jack
b: 1.12.1891, Mahia *d:* 24.6.1970, Napier
Loose forward

Represented NZ: 1923; 1 match

First-class record: Hawke's Bay 1923-25 (Mahia); Pioneer Battalion 1919

Educated Christ's College, 1st XV 1908. Served as a lieutenant with the Pioneer Battalion during WWI and toured New Zealand with that unit's team on its return home.

Ormond played in 10 Ranfurly Shield matches for Hawke's Bay during three seasons. His sole game for New Zealand was against New South Wales in the final match of the 1923 home series.

Member of Parliament for Eastern Maori 1943-63 under his Maori name of Tiaki Omana.

ORR Rex William
b: 19.6.1924, Gore
Fullback

Represented NZ: 1949; 1 match – 1 test

First-class record: Otago 1947 (Training College), 1948-51 (Zingari-Richmond); Auckland 1953 (Air Force/Ponsonby), 1955 (Ponsonby); South Island 1949; NZ Services 1952-55

Educated Gore High School. Served in the RNZAF before resuming at Dunedin Training College and representing Otago. A sound fullback of slight stature 5' 8" and 11st 4lb who was called into the first test team to play the 1949 Wallabies when wing Jack McLean withdrew and the original fullback, Graham Moore, was moved to the wing. Captained NZ Services 1953-55 while serving in the air force as a flight lieutenant.

OSBORNE, Glen Matthew
b: 27.8.1971, Wanganui
Fullback and wing

Represented NZ: 1995-97; 28 matches – 18 tests, 75 points – 15 tries

First-class record: Wanganui 1990,91 (Kaierau); North Harbour 1992,93 (Silverdale), 1994-97 (Takapuna); Waikato Chiefs 1996,97; NZ Colts 1991,92; South Zone Maoris 1991; North Zone Maoris 1992,94; Northern Region Maoris 1996; NZ Maoris 1994,96; Northland Invitation XV 1996; North Otago Invitation XV 1996; South Island Invitation XV 1997; Barbarians 1994,96,97

Glen Osborne was educated at St Augustine's College in Wanganui, where he played in the first XV 1986-89, mainly as a first five-eighth. He played for Wanganui in age grades and secondary schools and for Central Region Secondary Schools in 1989.

He made his first-class debut at 18 at first five-eighth in 1990 but was later moved to fullback or wing, where his attacking flair could be better utilised. He also played for Wanganui at centre.

Osborne moved to North Harbour in 1991 and though he played for New Zealand Colts in 1991 and 1992 and his attacking play was well known, he was used only occasionally by North Harbour until 1994, a year that brought a marked change in his fortunes. He moved to the Takapuna club from Silverdale and became a North Harbour regular, as well as gaining national recognition for his play at the Hong Kong sevens tournament.

Osborne made his test debut against Canada

Glen Osborne

in 1995 and was the first-choice fullback during the World Cup, in which he played in five of the six matches. He fared less well on the tour of Italy and France and he missed the test against Italy, went on as a replacement for Jeff Wilson in the first against France and played in the second because Wilson was injured.

He didn't play in any of the domestic tests in 1996, but regained a test place in South Africa – though this time on the wing, Christian Cullen having taken over at fullback. Injuries and the quality of other outside backs meant Osborne played tests sparingly in 1997, going on once as a replacement against Argentina, playing in two against Australia, and one on the tour of Britain and Ireland at the end of the year.

A brother, Charles, played for Wanganui 1989-94 and an uncle, Bill Osborne, played 16 tests between 1975 and 1982.

OSBORNE William Michael
b: 24.4.1955, Wanganui
Second five-eighth and centre

Represented NZ: 1975-78,80,82; 48 matches – 16 tests, 40 points – 10 tries

First-class record: Wanganui 1973-80,82-84 (Kaierau); NZ Colts 1974; King Country-

Bill Osborne . . . strong defender and gifted attacker.

Wanganui 1977; North Island 1978,80,84; NZ Trials 1974-78,85; NZ Maoris 1975,77,78; Waikato 1985,86 (Melville)

Osborne began his first-class career at the age of 18 and by the time he was 20 had played his first test for the All Blacks (against Scotland in 1975). He was chosen for the 1976 team to South Africa and although not selected for any of the tests, played in the second and fourth as a replacement. He played in each of the four tests against the 1977 Lions and in France later that year played in both tests (the first as a replacement). In 1978, he lost his place to Mark Taylor for the tests against Australia but played in each of the four tests on the Grand Slam tour, once at centre and three times at second five-eighth.

He missed most of 1979 through injury but returned in 1980 and after playing an unofficial test against Fiji, toured North America and Wales where he played in the only test. Osborne, who stood 1.78m and weighed 83kg, announced his retirement in early 1981 but made a comeback in 1982 and was chosen for all three tests against Australia (although he withdrew from the second because of injury). He again 'retired' and made another comeback in 1985, gaining a place in the side selected to tour South Africa. He withdrew from the replacement tour of Argentina but went to South Africa in 1986 with the unofficial Cavaliers.

Osborne's best series were at second five-eighth when he was in partnership with Bruce Robertson at centre – on the 1978 Grand Slam tour and in the Welsh centenary test. At his best, he was an exceptionally strong defensive back and a gifted, if sometimes unorthodox, attacker.

O'SULLIVAN James Michael
b: 5.2.1883, Okaiawa d: 21.12.1960, Hawera
Loose forward

Represented NZ: 1905,07; 29 matches – 5 tests, 6 points – 2 tries

First-class record: Taranaki 1901-04,06,08 (Okaiawa), 1909 (Kaponga); North Island 1905-07; Taranaki-Wanganui-Manawatu 1904

Educated Matapa School. A hard-working forward who was useful in the lineout; 5' 10" and 13½ stone. Made the preliminary tour of Australia before leaving with 1905-06 'Originals'. O'Sullivan appeared in all four internationals in Britain but a broken collarbone against Cardiff ended his tour. On the 1907 visit to Australia he was recalled for the third test.

O'SULLIVAN Terence Patrick Anthony
b: 27.11.1936, New Plymouth d: 25.4.1997, Mt Ruapehu
Second five-eighth and centre threequarter

Represented NZ: 1960-62; 16 matches – 4 tests, 21 points – 7 tries

First-class record: Taranaki 1955-59,61-66 (Okato); North Island 1959,61,63; NZ Trials 1959-63; NZ Juniors 1959; NZ Colts 1955

Educated Okato Primary and District High Schools and St Patrick's College (Silverstream), 1st XV 1952. Represented Taranaki as an 18-year-old.

Weighing 11 stone and standing 5' 8", Terry O'Sullivan was described as "a lively, fast and

Terry O'Sullivan

versatile back". Earned a place in the first test on the 1960 South African tour but a broken wrist suffered in the next game against Rhodesia put him out for the rest of the tour. Played in the first test v France in the home series the next year and scored an opportunist's try. A sprained ankle forced him to withdraw from the second test team. On the 1962 Australian tour O'Sullivan appeared in both internationals.

Coached the Okato club 1972-78 to two championship wins and served on the Taranaki RFU management committee.

PAEWAI Lui
b: 10.8.1906, Dannevirke d: 2.1.1970, Dannevirke
Five-eighth

Represented NZ: 1923,24; 8 matches, 6 points – 2 tries

First-class record: Hawke's Bay 1922,23 (MAC), 1925,26 (Dannevirke Aotea); Auckland 1927,28 (Grafton); NZ Trials 1924; NZ Maoris 1923,27,28; Hawke's Bay-Poverty Bay-East Coast 1923

Lui Paewai

Educated Maori Agricultural College 1919-22. Made his first-class debut when he was nine days past his 16th birthday and was selected for the New Zealand team to play New South Wales in the third match of the 1923 series. At the age of 17 years and 45 days Lui Paewai is the youngest player to represent New Zealand.

Selected for the 1924-25 'Invincibles', he did not make the preliminary visit to Sydney and appeared in only seven of the 30 matches in Britain and France. Standing 5' 8½" and weighing 11st 8lb at the time of this tour, Paewai was described as "a young player of promise . . . unorthodox in his methods he is difficult to anticipate and quick off the mark." Later moved to Auckland and represented that province at fullback in all but one of his games.

PAGE James Russell
b: 10.5.1908, Dunedin d: 22.5.1985, Auckland
First five-eighth and centre threequarter

Represented NZ: 1931,32,34,35; 18 matches – 6 tests, 9 points – 3 tries

First-class record: Wellington 1930-34 (Wellington); North Island 1933; NZ Trials 1934,35

Educated Southland Boys' High School, 1st XV 1923-26. Attended the Royal Military College (Sandhurst) 1927-30, played for the London Scottish club and acted as a reserve for the Scottish international team.

'Rusty' Page

He returned to New Zealand 1930 and in the next year was called into the New Zealand team to play Australia at Auckland when Charlie Oliver withdrew. Normally a first five-eighth he appeared at centre in his maiden international. Returned to his preferred position for the three tests in Australia 1932 (playing outside his Wellington team-mate and All Black captain Frank Kilby) and two tests on the 1934 tour.

A severe knee injury against Midland Counties in the second game of the 1935-36 British tour restricted him to only one further appearance where he aggravated his injury and ended his rugby career. The team's vice-captain, Charlie Oliver, commented: "I am convinced that had Page not suffered injury we would have been a far stronger attacking team closer to the scrum. He was sadly missed as no other first

five-eighth in the side was so quick off the mark and his equal at finding openings." His statistics were given as 5' 7" and 11st 2lb.

Served as Wellington club president 1963-67, Wellington RFU executive 1947-49 and NZRFU executive 1953,54. In a distinguished military career 'Rusty' Page was a lieutenant colonel at the age of 33, commanding officer of the 2nd NZEF 26th Battalion, won the DSO 1942 and retired from the NZ Army with the rank of brigadier 1963. CBE 1954.

PAGE Milford Laurenson
b: 8.5.1902, Lyttelton *d:* 13.2.1987, Christchurch
Halfback

Represented NZ: 1928; 1 match

First-class record: Canterbury 1922,23,28,29 (Sheffield); South Island 1923

Educated West Lyttelton Primary School and Christchurch Boys' High School, 1st XV 1919-21. Represented Canterbury in two seasons after leaving school but did not appear in first-class rugby again until 1928 when he played for his province and had his sole game for New Zealand at halfback against New South Wales. A slim but tough player, weighing 10 stone, 'Curly' Page was an outstanding cricketer. Represented Canterbury 1920-37 and scored 3247 runs in 88 first-class games. Played 14 test matches for 492 runs. Captained the 1937 New Zealand cricket team to England.

PALMER Bertram Pitt
b: 14.11.1901, Mosstown *d:* 4.9.1932, Auckland
Hooker and prop

Represented NZ: 1928,29,32; 18 matches – 3 tests, 14 points – 4 tries, 1 conversion

First-class record: Auckland 1924-31 (Ponsonby), 1932 (Otahuhu); North Island 1928,32; NZ Trials 1927,29,30

A short (5' 8" and 13 stone) player, Palmer was the ideal hooker in the two-fronted scrum. He first played for New Zealand in all three matches of the 1928 series against New South

Wales then toured Australia in the next year appearing in six matches including the second test. On the 1932 visit to Australia he hooked in the 3-4-1 scrum, playing in the second and third tests.

He suffered a head injury while making a tackle in a 1932 club game, playing for Otahuhu v University, and died the following day. The Bert Palmer Memorial Trophy was presented by J. Marsden Caughey to the Auckland RFU for sportsmanship among junior boys' teams.

PARKER James Hislop
b: 1.2.1897, Lyttelton *d:* 11.9.1980, Auckland
Wing forward

Represented NZ: 1924,25; 21 matches – 3 tests, 56 points – 18 tries, 1 conversion

First-class record: Canterbury 1920,23 (Christchurch HSOB); South Island 1924; NZ Trials 1924

Educated West Lyttelton Primary School and Christchurch Boys' High School. Served in WWII with the army, winning the MM. Parker had three games for Canterbury 1920 but did not play representative football again until 1923. At the end of that season he was selected for New Zealand to play New South Wales but withdrew.

He was named among the 16 certainties to make the 1924-25 British tour after the inter-island game and showed outstanding form for the 'Invincibles', keeping tour captain Cliff Porter out of the internationals in Britain. Parker was considered the fastest man in the team and scored 18 tries – more than any other forward on this tour. He played one game on the wing against Cumberland, and scored a try.

Retired from the game after the team's return but served on the NZRFU executive 1939-56 and managed the 1949 All Blacks in South Africa. Elected a life member of the NZRFU 1959.

PARKHILL Allan Archibald
b: 22.4.1912, Palmerston *d:* 26.8.1986, Dunedin
Number eight

Represented NZ: 1937,38; 10 matches – 6 tests, 9 points – 3 tries

Allan Parkhill

First-class record: Otago 1934,35 (Palmerston), 1936-41 (Pirates); Canterbury 1943 (Army); South Island 1935,37-39; NZ Trials 1937

Educated Palmerston District High School, 1st XV. At 5' 11" and 14st 3lb, Parkhill showed remarkable speed around the field. He played at number eight in all three internationals against the 1937 Springboks and appeared in seven of the nine games, including the three tests, in Australia the following year.

PARKINSON Ross Michael
b: 30.5.1948, Wairoa
Second five-eighth and centre threequarter

Represented NZ: 1972,73; 20 matches – 7 tests, 20 points – 5 tries

First-class record: Poverty Bay 1968,71-75,77 (Gisborne HSOB); North Island 1971-73; NZ Trials 1971-73; NZ Maoris 1970,72,74; Poverty Bay-East Coast 1971,72,77

Educated Wairoa College and Gisborne Boys' High School. Made his debut for New Zealand in the three-match 1972 series against the Wallabies. His 14 appearances for the 1972-73 All Black touring team included internationals against Wales, Scotland and England. After two games on the 1973 internal tour he was selected for the test v England but retired with an injury.

Standing six feet and weighing $12^{1/2}$ stone, Mike Parkinson was a strong and determined runner, effective in setting up second phase play and also a good tackler. Continued to represent Poverty Bay after his international career, playing 51 of his 88 first-class games for that union. The 1940s All Black, Johnny Smith, was his father-in-law.

PATERSON Alexander Marshall
b: 31.10.1885, Dunedin *d:* 29.7.1933, Dunedin
Loose forward

Represented NZ: 1908,10; 9 matches – 5 tests, 6 points – 2 tries

First-class record: Otago 1908-11,13,14,20,21 (Zingari-Richmond); Canterbury 1912 (Christchurch); South Island 1908-11

Mike Parkinson scores against Western Counties, 1972.

A well-built forward who normally appeared in the back or side row of the scrum, 'Sandy' Paterson played 43 games for Otago in a career spanning 14 years.

Made his All Black debut in the second test against the 1908 Anglo-Welsh tourists and held his place for the third match in that series and in Australia 1910. Collapsed and died while watching a rugby game at Carisbrook.

PATON Henry

b: 12.2.1881, Dunedin *d:* 21.1.1964, Dunedin
Lock

Represented NZ: 1907,10; 8 matches – 2 tests, 18 points – 6 tries

First-class record: Otago 1906-11 (Dunedin); Wellington 1912,13 (Oriental); South Island 1906-10

Educated Waitaki Boys' High School, 1st XV 1897,98. Played his school rugby at fullback and his early club football usually as a threequarter but developed into a fine lock. A tall man, weighing 13¹/₂ stone, Paton was noted for his ability in the lineout.

Had only one appearance on the 1907 tour of Australia at hooker but played in two tests in that country with the 1910 All Blacks. Paton captained Otago 1910 and in the same year led the South Island to victory in his fifth successive interisland game.

Served on the NZRFU management committee 1920,21. As a provincial referee he controlled the Ranfurly Shield fixture Wellington v Canterbury 1920.

PAULING Thomas Gibson

b: 17.6.1873, Ashburton *d:* 27.8.1927, Sydney, Australia
Forward

Represented NZ: 1896,97; 9 matches, 16 points – 4 tries, 2 conversions

First-class record: Wellington 1895,96 (Athletic); North Island 1897; New South Wales 1898,99

First represented New Zealand against Queensland at Wellington 1896 then toured Australia with the 1897 team. Remained in Australia and represented New South Wales before becoming a prominent referee.

He controlled three of the games played by the 1903 New Zealand team; two Australia v Great Britain 1904; three New South Wales v Anglo-Welsh 1908 and the first test New Zealand v Australia 1914. During the 1903 New South Wales game Pauling sent Reuben Cooke from the field. His son, Tom, played for Australia 1936,37. Apprenticed to the saddlery trade on leaving school he later served with the Defence Force. When named in the 1897 New Zealand team he was unable to obtain leave and was forced to resign from the Forces.

PENE Arran Rewi Brett

b: 26.10.1967, Hamilton
No 8

Represented NZ: 1992-94; 26 matches – 15 tests, 16 points – 4 tries

First-class record: Otago 1988-92 (University), 1993-95 (Taieri); NZ Trials 1990-95; New Zealand XV 1995; South Island 1995;

Southern Zone Maoris 1991,93,94; New Zealand Maoris 1993,94; South Island Universities 1988; Saracens 1992

A strong-driving No 8, Pene was in his fifth year of first-class play when he was chosen for New Zealand for the centenary series against a World XV, going on in the first test and being chosen for the other two. He retained his place for the following two tests against Ireland, but was supplanted on the tour of Australia and South Africa by Zinzan Brooke, who had missed the early part of the New Zealand season because he had been playing in Italy.

Arran Pene

The reverse applied the following year when Pene replaced Brooke after the lost second test to the British Isles and he remained the test No 8 on the tour of England and Scotland.

Injury restricted Pene's test appearances to three in 1994 and he was not wanted for the World Cup squad the following year.

Pene left New Zealand at the end of 1995 to take up a contract in Japan.

He played for the British Barbarians against Scotland and Wales in 1997.

PEPPER Cyril Stennart

b: 18.11.1911, Auckland *d:* 31.5.1943, Wellington
Prop

Represented NZ: 1935,36; 17 matches, 12 points – 4 tries

First-class record: Auckland 1933-39 (Manukau); NZ Trials 1935,37

Educated Te Papapa Primary and Auckland Grammar School. A fast but light (12st 9lb, 5' 10") prop, Pepper played in 16 matches for the 1935-36 All Blacks and continued to represent Auckland until 1939.

In his tour book, Charlie Oliver said: "Pepper was a good honest worker, very effective in following up." He was invalided home during WWII after winning the MC at Sidi Rezegh and died as a result of war injuries.

PERRY Arnold

b: 18.4.1899, Wellington *d:* 2.10.1977 Cherry Farm
First five-eighth

Represented NZ: 1923; 1 match

First-class record: Otago 1919-23 (University); South Island 1924; NZ Trials 1924; NZ Universities 1921

Educated Clyde Quay School and Wellington College, 1st XV as a fullback. While studying medicine in Dunedin, Perry played for Otago and had his only All Black game against New South Wales in the second of the three-match series 1923. He was widely regarded as a possible captain of the 1924-25 touring team but poor form in the trials kept him out of contention. Otago selector 1935; a member of that union's management committee 1927-40,46-56; president 1936,37.

PERRY Richard Grant

b: 26.5.1953, Christchurch
Hooker

Represented NZ: 1980; 1 match

First-class record: Mid Canterbury 1975-84 (Rakaia); South Island 1981-84; NZ Trials 1981,82

Educated Lauriston Primary School (Christchurch) and St Andrew's College. Began his rugby career as a loose forward but switched to hooker and captained Mid Canterbury from 1977.

Called into the 1980 All Blacks as a replacement for Hika Reid for a short tour of Fiji at the conclusion of the Australian tour, Grant Perry was injured in his first game against Nadroga in Fiji. Toured with the Cantabrians to Britain and Italy 1979. His brother, Bruce, played for Mid Canterbury 1976,77.

PETERSEN Louis Charles

b: 19.4.1897, Akaroa *d:* 25.6.1961, Christchurch
Loose forward

Represented NZ: 1921-23; 8 matches, 3 points – 1 try

First-class record: Canterbury 1919-23 (Marist); South Island 1919,21,22

While acting as a reserve for the All Blacks during the 1921 Springbok tour Petersen was selected for the New Zealand team to play New South Wales at Christchurch. Appeared in four of the five games on the 1922 Australian tour including all three against New South Wales and opposed that state twice in the 1923 home series.

Petersen switched to rugby league and represented New Zealand 1925-27. He was one of seven players banned from league after open revolt occurred on the 1926-27 tour of England.

PHILLIPS William John

b: 30.1.1914, Raglan *d:* 10.11.1982, Raglan
Wing threequarter

Represented NZ: 1937,38; 7 matches – 3 tests, 6 points – 2 tries

First-class record: King Country 1934-38 (Makomako); Waikato 1939,41,46 (Raglan),

Bill Phillips

1943 (Hamilton OB); North Island 1937-39; NZ Trials 1935,37; NZ Maoris 1934-36,39; Waikato-King Country-Thames Valley 1937

Educated Te Mata Primary School. A fast wing, standing six feet and weighing about 13½ stone, who made his debut for New Zealand in the second test against the 1937 Springboks after a good display for the Waikato-King Country-Thames Valley side which lost 3-6 to the tourists.

Bill Phillips distinguished himself by catching the speedy South African wing Williams from behind but he was dropped for the third test. On the 1938 Australian tour he appeared in six of the first seven games including two internationals.

PHILPOTT Shayne
b: 21.9.1965, Christchurch
Utility back

Represented NZ: 1988,90,91; 14 matches – 2 tests, 33 points – 5 tries, 2 conversions, 3 penalty goals

Shayne Philpott

First-class record: Canterbury 1986-88,90-95 (Burnside); NZ Colts 1986; NZ Trials 1990,91

The ultimate utility player, Philpott played in the midfield, on the wing or at fullback when required, and was a standby goalkicker when needed.

He was called into the New Zealand team in Australia in 1988 as a replacement, never having played an All Black trial, and played one game at fullback and one at second five-eighth.

He had a year out of first-class rugby in 1989 but returned to the All Blacks for the tour of France in 1990 and played in four matches, and toured again when the All Blacks went to Argentina in 1991.

Philpott also gained a place in the 1991 World Cup squad. His ability to play in several positions made him a natural for the reserves bench and his only two tests, against Italy and Scotland at the cup, were both as replacements.

PICKERING Ernest Arthur Rex
b: 23.11.1936, Te Kuiti
Loose forward and lock

Represented NZ: 1957-60; 21 matches – 3 tests, 21 points – 7 tries

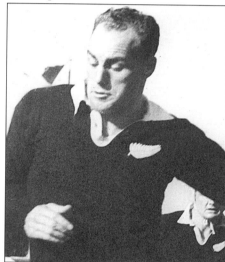

Rex Pickering

First-class record: Waikato 1955-65 (Frankton); North Island 1958,59; NZ Trials 1957-61; NZ Under 23 1958; New Zealand XV 1958

Educated Otorohanga Primary School and Nelson College, 1st XV 1953,54. Made his debut for Waikato at the age of 18 and in the following season helped in that province's defeat of the Springboks, playing much of the game as a substitute wing from which unfamiliar position he scored a try.

Toured Australia with the 1957 All Blacks and played his first international the next year in the second test against the Wallabies. Returned to the test side for the first and fourth internationals against the 1959 Lions and then toured South Africa 1960. A tall, versatile forward Rex Pickering was proficient in the lineout and showed speed in the loose. He was thought unlucky not to play in any of the tests in South Africa. Continued to represent Waikato for another five years.

Frankton club president and coach of various senior teams. Secretary of the Harlequins club. His brother, John, represented Wellington 1961-63,65.

PIERCE Murray James
b: 1.11.1957, Timaru
Lock

Represented NZ: 1984-90; 54 matches – 26 tests, 16 points – 4 tries

First-class record: Wellington 1982-90 (Wellington); NZ Trials 1984,87,89; North Island 1985; Central Zone 1988,89; NZ Combined Services 1980,83,85; Barbarians 1985; NZ Police Centennial XV 1986

Educated at Waitaki Boys', Roxburgh District and Dunstan High Schools, Pierce played club rugby in Roxburgh before moving to Wellington. He first played for Wellington in 1982 after having earlier played first-class rugby for Combined Services.

Pierce was selected for the All Black tours of Australia and Fiji in 1984 and made his test debut the following year against England. He was chosen for the cancelled tour of South Africa and went on the replacement tour of Argentina instead, and the following year joined other All Blacks as Cavaliers on the unauthorised tour of South Africa.

He immediately regained his test place when the Cavaliers were again eligible and, with the retirement of Andy Haden, became a regular test lock with Gary Whetton. He played in two tests against Australia and in both tests on the tour of France.

Pierce was an automatic choice for the 1987 World Cup, playing in five of the six matches, but was surprisingly left out of the team that toured Japan at the end of the year.

He played in all 12 tests in 1988 and 1989 and early in 1990 went to South Africa to play, forgoing his test place.

He was back in New Zealand midway through the season and regained a place in the New Zealand side for the 1990 tour of France, but didn't play in either test.

Pierce, who was a policeman, was a highly regarded ball winner in lineouts and one of the strengths of the All Blacks in their unbeaten peak of the late 80s.

His father, Jim, played for South Canterbury in 1957.

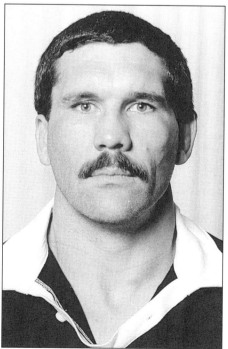

Murray Pierce

POKERE Steven Tahurata
b: 11.8.1958, Hawera
Centre threequarter and second five-eighth

Represented NZ: 1981-85; 39 matches – 18 tests, 36 points – 9 tries

First-class record: Southland 1977,78,81-83 (Invercargill); Auckland 1984,85 (Pakuranga); Wellington 1986,87 (Wellington College OB); South Island 1977,81-83; North Island 1984; NZ Trials 1981-85,87; NZ Juniors 1977; NZ Maoris 1981-83,85,87; Central Zone 1987

Educated Southland Boys' High School where he played soccer, representing the South Island in under 12 and under 14 teams. Pokere began his rugby career in 1975 and made a big impression in his first year with Southland, 1977. He missed the 1979 and 1980 seasons through work with the Mormon church and returned to rugby in 1981. He was picked as a second five-eighth for the third test against South Africa that year and toured Romania and France at the end of the year.

From 1982 to midway through 1985, he was the regular test centre for New Zealand, playing the 1982 and 1983 series against Australia and the Lions respectively, he toured England and Scotland in 1983 and Australia (missing the first test through injury) and Fiji in 1984. In 1985, Pokere played in the two domestic tests against England and one against Australia and was chosen for the cancelled tour of South Africa. On the replacement tour of Argentina, he lost his place for both internationals to new All Black Victor Simpson. Pokere went on the Cavaliers' tour of South Africa.

Steve Pokere

Pokere was regarded as a fine, elusive attacking midfield back and, despite a relatively slight build, was reliable on defence. He was able to play more than adequately in other positions and apart from his first test at second five, he also filled in on occasions at first five-eighth, a position in which he had considerable provincial experience.

POLLOCK Harold Raymond
b: 7.9.1909, Petone *d:* 10.1.1984, Otaki
Utility back

'Bunk' Pollock

Represented NZ: 1932,36; 8 matches – 5 tests, 41 points – 13 conversions, 1 penalty goal, 3 dropped goals

First-class record: Wellington 1929-39 (Petone); North Island 1932,35-37; NZ Trials 1935,37

Educated Petone West School, Wellington Primary Schools rep 1924,25. Of slight build (10st 6lb and 5' 10"), 'Bunk' Pollock played much of his early rugby as a five-eighth but was generally regarded as a better fullback.

He appeared in all three tests at second five-eighth and centre on the 1932 Australian tour but did not play again for New Zealand until 1936 when he was selected at fullback for the two-test series against the Wallabies and the intervening game v South Canterbury. Recurring injuries frequently prevented him from reaching top form.

PORTEOUS Harry Graeme
b: 20.1.1875, Blueskin *d:* 19.12.1951, Wellington
Wing forward

Repesented NZ: 1903; 3 matches

First-class record: Otago 1900,02-06 (Kaikorai); South Island 1902,03; Otago-Southland 1905

An aggressive wing forward who toured Australia with the 1903 New Zealand team but with competition for his position from 'Lofty' Armstrong and Dave Gallaher, he appeared in only three games. Played against the 1905 'Originals' for an Otago-Southland combination before the All Blacks left for Britain. Later played club football for Petone in Wellington.

PORTER Clifford Glen
b: 5.5.1899, Edinburgh, Scotland
d: 12.11.1976, Wellington
Wing forward

Represented NZ: 1923-26,28-30; 41 matches – 7 tests, 48 points – 16 tries

First-class record: Wellington 1917,18 (Wellington College OB), 1923,25-30

(Athletic); Horowhenua 1921,22 (Hui Mai); North Island 1924-26,28,29; NZ Trials 1924,27,29,30; Wellington-Manawatu 1923; Wellington-Manawatu-Horowhenua 1925; New Zealand XV 1929

Educated South Wellington School and Wellington College, 1st XV 1915. Played his early rugby as a five-eighth or threequarter, adopting the wing forward position 1923 in which year he was brought into the New Zealand team for the final match against New South Wales.

Captained the North Island to a 39-8 victory in the next season and toured New South Wales with the All Blacks. In a surprise move Porter replaced Ces Badeley as captain of the 1924-25 touring team. Played 17 of the 30 matches for the 'Invincibles'. A knee injury kept him out of the Irish international and his replacement, Jim Parker, retained the wing forward position for the Welsh and English games with Porter returning for the French international.

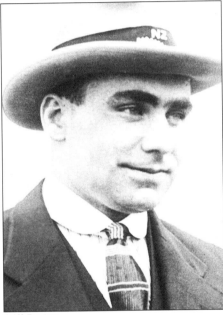

Cliff Porter

Led New Zealand to a 36-10 victory over New South Wales 1925 and then took the All Blacks to Australia in the following year. A surprise omission from the 1928 team to South Africa, Porter captained the All Blacks against New South Wales in a three-match series at home. On the 1929 Australian tour he was unable to play until the second test. Finally captained New Zealand to a series win against the 1930 Lions, playing an outstanding game in his final test when he scored two tries.

Porter's last first-class game was as captain of his own XV v Marlborough 1933. His statistics for the 1924-25 tour were given as 5' 8" and 12st 8lb, but by 1930 his weight had increased to 13½ stone.

POTAKA Waate Pene
b: c 1903 *d:* 3.11.1967, Taihape
Threequarter

Represented NZ: 1923; 2 matches, 3 points – 1 try

First-class record: Wanganui 1918,20,23,25,26 (Rata), 1930 (Aotea), 1931 (Ratana); North Island 1923; NZ Trials 1924; NZ Maoris 1922,23,26,27

A versatile player who commenced his rugby career as a halfback and subsequently appeared in every backline position. 'Pat' Potaka's two games for New Zealand were at centre threequarter in the first match against New South Wales 1923 and as a replacement wing for 'Jockey' Ford in the second encounter when he scored a try. Toured with the 1926-27 NZ Maoris to Europe.

PRESTON Jon Paul
b: 15.11.1967, Dunedin
Halfback and first five-eighth

Represented NZ: 1991-93,96,97; 27 matches – 10 tests, 83 points – 4 tries, 12 conversions, 13 penalty goals

First-class record: Canterbury 1988-92 (Burnside); Wellington 1993-97 (Harlequins); Wellington Hurricanes 1996,97; NZ Trials 1991,93,94,96; NZ Colts 1988; New Zealand B 1991; New Zealand XV 1991; NZRFU President's XV 1992,95; NZ Development 1994; North Island 1995; Northland Invitation XV 1996; Canterbury Crusaders Invitation XV 1996; North Otago Invitation XV 1996; Barbarians 1994,97

Educated at St Bede's High School in Christchurch, from where he played for New Zealand Secondary Schools in 1984 and 1985, Preston has had a varied career at either halfback or first five-eighth, depending on the demands of the moment.

He couldn't command a regular place in the Canterbury team, yet was chosen for the World Cup squad in 1991 for his versatility. In addition to his ability to play in either of the inside back positions, he is also a more than competent goalkicker.

Preston played against the United States and Scotland in the cup, both at first five-eighth, but was back as a halfback the following year when he toured Australia and South Africa, playing in the South African test as a replacement.

In 1993, after a move to Wellington where he was immediately installed as captain, Preston's fortunes seemed to soar because he replaced halfback Ant Strachan after the first test against the British Isles and stayed there for the tests against Australia and Western Samoa as well. But on the tour of England and Scotland at the end of the year, he was supplanted in the tests by Stu Forster.

Preston didn't again play for New Zealand until 1996 when he was included, again, presumably, because of his adaptability, in the enlarged squad for the tour of South Africa. His only test was as a replacement in Pretoria, when he kicked two late penalty goals to help ensure the All Blacks' first series victory in South Africa.

He was used only as a reserve during the domestic tests and tri nations series in 1997, but played in five matches on the tour of Britain and Ireland at the end of the year – including two tests as a replacement.

Preston became the ideal backup player: able to fit in where required (he has played as a replacement on the wing) and able to kick goals when required; a handy reserve to have, but well equipped to be in the starting XV if needed.

PRINGLE Alexander
b: 9.11.1899, Wellington *d:* 21.2.1973, Christchurch
Loose forward

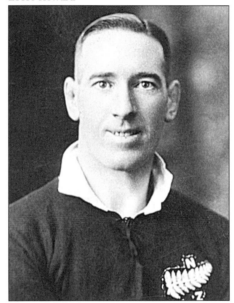

'Nugget' Pringle

Represented NZ: 1923; 1 match, 3 points – 1 try

First-class record: Wellington 1922-24,26,27 (Oriental); North Island 1923,24; NZ Trials 1924,27; Wellington-Manawatu 1923

A very tall (6' 5½") loose forward who excelled in the lineout, 'Nugget' Pringle had his only All Black appearance in the second match against the 1923 New South Wales touring team. He scored a try in New Zealand's 34-6 win. After representing the North Island when that team beat the South 39-8 and playing in the final 1924 trial game, he was considered unlucky to miss selection for the British tour.

PRINGLE Walter Peter
b: 17.7.1869, Hutt *d:* 24.2.1945, Palmerston North
Forward

Represented NZ: 1893; 5 matches

First-class record: Wellington 1890 (Epuni), 1891-95,99 (Petone); North Island 1894; NZ Trials 1893

Originally a member of the Epuni club which amalgamated with Petone 1891; elected a life member of that club midway through his playing career. His weight was given as 12st 2lb for the 1893 New Zealand tour of Australia. Described as being "very fast, always on the ball, hard to stop when under way."

PROCTER Albert Charles
b: 22.5.1906, Dunedin *d:* 11.10.1989, Mosgiel
Wing threequarter

Represented NZ: 1932; 4 matches – 1 test, 18 points – 6 tries

First-class record: Otago 1930-35 (Zingari-Richmond); South Island 1932

Educated Macandrew Primary School and King Edward Technical College. A 5' 10", 12st 3lb threequarter who scored four tries for the All Blacks v Newcastle before appearing in the first test of the 1932 Australian tour. 'Joe' Procter did not play for New Zealand again after injury in the New South Wales game, the fourth on this tour.

Coached the Zingari-Richmond club in Dunedin and also in North Otago as well as holding several administrative positions.

PURDUE Charles Alfred
b: 10.6.1874, Mataura *d:* 10.10.1941, Invercargill
Loose forward

Represented NZ: 1901,05; 3 matches – 1 test

First-class record: Southland 1896-98,1900-03,05 (Britannia); Otago-Southland 1905

Described as "a real type of lineout forward of those days, big, rugged and intelligent", Purdue played for the Marrickville club in Sydney and was claimed to have represented New South Wales against the 1899 British team but this is not correct.

He played for New Zealand in both 1901 matches against Wellington and New South Wales and in the international v Australia at Dunedin 1905. His weight was recorded as 13st 1lb. Purdue's brother, 'Pat', played in the same match for New Zealand while his son, Jack, represented Southland 1934-39 and was an All Black trialist 1939.

PURDUE Edward
b: c 1878, Dipton *d:* 16.7.1939, Invercargill
Lock

Jon Preston against the British Isles, 1993.

Represented NZ: 1905; 1 match – 1 test

First-class record: Southland 1899-1901 (Britannia), 1903,05 (Orepuki); Otago-Southland 1905

A husky forward who normally locked the scrum, 'Pat' Purdue appeared with his brother Charles in the 1905 New Zealand team which played Australia at Dunedin. His son, George, represented New Zealand 1931,32 and another son, Syd, played for Southland 1936-40,45.

PURDUE George Bambery
b: 4.5.1909, Invercargill
Lock and flanker

Represented NZ: 1931,32; 7 matches – 4 tests, 3 points – 1 try

First-class record: Southland 1929-34 (Star); South Island 1931-33; NZ Trials 1930,35; NZ Maoris 1931

Educated Makarewa and Orepuki Schools. A powerful forward, weighing 14st 10lb and standing 6' 2", who made his All Black debut in the 1931 test v Australia in the side row of New Zealand's last 2-3-2 scrum then appeared as a lock in all three tests on the Australian tour the following year. Played for Army Central during WWII.

His father, 'Pat', and an uncle, Charles, were both New Zealand representatives while his brother, Syd, also played for Southland.

PURVIS Graham Herbert
b: 14.10.1960, Waihi
Prop

Represented NZ: 1989-93; 28 matches – 2 tests, 4 points – 1 try

First-class record: Thames Valley 1983 (Waihi Athletic); Waikato 1984-93,97 (Hamilton OB); NZ Trials 1989-93; New Zealand B 1991; New Zealand XV 1993; Maunsell Sports Trust Invitation XV 1987

Graham Purvis

Graham Purvis typified the type of prop who toils away for his province for years without any reward other than satisfaction, and who regards

his prime role as being in the thick of the tight.

His All Black selection came after six years of first-class play and he was clearly selected as a backup to the established test props, Steve McDowell and Richard Loe, and later Olo Brown and Craig Dowd. He toured Wales and Ireland in 1989, France in 1990 and Argentina in 1991 without playing a test, and was finally given a chance against the United States in the second match of the 1991 World Cup.

He reverted to the backup role in 1992 and 1993 though when Brown was injured and couldn't play in the test against Western Samoa, Purvis took over at tighthead for his second test. His last tour was of England and Scotland later in 1993, again playing the midweek matches and warming the reserves bench.

He retired at the end of 1993 but made a comeback in 1997, at the age of 36, to play in all Waikato's games and set a provincial match record of 147.

PURVIS Neil Alexander
b: 31.1.1953, Cromwell
Wing threequarter

Neil Purvis

Represented NZ: 1976; 12 matches – 1 test, 36 points – 9 tries

First-class record: Wairarapa-Bush 1971,72 (Masterton); Otago 1973,75,77,78,80,81 (Upper Clutha); South Island 1975,78; NZ Trials 1972,76-78; NZ Juniors 1974,75; NZ Under 21 1972

Educated Tarras Primary School and John McGlashan College, 1st XV 1968,69. First played for Wairarapa-Bush as an 18-year-old five-eighth before becoming a threequarter. Made his international debut against Ireland at Wellington 1976. Weighed 82kg and stood 1.80m.

On the 1976 South African tour he appeared in 11 of the 24 games and the *DB Rugby Annual* of that year commented: "Determination, missing from his play early in the tour, later returned, enabling him to bag six tries in his last four outings and finish equal top try scorer."

Neil Purvis played Brabin Cup cricket for Otago 1973.

QUAID Charles Edward
b: 17.8.1908, Christchurch *d:* 18.12.1984, Upper Hutt
Hooker

Represented NZ: 1938; 4 matches – 2 tests

First-class record: Canterbury 1931 (Linwood); Wellington 1932,33 (Poneke); Otago 1935-39 (Southern); South Island 1935-38; NZ Trials 1937

Educated Woolston Convent School, Marist Brothers' (Christchurch) and East Christchurch Schools. Quaid won selection for the 1938 Australian tour after the South Island pack had dominated in the interisland game of that year. His four tour appearances included the first two tests. Standing 5' 9" and weighing 13st 8lb, he was prominent in loose play.

RANDELL Taine Cheyenne
b: 5.11.1974, Hastings
Loose forward

Represented NZ: 1995-97; 21 matches – 12 tests, 25 points – 5 tries

First-class record: Otago 1992,93 (University), 1994-97 (Dunedin); Otago Highlanders 1996,97; NZ Colts 1993-95; NZ Trial 1996; NZ Colts Black 1995; North Otago Invitation XV 1996; Barbarians 1996-97

Taine Randell was in the first XV at Lindisfarne College for three years (1989-91) and played for Hawke's Bay Schools and age grade sides. He also played for North Island Under 16, New Zealand Under 17 and for New Zealand Secondary Schools in 1990 and 1991. In 1992, after he had made his first-class debut for Otago at the age of 17, he played for New Zealand Under 19.

Randell played for New Zealand Colts for three years, captain for the second and third of them. Despite opposition for loose forward positions in Otago from Arran Pene, Jamie Joseph and Josh Kronfeld, Randell by 1994 was a regular Otago player, either at No 8 or flanker.

He was first chosen for the All Blacks' tour of Italy and France late in 1995 and played two games at No 8 and two on the side of the scrum. Even then, there was public speculation he may

Taine Randell

be a future All Black captain. In the expanded squad that toured South Africa the following year, Randell captained the midweek team in four matches from No 8.

He made his test debut in 1997 at No 8, taking injured Zinzan Brooke's place in the test against Fiji and when Michael Jones was injured in that match, Randell was then moved to the blindside flank, where he played in the other 11 tests of the year, gaining in stature and silencing many critics who felt he was too inexperienced for such a vital position. He had such an impressive season he was named one of the players of the year by the *Rugby Almanack*.

When Sean Fitzpatrick couldn't play on the tour of Britain and Ireland at the end of the year, coach John Hart made halfback Justin Marshall the captain – and this was widely interpreted as being an interim measure while Randell consolidated his place in the test team.

RANGI Ronald Edward
b: 4.2.1941, Auckland *d:* 13.9.1988, Auckland
Centre threequarter

Ron Rangi

Represented NZ: 1964-66; 10 matches – 10 tests, 9 points – 3 tries

First-class record: Auckland 1962-68 (Ponsonby); North Island 1965; NZ Trials 1965,66; NZ Maoris 1963-66; NZ Services 1961,62; Coronation Shield Districts 1965

A strong, determined centre who had a devastating tackle, Ron Rangi weighed 13st 4lb and stood 5' 10". He made his All Black debut in the second test against the 1964 Wallabies, scoring a try.

Subsequently appeared throughout the series against the 1965 Springboks and the 1966 Lions. All of his 10 All Black games were home internationals. Awarded the Tom French Cup as outstanding Maori player of the year 1964,65.

Rangi was suspended by the NZRFU in 1966 for misbehaviour, but later reinstated.

RANKIN John George
b: 14.2.1914, Christchurch *d:* 8.12.1989, Christchurch
Flanker

Represented NZ: 1936,37; 4 matches – 3 tests, 9 points – 3 tries

First-class record: Canterbury 1933-41 (Christchurch HSOB); Wellington 1941 (Hutt Army); South Island 1935-37; NZ Trials 1937

Educated St Michael's and Elmwood Primary School, Cathedral Grammar and Christchurch Boys' High School, 1st XV 1930-32. A light weight (12st 12lb and 5' 11") flanker possessing great pace and anticipation, he represented Canterbury in his first year out of school.

Played in both tests v Australia 1936 and against South Canterbury. Ill for the first test against the 1937 Springboks, he was able to play for the second but was dropped for the final match in that series.

Coached the Christchurch HSOB and Wellington College OB clubs. Canterbury selector and coach 1948-54. South Island selector 1955-57. Played Brabin Cup cricket for Canterbury. His son, Alistair, represented Victoria (Australia) against the 1971 Springboks.

REEDY William Joseph
b: c 1880 *d:* 1.4.1939, Porirua
Hooker

Represented NZ: 1908; 2 matches – 2 tests

First-class record: Wellington 1907,08,12-15 (Petone), 1909,11 (Athletic); North Island 1908,09

Played club football for the White Star club in Westport before moving to Wellington. A strong and nuggety hooker in the 2-3-2 scrum, he played in the second and third tests against the 1908 Anglo-Welsh tourists. Continued to represent Wellington for the next six seasons.

REID Alan Robin
b: 12.4.1929, Te Kuiti *d:* 16.11.1994, Morrinsville
Halfback

Represented NZ: 1951,52,56,57; 17 matches – 5 tests, 6 points – 2 tries

'Ponty' Reid

First-class record: Waikato 1950 (Raglan), 1951-57 (Frankton), 1958 (Kereone); North Island 1950-52,56,57; NZ Trials 1951,53,56,57; New Zealand XV 1952; Waikato-King Country-Thames Valley 1950

Educated Kiritehere, Waikeikei and Dilworth Schools and New Plymouth Boys' High School, 1st XV 1944-47. Played for the Training College team in Auckland before moving to the Waikato.

Toured Australia with the 1951 New Zealand team but did not make his international debut until the first test of the home series against the Wallabies in the next year. Reid was not recalled to the All Blacks until the third test against South Africa 1956 after captaining his province to victory over the Springboks in their first tour game.

He was appointed captain for the 1957 tour to Australia where he appeared in both tests. Retired from first-class rugby after one match for Waikato the following season but continued to play for the Kereone club until 1961.

A very small halfback at 5' 3" and under 9½ stone, 'Ponty' Reid was a fine tactical player possessing a good pass and a quick break around the scrum. He coached the Kereone club 1963,64 and was a Waikato selector 1966-69.

REID Hikatarewa Rockcliffe
b: 8.4.1958, Rotorua
Hooker

Hika Reid

Represented NZ: 1980,81,83,85,86; 38 matches – 7 tests, 32 points – 8 tries

First-class record: Bay of Plenty 1978-86 (Ngongotaha); North Island 1983,84; NZ Trials 1981-83,85; NZ Colts 1979; NZ Maoris 1982,83

Educated Ngongotaha Primary, Kaitao Intermediate and Western Heights High School, 1st XV 1973-77. Reid played for Bay of Plenty and North Island Under 16 in 1974 and made his first-class debut for Bay of Plenty in his first year of senior rugby. He toured with the national Colts team in 1979 and was a surprise choice for the All Black team to tour Australia in 1980. He was regarded as the find of the tour and played in the first two tests but a broken leg (while playing as a flanker) kept him out of the third. He beat Andy Dalton for the test place for the Welsh centenary test later that year, but lost out

to Dalton in all future tests for which they were both available. Reid went on the Cavaliers' tour of South Africa in 1986 and, with Dalton unavailable, regained a place in the All Blacks for the final two tests against Australia and the tour of France later that year. He lost his test place there, however, to Sean Fitzpatrick.

Reid, who began in rugby as a loose forward, was a lively, mobile player and was perhaps unfortunate that his career coincided with Dalton's.

His grandfather, J. Hikatarewa, played for NZ Maoris in 1913.

REID Keith Howard
b: 25.5.1904, Clareville *d:* 24.5.1972, Masterton
Hooker

Represented NZ: 1929; 5 matches – 2 tests, 3 points – 1 try

First-class record: Wairarapa 1920,21,23,25-35 (Carterton); Manawatu-Horowhenua 1925 (Palmerston North HSOB); North Island 1929,31; NZ Trials 1927,29,30; Wairarapa-Bush 1930

Wairarapa Primary Schools rep 1916. Reid played a total of 107 first-class matches including 91 for Wairarapa over 14 seasons. Toured Australia with the 1929 All Blacks, appearing in five games including the first and third tests. Weighing 13 stone and standing 5' 8" he played as a hooker in the two-fronted scrum.

Served as sole Wairarapa selector 1939-47,50-52 and on that union's management committee 1935-38, president 1950-59, elected a life member 1960.

REID Sana Torium
b: 22.9.1912, Tokomaru Bay
Lock and flanker

Represented NZ: 1935-37; 27 matches – 9 tests, 20 points – 6 tries, 1 conversion

First-class record: East Coast 1929,30 (Paikea), 1931,32 (Country), 1933 (Hauiti); Hawke's Bay 1934 (Whakaki), 1935-41,45-49 (MAC); North Island 1934,36,37,39; NZ Trials 1935,37,48; NZ Maoris 1931,36,49; Poverty Bay-East Coast-Bay of Plenty 1930; Hawke's Bay-Poverty Bay 1946

Educated Tokomaru Bay Native School and Tolaga Bay High School. Made his first-class debut for East Coast at the age of 16 and next year scored a try against the 1930 British tourists for Poverty Bay-East Coast-Bay of Plenty.

Reid moved to Hawke's Bay 1934 and played the first of his 81 games for that union in a career lasting until 1949. He toured Britain with the 1935-36 All Blacks, appearing in 19 matches including all four internationals and played throughout the home series v Australia 1936 and South Africa 1937.

A splendid lock, Tori Reid stood 6' 2" and weighed around 15 stone. His tally of 157 first-class games was a record for a New Zealander at the time. In his final season of representative rugby at the age of 37 he toured Australia with the NZ Maoris and appeared seven times for Hawke's Bay. Served as a Maori All Black selector 1952-54.

RESIDE Walter Brown
b: 6.10.1905, Masterton *d:* 3.5.1985, Masterton
Loose forward

Represented NZ: 1929; 6 matches – 1 test

First-class record: Wairarapa 1925-31,33 (Gladstone); NZ Trials 1929; NZ Maoris 1928,30; Wairarapa-Bush 1925,30

A tall (6' 2", 13st 12lb) loose forward who toured Australia with the 1929 All Blacks. 'Wattie' Reside played six of the 10 matches on tour including the first test.

RHIND Patrick Keith
b: 20.6.1915, Lyttelton *d:* 10.9.1996, Christchurch
Prop

Represented NZ: 1946; 2 matches – 2 tests

First-class record: Canterbury 1936-39,46,47 (Christchurch); Wellington 1947 (Wellington); South Island 1946; NZ Trials 1939,47; 2nd NZEF 1945,46; NZ Services 1945

Educated St Bede's College, 1st XV 1931. A big prop weighing 14st 11lb and standing just under six feet, Rhind was described as a tough and solid scrummager.

Played in the final All Black trials 1939 and must have been close to selection for the 1940 team scheduled to visit South Africa. Appeared for NZ Services in England before playing 22 games on tour with the 'Kiwis' army team, including those against England, Wales and France. On his return to New Zealand he played in the first post-war test series v Australia 1946.

Served as a selector for NZ Army teams 1949-53, NZ Services 1953 and Canterbury 1960-62.

RICHARDSON Johnstone
b: 2.4.1899, Dunedin *d:* 28.10.1994, Nowra, Australia
Loose forward

Represented NZ: 1921-25; 42 matches – 7 tests, 58 points – 18 tries, 2 conversions

First-class record: Otago 1920-22 (Alhambra); Southland 1923 (Waikiwi), 1925,26 (Pirates); South Island 1921,22,24,25; NZ Trials 1921,24

'Jock' Richardson

Educated Normal School (Dunedin). An outstanding loose forward during the early 1920s, 'Jock' Richardson weighed 14st 5lb and stood 6' 1". Made his international debut in the series against the 1921 Springboks, playing on the side row of the scrum.

Toured New South Wales 1922 and captained the All Blacks in the first two encounters with the visiting New South Wales team in the next season. Appointed vice-captain of the 1924-25 'Invincibles'. With the tour captain Cliff Porter out of contention for the internationals in Britain, Richardson led New Zealand against Ireland, Wales and England. He kept his place in the back row when Porter returned as wing forward and captain for the French international. His last All Black appearance was against New South Wales when the 'Invincibles' returned.

Served as accountant-secretary of the Southland RFU. Otago shot put champion 1921,22.

RICKIT Haydn
b: 19.2.1951, Taupo
Lock

Represented NZ: 1981; 2 matches – 2 tests

First-class record: Auckland 1972 (Eden); Queensland 1974; Waikato 1979-82 (Fraser Technical); NZ Trial 1981; NZ Maoris 1978,81,82

Educated Taupo-nui-a-tia College where he was in the 1st XV for four years. Rickit played briefly in Auckland Colts before going overseas,

'Hud' Rickit

playing for Queensland against the 1974 All Blacks and for Middlesex in 1975,76. He also played for Italy.

'Hud' Rickit's sole callup to the All Blacks was in 1981 when Andy Haden was forced to withdraw from the test team to play Scotland because of a suspension incurred for fighting in Auckland club play. Haden was eligible for the second test but Rickit was retained. Haden regained his place, and locked the scrum with Rickit, through injury to Graeme Higginson.

Rickit, despite his 2m being a decided advantage in lineouts, was not selected for New Zealand again.

RIDGE Matthew John
b: 27.8.1969, Rotorua
Fullback

Matthew Ridge

Represented NZ: 1989; 6 matches, 4 points – 1 try

First-class record: Auckland 1988-90 (Ponsonby); NZ Colts 1988,89; NZ Trial 1990

Educated at Mt Albert Grammar and Auckland Grammar, Ridge was a sporting prodigy who had already played age grade soccer for Auckland when he made a mark in rugby. He played rugby for Auckland age grade sides and was in the New Zealand Secondary Schools team in 1986, and played at first five-eighth for the New Zealand Colts.

Ridge was introduced at fullback for Auckland in the last game of the 1988 season when regular fullback Lindsay Harris was injured, and retained the spot for 1989, playing so effectively that he was included in the All Black team for the tour of Wales and Ireland. He played six matches on the tour and was being talked of as the ultimate successor to test fullback John Gallagher.

Within six months, however, both had joined league clubs, Gallagher in England and Ridge in Australia.

Ridge played for Manly and Auckland in the NSW competition and captained Auckland and the New Zealand team. He also fashioned a sideline career for himself as a television personality, most often in partnership with another All Black who had turned to league, Marc Ellis.

RIDLAND Alexander James
b: 3.3.1882, Invercargill *d:* 5.11.1918, France
Forward

Represented NZ: 1910; 6 matches – 3 tests

First-class record: Southland 1907-10,11-13 (Star); South Island 1909,10,13

A versatile forward who played in most scrum positions. Jim Ridland toured Australia with the 1910 New Zealand team, appearing in all three tests as a hooker. A blacksmith before serving with the NZ Rifle Brigade. Died during the last week of WWI from wounds received in action.

RIECHELMANN Charles Calvin
b: 26.4.1972, Nuku'alofa, Tonga
Lock and flanker

Represented NZ: 1997; 10 matches – 6 tests, 15 points – 3 tries

First-class record: Auckland 1994,95 (Grammar), 1997 (Grammar Carlton); Auckland Blues 1996,97; NZ Academy 1997; Barbarians 1997

Charles Riechelmann

Charles Riechelmann, who had been educated at Tonga High School, arrived in New Zealand when he was 13 and continued his education at Auckland Grammar. He first played rugby when he was 14 and his skills and his mobility, allied with his size (he was 108kg and 1.92m when he made his first-class debut), marked him out. He played for Auckland age grade teams and New Zealand Secondary Schools in 1990 and 1991.

After he broke into the Auckland team, he played at lock or flanker and though he missed most of 1996 because of injury, he continued to advance his claims in 1997.

A reserve for the domestic and tri nations tests of 1997, he played in four – all as replacements. On the tour of Britain and Ireland at the end of the year, he played in six matches, including two more tests as a replacement.

RIGHTON Leonard Stephen
b: 12.10.1898, Auckland *d:* 14.2.1972, Auckland
Lock and loose forward

Represented NZ: 1923,25; 9 matches, 9 points – 3 tries

First-class record: Auckland 1922-25,27,28 (Ponsonby); North Island 1923; Auckland-North Auckland 1923; NZ Trials 1924

Educated Vermont St Marist Brothers' School. A hard-working forward, standing 5' 10" and weighing 14 stone, Righton played for New Zealand in the first of the 1923 three-match series v New South Wales and then visited Australia with the 1925 All Blacks appearing in each game on tour. Secretary-treasurer of Ponsonby RFC.

RIKA Wiremu
See HEKE Wiremu Rika

ROBERTS Edward James
b: 10.5.1891, Wellington *d:* 27.2.1972, Wellington
Halfback

Represented NZ: 1913,14,20,21; 26 matches – 5 tests, 112 points – 14 tries, 35 conversions

The first father and son to represent New Zealand – Teddy (left) and Harry Roberts in 1946.

First-class record: Wellington 1910,11 (St James), 1912-14,19-21,23 (Athletic); North Island 1910,12-14,19,21; NZ Trials 1921

Educated Brooklyn School. A brilliant halfback who was particularly adept at blindside attacks and an accurate short-range goalkicker, Teddy Roberts stood 5' 6" and weighed 11st 4lb.

Toured North America with the 1913 All Blacks where his rugby was restricted by injury. The next season he appeared in all three tests in Australia. Captained Wellington during its 1919,20 tenure of the Ranfurly Shield although he competed for the halfback position with 'Ginger' Nicholls. Selected for the 1920 tour of Australia as a five-eighth and led the points-scorers with 46.

Nicholls was preferred by the New Zealand selectors for the first test against the 1921 Springboks but Roberts was brought back for the rest of the series and given the captaincy for the third test when George Aitken was dropped. He also played against New South Wales during this season.

Represented Wellington at cricket as a wicketkeeper in the 1910/11 season. His father, Harry, was a member of New Zealand's first rugby touring team 1884 while his brothers, Harry jnr (1909) and Len (1920) also played for Wellington.

ROBERTS Frederick
b: 7.4.1881, Wellington *d:* 21.7.1956, Wellington
Halfback

Represented NZ: 1905-08,10; 52 matches – 12 tests, 72 points – 19 tries, 4 conversions, 1 penalty goal, 1 dropped goal

First-class record: Wellington 1901-04,06-12 (Oriental); North Island 1904,05,07,08,11; South Island 1902; Wellington Province 1903

Educated Thorndon School, Wellington Schools rep 1895. Played soccer for two years before joining the Oriental club. Touring with the 1905-06 'Originals' as the only halfback selected, Roberts played 29 of the 32 games in Britain and appeared in all the internationals except the French game. His tour statistics were recorded as 5' 7" and 12st 4lb.

His subsequent career included three tests in Australia 1907, two in the 1908 home series against the Anglo-Welsh (an injury keeping him out of the second) and all three in Australia 1910. He captained the 1910 New Zealand team in Australia. Replaced Peter Harvey in the South Island team during the 1902 interisland game and two years later joined Duncan McGregor and Tom Cross as the first players to represent both islands.

Fred Roberts won wide acclaim for his halfback skills. The Welsh critic W.J.T. Collins wrote in *Rugby Recollections:* "Think of the powers which go to the making of the ideal half; Roberts had them. Great-hearted, class to his fingertips, he was one of the world's great players."

A 1949 article in the *NZ Sportsman* referred to him as "a pocket Hercules – he had a rugged physique, speed, an uncanny eye for an opening and a tremendous capacity for taking punishment."

Roberts played 58 matches for Wellington.

ROBERTS Henry
b: c 1862, Wellington *d:* 1.1.1949, Wellington
Halfback

Represented NZ: 1884; 7 matches, 8 points – 4 tries

First-class record: Wellington 1883,85 (Wellington), 1885,86,88,89 (Poneke); Canterbury 1887,88 (East Christchurch)

Harry Roberts had the distinction of scoring New Zealand's first try, against a Wellington XV for the 1884 team before touring Australia. Four years later he helped organise a team bearing his name from Wellington and Wairarapa representatives to play the 1888 British tourists when the Wellington RFU refused to field a side for a return game.

S.E. Sleigh, the 1884 team manager, described Roberts as "a very smart light man. The way he pounced around the scrummage onto the opposing halfbacks was worth seeing. Can play in any position."

He became the first New Zealand representative to have a son play for the country when Teddy Roberts was selected for the 1913 All Blacks. Two other sons, Harry jnr (1909) and Len (1920) also played for Wellington while a grandson, Bruce, played for a New Zealand XV 1944.

Roberts also represented Wellington at cricket on 12 occasions 1890-93, taking 13 wickets at an average of 13.15, with a best performance of 3-22. He scored 224 runs for Wellington, with a highest score of 42.

ROBERTS Richard William
b: 23.1.1889, Manaia *d:* 8.3.1973, Okaiawa
Centre threequarter

Represented NZ: 1913,14; 23 matches – 5 tests, 102 points – 22 tries, 15 conversions, 2 penalty goals

First-class record: Taranaki 1909-11 (Kaponga), 1912-14,20-22 (Okaiawa), 1915 (Hawera); North Island 1912-14; United Kingdom XV 1918,19; NZ Services 1919,20

Normally a centre but also appearing on occasion at second five-eighth, Roberts began his All Black career in the first test v Australia 1913 before touring North America and playing in the All-America international.

Captained the North Island the next year and led the New Zealand team in all three tests on the 1914 tour of Australia. He was described as "not big but strong, a remarkable natural footballer with excellent hands, much speed, a quick sidestep, a deceptive swerve, a fine eye for an opening, a neat way of running his wings into scoring positions, a stout defender and a good goalkicker."

Served with the New Zealand Rifle Brigade during WWI and played for the United Kingdom XV, New Zealand Services in the King's Cup competition and toured South Africa with the army team. On his return to New Zealand he captained Taranaki for three seasons including that province's scoreless draw with the 1921 Springboks.

ROBERTS William
b: 28.10.1871, Taita *d:* 25.8.1937, Wellington
Threequarter and second five-eighth

Represented NZ: 1896,97; 8 matches, 18 points – 6 tries

First-class record: Wellington 1889,90 (Melrose), 1892-94,96,97,99-1903 (Poneke), 1895 (Petone); North Island 1894,97

Educated Mt Cook School (Wellington). Made the first of his 47 appearances for Wellington, over a span of 15 seasons, as a 17-year-old. Played for New Zealand against Queensland 1896 and scored three tries for Wellington in a 49-7 win over the tourists.

A surprise omission from the 1897 team to tour Australia, 'Cocky' Roberts was sent as a reinforcement when Jimmy Duncan was injured in the first match. Roberts joined the team in time to appear in the last six matches and became the third highest tryscorer with a tally of six.

He was suspended for two years by the NZRFU following alleged misbehaviour after the post-tour match against Auckland.

ROBERTSON Bruce John
b: 9.4.1952, Hastings
Centre threequarter

Represented NZ: 1972-74,76-81; 102 matches – 34 tests, 142 points – 34 tries, 2 dropped goals

Bruce Robertson attacks against the NZRFU President's XV in 1973.

First-class record: Counties 1971-82 (Ardmore College), 78-80 (Ardmore); North Island 1971,72,74,75,77,80,81; NZ Trials 1972,74,76-81; Counties-Thames Valley 1977

Educated Mahora Primary, Heretaunga Intermediate, Hawke's Bay Schools rep 1965, and Hastings Boys' High School, 1st XV 1968,69. Robertson first played for the All Blacks on the 1972 internal tour, a year after his entry into first-class rugby. Later that season he appeared in the first and third tests against the Wallabies, missing the second because of injury.

Suffered a broken thumb against Cardiff on the 1972-73 British tour and missed 10 matches including the Welsh test but played in the other four internationals. In 1973 he was included in the internal tour but missed much of the season with injuries. Returned to the All Black test side for the internationals in Australia and Ireland 1974. A broken arm prevented his playing against Scotland 1975 but he appeared against Ireland the next year to score his first test try.

Robertson then played in all four tests in South Africa 1976, three against the 1977 Lions (missing the second because of concussion), the two in France later that year, all three against the 1978 Wallabies then three internationals in Britain, both tests against the 1979 French tourists and the sole international on a brief Australian tour. He was forced to withdraw from the tour to England/Scotland after being selected, due to a knee injury.

A surprise omission from the 1980 visit to Australia and Fiji, Robertson was called in as a reinforcement and joined the team in time to play the second and third tests. He made his 100th All Black appearance in the Welsh centenary test. Refusing to play against South Africa in 1981, he retired from test rugby after the two Scottish matches earlier that year.

Named as one of the *1976 DB Rugby Annual's* players of the year, Bruce Robertson was described as New Zealand's "most reliable and dangerous back revealing rare speed and thrust." Discussing the centres he had seen, Ian Kirkpatrick said that "Bruce Robertson has to be number one. He's so swift and consistent." Weighed 13½ stone and stood six feet. Although not a track athlete, he recorded 11.1 secs for 100 metres in the 1979 television *Superstars* series. His brother, Bill, represented Counties in the 1980s.

ROBERTSON Duncan John
b: 6.2.1947, Dunedin
First five-eighth and fullback

Represented NZ: 1974-77; 30 matches – 10 tests, 50 points – 11 tries, 2 dropped goals

First-class record: Otago 1966-71,73-75,77,78 (Zingari-Richmond); South Island 1975; NZ Trials 1973-77

Educated High St School (Dunedin) and King Edward Technical College. Played for Otago over six seasons at second five-eighth until adopting the first five-eighth position 1973. He made an immediate impression and played against the All Blacks for the President's and Invitation XVs that year.

Included in the New Zealand team to Australia 1974 and marked his test debut with a magnificent solo try on a saturated ground in the first test. His subsequent international career covered the remainder of that series, the 1974 test in Ireland, home internationals against

Duncan Robertson

Scotland and Ireland in the next two seasons and the 1976 tour of South Africa where he played the first and fourth tests at fullback and the third in his customary five-eighth position. Ended his All Black career with the first test against the 1977 Lions.

Duncan Robertson was a fine tactical player with the ability to get his backline going from any part of the field. He stood 1.78m and weighed 76kg. Bob Howitt in *Rugby News* acclaimed him after the Australian tour as "a huge success, an attacking genius, a good kicker, reads the game well."

Coached and served on the committee of the Zingari-Richmond club and also coached the Sassenachs.

ROBERTSON George Scott
b: c 1859 *d:* 26.4.1920, Hokitika
Forward

Represented NZ: 1884; 8 matches, 8 points – 4 tries

First-class record: Otago 1880,82,83 (Dunedin)

Played for the Blackheath club in England during the 1878,79 season. Replaced D.G. Cooper who was unable to travel to Australia with the 1884 New Zealand team. Robertson appeared in the three encounters with New South Wales.

Normally a forward, he played on the wing against Northern New South Wales. Described by the team manager Sam Sleigh as "a first-rate dribbler. His coolness and thorough knowledge of the rules won many a point. Unsurpassed at long chucking."

ROBILLIARD Alan Charles Compton
b: 20.12.1903, Ashburton *d:* 23.4.1990, Little Rakaia
Wing threequarter

Represented NZ: 1924-26,28; 27 matches – 4

tests, 75 points – 25 tries

First-class record: Canterbury 1923-27 (Christchurch); South Island 1924-27; NZ Trials 1924,27; Canterbury-South Canterbury 1925

Educated Ashburton Borough Primary and Ashburton High School. Selected for the 1924-25 touring team as a 20-year-old winger standing 5' 10" and weighing 11st 8lb. He did not accompany the team on the preliminary visit to Australia and then broke a bone in his foot against Somerset and played only two further games on the British tour and two in Canada.

Robilliard appeared as a replacement for 'Snowy' Svenson during the 1925 match against New South Wales. Toured Australia the next season and South Africa 1928 where he played in all four tests and was second highest try scorer with six.

His father, Fred, represented Canterbury

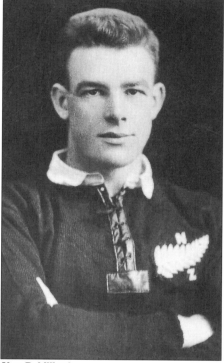

Alan Robilliard

1898; his brother, Noel, also played for that union, another brother, Guy, represented Nelson while a third brother, Jack, represented Canterbury and Otago and was an All Black trialist 1927.

ROBINS Bryce Graeme
b: 12.12.1958, Eltham
Wing

Represented NZ: 1985; 4 matches, 16 points – 4 tries

First-class record: Taranaki 1980 (Stratford), 1981-92 (Eltham); NZ Trials 1985

Educated Central and Vogeltown Primary Highlands Intermediate and New Plymouth, Boys' High School. Robins played rugby for Taranaki age teams and colts before joining the national side in 1980.

A strong, hard-running wing, he seemed destined to remain a provincial player until

1985 when he impressed at his only All Black trial and was a surprise choice for the All Black team to tour South Africa. He went on the replacement tour of Argentina, but never threatened a test place. Robins also went to South Africa in 1986 with the unofficial Cavaliers side.

Robins played two years of rugby league, representing Taranaki.

ROBINSON Alastair Garth
b: 5.11.1956, Waipukurau
Lock

Represented NZ: 1983; 4 matches

First-class record: North Auckland 1981-85,87 (Kerikeri); NZ Trials 1983,84,87

Educated at Christ's College, Christchurch, where he played three matches for the 1st XV, Robinson began his senior rugby in Christchurch with first Lincoln and then Christchurch, playing for the Canterbury Under 20 representatives.

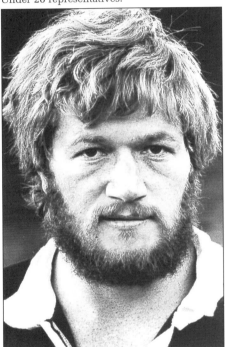

Alastair Robinson

With the three All Black test locks of 1983 unavailable, Robinson was included in the team at the end of that year to tour England and Scotland, but was not included in either test team.

ROBINSON Charles Edward
b: 5.4.1927, Bluff *d:* 4.3.1983, Bluff
Flanker

Represented NZ: 1951,52; 11 matches – 5 tests, 3 points – 1 try

First-class record: Southland 1948-55 (Bluff); South Island 1952,53; NZ Trials 1951,53

A vigorous flank forward who stood six feet and weighed about 13½ stone, Eddie Robinson toured Australia with the 1951 All Blacks, playing in all three internationals along with his fellow Southland loose forward Bill McCaw.

The following season he appeared in both internationals against the Wallabies. In the second test he spent all but 10 minutes of the game on the wing after Ray Bell retired hurt. He acquitted himself well in this position, scoring a try and making the opening for another. Surprisingly, he was not selected to play for New Zealand again.

Eddie Robinson coached teams for the Bluff club and served as delegate to the Southland RFU. Also represented his province at rowing 1945-48.

ROBINSON John Topi
b: c 1906 *d:* 29.3.1968, Wairoa
Loose forward

Represented NZ: 1928; 3 matches, 9 points – 3 tries

First-class record: Canterbury 1927-30 (Te Kotahitanga); South Island 1928; NZ Maoris 1929

'Toby' Robinson played in the second and third matches of the 1928 home series against New South Wales and in the intervening game v West Coast-Buller, scoring two tries in the latter and one against the tourists.

His brother, Tom, represented Canterbury 1928-31 and toured Europe with the 1926,27 New Zealand Maoris.

ROBINSON Mark Darren
b: 21.8.1975, Palmerston North
Halfback

Represented NZ: 1997; 3 matches, 5 points – 1 try

First-class record: North Harbour 1996,97 (East Coast Bays); Waikato Chiefs 1997; Northland Vikings 1996; Barbarians 1996; NZ Academy 1997; NZ Colts White 1995; NZ Colts 1995,96

Educated at Whangarei Boys' High School, where he played in the first XV, Robinson played at first five-eighth for Northland age grade teams before settling at halfback. He moved to North Harbour in 1994 and played for the Harbour Colts.

He gained regular selection for the Harbour senior team in 1996 and made such an impression that he was chosen for the Barbarians' two-match visit to Britain at the end of the year.

He was chosen in the enlarged All Black squad for the tour of Britain and Ireland in 1997, and played in three matches.

Robinson's strength and speed are regarded as his fortes.

His father, Lindsay, played for Horowhenua from 1974 to 1981 and uncles Warren and Richard also played for Horowhenua, Richard also playing for Hawke's Bay.

Mark Robinson's grandfather, Ray Robinson, played for Horowhenua 1946-49 as did his great-grandfather, R.L. Robinson, in 1922.

ROLLERSON Douglas Leslie
b: 14.5.1953, Papakura
Five-eighth and fullback

Represented NZ: 1976,80; 24 matches – 8 tests, 110 points – 7 tries, 14 conversions, 13 penalty goals, 5 dropped goals

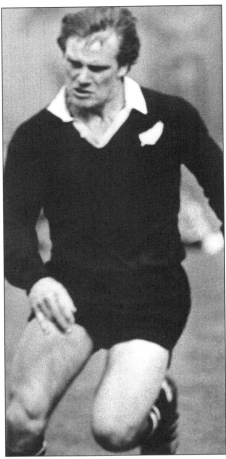

Doug Rollerson

First-class record: Manawatu 1972-77,80,81 (University); NZ Trials 1975-77; NZ Juniors 1974-76; NZ Universities 1973,74,76,77; Manawatu-Horowhenua 1977; Middlesex 1979

Educated Cosgrove Primary and Papakura Intermediate School and Wesley College. Represented Manawatu in his first year out of school. Toured Argentina with the 1976 All Blacks, playing in both games against the Pumas as a five-eighth and centre. During the 1979-80 English season Rollerson represented Middlesex from the London New Zealand club. Named as a reserve for the New Zealand XV which met Fiji at Auckland 1980 and then selected for the tour of Wales where he played at fullback in the centenary test. Rollerson was chosen as a first five for tests against Scotland, South Africa, Romania and France in 1981.

One of the *DB Rugby Annual's* five players of the year 1980, Rollerson was described as "by far the most consistently successful goalkicker in the country. He amassed 132 points in first-class matches, this asset being one the All Black selectors could not ignore." Weighed 81kg and stood 1.75m. Massey University's club captain 1975 and committee member 1974-77. A Counties School representative in tennis, cricket and athletics. Rollerson played rugby league in Sydney 1982,83.

Rollerson was appointed chief executive of the North Harbour Rugby Union late in 1997.

ROPER Roy Alfred
b: 11.8.1923, Owhango
Threequarter

Represented NZ: 1949,50; 5 matches – 5 tests, 9 points – 3 tries

First-class record: Taranaki 1944 (Tukapa), 1946,48-50 (New Plymouth HSOB); North Island 1949; NZ Services 1945; Taranaki-King Country 1946; NZ Trials 1950

Educated New Plymouth Boys' High School, 1st XV 1940,41. Made his first-class debut in service matches during WWII, once scoring five tries for the 4th Division v 1st Division. Played six games for New Zealand Services in England and scored eight tries.

Injuries hampered his career after the war but he won a place as a wing in the New Zealand team for the second test against Australia 1949. Roper scored a try in his maiden international and played much of the game at fullback after Jack Kelly retired injured. Appeared throughout the series against the 1950 Lions at centre and scored tries in the first two tests.

A speedy, clever and elusive threequarter, Roy Roper weighed 11st 4lb and stood 5' 8" during his All Black career. He was treasurer of the Taranaki RFU 1952-71. His province's sprint and long and triple jump champion, he represented West Coast North Island at national athletic championships. His son, Guy, played rugby for Manawatu and New Zealand Universities 1978.

ROSS John Charles
b: 24.4.1949, Ashburton
Lock

Represented NZ: 1981; 5 matches

First-class record: Mid Canterbury 1970,73-79,81-86 (Ashburton HSOB); Canterbury 1980 (Culverden); South Island 1981,82

Educated Lagmhor and Ashburton Borough Primary and Timaru Boys' High School, Jock Ross had given years of service to Mid Canterbury (and Canterbury for 16 games in 1980) when chosen for the All Blacks who toured Romania and France in 1981. Ross went on the tour as the third-string lock to Andy Haden and Gary Whetton and thus never played

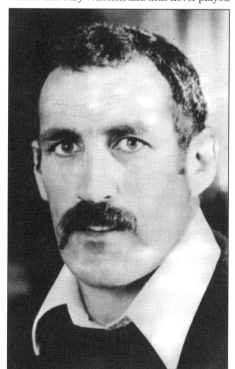

Jock Ross

any of the three tests, but he impressed with his lineout skills. At 2.03m he was one of the tallest men to represent New Zealand.

Ross continued to win ball for Mid Canterbury for another five years before he retired.

A cousin, Bruce Robertson, played for New Zealand Colts 1978 and Southland 1979,81-83.

ROWLANDS Gregory David
b: 10.12.1947, Rotorua
Fullback

Represented NZ: 1976; 4 matches, 44 points – 10 conversions, 8 penalty goals

First-class record: Bay of Plenty 1969,70,72,73 (Cadet OB), 1971 (St Michaels OB), 1974 (Otumoetai Cadet OB), 1975-82 (Otumoetai Cadets); North Island 1976; NZ Trials 1970,71,74,75-77

Educated St Joseph's and Greerton Primary, Tauranga Intermediate and Tauranga Boys' College, 1st XV 1965. Played his early rugby for Bay of Plenty as a five-eighth, switching to fullback in the mid-1970s.

Greg Rowlands

Rowlands was asked to stand by for the All Blacks when Joe Karam was in doubt for the test v Scotland 1975. He toured Argentina with the New Zealand team next year and played in both matches against the Pumas; second highest pointscorer with 44 from four appearances.

A fine running fullback and a consistent goalkicker, Rowlands stood 1.70m and weighed 74kg at the time of his selection. He scored over 100 points a season on five occasions and played a record 161 matches for Bay of Plenty, scoring 1008 points. Captained Bay of Plenty 1977.

Served on committees of the Cadets OB club 1967,68 and Otumoetai Cadets since 1977. His father, E.H. Rowlands, represented King Country 1945.

ROWLEY Harrison Cotton Banks
b: 15.6.1924, Cromwell *d:* 16.12.1956, Waimate
Number eight

Represented NZ: 1949; 1 match – 1 test

First-class record: Bush 1947 (Mangatainoka); Wanganui 1948-50 (Hunterville); Thames Valley 1951 (Netherton); North Auckland 1952,53 (Kaitaia Pirates); North Island 1949; NZ Trials 1950; Taranaki-Wanganui 1948

Educated Southland Boys' High School, 1st XV 1940,41. A tall and fast back-row forward who weighed 14st 1lb and stood 6' 1", Rowley played his sole match for the All Blacks in the second test v Australia 1949. Owing to the retirement of fullback Jack Kelly after 27 minutes he was required to play the rest of the match on the wing in a team reshuffle.

RUSH Eric James
b: 11.2.1965, Auckland
Wing

Represented NZ: 1992,93,95,96; 29 matches – 9 tests, 90 points – 18 tries

First-class record: Auckland 1986 (East Tamaki), 1987-90 (Otahuhu); North Harbour 1991-97 (Takapuna); Auckland B 1990; Northern Zone Maoris 1987-90,92-94; NZ Maoris 1987,88,90,92-94,96,97; NZ Trials 1992-94; North Island 1995; New Zealand XV 1992-94; Waikato Chiefs 1996,97; New Zealand A 1997; North Otago Invitation XV 1996; Barbarians 1996

Eric Rush began his rugby life as a south Auckland flanker and after making his Auckland debut in 1986, played only fleetingly and was relegated to Auckland B, which played two first-class games in 1990. He was already a member of the New Zealand sevens team (and had been since 1988), his speed and ball skills equipping him ideally for sevens.

His move to North Harbour in 1991 brought a change in fortunes. He played for North Harbour the first year as a flanker but when Harbour's coach, Peter Thorburn, became a national selector in 1992, Rush not only found himself to be an All Black, but also a wing.

He played in the All Black trial in 1992 as a wing but the transformation occurred after he was chosen for the tour of Australia and South Africa, on which he played in six matches – all as a wing. He continued as a wing under new coach Brad Meurant at North Harbour.

Rush toured England and Scotland in 1993 and played in six matches, was not required in 1994, but was chosen for the World Cup in 1995 and played his first two tests, the first as a replacement against Wales and the second against Japan. Injuries to other players led to him playing the three tests on the tour of Italy and France at the end of the year.

He retained his All Black position under new coach John Hart in 1996 and played in four tests, three of them as replacements and in the second against Scotland when Jonah Lomu was injured. Rush also toured South Africa in 1996, playing in four of the midweek matches.

Sevens remained a large part of Rush's life and he played in every Hong Kong tournament from 1988 to 1996, plus the World Cups in 1993 and 1997, was the New Zealand captain, and when the New Zealand union in 1997 decided to separately contract sevens players, Rush was among the first signed.

Eric Rush . . . ideally equipped for the sevens game.

RYAN Edmond

b: 17.2.1891, Petone *d:* 29.8.1965,
Wainuiomata
Centre threequarter

Represented NZ: 1921; 1 match

First-class record: Wellington 1912-
15,20,21,23 (Petone); NZ Services 1919,20; NZ
Division 1917

Eddie Ryan had 43 games for Wellington in a
career interrupted by WWI. While serving with
the New Zealand Field Artillery he played for
the New Zealand Division v France 1917 then
represented New Zealand Services in the King's
Cup competition and toured South Africa with
the army team.
 His sole match for New Zealand was at centre
against New South Wales at Christchurch 1921.
His brother, Jim, represented New Zealand
1910-14 and captained New Zealand Services in
the King's Cup. Three other brothers, Joe,
Michael and Bill, also played for Wellington.
Seven Ryan brothers appeared for the Petone
senior team.

RYAN James

b: 8.2.1887, Masterton *d:* 17.7.1957, Feilding
Utility back

Represented NZ: 1910,14; 15 matches – 4
tests, 20 points – 6 tries, 1 conversion

First-class record: Wellington 1905-15,20
(Petone); Manawatu 1920 (Feilding Technical
College OB); North Island 1914; NZ Services
1919; Wellington Province 1907

Represented Wellington for 11 consecutive
years and appeared again after WWI. Named in
the 1910 New Zealand team to Australia as a
threequarter, Ryan played at fullback in the
second test. Four years later he returned to his
normal five-eighth position for the three tests in
Australia.

Leicester Rutledge

He also played for the British Barbarians in
1990, 1991 and 1996.

RUSHBROOK Charles Archibald

b: 6.1.1907, Wellington *d:* 31.7.1987, Waikanae
Wing threequarter

Represented NZ: 1928; 10 matches, 53 points
– 17 tries, 1 conversion

First-class record: Wellington 1926,27,29,30
(Wellington College OB); NZ Trials 1927,29

Educated Terrace School and Wellington
College, 1st XV 1923,24. Leading try scorer on
the 1928 South African tour with 10 from nine
appearances. Playing against Victoria in
Australia on the way home, Rushbrook
recorded a further seven tries and a conversion
when the All Blacks won 58-9.
 Served on the Wellington College OB club
committee 1931,32. A good track sprinter, he
won his college's Senior Athletic Cup 1924 and
represented Wellington at national
championships 1924,25. His father, C.W.
Rushbrook, played rugby for that province
1899-1901.

RUTLEDGE Leicester Malcolm

b: 12.4.1952, Christchurch
Flanker

Represented NZ: 1978-80; 31 matches – 13
tests, 28 points – 7 tries

First-class record: Southland 1972-83 (Wrights
Bush); South Island 1976,78-80,82; NZ Trials
1977-80; NZ Colts 1973

Educated Woolston Primary and Riccarton High
School. Played rugby league as a youth.
Following an impressive display for his
province when the 1978 Wallabies were beaten,
Rutledge appeared in all three tests against the
visitors.
 Toured Britain with the All Blacks at the end
of that year and played in all four inter-
nationals. In 1979 he was selected for the two
tests v France and the international in
Australia. A surprise omission from the 1979
team which visited England and Scotland, he
returned to the test side for the 1980 series in
Australia.
 A very fit, energetic and constructive
flanker, Leicester Rutledge stood 1.85m and
weighed 91kg.

Ryan captained the New Zealand Services team which won the King's Cup in a tournament contested by South African, Australian, Canadian and New Zealand soldiers awaiting embarkation from England after the Armistice, together with the RAF and a 'Mother Country' selection. He toured South Africa 1919 with the New Zealand Army side led by Charlie Brown.

Seven Ryan brothers played for the Petone club senior team: Eddie, Joe, Michael and Bill joined Jim Ryan as Wellington representatives while Eddie had one game for the All Blacks 1921.

RYAN Patrick John
b: 20.4.1950, Pahiatua *d:* 5.3.1985, Taupo
Loose forward

Represented NZ: 1976; 5 matches, 4 points – 1 try

First-class record: Bush 1969 (Pahiatua); Wairarapa-Bush 1971-74 (Pahiatua); Hawke's Bay 1975-78 (Taupo); NZ Trials 1975,77; NZ Juniors 1972,73

Educated St Patrick's College (Silverstream). Joined the 1972 New Zealand Juniors in Australia as a replacement for the injured Ken Stewart and was a member of the Juniors team which beat the All Blacks next year. Toured Argentina 1976 playing in five of the nine matches.

Pat Ryan

At 94.5kg and 1.88m Ryan was described by the *1977 DB Rugby Annual* as "never far from the ball, extremely fit, a grand forward with the ball in hand, a fine cover defender and tackler." His father, Bill, represented Bush 1948-52.

RYAN Thomas
b: 2.12.1863, Auckland *d:* 22.2.1927, Auckland
Threequarter

Represented NZ: 1884; 9 matches, 35 points – 1 try, 7 conversions, 3 dropped goals

First-class record: Auckland 1880,82,83,86,88 (Grafton)

Educated Church of England Grammar School, Parnell. 'Darby' Ryan kicked the first conversion

and dropped goal for New Zealand, achieving this distinction against a Wellington XV before making the 1884 tour of Australia.

The team manager, Samuel Sleigh, described him as "a splendid threequarter back. His grand drop kicking fairly astonished the spectators. He could take his kick with either foot, in any place or position no matter how pressed by foes. Was supposed to be slow on his pins but the way he careered along the Australian turf gave one a decidedly contrary opinion."

Ryan studied art in Paris in the 1890s and became one of New Zealand's leading artists of his day. One of his paintings is in the Auckland City Art Gallery.

SADLER Bernard Sydney
b: 28.7.1914, Wellington
Halfback

Represented NZ: 1935,36; 19 matches – 5 tests, 12 points – 4 tries

First-class record: Wellington 1934,36,37 (Wellington College OB); NZ Trials 1935

Educated Berhampore School and Wellington College, 1st XV 1930-32. Despite competition from All Black Frank Kilby and future All Black Eric Tindill, 'Joey' Sadler managed to share the halfback position for Wellington in the 1934 season.

On the 1935-36 British tour he played in 15 matches including the Scottish, Irish and Welsh internationals before losing his place to Merv Corner for the English match. Appeared in both tests against the 1936 Wallabies. A knee injury in a 1937 club game ended his rugby career.

Tindill wrote of his play on the British tour: "Sadler comes back a great player. Ideally built for his position, he gave wonderful service from the base of the scrum, his passes being quick and accurately directed and his defensive work was beyond reproach. He possessed a very effective body wriggle which frequently enabled him to break away from the attentions of opposing forwards after they had taken hold of him. We certainly saw no halfback anywhere on our tour who even approached his class."

Sadler's statistics were given as 5' 5" and almost 10 stone. He coached grade teams for the Wellington College OB club and in Marlborough after his retirement.

SALMON James Lionel Broome
b: 16.10.1959, Hong Kong
Centre threequarter

Represented NZ: 1980,81; 7 matches – 3 tests, 8 points – 2 tries

First-class record: Wellington 1978-82 (Athletic), 1983 (Western Suburbs); NZ Juniors 1980; NZ Trials 1981,82; England 1985,86

Educated Oratory Prep School and Wellington College (Berkshire, England). Played for Kent Colts from the Blackheath club before moving to New Zealand.

A strongly built centre who weighed 83kg and stood 1.83m, Jamie Salmon was a thrustful runner who set his wings up well. After making an internal tour with the New Zealand Colts 1980 he played for a New Zealand XV against Fiji at Auckland and toured Romania and France in 1981, playing in each of the three tests.

Salmon returned to his native England in

Jamie Salmon

1984 and in 1985 he became the first to play tests for both New Zealand and England when he was chosen for the tour of New Zealand, playing in both internationals.

SAPSFORD Herbert Paul
b: 8.9.1949, Invercargill
Prop

Represented NZ: 1976; 7 matches, 8 points – 2 tries

First-class record: Otago 1973-76 (University), 1979,82 (Taieri); South Island 1974,76; NZ Trials 1974-76; NZ Universities 1973-76; Middlesex 1978

Educated James Hargest High School, Invercargill. A powerful prop who weighed 100kg and stood 1.83m, Paul Sapsford captained New Zealand Universities teams 1975,76. Toured Argentina with the 1976 All Blacks. Played in seven of the nine games including both matches against Argentina.

After this tour, he went to the United Kingdom where he played for the Harlequins and London New Zealand clubs and had three

Paul Sapsford

matches for Middlesex 1978. Returned to New Zealand and captained Otago 1979. His father, Don, represented Otago 1946.

SAVAGE Laurence Theodore
b: 17.2.1928, Nelson
Halfback

Represented NZ: 1949; 12 matches – 3 tests, 3 points – 1 try

First-class record: Canterbury 1947,48,50 (University); Wellington 1952,53 (University); Bush 1955,56 (Mangatainoka); South Island 1948,50; NZ Trials 1948,50; NZ Universities 1948,50,53; Bush-Wairarapa 1955

Educated Nelson Central Primary School and Nelson College, 1st XV 1944,45. A lively halfback who stood 5' 6" and weighed 10¹/₂ stone.
Toured South Africa 1949 and played in the first two tests, was replaced by the five-eighth Neville Black for the third but won back his place in the final match of the series. Served as a New Zealand Universities selector 1965-77.

SAXTON Charles Kesteven
b: 23.5.1913, Kurow
Halfback

Represented NZ: 1938; 7 matches – 3 tests, 12 points – 4 tries

First-class record: Otago 1935,36 (Pirates); South Canterbury 1937,38 (Timaru HSOB); Southland 1939 (Pirates); Canterbury 1940 (Army); South Island 1938,39; NZ Trials 1937; 2nd NZEF 1945,46; Swansea 1945

Educated Cheviot and Arthur Street Primary Schools and Otago Boys' High School, 1st XV 1931,32. A fine halfback renowned for his fast, long and accurate dive pass, Saxton was considered unlucky by some critics not to play for New Zealand against the 1937 Springboks. He toured Australia after a fine display in the 1938 interisland game and appeared in all three tests. His tour statistics were given as 10¹/₂ stone and 5' 5".

After distinguished service in WWII, rising to the rank of major with the 19th Armoured Regiment, Charlie Saxton captained the 2nd NZEF team – the 'Kiwis' – on their highly successful tour of Britain and Europe.

Charlie Saxton

Saxton returned to become an Otago selector 1948-57 with that province holding the Ranfurly Shield 1948-50. Manager New Zealand team in British Isles and France 1967. He also served on the NZRFU council 1956-71, president 1974 and elected a life member 1976. Author of *The ABC of Rugby* (NZRFU, 1960).

Mark Sayers

SAYERS Mark
b: 1.5.1947, Wellington
Second five-eighth

Represented NZ: 1972,73; 15 matches, 16 points – 4 tries

First-class record: Wellington 1967-69,71,72,74-76 (University), 1973 (Wellington College OB); North Island 1968; NZ Trials 1972-74; NZ Universities 1968

Educated Wellington College. A midfield back standing six feet and weighing 12¹/₂ stone, Sayers appeared in 15 of the 32 matches for the 1972-73 All Blacks in the British Isles and France.
He was a fine all-round player with a good sidestep. Continued to play well for his province before moving to South Africa where he played for Witwatersrand University 1978.

SCHULER Kevin James
b: 11.3.1967, Te Aroha
Flanker

Represented NZ: 1989,90,92,95; 13 matches – 4 tests, 8 points – 2 tries

First-class record: Manawatu 1987-90 (University); North Harbour 1991,92,95 (Silverdale); NZ Trials 1988-90,95; NZ Colts 1987; NZ Divisional XV 1990; NZ Development XV 1990; North Island Universities 1986,88; NZ Universities 1988,89; Central Zone 1988,89; Crusaders XV 1989

Kevin Schuler played age grade and secondary schools rugby for Thames Valley before moving to Palmerston North to attend Massey University. He played for Manawatu Colts and went on as a replacement for North Island Universities in 1986 and made his debut for Manawatu the following year. He was also a central figure in the New Zealand Colts' win over Australia in 1987.
Schuler was called into the All Blacks in Wales and Ireland in 1989 after Paul Henderson was injured and he played in five matches. He was a reserve for the domestic tests the following year and went on in the second against Australia in Auckland. He was surprisingly left out of the All Black team that toured France that year.
Schuler returned to the All Blacks for the 1992 tour of Australia and South Africa and played in the second test when Mike Brewer was injured and Michael Jones unavailable because it was a Sunday match.
He took up a contract in Japan and was lost to New Zealand rugby in 1993 and 1994, but was surprisingly recalled for the World Cup squad that year. He went on as a replacement against Ireland and played the full match against Japan. He then returned to Japan.

SCHUSTER Nesetorio Johnny
b: 17.1.1964, Apia, Western Samoa
Second five-eighth

Represented NZ: 1987-89; 26 matches – 10 tests, 32 points – 8 tries

First-class record: Wellington 1986-90 (Marist-St Pat's); NZ Colts 1985; NZ Trials 1987,89,90; North Island 1986; Central Zone 1987-89; Barbarians 1987

John Schuster

A gifted attacking player and a strong defender, John Schuster appeared to be All Black material from an early age.

He was among the favourites for the All Black squad for the first World Cup but a hamstring injury kept him out of some games and affected him in others and despite playing in the final trial, he was left out. He first gained national selection later in the year when he was chosen for the side that toured Japan.

He made his test debut the following year in Australia when he took over at second five-eighth from Warwick Taylor, who was injured, and he retained his test place throughout 1989, playing in all matches.

He played early-season matches for Wellington in 1990 and in an All Black trial before he moved to Australia to take up a league contract with Newcastle, later playing in Britain.

Schuster also played for a World XV that played in Sydney to mark Australia's bicentenary in 1988.

SCOTT Robert William Henry
b: 6.2.1921, Wellington
Fullback

Represented NZ: 1946,47,49,50,53,54; 52 matches − 17 tests, 242 points − 1 try, 58 conversions, 33 penalty goals, 8 dropped goals

First-class record: Auckland 1946-48,50-53 (Ponsonby); North Island 1946,48,51,53; NZ Trials 1947,48,50,53; 2nd NZEF 1945,46; NZ Services (UK) 1945

Educated Kapuni, Tangarakau and Ponsonby Schools. Played rugby league for the Ponsonby club reaching senior grade 1939. Enlisted in the army 1942 and played rugby union for the Motor Transport Pool side which won the Gallaher Shield in that year. While serving in the Middle East he was a member of the Divisional Ammunition Coy which reached the final of the Freyberg Cup 1944.

A prominent member of the 'Kiwis' army team, Scott played in 19 of 38 matches including those against Wales and France and was second highest pointscorer to Herb Cook with a total of 129.

Bob Scott made his debut for New Zealand in the 1946 series against Australia, kicking five conversions in the first test and 11 points in the second. In Australia the next year he led the points-scorers with 72 in six matches, including 15 in the second test. Again headed the points-scoring table for the 1949 All Blacks in South Africa with 60 from 17 appearances including all four tests. Played throughout the series against the 1950 Lions but was not available for the 1951 tour of Australia and announced his retirement from first-class rugby at the end of that season.

Persuaded to appear in one game for Auckland 1952 and to make himself available for the 1953-54 British tour. In his 22 matches Scott compiled 78 points, and third best tally behind Ron Jarden and Jack Kelly.

Played for the Petone club in Wellington 1954 and appeared with various invitation teams over the next few seasons. His good form for the Barbarians 1956 led some critics to argue for his inclusion in the series against the Springboks.

In his book, *Rugby in my Time*, Winston McCarthy wrote: "For me there will never be anyone as great as Scott. I have seen him in all his big football and the man amazed me even in his final moments. His positional play was of course something out of the box . . . he was a genius and what other fullbacks have had to do, Scott didn't, because he had the greatest balance, the greatest poise, that I've ever seen in any man."

The South African Hennie Muller recalled in his autobiography: "Scott always appeared to have plenty of time, even under pressure. He loved coming into the line and his speed and elusiveness were such that he was always a danger. Altogether, the greatest footballer I've ever played against in any position."

During his All Black career Scott stood 5' 10" and weighed between $12\frac{1}{2}$ and 13 stone. He served on the Petone club committee 1966-70. Co-author with Terry McLean of *The Bob Scott Story* (A.H. and A.W. Reed, 1956) and featured in an NZRFU coaching film in the 1970s.

SCOTT Stephen John
b: 11.9.1955, Christchurch *d:* 16.6.1994, Balclutha
Halfback

Represented NZ: 1980; 4 matches, 20 points − 5 tries

First-class record: Canterbury 1976,78-82 (Shirley); NZ Colts 1975,76; South Island 1981; NZ Trial 1981

Bob Scott at practice. Fred Allen is the ball-holder.

Educated Belfast Primary and Shirley Boys' High School. Played for the Belfast club before joining Shirley. First represented Canterbury when Lyn Davis retired injured against Ireland in 1976.

A reserve for the 1980 trial match and a surprise choice to replace the injured Mark Donaldson on the Australian tour of that year, he scored four tries – a record for an All Black halfback – in his debut v Queensland Country.

Scott was a strong-running halfback who sent out a long and accurate pass, was a sound kicker and a sturdy defender. Stood 1.70m and weighed about 71kg.

SCOWN Alistair Ian

b: 21.10.1948, Patea
Loose forward

Represented NZ: 1972,73; 17 matches – 5 tests, 8 points – 2 tries

First-class record: Taranaki 1968-76 (Patea); North Island 1970,72; NZ Trials 1971,72; NZ Juniors 1970

Educated Manutahi Primary and Patea District High School, 1st XV 1964-66. Appeared as a wing in five games for Taranaki 1968,69 before switching to flanker. A fast loose forward, weighing 15 stone and standing 6' 1", Scown also had two appearances as a threequarter for his province in the 1975 season.

Alistair Scown

Made his All Black debut in the 1972 series against the Wallabies playing in all three matches and toured Britain and France later that year. His 14 matches included the Scottish international and an appearance in the Welsh game as a replacement for Alex Wyllie.

Invited to play in the Scottish RFU centenary matches 1973. Served on the Patea club committee.

SCRIMSHAW George

b: 1.12.1902, Islington *d:* 13.7.1971, Christchurch
Wing forward

George Scrimshaw

Represented NZ: 1928; 11 matches – 1 test, 15 points – 5 tries

First-class record: Canterbury 1925-27,29,30 (Christchurch); South Island 1927,29; NZ Trials 1927,30; Canterbury-South Canterbury 1925

Educated Waitaki Boys' High School, 1st XV 1919,20. Played for the Cust club in North Canterbury 1921-24. A surprise selection for the 1928 New Zealand team to tour South Africa ahead of Cliff Porter, Scrimshaw played in 11 of the 22 matches including the first test at Durban. Stood six feet and weighed 12st 3lb.

SEEAR Gary Alan

b: 19.2.1952, Dunedin
Number eight

Represented NZ: 1976-79; 34 matches – 12 tests, 42 points – 8 tries, 2 conversions, 2 penalty goals

First-class record: Otago 1971-75,77-79,81,82 (Southern); South Island 1973-75,77,79,81; NZ Trials 1972-79,81; NZ Colts Under 21 1972; NZ Juniors 1973,74

Educated Anderson's Bay Primary and Bayfield High Schools. Made his debut for Otago as a 19-year-old lock. Captained the 1974 New Zealand Juniors on an internal tour.

Seear toured South Africa with the 1976 All Blacks but did not win a test place until the following year when he played at number eight in the two tests in France, kicking a 45m penalty goal in the second. Appeared in home series against the 1978 Wallabies and the 1979 French tourists, all four internationals in Britain and the sole test in Australia 1979.

Gary Seear

At 1.96m and weighing 100kg, Gary Seear was a good lineout jumper and effective in the loose. Played in Italy 1979 for the Fracasso San Dona club.

SEELING Charles Edward

b: 14.5.1883, Wanganui *d:* 29.5.1956, Stalybridge, England
Loose forward

Represented NZ: 1904-08; 39 matches – 11 tests, 33 points – 11 tries

First-class record: Wanganui 1903 (Pirates); Auckland 1904,06-09 (City); North Island 1906,08

Educated Wanganui District High School. Played his early rugby in the backline but after transferring to the side of the scrum, 'Bronco' Seeling developed into one of New Zealand's greatest forwards. Noted for his speed off the mark and deadly tackling, he stood six feet and weighed 13½ stone.

Seeling first played for New Zealand v Great Britain at Wellington 1904. He earned a tremendous reputation on tour with the 1905-06 'Originals', appearing in all the internationals among his 25 games. He remained in England

for some time to keep the invalided 'Massa' Johnston company. His All Black career continued with two tests in Australia 1907 and all three against the 1908 Anglo-Welsh team.

In his book, *Rugger – The Man's Game*, E.H.D. Sewell said of Seeling: "Never omitted from their world's pack by all initiated observers who saw a lot of Dave Gallaher's All Blacks . . . sturdily built, with grand loins, very fast, with long arms, this splendid specimen of manhood had everything necessary to the composition of a forward. Search where one may, a better forward than Seeling does not exist."

Seeling switched to rugby league and joined the Wigan club in England 1910, playing his last game at the age of 39.

SELLARS George Maurice Victor
b: 16.4.1886, Auckland *d:* 7.6.1917, Messines, Belgium
Hooker

Represented NZ: 1913; 15 matches – 2 tests, 6 points – 2 tries

First-class record: Auckland 1909-15 (Ponsonby); North Island 1912; NZ Maoris 1910,12,14

Educated Napier St School (Auckland). A member of the first New Zealand Maoris team to go overseas, Sellars toured Australia 1910 with that side and played 29 times for Auckland including 12 Ranfurly Shield challenges.

He played as a hooker in the 2-3-2 scrum in the first test v Australia 1913 and in the international on the North American tour. Weighing about 12 stone, Sellars was described as "hard as nails" by R.A. Stone. Not available for the 1914 New Zealand team.

He served during WWI with the Auckland Infantry Regt and was killed while carrying a wounded comrade during action at Messines.

SEYMOUR Dallas James
b: 19.8.1967, Tokoroa
Loose forward

Represented NZ: 1992; 3 matches, 5 points – 1 try

First-class record: Canterbury 1988,90-93 (University); Hawke's Bay 1994-96 (Taradale); Wellington Hurricanes 1996,97; NZ Colts 1987; NZ Trials 1988,90,92-94; South Zone 1988,89; Southern Zone Maoris 1990,92,93; NZ Maoris 1992,96; South Island Universities 1987,89; NZ Universities 1987,88,92; New Zealand XV 1992; North Island XV 1995; Divisional XV 1996; Central Region 1996; Harlequins 1996; Hawke's Bay Invitation XV 1996

Seymour, with Eric Rush, is one of New Zealand's most experienced and valuable sevens players and in later years, with the gradual restructuring of New Zealand rugby, concentrated more on sevens than on the first-class game. Like Rush, Seymour played in every Hong Kong tournament from 1988, as well as the World Cups in 1993 and 1997.

His only appearances for New Zealand in the first-class game were as a reinforcement player on the 1992 tour of Australia and South Africa, when he played in three matches, one in Australia and two in South Africa.

Though mostly an openside flanker, Seymour had experience on both sides of the scrum as well as No 8. He frequently captained teams

he was in, including Hawke's Bay and the Divisional team.

Dallas Seymour

SHANNON Graham
b: 13.6.1869, Nelson *d:* 25.10.1911, Wellington
Halfback and forward

Represented NZ: 1893; 6 matches, 9 points – 3 tries

First-class record: Manawatu 1890,94 (Feilding), 1892-94 (Marton); Manawatu-Wanganui 1894; NZ Trial 1893

Went into the New Zealand team for the 1893 Australian tour when an original selection, 'Mother' Elliot, withdrew and his replacement Charlie Caradus could not tour owing to injury. Shannon played six matches on tour including one appearance as a forward.

A son of the founder of the Shannon area in Manawatu. His brother, William, represented that province 1894-99.

SHAW Mark William
b: 23.5.1956, Palmerston North
Flanker

Represented NZ: 1980-86; 68 matches – 29 tests, 104 points – 26 tries

First-class record: Horowhenua 1975,76 (Paraparaumu); Manawatu 1978-85 (Kia Toa); Hawke's Bay 1986-88 (Celtic); North Island 1980,81,84,85; NZ Trials 1980-82,87; NZ Juniors 1979; IRB centenary 1986; Central Zone 1987; NZ Divisional 1988

Mark Shaw has Murray Mexted in support as he attacks against Australia.

Educated at Kapiti College, 'Cowboy' Shaw was first chosen for the All Black tour of Australia in 1980, where he developed enormously, playing in all three tests (replacing Murray Mexted at No 8 in the third) and scoring three tries in one match (against a Tasmanian side).

He toured North America and Wales at the end of that year and was again on the blindside of the scrum in the centenary test against Wales.

Shaw's 1980 form established him as the perfect foil to the openside flanker and as one of the most durable forwards of the 1980s in a period of stability in the All Black pack. His hard, uncompromising play gained him a reputation as the All Blacks' "enforcer" but his off the field demeanour belied the image.

Like most of the substance of the pack of the early 1980s, Shaw was chosen for the abandoned 1985 tour of South Africa and went on the unofficial Cavaliers tour instead. He regained his All Black place for the third test against Australia in 1986, was retained for the tour of France that year and captained the team when Jock Hobbs wasn't playing.

Shaw continued playing first-class rugby for another two years and captained the New Zealand Divisional team in 1988.

He later turned to coaching and in late 1997 was named assistant coach of the New Zealand Under 19 team.

SHEARER Jack Douglas
b: 19.8.1896, Wellington *d:* 18.9.1963, Christchurch
Loose forward

Represented NZ: 1920; 5 matches – 3 tests, 3 points – 1 try

First-class record: Wellington 1919,20 (Selwyn), 1921-25,27-29,31 (Poneke); North Island 1919; NZ Trials 1921

When the 1913,14 All Black Mick Cain and his replacement, L. O'Leary, withdrew from the 1920 New Zealand team to visit New South Wales, Shearer was added to the touring party. His five games included one against the state side and the fixture with Wellington after the tour.

Played 62 matches for Wellington in a long representative career and captained the Poneke club 1927-32. His brother, Syd, was an All Black 1921,22.

SHEARER Sydney David
b: 23.10.1890, Wellington *d:* 26.2.1973, Wellington
Hooker

Represented NZ: 1921,22; 8 matches, 3 points – 1 try

First-class record: Wellington 1913,14 (Oriental), 1919,20 (Selwyn), 1921,22,24,25 (Poneke); North Island 1922; NZ Trials 1921

Played initially as a wing forward but later appeared in the front and back rows of the scrum. Made his debut for New Zealand against the 1921 New South Wales tourists and toured Australia in the next season, appearing in all five matches there and two at home after the tour. Enjoyed a long club career from before WWI to 1930. His brother, Jack, was a 1920 All Black.

SHEEN Thomas Reginald
b: 29.3.1905, Waihi *d:* ? March, 1979, Melbourne
Five-eighth and centre threequarter

Represented NZ: 1926,28; 8 matches, 3 points – 1 try

First-class record: Auckland 1923-27 (College Rifles); North Island 1927; NZ Trials 1927; Auckland-North Auckland 1923

Educated King's College and Christ's College, 1st XV 1919-22. A strong five-eighth at 11 stone and 5' 7½" with swift acceleration and an accurate dropkick, 'Toby' Sheen first played for Auckland as an 18-year-old.

Toured Australia 1926 and South Africa as a centre where he suffered cartilage trouble in the game against Orange Free State and did not play again.

SHELFORD Frank Nuki Ken
b: 16.5.1955, Opotiki
Flanker

Represented NZ: 1981,83-85; 22 matches – 4 tests, 36 points – 9 tries

First-class record: Bay of Plenty 1977-81,84 (Opaiki United), 1982 (Waikite), 1985,86,87 (Mt Maunganui); Hawke's Bay 1983 (Napier HSOB); NZ Trials 1982-85; NZ Maoris 1979-85

Educated at Waioeka Primary and Opotiki College where he had three years in the 1st XV (and one in the hockey 1st XI).

Frank Shelford

Shelford, a dynamic flanker, was in the national Maori side within two years of making his first-class debut and his game for the Maoris against the 1981 Springboks undoubtedly was a persuasive factor in his selection for the All Blacks. He replaced an injured Ken Stewart for the third test against South Africa and toured Romania and France at the end of 1981, playing in the Romanian test when Graham Mourie was injured.

Shelford returned to the All Blacks for the 1983 tour of England and Scotland and in 1984, in Australia, played in the second and third tests. He was chosen for the 1985 tour of South

Africa and went to Argentina instead but was injured in his first game and could not play again. Shelford toured South Africa in 1986 with the Cavaliers.

A fast and willing open-side flanker, Shelford suffered from the fact that his career coincided with that of All Black captain Mourie and a future captain, Jock Hobbs. He represented Bay of Plenty at tennis. A second cousin of Wayne Shelford.

SHELFORD Wayne Thomas
b: 13.12.1957, Rotorua
No 8

Represented NZ: 1985-90; 48 matches – 22 tests, 88 points – 22 tries

First-class record: Auckland 1982-84 (North Shore); North Harbour 1985-91 (North Shore); North Island 1985; NZ Trials 1985,87-91; NZ Emerging Players 1985; NZ Colts 1978; NZ Maoris 1982,83,85,87-90; Northern Zone Maoris 1985,87,89-91; NZ Combined Services 1979,81,83,85; Wasps 1985,86; North Zone 1987-89; New Zealand XV 1991; New Zealand B 1991

Educated at Western Heights High School in Rotorua where he played in the first XV 1973,74. Wayne ('Buck') Shelford played for Bay of Plenty Secondary Schools and Auckland age grade sides before he made his Auckland debut in 1982.

He stayed with his North Shore club and automatically moved to North Harbour when the separate union on the North Shore was formed in 1985. It was that year in which he was first chosen for New Zealand, for the abandoned tour of South Africa. He went on the replacement tour of Argentina and played in four of the matches.

Shelford joined the unauthorised Cavaliers tour of South Africa in 1986 and, when he was eligible again for the All Blacks, was chosen for the second test against Australia but had to withdraw because of injury. He went on the tour of France at the end of the year, where he played in both tests.

The most dominant No 8 in the country, he was an automatic choice for the World Cup, and played in five of the six matches, and also played in Sydney test in which the All Blacks regained the Bledisloe Cup. He took over from David Kirk as captain for the tour of Japan in October and November and played in each of the five matches.

Shelford then led the All Blacks on one of their great periods of domination, going through unbeaten from 1987 to 1990, with only a drawn test against Australia in 1988 to mar the perfect record. The Welsh aura was shattered with two hidings in New Zealand in 1988, followed by a tour of Australia, then in 1989 Argentina and France were dispatched, as were Wales and Ireland at the end of 1989.

By the beginning of 1990, however, Shelford's form was not as dominant as it had been and after two tests against Scotland he was dropped, prompting a public outcry. The criticism of the selectors intensified during the following series against Australia, when the All Blacks were beaten in the third test. "Bring Back Buck" signs appeared at grounds and talkback radio callers and writers of letters to editors created a groundswell of opinion, which was ignored by the New Zealand selectors.

'Buck' was not brought back for the tour of France at the end of 1990 and in 1991 he was given consolation roles as captain of a New

The Maori word 'mana' may have been coined just for Wayne Shelford.

Suburbs rugby league club in Sydney. Weighed 78kg and stood 1.80m.

SIDDELLS Stanley Keith
b: 16.7.1897, Wellington *d:* 3.3.1979, Pahiatua
Wing threequarter

Represented NZ: 1921; 1 match – 1 test

First-class record: Wanganui 1914,15 (Wanganui & College OB); Wellington 1920-22 (University); Bush 1923,27 (Pahiatua); North Island 1922; NZ Universities 1921; Wellington-Manawatu 1922; Wairarapa-Bush 1923

Educated Wanganui Collegiate. Made his first-class debut at the age of 17. Served in WWI with the New Zealand Rifle Brigade and then returned to study at Victoria University.

Standing 6' 1" and weighing 13st 9lb, Keith Siddells was described as "an orthodox fullback, a big fellow with a high action." He played his only game for New Zealand as a wing brought into the team for the third test v South Africa 1921.

Selected for the 1922 tour of Australia but withdrew.

SIMON Harold James
b: 7.3.1911, Kingston *d:* 1.10,1979, Karitane
Halfback

Represented NZ: 1937; 3 matches – 3 tests

First-class record: Otago 1931-38 (Southern); South Island 1932-34,36; NZ Trials 1935,37; Rest of New Zealand 1934

Educated Dunback and Macandrew Road Primary Schools. Standing 5' 8" and weighing 11 stone, Harry Simon played behind the All Black scrum in the series against the 1937 Springboks. He was said to be "a solid, hard working halfback with quite a snappy service." Retired at the end of the 1938 season.

Harry Simon

Zealand XV that played Romania and the Soviet Union, and of a New Zealand B team that played Australia.

Shelford retired at the end of 1991. He later coached successfully in Britain and he maintained a high public profile with television commercials for the Accident Compensation Corporation and public speaking engagements. He was assistant coach at North Harbour in 1997 and late in the year, was appointed coach for 1998.

The Maori word 'mana' may have been coined just for Shelford. A competitive and skilful No 8, he led by example, whether driving over the advantage line from scrums or rucks, defending or standing up against real and imagined slights. His quickness to take the law into his own hands would have been harshly judged in rugby's more recent years, but there was no question that he was one of the great forwards to play for New Zealand.

Brothers Dean and Darral played for Combined Services and Bay of Plenty respectively. An uncle, Gordon McLennan, played for Otago and was an All Black trialist, and another, Jack McLennan, also played for Otago. All Black flanker Frank Shelford was a second cousin.

SHERLOCK Kurt
b: 31.12.1961, Auckland
Second five-eighth

Represented NZ: 1985; 3 matches

First-class record: Auckland 1984-86 (Suburbs); NZ Juniors 1984; North Island 1985; NZ Trials 1985,86; NZ Emerging Players 1985

Educated at Lincoln Heights Primary and Massey High School (Auckland) where he played in the 1st XV 1978,79 and represented Auckland Secondary Schools 1979.

Sherlock played for Auckland third grade 1981 and Colts 1982 before making his first-class debut in the 1983 season and playing for Auckland the following year. Sherlock became one of the key members of the Auckland side and in 1986 coach John Hart called him the most under-rated back in the country.

Sherlock was called into the 1985 All Blacks to tour Argentina when Bill Osborne made himself unavailable, but was not required by the national selectors again. At the end of the 1986 season, Sherlock signed with the Eastern

SIMONSSON Paul Lennard James
b: 16.2.1967, Tauranga
Wing threequarter

Represented NZ: 1987; 2 matches, 28 points – 7 tries

First-class record: Waikato 1986 (University), 1988,89 (Fraser-Tech); Wellington 1987 (Porirua); NZ Trials 1987-89; NZ Universities 1986; North Island Universities 1986; NZ Maoris 1988,89; Northern Zone Maoris 1988,89; North Zone 1989

Fast and strong, Simonsson was chosen for the tour of Japan after the 1987 domestic season and though he played in just two matches, against Japan B and the Asian Barbarians, scored seven tries. His four tries against Japan B in Tokyo equalled the record for tries scored on debut held by Jack McLean (1947, v Australian Capital Territory), Jon McLachlan (1974, v South Australia) and Steve Scott (1980, v Queensland Country).

Simonsson took up a league contract in 1990.

SIMPSON John George
b: 18.3.1922, Rotorua
Prop

Represented NZ: 1947,49,50; 30 matches – 9 tests, 6 points – 2 tries

First-class record: Auckland 1946-48,50 (Ponsonby); North Island 1947; NZ Trials 1947,48,50; 2nd NZEF 1945,46

Johnny Simpson

Educated Rotorua and Panmure Primary Schools. In an early career closely paralleling that of Bob Scott, Simpson played rugby league as a youth, was a member of the 1942 Auckland rugby club champions – the Motor Transport Pool team – played for army selections in Egypt and Italy (with the 25th Battalion) and for the 'Kiwis'.

Selected for the 1947 All Blacks to Australia where he appeared in both tests. Toured South Africa in 1949 playing in 17 of the 24 matches including all four tests. A severe knee injury in the third test against the 1950 Lions virtually ended his first-class rugby although he had a few invitation games 1952.

Johnny Simpson was an immensely strong prop and a surprisingly fast runner. Hennie Muller, the Springbok number eight, wrote: "The six foot, 207lb Simpson justified his sobriquet of 'Iron Man' playing with a perpetual scowl on his face and proving a fine leader."

Coached the Takapuna club and was co-opted by Fred Allen as assistant coach for Auckland 1957-62. A Wellington and Northern Districts lawn bowls representative.

Vic Simpson

SIMPSON Victor Lenard James
b: 26.2.1960, Gisborne
Centre threequarter

Represented NZ: 1985; 4 matches – 2 tests

First-class record: Poverty Bay 1979 (Gisborne Maori); Canterbury 1980-90 (University), 1984-86 (Lyttelton); South Island 1981,82,84; NZ Trials 1982; NZ Emerging Players 1985; NZ Juniors 1982; NZ Colts 1980; NZ Universities 1982; NZ Maoris 1981,82; Central Zone 1987

Educated at Gisborne Boys' High School where he was in the 1st XV four years to 1978, Simpson had a year with Poverty Bay (on the wing but one game at fullback) before moving to Canterbury, where he began to play at centre regularly. Simpson was a regular member of the Canterbury Ranfurly Shield team.

He was selected for the 1985 All Black tour of South Africa and on the replacement tour to Argentina, where he played in four matches, gaining the test centre position ahead of Steve Pokere.

Simpson went on the Cavaliers' tour of South Africa but was not called upon by the national selectors in 1986.

SIMS Graham Scott
b: 25.6.1951, Featherston
Centre threequarter

Represented NZ: 1972; 1 match – 1 test

First-class record: Otago 1971-73 (University); Canterbury 1974,75 (Suburbs); South Island 1972; NZ Trials 1972-75; NZ Juniors 1972; NZ Universities 1972

Educated Kahutara Primary and Wanganui Boys' College, 1st XV 1966-69. A threequarter who built up a reputation for sound and consistent play, Sims was chosen to play in the second test against the 1972 Wallabies when Bruce Robertson was forced to withdraw from the original selection with injury. Later in the season he scored five tries for Otago v West Coast.

Stood 5' 9 1/2" and weighed 12st 8lb. Injuries brought his career to a premature end.

Coached the Suburbs club in Christchurch 1976 and Papanui High School 1st XV 1978,79. A brother, Howard, represented Wairarapa 1968,69 and Manawatu 1970,71 and his brother in-law, Ross Murray, the New Zealand amateur golf champion, represented Otago as a fullback 1953.

SINCLAIR Robert Gemmell Burnett
b: 31.8.1896, New Plymouth *d:* 27.6.1932, Hawera
Fullback

Represented NZ: 1923; 2 matches, 23 points – 7 conversions, 3 penalty goals

First-class record: Otago 1922,23 (University); Taranaki 1924 (Hawera); South Island 1923; NZ Trials 1924

Educated New Plymouth Boys' High School. After serving as a 2nd lieutenant with the Auckland Infantry Regt during WWI he returned to study medicine at Dunedin.

In his two All Black appearances against the touring New South Wales team 1923 he scored 10 points in the second match of the series and 13 in the third, converting seven of 10 tries scored in these matches. J.M. McKenzie, in his book *All Blacks in Chains*, called Sinclair's performance: "a radiant debut for New Zealand, tackling like a demon, kicking prodigiously, diving fearlessly at the feet of opposing forwards. I have seen all the great ones in this country in the last 40 years from Gerhard Morkel to Don Clarke . . . never have I seen such an exhibition of fullback play as this."

Despite such fulsome praise 'Jimmy' Sinclair was not selected again although he did play in the 1924 trials.

SKEEN Jack Robert

b: 23.12.1928, Auckland
Flanker

Represented NZ: 1952; 1 match – 1 test

First-class record: Auckland 1951-57 (Marist); NZ Trials 1953,57

Educated Vermont St Marist Brothers' School and Sacred Heart College (Auckland), 1st XV 1945,46. A tireless loose forward, and later a lock, who was a particularly fine lineout specialist, standing 6' 3" and weighing 13st 8lb.

Jack Skeen played once for New Zealand, being called in to replace Hugh McLaren for the second test against the 1952 Wallabies. Both of his All Black trials came after this appearance but he did not win selection again. Coached the Marist club after his retirement. Represented Auckland in Brabin Cup cricket 1950.

Jack Skeen

SKINNER Kevin Lawrence

b: 24.11.1927, Dunedin
Prop

Represented NZ: 1949-54,56; 63 matches – 20 tests, 9 points – 3 tries

First-class record: Otago 1947,48,50-54 (Pirates); Counties 1956 (Waiuku); South Island 1948,50-53; NZ Trials 1948,50,51,53, Bay of Plenty-Thames Valley-Counties 1956; New Zealand XV 1952

Educated Christian Brothers' School (Dunedin) and St Kevin's College, 1st XV 1943,44 from where he played for Town v Country in the annual Otago trial.

Made his debut for New Zealand on the 1949 tour of South Africa, playing in all four tests and holding his place for the home series against the Lions the next year. On the 1951 tour of Australia he scored his only points in a 63-match career for New Zealand with three tries including one in the first test.

Skinner captained the All Blacks in the two-test series against the 1952 Wallabies and was a

Kevin Skinner (right) and J.B. Smith lead trial teams onto Athletic Park.

strong contender to lead the 1953-54 All Blacks. Although not appointed captain, he had a fine tour including all five internationals among his 27 appearances. Announced his retirement at the end of the 1954 season. At this stage he had played in 18 consecutive test matches and his 61 games in the All Black jersey equalled Maurice Brownlie's record.

After playing some club football in Dunedin 1955 he moved to Waiuku and made a comeback to first-class rugby the next season. Recalled to the All Blacks for the final two tests against the 1956 Springboks where his added strength in the scrum was a significant factor in New Zealand's series win. Stood six feet tall and weighed 15st 4lb.

The 1949 front row of Skinner, Has Catley and Johnny Simpson was labelled by Hennie Muller as "the best I played against". In his 1953-54 tour book, *Round the World with the All Blacks*, Winston McCarthy said Skinner's "main claims to fame were his great work at No 2 in the lineout, where his strength and experience were of outstanding value, and his remarkable ability to stop rushes. His value as tight prop is unexcelled."

Kevin Skinner was an amateur boxer of note. He won the Otago heavyweight championship 1946 and the New Zealand title the next year.

SKUDDER George Rupuha

b: 10.2.1948, Te Puke
Wing threequarter

Represented NZ: 1969,72,73; 14 matches – 1 test, 15 points – 4 tries

First-class record: Waikato 1968-73 (University); NZ Trials 1970-72; NZ Universities 1971; NZ Maoris 1968,69,72,73

Educated Te Matai Primary School and Te Aute College, 1st XV 1963-66. A surprise choice to replace the injured Grahame Thorne for the second test v Wales 1969, Skudder scored the All Blacks' first try to mark his debut. He did not appear again for New Zealand until the 1972-73 British tour when he suffered a hamstring injury in Vancouver which affected his play thereafter. Scored three tries in the match he played as a guest at the Scottish RFU centenary celebrations 1973.

At his best George Skudder was a fast and strong runner with a deceptive change of pace. Scored 38 tries in 67 first-class games in a career hampered by a series of leg injuries. Weighed 12st 11lb and stood 5' 10$\frac{1}{2}$".

Selector-coach of the Te Puke primary schools' Tai Mitchell Shield teams 1974,76-79

and vice-president of the Bay of Plenty Primary Schools RFU 1979.

SLATER Gordon Leonard
b: 21.11.1971, New Plymouth
Prop

Represented NZ: 1997; 3 matches

First-class record: Taranaki 1991-95,97 (NPOB); Wellington Hurricanes 1997; South Canterbury Invitation XV 1995; Counties-Manukau Invitation XV 1997; South Island Invitation XV 1997; NZ Divisional XV 1993; NZ Development 1994; NZ Colts 1991-92; Central Zone Trial 1993; NZ Trial 1993

After years of service to Taranaki and little national recognition, Gordon Slater was invited to a pre-season All Black camp in 1996, a broad hint of things that may have been to come. But Slater had broken a leg late the previous year and didn't play at all in 1996, missing Taranaki's winning of the Ranfurly Shield.

The rewards came a year later when he was included in the enlarged squad for the tour of Britain and Ireland by coach John Hart – who had coached him six years previously when he had been in the New Zealand Colts.

Slater's first match as an All Black was as a replacement against Wales A. A tighthead, he played two other games on tour.

A brother, Andrew, played for Taranaki 1989-97.

SLOANE Peter Henry
b: 10.9.1948, Whangarei
Hooker

Represented NZ: 1973,76,79; 16 matches – 1 test, 12 points – 3 tries

First-class record: North Auckland 1972-83 (Hikurangi); North Island 1973; NZ Trials 1972-74,77,79,81

Peter Sloane

Educated St Joseph's Convent School and Whangarei Boys' High School. Appeared in an All Black trial in his first year of representative rugby and included on the 1973 internal tour.

Sloane next played for New Zealand on the 1976 visit to Argentina where he appeared in both matches against Argentina. After acting as a reserve for the series against the 1977 Lions, he played in both games against the touring Argentine team and later in that season toured England and Scotland, making his one international appearance in the English game.

A fit and consistent hooker at 14 stone and six feet, Sloane captained North Auckland 1976-83, leading that province in its 1978-79 Ranfurly Shield tenure.

Sloane became assistant coach of the Canterbury Crusaders in the Super 12 in 1996 and early in 1998 was appointed an assistant All Black coach. He was NZ Colts coach in 1997.

SMITH Alan Edward
b: 10.12.1942, Stratford
Lock

Alan Smith

Represented NZ: 1967,69,70; 18 matches – 3 tests, 3 points – 1 try

First-class record: Taranaki 1962-72 (Stratford); NZ Trials 1965-70; NZ Colts 1964

Educated Douglas Primary and Stratford Technical High School. A powerful and energetic forward standing 6' 3" and weighing 16 stone.

Toured Britain and France with the 1967 All Blacks but did not play in an international until he joined Colin Meads locking the scrum for the two tests v Wales 1969. Also appeared in the first test on the 1970 South African tour.

Coached the Stratford club 1978,79. Represented Taranaki at cricket and Central Districts Colts as a fast bowler. His father, E.C. Smith, played rugby for Taranaki 1936-39 while his uncle, John Walter, was a 1925 All Black.

SMITH Bruce Warwick
b: 4.1.1959, Wairoa
Wing threequarter

Represented NZ: 1983,84; 13 matches – 3 tests, 28 points – 7 tries

First-class record: Waikato 1979-84 (Hamilton OB); North Island 1983; NZ Trials 1981-84; NZ Juniors 1982

Educated Reporoa College (Bay of Plenty), 1st XV 1974-76, the latter two years as captain. He played for Bay of Plenty age teams and secondary schools before he moved to Wellington where he was selected for the Under 21 side but had to withdraw because of a move to Hamilton.

Smith was a consistent performer on the wing and a prolific try scorer for Waikato and one of the notable figures in its Ranfurly Shield reign of 1980-81. Weighed 84kg and stood 1.82m. He was chosen for the All Blacks' tour of England and Scotland at the end of 1983 and played in four matches, but neither of the internationals. He made his test debut the following year against France and scored a try in the second test and was an automatic choice for the Australian tour. He was injured in the first test and played no further part in the tour and retired from rugby in 1985.

SMITH Charles Herbert
b: 13.2.1909, Dunedin *d:* 10.4.1976, Dunedin
Centre threequarter

Represented NZ: 1934; 2 matches, 3 points – 1 try

First-class record: Otago 1931-36 (Southern); South Island 1933,34; NZ Trials 1934

Herbert Smith was a 5' 9", 11st 10lb centre who toured Australia with the 1934 All Blacks playing in the second encounter with New South Wales and against Newcastle. Coached the RNZAF team at Taieri 1940.

SMITH George William
b: 20.9.1874, Auckland *d:* 8.12.1954, Oldham, England
Threequarter

Represented NZ: 1897,1901,05; 39 matches – 2 tests, 102 points – 34 tries

First-class record: Auckland 1896,97,1901,06 (City); North Island 1897,1905

Educated Wellesley St School (Auckland), Smith became a stable boy then a jockey after leaving school and his football prowess and speed became apparent in impromptu games. Selected for the 1897 New Zealand tour of Australia, Smith scored 11 tries including five against New England. He did not reappear in first-class rugby until 1901.

After playing against Wellington and New South Wales 1901 he again disappeared from rugby until the 1905 season when he won selection for the 'Originals'. His statistics were recorded as 5' 7" and 11st 12lb.

Smith produced brilliant form on the 1905-06 tour, first in Australia, in the intervening games at home and then in Britain where he scored 19 tries in as many games, including eight in the first three matches and two against Scotland. After playing in the Irish international he broke a collarbone in a tackle during the Munster

game and he appeared only once more on tour.

Although he continued with good club form he was not chosen for the 1907 All Blacks and was overlooked when a replacement threequarter was required. He turned to rugby league and was appointed vice-captain of the 'All Golds'. Signed with the Oldham club in England and played there until 1916, breaking his leg on the way home from his last match.

George Smith was one of New Zealand's outstanding athletes at the turn of the century. His national titles included the 100 yards 1898-1900,02,04; 250 yards 1900; 120 yard hurdles 1899,1900,02,04; 440 yard hurdles 1898-1900,02,04. Won two Australasian championships in the 440 yard hurdles and the 1902 British AAA title in the 120 yard hurdles. In 1904 he set an unofficial world record of 58.5 seconds over the 440 yard 3' 6" hurdles.

Remarkably, Smith was also a jockey in his younger years and won the New Zealand Cup on a horse called Impulse in 1894 with a weight of 7st 9lb. Some doubt had been expressed about whether the jockey listed as "G. Smith" was also the rugby player. His daughters and grandson in England confirmed it in 1993, producing newspaper clippings. They also said the Smith family had their passages booked to return home after World War I, but his wife died of food poisoning days before the sailing and the plans were abandoned.

SMITH Ian Stanley Talbot
b: 20.8.1941, Dunedin
Wing threequarter

Ian Smith

Represented NZ: 1963-66; 24 matches – 9 tests, 30 points – 10 tries

First-class record: Otago 1961 (Pirates), 1962-64 (Gimmerburn); North Otago 1965,66 (Oamaru OB); Southland 1966,67 (Wyndham), 1968 (Woodlands); South Island 1963-66; NZ Trials 1962,63,65-67; NZ Colts 1964; South Canterbury-North Otago-Mid Canterbury 1965,66

Educated Milton and Pinehills Primary Schools and King's High School, 1st XV 1959. An enterprising attacker with sharp acceleration 'Spooky' Smith weighed 13st 2lb and stood 5' 11" when he was selected to tour with the 1963-64 All Blacks, scoring eight tries in 15 of the 36 games in Britain, France and Canada.

Appeared in all three tests against the 1964 Wallabies and the first two of the 1965 series v South Africa. His replacement, Malcolm Dick, was injured for the final test allowing Smith to regain his place on the left wing and score two tries in New Zealand's 20-3 victory. After three tests on the right wing against the 1966 Lions, Smith gave way to Dick for the final game of that series.

SMITH John Burns
b: 25.9.1922, Kaikohe d: 3.12.1974, Auckland
Centre threequarter and second five-eighth

Represented NZ: 1946,47,49; 9 matches – 4 tests, 9 points – 2 tries, 1 dropped goal

First-class record: North Auckland 1946-54 (Kaikohe); North Island 1943,46-50,53; NZ Trials 1947,50,53; NZ Maoris 1948,51,52; 2nd NZEF 1945,46

Educated Kaikohe Primary and Kaikohe District High School, 1st XV 1935-37. Made his first-class debut for the 12th Brigade Group team 1942 and played for the 1st New Zealand Division later that year and the North Island 1943.

After serving in Italy with the 21st Battalion, Smith established himself as an outstanding member of the 'Kiwis' army team, playing in 26 matches on the European tour. After injuring his ankle in the North Auckland v Australia match he appeared in the first test of the 1946 series but withdrew from the second. Injuries again restricted his appearances on the 1947 Australian tour although he did play in the second test.

Johnny Smith, a Maori, could not be considered for the 1949 visit to South Africa but he captained the All Blacks in the two-match series against the Wallabies in that season. He did not play for New Zealand again although he was selected at second five-eighth for the first test against Australia in 1952, an injury forcing him to withdraw. Was considered unlucky to miss selection for the 1953-54 British tour.

Widely regarded as one of New Zealand's greatest midfield backs, he never reached his top form for the All Blacks. Writing of Smith's performances for the 'Kiwis', Winston McCarthy said: "Johnny remains among the unforgettable players, a player who had everything, plus an ice-cold brain while on the field. So great a player was he that he could make a mediocre wing look the tops . . . He was just as liable to go right into a tackle before releasing the ball to his winger as pass it to him while ten yards from an opponent. Big in the thighs he could break a tackle by an imperceptible lengthening of stride. He had a terrific fend, a two-footed sidestep and an educated boot."

Smith was the first recipient of the Tom French Cup 1949 as the most outstanding Maori player of the year. North Auckland selector 1956. His father, Len, played for North Island Country 1912 and his brother, Peter, joined him in the 1947 All Blacks.

SMITH Peter
b: 1.8.1924, Kaikohe d: 26.1.1954, Opononi
Second five-eighth

Represented NZ: 1947; 3 matches, 12 points – 4 tries

First-class record: North Auckland 1946,47,50,51 (Kaikohe); NZ Trials 1947,51; NZ Maoris 1946,49-51

Educated Kaikohe Primary and Kaikohe District High School. A fast and elusive runner with good hands; stood 5' 9" and weighed 12 stone.

Peter Smith made his first-class debut 1945, scoring three tries for New Zealand Maoris XV v Auckland. He toured Australia with his brother Johnny in the 1947 All Black team. Kept out of the major games by the All Black captain Fred Allen but scored four tries against Combined Northern in one of his three appearances.

Toured Australia with the 1949 New Zealand Maoris team. Injuries prevented his playing in much of the 1949 season but he had a fine game for the Maoris against the 1950 Lions.

SMITH Ross Mervyn
b: 21.4.1929, Ashburton
Wing threequarter

Represented NZ: 1955; 1 match – 1 test

First-class record: Canterbury 1948-60 (Christchurch); South Island 1955,56; NZ Trials 1953,55-57,59; New Zealand XV 1955

Educated Timaru Boys' High School. Ross Smith scored 102 tries in first-class matches from 152 appearances. Included in his 93 tries for Canterbury (in 137 games) were five v South Canterbury 1958.

Although he appeared in five All Black trials, his only match for New Zealand was in the first test v Australia 1955. A leg injury prevented his taking part in the rest of this series.

Larry Saunders in *Canterbury Rugby History, 1879-1979* wrote: "Ross Smith was not all that fast. But he had something. It was composed mainly of swerve, strength, guts and know how. His weight was given as 12½ stone and he stood just under six feet. Hawke's Bay selector 1973-75 and Nelson Bays selector 1976. A nephew of the 1920s All Black Alan Robilliard.

SMITH Wayne Ross
b: 19.4.1957, Putaruru
First five-eighth

Represented NZ: 1980,82-85; 35 matches – 17 tests, 36 points – 6 tries, 4 dropped goals

First-class record: Canterbury 1979-85 (Belfast); South Island 1981,85; NZ Trials 1980-83; IRB Centenary 1986

Educated Putaruru High School, played for Waikato Under 18, Under 21 and B teams before moving to Canterbury in 1979, where he made an immediate impact.

He toured Australia with the 1980 All Blacks and played in the first test before injuring a hamstring and returning home. He played intermittently for Canterbury in 1981 but made a full return to major rugby the following year and regained his place in the All Blacks for the three tests against Australia. In 1983, Smith was again troubled by injury. He missed the first and fourth tests against the Lions, but played the second and third. He returned to play both internationals on the tour of England and Scotland later that year and had a full year in 1984, playing in the tests against France and Australia.

Wayne Smith . . . key player for New Zealand during the 1980s.

Smith was again at first five-eighth for the three home tests in 1985 and was chosen for the ill-fated tour of South Africa. He missed the first test on the replacement tour to Argentina but played in the second. Smith announced his retirement after the Cavaliers' unofficial tour of South Africa.

Smith was a skilled, innovative first five-eighth and was a key player for the All Blacks and for Canterbury, the latter during its Ranfurly Shield reign. He scored the winning try that gained Canterbury the shield from Wellington in 1982 and was an outstanding player three years later when it was lost to Auckland. Weighed 74kg and stood 1.78m.

Smith later took up coaching, including a stint in Italy and a period in Hawke's Bay, and was the Canterbury Crusaders coach in the Super 12 in 1997 and 1998.

SMITH William Ernest
b: 9.3.1881, Wellington *d:* 25.5.1945, Wellington
First five-eighth

Represented NZ: 1905; 1 match – 1 test

First-class record: Nelson 1900-08 (Nelson); South Island 1902; Marlborough-Nelson-West Coast-Buller 1905; Marlborough-Nelson 1908

Educated Nelson College, 1st XV 1897. A big first five-eighth, standing 6' 2" and weighing almost 14 stone, Smith played once for New Zealand v Australia at Dunedin 1905.

SMYTH Bernard Francis
b: 11.2.1891, Boatmans *d:* 1.7.1972, Christchurch
Hooker

Represented NZ: 1922; 3 matches

First-class record: Canterbury 1915 (Marist); South Island 1922

In an unusual playing career Smyth played a sole match for Canterbury 1915. Seven years later he was selected for the South Island and on the strength of this match won selection for the 1922 All Blacks to tour New South Wales. Played against Wairarapa before the team departed, one match out of five in Australia and finally against Manawatu-Wellington after the tour. These five games were his total first-class record.

SNODGRASS Wallace Frankham
b: 24.4.1898, Nelson *d:* 16.7.1976, Masterton
Wing threequarter

Represented NZ: 1923,28; 3 matches, 13 points – 1 try, 5 conversions

First-class record: Hawke's Bay 1917 (Napier HSOB); Nelson 1921-32 (Nelson College OB); Nelson-Marlborough-Golden Bay-Motueka 1921; Seddon Shield Districts 1926; Nelson-Golden Bay-Motueka 1927; South Island Minor Unions 1928; South Island 1923,27,28; NZ Trials 1924,27

Educated Nelson College. Frank Snodgrass played for New Zealand in the first match against the 1923 touring New South Wales team and then in the final two games of that state's 1928 tour, after withdrawing from the first encounter with an injury. Represented Nelson at tennis.

SNOW Eric McDonald
b: 19.4.1898, Nelson *d:* 24.7.1974, Nelson
Loose forward

Represented NZ: 1928,29; 16 matches – 3 tests, 3 points – 1 try

First-class record: Nelson 1918-24,26,27,29,30 (Nelson); South Island 1923,27,29,30; NZ Trials 1921,24,27,29,30; Nelson-Marlborough-Golden Bay-Motueka 1921,30; South Island Country 1920; Seddon Shield Districts 1926

A strong, hard-working forward who was chosen for two All Black tours towards the end of his lengthy rugby career. Played nine matches in South Africa 1928 and seven, including all three tests, in Australia the next year. 'Fritz' Snow stood 6' 1½" and weighed 13½ stone when he represented New Zealand.

Nelson club captain 1926 and served on the committee 1923,27,29. Nelson selector 1934. Two brothers, Herbert and W.V. Snow, also played for that province.

SOLOMON David
b: 31.5.1913, Levuka, Fiji *d:* 15.8.1997, Auckland
Five-eighth and fullback

Represented NZ: 1935,36; 8 matches, 3 points – 1 try

First-class record: Waikato 1934 (Wardville); Auckland 1935-38 (Ponsonby); North Island 1934,37; NZ Trials 1935,37

Educated Edendale Primary and Kowhai Junior High School, Auckland Central rep in the Northern Roller Mills Shield 1926,27, and Mt Albert Grammar School, 1st XV 1931.

Played for the Matamata sub-union 1932-34 before representing Waikato and Auckland. On the 1935-36 All Black tour he played seven games in Britain and one in Canada. Turned to rugby league 1939 and was named in the New Zealand team whose English tour was abandoned after two matches because of the outbreak of WWII. Reinstated to rugby after the war and coached the East Coast Bays and Northcote clubs in Auckland.

Dave Solomon

Stood 5' 8" and weighed almost 12 stone at the time of his tour. Solomon was a very versatile player who represented Auckland in every back position except wing.

His brother, Frank, represented New Zealand 1931,32 and another brother, George, played for Waikato 1937,38.

SOLOMON Frank

b: 30.5.1906, Pago Pago, American Samoa
d: 12.12.1991, Auckland
Wing forward and number eight

Represented NZ: 1931,32; 9 matches – 3 tests, 9 points – 3 tries

First-class record: Auckland 1925,28 (North Shore), 1929-37,39 (Ponsonby); North Island 1931-33; NZ Trials 1930,35; NZ Maoris 1927

Educated Apia (Western Samoa) and Levuka (Fiji) Public Schools before coming to New Zealand then Wellesley St Normal School and Seddon Memorial Technical College. Played 54 matches for Auckland in a long representative career.

Frank Solomon was the last wing forward to play for New Zealand when he made his debut in the 1931 test v Australia. Although Tom Metcalfe became the first international number eight in Australia the following year, Solomon occupied this position in the second and third tests. Stood six feet and weighed 13st 10lb.

Served as a selector for Poverty Bay 1946-49 and coached the Gisborne HSOB club. Also coached the Ponsonby club in Auckland during the 1950s. Rowed in the eights for Auckland. His brother, David, was a 1935-36 All Black and another brother, George, played for Waikato 1937,38.

SONNTAG William Theodore Charles

b: 3.6.1894, Dunedin *d:* 30.6.1988, Dunedin
Lock

Represented NZ: 1929; 8 matches – 3 tests

First-class record: Otago 1915,21-23,25-30 (Kaikorai); Otago-Southland 1925; South Island 1926,29; NZ Trials 1929

Educated Kaikorai School and King Edward Technical College. Played on 60 occasions for Otago in a career spanning 16 years. Selected for the 1929 All Blacks to tour Australia on his 35th birthday; played in eight matches including all three tests.

Charlie Sonntag weighed 14st 3lb and stood 6' 1" at the time of his All Black tour. He was president and was a life member of the Kaikorai club. His uncle, T. Sonntag, represented Otago 1888,89 and the South Island 1888.

SOPER Alistair John

b: 7.9.1936, Invercargill
Number eight

Represented NZ: 1957; 8 matches, 3 points – 1 try

First-class record: Southland 1954-59,61-66 (Country Pirates); South Island 1956,57,59; NZ Trials 1956-60,63,65; NZ Under 23 1958; NZ Colts 1955

Educated Athol Primary and Waitaki Boys' High School, 1st XV 1951-53. A strong and fast loose

forward, Soper made an immediate impression when he came into the Southland team as a 17-year-old. Captained the 1955 New Zealand Colts on a tour of Australia and Ceylon.

Two years later he visited Australia with the 1957 All Blacks but did not appear in either test. His tour statistics were given as six feet and 13st 12lb.

'Ack' Soper played for the English club Blackheath in the 1960-61 season. He has coached the Country Pirates junior team from 1972, delegate to the Northern Southland sub-union 1973-79, president 1976,77. Southland junior athletics rep 1954,55. His father, Clarence, also played rugby for that province 1936-40.

SOUTER Robert

b: 5.1.1905, Cambusnethan, Scotland *d:* 1.1.1976, Auckland
Hooker

Represented NZ: 1929; 4 matches

First-class record: Otago 1927-31 (Alhambra); NZ Trials 1929,30

Arrived in New Zealand at the age of 14. A lightweight (12 stone, 5' 7") hooker in the two-fronted scrum, he played 26 matches for Otago and four games for the 1929 All Blacks in Australia.

SPEIGHT Charles Richard Barton

b: 13.7.1870, Auckland *d:* 23.12.1935, Hamilton
Forward

Represented NZ: 1893; 7 matches, 3 points – 1 try

First-class record: Auckland 1892,93,95,97 (Parnell)

A forward described as being "good in lineout and loose," 'Copper' Speight toured Australia with the 1893 New Zealand team, playing once against New South Wales and in the two Queensland games among his seven appearances. Weighed 11st 10lb.

Later became prominent as a rugby player, referee and administrator in the Hamilton area. His brother, H.H. Speight, also represented Auckland 1894. A great-grandson, Michael Speight, was a 1986 All Black.

SPEIGHT Michael Wayne

b: 24.2.1962, Auckland
Lock

Represented NZ: 1986; 5 matches – 1 test

First-class record: Waikato 1983-85 (University); North Auckland 1986 (Hora Hora); NZ Trials 1985; NZ Colts 1983; NZ Universities 1985

Educated Whangarei Boys' High School where he was in the 1st XV in 1979 and played for Whangarei age teams. Speight moved to Waikato University where he played for Waikato Under 18, 19 and 21. He made his first-class debut in 1983.

Speight was a member of the New Zealand Universities team on its world tour in 1985 and he returned to France the following northern season (1985-86) to play club rugby. He returned to North Auckland during the 1986 season and

was selected for the first test against Australia when chosen lock Gordon Macpherson withdrew because of injury. With Cavalier locks Gary Whetton and Murray Pierce available for the second and third tests, Speight was not chosen but he toured France at the end of 1986, playing in four matches. Weighed 103kg and stood 1.95m.

His great-grandfather C.R.B. Speight was an All Black, 1893.

SPENCER Carlos James

b: 14.10.1975, Levin
First five-eighth

Represented NZ: 1995-97; 17 matches – 8 tests, 239 points – 7 tries, 54 conversions, 32 penalty goals

First-class record: Horowhenua 1992,93 (Waiopehu College); Auckland 1994-97 (Ponsonby); Auckland Blues 1996,97; Colts Black 1995; NZ Colts 1994,95; NZ Maoris 1994; North Island 1995; Barbarians 1996; New Zealand A 1997

Carlos Spencer

Spencer made his first-class debut at 16 for Horowhenua, the same year he played for New Zealand Secondary Schools against Australia and Ireland. He had made Horowhenua age grade sides from the time he was 13.

He moved to Auckland for the 1994 season, immediately gaining a regular place at first five-eighth after Lee Stensness had bridged the gap after the retirement of Grant Fox.

Spencer played for New Zealand Colts and the North Island in 1995 and was called into the

All Blacks touring Italy and France as a replacement for Andrew Mehrtens, who had been injured in the first match. Spencer played in three matches, his first as a replacement.

He went to South Africa in 1996 and played in two of the midweek matches but made great advances during 1997. Mehrtens was injured in the first test against Fiji, and Spencer was the All Black first five-eighth for the remaining seven matches of the domestic and tri nations series. He scored 147 points in those seven tests from five tries, 31 conversions and 20 penalty goals.

Mehrtens was back in favour for the tour of Britain and Ireland at the end of the year and Spencer became a midweek player again, apart from going on in the final test, against England.

He is a gifted, elusive player of great ball skills and an audacious dummy, one of which earned him a try for the Barbarians against England in 1996 and which perhaps set up 1997 for him.

SPENCER George

b: 3.11.1878, Wellington *d:* 28.4.1950, Wellington
Fullback

Represented NZ: 1907; 5 matches, 6 points – 3 conversions

First-class record: Wellington 1900-08 (Melrose); North Island 1907; Wellington Province 1903,05; Wellington-Wairarapa-Horowhenua 1905

Educated Mt Cook School (Wellington). A 12 stone fullback described as "slow but sound with a slashing kick". Played 49 games for Wellington and five for the 1907 New Zealand team.

Transferred to rugby league and represented New Zealand 1908,09. Three brothers, Jack, Walter and Bill, played rugby union for Wellington with the former representing New Zealand 1903,05,07. Another brother, Tom Spencer, was national single sculls champion in 1900.

SPENCER John Clarence

b: 27.11.1880, Wellington *d:* 21.5.1936, Wellington
Loose forward

Represented NZ: 1903,05,07; 6 matches – 2 tests, 6 points – 2 tries

First-class record: Wellington 1898,1900-03,05-07 (Melrose); North Island 1903,06,07; Wellington Province 1903,05; Wellington-Wairarapa-Horowhenua 1905

Educated Mt Cook School (Wellington). First played for Wellington at the age of 17. After playing for Wellington Province against the 1903 New Zealand team he left with the touring party to Australia where an injured knee restricted him to two appearances.

Captained the New Zealand team v Australia at Dunedin 1905. Two years later he became the first New Zealander to go on as a replacement in an international when he took the field for the injured Jack Colman in the first test on the 1907 tour of Australia.

Turned to rugby league 1908 and represented New Zealand the next year. Later reinstated to rugby union and coached the Berhampore club in Wellington. Three other Spencer brothers represented Wellington around the turn of the century with George joining his brother on the 1907 tour.

SPIERS John Edmunde

b: 4.8.1947, Otahuhu
Prop

John Spiers

Represented NZ: 1976,79-81; 27 matches – 5 tests, 4 points – 1 try

First-class record: Counties 1970-82 (Pukekohe); NZ Trials 1977,78,80,81; Counties-Thames Valley 1977

Educated Onewhero High School. Considered to be one of the best maulers in New Zealand rugby, Spiers played 153 games for Counties. He toured Argentina with the 1976 All Blacks and visited England and Scotland 1979, playing in both internationals. Toured Australia and Fiji in 1980 playing in eight matches. Appeared in three games on the 1980 Welsh tour and toured Romania and France in 1981 playing in all three tests. His last first-class appearance was in 1985, for the Barbarians. Weighed 105kg and stood 1.85m.

SPILLANE Augustine Patrick

b: 10.5.1888, Geraldine *d:* 16.9.1974, Timaru
Second five-eighth

Represented NZ: 1913; 2 matches – 2 tests

First-class record: South Canterbury 1911-13,20,22,23 (Temuka)

A five-eighth who represented South Canterbury over a span of 13 years in a career interrupted by the years of WWI.

His All Black appearances were confined to the second and third tests v Australia after the 1913 New Zealand side departed for North America. His brothers, Charles (1902-05), William (1909-13) and Jack (1905), also played for South Canterbury with the former later refereeing in Taranaki and Wanganui and remembered for donating the Spillane Cup, competed for annually by the North Island Marist clubs.

STALKER John

b: 11.2.1881, Dunedin *d:* 28.11.1931, Feilding
Threequarter and second five-eighth

Represented NZ: 1903; 6 matches, 6 points – 2 tries

First-class record: Otago 1902,03 (Dunedin); Manawatu 1904,05 (Institute), 1914 (Referees Assn); 1906-11,13 (Kia Toa); Manawatu-Horowhenua 1908; Manawatu-Hawke's Bay-Bush 1905

Played in six matches on the New Zealand's 1903 tour of Australia including one each against the major state sides New South Wales and Queensland. Described as "a nuggety stamp of a player who stood out on attack".

Moved to Palmerston North and captained Manawatu on several occasions including the match against the 1908 Anglo-Welsh tourists. Played in that province's last match of the 1914 season whilst a member of the referees' association. Refereed the 1920 Ranfurly Shield game Wellington v Southland and South Africa v Otago 1921.

Stalker finished second in the national 440 yards event at the 1901 NZMA meeting and represented New Zealand at the Australasian championships that year.

STANLEY Jeremy Crispian

b: 26.3.1975, Auckland
Threequarter

Represented NZ: 1997; 3 matches

First-class record: Auckland 1994,95,97 (Ponsonby); Auckland Development 1996; Auckland Blues 1997; Barbarians 1994; Northland Vikings 1995; NZ Colts Black 1995; NZ Colts 1995; New Zealand A 1997

Educated at Auckland Grammar, Stanley was in the New Zealand Secondary Schools team in 1992 and made his first-class debut for Auckland two years later.

Jeremy Stanley

Elevation to the Auckland Blues in 1997 and a replacement role for New Zealand in an All Black trial match contributed to Stanley being chosen in the expanded squad that toured Britain and Ireland in 1997.

His first two matches were as a substitute, but he had a starting role for his third.

His father, Joe Stanley, played for New Zealand between 1986 and 1991 and the pair appeared together on the field in a first-class match when the New Zealand Barbarians played the Australian Barbarians in 1994. Both went on as replacements.

The Stanleys were the 15th father-son combination to play for New Zealand, but the six-year gap between one finishing and the other starting is the least of any of the combinations.

STANLEY Joseph Tito
b: 13.4.1957, Auckland
Centre

Joe Stanley

Represented NZ: 1986-91; 49 matches – 27 tests, 28 points – 7 tries

First-class record: Auckland 1982-91 (Ponsonby); North Island 1983; NZ Trials 1983,87,89,91; New Zealand B 1991; North Zone 1987; Barbarians 1987,89,94

Educated at Mt Albert Grammar School where he was in the first XV in 1973 and 1974, Stanley joined Ponsonby in 1975 and stayed there the rest of his career.

Joe Stanley was introduced to the Auckland team by new coach John Hart in 1982 and became one of the central if unobtrusive figures

in the rise of Auckland through the mid and late-1980s, and of the All Blacks' unbeaten test run friom 1987 to 1990.

He made his test debut in 1986 against France when the regular All Blacks were ineligible because of the Cavaliers' tour of South Africa, and he kept his place when they returned. That may be something of an understatement, because Stanley played an unbroken sequence of 27 tests, and was one of the key figures in the New Zealand team.

He was one of seven to play all six tests in the 1987 World Cup – the others were John Kirwan, Grant Fox, David Kirk, Alan and Gary Whetton, and Sean Fitzpatrick.

Stanley's run continued until the two-test series against Scotland in 1990 when illness forced him out, giving an opportunity to the rising star, Craig Innes, for the following series against Australia. Stanley was back for the tour of France at the end of 1990 and also of Argentina in 1991, but he was not chosen for any tests. He was given the captaincy of the midweek All Blacks on both tours by coach Alex Wyllie in recognition of his contribution.

Stanley, the ideal centre with a cool head, strong defence and fast and efficient distribution outside, retired at the end of 1991 and took up a contract in Japan.

On one of his visits home, in 1994, he played for the New Zealand Barbarians alongside his son, Jeremy.

Stanley also played for the British Barbarians in 1990 and for the Southern Hemisphere in 1991 in their 39-4 win over the Northern in Hong Kong.

STAPLETON Edgar Thomas
b: 21.11.1930, Sydney
Wing threequarter

Represented NZ: 1960; 1 match, 3 points – 1 try

First-class record: Australia 1951-55,58; New South Wales (St George) 1951-58

Eddie Stapleton made a guest appearance for the 1960 All Blacks en route to South Africa. The New Zealanders opposed two teams – Queensland and New South Wales – in one afternoon at Sydney and with Denis Cameron and Steve Nesbit incapacitated, local players Maurice Graham and Stapleton were invited to play against Queensland. Stapleton scored the All Blacks' first try.

Educated OLSH and St Bernard's De La Salle Colleges (New South Wales). Joined the St George club in Sydney 1948. Made his international debut in the three-test series against the 1951 All Blacks. Toured New Zealand 1952, South Africa 1953 and New Zealand again 1955, playing in all the tests on each tour. Aggravated a leg injury on his next Wallaby tour after the first test in New Zealand 1958 and returned home.

Stapleton continued to play club rugby until 1968. A strong-running wing, weighing 14st 4lb and standing six feet, he was leading try scorer on the Wallabies' 1952 (8 tries) and 1955 (12 tries) tours. Top points scorer on the latter tour with a total of 47. Played for New Zealand Barbarians 1956. Life member St George RFC. Cousin of 'Wild Bill' Cerutti and J.B. Young, both Australian representatives.

STEAD John William
b: 18.9.1877, Invercargill *d:* 21.7.1958, Bluff
Five-eighth

Represented NZ: 1903-06,08; 42 matches – 7 tests, 36 points – 12 tries

First-class record: Southland 1896-1904,06-08 (Star); South Island 1903,05; NZ Maoris 1910; Otago-Southland 1904,05

Educated Southland Boys' High School, 1st XV 1892,93. Toured Australia 1903 and then, in his international debut, became the first New Zealand captain in a home test match, leading his team to a 9-3 win over the British team at Wellington 1904.

Appointed as vice-captain of the 1905-06 touring team he appeared in all the internationals (captaining the All Blacks v Ireland when Gallaher was injured) except the Welsh game. He was said to have missed this match because of an attack of dysentery or a heavy cold while another source said that he stood down after selection to allow the disappointed 'Simon' Mynott to play. Appeared at halfback against France with Mynott at first five-eighth.

Captained the All Blacks again in the first and third tests against the 1908 Anglo-Welsh tourists, maintaining his distinction of never playing in a losing All Black team in 42 appearances. Stead played mostly at first five-eighth but occasionally at halfback, second five-eighth and centre.

Billy Stead was described by R.A. Stone as "fast . . . quick to see an opening, his defence was par excellence." His obituary in the *1959 Rugby Almanack* called him "one of the immortals . . . a key man in the New Zealand scoring machine, steadiness itself, a good tactical kicker, superb handler and of unruffled temperament."

He was included in the first New Zealand Maoris touring team which visited Australia 1910. He was manager and coach of the New Zealand team for the first two tests of the 1921 Springboks tour. Collaborated with the 'Originals' captain, Dave Gallaher, to write *The Complete Rugby Footballer* (Methuen, 1906) – a 270-page coaching book written in three weeks. Rugby columnist for *NZ Truth* for a number of years. Stead's brother, Norman, also represented Southland 1913,14,20 and New Zealand Maoris.

STEEL Anthony Gordon
b: 31.7.1941, Greymouth
Wing threequarter

Represented NZ: 1966-68; 23 matches – 9 tests, 60 points – 20 tries

First-class record: Canterbury 1964-68 (Christchurch HSOB); South Island 1967; NZ Trials 1965-67

Educated Greymouth Main and Waltham Primary Schools and Christchurch Boys' High School, 1st XV 1957-59. A knee injury kept him out of rugby for three years after leaving school.

A reserve for the series against the 1965 Springboks, he made his All Black debut the next year and played in all four tests against the Lions, scoring tries in each of the last three. Added two further tries v Australia in the 1967 jubilee test, playing in place of the injured Bill Birtwistle, and then toured Britain and France.

After an indifferent start to this tour Steel won back his test position against France and Scotland. A fine try enabled the All Blacks to draw with East Wales. He also scored a memorable try that enabled New Zealand to beat the Barbarians. An achilles tendon injury

ended his career after the 1968 Australian tour where he appeared in both tests. A very fast and dangerous wing when in top form, he stood 5' 11" and weighed almost 13 stone.

After retiring Tony Steel coached the Wests club in Brisbane, and was a Queensland selector 1974. A fine sprinter with a recorded best time in the 100 yards of 9.6 secs. New Zealand champion in both the 100 and 220 yard events 1965,66.

Steel was elected a Member of Parliament in 1990, defeated in 1993 and re-elected in 1996. He also became chairman of the Health Sponsorship Council.

STEEL John

b: 10.11.1898, Dillmanstown *d:* 4.8.1941, Greymouth
Wing threequarter

Represented NZ: 1920-25; 38 matches – 6 tests, 114 points – 35 tries, 3 conversions, 1 penalty goal

First-class record: West Coast 1919-26 (Greymouth Star); Canterbury 1927,29 (Albion); South Island 1919-25; NZ Trials 1921,24,27

A professional sprinter who made an immediate impact as a robust wing on his entry into first-class rugby.

Jack Steel

Included in the New Zealand team's 1920 tour of Australia he scored six tries in six matches. In the first test v South Africa 1921 'Jack' Steel scored a great All Black try when he gathered an awkwardly bouncing cross kick and ran 50 yards struggling to get the ball under control and beating Meyer and Gerhard Morkel to score between the posts.

Toured with the 1922 All Blacks to New South Wales and played against that state the following year in the first of a three-match series. Steel scored 21 tries (the second highest total) in Britain and France with the 1924-25 'Invincibles', appearing in 16 games including

internationals v Wales, England and France. His statistics for this tour were given as 5' 10" and 12½ stone.

A prominent standardbred owner who had the leading stake earner 1940-41, Zincoli, in his stable.

STEELE Leo Brian

b: 19.1.1929, Wellington
Halfback

Represented NZ: 1951; 9 matches – 3 tests, 5 points – 1 conversion, 1 dropped goal

First-class record: Wellington 1950-53 (Onslow); Horowhenua 1954 (Shannon); NZ Trials 1951

Educated St Joseph's, St John's and Brigidine Convent Schools and Wellington Technical College. A lively halfback who weighed 10st 6lb and stood 5' 5", Brian Steele was selected to tour Australia 1951 and appeared in all three tests. Played for the Athletic club in Wellington 1956-58 and coached junior teams for this club until 1966.

STEERE Edward Richard George

b: 10.7.1908, Raetihi *d:* 1.6.1967, Lower Hutt
Lock

Represented NZ: 1928-31; 21 matches – 6 tests, 3 points – 1 try

First-class record: Hawke's Bay 1927-34 (Napier HSOB); Wanganui 1935 (Wanganui & OB); North Island 1928,29,31-33; NZ Trials 1929,30,35; Rest of New Zealand 1934

Educated Napier Boys' High School. Made his All Black debut in the 1928 home series v New South Wales and then toured Australia the next season but did not appear in an international until he played throughout the series against the 1930 Lions.

Dick Steere locked New Zealand's last 2-3-2 test scrum against Australia 1931 and toured that country the following year partnering the previous side-row forward, Purdue, as lock in the 3-4-1 formation used in the first test. Stood 5' 11" and weighed around 14 stone.

Captained the Napier HSOB club, Hawke's Bay and Wanganui teams during his career. Wellington RFU president 1960. Represented Hawke's Bay as a sprinter and shot-putter finishing second in the latter event in the 1934 national championships.

STENSNESS Lee

b: 24.12.1970, Auckland
Five-eighth

Represented NZ: 1993,97; 14 matches – 8 tests, 15 points – 3 tries

First-class record: Manawatu 1990-92 (University); Auckland 1993-97 (University); Auckland Blues 1996,97; NZ Colts 1991; NZ Universities 1991,92,95; NZ Trials 1991-95; NZ Divisional 1992,93; New Zealand XV 1992; NZ Development 1994; North Island 1995; NZRFU President's XV 1995; Barbarians 1994,96-97

Lee Stensness's secondary education was at Taupo-Nui-A-Tia College in Taupo, for which he played in the First XV in 1987 and 1988 and also represented King Country Secondary

Lee Stensness

Schools. He went to Massey University and played for Manawatu Under 19 and Colts in 1990 before making his first-class debut.

An exciting, innovative first five-eighth, Stensness became a regular for Manawatu and had All Black trials in 1991 and 1992 before moving to Auckland for the 1993 season. He moved to second five-eighth to play outside Grant Fox and has swapped between the two positions since.

He was introduced to the All Blacks at second five-eighth for the third test against the 1993 Lions and played the other two domestic tests of the year, against Australia and Western Samoa. In England and Scotland at the end of the year, however, he played at second five-eighth and, recovering from injury, was not chosen for either test.

He remained in consistent and, sometimes, scintillating form for Auckland, but was not again chosen for the All Blacks until 1997. With other players injured, he played at second five-eighth in four tests before being replaced by Alama Ieremia. He was not chosen for the tour of Britain and Ireland at the end of the year.

STEPHENS Owen George

b: 9.1.1947, Paeroa
Wing threequarter

Represented NZ: 1968; 1 match – 1 test

First-class record: Bay of Plenty 1966 (Tauranga Cadets); Wellington 1967-70

(Athletic); North Island 1968,70; NZ Trials 1967-70; NZ Juniors 1966,68; Australia 1973,74; New South Wales 1973,74; Sydney 1972-74

Educated Tauranga Boys' College, 1st XV 1963. A speedy and enterprising wing who weighed 12½ stone and stood 5' 9". Appeared in four All Black trials but represented New Zealand only once – in the third test against the 1968 French tourists when Grahame Thorne was moved in to centre following injuries to Bill Davis and Ian MacRae.

Stephens moved to Australia 1970 and began playing league in Sydney but was reinstated to rugby two years later. He subsequently represented Australia against Tonga 1973 and on a short tour of England and Wales the same year, appearing in the Welsh international. In 1974 he became the third All Black to play international rugby both for and against New Zealand when he took the field for the Wallabies in the second and third tests in Australia. (Evan Jessep and Des Connor were the other players to achieve this distinction.)

Transferred back to rugby league later that year and played for the Parramatta club in Sydney and the Wakefield Trinity club in England. His father, Mortimer, represented Auckland at league 1934 and played for the St Helen's and Rochdale Hornets clubs in England while his brother, Bruce, played rugby for Waikato 1970-72,74,76 and New Zealand Universities 1973-77.

STEVENS Ian Neal
b: 13.4.1948, Waipawa
Halfback and first five-eighth

Ian Stevens

Represented NZ: 1972-74,76; 33 matches – 3 tests, 32 points – 8 tries

First-class record: Wellington 1967-76 (Petone); North Island 1968,72; NZ Trials 1967,68,70,72-76; NZ Juniors 1968

Educated Palmerston North Boys' High School 1st XV 1965,66. Began his representative career for Wellington in his first year out of school. A fine halfback (5' 10" and 12st 4lb) who excelled at the quick break from the scrum, Stevens showed good form as a first five-eighth in the 1972 season and was selected in this position for the 1972-73 All Blacks.

Made his international debut when Bob Burgess was injured before the Scottish game and also appeared against England. Played 13 matches on tour at first five-eighth and one at halfback but his subsequent All Black appearances were all in the latter position: on the 1973 internal tour, the 1974 visit to Australia (playing in the third test) and the 1976 tour of Argentina.

Stevens was invited to appear in matches to celebrate the Scottish RFU centenary 1973. He left New Zealand in the late 1970s and played for the Diggers club in Johannesburg.

STEVENSON Donald Robert Louis
b: 3.2.1903, Dunedin *d:* 11.4.1962, Doncaster, England
Fullback

Represented NZ: 1926; 4 matches

First-class record: Otago 1924,25,27-29 (University), 1930 (Southern); South Island 1926,28; NZ Universities 1923,25

Educated Otago Boys' High and Napier Boys' High Schools, 1st XV 1920. Selected for the New Zealand team to tour Australia 1926 but after appearing against Wellington and in three games in Sydney, illness forced him to return home early. Stood six feet and weighed 12st 9lb. Coached the Melbourne University club 1932.

STEWART Allan James
b: 11.10.1940, Temuka
Lock

Represented NZ: 1963,64; 26 matches – 8 tests, 6 points – 2 tries

First-class record: South Canterbury 1960,64 (Timaru HSOB); Canterbury 1961-63 (University); South Island 1962-64; NZ Trials 1961-63; NZ Universities 1961-63

Educated Timaru Technical College, 1st XV 1956,57. Made his debut for New Zealand in the two tests against the 1963 English tourists and continued to partner Colin Meads in the five internationals on the 1963-64 British tour. Recalled to the All Blacks for the final test of the home series v Australia 1964, on this occasion locking the scrum with Stan Meads while Colin Meads moved to number eight.

The Welsh critic, J.G.B. Thomas, commented on Stewart's play in his book *The Fifth All Blacks:* "Despite his comparative youth for the engine house of the scrum, he was a big man, perfectly proportioned, and a worker. Probably the best lineout jumper in the team, he shoved his weight in the scrum and worked hard in the loose . . . often seen emerging from mauls to make 40 yard dashes". Stood 6' 4" and weighed 15st 11lb.

His father, J. Stewart, represented South Canterbury 1936,37.

Allan Stewart

STEWART David
b: 24.1.1871, Fasque *d:* ?
Loose forward

Represented NZ: 1894; 1 match

First-class record: South Canterbury 1890,91,93-95 (Waihi), 1896 (United)

'Dick' Stewart's sole appearance for New Zealand was against New South Wales at Wellington 1894.

STEWART Edward Barrie
b: 29.10.1901, Milton *d:* 13.12.1979, Timaru
Wing threequarter

Represented NZ: 1923; 1 match, 6 points – 2 tries

First-class record: Otago 1921,27 (Pirates), 1922,23 (University); Southland 1926 (Otautau); NZ Trials 1924,27

Educated Tokomairiro District High School and John McGlashan College, 1st XV 1919-21. A fast wing standing 5' 11" and weighing 11st 4lb who played for the All Blacks in the final match of the 1923 home series v New South Wales, scoring two tries in a 38-11 win.

Stewart won the Otago 100yd and 220yd championships 1921. His best times in these events were 10.4 and 22.2 seconds.

STEWART James Douglas
b: 3.10.1890, Kaiapoi *d:* 5.5.1973, Whangarei
Threequarter

Represented NZ: 1913; 2 matches – 2 tests

First-class record: Auckland 1910-15 (City); North Island 1914

Normally a centre threequarter but equally good on the wing, Stewart played in the second and third tests v Australia 1913 in that position. In

his 29 games for Auckland he scored 14 tries including four v Southland 1914.

When his province lost the Ranfurly Shield to Taranaki 1913, Stewart was said to be "the only back to be trusted to field and clear in proper style".

STEWART Kenneth William

b: 3.1.1953, Gore
Flanker

Represented NZ: 1972-76,79,81; 55 matches – 13 tests, 24 points – 6 tries

First-class record: Southland 1971-76,79-81 (Balfour); South Island 1973,74,79,81; NZ Trials 1972-76; NZ Juniors 1972

Educated Balfour Primary and Otago Boys' High School, 1st XV 1968-70. Made an immediate impression playing for Southland in his first year out of school and was selected for the 1972-73 All Black tour of Britain and France appearing against New York in his All Black debut while aged 19.

Ken Stewart played in 12 of the 32 matches on this tour, scored two tries in the 1973 trials, appeared in all four games on the internal tour of that year and then made his international debut in the test against England. Toured Australia 1974, playing in all three tests, and continued to hold his place in the All Black scrum for the 1974 Irish tour and in home internationals v Scotland 1975 and Ireland 1976.

On the 1976 South African tour Stewart was troubled with a back injury but appeared in 11 matches including the first and third tests. He missed the next two seasons before making a comeback in the series against the 1979 Argentine team and then the two internationals in England and Scotland late in that year. Not available for national selection in the 1980 season but recalled for the series against South Africa in 1981.

Weighing about 15 stone and standing just

over six feet, Ken Stewart was described in the *1974 DB Rugby Annual* as "the self-sacrificing type who pursues the ball relentlessly and fearlessly charges in at every breakdown to get it back. Champion tackler with a giant-sized heart".

STEWART Ronald Terowie

b: 12.1.1904, Waikaia *d:* 15.12.1982, Queenstown
Loose forward

Represented NZ: 1923-26,28,30; 39 matches – 5 tests, 32 points – 10 tries, 1 conversion

First-class record: South Canterbury 1921-23,1925-27,29 (Timaru HSOB); Canterbury 1930 (Christchurch); South Island 1922-27,29; NZ Trials 1924,27,30; New Zealand XV 1929

Educated South School and Timaru Boys' High School, 1st XV 1918-20. First represented South Canterbury as a 17-year-old and made his All Black debut when aged 19 in the final match of the series v New South Wales two years later. Toured with the 1924-25 New Zealand team and played in nine games in England but did not appear after the London Counties match until the team reached Canada.

Stewart appeared against New South Wales on the return of the 'Invincibles' then in five of the six matches in Australia 1926. In South Africa 1928 he played the greatest number of games of any of the All Blacks – 18 out of 22 including all four tests. His final match for New Zealand was the second test against the 1930 British tourists with injury keeping him out of the rest of this series.

Standing 6' 1" and weighing between 14 stone and 15st 2lb during his All Black career, Ron Stewart played in the back row of the 2-3-2 scrum in the first and last of his test appearances and as a wing-forward in the remaining three. Served as a selector for the 'Kiwis' army team 1945 and Southland 1950 and also on the management committee of that union.

STEWART Vance Edmond

b: 28.10.1948, Christchurch
Lock

Represented NZ: 1976,79; 12 matches, 8 points – 2 tries

First-class record: Canterbury 1971-80 (Marist); South Island 1976-78; NZ Trials 1974-77; NZ Maoris 1974-77,79

Educated St Bede's College. A hard-working lock, weighing nearly 100kg and standing 1.93m, especially good in the lineout, Stewart toured Argentina 1976 and was selected for the 1977 French visit but was forced to withdraw because of a thumb injury.

Vance Stewart

Stewart announced his retirement after the New Zealand Maoris tour of Australia and the Pacific 1979 but appeared later that season in the two matches against the Pumas and won a place for the All Black tour of England and Scotland. Despite being hampered by injury he appeared in five of the 11 matches.

Winner of the Tom French Cup 1979 as the outstanding Maori player of the year.

Stewart coached Canterbury 1993-96 and the Canterbury Crusaders in the first year of the Super 12, 1996.

STOHR Leonard

b: 13.11.1889, New Plymouth *d:* 25.7.1973, Johannesburg, South Africa
Threequarter

Represented NZ: 1910,13; 15 matches – 3 tests, 73 points – 10 tries, 14 conversions, 5 penalty goals

First-class record: Taranaki 1908-14 (Tukapa); North Island 1912,14; NZ Services 1919

Educated West End and Central Schools and New Plymouth Boys' High School. Described as "a robust, strong-running centre who made a specialty of running his wings into position."

Ken Stewart . . . "champion tackler with a giant-sized heart".

'Jack' Stohr was also a remarkable goalkicker capable of finding the posts from prodigious distances. He was the first player to kick three penalty goals in a first-class match in New Zealand, achieving this feat for Taranaki v Wanganui 1909.

Toured Australia 1910, appearing in all three tests, and North America 1913 where he was the third highest pointscorer with 59. Stohr played for New Zealand Services in the King's Cup series of matches following WWI and toured South Africa with the army team. He is reputed to have kicked a goal from midway between the halfway and his own 25yd line against Transvaal.

STOKES Edward James Taite
b: 26.6.1950, Auckland
Centre threequarter

Represented NZ: 1976; 5 matches, 4 points – 1 try

First-class record: Bay of Plenty 1971-81 (Rangitaua); North Island 1976; NZ Trials 1974,77; NZ Maoris 1972-79

Educated Mt Maunganui College, 1st XV 1965-67. A strong-running and enterprising centre who weighed 91kg and stood 1.80m, Eddie Stokes toured Argentina with the 1976 All Blacks playing in five of the nine matches. He played more than 150 first-class matches.

STONE Arthur Massey
b: 19.12.1960, Auckland
Second five-eighth and centre threequarter

Represented NZ: 1981,83,84,86; 23 matches – 9 tests, 23 points – 5 tries, 1 dropped goal

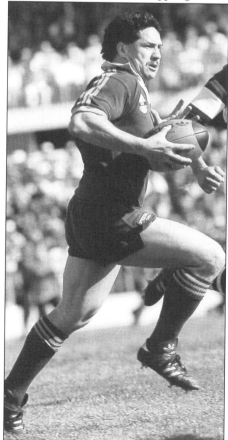

Arthur Stone

First-class record: Waikato 1980-85 (Melville); Bay of Plenty 1986 (Rotorua Pirates); Otago 1987-94 (Kaikorai) North Island 1982-85; NZ Trials 1982; NZ Colts 1981; NZ Maoris 1982,83

Educated Rotorua Boys' and Trident High Schools and had two years in the 1st XV at each, playing for Bay of Plenty, North Island Under 16 and North Island. He moved to Hamilton on leaving school and played for Waikato Under 18 and 21 before making his first-class debut in 1980.

Arthur Stone was first chosen for the All Blacks' tour of Romania and France in 1981 and made his test debut at centre in the first test against France, but played at second five-eighth in the second. Stone's next appearance for New Zealand was as a replacement in 1983 in the third test against the Lions. He was not wanted again until added to the injury-depleted 1984 All Blacks in Australia and he played the third test at second five-eighth. Stone sat out another year before being given another chance and was called into the All Blacks in 1986 when the regular players were in South Africa on the unofficial Cavaliers tour. He was dropped when Cavalier Warwick Taylor was re-eligible but regained his place for the third test against Australia and held it for the two tests in France at the end of the year. He was at second five-eighth in each of his 1986 matches.

Stone, who weighed 82kg and stood 1.78m, had exceptional ball skills and was regarded as a gifted player, adding to the mystery of why he was not more often chosen for the All Blacks. He was also dropped by the Waikato selector, Lindsay McIntosh, in 1985, prompting his move to Bay of Plenty and the following year he moved to Otago, where he played out his career.

STOREY Percival Wright
b: 11.2.1897, Temuka d: 4.10.1975, Timaru
Wing threequarter

Represented NZ: 1920,21; 12 matches – 2 tests, 50 points – 16 tries, 1 conversion

First-class record: South Canterbury 1920-23 (Zingari); South Island 1920; NZ Trials 1924; NZ Services 1919,20

Educated Waimate School. Played club rugby in Waimate and for the Excelsior club in Oamaru before WWI. Served with the Otago Infantry Battalion and was wounded at Passchendaele. Storey played for the United Kingdom XV before winning a place in the New Zealand Services team which won the King's Cup and toured South Africa 1919.

Toured Australia with the 1920 All Blacks prior to representing his union, playing in all 10 games there and in New Zealand. Top try scorer in Australia with 11 and scored a further three v Wellington. He appeared in the first two tests against the 1921 Springboks with an injured shoulder keeping him out of the last match of the series. Captained South Canterbury against the tourists. Stood 5' 9" and weighed 12st 2lb.

Percy Storey retired after a 1924 regional trial. He was a New Zealand selector 1944.

STRACHAN Anthony Duncan
b: 7.6.1966, Te Awamutu
Halfback

Represented NZ: 1992,93,95; 17 matches – 11 tests, 18 points – 4 tries

First-class record: Otago 1987,88 (University); Auckland 1989-92 (Grammar); North Harbour

New Zealand Representatives

1992-95 (East Coast Bays); South Island Universities 1987,88; NZ Universities 1987,88; Otago University Invitation XV 1986; NZ Trials 1992,93,95; Saracens 1992; King Country Invitation XV 1995

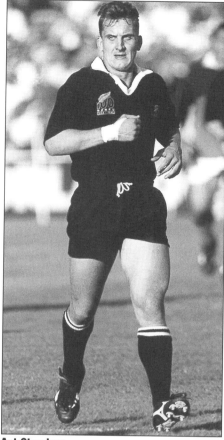

Ant Strachan

Ant Strachan was introduced into the All Blacks for the second and third NZRFU centenary tests against the World XV in 1992 and was retained for the two tests against Ireland and the four on the tour of Australia and South Africa.

He played in only the first test against the British Isles in 1993 and was not required again until selection of the World Cup squad two years later. He played in the pool match against Japan and went on in the final against South Africa as a temporary replacement for Graeme Bachop.

Strachan took up a contract in Japan toward the end of 1995.

Strachan's time at the top coincided with that of other talented halfbacks Graeme Bachop, Jon Preston and Stu Forster and he and Forster were the two to suffer in the pecking order.

STRAHAN Samuel Cunningham
b: 25.12.1944, Palmerston North
Lock

Represented NZ: 1967,68,70,72,73; 45 matches – 17 tests, 6 points – 2 tries

First-class record: Manawatu 1965-70,72-76 (Oroua); North Island 1967-69; NZ Trials 1967-70,74; NZ Juniors 1966; Manawatu-Horowhenua 1966

Educated Huntly Preparatory School and Wanganui Collegiate, 1st XV 1961. Strahan made his All Black debut in the 1967 jubilee test

v Australia and later that year toured Britain and France playing in all four internationals as Colin Meads' locking partner.

In 1968 he appeared in the two tests in Australia and all three v France. Missed selection for the 1969 series against Wales but won back his place for the first three tests on the 1970 South African tour. Strahan restricted his play to club level 1971 then played in the 1972 series against the Wallabies but was not available for the 1972-73 tour. In his last year as an All Black he was included in the 1973 internal tour and the international v England at Eden Park. Played infrequently over the next three seasons.

Sam Strahan

Commenting on Strahan's play on the 1970 South African tour, Gabriel David said: "One of the real successes of the tour, the big, tall Manawatu lock graduated from being just a lineout specialist to the distinction of becoming one of the most able and driving forwards in the All Black pack." Stood 6' 4½" and weighed around 16 stone.

STRANG William Archibald
b: 18.10.1906, Invercargill *d:* 11.2.1989, Tauranga
Five-eighth and halfback

Represented NZ: 1928,30,31; 17 matches – 5 tests, 44 points – 5 tries, 11 conversions, 1 penalty goal, 1 dropped goal

First-class record: South Canterbury 1925-27,31 (Timaru HSOB), 1929,30 (Temuka); South Island 1927,29,31; NZ Trials 1927,30

Educated Southland Boys' High School, 1st XV 1921, and Timaru Boys' High School, 1st XV 1922-24. Captained South Canterbury on a West Coast tour in his first year out of school.

Described as a bright, attacking back, Archie Strang stood 5' 8" and weighed 11st 9lb when he was selected for the 1928 South African tour. He appeared in the first two tests at second five-eighth, kicking a dropped goal 10 minutes from

Archie Strang

time in the second to give New Zealand a 7-6 win. His omission from the rest of the series was considered a surprise but he was recalled for the third and fourth tests against the 1930 British tourists at first five-eighth.

When Cliff Porter retired at the end of the 1930 series, Archie Strang was appointed All Black captain for the test against Australia at Auckland the next year. Strang retired after this test. He coached the Timaru HSOB club and was a selector-coach for the Tauranga sub-union and also for army teams during WWII. His brother, Jim, represented South Canterbury and the South Island 1935.

STRINGFELLOW John Clinton
b: 26.2.1905, Chertsey *d:* 3.1.1959, Mauriceville
Centre threequarter and fullback

Represented NZ: 1929; 7 matches – 2 tests, 16 points – 4 tries, 1 dropped goal

First-class record: Wairarapa 1925-35 (Greytown); Bush 1937 (Mangatainoka); North Island 1934; NZ Trials 1927,29,30,35; Rest of New Zealand 1934; NZ Services (UK) 1945; Wairarapa-Bush 1925,30

Educated Timaru Boys' High School. A speedy, brilliant centre who stood 5' 10" and weighed about 12½ stone, Clinton Stringfellow toured Australia with the 1929 New Zealand team. He played three of his seven games at fullback after George Nepia was injured (and replaced by Stringfellow) during the first test. Appeared in the third test in his usual position and scored a fine try after intercepting a pass well out from the line.

Although he continued to show excellent form, captaining the North Island 1934 and was thought a great prospect for the 1935-36 British tour, Stringfellow did not represent New Zealand again but played twice for NZ Services in England in the 1944-45 season. In 11 consecutive years for Wairarapa he appeared 109 times for that union in a total of 131 first-class matches.

STUART Angus John
b: c 1858, Scotland *d:* 8.10.1923, Dewsbury, England
Forward

Represented NZ: 1893; 7 matches

First-class record: Wellington 1889,91-93 (Poneke); Marlborough 1894; British Touring Team 1888; Yorkshire 1888; NZ Trial 1893

Played for Cardiff 1883-86. Was one of the threequarters who played in the first four threequarter lineup for Cardiff against Gloucester in February 1884. He later played for the Dewsbury club and represented Yorkshire 1888.

Toured Australia and New Zealand with Shaw and Shewsbury's 1888 British touring team and remained in Wellington. Toured Australia 1893 with the first New Zealand team sent by the NZRFU. Weighed 11st 9lb. He returned to England 1902 and acted as trainer to the Dewsbury rugby league club.

STUART Kevin Charles
b: 19.9.1928, Dunedin
Fullback

Represented NZ: 1955; 1 match – 1 test

First-class record: Canterbury 1948-56 (Marist); South Island 1952-56; NZ Trials 1950,51,53,56; New Zealand XV 1955; Rest of New Zealand 1955

Educated St Bede's College, 1st XV 1944-46. A grand all-round fullback and a fearless tackler who scored 383 points in 79 games for Canterbury and represented the South Island five times but played only once for New Zealand – in the first test against the 1955 Wallabies. Weighed 13st 4lb and stood just over six feet at the time of his All Black selection. Injury in 1956 ended his career.

Coached school teams and the Marist club in Napier. Played Brabin Cup cricket for Canterbury 1945/46. His brother, Bob, was captain of the 1953-54 All Blacks while another brother, John, played for Canterbury 1957. A cousin, Jim Kearney, represented New Zealand 1947,49.

STUART Robert Charles
b: 28.10,1920, Dunedin
Loose forward

Represented NZ: 1949,53,54; 27 matches – 7 tests, 3 points – 1 try

First-class record: Manawatu 1941 (St Patrick's OB); Canterbury 1946-53 (University); South Island 1948,49; NZ Trials 1948,50,53; NZ Universities 1946,48,49,51; NZ Services (UK) 1943; New Zealand XV 1949

Educated St Kevin's College. Represented Manawatu before serving in WWII with the Fleet Air Arm and playing once for New Zealand Services while in England. Captain New Zealand Universities 1949,51, and Canterbury from 1950.

Bob Stuart played as a number eight and flanker in the two tests against the 1949 Australian tourists but did not represent New Zealand again until he was a surprise choice at the age of 32 to captain the 1953-54 All Blacks on the tour of Britain and France. Played in all five internationals after missing seven matches

early in the tour owing to illness. Throughout the tour he played as flanker or number eight and played once as a prop. Weighed 14st 2lb and stood just over six feet.

In his tour book, Terry McLean wrote that Bob Stuart "personally revived great captaincy in New Zealand rugby . . . No finer leader of forwards could have been imagined, and if his captaincy tended to emphasise caution at the expense of adventure, the general effect was such that tribute to his ability as a field captain of the old-fashioned kind could be made with utter sincerity."

Served as Canterbury selector 1958,59, co-opted as coach 1956 All Blacks, NZRFU executive from 1974 and New Zealand representative on the International Board from 1978. His brother, Kevin, was a 1955 All Black his brother, John, played for Canterbury and a cousin, Jim Kearney, represented New Zealand 1947,49. OBE 1974.

Stuart stood down from the NZRFU council in 1989, but continued to be actively involved in administration, especially at the international level. He devised and wrote a five-year plan for the International Rugby Board which led, in 1995, to the restructuring of the board and the creation of an executive council and greatly increased membership.

STUART Robert Locksdale
b: 9.1.1948, Napier
Lock and prop

Represented NZ: 1977; 6 matches – 1 test, 4 points – 1 try

First-class record: Hawke's Bay 1967-72 (Napier Technical College OB), 1974-80 (Waipukurau HSOB); North Island 1976,77; NZ Trials 1978

Educated Napier Boys' High School. A rugged tight forward (1.91m and 102kg) who played for his province for 13 consecutive seasons, captain 1977. Played in six of the nine matches for the 1977 All Blacks in France, appearing in the first test as a second half replacement for Gary Knight. Hawke's Bay selector 1984-86.

SULLIVAN John Lorraine
b: 30.3.1915, Tahora *d:* 9.7.1990, Wellington
Threequarter and second five-eighth

Represented NZ: 1936-38; 9 matches – 6 tests, 18 points – 6 tries

First-class record: Taranaki 1934-40 (Tukapa); North Island 1936-39; NZ Trials 1939

Educated Tangarakau School, King Country Schools rep. Played for the Whangamomona sub-union before representing Taranaki. A reserve for the All Blacks in the 1936 series against Australia, he made his All Black debut against South Canterbury between the first and second tests.

In 1937 Sullivan appeared in all three tests against the Springboks, playing two at centre and one on the wing. Also played in all three tests in Australia 1938 and continued his outstanding form in the 1939 trials.

Standing 5' 10" and weighing around 12½ stone, Sullivan was described in the *Rugby Almanack* as "distinguished by fine, clean straight running, combined with initiative and the ability to score himself."

A leg injury suffered while playing for the Middle East Army in Egypt 1942 ended his active rugby but after the war he began a long career in administration of the game.

Taranaki selector-coach 1947-52; North Island selector 1952-59; New Zealand selector 1954-60. Assistant manager of the 1960 All Blacks in South Africa and the 1958 New Zealand Juniors in Japan. Served on the NZRFU executive 1962-65,67,68, chairman 1969-77. Elected a life member 1977. Also president and life member of the Taranaki RFU and the Tukapa club. Awarded CBE.

His brother, Colin, also played rugby for Taranaki. Another brother, George, refereed a New Zealand v British Isles test 1950.

SURMAN Frank
b: ? *d:* ?
Five-eighth and threequarter

Represented NZ: 1896; 1 match

First-class record: Canterbury 1889 (Merivale); Auckland 1895 (Grafton), 1896 (City); New South Wales 1892-94 (Randwick)

Frank Surman is reputed to have come from Thames but no record of his birth can be traced. He represented New South Wales against the 1893 New Zealand team in Australia and the following season captained that state on tour to an 8-6 win over New Zealand.

In his sole game for New Zealand, against Queensland at Wellington 1896, he was forced to retire after tripping over a wire keeping spectators off the field.

SURRIDGE Stephen Dennis
b: 17.7.1970, Auckland
No 8

Represented NZ: 1997; 3 matches, 5 points – 1 try

First-class record: Auckland 1991,92 (University); Canterbury 1996,97 (University); Canterbury Crusaders 1997; South Island Invitation XV 1997; NZ Universities 1992,93; NZ Colts 1991

Steve Surridge, who went to St Kentigern College in Auckland, impressed as a flanker for the New Zealand Colts in 1991 against Australia and made his debut for Auckland in the final game of 1991 when the All Blacks were away at the World Cup. He also played one game for Auckland in 1992 and then spent three years as a post-graduate engineering student at Cambridge University, playing rugby for the university.

He returned to New Zealand for the 1996 season and played the second half of the season at No 8.

He was chosen in the expanded squad for the All Black tour of Britain and Ireland in 1997 and played in three of the midweek matches.

Surridge, who is also an artist, was a national judo champion in several grades.

A brother, Paul, played three games on the wing for Auckland in 1995 and also played for New Zealand Universities and for Cambridge University.

SUTHERLAND Alan Richard
b: 4.1.1944, Blenheim
Lock and number eight

Represented NZ: 1968,70-73,76; 64 matches – 10 tests, 157 points – 32 tries, 17 conversions, 3 penalty goals

Alan Sutherland

First-class record: Marlborough 1962,64 (Awatere), 1965-76 (Opawa); South Island 1967,68,72,73,75; NZ Trials 1965-74,76; NZ Juniors 1966; Marlborough-Nelson-Golden Bay-Motueka 1965,66; Marlborough-Nelson Bays 1971; Rhodesia 1977

Educated Marlborough College. Sutherland did not play rugby at school but entered the Marlborough team after one season of senior club rugby. Toured Australia with the 1968 All Blacks and was second highest pointscorer with 66 from seven games but was not to represent New Zealand for another two years.

On the 1970 South African tour he appeared in the second and fourth tests as a lock. Broke his leg in a charity game after playing at number eight in the first test against the 1971 Lions and missed the rest of that season. His All Black career continued the next year with the internal tour and three tests against the 1972 Wallabies. On tour with the 1972-73 All Blacks he played in four internationals, missing the Scottish match because of 'flu. Sutherland was not called upon again until he was included in the 1976 South African tour but did not make the test team.

South African rugby writers named him among their five players of the year after the 1970 tour, commenting: "The big, strong and mobile Sutherland was equally well equipped for the lock, flank and No 8 positions." He was invited to appear in the Scottish RFU centenary matches 1973.

Took up a coaching position in Rhodesia 1977 and represented that country before moving to South Africa where he coached Witwatersrand University. His brother, Ray, represented Marlborough 1958-74 and was an All Black trialist.

SVENSON Kenneth Sydney

b: 6.12.1898, Toowoomba, Queensland
d: 7.12.1955, Raglan
Threequarter and second five-eighth

Represented NZ: 1922-26; 34 matches – 4 tests, 97 points – 26 tries, 8 conversions, 1 penalty goal

First-class record: Wanganui 1918-21 (Wanganui OB); Buller 1921,22 (White Star); Wellington 1923,25-27 (Athletic); Marlborough 1932,33 (Moutere); South Island 1922; North Island 1921,24,26; NZ Trials 1921,24; Wellington-Manawatu 1923

Svenson was first selected for New Zealand to visit Australia 1922 but after playing against Wairarapa at centre he was precluded by illness from any further games on tour. He was named in the 1924-25 All Blacks and scored five tries in three matches in Australia before departing for Europe.

'Snowy' Svenson

Enjoyed an outstanding tour with the 'Invincibles', scoring 18 tries including the unique distinction of one in each of the four internationals as a wing. Played against New South Wales on the team's return and toured Australia again 1926, playing second five-eighth, wing and fullback.

Svenson's fellow All Black, Mark Nicholls, described him as "the perfect footballer. Really a five-eighth and not fast for a wing, 'Snowy' was the most dependable player I have ever known. He never dropped the ball, never gave a bad pass, never put a team-mate in an impossible position. An ideal player, all heart." Stood 5' 7" and weighed 10st 12lb.

SWAIN John Patterson

b: 1902, Sydney, Australia *d:* 29.8.1960, Eskdale
Hooker

Represented NZ: 1928; 16 matches – 4 tests, 9 points – 3 tries

First-class record: Hawke's Bay 1920,21 (Pirates), 1925-27 (Napier Technical College

OB); Wellington 1922-24 (Athletic); North Island 1926,27; NZ Trials 1924,27; Wellington-Manawatu 1923

Educated Hastings St School (Napier) and Napier Technical College. A hooker in the two-fronted scrum, 'Tuna' Swain was noted for his fitness and speed. He scored three tries in the 1927 interisland match.

His statistics were given as 5' 9" and 13st 2lb when he was selected for the 1928 tour of South Africa. Played in all four tests and scored New Zealand's only try in the final international. Represented Wellington at water polo.

SWINDLEY James

b: ? *d:* October, 1918, Sumatra
Forward

Represented NZ: 1894; 1 match

First-class record: Wellington 1894,95 (Athletic); Auckland 1896 (Kuaotunu)

Believed to have come from the Mercury Bay area. He represented New Zealand against the touring New South Wales team 1894. Later played for Thames until 1901, captaining his side to beat Auckland 1899.

TAIAROA John Grey

b: 16 9.1862, Otakau *d:* 31.12.1907, Otago Harbour
Halfback

Represented NZ: 1884; 9 matches, 21 points – 9 tries, 1 conversion

First-class record: Otago 1881,82,84 (Dunedin); Hawke's Bay 1887,88 (Hawke's Bay County), 1889 (Heretaunga)

Educated Otago Boys' High School, 1st XV 1882. Standing 5' 10" and weighing 12st 9lb, Taiaroa was the ideal bulk for what is now known as the first five-eighth position. Leading try scorer for the 1884 New Zealand team in Australia with nine tries in as many appearances.

Commenting on his play in the second encounter with New South Wales, a newspaper acclaimed him "the hero of the day. His running, dodging and collaring fairly astonished both players and spectators who duly meted out their applause to this prince of footballers".

Jack Taiaroa set a New Zealand record for the long jump of 20' 1½" and was second in the national championships 1893. Represented Hawke's Bay at cricket 1891-99. His younger brother, Dick, was a member of the 1888-89 NZ Native rugby team and a cousin, Tom Ellison, represented New Zealand 1893.

TAITUHA Peina

also known as Taituha Peina and Taituha Peina Kingi
b: 30.4.1901, Wanganui *d:* 25.2.1958, Rata
Second five-eighth and wing threequarter

Represented NZ: 1923; 2 matches

First-class record: Hawke's Bay 1917-20 (Te Aute College); Wanganui 1921-23,26 (Rata); North Island 1923; NZ Maoris 1921-23,27

Educated Te Aute College from where he represented Hawke's Bay for four seasons. Played for New Zealand v New South Wales

1923 as a second five-eighth in the first encounter of the series and as a wing three-quarter in the second match.

TANNER John Maurice

b: 11.1.27, Auckland
Second five-eighth and threequarter

Represented NZ: 1950,51,53,54; 24 matches – 5 tests, 33 points – 11 tries

First-class record: Otago 1947 (University); Auckland 1949-57 (University); South Island 1947; North Island 1950; NZ Trials 1948,53; NZ Universities 1948-51,53,54,56; NZ XV 1954

Educated Auckland Grammar School, 1st XV 1942,43. Represented Otago while studying dentistry in Dunedin. He had not played for Auckland in the 1950 season when he was surprisingly named to replace the injured Ron Elvidge at second five-eighth for the final test against the Lions. Appeared in all three tests at centre in Australia 1951. On the 1953-54 All Black tour he played in 14 matches including the Welsh international.

Winston McCarthy commented on Tanner's play in Britain: "Had his ups and downs, mainly through being played at second, centre and wing. A demon on defence and cover-defence when being played on the wing." After his fine try for NZ Universities against the 1956 South African tourists, Terry McLean wrote that Tanner "played the best attacking game of any New Zealand midfield back fielded against the Springboks."

John Tanner

Stood 5' 10" and weighed between 12½ stone and 13st 9lb during his All Black career. His brother, Murray, represented Auckland 1948,50 and NZ Universities 1945,49,50,52.

TANNER Kerry John

b: 25.4.1945, Hamilton
Prop

Represented NZ: 1974-76; 27 matches – 7 tests

First-class record: Canterbury 1966-76 (New Brighton); South Island 1974; NZ Trials 1967,74-76; NZ Under 23 1967; NZ Juniors 1966

Educated Belmont Primary and Takapuna Grammar School. An Auckland third grade rep and Colt before moving to Christchurch and beginning an 11-year, 119-match career for Canterbury. A strong scrummager and a valuable man at the front of the lineout, Tanner stood 1.88m and weighed nearly 101kg.

Kerry Tanner

Toured Australia with the 1974 All Blacks appearing in all three tests and then visited Ireland later that year playing in the international and against a Welsh XV and the Barbarians. After home tests against Scotland 1975 and Ireland the following year he was selected for the 1976 South African tour but was able to play in only nine matches (including the first test) because of a blood disorder.

TAYLOR Glenn Lyndon
b: 23.9.1970, Whangarei
Flanker and lock

Represented NZ: 1992,96; 6 matches – 1 test

First-class record: Northland 1990-97 (Hora Hora); Waikato Chiefs 1996,97; NZ Colts 1991; NZ Trials 1992,94; New Zealand XV 1992; NZRFU President's XV 1992,96; NZ Divisional 1993,95; NZ Development 1994; North Island XV 1995; Harlequins 1996; Northland Invitation XV 1996; New Zealand A 1997

Educated at Dargaville High School, Taylor began his major rugby as a flanker but was gradually converted to lock and became valuable as a player who could cover both positions.

He was first chosen for New Zealand for the centenary series in 1992, but was not required for any of the three tests. He was not chosen either for the following tour of Australia and South Africa, but went as a replacement and went on in one match, the 40-17 loss to Sydney, for Pat Lam.

Glenn Taylor

Taylor continued as one of the stalwarts of Northland rugby but was not wanted by the New Zealand selectors again until the South African tour in 1996, when he played in five matches and appeared in the final test, going on for his former provincial team-mate, Ian Jones.

At 1.99 metres and 108kg and with a high workrate, as well as captaincy experience with Northland and some of the national selections for which he was chosen, it seemed surprising to many observers that Taylor was not selected for New Zealand more often.

TAYLOR Henry Morgan
b: 5.2.1889, Christchurch *d:* 20.6.1955, Christchurch
Halfback and threequarter

Represented NZ: 1913,14; 23 matches – 4 tests, 60 points – 20 tries

First-class record: Canterbury 1910-14 (Christchurch HSOB); South Island 1913,14

Educated Christchurch Boys' High School. Made his All Black debut in the first test v Australia 1913 as a halfback, retiring with an injury at halftime. Toured North America in that year and appeared in the Berkeley international.

Taylor was selected for the 1914 Australian tour as a halfback but when George Loveridge was injured early in the tour he was moved to the wing, scoring three tries from this position in the second test. Second highest points scorer on this tour with his 15 tries from 10 games including all three tests.

Played rugby for Trentham Military Forces during WWI. Represented Canterbury at cricket 1912,13,20,21.

TAYLOR John McLeod
b: 12.1.1913, Mataura *d:* 5.5.1979, Wellington
Fullback

Represented NZ: 1937,38; 9 matches – 6 tests, 45 points – 15 conversions, 5 penalty goals

First-class record: Otago 1933-38 (Pirates); Wellington 1939,40 (Wellington); South Island 1937,38; NZ Trials 1935,37,39

Educated Menzies Ferry School and Wyndham District High School. Described as "a sure field, deadly tackler, splendid line kick and accurate goalkicker", Jack Taylor played throughout the series against the 1937 Springboks and in Australia the following year. Leading points scorer on that tour with 45 from six appearances including 12 in the first test. Stood 5' 9" and weighed just over 12 stone.

Taylor coached the Wellington club and was selector for the provincial team 1954-62. President and life member of his club and on the Wellington RFU committee 1950-73, chairman 1969-73 and elected a life member 1974.

TAYLOR Kenneth John
b: 30.11.1957, Napier
Wing threequarter

Represented NZ: 1980; 1 match, 8 points – 2 tries

First-class record: Hawke's Bay 1977-81 (Waipawa), 1982 (Waipukurau OB), 1984,85 (Waipawa United); NZ Juniors 1979,80; NZ Colts 1978

Educated Tikokino Primary School and Central Hawke's Bay College. Represented North Island Under 18 1975 and marked his debut for Hawke's Bay with a fine try against the 1977 Lions.

Selected for the All Black team which played Fiji at Auckland 1980 and scored two tries before retiring injured. A fast and determined wing who weighed nearly 82kg and stood 1.75m.

TAYLOR Murray Barton
b: 25.8.1956, Hamilton
Five-eighth

Murray Taylor

Represented NZ: 1976,79,80; 30 matches – 7 tests, 28 points – 4 tries, 4 dropped goals

First-class record: Waikato 1975-81 (Fraser Tech); North Island 1976,79; NZ Trials 1977,79,81; NZ Juniors 1976; NZ Colts 1976

Educated Wardville Primary, Matamata Intermediate and Matamata College, 1st XV 1972-74 from where he represented North Island Under 18 1974. Played for Waikato in his first year out of school and toured Argentina with the 1976 All Blacks, appearing in both matches against Argentina.

Taylor suffered a broken leg early in the 1977 season and did not play again until late 1978. He appeared in both tests against the 1979 French tourists at first five-eighth and then in two matches in Australia at second five-eighth. On the tour of England and Scotland at that season's end he appeared in each five-eighth position in the internationals and again in the first and second tests in Australia 1980. Played in three matches in North America and Wales later that year. Was 5' 10" and 12 stone.

A younger brother, Warwick, was an All Black 1983-88.

TAYLOR Norman Mark
b: 11.1.1951, Auckland
Second five-eighth and wing threequarter

Represented NZ: 1976-78,82; 27 matches – 9 tests, 51 points – 11 tries, 2 conversions, 1 dropped goal

First-class record: Bay of Plenty 1973-75 (Reporoa), 1976-78 (Ngongotaha); Hawke's Bay 1982 (Napier Technical); North Island 1976-78; NZ Trials 1975,77; Middlesex 1978,79

Educated Te Kopuru Primary, North Auckland Schools rep, and Dargaville High School. Represented North Auckland Juniors and Northern Wairoa sub-union before moving to the Bay of Plenty.

Toured Argentina 1976 playing in both matches against Argentina on the wing. Replaced Grant Batty in the second test against the 1977 Lions and went on for Brian Ford during the fourth test. On the tour of France later that year he appeared at second five-eighth in the first test but again played in the second on the wing. Returned to his preferred position for the series against the 1978 Wallabies and the Irish international on the Grand Slam tour at the end of that season.

Taylor made a comeback appearance for NZ in 1982 against Australia in the second test.

A strongly built player who weighed 84kg and stood 1.78m, Mark Taylor was an enterprising and intelligent midfield back. He remained in England after the 1978 tour, played for the Wasps club and represented Middlesex.

TAYLOR Reginald
b: 23.3.1889, Hillsborough, Taranaki *d:* 20.6.1917, Messines, Belgium
Wing forward

Represented NZ: 1913; 2 matches – 2 tests, 3 points – 1 try

First-class record: Taranaki 1910-12 (Waimate), 1913,14 (Clifton); North Island 1914

Educated Inglewood School. A fine wing forward who played a tremendous match to help Taranaki lift the Ranfurly Shield from Auckland 1913 and then played in the second and third tests v Australia later that year. Scored a try in his All Black debut. Left New Zealand 1915 with the Sixth Reinforcements, and played for the NZ Division v France 1917. Killed in action.

TAYLOR Warwick Thomas
b: 11.3.1960, Hamilton
Second five-eighth

Warwick Taylor

Represented NZ: 1983-88; 40 matches – 24 tests, 32 points – 8 tries

First-class record: Otago 1980,81 (University); Canterbury 1982-90 (University); South Island 1984,85; NZ Trials 1983,87,89; NZ Colts 1980,81; NZ Universities 1983; South Zone 1987

Educated at Matamata College, Warwick Taylor moved to Otago University where he completed a physical education degree and played for Otago. He moved to Christchurch and immediately made the Canterbury team, becoming a major contributor to the Ranfurly Shield era of 1982-85.

Taylor was chosen for the All Blacks in 1983 for all four tests against the British Isles, played in the test against Australia that year and toured England and Scotland, playing in the Scottish test but missing the loss to England because of injury. He played two tests against France in 1984 and two in Australia and toured Fiji at the end of the year. Taylor played in both 1985 tests against England and the single test against Australia and was chosen for the cancelled tour of South Africa. He played in both tests on the replacement tour of Argentina and went on the unofficial Cavaliers' tour of South Africa.

He was reinstated in the All Blacks for the second test against Australia in 1986, but was dropped for the third and not chosen for the tour of France. He was back in favour the following year and played in five of the six World Cup matches and also in the Sydney Bledisloe Cup test.

Taylor played in the two tests against Wales in 1988 but was hampered by injury on the following tour of Australia and he played in only three matches, none of them tests. He was not selected for New Zealand again and retired from all first-class play at the end of the 1990 season.

Taylor was regarded as a tradesmanlike midfielder, doing his job efficiently and with little fuss. He was a strong defender and became noted for his swift following up of his own accurate up and unders.

Taylor also played in the International Rugby Board centennial matches in Britain in 1986.

A brother, Murray, played for New Zealand in 1976, 1979 and 1980.

TETZLAFF Percy Laurence
b: 14.7.1920, Taupiri
Halfback

Percy Tetzlaff

Represented NZ: 1947; 7 matches – 2 tests

First-class record: Waikato 1939 (Hamilton Technical OB); Auckland 1940-47 (Ponsonby); North Island 1943,44; NZ Trials 1947; New Zealand XV 1944

Educated Mercer Primary and Huntly District High School. Represented Waikato for a season before becoming Auckland's regular halfback during the war years. Toured Australia with the 1947 All Blacks playing in both tests.

His club, provincial and All Black teammate, Bob Scott, wrote of Tetzlaff in his biography: "He was constructed in a highly original fashion, for although he was only three inches over five feet in height he had the chest and limbs of a heavy man of more than six feet. The effect was that he could take all the punishment of a hard game and apparently suffered no ill effects.

"In addition to his great gameness, he had one other extraordinary quality – he was easily the best backing-up halfback I have ever seen. His instinct for trouble spots was quite incredible." Stood 5' 3" and weighed 10st 10lb.

Coached the Ponsonby club in the 1950s and served on its committee; president 1978,79.

THIMBLEBY Neil William
b: 19.6.1939, Lower Hutt
Prop

Represented NZ: 1970; 13 matches – 1 test

First-class record: Hawke's Bay 1959 (Taupo), 1960 (Hastings HSOB), 1961-69 (Marist), 1970,71 (Celtic); NZ Trials 1962,63,65,67,70

Educated Trentham Primary and Marton District High School. An energetic, mobile and durable prop (5' 10" and 15½ stone) who played 178 first-class matches in 13 consecutive seasons. Toured South Africa with the 1970 All Blacks playing in 12 of the 24 matches including the third test after withdrawing from the second test team with a thumb injury.

Hawke's Bay selector and coach 1979,80 and a North Island and NZ Marist selector 1977-79. President of the Saracens club 1979 and a committee member 1972-79.

THOMAS Barry Trevor
b: 21.7.1937, Auckland
Prop

Represented NZ: 1962,64; 4 matches – 4 tests

First-class record: Auckland 1958-63,65-67 (Manukau); Wellington 1964 (Oriental); North Island 1965; NZ Trials 1963,65-68

Educated Otahuhu College. Began his representative career as a lock but also appeared in the front row during Auckland's 1960s tenure of the Ranfurly Shield. Made his All Black debut as a prop in the final test of the 1962 home series v Australia. Recalled to the New Zealand team to join Bruce McLeod and Ken Gray in the front row for the three tests against the 1964 Wallabies. Weighed 15st 10lb and stood just over six feet.

Barry Thomas coached the Manukau club 1967-74. Committee member of the Manukau and Barbarian clubs and Auckland Rugby Union. His father-in-law, Sam Cameron, represented Taranaki 1910-14,17-23,25 and Wanganui 1924.

THOMAS Leslie Arthur
b: 13.8.1897, Kaiapoi d: 3.6.1971, Lower Hutt
Loose forward

Represented NZ: 1925; 3 matches

First-class record: Wellington 1917,18,22-28 (Petone); Hawke's Bay 1920,21 (Pirates); North Island 1926; NZ Trials 1924,27; Wellington-Manawatu 1923

Toured Australia with the 1925 New Zealand team playing in three of the six matches, including one appearance as a replacement. Arthur Thomas stood 5' 11" and weighed 13 stone. Poverty Bay selector 1934,35.

THOMPSON Barry Alan
b: 28.12.1947, Oxford
Prop

Represented NZ: 1979; 8 matches

First-class record: Canterbury 1970-79 (Oxford); South Island 1979; NZ Trials 1979

Educated Oxford Primary and Rangiora High School. Played in both matches against the 1979 Pumas and in six of the 11 games in England and Scotland later that year. Lacked pace but was strong in mauls. Coach and committee member of the Oxford club; president 1979,80.

THOMSON Hector Douglas
b: 20.2.1881, Napier d: 9.8.1939, Wellington
Wing threequarter

Represented NZ: 1905,06,08; 15 matches – 1 test, 50 points – 16 tries, 1 conversion

First-class record: Wellington 1900,06 (Wellington College OB), 1908 (Oriental);

Barry Thomas

New Zealand Representatives

Auckland 1901,02 (Grafton); Canterbury 1903 (Christchurch); Wanganui 1904 (Wanganui); South Island 1903; Taranaki-Wanganui-Manawatu 1904; North Island 1905,06

Educated Christchurch Boys' High School and Wellington College, 1st XV 1897. A wiry built speedster, who weighed 10st 9lb and stood 5' 8", 'Mona' Thomson was selected for the 1905-06 'Originals'. He played against Auckland before the team went to Australia where illness kept him out of this preliminary tour.

A leg injury hampered him in Britain and he appeared in only 11 games but scored 14 tries including six against British Columbia. After scoring a brilliant try for Wellington against the 1908 Anglo-Welsh tourists he scored another in the first test of the international series. An arm injury during this season forced his retirement from the game.

Commenting on his play in *With the British Rugby Team in Maoriland*, R.A. Barr wrote: "Thomson was first to show up for his splendid runs, the Wellington flyer frequently eluding the defence of Britain and piercing to its final line. Britain spread its reserves across the field but Thomson was frequently too swift to be intercepted."

His brother, Andrew, also played for Wellington 1906.

THORNE Grahame Stuart
b: 25.2.1946, Auckland
Threequarter and second five-eighth

Represented NZ: 1967-70; 39 matches – 10 tests, 119 points – 35 tries, 4 conversions, 1 penalty goal, 1 dropped goal

First-class record: Auckland 1967-70,74 (University); North Island 1968,69; NZ Trials 1967-70; NZ Universities 1967,69,70; Northern Transvaal 1971-73; Natal 1973; South African Trials 1971-73

Educated Epsom Primary, Normal Intermediate and Auckland Grammar School, 1st XV 1963,64. Before he represented Auckland, Thorne scored two sensational tries in the 1967 trial matches and was named in the 1967 All Black team to tour Britain. Although he did not appear in any internationals, his brilliant solo try against West Wales was one of the tour's highlights.

Made his test debut in Australia 1968 as a wing in both internationals, a position he held for the first two tests against the French later that year, moving in to centre for the third. Returned to the wing for the first test v Wales in the next season but an injury prevented his appearance in the second match of that series.

In his 19 games, including all four tests, in South Africa 1970, Thorne scored 17 tries – the highest total for a touring player in that country during the 20th century. Against the Gazelles he converted four of the All Blacks' six tries and kicked a penalty goal.

A brilliant attacking threequarter who possessed speed and a devastating sidestep off either foot, Grahame Thorne stood 5' 10" and weighed 13 stone during his All Black career. He moved to South Africa after the 1970 tour and represented Northern Transvaal and Natal, winning a place in three Springbok trials before returning to New Zealand. Played against the All Blacks in two invitation teams during the 1973 internal tour and had one game for Auckland the next year, later playing for the Pakuranga club. Played age group cricket for Auckland and represented NZ Universities.

Grahame Thorne . . . brilliant attacking threequarter.

Thorne was elected the National Member of Parliament for Onehunga in 1990, serving one term. Two former team-mates, Chris Laidlaw and Tony Steel, were MPs at the same time.

A son, Bruce, played for the Gauteng Lions in South Africa in 1997.

THORNTON Neville Henry
b: 12.12.1918, Otahuhu
Number eight

Represented NZ: 1947,49; 19 matches – 3 tests, 21 points – 6 tries, 1 penalty goal

First-class record: Auckland 1938,39 (University), 1947,48 (Grammar); King Country 1940 (Otorohanga); NZ Trials 1947,48; Second NZEF 1945,46

Educated Otahuhu College, 1st XV 1934,35. Played for the Training College team before making one appearance for Auckland 1939 from the University club. After serving in WWII Thornton played in 18 of the 38 tour games for the 'Kiwis' army team and was regarded as one of the fastest members of that side.

Toured Australia with the 1947 All Blacks, playing in eight of the nine games and leading the try scorers with four. He also kicked a long range penalty goal in the second test. In South Africa 1949 his only test was the first – the number eight position being occupied by a different player in each match of the series. His tour statistics were given as 6' 1½" and 14st 2lb.

Coached the Grammar club in Auckland 1953,54 and was on the executive of the Auckland Secondary Schools' RFU 1954-59.

TILYARD Frederick Joseph
b: 5.7.1896, Waratah, Tasmania *d:* 8.2.1954, Whakatane
First five-eighth

Represented NZ: 1923; 1 match, 3 points – 1 try

First-class record: Wellington 1918-23,25 (Poneke); North Island 1923; Wellington-Manawatu 1923

Arrived in New Zealand at an early age. Scored a try in his only All Black appearance, against New South Wales in the first match of the 1923 series. Tilyard served on the committee of the Poneke club 1918-21,24,27-36,42-46; secretary 1927-35,42-46; delegate to the Wellington RFU 1936-45. His brother, Jim, represented New Zealand 1913,20 while another brother, Charlie, played for Wellington 1919,20.

TILYARD James Thomas
b: 27.8.1889, Waratah, Tasmania *d:* 1.11.1966, Dannevirke
Five-eighth

Represented NZ: 1913,20; 10 matches – 1 test, 20 points – 4 tries, 2 conversions, 1 dropped goal

First-class record: Wellington 1908-11,13-15,18-20 (Poneke); Wanganui 1912 (Wanganui), 1921 (Wanganui & OB); North Island 1920

Educated South Wellington School. Originally a halfback, Jim Tilyard later played as a five-

eighth and occasionally as a threequarter in his 43 games for Wellington and 10 for Wanganui. He made his All Black debut at first five-eighth in the third test v Australia 1913 and then captained the 1920 New Zealand team in all seven matches in Australia and two at home. Represented Wellington at cricket in the 1907/08 season. His brother, Fred, had one game for the 1923 All Blacks and another brother, Charlie, also represented Wellington at rugby 1919,20.

TIMU John Kahukura Raymond
b: 8.5.1969, Dannevirke
Wing and fullback

Represented NZ: 1989-94; 50 matches – 26 tests, 117 points – 27 tries

First-class record: Otago 1988-92 (University), 1993,94 (Taieri); South Zone 1988,89; NZ Maoris 1988,90-92,94; NZ Trials 1990,91,93,94; NZ Colts 1990; Southern Zone Maoris 1990-94; New Zealand B 1991

John Timu was educated at Lindisfarne College in Hastings and played for the school's first XV as well as Hawke's Bay and New Zealand age grade sides, including two years in the national secondary schools team.

He was chosen for Otago in his first year at Otago University and made an immediate impact, scoring 16 tries to break Bill Meates's 1948 record of 15 in a season. Timu was called into the All Blacks in Wales and Ireland the following year as a replacement for the injured John Kirwan. He played in four matches and had another three on the tour of France at the end of 1990.

Timu made his test debut in Argentina in 1991, played each of the two tests against Australia and four of the matches in the World Cup, the quarterfinal against Canada marking his debut at fullback, a change brought about by injury to Terry Wright, another wing who'd been adapted to fullback.

John Timu

Timu in 1992 played in one of the centenary tests and one of the Irish tests, each on the wing, but by the tour of Australia and South Africa he had become a regular fullback, playing in each of the four tests. He was at fullback throughout 1993, playing the full series against the British Isles and against Australia and Western Samoa, as well as both tests on the tour of England and Scotland.

He had a change of fortunes in 1994. He played at fullback against France but Shane Howarth took over for the remaining tests against South Africa and Australia, and Timu reverted to the wing.

Timu was a fast, skilful player and a strong defender and his conversion to fullback was no doubt prompted by a desire to involve him more in games.

He switched to league in Sydney at the start of the 1995 season.

TINDILL Eric William Thomas
b: 18.12.1910, Nelson
Halfback and first five-eighth

Eric Tindill

Represented NZ: 1935,36,38; 17 matches – 1 test, 24 points – 6 dropped goals

First-class record: Wellington 1932-34,36,38-40,45 (Athletic); North Island 1939; NZ Trials 1935,39; Second NZEF 1940,43

Educated Motueka District High School, Newtown School and Wellington Technical College. Normally a halfback, he won selection for the 1935-36 All Black touring team as first five-eighth, appearing in 13 matches including the English international.

In Australia 1938 he played in three games at halfback and added another dropped goal to make his total points for New Zealand 24 from an unusual tally of six dropped goals. Captained the North Island 1939 and the Second NZEF team in South Africa and England early in WWII. Stood 5' 8" and weighed around 10½ stone.

Tindill served as a committee member,

auditor and president of the Athletic club in Wellington and compiled the club's centenary history 1976. Co-author with Charlie Oliver of *The Tour of the Third All Blacks* (Sporting Publications, 1936). As an international referee he controlled two tests New Zealand v British Isles 1950 and a test against the 1955 Wallabies.

An outstanding cricketer, Eric Tindill represented Wellington 1933/50 as a wicket keeper and left-hand batsman. He made his New Zealand debut against the MCC in the 1936/37 season, played in home series 1938-39, 1945/46, 1946/47 and toured England 1937 and Australia 1937/38. In 29 matches for New Zealand he scored 562 runs (ave. 17.03) and took 35 catches and 18 stumpings. Sole Wellington cricket selector 1949-54, New Zealand selector 1955,56 and stood as umpire in the first test v England 1959. His sons, Peter (1963,64) and Dennis (1964), played rugby for Wellington.

TIOPIRA Hoeroa
b: 10.1.1871, Omahu *d:* ?
Forward

Represented NZ: 1893; 8 matches

First-class record: Hawke's Bay 1889-93 (Te Aute), 1895 (Hawke's Bay County)

Educated Meanee School and Te Aute College from where he represented Hawke's Bay.

Tiopira was regarded as one of the outstanding forwards in the 1893 New Zealand team, noted for his ability to lead rushes. He was troubled by injury but appeared twice against New South Wales and once v Queensland. Weighed 12st 6lb.

TONU'U Ofisa Francis Junior
b: 3.2.1970, Wellington
Halfback

Ofisa Tonu'u

Represented NZ: 1996,97; 5 matches – 2 tests, 10 points – 2 tries

First-class record: Wellington 1991,92 (Poneke); Auckland 1993-97 (Ponsonby); Auckland Blues 1996,97; Crusaders XV 1995; NZRFU President's XV 1995; North Otago Invitation XV 1996; Poverty Bay Selection 1996; North Island 1995; NZ Trial 1994; New Zealand XV 1994; New Zealand A 1997

A strong halfback of the build that's called nuggety, Tonu'u was first chosen for the All Black tour of Italy and France in 1995, but had to withdraw on the eve of the tour when he failed a fitness test.

He got his chance in the expanded squad that toured South Africa in 1996 and played in three of the midweek matches.

He made his test debut in 1997 against Fiji when he went on for Justin Marshall and his only other test was against Australia in Dunedin, again as a replacement for Marshall. It was something of a surprise when he wasn't chosen for the tour of Britain and Ireland at the end of 1997.

Tonu'u, who is known more as Junior than Ofisa, which he prefers, also played for Western Samoa in 1992 and 1993.

TOWNSEND Lindsay James
b: 3.3.1934, Mataura
Halfback

Lindsay Townsend

Represented NZ: 1955; 2 matches – 2 tests

First-class record: Otago 1953 (University), 1954-57 (Southern); North Auckland 1958-63 (Kamo); South Island 1954-56; NZ Trials 1956-59; New Zealand XV 1954,55; Rest of New Zealand 1954,55

Educated Marist Brothers' School (Invercargill) and Christian Brothers' School (Dunedin). A nimble halfback, standing almost 5' 10" and weighing 12st 4lb, Townsend played in the first and third tests against the 1955 Wallabies giving

way to Keith Davis for the second. He later represented North Auckland on 46 occasions and was that union's selector-coach from 1976 to 1980. His father, L.G. Townsend, played for Otago 1922-25 and Southland 1927. His uncle, Frank, represented Southland 1929-31 while two cousins, Warren and Graeme, also appeared for both southern teams and the South Island.

TREGASKIS Christopher David

b: 5.1.1965, Lower Hutt
Lock

Represented NZ: 1991; 4 matches

First-class record: Wellington 1988-95 (Avalon); NZ Trials 1990-92; NZ Development 1990; New Zealand B 1991; New Zealand XV 1992

Tregaskis, 2.04 metres and 116 kilograms, had the ideal build for a lock and though he gave consistent service to Wellington, he was never consistent enough to stay at the top level.

He was chosen for the All Blacks' tour of Argentina in 1991 and each of his four matches were in midweek games. He showed he was still in coach Alex Wyllie's mind when he was chosen for New Zealand B that played Australia B, but he was not required for the World Cup, the backup lock position going instead to Steve Gordon.

TREMAIN Kelvin Robin

b: 21.2.1938, Auckland *d:* 2.5.1992, Napier
Flanker

Represented NZ: 1959-68; 86 matches – 38 tests, 108 points – 36 tries

First-class record: Southland 1957 (Riversdale); Manawatu 1958 (University); Canterbury 1959,61 (Lincoln College); Auckland 1960 (Grammar); Hawke's Bay 1962-70 (Napier HSOB); South Island 1959,61; North Island 1962-68; NZ Trials 1958-63,65-69; NZ Under 23 1958; NZ Universities 1958,59,61,62

Educated Northcote Primary and Auckland Grammar School, 1st XV 1954,55. Played his early representative rugby as a lock but had switched to flanker by the time he made his All Black debut in the second test against the 1959 Lions.

Tremain held his place for the rest of that series and in South Africa 1960, establishing himself as one of New Zealand's finest loose forwards over the next decade. Injury kept him out of the first test v France in the next season but he returned for the second and scored the winning try in a gale. With a try in the third test and another in the first of the 1962 series in Australia, he had scored tries in three successive internationals.

Dropped after the first test of the return series against the 1962 Wallabies was drawn, Tremain regained his place against England 1963 and in the British Isles and France 1963-64. In home series he played against the 1964 Wallabies, the 1965 Springboks (scoring tries in the first three tests and for Hawke's Bay against the tourists) and the 1966 Lions.

Appeared in the 1967 jubilee test v Australia and in three of the four internationals in Britain and France later that year and in the first test in Australia 1968, withdrawing from the second with an injury.

When Brian Lochore was unavailable for the

Kelvin Tremain, ever vigilant for Hawke's Bay against Wellington.

first test of the home series v France 1968, Tremain captained the All Blacks. He appeared in the remaining two tests, his last for New Zealand as he was surprisingly omitted from the team to meet the 1969 Welsh tourists.

Kelvin Tremain's total of nine tries in internationals was a record for an All Black forward at the time. His 136 tries in 268 first-class games is the second highest tally (behind Zinzan Brooke) by a forward.

In his biography, Colin Meads said: "Kel's try-scoring feats are a chapter of New Zealand rugby. But he was so much more. He had the strength and the size to provide the impetus for one of the All Blacks' most effective lineout driving tactics. He was an effective lineout player, a man gifted with sharpness of reflex and a natural anticipation. Within ten yards of the opposition line with the ball in hand he was the hardest man in world rugby to contain." Standing 6' 2", Tremain weighed 15st 2lb when first selected and over 16 stone at the end of his All Black career.

Tremain was chairman of the Hawke's Bay union from 1985 to 1990 and was on the NZRFU council from 1990 until his death. He became ill while managing the New Zealand team at the Hong Kong sevens tournament in March of 1992.

A son, Simon, played flanker for Otago (1988,89), Wellington (1990-92), Hawke's Bay (1993) and for New Zealand Universities.

TREVATHAN David

b: 6.5.1912, Mosgiel *d:* 11.4.1986, Dunedin
First five-eighth

Represented NZ: 1937; 3 matches – 3 tests, 16 points, 4 penalty goals, 1 dropped goal

First-class record: Otago 1934-40 (Southern), 1942 (Army); Southland 1943 (Pirate-Star); South Island 1935,37; NZ Trials 1935,37

Educated Caversham and Macandrew Road Schools. Standing 5' 8" and weighing 12 stone, Trevathan was a reliable five-eighth noted for his goal-kicking ability, particularly the drop kick. He played in all three tests against the 1937 Springboks outside his club and provincial halfback, Harry Simon. His 10 points in the first match gave New Zealand its only win of the series.

After his retirement he coached the Union and Alhambra clubs in Dunedin. His brother, Tommy, represented North Otago before playing rugby league for New Zealand 1936.

TUCK Jack Manson

b: 13.5.1907, Tikokino *d:* 23.3.1967, at sea off Whangaroa
Utility back

Represented NZ: 1929; 6 matches – 3 tests

First-class record: Waikato 1927-30 (Hamilton HSOB); Wellington 1929 (Wellington); NZ Trials 1927; Waikato-King Country-Thames Valley 1930

Educated Wanganui Collegiate and Hamilton High School, 1st XV 1922-25. Selected as a halfback for the 1929 All Blacks in Australia, Tuck played in that position in the first two tests but because of injuries in the touring party he appeared at fullback in the final test. Also played as a five-eighth on this tour and for Waikato. Stood 5' 6" and weighed 10st 6lb.

A shoulder injury caused his retirement in the 1931 season. Foundation member of the Harlequins club.

Jack Tuck

TUIGAMALA Va'aiga Lealuga

b: 4.9.1969, Faleasiu, Western Samoa
Wing threequarter

Represented NZ: 1989-93; 39 matches – 19 tests, 61 points – 14 tries

First-class record: Auckland 1988-93 (Ponsonby); NZ Trials 1988-90,92,93; NZ Colts 1988-90; New Zealand B 1991; New Zealand XV 1992; Barbarians 1989; NZ Samoa 1992

Educated at Kelston Boys High School, Tuigamala played age grade rugby and was in the national secondary schools side in 1986,87, and made his debut for Auckland the following year.

Though his fitness and commitment was sometimes questioned, Tuigamala's size (1.79m and just under 100kg) and speed were irresistible to most selectors, and Alex Wyllie was no exception and he added Tuigamala to the All Black team that toured Wales and Ireland in 1989. He played in six of the non-test

Va'aiga Tuigamala

matches and toured France the following year, playing in another three.

Unusually, Tuigamala, like John Timu, continued to play for New Zealand Colts after having been an All Black.

Despite his talents, Tuigamala was selected sparingly by Auckland in 1991 and he was not chosen for the New Zealand tour of Argentina though after playing for New Zealand B in Brisbane, he was included in the World Cup squad. Injury to Terry Wright, the wing who had been chosen as a fullback, meant a reshuffle of the outside backs and Tuigamala played in four of the cup matches, including the third place playoff against Scotland.

He was a test regular in 1992, playing in the NZRFU centenary series, against Ireland, Australia and South Africa. The only test he missed was the second against Ireland.

Tuigamala played in the three tests against the British Isles in 1993, as well as against Australia and the land of his birth, Western Samoa, and played in both tests on the tour of England and Scotland.

When fully fit, Tuigamala was a strong-running and elusive wing and difficult to defend against.

He switched to a league career in England after the 1993 tour though returned to rugby in 1996 after the game had been made professional.

His biography, *Inga The Winger* (Rugby Press, 1993), was written by Bob Howitt.

TUNNICLIFF Robert Graham

b: 25.6.1894, Nelson *d:* 7.1.1973, Wesport
Hooker

Represented NZ: 1923; 1 match, 3 points – 1 try

First-class record: Nelson 1919 (Nelson College OB); Buller 1922-28 (Umere); NZ Trials 1924,27; South Island Minor Unions 1928; Seddon Shield Districts 1926; West Coast-Buller 1925

Educated Nelson College, 1st XV 1910,11. Described as a player "endowed with strength and dash, follows fast and good with the ball at toe". His only game for New Zealand was as a hooker in the two-fronted scrum in the final match of the 1923 home series v New South Wales when he scored one of the All Blacks' eight tries. Stood 5' 9" and weighed 11st 10lb.

TURNBULL John Steele

b: 2.10.1898, East Taieri *d:* 18.1.1947, Mosgiel
Side-row forward

Represented NZ: 1921; 1 match

First-class record: Otago 1920,21 (Kaikorai)

Educated East Taieri school, 'Jock' Turnbull joined the Kaikorai club after WWI when the Taieri club was not fielding a senior team. A fast, strong flank forward who was also an accurate goalkicker. Chosen as a reserve for the 1921 New Zealand team that played New South Wales at Christchurch, he was required to replace Cabot during the match. Ill health forced him to give up rugby at the end of this season.

TURNER Richard Steven

b: 15.3.1968, Napier
Number eight

Represented NZ: 1992; 2 matches – 2 tests, 4 points – 1 try

First-class record: Hawke's Bay 1986 (Napier Boys High School), 1987,88 (Technical OB); North Harbour 1989-96 (Northcote); Waikato Chiefs 1996; NZ Trials 1990,92,93; New Zealand XV 1992,93; NZ Samoans 1992; Barbarians 1994

Educated at Napier Boys High School, Turner was still playing for the school when he made his first-class debut for Hawke's Bay in 1986. He was in the national secondary schools team the same year. He often played at lock early in his career as well as No 8.

After three years for Hawke's Bay, during which injuries hindered his development, Turner moved to North Harbour in 1989 and was recognised with an All Black trial the following year.

He was chosen for the All Blacks for the NZRFU centenary series against a World XV. He played in the first match, in Christchurch, and went on as a replacement in the second, in Wellington. He was not required by the national selectors again, though he continued to give valuable service to North Harbour and he captained the Waikato Chiefs in the first year of the Super 12.

TURTILL Hubert Sydney

b: 1.2.1880, London, England *d:* 9.4.1918, France
Fullback

Represented NZ: 1905; 1 match – 1 test

First-class record: Canterbury 1902,03,05 (Christchurch); South Island 1903,07; Canterbury-South Canterbury 1905

Came to New Zealand with his parents 1884. A chubby youngster who was nicknamed 'Jumbo' by the passengers travelling with his family on the ship; shortened to 'Jum' this name remained with him for the rest of his life.

Turtill played against Australia at Dunedin

1905 at a time when the 'Originals' were away on tour. He transferred to league and visited England with the 1907-08 'All Golds'. Signed with the St Helen's club in England and played league there 1909-14. Serving with the 422 Field Regiment as part of the 55th (West Lancashire) Division, he was killed by a shell burst.

TWIGDEN Timothy Moore

b: 14.5.1952, Taumarunui
Threequarter

Represented NZ: 1979,80; 15 matches – 2 tests, 28 points – 7 tries

First-class record: Auckland 1975-80 (Grammar); North Island 1975,80; NZ Trials 1976,80; NZ Juniors 1975

Educated Auckland Grammar School, 1st XV 1970. Called into the 1979 All Blacks to tour England and Scotland after Bruce Robertson withdrew, Twigden appeared in six of the 11 matches. In Australia the next year he scored six tries in nine games including the second and third tests as a wing. Suffered concussion in the final test and did not go to Fiji.

Tim Twigden

The *1980 DB Rugby Annual* described him as "the fastest man in the team, he used his speed with devastating effect at times . . . best at centre and never looked entirely happy on the wing". Twigden won beach sprints in national surf life saving championships 1973,74

TYLER George Alfred

b: 10.2.1879, Auckland *d:* 15.4.1942, Auckland
Hooker

Represented NZ: 1903-06; 36 matches – 7 tests, 27 points – 5 tries, 6 conversions

First-class record: Auckland 1899-1907,10,11 (City); North Island 1903

A fine hooker in the 2-3-2 scrum who made his New Zealand debut during the 1903 tour of

Australia and then appeared against the 1904 British tourists.

Tyler formed an effective partnership with the Otago hooker Steve Casey in the four internationals in Britain 1905-06 – this combination winning the All Blacks a vast majority of scrum possession on tour. When he partnered his Auckland team-mate Bill Mackrell against France 'Bubs' Tyler became one of only three forwards to play in all five internationals. Some records credit him with playing against Bristol and Munster on the tour but he appeared in neither match. Stood 5' 10" and weighed 13 stone.

George Tyler won several Auckland swimming titles and the 100 and 220 yard freestyle events in unofficial New Zealand championships 1900.

UDY Daniel Knight

b: 21.5.1874, Greytown *d:* 29.7.1935, Waikanae
Hooker

Represented NZ: 1901,03; 9 matches – 1 test, 3 points – 1 try

First-class record: Wairarapa 1894 (United Greytown), 1895-1904 (Greytown); North Island 1903; Wellington Province 1903

A consistent hooker in the 2-3-2 scrum who made 49 appearances for Wairarapa in 11 consecutive seasons. Played for New Zealand against Wellington and New South Wales 1901 and then toured Australia with the 1903 team, appearing in the first official test match in Sydney. His weight was given as 13st 10lb. A Wairarapa selector 1906. His cousin, Hart Udy, toured Australia with the 1884 New Zealand side.

UDY Hart

b: c 1860, Greytown *d:* 6.8.1933, Napier
Forward

Represented NZ: 1884; 8 matches

First-class record: Wellington 1882,83 (Greytown)

Educated Greytown High School. Toured Australia with the 1884 New Zealand team playing in the three encounters with New South Wales. Described by the tour manager, S.E. Sleigh, as "a powerful forward, always adjacent to the ball. Lasted from start to finish." Weighed 12st 12lb.

Hart Udy served as a Wellington selector 1884,85. His brother, A. Udy, played for Wairarapa 1886,88; his son, Leo, for Wanganui 1925,28; grandson, Peter, for Wairarapa 1965. His cousins, Dan (New Zealand 1901,03), Harry (Wairarapa 1894,96-99,1903) and Edwin (Wairarapa 1886,87,89,93-99), also played representative rugby.

UMAGA Tana Jonathan Falefasa

b: 27.5.1973, Lower Hutt
Wing

Represented NZ: 1997; 10 matches – 6 tests, 30 points – 6 tries

First-class record: Wellington 1994-97 (Petone); Wellington Hurricanes 1996,97; NZ Colts 1994; Barbarians 1997

Tana Umaga took an unusual route into top-level rugby – through league. He was a highly

promising league player and had played for the national junior team, the Junior Kiwis, when he was persuaded by his family to switch to rugby.

He did so with immediate success, making the New Zealand Colts and the Wellington side in his first year, playing usually on the right wing but an occasional game at fullback or at centre.

He quickly established himself as one of the best attacking wings in New Zealand and after 14 tries for the Hurricanes in the 1997 Super 12, was introduced to the All Blacks for the test against Fiji. With Glen Osborne recovering from injury and Jonah Lomu out for the domestic season because of illness, Umaga played six tests on the left wing. He was replaced by Osborne for the second and third against Australia.

Tana Umaga

Umaga played in four of the midweek matches on the tour of Britain and Ireland.

A brother, Mike, played mainly at fullback for Wellington from 1989 until 1994 and also played for Western Samoa.

URBAHN Roger James

b: 31.7.1934, Opunake *d:* 27.11.1984, New Plymouth
Halfback

Represented NZ: 1959,60; 15 matches – 3 tests, 9 points – 3 tries

First-class record: Taranaki 1955-60 (Eltham), 1961-63 (Okato), 1964-66 (New Plymouth HSOB); NZ Trials 1957,59,60

Educated Welbourn Primary, New Plymouth Boys' High and Stratford Technical High School, 1st XV 1951,52. Represented Auckland Colts from the Ardmore Training College team before becoming a regular member of the Taranaki side although he later faced competition for the halfback berth from Kevin Briscoe.

Roger Urbahn

After establishing a fine reputation for Taranaki during its 1958 Ranfurly Shield tenure, Urbahn was named in the first test team to meet the 1959 Lions. Lost his place to Briscoe for the second test but played in the last two when his rival was injured. Toured South Africa and played in 10 matches after suffering an early injury. Briscoe was preferred for the tests on this tour.

In his tour book, *Beaten by the Boks*, Terry McLean described Urbahn as "a clever chap who broke beautifully from the scrum or ruck and whose deftness in tactical kicking had often been blessed by forwards because it permitted them to carry a movement up the field." His statistics were given as 10st 3lb and 5' 8½". Co-author with Don Clarke of *The Fourth Springbok Tour of New Zealand* (Hicks Smith, 1965).

Roger Urbahn also represented Taranaki at cricket.

URLICH Ronald Anthony
b: 8.2.1944, Auckland
Hooker

Represented NZ: 1970,72,73; 35 matches – 2 tests, 30 points – 9 tries

First-class record: Auckland 1965-72 (Otahuhu); North Island 1971,72; NZ Trials 1970-72

Educated Wesley and Ponsonby Primary Schools, Wesley Intermediate and Mt Albert Grammar School, 1st XV 1960. Although he was unable to hold a regular place in the Auckland team, often acting as a reserve to Kevin O'Shannessey in the late 1960s, Urlich was selected for the 1970 All Black tour of South Africa.

He developed well on this tour and when Bruce McLeod's play was affected by an eye injury, Urlich won a place in the last two tests. Gave way to Tane Norton for the 1971 series against the Lions but was included in the 1972 internal tour and the visit to Britain and France at the end of that year as second-string hooker. Invited to play in matches celebrating the Rugby Football Union's centenary in 1971.

Ron Urlich

A quick striker for the ball and a useful forward around the field, who weighed 14st 3lb and stood six feet. Coached the Otahuhu club 1978-80.

UTTLEY Ian Neil
b: 3.12.1941, Christchurch
Centre threequarter

Ian Uttley

Represented NZ: 1963; 2 matches – 2 tests

First-class record: Wellington 1961-65,68 (University); Auckland 1966 (University); Bay of Plenty 1967 (Mt Maunganui); NZ Trials 1963,65,67; NZ Universities 1963,65

Educated Timaru Boys' High Preparatory School, Karori Main Primary and Wellington College, 1st XV 1959. A slightly built (10st 9lb, 5' 8") centre who was a smooth and deceptive runner, Ian Uttley played for New Zealand in the two-test series v England 1963.

A member of the Victoria University club's committee 1962-64; coach 1975-78. Assistant selector of the Auckland Colts team 1974. His grandfather, George, played for Otago 1901 and North Otago 1903-11. His father, Kenneth, played for Otago 1932,34 and NZ Universities 1933 and also represented Otago, Wellington and the South Island at cricket.

VALLI Geoffrey Thomas
b: 3.11.1954, Nightcaps
Fullback

Represented NZ: 1980; 1 match, 9 points – 3 conversions, 1 penalty goal

First-class record: Southland 1974-76,80 (Ohai-Nightcaps); North Auckland 1981-84 (Kamo); NZ Colts 1975

Educated St Patrick's School and Nightcaps District High School, 1st XV 1968,69. Entered the Southland team at the age of 19 and scored over 100 points in each of the next two seasons. He landed a record seven penalty goals for Southland v Mid Canterbury 1975.

In his one All Black appearance he converted three of the six tries scored against Fiji at Auckland 1980 and kicked a penalty goal. A solidly built 85kg and 1.83m player, Valli earned a reputation as a reliable goal kicker and a sound, often enterprising fullback. He played rugby for the Nedlands club in Victoria, 1977-79.

VINCENT Patrick Bernard
b: 6.1.1926, Wataroa *d:* 10.4.1983, Pittsburgh, USA
Halfback

Represented NZ: 1956; 2 matches – 2 tests

First-class record: Canterbury 1945 (Training College), 1946,48-56 (Christchurch HSOB); South Island 1953,56; NZ Trials 1951,53,56

Educated Shirley Primary and Intermediate Schools and Christchurch Boys' High School, 1st XV 1943. Pat Vincent enjoyed a long and distinguished career for Canterbury, leading the side effectively during its mid-1950s Ranfurly Shield era and becoming the first player to make 100 appearances for the union.

Captained New Zealand in his only All Black matches – the first two tests against the 1956 Springboks – but was dropped after the second match was lost. A rugged halfback, standing 5' 9" and weighing 12st 5lb, who delivered a quick pass and had a fine break from the scrum.

Vincent was selector-coach for Canterbury 1959-62 and president of the Christchurch Secondary Schools RFU 1966,67. In the US he coached teams at St Mary's College (California) and the Californian Grizzlies to British Columbia 1971; managed the Grizzlies on the 1972 tour of New Zealand; president of the

Pat Vincent

North California RFU 1973-76; governor of the USARFU 1975-77.

His brothers Bill (Canterbury 1931,32 and West Coast 1935,36) and Bob (West Coast 1939) also played representative rugby.

VODANOVICH Ivan Matthew Henry
b: 8.4.1930, Wanganui *d:* 2.9.1995, Wellington
Prop

Represented NZ: 1955; 3 matches – 3 tests, 3 points – 1 try

First-class record: King Country 1949 (Taumarunui); Wellington 1950-60 (Marist); North Island 1955,60; NZ Trials 1956-60; New Zealand XV 1955; Rest of New Zealand 1954

Educated Kaitangaweka Primary School. A strong, durable and consistent prop who played 112 times for Wellington in the 1950s and was included in the home series against the 1955 Wallabies, scoring a try in his All Black debut. Weighed 15st 2lb and stood just over six feet.

Vodanovich was a member of the NZRFU executive committee from 1969-91; North Island selector 1966-72, New Zealand selector 1967-72; assistant manager of the 1970 All Blacks in South Africa. Chairman Maori Advisory Board 1981-86. Life member NZRFU 1991

VORRATH Frederick Henry
b: 13.6.1908, Dunedin *d:* 1.7.1972, Dunedin
Utility forward

Represented NZ: 1935,36; 12 matches, 6 points – 2 tries

First-class record: Otago 1929,34,36-40 (Union), 1933 (Cromwell); North Otago 1930 (Awakino); Canterbury 1942 (Field Artillery Regiment); Auckland 1943 (Army); South Island 1934; NZ Trials 1935

A six feet, 13½ stone forward who played on the 1935-36 British tour as a lock and on the side and back of the scrum.

Considered unlucky not to appear in any of the internationals, he was described by Eric Tindill as "a really clever forward, adept at initiating passing movements among the backs from loose rushes".

'Did' Vorrath captained Otago 1938,39 and while serving in Egypt 1944 led a team of NZEF Reinforcements from Maadi Camp to victory over the South African 6th Division. Coach, committee member and life member of the Union club in Dunedin.

WALLACE William Joseph
b: 2.8.1878, Wellington *d:* 2.3.1972, Wellington
Utility back

Represented NZ: 1903-08; 51 matches – 11 tests, 379 points – 36 tries, 114 conversions, 9 penalty goals, 2 goals from marks, 2 dropped goals

First-class record: Wellington 1897,99,1901-04,06-08 (Poneke); Otago 1900 (Alhambra); North Island 1902,05,07,08

Educated Mt Cook School, Wellington Public Schools rep 1892,93. One of the greatest players in the history of New Zealand rugby, Billy Wallace's 379 points in the All Black jersey remained a record for 50 years until bettered by Don Clarke.

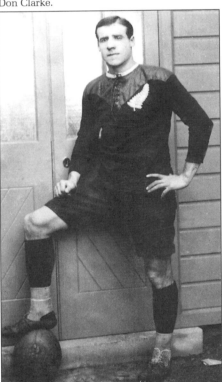

Billy Wallace

A threequarter who performed equally well at fullback, he made his international debut in this position, and scored 13 of New Zealand's 22 points in the first official test in Sydney 1903. He played on the wing against the 1904 British tourists and in the five internationals on the 1905-06 tour appeared three times on the wing, once at fullback and at centre. Led the points scorers on this tour with 246 – the 230 he scored from 25 games in Britain and France remains a record for a tourist.

In Australia 1907 Wallace scored points from the wing in all three tests. His last match for New Zealand was at fullback in the second test against the Anglo-Welsh 1908. Cartilage trouble ended his active rugby in that season.

Wallace was the first New Zealander to score 500 points – his total of 527 was achieved in 112 first-class appearances. The 28 points he scored v Devonshire 1905 in the first match of the British tour remained an All Black record until 1951. His statistics were given as 5' 8" and 12 stone.

British rugby writer E.H.D. Sewell described him as "the all-round utility back player of the famous All Blacks. Wallace is the only player I have seen score a try while wearing a sun hat (v Cornwall). The ease with which Wallace turned up at the right moment to cap the movement was that of a master player who had nothing to learn at this game. He went on scoring tries and dropping goals right through the tour, winding up with a dropped goal which saved a tiring and casualty handicapped team from defeat (v Swansea). Wallace was one of those sound threequarters who made up for a lack of sheer pace by his innate instinct of what to do and when to do it."

A Welsh journalist, W.J.T. Collins, in his *Rugby Recollections* wrote: "In physical gifts, football skills and perfection of movement, Wallace lives in my memory as one of the dozen greatest players l have known. lf I were selecting a World XV he would be my choice at fullback . . . in that position he was the greatest." Wallace played for New Zealand in every back position except halfback.

After his retirement Wallace was elected a life member of the Poneke club and the Wellington RFU. He served on the NZRFU management committee 1931-36; executive 1937,38; managed the 1932 All Blacks in Australia and co-managed the 1935 NZ Maoris on tour. A purse of 400 sovereigns presented to him in 1908 assisted him to establish his own iron foundry.

WALSH Patrick Timothy
b: 6.5.1936, Kaitaia
Utility back

Represented NZ: 1955-59,63,64; 27 matches – 13 tests, 23 points – 7 tries, 1 conversion

First-class record: Auckland 1954 (Ardmore), 1961,62 (Otahuhu); South Auckland Counties 1955 (Ardmore); Counties 1956,57 (Papakura), 1958-60 (Waiuku), 1963 (Manurewa); North Island 1955,59; NZ Trials 1956,57,59,63; NZ Maoris 1955,56,58,59,61; New Zealand XV 1955; NZ Under 23 1958; Bay of Plenty-Thames Valley-Counties 1956; King Country-Counties 1959

Educated Kaitaia and Ahipara Primary Schools, Kaitaia College and Sacred Heart College (Auckland), 1st XV 1951-53. The third youngest test player to represent New Zealand, Pat Walsh was 19 years and 106 days old when he appeared at second five-eighth in the first test against the 1955 Wallabies. Played at fullback in the rest of this series, a position he held for the first two tests v South Africa 1956. Replaced by Don Clarke for the third test but returned at centre for the fourth.

Walsh toured Australia with the 1957 All Blacks, this time playing on the wing in the two tests. Missed most of the rest of that season with illness. In 1958 he played in all three tests against the Wallabies, the first two at centre and the third on the wing. Gave way to Ralph

Caulton for the rest of the series against the 1959 Lions after playing on the wing in the first test.

He did not appear again for New Zealand until named as second five-eighth for the second match v England 1963 and then toured Britain and France where an early knee injury restricted his appearances to 12, mostly as a five-eighth.

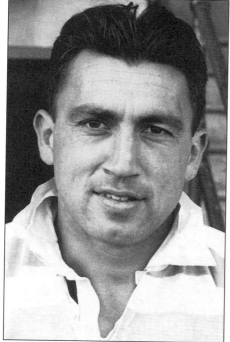

Pat Walsh

A fine, versatile back who represented New Zealand in four different positions, Pat Walsh was, according to Terry McLean, a shrewd and courageous player. He stood 5' 9" and weighed between 12st 3lb and 13st 1lb during his All Black career. Served as a New Zealand selector 1969-71; North Island selector 1971; Counties selector 1980-82.

WALTER John
b: 2.8.1904, Toko *d:* 25.4.1966, Stratford
Loose forward

Represented NZ: 1925; 7 matches, 12 points – 4 tries

First-class record: Taranaki 1924-32 (Stratford); North Island 1925; NZ Trials 1927; Taranaki-Wanganui 1925

The youngest member of the 1925 All Black team in Australia, Walter was aged 20 when selected, weighed 13 stone and stood almost six feet. He appeared in two games against New South Wales and scored four tries – the most by any forward on this tour. Played 85 matches for Taranaki, many as captain, over nine seasons. A selector for that union 1933. A nephew, Alan Smith, represented New Zealand 1967,69,70.

WARBRICK Joseph Astbury
b: c 1862, Rotorua *d:* 30.8.1903, Waimungu
Threequarter

Represented NZ: 1884; 7 matches, 12 points – 3 dropped goals

First-class record: Auckland Provincial Clubs 1877 (Ponsonby), 1882,94 (Tauranga); Auckland 1883 (North Shore), 1886 (Grafton);

Wellington 1879,80,88 (Wellington); Hawke's Bay Clubs 1885 (Hastings); Hawke's Bay 1887 (Hawke's Bay County); NZ Native Team 1888,89

Educated St Stephen's Native School (Auckland). In a remarkable career, Warbrick made his first-class debut as a 15-year-old fullback. Later he played as a threequarter in a number of North Island centres.

Toured Australia with the 1884 New Zealand team, appearing in the three matches v New South Wales. Organised, selected and captained the New Zealand Native team which played 107 games in Britain, Australia and New Zealand 1888-89. Warbrick was injured before the team departed and could not display his best form. He was accompanied on this tour by his brothers, William, Frederick, Arthur and Alfred.

Recalled by Auckland to play against Taranaki 1894.

Joe Warbrick was one of four killed by an eruption of the Waimungu geyser.

WARD Edward Percival
b: 28.6.1899, Timaru *d:* 25.9.1958, Timaru
Utility forward

Represented NZ: 1928; 10 matches, 3 points – 1 penalty goal

First-class record: South Canterbury 1921-23 (Zingari); Canterbury 1924,26 (Linwood); Taranaki 1925,27,30 (Clifton); South Island (1926); NZ Trials 1924,27; Taranaki-Wanganui 1925

Played his early rugby as a threequarter but appeared as a utility forward for the 1928 All Blacks in South Africa. Standing 5' 9" and weighing 15st 5lb, 'Pat' Ward was known for his ability at dribbling the ball.

WARD Francis Gerald
b: 17.3.1900, Wellington *d:* 11.3.1990, Palmerston North
Wing threequarter

Represented NZ: 1921; 1 match

First-class record: Otago 1920,21 (University)

Educated Wellington College, 1st XV 1917,18. Began his representative career as a five-eighth before switching to the wing. Chosen to play for New Zealand against New South Wales at Christchurch 1921. A knee injury ended his career in the next season.

WARD Ronald Henry
b: 1.12.1915, Riverton
Flanker

Represented NZ: 1936,37; 4 matches – 3 tests

First-class record: Southland 1935 (Gore Pioneer), 1936,37 (Pirates), 1939,40 (Riverton); Hawke's Bay 1938 (Hastings); Canterbury 1941 (Army); South Island 1936,37,39; NZ Trials 1937,39

Educated Winton District High School. Played for the Limehills and Fernhills clubs before joining the Southland team from Gore Pioneer. Made his All Black debut in 1936 as a 20-year-old against South Canterbury and three days later was included in the second test v Australia.

The next year he appeared in the first test against the Springboks and played most of the game on the wing when Don Cobden retired hurt. Missed the second test but was recalled for the third.

A fast and resourceful flanker who stood 6' 1" and weighed 14 stone. Southland selector 1957-61. His brother, J.C. Ward, represented Otago 1942.

WATERMAN Alfred Clarence
b: 31.12.1903, Auckland *d:* 22.10.1997, Whangarei
Wing threequarter

Represented NZ: 1929; 7 matches – 2 tests, 18 points – 6 tries

First-class record: North Auckland 1928,29 (Whangarei City); NZ Trials 1929

Educated Auckland Grammar School, 1st XV 1920. Joined the Ohaewai club on leaving school and later played for Kaeo, P & T, Kaitaia and Old Boys before representing his union from the City club in Whangarei, scoring a try and kicking two conversions in his provincial debut. Toured Australia 1929 playing in seven matches including the first two tests. Stood 5' 8" and weighed 11st 4lb. Coached junior teams for the Old Boys club in Whangarei 1937-40.

WATKINS Eric Leslie
b: 18.3.1880, Akaroa *d:* 14.8.1949, Lower Hutt
Hooker

Represented NZ: 1905; 1 match – 1 test

First-class record: Wellington 1901-06 (Wellington College OB); Wanganui 1907 (Raetihi); North Island 1904,06; Wellington Province 1905; Wellington-Wairarapa-Horowhenua 1905

Educated Wellington College. Played 40 games for Wellington and one for New Zealand, hooking with Dodd against Australia at Dunedin 1905. Joined rugby league and toured England with the 1907-08 'All Golds'.

WATSON James Donald
b: c 1872, Rochdale, England *d:* 25.12.1958, New Plymouth
Forward

Represented NZ: 1896; 1 match

First-class record: Taranaki 1894,95,99 (Clifton), 1896-98 (Tukapa)

Educated Watson's Academy (Edinburgh). Played for the Edinburgh Academicals club and later represented Lancashire from the Rochdale Hornets. Moved to New Zealand and settled in Waitara. Donald Watson represented New Zealand in the 1896 match against Queensland.

WATSON William Donald
b: 22.12.1869, Eketahuna *d:* 25.3.1953, Masterton
Forward

Represented NZ: 1893,96; 3 matches

First-class record: Wairarapa 1889,90 (Red Star), 1891-96,99 (Masterton); North Island 1894

One of four players sent to Australia to reinforce the 1893 New Zealand team, Watson arrived in time to appear in the two final matches, v Western NSW Branch and New South Wales. Three years later he played against Queensland at Wellington. Played on 24 occasions for Wairarapa and described in that union's jubilee history as "a long striding and speedy player . . . one of the finest loose forwards of his era".

WATT Bruce Alexander
b: 12.3.1939, Marton
First five-eighth

Represented NZ: 1962-64; 29 matches – 8 tests, 27 points – 4 tries, 5 dropped goals

First-class record: Wanganui 1957,58 (Hunterville); Canterbury 1959-68 (Christchurch); South Island 1960,61,64-67; NZ Trials 1958-63,65-67; NZ Juniors 1959; New Zealand XV 1960

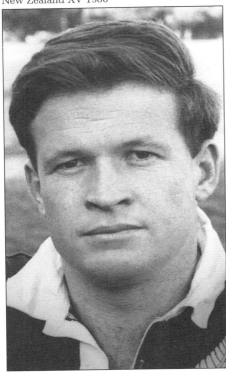

Bruce Watt

Educated Hunterville Primary School and Wanganui Technical College, 1st XV 1955. Selected for the 1962 tour of Australia where he marked his debut in international rugby by scoring two tries in the first test.

Missed the second test but was recalled for the second game of the return series against the Wallabies in that year – a series in which New Zealand fielded three different first five-eighths.

Watt played in both tests against the 1963 English tourists and then departed for Britain and France with the 1963-64 All Blacks. His 20 appearances on tour included the Welsh English and Scottish games. He dropped a goal to win the Welsh international. Played his last international in the first test against the 1964 Wallabies, although he continued to win selection for interisland fixtures and All Black trials until 1967.

Standing 5' 8" and weighing 12 stone, Bruce Watt was a steady five-eighth, quick on his feet and an accurate dropkicker. Marlborough selector 1976.

WATT James Michael
b: 5.7.1914, Dunedin *d:* 17.9.1988, Auckland
Wing threequarter

Represented NZ: 1936; 2 matches – 2 tests; 6 points – 2 tries

First-class record: Otago 1935,36 (University); Wellington 1937 (Wellington College OB); NZ Trials 1935; NZ Universities 1936

Educated Wellington College, 1st XV 1931. Started with the Otago team 1935 and scored a try when it lifted the Ranfurly Shield from Canterbury at the end of that season.

Toured Japan with the 1936 NZ Universities team; leading try scorer with seven. Later that year he appeared in the two tests v Australia, scoring a try in each. A knee injury the next year severely affected his rugby career. Jim Watt was described as having "speed and thrust, sure hands and a sound defence. Always in position and in many of his slashing runs was able to use a disconcerting change of pace." Stood 5' 10" and weighed 12½ stone.

Watt was NZ Universities title holder in the 440 yards 1934-36 and runner-up in this event at the 1937 national championships. His best time was 49.6 secs. His father, M.H. Watt, represented NZ Universities 1908 at rugby and his brother, M. Watt, also played for the students 1938.

WATT James Russell
b: 29.12.1935, Dunedin
Wing threequarter

Represented NZ: 1957,58,60-62; 42 matches – 9 tests, 114 points – 28 tries, 9 conversions, 4 penalty goals

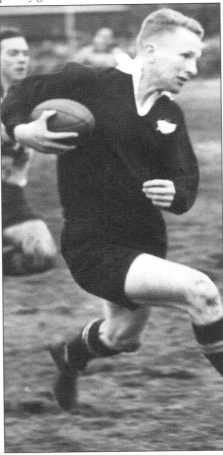

Russell Watt

First-class record: Otago 1955,56 (Kaikorai); Southland 1957 (Gore Pioneer); Wellington 1958-64 (Athletic); South Island 1956,57; North Island 1961; NZ Trials 1956,57,60-63; New Zealand XV 1958; NZ Under 23 1958

Educated Wakari Primary and Otago Boys' High School. Toured Australia with the 1957 All Blacks, playing in 10 of the 13 matches, but did not make his international debut until the next season when he was called into the second test against the Wallabies.

Watt was next selected for the 1960 tour of South Africa where he played in 19 of the 26 matches including all four tests. Included in the home series v France 1961, he could not play in the second test because of a suspension imposed after he was ordered off in a club game. Ended his All Black career with the 1962 visit to Australia where he appeared in both internationals.

In his 1960 tour book, *Trek out of Trouble* Noel Holmes described Russell Watt, "determined on attack, enterprising on defence – he popped up in the most surprising places. He could be picked on the far side of any ground by his effortless, flowing run. Reacted fiercely to obstruction." Stood almost six feet and weighed 12½ stone. His brother, Graeme Watt represented Otago 1976,77.

Murray Watts

WATTS Murray Gordon
b: 31.3.1955, Patea
Wing threequarter

Represented NZ: 1979,80; 13 matches – 5 tests, 28 points – 7 tries

First-class record: Manawatu 1975-77 (Teachers College); Taranaki 1978-85 (New Plymouth HSOB); NZ Trials 1979,80; NZ Juniors 1975-77; Manawatu-Horowhenua 1977

Educated Mangatoki, Mahoe and Eltham Primary Schools and Stratford High School. A strong and aggressive wing who displayed enterprise and backed up well, Murray Watts

was 1.80m and weighed nearly 82kg.

He appeared in both tests against the 1979 French tourists, scoring a try in his debut. Toured Australia later that year but did not make the test side, but then regained his place for the first two internationals in Australia 1980 and replaced the injured Tim Twigden in the third. His brother, Allan, represented NZ Services 1975.

WEBB Desmond Stanley
b: 10.9.1934, Kawakawa *d:* 24.3.1987, Whangarei
Hooker

Represented NZ: 1959; 1 match – 1 test

First-class record: Auckland 1957,58 (University); North Auckland 1959 (Whangarei HSOB), 1961 (Towai-Maromaku), 1962-65 (Mid-Northern); NZ Trials 1959,61; NZ Universities 1955-58

Educated Maromaku Primary, Wairoa Hill School and Gisborne Boys' High School. Represented NZ Universities (including the students' defeat of the 1956 Springboks) before playing at provincial level. Replaced Ron Hemi for the second test against the 1959 Lions – his sole All Black appearance. Webb was a quick-striking hooker and an indefatigable chaser of the ball who stood 5' 11" and weighed 12st 10lb. Captained North Auckland 1962-65.

WEBB Peter Purves
b: 15.2.1854, Wellington *d:* 28.11.1920, Wellington
Forward

Represented NZ: 1884; 8 matches

First-class record: Wellington Clubs 1875-77; Wellington 1882,83,85 (Wellington)

Educated Wellington College. Toured Australia with the 1884 New Zealand team after replacing an original selection, George Campbell. Webb played in the three fixtures with New South Wales.

He was described by the team manager, S.E. Sleigh, as "a strong, heavy forward invaluable in the scrummage. A quiet player who did a lot of really hard work". Wellington selector 1885 and served on that union's committee 1885,87; treasurer 1888; secretary 1888,89.

WEBB Thomas Robert Dobson
b: 12.7.1920, Waikouaiti *d:* 6.11.1972, Christchurch
Fullback

Represented NZ: 1947; 4 matches 38 points – 14 conversions, 2 penalty goals, 1 dropped goal

First-class record: Otago 1941 (Pirates); Wellington 1943 (Navy); Southland 1946-49 (Pirates); NZ Trials 1947

Educated Otago Boys' High School. Selected for the 1947 All Blacks in Australia as second-string fullback to Bob Scott. In three games he scored 38 points, including 19 against Combined Northern, but did not add any in the match against Auckland (lost 3-14) when the team returned. A steady player and an accurate goal kicker. Webster weighed 12st 10lb and stood six feet.

WELLS John
b: 4.1.1908, Dargaville *d:* 7.1.1994, Wellington
Flanker

Represented NZ: 1936; 3 matches – 2 tests

First-class record: North Auckland 1928-32 (Dargaville); Wellington 1933 (University), 1934-37 (Athletic); North Island 1936,37; NZ Trials 1937; NZ Universities 1933; 2nd NZEF 1941,42

Educated Dargaville High School. A robust and honest toiler, standing 5' 10" and weighing 14 stone, Jock Wells was selected for the 1936 home series against Australia and also appeared in the mid-week game v South Canterbury. During WWII he played for the 2nd NZEF team in Egypt. President of the Athletic club 1959-61 and the Wellington RFU 1969.

WELLS William J.G.
b: c 1872 *d:* ?
Forward

Represented NZ: 1897; 7 matches

First-class record: Taranaki 1891,94-97,99 (Clifton)

Replaced Alex Kerr before the 1897 New Zealand team left for Australia. Bill Wells weighed 13 stone and appeared twice against New South Wales among his seven tour matches.

WESNEY Arthur William
b: 1.2.1915, Invercargill *d:* 23.11.1941, Sidi Rezegh, Libya
Centre threequarter and fullback

Represented NZ: 1938; 3 matches, 23 points – 3 tries, 2 conversions, 2 penalty goals, 1 dropped goal

First-class record: Southland 1934,36-39 (Invercargill HSOB); Canterbury 1940 (Army); South Island 1938; NZ Trials 1939

Educated Southland Boys' High School. A reliable, versatile and straight running back who played twice at centre and once at fullback on the 1938 tour of Australia, scoring three tries in the 57-5 win over Federal Capital Territory.

Captained the 6th Brigade team and played for the 2nd NZEF side v South Africa in Egypt. Represented Southland at water polo and was runner-up at national diving championships 1933-35. Wesney was killed in action at Sidi Rezegh in the North African campaign.

WEST Alfred Hubert
b: 6.5.1893, Inglewood *d:* 7.1.1934, Hawera
Loose forward

Represented NZ: 1920,21,23-25; 24 matches – 2 tests, 20 points – 6 tries, 1 conversion

First-class record: Taranaki 1920-25 (Hawera); North Island 1920,21; NZ Trials 1921,24; NZ Services 1918-20

Educated Matapu School. Began playing senior club rugby 1911 but did not reach provincial level until after WWI. Served as a gunner with the NZ Field Artillery and was gassed but recovered to join the NZ Services team which won the King's Cup and toured South Africa.

After one game for Taranaki he was selected for the 1920 interisland game and then toured Australia with the All Blacks. In 1921 he appeared in the second and third tests v South Africa. Next played for New Zealand in the second of the three-match home series against New South Wales 1923. On tour with the 1924-25 'Invincibles', Alf West appeared in only 10 games in Great Britain and two in Canada. He retired after just one game for Taranaki in the 1925 season.

Described by Winston McCarthy as one of the hardest forwards to play for New Zealand . . . "Taranaki's favourite son," West's statistics for the 1924-25 tour were given as 6' 1" and 13st 12lb. Served on the Hawera club's committee 1922-26 and as club captain 1927-29.

WESTON Lynley Herbert
b: 1.9.1892, Auckland *d:* 2.11.1963, Whangarei
First five-eighth

Represented NZ: 1914; 1 match

First-class record: Auckland 1912-14 (College Rifles); North Auckland 1920-22 (Whangarei United); North Island 1914; Auckland-North Auckland 1921

Lyn Weston

A brilliant if slightly erratic five-eighth who toured Australia with the 1914 New Zealand team but appeared in only one game – the second encounter with Queensland. Settled in Whangarei after WWI and became North Auckland's first captain on the formation of that union 1920. Father of Dave Weston, Auckland 1949,50 and All Black reserve 1950.

WHETTON Alan James
b: 15.12.1959, Auckland
Loose forward

Represented NZ: 1984-91; 65 matches – 35 tests, 104 points – 26 tries

First-class record: Auckland 1981-92 (Grammar); North Island 1983; NZ Trials 1983,84,87,89,90; NZ Juniors 1982; NZ Colts

195

Gary, left, and Alan Whetton against Wales in 1988.

1980; North Zone 1987,88; S Wilson XV 1984; Barbarians 1985,87,89

Educated Auckland Grammar School, where he played in the first XV in 1977. Whetton played for Auckland third grade and Colts before he made his senior debut in 1981. He played variously on either side of the scrum, at No 8 or as a lock. He had specialised in the blindside flanker's role by the time he was first chosen for the All Blacks, for the tour of Australia in 1984.

He had an unusual beginning to his international career, his first four tests all being as a replacement (two against Australia, one against England and one against Argentina). He was chosen for the tour of South Africa in 1985 and went on the unofficial replacement tour the following year, making his full test debut on his return in the second test against Australia. He was dropped for the third, however, and not wanted for the tour of France at the end of the year.

Whetton's golden years began in 1987 with selection in the World Cup squad. He played in all six cup matches, scoring five tries, and from then became one of the permanent members of the dominant All Black side that went until 1990 without losing a test. He played in each test after the cup until the tour of Wales and Ireland in 1989, during which he pulled a hamstring and had to miss the tests.

He was back in 1990 for each of the tests against Scotland and Australia and played in both tests on the tour of France at the end of the year. He was again injured in 1991, though played in one test in Argentina and in the first five of the six at the World Cup. He was not selected for New Zealand again.

Whetton was the classic blindside flanker, having the height and strength for the tight forward's role as well as lineout ability, and speed that allowed him to fulfil ideally the loose forward's prime role of supporting the ball carrier. His number of tries was evidence of his ability to get to the right place by the right time.

The 1981-91 All Black lock and 1990,91 captain, Gary Whetton, is his twin brother. An uncle, Ron, played for Auckland in 1955.

Alan Whetton also played for the Southern Hemisphere in 1991.

WHETTON Gary William
b: 15.12.1959, Auckland
Lock

Represented NZ: 1981-91; 101 matches – 58 tests, 36 points – 9 tries

First-class record: Auckland 1980-92 (Grammar); North Island 1982-84,85; NZ Trials 1982,89-91; NZ Colts 1979,80; North Zone 1987,88; Barbarians 1987,89; S Wilson Invitation XV 1984

Whetton was educated at Auckland Grammar School where he played in the first XV in 1977 after playing soccer for the previous three years. He also played for Auckland third grade and Auckland Colts in 1979, the year he also played for New Zealand Colts.

Whetton was first chosen for the All Blacks in the third test against South Africa in 1981 and at the end of that year toured Romania and France, playing in each of the three tests. In 1982, he was selected for only the third test against Australia but played all four against the British Isles the following year. A knee injury during an invitation tour of South Africa ruled him out of the 1983 test against Australia and also of the tour of England and Scotland at the end of the year.

Whetton thereafter became an automatic test selection, playing against France and Australia in 1984 and against England in 1985. He would have been one of the first chosen for the abandoned tour of South Africa and went on the replacement tour of Argentina instead. He also went on the unauthorised Cavaliers' tour of South Africa in 1986 and thus missed a test against France and the first against Australia. He was back for the second and third though, and played in both on the tour of France. He did not miss another test until the end of 1991, giving him 40 in succession.

He was one of the key figures in the All Blacks' unbeaten test sequence from 1987, which included the World Cup, until 1991 and was one of the dominant figures in world rugby.

Auckland's ascendancy over the same period, including its record hold on the Ranfurly Shield, also owed much to the presence and skills of Whetton, among others.

He took over the New Zealand captaincy for the 1990 series against Australia after Wayne Shelford had been dropped, retaining it through to the end of 1991. The World Cup quarterfinal against Canada in Lille in France was Whetton's 56th test, beating the record of 55 set by Colin Meads. Whetton was to play only two more, however.

New coach Laurie Mains in 1992 did not select Whetton for even a trial, clearly telling him he did not figure in Mains's plans. Whetton was chosen for the World XV that played against Mains's All Blacks in the third test of the 1992 centenary series and he played the rest of the season just for Auckland. He thereafter played out his career in France, including the unusual distinction for a New Zealander of playing in a French club final.

Whetton, who weighed about 105kg and was 1.98m, for the early part of his career was seen as being the junior partner to Andy Haden but he became recognised as one of the greatest forwards to have played for New Zealand. His achievements as a lineout jumper and a tight forward with a loose forward's speed were immense.

Whetton was in regular demand for overseas matches, including a World XV in 1988 that marked Australia's bicentenary and a Welsh union World XV in 1984. Whetton also captained the Southern Hemisphere in its win over the Northern in Hong Kong in 1991.

An indication of New Zealand rugby's stability during the Whetton years was that he had just four locking partners in his 58 tests – Andy Haden (12), Albert Anderson (four), Murray Pierce (25) and Ian Jones (17).

Brothers In Arms, a biography of Gary and his brother Alan, was published in 1991 (Moa).

WHINERAY Wilson James
b: 10.7.1935, Auckland
Prop

Represented NZ: 1957-65; 77 matches – 32 tests, 24 points – 7 tries, 1 dropped goal

First-class record: Wairarapa 1953 (Martinborough); Mid Canterbury 1954 (Rakaia); Manawatu 1955 (University); Canterbury 1956,57 (Lincoln College); Waikato 1958 (City); Auckland 1959-63,65,66 (Grammar); South Island 1957; North Island 1958,59,61-63,65; NZ Trials 1957-63,65; NZ Under 23 1958; NZ Colts 1955; NZ Universities 1956,57; NZ XV 1958

Educated Auckland Grammar School, 1st XV 1950,51. Whineray played senior club rugby for

Waikaia in Southland 1952 but made his first-class debut for Wairarapa the following year. He went on to play for five other unions in both islands with his provincial career culminating in seven years representing Auckland. First captained that province 1959 when the Ranfurly Shield was lifted from Southland.

Toured Ceylon with the 1955 NZ Colts and then won a place in the Canterbury Ranfurly Shield side, which beat the 1956 Springboks, and represented NZ Universities when they too defeated the tourists. With his Colts team-mate Colin Meads, he was first selected for New Zealand on the 1957 tour of Australia.

After playing in nine matches for the All Blacks, including the two tests in Australia, Whineray led the NZ Under 23 team on an undefeated tour of Japan and Hong Kong in 1958 and was appointed captain of the New Zealand team to meet the Wallabies. At 23 he was the youngest man to gain this honour since Herb Lilburne led the All Blacks in the first test in Australia 1929. The 1958 series was won two tests to one. He subsequently captained his country against the 1959 Lions (3-1), in South Africa 1960 (lost 1½-2½), v France 1961 (3-0), in Australia (2-0) and against the 1962 Wallabies (2-0), v England 1963 (2-0) and on the 1963-64 tour of the British Isles and France where four internationals were won and the Scottish game drawn. When he chose to restrict his play to club level in the 1964 season, Whineray ended a sequence of 28 tests, 26 as captain.

He returned to first-class rugby to lead the All Blacks to a 3-1 series win over the 1965 Springboks. Retired from international play at the end of this year having suffered only five losses in the 30 test matches in which he captained New Zealand.

Wilson Whineray played all his internationals as a prop, normally on the loosehead side of the front row, but appeared later for Auckland and occasionally in All Black tour games as an effective number eight.

Describing his play, Colin Meads commented: "Whineray, it was said, was not a strong scrummager yet it is hard to recall a time when our scrum suffered because of any weakness. No man has been more effective in the move named for him, the 'Willie Away' . . . he had no peer with the ball at his feet at a time when such an exercise was fobbed off as being old-fashioned. As a captain he inspired fierce loyalty."

Writing of his leadership on the 1963-64 British tour, Terry McLean described Whineray variously as "highly intelligent, mature beyond his years, a most earnest student of the game, a firm but calm leader who commanded unqualified admiration. I would unhesitatingly acclaim him as New Zealand's greatest captain."

When Whineray scored the last of the All Blacks' eight tries in a brilliant display against the Barbarians, the Cardiff Arms Park crowd spontaneously chanted his name and rose to sing 'For He's a Jolly Good Fellow' in a moving tribute to the man.

Stood six feet and weighed between 14st 10lb and 15½ stone during his All Black career, captaining the team in 68 of his 77 appearances. He played a total of 240 first-class matches – his last being one game in the 1966 season when Auckland lost the Ranfurly Shield to Waikato.

Whineray coached the Grammar club in Auckland 1970-73 and Onslow in Wellington 1974. NZ Universities heavyweight boxing champion. Named as New Zealand sportsman of the year 1965. A member of the Eden Park Board of Control from 1980.

Whineray continued to make an impact beyond rugby in later life. He became managing director of Carter Holt Harvey, one of New Zealand's biggest companies, a director of several other companies, and became the second chairman of the Hillary Commission, the government agency responsible for fostering and funding sport and recreation. Whineray had also been publicly mentioned as a future governor-general.

Wilson Whineray on the attack against Australia in 1958.

New Zealand Representatives

WHITE Andrew
b: 21.3.1894, Invercargill *d:* 3.8.1968, Christchurch
Flanker

Represented NZ: 1921-25; 38 matches – 4 tests, 48 points – 10 tries, 9 conversions

First-class record: Southland 1919-23 (Waikiwi); Canterbury 1927 (Christchurch); South Island 1921,22,24; NZ Trials 1921,24

Educated Southland Boys' High School. Selected for the Southland team after serving in WWI with the Otago Mounted Rifles. Made his All Black debut in the first test against the 1921 Springboks but was dropped for the rest of the series. Toured Australia the next year, scoring four tries in as many games, and appeared in the final match against New South Wales in the 1923 home series.

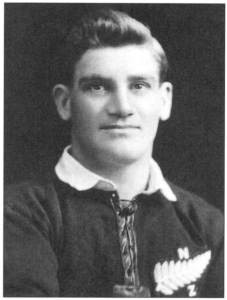
'Son' White

In Britain and France with the 1924-25 'Invincibles', 'Son' White played in 21 games including the Irish, English and French internationals. He was described as "the team's best forward in the loose; the most perfect player in control of the ball; follows up fast and is a demon on defence and attack." Stood 5' 10½" weighed 12½ stone and played a total of 75 first-class matches.

WHITE Hallard Leo
b: 27.3.1929, Kawakawa
Prop

Represented NZ: 1953-55; 16 matches – 4 tests, 6 points – 2 tries

First-class record: Auckland 1949-63 (Northcote); North Island 1955; NZ Trials 1953,57,59; Rest of New Zealand 1955

Educated Kawakawa District High School. White was a spirited and durable prop at 15st 4lb and six feet. In a total of 235 first-class matches he appeared a record 196 times for Auckland, continuing to perform effectively for that province during its early 1960s Ranfurly Shield tenure, almost 10 years after his All Black career ended.

First selected for New Zealand to tour Britain and France 1953-54 where he played in 15 of

the 36 matches including the Irish, English and French internationals. His next, and last, appearance in the All Black jersey was in the third test of the home series v Australia 1955.

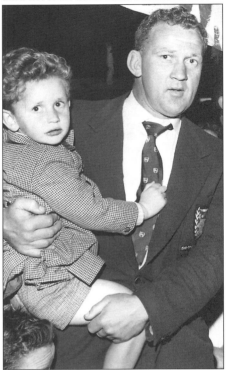

'Snow' White

'Snow' White has been a member of the Auckland RFU management committee, coached representative teams for that union and the Northcote and Mt Wellington clubs. President of Auckland 1988,89; NZRFU president 1990

WHITE Richard Alexander

b: 11.6.1925, Gisborne
Lock

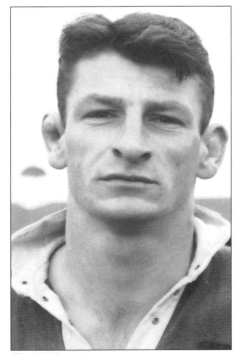

'Tiny' White

Represented NZ: 1949-56; 55 matches – 23 tests, 33 points – 11 tries
First-class record: Poverty Bay 1949-57 (Gisborne HSOB); North Island 1949-56; NZ Trials 1950,53,56; New Zealand XV 1949,52,54,55; Rest of New Zealand 1956; Poverty Bay-East Coast 1949,55,56; Poverty Bay-East Coast-Bay of Plenty 1950

Educated Ngatapa Primary, Gisborne District High School and Feilding Agricultural College, 1st XV 1941,42. Served in Japan at the end of WWII with J Force and returned to win selection in the two tests v Australia 1949 as Poverty Bay's first All Black.

White's international career continued with 23 consecutive tests: against the 1950 Lions, in Australia 1951, against the 1952 Wallabies, on the 1953-54 tour of Britain and France, against the 1955 Wallabies and the 1956 Springboks.

He played more often on the British tour than any other All Black – 30 of the 36 matches – and his outstanding form led Winston McCarthy to write: " 'Tiny' White will go down in rugby history alongside Charles Seeling and Maurice Brownlie as the best New Zealand has produced. Some of his performances were amazing . . . he looked as though he could play in 30 more matches."

In his book, *On With the Game* Norman McKenzie wrote: "Richard White is the greatest lock forward I have ever seen. He had the ability to shine in the lineout, to shine in the tight work, and to shine in the open. What more can you ask of a lock?" White stood over 6' 2" and his playing weight was around 16 stone.

Served as president of the Gisborne HSOB club. His son, David, represented Canterbury 1979-81. Mayor of Gisborne 1977-83.

WHITE Roy Maxwell

b: 18.10.1917, Dannevirke *d:* 19.1.1980, Wellington
Flanker

Represented NZ: 1946,47; 10 matches – 4 tests, 3 points – 1 try

First-class record: Wellington 1939-44,46-48 (Petone), 1945 (Trentham Army); North Island 1944,46,47; NZ Trials 1947,48; NZ Combined Services 1945

Educated Hastings Boys' High School. A regular Wellington representative during the years of WWII. White played for New Zealand in both tests against the 1946 Wallabies, scoring a try in his debut, and the following year toured Australia holding his place in the test scrum for the two-match series. His tour statistics were given as 6' 1" and 14st 6lb.

White captained Wellington 1945-48 and the North Island 1946. He served on the Petone club's committee for 19 years; president 1968,69,76-79. Wellington selector 1961,63 and a member of that union's junior management committee. New Zealand R class yachting champion.

WHITING Graham John

b: 4.6.1946, Wanganui
Prop

Represented NZ: 1972,73; 31 matches – 6 tests, 4 points – 1 try

First-class record: King Country 1969 (Taumarunui), 1970-74 (Athletic); North Island 1972; NZ Trials 1970-74; NZ Juniors 1969; Wanganui-King Country 1971

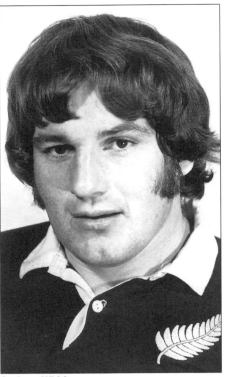

Graham Whiting

Educated Taumarunui High School. Whiting played his early rugby as a lock. Later appeared mostly in the front row. Included on the All Blacks' 1972 internal tour and appeared in the first two tests against the Wallabies in that season.

On the 1972-73 British tour Whiting won a place in four internationals. Played in three of the four matches on the 1973 internal tour.

The *1972 DB Rugby Annual* described him as "hugely successful in his All Black debut. Strong, if sometimes ungainly, scrummager. Perhaps inclined to laziness but top value when stirred." Stood over 6' 3" and weighed 17¹/₂ stone. Turned to rugby league 1975 and played for the Maritime club in Auckland.

WHITING Peter John

b: 6.8.1946, Auckland
Lock

Represented NZ: 1971-74,76; 56 matches – 20 tests, 20 points – 5 tries

First-class record: Auckland 1968-74 (Ponsonby); NZ Under 23 1967; North Island 1970,72-74; NZ Trials 1967,71-74; New Zealand XV 1974; New Zealand Juniors 1968,69; Coronation Shield Districts 1972

Educated Parnell Primary and Auckland Grammar School, 1st XV 1963,64. Made his All Black debut 1971, missing the third test against the Lions because of injury.

Continued his All Black career in the three tests against the 1972 Wallabies, remarkably, for a lock, scoring a try in each, and in 21 of the 32 matches, including all five internationals, on the 1972-73 visit to the British Isles and France. Injury kept him out of rugby for much of the 1973 season but he returned to the All Black scrum for the 1974 series in Australia and the centenary international in Ireland.

Whiting was overseas during 1975 but came back for the home test v Ireland the following year and was selected for the South African tour.

Injuries restricted him to 11 of the 24 games but he appeared in all four tests.

The 1976 *DB Rugby Annual* said that he "proved indestructible, although the Springboks and natural causes did their best to prove otherwise. Overcame a crippling injury to perform outstandingly in the first test; overcame torn rib ligaments to emerge as the hero of the second test; overcame Springbok sprigs which almost ripped off his ear, to see out the third test; and proved himself unchallenged as a lineout ace in the fourth test."

Standing 6' 6" and weighing 17st 4lb, 'Pole' Whiting was acclaimed by some critics as the best lineout performer of his time.

Peter Whiting

WICKES Craig David
b: 26.2.1962, Whakatane
Wing threequarter

Represented NZ: 1980; 1 match

First-class record: Manawatu 1979,80 (Palmerston North BHS), 1981,86 (Kia Toa); NZ Colts 1980,81

Educated Otakiri Primary, Kawerau Intermediate, Normal Intermediate and Palmerston North Boys' High School, 1st XV 1978-80 from where he represented Manawatu for two seasons and became the first schoolboy All Black, going on as a replacement for the injured Ken Taylor against Fiji at Auckland 1980.

A strongly built player, who weighed nearly 83kg and stood 1.80m, Wickes was exceptionally fast and a strong tackler. He also represented Rangitaiki Primary Schools 1973, Manawatu Under 16 1976, Manawatu Under 18 1978, NZ Secondary Schools 1979 and toured Australia with the 1980 NZ Colts team. West Coast North Island athletics rep 1977-79 with best times of 10.82 secs for the 100 metres and 23 secs for the 200. Injury interrupted his career.

WIGHTMAN David Ross
b: 10.8.1929, Hamilton
Threequarter

Represented NZ: 1951; 4 matches, 18 points – 6 tries

First-class record: Otago 1949,50 (University); Auckland 1951 (Training College); Waikato 1952,53 (Hamilton HSOB); North Island 1951; NZ Trials 1951

Educated Morrinsville District High School, 1st XV 1943-47. A member of Otago's Ranfurly Shield team while studying in Dunedin, Ross Wightman moved to Auckland then toured Australia with the 1951 All Blacks. Played in only four games but scored six tries including three against a Combined XV. Stood six feet and weighed 13st 3lb at the time of this tour. A selector and coach in Morrinsville. Represented Otago at indoor basketball and Waikato at cricket.

WILLIAMS Alexander Leonard
b: 18.10.1898, Middlemarch *d:* 13.6.1972, Dunedin
Lock

Represented NZ: 1922,23; 9 matches, 3 points – 1 try

First-class record: Otago 1921-25 (Kaikorai); South Island 1922-24; NZ Trials 1924

After only one match for Otago as a replacement, Len Williams played rugby for the South Island and toured Australia with the 1922 New Zealand team. He appeared again in the first two games against the 1923 New South Wales tourists. Considered unlucky to miss selection for the 1924-25 team after appearing in the interisland game and the final trial.

WILLIAMS Bryan George
b: 3.10.1950, Auckland
Threequarter

Represented NZ: 1970-78; 113 matches – 38 tests, 401 points – 66 tries, 22 conversions, 30 penalty goals, 1 dropped goal

First-class record: Auckland 1968-82 (Ponsonby); North Island 1974,75,77; NZ Trials 1970-72,74-77

Educated Mt Albert Grammar School, 1st XV 1965-67 and Auckland Secondary Schools rep 1967, also Roller Mills Primary Schools team 1961. Williams became a regular member of the Auckland team 1969 as an 18-year-old. The next year he was selected for the tour of South Africa, the youngest member of the 1970 All Blacks. An outstanding success on this tour, he appeared in all four tests and scored 14 tries in 13 appearances.

Later that year he was invited to take part in the RFU centenary matches in England. Williams missed only the third test against the 1971 Lions (with a groin injury); headed the try scorers on the 1972 internal tour with 12; scored a try in each of the three tests against the 1972

Bryan Williams against Australia in 1972.

Wallabies and then played 25 of the 32 games on the 1972-73 British tour including all five internationals.

Appeared in the 1973 home test v England but was not included in the internal tour. The following season he returned to the New Zealand team for the Australian tour, his seven matches included the three tests. Toured Ireland 1974 playing in the centenary test. Scored two of the All Blacks' four tries v Scotland on a waterlogged Eden Park 1975 and played against the Irish tourists 1976 before visiting South Africa again.

On this tour he was equal leading try scorer with nine and also scored 43 points from goal kicks in 16 games which included all four tests. After appearing in the home series against the 1977 Lions, Williams toured France with the 1977 All Blacks. He suffered a dislocated hip in the first test and was invalided home. This injury brought an end to his sequence of 25 internationals since the fourth test 1971.

Restored to full fitness, he played in the series against the 1978 Wallabies and then departed for Britain on his seventh All Black tour. Played in all four internationals although his appearance in the Irish match was as a second half replacement for Brian Ford.

Bryan Williams' total of 66 tries for New Zealand is only one behind John Kirwan's record. Williams scored New Zealand's only try in his international debut (first test v South Africa 1970).

In his biography, Lions and Welsh wing Gerald Davies said: "People frequently ask me which one of all the wingers I faced was the most difficult to mark. I always thought that Bryan Williams was a dangerous and effective winger. He was stockily built and very fast, with a devastating sidestep off his left foot."

Williams' fellow All Black Fergie McCormick wrote of him: "Power! What power in those great legs of his! He can beat men by power alone, by pace or by that giant sidestep. And he can kick goals too!" Bryan Williams stood 5' 10" and weighed between 13st 2lb and 14st 4lb during his All Black career. His biography, *Beegee* was published by Rugby Press, 1981. Named by sporting journalists as "Rugby Player of the Decade" 1980. His brother, Ken, represented Auckland 1968,69 and was an All Black trialist 1968.

Williams devoted his rugby energies through the 1990s to the emergence of Western Samoa as an international rugby force. He was first the team's technical director and by 1996 its coach. He was an unremitting and unapologetic advocate for Western Samoan rugby, often criticising New Zealand's treatment of it.

WILLIAMS Claude Wright
b: 16.5.1916, Winton
Loose forward and lock

Represented NZ: 1938; 4 matches, 6 points – 2 tries

First-class record: Canterbury 1937-39 (University); South Island 1938,39; NZ Trials 1937,39

Educated Ashburton High School and Timaru Boys' High School. Weighing 14st 12lb and standing 6' 2", he toured Australia with the 1938 All Blacks playing as a flanker, number eight and lock in his four appearances.

WILLIAMS Graham Charles
b: 26.1.1945, Wellington
Flanker

Represented NZ: 1967,68; 18 matches – 5 tests, 50 points – 16 tries, 1 conversion

First-class record: Wellington 1964-72,74-76 (Wellington); North Island 1970,72; NZ Trials 1965-69,71; NZ Juniors 1965,66; NZ Under 23 1967

Educated Rongotai Intermediate and Rongotai College, 1st XV 1960-63. A very fit, lightweight (13st 2lb, six feet) flanker, Graham Williams became a regular member of the Wellington team in his first year out of school.

Graham Williams

Toured Britain with the 1967 All Blacks appearing in all four internationals and scoring six tries in nine games – a total equalled only by Ian Kirkpatrick among the forwards. In 1968 he toured Australia, playing in eight matches including the second test. Surprisingly, he did not play for New Zealand again although he continued to represent Wellington until 1976, appearing on a record 174 occasions for that union.

WILLIAMS Peter
b: 22.4.1884, Dunedin *d:* 30.8.1976, Mosgiel
Hooker

Represented NZ: 1913; 9 matches – 1 test, 3 points – 1 try

First-class record: Otago 1908,10-14 (Alhambra); South Island 1912-14

Played his only international, the first test v Australia 1913, before touring North America where he appeared in eight games. Selected for the 1914 New Zealand team to tour Australia but was unable to travel.

WILLIAMS Raymond Norman
b: 25.4.1909, Taradale
Wing threequarter

Represented NZ: 1932; 1 match

First-class record: Canterbury 1930,31 (University); NZ Universities 1931

Educated Taradale School and Napier Technical College, 1st XV 1924-26. When playing for Napier Technical College OB club he was selected for the 1932 All Blacks to tour Australia but suffered a knee injury in the preliminary game v Wellington. Although he was passed fit by a doctor, Williams later approached the team's manager, Billy Wallace, and advised him that his knee would not stand the strain of a tour. Replaced in the touring party by Nelson Ball.

Williams weighed 9st 10lb and stood under 5' 9" (although one source gave his weight as 11st 3lb). He coached club rugby in Napier until leaving for South Africa 1937. Also coached in Cape Town and Salisbury, Rhodesia, (now Harare, Zimbabwe).

WILLIAMS Ronald Oscar
b: 20.7.1963, Suva
Prop

Represented NZ: 1988,89; 10 matches

First-class record: Auckland 1984 (Northcote); North Harbour 1985-94 (Northcote); Maunsell Sports Trust Invitation XV 1987; NZ Trials 1988-90,92

One of the originals when North Harbour was formed in 1985, Williams was first selected for the All Blacks for the tour of Australia in 1988, on which he played in six matches.

He was retained for the tour the following year, of Wales and Ireland, where he played in another four.

Williams, a stalwart of North Harbour for a decade, never played a test. He was essentially a tour backup player to established test props Richard Loe and Steve McDowell who, unfortunately for Williams, were seldom injured.

He also played test rugby for Fiji.

WILLIMENT Michael
b: 25.2.1940, Wellington *d:* 5.9.1994, Wellington
Fullback

Represented NZ: 1964-67; 9 matches – 9 tests, 70 points – 1 try, 17 conversions, 11 penalty goals

First-class record: Wellington 1958-68 (University); North Island 1965,66; NZ Trials 1961-63,65-68; NZ Universities 1962-67

Educated Rongotai College, 1st XV 1956,57. A competent all-round fullback who was an accurate goalkicker, Williment's All Black debut was delayed by the long career of Don Clarke. He appeared in the first test against the 1964 Wallabies when Clarke was not available and when his great rival retired at the end of that year, Williment was brought into the New Zealand team for the 1965 series v South Africa.

Played in the first three tests but was not able to appear in the fourth after suffering concussion in the NZ Universities match against the tourists. Scored 37 points in the home series against the 1966 Lions and a further 14 in the 1967 jubilee test v Australia but was surprisingly not picked for the tour to Britain later in that year. Stood 6' 2" and weighed 14st 4lb.

Mick Williment in action on his home ground, Athletic Park.

Williment served as a North Island Under 18 selector and club captain of the Centurions. A member of the 1959 New Zealand Brabin Cup cricket team.

WILLOCKS Charles
b: 28.6.1919, Balclutha *d:* 25.8.1991, Balclutha
Lock

Represented NZ: 1946,47,49; 22 matches – 5 tests

First-class record: Otago 1944-48 (Clutha); South Island 1945-48; NZ Trials 1947,48; New Zealand XV 1945

Educated South Otago High School, 1st XV 1932-34. Joined the Star club on leaving school but transferred to Clutha before WWII. A very fit and hard-driving lock who weighed 14st 3lb and stood 6' 1", Charlie Willocks made his All Black debut in the two-test series against Australia 1946 and toured that country the following year playing in six of the first seven matches before a badly cut eye ended his tour.

After fine form for Otago, the Ranfurly Shield holders, in the 1948 season he was named in the New Zealand team to visit South Africa 1949 where he missed only the second test of the series owing to injury.

WILLOUGHBY Stanley de Lar Poer
b: 21.1.1904, Masterton *d:* 27.9.1985, Masterton
Loose forward

Represented NZ: 1928; 4 matches

First-class record: Wairarapa 1922-26 (Masterton), 1928,29 (Red Star); North Island 1928; NZ Trials 1924; Wairarapa-Bush 1923

Educated Masterton Central School, Wairarapa Primary Schools rep, and Masterton District High School. Played for New Zealand in the three-match series against New South Wales 1928 and in the extra game v West Coast-Buller. Coach and president of the Masterton club 1945,46. His brother, Seymour, represented Wairarapa 1920-28 and the North Island 1928. His son, Rex, played for Wairarapa 1956-58.

WILLS Murray Clifton
b: 11.10.1941, Hawera
Flanker

Represented NZ: 1967; 5 matches

First-class record: Taranaki 1962-72 (Patea); NZ Trials 1965-68,70

Educated Manutahi Primary, Taranaki Primary Schools rep, and Hawera High School. A fast and fit loose forward who stood six feet and weighed 14 stone at the time of his selection in the 1967 All Blacks to tour Britain. Murray Wills was hampered with a groin injury and played in only five of the 17 tour games.

Represented Taranaki on 132 occasions. Coach and committee member of the Patea club. A referee in south Taranaki. His father, Cliff, played for Taranaki 1926-34.

WILSON Alexander
b: 28.7.1874, Auckland *d:* 6.10.1932, Auckland
Forward

New Zealand Representatives

Represented NZ: 1897; 8 matches, 15 points – 2 tries, 3 conversions, 1 penalty goal

First-class record: Auckland 1896,97,99,1900,02 (Newton); North Island 1897

Described as "a heady player, good goalkicker and a grafter," Alex Wilson toured Australia with the 1897 New Zealand team playing seven games in that country and against Auckland on the team's return. Weighed 13st 4lb.

WILSON Alfred Leonard
b: 15.6.1927, Dunfermline, Scotland
First five-eighth

Represented NZ: 1951; 7 matches, 20 points – 4 tries, 1 conversion, 2 penalty goals

First-class record: Southland 1950-56 (Collegiate); South Island 1956; NZ Trials 1951,53,56; Rest of NZ 1956

Arrived in New Zealand at the age of two. Began playing representative rugby as a wing before switching to first five-eighth. He toured Australia with the 1951 All Blacks but was kept out of the test team by Laurie Haig. His statistics were given as 5' 10" and 11st 10lb. Len Wilson was a lively player, quick off the mark, could kick well with either foot and was regarded as a good tactician.

WILSON Bevan William
b: 22.3.1956, Dunstan
Fullback

Represented NZ: 1977-79; 12 matches – 8 tests, 60 points – 6 conversions, 16 penalty goals

First-class record: Otago 1974-79 (Matakanui); South Island 1977,79; NZ Trials 1977-79; NZ Juniors 1977

Bevan Wilson

201

Educated Omakau Primary and Dunstan High School. Wilson went into the New Zealand team for the third and fourth tests against the 1977 Lions when Colin Farrell was dropped. He had an impressive debut, kicking goals in both appearances in this series.

Played in three games in France later that year but was invalided home with a thigh muscle injury. After appearing in the 1978 series against the Wallabies he was named in the team to visit Britain but withdrew because of a knee injury. Recovered to play both tests v France 1979 and the international in Australia. Wilson stood 1.85m and weighed 82.5kg. His father, Bill, represented Otago 1951-57.

WILSON Douglas Dawson
b: 30.1.1931, Wanganui
Five-eighth

Represented NZ: 1953,54; 14 matches – 2 tests, 18 points – 5 tries, 1 dropped goal

First-class record: Canterbury 1952-54 (Christchurch HSOB); Wellington 1955-58 (Oriental); South Island 1953,54; NZ Trials 1953

Educated Christchurch Boys' High School. Played twice on the 1953-54 British tour at first five-eighth but appeared in the rest of his 14 games, including the English and Scottish internationals, at second five-eighth. He later played impressively on the wing for Wellington. His tour statistics were given as 5' 10" and 11½ stone. A Canterbury and Brabin Cup cricket representative.

WILSON Frank Reginald
b: 28.5.1885, Auckland *d:* 19.9.1916, France
Wing threequarter

Represented NZ: 1910; 2 matches, 4 points – 1 dropped goal

First-class record: Auckland 1906,07 (Ponsonby), 1908-10 (University); North Island 1909

Educated Ponsonby School and Auckland Grammar School, 1st XV 1900. Called into the 1910 All Blacks to tour Australia when Donald Cameron withdrew, Frank Wilson played against Wellington before the team departed (scoring his only points for New Zealand) then was injured in the first game in Australia and did not appear again.

A good all-round sportsman, he was considered one of Auckland's fastest sprinters, captained the Ponsonby cricket club to two championships and was also a noted swimmer and tennis player. Died of wounds received during the Battle of the Somme.

WILSON Hector William
b: 27.1.1924, Beaumont
Prop

Represented NZ: 1949-51; 13 matches – 5 tests, 9 points – 3 tries

First-class record: Otago 1948-51 (Ida Valley); South Island 1949-51; NZ Trials 1950,51; New Zealand XV 1949

A rugged and energetic prop, standing 5' 11" and weighing 14st 12lb, who came into the Otago Ranfurly Shield team during the 1948 season.

Played in the first test against the 1949 Wallabies but did not appear in the All Black jersey again until he was called into the fourth test team against the 1950 Lions, playing in place of the injured Johnny Simpson. After scoring New Zealand's first try in that international he retained his place in the test team for the series in Australia 1951.

WILSON Hedley Brett
b: 23.8.1957, Auckland
Hooker

Represented NZ: 1983; 3 matches, 4 points – 1 try

First-class record: Counties 1981-84 (Ardmore); Hawke's Bay 1986 (Napier Technical College OB); North Island 1983; NZ Trials 1984

Educated King's College, 1st XV 1974,75, Brett Wilson went to Lincoln College and appeared for Canterbury Colts 1979, moving to Counties 1980.

He was chosen for the All Blacks' tour of England and Scotland in 1983, when he was the second-string hooker to Hika Reid, because of the unavailability of the man with whom he vied for the Counties hooking berth, captain Andy Dalton. Both Wilson and Dalton were chosen for the same All Black trial team in 1984 – Wilson playing on the side of the scrum. He weighed 100kg and stood 1.80m.

WILSON Henry Clarke
b: 2.2.1869, Hillend *d:* 16.12.1945, Christchurch
Fullback

Represented NZ: 1893; 7 matches, 11 points – 2 conversions, 1 penalty goal, 1 goal from a mark

First-class record: Canterbury 1886-91 (North Canterbury), 1894 (Christchurch); Manawatu 1893 (Marton); Hawke's Bay 1896 (Napier)

Represented Canterbury for six years but was playing for the Athletic club in Wellington when he was named in the 1893 New Zealand team to Australia, although he did not appear for that union. His seven tour games included two v New South Wales and the two against Queensland. Described as "a sturdy little player, who tackled and ran well and who always got his kick in".

WILSON Jeffrey William
b: 24.10.73, Invercargill
Wing threequarter and fullback

Represented NZ: 1993-97; 45 matches – 35 tests, 196 points – 30 tries, 11 conversions, 8 penalty goals

First-class record: Southland 1992 (Cargill HS); Otago 1993-97 (Harbour); Otago Highlanders 1996,97; NZ Colts 1993; NZ Divisional 1993; NZ Trials 1993-95; New Zealand XV 1994; Development XV 1994; South Island 1995; Harlequins 1995; NZRFU President's XV 1996; Barbarians 1997; NZ Academy 1997

Wilson started making the sporting headlines when he was at Cargill High School in Invercargill and he's continued to do so – for a number of sports and a variety of reasons. He is one of the most extraordinarily gifted players to

Jeff Wilson . . . Sportsman of the Year in 1997.

have been an All Black and played both rugby and cricket for New Zealand while he was still a teenager.

From primary school days, Wilson had been in Southland and New Zealand age group sides, as well as the New Zealand Secondary Schools team for two years, in the second of which he also played seven times for Southland.

Playing at fullback for the Cargill HS First XV against James Hargest HS in 1992, Wilson scored 66 points from nine tries and 15 conversions, believed to be the second-highest individual tally at any level in New Zealand. The highest is believed to have been 87 points scored by Roy Nieper for Caversham School in Dunedin against North-East Valley in 1927.

Wilson moved to Dunedin in early 1993, partly to attend teachers college and partly to play first division rugby. He made an immediate impact in Otago once he'd finished his cricket season. He scored 98 points for Otago and was also a star for New Zealand Colts, scoring 39 points against Thames Valley.

Inevitably and rightly, he was included in the All Black team on its tour of England and Scotland and on his debut against London and South-East Division at Twickenham on the eve of his 20th birthday, he scored two tries. On his test debut, against Scotland, three weeks later, he scored three tries and calmly kicked a sideline conversion of the last of them. He was the third New Zealander to score three tries on debut (after Frank Mitchinson in 1907 and Tom Lynch in 1913). A week after that, Wilson tasted a rare defeat when England beat the All Blacks at Twickenham and he missed several kicks at goal.

Wilson was a reserve for the domestic tests of 1994 but was chosen for the midweek Bledisloe Cup test in Sydney and almost scored a try that would have won the match — he was diving for the line when the ball was knocked out of his arms in a flying tackle by Australian halfback George Gregan.

He was one of the star All Blacks in the almost-successful 1995 World Cup campaign, playing in five of the six matches, and he also played the other three tests in the New Zealand season, against Canada and two against Australia. He played at fullback in the first two tests on the tour of Italy and France at the end of 1995, but was injured in the loss in Toulouse and missed the second test against France.

With Christian Cullen selected in 1996 at fullback, Wilson became a specialist wing again — though he was often at fullback for Otago or the Otago Highlanders — and played in all 22 tests in 1996 and 1997, becoming the NZRFU's official player of the year in 1997. He was also Sportsman of the Year in 1997.

By the end of 1997, Wilson had scored 24 tries in tests — the next-best after John Kirwan's record 35.

His play for Otago against Wellington in the NPC match at Athletic Park on September 27, 1997, was widely regarded as one of the most outstanding individual matches seen in New Zealand. Though he scored only one try in Otago's 32-27 win, he was commonly held to have been the difference between the two teams — as much for his defence as for his attacking skills.

Wilson and Otago and All Black team-mate Josh Kronfeld became the first All Blacks in 1995 to resist offers from the World Rugby Corporation and sign contracts with the New Zealand union.

Wilson also played age grade cricket for Southland and New Zealand, was in the national U-Bix (minor associations) team and made his first-class and one-day debut for Otago when 18. He played in four one-day internationals for New Zealand in 1993 when he was still 19 — scoring the winning runs in a match in Hamilton — and though rugby forced him to curtail his cricket, he had a further season of first-class play for Otago in the summer of 1995-96.

He excelled in athletics at school, winning titles at South Island and national secondary schools championships.

WILSON Nathaniel Arthur
b: 18.5.1886, Christchurch *d:* 11.8.1953, Lower Hutt
Loose forward

Represented NZ: 1908,10,13,14; 21 matches – 10 tests, 18 points – 6 tries

First-class record: Wellington 1906-15,20 (Athletic); North Island 1907,08,11-14; NZ Services 1919,20; Wellington Province 1907

Acclaimed as the best loose forward in New Zealand rugby in the immediate pre-WWI years, 'Ranji' Wilson played in the first two tests against the 1908 Anglo-Welsh team, in all three tests in Australia 1910, two against Australia in the 1913 home series and all three in Australia 1914.

A leading member of the NZ Services team in the King's Cup competition in England, after playing for the NZ Division and United Kingdom XVs, Wilson could not travel to South Africa with the army team because his English/West Indian parentage meant he was classed as 'coloured'.

After his retirement he served as a Wellington selector 1922-26 and an All Black selector 1924,25. President of the Athletic club 1945,46. His brothers, William (1910) and Sim (1924), also played for Wellington with the former representing New Zealand at rugby league 1914,19,21.

WILSON Norman Leslie
b: 13.12.1922, Masterton
Hooker

Represented NZ: 1949,51; 20 matches – 3 tests, 6 points – 2 tries

First-class record: Otago 1948,50-53 (Zingari-Richmond); South Island 1948,50-52; NZ Trials 1948,50,51

Educated Wairarapa College. Played for the Masterton club before serving in WWII. After the war Wilson had a season playing for Gisborne HSOB but did not reach provincial level until he moved to Dunedin.

Toured South Africa 1949 but was kept out of the test side by Has Catley. Made his international debut on the 1951 Australian tour, playing in all three tests and also appearing in three minor matches as a prop. Weighed 13½ stone and stood 5' 11".

Coached the Zingari-Richmond, Collegiate (Invercargill) and Hutt clubs.

WILSON Richard George
b: 19.5.1953, Leeston
Fullback

Represented NZ: 1976,78-80; 25 matches – 2 tests, 272 points – 5 tries, 48 conversions, 51 penalty goals, 1 dropped goal

First-class record: Canterbury 1973-81 (Christchurch); South Island 1976,80; NZ Trials 1977,79; NZ Juniors 1973,76; NZ Colts 1973,74

Educated Cathedral Grammar School and St Andrew's College. A member of the NZ Juniors team which beat the All Blacks on the 1973 internal tour. Although Wilson was unable to hold a regular place in the Canterbury team, he was selected for the 1976 New Zealand team to tour Argentina. Leading points scorer with 80 from five games.

In 1978 he was sent to join the All Blacks in Britain after Clive Currie was injured, and appeared in four matches scoring 39 points. Played in the series against the 1979 Pumas before touring England and Scotland. Again led the points scorers with 56 from seven appearances including both internationals. In Australia and Fiji 1980 Wilson was second on the tour points table with 75 in seven games.

Richard Wilson

Wilson's accuracy and consistency in goal kicking resulted in 272 points from 25 appearances. On the 1976 South American tour he kicked five conversions in several matches and achieved five penalty goals against the Pumas in the first of the 1979 encounters. He was 5' 11" and weighed 13½ stone. His father, George, represented Canterbury 1949.

WILSON Robert J.
b: ? *d:* ?
Forward

Represented NZ: 1884; 6 matches, 4 points – 2 tries

First-class record: Queensland 1887,88 (City)

A 10-stone forward who was called into the 1884 New Zealand team to Australia from the East Christchurch club when Edward D'Auvergne withdrew. Described by the tour manager, S.E. Sleigh, as "perhaps the youngest player in the team. All through the trip however he held his own with the other forwards." Shifted to Wellington after the tour and played for the Athletic club. Later represented Queensland 1887,88.

WILSON Stuart Sinclair
b: 22.7.1954, Gore
Threequarter

Represented NZ: 1976-83; 85 matches – 34 tests, 200 points – 50 tries

First-class record: Wellington 1973,74,76-83 (Wellington College OB); North Island 1976,77,79,82; NZ Trials 1978-81,83; NZ Colts 1976

Educated Cornwall St Primary, Masterton Intermediate and Wairarapa College, 1st XV 1970-72. Appeared for the 1973 Wellington Colts as a five-eighth but became a wing and occasionally a centre in the full representative team.

Wilson toured Argentina with the 1976 All Blacks, playing in both matches against Argentina. On the 1977 French tour he made his international debut and continued to hold his place in the test team in the 1978 series against the Wallabies, in the British Isles later that year where he scored the only try in the Welsh international, v France, in Australia and in England and Scotland 1979.

In 1980 a broken finger restricted his appearances after the first test in Australia but he recovered in time to tour Wales and play in the centenary test later that year.

Wilson appeared in all tests in 1981 and 1982 (Scotland, South Africa, Romania, France and Australia) and in 1983, against the Lions, set a new try-scoring record for internationals with 19, three better than Ian Kirkpatrick's 16. With Andy Dalton unavailable for the end of year tour to England and Scotland in 1983, Wilson was appointed captain. It was an experience, he said, that he did not particularly enjoy and most critics agreed that wing was a less than ideal position from which to captain the All Blacks.

The international against Scotland was drawn and that against England was lost. Wilson retired from all but festival rugby at the beginning of the 1984 season and at the end of the year a book about him and his wing colleague for Wellington and New Zealand, Bernie Fraser, *Ebony and Ivory*, (Moa, 1984) was published.

At about 1.83m and nearly 82kg, Wilson combined great speed with the ability to make the most of any try-scoring opportunity. He was described in 1977 by journalist Bob Howitt as "by far the most explosive and attacking back in New Zealand" – a comment that held good for most of Wilson's playing career.

WILSON Vivian Whitta
b: 6.1.1899, Auckland *d:* 14.8.1978, Auckland
Threequarter

Represented NZ: 1920; 7 matches, 18 points – 5 tries, 1 penalty goal

First-class record: Auckland 1916,17 (Grammar), 1918-20,23 (College Rifles); Bay of Plenty 1921,22 (Opotiki); North Island 1919,20

Educated Auckland Grammar School, 1st XV 1913,14. A prolific try scorer in club rugby who made his debut for Auckland during the war years as a 17-year-old. Toured Australia with the 1920 New Zealand team after scoring a try in his first All Black appearance against Manawatu-Horowhenua. Captained Bay of Plenty v South Africa 1921. School sprint champion with a best 100-yard time of 10.8 secs. Auckland Golf Club handicapper for 13 years.

WISE George Denis
b: 12.5.1904, Dunedin *d:* 1.9.1971, Dunedin
Wing threequarter

Stu Wilson about to score against Australia in 1982.

Represented NZ: 1925; 7 matches, 15 points – 5 tries

First-class record: Otago 1923-25 (Pirates); North Otago 1928 (Kurow); South Island Minor Unions 1928

Educated Otago Boys' High School, 1st XV 1920,21. Leading points and try scorer on the 1925 tour of Australia with five tries in as many appearances. Denny Wise also played for the All Blacks in New Zealand before and after the tour. His statistics were given as 5' 10" and 11st 5lb.

WOLFE Thomas Neil
b: 20.10.1941, New Plymouth
Five-eighth and centre threequarter

Neil Wolfe

Represented NZ: 1961-63,68; 14 matches – 6 tests, 6 points – 2 tries

First-class record: Wellington 1960-62 (University); Taranaki 1963-69 (Star); North Island 1961,62,66; NZ Trials 1961-63,65-68; NZ Colts 1964; NZ Universities 1960-62; Rest of NZ 1966

Educated New Plymouth Boys' High School, 1st XV 1956-59. Represented Wellington and NZ Universities in his first year out of school and in the next season appeared in the interisland match, All Black trials and all three tests against the French tourists before his 20th birthday.

In his debut he was one of three new test caps who engineered a blindside move leading to a try in the first minute of the game when Des Connor ran from a scrum, passed to Wolfe who drew the French wing giving Don McKay room to score in the corner.

The following year Wolfe toured Australia, played in the second test and then in the first match of a return series at home against the Wallabies. Appeared at second five-eighth in the first test v England 1963. Wolfe continued to perform well for Taranaki during their mid 1960s Ranfurly Shield tenure and visited Australia with the 1964 NZ Colts but did not play for New Zealand again until the 1968 tour of Australia after scoring two tries as a second-half replacement in the trial of that year.

A short (5' 4", 10½ stone) but well-built player, Neil Wolfe was quick off the mark, enterprising and astute.

WOOD Morris Edwin

b: 9.10.1876, Waipawa *d:* 9.8.1956, Paraparaumu
Five-eighth

Represented NZ: 1901,03,04; 12 matches – 2 tests, 34 points – 6 tries, 4 conversions, 2 dropped goals

First-class record: Bush 1894 (Pahiatua), 1896,97 (Woodville); Hawke's Bay 1898,99 (Napier); Wellington 1900,01 (Wellington); Canterbury 1902,03 (Christchurch); Auckland 1904 (Ponsonby); South Island 1902,03

Described as "an ideal type of five-eighth, good on defence, dazzling on attack", Wood represented five unions during his 11-year career in first-class rugby. He scored a try and kicked four conversions for the 1901 New Zealand team against Wellington and New South Wales.

Scored a brilliant try in the 1903 interisland match, running through half the North Island team without a hand laid on him to cross between the posts. In that year he toured Australia and appeared in the first official test match. Played against the 1904 British team but a recurring knee injury forced his retirement after Auckland's game against the tourists.

New Zealand's champion long jumper 1904 with a leap of 19' 7½". Represented Hawke's Bay in Hawke Cup cricket.

Fred Woodman

WOODMAN Freddy Akehurst

b: 10.2.1958, Kaikohe
Wing threequarter

Represented NZ: 1980,81; 14 matches – 3 tests, 24 points – 6 tries

First-class record: North Auckland 1978-86 (Ohaeawai); NZ Juniors 1979,80; NZ Maoris 1978-81; NZ Trials 1981,82; North Island 1982

Educated Kaikohe Primary and Intermediate and Northland College. First played for New Zealand against Fiji at Auckland, scoring a try in his debut. When Gary Cunningham withdrew from the team to visit Wales later that year Woodman was named as his replacement. He scored three tries against the USA in the first game and appeared in three others on tour. Played two tests against the 1981 Springboks and toured Romania and France, playing seven games including the second French international.

A speedy wing with an effective swerve, who weighed 74kg and stood 1.78m. His brother, Kawhena, was also an All Black and represented North Auckland.

WOODMAN Taui Ben Kawhena

b: 9.5.1960, Kaikohe
Wing threequarter

Represented NZ: 1984; 6 matches, 12 points – 3 tries

First-class record: North Auckland 1980-86 (Ohaeawai); NZ Trials 1985; NZ Maoris 1982-85,88

Educated Northland College, 1st XV 1977, Kawhena Woodman played for North Auckland Secondary Schools 1977 and North Auckland Under 21 1977-79. Toured Wales and Spain with New Zealand Maoris.

He was a replacement player for the 1984 All Blacks in Australia, appearing in three matches. At the end of the season, he toured Fiji with the All Blacks, playing in three of the four matches. Weighed 81kg and stood 1.80m.

Brother of 1980,81 All Black Fred Woodman.

WOODS Charles Arthur

b: 5.8.1929, Winton
Hooker

Represented NZ: 1953,54; 14 matches, 2 points – 1 conversion

First-class record: Southland 1951-56 (Limehills); South Island 1953,54; NZ Trials 1953,56

Arthur Woods

Educated Limehills Primary and Winton District High School. A fine hooker and an industrious tight forward, Arthur Woods weighed 13½ stone and stood 5' 9" when selected for the 1953-54 All Blacks.

Appeared in 14 of the 36 tour matches but gave way to Ron Hemi for the major fixtures.

Coached the Limehills club 1954-57; president 1960,61. Selector for the Central District sub-union in Southland 1958,59. His father, Billy, represented Southland 1928,29.

WRIGHT Alan Hercules

b: 14.4.1914, Upper Hutt *d:* 2.12.1990, Wellington
Wing threequarter

Represented NZ: 1938; 4 matches, 33 points – 11 tries

First-class record: Wellington 1934-41 (Wellington College OB); Manawatu 1942 (Field Artillery Regiment); North Island 1934; NZ Trials 1935

Educated Brooklyn Public School and Wellington College. Called into the 1938 All Blacks to Australia when Johnny Dick withdrew, Wright scored in each of his four games including four tries v Newcastle and three each in the Combined Western and Federal Capital Territory matches. Top try scorer with 11, the next best being five. Stood 5' 10½" and weighed 13½ stone.

Coach and committee member of the Upper Hutt club 1947-50 and the Wellington College OB club 1966-68. Coached Wellington College teams 1960-67. Wellington RFU committee member 1950-59; president 1973; selector 1961-63. His father, H.R. 'Bumper', played for Wellington 1903-07 and then captained the 'All Golds' league team in England. His brother, M.F. Wright, also played rugby for Wellington 1933-37.

Don Wright

WRIGHT Donald Hector

b: 20.10.1902, Auckland *d:* 26.12.1966, Napier
Halfback

Represented NZ: 1925; 6 matches, 12 points – 4 tries

First-class record: Auckland 1922-26 (Grammar); NZ Trials 1924; Auckland-North Auckland 1923,24

Educated Auckland Grammar School, 1st XV 1919. Though possessing a short pass, Wright was a sure and cool halfback known for his good defensive play. His omission from the 1924-25 British tour caused much controversy as he had displayed outstanding form in the final North Island trial. Visited New South Wales with the 1925 All Blacks, playing twice against the state side. Stood 5' 7" and weighed 10$^{1}/_{2}$ stone.

WRIGHT Terence John

b: 21.1.1963, Auckland
Wing and fullback

Represented NZ: 1986-92; 64 matches – 30 tests, 202 points – 48 tries, 2 conversions, 2 penalty goals

First-class record: Auckland 1984 (Northcote), 1985-93 (Marist); North Island 1985,86; NZ Emerging Players 1985; North Zone 1987-89; NZ Trials 1987,89-91

Educated at Northcote College, where he played in the first XV in 1980. Played for Auckland age grade sides before making his senior debut in 1984. He scored 19 tries in his first season for Auckland.

Terry Wright

Wright was first chosen for New Zealand for the two tests (against France and Australia) for which All Blacks who had made an unauthorised tour of South Africa were ineligible. He lost his place when the Cavalier returned, but toured France at the end of the year, playing in four matches.

Wright was in the 1987 World Cup squad and played one pool match, against Argentina, and toured Japan at the end of the year, playing in all five matches. The retirement of Craig Green at the end of 1987 freed up a test spot for Wright and he became a test regular with the two-match series against Wales in 1988. He was a regular high-scoring wing through the dominant periods of Auckland and the All Blacks in the late 1980s.

In 1990, when Matthew Ridge moved to league, Auckland coach Maurice Trapp tried Wright at fullback and it was such a success that the national selectors followed suit a year later. His first two tests at fullback were the Bledisloe Cup matches in Sydney and Auckland in 1991 and he was chosen in the World Cup squad as a fullback.

Injuries at the cup restricted his appearances to four and he missed the quarterfinal and semifinal.

Under new coach Laurie Mains, Wright toured Australia and South Africa in 1992 where he was back on the wing. He did not play in any of the tests.

Wright played for another year for Auckland, for whom he scored a record 112 tries in his career.

Slightly-built (72kg and 1.83m), Wright had blistering speed and superb ball skills, which made him ideally suited to the wing and, in an attacking role, to fullback. But despite his slight build, he was also a reliable defender. He was one of New Zealand's leading sevens players, representing New Zealand for seven consecutive years from 1986.

WRIGHT William Alexander

b: 1.2.1905, Auckland *d:* 19.9.1971, Auckland
Halfback

Represented NZ: 1926; 1 match

First-class record: Auckland 1926,27 (Marist)

Educated Sacred Heart College (Auckland), 1st XV 1922,23. Although Wright was not a member of the 1926 New Zealand team which toured Australia, he was called in to replace Bill Dalley during the final game against Auckland as no fit substitute from the touring party was available. This was his first first-class match.

WRIGLEY Edgar

b: 15.6.1886, Masterton *d:* 2.6.1958, Huddersfield, England
Second five-eighth

Represented NZ: 1905; 1 match – 1 test, 3 points – 1 try

First-class record: Wairarapa 1903-05 (Masterton), 1906,07 (Red Star); Wellington Province 1905,07; Wellington-Wairarapa-Horowhenua 1905

Edgar Wrigley became New Zealand's youngest international player – a distinction he held until Jonah Lomu's debut in 1994 – at 19 years and 79 days when he took the field in the 1905 test v Australia at Dunedin. He had previously scored three tries against the tourists for a combined Wellington-Wairarapa-Horowhenua team. Scored one of New Zealand's four tries in this, his only All Black appearance. Transferred to rugby league and toured England with the 'All Golds', signing with the Huddersfield club 1908. Later played for Hunslet and coached Bradford Northern and Hull. Brothers Harry and Tom also represented Wairarapa.

WYLIE James Thomas

b: 26.10.1887, Galatea *d:* 19.12.1956, Palo Alto, USA
Loose forward

Represented NZ: 1913; 12 matches – 2 tests, 18 points – 6 tries

First-class record: Auckland 1910,13 (University); North Island 1910; New South Wales 1911,12; Australia 1912

After playing four games for Auckland and appearing in the 1910 interisland match, Jim Wylie moved to Sydney where he joined the Glebe club. Represented New South Wales for two years and toured North America with the 1912 Australian team.

Returned to New Zealand 1913 and won selection for the New Zealand team to tour North America. Played in the first test against Australia before the team departed and against All-America on tour, scoring a try in the latter international. His height (6' 3") made him one of the team's outstanding lineout exponents.

Wylie remained in California to study at Stanford University where he coached rugby. He was invited to kick off the 1953-54 All Blacks' game with the Californian All Stars.

WYLLIE Alexander John

b: 31.8.1944, Christchurch
Loose forward

Represented NZ: 1970-73; 40 matches – 11 tests, 42 points – 12 tries

First-class record: Canterbury 1964-80 (Glenmark); South Island 1966-69,71-73,76; NZ Trials 1966-68,70-74

Educated Omihi Primary School and St Andrew's College, 1st XV 1960,61. Represented Canterbury for six seasons and appeared in a number of All Black trials and interisland matches before winning selection for the 1970 tour of South Africa.

Alex Wyllie

Played on the side of the scrum in the second and third tests on that tour and then replaced the injured Alan Sutherland at number eight after the first test of the 1971 series against the Lions. Sutherland regained his place for the three-test series against the 1972 Wallabies but Wyllie returned to the All Blacks' international scrum to play once at number eight and on four occasions as a flanker on the 1972-73 British tour. After the 1973 internal tour he made his last All Black appearance v England at Auckland. Invited to play in the 1973 Scottish RFU centenary matches.

A fast, aggressive and robust loose forward who weighed 16 stone and stood 6' 1" 'Grizz' Wyllie continued to show good form for Canterbury until he retired at the end of the 1979 season. He played 210 times for his province, captaining the team in more than 100 games in his total of 278 first-class matches. Wyllie coached Canterbury 1982-86, the period during which Canterbury notched up a record-equalling 25 Ranfurly Shield victories.

Fuelled by his success with Canterbury, Wyllie became a national selector late in 1986 and he, convenor Brian Lochore and John Hart put together the squad and the programme that won New Zealand the World Cup. Wyllie went to Japan as assistant to Hart at the end of the year, but was elected convenor soon after the tour.

Wyllie coached the All Blacks through their unbeaten run from 1988 to 1990 and stood down soon after the 1991 World Cup, during which he had Hart as a co-coach.

He later coached Eastern Province and Transvaal in South Africa and in 1996 became technical advisor – in effect, coach – of the Argentine national team.

WYLLIE Tutekawa
b: 24.10.1954, Manutuke
First five-eighth

Represented NZ: 1980; 1 match, 4 points – 1 try

First-class record: Wellington 1978-83 (Marist-St Pat's); NZ Maoris 1979,80,82; North Island 1980-82

Educated Manutuke Primary School and Gisborne Boys' High School, 1st XV. Played rugby league for NZ Universities 1975-77. Toured Australia and the Pacific with the 1979 NZ Maoris and won selection in the All Black team which met Fiji at Auckland 1980.

Scored a fine try in his debut and was thought unlucky not to be included on the Welsh centenary tour. Tu Wyllie was 1.63m and weighed about 69kg; an elusive and enterprising five-eighth who kicked well with either foot.

Wyllie in 1996 was elected the Member of Parliament for Te Tai Tonga (Southern Maori), representing the New Zealand First party.

WYNYARD James Gladwyn
b: 17.8.1914, Kihikihi *d:* 2.11.1941, El Alamein, Egypt
Loose forward

Represented NZ: 1935,36,38; 13 matches, 15 points – 5 tries

First-class record: Waikato 1934 (Waipa Suburbs), 1936 (Te Awamutu Rovers), 1937-39 (Te Awamutu); North Island 1938; NZ Trials 1935-39; Waikato-Thames Valley-King Country 1937; 2nd NZEF 1940

Educated Kihikihi School and New Plymouth Boys' High School. Aged 20, he was 6' 3" and weighed 14½ stone when he was selected for the 1935-36 British tour. Appeared in only eight games in Britain and one in Canada. Also visited Australia with the 1938 All Blacks, playing in four of the nine matches.

In *The Tour of the Third All Blacks*, Eric Tindill wrote: "Wynyard is an improving forward of whom more will be heard. He is at present lacking in experience. Quite a fair lineout forward." After an outstanding final trial 1939 he was considered a probable selection for the projected tour of South Africa. Killed in action in WWII. His uncle, 'Tabby' Wynyard, represented New Zealand 1893.

WYNYARD William Thomas
b: c 1869, Auckland *d:* 15.3.1938, Wellington
Threequarter

Represented NZ: 1893; 7 matches, 14 points – 5 tries

First-class record: Auckland 1887 (Grafton), 1889,95,96 (North Shore); Wellington 1893,94 (Poneke); North Island 1894; NZ Trial 1893; NZ Native Team 1888,89

Educated Devonport School. Established a reputation as a gifted threequarter with the 1888-89 NZ Native Team and went to Australia with the 1893 New Zealand team. Scored four tries on tour and one against a Combined XV at Petone before the team departed – this try counted as only two points. Described as "a fast runner, quick at grasping the situation, good at dropping goals, said to be weak on defence but seldom showed it."

An excellent all-round sportsman, 'Tabby' Wynyard represented Auckland and Wellington at cricket and on the running track. His brothers, 'Sherry' and 'Pye', joined him on the Native team's tour. A nephew, Jim, represented New Zealand 1935,36,38.

YATES Victor Moses
b: 15.6.1939, Kaitaia
Number eight

Represented NZ: 1961,62; 9 matches – 3 tests, 15 points – 3 tries, 3 conversions

First-class record: North Auckland 1959-65 (Rarawa); North Island 1961; NZ Trials 1961-63; NZ Maoris 1961,63,64

Educated Kaitaia College. A strong, powerful and energetic loose forward who weighed 13st 2lb and stood six feet when he appeared in all three tests v France 1961 and then toured Australia next year where John Graham took the number eight berth in the test scrum.

Winner of the Tom French Cup as the outstanding Maori player of the 1961 season, Vic Yates transferred to rugby league 1965. His father, Moses, played for North Auckland 1927-29,31 while his brother, John, played for that union 1951,52 and then represented New Zealand at league 1954-57.

YOUNG Dennis
b: 1.4.1930, Christchurch
Hooker

Represented NZ: 1956-58,60-64; 61 matches – 22 tests, 9 points – 1 try, 3 conversions

Dennis Young

First-class record: Canterbury 1948,50-59 (Christchurch Technical College OB), 1960,61 (Technical College OB-Shirley), 1962,63 (Shirley); South Island 1951,55-59,61-63; NZ Trials 1950,53,56-63

Educated Waltham Primary School and Christchurch Technical College, 1st XV 1945,46. Played once for a Canterbury XV 1948 before beginning his 14-year, 139-match career in the full representative team 1950. His 235 first-class appearances included nine interisland games and 10 All Black trials.

Young made his debut for New Zealand in the second test against the 1956 Springboks but Ron Hemi returned for the rest of that series. Toured Australia 1957 and with Hemi not available he played in all three tests against the 1958 Wallabies. Hemi and Webb shared the series against the 1959 Lions but Young won selection for the 1960 South African tour and played in all four tests when Hemi was injured early in the tour.

With his rival retired in the next season Young hooked in all three test packs v France and in both tests in Australia 1962. Surprisingly dropped for the second test in the return series against the Wallabies but won back his place for the third, the two home tests v England 1963 and all five internationals in Britain and France 1963-64, after which he retired.

Standing 5' 7¼" and weighing 13st 10lb, Young was a very swift striker who outhooked virtually every opponent he met during his international career and won numerous tightheads. He was described by Terry McLean, in *Beaten by the 'Boks*, as "indestructable . . . a comparatively tiny man whose four-square frame was built to withstand more than human pressures". New Zealand junior discus champion.

YOUNG Francis Beresford
b: c 1874, Tasmania *d:* 2.11.1946, Wellington
Forward

Represented NZ: 1896; 1 match

First-class record: Wellington 1894-97 (Poneke)

Regarded as one of the outstanding forwards of his era, Young usually played on the back or side rows of the scrum. His sole appearance for New Zealand was against Queensland at Wellington 1896. Weighed 13½ stone.

New Zealanders Capped Overseas

The original intention of this chapter was to list those players born in New Zealand who had played for other International Rugby Board member countries. That was when there were only seven other countries, the four in the British Isles, France, Australia and South Africa. Now, there are about 70 IRB members and qualifying for the World Cup has also brought about a huge increase in the number of test countries and the number of official tests played. The last 10 years has also seen a welcome upsurge in international participation by South Pacific countries, most particularly Western Samoa and Tonga, each of whom have special relationships with New Zealand, not just in rugby but in foreign affairs and in internal policies. Many Western Samoans and Tongans living in New Zealand are able to have dual citizenship.

The number of New Zealanders to have played rugby for other countries has, as a result of these changes, increased dramatically to the point where a definitive listing of them is an impractical task fraught with the risk of inadvertent omission. There are also grey areas. Viliame Ofahengaue and Daniel Manu, for example, both played rugby in New Zealand for New Zealand teams but both were born in Tonga and both later played test rugby for Australia. Then there are cases of New Zealanders popping up for odd teams at odd places, Frano Botica for Croatia for example, and a Bay of Plenty hooker, Tony Flay, has played for the United States. A high-profile player, Marty Brooke, has played sevens rugby for Japan and many other New Zealanders have also represented different countries at sevens. Of the many New Zealanders in Britain, several have played for a country's B – or A – side. Those who have played for a country in full internationals, such as Ross Nesdale for Ireland or Sean Lineen and Nick Broughton for Scotland, are listed.

ADAMS Alan Augustus
see Leading Administrators

AITKEN George Gothard
see New Zealand Representatives

ANDERSON John
b: 9.5.1850, Edinburgh, Scotland *d:* 25.5.1934, Christchurch
Forward

Represented: Scotland 1872 (West of Scotland); Canterbury 1875,76,79 (Christchurch)

Came to New Zealand as an infant in 1850 and educated Scot's College. Returned to Scotland 1866 and attended Merchiston Castle School, Played for Scotland v England 1872 while working at an ironworks in Glasgow before returning to New Zealand three years later.

Although Anderson was born in Scotland, he arrived here before his first birthday and later spent much of his life here. He was thus the first New Zealander to play in an international rugby match.

President of the Christchurch club 1903-26. Served on the Christchurch City Council and Canterbury University College Board of Governors.

BACHOP Stephen John
see New Zealand Representatives

BOTICA Frano Michael
see New Zealand Representatives

BOTTING Ian James
see New Zealand Representatives

BROUGHTON Nicholas James Royds
b: 11.5.1973, Invercargill
Loose forward

Represented: Otago 1995 (University); NZ Universities 1994,95; Scotland 1996

Nick Broughton played for New Zealand Secondary Schools in 1988 from Southland Boys High School. He played one game for Otago in 1995 and for New Zealand Universities in 1994 and 1995 before moving to Scotland, for whom he qualified because a grandmother had been born in the Shetland Islands.

He toured New Zealand with Scotland in 1996, playing in four matches. He also played for Scotland B.

BUNCE Frank Eneri
See New Zealand Representatives

CARSON John James
b: 9.3.1870, Grahamstown *d:* 1903, Sydney
Forward

Represented: Australia 1899; New South Wales 1893-95,97,99 (Pirates)

Toured New Zealand with the 1894 New South Wales team and represented Australia in the first test v Great Britain 1899 – the first international played by a fully representative Australian team. Carson's nephew, Bill, was an All Black and New Zealand cricket representative.

CAWKWELL George Law
b: 25.10.1919, Auckland
Prop or lock

Represented: Scotland 1947 (Oxford University); Auckland 1941 (University); Barbarians (UK) 1946,47

Educated King's College. After serving overseas in the NZ Army, during which time he was prominent in service rugby matches, Cawkwell won a Rhodes Scholarship. He was a rugby blue 1946,47 and played one international for Scotland v France.

After leaving university he joined the Oxford City club which he captained in the 1949-50 season.

CLARKEN James
b: 19.7.1876, Thames *d:* 1953, Sydney
Forward

Represented: Australia 1905,10,12; New South Wales 1904,05,07,10-12 (Glebe)

Made his debut in big football for New South Wales against the 1904 British team. Toured New Zealand with the 1905 Wallabies and played in the only test.

Appeared in all three tests against the 1910 All Blacks and toured California and British Columbia with the 1912 Australian team. Selected for the Australian Imperial Forces team after WWI at the age of 43 and took part in King's Cup matches.

Also a well-known surf-lifesaver who helped fellow rugby international Harald Baker bring ashore 12 people at Coogee 1911 in one of Australia's most famous mass recues.

CONNOR Desmond Michael
see New Zealand Representatives

COOPER Malcolm McGregor
b: 17.8.1910, Napier *d:* 1.9.1989,
Longhoughton, England
Flanker

Represented: Scotland 1936 (Oxford
University); Barbarians (UK) 1935,36;
Manawatu 1932,33 (University); Wellington
1938,39 (Wellington); NZ Universities 1933

Educated Napier Boys' High School. Represented
NZ Universities against the touring Australian
Universities team 1933. Won a Rhodes
Scholarship and entered Oxford University
where he won rugby blues 1934-36. Captained
Oxford against the 1935 All Blacks before being
capped for Scotland against Wales and Ireland.
 Returned to New Zealand and captained
Wellington 1939.

CORFE Arthur Cecil
b: 5.12.1878, Christchurch *d:* 30.1.1949,
England
Forward

Represented: Australia 1899; Queensland
1898,99 (Past Grammars)

Educated Christ's College. Excelled as a junior
track athlete at school. Played for Queensland v
New South Wales 1898,99 and against Great
Britain in 1899. Selected for the second test
against the tourists.
 Served with the 3rd Queensland Contingent
in the Boer War and as adjutant with the 10th
New Zealand Contingent.
 Moved to England and served in the Royal
West Kent Regiment WWI, reaching the rank of
lieutenant-colonel, winning the DSO and two
bars and the Croix de Guerre. Wounded twice
and taken prisoner. Served as the British
member of the commission appointed by
League of Nations for repatriation of Greeks and
Bulgarians after the war.

CORNES John Reginald
b: 30.10.1947, Cambridge
Halfback

Represented: Australia 1972; Queensland
1970-72 (Teachers)

Played his early football with the Carterton club
before going to Australia. Came to New Zealand
with the 1972 Wallabies after John Hipwell
became unavailable. Also played for Australia v
Fiji 1972.

DAVIS Gregory Victor
b: 27.7.1939, Matamata *d:* 24.7.1979, Rotorua
Flanker

Represented: Australia 1963-72; Thames
Valley 1958,59 (Katikati); Auckland 1960
(Otahuhu); Bay of Plenty 1962 (Tauranga
HSOB); New South Wales 1963-72
(Drummoyne); NZ Trials 1961

Educated Sacred Heart College (Auckland).
Davis began his first-class career as a midfield
back but switched to loose forward when he
moved to Auckland 1960. In 1963 he went to
Sydney and joined the Drummoyne club. That
year he was selected for New South Wales and

Greg Davis

was included in the Australian team to tour
South Africa. He eventually played against all
the major rugby countries, including his native
New Zealand. Altogether Davis appeared in 39
tests for Australia, 16 as captain. He was widely
regarded as one of the best loose forwards in the
world.
 Retired from active football after the 1972
New Zealand tour and later returned to his
homeland. The Drummoyne club raised
$60,000 in benefit for him before he died of a
brain tumour.

DONNELLY Martin Paterson
b: 17.10.1917, Ngaruawahia
Utility back

Represented: England 1947; Canterbury 1940
(University); NZ Universities 1940; Oxford
University 1946,47; Barbarians (UK) 1946,47

Educated New Plymouth Boys' High School, 1st
XV. 'Squib' Donnelly usually played at halfback
but could fill any back position with distinction,
appearing at fullback for Canterbury and NZ
Universities, scrumhalf and flyhalf for Oxford
and as a centre for England v Ireland.
 Served with the 2nd NZEF in the Middle
East, North Africa and Italy, rising to the rank of
major in the 4th Armoured Brigade, then went
to Oxford on a bursary after the war.
 As a cricketer, Martin Donnelly was one of
the greatest left-hand batsmen of all time.
Selected for the 1937 New Zealand team to tour
England in his first year out of school, he also
played for his country in Australia in the
1937/38 season and at home 1938/39. Joined the
1949 tour while in England. Played in 59
matches for New Zealand scoring 3745 runs
(ave 46.81) with a best innings of 206 v England
1949. An Oxford blue at both rugby and cricket.

DUSTIN Ian Henry
b: c 1918, New Zealand *d:* 11.4.1945, Norway
Hooker

Represented: England 1943-44; Manawatu
1939-40 (United); NZ Services 1942-45; RAF
1944

A rugged forward who played for England
against Wales 1943 and Scotland 1944. A pilot
officer in the RNZAF, Dustin was killed in
action while flying on an anti-shipping patrol
off Norway.

FELL Alfred Nolan
b: 17.1.1878, Nelson *d:* 20.4.1953, Colchester
Wing threequarter

Represented: Scotland 1901,03 (Edinburgh
University); Nelson 1896 (Nelson College);
Otago 1897 (University)

Educated Nelson College, 1st XV 1894-96 from
where he represented Nelson, later playing for
Otago while studying in Dunedin. Nolan Fell
won seven caps for Scotland while completing
his medical studies at Edinburgh University,
playing against England 1901-03, Wales 1901-03
and Ireland 1901. He was selected to play for his
adopted country against the 1905 All Blacks but
refused to take the field against his homeland.
He served as a captain in the RAMC during
WWI.

FOOKES Ernest Faber
b: 31.5.1874, Waverley *d:* 3.3.1948, New
Plymouth
Threequarter and fullback

Represented: England 1896-99 (Sowerby
Bridge); Yorkshire 1896-99; Barbarians (UK)
1896,97; Taranaki 1901,02,04 (Tukapa);
Taranaki-Wanganui-Manawatu 1904

Educated New Plymouth Boys' High School, 1st
XV 1888,89. Went to England 1890, attended
Heath Grammar School and graduated in
medicine from Manchester University.
 Fookes played for the Halifax club in England
until it joined the Northern Union when he
transferred to Sowerby Bridge. Won 10 English
caps appearing against Scotland 1896,97,99,
Ireland 1896-99 and Wales 1896-98.
 Returned to New Zealand 1900 and
represented Taranaki in three seasons. A
versatile player, equally at home at wing, centre
and fullback, Fookes was one of the great
personalities in English rugby at the end of the
19th century. President of the Taranaki RFU
1933. Three of his sons played first-class rugby
in New Zealand with Ken reaching the All
Black trials 1934 and the North Island team
1931.

GILRAY Colin Macdonald
see New Zealand Representatives

GODDARD Maurice Patrick
see New Zealand Representatives

GRANT Eric
b: 21.10.1914, Paeroa
Threequarter

Represented: Scotland 1943-45; Poverty Bay
1933,34,37,38 (Gisborne HSOB); Auckland
1935,36 (University); North Auckland 1939
(Whangarei HSOB); NZ Universities 1936; NZ
Services (UK) 1941-45; Barbarians (UK) 1943;
Royal Air Force 1943,44; Combined
Dominions 1945; Poverty Bay-Bay of Plenty-
East Coast 1937

Educated Gisborne Primary and Gisborne Boys'

High School, 1st XV 1930-32. Represented Poverty Bay in his first year out of school. Toured Japan with NZ Universities 1936. While serving with the air force in Britain during WWII, Grant helped found and captained the NZ Services team and was selected on four occasions for Scotland against England as a centre threequarter.

Returned to New Zealand after the war and played for the University club in Auckland 1946. Later served as a coach and administrator of University and the Auckland Primary Schools RFU.

GUDSELL Keith Eric
see New Zealand Representatives

HAMMON John Douglas Campbell
b: 3.3.1914, Invercargill
Threequarter and five-eighth

Represented: Australia 1936,37; Auckland 1934 (Grammar); Victoria 1935-39 (St Kilda)

Educated Palmerston North Boys' High School and Auckland Grammar School, 1st XV 1929,30. 'Bill' Hammon played five games for Auckland on the wing, including a Ranfurly Shield challenge against Hawke's Bay. Moved to Melbourne and was selected as a five-eighth in the 1936 Australian team which toured New Zealand but he did not play in the tests. Played for Victoria against the 1937 Springboks at five-eighth and for Australia in the second test at centre.

HARDCASTLE William Robert
see New Zealand Representatives

HARDING Mark Anthony
b: 28.12.1955, Christchurch
Prop

Represented: Australia 1983; NZ Colts 1976; NZ Juniors 1978; Canterbury 1978; Sydney 1981-85

Educated Spreydon Primary and Christchurch Boys' High Schools, 1st XV 1972,73. Played for High School Old Boys' club in Christchurch 1974-79. Later played for the San Francisco RFC 1979,80, St George RFC (Sydney) 1980,81, Port Hacking 1982-86. A durable prop weighing 105kg and standing 1.88m who was a member of the Australian team on tour in France and Italy 1983. He played in five of the 11 matches including the international against Italy.

Mark Harding represented New Zealand at water polo 1975-81.

HEMINGWAY Wilfred Hubert
b: 22.9.1908, Auckland *d:* 12.4.1981, Dubbo, Australia
Wing threequarter

Represented: Australia 1931,32 (New South Wales); New South Wales 1928,31 (University)

Educated Sydney Grammar School. Toured New Zealand with the 1928 New South Wales team and the 1931 Wallabies. A strong, hard-running wing who scored seven tries on the 1928 tour and four on the later visit.

HILLS Ernest Fryers
b: 3.3.1930, Auckland
Wing threequarter

Represented: Australia 1950; Victoria 1950 (Melbourne)

Educated Otahuhu College and played for the Otahuhu club before moving to Australia and representing that country in two tests against the 1950 Lions. An accomplished sprinter, he won junior titles in the Auckland and national championships 1949. Later ran professionally in Australia.

IEREMIA Alama
see New Zealand Representatives

JESSEP Evan Morgan
see New Zealand Representatives

JONES Michael Niko
see New Zealand Representatives

KELLEHER, Rodney James
b: 8.11.1947, Wellington
Loose forward

Represented: Australia 1969; Queensland 1968-71 (Brothers)

Educated Kura Street Primary and Mana College. Played early rugby for Titahi Bay RFC. Injured in a car accident when aged 19 and advised he would not be able to play rugby again. Returned to the game during a working holiday in Brisbane. Graduated to the Queensland team and selected for the 1969 Australian tour to South Africa. Played in 11 of the 26 tour matches including the second and third tests. Suffered numerous injuries and was also ordered off in the match against Rhodesia. Later returned to live in Wellington where he coached Titahi Bay RFC senior team.

KNIGHT Orton Wallace
b: 12.9.1912, Auckland
Flanker

Represented: England 1942; Auckland 1937-39 (Ponsonby); Manawatu 1940,43 (RNZAF Ohakea); Canterbury 1944 (RNZAF Wigram); NZ Services 1941,42

Educated Beresford St School and Auckland Grammar School. Wally Knight served in Britain with the RNZAF, reaching the rank of flight lieutenant at the end of WWII. Represented NZ Services in Britain and played for England against Wales before being posted back to New Zealand where he reappeared in provincial rugby.

Thames Valley RFU coach and secretary 1952-54, holding the same positions for the Counties RFU 1955-57. Represented Auckland in the 120yd hurdles. His son, Michael, was a 1968 All Black while his cousins, Laurie (1925) and 'Bubs' Knight (1926,28,34), also played for New Zealand.

LINDSAY Andrew Bonar
b: 19.7.1885, Otepopo *d:* 15.5.1970, Auckland
Halfback

Represented: Scotland 1910,11 (London Hospitals); Barbarians (UK) 1909,10

Educated Southland Boys' High School, 1st XV 1899-1903. Played for the University club in

Dunedin before leaving to continue his medical studies in London. Represented Scotland twice against Ireland. Returned to New Zealand 1912 and worked at Timaru Hospital but was in England when WWI broke out. Served in the RAMC as a major, winning the MC. OBE.

LINEEN Sean Raymond
b: 25.12.1961, Auckland
Second five-eighth

Represented: Counties 1983-85 (Papakura), 1987-89 (Bombay); Pontypool (1986); Scotland 1989-92 (Boroughmuir)

Sean Lineen, the son of 1957-60 All Black Terry Lineen, played 64 games for Counties before moving to Scotland at the end of the 1989 season. He qualified for Scotland because his maternal grandmother was born there and was first chosen for the national team in the 1989-90

Sean Lineen

Five Nations season. He toured New Zealand with Scotland in 1990, playing in both tests, and he played against New Zealand again in 1991, in the World Cup third place playoff. He played 29 tests for Scotland.

LOUDON Robert
b: 24.3.1902, Leeston *d:* 6.10.1991, Sydney
Threequarter and loose forward

Represented: Australia 1929,32-34; New South Wales 1923 (Great Public Schools OB), 1927-32 (Manly)

Educated Christ's College before moving to Australia. Toured New Zealand with the 1923 New South Wales team as a threequarter and fullback. Played as a loose forward for Australia in the second test against the 1929 All Blacks and in the second test against the 1934 All Blacks. Also toured South Africa with the 1933 Wallabies. Appeared in six tests for his adopted country.

McDONALD Barry Stuart
b: 9.6.1940, Matamata
Flanker

Represented: Australia 1969,70; New South Wales (Sydney University and Randwick)

Played in one test on the 1969 Australian tour to South Africa and in the only international of the 1970 Scottish team's visit to Australia. Although not selected for the Wallabies again, McDonald remained a force in Sydney club rugby and was rated one of Randwick's best forwards for a long period.

MacDONALD John Hoani
b: 26.10.1907, Blenheim *d:* 1.1.1982, Blenheim
Threequarter and fullback

Represented: England 1942; Manawhenua 1927 (Horowhenua County); Marlborough 1928-31,33-35 (Moutere); South Island 1929; NZ Trials 1935; NZ Maoris 1926,31,34,35; NZ Services 1942-45

At the age of 18 MacDonald visited Britain and France with the 1926 NZ Maoris. Showed good form in All Black trials but missed selection for the 1935-36 New Zealand team. After returning from the NZ Maoris tour of Australia 1935 he accepted an offer to join the English rugby league club Streatham & Mitcham, transferring to Huddersfield 1937.

While serving as a leading aircraftsman with the RNZAF in Britain, Jack MacDonald was automatically reinstated to rugby union along with other league players who had switched codes. He was a regular member of the NZ Services team and was selected for England v Wales, November 1942.

MacDonald won a gold and a silver medal for New Zealand as an oarsman at the 1930 British Empire Games and also rowed in the 1932 Olympics. He won a red coat at national rowing championships 1933,34 as a member of the Wairau club. Played tennis for NZ Services 1944,45.

His father, Jack, played rugby for the South Island 1911,12 and NZ Maoris 1913,14 and his brother, 'Manny', also represented NZ Maoris (1923,31).

McEVEDY Patrick Francis
see Leading Administrators

McKENZIE Roderick McCulloch
see New Zealand Representatives

MACPHERSON Donald Gregory
see New Zealand Representatives

NESDALE Ross Patrick
b: 30.7.1968, Feilding
Hooker

Represented: Auckland 1992-95 (University); NZ Universities 1993; Ireland 1997

Ross Nesdale was the standby hooker for Auckland behind Sean Fitzpatrick, though he captained Auckland on occasions when Fitzpatrick and Zinzan Brooke weren't available.

Nesdale, originally from the Manawatu, moved to Ireland in 1996 and went on for Ireland as a replacement against New Zealand in Dublin in 1997.

A cousin, Gary Nesdale, played for Manawatu 1989-96.

O'BRIEN Arthur Boniface
b: 15.5.1878, Westport, *d:* 31.5.1951, Christchurch
Threequarter

Represented: Great Britain 1904 (Guy's Hospital); Kent 1903,04; Barbarians (UK) 1906,07

Educated St Patrick's College (Wellington), 1st XV 1892,93 and Christchurch Boys' High. Went to London to study medicine. O'Brien was player-manager of the 1904 British team to New Zealand. He appeared mostly on the wing but was fullback for the test.

O'BRIEN Damian Patrick
b: 29.7.1966, Wellington
Wing threequarter

Represented: Wellington 1987-89 (Marist St Pat's); Ireland 1992

Damian O'Brien played 32 games on the wing for Wellington over a three-year period before moving to Ireland, where he played for the Clontarf club.

He was called up as a replacement on Ireland's tour of New Zealand in 1992 and played in one match.

OSBORNE Douglas Hugh
b: 19.7.1952, Thames
Wing threequarter

Represented: Australia 1975; Victoria 1973-75 (Kiwis)

Toured New Zealand with the 1973 Victoria team and played in five out of six games. Appeared in both tests for Australia against the 1975 English touring team. Later in that season he represented Australia in the first test v Japan.

PALMER Alexander Croydon
b: 2.8.1887, Dunedin *d:* 16.10.1963, Surrey, England
Centre threequarter

Represented: England 1909 (London Hospitals); Barbarians (UK) 1907-10; Eastern Counties

Educated Waitaki Boys' High School. Played for England against both Scotland and Ireland while studying medicine at London Hospital.

Served in the RAMC as a major and then became a gynaecological and obstetric surgeon at King's College Hospital for 35 years.

PARSONS Ernest Ian
b: 24.10.1912, Christchurch *d:* 14.8.1940, Turin, Italy
Fullback

Represented: England 1939 (Royal Air Force); Yorkshire 1939

Educated Christchurch Boys' High School. Although his rugby career in New Zealand was undistinguished, Parsons played well in service games for the RAF and represented England against Scotland in the last pre-war international between the two unions. A pilot officer in Bomber Command, he won the DFC 1940 but later that year was reported missing after air operations over Turin.

PUTT Kevin Barry
b: 28.7.1964, Cambridge
Halfback

Represented: Otago 1984-86 (University); Waikato 1987-90,92 (Hamilton OB); North Zone 1988,89; NZ Trial 1992; Natal 1992-97; South Africa 1994,96

Kevin Putt was a halfback so highly regarded in New Zealand that he was considered for New Zealand selection in the late 1980s and again in 1992. He had three seasons in Otago before moving home to Waikato in 1987. He went to

Kevin Putt

South Africa for three months in 1991 and then on to Ireland, where he played for the Terenure club in Dublin. He returned to New Zealand for the 1992 season but when he wasn't chosen for the All Blacks after playing in a trial, he returned to South Africa, where he soon established himself in the Natal team. He went on two tours with the South African national team, playing in a total of 11 matches and scoring three tries. He did not play in a test. He also played for the South African sevens team in 1995. Putt works as a rugby development officer among Zulus in Natal.

REDWOOD Charles Edward Joseph
b: c 1880, Blenheim *d:* 16.2.1954, London, England
Utility back

Represented: Australia 1903,04 (Queensland); Queensland 1903,04 (Toowoomba)

Educated St Patrick's College (Wellington). Played wing threequarter for Australia against New Zealand 1903 at Sydney. Selected for his adopted country in all three tests against Great Britain 1904, appearing at centre, wing and fullback Also played for Queensland against New South Wales 1903,04, against New Zealand 1903 and in the match with the touring British team in 1904.

RILEY Sidney Austin
b: 18.4.1878, Auckland *d:* 31.3.1964, Auckland
Centre threequarter

Represented: Australia 1903; New South Wales 1903 (Newtown)

Educated Ponsonby and Bayfield Schools. Played for the Ponsonby club before moving to Sydney to work in his brother's furniture factory. Represented both New South Wales and Australia against the 1903 New Zealand team and later returned to Auckland. Represented that province at rugby league 1912. His brother, Ollie, played rugby union for New South Wales and Auckland in the 1890s. His nephew, Brian, was a New Zealand league representative 1935,37. Sid Riley served with the NZ Army during WWI.

RITCHIE William Traill
b: 11.3.1882, Dunedin *d:* 22.5.1940, Timaru
Threequarter

Represented: Scotland 1905 (Cambridge University); Barbarians (UK) 1904,05

Educated Wanganui Collegiate, 1st XV 1898-1900. At Cambridge University Ritchie took a degree in mechanical science and won rugby blues 1903,04.
 Played for Scotland v England and Ireland. Served with the NZ Field Artillery in France during WWI. Ritchie was a fine all-round sportsman who represented his school at rugby, athletics, cricket and rowing as well as being head prefect.

SALMON James Lionel Broome
see New Zealand Representatives

SAMPSON James H.
b: c 1876 *d:* ?
Forward

Represented: Australia 1899; Auckland 1898 (Parnell)

Understood to have come from the Waihi district. First played rugby in the Waikato 1893-95 before having a season in the Ohinemuri district. Joined Parnell in 1897 and in 1898 played four matches for Auckland.
 Joined the Glebe club in Sydney in 1899 from where he won selection for the fourth test against the British team. He did not represent New South Wales and did not appear in top rugby again.

STEPHENS Owen George
see New Zealand Representatives

TAYLOR Hemi Takatou
b: 17.12.1963, Morrinsville
Loose forward

Represented: Waikato 1984 (Melville); Wairarapa-Bush 1986 (Carterton); Wales 1994-96 (Cardiff)

Hemi Taylor played for Waikato in 1984 and briefly for Wairarapa-Bush in 1986 before heading to Wales, for whom he qualified through a grandparent. He made his debut for Wales against Portugal in a World Cup qualifying match in 1994, becoming the first New Zealander to play for Wales. He was a member of the Welsh squad at the 1995 World Cup and played against New Zealand in the pool match in Johannesburg, won 34-9 by the All Blacks. Taylor, who played off the blind side of the scrum or at No 8, played 20 tests for Wales.

THOMPSON Robert John
b: 8.3.1947, Rotorua
Hooker

Represented: Australia 1971,72; Bay of Plenty 1968 (Kahukura); NZ Maoris 1968; Western Australia 1971,72 (Western Suburbs); Junior Wallabies 1971

Educated Rotorua Boys' High School. Represented Bay of Plenty and NZ Maoris then moved to Australia. Scored all of Western Australia's 18 points (six penalty goals) against the 1971 Springboks – the highest total amassed by a state side against the tourists – and then became that state's first Wallaby when he hooked in the third test of the series. Also selected for the 1972 Wallaby tour of France and North America, appearing as a replacement during the second French international. Played for Australia against Fiji 1972 and toured New Zealand but did not make the test team.

TONU'U Ofisa Francis Junior
see New Zealand Representatives

TUIGAMALA Va'aiga Lealuga
see New Zealand Representatives

WALSH Patrick Bernard
b: c 1879 *d:* 1953
Loose forward

Represented: Australia 1904; New South Wales 1903-05 (Newcastle); Auckland 1907 (Parnell)

Originally played for the City club in Auckland before going to Australia. Returned to Auckland in 1907 before again crossing the Tasman where he changed to rugby league and toured England with the first 'Kangaroos' in 1908-09. Subsequently signed for Huddersfield.
 Played in three tests for Australia against the 1904 British team.

WARD Peter
b: 5.11.1876, Invercargill *d:* ?
Five-eighth

Represented: Australia 1899; Southland 1897,98,1903 (Britannia); New South Wales 1899 (Marrickville); Auckland 1904 (Grafton); Hawke's Bay 1905 (Napier City); Taranaki 1906 (Waimate); Wanganui 1908 (Awarua)

After making an impression in Southland as an astute and skilful inside back, Ward went to Sydney 1899 and was selected for New South Wales in two games against the British tourists of that year and all four tests – playing in the first full Australian team. He returned to play for Southland again 1903 but then moved to Auckland and appeared in the first Ranfurly Shield challenge when Wellington took the trophy. Also played in shield games for Hawke's Bay and Wanganui before his retirement from first-class rugby.

WATSON William Thornton
b: 10.11.1887, Nelson *d:* 9.9.1961, New York, United States
Prop

Represented: Australia 1912-14; New South Wales 1912-14 (Newtown), 1919 (AIF), 1920 (Glebe-Balmain); Australian Imperial Forces 1919

Moved to Sydney 1911 and the following year was selected for the Australian team's tour of North America. Played in all three tests on the 1913 visit to New Zealand and then appeared twice for New South Wales and in the first test against the 1914 All Blacks.
 Serving with the Australian Imperial Forces, Watson won the DCM and the MC and bar. After the war he captained the Australian army team in the King's Cup competition in England and led the side on its return to Australia. Captained New South Wales in three matches against the 1920 All Blacks.
 Watson was given command of the Papuan Infantry Battalion with the rank of major during WWII and won the DSO.

WEBB William Phillips
b: 18.3.1868, Dunedin *d:* 1931, Sydney
Forward

Represented: Australia 1899 (New South Wales); Otago 1888 (Zingari-Richmond); New South Wales 1894-96,98-1900 (Wallaroo)

Educated Otago Boys' High School. Described as "a squat, powerfully built backrow forward" he forced his way into the Australian team for the final two internationals against Mullineaux's 1899 British team after a good game for New South Wales against the tourists.

WESTFIELD Robert
b: 26.5.1907, Hunterville *d:* 7.6.1970, Sydney
Fullback

Represented: Australia 1929; New South Wales 1928,30,33,34,36,37 (Randwick, University and Eastern Suburbs); Victoria 1935 (Kiwis); Australian Universities 1933,34

Educated St Patrick's College (Wellington) before studying at the University of Sydney. Toured New Zealand with the 1928 New South Wales team and was Australia's fullback in the second and third tests against the 1929 All Blacks. Toured New Zealand again with Australian Universities 1933 and captained that team in Japan 1934. Moved to Melbourne 1935 and represented Victoria against New Zealand Maoris.

WILLIAMS Ronald Oscar
see New Zealand Representatives

WOGAN Lawrence William
b: 10.9.1890, Hokitika *d:* Aug. 1979, Sydney
Centre threequarter

Represented: Australia 1912-14; New South Wales 1912,14,1920-24 (Glebe, Glebe-Balmain and Eastern Suburbs)

Selected for the 1912 Wallabies' tour of North America and the following year visited New Zealand, playing in all three tests. Played for New South Wales against the 1914 All Blacks and again represented Australia in the three tests. Wogan resumed his rugby career after WWI and appeared for New South Wales against touring South Africa and All Black teams. Toured New Zealand again with the 1921 New South Wales team. Retired after playing against the 1924 All Blacks at the age of 34.

Leading Administrators

To list every administrator of rugby in New Zealand since the birth of the sport in the 1870s would require a volume many times larger than this and perhaps more than one. Administrators, or officials as they're usually known, whose biographies are included here are those deemed to have had a national and/or long-lasting influence on the game.

Most New Zealand Rugby Football Union long-serving office-holders are included, as are many administrators who gave years of service to provincial unions.

They include managers of All Black sides – who are always chosen from within the NZRFU – and prominent coaches.

ADAMS Alan Augustus
b: 8.5.1880, Greymouth *d:* 28.7.1963, Greymouth

Educated Auckland Grammar School, 1st XV 1900. Represented Otago 1902,03,05,06 from the University club, and South Island 1906. Played one match for NZ Universities in Australia 1908 while en route to England to study medicine.
Adams played for London University and was capped for England v France 1910 as a centre threequarter. Appeared for the Barbarians (UK) 1909,12.
Chairman of the West Coast RFU. NZRFU council 1937-43; president 1929; life member 1945. New Zealand selector 1927,28. Represented West Coast at cricket.

ADAMS George Joseph
b: 1884, England *d:* 21.1.1952, Wanganui

Educated Wanganui Collegiate. Played for Edinburgh University while studying there. President of the Wanganui RFU 1923-31. NZRFU president 1930. Co-manager of the New Zealand touring team in Australia 1938.

ALLEN Frederick Richard

New Zealand selector 1964-68; assistant manager of the 1967 and 1968 All Blacks. For other details see *New Zealand Representatives.*

ARNEIL John
b: 1862, India *d:* 11.8.38, Auckland

Came to New Zealand 1864; educated St Paul's College and Auckland Grammar School. Represented Auckland 1880,82,83,86,87 as a threequarter and wing forward. Refereed two Auckland v British team matches 1888 and NSW v North Island 1894. Auckland RFU management committee 1883-85,88,90-92; auditor 1898-1902; selector 1890-1900; vice-president 1904-15; president 1915-34; vice-patron 1935-38; life member 1923. NZRFU president 1914.
Arneil also represented Auckland at cricket 1883-97 and captained his province in both sports.

ATKIN Graham William John
b: 7.10.1931, Wanganui

Graham Atkin was a member of the NZRFU council from 1986 until 1993 and was on the Wellington Rugby Union management committee from 1972 until 1993, the last 16 years as chairman. He had been an administrator with the University club for 41 years and played for the club for 24. Unusually for a rugby administrator, Atkin worked as an actor in television commercials.

BAKER Arthur Aaron
b: c 1898, Wellington *d:* 2.12.1968, Wanganui

Represented Wellington 1917,19 as a lock from the Poneke club and Poverty Bay 1923. Grafton club's delegate to the Auckland RFU management committee 1926-46; chairman 1936-46. Poneke club's delegate to the Wellington RFU 1947,48,50-52. NZRFU president 1944 and executive member 1948.

BANKS Michael Conrad Francis
b: 30.1.1948, Raglan

Mike Banks was a member of the NZRFU council in 1994 and 1995 and moved on to the restructured board. He managed the New Zealand Colts in 1994 and 1995 and has been manager of the All Blacks since 1996. Banks was a quantity surveyor for 15 years before becoming a hotelier and company director in 1981. He played senior club rugby in Hamilton and Palmerston North and played for Manawatu in its Ranfurly Shield era in the 70s. He was a member of the Manawatu union management committee from 1986 until 1996.

BAYLEY Alfred

NZRFU president 1907. For other details see *New Zealand Representatives.*

BAYLY George Thomas
b: 17.3.1856, New Plymouth *d:* 26.6.1938, Stanmore Bay

Educated Wanganui Collegiate and in Australia. Represented Patea County 1876,80; West Coast 1878; Wanganui 1879; Wellington Province 1879; Taranaki XV 1883. Hawera club captain 1876-85; president 1887-1902. Taranaki RFU president 1889-98. NZRFU president 1898.
A noted cricketer, Bayly represented Wellington and Taranaki against English touring teams. Elder brother of Alfred and Walter Bayly, both New Zealand rugby representatives.

BELCHER Alan St Clair
b: 10.11.1893, Auckland *d:* 15.4.1972, Wellington

Educated Auckland Grammar School. 'Slip' Belcher was a foundation member of the Grammar Schools' Old Boys club 1914. Life

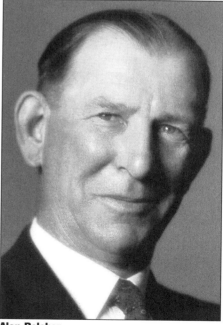

Alan Belcher

member 1935. Auckland RFU management committee 1921-35; chairman 1935; NZRFU council 1937-45; vice-president 1946; executive 1947; chairman 1948-52; life member 1955.

BEVEGE Ernest George
b: 1893, Wanganui *d:* 30.12.1964, Wanganui

213

Educated Aramoho School and Wanganui District High School. Played for the Kaierau club from 1910; club captain 1947,48; president 1949-55; patron 1961-64; life member 1948. Wanganui RFU president 1954-63. The Bevege Stand at Spriggens Park, Wanganui was named after him 1962. NZRFU president 1961.

BIRDSALL Walter Simpson
b: c 1895 *d:* 15.8.1977, Nelson

Golden Bay-Motueka RFU and Golden Bay sub-union president and life member. NZRFU president 1957.

BLAZEY Cecil Albert
b: 21.7.1909, Hastings *d:* 21.2.1998, Wellington

Educated Christchurch Boys' High School. Played senior club rugby for Canterbury University 1927,28,31-34. Served on the NZ Universities Rugby Council 1936-69, chairman 1945-67, life member. NZRFU executive 1957-86, chairman 1977-86, life member 1982. A member of the International Board 1964-86; International Laws Committee 1972-85.

Ces Blazey

Also chairman of the Wellington Amateur Athletic Association 1948-54; president 1954-57; patron and life member. NZAAA management committee 1954-80; president 1959,60; chairman 1966-81; life member. Member of the NZ Olympic and Commonwealth Games Association 1956-80. Christchurch secondary schools tennis champion 1926. His brother, Dick, represented Manawatu 1920 and Canterbury 1921 and another brother, Harry, was president of the NZRFU 1966. OBE.

BLAZEY Henry Charles
b: 2.4.1904, Hastings *d:* 18.6.1991, Christchurch

Educated Christchurch Boys' High School. Represented Canterbury B 1925 from the University club. Canterbury RFU treasurer 1945-52; vice-president 1953-58; president

1959-61, life member. NZRFU council 1964,65; president 1966.

Vice-chairman of the 1974 Commonwealth Games committee; chairman of the 1975 New Zealand Games committee. His brother, Dick, represented Manawatu 1920 and Canterbury 1921; Canterbury RFU president. Another brother, Ces, was chairman of the NZRFU 1977-86. OBE.

BOTTING Robert William Stanley
b: 9.2.1892, Naseby *d:* 16.7.1991, Nelson

Educated Otago Boys' High School. Played for the Otago University and Alexandra clubs. Otago RFU management committee 1936-44; vice-president 1945,46; president 1947,48. NZRFU council 1948-50; president 1951.

Co-manager of the 1951 All Blacks in Australia. His son, Ian, represented new Zealand 1949 and England 1950. Member of the Dunedin City Council 1953-62. A master at Otago Boys' High School 1920-53; Stan Botting was created MBE for his service to the Intellectually Handicapped Children's Society.

BRAMWELL Wallace Stanley
b: 1902, Feilding *d:* 20.9.1974, Hastings

Represented Manawatu 1921 as a five-eighth from the Feilding club. Hawke's Bay RFU management committee 1949-72; chairman 1960-72; life member 1972; NZRFU president 1971.

BROWN Gordon Alexander
b: 28.11.1907, Turakina *d:* 16.7.1982, Palmerston North

Played for the Kia Toa club. Manawatu RFU secretary 1939-49; president and chairman 1951-57; life member 1956. NZRFU council 1950-59; president 1959. Manger of the 1958 NZ Colts team in Japan. OBE.

BURK Ronald Leslie
b: 5.6.1916, Auckland *d:* 21.3.1981, Auckland

Educated Remuera Primary and Auckland Grammar School. Played for the College Rifles club. Served in WWII, winning the DCM. As a referee, Burk was a member of the big five panel of the Auckland RRA 1947-52 and controlled British Isles v Taranaki 1950 and the 1952 Ranfurly Shield match Waikato v West Coast. Auckland RRA president 1953,54; life member 1958. Referees and Takapuna club delegate to the Auckland RFU management committee 1955-68; chairman 1962-68; life member 1971. NZRFU council 1963-70. Manager of the 1970 All Blacks in South Africa.

BUSH Ronald George

New Zealand selector 1961-64; assistant manager of the 1962 All Blacks. For other details see *New Zealand Representatives.*

BYARS Leslie Alexander
b: 4.12.1925, Oamaru *d:* 18.4.1994, Taumarunui

Educated Weston Primary (Oamaru) and Waitaki Boys' High School. Played for the Athletic club in Taumarunui 1939-53. King

Country RFU management committee 1957-74; president 1963-74. NZRFU president 1973. New Zealand's delegate to the International Board 1973. Manager of the 1974 All Blacks in Australia. MBE.

CAMPBELL George Frederick Colin

NZRFU president 1893,1903,08. New Zealand selector 1893,94 and manager of the 1893 team in Australia.

CARMINE Louis Vincent
b: 11.8.1891, Lyell *d:* 6.7.1959, Wellington

Represented Buller 1914 from the White Star club. Buller RFU secretary-treasurer 1914-23; selector 1922,23. Wanganui selector 1925-30. Ruapehu sub-union president 1935. King Country RFU president 1935-38. NZRFU executive 1944-59; president 1940. New Zealand selector 1924. Carmine managed the 1956 All Blacks in the home series against South Africa.

CAVANAGH Victor George
b: 19.6.1909, Dunedin *d:* 20.7.1980, Dunedin

Educated Otago Boys' High School, 1st XV 1926. Represented Otago 1931 as a wing forward from the Southern club. An outstanding coach of the Otago Ranfurly Shield team in the late 1940s when 17 challenges were repulsed. Cavanagh developed the rucking game into a

Vic Cavanagh

great skill. When 11 Otago players were included in the 1949 All Blacks to South Africa, concern was expressed that Cavanagh did not accompany the team as assistant manager.

Served as Otago selector-coach 1946-49. Otago RFU president 1966; life member 1967. South Island selector 1948. Represented Otago at cricket 1928-36 and was 12th man for New Zealand v MCC 1933. His father, V.G. Cavanagh snr, represented Otago at rugby 1899 and coached the University and Southern clubs and Otago. New Zealand selector 1913. Otago RFU president 1922.

CLODE Leonard Alfred Henry
b: 14.8.1908, Colac Bay

Educated Colac Bay, Gorge Rd and St George's Primary School and Southland Technical College. Played for the St George OB club (Invercargill) and Pirates (Dunedin). Invercargill club captain 1933,42,43; committee member 1931-36,39-47,56-70; president 1944,45,60,61; life member 1969. Nelson club committee member 1974-76. Buccaneers club chairman 1975,76. Southland selector 1944-47,57-67, president 1968. Wellington selector 1952-55. NZRFU executive 1949-55. Co-manager of the 1951 All Blacks in Australia.

CRADDOCK William Arthur Gordon
b: 5.2.1907, Westport *d:* 1.3.1979, Westport

Buller RFU management committee 1926; secretary-treasurer 1928-49; selector 1941-46; treasurer 1950-79 president 1953-56; life member 1948. NZRFU council 1945-73; life member 1974; manager of the 1957 All Blacks in Australia. The youngest man to become NZRFU president, being 34 when he took office in 1941. MBE.

CRAWSHAW Richard George Kenhardt
b: 24.9.1947, Gisborne

Richard Crawshaw was a member of the NZRFU council from 1993 and of the restructured board from 1996. He was a past chairman of the Poverty Bay union and managed several New Zealand teams, including the national sevens team 1992-97. Crawshaw, a real estate agent and company director, was also president and chairman of NZCCS (formerly NZ Crippled Children's Society).

DEAN Stanley Sydney McPherson
b: 8.8.1887, Auckland *d:* 17.3.1971, Wellington

Educated Auckland Grammar School. Played rugby for the Grafton club in Auckland and the Mines club in Johannesburg, South Africa.
Poverty Bay selector 1914. Poneke club delegate to the Wellington RFU 1922,24,27-37; club president 1927-32,34-66. Wellington RFU

president 1953. NZRFU management committee 1920,21; chairman 1922-47; president 1931; life member 1947.
Stan Dean managed the 1922 New Zealand team in Australia and the 1924-25 'Invincibles' in Great Britain and France; co-manager of the 1938 NZ Maoris team in Fiji. Attended Imperial Rugby Conferences in London 1924,35 and was largely responsible for New Zealand's admission to the International Board 1948. OBE.

DEVORE Albert Edward Tyrell
b: 1843, Wiltshire, England *d:* 4.2.1916, Auckland

Educated Marlborough School. Went to Australia 1859 and to the Otago goldfields three years later.
Auckland RFU president 1889-1915. NZRFU president 1904. Auckland city councillor 1882-86; mayor 1886-89.

DIXON George Henry
b: 24.12.1859, Huddersfield, England *d:* 18.3.1940, Auckland

Arrived in New Zealand 1879. Played for the Albert club as a halfback. Auckland RFU secretary 1887-1900; life member 1911. NZRFU management committee 1901-10,13-18; chairman 1904-10,15-18; president 1911,12. First life member of the New Zealand Rugby Football Union 1921.
Manager of the 1905-06 New Zealand team to Great Britain and France; author of the tour book *The Triumphant Tour of the New Zealand Footballers* (Geddes and Blomfield, 1906).

DON Ronald Munro
b: 11.4.1925, Auckland

Educated Auckland Grammar School. Played for the Grammar club 1941-52. Auckland RFU management committee 1953-84; chairman 1969-84. NZRFU council 1971-79,80-86. Manager of the 1976 All Blacks in Argentina and the 1977 teams in France and against the Lions at home. Member of the Eden Park Board of Control 1963-86. His brother, Colin, represented Auckland 1942,46-48.

DOWLING John Anthony
b: 4.10.1938, Dunedin

John Dowling was on the NZRFU council from 1984 until 1995, deputy chairman for the last two years, and International Rugby Board delegate in 1992 and 1993. Educated at Christian Brothers and Otago University, Dowling was on the Otago union executive from 1974 until 1994 and Otago chairman from 1983 until 1989.

DUFF Robert Hamilton

New Zealand selector 1971-73 and assistant manager of the 1972-73 team in Britain and France. For other details see *New Zealand Representatives*.

DWYER Edward Patrick
b: 18.6.1925, Blenheim *d:* 24.9.1986, Blenheim

Educated Culverden and Marist Brothers' Primary Schools (Timaru) and St Patrick's High School (Timaru). Played for the RNZAF during WWII, the Albion club in 1946 and represented Marlborough 1952,54 from Blenheim OB as a forward.
Marlborough RFU selector coach 1958-62, president 1963-76. Life member. NZRFU president 1972. Represented Marlborough and Canterbury at athletics, boxing champion in both areas as well as in NZ Services. His son, Brian, represented Marlborough 1973-80.

EMPSON Walter
b: 1856, Northamptonshire, England *d:* 14.6.1934, Parkstone, England

Arrived in New Zealand 1884. NZRFU president 1900. President NZ Cricket Council, 1900,01.

EVANS Francis Thomas
b: 1868, Christchurch *d:* 27.8.1949, Christchurch

Educated East Christchurch School. Represented Canterbury 1888-93 as a forward from the Merivale club and the South Island v the 1888 British team. Refereed New Zealand v Great Britain 1904.
Canterbury RFU management committee 1892-1904; vice-president 1905-14; president 1915-19; selector and life member. NZRFU president 1919. New Zealand selector 1896,1903,05,07.

EVEREST Richard Alan
b: 12.5.1915, Hamilton *d:* 28.4.1992, Hamilton

Educated Whitiora Primary School and Hamilton Technical College. Represented Waikato as a midfield back 1937,38,40,41,44; Waikato-King Country-Thames Valley v South Africa 1937 and North Island Combined Services 1944.
Dick Everest coached Waikato through its Ranfurly Shield era in the early 1950s and to victory over the 1956 Springboks. Frankton club coach 1947. Waikato selector-coach 1950-56. North Island and New Zealand selector 1957-60. Assistant manager of the 1957 All Blacks in Australia.
His brothers E.W. Everest (1929) and J.K. Everest (1939,40) also represented Waikato.

A team of chairmen . . . from left, Stan Dean (1922-47), 'Slip' Belcher (1948-52), Cuth Hogg (1953-60), Tom Morrison (1961-68) and Jack Sullivan (1969-77).

EYTON Thomas

b: c 1843 Essex, England *d:* 16.2.1925, Auckland

Arrived in New Zealand 1862. Served with the Taranaki Bushrangers and the Patea Light Horse in the New Zealand Land Wars. A member of the Armed Constabulary team which played Wanganui 1873.

Inspired by the visit of the British team to New Zealand 1888, Eyton promoted a tour by mainly Maori players which was organised, selected and captained by Joe Warbrick. The team played 107 matches in the British Isles, Australia and New Zealand between June 1888 and August 1889. Responsible for the books *Rugby Football (Past and Present)* and *Tour of the Native Team in Great Britain, Australia and New Zealand in 1888,89.*

FACHE George Cox

b: 8.4.1870, Clyde *d:* 5.10.1948, Gore

Educated Clyde School and Otago Boys' High School, 1st XV 1886,87. Represented Wellington 1890 from the Wellington club. As a referee, Fache controlled three games involving New Zealand teams: v Combined XV 1893, v New South Wales 1894; v Wellington Province 1905. A life member of the Wellington club. Wellington RFU management committee 1892,93; selector 1893-98, 1903; life member 1925. NZRFU management committee 1902-06,15-18; secretary 1904. New Zealand selector 1896,97,1901,03-05. Fache also served on national boxing and rowing associations and on the Olympic Games Council. OBE.

FINLAYSON John Alexander

b: 25.5.1891, Maungaturoto
d: Jan. 1960, Waipu

Played rugby for the Maungaturoto club. President of the North Auckland RFU. NZRFU council 1946-49; president 1950. Member of the Legislative Council; chairman Marsden electorate and Dominion councillor of the National Party.

Brother of Innes (New Zealand 1925,26,28,30); Callum (Otago 1927-33) and North Auckland representatives, 'Bain', 'Tote' and Angus Finlayson.

FISHER Robert Anthony

b: 1.6.1944, Christchurch

Rob Fisher, a partner with the law firm of Simpson Grierson in Auckland, became chairman of the New Zealand Rugby Football Union board in 1997, replacing Richie Guy. Fisher had been a University club delegate to the Auckland union 1984-95, chairman of Auckland from 1990 to 1995 and a member of the NZRFU council from 1992. He was deputy chairman in 1994,95. He has been a New Zealand delegate to the International Rugby Board since 1994 and vice-chairman of the board from 1996. Fisher played for King's College and Auckland University.

FRASER Hanson Home

b: 9.4.1881, Timaru *d:* 19.12.1958, Timaru

Educated Heretaunga and Waimataitai Schools. Represented South Canterbury 1900,02-04; president of that union 1918-31. NZRFU president 1925. Represented South Canterbury

at swimming. Secretary of the NZ Athletic, Cycling and Axemen's Union 1911-20. MBE.

FRASER James George

b: 23.9.1923, Timaru

Educated Albury and Waimataitai Primary Schools and Timaru Boys' High School. Played for the Star (Timaru), Onslow (Wellington), Lake Tekapo, Blaketown (Greymouth), Albion (Christchurch) and Lake Waitaki clubs, normally as a five-eighth. Represented South Canterbury 1945-48, West Coast 1949, Canterbury 1950, North Otago 1951,52 and North Island RNZAF 1943.

Kaikorai club committee 1954-66; coach 1954-62. Otago RFU selector and treasurer 1963-66. Marlborough RFU management committee 1968-80; selector 1967-71; president 1979; chairman 1980. NZRFU president 1980.

FREEMAN Albert Purvis

b: 19.12.1922, Kaponga

Educated Kapuni and Otakeho Primary Schools and Hawera High School. Represented Wellington as a five-eighth 1942-44,48 from the Petone and Athletic clubs. President of the latter club 1976,77. Life member. Wellington RFU management committee 1961-73; selector 1964-70. NZRFU executive 1973-86. 'Bill' Freeman has been coaching director of the NZRFU since 1976.

FRENCH Thomas

b: 11.5.1893, Napier *d:* 15.7.1970, Manurewa

Represented Buller 1911,13,15, Auckland 1914 and NZ Maoris 1911,13. Lost an arm while serving with the NZEF at Passchendaele 1917. Poverty Bay selector 1936-39. Auckland RFU vice-president 1956-61. NZRFU life member 1957 and served on the Maori Advisory Board from 1922. Assistant manager of the 1949 NZ Maoris team in Australia. A cup presented by J. Morris of Sydney at the conclusion of this tour has been named in his honour and awarded each year to the outstanding Maori player. His son, T.J. French, represented Auckland 1951-53,55 and NZ Maoris 1951,52,54,55,57.

Rob Fisher

GALBRAITH Neil

b: 18.4.1867, Lyttelton *d:* 12.1.1927, Dunedin

Educated Lyttelton School. Wellington club life member 1900. Wellington RFU management committee 1879,99-1902. NZRFU committee 1902,04-14; treasurer 1904-08; chairman 1911-14. Liaison officer for the 1904 British team in New Zealand and manager of the 1905 All Blacks in Australia.

GALBRAITH Robert

b: 1859, Glasgow *d:* Dec. 1933, Stratford

Represented Otago 1882-84 and Southland 1888,89 both from the Invercargill club. An outstanding threequarter. Invercargill club captain 1879-86,88; life member 1887. Southland RFU management committee; president 1909,10, secretary for 25 years. Presented the Galbraith Shield for the Invercargill senior club championship. NZRFU president 1910. Represented Southland at cricket, Canterbury and New Zealand at lawn bowls. Mayor of Invercargill 1905,06 and Ashburton 1915-31.

GALLAWAY John McRae

b: 6.1.1854, Edinburgh *d:* 29.7.1929, Dunedin

Arrived in New Zealand 1878 and settled in Dunedin. President of the Pacific club 1896-98 which amalgamated with Caversham to form the Southern club of which Gallaway was joint president 1899-1920. Otago RFU president 1896-99. NZRFU president 1897.

GALVIN John Joseph

b: 27.10.1901, Hamua *d:* 12.8.1984, Whangarei

Educated St Patrick's College, 1st XV 1919 after representing Manawatu Schools 1916. Represented Bush 1921-33. Bush RFU president and life member. NZRFU president 1977.

GEDDES Arthur John

b: 3.3.1876, Balclutha
d: 11.6.1942, Invercargill

NZRFU president 1922. New Zealand selector 1924-30. Manager of the 1934 New Zealand team in Australia, Southland RFU president 1915-21. Father of Ben Geddes, a 1929 All Black.

George Geddes

GEDDES George Harper

b: 12.8.1912, Timaru *d:* 17.5.1977, Wellington

Educated Timaru Boys' High School. Played for the University club in Christchurch. Southland RFU management committee 1942-45; secretary 1946-50. NZRFU secretary-treasurer 1951-70. Represented Canterbury University and Canterbury at athletics. NZAA secretary 1951-60.

GIBBONS Clarence Gordon
b: 4.11.1904, Marton *d:* 26.3.1986, Lower Hutt

Educated Marton District High School. Represented Wanganui 1927-29 from the Marton and Marton OB clubs. Also played for the Eastbourne and Taieri clubs and in army teams. Otago RFU 1938-40 and Wellington RFU 1946-49 management committees. Wellington selector 1952-60; chairman 1963-69; life member 1969; NZRFU president 1967. Gibbons finished first in the mile at the 1927 national athletic championships but was disqualified. Wellington mile title holder 1933. NZ marathon champion 1939. Otago AAA committee member 1937-40. His brother, K.H. Gibbons, represented Wanganui at rugby, captaining his team against the 1930 British team.

GLASGOW Earl of (David Boyle)
b: 31.5.1833, Shewalton, Scotland
d: 13.12.1915, Fairlie, Scotland

David Boyle served in the Crimean War and Chinese War retiring as captain in the Royal Navy before succeeding his cousin as Seventh Earl of Glasgow.

Became the 14th Governor of New Zealand 1892 and the first NZRFU president 1892 and patron 1893-96. Left New Zealand 1897. GCMG and a barony for services to New Zealand.

GLEESON John
b: 24.5.1927, Manakau *d:* 2.11.1979, Feilding

Educated Feilding Convent School and St Patrick's College (Silverstream). Represented Manawatu as a threequarter 1947,49,50,53,55, playing 30 matches and scoring 12 tries. Feilding club coach 1958-61; president 1978,79; life member 1979. Manawatu selector 1962-69. North Island selector 1970-76. NZ Colts coach 1974-76. New Zealand selector 1972-79 and manager-coach of the All Blacks on the 1972 internal tour; coach in Argentina 1976, in France and Italy 1977 and on the tour of Britain 1978. His father, William, represented Manawhenua 1926-28,30 and Manawatu 1930 and a brother, Owen, represented Manawatu 1954,55,57.

GRAY Neil James
b: 13.4.1943, Morrinsville

Neil Gray, a Morrinsville farmer, was on the NZRFU council from 1990 to 1995 and manager of the All Blacks at home and overseas in 1992 and 1993, a period that included the resumption of contact with South Africa. He had been a member of the Waikato union management committee from 1977 until 1989 and was Waikato chairman 1985-89.

GRESSON Timothy Michael
b: 6.8.1944, Wellington

Tim Gresson was chairman of the South Canterbury union from 1989 to 1996 and a member of the NZRFU council 1990-96, moving on to the restructured board in 1996. He has been a delegate to the International Rugby Board since 1997. Educated at Christ's College, he played for Canterbury University and London Irish. Gresson has been crown solicitor in Timaru since 1980.

GUY Richard Alan
b: 6.4.1941, Upper Hutt

Richie Guy

Chairman, North Auckland Rugby Union 1981-86; NZRFU councillor 1984-97; chairman, 1995,96. For other details, see *New Zealand Representatives.*

HAMER Graham Edward
b: 9.11.1936, Auckland

Educated Edenvale Primary and Mt Albert Grammar School. Hamer played senior rugby in Auckland for the Eden Club as a number eight and was the side's captain 1962-64. He began his coaching career with the Eden third grade side and in the late 1960s moved to Palmerston North where he took charge of Kia Toa.

Hamer coached the Manawatu side from 1975 to 1986 and at the time of his retirement was the longest serving provincial coach in the country. Manawatu teams coached by Hamer won the national sevens title, held the Ranfurly Shield 1976-78.

In 1986 he stood unsuccessfully for a place on the national selection panel.

HARPER Raymond Aubrey Ian
b: 19.7.1927, Invercargill

Educated Waihopai Primary and Waitaki Boys' High School. Represented Southland 1948-54 from the Pirates club. Southland RFU selector 1962-67; management committee 1965-86; vice-president 1976-80. NZRFU council 1975-86. Managed the NZ Juniors 1975,78 and the All Blacks in Australia, Fiji and Wales 1980.

HARRIS Henry Forbury
b: 28.10.1869, Dunedin *d:* 13.1.1949, Dunedin

Educated Arthur Street School. Represented Otago 1893 as a halfback from the Union club. Representative referee and Otago selector. Served on Otago management committee 1897-1900; treasurer 1901-11; president 1912-21; vice president 1933-49; life member. NZRFU president 1918; life member 1939. Joint manager of the NZ Maoris touring team in Europe 1926-27.

HART John Bernard
b: 6.12.1945, Auckland

Educated at Mt Roskill Grammar School, Hart played for Auckland as a halfback from the Otahuhu club (1967,68) and from Waitemata (1970, 1974-76). He also played for Taranaki in 1969.

As a coach, Hart brought about a renaissance in Auckland rugby. Auckland won the national championship in his first year, 1982, as coach and twice again in his five-year tenure, giving Auckland a period of ascendancy that continued through the 1990s. Under Hart, Auckland won the Ranfurly Shield from Canterbury in 1985 to embark on a record tenure.

Hart was elected to the national selection panel in 1987 with convenor Brian Lochore and fellow selector Alex Wyllie and coached the New Zealand team in Japan that year. He was voted off the panel at the end of the year, but was re-elected at the end of 1988 and remained on the panel until 1991, when he was co-coach with Wyllie at the World Cup.

John Hart

After two unsuccessful attempts, Hart was elected convenor of the national panel at the end of 1995 and in his first year as All Black coach, New Zealand won a series in South Africa for the first time, and won the tri-series against Australia and South Africa in each of his first two years. From 22 tests under his coaching in 1996 and 1997, 20 were won, one was drawn and one lost.

Hart's All Black coaching coincided with the first two full years of professionalism in rugby

and it was through his and the New Zealand union's efforts that New Zealand was generally regarded as handling the transition better than in other countries. Hart introduced the squad concept to New Zealand, taking 36 players on tours of South Africa and Britain, arguing that the greater number was needed to spare the test players the potentially draining demands of also playing midweek matches. He also introduced assistant coaches as additional to the national selection panel. Hart at the beginning of 1997 was appointed through to the World Cup in 1999.

Hart had worked for Fletcher Challenge since leaving school and left the company toward the end of 1995 as the senior executive in charge of employee relations to form his own company, John Hart Consultancy.

He has also been active with the Barbarians club in Auckland and took a club team of All Black strength to Britain in 1996. He has had two biographies published, *Straight from the Hart* (1993) and *Change of Hart* (1997).

HAWKE Archibald Fotheringham

b: 1862, Stirling, South Australia *d:* 27.9.1936, Invercargill

Educated Invercargill Grammar School and M. Henri's Private School. Southland RFU president 1894,95,1900-03,05,06. NZRFU president 1901. Mayor of Gladstone Borough and served two terms on the Legislative Council.

HAYHURST John Turnbull Murray

b: 16.11.1860, At sea *d:* ?

Spent his early childhood in Temuka; educated Ley's School, Cambridge, England. Returned to New Zealand 1878. Played for Temuka, later president of that club and South Canterbury RFU 1898-1901. NZRFU president 1902.

HEATHER Duncan Stanley Burgoyne

b: 8.3.1898, Auckland *d:* 27.3.1972, Auckland

Educated Auckland Grammar School. Represented Bay of Plenty 1919-22. A referee in Waikato 1937-46. Waikato RFU chairman 1946-59; life member. NZRFU council 1949-51,56-58; president 1958. Manager of the NZ Maoris in Australia 1949. Prominent in swimming administration in Hamilton and city councillor 1956-59.

HENDERSON Thomas

b: 1849, Auckland *d:* 22.7.1924, Auckland

Represented Auckland 1876,77,80,82,83,86 from the Auckland club. Auckland RFU chairman 1893, management committee 1887-94,97-99; life member 1896. New Zealand selector 1893,94. NZRFU president 1895.

HOBEN Ernest Denis

b: 3.2.1864, Auckland *d:* Jan. 1918, Melbourne

Hoben spent his early years in Australia but returned to New Zealand while still a youth. He was prominent in football, boxing and athletics in the Tauranga area and helped to organise the game of rugby in the Bay of Plenty as secretary of the Tauranga club. Moved to Napier 1891 and became secretary of the Hawke's Bay RFU.

The establishment of a national rugby union

had been suggested before 1891 but without result. In that year Hoben toured the country explaining that a unified body was essential if overseas tours were to he organised on a sound basis.

On November 7, 1891, he convened a meeting in Wellington at which the NZRFU constitution was drafted – the union was founded at a second meeting of the delegates on April 16, 1892, and Hoben served as the first secretary 1892-95. Manawatu RFU president 1910.

HOGG Cuthbert Stuart

b: 1.4.1911, Auckland *d:* 21.4.1973, Wellington

Educated Whangarei Boys' High School where he lost a leg as the result of a rugby accident. Onslow club secretary 1932-34; chairman 1937-39,42,46; president 1940-42,54,55; patron 1972,73. Wellington RFU management committee 1945-52; president 1962. NZRFU executive 1951-61; chairman 1953-61; appeal council 1965-73; life member 1962.

His brother-in-law Jack Griffiths represented New Zealand 1934-36,38.

HORNBROOK Edward John

b: 19.2.1954, Timaru

By the end of 1997, John Hornbrook was the longest-serving chief executive of any of New Zealand's 27 provincial unions. He was appointed secretary-manager of the Otago Rugby Football Union in June 1985 when he was also responsible for the administration of Otago cricket.

His title and functions were redefined in October 1988, when he became executive director of the Otago union. The "new" title of chief executive officer evolved as rugby made the transition from its amateur to professional days.

Under Hornbrook and chairmen such as John Dowling and John Spicer, Carisbrook was re-established as a test venue and extensively redeveloped, and Otago was consolidated as a premier team that was much sought-after. Hornbrook was educated at John McGlashan and Nelson Colleges and played two games at lock for Otago in 1977, the same year he married Hillary Smith.

HORNIG William Francis

b: 5.6.1879, Havelock *d:* 30.9.1963, Wellington

Educated in Nelson. Played for the Prince Albert, Waimea and Oriental clubs. Coached the latter club and served as treasurer 1910-19; committee member 1920-22,27,29; president 1923-26,30-32; life member 1931. Wellington RFU management committee 1911-15,19,20; treasurer 1916-19; selector 1917. NZRFU management committee 1923-28. Manager of the 1928 All Blacks in South Africa.

HYAMS Isaac

b: 1.3.1862, Auckland *d:* 26.11.1927, Wellington

Committee member of the Athletic club in Wellington 1896; vice-president 1907. Wellington RFU treasurer 1893; management committee 1897; NZRFU management committee 1895,1907,14; treasurer 1896-1903. Manager of the 1897 New Zealand team in Australia.

ISAACS Robert Michael

b: 30.1.1869, Dunedin *d:* 1938

Educated Otago Boys' High School, 1st XV 1883-85. Represented Otago 1887,89-92 from the Montecillo and Dunedin clubs. Otago RFU management committee 1895-98; NZRFU management committee 1902-14; referees appointment board 1907-14. NZRRA president. Manager of the 1914 All Blacks in Australia.

JEFFS Jack Meadows

b: 3.4.1916, Napier *d:* 2.8.1992, Wellington

Educated Manchester St School (Feilding) and Palmerston North Boys' High School. Played for the Feilding (1934) and Victoria University (1935-40) clubs. Secretary and committee Member of the NZ Universities Rugby Council 1952-72; manager of the NZ Universities team in Australia 1960 and Hong Kong, Japan and Hawaii 1970. NZRFU secretary-treasurer 1973-78. Life member of the Victoria University club and NZ Universities Rugby Council.

JOHNSON Thomas William

b: 22.9.1938, Napier

Educated at Forrest Lake Primary and Hamilton Boys' High School, 1st XV 1953-55. Represented Counties 1957 (Ardmore); Waikato 1958 (Hamilton HSOB); Hawke's Bay 1959,60 (Napier TCOB) 1961-63,65-68 (Tech OB and Napier Marist); Auckland 1964 (Waitemata); North Island 1961,62; NZ Trials 1959,61,62. Tom Johnson had a lengthy playing career as a loose forward that took him close to All Black selection, but it was as an administrator that he made his national mark.

Tom Johnson

Johnson was first elected to the NZRFU's executive committee in 1973 and remained on the national council until 1986, when he retired. Johnson was regarded as one of the "new breed" of administrators and specialised in promotion and publicity areas.

Johnson's grandfather, J.A. Johnson (1897-99) and father, W.A. Johnson (1935-37) and an uncle J. Johnson (1920) all played first-class rugby for Hawke's Bay.

JONES Thomas Henry Ayes
b: 9.11.1888, Hokitika *d:* Sept. 1960, Auckland

Jones was a prominent referee in Wellington. NZRFU treasurer 1919,20. Manager of the 1920 All Blacks in Australia. He was later a journalist with the *Auckland Star* and wrote sports columns under the byline of 'Ponty' 1926-43.

KILBY Francis David
Manager of the All Blacks in Britain, France and Canada 1963-64. NZRFU life member 1976. For other details see *New Zealand Representatives.*

KING John David
b: 3.2.1900, Hampden *d:* 5.10.1966, Wellington

Played for the Central Hawke's Bay sub-union 1916-20 and represented Wellington 1921-24 from the Oriental and Petone clubs. President of the latter club 1948,49; life member 1949. Wellington RFU management committee 1931-52; life member 1953. NZRFU executive 1948-52,56-65. Manager of the 1962 All Blacks in Australia.

KIRKPATRICK Alexander
NZRFU president 1956. For other details see *New Zealand Representatives.*

KITTO Charles Adolph
b: 1.3.1883, Wellington *d:* 23.8.1953, Wellington

Educated Mt Cook School, Wellington. Played for St James club to senior level. 'Dolph' Kitto later became prominent in the administration of the game. Served on the Wellington RFU management committee 1913-18 and on the NZRFU management committee 1919,20,22-35, NZRFU executive committee 1937-43. Was also a prominent referee having controlled the NZ v Wellington 1914, North v South 1920 and two Ranfurly Shield matches.

He was also a prominent administrator in athletics where he served as president of both the Wellington and NZAAA, and in 1938 was assistant manager of the NZ Empire Games team. In 1950 he was a referee at the Empire Games in Auckland. Other positions held included patron of the Worser Bay surf club and president of the Eastern Suburbs rugby club. He is frequently given the incorrect initials A.C.

LEITH Henry Samuel
b: 9.1.1889, Dunedin *d:* 7.5.1957, Wellington

Played for Southern in Dunedin and was later a prominent referee, controlling the 1931 Ranfurly Shield match Canterbury v Otago, the 1923 interisland game and British Isles v Wairarapa-Bush 1930. Otago RFU management committee 1919. NZRFU management committee 1925-30; treasurer 1931-36. Manager of the 1926 All Blacks in Australia.

LITTLE Ernest Alfred
b: 7.8.1885, Wellington *d:* 16.2.1959, Wellington

Secretary of Wellington's Oriental club 1904; coached champion senior team 1910; president 1927,28,34-45; life member 1931. Wellington

RFU management committee 1911-14; treasurer 1915; president 1947. NZRFU management committee 1921-24. Manager of the 1924 All Blacks in Australia.

LITTLEJOHN Richard
b: 24.2.1931, Hamilton

Educated Whakatane Primary and New Plymouth Boys' High School. Dick Littlejohn played club rugby for Whakatane United and for the Whakatane sub-union of the Bay of Plenty union before settling on an administrative career.

He was elected to the council of the NZRFU in 1981 and managed the All Blacks at home and in Australia in 1984, and in domestic tests and in Argentina in 1985. He was elected to manage the New Zealand team scheduled to tour South Africa in 1985.

Littlejohn was the New Zealand director on the board of Rugby World Cup Ltd – the organisation charged with organising rugby's first World Cup.

LITTLEJOHN Willam Still
b: 1859, Aberdeen, Scotland *d:* ?

Founder Nelson RRA 1894; President Nelson RFU; NZRFU president 1899. Principal of Nelson College 1898-1903 then appointed to Scotch College in Melbourne.

LOGAN Francis
b: 1857, Edinburgh, Scotland *d:* 8.3.1933, Napier

Educated Bedford County School; came to New Zealand 1882. NZRFU president 1894,1909. A prominent referee and Hawke's Bay cricket representative; won the national tennis doubles title with M. Fenwicke 1892. Refereed Great Britain v Hawke's Bay 1888, NSW v Auckland 1894.

LOCHORE Brian James
New Zealand selector 1983-87; assistant manager of the 1985 All Blacks in Argentina and 1986 All Blacks in France. World Cup Coach in 1987 and campaign manager, 1995. For other details see *New Zealand Representatives.*

McDAVITT Cecil Michael Garland
b: 6.10.1889, Greymouth *d:* 29.8.1961, Tauranga

Educated Opunake School and Sacred Heart College. Played rugby for the University club in Auckland. A founder of the Waikato RFU 1921; Waikato's first secretary 1921-23; president 1924; life member 1925. NZRFU president 1926.

McDONALD Alexander
New Zealand selector 1929-32,44-48. Co-manager of the 1938 All Blacks in Australia and assistant manager of the 1949 team in South Africa. NZRFU life member 1951. For other details see *New Zealand Representatives.*

McEVEDY Patrick Francis
b: 17.3.1880, Taumutu *d:* 2.3.1935, Wellington

Educated St Patrick's College, Wellington, 1st XV 1898. Studied medicine at Guy's Hospital, London. Played rugby for the hospital team and a member of the Kent county side that won the English county championship 1903-04. English and Irish trialist in that season.

Toured New Zealand with the 1904 British team and was vice-captain of the 1908 Anglo-Welsh team. Played for the Barbarians (UK) 1906-08. Described as "a versatile player – a strong straight runner with the safest hands".

Returned to Wellington 1909 to set up medical practice. Wellington RFU president 1930-33. NZRFU management committee 1911,12,14-18. NZRFU president 1934 (died in office). NZ Boxing Council president.

McEWAN Robert John
b: 20.3.1905, Invercargill *d:* 3.6.1987, Riverton

Educated St George Primary and Middle School (Invercargill). Represented Southland 1924,27-29 from the Southern and Pirates club. An All Black trialist 1929. Pirates club president and life member. Southland RFU vice-president 1938-42; president 1946,47; selector 1946-56. South Island selector 1954-56. NZRFU president 1960. Manager of the 1960 NZ Maoris in Tonga and Samoa.

McKENZIE Edward
b: 26.5.1878, Greytown *d:* 7.9.1946, Carterton

A member of the Wairarapa family that gave remarkable service to New Zealand rugby, Ted McKenzie played 35 times for his province 1898,1900-07 as a fullback from the Carterton club. Represented the North Island 1902. Founder of the Wairarapa RRA; life member. Refereed the first test in the 1921 Springbok series.

McKenzie was Wairarapa RFU secretary 1911-29; life member. NZRFU management committee 1923-30; president 1946 (died in office); life member 1942. New Zealand selector 1924-37; sole selector 1938,39 – choosing a team which was never announced when the 1940 visit to South Africa was cancelled on the outbreak of WWII. Manager of the 1925 All Blacks in Australia.

Alex McDonald

McKENZIE Malcolm
b: 1883, Caithness, Scotland *d:* 4.4.1961, Blenheim

Came to New Zealand 1906. Marlborough RFU president and life member. NZRFU president 1939. Mayor of Blenheim 1925-35.

McKENZIE Norman Alfred
b: 24.5.1888, Carterton *d:* 28.3.1960, Napier

Educated Clareville School. Represented Wairarapa 1907-11 from the Carterton Rovers and Carterton clubs; Hawke's Bay 1912,14 (Marist); North Island Country 1911.
 Norman McKenzie was the sole selector for Hawke's Bay 1916-46 including its 1922-27 Ranfurly Shield era when 24 challenges were repulsed. NZRFU council 1949; life member 1950. New Zealand selector 1924-30,47-49 and manager of the 1947 All Blacks in Australia. NZAAA president 1949. Brother of the New Zealand representative William 'Off-side Mac' McKenzie, the prominent rugby administrator Ted, international referee Ben, and Wairarapa (1899-1903) representative Jack. OBE.

McLEOD James
b: 1878, Dunedin *d:* 31.3.1944, New Plymouth

Educated Otago Boys' High School. Taranaki RFU chairman 1912-42. NZRFU president 1920,21. Manager of the 1929 All Blacks in Australia. NZRFU life member 1940. A member of the Legislative Council. A plaque in his memory is a part of the main gates to Rugby Park, New Plymouth.

McPHAIL Alexander Edward
b: 27.6.1881, Christchurch *d:* May, 1957, Christchurch

Represented Canterbury 1902 from the Sydenham club, Canterbury RFU management committee 1913-17,19-21; vice-president 1922-29; president 1930-34; NZRFU president 1933.
 McPhail's sons, Neil and Clem, both represented Canterbury in the 1930s; the former also played for the 'Kiwis' in Britain 1945-46 while the latter represented the South Island 1935,36 and served as Canterbury RFU president 1968-70. His brother-in-law, 'Nut' Hasell, was an All Black 1913,20.

McPHAIL Neil James
b: 24.9.1913, Christchurch *d:* 7.11.1994, Christchurch

Educated Christchurch Boys' High School. Represented Canterbury as a front-row forward from the HSOB club 1935-39. An All Black trialist 1939 and played for the 'Kiwis' army team. Canterbury selector 1955-57. South Island selector 1958-64. New Zealand selector 1961-65 and assistant manager of the 1963-64 All Blacks in Britain and France. Represented Canterbury as a shot putter 1936,37. His father, A.E. McPhail, was NZRFU president 1933. His brother Clem played for Canterbury 1933-36 and the South Island 1935,36 while his son, Bruce, represented Canterbury 1973-75; NZ Colts 1973; NZ Juniors 1974,75.

McPHEE Hugh Alexander
b: 23.12.1905, Carterton *d:* 17.11.1981, Masterton

Educated Belvedere Primary and Carterton District High School. After playing for the Carterton club he served as secretary 1927-37. Wairarapa RFU treasurer 1933-39; secretary 1941-61; president 1967-69. NZRFU president 1963. His brother, N.M. McPhee, represented Wairarapa 1941-43.

MACE Roy Albert
b: 19.12.1907, Wellington *d:* 2.1.1972, Mediterranean Sea

A rugby administrator in the Nelson area for 25 years after WWII. NZRFU president 1968.

MADDISON George Alfred Roland
b: 9.10.1884, Hastings *d:* 7.1.1949, Dannevirke

A prominent referee who controlled four Ranfurly Shield matches 1923-25, including Hawke's Bay's record 77-14 defeat of Wairarapa. Also refereed Great Britain v Poverty Bay-East Coast-Bay of Plenty 1930. NZRFU president 1928.

MAINS Laurence William

Mains was convenor of the national selection panel and All Black coach from 1992 to 1995 after nine years as coach of Otago. For more details, see *New Zealand Representatives*.

MANOY Henry
b: 24.11.1879, Napier *d:* 15.12.1954, Motueka

Educated Nelson College. Golden Bay-Motueka RFU president. NZRFU president 1927.

MARRIS Basil Arthur
b: 18.6.1873, Westport *d:* 22.3.1940, Wellington

Served on the NZRFU management committee 1918,19; chairman briefly in 1919 until he resigned as Auckland delegate in favour of representing Taranaki and then left the committee. MBE.

Neil McPhail

MARSLIN Arthur Edward
b: 6.3.1901, Alexandra *d:* 1.12.1977, Alexandra

Educated Otago Boys' High School, 1st XV 1917-19. Represented Otago 1927-29 as a forward from the Alexandra club. All Black trialist 1927-29. Otago RFU president, life member and co-opted as a selector 1949. South Island and New Zealand selector 1950-56. Assistant manager of the 1953-54 All Blacks in Britain and France.

MASON George Harry
b: 1863, England *d:* 19.10.1934, Wellington

Arrived in New Zealand 1870. Canterbury University club coach 1928. Canterbury RFU management committee 1890,92,93,95; vice-president 1896-1909; president 1910; life member. NZRFU president 1913,15. Manager of the 1913 New Zealand team in North America.

MASTERS Robin Read

NZRFU president 1955. For other details see *New Zealand Representatives*.

MAX Donald Stanfield

NZRFU president 1949. For other details see *New Zealand Representatives*.

MEREDITH Vincent Robert Sissons
b: 31.3.1877, Whangarei *d:* 15.1.1965, Auckland

Vincent Meredith

Educated Onehunga High School and Auckland Grammar School, 1st XV 1894. Represented Wellington 1899-1902 as a halfback from the Wellington club. Wellington RFU management committee 1909; selector 1908,09; sole selector 1912,13. Auckland sole selector 1923,24,27-29,34. New Zealand selector 1910,34,35 and manager of the 1910 All Blacks in Australia and the 1935-36 team in Britain. Crown Prosecutor in Auckland from 1921. Sir Vincent Meredith was created a Knight Bachelor 1952 and a Queen's Counsel 1957.

MEREDITH Robert Thomas
b: 19.7.1882, Riverton *d:* 31.5.1952

NZRFU president 1937. President Southland RFU 1922-25.

MESSENGER Ronald Wallace
b: 15.11.1932, Greymouth

Educated Blaketown Primary and Greymouth High School. Played for the Blaketown club 1956-58; life member. West Coast RFU management committee 1959-80; secretary 1974-80; president 1969-73. NZRFU president 1976. Represented West Coast at yachting. His son, Alan, played rugby for West Coast 1979-81.

MILLARD John Norman
b: 11.2.1890, Fortrose, Southland *d:* 18.7.1978, Wellington

Norman Millard

Educated Southland Boys' High School. Represented Otago 1911 from the University club. Wellington RFU management committee 1916-64; chairman 1937-64; president 1950; sole selector 1927-33; selector 1952,53; life member 1964. The Millard Stand at Athletic Park was named after him. NZRFU executive 1953-66; president 1942; life member 1967. Manager of the 1953-54 All Blacks in Britain and France. OBE.

MITCHELL Paul William
b: 9.5.1940, Palmerston North

Paul Mitchell was a member of the NZRFU council from 1979 until 1983, during which time he managed the New Zealand Colts and Juniors, and the All Blacks against the British Isles and Australia in 1983, and on the tour of England and Scotland that year. He has been a member of the Wanganui union since 1968 and was chairman from 1974 until 1983. He has also been a Wanganui city councillor and deputy mayor and chairman of the Wanganui Community Sports Centre.

MOFFETT David
b: 17.5.1947, Doncaster, England

David Moffett, who had been educated in Kenya and Australia, became the first non-New

David Moffett

Zealander to be chief executive of the New Zealand Rugby Football Union when he was appointed in 1995, at first in an acting capacity when he replaced George Verry. Moffett, who was later confirmed in the position, was the architect of much of the change in New Zealand rugby as it made the transition from a fully amateur game to one with a professional elite but with a wide amateur base. Moffett played school and age grade rugby in Australia and was a first grade and provincial-level referee. He was executive director of the New South Wales union 1992-95 and the first chief executive of Sanzar, the body formed to control the three-country Super 12 and tri-nations series. He was also a secretary of the New South Wales Rugby Referees Association.

MONRO Charles John
b: 5.4.1851, Waimea West *d:* 9.4.1933, Palmerston North

The son of Sir David Monro, speaker of the NZ House of Representatives, Charles Monro was educated at Nelson College and was then sent to Christ's College in London to complete his schooling. While in England he played football under the rules of Rugby School and introduced the game in his home town on his return to New Zealand 1870. The Nelson Football Club, which had been playing soccer and the Victorian code (Australian rules), adopted the game and became the first rugby football club in New Zealand. The following year Monro arranged a match with Wellington and the game of rugby football rapidly spread throughout the colony. Monro settled in Palmerston North 1886.

MORGAN Raymond Ernest
b: 6.8.1923, Wellington *d:* 23.7.1975, Wellington

Educated Miramar South School and Rongotai College, 1st XV 1939. Played for the Eastern

Suburbs club in Wellington 1946-48; Petone 1949,51,52; Tukapa 1950. President of the Petone club 1974. NZRFU secretary-treasurer 1970-74. Represented Wellington at softball 1942,43. His son, Trevor, played rugby for Wellington 1971-73,75.

MORRISON Thomas Clarence
NZRFU executive 1946-48; chairman 1962-68; life member 1969. For other details see *New Zealand Representatives.*

Tom Morrison

MULLIGAN Thomas Eruera Whanaupani
b: 4.10.1936, Te Puia Springs

Tom Mulligan has been a member of the NZRFU council and board since 1995 and Maori representative on the board since 1996. He was chairman of the Hawke's Bay union for six years and was president of Hawke's Bay in 1997. He was manager of several Hawke's Bay teams and of varied NZRFU teams, including the national Colts and New Zealand Maoris.

NEILSEN Alfred Ernest
b: c 1878 *d:* 17.8.1965, Palmerston North

Educated Newtown School. Served in the Boer War and WWI. Refereed the second and third tests between New Zealand and the 1921 Springboks.
 Neilsen served as Wellington RFU president 1924-48. NZRFU secretary 1926-36 and secretary-treasurer 1937-50.

NEWMAN Alfred Kingcombe
b: 1849, India *d:* 3.4.1924, Wellington

Came to New Zealand 1853. Educated privately in New Zealand and in Bath, England. Studied medicine at Guy's Hospital, London before returning to New Zealand 1875.
 Wellington RFU president 1904-1924. NZRFU president 1916. member of the House of Representatives for Thornton 1884-90 and Hutt 1890-93. Author of *Who Are the Maoris?*

NORRIS Alfred Charles
b: 8.6.1862, Lyttelton *d:* 1.12.1923, Pakipaki

A prominent referee, 'Jack' Norris controlled New Zealand v Wellington 1901 and the 1904 Ranfurly Shield match Wellington v Canterbury and interisland match in 1903. NZRFU secretary 1902-04. Manager of the 1903 New Zealand team in Australia.

O'CONNOR Francis Patrick
b: 15.5.1923, Hamilton

Educated St Patrick's Convent School (Te Awamutu) and Sacred Heart College (Auckland). Played for Te Awamutu Rovers

Frank O'Connor

1939,40; Army 1941; Ohaupo 1945-50. Te Awamutu sub-union rep 1946,47. St Patrick's club president 1950-64, life member. Te Awamutu sub-union management committee 1950-80; life member. Waikato RFU management committee 1950-84; chairman 1960-84. NZRFU president 1975.

ONGLEY Arthur Montague
b: 21.6.1882, Oamaru *d:* 17.10.1974, Palmerston North

Educated St Patrick's College (Wellington). Represented Hawke's Bay 1902; Manawatu 1905-07,09-11; NZ Universities 1908; Manawatu-Hawke's Bay 1905; President of the Manawatu RFU 1919-22 and the Manawhenua RFU 1926. NZRFU president 1938.

'Joe' Ongley represented the South Island at cricket in the 1903/04 season and captained Manawatu 1905-30. President of the Manawatu Cricket Assn 1926-60 and the NZ Cricket Council 1954,55. Mayor of Feilding 1914-19.

PALMER David Alfred
b: c 1900, Dunedin *d:* 3.6.1964, Dunedin

Played for the Pirates club in Dunedin; committee member; president 1952; life member. Otago RFU management committee 1946-51, treasurer 1952-56, president 1957,58; life member. NZRFU president 1964 (died in office).

PARATA Wiremu Teihoka
b: 1879, Puketeraki *d:* 23.2.1949, Seacliff

Educated Te Aute College. One of the early organisers of Maori rugby, 'Ned' Parata managed his first representative NZ Maori team on its tour of Australia 1910. He visited that country again with NZ Maoris 1913,22,23 and was joint manager of the 1926-27 tour of Britain, France, Canada, Ceylon and Australia. The founder of the Bay of Plenty RFU, he was its first president 1911-25; life member 1925. First chairman of the Maori Advisory Board which he represented on the NZRFU management committee 1922-26; life member 1943. MBE.

PARKER James Hislop

Manager of the 1949 All Blacks in South Africa. NZRFU life member 1959. For other details see *New Zealand Representatives*.

PEARCE Thomas Henry
b: 4.6.1913, Auckland *d:* 10.11.1976, Auckland

Educated Mt Albert Grammar School, 1st XV 1929. Represented Auckland as a prop 1934,36,39,42,45,46 from the Manukau and Grafton clubs; North Island 1937,38; NZ Trials 1937. Named as a reserve for the series against the 1937 Springboks. Included by Danie Craven in his World XV in his book *Danie Craven on Rugby.*

Tom Pearce served on the management committee of the Auckland RFU 1947-61; chairman 1955-61; president 1964-66; selector 1951-53; life member 1960. NZRFU management committee 1955-65, president 1965; life member 1966. Manager of the 1960 All Blacks in South Africa where he was made an honorary vice-president of the SA Rugby Board. Eden Park Trust Board life member. Chairman of the Auckland Regional Authority 1968-76.

PHILLIPS Eric Vyse Maidstone
b: 9.1.1891, Christchurch *d:* 24.4.1981, Palmerston North

Educated Waitaki Boys' High School. Represented Canterbury Juniors 1914 from the Christchurch club. Canterbury RFU management committee 1923-32; president 1941-43; life member. NZRFU president 1945.

PINKER Eric Charles
b: 2.11.1917, Te Puke

Educated Paengaroa School. Played for the local club and represented the Te Puke sub-union 1939,40. A leg injury suffered during WWII ended his active rugby career. Te Puke sub union president and chairman 1956-61. Bay of Plenty RFU president and chairman 1961-74. NZRFU president 1969.

PITTAWAY Stewart Robertson
b: 16.12.1925, Waipara

Educated Addington and Waihopai Primary and Southland Boys' High School. Represented Southland 1946-48 (Southland HSOB), 1949 (Winton) as a flanker. When 'Mick' Pittaway ended his 14-year playing career for various clubs and sub-unions in Southland, he began an even longer period in administration.

He served terms on both the Southland and West Coast management committees (including three years as chairman of the latter), was Southland selector 1961-69 and a West Coast selector from 1973 to 1980. He was elected a vice-president and councillor of the NZRFU in 1983 and was the union's president in 1986. Pittaway also played indoor basketball for Southland and cricket for Southland Country.

POWNALL Geoffrey Herbert Sutcliffe
b: 5.12.1877, Motueka *d:* 4.5.1939, Wanganui

Educated Wanganui Collegiate. Represented Wanganui from the Wanganui College OB club. Sole selector Wanganui RFU 1935. NZRFU president 1932. Also represented Wanganui at tennis and athletics.

PRENDEVILLE James
b: 12.10.1876, Wellington *d:* 5.3.1951, Wellington

Educated Makara School and Wellington College. Represented Wairarapa 1904,06. Wairarapa RFU secretary 1903. Wellington RFU management committee 1919-36; chairman 1921-36; president 1938,39; life member 1937. NZRFU executive 1937-47; president 1948; life member 1948.

RHODES Arthur Edgar Gravenor
b: ?.3.1859, The Levels *d:* 26.12.1922, Christchurch

Educated Christ's College. Canterbury RFU president 1886-1908. NZRFU president 1896,1905. NZ Cricket Council president 1904,05. Mayor of Christchurch 1901; Member of the House of Representatives.

RHODES Charles Henry Jenman
b: 20.4.1924, Christchurch

Educated Sydenham School. Played for the RNZAF 1942-45 and Sydenham club 1946-58. Represented Canterbury 1951-53 as a forward. Sydenham club president 1959-66. Canterbury RFU management committee 1959-67; vice-president 1968-73; president 1974-76; life member 1980. NZRFU president 1978. Represented Canterbury and the South Island at indoor basketball.

RIPPIN Albert Charles
b: 25.4.1907, Christchurch *d:* 27.6.1990, Timaru

Educated Lyttelton Primary and Christchurch Boys' High School. Played for the Linwood club. Timaru OB club president 1961,62; club captain 1937. South Canterbury RFU treasurer 1939-79. NZRFU president 1970.

ROBERTS Kevin John
b: 20.10.1949, Lancaster, England

Kevin Roberts was formerly chief operating officer of Lion Nathan, one of the NZRFU's major sponsors, and was elected on to the restructured NZRFU board in 1996 as an independent member. He was a key figure in the establishment of the All Black Club, a supporters and fundraising venture formed in 1994 to assist the welfare of All Blacks. He was

also a member of the North Harbour board. Roberts, who played rugby in England, Switzerland and France, is the New York-based chief executive of advertising agency Saatchi and Saatchi.

ROPE Douglas Bryce
b: 11.2.1923, Te Kopuru

Educated Auckland Grammar School, 1st XV 1940-42, captain for the last two years. Represented Auckland 1947-52 (University); NZ Universities 1948,49,51-53. He played loose forward. Rope took up coaching when he finished his playing career, coaching Auckland's University club 1958-64 and was a NZ Universities selector 1965-73 (coaching the 1972 side to North America).

Bryce Rope

Rope became a North Island selector 1973 and was elected to the national panel 1980. He coached NZ Colts 1979-81 and NZ Juniors 1982 and took over as convenor of the national panel (and thus All Black coach) in 1983. He coached the All Blacks to wins over the Lions in 1983, was coach on the tour of England and Scotland later that year, and of the team that beat France in 1984 before touring Australia and Fiji. He was replaced as convenor by Brian Lochore 1985 but served another year as selector before standing down.

ROSS Duncan Kaipara
b: 12.7.1915, Dargaville *d:* 21.5.1981, Whangarei

Educated Whangarei Boys' High School. Played for the HSOB club in that city. North Auckland RFU chairman 1947-76. NZRFU council 1954-79; president 1979; life member 1980. Manager of the 1968 All Blacks in Australia. Life member NZRFU 1981.

SAXTON Charles Kesteven

Manager of the 1967 All Blacks in Britain and France. NZRFU life member 1976. For other details see *New Zealand Representatives.*

SCIASCIA Horace Noel
b: 23.12.1929, Levin

Educated Koputaroa Primary School and Horowhenua College. 'Sonny' Sciascia played a year of senior rugby for Levin Wanderers and two years third grade before a refereeing career that spanned 14 years to 1965 and included 13 NZRFU appointments (six Ranfurly Shield matches). Sciascia served on the Horowhenua RFU from 1955 to 1981 and was elected to the NZRFU council 1983. President NZRFU 1985.

His father, J.D. Sciascia, played for NZ Maoris 1910 and 1913 and a brother, G.J. Sciascia, for NZ Maoris 1948.

SHARP Stuart Alan
b: 7.11.1919, Wellington

Educated Seatoun Primary and Southland Boys' High School, Sharp's rugby career was concentrated on refereeing and administration. He refereed Ranfurly Shield and matches against international sides and served for 25 years until 1976 on the Southland union, chairman 1956-77; life member.

Elected to the NZRFU council 1980, president 1982.

SLADE George William
b: c 1883 *d:* 10.6.1940, Wellington

Served on the NZRFU management committee 1919-23, taking over the chairmanship (1919-22) when Basil Marris resigned.

SLEIGH Samuel Edmund
b: Nov. 1855, London *d:* 17.2.1909, Deal, England

Toured New Zealand with the Dunedin club 1877 and two years later played for Otago clubs, a forerunner to the Otago representative team. Sleigh served as a committee member and vice-president of the Dunedin club. First secretary treasurer of the Otago RFU 1881; management committee 1883.

In 1884, with the assistance of the Canterbury RFU secretary William Millton, Sleigh organised

Duncan Ross

a tour of Australia by the first New Zealand rugby team. Millton captained the team with Sleigh as manager and the 19 players – drawn from the Auckland, Wellington, Canterbury and Otago unions – were unbeaten in eight matches, scoring 167 points for; 17 against.

Sleigh edited the *NZ Rugby Football Annual 1885* – one of the earliest books published on New Zealand rugby. Returned to England and was a member of the Rugby Football Union committee 1888-91.

SMITH Robert John
b: 21.9.1882 *d:* 25.5.1961, Pahiatua

Represented Bush 1901-09 from the Konini club and played for Wairarapa-Bush against the 1908 Anglo-Welsh tourists. Bush RFU delegate to the national union for many years. NZRFU president 1936; life member 1949.

SPEDDING Douglas MacKenzie
b: 19.7.1885, Dunedin *d:* 4.3.1946, Dunedin

Educated Otago Boys' High School. Otago RFU management committee 1927-30; treasurer 1931-45. NZRFU council 1937-42,44,45; president 1943. Pirates RFC life member 1923.

SPICER John James
b: 18.6.1934, Loburn

John Spicer was elected to the NZRFU council in 1995 and retained his position on the new board when it was set up in 1996. He has been deputy chairman since 1996. He has been a member of the Otago union board since 1984 and chairman since 1990. Spicer, who was educated at Christchurch Boys' High School, played senior club rugby in Christchurch, Hamilton and Dunedin, and for Canterbury under 20.

SPRIGGENS George
b: 26.4.1863, Hertfordshire, England *d:* 23.6.1944, Wanganui

Came to New Zealand 1874. Played rugby for the Wanganui Voluntary Fire Brigade team from 1886. President of the Pirates club and Wanganui RFU. The main rugby ground in Wanganui (for which he donated the park gates) was named after him. NZRFU president 1917.

STANLEY Noel Henry
b: 28.7.1919, New Plymouth *d:* 11.8.1994, Opunake

Educated Okato and Warea Schools. Played club rugby for Rahotu 1933-40 and Opunake 1946,47. Served on the committee of the latter club 1947-80; president 1951-61; life member 1960. Taranaki RFU 1954-80; chairman 1959-77; president 1958, life member 1972. NZRFU council 1966-83, NZRFU president 1983. Manager of the 1972 NZ Juniors in Australia, the All Blacks on the 1973 internal tour, in Ireland 1974 and South Africa 1976.

STEWART John Joseph
b: 18.7.1923, Auckland

Educated Sacred Heart College (Auckland). Played club rugby for Massey University 1941,43,44; Auckland Training College 1946,47;

J.J. Stewart

New Plymouth HSOB 1948. Represented Manawatu 1944.

J.J. Stewart coached the New Plymouth Boys' High School 1st XV 1950-64. Taranaki selector-coach 1963-69. Wanganui selector-coach 1970,71. North Island selector 1972-77. New Zealand selector 1973-77; convenor 1973-76. Co-manager of the 1955 NZ Colts in Australia and Ceylon. Assistant manager of All Black teams touring Australia and Fiji 1974, Ireland, Wales and England 1974, South Africa 1976. Unsuccessful Labour candidate in several elections during the 1970s. NZRFU council 1985,86.

STRANG Harold Stanley
b: 7.4.1891, Invercargill *d:* 30.11.1962, Invercargill

Educated Southland Boys' High School. Represented Southland 1921,22 as a lock forward from the Star club; president 1931,32 and life member 1951. Southland RFU president and life member. NZRFU council 1946,49,50; president 1947; life member 1952. New Zealand selector 1945-49 and manager of the 1947 All Blacks in Australia.

STUART Donald McNaughton
b: 1880, Dunedin *d:* 23.3.1936, Dunedin

Educated Otago Boys' High School. Represented Otago 1904,05 as a forward from the Pirates club (life member) and played for the South Island 1904. Selected for 1905-06 NZ team to Britain but failed a medical examination. Otago RFU management committee 1909-13; vice-president 1914-25; president 1926-28. NZ selector 1920-23. NZRFU president 1935 (died in office). Skip of national bowls champion fours 1930.

STURGEON John Andrew
b: 12.12.1935, Motueka

John Sturgeon was a member of the NZRFU council from 1987 until 1995 and All Black manager 1988-91, making him the longest-serving manager of the New Zealand team. The

All Blacks, with Sturgeon as manager and Alex Wyllie as coach, went unbeaten from the beginning of 1988 until the third test against Australia in 1990. Sturgeon was on the West Coast union management committee 1976-86 and was chairman for three years from 1984. He is a life member of the Star United club in Greymouth and of the West Coast union and won several awards for administration on the Coast.

John Sturgeon

SULLIVAN John Lorraine

New Zealand selector 1954-60 and assistant manager of the 1960 All Blacks in South Africa. NZRFU chairman 1969-77 and life member 1977. For other details see *New Zealand Representatives*.

SULLIVAN Samuel Henry
b: 19.4.1890, Christchurch *d:* 8.3.1958, Timaru

Educated Belfast Primary and Rangiora High School. Served on the management committee and as president of the Ashburton County RFU during the 1920s; South Canterbury RFU management committee for 30 years; president for 17 years; selected and coached teams from that union and the Star club. NZRFU president 1953.

SUTHERLAND Frank Emanuel
b: 10.7.1892, Auckland *d:* 23.1.1963, Auckland

Educated Onehunga Primary, Auckland Grammar School, 1st XV 1908-10. Represented Auckland 1919 as a forward. Refereed the fourth test on the 1930 British team's tour of New Zealand. President and life member of the NZRRA and Auckland RRA.

Auckland RFU selector 1932,33; vice-president 1937-42; president 1945-51. NZRFU council 1942-51; president 1952; life member 1953. Attended the Imperial Rugby Conferences in London 1947,50 and International Board meetings 1952,57.

His brother, Pat, represented Auckland 1896,1901,03. MBE.

THOMAS Barry Charles
b: 14.1.1945, Invercargill

A Queenstown-based company director, Thomas was elected on to the restructured NZRFU board in 1996 as one of the two independent members. Educated at Southland Boys' High School, he played for the school's First XV, Otago University and Otago B. He has been a director of the New Zealand Tourism Board from 1995 and of New Zealand Way from 1993.

THOMAS Russell William
b: 17.2.1926, Christchurch

Though Russ Thomas achieved much in rugby including chairmanship of the NZRFU and of Rugby World Cup Ltd, history may remember him as one of the most successful and effective managers of All Black teams. He managed the All Blacks at home and overseas in 1978 and 1979, and the crowning achievement was the 1978 team in Britain winning the only grand slam by a New Zealand team. He was a member of the NZRFU council from 1974 until 1993 and chairman from 1986 until 1990, during which New Zealand successfully staged – and won – the first World Cup. After being beaten in a ballot for the chairmanship in 1990, Thomas was appointed chairman of Rugby World Cup Ltd, the IRB subsidiary wholly responsible for cup organisation. He is a life member of the New Zealand and Canterbury unions. He was on the Canterbury union management committee from 1959 until 1980 and president of the union 1977-80.

TODD Ernest Laurence
b: 18.9.1917, Wellington *d:* 8.11.1974, Wellington

Ernie Todd

Educated St Patrick's College (Wellington). Represented Wellington 1936-41,46 as a number eight from the St Patrick's College OB club, captained that province in the 1941 season. An All Black trialist 1939 and considered a leading prospect for the cancelled 1940 South African tour. Wellington RFU management committee 1958-66. NZRFU executive 1966-73. Manager of the 1972-73 All Blacks in Britain and France. National discus champion 1940.

TONKS Edward James
b: 30.12.1934, Wellington

Eddie Tonks was on the NZRFU council from 1986 until 1995, deputy chairman in 1988 and 1989, and chairman from 1990 until 1995. He had also been deputy chairman of the Wellington Rugby Union 1977-89. Tonks, who had been educated at Waipu District High School and Wellington Technical College, in 1984 bought the company he had worked for since 1958, Independent Casing Company, and built it into one of the world leaders in its field. It was this business expertise that Tonks took to rugby. He had been on the council less than a year when he took over much of the organisation of the first World Cup and he is widely credited with the cup being such a success. Tonks was also a rarity in that he successfully challenged

Eddie Tonks

Russ Thomas for the chairmanship in 1990. Previous successions had been by agreement, without ballot. Tonks stood down in 1995 in equally unusual circumstances, announcing on the morning of the annual meeting that he would not be seeking re-election.

USMAR Barry Ronald
b: 23.4.1929, Lower Hutt *d:* 11.4.1990, Wellington

Educated Waterloo Primary School and Wellington College. Played for the Wellington College OB club 1951-56 representing Wellington Juniors 1952. Wellington College OB committee member 1949-55; treasurer 1956-65; club captain 1966-75; life member 1977. Wellington RFU vice-president 1978,79. NZRFU secretary-treasurer 1978-90.

VERRY George Robin
b: 15.11.1940, New Plymouth

George Verry took over from Barry Usmar as chief executive of the NZRFU on Usmar's death in 1990. He came from a commercial and accounting background, most recently with Arthur Young and Company (later part of Ernst and Young), of which he had been a partner 1973-90. Verry and chairman Eddie Tonks oversaw a period of great change in rugby administration that some observers saw as preparing for the even greater change that occurred in 1995, the year that both Verry and Tonks left.

Ivan Vodanovich

VODANOVICH Ivan Matthew Henry

New Zealand selector 1967-72 and assistant manager of the 1970 All Blacks. For other details see *New Zealand Representatives.*

WALKER James Duncan Urquart
b: 27.4.1900, Dunedin *d:* 11.10.1974, Wanganui

Represented Otago 1924-26, as a threequarter and fullback from the Pirates club. Patea club coach and delegate to the Taranaki RFU; that union's president 1951. NZRFU president 1954. Manager of the 1954 NZ Maori team in Fiji.

WARREN Lincoln Francis
b: 18.10.1914, Auckland

Educated Avondale Primary School. Played for the Suburbs club 1939; Air Force 1940; North Island Combined Services 1940. Joined the Auckland RRA 1945; member of the big five panel 1953,54; graded as a No. 1 referee 1954. Auckland RFU secretary-treasurer 1954-76. Member of the NZRFU Junior and Teenage Committee. Eden Park Board of Control secretary-treasurer 1955-79. President Auckland union 1984-86. MBE 1979 for his services to rugby.

WASHINGTON George William
b: 31.1.1901, Blenheim *d:* 20.11.1964, Blenheim

Played 45 games for Marlborough 1921,22,24-29,32. Marlborough RFU management committee 1938; president 1950-55,59-62; life member. NZRFU president 1962.

WATSON Eric Alexander
b: 20.7.1925, Dunedin

Educated High St School (Dunedin) and Dunedin Technical College. Played for the Zingari-Richmond club 1945-55 and represented Otago 1945,46 as a five-eighth. Zingari-Richmond club coach and president 1972.

Otago RFU management committee 1973-80; selector 1962-71. South Island selector 1973-79. New Zealand selector 1974-80, convenor 1979,80. Coached NZ Juniors 1970s and the All Blacks in Australia 1979, England and Scotland 1979, Australia and Fiji 1980, Wales 1980. Represented Otago at cricket 1947-57. Watson's father, Ernie, played rugby for Otago 1910-15,20,21,23.

Eric Watson

WHATMAN Edmund Merrick Dew
b: c 1861 *d:* 21.10.1915, Tauera

Represented Wairarapa 1886,87 from the Masterton club. Wairarapa RFU president 1893-1906; selector 1891. NZRFU president 1906.

WILSON Samuel Frederick
b: 1878 *d:* 29.4.1938, Christchurch

A stalwart of the Albion club in Christchurch. Canterbury RFU management committee 1906-14, president 1920-29; life member. NZRFU president 1923. New Zealand selector 1908,10,13,14. Represented NSW.

WYLIE Edgar McMillan
b: 16.8.1878, Wellington *d:* 16.8.1946, Wellington

Educated Terrace School (Wellington). Played for the Oriental club as a forward, representing Wellington 1899-1904 and Manawatu 1902. Oriental club life member 1939. Wellington RFU management committee 1905; selector 1905,06,08. NZRFU secretary 1905,06; management committee 1907,08; treasurer 1912-18,21-30; life member 1931. Manager of the 1907 All Blacks in Australia – at 28, Wylie remains the youngest manager of a New Zealand side. Awarded the Royal Humane Society's silver medal for a rescue in Wellington Harbour.

WYLLIE Alexander John

After coaching Canterbury from 1982 to 1986, Wyllie was a national selector in 1987 and convenor of the national selection panel and All Black coach from 1988 to 1991. He later coached in South Africa and Argentina. For more details, see *New Zealand Representatives.*

New Zealand Selectors

The 1957-60 All Black selection panel. From left, Ron King, Jack Sullivan and Dick Everest.

Year	Selector	Region
1893	G.F.C. Campbell	Wellington
	T. Henderson	Auckland
	F. Logan	Hawke's Bay
1894	G.F.C. Campbell	Wellington
	W.J. Cotterill	Canterbury
	J.P. Firth	Nelson
	T. Henderson	Auckland
	F. Logan	Hawke's Bay
1896	A.D. Downes	Otago
	F.T. Evans	Canterbury
	G.C. Fache	Wellington
1897	H.J. Coutts	Wanganui
	G.C. Fache	Wellington
	W.G. Garrard	Canterbury
1901	A. Bayly	Taranaki
	G.C. Fache	Wellington
	J.S. Hutchison	Otago
1903	F.T. Evans	Canterbury
	G.C. Fache	Wellington
	H.F. Harris	Otago
	F.S.M. Murray	Auckland
1904	G.C. Fache	Wellington
	W.G. Garrard	Canterbury
	H.F. Harris	Otago
	F.S.M. Murray	Auckland
1905	A. Bayly	Taranaki
	F.T. Evans	Canterbury
	G.C. Fache	Wellington
	H.F. Harris	Otago
1907	F.T. Evans	Canterbury
	D. Gallaher	Auckland
	H.F. Harris	Otago
	H.W. Kelly	Wellington
1908	D. Gallaher	Auckland
	H.F. Harris	Otago
	H.W. Kelly	Wellington
	S.F. Wilson	Canterbury
1910	D. Gallaher	Auckland
	H.F. Harris	Otago
	V.R.S. Meredith	Wellington
	S.F. Wilson	Canterbury
1913	V.G. Cavanagh	Otago
	D. Gallaher	Auckland
	H.J. Mynott	Taranaki
	S.F. Wilson	Canterbury
1914	D. Gallaher	Auckland
	H.F. Harris	Otago
	J.H. Lynskey	Wellington
	S.F. Wilson	Canterbury
1920	A.J. Griffiths	Wellington
	D.J. Malone	Taranaki
	G.W. Nicholson	Auckland
	D.M. Stuart	Otago
	S.F. Wilson	Canterbury
1921	A.J. Griffiths	Wellington
	G.W. Nicholson	Auckland
	D.M. Stuart	Otago

Year	Selector	Region
1922	A.J. Griffiths	Wellington
	D.M. Stuart	Otago
1923	W.A. Drake	Canterbury
	A.J. Griffiths	Wellington
	E. Parata	Horowhenua
	D.M. Stuart	Otago
1924	L.V. Carmine	Buller
	H.E. Davis	Canterbury
	A.J. Geddes	Southland
	W.A. Guy	Taranaki
	E. McKenzie	Wairarapa
	N.A. McKenzie	Hawke's Bay
	N.A. Wilson	Wellington
1925	H.E. Davis	Canterbury
	A.J. Geddes	Southland
	E. McKenzie	Wairarapa
	N.A. McKenzie	Hawke's Bay
	N.A. Wilson	Wellington
1926	A.J. Geddes	Southland
	E. McKenzie	Wairarapa
1927-28	A.A. Adams	West Coast
	A.J. Geddes	Southland
	W.A. Guy	Taranaki
	E. McKenzie	Wairarapa
1929-30	A.J. Geddes	Southland
	W.E.J. Maxwell	Canterbury
	A. McDonald	Otago
	E. McKenzie	Wairarapa
	N.A. McKenzie	Hawke's Bay
	G.W. Nicholson	Auckland
1931-32	A. McDonald	Otago
	E. McKenzie	Wairarapa
1934-35	A.A. Adams	West Coast
	S.S.M. Dean	Wellington
	E. McKenzie	Wairarapa
	V.R.S. Meredith	Auckland
	W.J. Pearson	Otago

Year	Selector	Region
1936-37	A.A. Adams	West Coast
	J.T. Burrows	Canterbury
	E. McKenzie	Wairarapa
	F.H. Masters	Taranaki
	M.F. Nicholls	Wellington
	G.W. Nicholson	Auckland
	W.J. Pearson	Otago
1938-39	E. McKenzie	Wairarapa
1944	C. Brown	Taranaki
	A. McDonald	Wellington
	P.W. Storey	Canterbury
1945	F.W. Lucas	Auckland
	A. McDonald	Wellington
	H.S. Strang	Southland
1946	F.W. Lucas	Auckland
	A. McDonald	Wellington
	H.S. Strang	Southland
1947-48	A. McDonald	Wellington
	N.A. McKenzie	Hawke's Bay
	H.S. Strang	Southland
1949	R.R. Masters	Canterbury
	N.A. McKenzie	Hawke's Bay
	H.S. Strang	Southland
1950-53	M.M.N. Corner	Auckland
	A.E. Marslin	Otago
	T.C. Morrison	Wellington
1954-56	A.E. Marslin	Otago
	T.C. Morrison	Wellington
	J.L. Sullivan	Taranaki
1957-60	R.A. Everest	Waikato
	R.R. King	West Coast
	J.L. Sullivan	Taranaki
1961-63	R.G. Bush	Auckland
	J. Finlay	Manawatu
	N.J. McPhail	Canterbury

1964	F.R. Allen	*Auckland*
	R.G. Bush	*Auckland*
	D.L. Christian	*Horowhenua*
	V.L. George	*Southland*
	N.J. McPhail	*Canterbury*
1965-66	F.R. Allen	*Auckland*
	D.L. Christian	*Horowhenua*
	V.L. George	*Southland*
1967-68	F.R. Allen	*Auckland*
	V.L. George	*Southland*
	I.M.H. Vodanovich	*Wellington*
1969-70	V.L. George	*Southland*
	I.M.H. Vodanovich	*Auckland*
	P.T. Walsh	*Counties*
1971	R.H. Duff	*Canterbury*
	I.M.H. Vodanovich	*Wellington*
	P.T. Walsh	*Counties*
1972	R.H. Duff	*Canterbury*
	J. Gleeson	*Manawatu*
	I.M.H. Vodanovich	*Wellington*
1973	R.H. Duff	*Canterbury*
	J. Gleeson	*Manawatu*
	J.J. Stewart	*Wanganui*
1974-77	J. Gleeson	*Manawatu*
	J.J. Stewart	*Wanganui*
	E.A. Watson	*Otago*
1978-79	P.S. Burke	*Taranaki*
	J. Gleeson	*Manawatu*
	E.A. Watson	*Otago*
1980	P.S. Burke	*Taranaki*
	D.B. Rope	*Auckland*
	E.A. Watson	*Otago*
1981-82	P.S. Burke	*Taranaki*
	S.F. Hill	*Canterbury*
	D.B. Rope	*Auckland*
1983-84	S.F. Hill	*Canterbury*
	B.J. Lochore	*Wairarapa-Bush*
	D.B. Rope	*Auckland*

The 1967-68 selectors, from left, Les George, Ivan Vodanovich and Fred Allen.

1985	S.F. Hill	*Canterbury*
	B.J. Lochore	*Wairarapa-Bush*
	D.B. Rope	*Auckland*
1986	S.F. Hill	*Canterbury*
	B.J. Lochore	*Wairarapa-Bush*
	C.E. Meads	*King Country*
1987	J.B. Hart	*Auckland*
	B.J. Lochore	*Wairarapa-Bush*
	A.J. Wyllie	*Canterbury*

1988	E.W. Kirton	*Wellington*
	P.L. Penn	*Wairarapa-Bush*
	A.J. Wyllie	*Canterbury*
1989	J.B. Hart	*Auckland*
	P.L. Penn	*Wairarapa-Bush*
	A.J. Wyllie	*Canterbury*
1990	J.B. Hart	*Auckland*
	P.L. Penn	*Wairarapa-Bush*
	A.J. Wyllie	*Canterbury*
1991	J.B. Hart	*Auckland*
	P.L. Penn	*Wairarapa-Bush*
	A.J. Wyllie	*Canterbury*
1992	E.W. Kirton	*Wellington*
	L.W. Mains	*Otago*
	P.R. T Thorburn	*North Harbour*
1993	E.W. Kirton	*Wellington*
	L.W. Mains	*Otago*
	P.R.T. Thorburn	*North Harbour*
1994	G.L. Colling	*Auckland*
	E.W. Kirton	*Wellington*
	L.W. Mains	*Otago*
1995	R.M. Cooper	*Thames Valley*
	E.W. Kirton	*Wellington*
	L.W. Mains	*Otago*
1996	R.M. Cooper	Thames Valley
	J.B. Hart	*Auckland*
	G.R.R. Hunter	*Otago*
1997	R.M. Cooper	*Thames Valley*
	J.B. Hart	*Auckland*
	G.R.R. Hunter	*Otago*

All Black manager Mike Banks, coach John Hart and selectors Gordon Hunter (second left) and Ross Cooper (right) applaud the All Blacks in Pretoria in 1996 after they had won a series in South Africa for the first time.

World Cup

Officially it is called the International Rugby Football Board Tournament for the Webb Ellis Cup but to New Zealanders and the rest of the rugby world, it is quite simply rugby's World Cup.

The first in 1987 had been a long time a-coming. Rugby had been in the Olympics early this century and unlikely rugby countries like Italy had over the years proposed a World Cup, but the rugby establishment was always against the idea and even passed a resolution in 1958 expressly forbidding the members of the International Board from participating in any

The Webb Ellis Cup

tournament involving teams from several countries.

But even the International Board, still dominated then by the three British countries and Ireland, moves with the times and it took heed of calls from several international players and, most particularly, from New Zealand and Australia, that a cup was what the players wanted. In 1982 a cup proposal mounted by a private

sports promoter, Neil Durden-Smith, was dismissed by the IRB but the New Zealanders and Australians believed they could sway the board provided the cup remained under its control.

Separately and apparently unbeknown to each other, the New Zealand and Australian Rugby Football Unions during 1983 prepared their own cup proposals. Faced with this combined assault, the IRB in 1984 agreed the two Anzac nations should prepare a feasibility study and when that was presented to the IRB's meeting in Paris in 1985, the board gave the go-ahead.

There had been much consultation about when it would be held; the where was easier — the impetus had come from New Zealand and Australia and that was where it would be. It had at one time been suggested the first World Cup be staged in 1986 to coincide with the International Board's centenary but there was too little time in which to organise it. Two years later, in 1988, would have given a more practical preparation time but that would have then locked the World Cup into the Olympic cycle, creating unnecessary problems in seeking sponsorship, television coverage and publicity.

So 1987 was decided upon and the New Zealand and Australian officials, working under an umbrella IRB tournament committee, had just on two years to organise rugby's first truly international event. Among their first tasks was to decide which countries should play and how those countries should be selected.

South Africa, for the practical reasons that their players and officials would not be given visas to enter either Australia or New Zealand and that, even if they were, their presence would cause dissension and disruption, was the only IRB member not invited. The remaining seven IRB countries (England, Scotland, Ireland, Wales, France, Australia and New Zealand) became the seeded nations with a non-member, Argentina, becoming the eighth. The other eight invited were Fiji, Italy, the United States, Canada, Romania, Zimbabwe, Tonga and Japan. Western Samoa and South Korea were next on the list as replacements if needed.

Organisers divided the 16 into four pools, ensuring two seeds in each pool, with the first phase of the competition a round robin of pool matches followed by the knockout quarterfinals and semifinals.

Coincidental with the advent of the World Cup, the International Board also decided to widen its ambit and admit associate members for the first time. Of the eight non-seeds in the cup, only Fiji, Tonga and Romania were not associate members by the time the tournament began in Auckland on 22 May. They were added in 1987 along with other countries not involved in the first World Cup. All full and associate members of the IRB are eligible for the cup.

A superbly prepared All Black side, playing an innovative style of rugby, was easily the best team on display at the first World Cup, comfortably beating France 29-9 in the final at Eden Park.

Despite a recommendation from New Zealand and Australia that the cup should in future be held in one country, the second was held in the United Kingdom, Ireland and France, involving five separate rugby administrations. The All Blacks, as defending champions, opened the tournament against hosts England at Twickenham with an 18-12 win, but were eliminated in a semifinal in Dublin by Australia. The final at Twickenham against England, who had beaten Scotland in the other semifinal, was won by Australia.

South Africa had not been invited to either of the first two cup tournaments but were chosen at a meeting in Wellington in 1992 to host the third, in 1995. South Africa was then in the process of transition from a white minority government to the majority government led by Nelson Mandela.

The All Blacks and Australians toured South Africa later in 1992 to signal a full return to international rugby.

Despite some pre-cup reservations, the tournament was hugely successful with the All Blacks, with Jonah Lomu a dominating presence, generally regarded as the best side. They beat England – with Lomu scoring four tries – to make the final against South Africa but were beaten 15-12 when the cup final went into extra time.

The 1999 cup, despite criticism of an unwieldy draw and the separate administrations, will again be in the United Kingdom, Ireland and France, with Wales this time as the official host. After South Africa, the cup qualifying process changed and all countries must now play qualifying matches except for the two previous finalists and the winner of the playoff match, in this case France, who beat England.

NEW ZEALAND AT THE WORLD CUP

1987 in NEW ZEALAND and AUSTRALIA
(May 22-June 20)

Pool matches	v Italy	won 70-6	Auckland
	v Fiji	won 74-13	Christchurch
	v Argentina	won 46-15	Wellington
Quarterfinal	v Scotland	won 30-3	Christchurch
Semifinal	v Wales	won 49-6	Brisbane
Final	**v France**	**won 29-9**	**Auckland**

1991 in GREAT BRITAIN, IRELAND and FRANCE
(October 3-Nov 2)

Pool matches	v England	won 18-12	London
	v United States	won 46-6	Gloucester
	v Italy	won 31-21	Leicester
Quarterfinal	v Canada	won 29-13	Lille
Semifinal	v Australia	lost 6-16	Dublin
Third place playoff	v Scotland	won 13-6	Cardiff

Australia beat England 12-6 in the final

1995 in SOUTH AFRICA
(May 27-June 24)

Pool matches	v Ireland	won 43-19	Johannesburg
	v Wales	won 34-9	Johannesburg
	v Japan	won 145-17	Bloemfontein
Quarterfinal	v Scotland	won 48-30	Pretoria
Semifinal	v England	won 45-29	Cape Town
Final	v South Africa	lost 12-15	Johannesburg

WORLD CUP SCORING

	Tries*	Con	Pen	DG	Total
G.J. Fox	-	37	31	1	170
A.P. Mehrtens	1	14	14	3	84
S.D. Culhane	1	20	-	-	45
M.C.G. Ellis	7	-	-	-	35
J.T. Lomu	7	-	-	-	35
J.J. Kirwan	7	-	-	-	28
C.I. Green	6	-	-	-	24
J.P. Preston	-	4	5	-	23
J.A. Gallagher	5	-	-	-	20
D.E. Kirk	5	-	-	-	20
A.J. Whetton	5	-	-	-	20
W.K. Little	4	-	-	-	19
J.A. Kronfeld	3	-	-	-	15
E.J. Rush	3	-	-	-	15
J.W. Wilson	3	-	-	-	15
G.M. Osborne	3	-	-	-	15
Z.V. Brooke	3	-	-	1	15
J.T. Stanley	3	-	-	-	12
J.K.R. Timu	3	-	-	-	12
T.J. Wright	3	-	-	-	12
M.N. Jones	3	-	-	-	12
R.M. Brooke	2	-	-	-	10
F.E. Bunce	2	-	-	-	10
W.T. Shelford	2	-	-	-	8
V.I. Tuigamala	2	-	-	-	8
C.R. Innes	2	-	-	-	8
A.T. Earl	2	-	-	-	8
G.T.M. Bachop	1	-	-	-	5
C.W. Dowd	1	-	-	-	5
P.W. Henderson	1	-	-	-	5
A. Ieremia	1	-	-	-	5
R.W. Loe	1	-	-	-	5
S.B.T. Fitzpatrick	1	-	-	-	5
K.J. Crowley	1	-	-	-	4
W.T. Taylor	1	-	-	-	4
M. Brooke-Cowden	1	-	-	-	4
J.A. Drake	1	-	-	-	4
S.C. McDowell	1	-	-	-	4
G.H. Purvis	1	-	-	-	4
J.A. Hewett	1	-	-	-	4
B.J. McCahill	1	-	-	-	4
W.K. Little	1	-	-	-	4

* tries were worth four points in 1987 and 1991; five in 1995

WORLD CUP ALL BLACKS
* signifies did not play a match

Anderson A.	Canterbury	1987
Bachop G.T.M.	Canterbury	1991,95
Botica F.M.*	North Harbour	1987
Brewer M.R.	Canterbury	1995
Brooke R.M.	Auckland	1995
Brooke Z.V.	Auckland	1987,91,95
Brooke-Cowden M.	Auckland	1987
Brown O.M.	Auckland	1995
Bunce F.E.	North Harbour	1995
Carter M.P.	Auckland	1991
Crowley K.J.	Taranaki	1987,91
Culhane S.D.	Southland	1995
Dalton A.G.*	Counties	1987
Deans I.B.*	Canterbury	1987
Drake J.A.	Auckland	1987
Dowd C.W.	Auckland	1995
Dowd G.W.*	North Harbour	1991
Earl A.T.	Canterbury	1987,91
Ellis M.C.G.	Otago	1995
Fitzpatrick S.B.T.	Auckland	1987,91,95
Fox G.J.	Auckland	1987,91
Gallagher J.A.	Wellington	1987
Gordon S.P.*	Waikato	1991
Green C.I.	Canterbury	1987
Henderson P.W.	Otago	1991
	Southland	1995
Hewett J.A.	Auckland	1991
Hewitt N.J.	Hawke's Bay	1995
Ieremia A.	Wellington	1995
Innes C.R.	Auckland	1991
Jones I.D.	North Auckland	1991
	North Harbour	1995
Jones M.N.	Auckland	1987,91
Joseph J.W.	Otago	1995
Kirk D.E.	Auckland	1987
Kirwan J.J.	Auckland	1987,91
Kronfeld J.A.	Otago	1995
Larsen B.P.	North Harbour	1995
Little W.K.	North Harbour	1991,95
Loe R.W.	Waikato	1987,91
	Canterbury	1995
Lomu J.T.	Counties-Manukau	1995
McCahill B.J.	Auckland	1987,91
McDowell S.C.	Auckland	1987,91
Mehrtens A.P.	Canterbury	1995
Osborne G.M.	North Harbour	1995
Philpott S.	Canterbury	1991
Pierce M.J.	Wellington	1987
Preston J.P.	Wellington	1991
Purvis G.H.	Waikato	1991
Rush E.J.	North Harbour	1995
Schuler K.J.	North Harbour	1995
Shelford W.T.	North Harbour	1987
Stanley J.T.	Auckland	1987,91
Strachan A.D.	North Harbour	1995
Taylor W.T.	Canterbury	1987
Timu J.K.R.	Otago	1991
Tuigamala V.I.	Auckland	1991
Whetton A.J.	Auckland	1987,91
Whetton G.W.	Auckland	1987,91
Wilson J.W.	Otago	1995
Wright T.J.	Auckland	1987,91

Major Trophies

RANFURLY SHIELD

In 1901, the Earl of Ranfurly, Governor of New Zealand, announced his intention of presenting a cup to the New Zealand Rugby Football Union, of which he was patron. Ranfurly made no stipulation as to what form the competition for the trophy should take, leaving the national union to decide. The annual general meeting of the NZRFU in 1902 decided that the cup should be for competition among affiliated unions on a challenge basis, the first holder to be the union with the best record for the 1902 season.

When the trophy arrived it was found to be a shield, rather than a cup, and had obviously been designed for a soccer competition. The centre-piece was duly altered and on September 13, 1902, the shield was presented by the Governor to G.H. Dixon, the Auckland delegate to the NZRFU. Auckland, with an unbeaten record, was declared the first winner of the Ranfurly Shield.

ORIGINAL RULES

The following rules were drawn up by the NZRFU management committee for competition for the Ranfurly Shield:

The Shield shall be a Challenge Shield, open to all Unions affiliated to the New Zealand Union, subject to the following rules:

1. At the end of 1902 season the Management Committee of the New Zealand Union shall allot the shield to the union whose representative team it considers to have the best record of the year.

2. Such union shall hold it subject to the right of challenge by an affiliated union, but not to be called on to play more challenge matches in the season than the Management Committee of the New Zealand Union considers advisable, provided that any union meeting the holder of the shield in the course of its ordinary union matches shall have the right to declare beforehand to the New Zealand Union and to the union holding the shield that such match shall also be a challenge match.

3. All special challenge matches shall be played on the ground of the holder of the shield for the time being, except in the event of the shield being held by one union for two consecutive seasons. Such unions shall have the option of declaring any matches played on tour shield matches.

4. Any union desiring to play a challenge match with the holder shall give notice to the New Zealand Union of such desire not later than the end of August in each year, provided that the holder for the time being shall not be required, unless they elect otherwise, to play any challenge match before the first Saturday in July.

5. The New Zealand Union shall have the right to declare which, if any, of the challenges shall be allowed.

6. A challenge match shall be played on a date to be arranged by the unions engaged; but, failing such arrangement, the date of playing shall be fixed by the New Zealand Union. No match, however, shall be played after the last Saturday in September.

7. In all challenge matches for the shield (as distinguished from an ordinary match declared to be a challenge match under Rule 2) the New Zealand Rugby Football Union shall, if requested by either the challenging or the

The fifth Earl of Ranfurly

The Ranfurly Shield

challenged union, appoint the referee. The challenging union shall be entitled so far as the proceeds of that particular match will allow (after the payment of all actual ground charges, gatekeepers' wages, advertising, and other incidental expenses of the match) to reasonable expenses incurred by the challenging union in playing the match. Any balance of such proceeds shall belong to the union challenged. Provided however that 5 per cent of such balance shall be paid to the New Zealand Rugby Football Union to form the nucleus of a fund for the assistance of such unions requiring it.
8. The union for the time being holding the shield shall keep the same insured against fire to the full insurance value thereof, and in the event of the shield being damaged or destroyed will contribute the amount of such insurance towards the cost of making good such damage or replacing the shield.
9. If any dispute shall arise as to the amount of expenses to be paid to the challenging union, or as to any matter or question arising out of these regulations, then the question in dispute shall be referred to the Management Committee of the New Zealand Rugby Football Union.

• In accordance with Rule 3, Auckland did not play any challenge matches for the shield in 1903, as its team was on tour that season and did not play any home games. Thus the first challenge match was played against Wellington in 1904, the holders being defeated 6-3 and the Ranfurly Shield passed to Wellington. However, some shield holders have taken the trophy on tour, the first to do so being Wellington, who defeated Canterbury at Christchurch in 1919. In the next season Wellington played five shield matches away from home, losing the trophy to Southland at Invercargill.

PRESENT RULES
1. The Ranfurly Shield shall be a challenge shield open to all affiliated unions.
2. The affiliated union from time to time holding the shield shall hold it subject to the rights of challenge by an affiliated union in accordance with these regulations.
Conditions for all challenge matches
3. (a) The holders shall not be required to play any challenge match before the first day of July. Nevertheless, at its sole discretion, the holders may play a match before the first day of July.

(b) Unless the consent of the NZRFU is obtained, no challenge match shall be played by the holders against a union which is in a different division of the National Provincial Championship from that of the holders during the period of the first day of August to the last day of the round robin of the NPC, both days inclusive.
(c) No challenge match shall be played after the last day of the round robin of the NPC.
4. The members of the challenging team and the team of the holders must in all cases comprise players who are eligible to play for the respective unions in accordance with rule 74 of the rules of the NZRFU.
5. All challenge matches shall be played on a ground of the holders on a date to be arranged by the unions concerned, but failing such arrangement, the date of playing of the match shall be fixed by the NZRFU; provided, however, that the holders may, at their option, agree to play a challenge match on a ground of the challenging union.
6. In all shield matches, the referee shall be appointed by the NZRFU, which shall meet the reasonable expenses of the referee.
7. A challenging union, if it is in a division of the NPC different from that of the holder, shall be eligible to receive a special travel grant, the amount to be determined from time to time by the board, if the sponsorship arrangements for the shield are not applicable.

0	to 100km	$1000 plus GST
101	to 250km	$2000
251	to 500km	$3000
501	to 750km	$4000
751	to 1000km	$5000
over 1000km		$6000

No grant should exceed 10 per cent of the net gate.
8. A surcharge as determined annually by the board is to be added to the gate charges, except for charges to children. The surcharge is not to be subject to any deduction and is to be remitted in full to the NZRFU. The surcharge is to be applied as part of the overall funding of the NPC.
9. Any union desiring to play a challenge match with the holders must give written notice to the holders and the NZRFU of such desire not later than the 21st day of October in the preceding year.
10. The holders shall advise all unions which have lodged challenges in accordance with regulation No 9 and the NZRFU not later than the 31st day of October in the year the challenges are received, the challenges which have been accepted and the dates on which the respective matches are to be played.
11. The holders shall not be called upon to play more challenge matches during the season than are considered fair and reasonable by the NZRFU, but in no case may fewer than four challenges be accepted by the holders.
12. Provided in each case the challenge has been lodged as provided in regulation No 9, then:
(a) if the holders are in division one of the NPC, they shall accept challenges totalling not less than two from unions in divisions two and three, provided not fewer than two challenges have been lodged by unions in divisions two and three.
(b) if the holders are in division two of the NPC, they shall accept not less than two challenges from unions in division one and two challenges from unions in division three, provided in each case challenges had been lodged by not fewer than two unions.
(c) if the holders are in division three of the NPC, they shall accept not less than two challenges from unions in divisions one and three challenges from unions in division two,

provided in each case challenges had been lodged by not fewer than two unions and three unions respectively.
13. Notwithstanding regulations 9, 10 and 11, all matches arranged to be played by the holders against other affiliated unions on any ground of the holders between the first day of July and the last day of the round robin of the NPC inclusive, shall be challenge matches.
Additional conditions when holders are defeated
14. All matches to be played by the new holders against other affiliated unions on any ground of the holders up to and including the first full weekend in October shall be challenge matches for the shield except when the game concerned would be a championship semifinal for the holder subject to the provisions of condition 3.
15. Any union which did not previously have a match arranged with the new holders on the holders' ground may, within six days of the new holders winning the shield, notify the new holders and the NZRFU of its challenge for the shield.
16. The new holders may accept additional challenges lodged in accord with regulation 15. However, in determining which additional challenges are to be accepted, the new holders shall give priority to unions which had had a challenge accepted by the holders of the shield at the beginning of the season and whose challenge remained unplayed. The new holders shall declare within eight days of winning the shield which additional challenges lodged in terms of regulation 15 it has accepted.
17. If the holders are defeated but regain the shield in the same season, then any challenges previously accepted by the union for dates subsequent to the date on which it regained the shield shall be automatically reinstated.
18. Not more than seven players are to be nominated and available under the laws of the game [Law 3(2)(b)] as replacements and the names of these replacements are to be given in writing to a representative of the opposing team before the match commences. The players so nominated as replacements may be changed ready for play, but they must be seated in the stand.
Disputes and interpretation
19. If any dispute shall arise as to the meaning or interpretation of these regulations, or as to any matter or question relating to challenge matches but not provided for in these regulations, then such dispute or question shall be decided by the NZRFU, subject to rule 60 of the rules of the NZRFU.

RANFURLY SHIELD CHALLENGE MATCHES WITH VENUES

1904	Wellington 6	
	Auckland 3	Auckland
	Wellington 6	
	Canterbury 3	Wellington
	Wellington 15	
	Otago 13	Wellington
1905	Wellington 3	
	Wairarapa 3	Wellington
	Wellington 11	
	Hawke's Bay 3	Wellington
	Auckland 10	
	Wellington 6	Wellington
1906	Auckland 29	
	Canterbury 6	Auckland
	Auckland 18	
	Taranaki 5	Auckland
	Auckland 48	
	Southland 12	Auckland
	Auckland 11	
	Wellington 5	Auckland

1907 Auckland 21 / Buller 0 — Auckland
Auckland 12 / Hawke's Bay 3 — Auckland
Auckland 6 / Wanganui 5 — Auckland

1908 Auckland 32 / Marlborough 0 — Auckland
Auckland 24 / Wellington 3 — Auckland
Auckland 9 / Taranaki 0 — Auckland
Auckland 11 / Otago 5 — Auckland

1909 Auckland 18 / Taranaki 5 — Auckland

1910 Auckland 11 / Hawke's Bay 3 — Auckland
Auckland 3 / Wellington 3 — Auckland
Auckland 16 / Taranaki 9 — Auckland
Auckland 6 / Canterbury 4 — Auckland

1911 Auckland 21 / South Auckland 5 — Auckland
Auckland 29 / Poverty Bay 10 — Auckland

1912 Auckland 6 / Taranaki 5 — Auckland
Auckland 12 / Wellington 0 — Auckland
Auckland 5 / Otago 5 — Auckland

1913 Auckland 6 / Wellington 5 — Auckland
Auckland 27 / Poverty Bay 3 — Auckland
Taranaki 14 / Auckland 11 — Auckland

1914 Taranaki 17 / Wanganui 3 — Hawera
Taranaki 11 / Manawatu 3 — New Plymouth
Taranaki 14 / Horowhenua 3 — Hawera
Taranaki 22 / Wairarapa 3 — Stratford
Taranaki 6 / Canterbury 5 — New Plymouth
Taranaki 6 / Southland 0 — New Plymouth
Wellington 12 / Taranaki 6 — Stratford

1919 Wellington 21 / Canterbury 8 — Wellington
Wellington 18 / Taranaki 10 — Wellington
Wellington 23 / Canterbury 9 — Christchurch
Wellington 24 / Auckland 3 — Wellington
Wellington 30 / Wanganui 3 — Wellington

1920 Wellington 15 / Canterbury 3 — Wellington
Wellington 22 / Bay of Plenty 3 — Wellington
Wellington 20 / Taranaki 9 — Hawera
Wellington 20 / Hawke's Bay 5 — Wellington

Wellington 23 / Auckland 20 — Auckland
Wellington 16 / Taranaki 5 — Wellington
Wellington 20 / Wanganui 14 — Wellington
Wellington 20 / Auckland 3 — Wellington
Wellington 32 / South Canterbury 16 — Timaru
Wellington 16 / Otago 5 — Dunedin
Southland 17 / Wellington 6 — Invercargill

1921 Southland 10 / Otago 8 — Invercargill
Wellington 28 / Southland 13 — Wellington
Wellington 27 / Auckland 19 — Wellington
Wellington 13 / Otago 8 — Wellington

1922 Hawke's Bay 19 / Wellington 9 — Wellington
Hawke's Bay 17 / Bay of Plenty 16 — Hastings
Hawke's Bay 42 / King Country 8 — Napier

1923 Hawke's Bay 6 / Wairarapa 0 — Napier
Hawke's Bay 10 / Wellington 6 — Napier
Hawke's Bay 15 / Poverty Bay 0 — Hastings
Hawke's Bay 9 / Canterbury 8 — Hastings
Hawke's Bay 38 / Horowhenua 11 — Napier
Hawke's Bay 20 / Auckland 5 — Napier

1924 Hawke's Bay 30 / Wairarapa 14 — Napier
Hawke's Bay 46 / Poverty Bay 10 — Napier
Hawke's Bay 35 / Nelson 3 — Hastings
Hawke's Bay 23 / Auckland 6 — Napier
Hawke's Bay 31 / Manawatu 5 — Hastings

1925 Hawke's Bay 22 / Wairarapa 3 — Napier
Hawke's Bay 24 / Canterbury 18 — Napier
Hawke's Bay 31 / Southland 12 — Napier
Hawke's Bay 28 / Taranaki 3 — Hastings
Hawke's Bay 20 / Wellington 11 — Wellington
Hawke's Bay 34 / Otago 14 — Hastings

1926 Hawke's Bay 77 / Wairarapa 14 — Napier
Hawke's Bay 36 / Wanganui 3 — Hastings
Hawke's Bay 58 / Wellington 8 — Napier
Hawke's Bay 41 / Auckland 11 — Napier
Hawke's Bay 17 / Canterbury 15 — Christchurch

1927 Wairarapa 15 / Hawke's Bay 11 — Napier

Wairarapa 53 / Bush 3 — Masterton
Hawke's Bay 21 / Wairarapa 10* — Masterton
Manawhenua 18 / Wairarapa 16 — Carterton
Manawhenua 9 / Taranaki 3 — Palmerston North
Manawhenua 25 / Wanganui 6 — Palmerston North
Canterbury 17 / Manawhenua 6 — Palmerston North

*match awarded to Wairarapa following an appeal to the NZRFU. Hawke's Bay fielded W.P. Barclay in this game but he had not fulfilled the necessary residential qualifications and his team lost the match.

1928 Canterbury 29 / South Canterbury 9 — Christchurch
Wairarapa 8 / Canterbury 7 — Christchurch
Wairarapa 57 / Bush 11 — Masterton
Wairarapa 26 / Marlborough 8 — Carterton
Wairarapa 9 / Wellington 3 — Carterton
Wairarapa 31 / Manawhenua 10 — Carterton

1929 Wairarapa 10 / Hawke's Bay 6 — Masterton
Wairarapa 17 / Auckland 14 — Carterton
Wairarapa 37 / Manawhenua 16 — Masterton
Wairarapa 17 / Canterbury 12 — Masterton
Southland 19 / Wairarapa 16 — Carterton

1930 Southland 19 / Wanganui 0 — Invercargill
Southland 37 / Otago 5 — Invercargill
Southland 9 / Hawke's Bay 6 — Invercargill
Wellington 12 / Southland 3 — Invercargill

1931 Wellington 36 / Southland 13 — Wellington
Canterbury 8 / Wellington 6 — Wellington
Canterbury 17 / Otago 6 — Christchurch

1932 Canterbury 11 / South Canterbury 5 — Christchurch
Canterbury 14 / Auckland 0 — Christchurch
Canterbury 5 / West Coast 3 — Christchurch
Canterbury 9 / Wellington 8 — Christchurch
Canterbury 13 / Buller 0 — Christchurch
Canterbury 17 / Waikato 6 — Christchurch

1933 Canterbury 31 / Ashburton County 7 — Christchurch
Canterbury 21 / Southland 3 — Christchurch
Canterbury 8 / Otago 5 — Christchurch
Canterbury 23 / West Coast 14 — Christchurch
Canterbury 13 / Buller 3 — Christchurch
Canterbury 15 / Taranaki 15 — Christchurch

Canterbury 6		
South Canterbury 3	Christchurch	
Canterbury 36		
King Country 0	Christchurch	

1934 Hawke's Bay 9
Canterbury 0 — Christchurch
Hawke's Bay 39
Wanganui 16 — Napier
Hawke's Bay 23
Taranaki 8 — Napier
Auckland 18
Hawke's Bay 14 — Napier

1935 Auckland 29
North Auckland 8 — Auckland
Canterbury 16
Auckland 13 — Auckland
Canterbury 27
Wairarapa 16 — Christchurch
Canterbury 8
Southland 3 — Christchurch
Canterbury 16
West Coast 11 — Christchurch
Canterbury 12
South Canterbury 11 — Christchurch
Otago 15
Canterbury 6 — Christchurch

1936 Otago 16
Southland 3 — Dunedin
Otago 14
Auckland 5 — Dunedin
Otago 11
Manawatu 5 — Dunedin
Otago 26
South Canterbury 3 — Dunedin
Otago 16
Canterbury 0 — Dunedin
Otago 30
North Auckland 0 — Dunedin
Otago 16
Wellington 3 — Dunedin
Otago 30
West Coast 0 — Dunedin

1937 Southland 12
Otago 7 — Dunedin

1938 Otago 7
Southland 6 — Invercargill
Otago 16
Canterbury 7 — Dunedin
Otago 27
South Canterbury 16 — Dunedin
Otago 12
North Otago 0 — Dunedin
Otago 4
Hawke's Bay 0 — Dunedin
Otago 24
Taranaki 3 — Dunedin
Southland 10
Otago 5 — Dunedin
Southland 10
Wellington 3 — Invercargill
Southland 20
Ashburton County 16 — Invercargill

1939 Southland 23
Otago 4 — Invercargill
Southland 17
Manawatu 3 — Invercargill
Southland 38
Bush 0 — Invercargill
Southland 50
Ashburton County 0 — Invercargill

1946 Southland 3
Otago 0 — Invercargill
Southland 11
Canterbury 3 — Invercargill

Southland 35
South Canterbury 9 — Invercargill
Southland 12
Wairarapa 3 — Invercargill
Southland 15
North Otago 3 — Invercargill

1947 Otago 17
Southland 11 — Invercargill
Otago 31
North Auckland 12 — Dunedin
Otago 18
Auckland 12 — Dunedin
Otago 8
Southland 0 — Dunedin
Otago 42
North Otago 3 — Dunedin

1948 Otago 25
Southland 0 — Dunedin
Otago 31
Canterbury 0 — Dunedin
Otago 20
Wanganui 3 — Dunedin
Otago 12
Hawke's Bay 6 — Dunedin
Otago 40
Poverty Bay 0 — Dunedin
Otago 36
South Canterbury 6 — Dunedin
Otago 11
Wellington 0 — Dunedin

1949 Otago 6
Buller 6 — Dunedin
Otago 22
Manawatu 3 — Dunedin
Otago 6
Southland 3 — Dunedin
Otago 27
Waikato 5 — Dunedin
Otago 6
Taranaki 5 — Dunedin
Otago 16
Auckland 5 — Dunedin

1950 Otago 22
Southland 3 — Dunedin
Canterbury 8
Otago 0 — Dunedin
Wairarapa 3
Canterbury 0 — Christchurch
South Canterbury 17
Wairarapa 14 — Masterton
North Auckland 20
South Canterbury 9 — Timaru

1951 North Auckland 16
Bay of Plenty 12 — Whangarei
North Auckland 19
Thames Valley 6 — Whangarei
Waikato 6
North Auckland 3 — Whangarei
Waikato 14
Auckland 6 — Hamilton
Waikato 32
Bay of Plenty 10 — Hamilton
Waikato 21
Taranaki 12 — Hamilton
Waikato 14
Wanganui 0 — Hamilton

1952 Waikato 17
Thames Valley 3 — Hamilton
Waikato 14
Wairarapa 0 — Hamilton
Auckland 9
Waikato 0 — Hamilton
Waikato 6
Auckland 3 — Auckland

Waikato 18
King Country 8 — Hamilton
Waikato 12
Manawatu 3 — Hamilton
Waikato 20
West Coast 6 — Hamilton

1953 Waikato 19
Bay of Plenty 3 — Hamilton
Waikato 24
North Auckland 5 — Hamilton
Waikato 3
Taranaki 3 — Hamilton
Wellington 9
Waikato 6 — Hamilton
Wellington 22
Southland 6 — Wellington
Wellington 42
East Coast 0 — Wellington
Wellington 9
Otago 3 — Wellington
Wellington 26
Taranaki 3 — Wellington
Wellington 23
Auckland 6 — Wellington
Canterbury 24
Wellington 3 — Wellington
Canterbury 19
Buller 3 — Christchurch

1954 Canterbury 18
Southland 10 — Christchurch
Canterbury 16
Wairarapa 3 — Christchurch
Canterbury 24
South Canterbury 11 — Christchurch
Canterbury 6
Waikato 6 — Christchurch
Canterbury 11
Taranaki 6 — Christchurch
Canterbury 8
West Coast 0 — Christchurch
Canterbury 9
Otago 9 — Christchurch
Canterbury 17
Wanganui 13 — Christchurch
Canterbury 22
Buller 0 — Christchurch

1955 Canterbury 12
Auckland 6 — Christchurch
Canterbury 19
South Canterbury 6 — Christchurch
Canterbury 30
Wellington 11 — Christchurch
Canterbury 39
North Auckland 11 — Christchurch
Canterbury 15
Otago 8 — Christchurch
Canterbury 20
West Coast 11 — Christchurch
Canterbury 24
Thames Valley 11 — Christchurch

1956 Canterbury 14
Mid Canterbury 6 — Christchurch
Canterbury 21
Hawke's Bay 9 — Christchurch
Canterbury 19
Wanganui 6 — Christchurch
Canterbury 38
West Coast 17 — Christchurch
Canterbury 32
South Canterbury 17 — Christchurch
Canterbury 17
Southland 3 — Christchurch
Wellington 8
Canterbury 0 — Christchurch
Wellington 9
Auckland 6 — Wellington

1957	Wellington 22 Bush 9	Wellington
	Wellington 15 Poverty Bay 3	Wellington
	Wellington 34 Wanganui 5	Wellington
	Otago 19 Wellington 11	Wellington
	Otago 6 South Canterbury 3	Dunedin
	Taranaki 11 Otago 9	Dunedin
1958	Taranaki 56 Golden Bay- Motueka 8	New Plymouth
	Taranaki 16 Mid Canterbury 0	New Plymouth
	Taranaki 15 King Country 11	New Plymouth
	Taranaki 9 Manawatu 8	New Plymouth
	Taranaki 22 Wanganui 9	New Plymouth
	Taranaki 6 Wellington 6	New Plymouth
	Taranaki 15 Waikato 3	New Plymouth
	Taranaki 14 North Auckland 3	New Plymouth
	Taranaki 11 Counties 5	New Plymouth
1959	Taranaki 31 Nelson 14	New Plymouth
	Taranaki 17 Wanganui 11	New Plymouth
	Taranaki 22 Wellington 6	New Plymouth
	Taranaki 23 Otago 3	New Plymouth
	Southland 23 Taranaki 6	New Plymouth
	Auckland 13 Southland 9	Invercargill
1960	Auckland 22 Thames Valley 6	Auckland
	Auckland 14 Counties 3	Auckland
	North Auckland 17 Auckland 11	Auckland
	North Auckland 24 Poverty Bay 3	Whangarei
	Auckland 6 North Auckland 3	Whangarei
	Auckland 31 Manawatu 8	Auckland
	Auckland 9 Bay of Plenty 6	Auckland
	Auckland 22 Wellington 9	Auckland
	Auckland 25 Taranaki 6	Auckland
	Auckland 19 Canterbury 18	Auckland
1961	Auckland 5 Hawke's Bay 3	Auckland
	Auckland 17 King Country 3	Auckland
	Auckland 17 Counties 12	Auckland
	Auckland 14 Otago 9	Auckland
	Auckland 9 Southland 6	Auckland
	Auckland 13 Wellington 8	Auckland
	Auckland 10 Waikato 0	Auckland
	Auckland 26 North Auckland 11	Auckland
1962	Auckland 24 Thames Valley 9	Auckland
	Auckland 29 Bay of Plenty 6	Auckland
	Auckland 8 North Auckland 3	Auckland
	Auckland 52 West Coast 6	Auckland
	Auckland 15 Waikato 11	Auckland
	Auckland 27 Taranaki 3	Auckland
	Auckland 15 Canterbury 6	Auckland
	Auckland 46 Bush 6	Auckland
	Auckland 20 Wellington 8	Auckland
1963	Auckland 22 Wairarapa 8	Auckland
	Auckland 41 Wanganui 18	Auckland
	Auckland 3 Hawke's Bay 3	Auckland
	Wellington 8 Auckland 3	Auckland
	Taranaki 17 Wellington 3	Wellington
	Taranaki 14 Wanganui 12	New Plymouth
1964	Taranaki 11 Buller 0	New Plymouth
	Taranaki 15 Wanganui 15	New Plymouth
	Taranaki 3 Wellington 0	New Plymouth
	Taranaki 21 King Country 0	New Plymouth
	Taranaki 12 Canterbury 9	New Plymouth
	Taranaki 32 Wairarapa 8	New Plymouth
	Taranaki 14 Waikato 9	New Plymouth
	Taranaki 6 Manawatu 3	New Plymouth
	Taranaki 12 North Auckland 8	New Plymouth
1965	Taranaki 33 Bush 6	New Plymouth
	Taranaki 23 Wanganui 9	New Plymouth
	Taranaki 11 Wellington 3	New Plymouth
	Taranaki 6 Southland 6	New Plymouth
	Taranaki 21 Hawke's Bay 17	New Plymouth
	Auckland 16 Taranaki 11	New Plymouth
	Auckland 14 Waikato 6	Auckland
1966	Auckland 14 King Country 6	Auckland
	Auckland 11 Canterbury 11	Auckland
	Waikato 15 Auckland 11	Auckland
	Hawke's Bay 6 Waikato 0	Hamilton
1967	Hawke's Bay 11 Manawatu 6	Napier
	Hawke's Bay 35 Waikato 9	Napier
	Hawke's Bay 27 Wairarapa 6	Napier
	Hawke's Bay 29 Southland 6	Napier
	Hawke's Bay 16 Taranaki 3	Napier
	Hawke's Bay 9 Otago 8	Napier
	Hawke's Bay 12 Wellington 12	Napier
1968	Hawke's Bay 36 Bush 6	Napier
	Hawke's Bay 31 East Coast 0	Napier
	Hawke's Bay 21 Poverty Bay 5	Napier
	Hawke's Bay 30 Marlborough 3	Napier
	Hawke's Bay 18 Counties 3	Napier
	Hawke's Bay 14 Bay of Plenty 0	Napier
	Hawke's Bay 9 Auckland 9	Napier
1969	Hawke's Bay 18 Wairarapa 11	Napier
	Hawke's Bay 22 Manawatu 6	Napier
	Hawke's Bay 19 King Country 16	Napier
	Hawke's Bay 27 Waikato 13	Napier
	Hawke's Bay 14 Wellington 6	Napier
	Hawke's Bay 10 North Auckland 8	Napier
	Hawke's Bay 24 Taranaki 8	Napier
	Canterbury 18 Hawke's Bay 11	Napier
1970	Canterbury 19 South Canterbury 8	Christchurch
	Canterbury 14 Waikato 9	Christchurch
	Canterbury 13 Taranaki 3	Christchurch
	Canterbury 14 Buller 5	Christchurch
	Canterbury 28 Mid Canterbury 8	Christchurch
	Canterbury 20 Southland 9	Christchurch
	Canterbury 16 Otago 12	Christchurch
	Canterbury 3 Wellington 3	Christchurch
1971	Canterbury 14 North Otago 0	Christchurch
	Canterbury 16 Auckland 17	Christchurch
	Counties 8 North Auckland 17	Auckland
	Auckland 12 North Auckland 16	Auckland
	King Country 6	Whangarei
1972	North Auckland 35 Buller 0	Whangarei
	North Auckland 31 Poverty Bay 3	Whangarei
	North Auckland 4 Manawatu 4	Whangarei
	North Auckland 27 Taranaki 15	Whangarei

North Auckland 22
Bay of Plenty 6 Whangarei
Auckland 16
North Auckland 15 Whangarei
Canterbury 12
Auckland 6 Auckland
Canterbury 47
West Coast 3 Christchurch
Canterbury 23
Otago 9 Christchurch

1973 Marlborough 13
Canterbury 6 Christchurch
Marlborough 36
Wairarapa-Bush 0 Blenheim
Marlborough 26
North Otago 9 Blenheim
Marlborough 30
Wanganui 6 Blenheim
Marlborough 29
Nelson Bays 9 Blenheim
Marlborough 36
Mid Canterbury 9 Blenheim

1974 Marlborough 18
West Coast 0 Blenheim
South Canterbury 18
Marlborough 6 Blenheim
South Canterbury 9
North Otago 3 Timaru
Wellington 9
South Canterbury 3 Timaru
Wellington 18
Waikato 12 Wellington
Auckland 26
Wellington 13 Wellington
Auckland 9
Waikato 6 Auckland

1975 Auckland 22
Thames Valley 0 Auckland
Auckland 19
Hawke's Bay 6 Auckland
Auckland 19
Wellington 14 Auckland
Auckland 7
Counties 6 Auckland
Auckland 22
North Auckland 16 Auckland
Auckland 17
Waikato 13 Auckland
Auckland 13
Marlborough 4 Auckland

1976 Auckland 16
Wanganui 9 Auckland
Auckland 9
Southland 9 Auckland
Manawatu 12
Auckland 10 Auckland
Manawatu 36
Horowhenua 16 Palmerston North
Manawatu 15
Hawke's Bay 3 Palmerston North

1977 Manawatu 12
Wairarapa-Bush 6 Palmerston North
Manawatu 26
Wanganui 9 Palmerston North
Manawatu 15
Counties 10 Palmerston North
Manawatu 21
Marlborough 7 Palmerston North
Manawatu 18
Southland 6 Palmerston North
Manawatu 6
Taranaki 3 Palmerston North
Manawatu 17
Otago 3 Palmerston North

1978 Manawatu 51
West Coast 10 Palmerston North
Manawatu 42
Horowhenua 14 Palmerston North
Manawatu 24
Poverty Bay 0 Palmerston North
Manawatu 13
Wellington 6 Palmerston North
North Auckland 12
Manawatu 10 Palmerston North

1979 North Auckland 21
King Country 6 Whangarei
North Auckland 35
Thames Valley 3 Whangarei
North Auckland 29
Marlborough 6 Whangarei
North Auckland 20
South Canterbury 12 Whangarei
North Auckland 23
Taranaki 11 Whangarei
Auckland 9
North Auckland 3 Whangarei
Auckland 11
Counties 9 Auckland

1980 Auckland 37
Horowhenua 3 Auckland
Auckland 29
King Country 3 Auckland
Auckland 19
Poverty Bay 12 Auckland
Auckland 25
Southland 3 Auckland
Auckland 43
Otago 13 Auckland
Waikato 7
Auckland 3 Auckland
Waikato 16
Thames Valley 7 Hamilton
Waikato 15
Taranaki 0 Hamilton

1981 Waikato 24
Otago 12 Hamilton
Waikato 13
Bay of Plenty 3 Hamilton
Waikato 54
East Coast 0 Hamilton
Waikato 14
Canterbury 7 Hamilton
Waikato 20
Counties 20 Hamilton
Waikato 22
King Country 9 Hamilton
Wellington 22
Waikato 4 Hamilton

1982 Wellington 31
Marlborough 6 Wellington
Wellington 30
Wanganui 9 Wellington
Wellington 13
Hawke's Bay 12 Wellington
Wellington 19
Taranaki 6 Wellington
Canterbury 16
Wellington 12 Wellington
Canterbury 15
Counties 15 Christchurch
Canterbury 51
Wairarapa-Bush 6 Christchurch

1983 Canterbury 88
North Otago 0 Christchurch
Canterbury 28
Southland 10 Christchurch
Canterbury 28
Mid Canterbury 0 Christchurch
Canterbury 39
North Auckland 9 Christchurch

Canterbury 50
South Canterbury 12 Christchurch
Canterbury 32
Hawke's Bay 3 Christchurch
Canterbury 20
Wellington 16 Christchurch
Canterbury 31
Auckland 9 Christchurch
Canterbury 28
Manawatu 15 Christchurch

1984 Canterbury 34
Nelson Bays 10 Christchurch
Canterbury 57
Buller 13 Christchurch
Canterbury 68
West Coast 3 Christchurch
Canterbury 24
Wairarapa-Bush 6 Christchurch
Canterbury 44
Otago 3 Christchurch
Canterbury 16
Waikato 10 Christchurch
Canterbury 27
Counties 19 Christchurch
Canterbury 18
Bay of Plenty 13 Christchurch

1985 Canterbury 33
King Country 0 Christchurch
Canterbury 27
Taranaki 3 Christchurch
Canterbury 53
Southland 0 Christchurch
Canterbury 42
Marlborough 4 Christchurch
Canterbury 17
Mid Canterbury 7 Christchurch
Canterbury 29
North Auckland 3 Christchurch
Auckland 28
Canterbury 23 Christchurch
Auckland 39
Waikato 0 Auckland
Auckland 12
Counties 9 Auckland

1986 Auckland 97
Thames Valley 0 Auckland
Auckland 18
North Harbour 6 Auckland
Auckland 82
Horowhenua 6 Auckland
Auckland 50
Wairarapa-Bush 7 Auckland
Auckland 42
Otago 7 Auckland
Auckland 21
Manawatu 0 Auckland
Auckland 28
Canterbury 15 Auckland
Auckland 32
North Auckland 6 Auckland

1987 Auckland 59
Wanganui 6 Auckland
Auckland 56
Hawke's Bay 18 Auckland
Auckland 72
East Coast 0 Auckland
Auckland 43
Bay of Plenty 3 Auckland
Auckland 49
Taranaki 6 Auckland
Auckland 34
Waikato 11 Auckland
Auckland 33
Wellington 18 Auckland
Auckland 48
Counties 9 Auckland

1988 Auckland 28
King Country 0 Te Kuiti
Auckland 41
Taranaki 13 New Plymouth
Auckland 43
North Auckland 15 Auckland
Auckland 62
Hawke's Bay 9 Napier
Auckland 39
North Harbour 12 Auckland
Auckland 59
Manawatu 3 Auckland
Auckland 27
Otago 17 Auckland
Auckland 31
Canterbury 10 Auckland

1989 Auckland 58
Thames Valley 7 Paeroa
Auckland 44
Taranaki 15 Auckland
Auckland 66
Mid Canterbury 0 Ashburton
Auckland 84
Counties 3 Auckland
Auckland 34
Bay of Plenty 21 Auckland
Auckland 22
Waikato 9 Auckland
Auckland 29
Wellington 6 Auckland

1990 Auckland 58
King Country 3 Auckland
Auckland 42
Poverty Bay 3 Gisborne
Auckland 78
Southland 7 Auckland
Auckland 45
Otago 9 Auckland
Auckland 41
North Auckland 21 Auckland
Auckland 18
North Harbour 9 Auckland
Auckland 33
Canterbury 30 Auckland

1991 Auckland 76
Nelson Bays 0 Nelson
Auckland 29
Bay of Plenty 18 Auckland
Auckland 27
Counties 0 Auckland
Auckland 52
Manawatu 4 Auckland
Auckland 55
Taranaki 9 Auckland
Auckland 40
Waikato 12 Auckland
Auckland 31
Wellington 21 Auckland
Auckland 32
South Canterbury 6 Timaru

1992 Auckland 55
Marlborough 3 Blenheim
Auckland 21
Otago 16 Auckland
Auckland 40
Hawke's Bay 9 Napier
Auckland 42
King Country 15 Taupo
Auckland 49
North Auckland 3 Auckland
Auckland 47
Canterbury 38 Auckland
Auckland 24
Counties 19 Pukekohe
Auckland 25
North Harbour 16 Auckland

1993 Auckland 80
Horowhenua 17 Levin
Auckland 48
Buller 3 Westport
Auckland 69
Hawke's Bay 31 Auckland
Auckland 139
North Otago 5 Oamaru
Auckland 51
Wellington 14 Auckland
Waikato 17
Auckland 6 Auckland
Waikato 28
Otago 11 Hamilton

1994 Waikato 74
Thames Valley 3 Hamilton
Waikato 26
Manawatu 11 Hamilton
Waikato 98
South Canterbury 22 Hamilton
Waikato 45
King Country 10 Hamilton
Canterbury 29
Waikato 26 Hamilton
Canterbury 42
Counties 16 Christchurch
Canterbury 22
Otago 20 Christchurch

1995 Canterbury 64
Mid Canterbury 19 Ashburton
Canterbury 43
Nelson Bays 17 Christchurch
Canterbury 79
Marlborough 0 Christchurch
Canterbury 72
South Canterbury 17 Christchurch
Canterbury 27
Southland 22 Christchurch

Canterbury 58
Waikato 30 Christchurch
Canterbury 66
Wellington 17 Christchurch
Auckland 35
Canterbury 0 Christchurch
Auckland 26
Waikato 17 Auckland

1996 Auckland 88
Poverty Bay 20 Gisborne
Auckland 30
Bay of Plenty 29 Auckland
Taranaki 42
Auckland 39 Auckland
Taranaki 13
North Harbour 11 New Plymouth
Waikato 40
Taranaki 19 New Plymouth
Waikato 17
North Harbour 14 Hamilton
Auckland 27
Waikato 7 Hamilton
Auckland 69
North Harbour 27 Auckland

1997 Auckland 115
East Coast 6 Ruatoria
Auckland 47
Northland 14 Auckland
Auckland 34
Southland 32 Auckland
Auckland 27
Counties-
Manukau 12 Auckland
Auckland 93
West Coast 20 Greymouth
Waikato 31
Auckland 29 Auckland

RANFURLY SHIELD SUMMARY

First and most recent shield match	Played	Won	Lost	Drawn as Holder	Challenger	for	against
Auckland (1904-97)	186	149	31	5	1	5234	2031
Bay of Plenty (1920-96)	15	-	15	-	-	149	347
Buller (1907-93)	11	-	10	-	1	33	249
Bush (1927-68)	7	-	7	-	-	41	258
Canterbury (1904-95)	130	92	32	5	1	2814	1406
Counties (1958-97)[1]	18	-	16	-	2	178	426
East Coast (1953-97)	5	-	5	-	-	6	314
Golden Bay-Motueka (1958)	1	-	1	-	-	8	56
Hawke's Bay (1905-93)	74	49	22	2	1	1451	887
Horowhenua (1914-93)[2]	7	-	7	-	-	69	329
King Country (1922-94)	17	-	17	-	-	104	476
Manawatu (1914-94)	32	14	17	-	1	408	488
Manawhenua (1927-29)	6	3	3	-	-	84	110
Marlborough (1908-95)	18	7	11	-	-	235	415
Mid Canterbury (1933-95)	11	-	11	-	-	72	370
Nelson (1924-59)	2	-	2	-	-	17	66
Nelson Bays (1973-95)	4	-	4	-	-	36	182
North Auckland (1935-97)[3]	40	17	22	1	-	568	697
North Harbour (1986-96)	7	-	7	-	-	95	199
North Otago (1938-93)	8	-	8	-	-	23	345
Otago (1904-94)	70	35	32	1	2	956	318
Poverty Bay (1911-96)	13	-	13	-	-	72	421
South Auckland (1911)	1	-	1	-	-	5	21
South Canterbury (1920-95)	24	3	21	-	-	248	638
Southland (1906-97)	51	20	29	-	2	619	800
Taranaki (1906-96)	76	36	35	3	2	919	1071
Thames Valley (1951-94)	11	-	11	-	-	55	408
Waikato (1932-97)	59	31	25	2	1	1022	811
Wairarapa (1905-69)	30	12	17	-	1	431	504
Wairarapa-Bush (1973-86)	5	-	5	-	-	25	173
Wanganui (1907-1987)	24	-	23	-	1	190	589
Wellington (1904-95)	86	44	37	1	5	1169	1058
West Coast (1932-97)	14	-	14	-	-	104	484

[1] Counties-Manukau from 1997 [2] Horowhenua-Kapiti from 1997 [3] Northland from 1994

RANFURLY SHIELD STATISTICS

Longest tenures

Auckland	1985-93	61 challenges resisted
Auckland	1960-63	25
Canterbury	1982-85	25
Hawke's Bay	1922-27	24
Auckland	1905-13	23
Canterbury	1953-56	23
Hawke's Bay	1966-69	21

Shortest tenures

Wellington	1973	7 days
Auckland	1972	10
North Auckland	1960	11
Wairarapa	1950	14
South Canterbury	1950	14
Auckland	1952	14

UNIONS WHICH HAVE NEVER HELD THE SHIELD

Bay of Plenty, Buller, Counties, East Coast, Horowhenua, King Country, Mid Canterbury, Nelson Bays, North Harbour, North Otago, Poverty Bay, Thames Valley, Wairarapa-Bush (Wairarapa held the shield but the combined union, formed in 1971, has not), Wanganui, West Coast.

HIGHEST WINNING MARGIN
134 points
Auckland 139 North Otago 5 1993

BIGGEST ATTENDANCES
52,000 Canterbury v Auckland, Lancaster Park, 1985
50,000 Auckland v Counties, Eden Park, 1979
48,000 Auckland v Waikato, Eden Park, 1961

SMALLEST ATTENDANCES
(Difficult to be definitive because of the scarcity of records but these were among the smallest)
1000 Taranaki v Manawatu, New Plymouth, 1914
1500 Taranaki v Southland, New Plymouth, 1914
1500 Auckland v East Coast, Ruatoria, 1997

HOLDERS TO TAKE THE SHIELD ON TOUR
1919 Wellington to Christchurch.
1920 Wellington to Hawera, Auckland, Timaru, Dunedin, Invercargill.
1921 Southland to Wellington.
1925 Hawke's Bay to Wellington.
1926 Hawke's Bay to Christchurch.
1988 Auckland to Te Kuiti, New Plymouth, Napier.
1989 Auckland to Paeroa, Ashburton.
1990 Auckland to Gisborne.
1991 Auckland to Nelson, Timaru.
1992 Auckland to Blenheim, Napier, Taupo, Pukekohe.
1993 Auckland to Levin, Westport, Oamaru.
1995 Canterbury to Ashburton.
1996 Auckland to Gisborne.
1997 Auckland to Ruatoria, Greymouth.

INDIVIDUAL PERFORMANCES
Most matches
57 *G.J. Fox, Auckland*
Most points
932 *G.J. Fox, Auckland*
Most tries
53 *T.J. Wright, Auckland*
Most conversions
233 *G.J. Fox, Auckland*
Most penalty goals
142 *G.J. Fox, Auckland*
Most dropped goals
14 *R.H. Brown, Taranaki*
 D. Trevathan, Otago

John Kirwan's eight-try, 40-point haul against North Otago in 1993 earned him two Ranfurly Shield records.

Most goals from a mark
3 *J.H. Dufty, Auckland*
Most points in a match
40 *J.J. Kirwan, Auckland v North Otago, 1993*
Most tries in a match
8 *J.J. Kirwan, Auckland v North Otago, 1993*
Most conversions in a match
12 *B.M. Craies, Auckland v Horowhenua, 1986*
Most penalty goals in a match
7 *R.M. Deans, Canterbury v Counties, 1984*
Most dropped goals in a match
3 *R.H. Brown, Taranaki v Wanganui, 1964 and Taranaki v North Auckland, 1964*
 G.P. Coffey, Canterbury v Auckland, 1990
Most goals from a mark in a match
2 *A. Scott, South Canterbury v Wellington, 1920*

BLEDISLOE CUP
The trophy is at stake whenever New Zealand and Australia meet in test matches and the holder retains it if matches or series are drawn. It was presented in 1931 by Lord Bledisloe (later Viscount Bledisloe), Governor-General of New Zealand from 1930 to 1935. The two countries agreed that from 1982 at least one match a year should be played. From 1996, the international season structure altered and Australia, South Africa and New Zealand meet in an annual tri-nations series, playing each other twice. A third match between New Zealand and Australia was played in each of the first two years and the Bledisloe Cup was at stake for the series winner.

BRUCE STEEL CUP
Originally for competition between the Wairarapa, Manawatu, Horowhenua and Bush unions. Wanganui was added in 1966 but when Wairarapa and Bush merged in 1970, the number of competing unions reverted to four. The trophy is at stake when the holder and any of the other participants first meet in a season, whether the holder is playing at home or away. Presented in 1965 by Mr and Mrs W.H. Steel of Carterton as a memorial to their son.

CORONATION SHIELD
For competition between the unions of the Auckland province, the original six being North Auckland, Auckland, Counties, Thames Valley, Waikato and Bay of Plenty. King Country was added in 1966 and North Harbour in 1985. The Coronation Shield is at stake on a challenge basis whenever the holder meets another participating union either at home or away. The trophy commemorates the coronation of Queen Elizabeth II in 1953 although competition began in 1956.

HANAN SHIELD
For competition between the Mid Canterbury (previously Ashburton County), South Canterbury and North Otago unions. Presented in 1946 by the mayor of Timaru, A.E.S. Hanan.

SEDDON SHIELD
Originally for competition between the Marlborough, West Coast, Buller and Nelson unions who subscribed to a fund to purchase a trophy in memory of Prime Minister Richard Seddon – a keen rugby supporter and parliamentary representative of electorates in the West Coast area. The first competition was held in 1906, the year of Seddon's death. Golden Bay-Motueka was added in 1922 but when that union amalgamated with Nelson in 1969 under the name Nelson Bays, the competition reverted to four contestants.

Super 12

Various early-season competitions were played from the mid-1980s, usually involving the bigger first division unions, but it was only in the year of rugby's tumultuous change, 1995, that a nationwide competition was agreed. Faced with an escalating threat from rugby league, which had split in Australia into two competitions, the national rugby unions of New Zealand, Australia and South Africa jointly approached the multinational news media company, News Corporation, with a commercial proposition. The three unions formed themselves into Sanzar and together sold the corporation the television coverage rights for all their domestic and test rugby for 10 years for $US550 million. The sale was made up of three elements – an early season competition called the International Provincial Competition (IPC), later renamed the Super 12, a tri-nations test series, and their main domestic competitions which, in New Zealand's case, was the national provincial championship.

The agreement was announced in Johannesburg on the eve of the 1995 World Cup final but, unknown to the administrators, the players had ideas of their own. Most had indicated a willingness to join the Australian-based World Rugby Corporation, which had rugby "globalisation" plans of its own, plans which precluded the involvement of the game's governing bodies. Without the players, the News Corp deal would have faltered if not folded, but by the end of the 1995 season the national unions had reached agreement with most players and it was the WRC that foundered.

The IPC, in a New Zealand context, called for the top 165 players in New Zealand to be distributed equally among five teams formed solely for playing the Super 12, and a former All Black selector, Peter Thorburn, was made IPC commissioner for the first year to ensure this would happen. The teams – which modern rugby administration calls franchises – were the Auckland Blues (Auckland and Counties-Manukau), the Waikato

The 1997 Auckland Blues
Back row: Adrian Cashmore, Brian Lima, Tony Marsh, Mark Carter, Xavier Rush, Joeli Vidiri, Jeremy Stanley, Olo Brown.
Third row: Dylan Mika, Andrew Blowers, Charles Riechelmann, Robin Brooke, Richard Fromont, Jim Coe, Paul Thomson, Leo Lafaiali'i.
Second row: Jim Blair (fitness trainer), Graham Patterson (doctor), Michael Jones, Eroni Clarke, Sean Fitzpatrick, Paul Wilson (physiotherapist), Norman Berryman, Andrew Roose, Shane Howarth, Mac McCallion (assistant coach), Rex Davy (manager).
Front row: Peter Scutts (Auckland CEO), Joe Hickey (Counties chairman), Michael Scott, Lee Stensness, Carlos Spencer, Zinzan Brooke (captain), Junior Tonu'u, Craig Dowd, Reuben O'Neill (Auckland chairman), Graham Henry (coach).
Absent: Orcades Crawford, Dean Sheppard, Matthew Webber.

Chiefs (Waikato, North Harbour, Northland, Thames Valley, Bay of Plenty, King Country), the Wellington Hurricanes (Wellington, Manawatu, Hawke's Bay, Wairarapa-Bush, Horowhenua, Wanganui, Taranaki, Poverty Bay, East Coast), the Canterbury Crusaders (Canterbury, Mid and South Canterbury, Marlborough, Nelson Bays, Buller, West Coast) and the Otago Highlanders (Otago, North Otago, Southland). The guiding principle, which reality did not always mirror, was that teams would be evenly matched and that leading players in lesser provinces would not be penalised. A draft system was introduced to oversee the ideal of an even player spread.

There were faults and criticisms, especially from North Harbour about its players being lumped in with Waikato's, but the concept gained general acceptance and the fast, open quality of the play in the first year ensured the competition's success. Australia fielded its two main state sides, New South Wales and Queensland, and added a third, the Australian Capital Territory Brumbies, while South Africa for the first two years stuck to the concept of involving the top four sides in the Currie Cup in the Super 12. It planned to introduce regional teams for the 1998 competition.

Points incentives used in the pioneering early-season competitions, such as bonus points for a loss by six or fewer points, bonus point for four or more tries, were incorporated in the Super 12.

SOUTH PACIFIC CHAMPIONSHIP, 1986

	Won	Lost	Drew	For	Ag	Pts
Canterbury	4	1	-	93	56	17
Auckland	3	2	-	100	76	12
New South Wales	3	2	-	112	103	12
Queensland	3	2	-	75	77	12
Wellington	2	3	-	110	92	9
Fiji	-	5	-	54	140	1

SOUTH PACIFIC CHAMPIONSHIP, 1987

Canterbury	4	1	-	121	92	17
Auckland	4	1	-	175	79	17
Queensland	3	2	-	137	96	13
New South Wales	3	2	-	112	85	13
Fiji	1	4	-	69	189	6
Wellington	-	5	-	87	150	1

SOUTH PACIFIC CHAMPIONSHIP, 1988

Auckland	5	-	-	188	51	20
Wellington	3	2	-	88	139	12
New South Wales	2	3	-	118	120	9
Canterbury	2	3	-	86	107	9
Fiji	2	3	-	94	101	8
Queensland	1	4	-	84	140	5

SOUTH PACIFIC CHAMPIONSHIP, 1989

Auckland	4	1	-	191	58	17
New South Wales	4	1	-	99	93	16
Queensland	3	2	-	119	78	12
Wellington	2	3	-	94	139	9
Fiji	2	3	-	70	171	8
Canterbury	-	5	-	93	128	3

CANZ SERIES, 1989

Waikato	4	1	-	201	66	20
Otago	4	1	-	155	122	16
Banco Nationale	3	2	-	149	163	12
Canada	2	3	-	110	128	9
North Auckland	1	4	-	119	149	5
San Isidro	-	5	-	79	185	-

SOUTH PACIFIC CHAMPIONSHIP, 1990

Auckland	5	-	-	188	54	20
Queensland	4	1	-	135	68	16
New South Wales	3	2	-	83	124	12
Canterbury	1	4	-	86	131	5
Fiji	1	4	-	66	102	5
Wellington	1	4	-	94	173	5

CANZ SERIES, 1990

Otago	2	1	-	53	39	9
Waikato	2	1	-	103	24	9
North Auckland	2	1	-	55	50	8
Canada	-	3	-	27	125	-

SUPER SIX SERIES, 1992

Queensland	5	-	-	120	58	20
Auckland	4	1	-	136	59	16
New South Wales	3	2	-	150	99	13
Wellington	1	4	-	99	132	4
Canterbury	1	4	-	82	141	4
Fiji	1	4	-	63	162	4

CANZ SERIES, 1992

	Won	Lost	Drew	For	Ag	Pts
Waikato	3	-	1	133	44	14
Otago	3	1	-	92	59	12
North Harbour	2	1	1	56	48	10
North Auckland	1	3	-	68	118	4
Canada	-	4	-	43	123	1

SUPER 10 SERIES, 1993

Pool A final standings

Auckland	4	-	-	125	59	16
Natal	3	1	-	129	63	12
Western Samoa	2	2	-	80	113	8
Queensland	1	3	-	75	89	5
Otago	-	4	-	63	148	-

Pool B final standings

Transvaal	4	-	-	121	53	16
New South Wales	2	2	-	57	84	9
Northern Transvaal	2	2	-	109	109	8
North Harbour	1	3	-	82	99	6
Waikato	1	3	-	75	99	5

Final: Transvaal 20, Auckland 17, *in Johannesburg*

SUPER 10 SERIES, 1994

Pool A final standings

Queensland	3	1	-	93	54	13
North Harbour	3	1	-	83	59	13
Otago	2	2	-	119	109	9
Transvaal	2	2	-	95	74	8
Eastern Province	-	4	-	70	164	-

Pool B final standings

Natal	3	-	-	92	62	16
New South Wales	3	-	-	90	58	12
Western Samoa	2	2	-	96	102	9
Auckland	1	3	-	71	61	7
Waikato	-	4	-	66	132	1

Final: Queensland 21, Natal 10, *in Durban*

SUPER 10 SERIES, 1995

Pool A final standings

Transvaal	3	1	-	78	65	13
New South Wales	2	1	1	78	64	11
Western Province	2	2	-	99	106	9
Otago	2	2	-	102	91	8
North Harbour	-	3	1	69	100	4

Pool B final standings

Queensland	4	-	-	116	48	16
Free State	3	1	-	85	91	12
Auckland	2	2	-	94	99	9
Canterbury	1	3	-	138	98	7
Tonga	-	4	-	62	159	1

Final: Queensland 30, Transvaal 16, *in Johannesburg*

ANZA TOURNAMENT, 1995

(winner determined by total tries scored)
Australian Capital Territory 70, Rosario 18; Wellington 67, Hawke's Bay 36; ACT 27, Wellington 10; Hawke's Bay 64, Rosario 26; Hawke's Bay 37, ACT 31; Wellington 118, Rosario 17. Wellington scored 28 tries, Hawke's Bay 19, ACT 18 and Rosario 10.

SUPER 12, 1996

Final standings

	W	L	D	F	A	Bonus	Pts
Queensland Reds	9	2	-	320	247	5	41
Auckland Blues	8	3	-	408	354	9	41
Northern Transvaal	8	3	-	329	208	6	38
Natal	6	5	-	389	277	9	33
ACT Brumbies	7	4	-	306	273	4	32
Waikato Chiefs	6	5	-	291	269	4	28
NSW Waratahs	5	6	-	312	290	8	28
Otago Highlanders	5	6	-	329	391	6	26
Wellington Hurricanes	3	8	-	290	353	5	17
Transvaal	3	8	-	233	299	4	16
Western Province	3	7	1	251	353	1	15
Canterbury Crusaders	2	8	1	234	378	3	13

First semifinal *at Ballymore, Brisbane*
Natal 43, Queensland 25

Second semifinal *at Eden Park, Auckland*
Auckland Blues 48, Northern Transvaal 11

Final *at Eden Park, Auckland*
Auckland Blues 45, Natal 21

SUPER 12, 1997

Final standings

Auckland Blues	10	1	-	435	283	8	50
ACT Brumbies	8	3	-	406	291	9	41
Wellington Hurricanes	6	5	-	416	314	10	34
Natal	5	4	2	321	350	6	30
Gauteng Lions	5	5	1	302	346	6	28
Canterbury Crusaders	5	5	1	272	235	4	26
Free State	5	6	-	301	327	5	25
Northern Transvaal	3	5	3	264	342	4	22
NSW Waratahs	4	7	-	255	296	4	20
Queensland Reds	4	7	-	263	318	4	20
Waikato Chiefs	4	7	-	272	295	3	19
Otago Highlanders	3	8	-	299	409	5	17

First semifinal *at Eden Park, Auckland*
Auckland Blues 55, Natal 36

Second semifinal *at Bruce Stadium, Canberra*
ACT Brumbies 33, Wellington Hurricanes 20

Final *at Eden Park, Auckland*
Auckland Blues 23, ACT Brumbies 7

National Provincial Championship

A century after the first interprovincial match in New Zealand, in 1875 in Dunedin between combined Dunedin clubs and combined Auckland clubs, the New Zealand union introduced a national provincial championship, played in three divisions.

The original 11 first division unions were chosen based on performances in the previous five years and were: Auckland, Bay of Plenty, Canterbury, Counties, Hawke's Bay, Manawatu, Marlborough, North Auckland, Otago, Southland and Wellington. Since then, only Auckland, Canterbury, Otago and Wellington have constantly remained in the first division.

The first competition, in 1976, comprised the first division and second divisions based on the North and South Islands, a format that continued until 1984. That system ensured four South Island teams in the first division, though it worked against North Island teams. Taranaki was relegated in 1979, despite finishing ahead of three South Island teams. A split third division was introduced in 1985 but it applied only for the one year and the three-division format followed with no further changes until 1992, when the major round format was introduced. Three first division unions were relegated in 1991 to provide for nine teams in each division.

NPC matches from 1976 were played throughout the season, usually at the convenience of unions, and sometimes leading to confusion about how teams were placed in the competition. The championship became more structured in 1995 when matches were confined to the August-October period.

The NPC underwent more change at the end of the 1997 season when the NZRFU adopted a 10-team format for the first division, thus avoiding byes, with the result that the bottom team, Southland, was not relegated. The 1997 season also marked the entry of a combined Hawke's Bay-Manawatu team, the Central Vikings, but the NZRFU ruled that if it won the second division, it could not be promoted because the unions had not combined. In the event, it was beaten in the final by Northland.

The NPC saw the introduction of North Harbour in 1985. It began in the third division and gained first division status from the 1988 season, where it has remained since.

1976
First division — Bay of Plenty (North Auckland automatically relegated)
Second division (North) — Taranaki (automatically promoted)
Second division (South) — South Canterbury (beaten in a promotion-relegation match by Southland, the lowest placed South Island team in the first division)

1977
First division — Canterbury (Bay of Plenty (automatically) and Marlborough relegated)
Second division (North) — North Auckland (automatically promoted)
Second division (South) — South Canterbury (promoted after beating Marlborough in promotion-relegation)

1978
First division — Wellington (Hawke's Bay automatically relegated)
Second division (North) — Bay of Plenty (automatically promoted)
Second division (South) — Marlborough (drew with South Canterbury in promotion-relegation match, South Canterbury therefore remaining in first division)

1979
First division — Counties (Taranaki relegated because it was the lowest-placed North Island team)
Second division (North) — Hawke's Bay (automatically promoted)
Second division (South) — Marlborough (lost promotion-relegation match against Otago)

1980
First division — Manawatu (South Canterbury relegated)
Second division (North) — Waikato (promoted after beating Mid Canterbury in a promotion match and South Canterbury in promotion-relegation)
Second division (South) — Mid Canterbury

1981
First division — Wellington (Southland relegated)
Second division (North) — Wairarapa-Bush (promoted after beating South Canterbury in a promotion match and Southland in promotion-relegation)
Second division (South) — South Canterbury

1982
First division — Auckland
Second division (North) — Taranaki (beat Southland in promotion match but lost to Bay of Plenty in promotion-relegation)
Second division (South) — Southland

1983
First division — Canterbury
Second division (North) — Taranaki
Second division (South) — Mid Canterbury (beat Taranaki in promotion match but lost to Hawke's Bay in promotion-relegation)

1984
First division — Auckland (Hawke's Bay relegated)
Second division (North) — Taranaki
Second division (South) — Southland (beat Taranaki in promotion match and Hawke's Bay in promotion-relegation)

1985
First division — Auckland (Waikato automatically relegated)
Second division — Taranaki (automatically promoted, West Coast relegated)
Third division (North) — North Harbour (beat Nelson Bays in promotion match)
Third division (South) — Nelson Bays

1986
First division — Wellington (Southland automatically relegated)
Second division — Waikato (automatically promoted, Buller relegated)
Third division — South Canterbury (automatically promoted)

1987
First division — Auckland (Wairarapa-Bush automatically relegated)
Second division — North Harbour (automatically promoted, Wanganui relegated)
Third division — Poverty Bay (automatically promoted)

1988
First division — Auckland (Manawatu relegated)
Second division — Hawke's Bay (automatically promoted, South Canterbury relegated)
Third division — Thames Valley (automatically promoted)

240

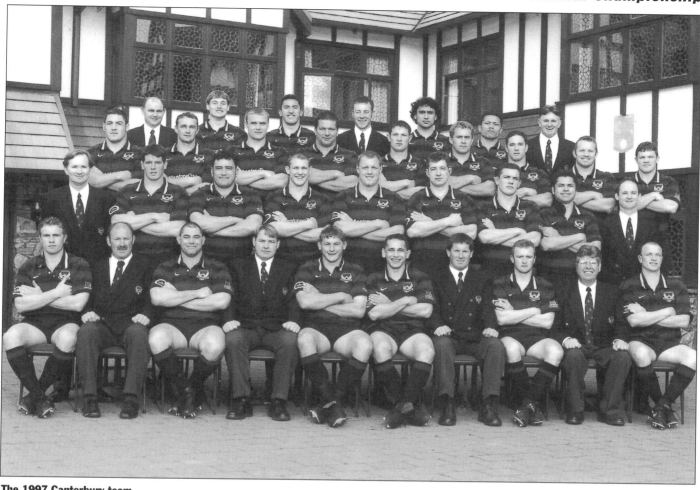

The 1997 Canterbury team
Back row: Terry Williamson (liaison officer), Andrew Mehrtens, Daryl Gibson, Mike Anthony (trainer), Brad Fleming, Afato So'oalo, Erroll Collins (masseur).
Third row: Mark Hammett, Angus Gardiner, Scott Robertson, Stu Loe, Leon MacDonald, Clark McLeod, Milton Going, Matt Sexton, Aaron Flynn.
Second row: Rob Campbell (doctor), Dan Charteris, Kevin Nepia, Steve Surridge, Steve Lancaster, Graham Jack, Reuben Thorne, Tabai Matson, Steve Cope (physiotherapist).
Front row: Justin Marshall, Don Hayes (co-ordinator), Con Barrell, Steve Hansen (assistant coach), Todd Blackadder (captain), Mark Mayerhofler (vice-captain), Rob Deans (coach), Daryl Lilley, Bob Stewart (manager), Darryn Perfect.

1989
First division — Auckland (Hawke's Bay relegated)
Second division — Southland (automatically promoted, Thames Valley relegated)
Third division — Wanganui (automatically promoted)

1990
First division — Auckland (Southland relegated)
Second division — Hawke's Bay (automatically promoted, Mid Canterbury relegated)
Third division — Thames Valley (automatically promoted)

1991
First division — Otago (Counties, Bay of Plenty and Taranaki relegated)
Second division — King Country (promoted after beating Bay of Plenty in promotion-relegation match; Wanganui automatically relegated and Marlborough relegated after losing promotion-relegation match to South Canterbury)
Third division — South Canterbury (promoted)

1992
First division — Waikato (North Auckland relegated)
First semifinal in Auckland: — Waikato 27, Auckland 21.
Second semifinal in Dunedin: — Otago 26, North Harbour 23 (after extra time)
Final in Hamilton: — Waikato 40, Otago 5.

Second division — Taranaki (automatically promoted, Thames Valley relegated)
First semifinal in Palmerston North: — Taranaki 29, Manawatu 18.

Second semifinal in Pukekohe: — Counties 31, Bay of Plenty 29.
Final in New Plymouth: — Taranaki 12, Counties 0.

Third division — Nelson Bays (automatically promoted)
First semifinal in Nelson: — Nelson Bays 27, Mid Canterbury 13.
Second semifinal in Levin: — Horowhenua 30, Wanganui 22.
Final in Levin: — Nelson Bays 25, Horowhenua 23.

1993
First division — Auckland (Hawke's Bay relegated)
First semifinal in Dunedin: — Otago 36, Waikato 22.
Second semifinal in Auckland: — Auckland 43, North Harbour 20.
Final in Auckland: — Auckland 27, Otago 18.

Second division — Counties (automatically promoted, Poverty Bay relegated)

First semifinal in Rotorua: — Bay of Plenty 41, North Auckland 26.
Second semifinal in Pukekohe: — Counties 33, South Canterbury 18.
Final in Pukekohe: — Counties 38, Bay of Plenty 10.

Third division — Horowhenua (automatically promoted)
First semifinal in Wanganui: — Wanganui 30, Thames Valley 14.
Second semifinal in Levin: — Horowhenua 30, Mid Canterbury 22.
Final in Wanganui: — Horowhenua 15, Wanganui 9.

1994
First division — Auckland (Taranaki automatically relegated)
First semifinal
 in Takapuna: — North Harbour 59, Canterbury 27.
Second semifinal
 in Dunedin: — Auckland 33, Otago 16.
Final in Takapuna: — Auckland 22, North Harbour 16.

Second division — Southland (automatically promoted, Horowhenua relegated)

First semifinal
 in Whangarei: — Southland 29, Northland 22.
Second semifinal
 in Napier: — Hawke's Bay 65, Bay of Plenty 17.
Final in Invercargill: — Southland 20, Hawke's Bay 18.

Third division — Mid Canterbury (automatically promoted)
First semifinal
 in Gisborne: — Poverty Bay 40, Thames Valley 20.
Second semifinal
 in Wanganui: — Mid Canterbury 22, Wanganui 13.
Final in Ashburton: — Mid Canterbury 26, Poverty Bay 16.

1995
First division — Auckland (Southland automatically relegated)
First semifinal
 in Auckland: — Auckland 60, North Harbour 26.
Second semifinal
 in Pukekohe: — Otago 41, Counties 32.
Final in Auckland: — Auckland 23, Otago 19.

Second division — Taranaki (automatically promoted, Mid Canterbury relegated)

First semifinal
 in Whangarei: — Northland 36, Hawke's Bay 6.
Second semifinal
 in Rotorua: — Taranaki 37, Bay of Plenty 12.
Final in Whangarei: — Taranaki 22, Northland 18.

Third division — Thames Valley (automatically promoted)
First semifinal in Paeroa: — Thames Valley 32, Horowhenua 17.
Second semifinal
 in Gisborne: — Poverty Bay 26, Wanganui 19.
Final in Paeroa: — Thames Valley 47, Poverty Bay 8.

1996
First division — Auckland (King Country automatically relegated)
First semifinal
 in Auckland: — Auckland 59, Otago 18.
Second semifinal
 in Pukekohe: — Counties-Manukau 46, Canterbury 33.
Final in Auckland: — Auckland 46, Counties-Manukau 15.

Second division — Southland (automatically promoted)
First semifinal
 in Invercargill: — Southland 23, Hawke's Bay 11.
Second semifinal
 in Whangarei: — Northland 31, Manawatu 16.
Final in Invercargill: — Southland 12, Northland 6.

Third division — Wanganui (automatically promoted)
First semifinal
 in Blenheim: — Marlborough 34, Mid Canterbury 22.
Second semifinal
 in Wanganui: — Wanganui 22, Buller 15.
Final in Blenheim: — Wanganui 22, Marlborough 17.

1997
First division — Canterbury (no relegation)
First semifinal
 in Hamilton: — Counties-Manukau 43, Waikato 40.
Second semifinal
 in Christchurch: — Canterbury 21, Auckland 15.
Final in Christchurch: — Canterbury 44, Counties-Manukau 13.

Second division — Northland (automatically promoted, South Canterbury relegated)

First semifinal
 in Whangarei: — Northland 51, King Country 12.
Second semifinal
 in Rotorua: — Central Vikings 29, Bay of Plenty 6.
Final in Whangarei: — Northland 63, Central Vikings 10.

Third division — Marlborough (automatically promoted)
First semifinal
 in Oamaru: — North Otago 37, Horowhenua-Kapiti 7.
Second semifinal
 in Gisborne: — Marlborough 17, Poverty Bay 14.
Final in Oamaru: — Marlborough 32, North Otago 17.

THE WINNERS			
Year	First division	Second division	Third division
1976	Bay of Plenty	Taranaki	
		South Canterbury	
1977	Canterbury	North Auckland	
		South Canterbury	
1978	Wellington	Bay of Plenty	
		Marlborough	
1979	Counties	Hawke's Bay	
		Marlborough	
1980	Manawatu	Waikato	
		Mid Canterbury	
1981	Wellington	Wairarapa-Bush	
		South Canterbury	
1982	Auckland	Taranaki	
		Southland	
1983	Canterbury	Taranaki	
		Mid Canterbury	
1984	Auckland	Taranaki	
		Southland	
1985	Auckland	Taranaki	North Harbour
			Nelson Bays
1986	Wellington	Waikato	South Canterbury
1987	Auckland	North Harbour	Poverty Bay
1988	Auckland	Hawke's Bay	Thames Valley
1989	Auckland	Southland	Wanganui
1990	Auckland	Hawke's Bay	Thames Valley
1991	Otago	King Country	South Canterbury
1992	Waikato	Taranaki	Nelson Bays
1993	Auckland	Counties	Horowhenua
1994	Auckland	Southland	Mid Canterbury
1995	Auckland	Taranaki	Thames Valley
1996	Auckland	Southland	Wanganui
1997	Canterbury	Northland	Marlborough

Women's Rugby

Various attempts, even as early as the 1890s, had been made to organise women's rugby on a regular basis rather than occasional novelty matches which were more akin to picnic games than any serious attempt at involving women.

It wasn't until the late 1980s that women's rugby was seen as a game in its own right and a breakthrough was made in 1989 when a national women's team, chosen by selectors appointed by the New Zealand union, took the field. Even then though, there were official reservations and the 1989 team was known only as a New Zealand XV rather than simply New Zealand. Nevertheless, the 1989 game, on July 22 at Lancaster Park, constituted the first appearance by a national women's team chosen by selectors appointed by the NZRFU and announced by it. The impetus

for national recognition came from Canterbury. A University of Canterbury women's team made a world tour in 1988 and the International Federation of Women's Rugby, then controlling the game, was so impressed it was determined that New Zealand would be represented at the 1991 World Cup, which had previously been known as the European Cup. The New Zealand union, faced with the inevitable, appointed a women's subcommittee convened by former All Black coach J.J. Stewart. Laurie O'Reilly, who coached the Canterbury women's team, was made selection convener.

Despite those moves, neither the New Zealand women's team in 1989 nor the team that played in the 1991 World Cup were officially recognised by the New Zealand union.

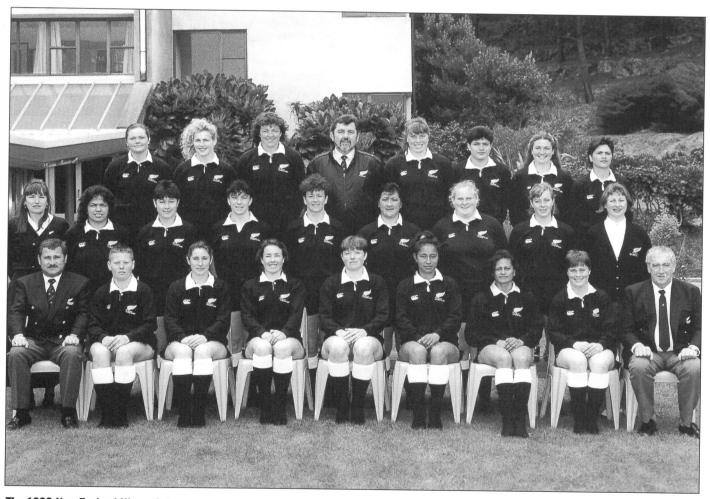

The 1993 New Zealand Women's team
Back row: Julie Reynolds, Fiona Richards, Jude Ellis, Laurie O'Reilly (coach), Sarah Huxford, Vivian Rees, Mary Davie, Lenadeen Rangihuna.
Second row: Vicki Dombroski, Erica Rere, Natasha Wong, Pauline O'Leary, Jacquie Apiata, Regina Sheck, Carol Hayes, Heidi Reader, Trish Townsend (assistant manager).
Front row: Graeme Taylor (manager), Rocky Tahuri, Lauren O'Reilly, Anna Richards (vice captain), Helen Littleworth (captain), Davida Suasua-White, Debbie Chase, Neroli Knight, Leo Walsh (NZRFU women's rugby sub-committee).

NEW ZEALAND WOMEN'S RESULTS

1989 in NEW ZEALAND
v California Grizzlies
 at Christchurch won 13-7

1991 WORLD CUP
v Canada *at Cardiff* won 24-8
v Wales *at Cardiff* won 24-6
v United States (semifinal)
 at Cardiff lost 7-0
The United States beat England in the
final

1992 in NEW ZEALAND
v Auckland *at Auckland* won 36-0

1993 in NEW ZEALAND
v NZRFU President's XV
 at Wellington won 34-12

1994 in AUSTRALIA
v ACT *at Canberra* won 87-0
v NSW *at Richmond* won 85-0
v Australia *at Sydney* won 37-0

1995 in NEW ZEALAND
v Australia *at Auckland* won 64-0

1996 in AUSTRALIA and CANADA
v Australia *at Sydney* won 28-5
v Canada *at St Albert* won 88-3
v United States *at Edmonton* won 86-8
v France *at Edmonton* won 109-0

1997 in NEW ZEALAND
v England *at Burnham* won 67-0
v Australia *at Dunedin* won 40-0

NEW ZEALAND REPRESENTATIVES

Name	Province	Year
Andrew S.R.	Auckland	1996
Apiata J.W.	Canterbury	1989,91-95
Atkins L.T.	Northland	1994
Baker M.	Auckland	1989,91
Ballinger S.	Wellington	1991
Barclay F.J.	Otago	1996-97
Blyde C.	Taranaki	1992
Brett M.	Canterbury	1991
Chase D.	Canterbury	1991-93
Cobley R.J.	Canterbury	1992-94
Cootes V.	Waikato	1995-97
Cunningham V.	Auckland	1997
Davie M.	Canterbury	1992,93
Edwards T.	Auckland	1989
Ellis J.M.	Canterbury	1993-95
Epiha E.A.	Auckland	1994
Ewe D.	Auckland	1991
Fa'aope L.	Canterbury	1989
Fitzgibbon M.	Canterbury	1989,91
Ford A.	Canterbury	1991
Ford D.	Canterbury	1989,91
Frost S.	Wellington	1991
Garden S.	Canterbury	1989,91
Gavet S.	Auckland	1992
Hayes C.	Southland	1989,91-93
Heenan J.M.	Northland	1996
Hiemer R.	Wellington	1997
Hirovanaa M.J.	Auckland	1994-97
Huxford S.	Wellington	1993
Inwood N.	Canterbury	1989,91
Kiwi K.H.	Bay of Plenty	1996,97
Knight N.	Wellington	1991
Kupa M.	Hawke's Bay	1997
Lemon T.M.	Auckland	1991,94,95
Littleworth H.M.	Canterbury	1989,91-94
	Otago	1995,96
Mahon H.	Canterbury	1989
	Wellington	1991
	Waikato	1992
Martin R.L.	Wellington	1994,95
	Auckland	1996,97
Mihinui M.T.E.	Auckland	1994
Neilson J.	Otago	1997
Nemaia A.	Auckland	1989
Nesbit J.	Canterbury	1989
O'Leary P.	Wanganui	1993
O'Reilly L.M.	Canterbury	1992-94
Paitai E.	Auckland	1991
Palmer F.R.	Otago	1996
	Waikato	1997
Papalii C.	Auckland	1989,92
Paul G.	Bay of Plenty	1991-97
	Taranaki	1994
	Wellington	1992
Ratu E.	Otago	1993
Reader H.C.	Waikato	1994-96
	Bay of Plenty	1995
Rees V.L.	Wellington	1993-95
Rere E.	Wellington	1991
	Bay of Plenty	1993
Reynolds J.	Canterbury	1993,94
Richards A.M.	Auckland	1991-94, 96,97
Richards F.C.	Canterbury	1993-96
	Auckland	1997
Robinson M.C.	Wellington	1996,97
Rodd C.	Canterbury	1991
Ross L.C.	Mid Canterbury	1989,92-96
	Canterbury	1991
Rush A.M.	Otago	1996,97
Sheck R.	Auckland	1994,96-97
Shortland S.	Auckland	1997
Simpson-Brown L.H.	Canterbury	1994
	Waikato	1995-97
Sio, N.	Auckland	1989,91, 92
	Waikato	1994
Su'a S.M.A.	Auckland	1996
Suasua-White D.	Auckland	1993-96
Tahu B.M.	Auckland	1996
Tamihana F.	Wellington	1995
Taylor K.	Bay of Plenty	1996
Thomas E.H.	Bay of Plenty	1996,97
Tiriamai K.	Auckland	1991
Waaka C.	Auckland	1997
Wall L.H.	Waikato	1994
	Auckland	1995-97
Waters T.J.R.	Canterbury	1995,96
Williams T.A.	Manawatu	1994
Wong N.A.	Canterbury	1991-94

Interisland Rugby

The first match between the two islands was played in 1897 at Athletic Park, Wellington, just before the departure of the New Zealand team on its Australian tour. The North Island, who won by 16-3, played in yellow and black and the South in black.

Five years passed before the second interisland game was played. This match also took place in Wellington but the result was reversed, South winning by 20-14. North played in blue and white and South in red and black.

The New Zealand Rugby Football Union decided to make the North v South match an annual fixture and from 1902 matches between the two islands were played each year, except during the First World War, in 1930, and in the early years of the Second World War. Since 1904 North have played in black and South in white.

Teams representing each island had been selected before the first interisland clash in 1897. In 1888, playing in blue jerseys, a South Island team met Great Britain at Dunedin, on September 26, the visitors winning 5-3. Bean scored the South's points with a goal from a mark. Three days later the two teams met again at Christchurch where the South Island, taking the field in red jerseys, lost the game 6-0.

Those who represented the South Island in the first of the two games, with players who also appeared in the second game indicated*, were: P. Anderson *Otago*, W.D. Bean* *Canterbury*, J. Croxford *Otago*, A.D. Downes* *Otago*, V. Ekensteen *Southland*, F.T. Evans *Canterbury*, G. Harper* *Nelson*, I.W.W. Hunter* *Otago*, T.W. Lynch *Otago*, E.E. Morrison *Otago*, T. Sonntag* *Otago*, J.H. Stephenson *Otago*, W.G. Thomas *Otago*, J.B. Thomson *Otago*, J.H. Treseder *Southland*.

In addition to those indicated*, the following players took the field in the second match against the British

side: J. Donnelly *Canterbury*, W. Dow *Canterbury*, F. Fuller *Canterbury*, A.M. Plank *Canterbury*, M. Riley *Canterbury*, J. Sincock *Canterbury*, W.C. Thompson *Otago*, J.M. Turnbull *Canterbury*, A.J. Weekes *Canterbury*.

Playing in the Auckland union's colours of blue and white, a North Island team defeated New South Wales 15-3 at Auckland, on August 29, 1894. The two Baylys and Roberts scored tries and Murray kicked two penalty goals. Those who represented the North Island were: A. Bayly *Taranaki*, W. Bayly *Taranaki*, C.A. Caradus *Hawke's Bay*, S.G. Cockroft *Hawke's Bay*, D.R. Gage *Wellington*, J.T. Lambie *Taranaki*, R. Masefield *Auckland*, F.S. Murray *Auckland*, R.H. McKenzie *Auckland*, R. Oliphant *Auckland*, J. Poynter *Poverty Bay*, W.P. Pringle *Wellington*, W. Roberts *Wellington*, W.D. Watson *Wairarapa*, W.T. Wynyard *Wellington*.

Apart from the official North v South matches, various other games between teams from the two islands took place. These included North Island XV v South Island XV matches used as All Black trials, as well as minor unions, services, colts, universities, secondary schools and age group fixtures.

From the 1970s, interest in the interisland match began to wane and in an effort to alleviate this, the NZRFU staged it in smaller centres. Players did not give it a high priority and the selections in its last few years, particularly for the North, were marked by unavailabilities or withdrawals.

The NZRFU council in August 1986 discarded the match, replacing it for 1987 with a zonal tournament involving South (the whole of the South Island), North (the Coronation Shield provinces) and Central. The series, played for the George Nepia Memorial Trophy, lasted for three years until it was abandoned. The interisland match was revived temporarily in 1995.

INTERISLAND MATCHES WITH VENUES

Year	Result	Venue
1897	North 16 South 3	Wellington
1902	South 20 North 14	Wellington
1903	South 12 North 5	Auckland
1904	drawn 3-3	Dunedin
1905	North 26 South 0	Wellington
1906	North 9 South 5	Wellington
1907	North 11 South 0	Christchurch
1908	North 12 South 5	Wellington
1909	South 19 North 11	Wellington
1910	South 14 North 10	Christchurch
1911	North 19 South 9	Wellington
1912	North 12 South 8	Napier
1913	South 25 North 0	Christchurch
1914	South 8 North 0	Wellington
1919	North 28 South 11	Wellington
1920	North 12 South 3	Wellington
1921	North 28 South 13	Christchurch
1922	South 9 North 8	Auckland
1923	drawn 6-6	Wellington
1924	North 39 South 8	Wellington
1925	North 16 South 5	Invercargill
1926	North 41 South 9	Wellington
1927	South 31 North 30	Wellington
1928	South 15 North 14	Christchurch
1929	North 29 South 20	Wellington
1931	drawn 20-20	Wellington
1932	North 28 South 10	Christchurch
1933	North 27 South 18	Wellington
1934	South 27 North 20	Dunedin
1935	North 15 South 9	Wellington
1936	North 17 South 6	Christchurch
1937	South 30 North 21	Wellington
1938	South 23 North 3	Wellington
1939	South 25 North 19	Wellington
1943	South 17 North 16	Wellington
1944	North 28 South 3	Christchurch
1945	South 31 North 19	Auckland
1946	North 8 South 3	Wellington
1947	North 13 South 11	Invercargill
1948	South 12 North 11	Wellington
1949	North 23 South 3	Christchurch
1950	North 10 South 8	Auckland
1951	North 14 South 12	Wellington
1952	South 11 North 3	Dunedin
1953	North 15 South 14	Wellington
1954	North 13 South 9	Christchurch
1955	North 15 South 9	Wellington
1956	South 13 North 11	Wellington
1957	North 19 South 3	Auckland
1958	North 13 South 6	Dunedin
1959	North 30 South 14	Wellington
1960	South 26 North 11	Christchurch

Year	Result	Venue
1961	North 25 South 3	Wellington
1962	South 17 North 14	Christchurch
1963	South 14 North 13	Christchurch
1964	North 12 South 9	Auckland
1965	North 25 South 14	Wellington
1966	North 12 South 3	Hamilton
1967	North 17 South 6	Dunedin
1968	North 34 South 17	Christchurch
1969	South 13 North 3	Wellington
1970	North 11 South 6	Nelson
1971	North 31 South 9	New Plymouth
1972	North 19 South 8	Christchurch
1973	North 27 South 14	Whangarei
1974	North 22 South 0	Auckland
1975	South 17 North 14	Christchurch
1976	South 20 North 16	Hamilton
1977	South 6 North 4	Dunedin
1978	North 29 South 13	New Plymouth
1979	North 9 South 3	Invercargill
1980	North 13 South 9	Palmerston North
1981	North 10 South 4	Dunedin
1982	South 22 North 12	Wanganui
1983	North 22 South 9	Blenheim
1984	North 39 South 3	Rotorua
1985	North 29 South 12	New Plymouth
1986	North 22 South 10	Oamaru
1995	North 55, South 22	Dunedin

INTERISLAND STATISTICS

Total wins: North 50, South 26
Three matches were drawn

Most successive wins: North 5 (1964-68,70-74,83-95), South 4 (1937-39,43)

Biggest winning margin: North 36 points (39-3 in 1984), South 25 points (25-0 in 1913)

Highest scores: North 55-22 in 1995, South 31-30 in 1927

Venues: Wellington was the venue for 32 of the 78 interisland matches. Christchurch followed with 16

Colin Meads appeared on 12 occasions for the North Island; Fergie McCormick on 10 occasions for the South Island

PLAYERS WHO REPRESENTED BOTH THE NORTH AND SOUTH ISLANDS

Name	Province	I	Year
Badeley C.E.O.	Auckland	N	1919-21
replaced an injured South Island player		S	1922
Birtwistle W.M.	Canterbury	S	1964-66
	Waikato	N	1967
Bush R.G.	Otago	S	1931
	Auckland	N	1934
Byrne P.C.	Nelson	S	1919
	King Country	N	1922
Cooper G.J.L.	Otago	S	1985
	Auckland	N	1986
Cross T.	Canterbury	S	1902
	Wellington	N	1904-06
Currie C.J.	Wellington	N	1977
	Canterbury	S	1978
Dick J.	Auckland	N	1936,38
	Canterbury	S	1943
Edwards L.H.	Taranaki	N	1935
	Wellington	N	1936
	Marlborough	N	1945
Elvy W.L.	Canterbury	S	1926
	Wellington	N	1929
Gillett G.A.	Canterbury	S	1905
	Auckland	N	1906
Green C.H.	Wellington	N	1909
	Buller	S	1910,11
Heazlewood L.K.	Otago	S	1927
	Wellington	N	1929
Hughes E.	Southland	S	1907
	Wellington	N	1921
Kelly J.W.	Canterbury	S	1947
	Auckland	N	1954
Kilby F.D.	Southland	S	1926
	Wellington	N	1927,31-33-35
Kirk D.E.	Otago	S	1982-84
	Auckland	N	1986
Kirkpatrick I.A.	Canterbury	S	1968,69
	Poverty Bay	N	1971-75
Lilburne H.T.	Canterbury	S	1927,29
	Wellington	N	1931-33
Macdonald H.H.	Canterbury	S	1971-74
	North Auckland	N	1975
MacDonald M.S.	Marlborough	S	1938
	Hawke's Bay	N	1939
McGregor D.	Canterbury	S	1902,03,06
	Wellington	N	1904
Morrison T.C.	South Canterbury	S	1935
	Wellington	N	1946
Nelson K.A.	Otago	S	1962,63
	Auckland	N	1964
O'Callaghan T.R.	Canterbury	S	1944
	Auckland	N	1947
	Wellington	N	1949
Oliver F.J.	Southland	S	1972,74,75,77
	Otago	S	1979
	Manawatu	N	1980-81
Paewai M.N.	Otago	S	1943
	Auckland	N	1945
	Wellington	N	1946
Pokere S.T.	Southland	S	1977,81-83
	Auckland	N	1984
Roberts F.	Wellington	S*	1902
	Wellington	N	1904,05,07,08

** replaced an injured South Island player*

Name	Province	I	Year
Svenson K.S.	Wanganui	N	1921
	Buller	S	1922
	Wellington	N	1924,26
Tanner J.M.	Otago	S	1947
	Auckland	N	1950
Thomson H.D.	Canterbury	S	1903
	Wanganui	N	1905
	Wellington	N	1906
Tremain K.R.	Canterbury	S	1959,61
	Hawke's Bay	N	1962-68
Watt J.R.	Southland	S	1957
	Wellington	N	1961
Whineray W.J.	Canterbury	S	1957
	Waikato	N	1958
	Auckland	N	1959,61-63,65

NORTH ISLAND REPRESENTATIVES 1897-1995

** indicates a player who represented New Zealand*

R indicates a player who appeared as a replacement

Name	Province	Year
Abbott J.R.‡	Otago	1904

‡ played in place of C.E. Seeling who did not arrive at Dunedin in time for the interisland match

Name	Province	Year
Aitken G.G.*	Wellington	1921
Algar B.*	Wellington	1919-21
Allen F.R.*	Auckland	1946-48
Allen L.*	Taranaki	1897
Ancell J.D.	Taranaki	1897
Anderson B.L.*	Wairarapa-Bush	1986
Anderson C.D.	Hawke's Bay	1931
Anderson M.	Waikato	1928
Anderson P.G.	Waikato	1972
Anderson R.K.	Auckland	1935,37R
Apsey E.G.	Hawke's Bay	1934,35
Armstrong A.L.*	Wairarapa	1902,03
Asher A.A.*	Auckland	1902
Ashworth B.G.*	Auckland	1976
Avery H.E.*	Wellington	1910
Badeley C.E.O.*	Auckland	1919-21
Badeley V.I.R.*	Auckland	1922R
Bagley K.P.*	Manawatu	1952,54
Bailey J.J.	Hawke's Bay	1907
Baldwin H.L.	Wellington	1935
Ball N.*	Wellington	1932
Barchard D.A.	Auckland	1945,46
Barker N.A.J.	Wellington	1920
Barry K.E.*	Thames Valley	1962
Barton D.G.	Wanganui	1937,38R
Batty G.B.*	Wellington	1973-75
Batty W.*	Auckland	1928,29,31
Bayly A.*	Taranaki	1897
Beard D.D.	Wanganui	1949
Beatty G.E.*	Taranaki	1949
Beazley B.W.	North Auckland	1951,54
Belliss E.A.*	Wanganui	1920-22
Berridge A.A.	Auckland	1927
Berry M.J.*	Wairarapa-Bush	1986
Bevan H.R.	Horowhenua	1923
Bevan V.D.*	Wellington	1947-49,53
Birtwistle W.M.*	Waikato	1967
Bishop H.	Hawke's Bay	1904
Blair H.T.	Manawatu	1978
Blair J.A.*	Wanganui	1897
Blake A W.*	Wairarapa	1948,50,52
Blake J.M.*	Hawke's Bay	1925,26
Boggs E.G*	Wellington	1934
	Auckland	1948
Borell D.	Bay of Plenty	1922
Boroevich K G.*	King Country	1983
	Wellington	1986
Botica F.M.*	North Harbour	1986
Bowden N.J.G.*	Taranaki	1952
Bowman A.W.*	Hawke's Bay	1937-39
	Wellington	1945
Bramwell I.D.	Poverty Bay	1928
Briscoe K C.*	Taranaki	1959,63,65
Brook E.G.	Wellington	1922
Brooke R.M.*	Auckland	1995
Brooke Z.V.*	Auckland	1995
Brooke-Cowden M.*	Auckland	1986
Brown C.*	Taranaki	1911,20
Brown O.M.*	Auckland	1995
Brown R.H.*	Taranaki	1954,56,58,61,62
Brownlie C.J.*	Hawke's Bay	1924,25,27
Brownlie M.J.*	Hawke's Bay	1922-25,27
Bruce J.A.*	Wellington	1909
	Auckland	1912-14
Bullock-Douglas G.A.H.*	Wanganui	1931R-33
Bunce F.E.*	Auckland	1986
	North Harbour	1995
Burgess G.A.J.*	Auckland	1981,82
Burgess R.E.*	Manawatu	1972
Burke P.S.*	Taranaki	1951-54,57
Bush R.G.*	Auckland	1934
Butler J.H.	Auckland	1935
Byrne P.C.	King Country	1922
Cadwallader A.	Wairarapa	1902
Cain M.J.*	Taranaki	1913,14,20
Calcinai U.P.*	Wellington	1922
Calcinai V.L.	Wellington	1943
Callesen J.A.*	Manawatu	1972,74,75,77
Calnan J.J.*	Wellington	1897
Cameron C.	Waikato	1931
Cameron D.*	Taranaki	1908,09
Cameron K.	King Country	1938

Name	Team	Year(s)
Campbell A.B.	Wanganui	1935
Campbell C.	Hawke's Bay	1929
Carlson A.	Hawke's Bay	1905
Carlson W.H.	Wanganui	1928
Carrington K.R.*	Auckland	1973
Carroll A.J.*	Manawatu	1919-21
Carroll J.R.	Manawatu	1956
Carson W.N.*	Auckland	1938,39
Catley E.H.*	Waikato	1944-48
Caughey T.H.C.*	Auckland	1932,33
Caulton R.W.*	Wellington	1962-64
Cherrington N.P.*	North Auckland	1947,50
Christian D.L.*	Auckland	1944,45,47,48,50
Clark W.H.*	Wellington	1953-56
Clarke D.B.*	Waikato	1956-59,61-64
Clarke I.J.*	Waikato	1953-57,59,61
Clarke R.L.*	Taranaki	1932,33R,34
Clothier L.S.	Hawke's Bay	1937
Codlin B.W.*	Counties	1980
Coleman G.J.	Wanganui	1976
Coles W.R.	Taranaki	1964R
Collier A.R.	Wanganui	1925
Collins A.H.*	Taranaki	1932
Collins J.L.*	Poverty Bay	1964,65
Colman J.T.H.*	Taranaki	1907,08,11
Colthurst F.J.	Auckland	1964
	Thames Valley	1965R
Conn S.B.*	Auckland	1976
Connor D.M.*	Auckland	1960-62,64,65R
Conway R.J.*	Waikato	1961
Cooke A.E.*	Auckland	1924,25
	Hawke's Bay	1926,31
	Wairarapa	1928,29
Cooper F.C.	North Auckland	1933
Cooper G.J.L.*	Auckland	1986
Corner M.C.	Wellington	1919
Cossey R.R.*	Counties	1958
Cotter H.F.	Wellington	1914
Couch M.B.R.*	Wairarapa	1947
Coull J.B.	Taranaki	1939,43-45
Cowley B.A.C.	Waikato	1955
Crimp C.H.	Wanganui	1952
Cross T.*	Wellington	1904,06
Crossman C.A.	King Country	1937,38
Crossman G.M.*	Bay of Plenty	1974,75
Crowley K.J.*	Taranaki	1983
Crowley P.J.B.*	Auckland	1946-48,50
Cull B.A.	Wellington	1960R
Cunningham G.R.*	Auckland	1979
Cunningham W.*	Auckland	1902,08
Cupples L.F.*	Bay of Plenty	1922
Currie C.J.*	Wellington	1977
Cutler D.A.	Auckland	1949
Dalton A.G.*	Counties	1976-82
Dalton D.*	Hawke's Bay	1936,38
Davies M.P.H.	Bay of Plenty	1934
Davis K.*	Auckland	1954,55,58
Davis W.L.*	Hawke's Bay	1964,65
Dawson A.J.	Counties	1981,83,85R
Dawson H.H.	Wellington	1910
Delamore G.W.*	Manawatu	1943,44
	Wellington	1948
Desmond A.	Wairarapa	1911,12
Dewar H.*	Taranaki	1913
Dick J.*	Auckland	1936,38
Dick M.J.*	Auckland	1963,66
Dickson G.R.	Auckland	1984,85
Dive E.	Taranaki	1906
Dodd E.H.*	Wellington	1902
Donald A.J.*	Wanganui	1981,83,84
Donald J.G.*	Wairarapa	1920,21
Donald Q.*	Wairarapa	1919,24
Donaldson M.W.*	Manawatu	1980,82
Dougan J.P.*	Wellington	1972R,74
Douglas A.J.	Bay of Plenty	1950,51
Dowd C.W.*	Auckland	1995
Downing A.J.*	Hawke's Bay	1911,12
	Auckland	1914
Dufty J.H.	Auckland	1906
Duncan M.G.*	Hawke's Bay	1969
Dunn E.J.	North Auckland	1977-79,81R
Dunn E.F.	North Auckland	1950R
Dunn J.M.*	Auckland	1944,45
Dunning C.	Auckland	1906
Dustin W.S.	Wanganui	1912,13
Dyer M.M.	Hawke's Bay	1939
Edwards L.H.	Taranaki	1935
	Wellington	1936
Eliason I.M.*	Taranaki	1970,71
Elliot H.	Wellington	1911,12,19
Elliott K.G.*	Wellington	1944,46
Elvy W.L.*	Wellington	1929
Ensor V.A.	Waikato	1945,46
Erceg C.P.*	Auckland	1951
Eveleigh K.A.*	Manawatu	1973-75,78R
Evensen A.C.	Wellington	1913
Falwasser A.C.	Hawke's Bay	1925
Fatialofa P.	Auckland	1986
Finlay B.E.L.*	Manawatu	1952,59
Finlay J.*	Manawatu	1946
Finlayson A.	Auckland	1928,29
Finlayson A.N.	North Auckland	1932
Finlayson I.*	North Auckland	1926,27
Fitzgerald J.T.*	Wellington	1953,54,56
Fitzpatrick B.B.J.*	Poverty Bay	1951
	Wellington	1952
Fitzpatrick S.B.T.*	Auckland	1995
Flavell I.C.A.	Taranaki	1960
Fleming J.K.*	Wellington	1978,79
Fleming W.S.	Wellington	1958
Fletcher C.J.C.*	Auckland	1920
Fookes K.F.	Taranaki	1931
Fox G.J.*	Auckland	1983-85
Fox R.J.	Auckland	1944
Francis A.R.H.*	Auckland	1906,08-10
Francis W.C.*	Wellington	1914
Fraser B.G.*	Wellington	1979-82,84
Fraser R.J.	Taranaki	1977-79
Frazer H.F.*	Auckland	1943
	Hawke's Bay	1946-48
Freebairn W.S.S.*	Manawatu	1953,57,60
Fuller F.S.	Wellington	1933
Furrie L.J.	Manawatu	1904
Gallaher D.*	Auckland	1903,05
Gardiner A.J.	Taranaki	1974
Gargan F.E.	Taranaki	1935
Gascoigne W.F.	Auckland	1972
Geddes W.M.	Auckland	1913
Gemmell S.W.*	Hawke's Bay	1923
Gillespie C.T.*	Wellington	1913
Gillett G.A.*	Auckland	1906
Gilmour L.J.	Auckland	1943
Glasgow F.T.*	Taranaki	1905
Glenn W.S.*	Taranaki	1904,05
Going B.L.	North Auckland	1968R
Going K.T.*	North Auckland	1968
Going S.M.*	North Auckland	1966-69,71,73-75,77
Grace T.M.P.	Wellington	1910,11
Graham J.T.	Waikato	1951-54
Graham R.H.	Auckland	1960,62,64
Granger K.W.*	Manawatu	1976
Grant D.E.	Wanganui	1949
Granville S.T.	Wanganui	1950
Gray K.F.*	Wellington	1963,64,66-69
Gray W.N.*	Bay of Plenty	1956,57
Green C.H.	Wellington	1909
Grenside B.A.*	Hawke's Bay	1923,27
Grierson M.R.	Auckland	1921
Griffiths J.L.*	Wellington	1934,36
Gunning J.A.	Auckland	1944,45
Gunson M.J.	North Auckland	1979
Guy R.A.*	North Auckland	1970,71
Guy W.A.	Taranaki	1904
Haden A.M.*	Auckland	1973,76,79-84
Hadley S.*	Auckland	1927,31
Hadley W.E.*	Auckland	1933,36
Handcock R.A.*	Auckland	1897
Hardcastle W.R.*	Wellington	1897
Harker D.G.	Wellington	1960
Harkness H.D.	Manawatu	1949
Harris L.G.	Auckland	1984,85
Harrison W.	Auckland	1903
Hart A.H.*	Taranaki	1924
Harvey A.R.	Auckland	1983
Harvey B.A.*	Wairarapa-Bush	1986
Harvey I.H.*	Wairarapa	1924,26,27
Hayes A.	Waikato	1958
Hay-MacKenzie W.E.*	Auckland	1905
Hayward H.O.*	Auckland	1908
Heazlewood L.K.	Wellington	1929
Heeps T.R.*	Wellington	1962
Hemara B.S.*	Manawatu	1985-86
Hemi R.C.*	Waikato	1953-56,59
Henderson G.F.	Wairarapa	1948
Henderson P.*	Wanganui	1948
Hepple M.	North Auckland	1973
Herewini M.A.*	Auckland	1963-65R-68
Herring F.H.	Auckland	1909
Hewson A.R.*	Wellington	1981-82
Hickey P.H.*	Taranaki	1922
Hogan J.*	Wanganui	1907
Holmes B.*	North Auckland	1968,69,71
Hook G.H.	1st NZ Division	1943
Hook L.S.*	Auckland	1927
Horsley R.H.*	Wellington	1961
Hughes A.M.*	Auckland	1948R,49
Hughes E.*	Wellington	1921
Hughes L.J.	Counties	1978-80
Hull R.R.	Wellington	1935
Humphries A.L.*	Taranaki	1897,1903
Hunter J.*	Taranaki	1904-08
Hunter R.P.	Hawke's Bay	1971
Irvine I.B.*	North Auckland	1952
Irvine W.R.*	Hawke's Bay	1923-26
Jackson E.S.*	Hawke's Bay	1935-39
Jacob H.*	Horowhenua	1919-21,23
Jamieson E.W.A.	Manawatu	1943
Jarden R.A.*	Wellington	1950,52-56
Jefferd A.C.R.*	East Coast	1981
Jessep E.M.*	Wellington	1932
Johnson A.	Wairarapa	1905
Johnson L.M.*	Wellington	1927,29
Johnson T.W.	Hawke's Bay	1962,63
Johnston D.*	Taranaki	1923
Johnstone B.R.*	Auckland	1975,79
Johnstone R.D.	Auckland	1948
Jones I.D.*	North Harbour	1995
Jones M.G.*	North Auckland	1970,73
Jones M.N.*	Auckland	1995
Jones P.F.H.*	North Auckland	1953-55,57,58
Kaipara A.P.	Poverty Bay	1910-12
Kane G.N.*	Waikato	1974R

Karam J. F.* | Wellington | 1973
| Horowhenua | 1975
Katene T.* | Wellington | 1955,56
Keenan M.G. | Auckland | 1986
Keenan R.A. | Manawatu | 1949
Keene A. | Auckland | 1927
Keepa R.H. | Bay of Plenty | 1957R
Kelly J.W.* | Auckland | 1954
Kember G.F.* | Wellington | 1966,67
Kemp R. | Waikato | 1928
Kerr G.A. | North Auckland | 1931
Kershaw T. | Taranaki | 1909
Ketels R.C.* | Counties | 1978,80-82

Kiernan H.A.D.* | Auckland | 1902,03,06
Kilby F.D.* | Wellington | 1927,31-33,35

Killeen B.A.* | Wellington | 1933
| Auckland | 1936
King G.F. | Poverty Bay | 1947
Kingstone C.N.* | Taranaki | 1921
Kinvig J.G. | Wellington | 1911,13
Kipa T.D. | Wanganui | 1952
Kirk, D.E.* | Auckland | 1986
Kirkpatrick A.* | Hawke's Bay | 1925
Kirkpatrick I.A.* | Poverty Bay | 1971-75
Kirwan J.J.* | Auckland | 1983-85
Kivell A.L.* | Taranaki | 1926
Knight A.* | Auckland | 1928
Knight G.A.* | Manawatu | 1977,84,85
Knight L.G.* | Auckland | 1973,74
| Poverty Bay | 1975
Kururangi R.* | Counties | 1978,82

Laing J. | Auckland | 1902
Lambert K.K.* | Manawatu | 1973-75
Lambourn A.* | Wellington | 1934,37,39
Langlands W.J. | Poverty Bay | 1925,28
Larsen B.P.* | North Harbour | 1995
Laurie R.D. | Auckland | 1967
Laws F.A. | Wellington | 1897
Leahy R. | Wellington | 1910
| Wanganui | 1911
Leeson J.* | Waikato | 1933-35
Lendrum R.N.* | Counties | 1969-72, 74,78

le Quesne C.M. | Hawke's Bay | 1935
Leslie A.R.* | Wellington | 1977
Lilburne H.T.* | Wellington | 1931-33R
Lile W. | Wellington | 1907
Lineen T.R.* | Auckland | 1955,58,59
Little P.F.* | Auckland | 1962
Lochore B.J.* | Wairarapa | 1964-69
Lockington T.M.* | Auckland | 1936,38
Lomas A.R.* | Auckland | 1926
Lomu J.T.* | Counties-Manukau | 1995
Long A.J.* | Auckland | 1902,03
Love G.W. | Hawke's Bay | 1964
Loveday J.K.* | Manawatu | 1978
Loveridge D.S.* | Taranaki | 1978,79,85
Loveridge G.* | Taranaki | 1913
Lucas F.W.* | Auckland | 1924,26,29
Lyons D.J. | Hawke's Bay | 1946

McAneney A.I. | Poverty Bay | 1939R
McCarroll D.S. | Hawke's Bay | 1976
McCullough J.F.* | Taranaki | 1957,59, 60,63

McCullough R.C. | Auckland | 1922
McDermott J.B. | Auckland | 1986
Macdonald H.H.* | North Auckland | 1975
Macdonald M.S. | Hawke's Bay | 1939
McDuff R.B. | Auckland | 1902,03
McEldowney J.T.* | Taranaki | 1976,77
McEvoy A.F. | Auckland | 1952
MacEwan I.N.* | Wellington | 1956-59,62

McGrattan B.* | Wellington | 1983-85
McGregor A.J.* | Auckland | 1909,12

McGregor D.* | Wellington | 1904
McGregor R.W.* | Auckland | 1902,03
McGuigan J.S.F. | Auckland | 1950,51
McHugh M.J.* | Auckland | 1944-46, 48

McIntosh D.N.* | Wellington | 1957
McIntyre I.A. | Wanganui | 1934
McKay D.W.* | Auckland | 1960,61,65
McKenzie E. | Wairarapa | 1902
McKenzie H.J. | Wairarapa | 1913
McKenzie R.J.* | Wellington | 1912,13
| Auckland | 1914
McKenzie R.M.* | Manawatu | 1933,34, 37-39

McKenzie W.* | Wellington | 1897
Mackrell W.H.C.* | Auckland | 1905
McLaren A. | Thames Valley | 1925
McLaren H.C.* | Waikato | 1952,53
McLean A.L.* | Bay of Plenty | 1921
McLean H.F.* | Taranaki | 1929
| Wellington | 1931-33
McLean J.K.* | King Country | 1947
McLeod B.E.* | Counties | 1965,66, 68,69

McLeod H. | Wellington | 1910
McMinn A.F.* | Wairarapa | 1903
McMullen R.F.* | Auckland | 1958,59
McNab J.A.* | Hawke's Bay | 1922R,24
McNae A.R. | Manawatu | 1907
McNaughton A.M.* | Bay of Plenty | 1969-71
McNeile J.P. | Taranaki | 1936
McNicol A.L.R. | Wanganui | 1972
McPhail A.G. | Poverty Bay | 1929
MacRae I.R.* | Hawke's Bay | 1964,66,69
McRobbie E.S. | Counties | 1973
McWilliams R.G. | Auckland | 1927
Mahoney A.* | Bush | 1933
Major J.* | Taranaki | 1963,67
Malcolm J.A. | Wellington | 1926
Malin F.A. | Wellington | 1919
Maniapoto H.J. | Bay of Plenty | 1971
Manners B. | Waikato | 1955
Marett H.C. | Hawke's Bay | 1954,57
Martin G.I. | Hawke's Bay | 1970R
Masters F.H.* | Taranaki | 1919,22
Masters R.C. | North Auckland | 1938
Matthews K. | Wairarapa | 1950
Meads C.E.* | King Country | 1956-59, 62,63, 65-69,71

Meads S.T.* | King Country | 1960,61, 63-66

Meuli L.W. | Wanganui | 1909
Mexted G.G.* | Wellington | 1951
Mexted M.G.* | Wellington | 1978-80, 84

Middleton A.B. | Wanganui | 1981
Mill J.J.* | Hawke's Bay | 1923-26
| Wairarapa | 1929
Mills H.P.* | Taranaki | 1897
Milne W.H. | Wanganui | 1909
Minns P.C. | Auckland | 1929
Mitchell J.‡ | Otago | 1904

‡ played in place of G.W. Nicholson who did not arrive at Dunedin in time

Mitchinson F.E.* | Wellington | 1906-10
Moeke J.J. | Bay of Plenty | 1960
Moffitt J.E.* | Wellington | 1920,21
Montgomerie H.W. | Wanganui | 1904
Morgan J.E.* | North Auckland | 1970,74,75
Morrison T.C.* | Wellington | 1944,45
Mourie G.N.K.* | Taranaki | 1976-80, 82

Muller B.L.* | Taranaki | 1967-69
Murdoch P.H.* | Auckland | 1965
Murray F.S.* | Auckland | 1897
Murray P.C.* | Wanganui | 1904,08
Myers P.J.A. | Wellington | 1966

Mynott H.J.* | Taranaki | 1904-08
Nathan W.J.* | Auckland | 1960,61, 63,65-67
Nelson K.A.* | Auckland | 1964
Nepia G.* | Hawke's Bay | 1924,25
| East Coast | 1933
Nicholls H.E.* | Wellington | 1919,22
Nicholls M.F.* | Wellington | 1922,24, 26,27,31
Nicholls W.J. | Wellington | 1970
Nicholson G.W.* | Auckland | 1902,03
Nunn R.N. | Wairarapa | 1934

O'Brien A.J.* | Auckland | 1922
O'Brien J.G.* | Auckland | 1920
O'Callaghan M.W.* | Manawatu | 1968-70
O'Callaghan T.R.* | Auckland | 1947
| Wellington | 1949
O'Donnell D.H.* | Wellington | 1949
Old G.H.* | Manawatu | 1982
O'Leary M.J.* | Wairarapa | 1907,08
| Auckland | 1909,10
Oliver F.J.* | Manawatu | 1980-81
Osborne G.M.* | North Harbour | 1995
Osborne W.M.* | Wanganui | 1978,80, 84R
O'Sullivan J.M.* | Taranaki | 1905-07
O'Sullivan T.P.A.* | Taranaki | 1959,61,63

Paewai M.N. | Auckland | 1945
| Wellington | 1946
Page J.R.* | Wellington | 1933
Palmer B.P.* | Auckland | 1928,32
Palmer D.L. | Auckland | 1971,72
Paratene M. | Poverty Bay | 1912
Parkinson R.M.* | Poverty Bay | 1971-73
Paton R.J. | Wellington | 1913,19
Paterson N.M. | Taranaki | 1923
Pauling T.G.* | Wellington | 1897
Pearce T.H. | Auckland | 1937,38
Pearman N.C. | Auckland | 1939
Pearson F.L. | Waikato | 1945
Perry E. | Wellington | 1910
Phillips D.E. | Waikato | 1972R
Phillips W.J.* | King Country | 1937-39
Pickering E.A.R.* | Waikato | 1958,59
Pierce M.J.* | Wellington | 1985
Pike A.D. | Auckland | 1943
Pinfold A.J. | Wairarapa | 1947R
Pokere S.T.* | Auckland | 1984
Pollock H.R.* | Wellington | 1932, 35-37

Porter C.G.* | Wellington | 1924-26, 28,29

Potaka W.* | Wanganui | 1923
Preston J.P.* | Wellington | 1995
Pringle A.* | Wellington | 1923,24
Pryor A. | Auckland | 1956

Rae L.S. | Auckland | 1944
Rangi R.E.* | Auckland | 1965
Rapson T. | Wellington | 1910
Rawhiri H. | Horowhenua | 1911
Reedy W.J.* | Wellington | 1908,09
Reid A.R.* | Waikato | 1950-52, 56,57
Reid H.R.* | Bay of Plenty | 1983-84
Reid K.H.* | Wairarapa | 1929,31
Reid P.J. | Hawke's Bay | 1939
Reid S.T.* | Hawke's Bay | 1934,36, 37,39

Renton P.J. | Hawke's Bay | 1986
Rich G.J.W. | Auckland | 1982,83
Richards P.M. | Auckland | 1975
Richardson L. | Manawatu | 1951
Righton L.S.* | Auckland | 1923
Riley T.J.S. | Wellington | 1953
Roach L.M. | Wairarapa | 1928
Roberts B. | Wellington | 1944

Roberts E.J.*	Wellington	1910, 12-14,19
Roberts F.*	Wellington	1904,05, 07,08,11
Roberts R.W.*	Taranaki	1912-14
Roberts W.*	Wellington	1897
Robertson B.J.*	Counties	1971,72, 74,75,77, 80,81
Rogers J.J.	Waikato	1970
Rolls C.H.	Hawke's Bay	1934
Roper R.A.*	Taranaki	1949
Rowan A.E.	Waikato	1949
Rowe H.W.T.	Thames Valley	1935
Rowlands A.G.E.	Poverty Bay	1957,58
Rowlands G.D.*	Bay of Plenty	1976
Rowley H.C.B.*	Wanganui	1949
Rush E.J.*	North Harbour	1995
Russell L.G.	North Auckland	1960
Russell L.T.	Waikato	1936,38
Ryan J.*	Wellington	1914
Ryan W.T.	Wellington	1919
Ryland C.	Poverty Bay	1911
Sage J.K.	Wellington	1957,58
Satherly C.A.M.	Hawke's Bay	1932
Sayers M.*	Wellington	1968
Schubert L.W.	Auckland	1939
Schuster N.J.*	Wellington	1986
Scott P.E.	Bay of Plenty	1966
Scott R.W.H.*	Auckland	1946,48, 51,53
Scown A.I.*	Taranaki	1970R
Seeling C.E.*	Auckland	1906,08
Sellars G.M.V.*	Auckland	1912
Shaw M.W.*	Manawatu	1980,81, 84,85
Shearer J.D.*	Wellington	1919
Shearer S.D.*	Wellington	1922
Sheen T.R.*	Auckland	1927
Shelford W.T.*	North Harbour	1985
Sherlock K.*	Auckland	1985

Sherratt J.R.	Wellington	1946
Siddells S.K.*	Wellington	1922
Simpson J.G.*	Auckland	1947
Singe A.P.	Auckland	1920R
Sloane P.H.*	North Auckland	1973
Sly H.R.	Wellington	1925
Smith A.	Taranaki	1914
Smith B.A.	Auckland	1986
Smith B.W.*	Waikato	1983
Smith F.H.F.	Wellington	1935,36
Smith G.W.*	Auckland	1897, 1905
Smith J.B.*	1st NZ Division	1943
	North Auckland	1946-50, 53
Smith J.G.	Wellington	1951
Smith M.M.	Auckland	1943
Solomon D.*	Waikato	1934
	Auckland	1937
Solomon F.*	Auckland	1931-33
Sorenson R.G.	Auckland	1943,45
Spencer C.J.*	Auckland	1995
Spencer G.*	Wellington	1907
Spencer J.C.*	Wellington	1903,06,07
Spry T.A.	Wanganui	1971R
Stanaway P.	Wellington	1943
Stanley J.T.*	Auckland	1983
Steere E.R.G.*	Hawke's Bay	1928,29, 31-33
Stensness L.*	Auckland	1995
Stephens O.G.*	Wellington	1968,70
Stevens I.N.*	Wellington	1968R,72
Stewart A.	Bay of Plenty	1923
Stewart J.D.*	Auckland	1914
Stohr L.*	Taranaki	1912,14
Stokes E.J.T.*	Bay of Plenty	1976
Stone A.M.*	Waikato	1982-85
Strahan S.C.*	Manawatu	1967-69
Stringfellow J.C.*	Wairarapa	1934
Stuart R.L.*	Hawke's Bay	1976,77
Sullivan D.	Wellington	1911
Sullivan J.L.*	Taranaki	1936-39

Svenson K.S.*	Wanganui	1921
	Wellington	1924,26
Swain J.P.*	Hawke's Bay	1926,27
Taituha P.*‡	Wanganui	1923
‡ also known as T. Peina and as T.P. Kingi		
Takarangi A.M.	Wanganui	1904
Tanner J.M.*	Auckland	1950
Taylor M.B.*	Waikato	1976-78
Taylor N.M.*	Bay of Plenty	1976,79
Taylor R.*	Taranaki	1914
Terry G.H.	1st NZ Division	1943
Tetzlaff P.L.*	Auckland	1943,44
Thomas B.T.*	Auckland	1965
Thomas L.A.*	Wellington	1926
Thompson E.J.	North Auckland	1957,60
Thompson H.D.*	Wanganui	1905
	Wellington	1906
Thorne G.S.*	Auckland	1968,69
Tilyard F.J.*	Wellington	1923
Tilyard J.T.*	Wellington	1920
Tindill E.W.T.*	Wellington	1939
Tonu'u O.F.J.*	Auckland	1995R
Tregear E.N.	Wanganui	1902
Tremain K.R.*	Hawke's Bay	1962-68
Twigden T.M.*	Auckland	1975R,80
Tyler G.A.*	Auckland	1903
Udy D.K.*	Wairarapa	1903
Urlich R.A.*	Auckland	1971,72
Vodanovich I.M.H.*	Wellington	1955,60
Waddell A.	Auckland	1909
Waldegrave B.M.	Auckland	1945
Wales G.R.	Wellington	1944
Wallace W.J.*	Wellington	1902,05, 07,08
Walsh P.T.*	South Auckland Counties	1955
	Counties	1959

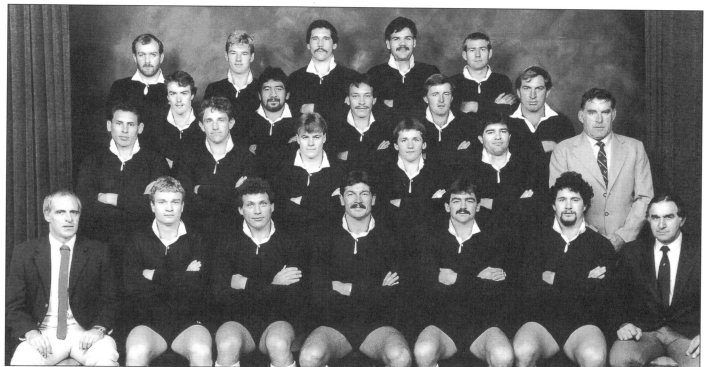

The 1985 North Island team
Back row: Brian McGrattan, John Kirwan, Murray Pierce, Gary Whetton, Mark Shaw.
Third row: Terry Wright, Bruce Hemara, Lindsay Harris, Kieran Crowley, Gary Knight.
Second row: Wayne Shelford, Grant Dickson, Mark Cameron, David Kirk, Steve McDowell, Colin Meads (selector/convenor).
Front row: George Simpkin (selector), Grant Fox, Bill Osborne, Murray Mexted, Dave Loveridge (captain), Arthur Stone, Ivan Vodanovich (manager).
Absent: Alan Dawson, Hika Reid, Kurt Sherlock.

Walter J.*	Taranaki	1925
Walters M.	North Auckland	1960
Watkins A.M.	Auckland	1969-71
Watkins E.L.*	Wellington	1904-05
Watson R.	Taranaki	1931
Watt J.R.*	Wellington	1961
Wells J.*	Wellington	1936,37
West A.H.*	Taranaki	1920,21
West A.J.	Taranaki	1944
Weston L.H.*	Auckland	1914
Whatarau E.H.	South Auckland Counties	1955
Whetton A.J.*	Auckland	1983
Whetton G.W.*	Auckland	1982,84,85
Whineray W.J.*	Waikato	1958
	Auckland	1959, 61-63,65
Whisker D.	Manawatu	1905
White H.L.*	Auckland	1955
White R.A.*	Poverty Bay	1949-56
White R.M.*	Wellington	1944,46,47
Whiting G.J.*	King Country	1972
Whiting P.J.*	Auckland	1970,73,74
Whittington H.G.	Taranaki	1910
Wightman D.R.*	Auckland	1951
Wilkes T.M.	Auckland	1909
Williams B.G.*	Auckland	1974,75,77
Williams C.P.	Wellington	1951
Williams G.C.*	Wellington	1970,72
Williment M.*	Wellington	1965,66
Willoughby S.de L.P.*	Wairarapa	1928
Willoughby S.E.	Wairarapa	1928
Wilson A.*	Auckland	1897
Wilson F.R.*	Auckland	1909
Wilson H.B.*	Counties	1983R
Wilson J.S.	Wellington	1903
Wilson N.A.*	Wellington	1907,08, 11-14
Wilson S.S.*	Wellington	1976,77, 79,82
Wilson V.W.*	Auckland	1919,20
Winiata M.	Horowhenua	1903
Winiata W.	Horowhenua	1910
Winitana V.	Wellington	1970
Wishnowsky B.A.	Wellington	1945
	Hawke's Bay	1950
Wolfe T.N.*	Wellington	1961,62
	Taranaki	1966
Woodman F.A.*	North Auckland	1981
Wordley W.R.*	King Country	1960-62
Wright A.H.*	Wellington	1934
Wright G.W.J.	Waikato	1970
Wright T.J.*	Auckland	1985-86
Wylie E.M.	Manawatu	1902
Wylie J.T.*	Auckland	1910
Wylie T.*	Wellington	1980-82
Wynyard J.G.*	Waikato	1938
Yates V.M.*	North Auckland	1961
Young O.M.	Taranaki	1911
Young S.L.	Wellington	1943

SOUTH ISLAND REPRESENTATIVES
1897-1995
** indicates a player who represented New Zealand*
R indicates a player who appeared as a replacement

Abel R.S.	Canterbury	1962
Adams A.A.	Otago	1906
Adkins G.T.A.*	Sth Canterbury	1934
Alexander W.	Otago	1912
Allen M.W.	Canterbury	1960,61
Allen W.R.	Otago	1931
Alley G.T.*	Southland	1926
	Canterbury	1927
Allison J.G.	Southland	1960-63
Anderson A.*	Canterbury	1983,85
Anderson G.	Buller	1949,55, 56R
Anderson J.F.	Otago	1958

Anderson P.A.	West Coast	1910
Anderson W.J.	Sth Canterbury	1976
Andrews A.H.	Canterbury	1931-33
Archer W.R.*	Otago	1955
	Southland	1957,59
Argus W.G.*	Canterbury	1946
Armit A.M.*	Otago	1897
Arnold D.A.*	Canterbury	1963-66, 69R
Ashby D.L.*	Southland	1957-59
Ashworth J.C.*	Canterbury	1977-80, 81,82,84
Atkins D.P.	Canterbury	1984,85
Atkinson H.*	West Coast	1910
Avery N.M.	Marlborough	1968R
Bachop G.T.M.*	Canterbury	1995
Bachop S.J.*	Otago	1995
Bacon G.J.	Canterbury	1969
Badeley C.E.O.*‡	Auckland	1922R

‡ replaced an injured South Island player, J. Steel, during the match

Bain T.	Canterbury	1908,10
Bain W.	Otago	1919
Baird D.L.*	Southland	1920
Banks A.J.	Otago	1967
Barber R.J.	North Otago	1963
Barkle G.P.	Canterbury	1978
Barnes B.H.	Otago	1945
Batchelor S.	Southland	1928
Begg A.T.	Otago	1919
Bell J.R.*	Southland	1923,25
Bell R.C.*	Otago	1922
Bell R.H.*	Otago	1950-52
Benjamin A.	West Coast	1897
Bennet R.*	Otago	1904
Berghan T.*	Otago	1938
Best J.E.	Nelson	1911
Best J.J.	Marlborough	1934
Biggar E.	Southland	1911
Birchfield R.T.	West Coast	1943,44
Bird R.M.	Southland	1928
Birtwistle W.M.*	Canterbury	1964-66
Black J.E.*	Canterbury	1976-79
Black R.S.*	Otago	1912,14
Black W.	Southland	1904
Black W.A.	Otago	1936
Bligh S.*	West Coast	1909
Bloxham K.C.*	Otago	1980
Bond J.G.P.*	Canterbury	1949R
Booth E.E.*	Otago	1902,04-07
Booth G.P.	Otago	1967
Botting I.J.*	Otago	1948
Bowers R.G.*	Golden Bay-Motueka	1956
Bradanovich N.M.*	Otago	1928
Breeze R.K.	West Coast	1951,52
Brewer M.R.*	Otago	1986
	Canterbury	1995
Brooker F.J.*	Canterbury	1897
Brosnahan T.E.	Canterbury	1919
Bruce O.D.*	Canterbury	1970,73, 74,77
Brunsden A.R.	Canterbury	1902
Buchan J.A.S.	Canterbury	1986
Budd A.E.	Southland	1919
Budd T.A.*	Southland	1946,49
Burcher T.J.	Otago	1976
Burgess G.F.*	Southland	1904
Burleigh C.W.	Canterbury	1985R,86
Burley G.	Southland	1904
Burns J.F.*	Canterbury	1968-71
Burns P.J.*	Canterbury	1906-11
Burrows J.T.*	Canterbury	1925,27,29
Burt W.M.	Southland	1925
Bush R.G.	Otago	1931
Bush W.K.Te P.*	Canterbury	1973-75, 78,81,82
Buxton J.B.*	Canterbury	1956
	Otago	1957

Byrne P.C.	Nelson	1919
Cabot P.S.de Q.*	Otago	1921
Callanan P.R.	Canterbury	1943-46
Callon D.K.	Otago	1986
Campbell C.J.	Otago	1919
Carleton S.R.	Canterbury	1927
Carnegie N.	Canterbury	1922
Cartwright S.C.*	Canterbury	1976
Casey S.T.*	Otago	1904-07
Chesley C.D.	Canterbury	1928R
Church W.C.	West Coast	1912R
Clark D.W.*	Otago	1960, 64-66
Clark F.L.*	Canterbury	1928
Clark L.A.*	Otago	1973, 76,77
Clark T.A.	Southland	1907
Clarke J.	Golden Bay-Motueka	1926
Cobden D.G.*	Canterbury	1937
Cochrane R.G.	Canterbury	1961
Cockroft E.A.P.*	Sth Canterbury	1914
Coles E.G.	Sth Canterbury	1910
Colling D.V.	Otago	1973-76
Colling G.L.*	Otago	1969,72,73
Collins M.P.	Otago	1970,71
Colvin R.A.	Buller	1909,10
Connolly A.M.	Marlborough	1921
Connolly L.	Sth Canterbury	1932
Connolly L.S.*	Otago	1943,44
	Southland	1947
Cooke R.J.*	Canterbury	1902,03
Cooper G.J.L.*	Otago	1985
Corbett J.*	West Coast	1904-06
	Buller	1909
Cornelius N.G.	Canterbury	1966
Cottrell A.I.*	Canterbury	1929, 31-33
Cottrell W.D.*	Canterbury	1967-69, 71
Coughlan T.D.*	Sth Canterbury	1955-58, 60
Couling A.R.	Canterbury	1950,51
Crawshaw E.E.	Canterbury	1914
Creighton J.N.*	Canterbury	1960,64
Cron S.E.G.*	Canterbury	1970,72, 75,76R
Cross T.*	Canterbury	1902
Cummings E.	Canterbury	1919R
Currie C.J.*	Canterbury	1978
Cuthill J.E.*	Otago	1913
Dalley W.C.*	Canterbury	1924R-27
Dalton R.A.*	Otago	1948
Dalton W.	Sth Canterbury	1911
Dalzell G.N.*	Canterbury	1950,51R, 52
Dansey G.R.	West Coast	1905
Dansey R.I.	Otago	1907,08
Darracott R.D.	Otago	1954
Davidson C.G.	Otago	1920
Davie M.G.*	Canterbury	1983-85
Davis L.J.*	Canterbury	1964R, 67,70, 71,75,77
Day G.D.	Canterbury	1931,32
Deans I.B.*	Canterbury	1985,86
Deans R.G.*	Canterbury	1904,05,07
Deans R.M.*	Canterbury	1982-84
Deavoll H.	Canterbury	1935
Dempster W.G.	Nelson Bays	1982
Dench R.H.	Sth Canterbury	1965
Dennehy D.	Buller	1906
Dennison N.F.	Sth Canterbury	1975
Dermody G.H.	Southland	1970
Diack E.S.*	Otago	1957-59
Dick J.*	Canterbury	1943
Dickinson G.R.*	Otago	1922
Dickson R.P.	Nelson	1967
Dickson W.	Buller	1949
Dixon M.J.*	Canterbury	1953,54,56R

Doell A.E.	*Canterbury*	1908,12
Donaldson I.H.	*Southland*	1979
Douglas J.B.*	*Otago*	1913
Duff R.H.*	*Canterbury*	1951-53, 55-57
Duggan W.	*Canterbury*	1902
Duncan B.F.	*Otago*	1965
Duncan J.*	*Otago*	1897
Duncan W.D.*	*Otago*	1920,21
Dunne M.R.	*Canterbury*	1958-60, 65
Dunne W.T.	*Otago*	1933
Earl, A.T.*	*Canterbury*	1985-86
Earl, C.C.	*Canterbury*	1986
Eastgate B.P.*	*Canterbury*	1953,54
Easton S.F.	*North Otago*	1939
Eckhold A G.*	*Otago*	1907,08
Edwards L.H.	*Marlborough*	1945
Ellery J.S.	*Sth Canterbury*	1960R
Ellis E.H.	*Canterbury*	1919,21
Ellis M.C.G.*	*Otago*	1995
Elsom A.E.G.*	*Canterbury*	1953, 55-57
Elvidge R.R.*	*Otago*	1943, 45-48
Elvy W.L.*	*Canterbury*	1926
Evans C.E.*	*Canterbury*	1920
Everett C.G.	*Nelson*	1920
Fairbrother D.G.	*Sth Canterbury*	1924
Fanning B.J.*	*Canterbury*	1897,1902, 03
Fawcett C.L.*	*Otago*	1975R
Fea W.R.*	*Otago*	1920,22
Fenwick A.	*Otago*	1902
Fisher T.*	*Buller*	1914,19
Fitzgerald C.J.*	*Marlborough*	1922
Fitzgerald G.	*Sth Canterbury*	1910
Fitzgerald P.G.	*Canterbury*	1945
Fitzpatrick P.	*Otago*	1908
Fleming F.R.	*Canterbury*	1945
Fong A.S.	*West Coast*	1933
Forbes R.G.	*Marlborough*	1910-12
Ford B.R.*	*Marlborough*	1972, 74-81
Ford W.A.*	*Canterbury*	1921
Forscutt H.R.	*Canterbury*	1944
Forrest S.J.	*Canterbury*	1995
Freitas D.F.E.*	*West Coast*	1928,29
Frew G.C.	*Mid Canterbury*	1982,83,85
Frew W.A.	*Mid Canterbury*	1983
Fryer F.C.*	*Canterbury*	1906-09
Fuller W.B.*	*Canterbury*	1908,09
Gaffaney G.J.	*Sth Canterbury*	1934-36
Gallagher J.P.	*Sth Canterbury*	1953-55
Gard P.C.*	*North Otago*	1969-72
Geddes J.H.*	*Southland*	1931
George V.L.*	*Southland*	1933,35, 38,39
Gerard G.V.	*Sth Canterbury*	1925
Gibbons S.A.	*Canterbury*	1979,80
	Otago	1981
Gibson R.	*Canterbury*	1978
Gibson W.	*Otago*	1934
Gilbert G.D.M.*	*West Coast*	1936
Gilbert J.	*Buller*	1974
Gillan J.E.	*West Coast*	1950,51
Gillespie W.D.*	*Otago*	1956,58,59
Gillett G.A.*	*Canterbury*	1905
Gillies C.C.*	*Otago*	1936
Gilmour E.M.	*Southland*	1924
Gilray C.M.*	*Otago*	1904
Gilson R.W.	*Southland*	1955
Gimblett K.J.	*Canterbury*	1970
Given F.J.*	*Otago*	1903
Glennie E.*	*Canterbury*	1897
Goddard A.M.	*Sth Canterbury*	1976
Goddard J.W.*	*Sth Canterbury*	1948
Goddard M.P.*	*Sth Canterbury*	1946-48

Goodall G.V.	*Buller*	1922
Gordon A.H.	*Mid Canterbury*	1985
Gordon G.D.	*Otago*	1944
Gorton E.A.	*Southland*	1961
Grace M.P.	*Southland*	1939,45
Graham D.J.*	*Canterbury*	1958, 61-65
Graham J.B.*	*Otago*	1910,14
Graham W.G.*	*Otago*	1978,79
Granger J.H.	*North Otago*	1933
Grant L.A.*	*Sth Canterbury*	1947,48R, 51
Grant P.J.	*Sth Canterbury*	1980, 82-84
Gray G.D.*	*Canterbury*	1908-13
Green C.H.	*Buller*	1910,11
Green C.I.*	*Canterbury*	1983-85
Green F.J.	*Otago*	1935,36
Greenslade J.W.	*Mid Canterbury*	1968
Gugich F.W.	*West Coast*	1954
Guthrie D.C.	*Canterbury*	1911
Haig J.S.*	*Otago*	1946
Haig L.S.*	*Otago*	1950,51,53
Hales D.A.*	*Canterbury*	1971,72
Hall, A.C.	*West Coast*	1920
Halligan D.M.	*Otago*	1981
Hamilton D.C.*	*Southland*	1908
Hamilton D.H.	*Otago*	1947
Hanham M.J.	*Mid Canterbury*	1970
Hardie C.L.	*Canterbury*	1949R,50
Harley J.H.	*Sth Canterbury*	1913
Harper E.T.*	*Canterbury*	1902,05
Harris J.H.*	*Canterbury*	1925,29
Harris W.A.*	*Otago*	1897
Hart G.F.*	*Canterbury*	1931-34, 36
Harty H.R.	*Otago*	1920
Harvey A.R.	*Canterbury*	1978
Harvey L.R.*	*Otago*	1948
Harvey P.*	*Canterbury*	1902,03
Hasell E.W.*	*Canterbury*	1911,20
Hatchwell P.K.	*Canterbury*	1968
Hattersley J.O.	*Canterbury*	1936,37
Hay, D.M.	*Canterbury*	1928
Hayes D.B.	*Canterbury*	1983
Hazlett E.J.*	*Southland*	1964-67
Hazlett W.E.*	*Southland*	1926,27,29
Heazlewood L.K.	*Otago*	1927R
Hegglun T.F.	*Marlborough*	1946
Henderson P.W.*	*Southland*	1995
Henderson S.K.	*Canterbury*	1959
Henry A.H.	*Marlborough*	1919
Herman D.H.	*Canterbury*	1943,44, 46,48
Herron D.B.	*Southland*	1939
Hewitt L.W.	*Canterbury*	1944,45R
Higginson G.*	*Canterbury*	1978,80,81
Hiini C.W.	*Southland*	1980
Hill S.F.*	*Canterbury*	1954, 56-60
Hobbs F.G.*	*Canterbury*	1946,47
Hobbs M.J.B.*	*Canterbury*	1984,85
Holden A.W.*	*Otago*	1928
	Southland	1929
Holder E.C.*	*Buller*	1932,33R
Hollander A.R.	*Otago*	1981
Hooper G.J.	*Canterbury*	1982
Hooper J.A.*	*Canterbury*	1937
Hopkinson A.E.*	*Canterbury*	1966-69
Hore J.*	*Otago*	1927,31-34
Horgan D.	*Sth Canterbury*	1903,05
Hoskin R.D.	*Canterbury*	1960,61
Hotop J.*	*Canterbury*	1952,60
Howden J.*	*Southland*	1928
Hughes E.*	*Southland*	1907
Hurst I.A.*	*Canterbury*	1973,74
Irvine J.G.*	*Otago*	1914
Irving E.G.	*West Coast*	1911

Irwin M.W.*	*Otago*	1954-56,58,59
Ivimey F.E.B.*	*Otago*	1908
Jackson J.B.	*Canterbury*	1928
Jaffray J.L.*	*Otago*	1975,77,78
Jaffray M.W.R.*	*Otago*	1975-77
Jeffs S.A.	*Otago*	1921
Jenkins I.	*Southland*	1903
Johnston W.*	*Otago*	1905,07
Johnstone A.R.	*Canterbury*	1897
Johnstone P.*	*Otago*	1948,51
Joseph J.W.*	*Otago*	1995
Julian T.A.	*Nelson Bays*	1970
Keane K.J.*	*Canterbury*	1979
Kearney J.C.*	*Otago*	1947,48
Kearney P.V.	*Canterbury*	1949
Keeble R.A.	*Nelson*	1943
Kelly G.N.	*Canterbury*	1995
Kelly J.W.*	*Canterbury*	1947
Kennedy D.P.	*Sth Canterbury*	1962,63
Kerr J.E.B.	*Canterbury*	1943
Kilby F.D.*	*Southland*	1926
King G.	*Sth Canterbury*	1935
King J.D.	*Otago*	1904
King P.W.	*Canterbury*	1945
King R.R.*	*West Coast*	1934,36-39
Kirk D.E.*	*Otago*	1982-84
Kirkpatrick I.A.*	*Canterbury*	1968,69
Kirton E.W.*	*Otago*	1963,65, 68,69
Knight R.J.	*Otago*	1986
Knox O.	*Otago*	1925
Knox W.	*Otago*	1923
Kreft A.J.*	*Otago*	1968,70
Laidlaw C.R.*	*Otago*	1962,66
	Canterbury	1968
Laidlaw K.F.*	*Southland*	1959
Laidlaw P.A.	*Southland*	1985
Langford T.H.	*Sth Canterbury*	1914
Lavery J.	*Canterbury*	1903
Learmont T.	*West Coast*	1904,05
Le Lievre J.M.*	*Canterbury*	1960-65
Leota J.N.	*Canterbury*	1986
Leslie J.A.	*Otago*	1995
Levien H.J.*	*Otago*	1957
Lewis A.J.	*Otago*	1984
Lilburne H.T.*	*Canterbury*	1927,29
Lindbom A.J.	*West Coast*	1952
Lindsay J.C.	*Southland*	1966
Lindsay W.G.*	*Southland*	1914
Lister T.N.*	*Sth Canterbury*	1968,69, 71,74
Lockwood R.J.	*Canterbury*	1972
Loe R.W.*	*Canterbury*	1995
Loe S.J.	*Canterbury*	1995R
Love J.H.M.	*Marlborough*	1980,82, 83,84
Lucy W.E.	*Otago*	1932
Ludbrook D.W.	*Otago*	1954
Lynch T.W.*	*Sth Canterbury*	1911-14
Lynch T.W.*	*Canterbury*	1950,51R
McAra T.N.	*West Coast*	1962
McAtamney F.S.*	*Otago*	1956
McAuliffe J.J.	*Canterbury*	1937
McCall C.B.	*Southland*	1985
McCarthy P.*	*Canterbury*	1923
McCaw W.A.*	*Southland*	1950-54
McCleary B.V.*	*Canterbury*	1923,24
McClymont W.G*	*Otago*	1928,29
McCormick A.G.*	*Canterbury*	1925
McCormick D.	*Canterbury*	1919,21
McCormick W.F.*	*Canterbury*	1960-69
McDonald A.*	*Otago*	1904-07,13
McDonald A.	*Canterbury*	1912

McDonald C.A. *Canterbury* 1958
McDonald G.R. *Otago* 1934,39
Macdonald H.H.* *Canterbury* 1971-74
MacDonald J.H. *Marlborough* 1911,12
MacDonald J.H. *Marlborough* 1929
MacDonald M.S. *Marlborough* 1938
McFarland W.J.B. *Otago* 1935
MacFie P.A. *Canterbury* 1978
McGee G.W. *Otago* 1970,71
McGregor A.A.* *Southland* 1978
McGregor D.* *Canterbury* 1902,03,06
McGregor N.P.* *Canterbury* 1924-27
McGuffog J.H. *Canterbury* 1912
McHugh W.P. *West Coast* 1944
McIntosh R.B. *Otago* 1944
McIntosh T. *West Coast* 1913
McKechnie B.J.* *Southland* 1979,80
McKenzie A.D. *Canterbury* 1943-45
McKenzie B.T. *Southland* 1986
McKenzie J.T. *Southland* 1949
McLaren D. *Otago* 1897
McLean C.* *Buller* 1920,21
McLellan A. *Canterbury* 1970
McLennan T. *Otago* 1983
McLeod M.A. *Mid Canterbury* 1986
McMeeking D.T.M.* *Otago* 1923
McNab J.R.* *Otago* 1974R,48, 52
McNeece J.* *Southland* 1913,14
McNeight W.J. *Buller* 1931,32R
McNie A. *Southland* 1902,03,05
McPhail B.E.* *Canterbury* 1958,59
 Nelson 1960,61
McPhail C.H. *Canterbury* 1935R,36R
McPherson A.W.C. *Canterbury* 1954
Macpherson G.* *Otago* 1985
McRae J.A.* *Southland* 1945-47
McRae J.K. *Southland* 1968
Mackareth J.G. *Otago* 1919,23
Mahoney J. *Canterbury* 1908
Mains L.W.* *Otago* 1970,71,75
Manchester J.E.* *Canterbury* 1931-33
Mann W. *West Coast* 1935,36
Marfell S.W.P. *Marlborough* 1976,79
Marslin A.E. *Otago* 1927,28
Mason G.D. *Buller* 1938
Masters R.R.* *Canterbury* 1924,25
Mather I.G. *Canterbury* 1980
Matheson A.E. *Canterbury* 1971
Matheson J.D.* *Otago* 1972
Mathieson R.G.* *Otago* 1922
Matson J.T.F.* *Canterbury* 1995
Max D.J. *Nelson* 1949
Max D.S.* *Nelson* 1931-33
Max G.S. *Nelson* 1944
Maxwell W.E.J. *Canterbury* 1912
Meates K.F.* *Canterbury* 1952
Meates W.A.* *Otago* 1948,50
Meikle M.C. *Canterbury* 1964
Metcalfe T.C.* *Southland* 1931-34
Miles A.C. *Southland* 1909
Millar J.T. *Southland* 1950,51
Miller I.M. *Southland* 1960,61
Milliken H.M.* *Canterbury* 1936-38
Mills C. *Southland* 1926
Milne R.G. *Otago* 1983
Mitchell M.A. *Southland* 1976R
Mitchell N.A.* *Southland* 1934,37
 Otago 1938
Mitchell T.W.* *Canterbury* 1974
Molloy B.P.J.* *Canterbury* 1957,58
Molloy P. *Canterbury* 1980
Moore G.J.T.* *Otago* 1949
Moore N.S. *Otago* 1995
Moreton R.C.* *Canterbury* 1962,64
Morris T.J. *Nelson Bays* 1972
Morrison H. *Otago* 1965
Morrison T.C.* *Sth Canterbury* 1935,37-39

Morrison T.G.* *Otago* 1973
Morrissey P.J.* *Canterbury* 1962
 Otago 1963
Mortlock K.S. *Canterbury* 1934
Mosely S. *North Otago* 1950
Mowat A.L. *Marlborough* 1967,68
Mumm W.J.* *Buller* 1945-47,49
Munro H.G.* *Otago* 1924
Murcott W.D. *Southland* 1980
Murdoch D.H. *Otago* 1943
Murdoch K.* *Otago* 1969,71
Murray H.V.* *Canterbury* 1910,11, 13,14

Nelson K.A.* *Otago* 1962,63
Newton F.* *Canterbury* 1905
Nichol D.A. *Sth Canterbury* 1974
Niven L.J. *Otago* 1935
Nolan G.T. *Canterbury* 1934
Nolan J.G. *Buller* 1912
Norton R.W.* *Canterbury* 1971-75
Nuttall I.A. *North Otago* 1951,52

O'Brien J. *Marlborough* 1909
O'Callaghan T.R.* *Canterbury* 1944
O'Connor K.J. *Otago* 1947
O'Gorman P.T. *Canterbury* 1986
O'Leary J. *Sth Canterbury* 1906
O'Leary L. *Sth Canterbury* 1920
Oliver A.D.* *Otago* 1995
Oliver C.J.* *Canterbury* 1926,28, 31-34
Oliver D.J.* *Otago* 1929
Oliver F.J.* *Southland* 1972,74, 75,77
 Otago 1979
Oliver D.O.* *Otago* 1953
Oliver P.T. *Otago* 1976R
Ongley P.A. *Otago* 1912
Orchard S.A.* *Canterbury* 1897
Orman G.A. *Buller* 1935-37
Orr R.W.* *Otago* 1949

Paewai M.N. *Otago* 1943
Page M.L.* *Canterbury* 1923
Palmer I.D. *Sth Canterbury* 1977
Parker J.H.* *Canterbury* 1924
Parkhill A.A.* *Otago* 1935,37-39
Parkin B.J. *Mid Canterbury* 1980
Parsons D.J. *Sth Canterbury* 1947
Paterson A.M.* *Otago* 1908-11
Paton H.* *Otago* 1906-10
Pauling K. *Canterbury* 1986
Peacocke P.A. *Canterbury* 1972
Pearce C.J. *Canterbury* 1906
Pegley J.F. *West Coast* 1945
Pene A.R.B.* *Otago* 1995R
Perriam W.I. *Otago* 1939
Perry A.* *Otago* 1924
Perry R.G.* *Mid Canterbury* 1981-84
Pescini D.A. *Otago* 1970
Petersen L.C.* *Canterbury* 1919,21-23
Peterson E.J. *Otago* 1944
Phillips H. *Marlborough* 1921
Pickrang N.A.M. *Otago* 1973
Pohlen G.J. *Otago* 1966
Pokere S.T.* *Southland* 1977,81-83
Polson J.G. *Canterbury* 1935
Porteous H.G.* *Otago* 1902,03
Prain H.C. *Otago* 1958
Priest P.J. *Otago* 1897
Prior I.A.M. *Otago* 1943
Procter A.C.* *Otago* 1932
Purdue G.B.* *Southland* 1931-33
Purvis N.A.* *Otago* 1975,78
Pyle W.R. *Otago* 1914

Quaid C.E.* *Otago* 1935-38

Rankin J.G.* *Canterbury* 1935-37
Reed W.A. *Nelson* 1925
Reeves D.E.A. *Canterbury* 1949
Reid A. *Southland* 1905
Rhind P.K.* *Canterbury* 1946
Rhodes W. *Buller* 1897
Richards J. *West Coast* 1912
Richardson J.* *Otago* 1921,22
 Southland 1924,25
Ridland A.J.* *Southland* 1909,10,13
Roach J.R. *Canterbury* 1946
Roberts F.* *Wellington* 1902R

Replaced an injured South Island player, P. Harvey, during the match

Roberts N.S. *Canterbury* 1955
Roberts R.I. *West Coast* 1938
 Canterbury 1939R
Robertson D.J.* *Otago* 1975
Robilliard A.C.C.* *Canterbury* 1924-27
Robinson C.E.* *Southland* 1952,53
Robinson J.T.* *Canterbury* 1928
Roddick J. *Otago* 1902
Rodgers R.A. *Sth Canterbury* 1909
Ross J.C.* *Mid Canterbury* 1981,82
Rothwell R.R. *Canterbury* 1944
Roulston M.B. *Mid Canterbury* 1982-84
Russell J. *West Coast* 1921
Rutledge L.M.* *Southland* 1976,78-80,82
Ryan M. *Nelson* 1909R

Sampson B.V. *Mid Canterbury* 1969
Sandman D.M. *Canterbury* 1920
Sapsford H.P.* *Otago* 1974R,76
Savage L.T.* *Canterbury* 1948,50
Saxton C.K.* *Sth Canterbury* 1938
 Southland 1939
Scandrett R.B. *West Coast* 1933
Scherp L.A. *Otago* 1964
Scott D.C. *Sth Canterbury* 1914
Scott G. *Otago* 1910,11,13
Scott H.A. *Sth Canterbury* 1919 21
Scott J. *Sth Canterbury* 1903
Scott S.J.* *Canterbury* 1981
Scott W. *Sth Canterbury* 1908
Scrimshaw G.* *Canterbury* 1927 29
Seear G.A.* *Otago* 1973-75, 77,79,81
Shaw J.B. *Buller* 1955,57, 62,63
Sherriff W.G. *Southland* 1939
Simon H.J.* *Otago* 1932,34,36
Simpson V.L.J.* *Canterbury* 1981,82,84
Sims G.S.* *Otago* 1972
Sinclair R.G.B.* *Otago* 1923
Skinner K.L.* *Otago* 1948,50-53
Smallholme O. *Buller* 1944
Smeaton A.T. *Southland* 1943
Smeaton D. *Southland* 1951,52
Smith A.W. *Southland* 1913
Smith C.H.* *Otago* 1933,34R
Smith H.L.M. *Otago* 1954
Smith I.D. *Otago* 1961
Smith I.S.T.* *Otago* 1963,64
 North Otago 1965,66
Smith L.R. *Otago* 1986
Smith R.M.* *Canterbury* 1955,56
Smith W. *Otago* 1897
Smith W.E.* *Nelson* 1902
Smith W.R.* *Canterbury* 1981,85
Smyth B.F.* *Canterbury* 1922
Snodgrass W.F.* *Nelson* 1923,27,28
Snow E.M.* *Nelson* 1923,27,29
Sonntag W.T.C.* *Otago* 1926,29
Soper A.J.* *Southland* 1956,57,59
Sotheran W. *West Coast* 1909

Spencer G.G.	*Southland*	1959,66
Spiers B.	*Otago*	1904,06
Stack B.J.	*Buller*	1966,67
Stead J.W.*	*Southland*	1903,05
Steel A.G.*	*Canterbury*	1967
Steel J.*	*West Coast*	1919-25
Stevens J.J.	*Canterbury*	1906
Stevenson D.R.L.*	*Otago*	1926,28
Stewart A.J.*	*Canterbury*	1962-64
Stewart C.	*Otago*	1904
Stewart D.M.	*Sth Canterbury*	1926
Stewart K.W.*	*Southland*	1973,74, 79,81
Stewart R.J.	*Otago*	1897
Stewart R.T.*	*Sth Canterbury*	1922R-27,29
Stewart V.E.*	*Canterbury*	1976 78
St George J.C.	*Otago*	1924
Storey P.W.*	*Sth Canterbury*	1920
Strang J.T.	*Sth Canterbury*	1935R
Strang W.A.*	*Sth Canterbury*	1927,29,31
Stuart D.M.	*Otago*	1904
Stuart G.	*Buller*	1923
Stuart K.C.*	*Canterbury*	1952-56
Stuart R.C.*	*Canterbury*	1948R,49
Stuck J.R.	*Southland*	1949
Surgenor M.J.	*Marlborough*	1960R
Sutherland A.G.	*Southland*	1939 45-47
Sutherland A.R.*	*Marlborough*	1967,68, 72,73,75
Svenson K.S.*	*Buller*	1922
Sykes V.C.	*Canterbury*	1958
Tanner J.M.*	*Otago*	1947
Tanner K.J.*	*Canterbury*	1974
Taylor C.G.	*Canterbury*	1943
Taylor H.M.*	*Canterbury*	1913,14
Taylor J.L.	*Sth Canterbury*	1949
Taylor J.M.*	*Otago*	1937,38
Taylor W.H.	*Golden Bay-Motueka*	1949R

Taylor W.T.*	*Canterbury*	1984,85
Thompson A.	*Canterbury*	1920,21R
Thompson B.A.*	*Canterbury*	1979
Thomson H.D.*	*Canterbury*	1903
Thorpe A.J.	*Canterbury*	1984
Timmins B.P.	*Otago*	1995
Tinker W.	*Southland*	1979
Townsend G.A.	*Southland*	1962
Townsend L.J.*	*Otago*	1954-56R
Townsend W.W.	*Otago*	1967,69
Tremain K.R.*	*Canterbury*	1959,61
Trevathan D.*	*Otago*	1935,37
Turpin O.W.	*Canterbury*	1922,24
Turtill H.S.*	*Canterbury*	1903,07
Tyne E.	*Canterbury*	1906
Valentine J.J.	*Otago*	1919
Vincent P.B.*	*Canterbury*	1953,56
Vorrath F.H.*	*Otago*	1934
Wade F.C.	*West Coast*	1907
Walker E.G.	*West Coast*	1948R,53
Wall G.	*Sth Canterbury*	1910
Ward E.P.*	*Canterbury*	1926
Ward R.H.*	*Southland*	1936,37,39
Watson H.	*Canterbury*	1914R
Watt B.A.*	*Canterbury*	1960,61, 64-67
Watt J.R.*	*Otago*	1956
	Southland	1957
Wesney A.W.*	*Southland*	1938,39
Weston J.	*Canterbury*	1909
Whineray W.J.*	*Canterbury*	1957
White A.*	*Southland*	1921,22,24
Whitta M.F.	*Canterbury*	1959-61
Williams A.L.*	*Otago*	1922-24R
Williams C.W.*	*Canterbury*	1938,39
Williams P.*	*Otago*	1912-14
Willocks C.*	*Otago*	1945-48
Wilson A.L.*	*Southland*	1956
Wilson B.W.*	*Otago*	1977,79
Wilson C.A.	*Canterbury*	1943

Wilson D.D.*	*Canterbury*	1953,54
Wilson J.W.*	*Otago*	1995
Wilson H.W.*	*Otago*	1949-51
Wilson N.L.*	*Otago*	1948,50-52
Wilson R.G.*	*Canterbury*	1976,80
Wood M.E.*	*Canterbury*	1902,03
Wood T.	*Otago*	1897
Woods C.A.*	*Southland*	1953,54
Woods D.J.	*Southland*	1986
Woolhouse R.J.	*Canterbury*	1970
Woolley S.W.	*Marlborough*	1949
Wyllie A.J.*	*Canterbury*	1966-69, 71-73,76
Young D.*	*Canterbury*	1951R,55-59,61-63

ZONAL SERIES

The zonal series for the George Nepia Memorial Trophy was designed to replace the interisland match and more accurately reflect the strengths of New Zealand rugby. It was short-lived, however, and was played for only three seasons.

Zonal matches with venues

1987	North 40 South 19	Ashburton
	Central 21 South 21	New Plymouth
	North 29 Central 6	Pukekohe
	North won series	
1988	North 68 Central 6	Rotorua
	South 27 Central 10	Masterton
	North 28 South 21	Timaru
	North won series	
1989	Central 30 South 17	Dunedin
	North 45 Central 11	Wanganui
	North 25 South 19	Takapuna
	North won series	

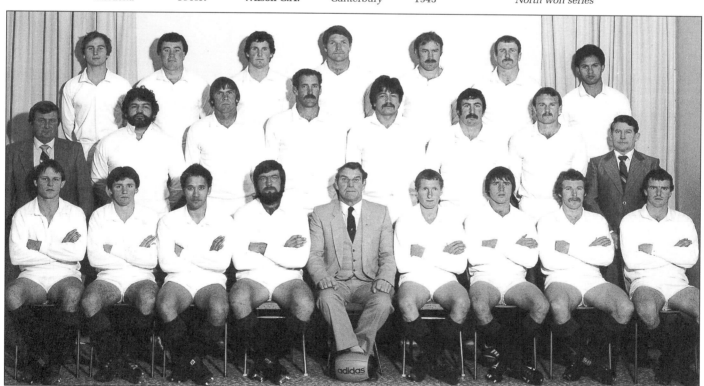

The 1982 South Island team
Back row: Paul Morris, Leicester Rutledge, Robbie Deans, Murray Davie, Don Hayes, Lex Chisholm, Victor Simpson.
Second row: Neville Goodwin (selector), Bill Bush, Peter Grant, Jock Ross, Jim Love, John Ashworth, Will Dempster, Alastair Tait (selector/convenor).
Front row: David Halligan, David Kirk, Steven Pokere, Grant Perry (captain), Ray Harper (manager), Murray Roulston, Geoff Frew, Garry Hooper, Ralph Milne.

NORTH ZONE REPRESENTATIVES

Boroevich K.G.	*North Harbour*	1988
Botica F.M.	*North Harbour*	1987
Brooke M.V.	*Auckland*	1989
Brooke Z.V.	*Auckland*	1988,89
Brooke-		
Cowden M.	*Auckland*	1987
Cole P.R.	*Counties*	1989
Cooper G.J.L.	*Auckland*	1987
Dalton A.G.	*Counties*	1987
Drake J.A.	*Auckland*	1987
Fitzpatrick S.B.T.	*Auckland*	1988
Fox G.J.	*Auckland*	1987,88,89
Gatland W.D.	*Waikato*	1989
Gordon S.B.	*Waikato*	1988
Gordon W.R.	*Waikato*	1988
Jerram R.M.	*Waikato*	1989
Jones I.D.	*North Auckland*	1989
Jones M.N.	*Auckland*	1987,88,89
Kirk D.E.	*Auckland*	1987
Kirwan J.J.	*Auckland*	1987,88
Little W.K.	*North Harbour*	1989
Loe R.W.	*Waikato*	1987,88,89
McCahill B.J.	*Auckland*	1987,88,89
McDowell S.C.	*Auckland*	1987,88
	Bay of Plenty	1989
Morton B.D.	*Auckland*	1989
Putt K.B.	*Waikato*	1988,89
Raki L.E.	*Counties*	1988
Shelford W.T.	*North Harbour*	1987,88,89
Simonsson P.L.J.	*Waikato*	1989
Speight M.W.	*North Auckland*	1987
Stanley J.T.	*Auckland*	1987
Stone A.M.	*Bay of Plenty*	1987
Whetton A.J.	*Auckland*	1987,88
Whetton G.W.	*Auckland*	1987,88
Williams R.O.	*North Harbour*	1989
Wood I.D.	*North Harbour*	1988,89
Wright T.J.	*Auckland*	1987,88,89

CENTRAL ZONE REPRESENTATIVES

Anderson B.L.	*Wairarapa-Bush*	1987,88
Boroevich K.G.	*Wellington*	1987
Bunn L.A.	*Taranaki*	1987
Bunn W.G.	*Taranaki*	1988
Cheval R.E.	*Wellington*	1988,89
Clamp M.	*Wellington*	1987
Cooke P.J.	*Hawke's Bay*	1987
Cooper M.J.A.	*Hawke's Bay*	1988,89
Crowley A.E.	*Taranaki*	1987
Crowley K.J.	*Taranaki*	1987,88
Donald A.J.	*Wanganui*	1987
Fraser D.G.	*Wellington*	1988
Gallagher J.A.	*Wellington*	1987,88
Geany N.P.	*Wellington*	1989
Gordon H.S.	*Wanganui*	1989
Hainsworth J.D.	*Wanganui*	1989
Hansen A.B.	*Poverty Bay*	1989
Hansen B.W.	*Wanganui*	1989
Harvey B.A.	*Wairarapa-Bush*	1987
Hemara B.S.	*Manawatu*	1987
Hewett J.A.	*Manawatu*	1989
Hullena L.C.	*Wellington*	1988,89
Jerram R.M.	*Manawatu*	1987
Kendrick M.P.	*Manawatu*	1988
Koloto E.T.	*Manawatu*	1987
	Wellington	1988
Laursen D.C.	*Horowhenua*	1988
Leiasamaivao T.	*Wanganui*	1989
McGrattan B.	*Wellington*	1987
McKenzie A.G.	*Manawatu*	1989
McLean R.J.	*Wairarapa-Bush*	1988,89
McMaster A.	*Manawatu*	1987,88
Muir V.G.	*Wellington*	1989
O'Shaughnessy		
P.G.	*Wellington*	1989
Pierce M.J.	*Wellington*	1988,89
Pokere S.T.	*Wellington*	1987
Renton P.J.	*Hawke's Bay*	1988,89
Schuler K.J.	*Manawatu*	1988,89
Schuster N.J.	*Wellington*	1987,88,89
Shaw M.W.	*Hawke's Bay*	1987
Sorenson N.A.	*Wellington*	1988
Styles B.E.	*Wairarapa-Bush*	1988, 89
Thorpe A.J.	*Poverty Bay*	1989
Williams D.A.	*Wellington*	1987, 88

SOUTH ZONE REPRESENTATIVES

Anderson A.	*Canterbury*	1987,88,89
Bachop G.T.M.	*Canterbury*	1988,89
Bachop S.J.	*Canterbury*	1987,88,89
Bale P.	*Canterbury*	1989
Brewer M.R.	*Otago*	1987,88
Buchan J.A.S.	*Canterbury*	1987,88,89
Cooper G.J.L.	*Otago*	1988,89
Cottrell S.R.	*Otago*	1989
Deans I.B.	*Canterbury*	1987,88,89
Deans R.M.	*Canterbury*	1987
Earl A.T.	*Canterbury*	1987,89
Earl C.C.	*Canterbury*	1987,88
Ellison D.R.	*Otago*	1988,89
Green C.I.	*Canterbury*	1987
Henderson P.W.	*Otago*	1987,89
Hotton S.E.	*Otago*	1987,88
Jackson J.F.	*Canterbury*	1989
Kenworthy M.E.	*Otago*	1989
Knight R.J.	*Otago*	1987
Latta D.E.	*Otago*	1988
Leota J.N.	*Canterbury*	1987
McCormick A.F.	*Canterbury*	1988
McDonald L.	*Mid Canterbury*	1989
Macpherson G.	*Otago*	1988,89
Maunsell W.K.	*Canterbury*	1989
Mickell G.R.	*Canterbury*	1987
Morgan D.J.	*Otago*	1989
Pilcher N.K.C.	*Otago*	1988
Pope B.M.	*Otago*	1987,88,89
Seymour D.J.	*Canterbury*	1988,89
Simpson V.L.J.	*Canterbury*	1987
Sio T.G.	*Canterbury*	1989
Stark I.D.	*Marlborough*	1989
Taylor W.T.	*Canterbury*	1987,88
Timu J.K.R.	*Otago*	1988,89

Maori Rugby

As the rugby game spread throughout New Zealand in the 1870s, it attracted large numbers of adherents among Maori. The nature of the game appealed to them and they played it with a flair and unorthodoxy which has marked their approach to rugby ever since. Some Maori formed their own clubs but mostly they mixed with white players.

Although a New Zealand Maoris team was not given official status until 1910, we feel that a chapter on Maori rugby would be incomplete without mention of the so called 'Native Team' of 1888-89. Twenty-five players embarked upon a year-long tour privately promoted by Thomas Eyton and organised, selected and captained by the famous Maori player Joe Warbrick.

1888-89 NEW ZEALAND NATIVE TEAM

Backs: W. Elliot *Grafton*; D.R. Gage *Poneke*; C. Goldsmith *Te Aute College*; E. Ihimaira *Te Aute College*; P. Keogh *Kaikorai*; H.H. Lee *Riverton*; C. Madigan *Grafton*; E. McCausland *Gordon*; F. Warbrick *Tauranga*; J.A. Warbrick *Hawke's Bay*; W. Warbrick *Matata*; H.J. Wynyard *North Shore*; W.T. Wynyard *North Shore*
Forwards: W. Anderson *Hokianga*; T.R. Ellison *Poneke*; W. Karauria *Nelson*; R. Maynard *North Shore*; W. Nehua *Te Aute College*; T. Rene *Nelson*; D. Stewart *Thames*; R.G. Taiaroa *Dunedin*; Alfred Warbrick *Matata*; Arthur Warbrick *Matata*; A. Webster *Hokianga*; G.A. Williams *Poneke*; G. Wynyard *North Shore*
Captain: J.A. Warbrick
Manager: J.R. Scott

The original intention was to select a team of Maori or part-Maori footballers but four white players — Elliot, Keogh, Williams and Madigan — were included to strengthen the touring party. It is popularly believed that these four Europeans were New Zealand-born and that the team was in that sense truly 'native', but our research has revealed that 'Paddy' Keogh and George Williams were born in England although both came to New Zealand at an early age.

Joe Warbrick had toured New South Wales with the New Zealand team of 1884. Gage, W.J. Wynyard and Ellison were to become members of the 1893 New Zealand side, which Ellison captained, while Gage led New Zealand against Queensland in 1896.

The Native team played the colossal total of 107 games during a tour which lasted from June 1888 to August 1889; 74 matches were played in the British Isles, 16 in Australia and 17 in New Zealand. Many were played with two or three days between and in the period 20 November to 1 December, seven fixtures were squeezed in with three on consecutive days.

The tour included games against international teams in Britain and state sides in Australia. These are detailed below:

v Ireland *at Dublin*		won	13-4
v Wales *at Swansea*		lost	0-5
v England *at Blackheath*		lost	0-7
v New South Wales *at Sydney*		won	12-9
v New South Wales *at Sydney*		won	16-12
v Queensland *at Brisbane*		won	22-0
v Queensland *at Brisbane*		won	11-7

Summary:
Played 107, won 78, lost 23, drew 6
Points for 772, against 305

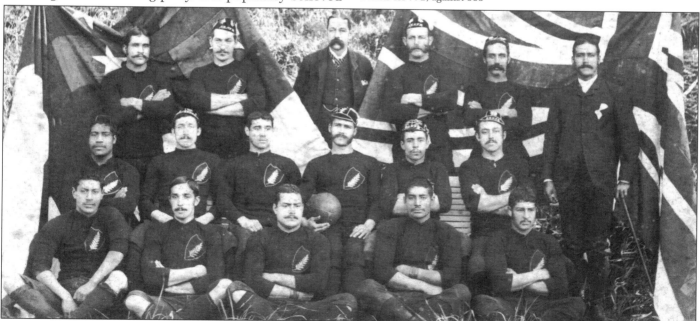

Members of the 1888-89 New Zealand Native team pose prior to a match in Queensland on their way home from Great Britain
Back row: Arthur Warbrick, A. Webster, J.R. Scott (manager), G.A. Williams W. Warbrick, Alfred Warbrick.
Second row: E. Ihimaira, W.T. Wynyard, D.R. Gage, J.A. Warbrick (captain), F. Warbrick, G. Wynyard.
Front row: R.G. Taiaroa, T.R. Ellison, R. Maynard, W. Karauria, C. Goldsmith.

In an unofficial game against the 1904 British team, a Maori XV beat the tourists 8-6 at Pukeroa, near Rotorua. Another unofficial encounter was planned against the 1908 Anglo-Welsh team but, because a national Maori team could not be assembled, an Arawa XV took the field and were defeated 24-3.

The first official New Zealand Maori team was selected in 1910, beginning a tour of New Zealand in May, visiting Australia during June and July, and playing a further five matches on its return to New

Zealand. While in Australia the Maoris played and won two games against the American Universities team which was also on an Australian tour.

TOM FRENCH CUP

Named for the coach of the New Zealand Maoris team in Australia in 1949, T.A. French, the cup is awarded annually by the New Zealand selectors to whom they consider the outstanding Maori player of the year.

WINNERS OF THE TOM FRENCH CUP

Year	Player	Province
1949	J.B. Smith	*North Auckland*
1950	M.N. Paewai	*North Auckland*
1951	C.P. Erceg	*Auckland*
1952	K. Davis	*Auckland*
1953	K. Davis	*Auckland*
1954	K. Davis	*Auckland*
1955	P.T. Walsh	*South Auckland Counties*
1956	W.N. Gray	*Bay of Plenty*
1957	M. Walters	*North Auckland*
1958	P.T. Walsh	*Counties*
1959	W.R. Wordley	*King Country*
1960	M.A Herewini	*Auckland*
1961	V.M. Yates	*North Auckland*
1962	W.J. Nathan	*Auckland*
1963	M.A. Herewini	Auckland
1964	R.E. Rangi	*Auckland*
1965	R.E. Rangi	*Auckland*
1966	W.J. Nathan	*Auckland*
1967	S.M. Going	*North Auckland*
1968	S.M. Going	*North Auckland*
1969	S.M. Going	*North Auckland*
1970	S.M. Going	*North Auckland*
1971	S.M. Going	*North Auckland*
1972	S.M. Going	*North Auckland*
1973	R.W. Norton	*Canterbury*
1974	R.W. Norton	*Canterbury*
1975	W.K. te P. Bush	*Canterbury*
1976	K.K. Lambert	*Manawatu*
1977	W.M. Osborne	*Wanganui*
1978	E.J. Dunn	*North Auckland*
1979	V.E. Stewart	*Canterbury*
1980	H.R. Reid	*Bay of Plenty*
1981	F.N.K. Shelford	*Bay of Plenty*
1982	S.T. Pokere	*Southland*
1983	H.R. Reid	*Bay of Plenty*
1984	M. Clamp	*Wellington*
1985	W.T. Shelford	*North Harbour*
1986	F.M. Botica	*North Harbour*
1987	W.T. Shelford	*North Harbour*
1988	W.T. Shelford	*North Harbour*
1989	W.T. Shelford	*North Harbour*
1990	S.C. McDowell	*Auckland*
1991	J.K.R. Timu	*Otago*
1992	Z.V. Brooke	*Auckland*
1993	A.R.B. Pene	*Otago*
1994	Z.V. Brooke	*Auckland*
1995	R.M. Brooke	*Auckland*
1996	E.F. Brain	*Counties-Manukau*
1997	M.A. Mayerhofler	*Canterbury*

Multiple winners:
6 Going
4 W.T. Shelford
3 Davis
2 Z.V. Brooke, Herewini, Nathan, Norton, Rangi, Reid, Walsh.

Provinces of winners:
14 Auckland
11 North Auckland
5 Canterbury, North Harbour
4 Bay of Plenty
3 Counties-Manukau (Counties, South Auckland)
2 Otago

PRINCE OF WALES CUP

Prince Edward, the Prince of Wales (later King Edward VIII and the Duke of Windsor) presented the trophy in 1928 for competition among Maori teams. A contest was devised in which New Zealand was divided into four districts, the composition of which varied from time to time. They were designated Tai Tokerau, Tai Rawhiti, Tai Hauauru and Te Waipounamu. A Maori competition already existed in 1928, for the Te Mori Rosebowl, which had been presented by Mrs M.A. Perry of Hawke's Bay in 1923 for matches between North and South.

From 1928, the winner of the Prince of Wales Cup also received the Rosebowl. The Jack Ruru Memorial Cup was added to the Maori trophies in 1935 in memory of Ruru, of Hawke's Bay and Wellington, who

died in 1934 after being injured in the Prince of Wales Cup match.

The four-district scheme was replaced in 1963 by a Northern-Southern contest, the Northern chosen from North Auckland, Auckland, Counties, Waikato, Thames Valley and Bay of Plenty.

Another change was made in 1995 with the introduction of a third zone, Central, and the Prince of Wales Cup was replaced by the George Nepia Memorial Trophy, which had been designed for the interzonal series of 1987-89.

That lasted two seasons and in 1997 the regions were replaced by trial teams known as Team Ikaroa and Team Mangaroa. Ikaroa is Maori for the milky way, said to reflect players who stand out as a group, and Mangaroa translates into English as the universe, therefore reflecting players from all levels of the game.

PRINCE OF WALES CUP MATCHES WITH VENUES

Year	Result	Venue
1928	Tai Tokerau 15	
	Tai Rawhiti 8	Gisborne
1929	Tai Hauauru 12	
	Tai Tokerau 6	Auckland
	Tai Hauauru 24	
	Tai Rawhiti 11	Wellington
1930	Te Waipounamu 19	
	Tai Hauauru 3	Christchurch
1931	Te Waipounamu 10	
	Tai Rawhiti 9	Christchurch
1932	Tai Hauauru 35	
	Te Waipounamu 8	Palmerston North
1933	Tai Hauauru 19	
	Tai Tokerau 14	New Plymouth
1934	Tai Rawhiti 16	
	Tai Hauauru 10	Rotorua
1935	Tai Rawhiti 13	
	Te Waipounamu 3	Gisborne
1936	Tai Rawhiti 22	
	Tai Tokerau 14	Ruatoria
1937	cancelled	
1938	Tai Rawhiti 14	
	Tai Hauauru 9	Wairoa
1939	Tai Rawhiti 12	
	Te Waipounamu 9	Gisborne
1940-45	no competition	
1946	Tai Tokerau 17	
	Tai Rawhiti 6	Whangarei
1947	Tai Tokerau 34	
	Tai Hauauru 13	Whangarei
1948	Tai Tokerau 45	
	Te Waipounamu 3	Whangarei
1949	Tai Tokerau 11	
	Tai Rawhiti 6	Whangarei
1950	Tai Hauauru 8	
	Tai Tokerau 3	Whangarei
1951	Tai Hauauru 36	
	Te Waipounamu 5	Whangarei
1952	Tai Rawhiti 26	
	Tai Hauauru 17	New Plymouth
1953	Tai Rawhiti 16	
	Tai Tokerau 14	Whakatane
1954	Tai Rawhiti 16	
	Te Waipounamu 8	Napier
1955	Tai Rawhiti 21	
	Tai Hauauru 21	Rotorua
1956	Tai Rawhiti 16	
	Tai Tokerau 8	Whakatane
1957	Tai Rawhiti 19	
	Te Waipounamu 17	Gisborne

1958	Tai Hauauru 14	
	Tai Rawhiti 13	Rotorua
1959	Tai Hauauru 25	
	Tai Tokerau 15	Wanganui
1960	Tai Hauauru 27	
	Te Waipounamu 6	Wellington
1961	Tai Hauauru 11	
	Tai Rawhiti 8	Palmerston North
1962	Tai Tokerau 11	
	Tai Hauauru 3	Taumarunui
1963	Northern 16	
	Southern 13	Onerahi
1964	Northern 15	
	Southern 9	Te Awamutu
1965	Northern 18	
.	Southern 11	Gisborne
1966	Northern 22	
	Southern 20	Tauranga
1967	Northern 21	
	Southern 14	Wellington
1968	Northern 45	
	Southern 14	Palmerston North
1969	Northern 17	
	Southern 17	Gisborne
1970	Northern 17	
	Southern 12	Whangarei
1971	Northern 6	
	Southern 0	Napier
1972	Northern 40	
	Southern 4	Thames
1973	Southern 35	
	Northern 21	Wanganui
1974	Northern 19	
	Southern 12	Rotorua
1975	Southern 20	
	Northern 13	Kaikohe
1976	Southern 34	
	Northern 15	Oamaru
1977	Northern 25	
	Southern 0	New Plymouth
1978	Northern 29	
	Southern 8	Gisborne
1979	Southern 12	
	Northern 7	Tauranga
1980	Southern 32	
	Northern 12	Blenheim
1981	Northern 18	
	Southern 7	Pukekohe
1982	Southern 24	
	Northern 10	Oamaru
1983	Southern 19	
	Northern 13	Thames
1984	Northern 32	
	Southern 20	Hastings
1985	Northern 24	
	Southern 12	Hamilton
1986	Northern 24	
	Southern 3	Dunedin
1987	Northern 24	
	Southern 13	Wanganui
1988	Southern 19	
	Northern 15	Nelson
1989	Northern 40	
	Southern 17	Gisborne
1990	Northern 32	
	Southern 7	Auckland
1991	Southern 26	
	Northern 24	Palmerston North
1992	Southern 33	
	Northern 17	Tauranga
1993	Northern 28	
	Southern 24	Levin
1994	Northern 36	
	Southern 32	Oamaru

George Nepia Memorial Trophy

1995	Northern 74	
	Southern 17	Napier
	Northern 42	
	Central 8	Napier

1996	Southern 51	
	Central 17	Takapuna
	Northern 95	
	Southern 18	Takapuna

Maori trial

| 1997 | Ikaroa 53 | |
| | Mangaroa 21 | Tauranga |

MATCHES PLAYED BY MAORI TEAMS

Unofficial matches played by New Zealand Maori XVs are not included

1910 in AUSTRALIA and NEW ZEALAND

v Rotorua Sub-union *at Rotorua*	won	25-5
v Auckland *at Auckland*	lost	6-14
v Rotorua-East Coast XV *at Rotorua*	won	26-8
v New South Wales *at Sydney*	lost	0-11
v New England *at Armidale*	drew	6-6
v Queensland *at Brisbane*	won	13-8
v Northern Branch *at Newcastle*	drew	6-6
v New South Wales *at Sydney*	lost	13-27
v Western Branch *at Bathurst*	won	12-8
v American Universities *at Sydney*	won	14-11
v American Universities *at Sydney*	won	21-3
v Central Southern *at Goulburn*	won	40-3
v Victoria *at Melbourne*	won	32-5
v Victoria *at Melbourne*	won	50-11
v Southland *at Invercargill*	lost	3-6
v Otago *at Dunedin*	won	17-8
v Wellington *at Wellington*	drew	8-8
v Manawatu-Horowhenua *at Palmerston North*	won	15-6
v Auckland *at Auckland*	won	8-6

Summary:
Played 19, won 12, drew 3, lost 4
Points for 315, against 160

1911 in NEW ZEALAND

v Hawke's Bay *at Napier*	won	3-0
v Hastings Sub-union *at Hastings*	won	3-0
v Poverty Bay *at Gisborne*	won	19-6
v Wairarapa *at Carterton*	drew	3-3
v Manawatu-Horowhenua *at Palmerston North*	won	14-11
v Taranaki *at Stratford*	lost	16-17
v Wanganui *at Wanganui*	won	8-0
v Wellington *at Wellington*	lost	5-26
v Canterbury *at Christchurch*	lost	0-26
v Otago *at Dunedin*	lost	8-20

Summary:
Played 10, won 5, drew 1, lost 4
Points for 79, against 109

1912 in NEW ZEALAND

| v Auckland *at Auckland* | lost | 0-27 |

1913 in AUSTRALIA and NEW ZEALAND

v Rotorua Sub-union *at Rotorua*	won	17-9
v Thames Sub-union *at Thames*	won	24-0
v New South Wales *at Sydney*	lost	3-15
v Northern Districts *at Tamworth*	won	29-8
v Queensland *at Brisbane*	lost	9-19
v Queensland *at Brisbane*	won	11-0
v Metropolitan Union *at Sydney*	won	6-3
v New South Wales *at Sydney*	lost	5-16
v Western Districts *at Bathurst*	won	11-8
v City & Suburban Association *at Sydney*	won	31-3
v Auckland *at Auckland*	lost	0-25
v Horowhenua *at Levin*	won	7-6
v Canterbury *at Christchurch*	lost	0-11

v Southland *at Invercargill*	won	8-5
v Otago *at Dunedin*	drew	3-3
v South Canterbury *at Timaru*	won	19-8
v Wellington *at Wellington*	lost	21-23

Summary:
Played 17, won 10, drew 1, lost 6
Points for 204, against 162

1914 in NEW ZEALAND

| v Wellington *at Wellington* | lost | 13-15 |

1921 in NEW ZEALAND

| v Hawke's Bay *at Napier* | lost | 5-17 |
| v South Africa *at Napier* | lost | 8-9 |

1922 in AUSTRALIA and NEW ZEALAND

v New South Wales *at Sydney*	won	25-22
v New South Wales *at Sydney*	lost	13-28
v Walcha *at Walcha*	won	45-6
v Inverell *at Inverell*	won	36-0
v New South Wales *at Sydney*	won	23-22
v New South Wales 2nd XV *at Sydney*	won	27-18
v Hawke's Bay *at Napier*	won	18-11
v Horowhenua *at Levin*	lost	3-14
v Wellington *at Wellington*	drew	6-6
v North Auckland *at Whangarei*	won	13-9
v Auckland *at Auckland*	lost	11-16
v Poverty Bay *at Gisborne*	lost	8-15
v New Zealand *at Wellington*	lost	14-21

Summary:
Played 13, won 7, drew 1, lost 5
Points for 242, against 188

1923 in AUSTRALIA and NEW ZEALAND

v Waikato *at Hamilton*	lost	11-14
v New South Wales *at Sydney*	lost	23-27
v New South Wales *at Sydney*	lost	16-21
v New South Wales *at Sydney*	lost	12-14
v Metropolitan Union *at Manly*	drew	16-16
v Auckland *at Auckland*	lost	3-8
v Wanganui *at Wanganui*	won	15-8
v South Canterbury *at Timaru*	won	13-0
v Otago *at Dunedin*	won	21-14
v Southland *at Invercargill*	won	11-8
v Canterbury *at Christchurch*	lost	3-7
v Horowhenua *at Levin*	won	14-3

Summary:
Played 12, won 5, drew 1, lost 6
Points for 158, against 140

1925 in NEW ZEALAND

| v Canterbury *at Christchurch* | lost | 10-15 |

1926-27 in NEW ZEALAND, AUSTRALIA, CEYLON, FRANCE, ENGLAND and WALES

v Auckland *at Auckland*	won	13-12
v Wellington *at Wellington*	lost	16-28
v Melbourne *at Melbourne*	won	30-0
v Victoria *at Melbourne*	won	57-0
v Ceylon *at Colombo*	won	37-6
v Olympique Club *at Marseilles*	won	87-0
v Burgundy *at Dijon*	won	27-3
v Les Alpes *at Grenoble*	won	23-6
v Le Littoral *at Avignon*	won	29-8
v Le Lyonnais *at Lyon*	won	17-3
v Le Languedoc *at Narbonne*	won	13-8
v Le Cote Basque *at Bayonne*	won	13-3
v Equip du Centre *at Clemont-Ferrand*	won	16-3
v Paris *at Paris*	lost	9-11
v Somerset *at Weston-super-Mare*	won	21-8

v Newport *at Newport* — drew — 0-0
v Swansea *at Swansea* — won — 11-6
v Yorkshire *at Bradford* — won — 17-9
v Harlequins *at Twickenham* — lost — 5-11
v Devon *at Devonport* — lost — 0-20
v Cardiff *at Cardiff* — won — 18-8
v Gloucester *at Bristol* — lost — 0-3
v Llanelli *at Llanelli* — lost — 0-3
v East Midlands *at Northampton* — drew — 6-6
v Blackheath *at Blackheath* — won — 9-5
v Cornwall *at Falmouth* — lost — 3-6
v Leicester *at Leicester* — won — 15-13
v Lancashire *at Manchester* — won — 11-6
v Selection Francais *at Bordeaux* — won — 13-3
v Le Limousin *at Limoges* — won — 34-7
v Les Pyrenees *at Toulouse* — won — 9-8
v Bearn-Armagnac-Bigorre *at Pau* — won — 11-6
v Selection Francais *at Beziers* — won — 25-12
v France *at Paris* — won — 12-3
v Cardiff *at Cardiff* — won — 5-3
v Pontypool *at Pontypool* — lost — 5-6
v Vancouver *at Vancouver* — won — 33-9
v University of British Colombia
 at Vancouver — won — 12-3
v Mainland *at Vancouver* — won — 43-0
v Victoria *at Victoria* — won — 41-3

Summary:
Played 40, won 30, drew 2, lost 8
Points for 741, against 255

1927 in NEW ZEALAND

v Auckland *at Auckland* — lost — 6-31
v Bay of Plenty *at Whakatane* — lost — 12-15
v Poverty Bay *at Gisborne* — won — 28-18
v Bush Districts *at Pahiatua* — won — 23-9
v Manawhenua
 at Palmerston North — drew — 24-24
v Wairarapa *at Masterton* — lost — 11-49
v Nelson-Golden Bay-Motueka
 at Nelson — lost — 11-14
v Buller *at Westport* — won — 22-9
v West Coast *at Greymouth* — won — 22-0
v North Otago *at Oamaru* — won — 13-6
v Southland *at Invercargill* — won — 21-6
v Otago *at Dunedin* — won — 11-5

Summary:
Played 12, won 7, drew 1, lost 4
Points for 204, against 186

1928 in NEW ZEALAND

v New South Wales *at Wellington* — won — 9-8

1929 in NEW ZEALAND

v New Zealand XV *at Wellington* — lost — 18-37

1930 in NEW ZEALAND

v Horowhenua *at Levin* — lost — 22-31
v Great Britain *at Wellington* — lost — 13-19

1931 in NEW ZEALAND

v West Coast *at Greymouth* — won — 26-8
v Buller *at Westport* — lost — 7-8
v Marlborough *at Blenheim* — won — 9-6
v Australia *at Palmerston North* — lost — 3-14

1932 in NEW ZEALAND

v Wairoa County *at Wairoa* — won — 18-11
v Poverty Bay *at Gisborne* — drew — 17-17
v East Coast *at Ruatoria* — won — 13-8
v Bay of Plenty *at Te Puke* — lost — 0-28
v Thames Valley *at Paeroa* — won — 35-6
v North Auckland *at Ohaeawai* — won — 24-3
v North Auckland *at Dargaville* — won — 28-8

v Waikato *at Hamilton* — won — 14-8
v King Country *at Te Kuiti* — lost — 12-16

Summary:
Played 9, won 6, drew 1, lost 2
Points for 161, against 105

1934 in NEW ZEALAND

v South Canterbury *at Timaru* — won — 23-16
v Otago *at Dunedin* — lost — 13-17
v Southland *at Invercargill* — won — 24-20
v Wellington *at Wellington* — lost — 6-11

1935 in AUSTRALIA and NEW ZEALAND

v Warwick *at Warwick* — won — 32-10
v Queensland *at Brisbane* — lost — 22-39
v Toowoomba *at Toowoomba* — won — 35-13
v Queensland *at Brisbane* — won — 15-13
v Far West *at Dubbo* — won — 38-3
v New South Wales *at Sydney* — won — 6-5
v Central Western *at Bathurst* — won — 42-8
v Victoria *at Melbourne* — won — 28-16
v New South Wales *at Sydney* — lost — 13-20
v New South Wales *at Sydney* — won — 14-5
v Newcastle *at Newcastle* — won — 11-0
v Wellington *at Wellington* — lost — 9-11
v Auckland *at Auckland* — won — 14-10

Summary:
Played 13, won 10, lost 3
Points for 279, against 153

1936 in NEW ZEALAND

v Australia *at Palmerston North* — lost — 6-31

1938 in FIJI and NEW ZEALAND

v Wanganui *at Wanganui* — lost — 18-19
v Fiji 2nd XV *at Suva* — won — 14-6
v Fiji Europeans *at Suva* — won — 17-6
v Fiji *at Suva* — drew — 3-3
v Fiji *at Suva* — lost — 5-11
v Fiji *at Suva* — won — 6-3
v Auckland *at Auckland* — lost — 6-14

Summary:
Played 7, won 3, drew 1, lost 3
Points for 69, against 62

1939 in NEW ZEALAND

v Fiji *at Hamilton* — lost — 4-14

1946 in NEW ZEALAND

v Manawatu *at Palmerston North* — won — 14-11
v Australia *at Hamilton* — won — 20-0

1947 in NEW ZEALAND

v King Country *at Otorohanga* — won — 17-0
v Thames Valley *at Te Aroha* — won — 26-0
v Bay of Plenty *at Tauranga* — won — 34-6
v Tai Rawhiti *at Ruatoria* — won — 24-11
v Canterbury *at Christchurch* — lost — 11-14
v North Otago *at Oamaru* — drew — 12-12
v South Canterbury *at Timaru* — won — 16-3
v Wellington *at Wellington* — lost — 8-29

Summary:
Played 8, won 5, drew 1, lost 2
Points for 148, against 75

1948 in FIJI and NEW ZEALAND

v Taranaki *at New Plymouth* — won — 13-9
v Combined Northern Districts
 at Lautoka — won — 36-0

v Suva European XV *at Suva* — won — 46-3
v Suva-Rewa *at Suva* — drew — 3-3
v Fiji *at Suva* — won — 22-6
v Fiji *at Suva* — lost — 8-9
v Fiji *at Suva* — won — 14-6
v Auckland *at Auckland* — lost — 3-33
v North Auckland *at Whangarei* — won — 37-24

Summary:
Played 9, won 6, drew 1, lost 2
Points for 182, against 93

1949 in AUSTRALIA and NEW ZEALAND

v Southern States *at Melbourne* — won — 35-8
v Australia Capital Territory
 at Canberra — won — 47-3
v New South Wales *at Sydney* — won — 19-14
v Newcastle *at Newcastle* — won — 17-0
v Australia *at Sydney* — won — 12-3
v New England *at Armidale* — won — 42-10
v Australia *at Brisbane* — drew — 8-8
v Queensland *at Brisbane* — won — 13-8
v New South Wales *at Newcastle* — won — 11-9
v Combined Central Western
 at Orange — won — 51-5
v Australia *at Sydney* — lost — 3-18
v Auckland *at Auckland* — lost — 6-9

Summary:
Played 12, won 9, drew 1, lost 2
Points for 266, against 95

1950 in NEW ZEALAND

v Manawatu *at Palmerston North* — won — 21-15
v British Isles *at Wellington* — lost — 9-14

1951 in NEW ZEALAND

v Taranaki *at New Plymouth* — won — 20-11
v Fiji *at Wellington* — lost — 14-21

1952 in NEW ZEALAND

v Golden-Bay-Motueka *at Motueka* — won — 37-3
v West Coast *at Greymouth* — won — 30-23
v Buller *at Westport* — won — 21-17
v Marlborough *at Blenheim* — won — 14-13
v New Zealand XV *at Wellington* — lost — 22-28

Summary:
Played 5, won 4, lost 1
Points for 124, against 84

1954 in FIJI and NEW ZEALAND

v Wanganui *at Wanganui* — won — 22-9
v Taranaki *at New Plymouth* — won — 14-0
v Waikato *at Hamilton* — won — 13-6
v North Auckland *at Whangarei* — won — 16-9
v Auckland *at Auckland* — lost — 9-16
v Fiji European XV *at Lautoka* — won — 31-28
v Vatukoula-Nadroga *at Vatukoula* — won — 25-3
v Northern Districts *at Lautoka* — won — 20-19
v Fiji *at Lautoka* — lost — 12-19
v Suva *at Suva* — won — 15-0
v Rewa-Lomaiviti *at Suva* — won — 22-6
v Fiji *at Suva* — won — 16-0
v Fiji *at Suva* — won — 9-6
v New Zealand XV *at Auckland* — lost — 20-24

Summary:
Played 14, won 11, lost 3
Points for 244, against 153

1955 in NEW ZEALAND

v King Country *at Otorohanga* — won — 21-11
v Thames Valley *at Thames* — lost — 14-17
v Auckland *at Auckland* — won — 19-17

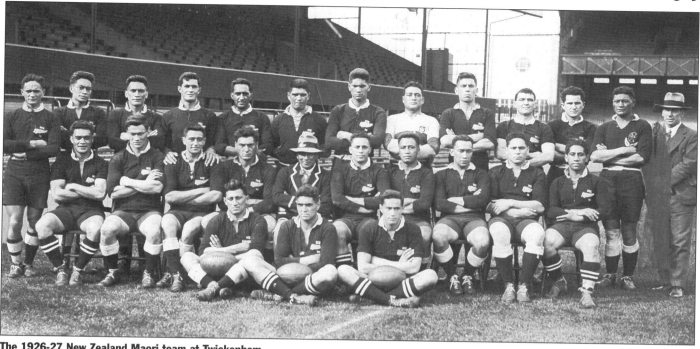

The 1926-27 New Zealand Maori team at Twickenham
Back row: R. Pelham, D. Wi Neera, H. Phillips, O.S. Olsen, W. Lockwood, T. Manning, P. Matene, T. Dennis, J. MacDonald, J. Stewart,
 S.W. Gemmell, P. Haupapa, S.F. Cooper (sec RFU).
Front row: W.P. Potaka, T.P. Robinson, D. Tatana, W. Rika (Heke), W.T. Parata (manager), A.C. Falwasser, M. Mete, E.T.W. Love, A. Crawford,
 H. Kingi.
In front: J. Manihera, W.H. Wilson, L.R. Grace.
Absent: W.P. Barclay (captain), R.J. Bell, J. Gemmell, W.H. Shortland.

1956 in NEW ZEALAND

v West Coast *at Greymouth*	won	26-20
v West Coast-Buller *at Westport*	won	22-3
v Nelson-Marlborough-Golden Bay- Motueka *at Blenheim*	won	51-5
v South Canterbury-Mid Canterbury- North Otago *at Timaru*	won	18-15
v Counties *at Waiuku*	won	30-3
v South Africa *at Auckland*	lost	0-37

Summary:
Played 6, won 5, lost 1
Points for 147, against 83

1957 in NEW ZEALAND

v Horowhenua *at Levin*	won	42-8
v Fiji *at Wellington*	lost	13-36
v North Otago *at Oamaru*	won	18-6
v Fiji *at Dunedin*	lost	8-17

1958 in AUSTRALIA and NEW ZEALAND

v Australian Capital Territory *at Canberra*	won	30-13
v South Harbour *at Sydney*	won	19-3
v Australian Barbarians *at Sydney*	won	38-8
v Newcastle *at Newcastle*	won	20-13
v Queensland *at Brisbane*	won	24-12
v Australia *at Brisbane*	lost	14-15
v New England *at Armidale*	won	27-6
v New South Wales *at Sydney*	won	14-11
v Central West *at Orange*	lost	15-18
v Australia *at Sydney*	drew	3-3
v South Australia *at Adelaide*	won	48-6
v Australia *at Melbourne*	won	13-6
v New Zealand XV *at Auckland*	lost	8-24

Summary:
Played 13, won 9, drew 1, lost 3
Points for 273, against 138

1959 in NEW ZEALAND

v East Coast *at Ruatoria*	won	29-9
v Poverty Bay *at Gisborne*	lost	16-20
v British Isles *at Auckland*	lost	6-12

1960 in TONGA, WESTERN SAMOA and NEW ZEALAND

v Town XV *at Nuku'alofa*	won	26-8
v Country XV *at Nuku'alofa*	won	17-6
v Northern Districts *at Nuku'alofa*	won	30-3
v Tonga *at Nuku'alofa*	lost	16-27
v Country XV *at Apia*	won	36-8
v Western Samoa *at Apia*	won	28-6
v Town XV *at Apia*	won	36-8
v Western Samoa *at Apia*	won	31-5
v Auckland *at Auckland*	drew	6-6

Summary:
Played 9, won 7, drew 1, lost 1
Points for 226, against 77

1961 in NEW ZEALAND

v Hawke's Bay *at Hastings*	won	17-6
v France *at Napier*	won	5-3

1963 in NEW ZEALAND

v North Auckland *at Whangarei*	lost	0-9
v Mid Canterbury *at Ashburton*	won	28-18
v Southland *at Invercargill*	won	23-9
v Otago *at Dunedin*	won	13-6
v West Coast *at Greymouth*	won	53-8

1964 in FIJI and NEW ZEALAND

v Waikato *at Hamilton*	lost	3-23
v Nadroga *at Sigatoka*	won	19-8
v Suva *at Suva*	won	21-11
v Northern Unions *at Savusavu*	won	34-9
v Fiji *at Suva*	won	26-9

v Rewa-Lomaiviti *at Nausori*	won	44-6
v North Viti Levu *at Vatukoula*	won	6-0
v Lautoka *at Lautoka*	won	33-3
v Nadi *at Nadi*	won	27-8

Summary:
Played 9, won 8, lost 1
Points for 213, against 77

1965 in NEW ZEALAND

v Horowhenua *at Levin*	won	43-9
v Poverty Bay-East Coast *at Gisborne*	won	14-5
v South Africa *at Wellington*	lost	3-9

1966 in NEW ZEALAND

v Counties *at Papakura*	won	24-11
v Bay of Plenty *at Rotorua*	lost	5-13
v British Isles *at Auckland*	lost	14-16

1968 in NEW ZEALAND

v Manawatu *at Palmerston North*	won	11-6

1969 in NEW ZEALAND

v Poverty Bay *at Gisborne*	won	9-8
v Tonga *at Christchurch*	lost	19-26
v Tonga *at Auckland*	lost	6-19

1970 in NEW ZEALAND

v North Auckland *at Whangarei*	lost	13-19
v Fiji *at Christchurch*	won	11-6
v Fiji *at Auckland*	drew	9-9

1971 in NEW ZEALAND

v Waikato *at Hamilton*	lost	9-19
v British Isles *at Auckland*	lost	12-23

1972 in NEW ZEALAND

v California *at Auckland* won 28-21

1973 in WESTERN SAMOA, TONGA, FIJI and NEW ZEALAND

v Wanganui *at Wanganui*	won	16-6
v Western Samoa *at Apia*	won	11-6
v Western Samoa *at Apia*	won	12-0
v Vava'u-Ena *at Nuku'alofa*	won	35-8
v Patron's XV *at Nuku'alofa*	won	15-0
v Tonga *at Nuku'alofa*	lost	3-11
v Suva-Rewa *at Suva*	lost	9-39
v Nadroga *at Sigatoka*	lost	15-16
v Fiji *at Suva*	won	6-4
v North-West Fiji *at Nadi*	won	19-15
v Fiji *at Lautoka*	won	9-3
v New Zealand *at Rotorua*	lost	8-18

Summary:
Played 12, won 8, lost 4
Points for 158, against 126

1974 in NEW ZEALAND

v Bay of Plenty *at Rotorua*	won	47-6
v Fiji *at Auckland*	won	24-9
v Fiji *at Wellington*	won	39-25

1975 in NEW ZEALAND

v North Auckland *at Whangarei*	won	17-15
v Tonga *at New Plymouth*	won	23-16
v Tonga *at Auckland*	won	37-7

1976 in NEW ZEALAND

v Otago *at Dunedin*	lost	9-24
v Western Samoa *at Rotorua*	won	19-6
v Western Samoa *at Auckland*	won	24-8

1977 in NEW ZEALAND

v Taranaki *at New Plymouth*	won	28-11
v British Isles *at Auckland*	lost	19-22

1978 in NEW ZEALAND

v Poverty Bay-East Coast *at Gisborne*	won	39-14

1979 in AUSTRALIA, FIJI, WESTERN SAMOA and TONGA

v Queensland *at Brisbane*	drew	18-18
v New South Wales Country *at Lismore*	won	22-3
v New South Wales *at Sydney*	won	15-12
v Fiji Minor Unions *at Lautoka*	won	45-18
v Fiji *at Suva*	won	19-13
v Tonga *at Nuku'alofa*	won	26-9
v Western Samoa *at Apia*	won	26-3

Summary:
Played 7, won 6, drew 1
Points for 171, against 76

1980 in NEW ZEALAND

v Marlborough *at Blenheim*	won	16-3
v Fiji *at Rotorua*	won	22-9

1981 in NEW ZEALAND

v Counties *at Pukekohe*	won	12-8
v South Africa *at Napier*	drew	12-12

1982 in NEW ZEALAND, WALES and SPAIN

v North Otago *at Dunedin*	won	69-4

v Canterbury *at Christchurch*	won	27-12
v Cardiff *at Cardiff*	won	17-10
v Maesteg *at Maesteg*	drew	10-10
v Swansea *at Swansea*	lost	12-15
v Monmouthshire *at Newport*	won	18-9
v Llanelli *at Llanelli*	lost	9-16
v Aberavon *at Port Talbot*	won	34-6
v Wales XV *at Cardiff*	lost	19-25
v Spanish President's XV *at Barcelona*	won	62-13
v Spain *at Madrid*	won	66-3

Summary:
Played 11, won 7, drew 1
Points for 343, against 123

1983 in NEW ZEALAND

v Tonga *at Rotorua*	won	28-4
v Tonga *at Auckland*	won	52-4

1984 in NEW ZEALAND

v Hawke's Bay *at Hastings*	won	25-18

1985 in NEW ZEALAND

v Waikato *at Hamilton*	won	22-6

1986 in NEW ZEALAND

v Southland *at Invercargill*	won	28-17
v East Coast *at Ruatoria*	won	54-9
v Wairarapa Bush *at Masterton*	won	41-9

1987 in NEW ZEALAND

v Wanganui *at Wanganui*	won	42-3

1988 in NEW ZEALAND

v Marlborough *at Blenheim*	won	22-11

1988 in FRANCE, ITALY, SPAIN and ARGENTINA

v NZ Universities *at Auckland*	won	37-19
v Italian Barbarians *at Rome*	won	57-9
v Littoral Selection *at Toulon*	won	22-9
v Drome-Ardeche *at Valence*	won	17-12
v Pyrenees Selection *at Rodez*	drew	10-10
v Languedoc Selection *at Narbonne*	lost	25-31
v French Army XV *at Castres*	won	20-16
v French Barbarians *at Mont-de-Marsan*	won	31-14
v Spanish Selection *at Seville*	won	22-12
v President's XV *at Madrid*	won	42-3
v Rosario *at Rosario*	won	88-12
v Tucuman *at Tucuman*	won	12-3

Summary:
Played 12, won 10, drew 1, lost 1
Points for 383, against 150

1989 in NEW ZEALAND

v Poverty Bay-East Coast *at Gisborne*	won	40-19

1990 in NEW ZEALAND

v Auckland *at Auckland*	won	22-9
v NZ Universities *at Rotorua*	won	63-9

1991 in NEW ZEALAND

v Wellington *at Wellington*	lost	19-36

1992 in NEW ZEALAND

v King Country *at Taupo*	won	27-6
v NZ President's XV *at Rotorua*	won	30-11

1992 in PACIFIC ISLANDS

v Cook Islands *at Rarotonga*	won	29-17
v Samoan Development *at Apia*	won	27-16
v Tonga President's XV *at Nuku'alofa*	lost	15-22
v Tonga *at Nuku'alofa*	won	33-10
v Fiji Development XV *at Nadi*	won	17-5
v Fiji *at Suva*	won	35-34

Summary:
Played 6, won 5, lost 1
Points for 156, against 104

1993 in NEW ZEALAND

v Manawatu *at Palmerston North*	won	67-20
v British Isles *at Wellington*	lost	20-24

1994 in SOUTH AFRICA

v Vaal Triangle *at Sasolburg*	won	119-3
v Orange Free State *at Johannesburg*	drew	16-16
v Griqualand West *at Kimberley*	lost	21-30
v Eastern Province *at Johannesburg*	lost	24-26

1994 in NEW ZEALAND

v Mid Canterbury *at Ashburton*	won	58-13
v Fiji *at Christchurch*	won	34-3

1995 in NEW ZEALAND

v King Country *at Taupo*	won	44-28
v Waikato *at Hamilton*	won	60-22

1996 in NEW ZEALAND

v Bay of Plenty *at Rotorua*	won	48-28
v Western Samoa *at Auckland*	won	28-15

1996 in FIJI and TONGA

v Fiji *at Suva*	won	25-10
v Tonga Barbarians *at Nuku'alofa*	won	26-19
v Tonga *at Nuku'alofa*	won	29-20

1997 in NEW ZEALAND

v Ireland A *at Palmerston North*	won	41-10
v Argentina *at Napier*	won	39-17

1997 in WESTERN SAMOA

v Western Samoan XV *at Apia*	won	40-8
v Western Samoa *at Apia*	won	34-20

NEW ZEALAND MAORI REPRESENTATIVES 1910-1997

** indicates a player who represented New Zealand*

Abraham J.	*Canterbury*	1992
Adams I.H.	*Wellington*	1988,92
Ake B.W.	*Auckland*	1987
Akuira W.R.	*Hawke's Bay*	1922
	Manawatu	1923
Amowhanga R.	*King Country*	1923
Anderson C.R.	*Auckland*	1955
Aratema D.J.	*Bay of Plenty*	1966
Arthur Te R.	*Wellington*	1980,83
Atkins D.P.	*Canterbury*	1980,83
Atuahiva J.J.	*Counties*	1993
Awarau W.M.	*East Coast*	1923
Bailey H.	*Taranaki*	1923
Baker A.W.	*Waikato*	1979,82
Baker C.D.	*Wairarapa-Bush*	1982
Baker V.R.	*Taranaki*	1970,71
Bannister J.	*West Coast*	1922,23
Barbara G.J.	*Counties*	1969

Name	Region	Years
Barber R.J.*	Southland	1972-74,76
Barclay T.	Bay of Plenty	1922
Barclay W.P.	Hawke's Bay	1921-23,26,27
Barton E.	Waikato	1923
Beattie E.	Bay of Plenty	1966
Beazley B.W.	North Auckland	1949,52
Beazley J.T.	Southland	1965
Bell J.R.*	Southland	1922,23,26,30,31
Bell T.	South Auckland	1921
Berryman N.R.	North Auckland	1992,95-97
Bevan H.R.	Horowhenua	1922,23
	Manawhenua	1925
Bevan M.V.	Wellington	1954-58,60,61
Black K.	Bay of Plenty	1923
Blackburn M.	Wellington	1969
Blackie J.	Bay of Plenty	1921
Blake A.W.*	Wairarapa	1948-50,52
Blake G.	Bay of Plenty	1958
Blake J.M.*	Hawke's Bay	1921,22
Blake P.	Hawke's Bay	1913
Blake P.A.	Manawatu	1978
	Hawke's Bay	1982-84
Bluett J.	Bay of Plenty	1911
Boroevich K.G.*	King Country	1980,82,83,85
	Wellington	1986
	North Harbour	1989,93
Botica F.M.*	North Harbour	1985,86,87-89
Brain E.F.	Counties	1991,95-97
Broderick J.	Bay of Plenty	1935
Brooke M.V.	Auckland	1985,88,90
Brooke R.M.*	Auckland	1988-92,95
Brooke Z.V.*	Auckland	1986,88,90,92-94
Brooke-Cowden M.*	Auckland	1985,86
Brooking J.	East Coast	1931
Brooking J.S.	South Canterbury	1957
Broughton N.J.	Wellington	1995
Broughton R.	Horowhenua	1921-23
Brown T.E.*	Otago	1996
Bryers R.F.*	King Country	1946,49
Bullivant K.W.	Poverty Bay	1951
Burgoyne M.M.*	North Auckland	1978,79
Burnett W.	Poverty Bay	1910,11
Bush W.K. Te P.*	Canterbury	1973-75,77-79,81,82
Carrington E.	Poverty Bay	1946-48
Carrington K.R.*	Auckland	1970,71
Carrington W.	Poverty Bay	1947-49,51
Carter T.J.	Hawke's Bay	1973-76
Cashmore A.R.*	Auckland	1996,97
Chalmers W.	Wellington	1925
Chase T.C.	Wanganui	1934,35
Cherrington N.P.*	North Auckland	1947-52,54
Clamp M.*	Wellington	1980-85,88
Clark S.	Auckland	1910
Clarke R.A.	Counties	1969
Clarke R.S.	North Auckland	1952,54-56
Clarke T.H.	Counties	1984
Clarke Te R.	Counties	1984
Cochrane F.	Auckland	1911
Coe J.N.	Counties	1992,93,95-97
Coffin H.C.	King Country	1992
Coffin P.H.*	King Country	1991-97
Coffin R.	King Country	1961,63
Collins J.L.*	Poverty Bay	1964-66
Cook L.G.	North Auckland	1965,66
Cooke P.J.	Otago	1992-95
Cooksley M.S.B.*	Counties	1992-97
Cooper C.G.	Taranaki	1982,83
Cooper L.W.	Hawke's Bay	1959
Cooper N.W.	Marlborough	1957
Cooper W.J.	North Auckland	1934,35
	Auckland	1936
Couch M.B.R.*	Wairarapa	1948-50
Crawford A.	East Coast	1926,27
Crawford J.C.S	Otago	1975,76
Crawford K.K.	Hawke's Bay	1964,66
Crawford O.H.	Hawke's Bay	1994
Cressy B.A.	King Country	1964-66
Crichton S.*	Wellington	1982,84,85,87
Crosby T.D.	Poverty Bay	1991
Cunningham J.B.	Hawke's Bay	1995,97
Cunningham W.*	Auckland	1910,12
Dansey R.I.	Otago	1910,11
Davis B.	King Country	1938
Davis K.*	Auckland	1952,54-56,58,59
Davis M.H.	Waikato	1958-60
Davis R.	Southland	1932
Davis T.R.	Auckland	1973
	Bay of Plenty	1976
Davis T.W.	Hawke's Bay	1969
Davis W.R.	North Auckland	1934
Delamere M.E.	Bay of Plenty	1946-49
Dennis T.	Poverty Bay	1926
Doughty R.J.	Thames Valley	1976
Douglas A.J.	Bay of Plenty	1950-52,54,55
Douglas R.	Thames Valley	1950
Downs M.	Wanganui	1932
Doyle S.C.	Manawatu	1992-94
Duggan R.J.	Waikato	1996,97
Dunn E.J.*	Auckland	1976
	North Auckland	1977,79,81,82
Dunn I.T.W.*	North Auckland	1983,84,88
Dunn R.R.	Auckland	1979-82
Edwards J.P.R.	Bay of Plenty	1996
Edwards M.	Hawke's Bay	1922
Ellison D.R.	Otago	1986,88
	Waikato	1992-94
Ellison E.P.	Otago	1911
Emery H.K.	Auckland	1954-58
Erceg C.P.*	Auckland	1950-52
Eruera T.	Auckland	1910
Falcon G.J.	Hawke's Bay	1991,92,94
Falcon R.N.	East Coast	1977
Falwasser A.C.	Taranaki	1926,27
	Auckland	1928
Fenton D.R.	Auckland	1957
Ferris G.	East Coast	1931
Flavell D.M.	King Country	1982
Forster S.T.*	Otago	1990,92-96
Fox L.	Thames Valley	1978
Foy S.R.	North Auckland	1968
Fransen M.T.	Canterbury	1986
French T.A.	Buller	1911,13
French T.J.	Auckland	1951,52,54,55,57
Gardiner J.	Bay of Plenty	1946
Gardiner R.	Bay of Plenty	1951,52
Garlick J.	Bay of Plenty	1921,22
Gemmell B.	Hawke's Bay	1914,21
Gemmell J.	Hawke's Bay	1926,27,29-31
Gemmell P.	Hawke's Bay	1927
Gemmell S.W.*	Hawke's Bay	1922,23,26-29
George R.	Horowhenua	1923
George R.	Bay of Plenty	1992,94
Gibbons S.A.	Canterbury	1978-80
Gibson D.P.E.	Canterbury	1996,97
Gillett J.J.	Waikato	1969-71
Glendinning C.R.	Counties-Manukau	1997
Going B.L.	North Auckland	1968-76
Going K.T.*	North Auckland	1966,68-75
Going M.R.	Northland	1996,97
Going S.M.*	North Auckland	1965,66,68,69,71,72,74,75,77
Goldsmith J.	Bay of Plenty	1947
Goldsmith J.A.*	Auckland	1988,91
Goldsmith P.C.	Counties	1972-74,75,77
Goldsmith T.	Wanganui	1950,54
Gordon A.H.	Wellington	1990
Gordon H.S.	Wanganui	1990
Grace L.R.	Hawke's Bay	1926
Grace T.A.	South Auckland	1910
	Bay of Plenty	1911,21
Grace T.M.P.	Wellington	1911,13,14
Graham F.J.	North Auckland	1955
Graham R.P.	Hawke's Bay	1992,94
Gray W.B.	Wellington	1987
Gray W.N.*	Bay of Plenty	1954-58
Grbich J.	Wellington	1958-60
Greening J.	Hawke's Bay	1935
Griffin S.	North Auckland	1979
Guest E.J.	North Auckland	1979
Haddon L.P.	North Auckland	1964-66,69-73
Haera E.	Bay of Plenty	1921
Haka W.	Hawke's Bay	1923
Hall J.H.	Auckland	1910,12
Hamilton A.R.	King Country	1995
Hansen A.	Auckland	1974
Hapi P.	Hawke's Bay	1952
Harrison G.R.	Taranaki	1934,35
Harrison H.	Auckland	1910
Harrison H.	East Coast	1927,30,31,34,35
Hartley D.M.	Wanganui	1951
Harvey G.	Hawke's Bay	1939
Haupapa P.	Bay of Plenty	1921,26
Hauraki J.D.	Bay of Plenty	1969
Haynes D.A.	North Auckland	1976,77
Heath W.	Auckland	1921
Heke J.	Bay of Plenty	1925
Heke L.R.	Waikato	1986,88,90
Heke M.R.	North Auckland	1930,32,34
played under the name of M. Rika		
Heke W.R.*	North Auckland	1926-28
played under the name of W. Rika		
Heketa T.	Wellington	1913
Hemara B.S.*	Manawatu	1982,85,86,88
Hemi J.	Wairarapa	1934,35
Hemi T.	Waikato	1994,96
Henare K.	East Coast	1951
Hepere S.	Wellington	1949-51
Herewini M.A.*	Auckland	1960,61,64-66,70,71
Heta P.	North Auckland	1923
Hewitt N.J.*	Hawke's Bay	1990-94
	Southland	1997
Hiha R.H.	Hawke's Bay	1954,56,57
Hiini C.W.	Southland	1985
Hikatarewa J.	Bay of Plenty	1913
Hill G.I.	Wellington	1991
Hill S.F.*	Canterbury	1956
Himona P.	Wairarapa	1932,34
Hingston L.H.	Hawke's Bay	1923
Hingston S.	Hawke's Bay	1911
Hirini S.M.	Wellington	1992-94,97
Hohaia C.	Taranaki	1929-31
Hohaia C.W.	Taranaki	1954,55
	Wellington	1956
Hohaia L.	Canterbury	1980
Hohaia L.W.	Taranaki	1946-52

Hohaia R.L.	*Wellington*	1948,49	Jones M. TeK.	*Bay of Plenty*	1997	Kingi T.P.*	*Wanganui*	1921-23,27
Hohapata E.R.	*Bay of Plenty*	1934,38	Jones P.N.	*Auckland*	1952	*see Taituha P.*		
Hooper I.H.	*East Coast*	1947,50	Jones T.P.	*Wanganui*	1927	Kipa T.D.	*Auckland*	1949-51
Horua B.	*East Coast*	1932	Jones W.E.	*King Country*	1929		*Wanganui*	1952
Hotton S.E.	*Otago*	1988	Joseph J.W.	*Marlborough*	1968-72	Kite T.	*Wellington*	1955-57
Howarth S.P.*	*Auckland*	1990,92,94	Joseph J.W.*	*Otago*	1991-94	Kiwha K.	*Wellington*	1969
Howell E.N.	*Poverty Bay*	1930	Jury R.	*Wairarapa*	1925,28	Koni D.W.	*King Country*	1969
	Bay of Plenty	1938	Kahu M.	*Auckland*	1929,30	Konia G.N.	*Manawatu*	1991-95
Hudson M.W.	*Wellington*	1986	Kaipara A.P.	*Poverty Bay*	1910,11	Koopu B.M.	*Wellington*	1966,69-71
	Canterbury	1987	Kaipara W.	*Bay of Plenty*	1938	Koopu G.	*Hawke's Bay*	1956,57,61
Hughes J.	*Manawatu*	1911-13	Kaka C.H.	*Wairarapa-Bush*	1984		*King Country*	1958
Hughes L.J.	*Counties*	1977	Kane W.	*Wanganui*	1923	Kopu W.	*Poverty Bay*	1922
Huria F.	*Canterbury*	1911	Kapa R.M.	*North Harbour*	1989,90	Korariko J.	*Bay of Plenty*	1921
Huriwai H.P.	*Poverty Bay*	1973	Kapene C.R.	*Wairarapa-Bush*	1983,86,88	Koteka T.T.*	*Waikato*	1980-84
Hurunui G.M.	*Horowhenua*	1992-95	Kapua R.	*Hawke's Bay*	1957,58	Kotua N.	*Nelson*	1935,39
Ihaia P.	*Taranaki*	1927	Karaka J.L.	*East Coast*	1959		*Marlborough*	1936
Ingersoll G.M.	*Wellington*	1987	Karatau J.H.	*Wanganui*	1956	Kouka W.	*Poverty Bay*	1911,13
Isaacs J.W.	*North Auckland*	1946,48	Karena A.T.	*North Auckland*	1959	Kowhai H.	*Taranaki*	1976
Iti B.P.	*Bay of Plenty*	1986	Katene T.*	*King Country*	1950,52,57	Kuru E.	*Hawke's Bay*	1921
	Auckland	1987-90		*Wellington*	1955,56	Kururangi R.*	*Counties*	1982
Iti C.K.	*King Country*	1989	Kaua P.	*Poverty Bay*	1931,34	Kutia P.	*Poverty Bay*	1938
Jackson E.S.*	*Hawke's Bay*	1936,39	Kawe L.	*King Country*	1934,35	Lambert A.A.	*Auckland*	1968
Jackson R.	*Waikato*	1932	Kawe T.N.	*Otago*	1939,46	Lambert K.K.*	*Manawatu*	1973-75
Jackson S.F.	*Hawke's Bay*	1938	Keepa A.	*Bay of Plenty*	1921,23	Lanigan W.	*East Coast*	1949
Jacob C.T.	*Bay of Plenty*	1973	Keepa R.H.	*Bay of Plenty*	1954-58	Leach J.	*East Coast*	1928-31
Jacob H.*	*Horowhenua*	1913,14,	Kelly G.N.	*Waikato*	1992		*Poverty Bay*	1938
		22,23		*Canterbury*	1992,94-96	Leaf H.W.	*Auckland*	1913
Jacob R.	*Wellington*	1946,48	Kenny A.C.	*Wellington*	1938	Leonard P.F.H.	*North Harbour*	1988,89
James A.A.	*Bay of Plenty*	1969	Kenny D.J.*	*Otago*	1985,86,88	Lewis H.	*North Harbour*	1992
Johnson A. Te P.H.	*Waikato*	1968,69	Kenny H.W.	*Wellington*	1948,49	Lidgard L.L.	*Counties-*	
Johnson M.	*Manawhenua*	1925,31	Kerr D.P.T.	*Canterbury*	1991,92		*Manukau*	1996,97
Johnston W.B.	*Northland*	1994	Kershaw J.	*East Coast*	1935	Lockwood J.E.	*East Coast*	1936
Jones B.K.	*Wanganui*	1952,54	King R.M.	*Auckland*	1958,59	Lockwood R.J.	*Canterbury*	1970,72
	Manawatu	1958	Kingi D.	*Marlborough*	1950		*Waikato*	1973-77
Jones E.C.	*Bay of Plenty*	1931,32	Kingi H.	*Wanganui*	1923,25-	Lockwood W.	*Hawke's Bay*	1925
Jones G.L.	*Horowhenua*	1960			27		*East Coast*	1926,27

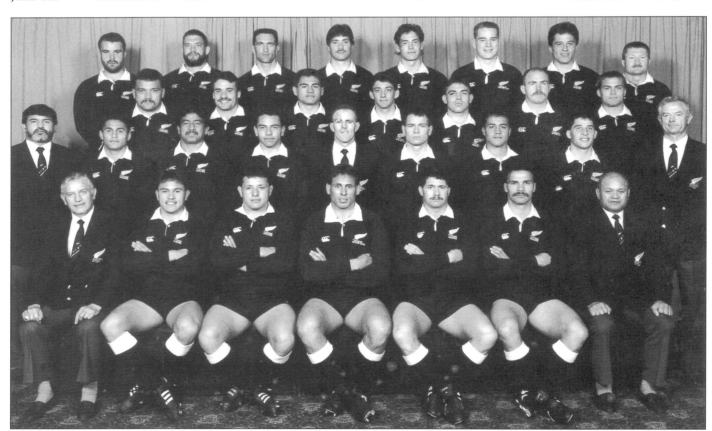

The 1988 New Zealand Maori team to France, Italy, Spain and Argentina
Back row: Len Mason, Mike Te Paa, Paul Leonard, Liston Heke, Marty Brooke, Robin Brooke, Zinzan Brooke, Arthur McLean.
Third row: Chris Kapene, Lindsay Raki, Eric Rush, Paul Simonsson, Rhys Ellison, Steve Hotton, Jasin Goldsmith.
Second row: Bill Bush (assistant coach), Frano Botica, Bruce Hemara, Ian Dunn, Neil Familton (physiotherapist), Dean Kenny, Wiremu Maunsell, Brett Iti, Dr D.R. Dalley.
Front row: Keith Pearson (manager), John Timu, Hika Reid, Wayne Shelford (captain), Arthur Stone, Kawhena Woodman, Mattie Blackburn (assistant manager/coach).
Absent: Steve McDowell.

Loughlan A.M.	Hawke's Bay	1963,65
Love D.A.	Counties	1995
Love E.T.W.	Wellington	1925,26
Love J.H.M.	Marlborough	1978-82,84
Love M.	Wellington	1922,25
Love M.R.	Manawatu	1983
Love T.M.	Wellington	1958
McAlister C.P.	Taranaki	1986,87
McCallion L.W.	Counties	1978,79
McCarthy D.	Wanganui	1947
McCarthy R.A.	Wellington	1980,82,83
MacDonald E.	Otago	1947
MacDonald l.M.	Marlborough	1957
MacDonald J.D.	Marlborough	1947
MacDonald J.H.	Marlborough	1913,14
MacDonald J.H.	Marlborough	1923,26,31,34,35
MacDonald J.N.	Marlborough	1923,31
MacDonald M.S.	Marlborough	1938
	Hawke's Bay	1939,46
McDonald L.	Mid Canterbury	1989
McDonald P.	Horowhenua	1957
McDowell S.C.*	Bay of Plenty	1988,89
	Auckland	1990-92
McFarland S.P.	North Harbour	1994-97
McGrath C.	Auckland	1997
McGregor J.C.	Hawke's Bay	1922,23
McIntosh R.N.	Waikato	1989
McKay W.H.	Poverty Bay	1929,30
McKinley C.	Poverty Bay	1936
McKinley R M.	Poverty Bay	1949
McLaughlin S.K.	Bay of Plenty	1950-52
McLean A.D.	Bay of Plenty	1988,90
McLean W.D.	Counties	1980-82,84
Mahupuku G.R.	Wairarapa	1963,64,66,68,69
Mahura W.	Taranaki	1977
Maihi M.M.	Auckland	1955,57,58
Maioha S.	Auckland	1912
Maniapoto H.	King Country	1963
Maniapoto H.J.	Auckland	1964
	Bay of Plenty	1965,66,68-73
Maniapoto M.	Bay of Plenty	1960,61,63-66
Manihera J.	Canterbury	1926,27,31
Manning T.	South Canterbury	1926
Mapu W.	Hawke's Bay	1921
Marriner A.S.	King Country	1969,70,75
Marriner J.H.	King Country	1946-50
Marriner K.J.	King Country	1970,71
Marriner T.S.	King Country	1970
Marshall P.E.	North Auckland	1961,64
Martin D.T.	Bay of Plenty	1989
Martin E.M.	Waikato	1997
Martin H.	Taranaki	1910
Martin J.	Taranaki	1910,13
Mason D.	Marlborough	1939
Mason H.	North Otago	1934,36
Mason L.R.	Marlborough	1988,92
	Wellington	1994
Mataira H.K.*	Hawke's Bay	1932,35,36
Matene D.	North Auckland	1978
Matene P.	Taranaki	1922,23
	North Auckland	1926
Mathews D.H.	King Country	1996
Mathieson D.J.	Taranaki	1958-60
Matthews A.F.	Poverty Bay	1925
Matthews K.	Wairarapa	1946,47,49,50
Maunsell W.K.	Canterbury	1988-91
Maxwell H.M.R.	Counties	1986
Maxwell N.M.	Northland	1997
Mayerhofler C.S.	North Harbour	1997
Mayerhofler M.A.	North Harbour	1994-96
	Canterbury	1997
Mei J.R.	Wellington	1987
Mellish C.E.	Marlborough	1935,36
Melsom N.S.	Waikato	1978,81,82
Menzies D.F.	Auckland	1954-56
Meremere W.	King Country	1932
Merito D.	Canterbury	1968
	Waikato	1970
Mete M.	Manawhenua	1926
Mill J.J.*	Poverty Bay	1921
	East Coast	1922
	Hawke's Bay	1923
Miln S.	Bay of Plenty	1990
Milner H.P.*	Wanganui	1971,73
	Counties	1974,75
Mitai J.	Bay of Plenty	1921,22
Mitchell H.	Bay of Plenty	1913
Mitchell R.D.	Bush	1934,35
Mitchell T.W.*	Nelson-Bays	1971
	Canterbury	1974,75
Moffitt B.	Auckland	1910
Mohi D.R.	Bay of Plenty	1964,69,74,76
Mohi E.	Bay of Plenty	1970
Montgomery E.	Bay of Plenty	1912,13
Morgan J.	Hawke's Bay	1914
Morgan J.P.	Wellington	1984
Morrison T.L.	Bay of Plenty	1931
Morrow N.J.	Waikato	1979
Muir D.D.	Waikato	1996
Murray E.	Bay of Plenty	1952
Murray J.	Hawke's Bay	1938
	North Auckland	1948
Muru H.	Waikato	1984
Myers P.J.A.	Wellington	1963-66
Naera D.	Auckland	1963
Nahona J.K.N.	Wanganui	1990
Nathan W.J.*	Auckland	1959-61,65,66
Nepia K.T.	Auckland	1992,94-97
Nepia G.*	East Coast	1928-30,35
Ngaia G.	Taranaki	1935,38
Ngarimu W.P.	Poverty Bay	1995,96
	Hawke's Bay	1997
Ngatai D.	Wanganui	1980
Ngawati K.A.A.	Auckland	1954
Ngawati P.J.	North Auckland	1957
Nicholls J.J.	Manawatu	1963
Nikera D.	Hawke's Bay	1911
Noble M.R.	Wellington	1974
Nohokau H.	Hawke's Bay	1912
Norton R.W.*	Canterbury	1969-75,77
Nuku J.W.	Bay of Plenty	1964
Nuku R.	South Auckland	1910
	Bay of Plenty	1911-13
Nunn R.	Wairarapa	1932
O'Carroll F.K.	Taranaki	1976,79,80-82
O'Connor M.	South Canterbury	1936
Olney T.T.	Wanganui	1976
Olsen O.S.	North Auckland	1925,26
Orme A.F.	Canterbury	1961
Ormond A.	Canterbury	1911
Osborne G.M.*	North Harbour	1994,96
Osborne W.M.*	Wanganui	1975,77,78,80
	Waikato	1985
Oxley R.	Wanganui	1930,31
Paea J.M.	East Coast	1954
	Poverty Bay	1955
Paewai H.J.	Hawke's Bay	1969
Paewai L.*	Hawke's Bay	1923
	Auckland	1927,28
Paewai M.N.	Wellington	1946
	North Auckland	1950,51
Paewai M.R.	Hawke's Bay	1992,94
Paewai N.H.	Hawke's Bay	1996
Paiaka H.J.	King Country	1957-61,63-66
Paki G.	South Auckland	1913
Paki Paki G.M.	Taranaki	1971
	Wanganui	1976
Papakura S.	Southland	1913
Paponi C.	Bay of Plenty	1923
Parahi G.K.	Hawke's Bay	1948,49,52
Parai P.	Wellington	1931,32
Parakuka S.	Bay of Plenty	1922,25
Parata N.S.	Wellington	1989
Parata P.	Otago	1935
Parata T.	Manawhenua	1929
Parata W.	Manawhenua	1928,29
Paratene M.	Poverty Bay	1910
	Wairarapa	1911
Park R.	Wellington	1922
Parkinson H.D.	Bay of Plenty	1960
Parkinson R.M.*	Auckland	1970
	Poverty Bay	1972,74
Parr R.S.	King Country	1955
Pearson K.	North Auckland	1948
Pelham R.	Auckland	1926,27
	Wellington	1928-30
Pene A.R.B.*	Otago	1993-95
Pepere G.	East Coast	1936
Petiha M.	Hawke's Bay	1911
Pewhairangi E.	Poverty Bay	1911
Philips C.M.	North Auckland	1986
Phillips G.	Bay of Plenty	1913
Phillips G.R.	North Auckland	1972,73
Phillips H.	Marlborough	1921,22,25,26
Phillips H.W.	Counties	1957
	Hawke's Bay	1958-60
Phillips W.J.*	King Country	1934-36
	Waikato	1939
Pickrang N.A.M.	Waikato	1969,71
	Otago	1973,76
Piki S.M.J.	Canterbury	1910,11,13
Pile J.H.	Auckland	1939
Pine W.	Wanganui	1927,28
Pitahira R.	Manawatu	1910
Poananga H.	Auckland	1910,11
Poi W.	East Coast	1923
Pokere S.T.*	Southland	1981-83
	Auckland	1985,87
Porima J.T.	Waikato	1959-61,63-66
Porohiwi H.	Hawke's Bay	1911
Potae H. Te M.P.	Bay of Plenty	1955
	East Coast	1956
Potae W.J.	Bay of Plenty	1964-66
Potaka R.	Wanganui	1932
Potaka W.*	Wanganui	1922,23,26,27
Pratt C.	Wanganui	1921
Preston R.J.	Bay of Plenty	1986,91
Prince A.R.	Nelson Bays	1993,94
Proctor I.	North Auckland	1946,47
	Auckland	1948
Pryor A.	Bay of Plenty	1952,54,55
	Auckland	1956-60
Pryor K.F.	Bay of Plenty	1993
Puke H.	Waikato	1947
Puketapu l.P.	Wellington	1955
Purdue G.B.*	Southland	1931
Quinn P.B.	Wellington	1979,80,82
Rabarts M.G.	Thames Valley	1976
Raki L.E.	Counties	1985,86,88-90
Ralph C.S.	Bay of Plenty	1996,97
Ramsbotham G.	Horowhenua	1946
Ranapia H.	Bay of Plenty	1947,48
Randell T.C.*	Otago	1996
Randle R.Q.	Hawke's Bay	1996
Rangi R.E.*	Auckland	1963-66
Ransley P.S.R.	Poverty Bay	1961,64,65
Ranui J.W.	Bay of Plenty	1984,86,90
Ranui P.	Bay of Plenty	1971,75
Raroa U.	East Coast	1928,29
Rata J.	King Country	1928,31
Ratima J.	King Country	1950
Ratima T.	Wairarapa	1911
Raureti L.F.	Bay of Plenty	1949
Raureti M.H.	Waikato	1956-60

Rawhiri H.	Horowhenua	1910,11,14
Reardon R.W.	Waikato	1965,66
Reedy J.C.	East Coast	1935
Reedy K.	East Coast	1935
Reedy T.M.	East Coast	1960
Reid H.R.*	Bay of Plenty	1982,83, 87,88
Reid S.T.*	East Coast	1930,31
	Hawke's Bay	1936,49
Rene J.	Wellington	1927
Reside W.B.*	Wairarapa	1928,30
Rickit H.*	Waikato	1978,81,82
Rika M. see Heke M.R.		
Rika W. see Heke W.R.		
Roberts M.	Horowhenua	1922,23
Robertson W.	South Canterbury	1936
Robinson J.T.*	Canterbury	1929
Robinson T.	Taranaki	1929,30
Robinson T.P.	Canterbury	1926,30,32
Rogers B.E.	Poverty Bay	1934-36
Rogers G.	South Auckland	1910
	Bay of Plenty	1911-14
Rogers J.J.	Waikato	1970
Rogers T.E.	West Coast	1964
Rogers W.A.	North Auckland	1963-65
Ropata E.J.	Horowhenua	1934
Ropata K.	Marlborough	1930,31
Rota D.T.	Auckland	1969
Rowlands W.N.	Wairarapa	1969,70
	Wairarapa-Bush	1976
Rua W.	South Auckland	1910
Rukingi W.	Poverty Bay	1913
Ruru J.H.	Hawke's Bay	1927,30
	Wellington	1931
Ruru R.	Taranaki	1927
Ruru T.	Taranaki	1923
Rush E.J.*	Auckland	1987-90
	North Harbour	1992-94, 96,97
Rutene H.	Poverty Bay	1959,60
Ryland C.	Poverty Bay	1910-14
Sargeant C.	Bay of Plenty	1923
Sciascia C.R.	Horowhenua	1913
Sciascia G.J.	Horowhenua	1948
Sciascia J.de T.	Horowhenua	1910,13
Scott M.W.	Auckland	1992,94,97
Sellars G.M.V.*	Auckland	1910,12,14
Sellars R.	Auckland	1912
Semenoff S.	North Auckland	1979
Seymour D.J.*	Canterbury	1992
	Hawke's Bay	1996
Seymour T.	Hawke's Bay	1927
Shelford D.M.	Bay of Plenty	1989,90
Shelford F.N.K.*	Bay of Plenty	1979-82
	Hawke's Bay	1983
	Bay of Plenty	1984,85
Shelford W.T.*	Auckland	1982,83
	North Harbour	1985,87-90
Shortland W.H.	Hawke's Bay	1926
	North Auckland	1928
Simonsson P.L.J.*	Waikato	1988,89
Simpkins T.	Bay of Plenty	1911
Simpson V.L.J.*	Canterbury	1981,82
Skipper G.W.	Wellington	1975-77
Skudder G.R.*	Waikato	1968,69, 72,73
Small D.	Southland	1910,11,13
Smith B.	Auckland	1986
Smith C.	Hawke's Bay	1934,35
Smith J.B.*	North Auckland	1948,51,52
Smith P.	Hawke's Bay	1932,34, 35,38,39
Smith P.*	North Auckland	1946,49-51
Smith R.P.	North Auckland	1965
Smith S.	Hawke's Bay	1927
Smith T.A.	Hawke's Bay	1946-48
Solomon F.*	Auckland	1927
Sparks W.R.	Otago	1957
Spencer C.J.*	Horowhenua	1994
	Auckland	1996
Stead J.W.*	Southland	1910
Stead N.F.	Southland	1922

Stead R.M.	Southland	1911
Steele H.A.	Otago	1938,39
Stewart J.	Otago	1926
Stewart V.E.*	Canterbury	1974-77,79
Stirling C.W.	North Auckland	1946,49
Stokes E.J.T.*	Bay of Plenty	1972-79
Stone A.M.*	Waikato	1982,83,86
	Bay of Plenty	1987
	Otago	1988
Stone R.S.	Otago	1989
	Bay of Plenty	1994,95
Stroud B.L.	Taranaki	1963
Subritzky R.	North Auckland	1960
Swainson A.	Hawke's Bay	1925
Tahiwi P.	Horowhenua	1913
Taiapa P.	Poverty Bay	1921
	East Coast	1922,23
Tainui G.	West Coast	1911
Tairoa M.	Bay of Plenty	1914
Taitoko J.D.P.	Wellington	1956,57,60
	Manawatu	1963,64
Taituha P.*	Wanganui	1921-23, 27
also known as T. Peina and as T.P. Kingi		
Taiuru J.	Wanganui	1927
Taiuru M.	Wanganui	1931
Takarangi A.	Wanganui	1910,11,13
Tamu H.	Taranaki	1910
Tangaere H.J.	Otago	1973
Tangira W.	East Coast	1952
Tangitu I.	Bay of Plenty	1934
Tangitu T.	Bay of Plenty	1921,22
Tapsell H.	Bay of Plenty	1913
Tapsell P.W.	Auckland	1954
Tapsell W.	Bay of Plenty	1921
Tatana D.	Manawhenua	1925,26, 28,29
Tataurangi T.W.M.	Auckland	1969
Tate T.	Auckland	1922
Taylor W.H.	Golden Bay-Motueka	1949,50
Tauroa E. Te R.	Manawatu	1951
	Taranaki	1954
Te Haara J.L.	North Auckland	1947,48
Te Mata F.P.	Waikato	1968
Te Ngaio E.	Hawke's Bay	1927
Te Paa M.W.	North Harbour	1988
Te Pou M.J.K.	Thames Valley	1996
Te Puni D.R.	Northland	1994
Te Puni T.H.	Wellington	1951
Te Wahia J.	Otago	1913
Te Whata W.	Poverty Bay	1921
Thomas M.	Bay of Plenty	1921
Thompson E.J.	North Auckland	1958,60, 61,63
Thompson R.J.	Bay of Plenty	1968
Thomson P.H.	Auckland	1996,97
Tibble N.	Poverty Bay	1968
Tibble T.	East Coast	1932
Timu J.K.R.*	Otago	1988,90-92,94
Tipene C.	Otago	1910,11,13
Toki J.M.	North Auckland	1963,64
Toki L.	Auckland	1977-79
Toki N.	Auckland	1970,71
Tresize F.L.	Auckland	1912-14, 22,23
Tuhakaraina H.A.	Auckland	1973
also known as H.A. Tu		
Tuhoro D.	East Coast	1938,39
Tuhoro W.	East Coast	1932
Tuoro P.S.	Counties	1980-85
Tupaea M.W.	Wanganui	1947
Tureia P.	Poverty Bay	1921,23
Turei P.	Poverty Bay	1914
Turei W.T.	Hawke's Bay	1927
	Auckland	1928
Vercoe H.R.	Bay of Plenty	1914
Waaka T.J.	Auckland	1972,73
	Bay of Plenty	1974,76,77
	North Auckland	1978
Waaka W.	Wairarapa	1950

Waiariki A.T.R.	Marlborough	1968
Waiariki H.J.	Auckland	1959
Waiatua H.	Bay of Plenty	1912
Wainohu R.M.	Canterbury	1963,64
Walford J.A.	East Coast	1931,32
Walker F.B.H.	Wellington	1973,79
Walker J.	Hawke's Bay	1923
Walker J.	Wairarapa	1932
Walker R.	Southland	1957,58, 61
Walker R.H.	Bay of Plenty	1963,65, 66
Walker W.	Bay of Plenty	1912,14
Waller D.A.G.	King Country	1996
	Manawatu	1997
Walsh P.T.*	South Auckland Counties	1955
	Counties	1956,58,59
	Auckland	1961
Walters M.	Otago	1954
	North Auckland	1956-61, 63
Wanoa D.C.	Bay of Plenty	1979
Wanoa N.	Hawke's Bay	1927,30,31
Warbrick P.	Auckland	1910
Warlow W.S.	Waikato	1992,94
Wattereus G.J.	Canterbury	1964,65
Watson R.	Taranaki	1930-32
	Nelson	1934
Watts R.A.M.	King Country	1992
Wehi M.	Wanganui	1938
West A.J.	Southland	1939
	Taranaki	1946
	Auckland	1947,49
West M.G.	Wellington	1974
	Nelson Bays	1977
Wetere J.H.	Taranaki	1938
Wetere K.	Taranaki	1932
Wetere W.	King Country	1931,32
Whatarau E.H.	South Auckland Counties	1955
	Counties	1956,60
	East Coast	1957,58
Whiley B.L.	Horowhenua	1976
White C.	North Auckland	1938
White D.R.	Waikato	1956
White R.P.	North Auckland	1936,39
Whiteley T.E.	Bay of Plenty	1935,39
Whiu H.	North Auckland	1935,36
Whiu H.K.	Auckland	1976-78
Whiu P.W.	North Auckland	1954,55
Wi Hapu W.	Poverty Bay	1922
Wiki H.	Auckland	1979
Williams D.R.	Auckland	1987
Wllliams P.C.	Mid-Canterbury	1976
Wilson A.J.	Bay of Plenty	1954,56,57
Wilson W.H.	Hawke's Bay	1926-28,31
Wi Neera D.	Wellington	1926,27
Winiata J.	Waikato	1993,94
Winiata K.	Hawke's Bay	1921
Winiata M.	Horowhenua	1910,11, 13,14
Winiata R.W.	Horowhenua	1939
Winiata T.	Horowhenua	1923
Winiata W.	Horowhenua	1910,11
Winitana V.	Wellington	1970,71
Winterburn A.	Horowhenua	1966
Wi Repa R.T.	East Coast	1938,39
Wirepa R.W.	Wellington	1960,61, 63,64
Witoenga R.	Bay of Plenty	1912
Woodman F.A.*	North Auckland	1978-81
Woodman T.B.K.*	North Auckland	1982-85,88
Woods C.	Bay of Plenty	1913
Wordley A.W.	North Auckland	1938
Wordley W.R.	King Country	1958-61, 64-66
Wyllie T.*	Wellington	1979,80,82
Yates P.	Counties	1973,76, 77,79
Yates R.	North Auckland	1961
Yates V.M.*	North Auckland	1961,63,64

Services Rugby

The earliest references to services rugby in New Zealand involve matches arranged between sailors and local teams in Auckland, Wellington and Nelson.

In June 1870, at the Albert Barracks in Auckland, sailors from HMS *Rosario* beat a team of local players. Although this game was played under 'Westminster Rules' — a combination of Victorian rules and association football — it led to the formation of the Auckland club which adopted the rules of rugby in 1873 and founded the game there. HMS *Rosario* also played a team of Wellingtonians later in 1870.

A team from HMS *Blanche* met Nelson in 1874, losing by two goals to nil.

Another form of armed services to foster the growth of rugby was the Armed Constabulary, formed during the New Zealand Wars. Teams comprising members of this combined military and police force played the Wellington club in 1871 and Wanganui two years later. A member of the Armed Constabulary team in the latter match, Thomas Eyton, was to become the promoter of the 1888-89 New Zealand Native team.

From this time until the beginning of the twentieth century when soldiers from New Zealand contingents in the Boer War took part in matches in South Africa, little was recorded of services rugby. Few details are available about matches played in South Africa although it is known that such players as Dave Gallaher (later captain of the 1905-06 All Blacks), Bill Hardham (who won the VC at Naauwpoort) and 'Bunny' Abbott all played there while serving with various New Zealand contingents.

When the First World War began, volunteers to join up included many rugby players. Interisland and Ranfurly Shield matches were suspended from 1915 to 1918 and the representative programme severely curtailed with most games played being confined to men below military age. Matches were played between reinforcements in camp at Trentham and a Wellington team in May 1915 and an Auckland side in June. Further matches between military teams and local sides occurred in 1917 and 1918 as well as games between various camps. New Zealand soldiers serving overseas played when the opportunity arose in France, Palestine, Egypt and Great Britain.

SOMME CUP 1917

A New Zealand Division team won the Somme Cup contested among servicemen in France in 1917. Military censorship prevented much detail on this competition being available beyond the results:

v a British Division	won	74-3
v a British Division	won	44-0
v Royal Engineers	won	22-0
v a Welsh Division	won	18-3
v an Irish Division	won	49-3
v Royal Flying Corps	won	82-0
v a Welsh Division	won	3-0
v France	won	40-0
v NZ Hospital (Amiens)	won	44-0

Summary:
Played 9, won 9
Points for 376, against 9

The New Zealand Mounted Rifle Brigade Training Unit won the Moascar Cup in a rugby tournament in Egypt. This trophy was presented by Lt Col E.J. Hulbert on behalf of the brigade to the New Zealand Rugby Football Union in 1919 and it was allocated for competition between secondary schools.

Rugby became a major interest for troops awaiting return home. A 'United Kingdom' team, made up of New Zealanders from the various training camps and administrative depots, played a series of matches during December 1918 and January 1919 including a loss to a Welsh XV at Swansea and a draw in a return game at Cardiff. By the middle of January a team made up from soldiers who had been serving in France at the time of the Armistice had been formed. This 'Trench' or 'Divisional' fifteen met the 'United Kingdom' team at Richmond, on January 18, 1919, for the purposes of selecting a New Zealand Army team to contest the King's Cup.

The following players took part in that match, won 5-3 by the 'Divisional' selection:

'DIVISIONAL' XV

Backs: Bom C.H. Capper* *Field Artillery*; Bom G.L. Owles* *Field Artillery*; Pte L. Stohr* *Medical Corps*; Rfn W.A. Ford* *Rifle Brigade*; Cpl G.A.T. Yardley *Auckland Inf Regt*; RSM J. Ryan* *Otago Inf Regt*; Cpl C. Brown* *Field Engineers*.

Forwards: Gnr A.A. Lucas* *Field Artillery*; Gnr A.H. West* *Field Artillery*; Pte E.A. Belliss* *Otago Inf Regt*; Gnr R.W. Bilkey *Field Artillery*; Gnr A. Gilchrist* *Field Artillery*; Pte J.B. Douglas* *Otago Inf Regt*; Gnr S.J. Standen* *Field Artillery*; Sgt E.J. Naylor* *Otago Inf Regt*.

'UNITED KINGDOM' XV

Backs: Cpl J.G. O'Brien* *HQ*; Sgt P.W. Storey* *Bulford*; Lt E.A.P. Cockroft* *Belton Park*; Rfn R.W. Roberts* *Brocton*; Lt G.J. McNaught* *Cambridge*; Pte W.L. Henry* *Bulford*; Sgt F. Juno *Codford*.

Forwards: Cpl H.V. Murray *Grantham*; Sgt R. Fogarty* *Boscombe*; Spr J. Kissick* *Boscombe*; Pte P. Allen* *Boscombe*; Spr J.A. Bruce* *Boscombe*; Sgt N.A. Wilson* *HQ*; Spr R. Sellars *Sevenage*; Bom E.W. Hassell* *HQ*.

KING'S CUP 1919

Many of these players were included in the New Zealand Army team which played a series of matches for the King's Cup presented by King George V. Those indicated * in the 'Divisional' and 'United Kingdom' teams participated in one or more of the games together with:

Backs: Bom E. Ryan *Field Artillery*; Sgt E. Watson *Wellington Inf Regt*; Rfn W.R. Fea *Rifle Brigade*; Pte D.M. Sandman *Canterbury Inf Regt*.

Forwards: Pte M.J. Cain *Otago Inf Regt*; Sgt F.P. Arnold *Auckland Inf Regt*; C.W. Tepene *Otago Inf Regt*; Pte A.P. Singe *Auckland Inf Regt*; Cpl H.G. Whittington *Rifle Brigade*; Lt J.E. Moffitt *Auckland Inf Regt*; Sgt E.L.J. Cockroft *Field Artillery*.

The New Zealand Army team, captained by Jimmy Ryan, won the King's Cup, played at various venues in 1919, with the following record:

v Royal Air Force *at Swansea*	won	22-3
v Canadian Expeditionary Force *at Portsmouth*	won	11-0
v South African Forces *at Twickenham*	won	14-5
v Mother Country *at Edinburgh*	won	6-3
v Australian Imperial Forces *at Bradford*	lost	5-6
v Mother Country *Final at Twickenham*	won	9-3

Summary:
Played 6, won 5, lost 1
Points for 67, against 20

As well as the King's Cup tournament, the New Zealand Army team played 32 other games in Britain and France, winning 28, drawing three and losing only to Monmouthshire 3-4.

NEW ZEALAND ARMY TEAM IN SOUTH AFRICA 1919

An invitation was accepted from the South African Rugby Board for the Army team to make a tour on the way home. Because of the colour bar in South Africa, 'Ranji' Wilson, an outstanding member of the King's Cup team and a pre-war All Black, was not able to go. It is interesting to note that members of this team received sudden promotions in rank before the tour:

Backs: Sgt-Maj J.G. O'Brien; Sgt W.L. Henry; Sgt L. Stohr; Sgt E. Ryan; Sgt W.A. Ford; St Sgt P.W. Storey; Sgt R.W. Roberts; Sgt W.R. Fea; Lt G.J. McNaught; Sgt-Maj J. Ryan; St Sgt C. Brown; Sgt D.M. Sandman.

Forwards: Sgt A.A. Lucas; Sgt A.P. Singe; Sgt M. Cain; St Sgt H.G. Whittington; Sgt S.J. Standen; St Sgt E.W. Hasell; Lt J.E. Moffitt; Sgt J.A. Bruce; Sgt J. Kissick; Sgt A.H. West; Sgt E.A. Belliss; Sgt A. Gilchrist; St Sgt R. Fogarty; St Sgt E.J. Naylor; St Sgt E.L.J. Cockroft.

Captain: St Sgt C. Brown.
Manager: Lt R.W. Baumgart.
Assistant Manager: Lt E.W. King.

Percy Day, the South African manager of the tour and manager of the 1937 Springbok team in New Zealand, commented: "I have never been associated with a more

Charlie Brown, later to captain the 1919 New Zealand Army team in South Africa, is introduced before the King's Cup final at Twickenham to three kings – George V (shaking hands), the Prince of Wales (later Edward VIII) and the Duke of York (later George VI).

gentlemanly, sportsmanlike body of footballers . . . In my considered opinion, the best fifteen of the Services team was superior to the best fifteen the 1928 All Blacks could field in this country. Being all ex-soldiers, their team-work and team spirit were alike admirable, and they blended into a most workmanlike side."

Tour record:
First match 24 July,
last match 16 September 1919

v Western Province *at Cape Town*	won	8-6
v Capetown Clubs *at Cape Town*	drew	3-3
v South Western Districts *at Oudshoorn*	won	23-0
v Eastern Province *at Port Elizabeth*	won	15-0
v Orange Free State *at Bloemfontein*	won	16-5
v Griqualand West *at Kimberley*	lost	3-8
v Witwatersrand *at Johannesburg*	won	6-0
v Rand Mines *at Johannesburg*	won	24-3
v Pretoria Clubs *at Pretoria*	won	5-4
v Transvaal *at Johannesburg*	won	5-3
v Natal *at Durban*	won	17-3
v Western Province Universities *at Cape Town*	lost	8-9
v Western Province *at Cape Town*	lost	6-17
v Western Province *at Cape Town*	won	20-3
v Natal *at Durban*	won	11-4

Summary:
Played 15, won 11, lost 3, drew 1
Points for 170, against 68

After their return home in October 1919, the Services team beat Auckland 19-6 and in May 1920, reassembled and including 'Ranji' Wilson in their team, ended their highly successful association with a 23-8 victory over Wellington.

In comparison with the First World War when little rugby was played at home or overseas, the Second World War saw a great deal of the game in both arenas. At home, services teams started to play in club competitions in some unions. Papakura Army won the Gallaher Shield in Auckland in 1941, Motor Transport Pool in 1942 and Garrison Artillery in 1943 while the Air Force and Army fielded senior teams in the Wellington and Christchurch competitions, Air Force A winning the latter championship in 1942.

Interisland army matches were played in 1942, '43 and '44. The RNZAF held a North v South game in 1943, the Army met the Air Force in the same year, the Navy played the 1st New Zealand Division and various units, brigades and battalions organised matches throughout the duration of the war. A Combined Services team played a New Zealand XV in 1944 and 1945.

Overseas, anywhere a suitable number of New Zealanders were gathered, in transit, at the front and even in prisoner-of-war camps, and a ball fashioned, rugby was a popular escape from the grim realities of warfare. If enough representatives of another country could be mustered to provide the opposition, so much the better.

As early as March 1940, just a few weeks after the arrival of the 2nd NZ Expeditionary Force in Egypt, a competition was held between the various battalions and units. The final was played on 30 March and won by the 19th Battalion captained by Jack Griffiths, an All Black in 1934, '35, '36 and '38. General Freyberg,

himself an old representative player, was so impressed with the high standard of play in this tournament that he presented a trophy to be called the Divisional Commander's Cup (later commonly known as the Freyberg Cup) for inter-unit competition:

1940	19th Battalion 11; 27th Machine Gun Battalion 0
1941	32nd Reinforcement Battalion beat Divisional Cavalry
1942	no competition
1943	28th Maori Battalion 9; Divisional Signals 5
1944	22nd Battalion 4; 2nd Ammunition Coy 0

The original 2nd NZ Expeditionary Force team (including such notable players as Jack Griffiths and Tom Morrison) had its first match on 26 March, 1940, defeating Combined Services 20-0 at Zamalek in Egypt. They were strengthened by the arrival of the 2nd Echelon (with ex-All Blacks Eric Tindill, Frank Solomon and Cyril Pepper) who had played in Cape Town in May 1940 and in England from October to December.

The game was enjoyed by servicemen throughout the Pacific and, although not as well publicised as in the Middle East or Britain, the competition among New Zealanders was keen and chances to meet other services on the football field welcomed. An inter-unit competition was held in Fiji with the RNZAF and sailors from HMS *Leander* were also seen in action. In New Caledonia, New Zealand battalions staged a knock-out competition for a cup bearing the name of the Divisional Commander, Major-General H.E. Barrowclough, won by the 37th Infantry Battalion in 1943. A team captained by Fred Allen and selected from the Third Division newly returned from Fiji defeated Auckland 20-13 in 1942 — an indication of the standard of play which developed on the hard and hot grounds of the Pacific Islands.

NEW ZEALAND SERVICES TEAMS IN BRITAIN 1941-46

Rugby enthusiasts serving in the RNZAF formed a New Zealand Services team in England which played regularly from 1941 to January 1946, incorporating Navy and Army personnel as they arrived in the United Kingdom:

1941-42: Played 7, won 3, lost 4
Points for 68, against 81

1942-43: Played 12, won 7, lost 5
Points for 108, against 102

1943-44: Played 12, won 8, lost 2, drew 2
Points for 113, against 63

1944-45: Played 20, won 9, lost 10, drew 1
Points for 284, against 239

1945-46: Played 22, won 19, lost 2, drew 1
Points for 359, against 112

The team was subject to the constant demands of active service operations and seldom fielded the same team twice. Six of the team's players took part in war-time internationals: Pilot Officer O.W. Knight, Leading

The 1945-46 NZEF 'Kiwis'
Back row: R.L. Dobson, E.G. Boggs, N.J. McPhail, K.D. Arnold, W.A. Meates, N.H. Thornton, J.G. Bond, D.S. Bell, F.N. Haigh, R.W.H. Scott.
Third row: P.J. Guyton (masseur), J.G. Simpson, J.R. Sherratt, G.B. Nelson, DSO, L.A. Grant, S.L. Young, A.W. Blake, S.W. Woolley, W.G. Argus, J.A. Gasson (press correspondent).
Second row: V.C. Butler (assistant manager and selector), R.D. Johnstone, P.K. Rhind, C.K. Saxton (captain), A.H. Andrews, OBE (manager), J. Finlay, MC (vice captain), J.B. Smith, F.R. Allen, W.J. McCarthy (radio commentator).
Front row: W.S. Edwards, I. Proctor, H.E. Cook, J.C. Kearney, M.S. Ingpen, A.N. King.
Absent: J. Maclean

Air Craftsman J.H. MacDonald, Flight Sgt I.H. Dustin and Flight Sgt M.P. Goddard (England); Flying Officer E. Grant and Pte R.M. McKenzie (Scotland). McKenzie had represented New Zealand from 1934 to 1938 and Goddard was to represent his country in 1946, '47 and '49. Others who had or were to represent New Zealand included: Ray Dalton, Bob Stuart, Roy Roper, Ian Botting, Pat Rhind, Lachie Grant, Bill Meates, Ron Dobson, Bob Scott and Clinton Stringfellow. Details of these players can be found in the chapters on *New Zealanders Capped Overseas* and *New Zealand Representatives*.

THE 'KIWIS' 2nd NZEF ARMY TEAM IN BRITAIN AND EUROPE

In 1945 trials were held in Austria, Egypt and England to select a 2nd NZEF team for a tour of the United Kingdom, France and Germany – an idea fostered by General Freyberg. A total of 64 players were assembled to appear in the final trials held in England during October 1945; 29 were chosen for the Kiwis, Grant and Ingpen being added to the team as reinforcements during the year.

Backs: Tpr H.E. Cook *19th Armoured Regt*; Dvr R.W.H. Scott *ASC Tank Trans*; Dvr W.G. Argus *ASC Tank Trans*; Cpl E.G. Boggs *27th Inf Bn*; Tpr J.C. Kearney *18th Armoured Regt*; Pte W.A. Meates *Middle East Inf*; Lt J.R. Sherratt *22nd Inf Bn*; Pte J.B. Smith *21st Inf Bn*; Lt F.R. Allen *27th Inf Bn*; L/Bom R.L. Dobson *6th Field Artillery Regt*; Gnr A.N. King *Anti-Tank Regt*; Pte I. Proctor *21st Inf Bn*; Pte W.S. Edwards *NZEME*; Mjr C.K. Saxton *19th Armoured Regt*.

Forwards: Pte K.D. Arnold *21st Inf Bn*; Gnr D.S. Bell *4th Field Artillery Regt*; Tpr A.W. Blake *20th Armoured Regt*; Pte J.G.P. Bond *26th Inf Bn*; Mjr J. Finlay *25th Inf Bn*; Sgt L.A. Grant *Div Cavalry Regt*; Pte F.N. Haigh *Middle East Inf*; Pte M.S. Ingpen *Middle East Inf*; Pte R.D. Johnstone *NZEME*; Dvr J. Maclean *NZASC*; Capt N.J. McPhail *20th Inf Regt*; Mjr G.B. Nelson *18th Armoured Regt*; Capt P.K. Rhind *20th Inf Bn*; Pte J.G. Simpson *25th Inf Bn*; Lt N.H. Thornton *4th Brigade HQ*; Cpl S.W. Woolley *23rd Inf Bn*; Cpl S.L. Young *27th Inf Bn*.

Captain: C.K. Saxton.
Manager: Col A.H. Andrews *HQ*.

As a guide to the calibre of the 'Kiwis' it should be noted that 16 of the touring party later represented New Zealand and Saxton had been an All Black in 1938.

Tour record:
First match 27 October, 1945
last match 31 March, 1946

v Swansea *at Swansea*	won	22-6
v Llanelli *at Llanelli*	won	16-8
v Neath *at Neath*	won	22-15
v Northern Services *at Headingley*	won	14-7
v Ulster *at Belfast*	won	10-9
v Leinster *at Dublin*	drew	10-10
v England *at Twickenham*	won	18-3
v British Army *at Bristol*	won	25-5
v Royal Air Force *at Leicester*	won	11-0
v Royal Navy *at Portsmouth*	won	6-3
v London Clubs *at White City*	won	30-0
v Cardiff *at Cardiff*	won	3-0
v Newport *at Newport*	drew	3-3
v Wales *at Cardiff*	won	11-3
v Combined Services *at Gloucester*	won	31-0

v Scotland *at Edinburgh*	lost	6-11
v Scottish Universities *at Glasgow*	won	57-3
v Midlands XV *at Coventry*	won	24-9
v Leicestershire & East Midlands *at Leicester*	won	14-0
v Northern Counties *at Newcastle*	won	25-8
v Yorkshire, Lancashire & Cheshire *at Manchester*	won	41-0
v Oxford University *at Oxford*	won	31-9
v Devonshire & Cornwall *at Torquay*	won	11-3
v Cambridge University *at Cambridge*	won	15-7
v Gloucestershire & Somersetshire *at Bristol*	won	11-0
v Monmouthshire *at Pontypool*	lost	0-15
v Aberavon *at Aberavon*	won	17-4
v France *at Paris*	won	14-9
v British Army of the Rhine *at Wuppertal*	won	12-0
v BAOR Combined Services *at Hamburg*	won	20-3
v France *at Toulouse*	won	13-10
v A French selection *at Bordeaux*	won	38-9
v L'Ile de France *at Paris*	won	24-13

Summary:
Played 33, won 29, lost 2, drew 2
Points for 605, against 185

This tour, outstanding not only in terms of matches won but in which some brilliant attacking rugby was played, created intense public interest both in Britain and in New Zealand. The 'Kiwis' gave evidence of their great skills and team spirit by playing five games against provincial sides on their return home.

v Auckland *at Auckland*	drew	20-20
v Wairarapa-Bush *at Masterton*	won	21-10
v Canterbury *at Christchurch*	won	36-11
v Otago *at Dunedin*	won	19-8
v Wellington *at Wellington*	lost	11-18

COMBINED SERVICES in AUSTRALIA, 1952

v Canberra Services *at Canberra*	won	38-8
v Combined Australian Universities *at Sydney*	won	17-9
v Australian United Services *at Sydney*	won	15-3
v New England *at Tamworth*	won	24-16
v Queensland Services *at Brisbane*	drew	11-11

The team included former All Black Rex Orr and future All Black Stan Hill.

NEW ZEALAND SERVICES in FIJI, 1964

v Western Union *at Lautoka*	won	9-3
v Nadroga *at Sigatoka*	won	15-11
v Fiji Combined Services *at Suva*	won	30-6
v Suva-Rewa *at Suva*	won	28-9

COMBINED SERVICES in NEW ZEALAND AND AUSTRALIA, 1970

v Marlborough *at Blenheim*	drew	6-6
v Australian Services *at Duntroon*	drew	14-14
v Riverina *at Wagga Wagga*	won	31-6
v President's XV *at Brisbane*	won	43-3
v Barbarians *at Sydney*	won	15-11

NEW ZEALAND SERVICES in AUSTRALIA, 1978

v New South Wales Services *at Sydney*	won	29-9
v Queensland Services *at Brisbane*	won	11-3
v Victorian Services *at Melbourne*	won	13-4
v Australian Combined Services *at Canberra*	won	18-0

The team was captained by All Black Stu Conn and included a future All Black captain, Wayne Shelford.

NEW ZEALAND SERVICES in NEW ZEALAND, 1981

v Thames Valley *at Te Aroha*	won	26-6
v an Auckland XV *at Auckland*	won	4-3
v East Coast *at Te Araroa*	won	42-3
v Poverty Bay *at Gisborne*	won	20-3

Captained by Conn and again included Shelford.

COMBINED SERVICES in NEW ZEALAND, 1983

v Wellington *at Wellington*	lost	15-32
v Mid Canterbury *at Ashburton*	won	18-16
v South Canterbury *at Timaru*	won	34-15
v North Otago *at Oamaru*	won	25-12
v Otago *at Dunedin*	won	26-19

Shelford and another future All Black, Murray Pierce, were members.

COMBINED SERVICES in NEW ZEALAND, 1984

v Wellington *at Wellington*	won	15-3
v South Canterbury *at Timaru*	won	16-6
v A Canterbury XV *at Christchurch*	lost	21-39
v King Country *at Taumarunui*	won	22-12
v Wanganui *at Wanganui*	won	32-12

A former All Black, Geoff Old, played against Wellington.

COMBINED SERVICES in NEW ZEALAND and BRITAIN, 1985

| v Manawatu *at Palmerston North* | won | 27-17 |

The match formed part of the 40th anniversary reunion of the 1945-46 Kiwis.

v Royal Air Force *at Brize Norton*	won	26-9
v British Army *at Aldershot*	won	37-6
v British Police *at Cardiff*	won	60-0
v Salisbury Selection *at Salisbury*	won	39-6
v Royal Navy *at Portsmouth*	won	36-6
v UK Combined Services *at Devonport*	won	41-0
v Public School Wanderers *at Sudbury*	won	19-3
v Middlesex County Clubs *at Osterley*	won	22-6

The team was captained by Wayne Shelford.

COMBINED SERVICES in NEW ZEALAND, 1986

v Waikato *at Hamilton*	lost	13-37
v Taranaki *at New Plymouth*	lost	14-23
v Hawke's Bay *at Hastings*	lost	6-19
v Horowhenua *at Levin*	won	47-9

NEW ZEALAND POLICE, 1986

| NZ Police v Manawatu *at Palmerston North* | lost | 6-24 |

This match marked the centenary of the police.

COMBINED SERVICES in NEW ZEALAND, 1987

v Counties *at Pukekohe*	lost	12-16
v North Auckland *at Whangarei*	lost	9-21
v North Harbour *at Takapuna*	lost	9-37
v Waikato *at Hamilton*	lost	13-62

COMBINED SERVICES in NEW ZEALAND, 1988

v Horowhenua *at Levin*	won	45-3
v Wairarapa-Bush *at Masterton*	lost	0-26
v British Combined Services and Police *at Wellington*	drew	19-19
v Nelson Bays *at Nelson*	won	65-3
v Marlborough *at Blenheim*	lost	12-20

COMBINED SERVICES in NEW ZEALAND, 1989

v South Canterbury *at Timaru*	won	44-13
v Otago *at Dunedin*	lost	13-21
v East Coast *at Ruatoria*	won	21-19
v Poverty Bay *at Gisborne*	won	14-13
v Thames Valley *at Te Aroha*	lost	13-20

COMBINED SERVICES in NEW ZEALAND, 1990

v Wanganui *at Wanganui*	won	48-15
v West Coast *at Greymouth*	won	43-0
v Buller *at Westport*	won	27-3

The side was coached by Gordon Hunter, future Otago coach and All Black selector.

COMBINED SERVICES in NEW ZEALAND, 1991

| v Thames Valley *at Paeroa* | won | 41-9 |
| v North Harbour *at Takapuna* | drew | 19-19 |

COMBINED SERVICES in NEW ZEALAND, 1992

v Royal Navy *at Takapuna*	won	50-3

COMBINED SERVICES in ENGLAND 1992

v Hampshire *at Havant*	won	33-9
v Royal Navy *at Plymouth*	won	28-6
v Cornwall *at Redruth*	won	13-6
v British Police *at Northampton*	won	25-3
v Royal Air Force *at Brize Norton*	won	36-0
v British Army *at Aldershot*	won	54-10
v British Combined Services and Police *at London*	won	39-23

The team was again coached by Hunter.

COMBINED SERVICES in NEW ZEALAND, 1993

v Wairarapa-Bush *at Masterton*	won	23-13

COMBINED SERVICES in NEW ZEALAND, 1995

v Counties *at Pukekohe*	lost	11-56

NEW ZEALAND ARMY in NEW ZEALAND, 1995

v Poverty Bay *at Gisborne*	lost	17-23

NEW ZEALAND ARMY in BRITAIN and GERMANY, 1995

v Public School Wanderers *at London*	won	41-14
v Royal Navy *at Devonport*	won	15-6
v East Midlands *at Bedford*	won	25-19
v Pontypool *at Pontypool*	won	25-16
v British Army (Germany) *at Rheindahlen*	won	58-10
v British Army *at Aldershot*	lost	22-24

This tour commemorated the 50th anniversary of the end of the war in Europe and the Kiwis' 1945-46 tour. Twelve members of the Kiwis accompanied the team.

NEW ZEALAND ARMY in NEW ZEALAND, 1997

v British Army (Germany) *at Palmerston North*	won	23-10

KING GEORGE V CUP

The three services compete for the King George V Cup, which was originally presented to the New Zealand Army team in 1919. The matches are not of first-class status.

SPENCER CUP

The cup was presented by Police Commissioner C.L. Spencer for competition between the three armed services and the police. The police withdrew from the combined services organisation in 1996. Cup winners:

1960	Air Force, Army, Police	1980	Army, Navy, Police
1961	Air Force, Police	1981	no competition
1962	Army	1982	Air Force
1963	Police	1983	Police
1964	Navy, Police	1984	Police
1965	Army	1985	Police
1966	Navy, Police	1986	Police
1967	Army, Police	1987	Police
1968	Navy	1988	Police
1969	Police	1989	Police
1970	Air Force	1990	Navy
1971	Air Force	1991	Police
1972	Police	1992	Police
1973	Police	1993	Police
1974	Police	1994	Police
1975	Police	1995	Police
1976	Army, Navy, Police	1996	Police
1977	Army		
1978	Navy		
1979	Police		

CASUALTIES

Many noted rugby players were among the dead in both world wars. All Blacks to have been killed were — World War I: Jim Baird, Bobby Black, 'Norkey' Dewar, Ernest Dodd, 'Doolan' Downing, Dave Gallaher, Eric Harper, Jim McNeece, Jimmy Ridland, George Sellars, Reginald Taylor, 'Jum' Turtill, Frank Wilson. World War II: Bill Carson, Don Cobden, Jack Harris, George Hart, Cyril Pepper, Arthur Wesney, Jim Wynyard.

Other prominent players killed — World War I: Robert Duthie, Tom Grace, Jim Kinvig, Autini Kaipara, Roy Lambert, David McFarlane, Rupert Pyle. World War II: Roger Anderson, Les Arnonld, Jim Cartwright, Alf Cobden, Tommy Dance, Ronald Devine, Ian Dustin, Les Ellis, Fred Fuller, Bill Fulton, Robert Hunter, Bill Lange, George Mills, Ken Moses, Johnny Pile, Charlie Saundercock, Reg Veich.

George Nepia's son, George jnr, was killed during the Malayan campaign in the late 1950s.

Universities Rugby

The rugby game was well established in New Zealand's universities when the first combined university team was selected in 1908. Lincoln College, originally known as Canterbury Agricultural College, had a rugby club in 1881; Canterbury University College began playing the game two years later; Otago University, Auckland University College, and Victoria University College followed suit in 1884, 1888 and 1903 respectively. Since 1908, Massey University (originally Massey College) and University of Waikato have formed clubs, in 1927 and 1966 respectively.

University clubs have been very successful in their unions' championships over the years and among them they have provided a large number of All Blacks. In both these respects Otago has been particularly strong, having won the Dunedin club championship on 36 occasions and having produced more All Blacks than any other club except Ponsonby.

The first team to represent New Zealand Universities went on a short tour to Sydney in 1908. Managed by Dr Irwin Hunter (who had played against the 1888 British team for Otago and for South Island) and captained by R.I. Dansey, of Otago University, this pioneer team lost all three of its matches by fairly substantial margins. University of Sydney beat the tourists 30-9 and 26-11 while a Metropolitan Union side won by 14 points to 6.

The visit was returned by University of Sydney in 1909, when the visitors played New Zealand Universities twice for a win each. An American Universities team toured New Zealand in 1910 but confined its matches to the unions. It seems strange that the Americans did not play a university side.

The first 'test' match played by New Zealand Universities took place in 1929 when a fully representative student team from Australia toured the Dominion. All three 'tests' were won easily by the home team. Since 1929, regular exchanges between the countries have been maintained.

In 1936, New Zealand Universities broke new ground when they became the first team from this country to visit Japan. At the time of writing the Japan national side has played 13 matches against the universities. Other overseas tours by the students include visits to the Pacific Coast and Europe.

Apart from games against various provincial teams over the years, the universities have also engaged touring international sides in home matches. The first of these encounters was with South Africa in 1956, when the Springboks went down to a shock 22-15 defeat. The universities also defeated the 1977 Lions, being the only team besides the All Blacks to beat the tourists.

As one would expect, some famous men have played for New Zealand Universities. These include two Chief Justices, Sir Humphrey O'Leary and Sir Richard Wild; Sir Harcourt Caughey, knighted for his services to the Auckland Hospital Board; Martin Donnelly, the great New Zealand cricketer who also played rugby for England; All Black captains George Aitken, Ron Elvidge, John Graham, Bob Stuart, Kelvin Tremain, Chris Laidlaw, Wilson Whineray, Graham Mourie and David Kirk; Rhodes Scholars George Aitken, Mac Cooper, 'Chook' Henley, Chris Laidlaw, Percy Minns, Allan Stewart and David Kirk; and numerous All Blacks and overseas internationals.

MATCHES PLAYED BY NEW ZEALAND UNIVERSITIES TEAMS

1908 in AUSTRALIA
v University of Sydney *at Sydney* lost 9-30
v University of Sydney *at Sydney* lost 11-26
v Metropolitan Union *at Sydney* lost 6-14

1909 in NEW ZEALAND
v University of Sydney *at Dunedin* lost 5-15
v University of Sydney
 at Wellington won 17-14

1911 in AUSTRALIA and NEW ZEALAND
v Wellington B *at Wellington* lost 3-32
v University of Sydney *at Sydney* won 15-10
v University of Sydney *at Sydney* won 9-3
v Metropolitan Union *at Sydney* lost 6-22

1913 in AUSTRALIA
v University of Sydney *at Sydney* won 14-11
v University of Sydney *at Sydney* won 21-19
v Metropolitan Union *at Sydney* won 27-10
v University of Sydney *at Sydney* won 30-15

1920 in NEW ZEALAND
v University of Sydney
 at Christchurch won 17-9
v University of Sydney
 at Wellington lost 8-11

1921 in AUSTRALIA and NEW ZEALAND
v Wellington *at Wellington* won 12-6
v Metropolitan Union
 at Sydney lost 17-31
v University of Sydney
 at Sydney drew 9-9
v Royal Military College
 at Duntroon won 34-4
v University of Sydney
 at Sydney won 19-11

1922 in NEW ZEALAND
v University of Sydney
 at Auckland won 23-22
v University of Sydney
 at Dunedin won 21-11
v University of Sydney
 at Sydney lost 19-22

1923 in AUSTRALIA
v Metropolitan Union
 at Sydney lost 14-20
v University of Sydney
 at Sydney drew 11-11
v Manly Club *at Manly* lost 8-13
v University of Sydney
 at Sydney won 26-18
v University of Sydney
 at Sydney lost 11-37

1925 in NEW ZEALAND
v University of Sydney
 at Dunedin won 22-5
v University of Sydney
 at Christchurch won 33-17
v University of Sydney
 at Auckland won 19-17

1927 in AUSTRALIA
v E.J. Thorn's XV *at Sydney* won 26-11
v University of Sydney *at Sydney* lost 12-31
v University of Sydney *at Sydney* won 15-11
v University of Sydney *at Sydney* lost 15-17

1929 in NEW ZEALAND
v Aust Universities *at Christchurch* won 15-3
v Aust Universities *at Wellington* won 26-17
v Aust Universities *at Auckland* won 18-3

1931 in AUSTRALIA
v University of Sydney *at Sydney* won 16-3
v Australian Navy XV *at Sydney* won 22-0
v University of Sydney *at Sydney* won 35-21
v University of Sydney *at Sydney* drew 11-11
v Western Districts *at Orange* won 24-7
v Metropolitan Union *at Sydney* won 28-10

1933 in NEW ZEALAND
v Aust Universities *at Auckland* won 28-8
v Aust Universities *at Dunedin* won 25-0
v Aust Universities *at Christchurch* won 44-8

1936 in JAPAN and HONG KONG
v Hong Kong *at Hong Kong* won 29-8
v All Kansai XV *at Koshien* won 31-3
v Keio University *at Tokyo* won 23-6
v Meiji University *at Tokyo* won 13-11
v Waseda University *at Tokyo* won 22-17
v All Japan Student XV *at Tokyo* won 16-8
v All Kansai Student XV *at Kyoto* won 23-8
v All Japan Student XV *at Kyoto* drew 9-9
v Hong Kong *at Hong Kong* won 26-0

1938 in NEW ZEALAND
v Waikato *at Hamilton* lost 6-13

1939 in NEW ZEALAND
v Canterbury *at Christchurch* won 24-5

1940 in NEW ZEALAND
v Combined Services *at Auckland* won 12-11

1941 in NEW ZEALAND
v Wellington *at Wellington* drew 6-6

1945 in NEW ZEALAND
v Otago *at Dunedin* lost 9-19

1946 in NEW ZEALAND
v A Wellington XV *at Wellington* won 20-14

1947 in NEW ZEALAND
v Canterbury *at Christchurch* won 21-0

1948 in NEW ZEALAND
v Auckland *at Auckland* lost 5-16

1949 in NEW ZEALAND
v Australian Universities
 at Wellington lost 3-8
v Australian Universities
 at Dunedin won 11-8
v Australian Universities
 at Auckland drew 0-0

1950 in NEW ZEALAND
v Otago *at Dunedin* lost 9-19

1951 in AUSTRALIA and NEW ZEALAND
v University of Queensland
 at Brisbane won 30-6
v Australian Universities
 at Brisbane won 14-9
v New England University College
 at Armidale won 51-8
v Southern Universities *at Sydney* won 62-6
v Royal Military College
 at Canberra won 42-0
v Australian Universities
 at Sydney won 27-17
v University of Sydney *at Sydney* won 14-5
v Wellington *at Wellington* lost 9-11

1952 in NEW ZEALAND
v Canterbury *at Christchurch* won 32-18

1953 in NEW ZEALAND
v Auckland *at Auckland* lost 13-15

1954 in NEW ZEALAND
v Australian Universities
 at Dunedin won 16-12
v Australian Universities
 at Wellington lost 20-23
v Australian Universities
 at Auckland won 14-8

1955 in NEW ZEALAND
v Otago *at Dunedin* won 14-3

1956 in NEW ZEALAND
v Wellington *at Wellington* won 18-12
v Manawatu *at Palmerston North* won 14-8
v South Africa *at Wellington* won 22-15

1957 in NEW ZEALAND
v Canterbury *at Christchurch* lost 3-8

1958 in NEW ZEALAND
v Auckland *at Auckland* won 14-6

1959 in NEW ZEALAND
v Otago *at Dunedin* lost 12-16
v Southland *at Invercargill* lost 3-30
v British Isles *at Christchurch* lost 13-25

1960 in AUSTRALIA and NEW ZEALAND
v University of New South Wales
 at Sydney won 47-11
v Newcastle University
 at Newcastle won 64-0
v New England University
 at Armidale won 62-0
v University of Queensland
 at Brisbane won 26-5
v Australian Universities
 at Brisbane won 23-8
v University of Sydney *at Sydney* lost 14-16
v Australian Universities
 at Sydney won 15-3
v Southern Universities
 at Melbourne won 46-5
v Canterbury *at Christchurch* lost 8-17

1961 in CALIFORNIA, BRITISH COLUMBIA and NEW ZEALAND
v Manawatu *at Palmerston North* won 23-16
v University of California,
 Los Angeles *at Los Angeles* won 37-3
v San Diego State College
 at San Diego won 52-5
v Southern California
 at Pasadena won 41-3
v Stanford University *at Stanford* won 29-9
v University of California
 at Berkeley won 11-0
v Northern California
 at San Francisco won 25-6
v Victoria *at Victoria* won 18-6
v University of British Columbia
 at Vancouver won 32-3
v Vancouver *at Vancouver* lost 0-3
v British Columbia *at Vancouver* lost 6-9

1962 in NEW ZEALAND
v Canterbury *at Christchurch* drew 10-10

1963 in NEW ZEALAND
v Wellington *at Wellington* won 16-8

1964 in NEW ZEALAND
v Australian Universities
 at Wellington won 28-9
v Australian Universities
 at Dunedin won 37-9
v Australian Universities
 at Christchurch won 11-9

1965 in NEW ZEALAND
v Manawatu *at Palmerston North* won 16-14
v Wanganui *at Wanganui* won 40-0
v South Africa *at Auckland* lost 11-55

1966 in NEW ZEALAND
v Otago *at Dunedin* won 9-3
v Southland *at Invercargill* lost 3-24
v British Isles *at Christchurch* lost 11-24

1967 in HONG KONG, JAPAN and NEW ZEALAND
v Colony XV *at Hong Kong* won 58-11
v All Waseda University *at Tokyo* won 38-0
v All Japan Universities
 at Nagoya won 63-15
v Kanto Universities *at Tokyo* won 35-14
v All Doshisha University
 at Kyoto won 53-6
v Japan *at Osaka* won 19-3
v Ohita Teachers' XV *at Ohita* won 62-3
v All Kyushu *at Fukuoka* won 56-11
v All Hosei University *at Tokyo* won 49-12
v Japan *at Tokyo* won 55-8
v Wellington Inv XV
 at Wellington won 27-3
v Auckland *at Auckland* lost 6-8

1968 in NEW ZEALAND
v Japan *at Wellington* won 25-16

1969 in NEW ZEALAND
v Otago *at Dunedin* won 8-6

1970 in HONG KONG, JAPAN, HAWAII and NEW ZEALAND
v Colony XV *at Hong Kong* won 20-0
v All Waseda University *at Tokyo* won 36-3
v All Hosei University *at Tokyo* won 29-14
v Japan *at Tokyo* won 16-6
v All Doshisha University
 at Kyoto won 46-12
v Japan *at Osaka* won 28-14
v Toyota Motors *at Nagoya* won 79-8
v All Kyushu *at Fukuoka* won 35-11
v British Columbia *at Tokyo* won 41-6
v Japan *at Tokyo* won 46-14
v Hawaii All Stars *at Honolulu* won 19-3
v Wellington *at Wellington* lost 8-9
v Marlborough *at Blenheim* won 24-6
v Nelson-Bays *at Nelson* won 32-5

1971 in NEW ZEALAND
v Manawatu *at Palmerston North* won 23-16
v British Isles *at Wellington* lost 6-27

1972 in NEW ZEALAND
v California *at Auckland* lost 6-13

1973 in AUSTRALIA and NEW ZEALAND
v Southern Universities
 at Melbourne won 56-6
v An Australian Universities XV
 at Canberra won 69-4
v Australian Universities
 at Canberra won 16-0
v New South Wales-Newcastle-Macquarie
 Universities *at Sydney* won 38-0
v University of Sydney *at Sydney* lost 12-16
v New England-Queensland
 Universities *at Armidale* lost 13-19
v Australian Universities
 at Brisbane won 33-6
v Auckland Under-23
 at Auckland won 19-13

1974 in NEW ZEALAND
v Japan *at Wellington* lost 21-24

1975 in NEW ZEALAND
v Manawatu *at Palmerston North* won 18-7

Universities Rugby

1976 in USA, IRELAND, JAPAN and NEW ZEALAND

v San Francisco Bay Combined Universities *at Stanford*	won	37-0	
v Pacific Coast *at San Francisco*	won	25-6	
v Los Angeles Combined Counties *at Los Angeles*	won	26-0	
v Southern California Clubs *at Los Angeles*	won	32-0	
v Southern California Universities *at Los Angeles*	won	27-10	
v Dublin Universities *at Dublin*	lost	12-19	
v Queen's University *at Belfast*	won	9-3	
v Irish Universities *at Cork*	lost	16-18	
v All Kyushu *at Fukuoka*	won	48-0	
v All Kansai *at Osaka*	won	69-6	
v Waseda Meiji Universities *at Tokyo*	won	39-6	
v Japan *at Tokyo*	won	45-6	
v Wellington *at Wellington*	won	26-21	

1977 in NEW ZEALAND

v Canterbury *at Christchurch*	lost	9-18	
v Mid Canterbury-South Canterbury-North Otago *at Ashburton*	won	22-15	
v British Isles *at Christchurch*	won	21-9	

1978 in NEW ZEALAND

v Irish Universities *at Wellington*	won	15-10	
v Irish Universities *at Dunedin*	lost	4-18	

1979 in NEW ZEALAND

v Japan *at Auckland*	won	53-13	

1980 in the FAR EAST

v Singapore *at Singapore*	won	27-6	
v Hong Kong *at Hong Kong*	won	9-6	
v Japanese Universities *at Tokyo*	won	25-18	
v Japan B *at Osaka*	won	72-6	
v All Kyushu *at Nagasaki*	won	38-3	
v South Korea *at Seoul*	won	36-10	
v Japan *at Tokyo*	drew	25-25	

1982 in NEW ZEALAND

v Wellington *at Hutt*	won	15-6	
v All Japan *at Wellington*	won	35-20	
v All Japan *at Pukekohe*	won	22-6	

1982 in JAPAN

v All Kantor *at Hakodate*	won	59-8	
v Japan Universities *at Yokohama*	won	13-0	
v Japan B *at Shizuoka*	won	51-6	
v English Universities *at Tokyo*	lost	9-19	
v All Japan *at Tokyo*	lost	15-31	

1983 in NEW ZEALAND

v Canterbury *at Christchurch*	lost	6-37	

1984 in NEW ZEALAND

v Counties *at Pukekohe*	won	21-12	

1985 in EUROPE and NEW ZEALAND

v Oxford University *at Oxford*	won	18-0	
v Cambridge University *at Cambridge*	won	25-13	
v Luddites *at Otley*	won	22-10	
v Combined Dublin Universities *at Dublin*	won	19-12	
v Combined Cork and Galway Universities *at Cork*	drew	6-6	
v Irish Universities *at Dublin*	won	33-9	
v Paris University *at Paris*	won	21-12	
v Italy 'B' *at Cantania*	won	8-3	
v Italy *at Rovigo*	won	10-9	
v Italian Universities *at Brescia*	won	35-7	
v French Universities B *at Montpelier*	won	9-8	
v French Universities *at Biarritz*	won	21-9	
v Otago *at Dunedin*	lost	8-15	

1986 in NEW ZEALAND

v Taranaki *at New Plymouth*	lost	13-16	

1987 in NEW ZEALAND

v Manawatu *at Palmerston North*	won	19-6	

1988 in NEW ZEALAND

v Otago *at Dunedin*	lost	10-22	
v New Zealand Maoris *at Auckland*	lost	19-37	

The 1977 Universities team which beat the British Isles
Back row: Doug Heffernan, Dan Fouhy, Paul Oliver, Gary Brown, Wayne Graham, Mark Wright, John Edmondson.
Second row: Barrie Hutchinson (selector), Dave Syms, Terry Sole, Dennis Thorn, Randall Scott, Ray Scott, John Black.
Front row: Paul Macfie, Bill Clark (manager), Russell Hawkins, Doug Rollerson (captain), Graeme Elvin (vice captain), Brian Molloy (selector), Mike Deane.
In front: Mark Romans, Kieran Keane, Alan Innes.
Inset: Greg Denholm.

The Encyclopedia of New Zealand Rugby

1989 in NEW ZEALAND
v Wellington *at Lower Hutt* lost 18-38
v Oxbridge *at Auckland* lost 15-25

1990 in NEW ZEALAND
v New Zealand Maoris *at Rotorua* lost 9-63

1991 in NEW ZEALAND
v New Zealand XV *at Auckland* lost 12-37

1992 in NEW ZEALAND
v England B *at Wellington* lost 15-32
v Otago XV *at Dunedin* lost 11-30

1992 at STUDENT WORLD CUP, ITALY
v Romania *at Catania* won 22-10
v Netherlands *at Catania* won 118-3
v Wales *at Catania* won 15-7
v Ireland *quarterfinal at Cagliari* won 53-9
v Argentina *semifinal*
 at Castellamara won 21-9
v France *final at Rovigo* lost 21-9

1993 in NEW ZEALAND
v Australian Universities
 at Wellington won 68-3
v Western Samoa *at Wellington* lost 48-10

1994 in NEW ZEALAND and AUSTRALIA
v Wairarapa-Bush *at Masterton* lost 24-23
v Fiji *at Palmerston North* won 11-5
v Japan Under 23 *at Wellington* won 106-9
v Australian Universities
 at Sydney lost 24-14

1995 in NEW ZEALAND
v Thames Valley *at Paeroa* won 17-5
v Australian Universities
 at Takapuna won 38-19

**1996 at STUDENT WORLD CUP,
SOUTH AFRICA**
v Uruguay *at Pretoria* won 70-28
v England (non-cup)
 at Johannesburg won 28-23
v Scotland *at Pretoria* lost 25-26
v France *quarterfinal*
 at Johannesburg lost 29-38

**1997 in JAPAN, THAILAND and
AUSTRALIA**
v West Japan Universities
 at Osaka won 85-19
v Japan A *at Osaka* won 41-17
v East Japan Universities *at Tokyo* won 65-22
v Japan Under 21 *at Tokyo* won 61-31
v Japan A *at Tokyo* won 39-24
v Thailand Universities
 at Bangkok won 117-6
v Australian Universities
 at Brisbane lost 52-25

**NEW ZEALAND UNIVERSITIES
REPRESENTATIVES 1908-1997**
* *indicates a player who represented New Zealand*

Adam M.A.	*Massey*	1985
Adams A.A.	*Otago*	1908
Afeaki I.U.	*Victoria*	1997
Aitken G.G.*	*Victoria*	1920,21
Alecock G.J.	*Canterbury*	1952
Alexander W.E.	*Canterbury*	1929
Allen M.W.	*Canterbury*	1959-62
Allen N.H.*	*Auckland*	1979,80
Alley G.T.*	*Canterbury*	1927
Alston P.J.	*Massey*	1991-93
Anderson A.*	*Lincoln*	1982
Anderson K.D.	*Auckland*	1929,33
Anderson P.G.	*Waikato*	1971,72
Anderton N.	*Auckland*	1985
Anderton N.K.	*Auckland*	1988
Andrews A.H.	*Canterbury*	1933

Aoake M.S.	*Canterbury*	1985
Archer W.R.*	*Otago*	1954
Arkle J.A.	*Auckland*	1923
Armitage R.A.	*Auckland*	1940,41
Ashcroft J.	*Massey*	1985
Aston A. W.	*Auckland*	1960,62
Atkins D.P.	*Canterbury*	1983-85,87
Bamford E.	*Auckland*	1909
Banks A.J.	*Lincoln*	1967
Bark P.G.	*Canterbury*	1961
Barker W.L.	*Auckland*	1931
Barkle G.P.	*Canterbury*	1978
Barlow R.M.J.	*Victoria*	1969-71
Barter H.G.	*Auckland*	1945,49,51
Barrett P.S.	*Otago*	1967
	Victoria	1969-71
Barton H.D.H.	*Victoria*	1964,66
Battell R.W.	*Victoria*	1953
Batty G.B.*	*Victoria*	1970
Begg A.T.	*Otago*	1920
Bell A.R.H.	*Otago*	1989
Berghan T.*	*Otago*	1939
Bevin B.A.P.	*Auckland*	1979,80, 82,84-86
Bilkey W.	*Auckland*	1913
Black J.E.*	*Canterbury*	1975-79
Blacker E.	*Victoria*	1929
Blaikie J.W.K.	*Otago*	1995
Blair H.T.	*Massey*	1973-76,78
Blank A.R.	*Canterbury*	1911
Bodie J.W.	*Victoria*	1994
Botting I.J.*	*Otago*	1947
Bowler D.G.	*Massey*	1940
Boyd-Wilson E.J.	*Canterbury*	1908
Bracey N.C.	*Auckland*	1960
Bradanovich N.M.*	*Auckland*	1927
Bradley M.E.	*Victoria*	1992,94
Brebner K.	*Otago*	1961
Bremner S.G.*	*Canterbury*	1955-57
Brewer M.R.*	*Otago*	1984,85
Brodie J.	*Canterbury*	1923,25
Brooker L.E.	*Auckland*	1923
Brosnan J.D.	*Victoria*	1908,09,11
Broughton N.J.R.	*Otago*	1994,95
Brown G.J.	*Canterbury*	1975-78
Brown M.	*Auckland*	1990
Brown M.	*Auckland*	1994,95
Brown M.T.	*Canterbury*	1970
Brown N.J.	*Auckland*	1957,59,60
Bruning L.	*Canterbury*	1997
Bryers J.	*Victoria*	1938
Buchan J.A.S.*	*Canterbury*	1985,86
Buckley T.J.	*Otago*	1945,46
Bunn L.A.	*Massey*	1982
Burcher T.J.	*Auckland*	1979,80, 82,85
Burgess R.E.*	*Massey*	1968,70,71
Burke R.B.	*Canterbury*	1936
	Victoria	1938-40,46
Burkhart B.F.	*Otago*	1956
Burkhart S.A.	*Waikato*	1988
Burns H.N.	*Victoria*	1921,25,27
Burrell R.	*Auckland*	1990
Burrows J.T.*	*Canterbury*	1925
Burry H.C.*	*Canterbury*	1956
Bush R.G.*	*Auckland*	1929,33,36
	Otago	1931
Butler V.C.*	*Auckland*	1927
Buxton J.B.*	*Lincoln*	1955,56
	Otago	1957
Bydder D.E.	*Massey*	1968
Cabot P.S.deQ.*	*Otago*	1921,22,25
Calder H.S.‡	*Auckland*	1961

‡ *an ex-Auckland engineering student living in Vancouver who played for the touring NZU team when it was depleted through injuries*

Calder J.N.	*Canterbury*	1922
Calvert M.	*Victoria*	1987
Cameron L.M.*	*Massey*	1979,80,82
Cameron M.W.	*Waikato*	1982,84,85

Campbell C.	*Otago*	1920
Campbell D.N.	*Otago*	1959
Campbell J.W.	*Otago*	1992-94
Campbell S.O.	*Lincoln*	1940
Cannon T.P.	*Otago*	1945
Carroll J.R.	*Massey*	1955
Carter G.E.	*Auckland*	1931
Carter J.	*Auckland*	1925
Cartwright J.S.	*Canterbury*	1939,40
Cartwright W.J.	*Canterbury*	1913
Caughey B.K.	*Auckland*	1948
Caughey D.E.	*Otago*	1955
	Auckland	1956,57,59
Caughey T.H.C.*	*Auckland*	1933
Chandler G.T.	*Auckland*	1955
Chapman O.W.	*Otago*	1936
Chesterman E.R.	*Victoria*	1936
Childs H.P.J.	*Otago*	1913
Childs S.C.	*Victoria*	1927
Church R.	*Otago*	1949
Clark A.S.	*Victoria*	1955,58,60
Clark W.H.*	*Victoria*	1951-56
Cockburn M.	*Canterbury*	1995
Codlin B.W.*	*Lincoln*	1980
Codlin M.M.	*Lincoln*	1976
Coleman A.D.	*Lincoln*	1960
Coleman D.	*Massey*	1992
Coleman G.T.	*Waikato*	1997
Collins M.P.	*Otago*	1969-71
	Canterbury	1972
Collinson J.R.	*Auckland*	1984,85
Collyns G.S.	*Canterbury*	1908
Cook P.E.	*Canterbury*	1976
Cooke B.S.	*Otago*	1961
Cooney D.S.	*Auckland*	1948,51
Cooper M.M.	*Massey*	1933
Coplestone T.B.	*Massey*	1982
Cormack L.G.	*Auckland*	1970
Cottrell S.R.	*Otago*	1989,92
	Victoria	1993
Coughlan T.J.D.	*Lincoln*	1985
Coventry T.J.	*Otago*	1987
Craig A.M.	*Waikato*	1996
Cran A.J.	*Otago*	1987
Craven E.S.	*Canterbury*	1920,21
Creighton J.N.*	*Canterbury*	1959,60,62-64,66,67
Cullen J.A.	*Otago*	1992-95
Cullimore N.R.	*Auckland*	1967
Cunliffe T.S.M.	*Canterbury*	1950
Currey C.R.	*Canterbury*	1982,86
Currie M.S.	*Auckland*	1988-90
Currie P.J.	*Massey*	1988
Curtayne A.	*Victoria*	1909,11
Curtin V.I.	*Waikato*	1995-97
Cuthill J.E.*	*Otago*	1913
Dalgleish J.M.	*Canterbury*	1921
Dalzell A.G.	*Lincoln*	1983,84
Dalzell Z.L.	*Canterbury*	1950,51
Dansey R.I.	*Otago*	1908,09
Darby G.	*Auckland*	1913
Davies L.D.	*Canterbury*	1950,51
Davies W.A.*	*Auckland*	1959,66
	Otago	1961,63,64
Davis C.S.*	*Massey*	1994
Davis S.N.	*Waikato*	1997
Davison D.J.	*Canterbury*	1962
Deane M.J.	*Waikato*	1977
de Cleene R.T.	*Massey*	1966-71
de la Mare F.A.	*Victoria*	1908,09
Denholm G.P.	*Auckland*	1977
Diack E.H.	*Otago*	1923
Diack E.S.*	*Otago*	1955-60
Dickson D.M.	*Otago*	1921,22,25
Diederich E.R.P.	*Victoria*	1929,31,33
Dineen B.M.J.	*Canterbury*	1956
Dixon C.E.	*Victoria*	1931
Dobson A.D.	*Canterbury*	1913
Doherty B.H.	*Otago*	1950,51
Donaldson W.	*Massey*	1952
Donnelly M.P.	*Canterbury*	1940

Donnelly T.P.	Auckland	1991-93
Douglas H.S.	Otago	1929
Dowling L.J.	Lincoln	1970
Drader C.P.	Canterbury	1925
Drake J.A.*	Auckland	1980,82
Drake L.S.	Auckland	1933,36,
		38,39
Drummond G.A.	Canterbury	1945,46
Drummond R.B.D.	Victoria	1976
Duncan A.T.	Victoria	1909
Duncan P.N.	Canterbury	1969,70,72
Duncan P.A.	Massey	1985
	Auckland	1987
Dunne B.J.	Otago	1927
Dunne M.R.	Canterbury	1958,59,65
Dunne W.T.	Otago	1933
Dunnett C.M.	Victoria	1996
Eade S.G.	Victoria	1936
Earl J.	Canterbury	1923
East H.	Otago	1994
Eddowes G.N.	Auckland	1921
Edgar A.A.T.	Auckland	1960
Edgar J.M.	Victoria	1929
Edmondson J.A.	Canterbury	1975-80
Edward D.	Otago	1968
Edwards J.W.	Auckland	1938
Edwards W.A.	Auckland	1931
	Victoria	1933
Edwards W.C.	Auckland	1963
Egan J.F.J.	Otago	1938
Eggleton F.D.	Lincoln	1964,65
Eggleton P.A.	Waikato	1975,76,82
Eglinton K.H.	Otago	1961
Ellery J.B.	Massey	1950
Ellis A.L.	Canterbury	1939
Ellis M.C.G.*	Otago	1991,93,94
Ellison B.	Canterbury	1994
Ellison D.R.	Otago	1986
Elvidge A.D.	Canterbury	1994,95
Elvidge D.G.	Lincoln	1964,65
Elvidge R.R.*	Otago	1945,46
Elvin G.W.	Otago	1975-78
Eru S.W.	Otago	1996,97
Evans T.J.	Canterbury	1949
Ewart J.W.	Canterbury	1931
Faire A.S.	Victoria	1911,13
Fawcett C.L.*	Otago	1975,76
	Waikato	1978
Fawcett T.	Victoria	1913
Faulkner D.J.	Canterbury	1973,74
Fea W.R.*	Otago	1920-22
Fenwick D.E.	Otago	1908,09
Fisher G.G.	Otago	1913
Fitzgerald J.T.*	Otago	1949
	Victoria	1952,54
Fitzpatrick		
B.B.J.*	Victoria	1952
	Auckland	1954,56
Fitzpatrick		
S.B.T.*	Auckland	1984
Flavell J.W.	Auckland	1982
Fookes H.F.	Otago	1931,33,36
Fookes S.F.	Canterbury	1927
Foreman H.M.	Auckland	1938,39
Foreman J.M.	Otago	1945
Foster A.H.	Otago	1947,49
Fouhy D.T.	Victoria	1976,77,82
Fountain M.D.	Canterbury	1941
Fox G.J.*	Auckland	1982
Fraser R.D.	Otago	1949,51
Free M.	Auckland	1987,89
Freeman L.	Auckland	1927
Fry R.J.	Auckland	1984
Fuatai S.	Otago	1978
Fuller E.	Victoria	1992
Gadsby A.	Waikato	1985
Gard M.R.	Otago	1972
	Canterbury	1974
Garrett H.E.	Canterbury	1940
Gaukrodger M.	Lincoln	1975
Geary M.V.	Auckland	1964

Geary T.F.C.	Otago	1947
George M.D.	Massey	1988
	Auckland	1989,90
Gibbs S.J.	Massey	1996,97
Gilberd L.	Otago	1925
Gillies C.C.*	Otago	1936
Gilmour G.G.H.	Auckland	1948-51
Gomez M.	Canterbury	1938
Goodbehere F.W.B.	Victoria	1908
Goodwin A.	Auckland	1929
Goodwin D.S.	Victoria	1946
Gordon G.D.	Otago	1945
	Canterbury	1947
Gordon J.W.	Canterbury	1941
Gordon L.G.M.	Auckland	1957
Gordon R.W.	Otago	1986
Gordon W.R.*	Waikato	1988,89
Gourlay M.J.	Victoria	1965,67
Grace D.T.	Auckland	1945,48,49
Grace L.W.H.T.	Canterbury	1908,09,11
Graham D.J.*	Auckland	1957
Graham R.H.	Auckland	1958-60,
		63-65
Graham W.G.*	Otago	1976,77
Grant B.J.	Otago	1973
Grant E.	Auckland	1936
Grant K.N.	Victoria	1965,67
Gray M.A.	Auckland	1982,84
Gray M.W.N.	Victoria	1982,85-87
Gray W.A.	Auckland	1908
Green C.I.*	Lincoln	1983
Green J.W.	Otago	1940,41
Green R.	Victoria	1974
Greig H.E.M.	Victoria	1941,46
Grenside M.A.	Lincoln	1997
Groome J.G.	Canterbury	1946
Gudsell K.E.*	Massey	1945,47
Guild A.I.	Massey	1938
Guscott P.J.	Lincoln	1972
Hales D.A.*	Lincoln	1972
Halligan D.M.	Otago	1979,80,82
Halligan H.D.	Otago	1986-88
Halse G.W.	Auckland	1980
Hamilton G.	Otago	1988
Hamilton J.A.	Otago	1933
Hanning R.M.	Lincoln	1989,90
Hansen R.P.	Victoria	1939
Hanson F.M.H.	Victoria	1920,21
Harding R.A.	Otago	1980,82
Hardy R.B.	Auckland	1922
Hargreaves W.A.	Canterbury	1949,50
Harper A.G.	Canterbury	1941
Harris R.M.	Auckland	1953
Hart D.E.	Otago	1922,23
Hart G.D.	Auckland	1976
Hartnell A.M.	Canterbury	1933
Harty H.R.	Otago	1920-22
Haughton T.J.	Otago	1929
Hawkes J.R.	Canterbury	1929
Hawkins R.S.	Massey	1974-77
Hay I.	Canterbury	1945
Hay P.B.	Auckland	1967
Hay S.	Canterbury	1909
Hays B.C.	Canterbury	1973
Heffernan M.D.	Canterbury	1977-80
Heiler D.A.	Canterbury	1996
	Victoria	1997
Henderson A.K.O.	Victoria	1986-87
Henderson C.G.	Victoria	1958,59
Henley W.E.	Otago	1929
Hermansson		
G. Le R.	Victoria	1963-67
Hewett J.A.*	Massey	1989
	Auckland	1992,93
Hewett T.S.	Waikato	1996
Hindenach J.C.R.	Otago	1927,29
Hockley C.R.	Canterbury	1957,60
Hodge H.G.	Otago	1931
Hodges R.A.	Massey	1961,62
Hogg D.G.	Victoria	1965,66
Holden A.W.*	Otago	1927

Holland J.J.	Massey	1993,94
Holloway I.	Massey	1982
Hopkins B.P.	Canterbury	1923
Hoskin R.D.	Canterbury	1961
Hotop J.*	Massey	1950
	Lincoln	1951,52
House R.W.	Otago	1970
Howard E.	Otago	1982
Hudson D.A.	Canterbury	1936
Hughes M.	Massey	1982
Hunt G.S.	Waikato	1996
Hunt T.J.	Otago	1991,92
Hunter A.G.	Canterbury	1938,39
Hurst I.A.*	Lincoln	1973
Hutchison J.D.	Victoria	1920
Hutchinson J.B.S.	Auckland	1950,58,59
	Victoria	1951,52,
		56,57
Hutton J.B.	Massey	1949
Innes A.C.	Massey	1976,77
Irwin B.S.	Auckland	1954
Irwin M.W.*	Otago	1954,55,
		58,59
Irwin N.H.	Otago	1939
Isaacs D.C.	Massey	1951
Jackson A.D.	Victoria	1920-22
Jackson J.B.	Canterbury	1920-23
Jackson J.H.	Lincoln	1988
	Canterbury	1989
Jacob R.	Victoria	1946-48
Jarden R.A.*	Victoria	1951-56
Jefferd A.C.R.*	Lincoln	1976
Jenkin N.C.	Auckland	1929
Jennings K.R.	Canterbury	1973,75,76
Jennings P.N.	Otago	1960
Jensen P.	Victoria	1982
Jerram R.M.	Massey	1987
Jolly S.N.	Otago	1929
Jones B.V.A.	Otago	1936
Joseph H.T.*	Canterbury	1970,71
Kane A.	Waikato	1979,80
Kane G.N.*	Waikato	1972,76
Karatau L.H.	Lincoln	1968,70
Keane K.J.*	Canterbury	1978
Keegan C.T.	Auckland	1925,27
Keenan M.G.	Auckland	1982-
		85,88-91
Kelly J.W.*	Canterbury	1946-48
Kelly P.	Otago	1990
Kember G.F.*	Victoria	1965-71
Kendrick M.P.	Massey	1985,88
Kennett C.J.	Massey	1996
Kerr S.	Otago	1991,92
Kidd A.	Otago	1913
Kidd M.R.	Massey	1973
Kimberley H.M.	Canterbury	1939,40
King C.	Lincoln	1990
King R.K.	Canterbury	1931
Kinnaird R.J.	Otago	1994
Kirk D.E.*	Otago	1983-85
Kirkby J.H.W.	Victoria	1970
Kirman A.J.	Auckland	1989
Kirton E.W.*	Otago	1963-
		67,69,70
Koloto E.	Massey	1985
Kronfeld J.A.*	Otago	1993
Kurtovich S.S.	Auckland	1949,51
Lafaiali'i A.	Auckland	1997
Laidlaw C.R.*	Otago	1962-67
Lambert K.K.*	Massey	1974
Laney W.R.	Otago	1936
Lang J.H.	Otago	1908
Lange W.	Auckland	1938
Langbein W.T.	Canterbury	1922
Lawson P.	Victoria	1980
Leary D.C.	Otago	1959
	Canterbury	1960-62
Leitch J.	Otago	1923
Lennox G.R.J.	Massey	1989
Leslie J.A.	Otago	1992-95
Lewis A.J.	Otago	1982,85

Name	Team	Year
Lewis J.D.	Auckland	1936
Lewis P.T.	Auckland	1996,97
Lewis W.A.	Canterbury	1976
Lewis W.J.	Canterbury	1976
Leys E.T.*	Victoria	1929
Limmer S.	Waikato	1990
	Auckland	1991
Lindesay P.A.	Auckland	1965,66,70-72
Lindsay D.F.*	Otago	1927
Lindsay J.C.	Otago	1961,62
Linford G.B.	Victoria	1960
Lino N.P.	Otago	1941
Linton A.M.	Auckland	1927,29
Lockwood R.J.	Lincoln	1970-72
Lomas E.K.	Otago	1908
Love D.A.N.	Massey	1991-92
Love E.T.W.	Victoria	1927
Loveridge G.G.	Auckland	1960,61
	Canterbury	1963-65
Loveridge L.G.	Canterbury	1927,29
Lowe J.P.	Waikato	1974
Luaiufi E.	Canterbury	1987
Ludbrook D.W.	Otago	1952-54
Lusk R.G.B.	Otago	1922
Lynch A.D.	Victoria	1908
MacAlister A.D.	Otago	1945
McAuliffe J.J.	Canterbury	1936
McAuley T.	Victoria	1994
McCallum S.P.	Canterbury	1913
McCaw J.	Canterbury	1990
McClymont W.G.*	Otago	1929
McCredie K.B.	Otago	1955
McCurdy J.M.	Otago	1931
McDermott J.B.	Auckland	1982
McDonald A.N.	Otago	1923
MacDonald D.	Otago	1978,80
MacDonald G.S.R.	Auckland	1948-50
McDonald T.K.	Victoria	1966,67,69,70
McDowell C.R.	Canterbury	1982-85
McFarlane T.A.	Otago	1933
Macfie P.A.	Lincoln	1977
McGee G.W.	Otago	1971,73
McHalick D.M.	Victoria	1954
McIntosh M.	Lincoln	1980
McIntosh W.S.	Otago	1995
	Waikato	1996,97
MacKay J.D.*	Victoria	1929,31
MacKay R.H.	Auckland	1921
McKechnie W.R.	Otago	1931
McKenzie A.	Otago	1982
McKenzie A.D.	Canterbury	1941,45,47-49
McKenzie A.G.	Massey	1989
McKenzie D.J.	Otago	1979,80
McKenzie G.S.	Canterbury	1909
McKenzie J.	Otago	1920
MacKenzie R.H.C.*	Victoria	1925,29
MacIntosh M.	Lincoln	1982
McLay J.A.	Lincoln	1975
McLean A.M.	Massey	1994,95
McLean M.	Lincoln	1983
McLellan A.	Lincoln	1968-71
McLeod A.	Canterbury	1920
McLeod A.S.	Victoria	1947,49
McLeod R.W.	Massey	1986
McMaster A.	Massey	1988
McNeil S.	Massey	1989
McNicol S.	Victoria	1938-40
McRae A.D.	Victoria	1922,23
McVeagh J.P.	Auckland	1931,36
Mack C.W.	Otago	1938
Mackie A.S.	Canterbury	1986
Malfroy J.O.J.	Victoria	1923,25
Mansell W.J.	Canterbury	1911
Mantell C.D.	Victoria	1964-66
Mantell N.N.	Auckland	1991,92
Martin C.G.	Auckland	1954
Martin D.L.M.	Auckland	1939
Martin E.A.	Canterbury	1948,49
Martin S.H.	Otago	1980
Martin-Smith P.	Victoria	1923,25
Mather B.C.	Waikato	1984-86,88
Mather S.	Auckland	1990,91
Matheson A.E.	Canterbury	1970,71
Matheson J.A.	Otago	1972-74
Maxwell V.	Auckland	1921
Meads O.S.	Victoria	1940,41,47,48
Meates J.J.B.	Canterbury	1996
Meates W.J.W.	Canterbury	1982,86
Mee C.J.	Otago	1996,97
Meech H.	Lincoln	1966
Meikle M.C.	Otago	1961,63
	Canterbury	1964
Mika M.A.N.	Otago	1992,93,95
Miles R.H.	Auckland	1925
Millar A.	Auckland	1922,23,25
Millar J.W.	Victoria	1958,61
Milliken T.	Auckland	1920,22
Milliken T.W.	Otago	1945,46
Milliken W.M.	Auckland	1933
Minns P.C.	Auckland	1929
Mitchell C.L.	Massey	1959
	Lincoln	1960,61
Mitchell J.G.	Massey	1938
Moffatt C.R.	Canterbury	1983,84
Moffatt R.W.	Lincoln	1955
	Canterbury	1957
Molloy B.P.J.*	Canterbury	1956,57
Molloy C.H.	Otago	1911
Molloy J.	Auckland	1920-22
Montgomery A.Y.	Canterbury	1925
Montgomery D.H.	Otago	1964
	Auckland	1966,67
Moore C.R.	Otago	1949-51
Moore G.J.T.*	Otago	1946-50
Moore M.S.	Canterbury	1970
Moore N.S.	Otago	1992-95
Morete Te W.T.	Otago	1925,27
Moreton R.C.*	Canterbury	1962,64,65
Morgan E.P.	Otago	1997
Morgan H.J.M.	Auckland	1946
Morris J.B.	Otago	1954,55
Morrison D.B.	Massey	1987-89
Morrison T.G.*	Otago	1973
Mourie G.N.K.*	Victoria	1973,74
Moyes W.W.	Auckland	1961
Mulvihill D.B.	Auckland	1933
Munro H.G.*	Canterbury	1920,21
	Otago	1922,23
Murdoch D.H.	Otago	1941
Murphy J.P.	Victoria	1945
Murphy W.	Otago	1940
Myers R.G.*	Massey	1973
Nelson K.A.*	Otago	1959,60,62
Nepia B.A.	Auckland	1958,60
Nesdale R.P.	Auckland	1993
Norrie J.H.B.	Canterbury	1911
Norrie J.M.	Otago	1911
Northey G.S.	Waikato	1974
Nuku R.	Otago	1908
O'Callaghan M.W.*	Massey	1968,70
O'Connor K.J.	Otago	1946-49
O'Leary H.F.	Victoria	1908,09
Oliver B.R.	Otago	1995-97
Oliver D.O.*	Victoria	1954
Oliver P.T.	Otago	1975-77
Olliver R.	Canterbury	1994
Olsen F.	Auckland	1925
Ongley M.	Otago	1911
Ongley P.A.	Otago	1911
Oram M.A.	Massey	1973
Orangi A.	Otago	1994
O'Reagan C.J.	Victoria	1925-27
Orme A.F.	Canterbury	1961
O'Rorke J.G.	Victoria	1989
Osborne A.J.	Victoria	1963-66
Osborne P.C.	Victoria	1953,54,58
O'Shannessy K.J.P.	Auckland	1965,66
O'Shannessey P.	Auckland	1993-95
Otai K.M.F.	Massey	1988,89,92
Otterson A.	Auckland	1909
Owen N.	Otago	1925
Pacey H.K.	Otago	1927
Paddy D.C.	Otago	1966
	Auckland	1968
Paewai M.N.	Otago	1941
Palmer D.L.	Auckland	1970,71
Palmer G.R.	Auckland	1996,97
Park R.S.	Auckland	1920,22
Parker W.	Massey	1978
Parr S.	Canterbury	1911
Parsons G.A.	Canterbury	1936
Patrick R.D.	Victoria	1941
Paulsen A.	Victoria	1913
Paulsen N.M.	Victoria	1911
Pavitt A.E.D.	Massey	1997
Peacock R.W.	Auckland	1931
Perkins C.H.	Canterbury	1929,31
Perrett M.	Otago	1980
Perriam W.	Otago	1987
Perry A.*	Otago	1920-22
Petch W.V.	Otago	1953
Peters W.W.	Auckland	1976
	Otago	1978
Petre F.W.	Canterbury	1931
Phelan M.J.L.	Otago	1941
Phillips C.E.	Victoria	1909
Phillips L.	Auckland	1920
Philp T.A.	Massey	1997
Pickering J.M.	Victoria	1961
Pohlen G.J.	Otago	1966
Pomare R.	Victoria	1992
Pope B.M.	Otago	1986
Porter C.	Canterbury	1992
Porter G.	Canterbury	1913
Porter L.J.	Otago	1908,11
Potter T.R.	Auckland	1997
Prain H.C.	Otago	1958,59
Prestidge B.R.	Canterbury	1964
Prior I.A.M.	Otago	1941
Proffit R.F.	Waikato	1996
Pryde N.W.	Otago	1931
Pullar C.	Lincoln	1982
Putt K.B.	Otago	1986
Quilliam R.H.	Victoria	1911,13
Quinlivan H.	Massey	1982,83
Rae G.G.	Otago	1933
	Victoria	1936
Reaney S.H.O.	Otago	1968-70
Reeves D.W.	Auckland	1952,53
Reid O.G.	Otago	1909
Reilly P.T.	Massey	1979
Rejthar C.R.	Waikato	1973
Rennie G.P.	Lincoln	1968
Rhodes M.H.	Canterbury	1908
Riggs H.B.	Victoria	1923
Rikys R.A.	Lincoln	1960
Roberts E.M.	Massey	1951
Roberts P.G.	Canterbury	1933
Robertson G.H.	Canterbury	1923
Robertson J.S.	Otago	1973
Robertson M.	Otago	1920
Robertson W.J.	Victoria	1909,11
Robinson G.	Auckland	1929
Robinson L.G.	Auckland	1908,09
Robinson M.P.	Victoria	1994-97
Robson P.D.	Canterbury	1982,83
	Massey	1985
Rogers R.G.	Massey	1963
Rollerson D.L.*	Massey	1973,74,76,77
Rolleston K.R.	Canterbury	1991
Romans M.J.T.	Otago	1975,76
	Canterbury	1977
Roose A.T.	Otago	1990,91

Name	University	Years
Rope D.B.	Auckland	1948,49,51-53
Ross B.D.	Massey	1996
Ross D.V.	Otago	1994,96
Ross J.I.	Otago	1927
Ross W.H.	Auckland	1921
Roy R.A.	Otago	1970,72
Ruff W.E.	Lincoln	1933
Rumball P.J.	Massey	1962
Ruru J.H.	Victoria	1931
Rutherford D.	Victoria	1980,82,83
Ryan J.J.	Lincoln	1972
Ryan P.J.	Victoria	1911,13
Ryan T.J.	Victoria	1957
Saga S.	Massey	1994
Sakata Y.	Canterbury	1969,70
Salmond M.R.J.	Massey	1985,86
Sandle A.	Victoria	1913
Sapsford H.P.*	Otago	1973-76
Saseve T.D.	Auckland	1983-85
Savage L.T.*	Canterbury	1950
	Victoria	1953
Sayers M.*	Victoria	1968
Sceats G.J.	Victoria	1925
Schaumkell S.	Victoria	1994
Scherp R.A.	Lincoln	1969
Schuler K.J.*	Massey	1988,89
Schuster H.	Victoria	1990,91
Scott D.H.	Victoria	1920-22
Scott R.C.	Canterbury	1974,76-78
Scott R.F.S.	Canterbury	1976-78,80
Scott R.R.	Victoria	1920
Seed W.S.	Otago	1909
Service H.	Otago	1933
Seymour D.J.*	Canterbury	1987,88,92
Shannon C.A.	Victoria	1948,49
Shannon P.J.	Waikato	1973,76,78
Shannon R.T.	Victoria	1941,45-47,49
Sharland D.	Canterbury	1982
Sharrock E.G.	Waikato	1988,89
Shaw J.T.	Canterbury	1925
Shaw L.J.	Victoria	1913
Sherlock J.D.	Auckland	1967-71
Siddells S.K.*	Victoria	1920-22
Simcock A.J.	Canterbury	1988-90
Simmers W.H.K.	Otago	1936
Simonsson P.L.J.	Waikato	1986
Simpson L.H.	Otago	1939,40
Simpson V.L.J.*	Canterbury	1982
Sims G.S.*	Otago	1972
Sims M.L.	Massey	1959
Sinclair R.	Auckland	1909
Sinclair R.G.B.*	Otago	1922
Sio T.G.	Canterbury	1986-89
Skudder G.R.*	Waikato	1971
Smart E.C.	Canterbury	1923
Smith A.	Lincoln	1985
Smith A.R.	Canterbury	1927,29
Smith H.L.M.	Otago	1954,55
Smith J.G.	Victoria	1949,52
Smith R.B.	Auckland	1982,85
Smith R.M.	Otago	1973
Smither B.R.	Canterbury	1959-62
Snow D.E.	Lincoln	1963
Sole T.J.	Massey	1976,77,80
Speedy P.	Canterbury	1994
Speight M.W.*	Waikato	1985
Spice J.E.	Waikato	1994-97
Stace I.O.	Canterbury	1936
Stacey R.S.	Auckland	1933
Steel J.J.	Canterbury	1952,53
Steele H.A.	Otago	1939
Steffert M.	Waikato	1992
Steinmetz P.C.	Victoria	1997
Stensness L.*	Massey	1991,92,95
Stephens B.A.	Waikato	1973-76
Stevens P.J.	Waikato	1996
Stevenson D.	Otago	1978
Stevenson D.R.L.*	Otago	1923,25
Stevenson-Wright E.	Otago	1931
Stewart A.	Massey	1940
Stewart D.	Massey	1978
Stewart E.B.*	Otago	1923
Stewart I.	Canterbury	1979,80,82
Stewart J.D.	Lincoln	1947,49
	Canterbury	1951,52,54
Stotter D.	Auckland	1929
Strachan A.D.*	Otago	1987,88
Straker-Smith T.D.	Canterbury	1913
Strang W.R.	Victoria	1965
Stratton P.	Massey	1982
Stuart I.E.	Victoria	1953,54
Stuart R.C.*	Canterbury	1946,48,49,51
Stuckey R.G.	Victoria	1941
Surridge P.A.	Auckland	1992,94-96
Surridge S.D.*	Auckland	1992-93
Sweet B.A.	Auckland	1948,49,51
Syms D.A.	Auckland	1973,74,76,77
Taiaroa R.M.	Canterbury	1959,61
Tait N.D.	Otago	1911
Takurua T.	Massey	1988
Tanner J.M.*	Otago	1948
	Auckland	1949-51,53,54,56
Tanner M.J.	Auckland	1945,49,50,52
Tansey L.M.	Otago	1908
Tapsell P.W.	Otago	1953
	Auckland	1954
Tapsell Q.T.	Canterbury	1961,62
Taufa A.	Victoria	1992
Tauroa E.Te R.	Massey	1951
Taylor C.	Massey	1994
Taylor E.S.	Otago	1968-73
Taylor W.T.*	Canterbury	1983
Telford J.K.	Massey	1996
Tennent O.K.	Victoria	1909
Theed S.H.	Lincoln	1997
Thomas C.B.	Victoria	1922,23
Thomas R.F.	Otago	1931
Thomas R.J.	Auckland	1936
Thompson J.	Otago	1911
Thompson W.J.	Lincoln	1963-67
Thorn D.N.	Auckland	1970,76,78,79
Thorne G.S.*	Auckland	1969,70
Tietjens B.R.	Otago	1970
Timmins B.P.	Otago	1990-94
Tohill A.G.J.	Auckland	1961
Tongo Tongo A.	Auckland	1991
Torrance C.J.	Massey	1996,96
Tovey P.H.	Canterbury	1941
Tremain K.R.*	Massey	1958
	Lincoln	1959-61
Tremain S.D.	Otago	1989
Trethewey P.H.	Auckland	1996,97
Tricklebank W.	Victoria	1936
Trott T.C.	Otago	1938,39
Tui'avii D.	Victoria	1992
Tuipulotu S.B.	Auckland	1997
Turner P.W.	Otago	1982,83,85
	Auckland	1988,89
Uluiviti N.	Auckland	1956
Uttley I.N.*	Victoria	1963,65
Uttley K.F.M.	Otago	1933
Valentine J.W.	Otago	1920
Vivian R.J.	Canterbury	1965
Vosailagi I.L.	Otago	1938
Waddell J.F.	Massey	1951
Walker J.H.R.	Massey	1957
Wall M.J.	Otago	1938
Wall R.W.	Auckland	1953,54,56
Walpole E.	Victoria	1925
Walter G.S.	Canterbury	1939,40
	Auckland	1947
Walters J.M.	Waikato	1976
Ward F.G.*	Otago	1921
Watson C.O.	Canterbury	1923
Watt J.M.*	Otago	1936
Watt M.	Otago	1938
Watt M.H.	Otago	1909
Webb D.S.*	Auckland	1955-58
Webb R.G.	Otago	1925,27
Weinberg G.R.	Victoria	1967
	Auckland	1972
Wells J.*	Victoria	1933
Weston D.L.	Auckland	1951
Weston G.C.	Auckland	1965,66
Whineray W.J.*	Lincoln	1956,57
White D.	Lincoln	1979,80
Wigley A.J.	Canterbury	1908,09
Wild H.R.C.	Victoria	1936,38
Wilkes T.M.	Victoria	1909
Williams B.	Auckland	1990
Williams D.A.	Otago	1982,83
Williams E.P.	Canterbury	1909
Williams G.E.D.	Lincoln	1983
Williams R.N.*	Canterbury	1931
Williment M.*	Victoria	1962-67
Wilson D.D.	Canterbury	1966
Wilson D.M.	Waikato	1993
Wilson F.J.	Canterbury	1936
Winchman G.	Auckland	1990
Winiata W.	Victoria	1958
Wiseman W.L.	Auckland	1921
Withers R.L.	Otago	1913
Wolfe T.N.*	Victoria	1960-62
Wong T.	Victoria	1992
Wood D.R.	Massey	1958
Wood I.D.	Auckland	1987
Woodhams S.J.	Canterbury	1995-97
Woods D.J.	Massey	1982
	Lincoln	1983
Wotherspoon K.J.	Massey	1997
Wright J.A.	Otago	1992
Wright M.A.	Massey	1976,77
Young G.L.	Auckland	1982,84,85
Young H.A.	Canterbury	1908,09
Young H.C.	Massey	1949

Juniors

The New Zealand Rugby Football Union decided during 1957 that a national team comprising players under the age of 23 at 1 January, 1958, would be chosen to tour Japan and Hong Kong in February and March of 1958.

The team was led by a future All Black captain, W.J. Whineray, and coached by a former All Black and future chairman of the NZRFU council, J.L. Sullivan. The only restriction was one of age.

Despite the success of the tour both from a results view and the development of young players, the next Under 23 team was not chosen until 1965, when it played one match against the South Africans. For this and all subsequent Under 23 teams, an added restriction was that players who had been chosen for the full national side were ineligible.

Known informally as the Juniors, the Under 23 sides had their greatest years in the early 70s when one team had an unbeaten tour of Australia and in the following year, 1973, the Juniors beat the All Blacks who earlier that year had returned from their tour of the United Kingdom, Ireland and France.

The last Juniors side was fielded in 1984 and replaced by a team designated Emerging Players, largely for the reason that the age limit of 23 was restrictive. It was felt that many players did not realise their playing potential until after that age.

MATCHES PLAYED BY NEW ZEALAND JUNIORS TEAMS

1958 in JAPAN and HONG KONG
v Waseda University at Tokyo	won	33-12
v All Kanto at Tokyo	won	22-3
v All Japan at Fukuoka	won	34-3
v All Kansai at Nishinomiya	won	39-6
v All Japan at Osaka	won	32-6
v All Japan Students at Nagoya	won	22-10
v Meiji University at Tokyo	won	55-3
v Keio University at Tokyo	won	33-3
v All Japan at Tokyo	won	56-3
v Hong Kong at Hong Kong	won	47-0

Summary:
Played 10, won 10
Points for 373, against 49

1965 in NEW ZEALAND
v South Africa at Christchurch	lost	3-23

1966 in NEW ZEALAND
v Marlborough at Blenheim	won	19-8
v British Isles at Wellington	lost	3-9

1967 in NEW ZEALAND
v Taranaki at New Plymouth	lost	6-16

1968 in NEW ZEALAND
v Japan at Wellington	lost	19-23

1969 in NEW ZEALAND
v Tonga at Wellington	won	43-3

1970 in NEW ZEALAND
v Fiji at Wellington	won	29-9

1972 in NEW ZEALAND and AUSTRALIA
v New Zealand at Wellington	lost	9-25
v Victoria at Melbourne	won	15-6
v Sydney at Sydney	won	23-13
v Brisbane at Brisbane	won	26-22
v Darling Downs at Toowoomba	won	23-9
v Queensland at Brisbane	won	17-0
v Rockhampton at Rockhampton	won	56-0
v Queensland Country at Townsville	won	49-6
v Queensland Barbarians at Brisbane	won	46-15

Summary:
Played 9, won 8, lost 1
Points for 264, against 96

1973 in NEW ZEALAND
v South Canterbury at Timaru	won	19-9
v Southland at Invercargill	won	14-10
v Manawatu at Palmerston North	won	10-7
v King Country at Taumarunui	won	27-6
v Thames Valley at Te Aroha	won	29-12
v Counties at Pukekohe	won	21-12
v Hawke's Bay at Napier	won	25-16
v Waikato at Hamilton	lost	13-16
v New Zealand at Dunedin	won	14-10

Summary:
Played 9, won 8, lost 1
Points for 172, against 98

1974 in NEW ZEALAND
v Mid Canterbury at Ashburton	won	23-15
v West Coast at Greymouth	won	29-9
v Nelson Bays at Nelson	won	31-3
v Taranaki at New Plymouth	won	13-12
v East Coast at Ruatoria	won	57-3
v North Auckland at Whangarei	lost	6-25
v Japan at Auckland	won	55-31

Summary:
Played 7, won 6, lost 1
Points for 214, against 98

1975 in NEW ZEALAND
v North Otago at Oamaru	won	37-4
v Otago at Dunedin	lost	6-21
v Horowhenua at Levin	won	39-0
v Buller at Westport	won	30-9
v Romania at Wellington	drew	10-10

Summary:
Played 5, won 3, lost 1, drew 1
Points for 122, against 44

1976 in NEW ZEALAND
v Mid Canterbury at Ashburton	won	31-9
v West Coast at Greymouth	won	20-8
v Nelson Bays at Nelson	won	38-11
v Marlborough at Blenheim	won	23-12
v Wairarapa-Bush at Masterton	won	24-3
v Manawatu at Palmerston North	won	18-16

Summary:
Played 6, won 6
Points for 154, against 59

1977 in NEW ZEALAND
v British Isles at Wellington	lost	9-19

1978 in AUSTRALIA
v Townsville and District at Townsville	won	33-7
v Mount Isa at Mount Isa	won	50-0
v North Queensland at MacKay	won	43-12
v Central Queensland at Rockhampton	won	84-0
v Queensland at Brisbane	lost	3-41
v Darling Downs at Toowoomba	won	38-10
v Queensland at Brisbane	drew	10-10

Summary:
Played 7, won 5, lost 1, drew 1
Points for 261, against 80

1979 in NEW ZEALAND
v Wairarapa-Bush at Masterton	won	29-0
v Horowhenua at Levin	won	39-6
v East Coast at Ruatoria	won	38-3
v Thames Valley at Paeroa	won	11-0
v King Country at Taumarunui	won	21-6
v Wanganui at Wanganui	won	28-9

Summary:
Played 6, won 6
Points for 166, against 24

1980 in NEW ZEALAND
v South Canterbury at Timaru	won	33-3
v Mid Canterbury at Ashburton	won	25-13
v Poverty Bay at Gisborne	won	26-10
v Waikato at Hamilton	won	30-22
v Italy at Auckland	won	30-13

Summary:
Played 5, won 5
Points for 144, against 61

1982 in NEW ZEALAND
v Marlborough at Blenheim	won	28-16
v King Country at Taumarunui	won	22-6
v Poverty Bay at Gisborne	won	50-0
v Wairarapa-Bush at Masterton	won	13-12

The 1979 New Zealand Juniors
Back row: Pat Benson, Mark Shaw, John Williams, Paul Tuoro, Harvey King, Doug Murcott, Quentin Schofield.
Second row: Terry Murphy, Grant Cederwall, Paul Koteka, Lachie Cameron, Mike Gunson, Paul Macfie, Andrew Donald.
Front row: Pat Gill (manager), Barry Gallagher, Bill Preston, Gary Barkle (captain), Ken Taylor, Steve Vaotu'ua, Peter Burke (coach).
In front: Laurie Holmes, Dave Ngatai.
Absent: Fred Woodman.

Summary:
Played 4, won 4
Points for 113, against 34

1984 in NEW ZEALAND

v Buller at Westport	won	33-9	
v South Canterbury at Timaru	won	55-9	
v Southland at Invercargill	won	24-19	
v Otago at Dunedin	won	24-12	
v Manawatu at Palmerston North	won	15-12	

Summary:
Played 5, won 5
Points for 151, against 61

NEW ZEALAND JUNIORS
REPRESENTATIVES 1958-1984
** indicates a player who represented New Zealand*

Allen G.J.	*Poverty Bay*	1967,68
Allen J.A.	*Auckland*	1975
Allen N.H.*	*Counties*	1980
Anderson A.*	*Canterbury*	1982
Anderson P.G.	*Waikato*	1970,72
Atkins D.P.	*Canterbury*	1984
Bacon G.J.	*Canterbury*	1969
Baker C.D.	*Wairarapa-Bush*	1982
Barkle G.P.	*Canterbury*	1978-80
Barry K.E.*	*Counties*	1958
Bartie B.A.	*Waikato*	1974
Basham M.P.	*Bay of Plenty*	1982
Benson W.P.B.	*Hawke's Bay*	1979
Best M.J.	*Marlborough*	1976
Bennett L.E.	*Auckland*	1970

Black J.E.*	*Canterbury*	1973,74
Blair H.T.	*Manawatu*	1974
Bloxham K.C.*	*Otago*	1975,76
Boon R.J.*	*Taranaki*	1958
Borich J.	*Auckland*	1975
Boroevich K.G.*	*King Country*	1980
Briscoe K.C.*	*Taranaki*	1958
Brown R.H.*	*Taranaki*	1958
Bruce O.D.*	*Canterbury*	1970
Bunn W.G.	*Taranaki*	1982
Burgess R.E.*	*Manawatu*	1968
Callesen J.A.*	*Manawatu*	1972,73
Cameron B.L.	*Bay of Plenty*	1980
Cameron L.M.*	*Manawatu*	1979
Campbell A.K.	*King Country*	1982,84
Carroll J.P.J.	*Manawatu*	1973,74
Carroll P.V.	*Auckland*	1975
Cartwright S.C.*	*Canterbury*	1976
Cederwall B.W.	*Wellington*	1973,74
Cederwall G.N.	*Wellington*	1979
Clamp M.*	*Wellington*	1982
Cochrane B.C.	*Canterbury*	1972
Codlin M.M.	*Counties*	1976
Collins G.J.	*Canterbury*	1977
Collins M.P.	*Otago*	1969
Conn S.B.*	*Auckland*	1975
Connor T.M.	*Bay of Plenty*	1972
Cook G.J.	*West Coast*	1975
Cooper C.G.	*Taranaki*	1982
Cossey R.R.*	*Poverty Bay*	1958
Cotter J.A.	*Wairarapa-Bush*	1978
Cottrell W.D.*	*Canterbury*	1966
Craig R.H.	*Counties*	1969,70

Craig W.A.	*Auckland*	1977
Crawford K.K.	*Hawke's Bay*	1965
Creighton J.N.*	*Canterbury*	1958
Cunningham		
G.R.*	*Auckland*	1978
Currey W.D.R.*	*Taranaki*	1967
Currie C.J.*	*Canterbury*	1978
Darrah M.A.	*Thames Valley*	1984
Davis L.J.*	*Canterbury*	1965,66
Davison D.J.	*Canterbury*	1958
Dawson A.J.	*Counties*	1977,78
Deane M.J.	*Waikato*	1978
Deans R.M.*	*Canterbury*	1982
Dermody G.H.	*Southland*	1968
Dickson L.R.	*Canterbury*	1969
Dineen B.M.J.	*Canterbury*	1958
Donald A.J.*	*Wanganui*	1979,80
Donaldson M.W.*	*Manawatu*	1977
Dougan J.P.*	*Wellington*	1967,68
Duncan M.G.*	*Hawke's Bay*	1969,70
Duncan P.J.	*Poverty Bay*	1973,74
Dunn R.R.	*Auckland*	1978
Dunstan B.R.	*Hawke's Bay*	1976
Earl A.T.*	*Canterbury*	1984
Eggleton P.A.	*Waikato*	1975
Elder B.F.	*Wairarapa*	1967
Eliason I.M.*	*Taranaki*	1966,68
Elliott M.E.C.	*North Auckland*	1978
Ellis C.A.J.	*Waikato*	1982
Elvin G.W.	*Otago*	1976,77
Falconer G.E.	*Wairarapa*	1970
Fawcett C.L.*	*Otago*	1975
Ferguson C.L.	*Hawke's Bay*	1980

Fatialofa M.J.	Auckland	1973
Finlay I.G.	Bay of Plenty	1974
Finn J.M.	Wellington	1965,66
Flavell D.	Waikato	1965
Fleming J.K.*	Wellington	1976
Fouhy D.T.	Wellington	1977
Fowlie K D.	North Auckland	1974
Fox G.J.*	Auckland	1984
Fulford P.A.	Hawke's Bay	1982
Gallagher B.F.	South Canterbury	1979
Gardiner A.J.*	Taranaki	1968
Gemmell B.M.*	Auckland	1970,73
Gilbert P.C.	Bay of Plenty	1972-74
Gilhooly B.P.R.	Taranaki	1967
Graham W.G.*	Otago	1977,78
Grant G.L.	Manawatu	1980
Grant I.G.	Hawke's Bay	1972
Grant K.N.	Wellington	1965
Green R.D.	Canterbury	1958
Greene K.M.*	Waikato	1972
Groot P.	Buller	1978
Gunson M.J.	North Auckland	1979
Haden A.M.*	Auckland	1972
Hainsworth J.D.	Wanganui	1984
Halligan D.M.	Otago	1980,82
Harding M.A.	Canterbury	1978
Hart K.R.	Marlborough	1984
Harvey A.R.	Canterbury	1976
Hayes A.	Waikato	1957
Hayes D.B.	Canterbury	1978
Haynes D.A.	North Auckland	1977
Heffernan M.D.	Canterbury	1975
Hobbs M.J.B.*	South Canterbury	1978
Hollander A.R.	Otago	1980
Holmes B.*	North Auckland	1968,69
Holmes L.A.	Wellington	1979
Hunter R.P.	Hawke's Bay	1972-74
Hurley P.J.	King Country	1980
Irving J.E.	Taranaki	1966
Japeth W.C.	Auckland	1968
Jefferd A.C.R.*	Canterbury	1976
Johns P.A.*	Wanganui	1966
Johnston D.	Otago	1958
Johnstone B.R.*	Auckland	1972,73
Jones M.G.*	Auckland	1965
Julian T.A.	Nelson Bays	1970
Kamizona J.T.	Bay of Plenty	1976
Kane G.N.*	Waikato	1973
Karam J.F.*	Wellington	1972
Kember G.F.*	Wellington	1966,67
Kenny D.J.*	Otago	1984
Ketels R.C.*	Counties	1976,77
King R.H.	South Canterbury	1979
Kirkpatrick I.A.*	Canterbury	1967
Knofflock J.E.	Wanganui	1972
Koteka T.T.*	Waikato	1978,79
Kreft A.J.*	Otago	1967
Kururangi R.*	Counties	1978
Lambert K.K.*	Manawatu	1972
Langford D.J.	Southland	1972
Latham R.T.	Canterbury	1980
Laurie R.D.	Auckland	1966
Lendrum R.N.*	Counties	1969,70
Letica S.L.	Wellington	1966
Lineen T.R.*	Auckland	1958
Lister T.N.*	Wellington	1965,66
Loe R.W.*	Marlborough	1982
Love M.R.	Wanganui	1984
Loveridge D.S.*	Taranaki	1975
McCall C.B.	Southland	1984

McCarroll D.S.	Hawke's Bay	1976
McCashin T.M.*	Wellington	1966
McCool M.J.*	Hawke's Bay	1974
McDowell S.C.*	Bay of Plenty	1984
McGarva P.S.	Hawke's Bay	1974
McGee G.W.	Otago	1972
McKenzie B.T.	Southland	1984
McKillop S.B.	Bay of Plenty	1984
McLachlan J.S.*	Auckland	1970
McLean W.D.	Counties	1980
MacLellan E.D.	Southland	1975
Macmillan K.H.	Counties	1965
McNaughton A.M.*	Bay of Plenty	1969,70
McPhail B.A.	Canterbury	1974,75
Macpherson G.*	Poverty Bay	1984
McRae J.K.	Southland	1967
Macfie P.A.	Otago	1979
Mains L.W.*	Otago	1968
Maniapoto H.J.	Bay of Plenty	1965
Marfell S.W.P.	Marlborough	1973,74
Marinkovich Z.M.	North Auckland	1972
Marriner A.S.	King Country	1969
Maxwell H.M.R.	Counties	1982
Meads C.E.*	King Country	1958
Mehrtens T.L.	Canterbury	1965,67
Middleton A.B.	Wanganui	1978
Mills J.G.	Canterbury	1982
Mills M.W.	Auckland	1980
Milner H.P.*	East Coast	1965
Mitchell M.A.	Southland	1973
Mitchell T.W.*	Canterbury	1973
Morris R.R.	Waikato	1958
Mourie G.N.K.*	Wellington	1973-75
	Taranaki	1975
Murcott W.D.	Southland	1979,80
Murphy T.M.	South Canterbury	1980
Myers R.G.*	Waikato	1973
Natusch M.R.S.	Hawke's Bay	1970
Neal D.W.	Marlborough	1974
Neilson G.R.	Wanganui	1973
Newlands G.R.	Poverty Bay	1970,72
Newlands R.A.	Poverty Bay	1974-76
Ngatai D.	Canterbury	1979
Niven B.R.	Wellington	1969
Nutting M.D.	Horowhenua	1978
O'Callaghan M.W.*	Manawatu	1968
O'Connor J.M.	Waikato	1973,74
	Hawke's Bay	1975
Old G.H.*	Manawatu	1976,78
Oliver F.J.*	Southland	1969,70
Oliver P.T.	Otago	1975,76
Olsen P.A.	Waikato	1975
Osborne A.J.	Wellington	1965,66
O'Shaughnessey P.G.	Hawke's Bay	1982
Palmer D.L.	Auckland	1969
Panther D.R.	North Auckland	1967,68
Parsons R.J.	Manawatu	1984
Patterson R.J.	Auckland	1965
Peacocke P.A.	Canterbury	1972
Penny K.W.	Waikato	1980
Pervan M.I.	Auckland	1977
Pescini D.A.	Otago	1968
Peters W.W.	Otago	1978
Pickering E.A.R.*	Waikato	1958
Pokere S.T.*	Southland	1977
Pollock A.W.	Wellington	1984
Potae W.J.	Bay of Plenty	1966
Prain H.C.	Otago	1958
Preston R.J.	Bay of Plenty	1982

Preston W.A.	Auckland	1979
Proctor P.M.	Wellington	1984
Purvis N.A.*	Otago	1974,75
Reilly P.T.	Counties	1978,80
Renton P.J.	Mid Canterbury	1984
Rich G.J.W.	Auckland	1977
Rollerson D.L.*	Manawatu	1974-76
Romans M.J.T.	Otago	1975
Rosenbrook M.R.	Manawatu	1980
Rowlands A.G.E.	Poverty Bay	1958
Ruddell N.K.	North Auckland	1982
Ryan P.J.*	Wairarapa-Bush	1972,73
Salmon J.L.B.*	Wellington	1980
Saseve T.M.	Auckland	1976
Schofield Q.E.	King Country	1979
Scown A.I.*	Taranaki	1970
Seear G.A.*	Otago	1973,74
Senior G.H.	Wellington	1973
Shannon P.J.	Wellington	1972
Shaw M.W.*	Manawatu	1979
Sheehan P.J.	Thames Valley	1974
Sherlock K.*	Auckland	1984
Simpson V.L.J.*	Canterbury	1982
Sims G.S.*	Otago	1972
Sisam M.K.	Auckland	1976,77
Smith B.W.*	Waikato	1982
Sole T.J.	Manawatu	1976
Soper A.J.*	Southland	1958
Sorensen N.A.	Wellington	1984
Stephens O.G.*	Bay of Plenty	1966,68
Stevens I.N.*	Wellington	1968
Stewart B.N.	West Coast	1972
Stewart K.W.*	Southland	1972
Strahan S.C.*	Manawatu	1966
Sullivan J.D.	West Coast	1977
Sutherland A.R.*	Marlborough	1966
Syms D.A.	Auckland	1972
Tanner K.J.*	Canterbury	1966,67
Tataurangi T.W.M.	Auckland	1965
Taylor H.G.	Canterbury	1973,74
Taylor K.J.*	Hawke's Bay	1979,80
Taylor M.B.*	Waikato	1976
Thompson E.J.	North Auckland	1958
Thorne G.S.*	Auckland	1967
Thorpe A.J.	Canterbury	1984
Torrance M.C.	Otago	1982
Tremain K.R.*	Southland	1958
Tuoro P.S.	Counties	1979
Turley I.F.	Wairarapa	1967,68
Twigden T.M.*	Auckland	1975
Vance H.G.	Wellington	1978
Vaotu'ua S.	Auckland	1979
Vincent M.R.	Canterbury	1984
Waldron V.J.	Otago	1978
Walsh P.T.*	Counties	1958
Watkins A.M.	Auckland	1969
Watt J.R.*	Southland	1958
Watts M.G.*	Manawatu	1975-77
Whatman R.D.	Auckland	1967
Whetton A.J.*	Auckland	1982
Whineray W.J.*	Canterbury	1958
White D.A.	Canterbury	1980
Whiting G.J.*	King Country	1969
Whiting P.J.*	Auckland	1967-69
Whitta M.F.	Canterbury	1958
Wilkinson G.L.	Wellington	1980
Williams G.C.*	Wellington	1965-67
Williams J.N.	Waikato	1978,79
Wilson B.W.*	Otago	1977
Wilson R.G.*	Canterbury	1973,76
Winitana V.	Wellington	1970
Woodman F.A.*	North Auckland	1979,80

Colts

The concept of national under 21 teams, later well accepted, began in 1955 in the unusual rugby territory of the non-rugby states of Australia (Victoria, South Australia and Western Australia) and continued in the even less likely rugby country of Ceylon (which became Sri Lanka in 1972).

Another oddity of the first tour was that the players were each required to provide a bond of £250 towards their expenses. The coach of the 1955 team was J.J. Stewart, who was not asked to coach another national team until 18 years later when he was appointed coach of the All Blacks.

A Colts team was not again chosen until 1964 when Australia was again the country visited and, on this occasion, All Blacks under the age of 21 were eligible. Six full national representatives were chosen – W.L. Davis, C.R. Laidlaw (who captained the side), I.R. MacRae, R.C. Moreton, I.S.T. Smith and T.N. Wolfe.

Eight years passed before another national Colts side was selected but they have been chosen yearly since then and, since 1980, have had an annual fixture against the Australian Under 21 team. All Blacks are not usually available for Colts teams but sometimes have been chosen. Since 1995, the Colts have played in an annual southern hemisphere tournament.

MATCHES PLAYED BY NEW ZEALAND COLTS TEAMS

1955 in AUSTRALIA and CEYLON
v Victoria at Melbourne	won	17-3
v South Australia at Adelaide	won	9-6
v Western Australia at Perth	won	24-0
v Colombo Clubs at Colombo	won	35-5
v Up-Country at Kandy	won	24-3
v All Ceylon at Radella	won	35-0
v Ceylon Barbarians at Colombo	won	33-0
v All Ceylon at Colombo	won	34-0

1964 in AUSTRALIA
v Combined Southern States at Hobart	won	56-3
v South Australia at Adelaide	won	35-5
v Victoria at Melbourne	won	60-3
v Australian Universities at Sydney	won	22-6
v City of Sydney at Sydney	won	16-0
v New South Wales Country at Sydney	won	28-9
v Queensland at Brisbane	lost	12-30

1972 in NEW ZEALAND
v Taranaki at New Plymouth	won	21-6

1973 in NEW ZEALAND
v Marlborough at Blenheim	won	30-13
v Nelson Bays at Nelson	won	25-19
v Buller at Westport	won	10-0

1974 in NEW ZEALAND
v Thames Valley at Te Aroha	won	25-10
v Manawatu at Palmerston North	lost	12-23
v Horowhenua at Levin	won	47-3
v Wairarapa-Bush at Masterton	won	26-10

1975 in NEW ZEALAND
v East Coast at Ruatoria	won	7-0
v Hawke's Bay at Napier	lost	6-7
v Poverty Bay at Gisborne	lost	9-20
v Waikato at Hamilton	won	12-10

1976 in NEW ZEALAND
v Thames Valley at Thames	drew	3-3
v Wanganui at Wanganui	lost	13-19
v King Country at Te Kuiti	won	16-10
v Counties at Pukekohe	lost	7-15

1978 in NEW ZEALAND
v West Coast at Greymouth	won	33-4
v South Canterbury at Timaru	won	9-7
v Marlborough at Blenheim	won	19-16
v Wairarapa-Bush at Masterton	won	17-3
v Irish Universities at Auckland	lost	0-9

1979 in NEW ZEALAND
v Nelson Bays at Nelson	won	14-10
v Buller at Westport	won	9-0
v West Coast at Greymouth	won	17-0
v Mid Canterbury at Ashburton	won	10-6
v North Otago at Oamaru	won	14-4

1980 in NEW ZEALAND and AUSTRALIA
v Thames Valley at Thames	won	29-13
v Australian Capital Territory at Canberra	won	34-7
v Australia Under 21 at Sydney	won	10-8

1981 in NEW ZEALAND
v Waikato at Hamilton	lost	6-53
v Australia Under 21 at Auckland	won	37-7

1982 in NEW ZEALAND and AUSTRALIA
v Horowhenua at Levin	won	42-9
v West Coast at Greymouth	won	33-6
v Mid Canterbury at Ashburton	won	15-9
v Sydney Sub-district Combined XV at Sydney	won	45-0
v Australia Under 21 at Sydney	lost	12-36

1983 in NEW ZEALAND
v Nelson Bays at Nelson	won	45-6
v Taranaki at New Plymouth	lost	15-20
v Australia Under 21 at Pukekohe	lost	18-26

1984 in NEW ZEALAND and AUSTRALIA
v Poverty Bay at Gisborne	won	28-6
v Wanganui at Wanganui	won	29-12
v King Country at Taumarunui	lost	18-28
v Australia Under 21 at Sydney	lost	10-12

1985 in NEW ZEALAND
v Horowhenua at Levin	won	43-3
v Wanganui at Wanganui	won	12-3
v Manawatu at Palmerston North	won	15-9
v Australia Under 21 at Auckland	won	37-21

1986 in NEW ZEALAND and AUSTRALIA
v West Coast at Greymouth	won	61-13
v Nelson Bays at Nelson	won	62-3
v Wellington at Wellington	lost	6-52
v Australia Under 21 at Sydney	lost	11-35

1987 in NEW ZEALAND
v Wairarapa Bush at Masterton	lost	18-24
v Horowhenua at Levin	won	45-19
v King Country at Taumarunui	won	31-10
v Australia Under 21 at Takapuna	won	37-12

1988 in NEW ZEALAND and AUSTRALIA
v Wellington Invitation XV at Upper Hutt	lost	14-23
v Queensland Under 21 at Brisbane	lost	14-22
v Queensland Country Under 21 at Nambour	won	72-0
v Australia Under 21 at Brisbane	lost	19-24

1989 in NEW ZEALAND
v Horowhenua at Levin	won	53-20
v Taranaki at New Plymouth	won	48-18
v Thames Valley at Paeroa	won	25-4
v Australia Under 21 at Auckland	won	38-15

1990 in AUSTRALIA
v New South Wales Country Colts at Maitland	won	57-0
v Western Australia at Sydney	won	26-16
v Australia Under 21 at Sydney	won	24-21

1991 in NEW ZEALAND
v North Otago at Oamaru	won	54-6
v Southland at Invercargill	won	30-9
v South Canterbury at Timaru	won	46-14
v Australia Under 21 at Christchurch	won	61-9

1992 in AUSTRALIA
v Gold Coast at Brisbane	won	83-7
v Darling Downs at Toowoomba	won	36-0
v Australia Under 21 at Brisbane	won	20-10

The 1995 New Zealand Colts team which won the Southern Hemisphere tournament in Argentina.
Back row: Andrew Blowers, Paul Thomson, Chris Hammett, Dion Waller, Chresten Davis, Keryn Martin, Andrew Gallagher.
Third row: Kees Meeuws, Carlos Spencer, Roger Randle, Scott Robertson, James Kerr, Adam Larkin, Isitolo Maka, Jeremy Stanley.
Second row: Lin Colling (assistant coach), Daryl Gibson, Matthew Carrington, Michael Collins, Anton Oliver, Carl Hoeft, Shane Carter, Chris McCullough (physiotherapist).
Front row: Cameron Rackham, Ross Cooper (coach), Mark Robinson, Taine Randell (captain), Christian Cullen, Mike Banks (manager), Danny Lee.

1993 in NEW ZEALAND

v Thames Valley *at Paeroa*	won	64-12	
v Australia Under 21			
at Auckland	lost	8-31	

1994 in AUSTRALIA

v New South Wales Country			
Under 21 *at Port Macquarie*	won	76-3	
v NSW Under 21 Development			
team *at Sydney*	won	60-10	
v Australia Under 21 *at Sydney*	won	41-31	

1995 at SOUTHERN HEMISPHERE COLTS TOURNAMENT in ARGENTINA

v Argentina *at Buenos Aires*	won	24-19	
v South Africa *at Buenos Aires*	won	24-7	
v Australia *at Buenos Aires*	won	33-16	

1996 at SOUTHERN HEMISPHERE COLTS TOURNAMENT in NEW ZEALAND

v Manawatu Invitation XV			
at Palmerston North	lost	10-12	
v Horowhenua *at Otaki*	won	65-3	
v Argentina			
at Palmerston North	won	88-21	
v South Africa *at Taupo*	won	28-18	
v Australia *at Takapuna*	lost	14-17	

1997 in FIJI

v Fiji Under 21 *at Suva*	won	33-3	
v Fiji Under 21 *at Nadi*	won	49-14	

1997 at SOUTHERN HEMISPHERE COLTS TOURNAMENT in AUSTRALIA

v Argentina *at Sydney*	won	29-25	
v South Africa *at Sydney*	won	46-20	
v Australia *at Sydney*	lost	14-33	

NEW ZEALAND COLTS REPRESENTATIVES 1955-1997

** indicates a player who represented New Zealand*

Adams L.J.	*North Otago*	1955
Ake B.	*Auckland*	1985
Alatini P.F.	*Southland*	1997
Allen B.S.	*Wellington*	1975
Allen J.A.	*Auckland*	1974
Allen K.R.	*Poverty Bay*	1972
Allen N.H.*	*Counties*	1978
Allington M.G.	*Counties*	1973
Anderson A.*	*Canterbury*	1980,81
Ashby K.H.	*Counties*	1979
Atkins D.P.	*Canterbury*	1980,81
Atkinson M.	*Hawke's Bay*	1994
Atuahiva J.J.	*Counties*	1982,84
Avery R.G.	*Marlborough*	1985
Bachop G.T.M.*	*Canterbury*	1987
Bachop S.J.*	*Canterbury*	1986,87
Barbara G.	*Auckland*	1975
Barry L.J.*	*North Harbour*	1991,92
Batty G.B.*	*Wellington*	1972
Bellamy D.A.	*Hawke's Bay*	1993
Berry M.J.*	*Wairarapa-Bush*	1985,86
Best M.J.	*Marlborough*	1974
Bird J.G.	*Hawke's Bay*	1981
Black J.E.*	*Canterbury*	1972
Blackadder T.J.*	*Canterbury*	1991,92
Blowers A.F.*	*Auckland*	1995,96
Bloxham K.C.*	*Otago*	1974
Bodie J.W.	*Wellington*	1986
Boon R.J.*	*Taranaki*	1955
Boroevich K.G.*	*King Country*	1978,79
Borrie J.N.	*North Otago*	1976
Botica F.M.*	*Auckland*	1984
Bradley J.J.	*Waikato*	1975
Brain E.R.	*Counties*	1987-89

Brewer M.R.*	*Otago*	1985
Broederlow P.W.	*Manawatu*	1976
Brooke M.V.	*Auckland*	1984
Brooke R.M.*	*Auckland*	1987
Brooke Z.V.*	*Auckland*	1985,86
Brown T.E.	*Otago*	1996
Bruning L.P.	*Canterbury*	1996
Buchan J.P.*	*Auckland*	1985
Bunn W.G.	*Taranaki*	1980
Calder I.R.	*Otago*	1987
Calvert M.J.	*Wellington*	1987,88
Cameron B.G.	*Auckland*	1964
Cameron L.M.*	*Manawatu*	1978
Campbell A.K.	*King Country*	1980,81
Campbell J.W.	*Otago*	1993
Carrington M.J.	*Auckland*	1995-97
Carroll J.P.J.	*Manawatu*	1973
Carroll P.V.	*Auckland*	1973
Carter J.S.	*Auckland*	1988
Carter M.P.*	*Auckland*	1989
Carter S.	*Nelson Bays*	1994
	Wellington	1995
Cashmore A.R.*	*Bay of Plenty*	1993,94
Christian J.	*Auckland*	1997
Clamp M.*	*Wellington*	1981
Clare D.B.	*Manawatu*	1973
Coe J.E.	*Counties*	1985
Coffey G.P.	*Canterbury*	1985
Coffin P.H.*	*King Country*	1985
Collins G.J.	*Canterbury*	1976
Collins J.A.	*Northland*	1994
Collins M.	*Waikato*	1995
Collinson J.R.	*Canterbury*	1978,79
Cook G.J.	*West Coast*	1974
Cooke P.J.	*Hawke's Bay*	1986,87
Cooksley M.S.*	*Counties*	1991
Cooper G.J.L.*	*Otago*	1985

Name	Region	Year
Cooper M.J.A.*	Hawke's Bay	1987
Cormack J.A.	Southland	1984
Cornelius A.F.	Mid Canterbury	1964
Costello C.M.	Thames Valley	1989
Coughlan T.J.D.	Canterbury	1984
Cox S.J.	Wellington	1985
Crabb S.J.	Waikato	1990
Crawford O.	Waikato	1986
Cron S.*	Canterbury	1974,75
Cropper P.A.	Canterbury	1984,85
Crowley A.E.	Taranaki	1985-86
Crowley K.J.*	Taranaki	1980-82
Crowley S.J.	Wanganui	1982
Cullen C.M.	Manawatu	1995
Currie C.J.*	Wellington	1976
Daniel J.B.B.	Wellington	1992
Davis C.S.*	Manawatu	1994-96
Davis W.L.*	Hawke's Bay	1964
Deans R.M.*	Canterbury	1980
Donald A.J.*	Wanganui	1978
Donaldson M.W.*	Manawatu	1974,76
Dorgan C.J.	South Canterbury	1986,87
Dowd C.W.*	Auckland	1989,90
Doyle S.C.	Manawatu	1991
Driver M.J.	Waikato	1993
Duncan A.J.	Otago	1955
Duncan B.F.	Otago	1955
Duncan P.J.	Poverty Bay	1972,73
Dunn E.J.*	Auckland	1974,75
Dunn I.T.W.*	North Auckland	1980
Dunstan B.R.	Hawke's Bay	1975
Earl A.T.*	Wairarapa-Bush	1982
Earl C.C.	Canterbury	1984
Edwards J.P.R.	Bay of Plenty	1990
Edwards M.R.W.	Wellington	1989,91
Eggleton P.A.	Waikato	1974
Ellis M.C.G.*	Otago	1991
Ellison D.R.	Otago	1986
Elvin G.W.	Otago	1974
Fairweather P.M.	Bay of Plenty	1990
Farrell B.F.	Auckland	1973
Farrell C.P.*	Auckland	1976
Feek G.E.	Taranaki	1996
Ferguson C.L.	Waikato	1978,79
Fergusson A.J.	Auckland	1981
Filipo M.T.	Auckland	1992
Finlay M.C.*	Manawatu	1982-84
Finn J.M.	Wellington	1964
Fitzpatrick S.B.T.*	Auckland	1983,84
Fitzsimmons E.N.	Nelson	1964
Fitzsimons S.D.	Poverty Bay	1990
Flavell T.	North Harbour	1997
Fleming B.R.M.	Canterbury	1996,97
Fleming J.K.*	Auckland	1973
	Wellington	1974
Flutey M.R.	Hawke's Bay	1994
Flynn J.P.	Southland	1987
Foote B.M.	Thames Valley	1994
Ford B.R.*	Marlborough	1972
Forster S.T.*	Otago	1990
Fortune J.D.	Southland	1979
Foster M.T.	Wairarapa-Bush	1985
Fox G.J.*	Auckland	1982,83
Frederikson B.T.	Horowhenua	1955
Freshwater P.T.	Wellington	1993
Gallagher A.R.	Wellington	1995
Geany N.P.	Wellington	1987,88
Gibbs J.	Waikato	1997
Gibbes C.J.	Hawke's Bay	1994
Gibson D.P.E.	Canterbury	1994-96
Gibson R.	Canterbury	1978,80
Gillespie B.A.	North Harbour	1994
Glass N.E.	South Canterbury	1976
Godbold D.J.K.	Poverty Bay	1996
Going V.S.	Waikato	1991,92
Goldsmith J.A.*	Auckland	1990
Gordon S.B.*	Waikato	1987,88
Grant R.I.	Canterbury	1973
Green J.L.	Marlborough	1955
Goodwin P.R.	Wellington	1986
Goodwin S.W.	Mid Canterbury	1955
Gordon A.H.	Mid Canterbury	1980-82
Gordon R.W.	Otago	1986
Gordon R.E.	Hawke's Bay	1978
Graham W.G.*	Otago	1976
Green C.I.*	Canterbury	1982
Haig B.S.	Otago	1979
Halford G.A.	Hawke's Bay	1990,91
Halligan D.J.	Waikato	1986
Halligan D.M.	Otago	1979
Hammett C.	Canterbury	1995
Hammett M.G.	Canterbury	1992,93
Hanning R.M.	Canterbury	1989
Hardiman S.R.	Southland	1964
Harding M.A.	Canterbury	1976
Hart G.D.	Auckland	1975
Hart K.R.I.	Marlborough	1982
Harvey R.B.	North Otago	1983,84
	Canterbury	1985
Hassan C.A.	Counties	1991
Hawkins P.H.	Wairarapa-Bush	1979
Hayes A.	Waikato	1955
Haynes D.A.	North Auckland	1976
Henare H.H.	Poverty Bay	1964
Henderson P.W.*	Southland	1983,84
Hewett J.A.*	Manawatu	1988,89
Hewitt N.J.*	Hawke's Bay	1989
Hiini C.W.	Southland	1978,80
Hill G.	Auckland	1997
Hill M.C.	Thames Valley	1974
Hill W.E.	Auckland	1979,80
Hines G.R.*	Waikato	1979
Hoeft C.H.	Thames Valley	1995
Hollander A.R.	Canterbury	1978
Holmes L.A.	Wellington	1978
Holwell D.E.	Northland	1996
Howlett D.C.	Auckland	1997
Hunt L.J.	South Canterbury	1983
Hunter R.P.	Hawke's Bay	1973
Innes C.R.*	Auckland	1988-90
Innes M.J.	Waikato	1991
Iti B.P.	Waikato	1985,86
Izatt C.S.	Manawatu	1992
Jackson B.T.	Auckland	1990,91
Jensen P.D.K.	Wellington	1981,82
Jerram R.M.	Manawatu	1986
Johns R.R.	Canterbury	1976
Johnson M.	King Country	1990
Johnson P.R.	North Otago	1979
Johnston W.B.	North Auckland	1988
Jones L.D.G.	Waikato	1993
Jones M.N.*	Auckland	1986
Joseph J.W.*	Otago	1989
Kane G.N.*	Waikato	1972,73
Karam J.F.*	Wellington	1972
Kaui D.A.	Bay of Plenty	1991
Kendrick M.P.	Wanganui	1983,84
Kerr D.P.	Canterbury	1990
Kerr J.S.	Auckland	1995,96
Ketels R.C.*	Counties	1975
Kingi P.	Counties	1974
Kirman A.J.	Auckland	1988
Kirwan J.J.*	Auckland	1983
Konia G.N.	Manawatu	1989-90
Laidlaw C.R.*	Otago	1964
Lam P.R.*	Auckland	1989
Lambert K.K.*	Manawatu	1972
Lancaster S.C.	Auckland	1992
Laney B.J.	Sth Canterbury	1994
Larsen B.P.*	North Harbour	1990
Latham R.T.	Canterbury	1981
Lealamanua K.	Wellington	1997
Le Bas R.L.J.	North Auckland	1991
Lee D.D.	Hawke's Bay	1995-97
Leggat J.E.	Canterbury	1984
Leiasamaivao T.	Wanganui	1988
Lennox G.R.J.	Manawatu	1989
Leslie M.D.	Wellington	1992
Lewis A.J.	Otago	1982
Lines S.	Taranaki	1994
Lister T.N.*	South Canterbury	1964
Little W.K.*	North Harbour	1989
Loe S.J.	Canterbury	1986
Lomu J.T.*	Counties	1994
Lose W.K.	Auckland	1988
Love G.N.	Hawke's Bay	1964
McAlpine I.D.	Marlborough	1975
McCahill B.J.*	Auckland	1984,85
McCallum W.A.	Southland	1982
McCashin T.M.*	Horowhenua	1964
McCormack B.J.	Otago	1991,92
McCormick A.F.	Canterbury	1988
McCormick G.J.	Mid Canterbury	1978
MacDonald D.N.	Otago	1979
McDonald L.	Mid Canterbury	1983
MacDonald L.	Marlborough	1978
MacDonald L.R.	Canterbury	1997
McDonald S.	Taranaki	1991
McDowell S.C.*	Bay of Plenty	1982
McEnaney A.J.	West Coast	1955
McFarland S.P.	North Harbour	1993
Macfie P.A.	Canterbury	1976
McGahan G.	Auckland	1984
McGahan P.W.*	Counties	1984
McGurk J.G.	West Coast	1981
McIntosh R.N.	Waikato	1988
McIntosh R.R.	Wellington	1980
McKay P.B.	Canterbury	1975
McKellar R.D.	Mid Canterbury	1987
McKenzie A.G.	Manawatu	1988
McLay J.A.	Mid Canterbury	1974
Maclean A.M.	Manawatu	1994
McLean M.D.	Counties	1982,83
MacLellan E.D.	Southland	1974
McLenaghen R.H.	Mid Canterbury	1955
McLeod C.	Canterbury	1996
McMaster A.	Canterbury	1983
Macmillan K.H.	Counties	1964
McPhail B.A.	Canterbury	1973
MacRae I.R.*	Hawke's Bay	1964
Macklow B.B.	Hawke's Bay	1973
Magill K.J.	Waikato	1976
Maka F.	Auckland	1997
Maka I.	Auckland	1995,96
Male K.G.	Auckland	1964
Maling S.	Otago	1996
Maniapoto H.J.	Auckland	1964
Mannering R.	Canterbury	1980
Manning N.H.	Taranaki	1975
Mannix S.J.*	Wellington	1990
Mantell N.M.	Auckland	1987
Manu D.	Auckland	1990
Marfell F.W.	Marlborough	1982,83
Marfell S.W.P.	Marlborough	1973
Marshall J.B.	Buller	1955
Marshall J.W.*	Southland	1993,94
Marshall K.A.W.	Wellington	1995,96
Matthews D.H.	King Country	1992
Mathewson A.D.	Hawke's Bay	1982
Maxwell H.J.	Poverty Bay	1981
Maxwell N.M.	Northland	1996,97
Maxwell S.B.	Manawatu	1991
Mayerhofler M.A.	North Harbour	1992,93
Meads C.E.*	King Country	1955
Meeuws K.J.	Auckland	1994,95
Mehrtens A.P.*	Canterbury	1993,94
Mexted F.M.	Wellington	1983
Mickell G.R.	Canterbury	1985
Middleton A.B.	Wanganui	1975,76
Miller P.	Otago	1997
Miller T.J.*	Waikato	1994
Mills M.W.	Auckland	1979
Milner H.P.*	East Coast	1964
Mitchell S.J.	Canterbury	1973
Moncrieff E.A.	Wellington	1992,93
Monkley D.I.	Waikato	1987
Moreton R.C.*	Canterbury	1964
Morgan D.J.	Waikato	1988-90

Morgan E.	*Otago*	1997
Moore M.J.	*Mid Canterbury*	1972
Morris B.C.	*Manawatu*	1976
Morris D.T.K.	*Hawke's Bay*	1989
Morrison D.B.	*Manawatu*	1986
Mourie G.N.K.*	*Wellington*	1972
Muir G.W.	*Poverty Bay*	1979
Mullins D.C.	*Waikato*	1975
Munro B.G.	*Auckland*	1972
Murdoch P.H.*	*Auckland*	1964
Murphy T.M.	*South Canterbury*	1978
Muru H.	*Waikato*	1985,86
Nahona J.K.	*Wanganui*	1989
Neal D.W.	*Marlborough*	1972
Neilson T.A.	*Wellington*	1973
Ngauamo M.	*Auckland*	1997
O'Connor J.M.	*Auckland*	1972
	Waikato	1973
Oliver A.D.*	*Otago*	1994-96
Oliver P.T.	*Otago*	1973
Osborne G.M.*	*Wanganui*	1991,92
Osborne W.M.*	*Wanganui*	1974
Osbourn K.G.N.	*Canterbury*	1955
O'Sullivan T.P.A.*	*Taranaki*	1955
Otai K.M.F.	*Manawatu*	1988
Paewai M.R.	*Hawke's Bay*	1992,93
Parsons R.J.P.	*Wanganui*	1982,83
Paterson I.V.	*Waikato*	1964
Patterson R.J.	*Auckland*	1964
Perelini A.	*Auckland*	1989,90
Pervan M.I.	*Auckland*	1976
Phillips M.	*Waikato*	1996
Philp T.A.	*Manawatu*	1996
Philpott S.*	*Canterbury*	1986
Pollock A.W.	*Wellington*	1982
Porter N.M.	*Canterbury*	1978,79
Pothan J.A.	*Wellington*	1994
Power D.T.	*Wellington*	1990
Preston B.J.	*Poverty Bay*	1955
Preston J.P.*	*Canterbury*	1988
Proctor M.B.	*Auckland*	1976
Purcell T.J.	*Waikato*	1983
Purvis N.A.*	*Wairarapa-Bush*	1972
Rackham C.J.	*Auckland*	1995
Ralph C.S.	*Bay of Plenty*	1997
Ranby R.M.	*Manawatu*	1997
Randell T.C.*	*Otago*	1993-95
Randle R.Q.	*Hawke's Bay*	1995
Raureti M.H.	*Bay of Plenty*	1955
Reid H.R.*	*Bay of Plenty*	1979
Reihana B.T.	*Waikato*	1996,97
Reilly P.T.	*Counties*	1979
Renton P.J.	*Manawatu*	1983
Richan R.N.	*Otago*	1978
Ridge M.J.*	*Auckland*	1988,89
Robertson A.B.	*Manawatu*	1981
Robertson B.	*Southland*	1978
Robertson S.M.	*Bay of Plenty*	1995
Robinson M.D.*	*North Harbour*	1995,96
Robson P.D.	*Canterbury*	1983
Rolleston K.R.	*Wellington*	1992
Romans M.J.T.	*Otago*	1974
Roose A.T.	*Otago*	1989
Ropati R.L.	*Auckland*	1996,97
Ross C.J.	*Waikato*	1975,76
Ross G.B.	*Waikato*	1974,75
Ruddell N.K.	*North Auckland*	1980,81
Rush X.	*Auckland*	1997
Rutene D.	*Wairarapa-Bush*	1984
Rutene P.D.	*Wairarapa-Bush*	1982
Rutledge L.M.*	*Southland*	1973
Schuler K.J.*	*Manawatu*	1987,88
Schuster N.J.*	*Auckland*	1985
Scott S.J.*	*Canterbury*	1975,76
Seear G.A.*	*Otago*	1972
Seve F.	*Wellington*	1997
Sexton M.R.	*Canterbury*	1990,91
Seymour D.J.*	*Canterbury*	1987
Sharrock E.G.	*Wellington*	1987
Shaw K.	*Horowhenua*	1978
Shelford W.T.*	*Auckland*	1978
Simpkins S.A.	*Bay of Plenty*	1992
Simpkins G.L.	*North Harbour*	1992
Simpson V.L.J.*	*Canterbury*	1980
Sims C.L.	*Wairarapa-Bush*	1987
Sisam M.K.	*Auckland*	1975
Slater G.L.*	*Taranaki*	1991,92
Smith A.E.*	*Taranaki*	1964
Smith I.S.T.*	*Otago*	1964
Sole T.J.	*Manawatu*	1975
Somerville G.	*Hawke's Bay*	1997
Soper A.J.*	*Southland*	1955
Sorensen N.A.	*Manawatu*	1981
	Wellington	1982
Spanhake J.R.	*Bay of Plenty*	1991
Speight M.W.*	*Waikato*	1983
Spencer C.S.*	*Horowhenua*	1993,94
	Auckland	1995
Stanley J.C.*	*Auckland*	1995
Steele M.J.	*Nelson Bays*	1987,88
Stensness L.*	*Manawatu*	1991
Stone A.M.*	*Waikato*	1981
Surridge S.D.*	*Auckland*	1991
Sutherland K.G.	*Marlborough*	1974
Symon G.D.	*Canterbury*	1981
Tagaloa T.D.	*Auckland*	1983
Taimaliefane R.	*Auckland*	1992
Tapara L.I.	*Bay of Plenty*	1993
Tataurangi T.W.M.	*Auckland*	1964
Taylor G.L.*	*North Auckland*	1991
Taylor H.G.	*Canterbury*	1973
Taylor K.J.*	*Hawke's Bay*	1978
Taylor M.B.*	*Waikato*	1976
Taylor S.M.	*Hawke's Bay*	1996
Taylor W.T.*	*Otago*	1980,81
Telea A.	*Wellington*	1993
Thomsen G.	*South Canterbury*	1975
Thomson P.	*Auckland*	1995
Thorpe R.S.	*Wellington*	1975
Thurston D.E.	*Wanganui*	1955
Tiatia S.A.A.	*Otago*	1996
	Wellington	1997
Timu J.K.R.*	*Otago*	1988,90
Todd K.R.	*Auckland*	1992,93
Todd R.B.	*North Harbour*	1991
Tolich P.I.	*Auckland*	1975
Torrance C.J.	*Manawatu*	1993
Torrance M.C.	*Otago*	1979,80
Tregaskis C.D.*	*Wellington*	1984
Tremain S.D.	*Otago*	1989
Tuigamala V.*	*Auckland*	1988-90
Turner R.S.*	*North Harbour*	1989
Ujdur I.M.	*Hawke's Bay*	1955
Umaga T.J.F.*	*Wellington*	1994
Valli G.T.*	*Southland*	1975
Vincent M.H.	*Wellington*	1984
Waller D.	*Waikato*	1995
Walsh G.L.	*Auckland*	1986,87
Walters J.M.	*Waikato*	1975
Waterson I.	*Auckland*	1979
Watts D.J.	*Hawke's Bay*	1992,93
Watts R.A.M.	*North Auckland*	1990
Webb R.A.	*Auckland*	1964
Weedon M.	*Auckland*	1989
Wheeler E.C.	*Wellington*	1955
Whetton A.J.*	*Auckland*	1980
Whetton G.W.*	*Auckland*	1979
Whetton K.J.	*Auckland*	1988
Whineray W.J.*	*Manawatu*	1955
White G.A.	*Canterbury*	1986
Whitelock B.J.	*Canterbury*	1979
Whitta M.F.	*Canterbury*	1955
Wickes C.D.*	*Manawatu*	1980,81
Wilkinson G.L.	*Wellington*	1978
Williams D.A.	*Otago*	1982
Williams D.R.	*Auckland*	1985
Williams R.O.*	*Auckland*	1984
Willis B.	*Auckland*	1997
Willis R.	*Waikato*	1996
Wilson P.	*North Harbour*	1997
Wilson R.G.*	*Canterbury*	1973,74
Wilson S.S.*	*Wellington*	1976
Wilson J.W.*	*Otago*	1993
Wisker G.M.	*Canterbury*	1983,84
Wolfe T.N.*	*Taranaki*	1964
Wood I.D.	*Manawatu*	1983
Wootton W.J.	*Wellington*	1974

Other National Teams

After the concept of an under 23 team, the Juniors, was dropped at the end of the 1984 season, the New Zealand union introduced an Emerging Players team, reasoning that some players did not reach their playing maturity until they were older than 23. Since then, various other national team concepts have been used, including a Divisional team chosen from second and third division players.

MATCHES PLAYED BY NEW ZEALAND EMERGING PLAYERS TEAMS

1985 in NEW ZEALAND
v Mid Canterbury at Ashburton	won	56-0
v Wairarapa-Bush at Masterton	won	20-11
v King Country at Taumarunui	won	32-8
v Bay of Plenty at Rotorua	lost	11-19
v Counties at Pukekohe	lost	6-16

1986 in NEW ZEALAND
v North Auckland at Whangarei	drew	27-27
v North Harbour at Takapuna	lost	20-21
v Taranaki at New Plymouth	lost	22-25
v Hawke's Bay at Hastings	lost	3-38
v Otago at Dunedin	lost	12-15

MATCHES PLAYED BY NEW ZEALAND DIVISIONAL TEAMS

1988 in the SOUTH PACIFIC
v Cook Islands Selection at Rarotonga	won	56-4
v Cook Islands at Rarotonga	won	9-6
v President's Selection at Teufaiva	won	28-8

v Tonga at Nuku'alofa	won	25-8
v Nadi Districts at Nadi	won	30-16
v Fiji at Suva	won	24-20

1989 in NEW ZEALAND
v Waikato at Hamilton	lost	25-32

1990 in NEW ZEALAND
v Poverty Bay at Gisborne	won	55-6
v Western Samoa at Taupo	won	57-9
v Counties at Pukekohe	won	45-4

1991 in AUSTRALIA
v ACT at Canberra	lost	13-18
v NSW Country at Batemans Bay	won	31-17
v Victoria at Melbourne	won	40-4
v South Australia at Adelaide	won	43-0
v Sydney at Sydney	lost	19-45

1992 in NEW ZEALAND
v Thames Valley at Te Aroha	won	30-6
v Waikato at Hamilton	drew	30-30
v Counties at Pukekohe	won	20-17

1993 in NEW ZEALAND
v King Country at Otorohanga	won	70-8

v Hawke's Bay at Napier	won	35-18
v Wellington at Wellington	won	34-22

1993 in the SOUTH PACIFIC
v Tonga President's XV at Nuku'alofa	won	66-0
v Tonga at Nuku'alofa	lost	18-21
v Western Division at Nadi	won	31-29
v Eastern Division at Suva	won	39-3
v President's XV at Rarotonga	won	30-24
v Cook Islands at Rarotonga	won	26-15
v Samoan President's XV at Apia	won	35-26

1995 in CANADA, FIJI and NEW ZEALAND
v British Columbia XV at Abbotsford	won	84-6
v British Columbia at Vancouver	drew	16-16
v Fiji XV at Suva	won	10-7
v Fiji XV at Nadi	lost	19-23
v NZRFU President's XV at Wanganui	won	71-22

1996 in NEW ZEALAND
v Otago at Dunedin	lost	18-23
v North Otago Inv XV at Oamaru	lost	25-33
v Canterbury at Timaru	won	33-27

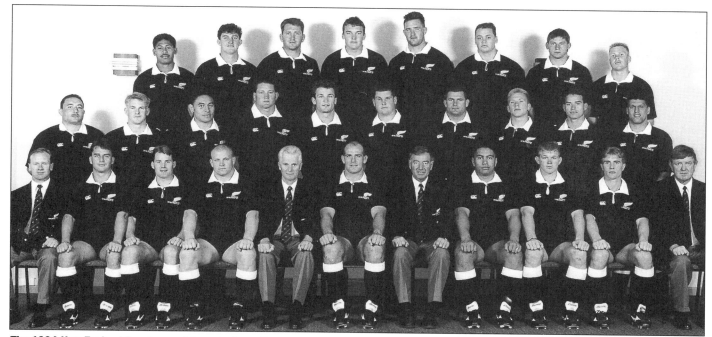

The 1994 New Zealand Development team to Argentina
Back row: Alama Ieremia, Liam Barry, Steve Gordon, Glenn Taylor, Mark Cooksley, Blair Larsen, Todd Blackadder, Jeff Wilson.
Second row: Norm Hewitt, Simon Mannix, Eroni Clarke, Gordon Slater, Steve Cottrell, Nick Moore, Craig Stevenson, Lee Stensness, George Konia, Paul Cooke.
Front row: Rob Cashman (physiotherapist), Shane Howarth, Jon Preston, Mark Allen, Lin Colling (assistant manager/coach), John Mitchell (captain), Laurie Mains (assistant coach), Slade McFarland, Dean Anglesey, Justin Marshall, Richard Crawshaw (manager).
Absent: Mark McAtamney.

MATCHES PLAYED BY NEW ZEALAND DEVELOPMENT TEAMS

1990 in CANADA
v Eastern Canada at St Johns		won	61-3
v Ontario at Toronto		won	63-3
v Prairie XV at Winnipeg		won	65-0
v British Columbia XV at Vancouver		won	25-3
v British Columbia at Vancouver		won	28-7

1994 in ARGENTINA
v Rosario Selection at Rosario	lost	20-25
v Entre Rios Selection at Parana	won	78-12
v Cordoba Selection at Cordoba	won	38-23
v Cuyo Selection at Mendoza	won	45-17
v Combined South at Trelew	won	75-16
v North-East at Resistencia	won	22-5
v Buenos Aires Sel. at Buenos Aires	lost	26-38

MATCHES PLAYED BY NEW ZEALAND XVs

1991 in NEW ZEALAND
v NZ Universities at Auckland	won	37-12
v Romania at Auckland	won	60-30
v USSR at Hamilton	won	56-6

1992 in NEW ZEALAND
v Saracens at Napier	lost	15-20
v England B at Hamilton	won	24-18
v North Harbour at Takapuna	won	28-19
v England B at Pukekohe	won	26-18

1993 in NEW ZEALAND
v Bay of Plenty at Tauranga	won	93-5
v Western Samoa at Rotorua	won	37-13

1994 in NEW ZEALAND
v France at Wanganui	lost	25-33

1995 in NEW ZEALAND
v Canada at Palmerston North	won	38-17

MATCHES PLAYED BY NEW ZEALAND B TEAMS

1991 in AUSTRALIA
v Australia B at Brisbane	won	21-15

MATCHES PLAYED BY NEW ZEALAND A TEAMS

1997 IN NEW ZEALAND
v Barbarians at Rotorua	lost	22-29

(this match was in effect an All Black trial)

THE PLAYERS
* indicates also played for New Zealand

Player	Province	Level	Years
Allen M.R.*	Taranaki	Dev	1990,94
		NZXV	1991,92,94
		Div	1996
Alston P.J.	Manawatu	Div	1992
Anderson B.L.*	Wairarapa-Bush	EP	1986
		Div	1988
Anglesey W.D.	King Country	Dev	1994
Atkinson M.	Hawke's Bay	Div	1995,96
Atuahiva J.J.	Counties	Div	1993
Axtens S.R.	Bay of Plenty	Div	1995
Bachop G.T.M.*	Canterbury	NZXV	1992,93
Bachop S.J.*	Otago	NZXV	1993
Baines G.E.	Horowhenua	Div	1993
Barrell C.K.*	North Auckland	Div	1993,95
	Canterbury	NZA	1997
Barrett K.F.	Taranaki	Div	1996
Barry L.J.*	North Harbour	Dev	1994
Benton M.F.C.	Wairarapa-Bush	EP	1986
Berry M.J.*	Wairarapa-Bush	NZXV	1992
		Div	1992,93
Berryman N.R.	Northland	Div	1995,96
		NZXV	1995
Blackadder T.J.*	Nelson Bays	Div	1991
	Canterbury	NZXV	1993
		Dev	1994
		NZA	1997
Borland R.	Southland	Div	1993
Boroevich K.G.*	North Harbour	NZXV	1993
Botica F.M.*	North Harbour	EP	1985
Brain E.F.	Counties	Dev	1990
Brewer M.R.*	Otago	NZXV	1992
Brightwell T.T.T.	Hawke's Bay	Div	1991
Brooke R.M.*	Auckland	Dev	1990
		NZXV	1991
		NZB	1991
Brown O.M.*	Auckland	Dev	1990
		NZXV	1991
Buchan J.A.S.*	Canterbury	EP	1986
Bunce F.E.*	North Harbour	NZXV	1992
Byers K.B.	Nelson Bays	Div	1995
Cameron J.B.	Taranaki	Div	1996
Campbell A.K.	King Country	EP	1985
Campbell J.W.	Northland	Div	1996
Carr M.P.B.	Taranaki	Div	1996
Carter M.P.*	Auckland	Dev	1990
		NZXV	1991,92
		NZB	1991
		NZA	1997
Cashmore A.R.*	Auckland	NZA	1997
Clarke E.*	Auckland	NZXV	1991,93
		Dev	1994
		NZA	1997
Coe J.N.	Counties	Dev	1990
		Div	1993
Coffey G.P.	Canterbury	NZXV	1991
Coffin P.H.*	King Country	Div	1991,92
		NZXV	1992
Cooke P.J.	Otago	Dev	1994
Cooksley M.S.B.*	Counties	Div	1993
		Dev	1994
		NZA	1997
Cooper G.J.L.*	Otago	NZXV	1992
Cooper M.J.A.*	Hawke's Bay	Div	1988,89
Costello C.M.	Thames Valley	Div	1990,91
Cottrell S.R.	Wellington	Dev	1994
Crabb S.J.	Waikato	NZXV	1992
Crawford O.H.	Hawke's Bay	Div	1996
Crosby T.D.	Poverty Bay	Div	1991
Crossan E.J.	Bay of Plenty	Div	1990
		Dev	1990
		NZXV	1991
		NZB	1991
Cruden S.N.	Manawatu	Div	1992
Culhane S.D.*	Southland	Div	1992,93,95,96
		NZXV	1995
Cunningham J.B.	Hawke's Bay	Div	1995,96
Darrah M.A.	Thames Valley	EP	1985
		Div	1988,89
Davis C.S.*	Manawatu	Div	1995
		NZXV	1995
Davis S.N.	Northland	Div	1995
Deans I.B.*	Canterbury	EP	1985
Dorgan C.J.	South Canterbury	Div	1988,90,91
Dowd C.W.*	Auckland	NZXV	1992,94
Dowd G.W.*	North Harbour	NZXV	1991
		NZB	1991
Doyle S.C.	Manawatu	Div	1992,93
Earl A.T.*	Canterbury	EP	1985,86
Earl C.C.	Canterbury	EP	1986
Ellis M.C.G.*	Otago	NZXV	1994
Erenavula L.	Counties	Div	1993
Falcon G.J.	Hawke's Bay	Div	1991,95
Fatialofa P.	Auckland	EP	1986
Fitisemanu P.A.	Nelson Bays	Div	1995
Fitzpatrick S.B.T.*	Auckland	NZXV	1992
Fitzsimons S.D.	Poverty Bay	Dev	1990,91
Forster S.T.*	Otago	NZXV	1992,95
Foster M.T.	Wairarapa-Bush	Div	1989,90
Fox G.J.*	Auckland	NZXV	1992
Fromont R.T.*	Auckland	NZXV	1993,94,95
Gatland W.D.*	Waikato	NZXV	1992
George R.	Bay of Plenty	Div	1993
Going M.R.	Northland	Div	1996
Goldsmith J.A.*	Auckland	Dev	1990
		NZXV	1991
Gordon A.H.	Mid Canterbury	EP	1985
Gordon H.S.	Wanganui	Div	1988,89,90
Gordon S.B.*	Waikato	NZXV	1992,93,94
		Dev	1994
Gordon W.R.*	Waikato	NZXV	1991
		NZB	1991
Graham D.P.D.	Taranaki	Div	1996
Hainsworth J.D.	Counties	EP	1985
	Wanganui	EP	1986
		Div	1988,89,93
Hansen A.B.	Poverty Bay	Div	1988
Hansen B.W.	Wanganui	Div	1988,89,90,92,93,95
		NZXV	1992
Harvey B.A.*	Wairarapa-Bush	EP	1985
Hemara B.S.*	Manawatu	EP	1985
Henderson D.B.	Southland	Div	1992
Henderson P.J.	Southland	Div	1990
Henderson P.W.*	Otago	NZB	1991
	Southland	Div	1993,95
Hewett J.A.*	Manawatu	Div	1990
	Auckland	Dev	1990
		NZXV	1991
		NZB	1991
Hewitt N.J.*	Hawke's Bay	Dev	1990,94
		NZXV	1991,93,94
		Div	1991,95
Hoeft C.H.	Otago	Div	1996
	Southland	Div	1996
Howarth S.P.*	Auckland	Dev	1990,94
		NZXV	1993,94,95
Hullena L.C.*	Wellington	NZB	1991
		NZXV	1992
Hurunui G.M.	Horowhenua	Div	1992,93,95
	Manawatu	Div	1995
Hutchins J.A.	Wairarapa-Bush	Div	1992
Ieremia A.*	Wellington	NZXV	1994,95
		Dev	1994
Iti C.K.	King Country	Div	1990
Jerram R.M.	Waikato	Dev	1990
		NZXV	1991,93
Johnson M.L.	Poverty Bay	Div	1991
Johnston W.B.	Northland	Div	1995
Jones I.D.*	North Auckland	NZXV	1992
Jones M.N.*	Auckland	NZXV	1994,95
Joseph J.W.*	Otago	NZXV	1994
Kapene C.R.	Wairarapa-Bush	EP	1986
Kaui D.A.	Bay of Plenty	Dev	1990
Kelly D.A.	Southland	EP	1985
Kenny D.J.*	Otago	EP	1985,86
Kerr J.S.	Auckland	NZA	1997
Kirwan J.J.*	Auckland	NZXV	1992
Konia G.N.	Manawatu	Div	1990,91,92,93
		Dev	1990
		NZXV	1993
	Hawke's Bay	Dev	1994
		NZXV	1994
		Div	1995,96
Lamborn F.A.	North Auckland	EP	1986
Larsen B.P.*	North Harbour	NZXV	1992,93
		Dev	1994
Latta J.C.	Otago	EP	1986
Laursen D.C.	Horowhenua	Div	1988,92

Name	Team	Comp	Year
Leiasamaivao T.	Wanganui	Div	1991
Leota J.N.	Canterbury	EP	1985,86
Leslie J.A.	Otago	Dev	1994
Lilley D.P.	Canterbury	NZA	1997
Little W.K.*	North Harbour	NZXV	1993,94
Loe R.W.*	Marlborough	EP	1985
	Waikato	NZXV	1992
Love M.R.	Manawatu	EP	1985
McAtamney M.R.	Canterbury	Dev	1994
McCahill B.J.*	Auckland	NZXV	1991
		NZB	1991
McCall C.B.	Southland	EP	1986
McCormick A.F.	Canterbury	Dev	1990
		NZXV	1991,92
McDonald L.	Mid Canterbury	Div	1988,89,90,92
McDonald S.R.	Taranaki	Div	1993,96
McDowell S.C.*	Auckland	EP	1985
McFarland S.P.	North Harbour	Dev	1994
		NZXV	1995
McKenzie A.G.	Manawatu	Div	1990,91
McKenzie B.T.	Southland	EP	1985,86
		Div	1988
McLean R.J.*	Wairarapa-Bush	Div	1988,90
Macpherson G.*	Otago	EP	1985
Maere W.	Hawke's Bay	Div	1995
Manako D.	North Auckland	Div	1993
Mannix S.L.*	Wellington	NZXV	1992
		Dev	1994
Mannix T.P.	Wellington	NZXV	1993
Manuel E.J.	East Coast	Div	1988,90
	King Country	Div	1991
Marfell F.W.	Marlborough	Div	1988,89,90,91
Marshall J.W.	Southland	Div	1993
		Dev	1994
Mataira D.F.B.	Poverty Bay	Div	1992
Matson J.T.F.*	Canterbury	NZXV	1995
Matthews B.A.	South Canterbury	Div	1988,89
Matthews D.	King Country	NZXV	1992
Maunsell W.K.	Canterbury	Dev	1990
		NZXV	1991
Maxwell H.M.R.	Counties	Div	1993
Mayerhofler M.A.	Canterbury	NZA	1997
Mayhew D.W.	North Harbour	NZXV	1991
Meads G.C.	King Country	EP	1985,86
		Div	1988,89,92
Mitchell J.E.P.*	Waikato	NZXV	1994
		Dev	1994
Monkley D.I.	Waikato	NZXV	1992,93
Moore N.S.	Otago	Dev	1994
		NZXV	1995
Moore S.L.	Northland	Div	1996
Morgan D.J.	Otago	Dev	1990
Murrell B.D.	Southland	Div	1992,93,95
Nahona J.K.N.	Wanganui	Div	1990
Nepia K.T.	Auckland	NZXV	1995
Nicholson P.C.	Marlborough	Div	1988,89,90
Oliver A.D.*	Otago	NZA	1997
O'Shaughnessy P.G.	Hawke's Bay	Div	1991
Oswald D.J.	Bay of Plenty	Div	1993
Otai K.M.F.	Manawatu	Div	1991,92,93
Paalvast W.G.	King Country	Div	1992
Paramore J.	Counties	Div	1993
Pene A.R.B.*	Otago	NZXV	1995
Perez T.	Wellington	EP	1986
Phillips P.L.	Marlborough	Div	1991
Pierce M.S.L.	North Harbour	EP	1986
		NZXV	1992
Preston J.P.*	Canterbury	Dev	1990,94
		NZXV	1991
		NZB	1991
Prince A.R.	Nelson Bays	NZXV	1993
		Div	1993
Purvis G.H.*	Waikato	NZB	1991
		NZXV	1993
Randle R.Q.	Hawke's Bay	Div	1996
Renton P.J.	Hawke's Bay	EP	1986
		Div	1988,89
Robertson S.M.	Bay of Plenty	Div	1996
Roose A.T.	Counties	Div	1993
Rush E.J.*	North Harbour	NZXV	1992,93,94
		NZA	1997
Rutene D.	Wairarapa-Bush	Div	1991
Schuler K.J.*	Manawatu	Div	1990,91
		Dev	1990
Scott M.W.	Counties	Div	1993
Seymour D.J.*	Canterbury	NZXV	1992
	Hawke's Bay	Div	1996
Seymour M.B.	North Auckland	Div	1993
Shaw M.W.*	Hawke's Bay	Div	1988,89
Shelford W.T.*	North Harbour	EP	1985
		NZXV	1991
		NZB	1991
Sherlock K.*	Auckland	EP	1985
Simpkins S.A.	Bay of Plenty	Div	1996
Slater G.L.*	Taranaki	Div	1993
		Dev	1994
Simpson V.L.J.*	Canterbury	EP	1985
Slee A.P.	Buller	Div	1988,90
Sorenson N.A.	Wellington	EP	1986
Sotutu W.	Auckland	NZXV	1992,95
Spencer C.J.*	Auckland	NZA	1997
Stanley J.*	Auckland	NZA	1997
Stanley J.T.*	Auckland	NZB	1991
Stark I.D.	Marlborough	Div	1988,89
Stensness L.*	Manawatu	NZXV	1992
		Div	1992,93
	Auckland	Dev	1994
Stevenson C.M.	Waikato	Dev	1994
Stone D.	Bay of Plenty	Div	1993
Stone S.R.	Bay of Plenty	Div	1995
Styles B.E.	Wairarapa-Bush	Div	1988,89,91
Tagaloa T.D.L.	Wellington	NZXV	1991,92
Tarrant S.B.	South Canterbury	Div	1993,95,96
Taylor G.L.*	North Auckland	NZXV	1992,94
		Div	1993,95,96
		Dev	1994
		NZA	1997
Thomson P.H.	Auckland	NZA	1997
Thorpe A.J.	Canterbury	EP	1986
	Poverty Bay	Div	1990
Tiatia F.I.	Wellington	NZA	1997
Timu J.K.R.*	Otago	NZB	1991
Tinnock M.	Bay of Plenty	Div	1993
Tinnock M.B.	Southland	Div	1992
Tonu'u O.F.J.*	Auckland	NZXV	1994
		NZA	1997
Tregaskis C.D.*	Wellington	Dev	1990
		NZB	1991
		NZXV	1992
Tuigamala V.L.*	Auckland	NZB	1991
		NZXV	1992
Tuoro P.S.	Counties	EP	1985
Turner R.S.*	North Harbour	Dev	1990
		NZXV	1992,93
Walsh G.L.	North Harbour	NZXV	1992
Watts R.A.M.	King Country	Div	1992
Weber N.M.	Hawke's Bay	Div	1991
Weedon M.	North Harbour	NZXV	1995
Wells J.E.	Poverty Bay	Div	1989
Wheeler R.J.	Taranaki	Div	1996
Wilkinson G.L.	Wellington	EP	1986
Williams K.J.	Manawatu	Div	1993
Wills C.N.	King Country	Div	1992
Wilson J.W.*	Southland	Div	1993
	Otago	NZXV	1994
		Dev	1994
Wood I.D.	Manawatu	EP	1985,86
Woods D.J.	Southland	EP	1986
Wright T.J.*	Auckland	EP	1985
Youle B.A.	Southland	Div	1988,90,92

Sevens Rugby

Until the mid 1980s New Zealand had never taken as serious an interest in seven-a-side rugby as the Northern Hemisphere nations although a national interprovincial competition was begun in 1975.

The winners of it annually competed in the Hong Kong invitation tournament but no invitation was issued for the 1982 contest because the Hong Kong organisers sought a national New Zealand team rather than a provincial side.

The New Zealand union agreed and since 1983 has selected a national side. A sevens World Cup was first played in 1993.

WINNERS OF THE INTERPROVINCIAL SEVENS COMPETITION

Year	Winner	Venue
1975	Marlborough	Auckland
1976	Marlborough	Christchurch
1977	Manawatu	Blenheim
1978	Manawatu	Hamilton
1979	Manawatu	Palmerston North
1980	Auckland	Palmerston North
1981	Taranaki	Palmerston North
1982	Taranaki	Feilding
1983	Auckland	Feilding
1984	Auckland	Feilding
1985	Counties	Feilding
1986	North Harbour	Feilding
1987	North Harbour	Christchurch
1988	Auckland	Pukekohe
1989	Auckland	Palmerston North
1990	Canterbury	Palmerston North
1991	Auckland	Palmerston North
1992	North Harbour	Palmerston North
1993	Canterbury	Palmerston North
1994	Counties	Palmerston North
1995	Counties	Palmerston North
1996*	Waikato	Palmerston North
	Waikato	Palmerston North
1997	Waikato	Rotorua

* two tournaments were played in 1996 because of change in date from March to November

HONG KONG INVITATION TOURNAMENT

1983
Pool matches:	v Bahrain	won	22-0
	v Singapore	won	48-0
	v Korea	won	18-0
	v American Eagles	won	26-0
Quarterfinal:	v Western Samoa	lost	0-4
Final:	Australia beat Fiji		14-4

1984
Pool matches:	v Indonesia	won	32-4
	v Hong Kong	won	8-0
Quarterfinal:	v French Barbarians	won	22-0
Semifinal:	v Irish Wolfhounds	won	12-10
Final:	v Fiji	lost	0-26

1985
Pool matches:	v Brunei	won	34-0
	v American Eagles	won	18-4
Quarterfinal:	v Crawshays Welsh	won	26-0
Semifinal:	v Public School Wanderers	lost	10-14
Final:	Australia beat Public School Wanderers		24-10

1986
Pool matches:	v Indonesia	won	34-0
	v Hong Kong	won	42-0

Quarterfinal:	v Tonga	won	26-0
Semifinal:	v Fiji	won	28-6
Final:	v French Barbarians	won	32-12

1987
Pool matches:	v Brunei	won	30-0
	v South Korea	won	38-0
Quarterfinal:	v American Eagles	won	20-6
Semifinal:	v Penguins	won	28-0
Final:	v Fiji	won	12-6

1988
Pool matches:	v Kwang-Hwa Taipei	won	28-6
	v Spain	won	36-0
Quarterfinal:	v Irish Wolfhounds	won	34-0
Semifinal:	v Penguins	won	16-0
Final:	v Australia	lost	12-13

1989
Pool matches:	v Bahrain	won	54-0
	v Tunisia	won	38-0
Quarterfinal:	v Western Samoa	won	22-6
Semifinal:	v Fiji	won	12-10
Final:	v Australia	won	22-10

1990
Pool matches:	v Arabian Gulf	won	42-0
	v South Korea	won	38-4
Quarterfinal:	v Scottish Borderers	won	20-12

The 1995 New Zealand sevens team which won the Hong Kong tournament
Back row: Murray Inglis (manager), Adrian Cashmore, Peter Woods, Jonah Lomu, Andrew Blowers, Joeli Vidiri, Gordon Tietjens (coach), Rob Cashman (physiotherapist).
Front row: Brad Fleming, Christian Cullen, Eric Rush (captain), Dallas Seymour, Joe Tauiwi.

Semifinal: v Barbarians won 24-6
Final: v Fiji lost 10-22

1991
Pool matches: v Kwang-Hwa Taipei won 40-0
v Japan won 40-0
Quarterfinal: v France won 30-0
Semifinal: v Canada won 26-0
Final: v Fiji lost 14-18

1992
Pool matches: v Malaysia won 54-0
v Hong Kong won 38-0
Quarterfinal: v Western Samoa won 18-12
Semifinal: v South Korea won 14-0
Final: v Fiji lost 6-22

1993
Pool matches: v Kwang-Hwa Taipei won 28-5
v South Korea won 34-0
Quarterfinal: v South Africa won 20-12
Semifinal: v Western Samoa lost 14-24
Final: Western Samoa
beat Fiji 14-12

1994
Pool matches: v Malaysia won 64-0
v Tonga won 38-5
Quarterfinal: v France won 21-12
Semifinal: v Fiji won 28-14
Final: v Australia won 32-20

1995
Pool matches: v Kwang-Hwa
Taipei won 42-5
v United States won 40-7
Quarterfinal: v South Africa won 26-0
Semifinal: v Western Samoa won 26-0
Final: v Fiji won 35-17

1996
Pool matches: v Sri Lanka won 75-0
v Japan won 77-0
v France won 28-14
Quarterfinal: v Ireland won 49-0
Semifinal: v England won 42-19
Final: v Fiji won 19-17

**NEW SOUTH WALES
INTERNATIONAL TOURNAMENT**

1986
*Preliminary
matches:* v Tonga won 22-0
v Wales lost 12-18
v United States won 28-0
Quarterfinal: v Fiji won 16-0
Semifinal: v Argentina won 24-4
Final: v Australia won 32-0

1987
Pool matches: v Hong Kong won 48-0
v French Barbarians won 18-12
v United States won 14-4
Quarterfinal: v Spain won 52-4
Semifinal: v Fiji won 14-12
Final: v Australia lost 10-22

1988
Pool matches: v Hong Kong won 36-0
v Wales won 26-0
v Western Samoa won 20-0
Quarterfinal: v United States won 28-0
Semifinal: v Fiji won 16-6
Final: v Scotland won 22-12

1989
Pool matches: v South Korea won 32-9
v United States won 32-0
v Wales won 32-10

Quarterfinal: v Argentina won 18-10
Semifinal: v Australia won 28-0
Final: v Western Samoa won 26-16

FIJI INTERNATIONAL SEVENS

1993
*Group
matches:* v Rewa won 14-12
v Canada lost 7-12
v Suva lost 7-17
*Plate
semifinal:* v Scotland won 40-5
Plate final: v Australia lost 12-31
Final: Fiji beat Suva 26-0

1994
*Group
matches:* v Malaysia won 35-5
v Tonga won 35-7
v Vanuatu won 56-0
Quarterfinal: v Western Samoa won 38-5
Semifinal: v Eastern Fiji lost 14-21
Final: Eastern Fiji beat Fiji 28-12

1995
*Group
matches:* v Vanuatu won 17-0
v Canada won 38-5
Quarterfinal: v Western Fiji lost 7-17
Final: Fiji beat Eastern Fiji 31-7

1996
*Group
matches:* v Uruguay won 36-0
v Australian Fijians won 28-0
v China won 33-5
Quarterfinal: v Papua New
Guinea won 27-5
Semifinal: v Tonga won 21-7
Final: v Fiji lost 21-22

**URUGUAY INTERNATIONAL
TOURNAMENT**

1995
*Group
matches:* v Canada won 42-0
v Rio de la Plata won 33-0
Quarterfinal: v Western Samoa lost 5-12

1996
*Group
matches:* v Buenos Aires won 21-12
v Spain won 49-0
Quarterfinal: v South Africa won 24-12
Semifinal: v Argentina won 38-14
Final: v France won 31-26

**ARGENTINA INTERNATIONAL
TOURNAMENT**

1995
*Group
matches:* v Uruguay won 45-0
v Spain won 19-14
v Argentina won 36-7
Quarterfinal: v Mar del Plata won 21-0
Semifinal: v Western Samoa won 14-10
Final: v Fiji won 26-21

JAPAN INTERNATIONAL TOURNAMENT

1995
*Group
matches:* v World won 59-5
v Doshisya
University won 71-5

Quarterfinal: v Canada won 38-5
Semifinal: v South Korea won 15-5
Final: v Fiji lost 26-47

1996
*Group
matches:* v Toyota won 63-0
v Chinese Taipei won 61-0
Quarterfinal: v Hong Kong won 28-7
Semifinal: v Wales won 24-0
Final: v Fiji lost 5-61

WORLD CUP

1993 in SCOTLAND

*Group
matches:* v Holland won 49-7
v United States won 19-5
v France won 19-5
v South Korea won 46-0
Quarterfinals: v England lost 12-21
v Australia won 42-0
v South Africa lost 12-31
New Zealand did not qualify for the semifinals.
Final: England beat Australia 21-17

1996 qualifying tournament in Portugal
*Group
matches:* v Lithuania won 73-0
v Moldova won 94-0
v Luxembourg won 66-10
v Hungary won 89-0
Quarterfinal: v Namibia won 47-0
Semifinal: v South Korea won 26-0
Final: v Spain won 68-5

1997 in HONG KONG

*Group
matches:* v Japan won 47-14
v Tonga won 21-7
v Japan won 47-0
v Tonga won 35-0
Quarterfinal: v Australia won 38-12
Semifinal: v South Africa lost 7-31
Final: Fiji beat South Africa 24-21

An unofficial New Zealand team competed in a sevens tournament in Cardiff in May 1986. It beat Scotland 24-4, France 22-0, England 16-10, Rest of the World 24-12 and in the final, England 32-6.

**NEW ZEALAND SEVENS
REPRESENTATIVES 1983-97**
** indicates a player who also played first-class rugby
for New Zealand*

Alley G.	*North Harbour*	1992,93
Bachop G.T.M.*	*Canterbury*	1990-92,94
Bale P.	*Canterbury*	1990,92,93
Blackadder T.J.*	*Canterbury*	1993
Blowers A.F.*	*Auckland*	1995
Botica F.M.*	*North Harbour*	1985-88
Brooke Z.V.*	*Auckland*	1986-90
Brooke-		
Cowden M.*	*Auckland*	1986,87
Bruning K.T.	*Waikato*	1994
	Nelson Bays	1995
Bunce F.E.*	*North Harbour*	1993
Cashmore A.R.*	*Auckland*	1995
Clamp M.*	*Wellington*	1984-86
Clarke E.*	*Auckland*	1993
Crowley A.E.	*Taranaki*	1987-89,91
Cullen C.M.*	*Manawatu*	1995,96
Dawson A.J.	*Counties*	1983,85
Donald A.J.*	*Wanganui*	1983
Ellis M.C.G.*	*Otago*	1993

Erenavula L.	Counties	1994
Fleming B.R.M.	Bay of Plenty	1995
	Canterbury	1996
Forster S.T.*	Otago	1993
Fry R.J.	Auckland	1983,84
Gallagher J.A.*	Wellington	1989,90
Granger K.W.*	Manawatu	1983
Green C.I.*	Canterbury	1986
Hamilton A.R.	Hawke's Bay	1994-96
Howarth S.P.*	Auckland	1991
John O.W.	Counties-Manukau	1996
Jones M.Te K.	Bay of Plenty	1993-96
Karauna D.T.	Waikato	1996
Kirk D.E.*	Otago	1984
	Auckland	1985,86
Kirwan J.J.*	Auckland	1984-86,88
Koloto E.T.	Manawatu	1987
Lam P.R.*	Auckland	1989-93
Lewis A.J.	Otago	1984
Lindsay A.C.	Canterbury	1983,84
Lomu J.T.*	Counties-Manukau	1994-96
McMaster A.	Manawatu	1987
Maidens T.K.	Hawke's Bay	1995
Martin E.M.	Waikato	1996
Masirewa W.	Counties-Manukau	1996
Mills J.G.*	Auckland	1984
Murray C.D.	Counties	1994
Osborne G.M.*	North Harbour	1992-94,96,97
Paramore J.	Counties	1993
Peacocke G.M.	North Harbour	1996
Phillips C.M.	North Auckland	1986
Philpott S.*	Canterbury	1988
Pierce M.S.L.	North Harbour	1989,91-93,95
Putt K.B.	Waikato	1987,89
Raki L.E.	Counties	1985,87
Ralph C.S.	Bay of Plenty	1996,97
Randle R.Q.	Hawke's Bay	1995-97
Rayasi P.	Wellington	1993
Reid H.R.*	Bay of Plenty	1983
Rich G.J.W.	Auckland	1983-85
Ruddell N.K.	North Auckland	1986
Rush E.J.*	Auckland	1988-91
	North Harbour	1992-97
Schuster N.J.*	Wellington	1986,88-90
Scrimgeour O.J.	Waikato	1995-97
Seymour D.J.*	Canterbury	1988-93
	Hawke's Bay	1994-97
Shelford W.T.*	North Harbour	1985-87
Smith B.W.*	Waikato	1983
Smith D.A.	Canterbury	1996
Smith W.R.*	Canterbury	1984-86
Stanley J.T.*	Auckland	1983
Tagaloa T.D.L.	Wellington	1991
Tauiwi J.J.	Bay of Plenty	1994-97
Te Nana K.S.	Wellington	1996,97
Thorpe A.J.	Canterbury	1984
Tietjens G.F.	Waikato	1983
Timu J.K.R.*	Otago	1993
Tipoki R.	Auckland	1997
Tuivaii D.	Wellington	1993
Vidiri J.	Counties-Manukau	1995,96
Wolfe T.W.N.	Taranaki	1993
Woods P.G.A.	Bay of Plenty	1993
	North Harbour	1994-97
Wotherspoon K.J.	Hawke's Bay	1996
Wright T.J.*	Auckland	1986-92

Selected but did not play

A New Zealand team that did not play was chosen after the 1982 national tournament. The team comprised: D.B. Clare, K.W. Granger (*Manawatu*), K.J. Crowley, D.S. Loveridge (*Taranaki*), T.R. Hemmington, S.T. Pokere (*Southland*), W.T.Shelford, M. Treweek (*Auckland*), W.R. Smith (*Canterbury*).

A.W. Pollock (*Wellington*) was selected in 1984 but could not travel. R. Koko (*Wellington*) was chosen in 1993 but withdrew to play for Western Samoa.

Secondary Schools Rugby

Six years after the introduction of rugby to New Zealand, the first inter-collegiate match was played between Nelson College and Wellington College at the Basin Reserve on 20 June, 1876. The home team won 14-0 but in a return match the result was reversed, Nelson winning 7-2.

While the Nelson v Wellington fixture has been more or less a regular one since its inception, there have been seasons in which it was not played. The oldest continuous fixture is that between Christ's College and Otago Boys' High School which dates from 1883. The following year saw the beginning of the rivalry between Christ's and Wellington College. The first match between Timaru Boys' High School and Waitaki Boys' High School was also played in 1884.

In 1890 a triangular tournament involving Christ's, Wellington College and Wanganui Collegiate was initiated. This became the present quadrangular tournament when Nelson College joined in 1925.

The first secondary schools' championship in Auckland was contested in 1896 between Auckland Grammar School, King's College, St John's College and Queen's College, Grammar emerging as winners. Prince Albert College joined the competition in 1897 and Sacred Heart College in 1903.

Matches for second to seventh grade are played on Saturday mornings throughout the winter with the first fifteens playing in the afternoons. More than 3000 boys representing some 150 teams take part in matches controlled by the Secondary Schools' Union.

At the end of the First World War the Moascar Cup was presented to the New Zealand Rugby Union by Lt-Col. E.J. Hulbert, the commanding officer of the New Zealand Mounted Rifles who had won the trophy playing service rugby in Egypt. The union decided in 1920 to put up the Moascar Cup for competition among secondary schools and elimination tournaments were held in both islands to find the two finalists to play for the trophy. Palmerston North Boys' High School met Christchurch Boys' High School in the final, which was played at Athletic Park under appalling conditions. At the end of the game neither side had scored and the referee ordered an extra five minutes each way. If neither side scored a forcedown was to count. The southerners won by a disputed kick into touch by the defenders that was counted as a forcedown by the referee thus becoming the first holders.

The Moascar Cup was competed for on similar lines for the next two seasons but in 1923 it was decided to do away with the elimination matches and turn the trophy into a challenge cup. It is played for when the holder meets a traditional rival either at home or away but special challenges may be lodged.

One of the major features of secondary school rugby in New Zealand has been the dedicated service given by coaches at all levels. Some first fifteen coaches in particular have become legends not only in their own schools but all over the country. In the days when schoolmasters tended to spend their entire teaching careers in one school, coaches frequently spent many years in charge of their teams.

Among the 'greats' of secondary school coaches were J.P. Firth and T.B. Brodie of Wellington College; A. Milburn, Napier Boys' High School; T.W.C. Tothill, Christ's College; R.W.S. Botting, Otago Boys' High School; H.T. Revell and G.N.T. Greenbank, King's College; H.T. Hall, Waitaki Boys' High School; H.E. Dyer, Christchurch Boys' High School; A.J. Papps and J.J. Stewart, New Plymouth Boys' High School; A.M. Nicholson and J.G.S. Bracewell, Auckland Grammar School; R.B. Hardy, Mt Albert Grammar School; H.A. Henderson, Dannevirke High School; and I.A. Colquhoun, Palmerston North Boys' High School.

INTERNATIONAL SECONDARY SCHOOLS' RUGBY

Although the first rugby match played in New Zealand took place at a school (Nelson College) in 1870,108 years were to pass before a New Zealand team entered the arena of schoolboy international rugby. Test matches at secondary school level have been played all over the world for many years: for example, the England v Wales game dates back to the pre-First World War era and some of the most prominent English and Welsh players have won their first caps as schoolboy internationals.

New Zealand was the last of the major rugby-playing countries to play school football at international level, although individual schools and unions have undertaken overseas tours regularly since the end of the Second World War. Most of the older New Zealand schools have rivalries dating back to the nineteenth century so it seems strange that it took so long for this country to enter schools' rugby at the highest level. However, a New Zealand Secondary Schools' Rugby Council was eventually formed in 1976.

The development towards the formation of the NZSSRC began in 1970 when the Auckland firm of Hughes and Cossar Ltd sponsored the first inter-secondary schools' representative tournament. From this competition the Northern Region Rugby Council was formed and other regional bodies followed. Arrangements were then made for delegates to attend a meeting in Auckland to set up a New Zealand council.

This body was set up in 1976 with the following aims:
1. To promote and strengthen rugby in New Zealand secondary schools.

2. To act as an advisory body that may be called upon by the NZRFU in order to assist and promote the game at secondary school level.
3. To provide a channel of communication for NZRFU regional councils and secondary school principals throughout New Zealand.

In 1978 the first New Zealand schoolboy team played a test against Australia at Eden Park, Auckland. Coached by the former representative loose forward, Don Riesterer, and captained by Miles Valentine of Auckland Grammar School, the New Zealanders won 7-6. This was Australia's first loss in an international since 1974 although the visitors had gone down to a strong Northern Region side on the Wednesday before the test.

RESULTS OF NEW ZEALAND SECONDARY SCHOOLS MATCHES

1978 in NEW ZEALAND
v Australia *at Auckland* — won 7-6

1979 in NEW ZEALAND
v England *at Pukekohe* — lost 4-23

1980 in AUSTRALIA
v Queensland Country
 at Rockhampton — won 54-8
v Queensland *at Toowoomba* — won 29-6
v New South Wales Country
 at Woolongong — won 18-3
v Australia *at Canberra* — lost 19-21

Summary:
Played 4, won 3, lost 1;
Points for 120, against 38.

1982 in NEW ZEALAND
v Australia *at Lower Hutt* — won 12-3

1983 in AUSTRALIA
v New South Wales *at Sydney* — won 13-7
v New South Wales Country
 at Newcastle — won 48-0
v Great Public Schools
 at Sydney — won 38-0
v Australia *at Sydney* — lost 9-12

Summary:
Played 4, won 3, lost 1;
Points for 108, against 19

1984 in NEW ZEALAND and the UNITED KINGDOM
v Australia *at Auckland* — won 18-10
v East Wales *at Cross Keys* — won 36-3
v Scottish Districts *at Melrose* — won 48-3
v Scotland *at Murrayfield* — won 37-6
v West Wales *at Swansea* — won 46-6
v Wales *at Cardiff* — lost 9-12
v Southern England *at Bath* — won 21-3
v Leinster *at Donnybrook* — won 18-3
v Ulster *at Belfast* — won 12-9
v Ireland *at Cork* — won 20-3
v Midland Counties
 at Stourbridge — won 26-3
v Northern Counties *at Otley* — won 21-0
v England *at Twickenham* — won 12-6

Summary:
Played 13, won 12, lost 1;
Points for 324, against 67.

1985 in AUSTRALIA
v Queensland *at Brisbane* — won 26-15
v New South Wales Country
 at Coffs Harbour — won 35-6
v Queensland Country
 at Toowoomba — won 13-6
v Australia *at Brisbane* — lost 9-20

Summary:
Played 4, won 3, lost 1;
Points for 83, against 47.

1986 in NEW ZEALAND
v Japan High Schools *at Pukekohe* — won 44-13
v Australian Schools
 at Christchurch — won 18-8

1987 in NEW ZEALAND and JAPAN
v Invitation XV *at Takapuna* — won 63-6
v Kyushu High Schools
 at Fukuoka — won 35-3
v Kansai High Schools
 at Hiroshima — won 81-7
v All-Japan High Schools
 at Osaka — won 49-16
v Kanto High Schools *at Tokyo* — won 40-6
v All-Japan High Schools
 at Yokohama — won 49-4

A New Zealand team was also chosen in 1987 to play Australian Secondary Schools but the match was cancelled.

Summary:
Played 6, won 6;
Points for 317, against 42.

1988 in NEW ZEALAND and AUSTRALIA
v Auckland Schools XV
 at Auckland — won 32-11
v Scotland Schools *at Auckland* — won 36-10
v NSW Combined High Schools
 at Parramatta — won 44-3
v Catholic Colleges of Sydney
 at Sydney — won 84-3
v England Schools *at Sydney* — lost 8-15
v Australian Division 2 Schools
 at Nowra — won 38-12
v ACT Schools *at Canberra* — won 33-9
v Brisbane Under 19 *at Brisbane* — won 24-4
v Australian Schools *at Brisbane* — won 23-13

Summary:
Played 9, won 8, lost 1;
Points for 322, against 80.

1989 in NEW ZEALAND
v Australian Schools
 at Wellington — won 25-3

1990 in NEW ZEALAND and AUSTRALIA
v Welsh Schools
 at Christchurch — lost 11-17
v NSW Country Schools
 at Bowral — won 52-6
v Australian Schools President's
 XV *at Sydney* — won 41-9
v Australian Schools *at Sydney* — lost 7-9

Summary:
Played 4, won 2, lost 2;
Points for 111, against 41.

1991 in NEW ZEALAND
v New Zealand Under 19
 at Napier — lost 15-22
v Australian Schools *at Napier* — won 16-3

1992 in NEW ZEALAND and AUSTRALIA
v Irish Schools *at New Plymouth* — won 27-25
v Australian Division 2 Schools
 at Melbourne — won 112-5
v ACT Schools *at Canberra* — won 65-7
v Australian Schools *at Sydney* — won 31-8

Summary:
Played 4, won 4;
Points for 235, against 45.

1993 in NEW ZEALAND
v England Schools *at Dunedin* — won 51-5
v Australian Schools *at Rotorua* — won 32-7

1994 in NEW ZEALAND
v Japan Schools
 at Palmerston North — won 52-5

1995 in UNITED KINGDOM and NEW ZEALAND
v Midlands Under 19
 at Wrekin College — won 34-6
v Wales Youth *at Swansea* — won 29-3
v East Wales *at East Glamorgan* — won 37-9
v Wales *at Cardiff* — won 42-6
v West Wales *at Swansea* — won 44-11
v Scotland *at Edinburgh* — won 19-7
v Scotland A *at East Lothian* — won 69-8
v England A *at Newcastle* — won 24-0
v England *at Leicester* — won 23-12
v London/South-East Schools
 at Cambridge — won 39-13
v New Zealand Under 19
 at Auckland — won 24-14

Summary:
Played 11, won 11;
Points for 384, against 89.

1996 in NEW ZEALAND
v Australian Schools *at Christchurch* won 31-22

1997 in NEW ZEALAND and AUSTRALIA
v Welsh Schools *at Auckland* — won 45-10
v NSW Academy Under 18
 at Sydney — won 35-10
v Australia A *at Coff's Harbour* — won 23-0
v Australian Schools *at Brisbane* — lost 23-27

Summary:
Played 4, won 3, lost 1;
Points for 126, against 47.

NEW ZEALAND SECONDARY SCHOOLS REPRESENTATIVES

** denotes later played for New Zealand*

Adams J.	*Taihape HS*	1978,79
Ah Kuoi P.	*Mt Albert GS*	1988
Ai'i O.	*Otahuhu College*	1997
Alatini P.F.	*King's College*	1993,94
Alatini S.	*King's College*	1991
Alton N.R.	*Cambridge HS*	1985
Anderson S.J.	*St Andrew's College*	1987,88
Anniss N.K.	*Palmerston North BHS*	1983

Atuahiva J.J.	Papatoetoe HS	1980
Bachop S.J.*	Hagley HS	1983,84
Baistow S.	Gisborne BHS	1990
Barchard T.	St Stephen's School	1988
Barr P.	Whakatane HS	1980
Barrett C.	Waitaki BHS	1979
Barron A.	King's HS	1996
Bartlett M.	King's College	1997
Bell A.R.H.	Lindisfarne College	1988
Bellamy D.A.	Hastings BHS	1989
Bendall S.C.	Westlake BHS	1984
Benton M.F.C.	Te Aute College	1980
Binnie H.M.	Shirley BHS	1991
Blaikie D.J.O.	Otago BHS	1993
Blowers A.F.*	Mt Albert GS	1993
Bowie J.B.	Wanganui Collegiate	1989
Brain E.F.	Tikipunga HS	1985,86
Bristow S.A.	Palmerston North BHS	1983
Brodie J.W.	Hamilton BHS	1983
Brooke R.M.*	Mahurangi College	1984
Broughton N.	Hato Paora College	1990
Broughton N.J.R.	Southland BHS	1990
Brown O.M.*	Mt Albert GS	1985
Burkhart S.A.	Fraser HS	1980
Buutveld J.T.W.	St Paul's College	1978
Cameron J.B.	Forest View HS	1987
Cameron K.N.	Otago BHS	1996
Campbell A.A.	Southland BHS	1990
Carrington M.J.	King's College	1994,95
Cashmore A.R.*	Tauranga BHS	1991
Charteris B.J.	St Andrew's College	1988
Charteris D.	St Andrew's College	1991
Chittock R.G.	Otago BHS	1987
Clavis S.F.	Palmerston North BHS	1984
Codd S.P.	Kelston BHS	1995
Cole P.R.	Rosehill College	1985
Coleman S.	St Paul's Collegiate	1995
Collard S.W.	King's College	1980
Collins A.	St Bernard's College	1997
Collins J.	St Patrick's College, Wellington	1997
Cook R.J.	St Kevin's College	1987
Cooksley M.S.B.*	Manurewa HS	1988
Cooper G.J.L.*	St John's College	1982,83
Cooper M.J.A.*	St John's College	1984
Crabb S.J.	Fraser HS	1986,87
Crawford O.	Te Aute College	1983,84
Cribb R.T.	Massey HS	1995
Crosswell P.	Feilding Agricultural HS	1979
Cullen C.M.*	Kapiti College	1993,94
Davis C.S.*	Morrinsville College	1992,93
Davis G.R.	Christchurch BHS	1988
Dawkins A.	Queen Charlotte College	1980
Dermody C.	Southland BHS	1997
Dew K.	Palmerston North BHS	1982
Dickson S.	Scots College	1988
Didovich F.	St Peter's College	1985
Dorgan C.J.	Roncalli College	1984
East H.	Shirley BHS	1990
Edwards A.K.	St Augustine's	1995
Edwards J.	Opotiki College	1989
Edwards T.T.	King's College	1996,97
Ellis M.C.G.*	Wellington College	1990
Ellison D.R.	Hamilton BHS	1982-84
England C.L.	Napier BHS	1983
Epati P.	King's College	1997
Falcon G.	Lindisfarne College	1988
Fata F.	Hutt Valley HS	1988
Ferrier D.M.	King's College	1980
Ferris C.	Colenso HS	1985
Ferris H.	St Stephen's School	1985
Fifield C.	Timaru BHS	1996
Filipo R.	Hutt Valley HS	1997
Fitisemanu N.	St Patrick's College, Wellington	1996

Fitzsimons S.D.	Gisborne BHS	1987
Fleming B.R.	Mt Maunganui College	1993
Flutey M.R.	Te Aute College	1990,91
Flutey R.	Te Aute College	1997
Forth G.W.	Horowhenua College	1984
Fox G.J.*	Auckland GS	1980
Freeman W.	Gisborne BHS	1989
Freshwater P.	Wellington College	1990,91
Galliven K.	Taieri HS	1979
George M.D.	Auckland GS	1985,86
Gibson D.	New Plymouth BHS	1997
Gibson D.P.E.	Christchurch BHS	1992
Gillespie B.	Rangitoto College	1991
Godbold D.	Gisborne BHS	1993,94
Goldsmith J.A.*	Forest View HS	1987
Goodwin P.R.	Rathkeale College	1982
Gordon S.B.*	Te Awamutu College	1984,85
Gordon W.R.*	Te Awamutu College	1983,84
Grace M.T.	Sacred Heart College	1992
Graham A.	Rotorua BHS	1997
Grealish D.	St Patrick's College, Silverstream	1983
Haami B.	Stratford HS	1993
Halbert K.	St John's College	1994
Halford G.A.	Napier BHS	1988
Hall D.J.	Timaru BHS	1995
Halligan D.J.	Hamilton BHS	1984
Hanley J.M.	Whakatane HS	1979
Hansen S.L.R.	Christchurch BHS	1993,94
Harding S.R.	Burnside HS	1984
Harmer P.	Te Aute College	1979
Harper D.	Waiopehu College	1993
Hawera G.	St Stephen's School	1982
Hayman C.	King's HS	1996,97
Haynes J.	Okaihau College	1991,92
Henare D.	Gisborne BHS	1983
Henderson P.W.*	Southland BHS	1980,82
Henwood T.	Auckland GS	1994
Herewini M.L.	St Stephen's School	1980,82
Hewett J.A.*	Kelston BHS	1986,87
Hill G.C.	St Kentigern	1994,95
Hireme H.	St Paul's Collegiate	1997
Hodges W.	Hamilton BHS	1985
Hoeft C.H.	Te Aroha College	1992
Holm M.E.	Mt Albert GS	1991,92
Holmes M.S.	Rathkeale College	1982
Holmes W.D.	Kelston BHS	1983
Hore A.	John McGlashan College	1996
Houghton J.	Otago BHS	1990
Howlett D.C.	Auckland GS	1995,96
Huaki W.	Waitaki BHS	1979
Hullena L.C.*	Wairarapa College	1982
Hunter S.T.	Tauranga Boys College	1984
Innes C.R.*	Sacred Heart College	1986,87
Innes M.J.	Sacred Heart College	1988,89
Iosefo D.	Aranui HS	1997
Iwashita O.G.	Otago BHS	1986,87
Jackson B.T.	Auckland GS	1987,88
Jackson S.C.	Waitakere College	1991
Jayne A.G.	Auckland GS	1978
Jefferson M.R.	Gisborne BHS	1995
Jenkins P.D.C.	Rangiora HS	1995
Jennings W.	Hamilton BHS	1982
Jensen P.	Hamilton BHS	1985
Johnstone C.	Lindisfarne College	1997
Johnstone S.R.	Otago BHS	1995
Jones D.	Southland BHS	1984
Joseph J.W.*	Church College	1987
Josephs A.	Palmerston North BHS	1978
Kafatolu M.	St Bernard's College	1997
Kamete M.	St Stephen's School	1978

Karam J.	St Patrick's College, Silverstream	1983
Karpick S.	James Cook HS	1978
Katene P.	Motueka HS	1978
Katene R.	St Stephen's School	1992
Kaua A.	Wanganui Boys' College	1987
Kaufana K.	St Kevin's College	1996
Kelly G.	St Stephen's School	1989
Kemp N.	St Peter's College	1997
Kennedy S.F.	Shirley BHS	1988
Kepu S.	Wesley College	1997
Kerr J.S.	Gisborne BHS	1993,94
Kerr S.J.	Napier BHS	1986
Koloto E.T.	Palmerston North BHS	1983
Kora J.	Te Aute College	1990
Lam P.R.*	St Peter's College	1986,87
Langley A.D.	St Kevin's College	1985
Lea'aetoa T.S.O.	Auckland GS	1995
Leaupepe D.	St Peter's College	1993
Le Bas K.	New Plymouth BHS	1983,84
Lee D.	Hastings BHS	1994
Leota T.	Kelston BHS	1992,93
Lewis A.J.	St Paul's HS	1980
Lidgard L.A.R.	St Stephen's School	1986
Little N.T.	Te Awamutu College	1995
Little W.K.*	Hato Petera College	1987
Lloyd S.	Bay of Islands College	1979
Lomu J.T.*	Wesley College	1992,93
Lose W.K.	Kelston BHS	1986
McCahill M.	St Peter's College	1997
MacDonald L.R.	Marlborough Boys' College	1995
MacDonald T.J.	St Thomas's College	1984
McDonell H.	Avondale College	1992
McDowell J.P.	Napier BHS	1987
McFarland S.	Rangitoto College	1990
McIntosh R.	Ngaruawahia HS	1985
McKillop D.R.	Opotiki College	1980
MacKinnon S.	St Kentigern's College	1997
McLeod B.R.	Gisborne BHS	1995
McQuoid G.	Matamata College	1997
Maginnes A.	St Andrew's College	1987
Major B.	Otumoetai College	1985
Maka I.	Sacred Heart College	1992,93
Maka S.F.	Sacred Heart College	1995
Makiri H.	St Stephen's School	1996
Mannix S.J.*	St Patrick's College, Silverstream	1989
Mantell N.M.	Auckland GS	1984
Manu N.	Forest View HS	1988
Manukia F.	Kelston BHS	1989,90
Maposua B.T.	King's College	1992
Martens S.V.	Onehunga HS	1995
Martin D.	Te Aute College	1984
Martin J.	Cashmere HS	1980
Maru Te H.	Wesley College	1983
Matafa M.	Rotorua BHS	1997
Matheson J.T.A.M.	Lindisfarne College	1995
Matson J.T.F.*	Christ's College	1990,91
Maunsell W.K.	St Stephen's School	1984,85
Mawhinney J.W.	Southland BHS	1984
Maxwell N.M.	Whangarei BHS	1994
Mealamu K.	Aorere College	1996
Mika D.	St Peter's College	1991
Miller B.M.	Kamo HS	1995
Miller P.C.	King's HS	1995
Miller T.J.*	Kamo HS	1990-92
Moncrieff E.A.	St Patrick's College, Silverstream	1990
Monkley D.I.	Morrinsville College	1984
Moreton K.	Auckland GS	1989
Morgan E.P.	Gisborne BHS	1993-95

Morris B.J.	King's College	1994,95
Nally K.J.	Sacred Heart College	1992
Naufahu J.S.P.	Auckland GS	1995,96
Newton K.	Rotorua BHS	1991
Ngapaku N.	De La Salle College	1992
Ngatai G.P.	Western Heights HS	1980
Noble J.	Gisborne BHS	1994
Nonoa S.	Wesley College	1991
Norton R.	Shirley BHS	1990
O'Brien R.K.	Hato Petera College	1979
Oliver A.D.*	Marlborough BHS	1993
Ofahengaue V.	Seddon HS	1988
O'Halloran S.	Kelston BHS	1980
O'Rourke J.G.	Rathkeale College	1988
Orsmby M.	Tauranga Boys College	1978
Palamo G.	De La Salle College	1997
Palmer T.	Otago BHS	1997
Parkes D.	Palmerston North BHS	1983,84
Parkinson R.	St Stephen's School	1991
Peita H.	Panguru Area School	1993,94
Petelo P.	De La Salle College	1995
Petera W.R.	Dannevirke HS	1995
Piper M.	St Peter's College	1991
Porima G.	Lindisfarne College	1988
Pourewa K.G.	Wesley College	1991
Preston J.P.*	St Bede's College	1984,85
Puleitu E.	Onehunga HS	1994
Rackham S.	Auckland GS	1989
Rae P.	St Stephen's School	1984
Raki L.E.	Manurewa HS	1980
Ralph C.S.	Western Heights HS	1995
Ranby R.M.	Freyberg HS	1995
Randall R.	Church College	1985,86
Randell T.C.*	Lindisfarne College	1990,91
Rangihuna A.	Tauranga Boys College	1982
Rasmussen R.	Kelston BHS	1996
Ratapu H.	St Stephen's School	1978
Renata S.	Tokomairiro College	1985
Renton P.	Rathkeale College	1980
Ridge M.J.*	Auckland GS	1986
Riechelmann C.C.*	Auckland GS	1989-91
Riley S.	Southland BHS	1992

Ririnui B.R.	Tauranga Boys College	1985
Robertson A.	Palmerston North BHS	1979
Ronaki K.	Te Puke HS	1992
Roose A.T.	Pukekohe HS	1986,87
Ropati R.L.	Auckland GS	1995
Rush X.J.	Sacred Heart College	1995
Rusk B.	Rosmini College	1997
Rutene P.	Wairarapa College	1980
Ryan T.J.	Hato Petera College	1986
Sanft Q.A.	De La Salle College	1995
Savage B.	Putaruru HS	1978,79
Senio K.	Kelston BHS	1996
Seymour D.J.*	St Stephen's School	1985
Sexton M.R.	Shirley BHS	1988
Shaw C.	Sacred Heart College	1984
Shaw P.	Sacred Heart College	1992
Simpkins G.P.	Western Heights HS	1986
Simpson G.	Rosmini College	1989
Skipworth J.J.	Napier BHS	1995
Slater G.L.*	New Plymouth BHS	1988,89
Smith G.	Gisborne BHS	1990
Smyth J.F.W.	St Stephen's School	1984
Soper R.	Nelson College	1997
Sorensen N.A.	St John's HS	1979
Sotutu W.R.R.	Wesley College	1988,89
Spencer C.J.*	Waiopehu College	1992,93
Stanley J.C.*	Auckland GS	1992
Stead J.N.	Birkdale College	1985
Stichbury C.J.	Hastings BHS	1987
Stirling H.M.	St Stephen's School	1986
Stone M.A.B.	St Bede's College	1983,84
Stowers F.	Kelston BHS	1994
Stratford N.	Southland BHS	1990
Surridge S.D.*	St Kentigern College	1988
Ta'ala L.	Rongotai College	1990,91
Tagaloa T.D.L.	Henderson HS	1982
Taimalietane R.	Mt Albert GS	1990
Takau T.	St Paul's College	1988
Talakai E.	Wesley College	1989
Taofinu'u M.	De La Salle College	1997
Taylor C.	New Plymouth BHS	1991
Te Moana J.	Lynfield College	1987
Te Nana K.	Te Aute College	1993

Thomas P.	Hato Petera College	1983
Thomas R.	Queen Charlotte College	1978
Thomas S.R.	Auckland GS	1983
Thomsen L.G.	Otahuhu College	1978
Thomson D.	Auckland GS	1993
Tiatia S.A.A.	Wellington College	1994,95
Tiatia F.I.	Wellington College	1990
Tikao T.	Te Aute College	1984
Timu J.K.R.*	Lindisfarne College	1986,87
Tocker D.A.	St Patrick's College, Silverstream	1982
Toleafoa B.	Liston College	1995,96
Tremain S.R.	Napier BHS	1986
Trethewey G.A.	Auckland GS	1980
Tuigamala V.I.*	Kelston BHS	1986,87
Tukino K.	Wesley College	1995
Turner R.S.*	Napier BHS	1986
Uluinayau A.	Mt Albert GS	1988
Vaemolo J.	St John's College	1980
Valentine M.J.	Auckland GS	1978
Vallance R.	Havelock North HS	1979
Veale R.	Western Heights HS	1978
Vegar P.	Rosmini College	1987
Vile S.	Kelston BHS	1988
Walker C.	Tikipunga HS	1992
Walker W.C.	King's College	1995,96
Walker T.H.	Makora College	1983
Watt A.W.	King's College	1979
Webber M.	St Peter's College	1987
Weedon M.	Katikati HS	1986
Wells D.J.	St Stephen's School	1987
Whitley M.	Christchurch BHS	1983
Wickes C.D.*	Palmerston North BHS	1979
Williams D.	Papatoetoe HS	1983
Williams D.A.	Mt Maunganui College	1979
Willis B.J.	King's College	1995
Willis J.	King's HS	1996
Willis T.	King's HS	1997
Willis R.K.	Tauranga Boys'	1992-94
Willock A.	Wanganui Collegiate	1992
Wilson J.W.*	Cargill HS	1991,92
Wilson P.W.H.	Otago BHS	1995
Wilton M.	Rathkeale College	1990
Wood D.	Pukekohe HS	1992
Wood I.D.	Auckland GS	1980

International Referees

Early games of rugby were commonly controlled by a referee and two field umpires to whom the captains of the opposing teams appealed for adjudication of infringements. If both umpires raised the sticks they carried, the referee stopped the game and the appropriate penalty was imposed.

As the concept of a sole referee was adopted, the stick (or flag) carriers retreated to the sidelines as touch judges. William Atack is credited as being the first referee to use a whistle when he introduced one in an 1884 club match in Christchurch. The whistle gained wide acceptance and by 1892 became compulsory. Prior to this, referees called out to stop play. The white uniform seems to have been worn by New Zealand referees by the turn of the century although some of their British counterparts dressed in street clothes and shoes when they controlled matches involving the 1905-06 All Blacks.

A New Zealand Referees' Association was formed in 1894 and branches were established in Auckland, Taranaki, Hawke's Bay, Wellington, Marlborough, Nelson, Canterbury, West Coast and South Canterbury, but the present national body – the New Zealand Rugby Referees' Association (NZRM) – was not formed until 1905 when 16 groups sent delegates to a Wellington meeting. Two years later the NZRFU set up its Referees' Appointment Board with two rugby union nominees and one from the referees' association.

Every season each local association nominates a maximum of five referees to control matches under the direct jurisdiction of the NZRFU. These include overseas teams' games against provincial sides and Ranfurly Shield, National Championship, All Black trials, Colts, Universities and Maori fixtures.

Since 1979 international matches in New Zealand have been controlled by referees from overseas. The first of these appointments was in 1979 when John West of Ireland refereed both tests against France.

A reciprocal arrangement that saw New Zealand referees appointed to matches in the international championship in the northern hemisphere commenced in 1983 when Tom Doocey had control of the England v Scotland and Wales v France matches.

BISHOP David James
b: 13.9.1948, Christchurch

Appointments: Fiji v Wales, Romania v France, Ireland v Romania 1986; Wales v Tonga (RWC), Wales v Canada (RWC) 1987; Australia v England (2), England v Australia, Scotland v Australia 1988; Scotland v England, Ireland v Wales, United States v Canada (RWC qualifying), Argentina v Canada (RWC qualifying) 1990; Scotland v Wales, Wales v Ireland, Australia v Argentina (RWC), France v England (RWC) 1991; New Zealand v World XV, South Africa v Australia 1992; France v Australia (2) 1993; Spain v Wales (RWC qualifying) 1994; Australia v Argentina, Western Samoa v Argentina (RWC), England v Australia (RWC), France v England (RWC) 1995.

Bishop, who refereed 26 tests – more than any other New Zealander – has been a regional refereeing development officer since his retirement at the end of the 1995 season.

CAMPBELL Angus
b: ? d: ?

Appointments: NZ v Anglo-Welsh (2nd,3rd) 1908 also three Ranfurly Shield matches

DAINTY Clifford John
b: 16.3.1949, Bridgend, Wales

Appointments: Canada v USA 1982,86, NZ Trials 1981,83, South Africa v Manawatu 1981, Australia v Otago 1982, British Isles v Canterbury 1983, England v Southland and North Island v South Island 1985, France v North Auckland and Australia v Canterbury 1986 plus one Ranfurly Shield match

DOOCEY Thomas Francis
b: 25.6.1942, Christchurch

Appointments: NZ v Ireland 1976, England v Scotland and France v Wales 1983 also Fiji v Hawke's Bay 1974, Tonga v NZ Maoris 1975, Scotland v Hawke's Bay 1975; Ireland v

Auckland 1976, Queensland v Canterbury and British Isles v Manawatu-Horowhenua 1977, Australia v Wanganui 1978, France v Wellington, Argentina v Manawatu, Argentina v New Zealand XV (2nd) and Fiji v Western Samoa 1979, Western Samoa v Tonga 1980, Scotland v King Country and South Africa v Auckland 1981, Australia v North Auckland and Australia v Hawke's Bay 1982, British Isles v Wellington and British Isles v Hawke's Bay 1983, France v Counties 1984 plus three Ranfurly Shield and two interisland matches

DOWNES Alexander Dalziel
b: 2.2.1868, Emerald Hill, Victoria
d: 10.2.1950, Dunedin

Appointments: NZ v Australia (2nd) 1913

DUFFY Brian Walter
b: 31.5.1937, Petone

Appointments: NZ v British Isles (2nd) 1977 also Japan v Taranaki 1974, British Isles v Otago 1977, Australia v Mid-Canterbury 1978, Argentina v Auckland and All Japan v Taranaki 1979, Scotland v Wellington and South Africa v NZ Maoris 1981 plus one interisland and six Ranfurly Shield matches

FARQUHAR Allan Burnett
b: 16.4.1923, Whakatane d: 21.12.1995, Auckland

Appointments: NZ v France (1st,2nd,3rd) 1961, NZ v Australia (2nd,3rd) 1962, NZ v

David Bishop

Australia (1st) 1964 also British Isles v Otago 1959, France v Waikato 1961, England v Wellington 1963, Australia v Wanganui 1964, South Africa v Taranaki 1965 plus two Ranfurly Shield matches

FLEURY Allan Leslie
b: 4.5.1922, Dunedin *d:* 3.8.1992, Dunedin

Allan Fleury

Appointments: NZ v British Isles (1st) 1959 also South Africa v Manawatu-Horowhenua 1956, Australia v Taranaki 1958, British Isles v Poverty Bay-East Coast 1959, France v Nelson Bays and v Southland 1961 plus one interisland and six Ranfurly Shield matches

FONG Arthur Stanley
b: 12.6.1908, Greymouth

Appointments: NZ v Australia (1st) 1946 and NZ v British Isles (3rd) 1950 also 2nd NZEF v Canterbury 1946 and Australia v Hanan Shield Districts 1946, Australia v Canterbury 1949, British Isles v Southland 1950, Australia v Nelson 1952 plus two Ranfurly Shield matches

FORSYTH Robert Alexander
b: 29.7.1921, Auckland

Appointments: NZ v Australia (3rd) 1958 also South Africa v Poverty Bay-East Coast 1956, Australia v Hawke's Bay 1958, British Isles v South Canterbury-North Otago-Mid Canterbury, v Wellington and v NZ Maoris 1959

FRANCIS Robert Charles
b: 27.7.1942, Masterton

Appointments: Australia v England and Australia v Ireland 1984, Argentina v France (1st,2nd) 1985, Wales v Scotland and Scotland v England 1986 also Fiji v Western Samoa and Fiji v Tonga 1984, British Lions v The Rest (IRB Centenary match) and Western Samoa v Wales 1986, plus one interisland match and nine Ranfurly Shield matches

FRIGHT William Henry
b: 1913, Christchurch

Appointments: NZ v South Africa (3rd,4th) 1956 also British Isles v South Canterbury 1950, Australia v Southland 1952, Australia v Hawke's Bay 1955, South Africa v Southland and v NZ Maoris 1956, NZ v The Rest and Fiji v NZ Maoris 1957 plus one interisland and one Ranfurly Shield match

FROOD James
b: 3.2.1908, Glasgow *d:* 5.2.1969, Dunedin

Appointments: NZ v Australia (2nd) 1952 also Australia v Canterbury 1946 plus one interisland and two Ranfurly Shield matches

GARRARD William George
b: c 1864, London *d:* 20.10.1944, Christchurch

Appointments: Australia v Great Britain (1st in Sydney) 1899

GILLIES Cecil Roy
b: 25.8.1917, Hamilton

Appointments: NZ v Australia (1st,2nd) 1958 and NZ v British Isles (2nd,3rd) 1959 also Australia v Canterbury 1955, South Africa v Wairarapa-Bush 1956, Fiji v Canterbury 1957, Australia v Wanganui 1958, British Isles v Hawke's Bay, v Marlborough-Nelson-Golden Bay-Motueka and v North Auckland 1959, France v North Auckland 1961 plus four Ranfurly Shield matches

GRIFFITHS Ashley Allan
b: 3.3.1908, Greymouth

Appointments: NZ v Australia (1st) 1952 also Australia v NZ Maoris 1946, NZ v Auckland 1947, British Isles v North Auckland 1950, Fiji v Auckland 1951 plus one interisland and one Ranfurly Shield match

Bob Francis

HARRISON Graeme Lester
b: 31.3.1933, Christchurch *d:* 13.3.1996, Wellington

Appointments: Australia v France 1981, Australia v France 1983 (2nd), NZ v Argentina 1979, USA v Canada 1981 also British Isles v West Coast-Buller 1977, Australia v Counties 1978 and 1982, Argentina v Bay of Plenty and France v North Auckland 1979, British Isles v SA Barbarians 1980, South Africa v Nelson Bays 1981, Australia v Taranaki 1982, British Isles v Auckland 1983, France v Taranaki 1984

HAWKE Colin
b: 24.2.1953, Temuka

Colin Hawke

Appointments: Ireland v Argentina, England v Argentina 1990; Scotland v Argentina 1992; Tonga v Fiji 1993; South Africa v England 1994; Australia v Argentina, Canada v Romania (RWC) 1995; Tonga v Fiji, Australia v Wales 1996; Ireland v England, South Africa v British Isles, Australia v South Africa, England v South Africa, Tonga v Fiji 1997; England v Wales 1998.

Colin Hawke and Paddy O'Brien were the first two professional referees contracted to the NZRFU.

HILL Eric David
b: 4.6.1908, Auckland *d:* 14.6.1992

Appointments: NZ v Australia (1st) 1949 also Australia v North Auckland 1946, British Isles v Buller and v NZ Maoris 1950 plus one interisland match

HOLLANDER Samuel
b: ? *d:* c 1954, Fiji

Appointments: NZ v Great Britain (1st,2nd,3rd) 1930 and NZ v Australia 1931 also Great Britain v Otago 1930 plus one interisland and four Ranfurly Shield matches. Controlled three of the four tests against the 1930 British tourists, injury preventing him from officiating in the final test.

HONISS Paul Gerard
b: 18.6.1963, Hamilton

Appointments: Western Samoa v Fiji 1997

KING Joseph Stewart
b: c 1897 *d:* 20.10.1970, Auckland

Appointments: NZ v South Africa (2nd,3rd) 1937 also NZ v Wellington 1925, South Africa v Canterbury 1937 plus one Ranfurly Shield match

LAWRENCE Keith Harold
b: 16.9.1944, Auckland

Keith Lawrence

Appointments: Australia v Canada 1985; Australia v Canada, Australia v Italy 1986; France v Scotland, Scotland v Wales, Australia v England (RWC), Fiji v Italy (RWC), Argentina v Australia 1987; Australia v British Isles 1989; Australia v England 1990; Ireland v Zimbabwe (RWC), Australia v Wales (RWC) 1991

Lawrence has been manager of referee development at the NZRFU since 1996.

MACASSEY Lyndon Ewing
b: 16.5.1909, Dunedin *d:* 6.11.1992

Appointments: NZ v South Africa (1st) 1937 also Australia v Canterbury 1931, South Africa v Wellington 1937 plus one interisland and two Ranfurly Shield matches

McAULEY Clifford Johnston
b: 13.11.1926, Kaitangata

Appointments: NZ v Australia (1st) 1962 also England v Hawke's Bay 1963, Australia v Auckland 1964, South Africa v Marlborough-Nelson-Golden Bay-Motueka and v Hawke's Bay 1965, British Isles v Canterbury 1966 plus one interisland and three Ranfurly Shield matches

McDAVITT Peter Alan
b: 4.4.1931, Waitara

Appointments: NZ v Australia (1st) 1972, NZ v Scotland 1975, NZ v British Isles (1st) 1977 also British Isles v NZ Universities, v Hawke's Bay and v Counties-Thames Valley 1966, France v King Country and v Hawke's Bay 1968, Wales v Otago 1969, Tonga v North Auckland 1969, Fiji v Wanganui 1970, British Isles v Waikato and v North Auckland 1971, NZ v Counties 1972, Australia v Otago 1972, NZ v Invitation XV 1973, Tonga v Western Samoa (two matches) 1975, Scotland v Canterbury 1975, Romania v Poverty Bay and v NZ Juniors 1975, Ireland v North Auckland 1976, Western Samoa v NZ Maoris (2nd) 1976, British Isles v Taranaki and v Counties-Thames Valley 1977 plus one interisland and three Ranfurly Shield matches

McKENZIE Herbert James
b: 16.9.1883, Carterton *d:* 29.9.1952, Carterton

Appointments: NZ v Australia (2nd) 1936 also South Africa v Manawatu-Horowhenua 1921, Great Britain v Wanganui 1930, Australia v Hawke's Bay 1931, Australia v Hawke's Bay 1936, plus one interisland and 12 Ranfurly Shield matches

McLACHLAN Lindsay Lamont
b: 10.11.1954, Christchurch

Appointments: Argentina v United States 1989; Australia v Scotland 1992; Tonga v Scotland, Western Samoa v Scotland, Australia v South Africa 1993; Scotland v England, Wales v France 1994

MATHESON Alexander Malcolm
b: 27.2.1906, Omaha *d:* 31.12.1985, Auckland

Appointments: NZ v Australia (2nd) 1946 plus one interisland match

MILLAR David Howard
b: 25.3.1932, Dunedin

David Millar

Appointments: NZ v South Africa (4th) 1965, NZ v France (1st) 1968, NZ v British Isles (3rd,4th) 1977, NZ v Australia (1st,2nd,3rd) 1978 also South Africa v Poverty Bay-East Coast, v Waikato and v NZ Maoris 1965, British Isles v Wellington and v NZ Juniors 1966, France v Marlborough and v Waikato 1968, Wales v Wellington 1969, Fiji v NZ Juniors 1970, British Isles v NZ Maoris 1971, NZ v North Auckland 1972, Australia v Waikato 1972, NZ v President's XV 1973, Japan v NZ Universities 1974, Tonga v NZ Maoris and v Canterbury 1975, British Isles v Auckland and v Canterbury 1977, Australia v Manawatu 1978, Western Samoa v Tonga (in Tonga) 1978 plus one interisland and nine Ranfurly Shield matches

MOFFITT Joseph
b: ? *d:* c 1960, Wellington

Appointments: NZ v Australia (1st) 1936 also Great Britain v Auckland 1930 plus one interisland and four Ranfurly Shield matches

MURPHY John Patrick
b: 16.3.1923, Dargaville

Pat Murphy

Appointments: NZ v British Isles (4th) 1959, NZ v England (2nd) 1963, NZ v Australia (2nd,3rd) 1964, NZ v South Africa (1st,2nd,3rd) 1965, NZ v British Isles (2nd,3rd,4th) 1966, NZ v France (3rd) 1968, NZ v Wales (1st,2nd) 1969 also Fiji v Bay of Plenty 1957, Australia v Waikato 1958, British Isles v NZ Universities, v Manawatu-Horowhenua, v Waikato and v Bay of Plenty-Thames Valley 1959, France v Taranaki, v Manawatu and v South Canterbury 1961, South Africa v NZ Juniors 1965, British Isles v Bay of Plenty 1966, France v Southland and v Manawatu 1968, British Isles v Wanganui-King Country and v Bay of Plenty 1971 plus three interisland and 10 Ranfurly Shield matches

O'BRIEN Patric Denis
b: 19.7.1959, Invercargill

Paddy O'Brien

Appointments: Hong Kong v Korea (RWC qualifying), Japan v Hong Kong (RWC qualifying) 1994; Western Samoa v Fiji, Wales v Fiji, Ireland v Fiji 1995; Western Samoa v Fiji 1996; Australia v England, South Africa v Australia, France v South Africa, England v Scotland 1997; Scotland v France 1998

Paddy O'Brien and Colin Hawke were the first two professional referees contracted to the NZRFU.

PARKINSON Francis Graham Milne
b: c 1919, Marton

Appointments: NZ v Australia (1st) 1955 and NZ v South Africa (1st,2nd) 1956 also Australia v Wairarapa 1949, British Isles v Wanganui 1950, Fiji v NZ Maoris 1951, South Africa v Waikato 1956, Fiji v Marlborough 1957, British Isles v Wairarapa-Bush 1959 plus one interisland and eight Ranfurly Shield matches

PRING John Pym Gray
b: 30.12.1927, Auckland

Appointments: NZ v British Isles (1st) 1966, NZ v Australia 1967, NZ v France (2nd) 1968, NZ v British Isles (1st,2nd,3rd,4th) 1971, NZ v Australia (2nd) 1972 also South Africa v Wellington 1956, South Africa v Otago and v South Canterbury-Mid Canterbury-North Otago 1965, British Isles v Taranaki and v Waikato 1966, France v Taranaki 1968, Wales v Taranaki 1969, Fiji v Poverty Bay 1970, British Isles v Otago 1971, Australia v Bay of Plenty 1972, NZ v NZ Maoris 1973, Fiji v NZ Maoris 1974, Tonga v Wairarapa-Bush 1975, Romania v Waikato 1975, British Isles v Southland and v NZ Maoris 1977, Argentina v Counties 1979 plus three interisland and nine Ranfurly Shield matches

ROBSON Chisholm Forbes
b: 28.11.1926, Christchurch

John Pring

Appointments: NZ v England (1st) 1963 also British Isles v Canterbury and v Counties-Thames Valley-King Country 1959, Australia v Wairarapa-Bush 1964, South Africa v Wellington and v Auckland 1965, British Isles v Southland and v NZ Maoris 1966, Tonga v NZ Juniors 1969 plus one interisland and five Ranfurly Shield matches

SIMPSON John Lindsay
b: 18.4.1879, Christchurch *d:* 24.9.1945, Wellington

Appointments: NZ v Australia (1st) 1913 also NZ v New South Wales 1921, NZ v New South Wales (3rd) 1923, South Africa v Canterbury 1921 plus five Ranfurly Shield matches

SULLIVAN George
b: 20.12.1907, Taihape *d:* 11.8.1973, New Plymouth

Appointments: NZ v British Isles (4th) 1950 also British Isles v Auckland 1950 plus four Ranfurly Shield matches

TAYLOR Alan Ralph
b: 16.1.1934, Granity

Appointments: NZ v South Africa (3rd) 1965 and NZ v Australia (3rd) 1972 also South Africa v Southland and v Bay of Plenty-Counties-Thames Valley 1965, British Isles v Otago and v Auckland 1966, France v North Auckland and v Otago 1968, Fiji v NZ Maoris 1970, Australia v King Country 1972, NZ v NZ Juniors 1972, NZ v NZ Juniors 1973, Romania v Manawatu 1975, Western Samoa v NZ Maoris (1st) 1976, Ireland v South Canterbury 1976, British Isles v Wairarapa-Bush 1977, France v Waikato and v Fiji (in Fiji) 1979

THOMPSON Mark William
b: 20.10.1947, Auckland

Appointments: Western Samoa v Fiji 1983 and Western Samoa v Tonga 1983 also New South Wales v Queensland 1986 and Australia v Thames Valley 1986

WAHLSTROM Glenn Kayne
b: 10.7.1959, Wellington

Glenn Wahlstrom

Appointments: Australia v Western Samoa, South Africa v Argentina (2) 1994; Fiji v Tonga 1995; Australia v Wales 1996; Fiji v Tonga (RWC qualifying), Ireland v Western Samoa 1997

WALSH Leslie
b: 26.10.1913, Christchurch

Appointments: NZ v Australia (2nd) 1949 also Australia v Wellington 1946 plus four Ranfurly Shield matches

WALSH Stephen
b: 8.2.1960, Cardiff

Appointments: Fiji v Western Samoa 1994; Tonga v Western Samoa 1995; Western Samoa v Tonga 1996; Cook Islands v Fiji (RWC qualifying) 1997

WILLIAMS John
b: ? *d:* ?

Appointments: NZ v Australia 1905 plus six Ranfurly Shield matches

WOLSTENHOLME Birnie
b: 8.9.1915, Napier *d:* 9.7.1993, Gisborne

Appointments: NZ v Australia (3rd) 1955 also Fiji v Hawke's Bay 1951, Australia v Thames Valley-Bay of Plenty 1955, South Africa v North Auckland and v Taranaki 1956, Fiji v Wairarapa 1957 plus one Ranfurly Shield match

Writers, Broadcasters

Writers and broadcasters have made immense contributions to rugby in New Zealand, presenting the game to a wider audience and preserving their impressions and memories for later generations. Rugby is the most recorded sport in New Zealand and it is to the people listed in this section to whom thanks are due.

There are and have been many rugby reporters of course and many broadcasters, both radio and, in the last 30 years, television, from those who stand on wet and muddy touchlines at club games in midwinter to those who travel overseas with the All Blacks or tour internally with visiting teams. Many of them never specialised in rugby, merely carried out an assignment, but many did it for the love of the game. Those listed here are those who have made exceptional contributions to the documenting of the game and games over many years.

Although not listed, it should be recorded in a work of this type that the New Zealand Press Association has assigned a reporter to every All Black team touring overseas since 1949 and some on occasions before that, and has covered every internal tour since the Second World War. Mostly the NZPA journalists have been anonymous, their stories appearing under the byline of "NZPA staff correspondent" or something similar, but they have been the most widely read reporters – their copy available to newspapers from the *Southland Times* in Invercargill to the *Northern Advocate* in Whangarei.

Similarly, the work of radio broadcasters, first from the NZBC then Radio New Zealand and now Radio Network, who have called All Black matches, wherever they have been played. After Winston McCarthy and Bob Irvine came John Howson, John McBeth and Graeme Moodie.

ALLARDYCE Alan Russell
b: 4.10.1893, Christchurch *d:* 21.4.1982, Coromandel

Educated Sydenham Primary, West Christchurch District High and Christchurch Boys' High School. Sailed with the Main Body 1914 and took part in the Gallipoli landing, later serving in Egypt and the United Kingdom. Played senior club rugby and represented Wanganui in Hawke Cup cricket.

Allardyce made the first radio broadcast of a rugby match in New Zealand when he described play during a Christchurch club match, May 29, 1926. He subsequently broadcast commentaries of 183 major sporting events including the 1927 interisland match, the second test between New Zealand and Great Britain 1930 and a number of Ranfurly Shield games.

In August 1926 he made the first race commentary, from a haystack on the far side of the Riccarton course. Also covered test cricket, international soccer, national athletic and swimming championships, hockey, tennis and cycling events, boxing and wrestling bouts, galloping and trotting races. One of his celebrated nonsporting broadcasts was on Kingsford-Smith's landing after the 1928 trans-Tasman flight.

BUSH Peter George
b: 16.10.1931, Auckland

Educated Stanley Bay Primary School, St Leo's Convent (Devonport), Kumara Convent, Marist Brothers' School (Greymouth) and Sacred Heart College, 1st XV 1946,47. Played senior club rugby in Auckland for the Marist and College Rifles clubs and for Marist in Wellington. A photographer on the *NZ Herald* 1948-52 then on the *NZ Truth*, specialising in the coverage of rugby tours. Bush also worked for the Internal Affairs Dept as a wildlife and agricultural photographer. In 1958-59 he served as Public Relations Officer with the 1st Battalion NZ Regiment. Ron Bush, the 1931 All Black, is his uncle.

Peter Bush

Bush has won universal acclaim for his rugby photography, which included books on the 1983 British Isles tour, *Lions 83*, and a book depicting all facets of rugby, *The Game For All New Zealand*.

CAMERON Donald John
b: 20.2.1933, Dunedin

Educated St Brigid's Convent School, Christian Brothers High School, St Peter's and St Kevin's Colleges. A sports reporter on the *New Zealand Herald* in Auckland from 1950 until March 1998, Cameron specialised in cricket and rugby. He took over from Terry McLean as the paper's principal rugby writer in 1979. Author of the cricket tour book *Caribbean Crusade* (1972) and of rugby tour books *All Blacks Retreat From Glory* (1980), *Rugby Triumphant* (1981), *Barbed Wire Boks* (1981) and *On the Lions' Trail* (1983).

CARMAN Arthur Herbert
b: 2.8.1902, Paparangi *d:* 28.11.1982, Wellington

Educated Newlands and Johnsonville Schools and Wellington College. Widely regarded as one of the leading authorities on the game in New Zealand, Carman began his career as a New

Arthur Carman

The Encyclopedia of New Zealand Rugby

Zealand rugby writer when he travelled with 1924-25 'Invincibles'. He also earlier covered the British team's tour of South Africa 1924.

Since the inception of the *Rugby Almanack of New Zealand* 1935, Carman edited this annual publication, first in conjunction with Read Masters and Arthur Swan, and from 1974 as sole editor. Among his other rugby books were: *NZ International Rugby 1884-1976*, *Ranfurly Shield Story*, *W.N. Carson, Footballer and Cricketer* and *Maori Rugby 1884-1979*. He also wrote several books on cricket including *Almanacks* from 1948 and histories of the Wellington association and New Zealand international cricket.

Carman passed both the *Rugby* and *Cricket Almanacks* to MOA Publications shortly before his death.

CHESTER Roderick Henry
b: 13.1.1937, Auckland. *d:* 6.6.1994, Auckland

Educated at Parnell School and Auckland Grammar, Chester's boyhood love of sports, but especially rugby, grew with him into manhood and he became nationally known and respected for a prolific output, in partnership with Neville McMillan, of rugby history and statistics. He had played as a lock in junior grades at school and later went on to become a grade one referee, officiating in Dunedin and Melbourne as well as Auckland. He and McMillan produced the "bible" of New Zealand test rugby, *Men In Black*, and followed that with major books on outgoing and incoming tours, *Centenary* and *The Visitors*. They also produced the first *Encyclopedia of New Zealand Rugby* and in 1983 took over the *New Zealand Rugby Almanack* on the death of its founder, Arthur Carman. Chester, who was an executive of the New Zealand Phosphate Company, also played a leading role in the formation of the Association of Rugby Historians and Statisticians.

DEAKER Murray James
b: 12.4.45, Dunedin

Represented Otago in age grade rugby and cricket from 1957 to 1965, gained an Otago

Murray Deaker

University cricket blue and played senior rugby for Otago in 1968. Played senior cricket in Dunedin, Auckland and Northland for 17 years, playing for Northland in the Hawke Cup. Played senior rugby for Southern (Dunedin), Christchurch and Teachers (Auckland) and for New Zealand Teachers in 1971. Deaker taught for 17 years, the last eight of which were as deputy principal at Takapuna Grammar. Founder and executive director of the Foundation for Alcohol and Drug Education (FADE). After four years as a part-time host of a sports programme on Newstalk ZB in Auckland, Deaker became host of ZB *Scoreboard* and ZB *Sportstalk* in 1990. Both programmes have gradually been syndicated through Radio Network throughout New Zealand. Deaker also hosts a half-hour interview programme on Sky Television and co-hosts *Sportsnight* on TV1. He also writes a weekly column for the *New Zealand Herald* in Auckland.

HOWITT Robert John
b: 10.11.41, Petone

Bob Howitt

Educated Petone Central Primary School and Hutt Valley Memorial Technical College, 1st XV. Worked as a copyholder and sports reporter on the *Evening Post* 1959-62, rugby correspondent for the *Auckland Star* 1962-70 and *Sunday News* 1971-73. He was one of the founders of *Rugby News* and was editor from its inception until 1996. He then founded *NZ Rugby Monthly*. He was editor of the *NZ Rugby Annual* from its inception in 1971, author of three volumes of *Rugby Greats* and of several player biographies – Grant Batty, Sid Going, Bryan Williams, Inga Tuigamala, Walter Little/Frank Bunce and Laurie Mains – and collaborated with Winston McCarthy on *Haka – the Maori Rugby Story*.

HUTTER Nathaniel Mayer
b: 19.4.1901, Auckland *d:* 24.8.1968, Auckland

Educated Devonport School and Auckland Grammar School. Began his career as a commentator when he broadcast the games played by the 1930 British team in Auckland. For the next 20 years 'Gordon' Hutter was the

best-known sports commentator in New Zealand, covering rugby, rugby league, soccer, hockey, athletics, swimming, show jumping, cricket, rowing, tennis, yacht racing, boxing, wrestling, racing and trotting all with equal facility.

He was especially famous for his association with 'Blind Peter', a sightless Greek immigrant who used to sit beside Hutter when the latter broadcast wrestling bouts from the Auckland Town Hall. After resigning from broadcasting Hutter became a stipendiary steward with the NZ Trotting Conference.

IRVINE Robert Arthur
b: 8.9.1926, Waipukurau

Educated Whangarei Boys' High School. Served with J Force 1946-48. Played rugby in Japan and began broadcasting the game there as a member of the Armed Forces Radio Station. Joined the NZBS as a full-time staff member 1948. Went to South Africa 1960 as a commentator for the All Blacks' tour and then covered all major tours both in New Zealand and overseas until 1975.

Irvine's family has been associated with the game at top level. His grandfather, R. Irvine, played for Auckland 1899-1904 while his father, Bill Irvine, represented New Zealand 1923-26,30. The 1952 All Black, Ian Irvine, is his brother.

KNIGHT Lindsay Steven
b: 5.10.43, Matamata

Educated Kaiapoi Convent School and Xavier College (Christchurch) and began his career in journalism with the *Christchurch Star* in 1962, then worked on *The Dominion* 1963-75, sports editor from 1970 to 1975, the *Evening Post* 1976 and the *Auckland Star* 1977. He returned to *The Dominion* in 1990. He has covered several All Black tours as well as the World Cups in 1987 and 1991. Knight wrote the definitive work on the history of the Ranfurly Shield, *Shield Fever*, wrote the biographies of Ian Kirkpatrick and the front row of Andy Dalton, John Ashworth and Gary Knight, and books about All Black captains, *They Led the All Blacks*, and wings, *Great All Black Wingers*.

McCARTHY Winston John
b: 10.3.1908, Wellington *d:* 2.1.1984, Auckland

Educated Mitchelltown, St Thomas's and Marist Brothers' Schools and St Patrick's College (Wellington), 1st XV 1924,25. Moved to Palmerston North 1930 and joined the newly formed United club. Played for Manawatu B as a halfback before moving to the Bush Districts Union which he represented 1930-32 from the Hamua club. Transferred to Konini and then the Red Star club in Masterton. Played rugby league on the West Coast for the Waiuta club 1936 but a shoulder injury forced his retirement from active sport.

McCarthy joined the Wellington radio station 2YD as a programme assistant 1937 and made his first rugby broadcast 1942 while serving with the 2nd Wellington Regiment. His name became a household word throughout New Zealand when he accompanied the Kiwis' army team on tour. He continued broadcasting after the war, commentating on all sports including the 1950 and 1954 Empire Games and the 1956 Melbourne Olympics.

His last rugby commentary was the fourth test on the 1959 Lions' tour. McCarthy was a prolific writer on the game with his published works comprising *Broadcasting with the Kiwis*, *All Blacks on Trek Again*, *Round the World with the*

All Blacks 1953-54, Rugby in my Time, Haka! The All Blacks Story, Listen! It's a Goal! and (with Bob Howitt) *Haka —The Maori Rugby Story.*

McKENZIE Robert
b: 1887, Dunedin *d:* 24.6.1960, Dunedin

Educated Otago Boys' High School. Played rugby for the Alhambra club and was later a referee. Secretary of the Otago RRA. Sports editor of the *Otago Daily Times.* A versatile radio commentator, 'Wang' was well known for his broadcasts of rugby, wrestling, boxing and racing. He derived his nickname from his famous cry, 'Wang! It's a goal!' when a kick was successful.

McLEAN Terence Power
b: 15.7.1913, Wanganui

Educated Durie Hill School (Wanganui), Clyde Quay and Terrace Schools (Wellington), Parkvale and Central Schools (Hastings), Fitzroy School and New Plymouth Boys' High School. New Zealand's most experienced rugby writer, McLean began his career as a journalist with the *Auckland Sun* 1930. He subsequently worked on the *Hastings Tribune,* the *NZ Observer, Taranaki Daily News,* the *Evening Post* and *NZ Herald* which he joined as sports editor 1946. While serving in Italy and Japan with the 22nd Infantry Battalion he edited and published army newspapers.

McLean accompanied many All Black teams on tour and covered visiting sides in New Zealand from the early 1950s. His tour books comprise: *Bob Stuart's All Blacks* (1954), *The*

Terry McLean

Battle for the Rugby Crown (1956), *Kings of Rugby* (1959), *Beaten by the Boks* (1960), *Cock of the Rugby Roost* (1961), *Willie Away* (1964), *The Bok Busters* (1965), *The Lion Tamers* (1966), *All Black Magic* (1968), *All Black Power* (1968), *Red Dragons of Rugby* (1969), *Battling the Boks* (1970), *Lions Rampant* (1971), *They Missed the Bus* (1973), *All Blacks Come Back* (1975), *Goodbye to Glory* (1976), *Winter of Discontent* (1977), *Mourie's All Blacks* (1979).

Other books on the game include: *The Bob Scott Story* (1956), *Great Days in NZ Rugby* (1959), *I, George Nepia* (1963), *Bob Scott on Rugby* (1955), *Fred Allen on Rugby* (1970), *The Best of McLean* (1984) and *Rugby Legends* (1987).

Terry McLean comes from a notable rugby family. He played at junior representative level and in service matches before his newspaper commitments precluded active participation in the game. His father and four uncles represented Wanganui. His brothers, Gordon (Taranaki) and Bob (Wellington), reached provincial level while Hugh was an All Black in the 1930s. MBE 1978. McLean was knighted in 1996.

McMILLAN Neville Athol Channon
b: 1.6.1922, Auckland. *d:* 12.12.1997, Auckland

Neville McMillan, or 'Mac' as he was known to many, formed with Rod Chester a partnership that chronicled the history of New Zealand rugby like it had never been before. Their seminal *Men In Black, Centenary* and *The Visitors* record not just every game played by the All Blacks and every national team that visited New Zealand, but provide also a social history of the game. They also compiled the first *Encyclopedia of New Zealand Rugby* and took over the *New Zealand Rugby Almanack* in 1983. McMillan, who had been a prominent schoolboy athlete and later a rugby coach, was for 21 years head of the history department at Auckland Grammar. History was a hobby as well as a vocation and McMillan also wrote of pre-war sports heroes in *Sporting Legends* and wrote the history of Mt Albert Grammar, where he had been a pupil and also taught. He was working on this new edition of the *Encyclopedia* at the time of his death.

QUINN Keith
b: 1.9.46, Te Kuiti

Educated Benneydale and Berhampore Schools, South Wellington Intermediate and Wellington College. Quinn joined the New Zealand Broadcasting Corporation as a sports broadcaster in 1967 and made his first television test commentary when the All Blacks lost to

Keith Quinn

England in 1973. He toured Australia with the All Blacks in 1974 and has been on most tours since then. He has also covered Olympic and Commonwealth Games and has won numerous industry awards for his broadcasting. He also wrote several rugby tour books as well as *The Encyclopedia of World Rugby.* Quinn in 1997 was made a Member of the New Zealand Order of Merit (MNZM) for services to sports journalism.

SLATTER Gordon Cyril
b: 25.8.1922, Christchurch

Educated Wairarapa College, 1st XV 1940. Played rugby in service teams during WWII and in lower grades after the war. Author of two novels, both with a rugby background – *A Gun in My Hand* and *The Pagan Game.* He has also written three non-fiction rugby books – *On the Ball, Football is 15* and *Focus on Rugby.* An honours graduate in history, Slatter spent his working life as a schoolmaster and coached teams in various parts of New Zealand. For some years he had charge of the 1st XV at Christchurch Boys' High School, where he was senior history master until 1982.

SWAN Arthur Cameron
b: 2.4.1898, Christchurch *d:* 15.11.1973, Wellington

After his return from active service in WWI, Swan began a long and distinguished career in journalism and came to be universally accepted as New Zealand's leading rugby historian. He played senior rugby in Poverty Bay before taking up refereeing 1927. He was subsequently a senior referee in Poverty Bay, Bay of Plenty, East Coast, Manawatu and Wellington. The Wellington RRA honoured him with life membership, as did the NZRRA on which he served as president 1951 and chairman 1952-61.

A prolific writer on the game in New Zealand, Swan is best remembered for his two-volume *History of New Zealand Rugby Football,* a monumental work. His other books include *The New Zealand Rugby Football Union 1892-1967, The Log o' Wood – A History of the Ranfurly Shield, 1902-1959* and *They Played for New Zealand.* He also compiled numerous club and union histories and was co-editor of *The Rugby Almanack of New Zealand* from its inception in 1935 until his death. He was made a life member of the NZRFU 1968 in recognition of his services as the union's official historian.

VEYSEY Alexander Reid
b: 22.11.27, Nelson

Joined *The Dominion* in 1946 and became sports editor in 1958. Covered the 1963-64 All Black tour of Britain for the *New Zealand Press Association* and several other All Black and cricket tours, the 1987 World Cup and Olympic and Commonwealth Games. He became features editor of *The Dominion* in 1971, special writer for the *Sunday Times* in 1981, special writer and columnist for the *Evening Post* in 1988 and was assistant editor on retirement in 1991. Made an MBE for services to journalism, 1990. He collaborated with the New Zealand cricketer John Reid on his biography, *Sword of Willow,* wrote the Wellington Football Club's centenary history and player biographies with Colin Meads, the biggest-selling sports book in New Zealand, Fergie McCormick, Stu Wilson and Bernie Fraser, Murray Mexted, Grant Fox, Zinzan Brooke and Brian Lochore.

New Zealand Rugby Unions and Senior Clubs

Rugby had been established for more than 20 years in New Zealand before the founding of the New Zealand Rugby Football Union in 1892. The game was organised on a club basis at first but provincial unions began to emerge by the late 1870s. These unions arranged games among themselves and in 1884 a New Zealand team, organised by Samuel Sleigh of Dunedin, and consisting of players from Auckland, Wellington, Canterbury and Otago, toured New South Wales.

By the mid-eighties the necessity for a central controlling authority was recognised by some rugby administrators. In 1883 a dispute arose during a game between Auckland and Wellington. As there was no national body to arbitrate it remained unresolved. It was also difficult to arrange tours by overseas teams as unions had to be dealt with separately.

Largely through the efforts of Ernest Hoben, the secretary of the Hawke's Bay RFU, practical steps were taken to set up a national body in 1891. During that year Hoben spent some time travelling around New Zealand discussing the idea of a national union with the various local administrators. He received enough support to encourage him to convene a meeting at the Club Hotel in Wellington on 7 November, 1891.

This inaugural meeting was attended by the following union representatives: J.M. King (Wellington) chairman, R.C. Sim (Wellington), J.B. Waters (Otago), A.E. D'Arcy (Wairarapa), J.R. Gibbons (Manawatu), L. Coupland (Auckland), W. Fraser (Taranaki) and E.D. Hoben (Hawke's Bay) convenor. After a long discussion extending over two days it was moved by Hoben and seconded by D'Arcy: "That this meeting having considered the question of the formation of a New Zealand Rugby Union is of the opinion that the time has arrived for the matter to receive the attention of the various unions and that the constitution be submitted for their consideration." A draft of the constitution was passed and sent to the unions for confirmation at a later meeting.

On 16 April, 1892, a second meeting was held at the same place, those present being: G.F.C. Campbell (Wellington) chairman, J. Haliday (Auckland), E.D. Hoben (Hawke's Bay), W.D. Milne (Otago), T.S. Marshall (Canterbury), G. Newth (Manawatu), B. Ginders (Wairarapa), and T.S. Ronaldson (Taranaki). Both Marlborough and Nelson wrote stating their support for the formation of the national union and appointed delegates who, however, were not able to attend the meeting. Wanganui and South Canterbury also stated their allegiance but were not represented.

Southland wrote stating their reluctance to join at the time as they were so isolated that they could be represented on a national union only by proxy.

Hoben moved that a New Zealand Rugby Football Union should be formed and Haliday seconded the motion. Otago's delegate, Milne, spoke against the motion saying his union would not gain any advantage by joining. In fact, he saw a disadvantage in that his union did not want to be controlled by a Wellington body. Marshall supported him. Although Canterbury had at first agreed to the scheme his union had now changed its view. The motion was put and carried after which Milne and Marshall left the meeting.

Rules were considered and adopted and the following officers were elected: Hon. Secretary: E.D. Hoben; Hon. Treasurer: L. Coupland; Committee: F. Logan (Hawke's Bay), T. Henderson (Auckland), G.F.C. Campbell (Wellington). The three committee members became the first New Zealand selectors. Lord Glasgow, the new Governor, was asked to accept the office of president. The vice-presidents were: A.E.T. Devore (Auckland), F. Logan (Hawke's Bay), W.L. Bailey (Manawatu), J. Snodgrass (Marlborough), G.T. Bayly (Taranaki), M. Jonas (South Canterbury), E.D.M. Whatman (Wairarapa), A.D. Thomson (Wanganui), G. Fisher (Wellington) and G.H. Boyd (West Coast). In 1893 the Governor accepted office as patron with George Campbell as president.

When the 1893 New Zealand team was selected to tour Australia, players from the non-affiliated unions were not considered. The tour was a very successful one and footballers from Canterbury, Otago and Southland objected strongly to their exclusion. They brought pressure on their union officials to change their attitudes to the national union and in 1894 Canterbury joined the NZRFU, Otago following suit in 1895. Southland joined then withdrew in 1894 but was readmitted in 1895. Other provincial unions were affiliated on their formation.

Widespread changes in club competitions have occurred since the *Encyclopedia* was previously published in 1987. These involved many club mergers and some abolitions. Some club competitions are union-wide and others are within sub-unions; others have varied between the two. It was decided to list just the senior clubs in each union's main competition, though that means some noted clubs in sub-union competitions, Glenmark in North Canterbury or Clutha in South Otago for example, are not listed.

Auckland

Founded: 1883

Colours: Traditionally blue and white hoops, white shorts and blue and white hooped socks. Red was introduced into a stylised jersey in 1997. Between the two world wars, Auckland wore black shorts and black socks with white tops

Main ground and capacity: Eden Park, 45,000

Record attendance: 61,240 NZ v South Africa, 1956

Most appearances: H.L. White, 1949-63, 196

Most points: G.J. Fox, 2746, 1982-93

Most tries: T.J. Wright, 112, 1984-93

NZ representatives (172): F.R. Allen, A.A. Asher, B.G. Ashworth, C.E.O. Badeley, V.I.R. Badeley, J. Barrett, W. Batty, N.W. Black, A.F. Blowers, E.G. Boggs, S.G. Bremner, R.M. Brooke, Z.V. Brooke, M. Brooke-Cowden, H.M. Brown, O.M. Brown, J.A. Bruce, G.A.J. Burgess, V.C. Butler, K.R. Carrington, W.N. Carson, G. Carter, M.P. Carter, A.R. Cashmore, T.H.C. Caughey, D.L. Christian, A.H. Clarke, E. Clarke, S.B. Conn, D.M. Connor, A.E. Cooke, G.J.L. Cooper, M.M.N. Corner, P.J.B. Crowley, G.R. Cunningham, W. Cunningham, W.A. Davies, K. Davis, J. Dick, M.J. Dick, R.L. Dobson, C.W. Dowd, A.J. Downing, J.A. Drake, J.M. Dunn, C.P. Erceg, C.P. Farrell, C.L. Fawcett, S.B.T. Fitzpatrick, C.J.C. Fletcher, G.J. Fox, A.R.H. Francis, R.T. Fromont, D. Gallaher, W.M. Geddes, B.M. Gemmell, G.A. Gillett, A.M. Haden, S. Hadley, W.E. Hadley, R.A. Handcock, W.E. Hay-McKenzie, H.O. Hayward, M.A. Herewini, M. Herrold, J.A. Hewett, L.S. Hook, S.P. Howarth, A.M. Hughes, K.D. Ifwersen, C.R. Innes, F.M. Jervis, B.R. Johnstone, M.N. Jones, J.W. Kelly, H.A.D. Kiernan, B.A. Killeen, D.E. Kirk, J.J. Kirwan, A. Knight, L.A.G. Knight, L.G. Knight, P.R. Lam, J.G. Lecky, T.R. Lineen, P.F. Little, T.M. Lockington, A.R. Lomas, A.J. Long, F.W. Lucas, B.J. McCahill, S.C. McDowell, A.J. McGregor, R.W. McGregor, M.J. McHugh, D.W. McKay, R.H. McKenzie, R.J. McKenzie, W.H.C. Mackrell, J.V. Macky, J.S. McLachlan, H.F. McLean, J.K. McLean, R.F. McMullen, R.G. McWilliams, J.R. Maguire, H.A. Mattson, J.G. Mills, P.H. Murdoch, F.S. Murray, W.J. Nathan, S.R. Nesbit, G.W. Nicholson, A.J. O'Brien, J.G. O'Brien, T.B. O'Connor, M.J. O'Leary, R. Oliphant, B.P. Palmer, C.S. Pepper, S.T. Pokere, R.E. Rangi, M.J. Ridge, C.C. Riechelmann, L.S. Righton, T. Ryan, R.W.H. Scott, C.E. Seeling, G.M.V. Sellars, T.R. Sheen, K. Sherlock, J.G. Simpson, J.R. Skeen, G.W. Smith, D. Solomon, F. Solomon, C.R.B. Speight, C.J. Spencer, J. Stanley, J.T. Stanley, L. Stensness, J.D. Stewart, A.D. Strachan, F. Surman, J.M. Tanner, P.L. Tetzlaff, B.T. Thomas, G.S. Thorne, N.H. Thornton, O.F.J. Tonu'u, K.R. Tremain, V.I. Tuigamala, T.M. Twigden, G.A. Tyler, R.A. Urlich, J.A. Warbrick, L.H. Weston, A.J. Whetton, G.W. Whetton, W.J. Whineray, H.L. White, P.J. Whiting, D.R. Wightman, B.G. Williams, A. Wilson, F.R. Wilson, V.W. Wilson, M.E. Wood, D.H. Wright, T.J. Wright, W.A. Wright, J.T. Wylie.

The 1990 Auckland team
Back row: Ross Thompson, Pat Lam, John Kirwan, Robin Brooke, Zinzan Brooke, Mark Carter, Michael Jones.
Third row: Va'aiga Tuigamala, Olo Brown, Peter Fatialofa, Bernie McCahill, Frank Bunce, Bruce Morton, Craig Innes, Shane Howarth.
Second row: Eric Boggs (president), Paul Wilson (physiotherapist), Jason Hewett, Grant Paterson, Ant Strachan, John Carter (manager), Rob Fisher (chairman).
Front row: Bryan Williams (assistant coach), Terry Wright, Sean Fitzpatrick, Gary Whetton (captain), Alan Whetton, Grant Fox, Steve McDowell, Maurice Trapp (coach).

WINNERS OF THE AUCKLAND CLUB CHAMPIONSHIP

1883	Ponsonby	1941	Papakura Army
1884	Ponsonby	1942	Motor
1885	Ponsonby		Transport Pool
1886	Grafton	1943	Garrison
1887	Ponsonby	1944	University
1888	Grafton	1945	Whenuapai
1889	Gordon	1946	Grafton
1890	Ponsonby	1947	Marist
1891	Ponsonby &	1948	Ponsonby
	Parnell	1949	University
1892	Parnell	1950	Marist
1893	Parnell	1951	Grammar
1894	Parnell	1952	University
1895	Grafton	1953	Grammar
1896	Parnell,	1954	Ponsonby
	Newton & City	1955	University
1897	Ponsonby	1956	University &
1898	Newton		Otahuhu
1899	North Shore	1957	University
1900	City	1958	Waitemata
1901	Grafton	1959	Otahuhu
1902	City	1960	Otahuhu
1903	City	1961	Otahuhu
1904	Newton	1962	Waitemata
1905	City	1963	Otahuhu
1906	City	1964	College Rifles
1907	City	1965	Otahuhu
1908	Ponsonby	1966	University
1909	Ponsonby	1967	Grammar
1910	Ponsonby	1968	Manukau
1911	City	1969	Otahuhu
1912	Marist	1970	Grammar
1913	Ponsonby	1971	University
1914	University	1972	Grammar
1915	Marist	1973	Manukau
1916	University	1974	University
1917	Railway	1975	Waitemata
1918	University	1976	Ponsonby
1919	College Rifles	1977	Suburbs
1920	Grammar	1978	Ponsonby
1921	Grafton	1979	Ponsonby
1922	Grammar	1980	Takapuna
1923	Marist	1981	Ponsonby
1924	Ponsonby	1982	Otahuhu
1925	Ponsonby	1983	Ponsonby
1926	Ponsonby	1984	University
1927	Ponsonby	1985	Ponsonby
1928	University	1986	Ponsonby
1929	Ponsonby	1987	University
1930	Ponsonby	1988	Ponsonby
1931	Grammar	1989	Marist
1932	Grammar	1990	Ponsonby
1933	Marist,	1991	Marist
	Ponsonby &	1992	Suburbs
	University	1993	Ponsonby
1934	Grafton	1994	Marist
1935	Technical OB	1995	Ponsonby
1936	Ponsonby	1996	Marist
1937	Ponsonby	1997	University
1938	Ponsonby		
1939	Marist		*Most championships:*
1940	Takapuna		Ponsonby 34

SENIOR CLUBS

College Rifles	Navy blue
East Tamaki	Emerald green, red and white
Eden	Gold and black
Grammar Carlton	White
Manukau	Black, red and white
Marist	Light blue, dark blue and red
Mt Wellington	Gold and green
Otahuhu	Red and black
Pakuranga	Orange and green
Papatoetoe	Red and white

Ponsonby	Black and blue
Roskill Districts	Red, black and white
Suburbs	Red and blue
Tamaki	Royal blue, crimson band
Teachers Eastern	Light blue and white
Te Atatu	Maroon and white
Te Papapa	Gold and blue
University	Dark blue and white
Waitemata	Black, red and green

Bay of Plenty

Founded: 1911

Colours: Blue and gold

Main ground and capacity: Rotorua International Stadium, 50,000

Record attendance: 35,000, Bay of Plenty v British Isles, 1983

Most appearances: G.D. Rowlands, 1969-82, 161

Most points: G.D. Rowlands, 1969-82, 1008

Most tries: G.E.Moore, 1967-80, 62

NZ representatives (18): E.J. Anderson, G.B. Batty, G.J. Braid, L.J. Brake, R.J. Conway, G.M. Crossman, L.F. Cupples, W.N. Gray, A.G. Jennings, S.C. McDowell, A.L. McLean, A.M. McNaughton, H.R. Reid, G.D. Rowlands, F.N.K. Shelford, E.J.T .Stokes, A.M. Stone, N.M. Taylor.

Bay of Plenty began a partial union-wide club competition in 1997 after previous club competitions were solely within sub-union areas.

SENIOR CLUBS

Galatea sub-union

Galatea	Dark blue and white
Murupara	Maroon and gold
Painoaihio	Blue and gold
Ruatahuna	Red and white
Waiohau	Blue and white

Opotiki sub-union

Apanui	Yellow and black
Opotiki Sports	Black, white, maroon and gold
Opotiki United	Orange and black
Waimana	Red and black

Rangitaiki sub-union

Edgecumbe	Royal blue and light blue
Kawerau	Scarlet and white
Kawerau United	Cambridge blue
Matata	Black and white
Onepu	Green and yellow
Te Teko	Gold and black

Rotorua sub-union

Eastern Pirates	Green, black and white
Kahukura	Blue and red
Marist St Michael's	Black and white
Ngongotaha-Western	Gold and maroon
Reporoa	Green and white
Rotoiti	Scarlet and sky blue
Rotorua HSOB	Scarlet and white
Waikite	Black and yellow
Whakarewarewa	Black and red

Western Bay of Plenty sub-union

Arataki	Red and black
Eastern Districts	Red and white
Greerton Marist	Green
Judea	Dark blue and black
Kati Kati	Black and white
Mt Maunganui	Dark green and gold
Otumoetai Cadets	Green and black
Rangitahi College OB	Gold and black
Rangataua	Black
Rangiuru	Cambridge blue and white
Tauranga Sports	Blue and gold
Te Puke Sports	Gold, blue and red
Te Puna	Blue and black
United Pirates	Gold and black

Whakatane sub-union

Paroa	Black and white
Poroporo	Blue and white
Taneatua	Black and white
Uatoki	Black and gold
Whakatane Marist	Green, black and white
Whakatane United	White and blue

Buller

Founded: 1894

Colours: Cardinal and blue

Main ground and capacity: Victoria Square, Westport, 6000

Record attendance: 5000, South Africa v West Coast-Buller, 1956

Most appearances: J.G. Gilbert, 1971-86, 127

Most points: D.J. Baird, 1981-91, 575

Most tries: T.J. Stuart, 1984-97, 41

NZ representatives (7): S. Bligh, T. Fisher, E.C. Holder, C. McLean, W.J. Mumm, K.S. Svenson, R.G. Tunnicliff.

WINNERS OF THE BULLER CLUB CHAMPIONSHIP

1894 Denniston	1949 Granity Rover
1895 Denniston	1950 Millerton
1896 Denniston	Rangers
1897 Westport	1951 Ngakawau
1898 Denniston	1952 Ngakawau
1899 Charleston	1953 Granity Rover
1900 Westport	1954 Millerton
1901 Westport	Rangers
1902 Westport	1955 Ngakawau
1903 Westport	1956 Millerton
1904 White Star	Rangers
1905 White Star	1957 Ngakawau
1906 White Star	1958 Ngakawau
1907 Westport	1959 Westport
1908 Granity Rover	1960 White Star
1909 White Star	1961 Westport
1910 White Star	1962 Ngakawau
1911 Westport	1963 Westport
1912 Westport	1964 Westport
1913 Westport	1965 Westport
1914-1917	1966 Westport
no competition	1967 Westport
1918 Granity Rover	1968 Westport
1919 Hill United	1969 Westport
1920 Westport	1970 Westport
1921 Westport	1971 Waimangaroa
1922 Granity Rover	United
1923 Granity Rover	1972 Westport
1924 Granity Rover	1973 Waimangaroa
1925 Granity Rover	United
1926 Mokihinui	1974 Waimangaroa
1927 Mokihinui	United &
1928 Mokihinui	Ngakawau
1929 White Star	1975 Ngakawau
1930 Millerton	1976 Ngakawau
Rangers	1977 Ngakawau
1931 Ngakawau	1978 Ngakawau
1932 Granity Rover	1979 Ngakawau
1933 Waimangaroa	1980 Ngakawau
United	1981 Reefton
1934 Westport OB	1982 United
1935 Millerton	1983 White Star
Rangers	1984 White Star
1936 Millerton	1985 Old Boys
Rangers	1986 Reefton
1937 Westport OB	1987 Ngakawau
1938 Westport OB	1988 Ngakawau
1939 Westport OB	1989 Westport
1940 Westport OB	1990 Westport
1941 Ngakawau	1991 White Star
1942 Ngakawau	1992 White Star
1943 Ngakawau	1993 White Star
1944 Waimangaroa	1994 White Star
United	1995 Old Boys
1945 Ngakawau	1996 Westport
1946 Millerton	1997 Westport
Rangers	
1947 Granity Rover	*Most championships:*
1948 Granity Rover	Westport 22

SENIOR CLUBS

Karamea	Black
Ngakawau	Black and blue
Old Boys	White jersey with blue collar, cuffs, blue shorts
Reefton	Green and white
Westport	Black and gold
White Star	Blue jersey with white star, white shorts

Canterbury

Founded: 1879

Colours: Red and black

Main ground and capacity: Lancaster Park, 38,000

Record attendance: 57,700, New Zealand v British Isles, 1971

Most appearances: W.F. McCormick, 1958-75, 222

Most points: R.M. Deans, 1979-90, 1641

Most tries: P. Bale, 1989-96, 94

NZ representatives (156): G.T. Alley, A. Anderson, W.G. Argus, D.A. Arnold, J.C. Ashworth, G.T.M. Bachop, W. Balch, C.K. Barrell, W.M. Birtwistle, J.E. Black, T.J. Blackadder, J.G.P. Bond, S.G. Bremner, M.R. Brewer, F.J. Brooker, O.D. Bruce, J.A.S. Buchan, J.F. Burns, P.J. Burns, J.T. Burrows, H.C. Burry, W.K.Te P. Bush, J.B. Buxton, S.R. Carleton, S.C. Cartwright, F.L. Clark, D.G. Cobden, A.E. Cooke, R.J. Cooke, A.I. Cottrell, W.D. Cottrell, J.N. Creighton, S.E.G. Cron, T. Cross, W. Cummings, C.J. Currie, W.C. Dalley, G.N. Dalzell, M.G. Davie, L.J. Davis, I.B. Deans, R.G. Deans, R.M. Deans, M.J. Dixon, W.A. Drake, R.H. Duff, A.T. Earl, B.P. Eastgate, A.E.G. Elsom, W.L. Elvy, C.E. Evans, A.H.N. Fanning, B.J. Fanning, W.A. Ford, H. Frost, F.C. Fryer, W.B. Fuller, G.A. Gillett, E. Glennie, D.J. Graham, G.D. Gray, C.I. Green, D.A. Hales, E.T. Harper, J.H. Harris, G.F. Hart, P. Harvey, E.W. Hasell, G.H.N. Helmore, G. Higginson, S.F. Hill, F.G. Hobbs, M.J.B. Hobbs, J.A. Hooper, A.E. Hopkinson, J. Hotop, G.W. Humphreys, I.A. Hurst, G.D. Innes, H.T. Joseph, K.J. Keane, A. Kerr, I.A. Kirkpatrick, C.R. Laidlaw, J.M. Le Lievre, H.T. Lilburne, R.W. Loe, T.W. Lynch, P. McCarthy, B.V. McCleary, A.G. McCormick, W.F. McCormick, H.H. Macdonald, D. McGregor, N.P. McGregor, B.E. McPhail, J.E. Manchester, J.W. Marshall, R.R. Masters, J.T.F. Matson, K.F. Meates, A.P. Mehrtens, G.M. Mehrtens, H.H. Milliken, E.B. Millton, W.V. Millton, T.W. Mitchell, W.J. Mitchell, B.P.J. Molloy, R.C. Moreton, P.J. Morrissey, H.V. Murray, F. Newton, R.W. Norton, C.J. Oliver, S.A. Orchard, M.L. Page, J.H. Parker, L.C. Petersen, S. Philpott, J.P. Preston, J.G. Rankin, P.K. Rhind, A.C.C. Robilliard, J.T. Robinson, L.T. Savage, S.J. Scott, G. Scrimshaw, D.J. Seymour, V.L.J. Simpson, R.M. Smith, W.R. Smith,

B.F. Smyth, A.G. Steel, A.J. Stewart, R.T. Stewart, V.E. Stewart, K.C. Stuart, R.C. Stuart, S.D. Surridge, K.J. Tanner, H.M. Taylor, W.T. Taylor, B.A. Thompson, K.R. Tremain, H.S. Turtill, P.B. Vincent, B.A. Watt, W.J. Whineray, C.W. Williams, D.D. Wilson, R.G. Wilson, R.J. Wilson, M.E. Wood, A.J. Wyllie, D. Young.

WINNERS OF THE CHRISTCHURCH CLUB CHAMPIONSHIP

1883 East	1944 Linwood-
Christchurch	Technical & Air
1884 North	Force
Canterbury	1945 Marist
1885 East	1946 Technical OB
Christchurch	1947 Sydenham
1886 East	1948 Sydenham
Christchurch	1949 Technical OB
1887 East	1950 Marist
Christchurch	1951 Marist
1888 Sydenham	1952 Marist
1889 Sydenham	1953 High School OB
1890 Merivale	1954 High School OB
1891 Merivale	1955 High School OB
1892 East	& Christchurch
Christchurch	1956 University
1893 Merivale	1957 University
1894 Kaiapoi	1958 University
1895 Linwood	1959 University
1896 Linwood	1960 Christchurch &
1897 Linwood	Linwood
1898 Linwood	1961 University &
1899 Linwood	Christchurch
1900 Christchurch	1962 University
1901 Merivale	1963 University
1902 Linwood	1964 Linwood
1903 Albion	1965 University
1904 Albion	1966 Linwood &
1905 Sydenham	Christchurch
1906 Albion	1967 Linwood
1907 Sydenham	1968 New Brighton
1908 Albion	1969 Lincoln College
1909 Merivale	1970 University A &
1910 Albion	Christchurch
1911 Albion	1971 Christchurch &
1912 Merivale	New Brighton
1913 High School OB	1972 Christchurch
1914 High School OB	1973 Linwood
1915 Linwood	1974 Christchurch
1916-1918	1975 Christchurch
no competition	1976 Christchurch
1919 Marist	1977 University A
1920 Marist	1978 New Brighton
1921 Marist	1979 High School OB
1922 Marist	1980 University A
1923 Marist	1981 Lincoln College
1924 High School OB	1982 University A
1925 High School OB	1983 University A
1926 High School OB	1984 New Brighton
1927 Christchurch	1985 Marist
1928 University	1986 Shirley
1929 High School OB	1987 University
1930 Christchurch	1988 Marist
1931 Merivale	1989 Marist &
1932 Sydenham	Shirley
1933 Sydenham	1990 University
1934 Albion	1991 Marist
1935 High School OB	1992 Burnside
1936 Sunnyside	1993 Burnside
1937 High School OB	1994 Marist
& University	1995 Christchurch
1938 Linwood	HSOB
1939 University	1996 Sydenham
1940 University	1997 Sydenham
1941 Albion	
1942 Air Force A	*Most championships:*
1943 Linwood-	University 19
Technical &	
New Brighton	

SENIOR CLUBS

Belfast	Green and gold
Burnside	Red and white
Christchurch	Red and black
Christchurch	
HSOB	White
Linwood	Black and green
Marist Albion	Black, green and white
Merlins	Blue, gold and white
New Brighton	Gold and black
Otautahi	Black and gold
Shirley	Cambridge blue
Suburbs	Red and gold
Sumner	Royal blue and white
Sydenham	Cardinal and blue
University	Maroon and gold

Counties-Manukau

Founded: 1926 as South Auckland and affiliated to Auckland. Full union status as South Auckland Counties from 1955, Counties 1956, Counties-Manukau 1996

Colours: Red, white and black

Main ground and capacity: The Stadium, Pukekohe, 30,000

Record attendance: 26,500, Counties-Thames Valley v British Isles, 1977

Most appearances: A.J. Dawson, 1976-89, 201

Most points: D.A. Love, 1993-96, 698

Most tries: A.J. Dawson, 1976-89, 59

NZ representatives (16): N.H. Allen, B.W. Codlin, M.S.B. Cooksley, R.R. Cossey, A.G. Dalton, R.C. Ketels, M.O. Knight, R. Kururangi, R.N. Lendrum, J.T. Lomu, B.E. McLeod, B.J. Robertson, K.L. Skinner, J.E. Spiers, P.T. Walsh, H.B. Wilson.

WINNERS OF THE COUNTIES CLUB CHAMPIONSHIP

1955	City Ramblers	1964	Pukekohe
1956	Papakura	1965	Manurewa
1957	Papakura	1966	Manurewa
1958	Papakura &	1967	Manurewa
	Waiuku	1968	Papakura
1959	Onewhero	1969	Manurewa
	United	1970	Manurewa
1960	Ardmore &	1971	Manurewa
	Pukekohe	1972	Papakura
1961	Manurewa	1973	Papakura
1962	Manurewa	1974	Manurewa &
1963	Manurewa		Papakura

1975	Manurewa	1988	Manurewa
1976	Manurewa	1989	Bombay
1977	Manurewa	1990	Manurewa
1978	Manurewa	1991	Manurewa
1979	Ardmore	1992	Manurewa
1980	Manurewa	1993	Manurewa
1981	Ardmore	1994	Manurewa
1982	Papakura	1995	Manurewa
1983	Ardmore	1996	Papakura
1984	Manurewa	1997	Manurewa
1985	Bombay		
1986	Manurewa		
1987	Bombay		

Most championships:
Manurewa 25

SENIOR CLUBS

Ardmore Marist	Red and navy blue
Bombay	Black and gold
Drury	Green and yellow
Karaka	Scarlet
Manurewa	Green and white
Onewhero	Blue and black
Papakura	Red and black
Patumahoe	Blue and gold
Pukekohe	Green and gold
Puni	Maroon
Te Kauwhata	Gold and black
Te Kohanga	Black and white
Tuakau	Blue and white
Waiuku	Red and green
Weymouth	Sky blue and black

East Coast

Founded: 1921

Colours: Sky blue and white

Main ground and capacity: Whakarua Park, Ruatoria, 1300

Record attendance: no record.

Most appearances: S.R. Donald, 1972-85, 97

Most points: E.J. Manuel, 1985-96, 400

Most tries: J.R. Kururangi, 1983-95, 23

NZ representatives (2): A.C.R. Jefferd, G. Nepia.

WINNERS OF THE EAST COAST CLUB CHAMPIONSHIP

Results prior to 1972 not available

1972	Hicks Bay &	1976	Uawa &
	Waima		Combined
1973	Tolaga	1977	Uawa
1974	Combined	1978	Uawa
1975	Uawa	1979	Combined

1980	Hikurangi	1991	Waiapu
1981	Uawa	1992	Waiapu
1982	Ruatoria City	1993	Hikurangi
1983	Ruatoria City	1994	Waiapu
1984	Tawhiti	1995	Tokararangi
1985	Waiapu	1996	Hikurangi
1986	Combined	1997	Waiapu
1987	Waiapu		
1988	Waiapu		
1989	Uawa		
1990	Uawa		

Most championships:
Uawa 7

SENIOR CLUBS

Hick's Bay	Black and yellow
Hikurangi	Black and white
KK Combined	Red, white and blue
Ruatoria City	Black and gold
Ruatoria United	Green and black
Tawhiti	Red and black
Tokararangi	Red and black
Tokomaru United	Blue and white
TVC	Red and black
Uawa	Blue and white
Waiapu	Orange, black and white
Waima	Green and white

Hawke's Bay

Founded: 1884

Colours: Black and white

Main ground and capacity: McLean Park, Napier, 16,500

Record attendance: 26,500, Hawke's Bay v Wellington, 1967

Most appearances: N.W. Thimbleby, 1959-71, 158.

Most points: J.B. Cunningham, 1990-97, 951 (plus 209 for Central Vikings)

Most tries: B.A. Grenside, 1919-31, 74

NZ representatives (43): J.C. Ashworth, J.M. Blake, A.W. Bowman, C.J. Brownlie, J.L. Brownlie, M.J. Brownlie, S.G. Cockroft, W.R. Collins, A.E. Cooke, M.J.A. Cooper, T.G. Corkill, D. Dalton, W.L. Davis, M.G. Duncan, D.A. Evans, H.F. Frazer, B.D.M. Furlong, S.W. Gemmell, B.A. Grenside, N.J. Hewitt, G. Higginson, W.R. Irvine, E.S. Jackson, A. Kirkpatrick, J. McCormick, J.A. McNab, I.R. MacRae, H.K. Mataira, J.J. Mill, G. Nepia, J. Ormond, L. Paewai, S.T. Reid, P.J. Ryan, M.W. Shaw, E.R.G. Steere, R.L. Stuart, J.P. Swain, K.J. Taylor, N.W. Thimbleby, H. Tiopira, K.R. Tremain, R.N. Williams.

WINNERS OF THE NAPIER-HASTINGS CLUB CHAMPIONSHIP

1884 Napier	1912 Pirates	1940 Napier HSOB, Technical OB & MAC
1885 Union	1913 Pirates	1941 Havelock North
1886 Napier	1914 Pirates	1942-1944 no competition
1887 Napier	1915-1918 no competition	1945 Marist
1888 Union	1919 Hastings	1946 Pirates
1889 Napier	1920 Pirates	1947 Taradale
1890 Napier	1921 Hastings & Pirates	1948 Napier HSOB
1891 Union	1922 Hastings	1949 Hastings HSOB
1892 Ahuriri	1923 Hastings & Pirates	1950 Napier HSOB
1893 Ahuriri	1924 Hastings	1951 Napier HSOB & Hastings HSOB
1894 Hastings United	1925 Pirates	1952 Hastings HSOB
1895 Napier Rangers	1926 Hastings	1953 Technical OB
1896 Caledonians	1927 Pirates	1954 Hastings HSOB
1897 Clive	1928 Pirates	1955 Napier HSOB
1898 Te Aute	1929 Hastings	1956 MAC
1899 Clive	1930 Napier HSOB	1957 Technical OB
1900 Pirates	1931 Hastings	1958 Technical OB
1901 City	1932 Napier HSOB	1959 Hastings HSOB
1902 Ahuriri	1933 Napier HSOB	1960 Hastings HSOB
1903 Ahuriri	1934 Technical OB	1961 Hastings HSOB & Technical OB
1904 Scinde	1935 Celtic	1962 Marist
1905 Ahuriri	1936 Marist	1963 Marist
1906 Scinde	1937 Marist	1964 Napier HSOB
1907 Scinde	1938 MAC	1965 Napier HSOB
1908 Scinde	1939 Celtic, Hastings & MAC	1966 Napier HSOB
1909 Rovers		1967 MAC
1910 Havelock North		1968 Napier HSOB
1911 Pirates		

1969 Napier HSOB & Marist	1989 Napier Technical OB
1970 Napier HSOB	1990 NTOB
1971 Napier HSOB & Taradale	1991 Havelock North
1972 Taradale	1992 NTOB
1973 Taradale	1993 Taradale
1974 Taradale & Marist	1994 Clive
1975 Celtic won the Hastings competition; Taradale won the Napier competition	1995 Havelock North
	1996 Havelock North
	1997 Taradale
1976 Taradale	
1977 Taradale	*Most championships:*
1978 Celtic	Napier HSOB 15
1979 MAC	
1980 Hastings HSOB & Havelock North	
1981 Marist & Taradale	
1982 Tamatea	
1983 Taradale	
1984 Hastings HSOB	
1985 Marist, Celtic & Taradale	
1986 Marist	
1987 Marist	
1988 Celtic	

SENIOR CLUBS

Aotea	Green and gold
Central Hawke's Bay	Harlequins style including black, gold, emerald, scarlet and white
Clive	Royal blue and gold
Colenso Pirates	Black and white
Dannevirke Sports	Blue, black and white
Eskview	Blue
Flaxmere	Green and gold
Hastings Sports	Navy blue, green and white
Havelock North	Blue and black
MAC	Royal blue and white
Maraenui	Green, red and white
Napier OB Marist	Green, blue and white
Napier Technical	Red and white
Onga/Tiko	Blue
Otane	Blue and and white
Porangahau	Green and black
Rangitane	Maroon and gold
Tamatea	Red and black
Taradale	Maroon and white
Wairoa	Emerald green
YMP	Green and white

The 1968 Hawke's Bay team
Back row: N.R. Armstrong, D.G. Curtis, D.B. Smith, A. Meech, B. Albert, M.S. Reddy.
Third row: G.A. Condon, G.T. Wiig, H. Meech, R.S. Abel, R.L. Stuart, K.K. Crawford, J. Brownlie.
Second row: J.J. O'Connor (manager), P.D. Pratt, W.L. Davis, I.R. MacRae, M.G. Duncan, I.R. Bishop, P.R. Carney, I. Hay (masseur).
Front row: T.W. Johnson, W.S. Bramwell (chairman), K.R. Tremain (captain), C.M. Le Quesne (coach), B.D.M. Furlong, J.B. Buxton (assistant coach), N.W. Thimbleby.
In front: M.A. Thomas, J.P. Dougan, H.J. Paewai, G.I. Martin. **Absent:** D.R. Bone, K.A. Darlington.

Horowhenua-Kapiti

Founded: 1893. Amalgamated with Manawatu 1925-32; name changed to Horowhenua-Kapiti 1997

Colours: Red and white

Main ground and capacity: Park Domain, 12,000

Record attendance: 4,500, Jubilee Match, 1967

Most appearances: R.C. Puklowski, 1974-88, 137

Most points: C.W. Laursen, 1984-90, 440

Most tries: D.C. Laursen, 1980-92, 69

NZ Representatives (2): H. Jacob, J.F. Karam.

WINNERS OF THE HOROWHENUA CLUB CHAMPIONSHIP

1898 Levin	1922 Hui Mai	1946 Athletic	1976 Athletic
1899 Levin	1923 Hui Mai	1947 Foxton	1977 Levin
1900 Levin	1924 Levin	1948 Levin	Wanderers
1901 Otaki	Wanderers	Wanderers	1978 Paraparaumu
1902 Wanderers	1925 Levin	1949 Shannon	1979 Levin
1903 Wanderers	Wanderers	1950 Levin	Wanderers &
1904 Wanderers	1926 Levin	Wanderers	Rahui
1905 Wanderers	Wanderers	1951 Levin	1980 Levin
1906 Tainui	1927 Hui Mai	Wanderers	Wanderers
1907 Hui Mai	1928 Levin	1952 Rahui	1981 Shannon
1908 Hui Mai	Wanderers	1953 Rahui	1982 Levin
1909 Kia Toa	1929 Levin	1954 Rahui	Wanderers
1910 no competition	Wanderers	1955 Old Boys	1983 Levin
1911 Levin	1930 Otaki	1956 Rahui	Wanderers
Wanderers	1931 Levin	1957 Rahui	1984 Shannon
1912 Levin	Wanderers	1958 Rahui	1985 Athletic
Wanderers	1932 Punahau	1959 Foxton	1986 Foxton
1913 Hui Mai	1933 Punahau	1960 Levin	1987 Foxton and
1914 Levin	1934 Otaki	Wanderers	Paraparaumu
Wanderers	1935 no competition	1961 Foxton	1988 Foxton
1915 United	1936 Shannon	1962 Foxton	1989 Shannon
1916-1918	1937 Otaki	1963 Old Boys	1990 Shannon
no competition	1938 Shannon	1964 Old Boys	1991 Shannon
1919 Levin	1939 Kuku-Manakau	1965 Athletic	1992 Levin
Wanderers	1940 Foxton	1966 Athletic	Wanderers
1920 Levin	1941 Foxton	1967 Paraparaumu	1993 Levin
Wanderers	1942-1944	1968 Paraparaumu	Wanderers
1921 Levin	no competition	1969 Paraparaumu	1994 College Old
Wanderers	1945 Foxton	1970 Paraparaumu	Boys
		1971 Athletic	1995 Athletic
		1972 Athletic &	1996 Athletic
		Paraparaumu	1997 Paraparaumu
		1973 Athletic	
		1974 Athletic	*Most championships:*
		1975 Athletic	Levin Wanderers 23

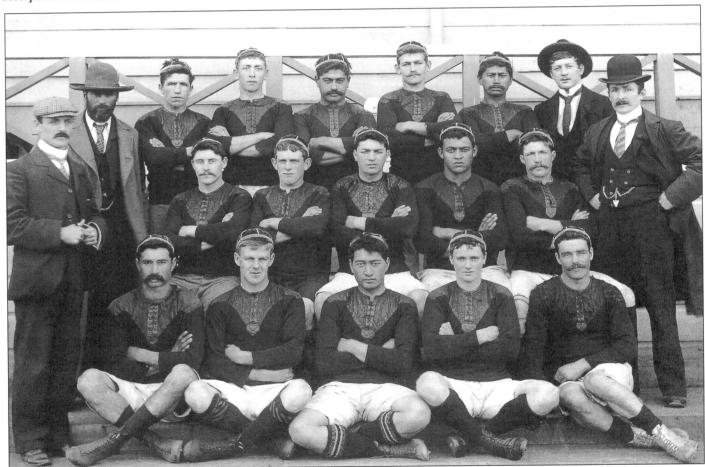

The 1901-02 Horowhenua team
Back row: Wineata (line umpire), J. Desmond, R. King, T. Parata, P. Anderson, R. Nicholls, E. Fuller.
Second row: J.G. Hankins (vice-president), C. Rogers, V. Hitchings, M. Wineata (captain), Whareo, R. White, J.G. Stevens (manager).
Front row: W. Bevan, B. Wallace, Pohio, A. Saxon, E. Hughes.

**WINNERS OF THE HOROWHENUA CLUB CHAMPIONSHIP
SENIOR CLUBS**

Athletic	Royal blue and black
College Old Boys	Light and dark blue
Foxton	Amber and black
Levin Wanderers	Black and white
Paekakariki	Green and black
Paraparaumu	Royal blue and gold
Rahui	Red and blue
Shannon	Maroon and white
Toa	Red and white
Waikanae	Red and black

King Country

Founded: 1922

Colours: Gold and maroon

Main ground and capacity: Taumarunui Domain, 12,000

Record attendance: 12,500, Wanganui-King Country v British Isles, 1977
Most appearances: P.H. Coffin, 1985-96, 142

Most points: H.C. Coffin, 1984-95, 917

Most tries: M.R. Kidd, 1974-84, 46

NZ representatives (8): K.G. Boroevich, R.F. Bryers, P.H. Coffin, C.E. Meads, S.T. Meads, J.K. McLean, W.J. Phillips, G.J. Whiting.

WINNERS OF THE KING COUNTRY CLUB CHAMPIONSHIP
Prior to 1976 the Hetet Shield was competed for by winners of sub-union championships

1976	Otorohanga & Waitete	1989	Waitete
1977	Taumarunui	1990	College Old Boys
1978	Waitete	1991	Waitete
1979	Pio Pio	1992	Waitete
1980	Waitete	1993	Otorohanga
1981	Waitete	1994	Otorohanga
1982	Manunui	1995	Otorohanga
1983	Pio Pio	1996	Waitete
1984	Waitete	1997	Waitete
1985	Waitete		
1986	Waitete	*Most championships:*	
1987	Waitete	Waitete 14	
1988	Waitete		

SENIOR CLUBS

Bush United	Black, red and white
Coast	Green and white
College OB Marist	Black, green and white
Huia	Red and white stripes
Kio Kio	Red and black
Manunui	Black and white
Ongarue	Royal blue, black and white
Otorohanga	Royal blue and gold
Piopio	Emerald green and gold
Rotoaira	Royal blue, black and white
Taumarunui	Red and black
Taupo	Black and white
Taupo United	Red and black
Tigers	Gold and black
Tihoi	Black, gold and maroon
Tongariro	Red and black
Waitomo	Green and black
Waitete	Royal blue and white

Manawatu

Founded: 1886 (amalgamated with Horowhenua 1925-32 and known as Manawhenua)

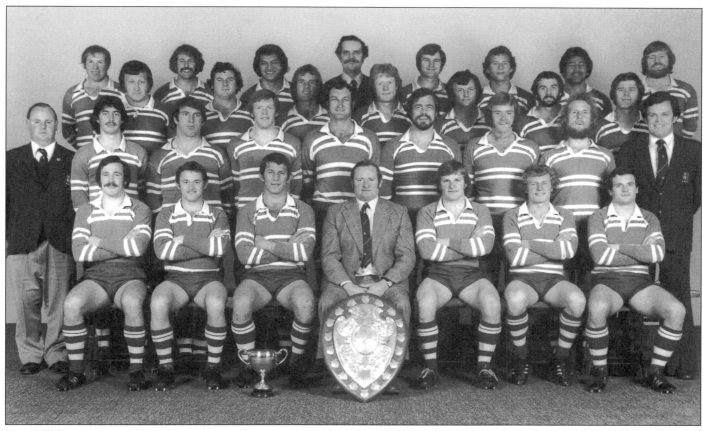

The 1977 Manawatu team
Back row: D.B. Clare, K.W. Granger, R.J. Brown, T.A. Boyens (masseur), M.C. Banks, P.W. Broederlow, B.S. Hemara, J.P. Carroll.
Third row: K.K. Lambert, K.G. Maharey, R.S. Hawkins, M.H. Wright, P.C. Harris, M.G. Watts, G.B. Pike.
Second row: R.J. Willan (manager), B.C. Morris, G.A. Knight, G.H. Old, J.A. Callesen, J.K. Loveday, W.B. Green, H.T. Blair, G.E. Hamer (coach).
Front row: T.J. Sole, A.C. Innes, K.A. Eveleigh (captain), W.D. Johnson (president), D.L. Rollerson, P.E. Cook, M.W. Donaldson.

Colours: Green and white

Main ground and capacity: Showgrounds Oval, 16,000

Record attendance: 24,996, Manawatu-Horowhenua v British Isles, 1959

Most appearances: 145, G.A. Knight, 1975-86

Most points: 641, J.J. Holland, 1991-96

Most tries: 66, K.W. Granger, 1971-84

NZ representatives (36): M.R. Allen, K.P. Bagley, R.E. Burgess, J.A. Callesen, L.M. Cameron, A.J. Carroll, S.G. Cockroft, C.M. Cullen, C.S. Davis, M.W. Donaldson, K.A. Eveleigh, B.E.L. Finlay, J. Finlay, M.C. Finlay, W.S.S. Freebairn, K.W. Granger, P.C. Harris, B.S. Hemara, R.H. Horsley, G.A. Knight, K.K. Lambert, A.D. Law, J.K. Loveday, R.M. McKenzie, A.F. McMinn, F.A. McMinn, J. Mowlem, M.W. O'Callaghan, G.H. Old, F.J. Oliver, D.L. Rollerson, K.J. Schuler, G. Shannon, M.W. Shaw, S.C. Strahan, C.D. Wickes.

WINNERS OF THE MANAWATU CLUB CHAMPIONSHIP

1886 Manchester	1920 Returned
1887 Palmerston	Services
North	Association
1888 Feilding	1921 Western United
1889 Feilding	1922 Feilding
1890 Feilding	1923 Woodville
1891 Feilding &	1924 Kia Toa
Palmerston	1925 Kia Toa
North	1926 Old Boys
1892 Palmerston	1927 Feilding
North	1928 Kia Toa
1893 Palmerston	1929 Old Boys
North	1930 Kia Toa
1894 Feilding	1931 Palmerston
1895 Feilding	North United
1896 Feilding	1932 Kia Toa
1897 Palmerston	1933 Feilding OB
North	1934 Old Boys
1898 Alambra	1935 Feilding OB
1899 Alambra	1936 Feilding OB
1900-1901	1937 Kia Toa
no competition	1938 Kia Toa
1902 Palmerston	1939 University
North Institute	1940 Old Boys
1903 Palmerston	1941 United
North Institute	1942-1944
1904 College Street	no competition
School OB	1945 Ohakea Air
1905 College Street	Force
School OB	1946 Old Boys
1906 College Street	1947 Old Boys
School OB	1948 Feilding & Old
1907 Feilding	Boys
1908 Feilding	1949 Old Boys
1909 Feilding	1950 University
1910 Kia Toa	1951 Feilding & Old
1911 Feilding	Boys
Athletic	1952 University
1912 Feilding	1953 Technical OB &
1913 Feilding	University
1914 Palmerston	1954 Kia Toa
North United	1955 Old Boys
1915-1917	1956 University
no competition	1957 Technical OB
1918 Western United	1958 University
1919 Western	1959 Old Boys
United, Pirates	1960 Technical OB
& Huia	1961 Technical OB &
(competition	University
not completed)	1962 Te Kawau

1963 Oroua	1982 University
1964 Oroua	1983 Queen
1965 Oroua	Elizabeth
1966 Oroua	College OB &
1967 Palmerston	Marist
North HSOB	1984 Feilding
1968 Oroua	1985 Queen
1969 Feilding	Elizabeth
1970 University A	College OB
1971 Freyberg OB	1986 Queen
1972 University A	Elizabeth
1973 Kia Toa,	College OB
University A &	1987 University
Freyberg OB	1988 University
1974 Kia Toa &	1989 Palmerston
Palmerston	North HSOB
North HSOB	1990 Queen
1975 University A	Elizabeth
1976 Queen	College OB
Elizabeth	1991 Queen
College OB	Elizabeth
1977 University A	College OB
1978 Queen	1992 Marist
Elizabeth	1993 Kia Toa
College OB &	1994 Feilding Old
Freyberg OB	Boys
1979 Queen	1995 Marist
Elizabeth	1996 Oroua
College OB	1997 Te Kawau
1980 Queen	
Elizabeth	*Most championships:*
College OB	Feilding 18
1981 University	

SENIOR CLUBS

Feilding	Amber and black
Feilding OB	White, red and black
Freyberg OB	Blue and gold
Kia Toa	Dark blue and light blue
Linton Army	Red and black
Marist	Green and white
Massey University	Light blue
Oroua	Royal blue, black and white
Palmerston North HSOB	Black and white
Queen Elizabeth College OB	White, yellow, maroon and black
Te Kawau	Green and black

Marlborough

Founded: 1888

Colour: Cardinal

Main ground and capacity: Lansdowne Park, Blenheim, 15,000

Record attendance: 13,200, Marlborough v Nelson Bays, 1973

Most appearances: R.S. Sutherland, 1958-74, 177

Most points: C.A.J. Forsyth, 1990-97, 696

Most tries: B.R. Ford, 1972-83, 81

NZ representatives (6): J.J. Best, P.H. Clarke, C.J. Fitzgerald, B.R. Ford, I.A. Hammond, A.R. Sutherland.

WINNERS OF THE MARLBOROUGH CLUB CHAMPIONSHIP

1888 Union	1947 Opawa
1889 Marlborough	1948 Central
1890 Marlborough	1949 Moutere
1891 Marlborough	1950 Central
1892 Union	1951 Central
1893 Marlborough	1952 Central
1894 Awarua	1953 Awatere
1895 Marlborough &	1954 Moutere
Awarua	1955 Moutere
1896 Marlborough	1956 Moutere
1897 Wairau	1957 Old Boys &
1898 Wairau	Waitohi
1899 Awarua	1958 Moutere
1900 Awarua	1959 Waitohi
1901 Awarua	1960 Moutere
1902 Awarua	1961 Old Boys
1903 Awarua	1962 Moutere
1904 Awarua	1963 Opawa
1905 Awarua	1964 Opawa
1906 Opawa	1965 Central
1907 Awatere	1966 Opawa
1908 Awatere	1967 Opawa
1909 Central	1968 Old Boys &
1910 Awatere	Air Force
1911 Awatere	1969 Opawa
1912 Central	1970 Moutere
1913 Opawa	1971 Old Boys
1914 Awatere	1972 Moutere
1915 Opawa	1973 Air Force
1916-1918	1974 Old Boys
no competition	1975 Old Boys
1919 Opawa	1976 Moutere
1920 Central	1977 Moutere &
1921 Moutere	Waitohi
1922 Moutere	1978 Old Boys
1923 Moutere	1979 Awatere
1924 Moutere	1980 Moutere
1925 Central	1981 Awatere
1926 Opawa	1982 Awatere
1927 Awatere	1983 Waitohi
1928 Opawa	1984 Redwood
1929 Moutere	1985 Kaikoura
1930 Moutere	1986 Redwood
1931 Moutere	1987 Waitohi
1932 Moutere	1988 Redwood
1933 Moutere	1989 Redwood
1934 Moutere	1990 Redwood
1935 Waitohi	1991 Redwood
1936 Opawa	1992 Waitohi &
1937 Opawa	Moutere
1938 Opawa	1993 Moutere
1939 Waitohi	1994 Waitohi
1940 Moutere	1995 Central
1941-42	1996 Harlequins
no competition	1997 Harlequins
1943 Woodbourne	
1944 Farnham	*Most championships:*
1945 Opawa	Moutere 25
1946 Waitohi	

SENIOR CLUBS

Awatere	Gold and green
Central	Light blue and black
Harlequins	Yellow, red, blue, green panels (formed from a merger between Old Boys, Opawa and Redwood)
Kaikoura	Blue and red
Moutere	Black and white
Pelorous	Royal blue and black
Renwick United	Green and white
Waitohi	Yellow and black

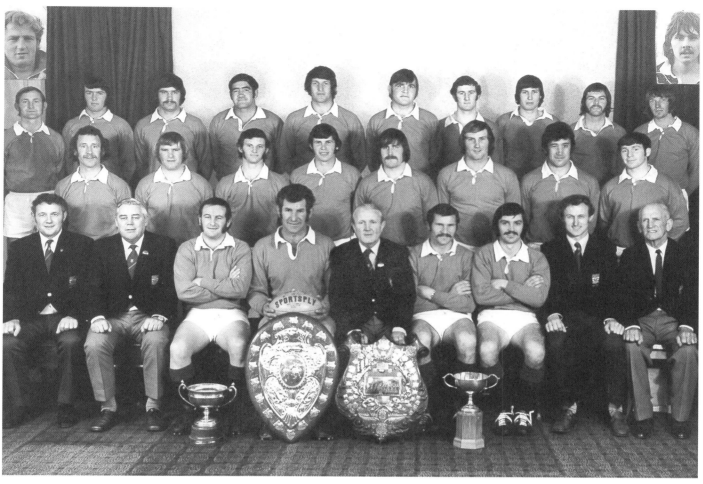

The 1973 Marlborough team
Back row: R.J. May, S.W.P. Marfell, D. Neal, J. Joseph, A.R. Sutherland, G.K. Cocks, B.P. Dwyer, B.R. Ford, J. Davie,
 M.W. Guillemot.
Second row: J.A. Thompson, R.E. Hegglun, K.G. Sutherland, M.F. McKee, P.J. Jeffs, M.J. Best, S.H. Huntley, T.W. Forrest.
Front row: D.J. Saul (co-selector), J.G. Fraser (manager), M.A. Goddard (vice-captain), R.S. Sutherland (captain), E.P. Dwyer (president),
 K.R. Hodges, D.D. Cassidy, R.W. Caulton (co-selector), W. Steele (masseur).
Inset: D.R. Hammond, C.M. Campbell.

Mid Canterbury

Founded: 1904 as Ashburton. Granted full union status in 1927 as Ashburton County and the name changed to Mid Canterbury in 1952

Colours: White, green and gold

Main ground and capacity: Ashburton Showgrounds, 10,000

Record attendance: 8,656, Mid Canterbury v British Isles, 1983

Most appearances: J.C. Ross, 1970-87, 158

Most points: A.H.A. Smith, 1955-68, 598

Most tries: G.R. Bryant, 1968-77, 47

NZ representatives (3): D.H. Cameron, R.G. Perry, J.C. Ross.

WINNERS OF THE MID CANTERBURY CLUB CHAMPIONSHIP

1927	Hampstead	1949	Rakaia
1928	Old Boys	1950	Celtic
1929	Old Boys	1951	Rakaia
1930	Methven	1952	Rakaia
1931	Rakaia	1953	Methven
1932	Mayfield	1954	Rakaia
1933	Methven	1955	Rakaia
1934	Rakaia	1956	Methven
1935	Methven	1957	Celtic &
1936	Methven		Technical
1937	Methven	1958	Allenton &
1938	Old Boys		Hampstead
1939	Old Boys	1959	Rakaia
1940	Old Boys	1960	Allenton
1941	Rakaia	1961	Allenton & Old
1942-1945			Boys
	no competition	1962	Celtic &
1946	Methven		Methven
1947	Allenton	1963	Rakaia
1948	Celtic	1964	Old Boys

1965	Old Boys	1983	Mayfield &
1966	Methven & Old		Methven
	Boys	1984	Tinwald
1967	Methven	1985	Tinwald
1968	Methven	1986	Tinwald
1969	Methven	1987	Tinwald
1970	Hinds	1988	Celtic
1971	Celtic	1989	Allenton
1972	Celtic	1990	Tinwald
1973	Technical	1991	Celtic
1974	Allenton	1992	Allenton
1975	Allenton	1993	Allenton
1976	Rakaia	1994	Tinwald
1977	Rakaia	1995	Collegiate
1978	Rakaia	1996	Allenton
1979	Mayfield &	1997	Celtic
	Rakaia		
1980	Allenton	*Most championships:*	
1981	Methven	Methven 14	
1982	Mayfield		

SENIOR CLUBS

Allenton	Maroon and gold
Celtic	Green
Collegiate	Red, yellow and black
Hampstead	Blue and yellow
Methven	Black and white
Southern	Blue and white
Tinwald	Orange and black

Nelson Bays

Founded: 1969, through a merger of Nelson (1885) and Golden Bay-Motueka (1920)

Colours: Royal blue and white

Main ground and capacity: Trafalgar Park, Nelson, 15,000

Record attendance: 10,200, Nelson v Marlborough, 1954

Most appearances: W.A.B. Dempster, 1979-92, 123

Most points: S.N. Dayman, 1980-89, 408

Most tries: W.A.B. Dempster, 1979-92, 25

NZ representatives (1): T.J. Morris.

Nelson (5): G. Harper, D.S. Max, W.E. Smith, W.F. Snodgrass, E.M. Snow.

WINNERS OF THE NELSON BAYS CLUB CHAMPIONSHIP

1970	Waimea OB	1988	Huia & Waimea Old Boys
1971	Rival		
1972	Takaka	1989	Waimea Old Boys
1973	Takaka		
1974	Waimea OB	1990	Waimea Old Boys
1975	Nelson		
1976	Rival	1991	Stoke
1977	Waimea OB	1992	Stoke
1978	Waimea OB	1993	Riwaka
1979	Nelson	1994	Nelson
1980	Celtic	1995	Waimea Old Boys
1981	Nelson		
1982	Stoke	1996	Stoke
1983	Nelson	1997	Stoke
1984	Stoke		
1985	Waimea OB	*Most championships:*	
1986	Stoke	Waimea Old Boys 9	
1987	Stoke		

SENIOR CLUBS

Huia	Green and white
Marist	
(formerly Celtic)	Black and green
Nelson	Dark blue and white
Riwaka	Dark blue and white
Stoke	Scarlet and white
Takaka	Scarlet and royal blue
Waimea Old Boys	Red and white
Wanderers	Blue and yellow

North Harbour

Founded: 1985

Colours: White, black and cardinal

Main ground and capacity: North Harbour Stadium, 25,000

Record attendance: 14,500, North Harbour v Australia, 1990; North Harbour v Auckland, 1994 (Onewa Domain, Takapuna)

Most appearances: R.O. Williams, 1985-94, 145

Most points: W.J. Burton, 1990-96, 1052

Most tries: R.M. Kapa, 1985-93, 63

The 1988 North Harbour team
Back row: Ron Williams, Alan Pollock, Nigel Blake, Mike Te Paa, Daryl Williams, Michael Speight, Paul Leonard, Russell Jones.
Third row: Rob Hartley, Mark Finlay, Teina Clarke, Dave Thomas, Scott Pierce, Graham Dowd, Paul Carlton, Ian Patterson (coaching co-ordinator).
Second row: David Abercrombie (physiotherapist), Paul Feeney, Ian Wood, Graham McKean, Stephen Bendall, Tony Vandermade, Paul McGahan, Clive Kelly (gear manager).
Front row: Peter Thorburn (coach), Mark Anscombe, John Patterson (manager), Frano Botica, Wayne Shelford (captain), Richard Kapa, Peter Dolan (assistant manager), Walter Little, Peter Lamont (assistant coach).
Absent: Stephen Bird, Kevin Boroevich, Gary Brunsdon, Simon Clavis, Glen Curran, Paul Terekia, Jim Thomson.

NZ representatives (16): L.J. Barry, F.M. Botica, F.E. Bunce, G.W. Dowd, I.D. Jones, B.P. Larsen, W.K. Little, P.W. McGahan, G.M. Osborne, M.D. Robinson, E.J. Rush, K.J. Schuler, W.T. Shelford, A.D. Strachan, R.S. Turner, R.O. Williams.

WINNERS OF THE NORTH HARBOUR CLUB CHAMPIONSHIP

1985	East Coast Bays	1993	Massey
1986	East Coast Bays	1994	Takapuna
1987	North Shore	1995	Takapuna
1988	North Shore	1996	Takapuna
1989	Northcote	1997	Takapuna
1990	Northcote		
1991	East Coast Bays	*Most championships:*	
1992	North Shore	Takapuna 4	

SENIOR CLUBS

East Coast Bays	Green and black
Glenfield	Red, white and black
Helensville	Red, black and gold
Kumeu	Green, black and white
Mahurangi	Blue and white
Marist	
North Harbour	Dark blue, light blue and red
Massey	White, blue, red and yellow
Northcote-Birkenhead	Maroon and gold
North Shore	Green and white
Navy	Navy blue and white
Silverdale United	Green and gold
Takapuna	Blue and gold

North Otago

Founded: 1904

Colour: Old gold

Main ground and capacity: Centennial Park, Oamaru, 7000

Record attendance: no record

Most appearances: P.R. White, 1974-84, 94

Most points: P.M. Ford, 1964-74, 429

Most tries: P.M. Ford, 1964-74; R.J.Skinner, 1991-97; 22

NZ representatives (2): P.C. Gard, I.S.T. Smith.

WINNERS OF THE NORTH OTAGO CLUB CHAMPIONSHIP
Results prior to 1971 not available

1971	Athletic	1974	Union
1972	Union	1975	Union
1973	Old Boys	1976	Kurow

1977	Kurow	1989	Maheno
1978	Athletic	1990	Maheno
1979	Union	1991	Old Boys
1980	Kurow	1992	Excelsior
1981	Union	1993	Athletic
1982	Kurow	1994	Athletic
1983	Union	1995	Excelsior
1984	Maheno	1996	Athletic
1985	Old Boys	1997	Excelsior
1986	Old Boys		
1987	Excelsior	*Most championships:*	
1988	Excelsior	Union 6	

SENIOR CLUBS

Athletic	Maroon and gold
Excelsior	Blue, black and maroon
Kurow	Scarlet and blue
Maheno	Green and black
Old Boys	Black
Valley (formerly Union)	Lemon and blue

Northland

Founded: 1920 (as North Auckland; name changed 1994)

Colours: Cambridge blue

Main ground and capacity: Lowe Walker Stadium (formerly Okara Park), Whangarei, 40,000

Record attendance: 40,000, North Auckland v Auckland, 1972

Most appearances: J.E. Morgan, 1967-81, 165

Most points: W.B. Johnston, 1986-97, 1671

Most tries: N.R. Berryman, 1991-97, 63

NZ representatives (28): M.M. Burgoyne, N.P. Cherrington, E.J. Dunn, I.T.W. Dunn, I. Finlayson, C.J.C. Fletcher, K.T. Going, S.M. Going, R.A. Guy, W.R. Heke (played as W. Rika), B. Holmes, I.B. Irvine, I.D. Jones, M.G. Jones, P.F.H. Jones, H.H. Macdonald, J.E. Morgan, W.R. Neville, A.G. Robinson, P.H. Sloane, J.B. Smith, P. Smith, G.L. Taylor, A.C. Waterman, D.S. Webb, F.A. Woodman, T.B.K. Woodman, V.M. Yates.

WINNERS OF THE NORTHLAND SUB-UNION CHAMPIONSHIP (Harding Shield)

1914	Northern Wairoa	1925	Whangarei
1915-1918	no competition	1926	Northern Wairoa
1919	Whangarei	1927	Whangarei
1920	Whangarei	1928	Whangarei
1921	Whangarei	1929	Whangarei
1922	Whangarei	1930	Mangonui
1923	Whangarei	1931	Whangarei
1924	Whangarei	1932	Hokianga

1933	Whangarei	1969	Whangarei
1934	Otamatea	1970	Mangonui
1935	Whangarei	1971	Whangarei
1936	Northern Wairoa	1972	Whangarei
1937	Northern Wairoa	1973	Bay of Islands
1938	Mangonui	1974	Whangarei
1939	Mangonui	1975	Whangarei
1940-1945	no competition	1976	Bay of Islands & Rodney
1946	Bay of Islands	1977	Whangarei
1947	Bay of Islands	1978	Rodney & Whangarei
1948	Bay of Islands	1979	Whangarei
1949	Bay of Islands	1980	Whangarei
1950	Bay of Islands	1981	Whangarei
1951	Bay of Islands	1982	Whangarei
1952	Whangarei & Mangonui	1983	Whangarei
1953	Mangonui	1984	Rodney
1954	Northern Wairoa	1985	Bay of Islands
1955	Northern Wairoa	1986	Whangarei
1956	Northern Wairoa		
1957	Mangonui	*Most championships:*	
1958	Mangonui	Whangarei 35	
1959	Mangonui		
1960	Whangarei	**WINNERS OF THE NORTHLAND-WIDE CLUB CHAMPIONSHIP**	
1961	Whangarei		
1962	Whangarei		
1963	Whangarei	1987	Hikurangi
1964	Rodney	1988	Hikurangi
1965	Northern Wairoa, Bay of Islands, Otamatea, Hokianga, Mangonui & Whangarei	1989	Otamatea
		1990	Otamatea Hora Hora
		1991	Otamatea
		1992	Hikurangi
		1993	Hikurangi
		1994	Kamo
1966	Whangarei	1995	Hikurangi
1967	Whangarei	1996	Hikurangi
1968	Whangarei	1997	Hikurangi

Most championships:
Hikurangi 7

SENIOR CLUBS

Aupouri	Red and black
Awanui	Black and white
City	Blue and white
Eastern United	Green and gold
Hikurangi	Red and black
Hora Hora	Maroon and gold
Kaeo	Blue and gold
Kaikohe	Maroon and blue
Kaitaia Pirates	Red, white and blue
Kamo	Black and white
Kerikeri	Red, white and blue
Manaia	Scarlet and blue
Marist	Green and blue
Mid Northern	Red and blue
Mid Western	Green and yellow
Moerewa	Black and white
Motukohu	Blue and white
Okaihau	Red and black
Old Boys	Black, yellow and blue
Onerahi	Yellow and blue
Otamatea	Green and white
Otiria	Blue and white
Panguru	Black and white
Rawene	Blue and black
Rodney Districts	Navy blue
Ruawai	Black
Southern	Red and black
Tikipunga	Orange and brown
United-Kawakawa	Green, black and yellow
Waima	Black and white
Waipu	Gold and black
Waitangi	Black and gold
Wellsford	Black
Whirinaki	Red and black

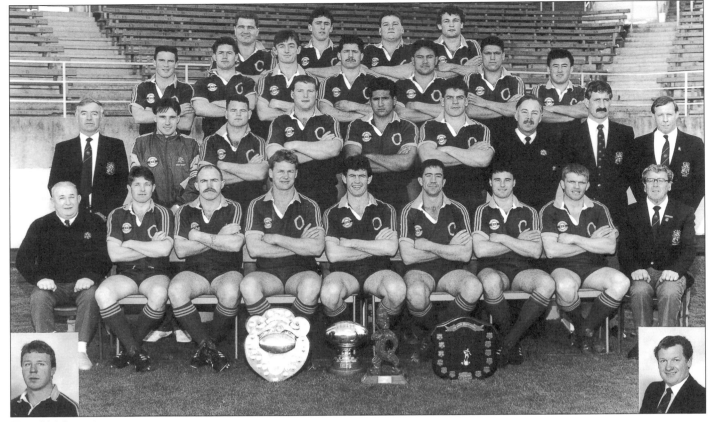

The 1991 Otago team
Back row: Brent Pope, John Leslie, Rod Blew, Stephen Cottrell.
Third row: Brett McCormack, Marc Ellis, Paul Henderson, Arthur Stone, John Timu, Paul Cooke, Stu Forster.
Second row: Laurie Mains (coach), Rick Laing (physiotherapist), Steve Cumberland, Andrew Rich, Jamie Joseph, Arran Pene, John Greave (doctor), Gordon Hunter (assistant coach), Gerard Simmons (manager).
Front row: Lex Cunningham (baggage man), John Haggart, Steve Hotton, Gordon Macpherson, Mike Brewer (captain), Richard Knight, Greg Cooper, David Latta, Bill Trevathan (president).
Inset: Andrew Roose, Don Cameron (masseur).

Otago

Founded: 1881

Colours: Blue and gold

Main ground and capacity: Carisbrook, Dunedin, 43,000

Record attendance: 43,500, New Zealand v British Isles, 1959

Most appearances: R.J. Knight, 1981-92, 170

Most points: G.J.L. Cooper, 1984-96, 1520

Most tries: P.J. Cooke, 1990-96, 73

NZ representatives (137): J. Allan, W.R.

Archer, A.M. Armit, S.J. Bachop, J.A.S. Baird, R.C. Bell, R.H. Bell, R. Bennett, T. Berghan, R.S. Black, K.C. Bloxham, E.E. Booth, I.J. Botting, H.Y. Braddon, N.M. Bradanovich, M.R. Brewer, J.R. Burt, R.G. Bush, P.S. deQ. Cabot, S.T. Casey, D.W. Clark, L.A. Clark, G.L. Colling, R.J. Conway, G.J.L. Cooper, J.E. Cuthill, R.A. Dalton, W.A. Davies, E.S. Diack, G.R. Dickinson, D.M. Dickson, J.B. Douglas, J. Duncan, W.D. Duncan, A.G. Eckhold, M.C.G. Ellis, R.R. Elvidge, W.R. Fea, S.T. Forster, W.D. Gillespie, C.C. Gillies, C.M. Gilray, F.J. Given, J.B. Graham, W.G. Graham, J.S. Haig, L.S. Haig, W.A. Harris, L.R. Harvey, P.W. Henderson, A.W. Holden, J. Hore, B.A. Hunter, J.G. Irvine, M.W. Irwin, F.E.B. Ivimey, J.L. Jaffray, M.W.R. Jaffray, W. Johnstone, P. Johnstone, J.W. Joseph, J.C. Kearney, D.J. Kenny, D.E. Kirk, E.W. Kirton, A.J. Kreft, J.A. Kronfeld, C.R. Laidlaw, H.J. Levien, D.F. Lindsay, W.A. Lunn, F.S. McAtamney, W.G. McClymont, A. McDonald, D.T.M. McMeeking, J.R. McNab, D.G. Macpherson, G. Macpherson, L.W. Mains, J.D. Matheson, R.G. Mathieson, W.A. Meates, N.A. Mitchell, G.J.T. Moore, H.D. Morgan, T.G. Morrison, H.G. Munro, K. Murdoch, K.A. Nelson, J. O'Donnell, A.D. Oliver, F.J. Oliver, O.D. Oliver, R.W. Orr, A.A. Parkhill, H. Paton, A.M. Paterson, A.R.B. Pene, A. Perry, H.G. Porteous, A.C. Procter, N.A. Purvis, C.E. Quaid, T.C. Randell, J. Richardson, D.J. Robertson, G.S. Robertson, H.P. Sapsford, G.A. Seear, H.J. Simon, G.S. Sims, R.G.B. Sinclair, K.L. Skinner, C.H. Smith, I.S.T. Smith, W.T.C. Sonntag, R.Souter, J. Stalker, D.R.L. Stevenson,

E.B. Stewart, J.G. Taiaroa, J.M. Taylor, J.K.R. Timu, L.J. Townsend, D. Trevathan, J.S. Turnbull, F.H. Vorrath, F.G. Ward, J.M. Watt, A.L. Williams, P. Williams, C. Willocks, B.W. Wilson, H.W. Wilson, J.W. Wilson, N.L. Wilson, G.D. Wise.

WINNERS OF THE DUNEDIN CLUB CHAMPIONSHIP

1885 Dunedin	1910 Alhambra
1886 Pirates	1911 University
1887 Union	1912 Southern
1888 Kaikorai	1913 Zingari-Richmond
1889 Kaikorai	
1890 Union	1914 Kaikorai
1891 Alhambra	1915 Southern
1892 Alhambra	1916 Union
1893 Kaikorai	1917 University
1894 Kaikorai	1918 Pirates
1895 Kaikorai	1919 University
1896 Kaikorai	1920 Alhambra
1897 Kaikorai	1921 Kaikorai
1898 Kaikorai	1922 University
1899 Kaikorai	1923 University
1900 Alhambra	1924 University
1901 Kaikorai	1925 Pirates
1902 Alhambra	1926 University
1903 Alhambra	1927 University
1904 Southern	1928 University
1905 Alhambra	1929 University
1906 University	1930 Alhambra
1907 University	1931 University
1908 Dunedin	1932 University
1909 Alhambra	1933 University

1934	University	1969	Southern
1935	Southern	1970	University
1936	Southern	1971	University
1937	Southern	1972	Southern
1938	Southern	1973	Green Island
1939	Union	1974	Green Island
1940-1945		1975	Southern
	no competition	1976	University
1946	University	1977	Southern
1947	Southern	1978	Green Island
1948	Pirates	1979	University
1949	University	1980	Southern
1950	Pirates	1981	Southern
1951	Dunedin	1982	Southern
1952	Pirates	1983	University A
1953	University	1984	University A &
1954	University		Southern
1955	University &	1985	Southern &
	Taieri		University A
1956	University	1986	Dunedin
1957	University	1987	University A
1958	University &	1988	University A
	Southern	1989	Southern
1959	Zingari-	1990	Dunedin
	Richmond	1991	University A
1960	Southern	1992	University A
1961	Zingari-	1993	University A
	Richmond	1994	University A
1962	University	1995	Dunedin
1963	Zingari-	1996	Dunedin
	Richmond	1997	Kaikorai
1964	University		
1965	University	*Most championships:*	
1966	University	University A 41	
1967	University		
1968	Zingari-		
	Richmond		

SENIOR CLUBS

Alhambra-Union	Maroon and gold
Dunedin	Blue and gold
Eastern	Green and gold
Green Island	Green and gold
Harbour	Red, white and blue
Kaikorai	Blue, black and white
Otago University	Light blue and gold
Pirates	Black
Southern	Black and white
Zingari-Richmond	Black, scarlet and gold

Poverty Bay

Founded: 1890

Colours: Scarlet

Main ground and capacity: Rugby Park, Gisborne, 18,000

Record attendance: 15,000, Poverty Bay-East Coast v British Isles, 1971

Most appearances: R.A. Newlands, 1972-85, 131

Most points: R.P. Owen, 1983-90, 464

Most tries: P.S.R. Ransley, 1961-74, 35

NZ representatives (6): J.L. Collins, B.B.J. Fitzpatrick, I.A. Kirkpatrick, L.G. Knight, R.M. Parkinson, R.A. White.

WINNERS OF THE POVERTY BAY CLUB CHAMPIONSHIP

1890	Gisborne	1943	no competition
1891	Gisborne	1944	Air Force Camp
1892	Turanganui	1945	Gisborne HSOB
1893	Turanganui	1946	Marist
1894	Gisborne	1947	Gisborne OB
1895	Turanganui	1948	Gisborne OB
1896	Turanganui	1949	Gisborne HSOB
1897	Te Rau-	1950	Gisborne HSOB
	Wanderers		A
1898	Gisborne	1951	Gisborne OB
1899	Turanganui	1952	Gisborne HSOB
1900	Gisborne	1953	Gisborne OB
1901	West End	1954	Gisborne OB
1902	West End	1955	Gisborne OB
1903	Huia	1956	Gisborne HSOB
1904	West End	1957	Gisborne HSOB
1905	Kaiti-City	1958	Gisborne OB
1906	West End	1959	Marist
1907	West End,	1960	Gisborne Maori
	Kaiti-City &		Club
	Takitimu	1961	Marist
1908	Kaiti-City	1962	Marist
1909	Kaiti-City	1963	Marist
1910	Kaiti-City	1964	Gisborne HSOB
1911	Gisborne	1965	Marist
	United	1966	Gisborne HSOB
1912	Kaiti-City	1967	Gisborne HSOB
1913	Gisborne	1968	Marist
	United	1969	Ngatapa
1914	Kaiti-City	1970	Gisborne HSOB
1915	abandoned	1971	Gisborne OB
1916	no competition	1972	Gisborne HSOB
1917	Kaiti-City	1973	Ngatapa
1918	Young Maori	1974	Ngatapa
	Party	1975	Gisborne OB
1919	Rowing Club	1976	Marist
1920	Gisborne	1977	Gisborne OB
	United	1978	Gisborne OB
1921	Young Maori	1979	Gisborne OB
	Party	1980	Gisborne OB
1922	Kaiti-City	1981	Gisborne OB
1923	Young Maori	1982	Gisborne Maori
	Party		Club
1924	Gisborne OB	1983	Ngatapa
1925	Gisborne OB	1984	Marist
1926	Celtic	1985	Gisborne Maori
1927	Gisborne OB		Club
1928	Gisborne OB	1986	Young Maori
1929	Young Maori		Party
	Party	1987	YMP
1930	Young Maori	1988	Old Boys
	Party	1989	Old Boys
1931	Gisborne OB		Marist
1932	Young Maori	1990	Old Boys
	Party	1991	YMP
1933	Celtic	1992	YMP
1934	Celtic	1993	YMP
1935	Celtic	1994	GMC
1936	Gisborne OB	1995	Horouta
1937	Gisborne HSOB	1996	YMP
	& Celtic	1997	Old Boys-
1938	Gisborne HSOB		Marist
	& Celtic		(amalgamated)
1939	Marist		
1940	Marist	*Most championships:*	
1941	Gisborne OB	Old Boys 24	
1942	Air Force A		

SENIOR CLUBS

Gisborne Maori Club	
(GMC)	Green and white
High School OB	Blue and white
Horouta	Gold and green
Mahia	Burgundy and white
Ngatapa	Green
Nuhaka	Royal blue and white
Old Boys-Marist	Red, blue and white
Pirates	Maroon
Rangatira	Navy
Tahora	Teal and black
Matawai	Navy and white
Whatatutu	Black
Young Maori Party	
(YMP)	Black and white

South Canterbury

Founded: 1888

Colours: Green and black

Main ground and capacity: Alpine Energy Stadium (formerly Fraser Park), Timaru, 17,000

Record attendance: 17,000, South Canterbury v France, 1961

Most appearances: S.B. Tarrant, 1984-97, 129

Most points: B.F. Fairbrother, 1981-92, 1048

Most tries: S.J. Todd, 1986-97, 48

NZ representatives (21): G.T. Adkins, A.E. Budd, E.A.P. Cockroft, T.D. Coughlan, J.H. Gardner, J.W. Goddard, M.P. Goddard, L.A. Grant, J.L. Jaffray, G.P. Lawson, T.N. Lister, T.W. Lynch, C.N. McIntosh, T.C. Morrison, C.K. Saxton, A.P. Spillane, A.J. Stewart, D. Stewart, R.T. Stewart, P.W. Storey, W.A. Strang.

WINNERS OF THE SOUTH CANTERBURY CLUB CHAMPIONSHIP

1911	Celtic	1928	Old Boys
1912	Zingari	1929	Star
1913	Celtic	1930	Old Boys
1914	Zingari	1931	Star
1915	Temuka	1932	Star
1916	no competition	1933	Star
1917	Geraldine	1934	Star
1918	Star	1935	Star
1919	Temuka	1936	Star
1920	Temuka	1937	Temuka
1921	Zingari	1938	Temuka
1922	Old Boys	1939	Temuka
1923	Zingari	1940	Temuka
1924	Old Boys	1941	Celtic
1925	Old Boys	1942	Army A
1926	Zingari	1943	no competition
1927	Old Boys	1944	Makikihi

1945	Temuka	1974	Old Boys
1946	Temuka	1975	Old Boys
1947	Old Boys	1976	Old Boys &
1948	Celtic		Temuka
1949	Geraldine	1977	Temuka
1950	Zingari	1978	Temuka
1951	Zingari	1979	Old Boys &
1952	Celtic		Temuka
1953	Celtic	1980	Temuka
1954	Zingari	1981	Temuka
1955	Celtic	1982	Temuka
1956	Temuka	1983	Old Boys
1957	Celtic	1984	Temuka
1958	Waimate	1985	Temuka
1959	Geraldine	1986	Temuka
1960	Waimate	1987	Star
1961	Zingari	1988	Star
1962	Old Boys	1989	Star
1963	Old Boys	1990	Waimate
1964	Temuka	1991	Temuka
1965	Temuka	1992	Temuka
1966	Temuka	1993	Temuka
1967	Temuka	1994	Waimate
1968	Temuka	1995	Waimate
1969	Zingari	1996	Temuka
1970	Zingari	1997	Temuka
1971	Old Boys		
1972	Star	*Most championships:*	
1973	Zingari	Temuka 30	

SENIOR CLUBS

Celtic	Emerald green
Geraldine	Black and red
Mackenzie	Gold and black
Old Boys	Royal blue
Pareora	Red and white
Pleasant Point	Maroon
Star	Blue and black
Temuka	Black and white
Waimate	Sky blue, white and red
Zingari	Black, yellow and red

Southland

Founded: 1887

Colours: Maroon, blue and white

Main ground and capacity: Homestead Stadium (formerly Rugby Park), Invercargill, 14,000

Record attendance: 23,500, Southland v France, 1961

Most appearances: G.H. Dermody, 1965-77, 121

Most points: S.D. Culhane, 1988-97, 942

Most tries: B.W. Pascoe, 1983-89, 46

NZ representatives (52): G.T. Alley, J.A. Archer, W.R. Archer, D.L. Ashby, D.L. Baird, R.J. Barber, J.R. Bell, T.A. Budd, G.F. Burgess, L.S. Connolly, S.D. Culhane, J.H. Geddes, V.L. George, F.T. Glasgow, D.C. Hamilton, E.J. Hazlett, W.E. Hazlett, P.W. Henderson, N.J. Hewitt, J. Howden, E. Hughes, J.P.leG. Jacob, K.F. Laidlaw, W.G. Lindsay, W.A. McCaw, A.A. McGregor, B.J. McKechnie, J. McNeece, J.A. McRae, N. McRobie, T.C. Metcalfe, N.A. Mitchell, F.J. Oliver, S.T. Pokere, C.A. Purdue, E. Purdue, G.B. Purdue, J. Richardson, A.J. Ridland, C.E. Robinson, L.M. Rutledge, A.J. Soper, J.W. Stead, K.W. Stewart, G.T. Valli, R.H. Ward, J.R. Watt, T.R.D. Webster, A.W. Wesney, A. White, A. Wilson, C.A. Woods.

WINNERS OF THE INVERCARGILL CLUB CHAMPIONSHIP

1908	Star	1956	Bluff
1909	Winton	1957	Marist
1910	Waikiwi	1958	Invercargill
1911	Invercargill	1959	Bluff
1912	Invercargill	1960	Pirates
1913	Star	1961	Old Boys
1914	Star	1962	Pirates
1915-1917		1963	Pirates
	no competition	1964	Invercargill
1918	Athletic	1965	Collegiate
1919	Star	1966	Star
1920	Star	1967	Invercargill &
1921	Star		Star
1922	Star	1968	Old Boys
1923	Star	1969	Star
1924	Star	1970	Invercargill
1925	Star	1971	Invercargill
1926	Star	1972	Star
1927	Pirates	1973	Star
1928	Star	1974	Invercargill
1929	Pirates	1975	Invercargill
1930	Invercargill	1976	Pirates
1931	Invercargill	1977	Invercargill
1932	Pirates	1978	Tokanui
1933	Pirates	1979	Marist
1934	Old Boys	1980	Star
1935	Pirates	1981	Invercargill
1936	Invercargill	1982	Invercargill
1937	Invercargill	1983	Invercargill
1938	Pirates	1984	Pirates
1939	Invercargill	1985	Star
1940	Marist	1986	Star
1941-1944		1987	Invercargill
	no competition	1988	Invercargill
1945	Invercargill &	1989	Invercargill
	Old Boys	1990	Invercargill
1946	Invercargill	1991	Invercargill
1947	Invercargill	1992	Invercargill
1948	Marist	1993	Invercargill
1949	Pirates	1994	Invercargill
1950	Bluff	1995	Albion
1951	Star	1996	Woodlands
1952	Bluff	1997	Wyndham
1953	Collegiate		
1954	Bluff	*Most championships:*	
1955	Bluff	Invercargill 29	

SENIOR CLUBS

Albion	Black, red and gold
Invercargill	Blue and black
Mataura	Maroon and gold
Midlands	White, red and black
Old Boys	Red, white and blue
Star	Navy and white
Waikaka	Green and white
Woodlands	Navy and red
Wyndham	Blue and white

Taranaki

Founded: 1885

Colours: Amber and black

Main ground and capacity: Rugby Park, New Plymouth, 40,000

Record attendance: 37,100, Taranaki v South Africa, 1965

Most appearances: I.M. Eliason, 1964-81, 222

Most points: K.J. Crowley, 1980-94, 1723

Most tries: K.J. Crowley, 1980-94, 64

NZ representatives (69): J.L. Abbott, L. Allen, M.R. Allen, A. Bayly, W. Bayly, G.E. Beatty, R.J. Boon, N.J.G. Bowden, K.C. Briscoe, C. Brown, H.W. Brown, R.H. Brown, P.S. Burke, M.J. Cain, D. Cameron, R.L. Clarke, M.S. Cockerill, A.H. Collins, J.T.H. Colman, K.J. Crowley, W.D.R. Currey, H. Dewar, I.M. Eliason, R. Fogarty, A.J. Gardiner, F.T. Glasgow, W.S. Glenn, A. Good, H.M. Good, A.H. Hart, P.H. Hickey, D.J. Hughes, A.L. Humphries, J. Hunter, D. Johnston, C.N. Kingstone, A.L. Kivell, J.T. Lambie, D.S. Loveridge, G. Loveridge, J.F. McCullough, J.T. McEldowney, J. Major, F.H. Masters, H.P. Mills, G.N.K. Mourie, B.L. Muller, H.J. Mynott, B.C. O'Dowda, J.M. O'Sullivan, T.P.A. O'Sullivan, R.W. Roberts, B.G. Robins, R.A. Roper, A.I. Scown, G.L. Slater, A.E. Smith, L. Stohr, J.L. Sullivan, R. Taylor, R.J. Urbahn, J. Walter, P.E. Ward, D. Watson, M.G. Watts, W.J.G. Wells, A.H. West, M.C. Wills, T.N. Wolfe.

WINNERS OF THE TARANAKI CLUB CHAMPIONSHIP

1889	Monganui	1911	Okaiawa
1890	Clifton	1912	Waimate
1891	Clifton	1913	Waimate
1892	Star	1914	Waimate
1893	Waimate	1915	Hawera
1894	Waimate	1916	Hawera
1895	Waimate	1917-1918	
1896	no competition		no competition
1897	Tukapa	1919	Hawera
1898-1899		1920	Hawera
	no competition	1921	Hawera
1900	Hawera	1922	Tukapa
1901	no competition	1923	Clifton
1902	Tukapa	1924	Hawera
1903	Star	1925	Stratford
1904	Tukapa	1926	Tukapa
1905	Hawera	1927	Stratford
1906	Stratford	1928	Stratford
1907	Stratford	1929	Opunake
1908	Waimate	1930	New Plymouth
1909	Waimate		HSOB
1910	Waimate	1931	Stratford

1932	Okaiawa	1967	Stratford
1933	Waimate	1968	Tukapa
1934	Patea	1969	Tukapa
1935	Stratford	1970	Inglewood
1936	Tukapa	1971	Stratford
1937	Stratford	1972	Clifton
1938	Okaiawa	1973	Clifton
1939	Tukapa	1974	Clifton
1940	Inglewood	1975	Okato
1941-1944		1976	Clifton
	no competition	1977	Okato
1945	Eltham	1978	Inglewood
1946	New Plymouth	1979	Inglewood
	HSOB	1980	Clifton
1947	Star	1981	Inglewood
1948	Star	1982	Hawera
1949	Eltham	1983	Inglewood
1950	Eltham	1984	Clifton
1951	Patea	1985	Inglewood
1952	Okato	1986	Inglewood
1953	Eltham	1987	Inglewood
1954	Eltham	1988	Inglewood
1955	Waimate	1989	Inglewood
1956	Eltham	1990	Eltham
1957	New Plymouth	1991	Eltham
	HSOB	1992	Clifton
1958	Eltham	1993	NPOB
1959	Stratford	1994	NPOB
1960	Inglewood	1995	NPOB
1961	Stratford	1996	NPOB
1962	Stratford	1997	NPOB
1963	Stratford		
1964	Stratford	*Most championships:*	
1965	Stratford	Stratford 16	
1966	Tukapa		

SENIOR CLUBS

Border	Blue, black, white and yellow
Clifton	Blue, green and yellow
Coastal	Green, white and black
Eltham	Black and white
Inglewood	Maroon
Kaponga	Black
NPOB	Black, white and yellow
Southern	Navy, green, yellow and white
Spotswood United	Red, black and white
Stratford	Red and black
Tukapa	Blue and white

Thames Valley

Founded: 1922

Colours: Gold and red

Main ground and capacity: Paeroa Domain, 5000

Record attendance: 7000, Thames Valley v Auckland, 1989

Most appearances: B.C. Duggan, 1970-84, 143

Most points: G.R. Dalgety, 1983-84, 1989-93, 520

Most tries: I.F. Campbell, 1981-94, 42

NZ representatives (2): K.E. Barry, R.J. O'Dea.

WINNERS OF THE THAMES VALLEY CLUB CHAMPIONSHIP

1953	Patetonga	1979	Te Aroha College OB
1954	Waitakaruru		
1955	Waitakaruru	1980	Paeroa West
1956	Thames United	1981	Paeroa West
1957	Paeroa OB	1982	Paeroa West
1958	Thames United	1983	Paeroa West
1959	Thames United	1984	Paeroa West
1960	Waihou	1985	Paeroa West
1961	Waihou	1986	Paeroa West
1962	Waihou	1987	Paeroa West
1963	Thames HSOB	1988	Paeroa West
1964	Thames United	1989	Thames
1965	Paeroa OB	1990	Paeroa West
1966	Paeroa OB	1991	Waihou
1967	Paeroa OB	1992	Hauraki North & Thames
1968	Paeroa West		
1969	Thames United	1993	Te Aroha College OB
1970	Kerepehi		
1971	Hauraki North	1994	Hauraki North
1972	Hauraki North	1995	Thames
1973	Waihou	1996	Thames
1974	Waihou	1997	Thames
1975	Waihou		
1976	Huimai	*Most championships:*	
1977	Paeroa West	Paeroa West 12	
1978	Paeroa West		

SENIOR CLUBS

Coromandel	Black and gold
Hauraki North	Royal blue and white
Mercury Bay	Gold and black
Ngatea	Black
Paeroa OB	White
Paeroa West	Black and white
Tairua	Navy and white
Te Aroha College OB	Red, blue and yellow
Thames	Blue and black
Waihi Athletic	Red and black
Waihou	Maroon and gold
Whangamata	Red and white

Waikato

Founded: 1909 as South Auckland and name changed to Waikato in 1921

Colours: Red, yellow and black

Main ground and capacity: Rugby Park, Hamilton, 28,000

Record attendance: 30,000, Waikato v South Africa, 1956

Most appearances: G.H. Purvis, 1984-97, 147

Most points: M.J.A. Cooper, 1990-97, 1258

Most tries: B.W. Smith, 1979-84, 70

NZ representatives (38): K.D. Arnold, W.M. Birtwistle, J.W. Boe, E.H. Catley, D.B. Clarke, I.J. Clarke, W.J.M. Conrad, M.S.B. Cooksley, M.J.A. Cooper, W.D. Gatland, S.B. Gordon, W.R. Gordon, K.M. Greene, R.C. Hemi, G.R. Hines, A.R. Hopa, G.N. Kane, T.T. Koteka, J. Leeson, R.W. Loe, S.J. McLeod, T.J. Miller, J.E.P. Mitchell, B.L. Morrissey, R.G. Myers, H.C. McLaren, E.A.R. Pickering, G.H. Purvis, A.R. Reid, H. Rickit, P.L.J. Simonsson, G.R. Skudder, B.W. Smith, A.M. Stone, M.B. Taylor, J.M. Tuck, W.J. Whineray, J.G. Wynyard.

WINNERS OF THE WAIKATO CLUB CHAMPIONSHIP

1968	Kereone & St Patrick's	1987	Fraser Technical OB
1969	Frankton	1988	Fraser Technical OB & Hamilton OB
1970	Frankton		
1971	Hamilton OB	1989	Hamilton OB
1972	Marist	1990	Fraser Technical OB
1973	Hamilton OB		
1974	Tokoroa	1991	Hamilton OB
1975	Fraser Technical OB	1992	Taupiri
		1993	Hamilton OB
1976	Fraser Technical OB	1994	Hamilton Marist
1977	Hamilton OB	1995	Fraser Technical OB
1978	Melville		
1979	Hamilton OB	1996	Fraser Technical OB
1980	Marist		
1981	Melville	1997	Hamilton OB
1982	Hamilton OB		
1983	Marist	*Most championships:*	
1984	Hamilton OB	Hamilton OB 11	
1985	Ngaruawahia		
1986	Ngaruawahia		

SENIOR CLUBS

Eastern Suburbs	White and black
Frankton	Blue and black
Fraser Technical OB	Royal blue and white
Hamilton OB	Red and black
Hamilton Marist	Green and white
Hinuera	Gold and black
Hautapu	Red and white
Leamington	Blue and white
Melville	Green and red
Morrinsville Sports	Navy, sky blue and scarlet
Ngaruawahia	Cambridge blue and yellow
Ohaupo	Gold and red
Pirates	Black, white and burgundy
Pirongia	Black and white
Putaruru	Blue and scarlet
Raglan	Green and black
Taupiri	Gold and black
Te Awamutu Marist	Green and gold
Te Awamutu Sports	Blue, green and gold
Te Rapa	Dark blue and scarlet
Tokoroa	Black and white
Tokoroa HSOB	Green and gold
United Matamata	Red, black and white
University	Black

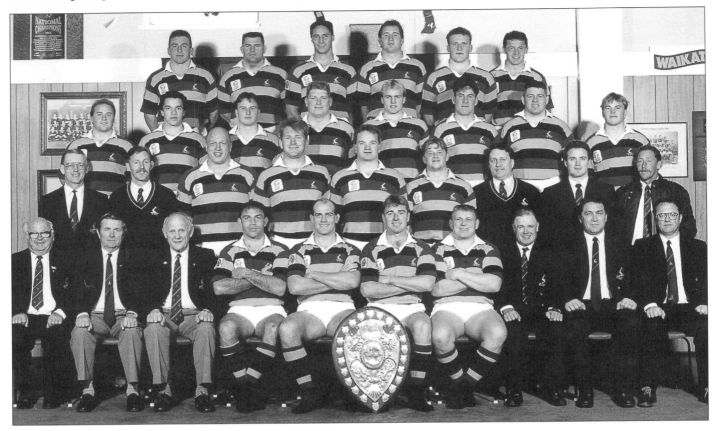

The 1993 Waikato team
Back row: Duane Monkley, Craig Stevenson, Wayne Warlow, Tom Coventry, Richard Kirke, Ian Foster.
Third row: Simon Crabb, Vaughan Going, Rhys Duggan, Paul Martin, Doug Wilson, Eugene Martin, Warren Gatland, Todd Miller.
Second row: Mike Bowen (doctor), Chris Strange (fitness director), Brent Anderson, Steve Gordon, Richard Jerram, John Walters, Steve Gilbert (assistant manager), Tim Robinson (physiotherapist), Rick Crews (masseur).
Front row: Tom Bourke (training manager), Stan Hickford (chairman), Keith Davis (president), Rhys Ellison, John Mitchell (captain), Matthew Cooper, Graham Purvis, Kevin Greene (coach), Farrell Temata (assistant coach), Brett Johnstone (manager).

Wairarapa-Bush

Founded: 1971, after a merger between Wairarapa (1886) and Bush (1893)

Colours: Green and red

Main ground and capacity: Memorial Park, Masterton, 10,000

Record attendance: 12,000, Wairarapa-Bush v British Isles, 1971 and 1983

Most appearances: G.K. McGlashan, 1971-83, 132

Most points: M.F.C. Benton, 1983-92, 454

Most tries: M.T. Foster, 1984-92, 43

NZ representatives (28) – Wairarapa-Bush: B.L. Anderson, M.J. Berry, B.A. Harvey, B.J. Lochore, M.J. McCool, R.J. McLean. *Wairarapa:* A.L. Armstrong, A.W. Blake, A.E. Cooke, M.B.R. Couch, R.T. Cundy, A.E. d'Arcy, J.G. Donald, Q. Donald, R. Gray, I.H. Harvey, W.R. Irvine, B.J. Lochore, W. McKenzie, A.F. McMinn, J.J. Mill, K.H. Reid, W.B. Reside, J.C. Stringfellow, D.K. Udy, W.D. Watson, S. de L.P. Willoughby, E. Wrigley. *Bush:* A. Mahoney.

WINNERS OF THE WAIRARAPA-BUSH CLUB CHAMPIONSHIP

1971	Masterton	1987	Masterton
1972	Masterton	1988	Carterton
1973	Masterton	1989	Martinborough
1974	Red Star	1990	Carterton
1975	Red Star	1991	Martinborough
1976	Red Star	1992	Greytown
1977	Red Star	1993	Pioneer
1978	Red Star	1994	Pioneer
1979	Masterton	1995	Greytown
1980	Gladstone	1996	Masterton Red Star
1981	Martinborough	1997	Marist
1982	Martinborough		
1983	Masterton	*Most championships:*	
1984	Masterton	Masterton 8	
1985	Martinborough		
1986	Masterton		

SENIOR CLUBS

Carterton	Maroon
East Coast	Red and white
Eketahuna	Yellow and black
Featherston	Blue and black
Gladstone	Gold
Greytown	Red, yellow and black
Marist	Green and white
Martinborough	Green and black
Masterton Red Star	Black and white
Pioneer	Royal blue
Puketoi	Green and gold
Tuhirangi	Blue and white

Wanganui

Founded: 1888

Colours: Royal blue, black and white

Main ground and capacity: Westpac Trust Stadium (Cook's Gardens), Wanganui, 13,000

Record attendance: 22,000, Wanganui-King Country v British Isles, 1971 (Spriggens Park)

Most appearances: T.T.T. Olney, 1973-90, 146

Most points: R.B. Barrell, 1963-77, 980

Most tries: J.D. Hainsworth, 1984-95, 48

NZ representatives (16): E.A. Belliss, J.A. Blair, G.A.H. Bullock-Douglas, A.J. Donald, K.E. Gudsell, P. Henderson, J. Hogan, P.A. Johns, P. McDonnell, H.P. Milner, P.C. Murray, W.M. Osborne, W. Potaka, H.C.B. Rowley, P. Taituha (also known as T.P. Kingi and T. Peina), H.D. Thomson.

WINNERS OF THE WANGANUI CLUB CHAMPIONSHIP

Wanganui-Rangitikei competition from 1959; union-wide since 1978

1888	Gordon	1946	Technical OB
1889	Wanganui	1947	Pirates
1890	Wanganui	1948	Pirates
1891	Kaierau	1949	Pirates
1892	Kaierau	1950	Kaierau
1893	Kaierau	1951	Technical OB
1894	Kaierau	1952	Technical OB
1895	Wanganui	1953	Waverley
1896	Kaierau	1954	Waverley
1897	Kaierau	1955	Waverley
1898	Waverley	1956	Waverley
1899	Kaierau	1957	Kaierau
1900	Kaierau	1958	Pirates
1901	Pirates	1959	Technical OB
1902	Waverley	1960	Kaierau
1903	Pirates	1961	Kaierau
1904	Wanganui CS	1962	Hunterville
1905	Wanganui CS	1963	Kaierau
1906	Kaierau	1964	Technical OB
1907	Pirates	1965	Bulls
1908	Pirates	1966	Bulls
1909	Kaierau	1967	Waverley
1910	Pirates	1968	Marton OB
1911	Pirates	1969	Technical OB
1912	Kaierau	1970	Marton OB
1913	Pirates	1971	Technical OB
1914	Kaierau	1972	Kaierau
1915	Kaierau	1973	Kaierau
1916	Kaierau	1974	Marton OB
1917	College	1975	Kaierau
1918	Old Boys	1976	Wanganui HSOB
1919	Old Boys		
1920	Old Boys	1977	Waverley
1921	Kaierau	1978	Utiku and Old Boys
1922	Imlay		
1923	Old Boys	1979	Ohakune-Karioi
1924	Kaierau	1980	Waverley
1925	Kaierau	1981	Waverley
1926	Pirates	1982	Marist
1927	Kaierau	1983	Marist
1928	Marist	1984	Ohakune-Karioi
1929	Kaierau	1985	Ohakune-Karioi
1930	Kaierau	1986	Ohakune-Karioi
1931	Technical OB	1987	Wanganui HSOB
1932	Kaierau		
1933	Kaierau	1988	Marist
1934	Kaierau	1989	Marton OB
1935	Kaierau	1990	Counties
1936	Old Boys	1991	Kaierau
1937	Bulls	1992	Utiku and OB
1938	Old Boys	1993	Kaierau
1939	Old Boys	1994	Marton
1940	Old Boys	1995	Waverley
1941	Technical OB	1996	Marist
1942-1943	no competition	1997	Kaierau
1944	Pirates	*Most championships:*	
1945	Pirates	Kaierau 35	

SENIOR CLUBS

Counties	Blue, green and black
Huia	Red and black
Kaierau	Maroon and gold
Marist Brothers OB	Emerald green
Pourewa	Green and gold and blue and gold
Ratana	Cardinal and blue
Ruapehu	Blue and green
Taihape Pirates	Black
Technical and College OB	Blue and white
Utiku and OB	Light blue and white
Waiouru	Scarlet and black
Wanganui Pirates	Black and white

Wellington

Founded: 1879

Colours: Black and gold

Main ground and capacity: Athletic Park, 39,500

Record attendance: 57,700, New Zealand v British Isles, 1959

Most appearances: G.C. Williams, 1964-76, 174

Most points: A.R. Hewson, 1977-86, 909

Most tries: B.G. Fraser, 1975-86, 105

NZ representatives (140): G.G. Aitken, B. Algar, H.E. Avery, N. Ball, E.F. Barry, G.B. Batty, M.J. Berry, V.D. Bevan, R.G. Bowers, U.P. Calcinai, J.J. Calnan, R.W. Caulton, M. Clamp, W.H. Clark, A.E. Cooke, S. Crichton, T. Cross, R.A. Dalton, E. Davy, G.W. Delamore, E.H. Dodd, J.P. Dougan, J.T. Dumbell, K.G. Elliott, T.R. Ellison, J.T. Fitzgerald, B.B.J. Fitzpatrick, J.K. Fleming, W.C. Francis, B.G. Fraser, D.R. Gage, J.A. Gallagher, C.T. Gillespie, K.F. Gray, J.L. Griffiths, W.R. Hardcastle, T.R. Heeps, A.R. Hewson, R.H. Horsley, E. Hughes, L.C. Hullena, A. Ieremia, R.A. Jarden, E.M. Jessep, L.M. Johnson, J.F. Karam, T. Katene, G.F. Kember, F.D. Kilby, A. Lambourn, A.R. Leslie, E.T. Leys, H.T. Lilburne, C.J. Loader, G. Maber, T.M. McCashin, B. McGrattan, I.N. MacEwan, D. McGregor, D.N. McIntosh, J.D. Mackay, G.F. McKellar, R.H.C. McKenzie, R.J. McKenzie, W. McKenzie, H.F. McLean, S.J. Mannix, P. Markham, D.F. Mason, G.G. Mexted, M.G. Mexted, F.E. Mitchinson, J.E. Moffitt, H.E. Nicholls, H.G. Nicholls, M.F. Nicholls, J. O'Brien, T.R. O'Callaghan, D.H. O'Donnell, R. Oliphant, D.J. Oliver, J.R. Page, T.G. Pauling, M.J. Pierce, H.R. Pollock, C.G. Porter, J.P. Preston, A. Pringle, W.P. Pringle, W.J. Reedy, E.J. Roberts, F. Roberts, H. Roberts, W. Roberts, C.A. Rushbrook, E. Ryan, J. Ryan, B.S. Sadler, J.L.B. Salmon, M. Sayers, N.J. Schuster, J.D. Shearer, S.D. Shearer, S.K. Siddells, G. Spencer, J.C. Spencer, L.B. Steele, O.G.

Stephens, I.N. Stevens, A.J. Stuart, K.S. Svenson, J. Swindley, B.T. Thomas, L.A. Thomas, H.D. Thomson, F.J. Tilyard, J.T. Tilyard, E.W.T. Tindill, C.D. Tregaskis, H. Udy, T.J.F. Umaga, I.N. Uttley, I.M.H. Vodanovich, W.J. Wallace, E.I. Watkins, J.R. Watt, P.P. Webb, J. Wells, R.M. White, G.C. Williams, M. Williment, N.A. Wilson, H.C. Wilson, S.S. Wilson, T.N. Wolfe, M.E. Wood, A.H. Wright, T. Wyllie, W.T. Wynyard, F.B. Young.

WINNERS OF THE WELLINGTON CLUB CHAMPIONSHIP

1880	Athletic	1944	Poneke & Oriental
1881	no competition		
1882	Athletic	1945	Athletic
1883	Wellington & Greytown	1946	University
		1947	Wellington
1884	Athletic	1948	Marist
1885	Wellington	1949	Petone & St Pat's OB
1886	Poneke		
1887	Poneke	1950	Marist
1888	Poneke	1951	Poneke
1889	Poneke	1952	University
1890	Wellington	1953	University
1891	Athletic	1954	University
1892	Poneke	1955	Onslow
1893	Poneke	1956	Petone
1894	Poneke	1957	Petone
1895	Petone	1958	University
1896	Melrose	1959	Petone
1897	Melrose	1960	Marist
1898	Melrose	1961	Petone
1899	Petone	1962	Marist & Onslow
1900	Melrose		
1901	Wellington	1963	Marist
1902	Melrose	1964	Marist & University
1903	Poneke		
1904	Petone	1965	Athletic
1905	Petone	1966	University
1906	Petone	1967	Petone
1907	Petone	1968	Petone
1908	Melrose	1969	Petone
1909	Poneke	1970	Petone
1910	Oriental	1971	Petone
1911	Athletic	1972	Wellington & Athletic
1912	Athletic		
1913	Athletic	1973	Petone
1914	Athletic & Wellington	1974	Petone
		1975	Petone
1915	Athletic	1976	Petone
1916	Petone	1977	Athletic
1917	Petone	1978	Marist-St Pat's & Wellington
1918	Poneke		
1919	Poneke	1979	Marist-St Pat's
1920	Petone	1980	Petone
1921	Poneke	1981	Marist-St Pat's
1922	Petone	1982	Wellington & Petone
1923	Petone		
1924	Petone	1983	Wellington
1925	Poneke	1984	Marist-St Pat's
1926	Athletic	1985	Wellington
1927	Wellington COB	1986	Petone
1928	University	1987	Wellington
1929	University	1988	Marist St Pat's
1930	Petone	1989	Petone
1931	Hutt	1990	Petone
1932	Poneke	1991	Hutt Old Boys Marist
1933	Wellington COB		
1934	Hutt	1992	Petone
1935	Petone	1993	Petone
1936	Athletic	1994	Marist St Pat's
1937	Athletic	1995	Marist St Pat's
1938	Petone	1996	Poneke
1939	Wellington	1997	Marist St Pat's
1940	Athletic		
1941	Athletic	*Most championships:*	
1942	Petone	Petone 35	
1943	Poneke & Oriental		

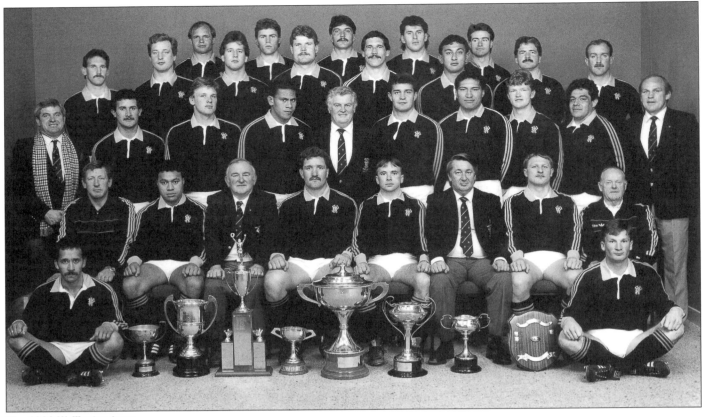

The 1986 Wellington team
Back row: Dave Mahanga, Denis Tocker, Wayne Gray, Mike Clamp, Peter Barlow.
Third row: Dirk Williams, Marc Verhoeven, Fraser Mexted, Gerard Wilkinson, Murray Pierce, Pat Dunn, Mike O'Leary, Brian McGrattan.
Second row: Earle Kirton (coach), John Schuster, Paul Goodwin, Lolani Koko, Brian Frederikson (manager), Mark Hudson, Isaac Adams, John Gallagher, Scott Crichton, Graham Williams (assistant coach).
Front row: Don Lister (masseur), Tim Perez, Ken Budge (president), Kevin Boroevich (captain), Neil Sorensen, Don Bond (manager), Paul McKay, Les Hall (masseur). In front: Steven Pokere, David Hansen.

SENIOR CLUBS

Avalon	Maroon, sky blue and white
Eastbourne	Green and gold
Harlequins	Green, gold, white, black and blue
Hutt Old Boys-Marist	Red, green and white
Johnsonville	Royal blue and Cambridge blue
Marist St Pat's	Scarlet
Northern United	Blue and white
Oriental-Rongotai	Black, white and gold
Paremata-Plimmerton	Black, yellow and scarlet
Petone	Blue and white
Poneke	Red and black
Rimutaka	Orange and black
Stokes Valley	Red and gold
Tawa	Red, blue and gold
Upper Hutt	Maroon, gold and white
Wainuiomata	Green and black
Wellington	Black and gold
Western Suburbs	Royal blue, white and red

West Coast

Founded: 1890

Colours: Red and white

Main ground and capacity: Rugby Park, Greymouth, 8000

Record attendance: 5500, West Coast v British Isles, 1983

Most appearances: K.J.J. Beams, 1965-78, 90

Most points: M.A. Foster, 1992-97, 378

Most tries: K.J.J. Beams, 1965-78, 27

NZ representatives (7): H. Atkinson, H. Butland, J. Corbett, D.F.E. Freitas, G.D.M. Gilbert, R.R. King, J. Steel.

WINNERS OF THE WEST COAST CLUB CHAMPIONSHIP

1930	United	1945	Blaketown
1931	Cobden	1946	Celtic
1932	Star	1947	Blaketown
1933	Cobden	1948	Star
1934	United	1949	Cobden
1935	United	1950	Cobden
1936	Excelsior	1951	Cobden
1937	Star	1952	Blaketown
1938	Star	1953	Excelsior
1939	Cobden	1954	St Mary's
1940-1943	no competition	1955	Cobden
		1956	Excelsior
1944	Cobden	1957	Excelsior
1958	Excelsior	1981	St Mary's
1959	Excelsior	1982	Star-United
1960	Excelsior	1983	St Mary's
1961	Marist	1984	Blaketown & St Mary's
1962	Blaketown	1985	Blaketown
1963	Blaketown	1986	Blaketown & St Mary's
1964	Marist		
1965	Excelsior	1987	Blaketown
1966	Blaketown	1988	Blaketown
1967	Excelsior	1989	St Mary's
1968	Blaketown	1990	St Mary's
1969	Hari Hari	1991	Blaketown
1970	Marist	1992	South Westland
1971	Marist	1993	Blaketown
1972	Blaketown	1994	Marist
1973	Star-United	1995	South Westland
1974	Blaketown	1996	South Westland
1975	Blaketown	1997	Marist
1976	Blaketown		
1977	Star-United		
1978	Star-United	*Most championships:*	
1979	Star-United	Blaketown 18	
1980	Star United		

Results prior to 1930 not available

SENIOR CLUBS

Blaketown	Black and white
Grey Valley	Yellow and black
Kiwi	Blue and white
Kokatahi	Scarlet, gold and black
Kumara	Black and blue
Marist	Green and red
South Westland	Maroon and white
Star-United	Royal blue and gold
Wests	Black, red and white

New Zealand Teams Overseas

In the team lists below players who appeared in international matches on tour are indicated either by * if there was only one test, by 1,2 etc for 1st, 2nd test etc or by E,W,I,S,F for matches against England, Wales, Ireland, Scotland and France. Replacements during a match are indicated by (r).

1884 in AUSTRALIA
First match 28 May, last match 14 July.

Backs: H.Y. Braddon *(Otago)*, G.H.N. Helmore *(Canterbury)*, T. Ryan *(Auckland)*, J.A. Warbrick *(Auckland)*, E. Davy *(Wellington)*, J.T. Dumbell *(Wellington)*, H. Roberts *(Wellington)*, J.G. Taiaroa *(Otago)*
Forwards: J. Allan *(Otago)*, G. Carter *(Auckland)*, J.G. Lecky *(Auckland)*, E.B. Millton *(Canterbury)*, W.V. Millton *(Canterbury)*, T.B. O'Connor *(Auckland)*, J. O'Donnell *(Otago)*, G.S. Robertson *(Otago)*, H. Udy *(Wellington)*, P.P. Webb *(Wellington)*, R.J. Wilson *(Canterbury)*
Captain: W.V. Millton
Manager: S.E. Sleigh *(Dunedin)*

Tour record:

v Cumberland Country *at Parramatta*	won	33-0
v New South Wales *at Sydney*	won	11-0
v Combined Suburbs XVII *at Sydney*	won	23-5
v Northern Team *at Newcastle*	won	29-0
v New South Wales *at Sydney*	won	21-2
v Western Branch *at Bathurst*	won	11-0
v Wallaroo & Sydney University *at Sydney*	won	23-10
v New South Wales *at Sydney*	won	16-0

Summary:
Played 8, won 8
Points for 167, against 17

Also: Before departure
| v Wellington *at Wellington* | won | 9-0 |

1893 in AUSTRALIA
First match 27 June, last match 29 July

Backs: A.E. D'Arcy *(Wairarapa)*, H.C. Wilson *(Wellington)*, A. Bayly *(Taranaki)*, A. Good *(Taranaki)*, G. Harper *(Nelson)*, F.M. Jervis *(Auckland)*, W.T. Wynyard *(Wellington)*, H. Butland *(West Coast)*, D.R. Gage *(Wellington)*, M. Herrold *(Auckland)*, G. Shannon *(Manawatu)*
Forwards: S.G. Cockroft *(Manawatu)*, T.R. Ellison *(Wellington)*, J.H. Gardner *(South Canterbury)*, R. Gray *(Wairarapa)*, J.T. Lambie *(Taranaki)*, C.N. Macintosh *(South Canterbury)*, R.H. McKenzie *(Auckland)*, W. McKenzie *(Wairarapa)*, J. Mowlem *(Manawatu)*, F.S. Murray *(Auckland)*, R. Oliphant *(Wellington)*, W.P. Pringle *(Wellington)*, C.R.B. Speight *(Auckland)*, A.J Stuart *(Wellington)*, H. Tiopira *(Hawke's Bay)*, W.D. Watson *(Wairarapa)*
Captain: T.R. Ellison
Manager: G.F.C. Campbell *(Wellington)*

Tour record:

v Cumberland County *at Parramatta*	won	8-0
v New South Wales *at Sydney*	won	17-8
v New South Wales Juniors *at Sydney*	won	19-0
v Northern Branch *at Newcastle*	won	25-3
v New South Wales *at Sydney*	lost	3-25
v Queensland *at Brisbane*	won	14-3
v Queensland 2nd XVIII *at Brisbane*	won	6-0
v Queensland *at Brisbane*	won	36-0
v Western Branch *at Bathurst*	won	24-5
v New South Wales *at Sydney*	won	16-0

Summary:
Played 10, won 9, lost 1
Points for 168, against 44

Also: Before departure
| v Combined XV *at Petone* | won | 7-4 |

1897 in AUSTRALIA
First match 3 July, last match 31 July.

Backs: S.A. Orchard *(Canterbury)*, L. Allen *(Taranaki)*, A.M. Armit *(Otago)*, A. Bayly *(Taranaki)*, W. Roberts *(Wellington)*, G.W. Smith *(Auckland)*, J. Duncan *(Otago)*, E. Glennie *(Canterbury)*, A.L. Humphries *(Taranaki)*
Forwards: J.A. Blair *(Wanganui)*, F.J. Brooker *(Canterbury)*, J.J. Calnan *(Wellington)*, R.A. Handcock *(Auckland)*, W.R. Hardcastle *(Wellington)*, W.A. Harris *(Otago)*, W. McKenzie *(Wellington)*, H.P. Mills *(Taranaki)*, F.S. Murray *(Auckland)*, T.G. Pauling *(Wellington)*, W.J.G. Wells *(Taranaki)*, A. Wilson *(Auckland)*
Captain: A. Bayly
Manager: I. Hyams *(Wellington)*

Tour record:

v New South Wales *at Sydney*	won	13-8
v Western Branch *at Bathurst*	won	16-15
v Central-Western Districts *at Orange*	won	27-3
v New South Wales *at Sydney*	lost	8-22
v Northern Branch *at Newcastle*	won	16-0
v Queensland *at Brisbane*	won	16-5
v Queensland 2nd XVI *at Brisbane*	won	29-5
v Queensland *at Brisbane*	won	24-6
v New England *at Armidale*	won	53-5
v New South Wales *at Sydney*	won	26-3

Summary:
Played 10, won 9, lost 1
Points for 228, against 72

Also: On return
| v Auckland *at Auckland* | lost | 10-11 |

1903 in AUSTRALIA
First match 18 July, last match 19 August.

Backs: W.J. Wallace *(Wellington)**, A.A. Asher *(Auckland)**, D. McGregor *(Canterbury)**, R.W. McGregor *(Auckland)**, J. Stalker *(Otago)*, J. Duncan *(Otago)**, J.W. Stead *(Southland)*, M.E. Wood *(Canterbury)**, A.L. Humphries *(Taranaki)*, H.A.D. Kiernan* *(Auckland)*
Forwards: A.L. Armstrong *(Wairarapa)*, R.J. Cooke *(Canterbury)**, B.J. Fanning *(Canterbury)**, D. Gallaher *(Auckland)**, F.J. Given *(Otago)*, A.J. Long *(Auckland)**, A.F. McMinn *(Wairarapa)**, G.W. Nicholson *(Auckland)**, H.G. Porteous *(Otago)*, J.C. Spencer *(Wellington)*, G.A. Tyler *(Auckland)**, D.K. Udy *(Wairarapa)**
Captain: J. Duncan
Manager: A.C. Norris *(Wellington)*

Tour record:

v New South Wales *at Sydney*	won	12-0
v Combined Western Districts *at Bathurst*	won	47-7
v New South Wales *at Sydney*	won	3-0
v Metropolitan Union *at Sydney*	won	33-3
v Queensland *at Brisbane*	won	17-0
v Western Queensland *at Brisbane*	won	29-0
v Queensland *at Brisbane*	won	28-0
v Combined Northern Districts *at West Maitland*	won	53-0
v Australia *at Sydney*	won	22-3
v NSW Country XV *at Sydney*	won	32-0

Summary:
Played 10, won 10
Points for 276, against 13

Also: Before departure
v Wellington Province *at Wellington*　　　　lost　5-14

1905 in AUSTRALIA
First match 8 July, last match 15 July.

Backs: G.A. Gillett *(Canterbury)*, E.E. Booth *(Otago)*, D. McGregor *(Wellington)*, G.W. Smith *(Auckland)*, H.D. Thomson *(Wanganui)*, W.J. Wallace *(Wellington)*, J. Hunter *(Taranaki)*, H.J. Mynott *(Taranaki)*, F. Roberts *(Wellington)*,
Forwards: S.T. Casey *(Otago)*, J. Corbett *(West Coast)*, F.T. Glasgow *(Taranaki)*, W.S. Glenn *(Taranaki)*, W. Johnson *(Otago)*, A. McDonald *(Otago)*, F. Newton *(Canterbury)*, G.W. Nicholson *(Auckland)*, J.M. O'Sullivan *(Taranaki)*, C.E. Seeling *(Auckland)*
Captain: J. Hunter
Manager: N. Galbraith *(Wellington)*

Tour record:
v New South Wales *at Sydney*	won	19-0
v Metropolitan Union *at Sydney*	won	22-3
v New South Wales *at Sydney*	drew	8-8

Summary:
Played 3, won 1, drew 1
Points for 49, against 11

Also: Before departure
v Auckland *at Auckland*　　　　　won　9-3

1905-06 in the BRITISH ISLES, FRANCE and NORTH AMERICA
First match 16 September, 1905, last match 13 February, 1906.

Backs: G.A. Gillett *(Canterbury)*s.i.e.w. W.J. Wallace *(Wellington)*s.i.e.w.f. H.L. Abbott *(Taranaki)*f. E.E. Booth *(Otago)*f. R.G. Deans *(Canterbury)*s.i.e.w. E.T. Harper *(Canterbury)*f. D. McGregor *(Wellington)*e.w. G.W. Smith *(Auckland)*s.i. H.D. Thomson *(Wanganui)*, J. Hunter *(Taranaki)*s.i.e.f. H.J. Mynott *(Taranaki)*i.w.f. J.W. Stead *(Southland)*s.i.e.f. F. Roberts *(Wellington)*s.i.e.w
Forwards: S.T. Casey *(Otago)*s.i.e.w. J. Corbett *(West Coast)*, W. Cunningham *(Auckland)* s.i.f. D. Gallaher *(Auckland)*s.e.w.f. F.T. Glasgow *(Taranaki)*s.i.e.w.f. W.S. Glenn *(Taranaki)*f. W. Johnston *(Otago)*, W.H.C. Mackrell *(Auckland)*f. A. McDonald *(Otago)*f. F. Newton *(Canterbury)*e.w.f. G.W. Nicholson *(Auckland)*, J.M. O'Sullivan *(Taranaki)*s.i.e.w. C.E. Seeling *(Auckland)*s.i.e.w.f. G.A. Tyler *(Auckland)*s.i.e.w.f.
Captain: D. Gallaher

Manager: G.H. Dixon *(Wellington)*
Coach: J. Duncan

Tour record:
v Devonshire *at Exeter*	won	55- 4
v Cornwall *at Camborne*	won	41- 0
v Bristol Club *at Bristol*	won	41- 0
v Northampton Club *at Northampton*	won	32-0
v Leicester Club *at Leicester*	won	28-0
v Middlesex *at Stamford Bridge*	won	34-0
v Durham County *at Durham*	won	16-3
v Hartlepool Clubs *at West Hartlepool*	won	63-0
v Northumberland *at North Shields*	won	31-0
v Gloucester City Club *at Gloucester*	won	44-0
v Somersetshire *at Taunton*	won	23-0
v Devonport Albion Club *at Devonport*	won	21-3
v Midland Counties *at Leicester*	won	21-5
v Surrey *at Richmond*	won	11-0
v Blackheath Club *at Blackheath*	won	32-0
v Oxford University *at Oxford*	won	47-0
v Cambridge University *at Cambridge*	won	14-0
v Richmond Club *at Richmond*	won	17-0
v Bedford XV *at Bedford*	won	41-0
v Scotland *at Inverleith*	won	12-7
v West of Scotland *at Glasgow*	won	22-0
v Ireland *at Dublin*	won	15-0
v Munster *at Limerick*	won	33-0
v England *at Crystal Palace*	won	15-0
v Cheltenham Club *at Cheltenham*	won	18-0
v Cheshire *at Birkenhead*	won	34-0
v Yorkshire *at Headingley*	won	40-0
v Wales *at Cardiff*	lost	0-3
v Glamorganshire *at Swansea*	won	9-0
v Newport Club *at Newport*	won	6-3
v Cardiff Club *at Cardiff*	won	10-8
v Swansea Club *at Swansea*	won	4-3
v France *at Paris*	won	38-8
v British Columbia *at Berkeley*	won	43-6
v British Columbia *at San Francisco*	won	65-6

Summary:
Played 35, won 34, lost 1
Points for 976, against 59

Also: Before departure
v Otago-Southland *at Dunedin*	drew	10-10
v Canterbury *at Christchurch*	won	21-3
v Wellington Province *at Wellington*	lost	0-3

The 1905 Original All Blacks
Back row: J. Corbett, W. Johnston, W. Cunningham, F. Newton, G.W. Nicholson, C.E. Seeling, J.M. O'Sullivan, A. McDonald, D. McGregor, J. Duncan (coach).
Second row: E.T. Harper, W.J. Wallace. J.W. Stead, G.H. Dixon (manager), D. Gallaher (captain), J. Hunter, G.A. Gillett, F.T. Glasgow, W.H.C. Mackrell.
Front row: S.T. Casey, H.L. Abbott, G.W. Smith, F. Roberts, H.D. Thomson, H.J. Mynott, E.E. Booth, G.A. Tyler, R.G. Deans.
Absent: W.S. Glenn.

1907 in AUSTRALIA
First match 13 July, last match 10 August.

Backs: E.E. Booth (Otago)[1,3], G. Spencer (Wellington), J.T.H. Colman (Taranaki)[1,2], F.C. Fryer (Canterbury)[1,2,3], F.E. Mitchinson (Wellington)[1,2,3], W.J. Wallace (Wellington)[1,2,3], A.G. Eckhold (Otago), J. Hunter (Taranaki)[1,2,3], H.J. Mynott (Taranaki)[1,2,3], F. Roberts (Wellington)[1,2,3]
Forwards: S.T. Casey (Otago)[1,2,3], W. Cunningham (Auckland)[1,2,3], A.R.H. Francis (Auckland)[1,2,3], G.A. Gillett (Auckland)[2,3], J. Hogan (Wanganui), E. Hughes (Southland) [1,2,3], W. Johnston (Otago)[1,2,3], A. McDonald (Otago)[1], G.W. Nicholson (Auckland)[2,3], J.M. O'Sullivan (Taranaki)[3], H. Paton (Otago), C.E. Seeling (Auckland)[1,2], J.C. Spencer (Wellington)[1(r)]
Captain: J. Hunter
Manager: E.M. Wylie (Wellington)

Tour record:

v New South Wales *at Sydney*	won	11-3
v New South Wales *at Sydney*	lost	0-14
v Australia *at Sydney*	won	26-6
v Queensland *at Brisbane*	won	23-3
v Queensland *at Brisbane*	won	17-11
v Australia *at Brisbane*	won	14-5
v Australia *at Sydney*	drew	5-5

Summary:
Played 7, won 5, drew 1, lost 1
Points for 96, against 47

Also: Before departure

v Wellington Province *at Wellington*	won	19-6

1910 in AUSTRALIA
First match 11 June, last match 2 July.

Backs: M.J. O'Leary (Auckland)[1,3], P.J. Burns (Canterbury)[1,2,3], W.J. Mitchell (Canterbury)[2,3], F.E. Mitchinson (Wellington)[1,2,3], J. Ryan (Wellington)[2], L. Stohr (Taranaki)[1,2,3], F.R. Wilson (Auckland), W.B. Fuller (Canterbury)[1,2], H.J. Mynott (Taranaki)[1,3], F. Roberts (Wellington)[1,2,3]
Forwards: H.E. Avery (Wellington)[1,2,3], A.E. Budd (South Canterbury), S. Bligh (Buller), D.A. Evans (Hawke's Bay)[2], A.R.H. Francis (Auckland)[1,2,3], F.E.B. Ivimey (Otago), J.R. Maguire (Auckland)[1,2,3], G.F. McKellar (Wellington)[1,2,3], H. Paton (Otago)[1,3], A.M. Paterson (Otago)[1,2,3], A.J. Ridland (Southland)[1,2,3], N.A. Wilson (Wellington)[1,2,3]
Captain: F. Roberts
Manager: V.R.S. Meredith (Wellington)

Tour record:

v New South Wales *at Sydney*	won	21-8
v New South Wales *at Sydney*	won	17-11
v Queensland *at Brisbane*	won	19-15
v Queensland *at Brisbane*	won	21-3
v Australia *at Sydney*	won	6-0
v Australia *at Sydney*	lost	0-11
v Australia *at Sydney*	won	28-13

Summary:
Played 7, won 6, lost 1
Points for 112, against 61

Also: Before departure

v Wellington *at Wellington*	won	26-17

1913 in NORTH AMERICA
First match 4 October, last match 25 November.

Backs: J.E. Cuthill (Otago)*, G. Loveridge (Taranaki), T.W. Lynch (South Canterbury), A.J. McGregor (Auckland)*, R.W. Roberts (Taranaki)*, L. Stohr (Taranaki), G.D. Gray (Canterbury)*, R.J. McKenzie (Wellington)*, F.E. Mitchinson (Wellington)*, E.J. Roberts (Wellington), H.M. Taylor (Canterbury)*
Forwards: H Atkinson (West Coast), J A. Bruce (Auckland), M.J. Cain (Taranaki)*, H. Dewar (Taranaki)*, J.B. Douglas (Otago), A.J. Downing (Auckland)*, J.B. Graham (Otago)*, A. McDonald (Otago)*, H.V. Murray (Canterbury)*, G.M.V. Sellars (Auckland)*, P. Williams (Otago), J.T. Wylie (Auckland)*
Captain: A. McDonald
Manager: G.H. Mason (Wellington)

Tour record:

v Olympic Club *at Oakland*	won	19-0
v University of California *at Berkeley*	won	31-0
v San Francisco Barbarian Club *at Oakland*	won	30-0
v Leland Stanford University *at Palo Alto*	won	54-0
v Leland Stanford University *at Palo Alto*	won	56-0
v University of Santa Clara *at Santa Clara*	won	42-0
v University of California *at Berkeley*	won	38-3
v University of Nevada *at Reno*	won	55-0
v University of California *at Berkeley*	won	33-0
v St Mary's College *at Oakland*	won	26-0
v University of Southern California *at Los Angeles*	won	40-0
v University of Santa Clara *at Santa Clara*	won	33-0
v All-America *at Berkeley*	won	51-3
v Victoria *at Victoria*	won	23-0
v Victoria *at Victoria*	won	35-0
v Vancouver *at Vancouver*	won	44-0

Summary:
Played 16, won 16
Points for 610, against 6

Also: Before departure

v Wellington *at Wellington*	won	19-18

1914 in AUSTRALIA
First match 11 July, last match 15 August.

Backs: E.A.P. Cockroft (South Canterbury)[2,3], J.G. O'Brien (Auckland)[1], G. Loveridge (Taranaki), T.W. Lynch (South Canterbury)[1,2,3], R.W. Roberts (Taranaki)[1,2,3], H.M. Taylor (Canterbury)[1,2,3], L.H. Weston (Auckland), R.S. Black (Otago)[1], R.J. McKenzie (Auckland)[2,3], J. Ryan (Wellington)[1,2,3], E.J. Roberts (Wellington)[1,2,3]
Forwards: J. Barrett (Auckland), J A. Bruce (Auckland)[1,2], M.J. Cain (Taranaki)[1,2,3], A.J. Downing (Auckland)[1,2,3], T. Fisher (Buller), W.C. Francis (Wellington)[1,2,3], J.B. Graham (Otago)[1,3], J.G. Irvine (Otago)[1,2,3], W.G. Lindsay (Southland), J. McNeece (Southland)[1,2,3], H.V. Murray (Canterbury)[2,3], N.A. Wilson (Wellington)[1,2,3]
Captain: R.W. Roberts
Manager: R.M. Isaacs (Wellington)

Tour record:

v New South Wales *at Sydney*	won	27-6
v Central-Western Districts *at Orange*	won	59-10
v Australia *at Sydney*	won	5-0
v New England *at Armidale*	won	35-6
v Queensland *at Brisbane*	won	26-5
v Queensland *at Brisbane*	won	19-0
v Australia *at Brisbane*	won	17-0
v Metropolitan Union *at Sydney*	won	11-6
v New South Wales *at Sydney*	won	25-10
v Australia *at Sydney*	won	22-7

Summary:
Played 10, won 10
Points for 246, against 50

Also: Before departure

v Wellington *at Wellington*	lost	14-19

1920 in AUSTRALIA
First match 24 July, last match 11 August.

Backs: J.G. O'Brien (Auckland), B. Algar (Wellington), J. Steel (West Coast), P.W. Storey (South Canterbury), V.W. Wilson (Auckland), C.E.O. Badeley (Auckland), E.J. Roberts (Wellington), J.T. Tilyard (Wellington), C. Brown (Taranaki)
Forwards: D.L. Baird (Southland), E.A. Belliss (Wanganui), A.J. Carroll (Manawatu), J.G. Donald (Wairarapa), W.D. Duncan (Otago), C.J.C. Fletcher (Auckland), E.W. Hasell (Canterbury), H. Jacob (Horowhenua), C. McLean (Buller), J.E. Moffitt (Wellington), J.D. Shearer (Wellington), A.H. West (Taranaki)
Captain: J.T. Tilyard
Manager: T. Jones (Wellington)

Tour record:

v New South Wales *at Sydney*	won	26-15
v Manning River District *at Taree*	won	70-9
v New South Wales *at Sydney*	won	14-6
v Metropolitan Union *at Sydney*	won	20-11
v New South Wales XV *at Sydney*	won	31-18

v New South Wales *at Sydney* won 24-13
v Metropolitan Union *at Sydney* won 79-5

Summary:
Played 7, won 7
Points for 264, against 77

Also: Before departure
v Auckland *at Auckland* drew 11-11
v Manawatu-Horowhenua-Wanganui
 at Palmerston North won 39-0

On return
v Wellington *at Wellington* won 38-3

1922 in AUSTRALIA
First match 29 July, last match 9 August.

Backs: R.C. Bell *(Otago)*, C.J. Fitzgerald *(Marlborough)*, W.A. Ford *(Canterbury)*, P.H. Hickey *(Taranaki)*, J.Steel *(West Coast)*, K.S. Svenson *(Buller)*, V.I.R. Badeley *(Auckland)*, G.R. Dickinson *(Otago)*, R.G. Mathieson *(Otago)*, M.F. Nicholls *(Wellington)*, H.E. Nicholls *(Wellington)*
Forwards: E.A. Belliss *(Wanganui)*, M.J. Brownlie *(Hawke's Bay)*, U.P. Calcinai *(Wellington)*, L.F. Cupples *(Bay of Plenty)*, J.G. Donald *(Wairarapa)*, F.H. Masters *(Taranaki)*, A.J. O'Brien *(Auckland)*, L.C. Petersen *(Canterbury)*, J. Richardson *(Otago)*, S.D. Shearer *(Wellington)*, B.F. Smyth *(Canterbury)*, A. White *(Southland)*, A.L. Williams *(Otago)*.
Captain: E.A. Belliss
Manager: S.S.M. Dean *(Wellington)*

Tour record:
v New South Wales *at Sydney* won 26-19
v Metropolitan Union *at Sydney* won 24-6
v New South Wales *at Sydney* lost 8-14
v New South Wales *at Sydney* lost 6-8
v New South Wales 2nd XV *at Manly* won 56-19

Summary:
Played 5, won 3, lost 2
Points for 120, against 66

Also: Before departure
v Wairarapa *at Carterton* won 12-11

On return
v Manawatu-Wellington XV *at Palmerston North* won 45-11
v New Zealand Maoris *at Wellington* won 21-14

1924 in AUSTRALIA
First match 5 July, last match 16 July.

Backs: G. Nepia *(Hawke's Bay)*, H.W. Brown *(Taranaki)*, A.H. Hart *(Taranaki)*, F.W. Lucas *(Auckland)*, K.S. Svenson *(Wellington)*, C.E.O. Badeley *(Auckland)*, A.E. Cooke *(Auckland)*, N.P. McGregor *(Canterbury)*, M.F. Nicholls *(Wellington)*, W.C. Dalley *(Canterbury)*, J.J. Mill *(Hawke's Bay)*
Forwards: C.J. Brownlie *(Hawke's Bay)*, M.J. Brownlie *(Hawke's Bay)*, L.F. Cupples *(Bay of Plenty)*, I.H. Harvey *(Wairarapa)*, W.R. Irvine *(Hawke's Bay)*, R.R. Masters *(Canterbury)*, B.V. McCleary *(Canterbury)*, H.G. Munro *(Otago)*, J.H. Parker *(Canterbury)*, C.G. Porter *(Wellington)*, J. Richardson *(Southland)*, A. White *(Southland)*
Captain: C.E.O. Badeley
Manager: E.A. Little *(Wellington)*

Tour record:
v New South Wales *at Sydney* lost 16-20
v Metropolitan Union *at Sydney* won 38-5
v New South Wales *at Sydney* won 21-5
v New South Wales *at Sydney* won 38-8

Summary:
Played 4, won 3, lost 1
Points for 113, against 38

Also: On return
v Auckland *at Auckland* lost 3-14
v Manawatu-Horowhenua *at Palmerston North* won 27-12

1924-25 in the BRITISH ISLES, FRANCE and CANADA
First match 13 September, 1924, last match 18 February, 1925.

Backs: G. Nepia *(Hawke's Bay)*ₗ.w.ₑ.ₚ. H.W. Brown *(Taranaki)*, A.H. Hart *(Taranaki)*ₗ. F.W. Lucas *(Auckland)*ₗ.ₚ. A.C.C. Robilliard *(Canterbury)*,

The 1924-25 Invincibles
Back row: H.W. Brown, M.F. Nicholls, R.R. Masters, I.H. Harvey, J.H. Parker, Q. Donald, B.V. McCleary.
Third row: J. Steel, M.J. Brownlie, R.T. Stewart, C.J. Brownlie, L.F. Cupples, A.H. West, L. Paewai, A. White.
Second row: A.C.C. Robilliard, H.G. Munro, W.R. Irvine, C.G. Porter (captain), S.S.M. Dean (manager), J. Richardson, G. Nepia, A.H. Hart, A.E. Cooke.
Front row: J.J. Mill, N.P. McGregor, W.C. Dalley, F.W. Lucas, K.S. Svenson, C.E.O. Badeley.

J. Steel *(West Coast)*w.e.f. K.S. Svenson *(Wellington)*ι.w.e.f. C.E.O. Badeley *(Auckland)*, A.E. Cooke *(Auckland)*ι.e.w.f. N.P. McGregor *(Canterbury)*w.e. M.F. Nicholls *(Wellington)*ι.w.e.f. L. Paewai *(Hawke's Bay)*, W.C. Dalley *(Canterbury)*ι. J.J. Mill *(Hawke's Bay)*w.e.f.
Forwards: C.J. Brownlie *(Hawke's Bay)*w.e.f. M.J. Brownlie *(Hawke's Bay)*ι.w.e.f. L.F. Cupples *(Bay of Plenty)*ι.w. Q. Donald *(Wairarapa)*ι.w.e.f. I.H. Harvey *(Wairarapa)*, W.R. Irvine *(Hawke's Bay)*ι.w.e.f. R.R. Masters *(Canterbury)*ι.w.e.f. H.G. Munro *(Otago)*, B.V. McCleary *(Canterbury)*, J.H. Parker *(Canterbury)*ι.w.e. C.G. Porter *(Wellington)*f. J. Richardson *(Southland)*ι.w.e.f. R.T. Stewart *(South Canterbury)*, A.H. West *(Taranaki)*, A. White *(Southland)*ι.e.f.
Captain: C.G. Porter
Manager: S.S.M. Dean *(Wellington)*

Tour record:

v Devonshire *at Devonport*	won	11-0
v Cornwall *at Camborne*	won	29-0
v Somersetshire *at Weston-super-Mare*	won	6-0
v Gloucestershire *at Gloucester*	won	6-0
v Swansea Club *at Swansea*	won	39-3
v Newport Club *at Newport*	won	13-10
v Leicester Club *at Leicester*	won	27-0
v North Midlands *at Birmingham*	won	40-3
v Cheshire *at Birkenhead*	won	18-5
v Durham County *at Sunderland*	won	43-7
v Yorkshire *at Bradford*	won	42-4
v Lancashire *at Manchester*	won	23-0
v Cumberland *at Carlisle*	won	41-0
v Ireland *at Dublin*	won	6-0
v Ulster *at Belfast*	won	28-6
v Northumberland *at Newcastle*	won	27-4
v Cambridge University *at Cambridge*	won	5-0
v London Counties *at Twickenham*	won	31-6
v Oxford University *at Oxford*	won	33-15
v Cardiff Club *at Cardiff*	won	16-8
v Wales *at Swansea*	won	19-0
v Llanelli Club *at Llanelli*	won	8-3
v East Midlands *at Northampton*	won	31-7
v Warwickshire *at Coventry*	won	20-0
v Combined Services *at Twickenham*	won	25-3
v Hampshire *at Portsmouth*	won	22-0
v London Counties *at Blackheath*	won	28-3
v England *at Twickenham*	won	17-11
v Selection Francais *at Paris*	won	37-8
v France *at Toulouse*	won	30-6
v Vancouver *at Vancouver*	won	49-0
v Victoria *at Victoria*	won	68-4

Summary:
Played 32, won 32
Points for 838, against 116

1925 in AUSTRALIA
First match 13 June, last match 1 July.

Backs: J.H. Harris *(Canterbury)*, J.M. Blake *(Hawke's Bay)*, W.L. Elvy *(Canterbury)*, A.D. Law *(Manawatu)*, G.D. Wise *(Otago)*, L.M. Johnson *(Wellington)*, D. Johnston *(Taranaki)*, G.P. Lawson *(South Canterbury)*, H.A. Mattson *(Auckland)*, T.G. Corkill *(Hawke's Bay)*, D.H. Wright *(Auckland)*
Forwards: J.A. Archer *(Southland)*, D.M. Dickson *(Otago)*, J.G. Donald *(Wairarapa)*, I. Finlayson *(North Auckland)*, A. Kirkpatrick *(Hawke's Bay)*, L.G. Knight *(Auckland)*, A.R. Lomas *(Auckland)*, A.G. McCormick *(Canterbury)*, J.A. McNab *(Hawke's Bay)*, L.S. Righton *(Auckland)*, L.A. Thomas *(Wellington)*, J. Walter *(Taranaki)*
Captain: J.G. Donald
Manager: E. McKenzie *(Wairarapa)*

Tour record:

v New South Wales *at Sydney*	won	26-3
v New South Wales 2nd XV *at Sydney*	lost	16-18
v New South Wales *at Sydney*	won	4-0
v New South Wales *at Sydney*	won	11-3
v New South Wales XV *at Newcastle*	won	20-13
v E.J. Thorn's XV *at Manly*	won	24-9

Summary:
Played 6, won 5, lost 1
Points for 101, against 46

Also: Before departure
v Wellington *at Wellington*	lost	6-10

On return
v Wellington-Manawatu-Horowhenua *at Wellington*	won	25-11

1926 in AUSTRALIA
First match 10 July, last match 29 July.

Backs: D.R.L. Stevenson *(Otago)*, J.M. Blake *(Hawke's Bay)*, H.W. Brown *(Taranaki)*, W.L. Elvy *(Canterbury)*, A.C.C. Robilliard *(Canterbury)*, K.S. Svenson *(Wellington)*, A.E. Cooke *(Hawke's Bay)*, M.F. Nicholls *(Wellington)*, T.R. Sheen *(Auckland)*, W.C. Dalley *(Canterbury)*, J.J. Mill *(Hawke's Bay)*
Forwards: G.T. Alley *(Southland)*, C.J. Brownlie *(Hawke's Bay)*, M.J. Brownlie *(Hawke's Bay)*, I. Finlayson *(North Auckland)*, I.H. Harvey *(Wairarapa)*, W.E. Hazlett *(Southland)*, W.R. Irvine *(Hawke's Bay)*, A. Kirkpatrick *(Hawke's Bay)*, A. Knight *(Auckland)*, A.R. Lomas *(Auckland)*, C.G. Porter *(Wellington)*, R.T. Stewart *(South Canterbury)*
Captain: C.G. Porter
Manager: H.S. Leith *(Wellington)*

Tour record:

v New South Wales *at Sydney*	lost	20-26
v New South Wales XV *at Sydney*	won	31-14
v New South Wales *at Sydney*	won	11-6
v New South Wales *at Sydney*	won	14-0
v Victoria *at Melbourne*	won	58-15
v New South Wales XV *at Sydney*	won	28-21

Summary:
Played 6, won 5, lost 1
Points for 162, against 82

Also: Before departure
v Wellington *at Wellington*	lost	14-21

On return
v Auckland *at Auckland*	won	11-6

1928 in SOUTH AFRICA
First match 30 May, last match 1 September.

Backs: H.T. Lilburne *(Canterbury)*3,4, S.R. Carleton *(Canterbury)*1,2,3, B.A. Grenside *(Hawke's Bay)*1,2,3,4, D.F. Lindsay *(Otago)*1,2,3, F.W. Lucas *(Auckland)*4, A.C.C. Robilliard *(Canterbury)*1,2,3,4, C.A. Rushbrook *(Wellington)*, T.R. Sheen *(Auckland)*, L.M. Johnson *(Wellington)*1,2,3,4, N.P. McGregor *(Canterbury)*, M.F. Nicholls *(Wellington)*4, W.A. Strang *(South Canterbury)*1,2, W.C. Dalley *(Canterbury)*1,2,3,4, F.D. Kilby *(Wellington)*
Forwards: G.T. Alley *(Canterbury)*1,2,3, C.J. Brownlie *(Hawke's Bay)*, M.J. Brownlie *(Hawke's Bay)*1,2,3,4, J.T. Burrows *(Canterbury)*, I. Finlayson *(North Auckland)*1,2,3,4, S. Hadley *(Auckland)*1,2,3,4, I.H. Harvey *(Wairarapa)*4, W.E. Hazlett *(Southland)*1,2,3,4, J. Hore *(Otago)*, R.G. McWilliams *(Auckland)*2,3,4, G. Scrimshaw *(Canterbury)*1, E.M. Snow *(Nelson)*, R.T. Stewart *(South Canterbury)*1,2,3,4, J.P. Swain *(Hawke's Bay)*1,2,3,4, E.P. Ward *(Taranaki)*
Captain: M.J. Brownlie
Manager: W.F. Hornig *(Wellington)*

Tour record:

v Western Province Country *at Cape Town*	won	11-3
v Cape Town Clubs *at Cape Town*	lost	3-7
v Griqualand West *at Kimberley*	won	19-10
v Transvaal *at Johannesburg*	lost	0-6
v Orange Free State *at Kroonstad*	won	20-0
v Transvaal *at Johannesburg*	won	5-0
v Western Transvaal *at Potchefstroom*	won	19-8
v Natal *at Pietermaritzburg*	won	31-3
v South Africa *at Durban*	lost	0-17
v Northern Provinces *at Kimberley*	drew	18-18
v Rhodesia *at Bulawayo*	won	44-8
v South Africa *at Johannesburg*	won	7-6
v Pretoria Clubs *at Pretoria*	won	13-6
v Orange Free State *at Bloemfontein*	won	15-11
v North-Eastern Districts *at Burghersdorp*	won	27-0
v Border *at East London*	won	22-3
v Border *at King William's Town*	won	35-3
v Eastern Province *at Port Elizabeth*	won	16-3
v South Africa *at Port Elizabeth*	lost	6-11
v South-Western Districts *at Oudtshoorn*	won	12-6
v Western Province *at Cape Town*	lost	3-10
v South Africa *at Cape Town*	won	13-5

Summary:
Played 22, won 16, drew 1, lost 5
Points for 339, against 144

Also: While returning

v Victoria *at Melbourne*	won	58-9

1929 in AUSTRALIA
First match 29 June, last match 31 July.

Backs: G. Nepia *(East Coast)*[1]. S.R. Carleton *(Canterbury)*[1,2,3]. J.H. Geddes *(Southland)*[1]. B.A. Grenside *(Hawke's Bay)*[2,3]. L.S. Hook *(Auckland)*[1,2,3]. J.C. Stringfellow *(Wairarapa)* [1(r),3]. A.C. Waterman *(North Auckland)*[1,2]. R.T. Cundy *(Wairarapa)*[2(r)]. H.T. Lilburne *(Canterbury)*[1,2,3]. C.J. Oliver *(Canterbury)*[1,2]. W.C. Dalley *(Canterbury)*, E.T. Leys *(Wellington)*[3]. J.M. Tuck *(Waikato)*[1,2,3].
Forwards: A.I. Cottrell *(Canterbury)*[1,2,3]. A.L. Kivell *(Taranaki)*[2,3]. A. Mahoney *(Bush)*, R.G. McWilliams *(Auckland)*[1,2,3]. B.P. Palmer *(Auckland)*[2]. C.G. Porter *(Wellington)*[2,3]. K.H. Reid *(Wairarapa)*[1,3]. W.B. Reside *(Wairarapa)*[1]. W. Rika (Heke) *(North Auckland)*[1,2,3]. E.M. Snow *(Nelson)*[1,2,3]. W.T.C. Sonntag *(Otago)*[1,2,3]. R. Souter *(Otago)*, E.R.G. Steere *(Hawke's Bay)*
Captain: C.G. Porter
Manager: J. McLeod *(Taranaki)*

Tour record:

v New South Wales *at Sydney*	drew	0-0
v Newcastle *at Newcastle*	won	35-6
v Australia *at Sydney*	lost	8-9
v New South Wales *at Sydney*	won	22-9
v Australian XV *at Melbourne*	won	25-4
v New South Wales Country *at Armidale*	won	27-8
v Australia *at Brisbane*	lost	9-17
v Queensland *at Brisbane*	won	27-0
v Australia *at Sydney*	lost	13-15
v New South Wales 2nd XV *at Sydney*	won	20-12

Summary:
Played 10, won 6, drew 1, lost 3
Points for 186, against 80

1932 in AUSTRALIA
First match 25 June, last match 27 July.

Backs: A.H. Collins *(Taranaki)*[2,3]. N. Ball *(Wellington)*[2,3]. G.A.H. Bullock-Douglas *(Wanganui)*[1,2,3]. T.H.C. Caughey *(Auckland)*[1,3]. G.F. Hart *(Canterbury)*, E.C. Holder *(Buller)*, J.R. Page *(Wellington)*[1,2,3]. A.C. Procter *(Otago)*, G.D. Innes *(Canterbury)*[2]. H.T. Lilburne *(Wellington)*[1]. H.R. Pollock *(Wellington)*[1,2,3]. M.M.N. Corner *(Auckland)*, F.D. Kilby *(Wellington)*[1,2,3].
Forwards: E.F. Barry *(Wellington)*, R.L. Clarke *(Taranaki)*[2,3]. A.I. Cottrell *(Canterbury)*[1,2,3]. J. Hore *(Otago)*[1,2,3]. E.M. Jessep *(Wellington)*[1]. J.E. Manchester *(Canterbury)*[1,2,3]. D.S. Max *(Nelson)*, H.F. McLean *(Wellington)*[1,2,3]. T.C. Metcalfe *(Southland)*, B.P. Palmer *(Auckland)*[2,3]. G.B. Purdue *(Southland)*[1,2,3]. F. Solomon *(Auckland)*[2,3]. E.R.G. Steere *(Hawke's Bay)*[1].
Captain: F.D. Kilby
Manager: W.J. Wallace *(Wellington)*

Tour record:

v New South Wales *at Sydney*	won	13-11
v Newcastle *at Newcastle*	won	44-6
v Australia *at Sydney*	lost	17-22
v New South Wales *at Sydney*	won	27-3
v Queensland *at Brisbane*	won	28-8
v Ipswich-Brisbane XV *at Ipswich*	won	44-12
v Australia *at Brisbane*	won	21-3
v Darling Downs *at Toowoomba*	won	30-6
v Australia *at Sydney*	won	21-13
v Western Districts (NSW) *at Wellington*	won	63-15

Summary:
Played 10, won 9, lost 1
Points for 308, against 99

Also: Before departure

v Wellington *at Wellington*	lost	23-36

1934 in AUSTRALIA
First match 1 August, last match 25 August.

Backs: A.H. Collins *(Taranaki)*[1]. G.A.H. Bullock-Douglas *(Wanganui)*[1,2]. T.H.C. Caughey *(Auckland)*[1,2]. G.F. Hart *(Canterbury)*, E.C. Holder *(Buller)*[2]. C.H. Smith *(Otago)*, J.L. Griffiths *(Wellington)*[2]. H.T. Lilburne *(Wellington)*[2]. C.J. Oliver *(Canterbury)*, J.R. Page *(Wellington)*[1,2]. M.M.N. Corner *(Auckland)*[1]. F.D. Kilby *(Wellington)*[2].
Forwards: E.F. Barry *(Wellington)*[2]. W.E. Hadley *(Auckland)*[1,2]. J. Hore *(Otago)*[1,2]. R.R. King *(West Coast)*[2]. A. Knight *(Auckland)*[1]. A. Lambourn *(Wellington)*[1,2]. J. Leeson *(Waikato)*[1]. A. Mahoney *(Bush)*, J.E. Manchester *(Canterbury)*[1,2]. H.K. Mataira *(Hawke's Bay)*[2]. D.S. Max *(Nelson)*[1,2]. R.M. McKenzie *(Manawatu)*[1]. H.F. McLean *(Auckland)*[1].
Captain: F.D. Kilby
Manager: A.J. Geddes *(Southland)*

Tour record:

v Western Districts *at Orange*	won	51-10
v New South Wales *at Sydney*	won	18-16
v New South Wales at Sydney	won	16-13
v Australia *at Sydney*	lost	11-25
v Queensland *at Brisbane*	won	31-14
v Australian XV *at Brisbane*	won	11-6
v Newcastle *at Newcastle*	won	35-3
v Australia *at Sydney*	drew	3-3

Summary:
Played 8, won 6, drew 1, lost 1
Points for 176, against 90

Also: On return

v Rest Of New Zealand *at Wellington*	won	25-17

1935-36 in the BRITISH ISLES and CANADA
First match 14 September, 1935, last match 29 January, 1936.

Backs: G.D.M. Gilbert *(West Coast)*[S,I,W,E]. N. Ball *(Wellington)*[W,E]. H.M. Brown *(Auckland)*, T.H.C. Caughey *(Auckland)*[S,I,E]. G.F. Hart *(Canterbury)*[S,I,W]. N.A. Mitchell *(Southland)*[S,I,W,E]. C.J. Oliver *(Canterbury)*[S,I,W]. J.L. Griffiths *(Wellington)*[W]. J.R. Page *(Wellington)*, D. Solomon *(Auckland)*, E.W.T. Tindill *(Wellington)*[E]. M.M.N. Corner *(Auckland)*[E]. B.S. Sadler *(Wellington)*[S,I,W]
Forwards: G.T. Adkins *(South Canterbury)*, J.J. Best *(Marlborough)*, W.R. Collins *(Hawke's Bay)*, D Dalton *(Hawke's Bay)*[I,W]. W.E. Hadley *(Auckland)*[S,I,W,E]. J. Hore *(Otago)*[S,E]. R.R. King *(West Coast)*[S,I,W,E]. A. Lambourn *(Wellington)*[S,I,W,E]. A. Mahoney *(Bush)*[S,I,W,E]. J.E. Manchester *(Canterbury)*[S,I,W,E]. R.M. McKenzie *(Manawatu)*[S]. H.F. McLean *(Auckland)*[I,W,E]. C.S. Pepper *(Auckland)*, S.T. Reid *(Hawke's Bay)*[S,I,W,E]. F.H. Vorrath *(Otago)*, J.G. Wynyard *(Waikato)*
Captain: J.E. Manchester
Manager: V.R.S. Meredith *(Auckland)*

Tour record:

v Devonshire & Cornwall *at Devonport*	won	35-6
v Midland Counties *at Coventry*	won	9-3
v Yorkshire & Cumberland *at Bradford*	won	14-3
v Abertillery & Cross Keys *at Abertillery*	won	31-6
v Swansea Club *at Swansea*	lost	3-11
v Gloucestershire & Somerset *at Bristol*	won	23-3
v Lancashire & Cheshire *at Birkenhead*	won	21-8
v Northumberland & Durham County *at Gosforth*	won	10-6
v South of Scotland *at Hawick*	won	11-8
v Glasgow & Edinburgh *at Glasgow*	won	9-8
v Combined Services *at Aldershot*	won	6-5
v Llanelly Club *at Llanelly*	won	16-8
v Cardiff Club *at Cardiff*	won	20-5
v Newport Club *at Newport*	won	17-5
v London Counties *at Twickenham*	won	11-0
v Oxford University *at Oxford*	won	10-9
v Hampshire & Sussex *at Bournemouth*	won	14-8
v Cambridge University *at Cambridge*	won	25-5
v Leicestershire & East Midlands *at Leicester*	won	16-3
v Scotland *at Edinburgh*	won	18-8
v North of Scotland *at Aberdeen*	won	12-6
v Ulster *at Belfast*	drew	3-3
v Ireland *at Dublin*	won	17-9
v Welsh Mid-Districts *at Aberdare*	won	31-10
v Neath & Aberavon *at Aberavon*	won	13-3
v Wales *at Cardiff*	lost	12-13
v London Counties *at Twickenham*	won	24-5
v England *at Twickenham*	lost	0-13

v Vancouver *at Vancouver*	won	32-0
v Victoria (BC) *at Victoria*	won	27-3

Summary:
Played 30, won 26, drew 1, lost 3
Points for 490, against 183

1938 in AUSTRALIA
First match 16 July, last match 13 August.

Backs: J.M. Taylor *(Otago)*₁,₂,₃, J. Dick *(Auckland)*₃, N.A. Mitchell *(Otago)*₁,₂, T.C. Morrison *(South Canterbury)*₁,₂,₃, W.J. Phillips *(King Country)*₁,₂, A.W. Wesney *(Southland)*, A.H. Wright *(Wellington)*, T. Berghan *(Otago)*₁,₂,₃, J.L. Griffiths *(Wellington)*₃, J.A. Hooper *(Canterbury)*, J.L. Sullivan *(Taranaki)*₁,₂,₃, C.K. Saxton *(South Canterbury)*₁,₂,₃, E.W.T. Tindill *(Wellington)*
Forwards: A.W. Bowman *(Hawke's Bay)*₁,₂,₃, W.N. Carson *(Auckland)*, D. Dalton *(Hawke's Bay)*₁,₂, V.L. George *(Southland)*₁,₂,₃, E.S. Jackson *(Hawke's Bay)*₃, R.R. King *(West Coast)*₁,₂,₃, A. Lambourn *(Wellington)*₃, R.M. McKenzie *(Manawatu)*₁, H.M. Milliken *(Canterbury)*₁,₂,₃, A.A. Parkhill *(Otago)*₁,₂,₃, C.E. Quaid *(Otago)*₁,₂, C.W. Williams *(Canterbury)*, J.G. Wynyard *(Waikato)*
Captain: N.A. Mitchell
Managers: G.J. Adams *(Wanganui)* and A. McDonald *(Wellington)*

Tour record:

v New South Wales *at Sydney*	won	28-8
v Combined Western *at Wellington*	won	31-0
v Australia *at Sydney*	won	24-9
v Newcastle *at Newcastle*	won	39-16
v Queensland *at Brisbane*	won	30-9
v Darling Downs *at Toowoomba*	won	36-6
v Australia *at Brisbane*	won	20-14
v Federal Capital Territory *at Canberra*	won	57-5
v Australia *at Sydney*	won	14-6

Summary:
Played 9, won 9
Points for 279, against 73

1947 in AUSTRALIA
First match 4 June, last match 28 June.

Backs: R.W.H. Scott *(Auckland)*₁,₂, T.R.D. Webster *(Southland)*, W.G. Argus *(Canterbury)*₁,₂, M.P. Goddard *(South Canterbury)*₁,₂, D.F. Mason *(Wellington)*₂(ᵣ), J.K. McLean *(King Country)*₁, J.B. Smith *(North Auckland)*₂, F.R. Allen *(Auckland)*₁,₂, M.B.R. Couch *(Wairarapa)*₁, J.C. Kearney *(Otago)*₂, P. Smith *(North Auckland)*, V.D. Bevan *(Wellington)*, P.L. Tetzlaff *(Auckland)*₁,₂
Forwards: K.D. Arnold *(Waikato)*₁,₂, E.H. Catley *(Waikato)*₁,₂, L.S. Connolly *(Southland)*, R.A. Dalton *(Wellington)*₁,₂, H.F. Frazer *(Hawke's Bay)*₁,₂, L.A. Grant *(South Canterbury)*₁,₂, F.G. Hobbs *(Canterbury)*, J. McCormick *(Hawke's Bay)*, J.G. Simpson *(Auckland)*₁,₂, N.H. Thornton *(Auckland)*₁,₂, R.M. White *(Wellington)*₁,₂, C. Willocks *(Otago)*
Captain: F.R. Allen
Manager: H.S. Strang *(Southland)*
Assistant Manager: N.A. McKenzie *(Hawke's Bay)*

Tour record:

v Australian Capital Territory *at Canberra*	won	58-11
v New South Wales *at Sydney*	lost	9-12
v New South Wales XV *at Sydney*	won	26-17
v Australia *at Brisbane*	won	13-5
v Queensland *at Brisbane*	won	23-14
v Queensland *at Toowoomba*	won	25-9
v New South Wales *at Sydney*	won	36-3
v Combined Northern *at Newcastle*	won	43-14
v Australia *at Sydney*	won	27-14

Summary:
Played 9, won 8, lost 1
Points for 260, against 99

Also: On return
v Auckland *at Auckland*

	lost	3-14

1949 in SOUTH AFRICA
First match 31 May, last match 17 September.

Backs: J.W. Goddard *(South Canterbury)*, R.W.H. Scott *(Auckland)*₁,₂,₃,₄, E.G. Boggs *(Auckland)*₁, I.J. Botting *(Otago)*, R.R. Elvidge *(Otago)*₁,₂,₃,₄, M.P. Goddard *(South Canterbury)* ₃,₄, P. Henderson *(Wanganui)*₁,₂,₃,₄, W.A. Meates *(Otago)*₂,₃,₄, F.R. Allen *(Auckland)*₁,₂, N.W. Black *(Auckland)*₃, G.W. Delamore *(Wellington)*₄, K.E. Gudsell *(Wanganui)*, J.C. Kearney *(Otago)* ₁,₂,₃, W.J.M. Conrad *(Waikato)*, L.T. Savage *(Canterbury)*₁,₂,₄
Forwards: E.H. Catley *(Waikato)*₁,₂,₃,₄, D.L. Christian *(Auckland)*₄, P.J.B. Crowley *(Auckland)*₃,₄, R.A. Dalton *(Otago)*, H.F. Frazer *(Hawke's Bay)*₂, L.A. Grant *(South Canterbury)*, L.R. Harvey *(Otago)*₁,₂,₃,₄, P. Johnstone *(Otago)*₂,₄, M.J. McHugh *(Auckland)*₃, J.R. McNab *(Otago)*₁,₂,₃, J.G. Simpson *(Auckland)*₁,₂,₃,₄, K.L. Skinner *(Otago)*₁,₂,₃,₄, N.H. Thornton *(Auckland)*₁, C. Willocks *(Otago)*₁,₃,₄, N.L. Wilson *(Otago)*
Captain: F.R. Allen
Manager: J.H. Parker *(Wellington)*
Assistant Manager: A. McDonald *(Wellington)*

Tour record:

v Western Province Universities *at Cape Town*	won	11-9
v Boland *at Wellington*	won	8-5
v South-Western Districts *at Oudtshoorn*	won	21-3
v Eastern Province *at Port Elizabeth*	won	6-3
v Border *at East London*	lost	0-9
v Natal *at Durban*	won	8-0
v Western Transvaal *at Potchefstroom*	won	19-3
v Transvaal XV *at Johannesburg*	won	6-3
v Orange Free State *at Kroonstad*	drew	9-9
v Eastern Transvaal *at Springs*	lost	5-6
v Western Province *at Cape Town*	won	6-3
v South Africa *at Cape Town*	lost	11-15
v Transvaal *at Johannesburg*	won	13-3
v Rhodesia *at Bulawayo*	lost	8-10
v Rhodesia *at Salisbury*	drew	3-3
v Northern Transvaal *at Pretoria*	won	6-3
v South Africa *at Johannesburg*	lost	6-12
v Northern Universities *at Pretoria*	won	17-3
v Griqualand West *at Kimberley*	won	8-6
v North-Eastern Districts *at Aliwal North*	won	28-3
v Orange Free State *at Bloemfontein*	won	14-9
v South Africa *at Durban*	lost	3-9
v Border *at East London*	drew	6-6
v South Africa *at Port Elizabeth*	lost	8-11

Summary:
Played 24, won 14, drew 3, lost 7
Points for 230, against 146

1951 in AUSTRALIA
First match 11 June, last match 21 July.

Backs: M.S. Cockerill *(Taranaki)*₁,₂,₃, R.H. Bell *(Otago)*₃, N.P. Cherrington *(North Auckland)*, C.P. Erceg *(Auckland)*₁,₂,₃, R.A. Jarden *(Wellington)*₁,₂, T.W. Lynch *(Canterbury)*₁,₂,₃, D.R. Wightman *(Auckland)*, B.B.J. Fitzpatrick *(Poverty Bay)*, L.S. Haig *(Otago)*₁,₂,₃, J.M. Tanner *(Auckland)*₁,₂,₃, A.L. Wilson *(Southland)*, A.R. Reid *(Waikato)*, L.B. Steele *(Wellington)*₁,₂,₃
Forwards: P.S. Burke *(Taranaki)*, R.H. Duff *(Canterbury)*₁,₂,₃, L.A. Grant *(South Canterbury)*, I.A. Hammond *(Marlborough)*, P. Johnstone *(Otago)*₁,₂,₃, W.A. McCaw *(Southland)*₁,₂,₃, G.G. Mexted *(Wellington)*, C.E. Robinson *(Southland)*₁,₂,₃, K.L. Skinner *(Otago)*₁,₂,₃, R.A. White *(Poverty Bay)*₁,₂,₃, H.W. Wilson *(Otago)*₁,₂,₃, N.L. Wilson *(Otago)*₁,₂,₃
Captain: P. Johnstone
Managers: R.W.S. Botting *(Otago)* and L.A.H. Clode *(Wellington)*

Tour record:

v Newcastle *at Newcastle*	won	20-6
v New South Wales *at Sydney*	won	24-3
v Australian United Services *at Sydney*	won	15-6
v Australia *at Sydney*	won	8-0
v Cental West *at Parkes*	won	65-6
v Australian XV *at Melbourne*	won	56-11
v Combined XV *at Wagga Wagga*	won	48-10
v Australia *at Sydney*	won	17-11
v New England *at Armidale*	won	49-6
v Queensland *at Toowoomba*	won	19-9
v Brisbane *at Brisbane*	won	29-9
v Australia *at Brisbane*	won	16-6

Summary:
Played 12, won 12
Points for 366, against 83

Also: On return
v Auckland *at Auckland* won 9-3

1953-54 in BRITISH ISLES, FRANCE and NORTH AMERICA
First match 31 October, 1953, last match 20 March, 1953.

Backs: J.W. Kelly *(Auckland)*, R.W.H. Scott *(Auckland)*w.i.e.s.f. M.J. Dixon *(Canterbury)*i.e.s.f. A.E.G. Elsom *(Canterbury)*w. J.T. Fitzgerald *(Wellington)*, W.S.S. Freebairn *(Manawatu)*, R.A. Jarden *(Wellington)*w.i.e.s.f. J.M. Tanner *(Auckland)*w. R.G. Bowers *(Wellington)*i.f. B.B.J. Fitzpatrick *(Wellington)*w.i.f. L.S. Haig *(Otago)*w.e.s. C.J. Loader *(Wellington)*i.e.s.f. D.D. Wilson *(Canterbury)*e.s. V.D. Bevan *(Wellington)*, K. Davis *(Auckland)*w.i.e.s.f
Forwards: K.P. Bagley *(Manawatu)*, W.H. Clark *(Wellington)*w.i.e.s. I.J. Clarke *(Waikato)*w. G.N. Dalzell *(Canterbury)*w.i.e.s.f. B.P. Eastgate *(Canterbury)*s. R.C. Hemi *(Waikato)*w.i.e.s.f. P.F.H. Jones *(North Auckland)*e.s. W.A. McCaw *(Southland)*w.f. R.J. O'Dea *(Thames Valley)*, O.D. Oliver *(Otago)*, K.L. Skinner *(Otago)*w.i.e.s.f. R.C. Stuart *(Canterbury)*w.i.e.s.f. H.L. White *(Auckland)*i.e.f. R.A. White *(Poverty Bay)*w.i.e.s.f. C.A. Woods *(Southland)*
Captain: R.C. Stuart
Manager: J.N. Millard *(Wellington)*
Assistant Manager: A.E. Marslin *(Otago)*

Tour record:
v Southern Counties *at Hove* won 24-0
v Cambridge University *at Cambridge* won 22-11
v London Counties *at Twickenham* won 11-0
v Oxford University *at Oxford* won 14-5
v Western Counties *at Bristol* won 11-0
v Llanelly Club *at Llanelly* won 17-3
v Cardiff Club *at Cardiff* lost 3-8
v Glasgow & Edinburgh *at Glasgow* won 23-3
v South of Scotland *at Galashiels* won 32-0
v North of Scotland *at Aberdeen* won 28-3
v Leicestershire & East Midlands *at Leicester* won 3-0
v South-Western Counties *at Camborne* won 9-0
v Swansea Club *at Swansea* drew 6-6
v Wales *at Cardiff* lost 8-13
v Abertillery & Ebbw Vale *at Abertillery* won 22-3
v Combined Services *at Twickenham* won 40-8
v Midland Counties *at Birmingham* won 18-3
v Ulster *at Belfast* drew 5-5
v Ireland *at Dublin* won 14-3
v Munster *at Cork* won 6-3
v Pontypool & Cross Keys *at Pontypool* won 19-6
v Newport Club *at Newport* won 11-6
v Neath & Aberavon *at Neath* won 11-5
v England *at Twickenham* won 5-0
v North-Eastern Counties *at Bradford* won 16-0
v Scotland *at Edinburgh* won 3-0
v North-Western Counties *at Manchester* won 17-3
v Barbarian Club *at Cardiff* won 19-5
v South-West France *at Bordeaux* lost 8-11
v France *at Paris* lost 0-3
v South-Eastern Counties *at Ipswich* won 21-13
v Victoria *at Victoria* won 39-3
v University of British Columbia *at Vancouver* won 42-3
v British Columbia Mainland *at Vancouver* won 37-11
v University of California *at Berkeley* won 14-6
v California All-Stars *at San Francisco* won 20-0

Summary:
Played 36, won 30, drew 2, lost 4
Points for 598, against 152

1957 in AUSTRALIA
First match 18 May, last match 26 June.

Backs: D.B. Clarke *(Waikato)*i.2. M.J. Dixon *(Canterbury)*i.2. R.F. McMullen *(Auckland)*i.2. P.T. Walsh *(Counties)*i.2. J.R. Watt *(Southland)*, W.R. Archer *(Southland)*, R.H. Brown *(Taranaki)*. W.N. Gray *(Bay of Plenty)*, H.J. Levien *(Otago)*, T.R. Lineen *(Auckland)*i.2. B.P.J. Molloy *(Canterbury)*, A.R. Reid *(Waikato)*i.2
Forwards: P.S. Burke *(Taranaki)*i.2. I.J. Clarke *(Waikato)*i.2. W.D. Gillespie *(Otago)*, R.C. Hemi *(Waikato)*i.2. S.F. Hill *(Canterbury)*i.2. I.N. MacEwan *(Wellington)*i.2. F.S. McAtamney *(Otago)*, D.N. McIntosh *(Wellington)*i.2.

C.E. Meads *(King Country)*i.2. E.A.R. Pickering *(Waikato)*, A.J. Soper *(Southland)*, W.J. Whineray *(Canterbury)*i.2. D. Young *(Canterbury)*
Captain: A.R. Reid
Manager: W.A.G. Craddock *(Buller)*
Assistant Manager: R.A. Everest *(Waikato)*

Tour record:
v New South Wales *at Sydney* won 19-3
v Western New South Wales *at Warren* won 33-6
v Australia *at Sydney* won 25-11
v Queensland *at Brisbane* won 30-0
v Australia *at Brisbane* won 22-9
v New England *at Gunnedah* won 38-14
v Newcastle *at Newcastle* won 20-9
v South West Zone *at Grenfell* won 86-0
v Australian Capital Territory *at Canberra* won 40-8
v Australian Barbarian Club *at Sydney* won 23-6
v Riverina *at Wagga Wagga* won 48-11
v Victoria *at Melbourne* won 28-3
v South Australia *at Adelaide* won 51-3

Summary:
Played 13, won 13
Points for 463, against 83

Also: On return
v Canterbury *at Christchurch* lost 9-11

1960 in AUSTRALIA, SOUTH AFRICA and RHODESIA
First match 14 May, last match 3 September.

Backs: D.B. Clarke *(Waikato)*i.2.3.4. W.A. Davies *(Auckland)*4. D.H. Cameron *(Mid Canterbury)*, R.W. Caulton *(Wellington)*i.4. K.F. Laidlaw *(Southland)*2.3.4. R.F. McMullen *(Auckland)*2.3.4. T.P.A. O'Sullivan *(Taranaki)*i. J.R. Watt *(Wellington)*i.2.3.4. S.G. Bremner *(Canterbury)*, A.H. Clarke *(Auckland)*i. T.R. Lineen *(Auckland)*i.2.3. S.R. Nesbit *(Auckland)*2.3. K.C. Briscoe *(Taranaki)*i.2.3.4. R.J. Urbahn *(Taranaki)*
Forwards: E.J. Anderson *(Bay of Plenty)*, R.J. Boon *(Taranaki)*, H.C. Burry *(Canterbury)*, I.J. Clarke *(Waikato)*2.4. R.J. Conway *(Otago)*i.3.4. W.D. Gillespie *(Otago)*, D.J. Graham *(Canterbury)*2.3. R.C. Hemi *(Waikato)*, R.H. Horsley *(Wellington)*2.3.4. M.W. Irwin *(Otago)*i. P.F.H. Jones *(North Auckland)*i. I.N. MacEwan *(Wellington)*i.2.3.4. C.E. Meads *(King Country)*i.2.3.4. E.A.R. Pickering *(Waikato)*, K.R. Tremain *(Canterbury)*i.2.3.4. W.J. Whineray *(Auckland)*i.2.3.4. D. Young *(Canterbury)*i.2.3.4
Captain: W.J. Whineray
Manager: T.H. Pearce *(Auckland)*
Assistant Manager: J.L. Sullivan *(Taranaki)*

Tour record:
v Queensland *at Sydney* won 32-3
v New South Wales *at Sydney* won 27-0
v Victoria-South Australia *at Orange* won 30-6
v New South Wales Country *at Orange* won 38-6
v Western Australia *at Perth* won 57-0
v Northern Universities *at Potchefstroom* won 45-6
v Natal *at Durban* drew 6-6
v Griqualand West *at Kimberley* won 21-9
v South West Africa *at Windhoek* won 27-3
v Boland *at Wellington* won 16-0
v Western Province Universities *at Cape Town* won 14-3
v Northern Transvaal *at Pretoria* won 27-3
v South Africa *at Johannesburg* lost 0-13
v Rhodesian XV *at Kitwe* won 13-9
v Rhodesia *at Salisbury* won 29-14
v Orange Free State *at Bloemfontein* lost 8-9
v Junior Springboks *at Durban* won 20-6
v Eastern Province *at Port Elizabeth* won 16-3
v Western Province *at Cape Town* won 20-8
v South-Western Districts *at Oudtshoorn* won 18-6
v South Africa *at Cape Town* won 11-3
v Central Universities *at East London* won 21-12
v Eastern Transvaal *at Springs* won 11-6
v South African Services *at Pretoria* lost 3-8
v Transvaal *at Johannesburg* won 19-3
v Western Transvaal *at Potchefstroom* won 28-3
v South Africa *at Bloemfontein* drew 11-11
v North-Eastern Districts *at Aliwal North* won 15-6
v Border *at East London* won 30-3

v South Africa *at Port Elizabeth* lost 3-8
v Transvaal XV *at Johannesburg* won 9-3

Summary:
Played 31, won 25, drew 2, lost 4
Points for 625, against 179

Also: On return
v The Rest of New Zealand *at Wellington* won 20-8

1962 in AUSTRALIA
First match 16 May, last match 16 June.

Backs: D.B. Clarke *(Waikato)*₁.₂. T.R. Heeps *(Wellington)*₁.₂. P.F. Little *(Auckland)*₂. D.W. McKay *(Auckland)*, T.P.A. O'Sullivan *(Taranaki)*₁.₂. J.R. Watt *(Wellington)*₁.₂. R.H. Brown *(Taranaki)*₁. R.C. Moreton *(Canterbury)*, B.A. Watt *(Canterbury)*₁. T.N. Wolfe *(Wellington)*₂. K.C. Briscoe *(Taranaki)*, D.M. Connor *(Auckland)*₁.₂.
Forwards: K.E. Barry *(Thames Valley)*, I.J. Clarke *(Waikato)*₁.₂. J.N. Creighton *(Canterbury)*, D.J. Graham *(Canterbury)*₁.₂. J.M. Le Lievre *(Canterbury)*, I.N. MacEwan *(Wellington)*₁.₂. C.E. Meads *(King Country)*₁.₂. S.T. Meads *(King Country)*, W.J. Nathan *(Auckland)*₁.₂. K.R. Tremain *(Hawke's Bay)*₁.₂. V.M. Yates *(North Auckland)*, W.J. Whineray *(Auckland)*₁.₂. D. Young *(Canterbury)*₁.₂
Captain: W.J. Whineray
Manager: J.D. King *(Wellington)*
Assistant Manager: R.G. Bush *(Auckland)*

Tour record:

v Central West *at Bathurst*	won	41-6
v New South Wales *at Sydney*	lost	11-12
v Queensland *at Brisbane*	won	15-5
v Australia *at Brisbane*	won	20-6
v Northern New South Wales *at Quirindi*	won	103-0
v Newcastle *at Newcastle*	won	29-6
v Australia *at Sydney*	won	14-5
v Southern New South Wales *at Canberra*	won	58-6
v South Australia *at Adelaide*	won	77-0
v Victoria *at Melbourne*	won	58-3

Summary:
Played 10, won 9, lost 1
Points for 426, against 49

1963-64 in BRITISH ISLES, FRANCE and CANADA
First match 23 October, 1963, last match 22 February, 1964.

Backs: D.B. Clarke *(Waikato)*₁.W.E.S.F. R.W. Caulton *(Wellington)*₁.W.E.S.F. W.L. Davis *(Hawke's Bay)*, M.J. Dick *(Auckland)*₁.W.E.S.F. P. F. Little *(Auckland)*₂. D.W. McKay *(Auckland)*, I.R. MacRae *(Hawke's Bay)*, I.S.T. Smith *(Otago)*, D.A. Arnold *(Canterbury)*₁.W.E.F. M.A. Herewini *(Auckland)*₁.S.F. E.W. Kirton *(Otago)*, P.T. Walsh *(Counties)*, B.A. Watt *(Canterbury)*W.E.S. K.C. Briscoe *(Taranaki)*₁.W.E.S. C.R. Laidlaw *(Otago)*F
Forwards: K.E. Barry *(Thames Valley)*, I.J. Clarke *(Waikato)*, D.J. Graham *(Canterbury)*₁.W.E.S.F. K.F. Gray *(Wellington)*₁.W.E.S.F. R.H. Horsley *(Manawatu)*, J.M.Le Lievre *(Wairarapa)*E.S. J. Major *(Taranaki)*, C.E. Meads *(King Country)*₁.W.E.S.F. S.T. Meads *(King Country)*₁. W.J. Nathan *(Auckland)*W.F. K.A. Nelson *(Otago)*, A.J. Stewart *(Canterbury)*₁.W.E.S.F. K.R. Tremain *(Hawke's Bay)*₁.W.E.S.F. W.J. Whineray *(Auckland)*₁.W.E.S.F. D. Young *(Canterbury)*₁.W.E.S.F.
Captain: W.J. Whineray
Manager: F.D. Kilby *(Wellington)*
Assistant Manager: N.J. McPhail *(Canterbury)*

Tour record:

v Oxford University *at Oxford*	won	19-3
v Southern Counties *at Hove*	won	32-3
v Newport Club *at Newport*	lost	0-3
v Aberavon & Neath *at Port Talbot*	won	11-6
v Abertillery & Ebbw Vale *at Abertillery*	won	13-0
v London Counties *at Twickenham*	won	27-0
v Cambridge University *at Cambridge*	won	20-6
v South of Scotland *at Hawick*	won	8-0
v Glasgow & Edinburgh *at Glasgow*	won	33-3
v Cardiff Club *at Cardiff*	won	6-5
v Pontypool & Cross Keys *at Pontypool*	won	11-0
v South Western Counties *at Exeter*	won	38-6
v Midland Counties *at Coventry*	won	37-9
v Ireland *at Dublin*	won	6-5
v Munster *at Limerick*	won	6-3
v Swansea Club *at Swansea*	won	16-9
v Western Counties *at Bristol*	won	22-14
v Wales *at Cardiff*	won	6-0
v Combined Services *at Twickenham*	won	23-9
v Midland Counties *at Leicester*	won	14-6
v Llanelli Club *at Llanelli*	won	22-8
v England *at Twickenham*	won	14-0
v North-Western Counties *at Manchester*	won	12-3

The 1967 team to the British Isles, France and Canada
Back row: P.H. Clarke, W.D. Cottrell, W.M. Birtwistle, G.F. Kember, W.J. Nathan, G.C. Williams, M.C. Wills, B.E. McLeod, A.G. Steel.
Second row: E.J. Hazlett, K.R. Tremain, I.A. Kirkpatrick, K.F. Gray, C.E. Meads, S.C. Strahan, A.E. Smith, A.E. Hopkinson, A.G. Jennings, B.L. Muller.
Front row: W.L. Davis, M.J. Dick, S.M. Going, I.R. MacRae (vice-captain), C.K. Saxton, B.J. Lochore (captain), F.R. Allen (coach), G.S. Thorne, E.W. Kirton, J. Major, W.F. McCormick.
In front: C.R. Laidlaw, M.A. Herewini.

v North-Eastern Counties *at Harrogate*	won	17-11
v North of Scotland *at Aberdeen*	won	15-3
v Scotland *at Murrayfield*	drew	0-0
v Leinster *at Dublin*	won	11-8
v Ulster *at Belfast*	won	24-5
v South-Eastern Counties *at Bournemouth*	won	9-6
v France B *at Toulouse*	won	17-8
v South-West France *at Bordeaux*	won	23-0
v France *at Paris*	won	12-3
v South-East France *at Lyon*	won	8-5
v Barbarian Club *at Cardiff*	won	36-3
v British Columbia under-25 XV *at Vancouver*	won	6-3
v British Columbia *at Vancouver*	won	39-3

Summary:
Played 36, won 34, drew 1, lost 1
Points for 613, against 159

1967 in BRITISH ISLES, FRANCE and CANADA
First match 14 October, last match 16 December.

Backs: W.F. McCormick *(Canterbury)*E.W.F.S. W.M. Birtwistle *(Waikato)*E.W.S. P.H. Clarke *(Marlborough)*, W.L. Davis *(Hawke's Bay)*E.W.F.S. M.J. Dick *(Auckland)*E.W.F. A.G. Steel *(Canterbury)*F.S. G.S. Thorne *(Auckland)*, W.D. Cottrell *(Canterbury)*, M.A. Herewini *(Auckland)*, G.F. Kember *(Wellington)*, E.W. Kirton *(Otago)*E.W.F.S. I.R. MacRae *(Hawke's Bay)*E.W.F.S. S.M. Going *(North Auckland)*F. C.R. Laidlaw *(Otago)*E.W.S
Forwards: K.F. Gray *(Wellington)*W.F.S. E.J. Hazlett *(Southland)*E. A.E. Hopkinson *(Canterbury)*S. A.G. Jennings *(Bay of Plenty)*, I.A. Kirkpatrick *(Canterbury)*F. B.J. Lochore *(Wairarapa)*E.W.F.S. J. Major *(Taranaki)*, C.E. Meads *(King Country)*E.W.F.S. B.L. Muller *(Taranaki)*E.W.F. B.E. McLeod *(Counties)*E.W.F.S. W.J. Nathan *(Auckland)*, A.E. Smith *(Taranaki)*, S.C. Strahan *(Manawatu)*E.W.F.S. K.R. Tremain *(Hawke's Bay)*E.W.S. G.C. Williams *(Wellington)*E.W.F.S. M.C. Wills *(Taranaki)*
Captain: B.J. Lochore
Manager. C.K. Saxton *(Otago)*
Assistant Manager: F.R. Allen *(Auckland)*

Tour record:

v British Columbia *at Vancouver*	won	36-3
v Eastern Canada *at Montreal*	won	40-3
v North of England *at Manchester*	won	33-3
v Midlands, London & Home Counties *at Leicester*	won	15-3
v South of England *at Bristol*	won	16-3
v England *at Twickenham*	won	23-11
v West Wales *at Swansea*	won	21-14
v Wales *at Cardiff*	won	13-6
v South-East France *at Lyon*	won	16-3
v France B *at Toulouse*	won	32-19
v South-West France *at Bayonne*	won	18-14
v France *at Paris*	won	21-15
v Scottish Districts *at Melrose*	won	35-14
v Scotland *at Edinburgh*	won	14-3
v Monmouthshire *at Newport*	won	23-12
v East Wales *at Cardiff*	drew	3-3
v Barbarians *at Twickenham*	won	11-6

Summary:
Played 17, won 16, drew 1
Points for 370, against 135

1968 in AUSTRALIA and FIJI
First match 21 May, last match 25 June.

Backs: W.F. McCormick *(Canterbury)*1,2. W.D.R. Currey *(Taranaki)*, W.L. Davis *(Hawke's Bay)*1,2. M.O. Knight *(Counties)*, A.G. Steel *(Canterbury)*1,2. G.S. Thorne *(Auckland)*1,2. W.D. Cottrell *(Canterbury)*1,2. P.A. Johns *(Wanganui)*, E.W. Kirton *(Otago)*1,2. T.N. Wolfe *(Taranaki)*, S.M. Going *(North Auckland)*, C.R. Laidlaw *(Canterbury)*1,2
Forwards: K.F. Gray *(Wellington)*1. A.E. Hopkinson *(Canterbury)*2. I.A. Kirkpatrick *(Canterbury)*1(r),2. A.J. Kreft *(Otago)*2. T.N. Lister *(South Canterbury)*1,2. B.J. Lochore *(Wairarapa)*1. T.M. McCashin *(Wellington)*, B.E. McLeod *(Counties)*1,2. C.E. Meads *(King Country)*1,2. B.L. Muller *(Taranaki)*1. S.C. Strahan *(Manawatu)*1,2. A.R. Sutherland *(Marlborough)*, K.R. Tremain *(Hawke's Bay)*1. G.C. Williams *(Wellington)*2
Captain: B.J. Lochore
Manager: D.K. Ross *(North Auckland)*
Assistant Manager: F.R. Allen *(Auckland)*

Tour record:

v Sydney *at Sydney*	won	14-9

v Tasmania *at Hobart*	won	74-0
v Junior Wallabies *at Adelaide*	won	43-3
v Victoria *at Melbourne*	won	68-0
v Australian Capital Territory *at Canberra*	won	44-0
v New South Wales *at Sydney*	won	30-5
v New South Wales Country *at Newcastle*	won	29-3
v Australian Combined Services *at Sydney*	won	45-8
v Australia *at Sydney*	won	27-11
v Queensland *at Brisbane*	won	34-3
v Australia *at Brisbane*	won	19-18
v Fiji President's XV *at Suva*	won	33-6

Summary:
Played 12, won 12
Points for 460, against 66

1970 in AUSTRALIA and SOUTH AFRICA
First match 20 June, last match 12 September.

Backs: W.F. McCormick *(Canterbury)*1,2,3. W.L. Davis *(Hawke's Bay)*2. M.J. Dick *(Auckland)*1,4. B.A. Hunter *(Otago)*, H.P. Milner *(Wanganui)*3. G.S. Thorne *(Auckland)*1,2,3,4. B.G. Williams *(Auckland)*1,2,3,4. W.D. Cottrell *(Canterbury)*1. B.D.M. Furlong *(Hawke's Bay)*4. G.F. Kember *(Wellington)*4. E.W. Kirton *(Otago)*2,3. I.R. MacRae *(Hawke's Bay)*1,2,3,4. S.M. Going *(North Auckland)*1(r),4. C.R. Laidlaw *(Otago)*1,2,3
Forwards: J.F. Burns *(Canterbury)*, B. Holmes *(North Auckland)*, A.E. Hopkinson *(Canterbury)*1,2,3. I.A. Kirkpatrick *(Poverty Bay)*1,2,3,4. T.N. Lister *(South Canterbury)*1,4. B.J. Lochore *(Wairarapa)*1,2,3,4. B.E. McLeod *(Counties)*1,2. C.E. Meads *(King Country)*3,4. B.L. Muller *(Taranaki)*1,2,4. K. Murdoch *(Otago)*4. A.E. Smith *(Taranaki)*1. S.C. Strahan *(Manawatu)*1,2,3. A.R. Sutherland *(Marlborough)*2,4. N.W. Thimbleby *(Hawke's Bay)*3. R.A. Urlich *(Auckland)*3,4. A.J. Wyllie *(Canterbury)*2,3
Captain: B.J. Lochore
Manager: R.L. Burk *(Auckland)*
Assistant Manager: I.M.H. Vodanovich *(Wellington)*

Tour record:

v President's XV *at Perth*	won	52-3
v Western Australia *at Perth*	won	50-3
v Border *at East London*	won	28-3
v Paul Roos Team *at Bethlehem*	won	43-9
v Griqualand West *at Kimberley*	won	27-3
v North-Western Cape *at Upington*	won	26-3
v South West Africa *at Windhoek*	won	16-0
v Eastern Transvaal *at Springs*	won	24-3
v Transvaal *at Johannesburg*	won	34-17
v Western Transvaal *at Potchefstroom*	won	21-17
v Orange Free State *at Bloemfontein*	won	30-12
v Rhodesia *at Salisbury*	won	27-14
v South Africa *at Pretoria*	lost	6-17
v Eastern Province *at Port Elizabeth*	won	49-8
v Boland *at Wellington*	won	35-9
v South Africa *at Cape Town*	won	9-8
v South-Western Districts *at George*	won	36-6
v Western Province *at Cape Town*	won	29-6
v South African Country *at East London*	won	45-8
v Natal *at Durban*	won	29-8
v Southern Universities *at Cape Town*	won	20-3
v South Africa *at Port Elizabeth*	lost	3-14
v North-Eastern Cape *at Burgersdorp*	won	85-0
v Northern Transvaal *at Pretoria*	won	19-15
v Gazelles *at Potchefstroom*	won	29-25
v South Africa *at Johannesburg*	lost	17-20

Summary:
Played 26, won 23, lost 3
Points for 789, against 234

1972-73 in BRITISH ISLES, FRANCE and NORTH AMERICA
First match 19 October, 1972, last match 10 February, 1973.

Backs: J.F. Karam *(Wellington)*W.S.E.I.F. T.J. Morris *(Nelson Bays)*, G.B. Batty *(Wellington)*W.S.E.I.F. D.A. Hales *(Canterbury)*W. I.A. Hurst *(Canterbury)*I.F. B.J. Robertson *(Counties)*S.E.I.F. G.R. Skudder *(Waikato)*, B.G.Williams *(Auckland)*W.S.E.I.F. R.E. Burgess *(Manawatu)*W.I.F. R.M. Parkinson *(Poverty Bay)*W.S.E. M.Sayers *(Wellington)*, I.N. Stevens *(Wellington)*S.E. G.L. Colling *(Otago)*, S.M. Going *(North Auckland)*W.S.E.I.F
Forwards: L.A. Clark *(Otago)*, I.M. Eliason *(Taranaki)*, A.M. Haden *(Auckland)*, B. Holmes *(North Auckland)*, I.A. Kirkpatrick *(Poverty Bay)*W.S.E.I.F. K.K. Lambert *(Manawatu)*S(r),E.I.F. H.H. Macdonald *(Canterbury)*W.S.E.I.F. A.L.R. McNicol *(Wanganui)*, J.D. Matheson *(Otago)*W.S.

K. Murdoch *(Otago)*w. R.W. Norton *(Canterbury)*w.s.e.i.f. A.I. Scown
*(Taranaki)*w(r).s. K.W. Stewart *(Southland)*, A.R. Sutherland
(Marlborough), G.J. Whiting *(King Country)*s.e.i.f. P.J. Whiting
*(Auckland)*w.s.e.i.f. A.J. Wyllie *(Canterbury)*w.e.i.f. R.A. Urlich
*(Auckland)*w.s.e.i.f
Captain: I.A. Kirkpatrick
Manager: E.L. Todd *(Wellington)*
Assistant Manager: R.H. Duff *(Canterbury)*

Tour record:

v British Columbia *at Vancouver*	won	31-3	
v New York Metropolitan *at New York*	won	41-9	
v Western Counties *at Gloucester*	won	39-12	
v Llanelli *at Llanelli*	lost	3-9	
v Cardiff *at Cardiff*	won	20-4	
v Cambridge University *at Cambridge*	won	34-3	
v London Counties *at Twickenham*	won	24-3	
v Leinster *at Dublin*	won	17-9	
v Ulster *at Belfast*	won	19-6	
v North-Western Counties *at Workington*	lost	14-16	
v Rest of Scottish Districts *at Hawick*	won	26-6	
v Gwent *at Ebbw Vale*	won	16-7	
v Wales *at Cardiff*	won	19-16	
v West Midland Counties *at Moseley*	lost	8-16	
v North-Eastern Counties *at Bradford*	won	9-3	
v Edinburgh & Glasgow *at Glasgow*	won	16-10	
v Scotland *at Murrayfield*	won	14-9	
v Southern Counties *at Oxford*	won	23-6	
v Combined Services *at Twickenham*	won	31-10	
v East Glamorgan *at Cardiff*	won	20-9	
v South-Western Counties *at Redruth*	won	30-7	
v England *at Twickenham*	won	9-0	
v Newport *at Newport*	won	20-15	
v East Midland Counties *at Leicester*	won	43-12	
v Munster *at Cork*	drew	3-3	
v Ireland *at Dublin*	drew	10-10	
v Neath & Aberavon *at Neath*	won	43-3	
v Barbarians *at Cardiff*	lost	11-23	
v South-Western France *at Tarbes*	won	12-3	
v France B *at Lyons*	won	23-8	
v Selection de L'Auvergne *at Clermond-Ferrand*	won	6-3	
v France *at Paris*	lost	6-13	

Summary:
Played 32, won 25, lost 5, drew 2
Points for 640, against 266

1974 in AUSTRALIA and FIJI
First match 1 May, last match 11 June.

Backs: J.F. Karam *(Wellington)*1,2,3, G.B. Batty *(Wellington)*1,3,
J.S. McLachlan *(Auckland)*2, B.G. Williams *(Auckland)*1,2,3, I.A. Hurst
*(Canterbury)*1,2, B.J. Robertson *(Counties)*, G.N. Kane *(Waikato)*,
J.E. Morgan *(North Auckland)*3, O.D. Bruce *(Canterbury)*, D.J. Robertson
*(Otago)*1,2,3, B.M. Gemmell *(Auckland)*1,2, I.N. Stevens *(Wellington)*3
Forwards: A.R. Leslie *(Wellington)*1,2,3, R.J. Barber *(Southland)*,
K.A. Eveleigh *(Manawatu)*, I.A. Kirkpatrick *(Poverty Bay)*1,2,3, L.G. Knight
(Auckland), K.W. Stewart *(Southland)*1,2,3, J.A. Callesen *(Manawatu)*1,2,3,
P.J. Whiting *(Auckland)*1,2,3, W.K.Te P. Bush *(Canterbury)*1,2, A.J. Gardiner
*(Taranaki)*3, K.J. Tanner *(Canterbury)*1,2,3, G.M. Crossman *(Bay of Plenty)*,
R.W. Norton *(Canterbury)*1,2,3
Captain: A.R. Leslie
Manager: L.A. Byars *(King Country)*
Assistant Manager: J.J. Stewart *(Wanganui)*

Tour record:

v South Australia *at Adelaide*	won	117-6	
v Western Australia *at Perth*	won	31-3	
v Victoria *at Melbourne*	won	41-3	
v Sydney *at Sydney*	won	33-10	

The 1972-73 team to the British Isles, France and North America
Back row: Bob Burgess, Bryan Williams, Tane Norton, Bruce Robertson, Kent Lambert, Ian Stevens.
Third row: Mike Parkinson, Jeff Matheson, Ken Stewart, Ron Urlich, Alex Wyllie, Mark Sayers, Keith Murdoch.
Second row: Alistair Scown, Ian Eliason, Hamish Macdonald, Andy Haden, Peter Whiting, Alan Sutherland, Graham Whiting, Bevan Holmes.
Front row: Ernie Todd (manager), Trevor Morris, Sid Going (vice-captain), Ian Kirkpatrick (captain), George Skudder, Ian Hurst, Bob Duff
 (coach).
In front: Lin Colling, Grant Batty, Duncan Hales, Joe Karam.

v New South Wales Country *at Dubbo*	won	27-4
v New South Wales *at Sydney*	won	20-0
v Australian Capital Territory *at Canberra*	won	49-0
v Australia *at Sydney*	won	11-6
v Queensland *at Brisbane*	won	42-6
v Australia *at Brisbane*	drew	16-16
v Queensland Country *at Toowoomba*	won	29-0
v Australia *at Sydney*	won	16-6
v Fiji XV *at Suva*	won	14-13

Summary:
Played 13, won 12, drew 1
Points for 446, against 73

1974 in IRELAND, WALES and ENGLAND
First match 6 November, last match 30 November.

Backs: J.F. Karam *(Wellington)**, K.T. Going *(North Auckland)*,
B.G. Williams *(Auckland)**, G.B. Batty *(Wellington)**, T.W. Mitchell
(Canterbury), B.J. Robertson *(Counties)**, G.N. Kane *(Waikato)*,
I.A. Hurst *(Canterbury)*, J.E. Morgan *(North Auckland)**, D.J. Robertson
*(Otago)**, O.D. Bruce *(Canterbury)*, S.M. Going *(North Auckland)**,
I.N. Stevens *(Wellington)*
Forwards: A.R. Leslie *(Wellington)**, L.G. Knight *(Auckland)*,
I.A. Kirkpatrick *(Poverty Bay)**, K.A. Eveleigh *(Manawatu)*,
K.W. Stewart *(Southland)**, P.J. Whiting *(Auckland)**, J.A. Callesen
(Manawatu), H.H. Macdonald *(Canterbury)*, W.K.Te P. Bush
(Canterbury), A.J. Gardiner *(Taranaki)*, K.J. Tanner *(Canterbury)**,
K.K. Lambert *(Manawatu)**, R.W. Norton *(Canterbury)**, G.M. Crossman
(Bay of Plenty)
Captain: A.R. Leslie
Manager: N.H. Stanley *(Taranaki)*
Assistant Manager: J.J. Stewart *(Wanganui)*

Tour record:

v Irish Universities *at Cork*	won	10-3
v Munster *at Limerick*	won	14-4
v Leinster *at Dublin*	won	8-3
v Ulster *at Belfast*	won	30-15
v Connacht *at Galway*	won	25-3
v Ireland *at Dublin*	won	15-6
v Welsh XV *at Cardiff*	won	12-3
v Barbarians *at Twickenham*	drew	13-13

Summary:
Played 8, won 7, drew 1
Points for 127, against 50

1976 in SOUTH AFRICA
First match 30 June, last match 18 September.

Backs: L.W. Mains *(Otago)*, C.L. Fawcett *(Auckland)*[2,3], B.G. Williams
(Auckland)[1,2,3,4], G.B. Batty *(Bay of Plenty)*[1,2,3,4], T.W. Mitchell
(Canterbury)[4(r)], N.A. Purvis *(Otago)*, B.J. Robertson *(Counties)*[1,2,3,4],
W.M. Osborne *(Wanganui)*[2(r),4(r)], J.E. Morgan *(North Auckland)*[2,3,4],
J.L. Jaffray *(Otago)*[1], D.J. Robertson *(Otago)*[1,3,4], O.D. Bruce *(Canterbury)*[1,2,4],
S.M. Going *(North Auckland)*[1,2,3,4], L.J. Davis *(Canterbury)*
Forwards: A.R. Leslie *(Wellington)*[1,2,3,4], A.R. Sutherland *(Marlborough)*,
I.A. Kirkpatrick *(Poverty Bay)*[1,2,3,4], L.G. Knight *(Poverty Bay)*,
K.A. Eveleigh *(Manawatu)*[2,4], K.W. Stewart *(Southland)*[1,3], H.H.
Macdonald *(North Auckland)*[1,2,3], F.J. Oliver *(Southland)*[4], P.J. Whiting
(Auckland)[1,2,3,4], G.A. Seear *(Otago)*, B.R. Johnstone *(Auckland)*[2],
K.K. Lambert *(Manawatu)*[1,3,4], W.K.Te P. Bush *(Canterbury)*[2,4], K.J. Tanner
(Canterbury), P.C. Harris *(Manawatu)*[3], R.W. Norton *(Canterbury)*[1,2,3,4],
G.M. Crossman *(Bay of Plenty)*
Captain: A.R. Leslie
Manager: N.H. Stanley *(Taranaki)*
Assistant Manager: J.J. Stewart *(Wanganui)*

Tour record:

v Border Invitation XV *at East London*	won	24-0
v Eastern Province *at Port Elizabeth*	won	28-15
v South African Coloureds *at Cape Town*	won	25-3
v South African Invitation XV *at Cape Town*	won	31-24
v Boland Invitation XV *at Wellington*	won	42-6
v Western Province *at Cape Town*	lost	11-12
v South African Gazelles *at Port Elizabeth*	won	21-15
v South Africa *at Durban*	lost	7-16
v Western Transvaal *at Potchefstroom*	won	42-3
v Transvaal *at Johannesburg*	won	12-10
v South African Universities *at Pretoria*	won	21-9

v Eastern Transvaal *at Springs*	won	26-12
v Orange Free State Country XV *at Bloemfontein*	won	31-6
v South Africa *at Bloemfontein*	won	15-9
v Quaggas Barbarians *at Johannesburg*	won	32-31
v Northern Transvaal *at Pretoria*	lost	27-29
v Transvaal Country *at Witbank*	won	48-13
v Natal *at Durban*	won	42-13
v South African Bantus *at East London*	won	31-0
v South Africa *at Cape Town*	lost	10-15
v North-West Cape XV *at Upington*	won	37-17
v Orange Free State *at Bloemfontein*	lost	10-15
v Griqualand West *at Kimberley*	won	26-3
v South Africa *at Johannesburg*	lost	14-15

Summary:
Played 24, won 18, lost 6
Points for 610, against 291

1976 in ARGENTINA
First match 12 October, last match 9 November.

Backs: G.D. Rowlands *(Bay of Plenty)*, R.G. Wilson *(Canterbury)*,
K.W. Granger *(Manawatu)*, S.C. Cartwright *(Canterbury)*, S.S. Wilson
(Wellington), E.J.T. Stokes *(Bay of Plenty)*, D.L. Rollerson *(Manawatu)*,
N.M. Taylor *(Bay of Plenty)*, L.J. Brake *(Bay of Plenty)*, M.B. Taylor
(Waikato), I.N. Stevens *(Wellington)*, K.M. Greene *(Waikato)*
Forwards: S.B. Conn *(Auckland)*, G.N.K. Mourie *(Taranaki)*,
M.W.R. Jaffray *(Otago)*, S.E.G. Cron *(Canterbury)*, P.J. Ryan *(Hawke's
Bay)*, J.A. Callesen *(Manawatu)*, A.M. Haden *(Auckland)*, V.E. Stewart
(Canterbury), J.T. McEldowney *(Taranaki)*, H.P. Sapsford *(Otago)*,
J.E. Spiers *(Counties)*, J.E. Black *(Canterbury)*, P.H. Sloane *(North
Auckland)*
Captain: G.N.K. Mourie
Manager: R.M. Don *(Auckland)*
Assistant Manager: J. Gleeson *(Manawatu)*

Tour record:

v Uruguay *at Montevideo*	won	64-3
v Buenos Aires Selection *at Buenos Aires*	won	24-13
v Interior Selection *at Cordoba*	won	30-13
v Casi *at Buenos Aires*	won	37-3
v Tucuman *at Tucuman*	won	51-15
v Argentina *at Buenos Aires*	won	21-9
v Rosario *at Rosario*	won	43-4
v Argentina *at Buenos Aires*	won	26-6
v Mendoza *at Mendoza*	won	25-6

Summary:
Played 9, won 9
Points for 321, against 72

1977 in ITALY and FRANCE
First match 22 October, last match 19 November.

Backs: B.W. Wilson *(Otago)*, B.G. Williams *(Auckland)*[1], B.R. Ford
(Marlborough), S.S. Wilson *(Wellington)*[1,2], B.J. Robertson *(Counties)*[1,2],
W.M. Osborne *(Wanganui)*[1(r),2], B.J. McKechnie *(Southland)*[1,2],
N.M. Taylor *(Bay of Plenty)*[1,2], O.D. Bruce *(Canterbury)*[1,2], K.M. Greene
(Waikato), M.W. Donaldson *(Manawatu)*[1,2]
Forwards: R.G. Myers *(Waikato)*, K.A. Eveleigh *(Manawatu)*, L.G.
Knight *(Poverty Bay)*[1,2], G.N.K. Mourie *(Taranaki)*, R.L. Stuart *(Hawke's
Bay)*[1(r)], A.M. Haden *(Auckland)*[1,2], G.A. Seear *(Otago)*[1,2], F.J. Oliver
(Southland)[1,2], J.C. Ashworth *(Canterbury)*, B.R. Johnstone *(Auckland)*[1,2],
G.A. Knight *(Manawatu)*[1,2], J.T. McEldowney *(Taranaki)*, J.E. Black
(Canterbury)[1], A.G. Dalton *(Counties)*[2]
Captain: G.N.K. Mourie
Manager: R.M. Don *(Auckland)*
Assistant Manager: J. Gleeson *(Manawatu)*

Tour record:

v Italian President's XV *at Padua*	won	17-9
v French Selection *at Brive*	won	45-3
v French Selection *at Lyon*	won	12-10
v French Selection *at Perpignan*	won	12-6
v French Selection *at Agen*	won	34-12
v French Selection *at Bayonne*	won	38-22
v France *at Toulouse*	lost	13-18
v French Selection *at Angouleme*	won	30-3
v France *at Paris*	won	15-3

Summary:
Played 9, won 8, lost 1
Points for 216, against 86

1978 in the BRITISH ISLES
First match 18 October, last match 16 December.

Backs: B.J. McKechnie *(Southland)*w(r),E.S. C.J. Currie *(Canterbury)*t.w.
R.G. Wilson *(Canterbury)*, B.G. Williams *(Auckland)*(r),W.E.S. S.S. Wilson
*(Wellington)*l,W.E.S. R. Kururangi *(Counties)*, B.R. Ford *(Marlborough)*l.
B.J. Robertson *(Counties)*W.E.S. W.M. Osborne *(Wanganui)*l,W.E.S. J.L. Jaffray
(Otago), N.M. Taylor *(Bay of Plenty)*l. O.D. Bruce *(Canterbury)*l,W.E.S.
E.J. Dunn *(North Auckland)*, M.W. Donaldson *(Manawatu)*l,E.S.
D.S. Loveridge *(Taranaki)*w
Forwards: A.A. McGregor *(Southland)*, G.A. Seear *(Otago)*l,W.E.S.
G.N.K. Mourie *(Taranaki)*l,W.E.S. B.G. Ashworth *(Auckland)*, W.G. Graham
(Otago), L.M. Rutledge *(Southland)*l,W.E.S. J.K. Fleming *(Wellington)*,
A.M. Haden *(Auckland)*l,W.E.S. J.K. Loveday *(Manawatu)*, F.J. Oliver
*(Otago)*l,W.E.S. J.C. Ashworth *(Canterbury)*, W.K.Te P. Bush *(Canterbury)*l,w.
B.R. Johnstone *(Auckland)*l,W.E.S. G.A. Knight *(Manawatu)*E.S. J.E. Black
(Canterbury), A.G. Dalton *(Counties)*l,W.E.S
Captain: G.N.K. Mourie
Manager: R.W. Thomas *(Canterbury)*
Assistant Manager: J. Gleeson *(Manawatu)*

Tour record:

v Cambridge University *at Cambridge*	won	32-12
v Cardiff *at Cardiff*	won	17-7
v West Wales *at Swansea*	won	23-7
v London Counties *at Twickenham*	won	37-12
v Munster *at Limerick*	lost	0-12
v Ireland *at Dublin*	won	10-6
v Ulster *at Belfast*	won	23-3
v Wales *at Cardiff*	won	13-12
v South and South-West England *at Bristol*	won	20-0
v Midland Counties *at Leicester*	won	20-15
v Combined Services *at Sandhurst*	won	34-6
v England *at Twickenham*	won	16-6
v Monmouthshire *at Newport*	won	26-9
v North of England *at Birkenhead*	won	9-6
v North & Midlands of Scotland *at Aberdeen*	won	31-3
v Scotland *at Edinburgh*	won	18-9
v Bridgend *at Bridgend*	won	17-6
v Barbarians *at Cardiff*	won	18-16

Summary:
Played 18, won 17, lost 1
Points for 364, against 147

1979 in AUSTRALIA
First match 24 July, second match 28 July.

Backs: B.W. Wilson *(Otago)**, S.S. Wilson *(Wellington)**, M.G. Watts
*(Taranaki)**, B.J. Robertson *(Counties)**, J.L. Jaffray *(South Canterbury)*,
B.J. McKechnie *(Southland)**, M.B. Taylor *(Waikato)**,
G.R. Cunningham *(Auckland)**, M.W. Donaldson *(Manawatu)**,
D.S. Loveridge *(Taranaki)*
Forwards: G.A. Seear *(Otago)**, L.M. Rutledge *(Southland)**,
M.J. McCool *(Wairarapa-Bush)**, G.N.K. Mourie *(Taranaki)**,
J.K. Fleming *(Wellington)*, A.M. Haden *(Auckland)**, G.A. Knight
*(Manawatu)**, W.K.Te P. Bush *(Canterbury)**, B.R. Johnstone
(Auckland), A.G. Dalton *(Counties)**, J.E. Black *(Canterbury)*
Captain: G.N.K. Mourie
Manager: R.W. Thomas *(Canterbury)*
Assistant Manager: E.A. Watson *(Otago)*

Tour record:

v Queensland B *at Brisbane*	won	35-3
v Australia *at Sydney*	lost	6-12

1979 in ENGLAND, SCOTLAND and ITALY
First match 24 October, last match 28 November.

Backs: R.G. Wilson *(Canterbury)*s.E. A.R. Hewson *(Wellington)*,
B.G. Fraser *(Wellington)*s.E. S.S. Wilson *(Wellington)*s.E. B.R. Ford
*(Marlborough)*E. G.R. Cunningham *(Auckland)*s.E. K.J. Keane
(Canterbury), T.M. Twigden *(Auckland)*, M.B. Taylor *(Waikato)*s.E.
E.J. Dunn *(North Auckland)*s. M.W. Donaldson *(Manawatu)*s(r).
D.S. Loveridge *(Taranaki)*s,E

The 1978 Grand Slam team to the British Isles
Back row: Doug Bruce, Brad Johnstone, Wayne Graham, Frank Oliver, John Fleming, Andy Haden, Gary Seear, John Loveday, Eddie Dunn.
Third row: Brian Ford, John Black, Ash McGregor, Barry Ashworth, Gary Knight, Bill Bush, Stu Wilson.
Second row: Brian McKenzie (physiotherapist), Robert Kururangi, Leicester Rutledge, Clive Currie, Bruce Robertson, John Ashworth, Dave
 Loveridge, Bill Osborne, Lyn Jaffray.
Front row: Brian McKechnie, Mark Donaldson, Mark Taylor, Russ Thomas (manager), Graham Mourie (captain), Jack Gleeson (coach), Andy
 Dalton, Bryan Williams.

Forwards: M.G. Mexted *(Wellington)*s.e. M.M. Burgoyne *(North Auckland)*, K.W. Stewart *(Southland)*s.e. G.N.K. Mourie *(Taranaki)*s.e. V.E. Stewart *(Canterbury)*, J.K. Fleming *(Wellington)*s.e. A.M. Haden *(Auckland)*s.e. J.E. Spiers *(Counties)*s.e. R.C. Ketels *(Counties)*, B.R. Johnstone *(Auckland)*s.e. B.A. Thompson *(Canterbury)*, A.G. Dalton *(Counties)*s. P.H. Sloane *(North Auckland)*e.
Captain: G.N.K. Mourie
Manager: R.W. Thomas *(Canterbury)*
Assistant Manager: E.A. Watson *(Otago)*

Tour record:

v London Division *at Twickenham*	won	21-18
v South of Scotland *at Hawick*	won	19-3
v Edinburgh *at Edinburgh*	won	16-4
v Midland Division *at Leicester*	won	33-7
v Glasgow *at Glasgow*	won	12-6
v Scotland *at Edinburgh*	won	20-6
v Anglo-Scots *at Dundee*	won	18-9
v Northern Division *at Otley*	lost	9-21
v South & South West Counties *at Exeter*	won	16-0
v England *at Twickenham*	won	10-9
v Italy *at Rovigo*	won	18-12

Summary:
Played 11, won 10, lost 1
Points for 192, against 95

1980 in AUSTRALIA and FIJI
First match 31 May, last match 23 July.

Backs: B.W. Codlin *(Counties)*1.2.3. R.G. Wilson *(Canterbury)*, S.S. Wilson *(Wellington)*1.2.3. M.G. Watts *(Taranaki)*1.2.3(r). B.G. Fraser *(Wellington)*3. G.R. Cunningham *(Auckland)*1.2. B.J. Robertson *(Counties)*2.3. T.M. Twigden *(Auckland)*2.3. L.M. Cameron *(Manawatu)*, W.R. Smith *(Canterbury)*1. N.H. Allen *(Counties)*3. M.B. Taylor *(Waikato)*1.2. A.C.R. Jefferd *(East Coast)*, D.S. Loveridge *(Taranaki)*1.2.3. M.W. Donaldson *(Manawatu)*
Forwards: M.G. Mexted *(Wellington)*1.2.3. G.R. Hines *(Waikato)*3. M.W. Shaw *(Manawatu)*1.2.3(r). L.M. Rutledge *(Southland)*1.2.3. G. Higginson *(Canterbury)*1.2.3(r). J.K. Fleming *(Wellington)*1.2.3. A.M. Haden *(Auckland)*1.2.3. J.E. Spiers *(Counties)*, B.R. Johnstone *(Auckland)*, G.A. Knight *(Manawatu)*1.2.3. J.C. Ashworth *(Canterbury)*1.2.3. J.E. Black *(Canterbury)*3. H.R. Reid *(Bay of Plenty)*1.2. R.G. Perry *(Mid Canterbury)*, K.C. Bloxham *(Otago)*
Captain: D.S. Loveridge
Manager: R.A.I. Harper *(Southland)*
Assistant Manager: E.A. Watson *(Otago)*

Tour record:

v Sydney *at Sydney*	drew	13-13
v South Australia *at Adelaide*	won	75-3
v Victoria *at Melbourne*	won	45-6
v Tasmanian Invitation XV *at Hobart*	won	73-0
v New South Wales *at Sydney*	won	12-4
v New South Wales Country *at Newcastle*	won	34-3
v Australia *at Sydney*	lost	9-13
v Queensland Country *at Townsville*	won	63-6
v Australia *at Brisbane*	won	12-9
v Australian Universities *at Brisbane*	won	33-3
v Queensland *at Brisbane*	lost	3-9
v Australian Capital Territory *at Canberra*	won	48-15
v Australia *at Sydney*	lost	10-26
v Nadroga *at Lautoka*	won	14-6
v Suva *at Suva*	won	33-4
v Fiji *at Suva*	won	30-6

Summary:
Played 16, won 12, lost 3, drew 1
Points for 507, against 126

1980 in NORTH AMERICA and WALES
First match 8 October, last match 1 November.

Backs: B.W. Codlin *(Counties)*, D.L. Rollerson *(Manawatu)**, S.S. Wilson *(Wellington)**, B.G. Fraser *(Wellington)**, F.A. Woodman *(North Auckland)*, W.M. Osborne *(Wanganui)**, B.J. Robertson *(Counties)**, M.B. Taylor *(Waikato)*, N.H. Allen *(Counties)**, D.S. Loveridge *(Taranaki)**, M.W. Donaldson *(Manawatu)*

Forwards: M.G. Mexted *(Wellington)**, G.H. Old *(Manawatu)*, G.N.K. Mourie *(Taranaki)**, M.W. Shaw *(Manawatu)**, G.R. Hines *(Waikato)*, G. Higginson *(Canterbury)**, A.M. Haden *(Auckland)**, F.J. Oliver *(Manawatu)*, G.A. Knight *(Manawatu)**, R.C. Ketels *(Counties)**, J.C. Ashworth *(Canterbury)*, A.G. Dalton *(Counties)*, H.R. Reid *(Bay of Plenty)**
Captain: G.N.K. Mourie
Manager: R.A. Harper *(Southland)*
Assistant Manager: E.A. Watson *(Otago)*

Tour record:

v United States of America *at San Diego*	won	53-6
v Canada *at Vancouver*	won	43-10
v Cardiff *at Cardiff*	won	16-9
v Llanelli *at Llanelli*	won	16-10
v Swansea *at Swansea*	won	32-0
v Newport *at Newport*	won	14-3
v Wales *at Cardiff*	won	23-3

Summary:
Played 7, won 7
Points for 197, against 41

1981 in ROMANIA and FRANCE
First match 20 October, last match 21 November.

Backs: A.R. Hewson *(Wellington)*R.F.1.2. B.G. Fraser *(Wellington)*R.F.1.2. S.S. Wilson *(Wellington)*R.F.1.2. F.A. Woodman *(North Auckland)*F.2. J.L.B. Salmon *(Wellington)*R.F.1.2(r). A.M. Stone *(Waikato)*F.1.2. L.M. Cameron *(Manawatu)*R. S.T. Pokere *(Southland)*, D.L. Rollerson *(Manawatu)*R.F.1(r).2. B.J. McKechnie *(Southland)*F.1. J.W. Boe *(Waikato)*, D.S. Loveridge *(Taranaki)*R.F.1.2. A.J. Donald *(Wanganui)*
Forwards: M.G. Mexted *(Wellington)*R.F.1.2. G.H. Old *(Manawatu)*R(r). B.L. Morrissey *(Waikato)*, G.N.K. Mourie *(Taranaki)*F.1.2. M.W. Shaw *(Manawatu)*R.F.1.2. F.N.K. Shelford *(Bay of Plenty)*R. A.M. Haden *(Auckland)*R.F.1.2. G.W. Whetton *(Auckland)*R.F.1.2. J.C. Ross *(Mid Canterbury)*, R.C. Ketels *(Counties)*R.F.1. T.T. Koteka *(Waikato)*F.2. W.N. Neville *(North Auckland)*, J.E. Spiers *(Counties)*R.F.1.2. H.R. Reid *(Bay of Plenty)*, A.G. Dalton *(Counties)*R.F.1.2
Captain: G.N.K. Mourie
Manager: P.J. Gill *(Wellington)*
Assistant Manager: P.S. Burke *(Taranaki)*

Tour record

v Romania South *at Consanta*	won	25-9
v Romania *at Bucharest*	won	14-6
v Alsace-Lorraine *at Strasbourg*	won	15-13
v Auvergne Selection *at Clermont-Ferrand*	won	18-10
v Alpes Selection *at Grenoble*	lost	16-18
v French Barbarians *at Bayonne*	won	28-18
v Languedoc-Roussillon Selection *at Perpignan*	drew	6-6
v France *at Toulouse*	won	13-9
v Charentes-Poitou XV *at La Rochelle*	won	17-13
v France *at Paris*	won	18-6

Summary:
Played 10, won 8, drew 1, lost 1
Points for 170, against 108

1983 in AUSTRALIA
20 August.

Backs: A.R. Hewson *(Wellington)*, S.S. Wilson *(Wellington)*, B.G. Fraser *(Wellington)*, S.T. Pokere *(Southland)*, W.T. Taylor *(Canterbury)*, I.T.W. Dunn *(North Auckland)*, D.S. Loveridge *(Taranaki)*
Forwards: M.G. Mexted *(Wellington)*, M.W. Shaw *(Manawatu)*, M.J.B. Hobbs *(Canterbury)*, A.M. Haden *(Auckland)*, G. Higginson *(Hawke's Bay)*, G.A. Knight *(Manawatu)*, J.C. Ashworth *(Canterbury)*, A.G. Dalton *(Counties)*
Captain: A.G. Dalton
Manager: P.W. Mitchell *(Wanganui)*
Assistant Manager: D.B. Rope *(Auckland)*

Tour record:

v Australia *at Sydney*	won	18-8

1983 in ENGLAND and SCOTLAND
First match 26 October, last match 19 November.

Backs: R.M. Deans *(Canterbury)*s.e. K.J. Crowley *(Taranaki)*, S.S. Wilson *(Wellington)*s.e. B.G. Fraser *(Wellington)*s.e. B.W. Smith *(Waikato)*,

C.I. Green *(Canterbury)*s(r),E. S.T. Pokere *(Southland)*s.E. W.T. Taylor *(Canterbury)*s. I.T.W. Dunn *(North Auckland)*, W.R. Smith *(Canterbury)*s.E. D.E. Kirk *(Otago)*, A.J. Donald *(Wanganui)*s.E.
Forwards: M.G. Mexted *(Wellington)*s.E. G.H. Old *(Manawatu)*, M.W. Shaw *(Manawatu)*s.E. F.N.K. Shelford *(Hawke's Bay)*, M.J.B. Hobbs *(Canterbury)*s.E. A.G. Robinson *(North Auckland)*, G.J. Braid *(Bay of Plenty)*s.E. A. Anderson *(Canterbury)*s.E. K.G. Boroevich *(King Country)*, M.G. Davie *(Canterbury)*E(r). B. McGrattan *(Wellington)*s.E. S. Crichton *(Wellington)*s.E. H.B. Wilson *(Counties)*, H.R. Reid *(Bay of Plenty)*s.E.
Captain: S.S. Wilson
Manager: P.W. Mitchell *(Wanganui)*
Assistant Manager: D.B. Rope *(Auckland)*

Tour record:

v Edinburgh *at Edinburgh*	won	22-6
v South of Scotland *at Hawick*	won	30-9
v Northern Division *at Gateshead*	won	27-21
v London Division *at Twickenham*	won	18-15
v Midland Division *at Leicester*	lost	13-19
v Scotland *at Murrayfield*	drew	25-25
v South and South-West England *at Bristol*	won	18-6
v England *at Twickenham*	lost	9-15

Summary:
Played 8, won 5, drew 1, lost 2
Points for 162, against 116

1984 in AUSTRALIA
First match 4 July, last match 18 August.

Backs: R.M. Deans *(Canterbury)*1(r),2,3. A.R. Hewson *(Wellington)*1. B.W. Smith *(Waikato)*1. M. Clamp *(Wellington)*2,3. J.J. Kirwan *(Auckland)*, B.G. Fraser *(Wellington)*1. T.B.K. Woodman *(North Auckland)*, C.I. Green *(Canterbury)*1,2,3. S.T. Pokere *(Auckland)*2,3. A.M. Stone *(Waikato)*3. W.T. Taylor *(Canterbury)*1,2. I.T.W. Dunn *(North Auckland)*, W.R. Smith *(Canterbury)*1,2,3. D.E. Kirk *(Otago)*, A.J. Donald *(Wanganui)*1,2,3
Forwards: M.G. Mexted *(Wellington)*1,2,3. A.J. Whetton *(Auckland)*1(r),3(r). M.W. Shaw *(Manawatu)*1. M.J.B. Hobbs *(Canterbury)*1,2,3. F.N.K. Shelford *(Bay of Plenty)*, G.J. Braid *(Bay of Plenty)*, M.J. Pierce *(Wellington)*, G.W. Whetton *(Auckland)*1,2,3. A.Anderson *(Canterbury)*1,2,3. K.G. Boroevich *(King Country)*, B. McGrattan *(Wellington)*, G.A. Knight *(Manawatu)*1,2,3. J.C. Ashworth *(Canterbury)*1,2,3. A.G. Dalton *(Counties)*1,2,3. H.R. Reid *(Bay of Plenty)*
Captain: A.G. Dalton
Manager: R.J. Littlejohn *(Bay of Plenty)*
Assistant Manager: D.B. Rope *(Auckland)*

Tour record:

v Queensland 'B' *at Brisbane*	won	37-0
v New South Wales *at Sydney*	won	37-10
v South Australia *at Adelaide*	won	99-0
v Western Australia *at Perth*	won	72-0
v Victoria *at Melbourne*	won	65-3
v Australia *at Sydney*	lost	9-16
v ACT *at Canberra*	won	40-16
v Sydney *at Sydney*	won	28-3
v NSW Country *at Tamworth*	won	21-3
v Australia *at Brisbane*	won	19-15
v Queensland Country *at Surfers Paradise*	won	88-0
v Queensland *at Brisbane*	won	39-12
v New South Wales 'B' *at Gosford*	won	21-15
v Australia *at Sydney*	won	25-24

Summary:
Played 14, won 13, lost 1
Points for 600, points against 117

1984 in FIJI
First match 17 October, last match 27 October.

Backs: M.C. Finlay *(Manawatu)*, K.J. Crowley *(Taranaki)*, M. Clamp *(Wellington)*, T.B.K. Woodman *(North Auckland)*, C.I. Green *(Canterbury)*, S.T. Pokere *(Auckland)*, W.T. Taylor *(Canterbury)*, A.M. Stone *(Waikato)*, G.J. Fox *(Auckland)*, W.R. Smith *(Canterbury)*, D.E. Kirk *(Otago)*, A.J. Donald *(Wanganui)*
Forwards: M.G. Mexted *(Wellington)*, M.J.B. Hobbs *(Canterbury)*, A.J. Whetton *(Auckland)*, M.W. Shaw *(Manawatu)*, F.N.K. Shelford *(Bay of Plenty)*, G.W. Whetton *(Auckland)*, A.M. Haden *(Auckland)*, M.J. Pierce *(Wellington)*, B. McGrattan *(Wellington)*, S. Crichton *(Wellington)*, K.G. Boroevich *(King Country)*, H.R. Reid *(Bay of Plenty)*, J.G. Mills *(Auckland)*, A. Anderson *(Canterbury)*

Captain: M.J.B. Hobbs
Manager: R.J. Littlejohn *(Bay of Plenty)*
Assistant Manager: D.B. Rope *(Auckland)*

Tour record:

v President's XV *at Suva*	won	39-0
v Western XV *at Nadi*	won	32-10
v Eastern XV *at Suva*	won	58-0
v Fiji *at Suva*	won	45-0

Summary:
Played 4, won 4
Points for 174, points against 10

1985 in ARGENTINA
First match 12 October, last match 2 November.

Backs: K.J. Crowley *(Taranaki)*1,2. R.M. Deans *(Canterbury)*, J.J. Kirwan *(Auckland)*1,2. C.I. Green *(Canterbury)*1,2. B.G. Robins *(Taranaki)*, M. Clamp *(Wellington)*, S.T. Pokere *(Auckland)*, V.L.J. Simpson *(Canterbury)*, K. Sherlock *(Auckland)*, W.T. Taylor *(Canterbury)*1,2. G.J. Fox *(Auckland)*1. W.R. Smith *(Canterbury)*2. D.E. Kirk *(Auckland)*1. D.S. Loveridge *(Taranaki)*2.
Forwards: M.G. Mexted *(Wellington)*1,2. W.T. Shelford *(North Harbour)*, A.J. Whetton *(Auckland)*1(r). M.J.B. Hobbs *(Canterbury)*1,2. F.N.K. Shelford *(Bay of Plenty)*, M.W. Shaw *(Manawatu)*1,2. G.W. Whetton *(Auckland)*2. A. Anderson *(Canterbury)*1. A.M. Haden *(Auckland)*1,2. G.A. Knight *(Manawatu)*, S.C. McDowell *(Auckland)*1,2. B. McGrattan *(Wellington)*1,2. S. Crichton *(Wellington)*, J.A. Drake *(Auckland)*, B.S. Hemara *(Manawatu)*, H.R. Reid *(Bay of Plenty)*1,2
Captain: M.J.B. Hobbs
Manager: R.J. Littlejohn *(Bay of Plenty)*
Assistant Manager: B.J. Lochore *(Wairarapa-Bush)*

Tour record:

v Club Atletico San Isidro *at Buenos Aires*	won	22-9
v Rosario Selection *at Rosario*	won	28-9
v Buenos Aires Selection *at Buenos Aires*	won	31-13
v Cordoba Selection *at Cordoba*	won	72-9
v Argentina *at Buenos Aires*	won	33-20
v Mar Del Plata Selection *at Mar Del Plata*	won	56-6
v Argentina *at Buenos Aires*	drew	21-21

Summary:
Played 7, won 6, drew 1
Points for 263, against 87

1986 in FRANCE
First match 21 October, last match 15 November.

Backs: K.J. Crowley *(Taranaki)*1,2. J.A. Gallagher *(Wellington)*, C.I. Green *(Canterbury)*1,2. J.J. Kirwan *(Auckland)*1,2. T.J. Wright *(Auckland)*, J.T. Stanley *(Auckland)*1,2. M.J. Berry *(Wairarapa-Bush)*, A.M. Stone *(Bay of Plenty)*1,2. F.M. Botica *(North Harbour)*, G.J. Fox *(Auckland)*, D.E. Kirk *(Auckland)*1,2. D.J. Kenny *(Otago)*
Forwards: W.T. Shelford *(North Harbour)*1,2. M.R. Brewer *(Otago)*1,2. M. Brooke-Cowden *(Auckland)*, A.T. Earl *(Canterbury)*2(r). M.J.B. Hobbs *(Canterbury)*1,2. M.W. Shaw *(Hawke's Bay)*, M.J. Pierce *(Wellington)*1,2. M.W. Speight *(North Auckland)*, G.W. Whetton *(Auckland)*1,2. K.G. Boroevich *(Wellington)*2(r). J.A. Drake *(Auckland)*1,2. S.C. McDowell *(Auckland)*1,2. R.W. Loe *(Waikato)*, S.B.T. Fitzpatrick *(Auckland)*1,2. H.R. Reid *(Bay of Plenty)*
Captain: M.J.B. Hobbs
Manager: R.A. Guy *(North Auckland)*
Assistant Manager: B.J. Lochore *(Wairarapa-Bush)*

Tour record:

v French Selection *at Strasbourg*	won	42-12
v French Selection *at Clermont-Ferrand*	won	23-19
v French Selection *at Toulon*	won	25-6
v Roussillon-Languedoc Selection *at Perpignan*	won	59-6
v Cote de Basque Selection *at Bayonne*	won	21-9
v France *at Toulouse*	won	19-7
v French Barbarians *at La Rochelle*	won	26-12
v France *at Nantes*	lost	3-16

Summary:
Played 8, won 7, lost 1
Points for 218, against 87

1987 in AUSTRALIA
25 July.

Backs: J.A. Gallagher *(Wellington)*, C.I. Green *(Canterbury)*, J.J. Kirwan *(Auckland)*, J.T. Stanley *(Auckland)*, W.T. Taylor *(Canterbury)*, G.J. Fox *(Auckland)*, D.E. Kirk *(Auckland)*
Forwards: W.T. Shelford *(North Harbour)*, A.J. Whetton *(Auckland)*, G.W. Whetton *(Auckland)*, M.J. Pierce *(Wellington)*, M.N. Jones *(Auckland)*, J.A. Drake *(Auckland)*, S.B.T. Fitzpatrick *(Auckland)*, S.C. McDowell *(Auckland)*
Captain: D.E. Kirk
Manager: R.A. Guy *(North Auckland)*

Tour record:

v Australia at Sydney	won	30-16

1987 in JAPAN
First match 21 October, last match 4 November.

Backs: J.A. Gallagher *(Wellington)*, T.J. Wright *(Auckland)*, J.J. Kirwan *(Auckland)*, P.L.J. Simonsson *(Waikato)*, M.J.A. Cooper *(Hawke's Bay)*, B.J. McCahill *(Auckland)*, N.J. Schuster *(Wellington)*, F.M. Botica *(North Harbour)*, G.J. Fox *(Auckland)*, I.B. Deans *(Canterbury)*, G.T.M. Bachop *(Canterbury)*
Forwards: W.T. Shelford *(North Harbour)*, Z.V. Brooke *(Auckland)*, A.J. Whetton *(Auckland)*, M.R. Brewer *(Otago)*, G.W. Whetton *(Auckland)*, A.T. Earl *(Canterbury)*, B.L. Anderson *(Wairarapa-Bush)*, S.C. McDowell *(Auckland)*, R.W. Loe *(Waikato)*, R.J. McLean *(Wairarapa-Bush)*, S.B.T. Fitzpatrick *(Auckland)*, J.A.S. Buchan *(Canterbury)*
Captain: W.T. Shelford
Manager: M.J. Dick *(Auckland)*
Coach: J.B. Hart *(Auckland)*
Assistant coach: A.J. Wyllie *(Canterbury)*

Tour record:

v Japan B at Tokyo	won	94-0
v Japan at Osaka	won	74-0
v Asian Barbarians at Kyoto	won	96-3
v Japan at Tokyo	won	106-4
v President's XV at Tokyo	won	38-9

Summary:
Played 5, won 5
Points for 408, against 16

1988 in AUSTRALIA
First match 19 June, last match 30 July.

Backs: J.A. Gallagher *(Wellington)*[1,2,3], J.A. Goldsmith *(Waikato)*, J.J. Kirwan *(Auckland)*[1,2,3], T.J. Wright *(Auckland)*[1,2,3], J.T. Stanley *(Auckland)*[1,2,3], S. Philpott *(Canterbury)*, W.T. Taylor *(Canterbury)*, N.J. Schuster *(Wellington)*[1,2,3], B.J. McCahill *(Auckland)*, F.M. Botica *(North Harbour)*, G.J. Fox *(Auckland)*[1,2,3], G.T.M. Bachop *(Canterbury)*, I.B. Deans *(Canterbury)*[1,2,3]
Forwards: W.T. Shelford *(North Harbour)*[1,2,3], Z.V. Brooke *(Auckland)*[1,2,3], M.R. Brewer *(Otago)*[1], M.N. Jones *(Auckland)*[2,3], A.J. Whetton *(Auckland)*[1,2,3], A. Anderson *(Canterbury)*, G.W. Whetton *(Auckland)*[1,2,3], M.J. Pierce *(Wellington)*[1,2,3], A.T. Earl (Canterbury), R.O. Williams *(North Harbour)*, S.C. McDowell *(Auckland)*[1,2,3], R.W. Loe *(Waikato)*[1,2,3], K.G. Boroevich *(North Harbour)*, S.B.T. Fitzpatrick *(Auckland)*[1,2,3], W.D. Gatland *(Waikato)*
Captain: W.T. Shelford
Manager: J.A. Sturgeon *(West Coast)*
Coach: A.J. Wyllie *(Canterbury)*
Assistant coach: P.L. Penn *(Wairarapa-Bush)*

Tour record:

v Western Australia at Perth	won	60-3
v Randwick at Sydney	won	25-9
v Australia B at Brisbane	won	28-4
v NSW Country at Singleton	won	29-4
v Australia at Sydney	won	32-7
v ACT at Quenbeyan	won	16-3
v Queensland at Brisbane	won	27-12
v Queensland B at Townsville	won	39-3
v Australia at Brisbane	drew	19-19
v New South Wales B at Gosford	won	45-9
v New South Wales at Sydney	won	42-6
v Victorian Invitation XV at Melbourne	won	84-8
v Australia at Sydney	won	30-9

Summary:
Played 13, won 12, drew 1
Points for 476, against 96

1989 in CANADA, GREAT BRITAIN and IRELAND
First match 8 October, last match 25 November.

Backs: J.A. Gallagher *(Wellington)*[W.I.], M.J. Ridge *(Auckland)*, J.J. Kirwan *(Auckland)*, V.I. Tuigamala *(Auckland)*, T.J. Wright *(Auckland)*[W.I.], J.K.R. Timu *(Otago)*, C.R. Innes *(Auckland)*[W.I.], B.J. McCahill *(Auckland)*, J.T. Stanley *(Auckland)*[W.I.], W.K. Little *(North Harbour)*, N.J. Schuster *(Wellington)*[W.I.], F.M. Botica *(North Harbour)*, G.J. Fox *(Auckland)*[W.I.], G.T.M. Bachop *(Canterbury)*[W.I.], I.B. Deans *(Canterbury)*
Forwards: Z.V. Brooke *(Auckland)*, W.T. Shelford *(North Harbour)*[W.I.], M.R. Brewer *(Otago)*[W.I.], A.T. Earl *(Canterbury)*[W.I.], P.W. Henderson *(Otago)*, A.J. Whetton *(Auckland)*, K.J. Schuler *(Manawatu)*, S.B. Gordon *(Waikato)*, I.D. Jones *(North Auckland)*, M.J. Pierce, *(Wellington)*[W.I.], G.W. Whetton *(Auckland)*[W.I.], R.W. Loe *(Waikato)*[W.I.], S.C. McDowell *(Auckland)*[W.I.], G.H. Purvis *(Waikato)*, R.O. Williams *(North Harbour)*, S.B.T. Fitzpatrick *(Auckland)*[W.I.], W.D. Gatland *(Waikato)*
Captain: W.T. Shelford
Manager: J.A. Sturgeon *(West Coast)*
Coach: A.J. Wyllie *(Canterbury)*

Tour record:

v British Columbia at Vancouver	won	47-6
v Cardiff at Cardiff	won	25-15
v Pontypool at Pontypool	won	47-6
v Swansea at Swansea	won	37-22
v Neath at Neath	won	26-15
v Llanelli at Llanelli	won	11-0
v Newport at Newport	won	54-9
v Wales at Cardiff	won	34-9
v Leinster at Dublin	won	36-9
v Munster at Cork	won	31-9
v Connacht at Galway	won	40-6
v Ireland at Dublin	won	23-6
v Ulster at Belfast	won	21-3
v Barbarians at London	won	21-10

Summary:
Played 14, won 14
Points for 454, against 122

1990 in FRANCE
First match 17 October, last match 10 November

Backs: K.J. Crowley *(Taranaki)*[1,2], S. Philpott *(Canterbury)*, J.J. Kirwan *(Auckland)*[1,2], V.I. Tuigamala *(Auckland)*, J.K.R. Timu *(Otago)*, T.J. Wright *(Auckland)*[1,2], C.R. Innes *(Auckland)*[1,2], J.T. Stanley *(Auckland)*, W.K. Little *(North Harbour)*[1,2], B.J. McCahill *(Auckland)*, G.J. Fox *(Auckland)*[1,2], S.J. Mannix *(Wellington)*, G.T.M. Bachop *(Canterbury)*[1,2], P.W. McGahan *(North Harbour)*
Forwards: Z.V. Brooke *(Auckland)*[1(t)], W.R. Gordon *(Waikato)*, M.R. Brewer *(Otago)*[1,2], P.W. Henderson *(Otago)*, M.N. Jones *(Auckland)*[1,2], A.J. Whetton *(Auckland)*[1,2], S.B. Gordon *(Waikato)*, I.D. Jones *(North Auckland)*[1,2], M.J. Pierce *(Wellington)*, G.W. Whetton *(Auckland)*[1,2], L.C. Hullena *(Wellington)*, R.W. Loe *(Waikato)*[1,2], S.C. McDowell *(Auckland)*[1,2], G.H. Purvis *(Waikato)*, O.M. Brown *(Auckland)*, S.B.T. Fitzpatrick *(Auckland)*[1,2], W.D. Gatland *(Waikato)*
Captain: G.W. Whetton
Manager: J.A. Sturgeon *(West Coast)*
Coach: A.J. Wyllie (Canterbury)

Tour record:

v Provence-Cote d'Azur Selection at Toulon	lost	15-19
v Languedoc Selection at Narbonne	won	22-6
v A French XV at Brive	won	27-24
v French Barbarians at Agen	won	23-13
v Cote Basque-Landes Selection at Bayonne	lost	12-18
v France at Nantes	won	24-3
v A French XV at La Rochelle	won	22-15
v France at Paris	won	30-12

Summary:
Played 8, won 6, lost 2
Points for 175, against 110

1991 in ARGENTINA
First match 15 June, last match 13 July.

Backs: K.J. Crowley *(Taranaki)*₁,₂, S. Philpott *(Canterbury)*, J.J. Kirwan *(Auckland)*₂, T.J. Wright *(Auckland)*₁,₂, J.K.R. Timu *(Otago)*₁, C.R. Innes *(Auckland)*₁,₂, J.T. Stanley *(Auckland)*, W.K. Little *(North Harbour)*₁,₂, B.J. McCahill *(Auckland)*, G.J. Fox *(Auckland)*₁,₂, S.J. Mannix *(Wellington)*, G.T.M. Bachop *(Canterbury)*₁,₂, P.W. McGahan *(North Harbour)*
Forwards: M.R. Brewer *(Otago)*, Z.V. Brooke *(Auckland)*₂, A.T. Earl *(Canterbury)*₁(r), P.W. Henderson *(Otago)*₁, M.N. Jones *(Auckland)*₁,₂, A.J. Whetton *(Auckland)*₁, S.B. Gordon *(Waikato)*, I.D. Jones *(North Auckland)*₁,₂, C.D. Tregaskis *(Wellington)*, G.W. Whetton *(Auckland)*₁,₂, L.C. Hullena *(Wellington)*, R.W. Loe *(Waikato)*₁,₂, S.C. McDowell *(Auckland)*₁,₂, G.H. Purvis *(Waikato)*, S.B.T. Fitzpatrick *(Auckland)*₁,₂, W.D. Gatland *(Waikato)*
Captain: G.W. Whetton
Manager: J.A. Sturgeon *(West Coast)*
Coach: A.J. Wyllie *(Canterbury)*
Assistant coach: P.L. Penn *(Wairarapa-Bush)*

Tour record:

v Rosario *at Rosario*	won	81-9
v Cordoba *at Cordoba*	won	38-9
v Buenos Aires *at Buenos Aires*	won	37-9
v Tucuman *at Tucuman*	won	21-9
v Argentina B *at Buenos Aires*	won	22-6
v Cuyo *at Mendoza*	won	47-12
v Argentina *at Buenos Aires*	won	28-14
v Mar del Plata *at Mar del Plata*	won	48-6
v Argentina *at Buenos Aires*	won	36-6

Summary:
Played 9, won 9
Points for 358, against 80

1991 in AUSTRALIA
10 August

Backs: T.J. Wright *(Auckland)*, J.J. Kirwan *(Auckland)*, J.K.R. Timu *(Otago)*, C.R. Innes *(Auckland)*, W.K. Little *(North Harbour)*, G.J. Fox *(Auckland)*, G.T.M. Bachop *(Canterbury)*
Forwards: Z.V. Brooke *(Auckland)*, A.T. Earl *(Canterbury)*, M.N. Jones *(Auckland)*, I.D. Jones *(North Auckland)*, G.W. Whetton *(Auckland)*, R.W. Loe *(Waikato)*, S.C. McDowell *(Auckland)*, S.B.T. Fitzpatrick *(Auckland)*
Captain: G.W. Whetton
Manager: J.A. Sturgeon *(West Coast)*
Coach: A.J. Wyllie *(Canterbury)*

Record:

v Australia *at Sydney*	lost	12-21

1991 at WORLD CUP in UNITED KINGDOM, IRELAND and FRANCE
First match 3 October, last match 30 October.

Backs: K.J. Crowley *(Taranaki)*ₐ, S. Philpott *(Canterbury)*(r)I,(r)S, T.J Wright *(Auckland)*ₑ,US,I,S, J.J. Kirwan *(Auckland)*ₑ,I,C,A,S,A, J.K.R. Timu *(Otago)*ₑ,US,C,A, V.I. Tuigamala *(Auckland)*US,I,C,S, C.R. Innes *(Auckland)*ₑ,US,I,C,A,S, W.K. Little *(North Harbour)*I,S, B.J. McCahill *(Auckland)*ₑ,US,C,A, G.J. Fox *(Auckland)*ₑ,I,C,A, J.P. Preston *(Canterbury)*US,S, G.T.M Bachop *(Canterbury)*ₑ,US,C,A,S, J.A. Hewett *(Auckland)*I
Forwards: Z.V. Brooke *(Auckland)*ₑ,I,C,A,S, A.T. Earl *(Canterbury)*ₑ(r),US,S, M.P. Carter *(Auckland)*I,A, P.W. Henderson *(Otago)*C, M.N. Jones *(Auckland)*ₑ,US,S, A.J. Whetton *(Auckland)*ₑ,US,I,C,A, S.B. Gordon *(Waikato)*, I.D. Jones *(North Auckland)*ₑ,US,I,C,A,S, G.W. Whetton *(Auckland)*ₑ,US,I,C,A,S, R.W. Loe *(Waikato)*ₑ,I,C,A,S, S.C. McDowell *(Auckland)*ₑ,US,I,C,A,S, G.H. Purvis *(Waikato)*US, G.W. Dowd *(North Harbour)*I, S.B.T. Fitzpatrick *(Auckland)*ₑ,US,I,C,A,S
Captain: G.W. Whetton
Manager: J.A. Sturgeon *(West Coast)*
Co-coaches: A.J. Wyllie *(Canterbury)*, J.B.Hart *(Auckland)*

Tour record:

v England *at London*	won	18-12
v United States *at Gloucester*	won	46-6
v Italy *at Leicester*	won	31-21
v Canada, quarterfinal *at Lille*	won	29-13
v Australia, semifinal *at Dublin*	lost	6-16
v Scotland, playoff *at Cardiff*	won	13-6

Summary:
Played 6, won 5, lost 1
Points for 143, against 74

1992 in AUSTRALIA and SOUTH AFRICA
First match 21 June, last match 15 August.

Backs: M.J.A. Cooper *(Waikato)*SA(r), T.J. Wright *(Auckland)*, J.J. Kirwan *(Auckland)*₁,₂,₃,SA, J.K.R. Timu *(Otago)*₁,₂,₃,SA, V.I. Tuigamala *(Auckland)*₁,₂,₃,SA, E.J. Rush *(North Harbour)*, F.E. Bunce *(North Harbour)*₁,₂,₃,SA, M.C.G. Ellis *(Otago)*, E. Clarke *(Auckland)*, W.K. Little *(North Harbour)*₁,₂,₃,SA, S.J. Bachop *(Otago)*, G.J. Fox *(Auckland)*, J.P. Preston *(Canterbury)*SA(r), A.D. Strachan *(Auckland)*₁,₂,₃,SA, G.T.M. Bachop *(Canterbury)*
Forwards: Z.V. Brooke *(Auckland)*₂,₃,SA, A.R.B. Pene *(Otago)*₁,₂(r), M.R. Brewer *(Otago)*₁, P.W. Henderson *(Southland)*, M.N. Jones *(Auckland)*₁,₃,SA, J.W. Joseph *(Otago)*₃,SA, K.J. Schuler *(North Harbour)*₂, A.T. Earl *(Canterbury)*₂,₃(r), D.J. Seymour *(Canterbury)*₂,₃(r), G.L. Taylor *(North Auckland)*, P.R. Lam *(Auckland)*,R.M. Brooke *(Auckland)*₁,₂,₃,SA, M.S.B. Cooksley *(Counties)*, I.D. Jones *(North Auckland)*₁,₂,₃,SA, B.P. Larsen *(North Harbour)*, O.M. Brown *(Auckland)*₁,₂,₃,SA, R.W. Loe *(Waikato)*₁,₂,₃,SA, S.C. McDowell *(Auckland)*, G.H. Purvis *(Waikato)*, G.W. Dowd *(North Harbour)*, S.B.T. Fitzpatrick *(Auckland)*₁,₂,₃,SA
Captain: S.B.T. Fitzpatrick
Coach: L.W. Mains *(Otago)*
Assistant coach: E.W. Kirton *(Wellington)*
Manager: N.J. Gray *(Waikato)*

Tour record:

v Western Australia *at Perth*	won	80-0
v South Australian Invitation XV *at Adelaide*	won	48-18
v New South Wales *at Sydney*	won	41-9
v Australian Capital Territory *at Canberra*	won	45-13
v Australia *at Sydney*	lost	15-16
v Victorian Invitation XV *at Melbourne*	won	53-3
v Queensland *at Brisbane*	won	26-19
v Queensland B *at Cairns*	won	32-13
v Australia *at Brisbane*	lost	17-19
v Sydney *at Penrith*	lost	17-40
v Australia *at Sydney*	won	26-23
v Natal *at Durban*	won	43-25
v Orange Free State *at Bloemfontein*	won	33-14
v Junior South Africa *at Pretoria*	won	25-10
v Central Unions *at Witbank*	won	39-6
v South Africa *at Johannesburg*	won	27-24

Summary:
Played 16, won 13, lost 3
Points for 567, against 252

1993 in GREAT BRITAIN
First match 23 October, last match 4 December.

Backs: S.P. Howarth *(Auckland)*, J.K.R. Timu *(Otago)*S,E, J.W. Wilson *(Otago)*S,E, V.I. Tuigamala *(Auckland)*S,E, E.J. Rush *(North Harbour)*, F.E. Bunce *(North Harbour)*S,E, E. Clarke *(Auckland)*S(r),E, M.J. Berry *(Wellington)*, L. Stensness *(Auckland)*, M.C.G. Ellis *(Otago)*S,E, S.J. Bachop *(Otago)*, M.J.A. Cooper *(Waikato)*, S.T. Forster *(Otago)*S,E, J.P. Preston *(Wellington)*
Forwards: J.E.P. Mitchell *(Waikato)*, A.R.B. Pene *(Otago)*S,E, Z.V. Brooke *(Auckland)*S,E, J.W. Joseph *(Otago)*S,E, P.W. Henderson *(Otago)*, L.J. Barry *(North Harbour)*, M.R. Brewer *(Canterbury)*, I.D. Jones *(North Auckland)*S,E, R.M. Brooke" *(North Auckland)*, R.T. Fromont *(Auckland)*, S.B. Gordon *(Waikato)*S,E, B.P. Larsen *(North Harbour)*, C.W. Dowd *(Auckland)*S,E, G.H. Purvis *(Waikato)*, O.M. Brown *(Auckland)*S,E, M.R. Allen *(Taranaki)*, S.B.T. Fitzpatrick *(Auckland)*S,E, N.J. Hewitt *(Hawke's Bay)*
" did not play
Captain: S.B.T. Fitzpatrick
Coach: L.W. Mains *(Otago)*
Assistant coach: E.W. Kirton *(Wellington)*
Manager: N.J. Gray *(Waikato)*

Tour record:

v London and South-East Division *at London*	won	39-12
v Midlands *at Leicester*	won	12-6
v South-West Division *at Redruth*	won	19-15
v Northern Division *at Liverpool*	won	27-21
v England A *at Gateshead*	won	26-12
v South of Scotland *at Galashiels*	won	84-5
v Scotland A *at Glasgow*	won	20-9
v Scottish Development XV *at Edinburgh*	won	31-12

v Scotland *at Edinburgh* — won 51-15
v England Emerging Players *at Gloucester* — won 30-19
v England *at London* — lost 9-15
v Combined Services *at Plymouth* — won 13-3
v Barbarians *at Cardiff* — won 25-12

Summary:
Played 13, won 12, lost 1
Points for 386, against 156

1994 in AUSTRALIA
17 August.

Backs: S.P. Howarth *(Auckland)*, J.K.R. Timu *(Otago)*, J.W. Wilson *(Otago)*, F.E. Bunce *(North Harbour)*, W.K. Little *(North Harbour)*, S.J. Bachop *(Otago)*, G.T.M. Bachop *(Canterbury)*
Forwards: Z.V. Brooke *(Auckland)*, M.R. Brewer *(Canterbury)*, B.P. Larsen *(North Harbour)*, M.N. Jones *(Auckland)*, M.S.B. Cooksley *(Waikato)*, I.D. Jones *(North Harbour)*, O.M. Brown *(Auckland)*, R.W. Loe *(Canterbury)*, S.B.T. Fitzpatrick *(Auckland)*
Captain: S.B.T. Fitzpatrick
Coach: L.W. Mains *(Otago)*
Assistant coach: E.W. Kirton *(Wellington)*
Manager: C.E. Meads *(King Country)*

Tour record:
v Australia *at Sydney* — lost 16-20

1995 at WORLD CUP in SOUTH AFRICA
First match 27 May, last match 24 June.

Backs: G.M. Osborne *(North Harbour)*I,W,J,E,SA. J.W. Wilson *(Otago)*I,J,S,E,SA. J.T. Lomu *(Counties)*I,W,S,E,SA. E.J. Rush *(North Harbour)*W(r),J. F.E. Bunce *(North Harbour)*I,W,S,E,SA. M.C.G. Ellis *(Otago)*I(r),W,J,S,SA(r). W.K. Little *(North Harbour)*I,W,S,E,SA. A. Ieremia *(Wellington)*J. S.D. Culhane *(Southland)*J. A.P. Mehrtens *(Canterbury)*I,W,S,E,SA. G.T.M. Bachop *(Canterbury)*I,W,S,E,SA. A.D. Strachan *(North Harbour)*J, SA(r)
Forwards: Z.V. Brooke *(Auckland)*J,S,E,SA. M.R. Brewer *(Canterbury)*I,W,E,SA. P.W. Henderson *(Southland)*J. J.W. Joseph *(Otago)*I,W,J(r),S,SA(r). J.A. Kronfeld *(Otago)*I,W,S,E,SA. K.J. Schuler *(North Harbour)*J(r),I. R.M. Brooke *(Auckland)*I,S,E,SA. I.D. Jones *(North Harbour)*I,W,S,E,SA. B.P. Larsen *(North Harbour)*I,W,J,E(r). O.M. Brown *(Auckland)*I,W,S,E,SA. C.W. Dowd *(Auckland)*I,W,J,E,SA. R.W. Loe *(Canterbury)*J,S,SA(r). S.B.T. Fitzpatrick *(Auckland)*I,W,S,E,SA. N.J. Hewitt *(Hawke's Bay)*J(r),I
Captain: S.B.T. Fitzpatrick
Coach: L.W. Mains
Assistant coach: E.W. Kirton *(Wellington)*
Campaign manager: B.J. Lochore *(Wairarapa-Bush)*
Manager: C.E. Meads *(King Country)*

Tour record:
v Ireland *at Johannesburg* — won 43-19
v Wales *at Johannesburg* — won 34-9
v Japan *at Bloemfontein* — won 145-17
v Scotland, quarterfinal *at Cape Town* — won 48-30
v England, semifinal *at Cape Town* — won 45-29
v South Africa, final *at Johannesburg* (extra time) — lost 12-15

Summary:
Played 6, won 5, lost 1
Points for 327, against 119

1995 in AUSTRALIA
29 July.

Backs: G.M. Osborne *(North Harbour)*, J.W. Wilson *(Otago)*, J.T. Lomu *(Counties)*, F.E. Bunce *(North Harbour)*, W.K. Little *(North Harbour)*, A.P. Mehrtens *(Canterbury)*, G.T.M. Bachop *(Canterbury)*
Forwards: Z.V. Brooke *(Auckland)*, M.N. Jones *(Auckland)*, J.A. Kronfeld *(Otago)*, M.R. Brewer *(Canterbury)*, R.M. Brooke *(Auckland)*, I.D. Jones *(North Harbour)*, O.M. Brown *(Auckland)*, S.B.T. Fitzpatrick *(Auckland)*, C.W. Dowd *(Auckland)*, R.W. Loe *(Canterbury)*
Captain: S.B.T. Fitzpatrick
Coach: L.W. Mains *(Otago)*
Assistant coach: E.W. Kirton *(Wellington)*
Manager: C.E. Meads *(King Country)*

Tour record:
v Australia *at Sydney* — won 34-23

1995 in ITALY and FRANCE
First match 25 October, last match 18 November.

Backs: G.M. Osborne *(North Harbour)*F1(r),F2. J.W. Wilson *(Otago)*I,F1. J.T. Lomu *(Counties)*I,F1,2. E.J. Rush *(North Harbour)*I,F1,2. A. Ieremia *(Wellington)*I,F1,2. F.E. Bunce *(North Harbour)*I,F1,2. J.T.F. Matson *(Canterbury)*, W.K. Little *(North Harbour)*I,F1,2. S.D. Culhane *(Southland)*I,F1. A.P. Mehrtens *(Canterbury)*, C.J. Spencer *(Auckland)*, S.T. Forster *(Otago)*I,F1. J.W. Marshall *(Canterbury)*F2
Forwards: Z.V. Brooke *(Auckland)*I,F1,2. T.C. Randell *(Otago)*, T.J. Blackadder *(Canterbury)*, L.J. Barry *(North Harbour)*F2. M.N. Jones *(Auckland)*I,F1,2. J.A. Kronfeld* *(Otago)*, B.P. Larsen *(North Harbour)*I,F1. R.M. Brooke *(Auckland)*I,F1,2. I.D. Jones *(North Harbour)*I,F1,2. M.S.B. Cooksley *(Waikato)*, R.T. Fromont *(Auckland)*, M.R. Allen *(Taranaki)*, O.M. Brown *(Auckland)*I,F1,2. C.W. Dowd *(Auckland)*I,F1,2. R.W. Loe *(Auckland)*F2(r). N.J. Hewitt *(Southland)*, S.B.T. Fitzpatrick *(Auckland)*I,F1,2
did not play
Captain: S.B.T. Fitzpatrick
Coach: L.W. Mains *(Otago)*
Assistant coach: E.W. Kirton *(Wellington)*
Manager: C.E. Meads *(King Country)*

Tour record:
v Italy A *at Catania* — won 51-21
v Italy *at Bologna* — won 70-6
v French Barbarians *at Toulon* — won 34-19
v Languedoc-Roussillon *at Beziers* — won 30-9
v Cote Basque-Landes *at Bayonne* — won 47-20
v France *at Toulouse* — lost 15-22
v French Selection *at Nancy* — won 5-17
v France *at Paris* — won 37-12

Summary:
Played 8, won 7, lost 1
Points for 339, against 126

1996 in AUSTRALIA and SOUTH AFRICA
First match 27 July, last match 31 August.

Backs: A.R. Cashmore* *(Auckland)*, M.J.A. Cooper *(Waikato)*, C.M. Cullen *(Manawatu)*A,1,2,3,4. J.W. Wilson *(Otago)*A,1,2,3,4. J.T. Lomu *(Counties-Manukau)*A. G.M. Osborne *(North Harbour)*I,2,3,4. F.E. Bunce *(North Harbour)*A,1,2,3,4. A. Ieremia *(Wellington)*1(r),4(r). J.T.F. Matson *(Canterbury)*, E.J. Rush *(North Harbour)*, S.J. McLeod *(Waikato)*, W.K. Little *(North Harbour)*A,1,2,3,4. C.J. Spencer *(Auckland)*, S.D. Culhane *(Southland)*2,3. A.P. Mehrtens *(Canterbury)*A,1,4. J.P. Preston *(Wellington)*3(r). O.F.J. Tonu'u *(Auckland)*
Forwards: T.J. Blackadder *(Canterbury)*, A.F. Blowers *(Auckland)*1(r),3(r). Z.V. Brooke *(Auckland)*A,1,2,3,4. C.S. Davis *(Manawatu)*, M.N. Jones *(Auckland)*A,1,2,3,4. J.A. Kronfeld *(Otago)*A,1,2,3,4. T.C. Randell *(Otago)*, R.M. Brooke *(Auckland)*A,1,2,3,4. I.D. Jones *(North Harbour)*, B.P. Larsen *(North Harbour)*3(r). G.L. Taylor *(Northland)*4(r). M.R. Allen *(Taranaki)*, C.K. Barrell *(Canterbury)*, O.M. Brown *(Auckland)*A,1,2,3,4. P.H. Coffin *(King Country)*, C.W. Dowd *(Auckland)*A,1,2,3,4. S.B.T. Fitzpatrick *(Auckland)*A,1,2,3,4. N.J. Hewitt *(Southland)*, A.D. Oliver *(Otago)*
did not play
Captain: S.B.T. Fitzpatrick
Coach: J.B. Hart *(Auckland)*
Assistant coaches: G.R.R. Hunter *(Otago)*, R.M. Cooper *(Thames Valley)*
Manager: M.C.F. Banks *(Manawatu)*

Tour record:
v Australia+ *at Brisbane* — won 32-25
v Boland Invitation *at Worcester* — won 32-21
v South Africa+ *at Cape Town* — won 29-18
v Eastern Province *at Port Elizabeth* — won 31-23
v South Africa *at Durban* — won 23-19
v Western Transvaal *at Potchefstroom* — won 31-0
v South Africa *at Pretoria* — won 33-26
v Griqualand West *at Kimberley* — drew 18-18
v South Africa *at Johannesburg* — lost 22-32
+ Tri Nations tests

Summary:
Played 9, won 7, drew 1, lost 1
Points for 251, against 182

The 1995 team to Italy and France
Back row: Liam Barry, Zinzan Brooke, Blair Larsen, Ian Jones, Robin Brooke, Richard Fromont, Jonah Lomu, Jeff Wilson.
Third row: Ric Salizzo (media liaison officer), Josh Kronfeld, Eric Rush, Richard Loe, Craig Dowd, Todd Blackadder, Frank Bunce, Taine Randell.
Second row: Don Cameron (masseur), Andrew Mehrtens, Justin Marshall, Michael Jones, Olo Brown, Alama Ieremia, Glen Osborne, Mark Allen, Chris McCullough (physiotherapist).
Front row: Michael Bowen (doctor), Stu Forster, Walter Little, Laurie Mains (coach), Sean Fitzpatrick (captain), Colin Meads (manager), Norm Hewitt, Simon Culhane, Ross Cooper (assistant coach).
Absent: Tabai Matson, Mark Cooksley.

1997 in SOUTH AFRICA and AUSTRALIA
First match 19 July, second match 26 July.

Backs: C.M. Cullen *(Manawatu)*SA.A. J.W. Wilson *(Otago)*SA.A. T.J.F. Umaga *(Wellington)*SA. G.M. Osborne *(North Harbour)*A. A.R. Cashmore *(Auckland)*A. F.E. Bunce *(North Harbour)*SA.A. L. Stensness *(Auckland)*SA. A. Ieremia *(Wellington)*SA(r).A. C.J. Spencer *(Auckland)*SA.A. J.W. Marshall *(Canterbury)*SA.A
Forwards: Z.V. Brooke *(Auckland)*SA.A. T.C. Randell *(Otago)*SA.A. J.A. Kronfeld *(Otago)*SA.A. R.M. Brooke *(Auckland)*SA.A. I.D. Jones *(North Harbour)*SA.A. O.M. Brown *(Auckland)*SA.A. C.W. Dowd *(Auckland)*SA.A. S.B.T. Fitzpatrick *(Auckland)*SA.A. N.J. Hewitt *(Southland)*SA(r)
Captain: S.B.T. Fitzpatrick
Coach: J.B. Hart *(Auckland)*
Assistant coaches: G.R.R. Hunter *(Otago)*, R.M. Cooper *(Thames Valley)*
Manager: M.C. Banks *(Manawatu)*

Tour record:

v South Africa *at Johannesburg*	won	35-32
v Australia *at Melbourne*	won	33-18

Summary:
Played 2, won 2
Points for 68, against 50

1997 in BRITAIN and IRELAND
First match 8 November, last match 6 December.

Backs: C.M. Cullen *(Manawatu)*I.W.E1.2. T.J. Miller *(Waikato)*, J.W. Wilson *(Otago)*I.W.E1.2. J.T. Lomu *(Counties-Manukau)*W.E1.2. G.M. Osborne *(North Harbour)*I. T.J.F. Umaga *(Wellington)*, F.E. Bunce *(North Harbour)*I.W.E1.2. S.J. McLeod *(Waikato)*I(r).W(r).E1(r).2. J.C. Stanley *(Auckland)*, A.Ieremia *(Wellington)*I.E1. W.K. Little *(North Harbour)*W.E2. A.P. Mehrtens *(Canterbury)*I.W.E1.2. C.J. Spencer *(Auckland)*E2(r). J.W. Marshall *(Canterbury)*I.W.E1.2. J.P. Preston *(Wellington)*I(r).E1(r). M.D. Robinson *(North Harbour)*
Forwards: T.J. Blackadder *(Canterbury)*, A.F. Blowers *(Auckland)*I.E1(r).W(r) Z.V. Brooke *(Auckland)*I.W.E1.2. M.P. Carter *(Auckland)*, A.R. Hopa *(Waikato)*, J.A. Kronfeld *(Otago)*I(r).W.E1.2. T.C. Randell *(Otago)*I.W.E1.2. S.D Surridge *(Canterbury)*, R.M. Brooke *(Auckland)*I.W.E1.2. M.S.B. Cooksley *(Waikato)*I(r)5.E2(r). I.D. Jones *(North Harbour)*I.W.E1.2. C.C. Reichelmann *(Auckland)*I(r)5.E2(r). M.R. Allen *(Manawatu)*W(r).E2. C.K. Barrell *(Canterbury)*, O.M. Brown *(Auckland)*I.W.E1.2. C.W. Dowd *(Auckland)*I.W.E1. G.L. Slater *(Taranaki)*, S.B.T. Fitzpatrick *(Auckland)*W(r). N.J. Hewitt *(Southland)*I.W.E1.2. A.D. Oliver *(Otago)*
Captain: S.B.T. Fitzpatrick
Coach: J.B. Hart *(Auckland)*
Assistant coaches: G.R.R. Hunter *(Otago)*, R.M. Cooper *(Thames Valley)*
Manager: M.C.F. Banks (Manawatu)

Tour record:

v Llanelli *at Llanelli*	won	81-3
v Wales A *at Pontypridd*	won	51-8
v Ireland *at Dublin*	won	63-15
v Emerging England *at Huddersfield*	won	59-22
v England *at Manchester*	won	25-8
v Partnership XV *at Bristol*	won	18-11
v Wales *at Wembley*	won	42-7
v England A *at Leicester*	won	30-19
v England *at Twickenham*	drew	26-26

Summary:
Played 9, won 8, drew 1
Points for 395, against 119

New Zealand Teams at Home

1894 v NEW SOUTH WALES
15 September.

Backs: A.E. D'Arcy *(Wairarapa)*, W. Balch *(Canterbury)*, A. Bayly *(Taranaki)*, H.M. Good *(Taranaki)*, H. Butland *(West Coast)*, A.E. Cooke *(Canterbury)*
Forwards: W. Bayly *(Taranaki)*, S.G. Cockcroft *(Hawke's Bay)*, D.J. Hughes *(Taranaki)*, G.W. Humphreys *(Canterbury)*, J.T. Lambie *(Taranaki)*, G. Maber *(Wellington)*, W. McKenzie *(Wellington)*, D. Stewart *(South Canterbury)*, J. Swindley *(Wellington)*
Captain: A. Bayly

Record:

v New South Wales *at Christchurch*	lost	6-8

1896 v QUEENSLAND
15 August.

Backs: S.A. Orchard *(Canterbury)*, L. Allen *(Taranaki)*, P. McDonnell *(Wanganui)*, W. Roberts *(Wellington)*, F. Surman *(Auckland)*, D.R. Gage *(Wellington)*
Forwards: H. Frost *(Canterbury)*, A. Kerr *(Canterbury)*, W. McKenzie *(Wellington)*, N. McRobie *(Southland)*, R. Oliphant *(Auckland)*, T.G. Pauling *(Wellington)*, D.J. Watson *(Taranaki)*, W.D. Watson *(Wairarapa)*, F.B. Young *(Wellington)*
Captain: D.R. Gage

Record:

v Queensland *at Wellington*	won	9-0

1901 v NEW SOUTH WALES
First match 28 August, second match 31 August.

Backs: W.E. Hay-MacKenzie *(Auckland)*, J.P.le G. Jacob *(Southland)*, R.W. McGregor *(Auckland)*, G.W. Smith *(Auckland)*, L. Allen *(Taranaki)*, M.E. Wood *(Wellington)*, A.L. Humphries *(Taranaki)*
Forwards: J.R. Burt *(Otago)*, T. Cross *(Canterbury)*, W. Cunningham *(Auckland)*, E.H. Dodd *(Wellington)*, W.A. Drake *(Canterbury)*, J. Duncan *(Otago)*, J. O'Brien *(Wellington)*, B.C. O'Dowda *(Taranaki)*, C.A. Purdue *(Southland)*, D.K. Udy *(Wairarapa)*
Captain: J. Duncan

Record:

v Wellington *at Wellington*	won	24-5
v New South Wales *at Wellington*	won	20-3

1904 v GREAT BRITAIN
13 August.

Backs: R.W. McGregor *(Auckland)*, E.T. Harper *(Canterbury)*, D. McGregor *(Wellington)*, W.J. Wallace *(Wellington)*, J.W. Stead *(Southland)*, M.E. Wood *(Auckland)*, P. Harvey *(Canterbury)*
Forwards: T. Cross *(Wellington)*, B.J. Fanning *(Canterbury)*, D. Gallaher *(Auckland)*, W.S. Glenn *(Taranaki)*, F.A. McMinn *(Manawatu)*, G.W. Nicholson *(Auckland)*, C.E. Seeling *(Auckland)*, G.A. Tyler *(Auckland)*
Captain: J.W. Stead

Record:

v Great Britain *at Wellington*	won	9-3

1905 v AUSTRALIA
2 September.

Backs: H.S. Turtill *(Canterbury)*, C.M. Gilray *(Otago)*, R. Bennet *(Otago)*, D.G. Macpherson *(Otago)*, W.E. Smith *(Nelson)*, E. Wrigley *(Wairarapa)*, G.F. Burgess *(Southland)*

Forwards: T. Cross *(Wellington)*, E.H. Dodd *(Wellington)*, A.R.H. Francis *(Auckland)*, A.F. McMinn *(Manawatu)*, C.A. Purdue *(Southland)*, E. Purdue *(Southland)*, J.C. Spencer *(Wellington)*, E.L. Watkins *(Wellington)*
Captain: J.C. Spencer

Record:

v Australia *at Dunedin*	won	14-3

1908 v ANGLO-WELSH
First match 6 June, last match 29 July.

Backs: J.T.H. Colman *(Taranaki)*[1,3], W.J. Wallace *(Wellington)*[2], D. Cameron *(Taranaki)*[1,2,3], R.G. Deans *(Canterbury)*[3], F.C. Fryer *(Canterbury)*[2], F.E. Mitchinson *(Wellington)*[1,2,3], H.D. Thomson *(Wellington)*[1], G.D. Gray *(Canterbury)*[2], J. Hunter *(Taranaki)*[1,2,3], J.W. Stead *(Southland)*[1,3], P.J. Burns *(Canterbury)*[2], F. Roberts *(Wellington)*[1,3]
Forwards: S.T. Casey *(Otago)*[1], W. Cunningham *(Auckland)*[1,2,3], A.R.H. Francis *(Auckland)*[1,2,3], G.A. Gillett *(Auckland)*[1,3], F.T. Glasgow *(Southland)*[3], D.C. Hamilton *(Southland)*[2], H.O. Hayward *(Auckland)*[3], E. Hughes *(Southland)*[1], A. McDonald *(Otago)*[1], P.C. Murray *(Wanganui)*[2], A.M. Paterson *(Otago)*[2,3], W.J. Reedy *(Wellington)*[2,3], C.E. Seeling *(Auckland)*[1,2,3], N.A. Wilson *(Wellington)*[1,2]
Captains: J.W. Stead [1,3], J. Hunter [2]

Record:

v Anglo-Welsh *at Dunedin*	won	32-5
v Anglo-Welsh *at Wellington*	drew	3-3
v Anglo-Welsh *at Auckland*	won	29-0

Summary:
Played 3, won 2, drew 1
Points for 64, against 8

1913 v AUSTRALIA
First match 6 September, last match 20 September.

Backs: J.E. Cuthill *(Otago)*[1], M.J. O'Leary *(Auckland)*[2,3], A.J. McGregor *(Auckland)*[1], R.W. Roberts *(Taranaki)*[1], T.W. Lynch *(South Canterbury)*[1], J.A.S. Baird *(Otago)*[2], P.J. Burns *(Canterbury)*[3], E.A.P. Cockroft *(South Canterbury)*[3], J.V. Macky *(Auckland)*[2], J.D. Stewart *(Auckland)*[2], R.J. McKenzie *(Wellington)*[1], G.D. Gray *(Canterbury)*[1], W.M. Geddes *(Auckland)*[2], A.P. Spillane *(South Canterbury)*[2,3], J.T. Tilyard *(Wellington)*[3], H.M. Taylor *(Canterbury)*[1], C. Brown *(Taranaki)*[2,3], F.E. Mitchinson *(Wellington)*[1(r)]
Forwards: A. McDonald *(Otago)*[1], H. Dewar *(Taranaki)*[1], A.J. Downing *(Auckland)*[1], H. Atkinson *(West Coast)*[1], J.T. Wylie *(Auckland)*[1], G.M.V. Sellers *(Auckland)*[1], P. Williams *(Otago)*[1], J. Barrett *(Auckland)*[2,3], A.H.N. Fanning *(Canterbury)*[3], W.C. Francis *(Wellington)*[2,3], C.T. Gillespie *(Wellington)*[2], E.W. Hasell *(Canterbury)*[2,3], J. McNeece *(Southland)*[2,3], R. Taylor *(Taranaki)*[2,3], N.A. Wilson *(Wellington)*[2,3], H.V. Murray *(Canterbury)*[1], W. Cummings *(Canterbury)*[2,3]
Captains: A. McDonald [1]; M.J. O'Leary [2,3]

Record:

v Australia *at Wellington*	won	30-5
v Australia *at Dunedin*	won	25-13
v Australia *at Christchurch*	lost	5-16

Summary:
Played 3, won 2, lost 1
Points for 60, against 34

1921 v SOUTH AFRICA
First match 13 August, last match 17 September.

Backs: C.N. Kingstone *(Taranaki)*[1,2,3], G.G. Aitken *(Wellington)*[1,2], S.K. Siddells *(Wellington)*[3], J. Steel *(West Coast)*[1,2,3], P.W. Storey *(South Canterbury)*[1,2], C.E.O. Badeley *(Auckland)*[1,2], W.R. Fea *(Otago)*[3], K.D. Ifwersen *(Auckland)*[3], M.F. Nicholls *(Wellington)*[1,2,3], H.E. Nicholls

(Wellington)[1], E.J. Roberts *(Wellington)*[2,3]
Forwards: E.A. Belliss *(Wanganui)*[1,2,3], J.G. Donald *(Wairarapa)*[1,2],
W.D. Duncan *(Otago)*[1,2,3], C.J.C. Fletcher *(North Auckland)*[3], R. Fogarty
(Taranaki)[1,3], E. Hughes *(Wellington)*[1,2,3], J. Richardson *(Otago)*[1,2,3],
A.H. West *(Taranaki)*[2,3], A. White *(Southland)*[1].
Captains: G.G. Aitken [1,2]; E.J. Roberts [3]

Record:

v South Africa *at Dunedin*	won	13-5
v South Africa *at Auckland*	lost	5-9
v South Africa *at Wellington*	drew	0-0

Summary:
Played 3, won 1, lost 1, drew 1
Points for 18, against 14

1921 v NEW SOUTH WALES
3 September.

Backs: C.E. Evans *(Canterbury)*, W.A. Ford *(Canterbury)*, E. Ryan
(Wellington), F.G. Ward *(Otago)*, B. Algar *(Wellington)*, P. Markham
(Wellington), E.J. Roberts *(Wellington)*.
Forwards: J.L. Brownlie *(Hawke's Bay)*, P.S.de Q. Cabot *(Otago)*,
A.J. Carroll *(Manawatu)*, W. Cummings *(Canterbury)*, C.J.C. Fletcher
(North Auckland), L.C. Petersen *(Canterbury)*, S.D. Shearer
(Wellington), A. White *(Southland)*, J.S. Turnbull *(Otago)*[r]
Captain: E.J. Roberts

Record:

v New South Wales *at Christchurch*	lost	0-17

1923 v NEW SOUTH WALES
First match 25 August, last match 15 September.

Backs: A.L. McLean *(Bay of Plenty)*, R.G.V. Sinclair *(Otago)*, W.A. Ford
(Canterbury), P. Taituha *(Wanganui)*, F.W. Lucas *(Auckland)*,
H.D. Morgan *(Otago)*, W. Potaka *(Wanganui)*, W.F. Snodgrass *(Nelson)*,
J. Steel *(West Coast)*, E.B. Stewart *(Otago)*, J.R. Bell *(Southland)*,
H.G. Nicholls *(Wellington)*, L. Paewai *(Hawke's Bay)*, A. Perry *(Otago)*,
F.J. Tilyard *(Wellington)*, P. McCarthy *(Canterbury)*, J.J. Mill *(Hawke's
Bay)*, H.E. Nicholls *(Wellington)*

Forwards: E.A. Belliss *(Wanganui)*, M.J. Brownlie *(Hawke's Bay)*, L.F.
Cupples *(Bay of Plenty)*, Q. Donald *(Wairarapa)*, S.W. Gemmell
(Hawke's Bay), W.R. Irvine *(Hawke's Bay)*, R.R. Masters *(Canterbury)*,
D.T.M. McMeeking *(Otago)*, J. Ormond *(Hawke's Bay)*, L.C. Petersen
(Canterbury), C.G. Porter *(Wellington)*, A. Pringle *(Wellington)*, J.
Richardson *(Southland)*, L.S. Righton *(Auckland)*, R.T. Stewart *(South
Canterbury)*, R.G. Tunnicliff *(Buller)*, A.H. West *(Taranaki)*, A. White
(Southland), A.L. Williams *(Otago)*
Captains: J. Richardson [1,2]; H.E. Nicholls [3]

Record:

v New South Wales *at Dunedin*	won	19-9
v New South Wales *at Christchurch*	won	34-6
v New South Wales *at Wellington*	won	38-11

Summary:
Played 3, won 3
Points for 91, against 26

1925 v NEW SOUTH WALES
19 September.

Backs: G. Nepia *(Hawke's Bay)*, A.E. Cooke *(Auckland)*; F.W. Lucas
(Auckland), A.C.C. Robilliard *(Canterbury)*[r], K.S. Svenson *(Wellington)*,
N.P. McGregor *(Canterbury)*, M.F. Nicholls *(Wellington)*, J.J. Mill
(Hawke's Bay)
Forwards: M.J. Brownlie *(Hawke's Bay)*, I. Finlayson *(North Auckland)*,
W.R. Irvine *(Hawke's Bay)*, A.R. Lomas *(Auckland)*, R.R. Masters
(Canterbury), C.G. Porter *(Wellington)*, J. Richardson *(Southland)*,
R.T. Stewart *(South Canterbury)*
Captain: C.G. Porter

Record:

v New South Wales *at Auckland*	won	36-10

1928 v NEW SOUTH WALES
First match 5 September, last match 15 September.

Backs: V.C. Butler *(Auckland)*, G.M. Mehrtens *(Canterbury)*, L.S. Hook
(Auckland), J.D. Mackay *(Wellington)*, W.G. McClymont *(Otago)*,
C.J. Oliver *(Canterbury)*, W.F. Snodgrass *(Nelson)*, N.M. Bradanovich

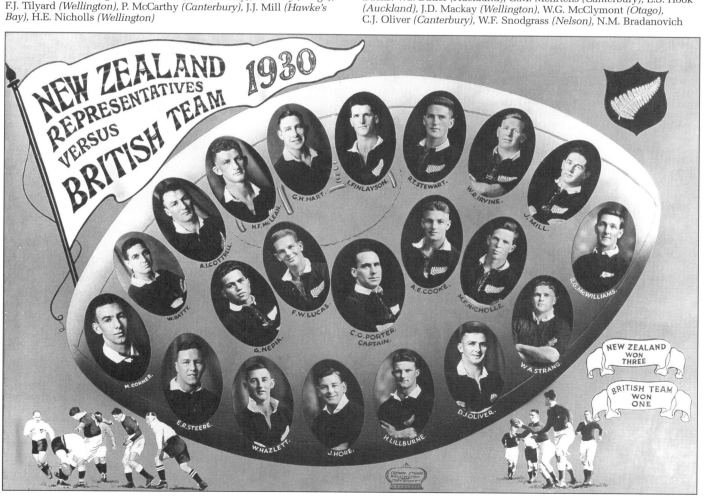

(Otago), A.E. Cooke *(Wairarapa)*, R.H.C. Mackenzie *(Wellington)*,
A.W. Holden *(Otago)*, M.L. Page *(Canterbury)*
Forwards: W. Batty *(Auckland)*, F.L. Clark *(Canterbury)*, D.F.E. Freitas
(West Coast), J. Howden *(Southland)*, A. Knight *(Auckland)*, B.P. Palmer
(Auckland), C.G. Porter *(Wellington)*, J.T. Robinson *(Canterbury)*,
E.R.G. Steere *(Hawke's Bay)*, S.de L.P. Willoughby *(Wairarapa)*
Captain: C.G. Porter

Record:

v New South Wales *at Wellington*	won	15-12
v New South Wales *at Dunedin*	won	16-14
v West Coast-Buller *at Greymouth*	won	40-3
v New South Wales *at Christchurch*	lost	8-11

Summary:
Played 4, won 3, lost 1
Points for 79, against 40

1930 v GREAT BRITAIN
First match 18 June, last match 9 August.

Backs: G. Nepia *(East Coast)*₁.₂.₃.₄. G.F. Hart *(Canterbury)*₁.₂.₃.₄. F.W. Lucas
*(Auckland)*₁.₂.₃.₄. D.J. Oliver *(Wellington)*₁.₂.₃.₄. A.E. Cooke *(Wellington)*₁.₂.₃.₄.
L.M. Johnson *(Wellington)*; H.T. Lilburne *(Canterbury)*₁.₄. M.F. Nicholls
*(Wellington)*₂.₃. W.A. Strang *(South Canterbury)*₃.₄. M.M.N. Corner
*(Auckland)*₂.₃.₄. J.J. Mill *(Wairarapa)*₁
Forwards: W. Batty *(Auckland)*₁.₃.₄. A.I. Cottrell *(Canterbury)*₁.₂.₃.₄.
I. Finlayson *(North Auckland)*₁.₂. W.E. Hazlett *(Southland)*₁.₂.₃.₄. J. Hore
*(Otago)*₂.₃.₄. W.R. Irvine *(Wairarapa)*₁ H.F. McLean *(Wellington)*₃.₄.
R.G. McWilliams *(Auckland)*₁.₂.₃.₄. C.G. Porter *(Wellington)*₁.₂.₃.₄.
E.R.G. Steere *(Hawke's Bay)*₁.₂.₃.₄. R.T. Stewart *(Canterbury)*₂
Captain: C.G. Porter

Record:

v North Otago *at Oamaru*	won	34-6
v Great Britain *at Dunedin*	lost	3-6
v Great Britain *at Christchurch*	won	13-10
v Great Britain *at Auckland*	won	15-10
v Great Britain *at Wellington*	won	22-8

Summary:
Played 5, won 4, lost 1
Points for 87, against 40

1931 v AUSTRALIA
12 September.

Backs: R.G. Bush *(Otago)*, N.Ball *(Wellington)*, G.F. Hart *(Canterbury)*,
J.R. Page *(Wellington)*, H.T. Lilburne *(Wellington)*, W.A. Strang *(South
Canterbury)*, M.M.N. Corner *(Auckland)*
Forwards: W. Batty *(Auckland)*, A.I. Cottrell *(Canterbury)*, E.M. Jessep
(Wellington), D.S. Max *(Nelson)*, T.C. Metcalfe *(Southland)*, G.B. Purdue
(Southland), F. Solomon *(Auckland)*, E.R.G. Steere *(Hawke's Bay)*
Captain: W.A. Strang

Record:

v Australia *at Auckland*	won	20-13

1936 v AUSTRALIA
First match 5 September, last match 12 September.

Backs: H.R. Pollock *(Wellington)*₁.₂. T.H.C. Caughey *(Auckland)*₁.
G.F. Hart *(Canterbury)*₁.₂. N.A. Mitchell *(Southland)*₂. J.L. Sullivan
(Taranaki); J.M. Watt *(Otago)*₁.₂. C.C. Gillies *(Otago)*₂. J.L. Griffiths
*(Wellington)*₁.₂. B.A. Killeen *(Auckland)*₁. B.S. Sadler *(Wellington)*₁.₂
Forwards: D. Dalton *(Hawke's Bay)*₁.₂. W.E. Hadley *(Auckland)*₁.₂.
E.S. Jackson *(Hawke's Bay)*₁.₂. R.R. King *(West Coast)*₁.₂. T.M. Lockington
(Auckland); R.M. McKenzie *(Manawatu)*₁ J.G. Rankin *(Canterbury)*₁.₂.
S.T. Reid *(Hawke's Bay)*₁.₂. R.H. Ward *(Southland)*₂. J. Wells
*(Wellington)*₁.₂
Captain: J.L. Griffiths

Record:

v Australia *at Wellington*	won	11-6
v South Canterbury *at Timaru*	won	16-13
v Australia *at Dunedin*	won	38-13

Summary:
Played 3, won 3
Points for 65, against 32

1937 v SOUTH AFRICA
First match 14 August, last match 25 September.

Backs: J.M. Taylor *(Otago)*₁.₂.₃. T.H.C. Caughey *(Auckland)*₃. D.G. Cobden
*(Canterbury)*₁. J. Dick *(Auckland)*₁.₂. N.A. Mitchell *(Southland)*₃.
W.J. Phillips *(King Country)*₁ J.L. Sullivan *(Taranaki)*₁.₂.₃. J.A. Hooper
*(Canterbury)*₁.₂.₃. D. Trevathan *(Otago)*₁.₂.₃. H.J. Simon *(Otago)*₁.₂.₃.
Forwards: D.Dalton *(Hawke's Bay)*₁.₂.₃. E.S. Jackson *(Hawke's Bay)*₁.₂.₃.
R.R. King *(West Coast)*₁.₂.₃. A. Lambourn *(Wellington)*₁.₂.₃. R.M. McKenzie
*(Manawatu)*₁.₂.₃. A.A. Parkhill *(Otago)*₁.₂.₃. J.G. Rankin *(Canterbury)*₂.
S.T. Reid *(Hawke's Bay)*₁.₂.₃. R.H. Ward *(Southland)*₁.₃
Captain: R.R. King

Record:

v South Africa *at Wellington*	won	13-7
v South Africa *at Christchurch*	lost	6-13
v South Africa *at Auckland*	lost	6-17

Summary:
Played 3, won 1, lost 2
Points for 25, against 37

1946 v AUSTRALIA
First match 14 September, second match 28 September.

Backs: R.W.H. Scott *(Auckland)*₁.₂. W.G. Argus *(Canterbury)*₁.₂. E.G. Boggs
*(Auckland)*₂. J.M. Dunn *(Auckland)*₁. M.P. Goddard *(South Canterbury)*₂.
J.B. Smith *(North Auckland)*₁. F.R. Allen *(Auckland)*₁.₂. R.R. Elvidge
*(Otago)*₁.₂. J.S. Haig *(Otago)*₁
Forwards: T.A. Budd *(Southland)*₁. E.H. Catley *(Waikato)*₁.₂. K.G. Elliott
*(Wellington)*₁.₂. J. Finlay *(Manawatu)*₁. H.F. Frazer *(Hawke's Bay)*₁.₂.
M.J. McHugh *(Auckland)*₁.₂. J.A. McRae *(Southland)*₁(r)₂. P.K. Rhind
*(Canterbury)*₁.₂. R.M. White *(Wellington)*₁.₂. C.Willocks *(Otago)*₁.₂
Captain: F.R. Allen

Record:

v Australia *at Dunedin*	won	31-8
v Australia *at Auckland*	won	14-10

Summary:
Played 2, won 2
Points for 45, against 18

1949 v AUSTRALIA
First match 3 September, second match 24 September.

Backs: R.W. Orr *(Otago)*₁. J.W. Kelly *(Auckland)*₁.₂. J.K. McLean
*(Auckland)*₂. G.J.T. Moore *(Otago)*₁. R.A. Roper *(Taranaki)*₂. J.B. Smith
*(North Auckland)*₁.₂. M.B.R. Couch *(Wairarapa)*₁.₂. R.L. Dobson
*(Auckland)*₁. T.R. O'Callaghan *(Wellington)*₂. V.D. Bevan *(Wellington)*₁.₂
Forwards: A.W. Blake *(Wairarapa)*₂. J.G.P. Bond *(Canterbury)*₂.
R.F. Bryers *(King Country)*₁. T.A. Budd *(Southland)*₁. A.M. Hughes
*(Auckland)*₁.₂. W.A. Lunn *(Otago)*₁.₂. W.J. Mumm *(Buller)*₁. D.H. O'Donnell
*(Wellington)*₂. H.C.B. Rowley *(Wanganui)*₂. R.C. Stuart *(Canterbury)*₁.₂.
R.A. White *(Poverty Bay)*₁.₂. H.W. Wilson *(Otago)*₁
Captain: J.B. Smith

Record:

v Australia *at Wellington*	lost	6-11
v Australia *at Auckland*	lost	9-16

Summary:
Played 2, lost 2
Points for 15, against 27

1950 v BRITISH ISLES
First match 27 May, last match 29 July.

Backs: R.W.H. Scott *(Auckland)*₁.₂.₃.₄. N.P. Cherrington *(North Auckland)*₁.
P. Henderson *(Wanganui)*₂.₃.₄. W.A. Meates *(Otago)*₁.₂.₃.₄. R.A. Roper
*(Taranaki)*₁.₂.₃.₄. G.E. Beatty *(Taranaki)*₁. R.R. Elvidge *(Otago)*₁.₂.₃. L.S. Haig
*(Otago)*₂.₃.₄. J.M. Tanner *(Auckland)*₄. V.D. Bevan *(Wellington)*₁.₂.₃.₄
Forwards: P.J.B. Crowley *(Auckland)*₁.₂.₃.₄. L.R. Harvey *(Otago)*₁.₂.₃.₄.
A.M. Hughes *(Auckland)*₁.₂.₃.₄. P. Johnstone *(Otago)*₁.₂.₃.₄. J.R. McNab
*(Otago)*₁.₂.₃. G.G. Mexted *(Wellington)*₂. J.G. Simpson *(Auckland)*₁.₂.₃. K.L.
Skinner *(Otago)*₁.₂.₃.₄. R.A. White *(Poverty Bay)*₁.₂.₃.₄. H.W. Wilson *(Otago)*₄
Captains: R.R. Elvidge ₁.₂.₃; P. Johnstone ₄

Record:

v British Isles *at Dunedin*	drew	9-9
v British Isles *at Christchurch*	won	8-0

v British Isles *at Wellington* won 6-3
v British Isles *at Auckland* won 11-8

Summary:
Played 4, won 3, drew 1
Points for 34, against 20

1952 v AUSTRALIA
First match 6 September, second match 13 September.

Backs: R.H. Bell *(Otago)*₁,₂, N.J.G. Bowden *(Taranaki)*₂, A.E.G.Elsom *(Canterbury)*₁,₂, C.P. Erceg *(Auckland)*₁, R.A. Jarden *(Wellington)*₁,₂, S.G. Bremner *(Auckland)*₂, J.T. Fitzgerald *(Wellington)*₁, J. Hotop *(Canterbury)*₂, K. Davis *(Auckland)*₂, A.R. Reid *(Waikato)*₁
Forwards: R.H. Duff *(Canterbury)*₁,₂, B.P. Eastgate *(Canterbury)*₁,₂, I.A. Hammond *(Marlborough)*₂, I.B. Irvine *(North Auckland)*₁, H.C. McLaren *(Waikato)*₁, K.F. Meates *(Canterbury)*₁,₂, C.E. Robinson *(Southland)*₁,₂, J.R. Skeen *(Auckland)*₂, K.L. Skinner *(Otago)*₁,₂, R.A. White *(Poverty Bay)*₁,₂
Captain: K.L. Skinner

Record:
v Australia *at Christchurch* lost 9-14
v Australia *at Wellington* won 15-8

Summary:
Played 2, won 1, lost 1
Points for 24, against 22

1955 v AUSTRALIA
First match 20 August, last match 17 September.

Backs: K.C. Stuart *(Canterbury)*₁, R.H. Brown *(Taranaki)*₃, A.E.G. Elsom *(Canterbury)*₁,₂,₃, R.A. Jarden *(Wellington)*₁,₂,₃, T. Katene *(Wellington)*₂, R.M. Smith *(Canterbury)*₁, W.R. Archer *(Otago)*₁,₂, W.N. Gray *(Bay of Plenty)*₂,₃, J. Hotop *(Canterbury)*₃, P.T. Walsh *(South Auckland)*₁,₂,₃, K. Davis *(Auckland)*₂, L.J. Townsend *(Otago)*₁,₃

Forwards: P.S. Burke *(Taranaki)*₁, J.B. Buxton *(Canterbury)*₃, W.H. Clark *(Wellington)*₁,₂, I.J. Clarke *(Waikato)*₁,₂,₃, R.H. Duff *(Canterbury)*₂,₃, R.C. Hemi *(Waikato)*₁,₂,₃, S.F. Hill *(Canterbury)*₃, M.W. Irwin *(Otago)*₁,₂, P.F.H. Jones *(North Auckland)*₁,₂, I.M.H. Vodanovich *(Wellington)*₁,₂,₃, H.L. White *(Auckland)*₃, R.A. White *(Poverty Bay)*₁,₂,₃
Captain: I.J. Clarke

Record:
v Australia *at Wellington* won 16-8
v Australia *at Dunedin* won 8-0
v Australia *at Auckland* lost 3-8

Summary:
Played 3, won 2, lost 1
Points for 27, against 16

1956 v SOUTH AFRICA
First match 14 July, last match 1 September.

Backs: D.B. Clarke *(Waikato)*₃,₄, P.T. Walsh *(Counties)*₁,₂,₄, R.H. Brown *(Taranaki)*₁,₂,₃,₄, M.J. Dixon *(Canterbury)*₁,₂,₃,₄, R.A. Jarden *(Wellington)*₁,₂,₃,₄, W.R. Archer *(Southland)*₁,₃, S.G. Bremner *(Canterbury)*₁, W.N. Gray *(Bay of Plenty)*₁,₂,₃,₄, A.R. Reid *(Waikato)*₃,₄, P.B. Vincent *(Canterbury)*₁,₂
Forwards: J.B. Buxton *(Canterbury)*₁, W.H. Clark *(Wellington)*₂,₃,₄, I.J. Clarke *(Waikato)*₁,₂,₃,₄, R.H. Duff *(Canterbury)*₁,₂,₃,₄, R.C. Hemi *(Waikato)*₁,₃,₄, S.F. Hill *(Canterbury)*₃,₄, M.W. Irwin *(Otago)*₁, P.F.H. Jones *(North Auckland)*₃,₄, I.N. MacEwan *(Wellington)*₂, F.S. McAtamney *(Otago)*₂, D.N. McIntosh *(Wellington)*₁,₂, K.L. Skinner *(Counties)*₃,₄, R.A. White *(Poverty Bay)*₁,₂,₃,₄, D. Young *(Canterbury)*₂
Captains: P.B. Vincent ₁,₂; R.H. Duff ₃,₄

Record:
v South Africa *at Dunedin* won 10-6
v South Africa *at Wellington* lost 3-8
v South Africa *at Christchurch* won 17-10
v South Africa *at Auckland* won 11-5

The 1956 team which beat South Africa in the fourth test at Auckland
Back row: R.F. McMullen, P.T. Walsh, R.C. Hemi, K.L. Skinner, W.H. Clark, W.N. Gray, D.A. Young.
Second row: D.B. Clarke, R.C. Stuart (coach), P.F. Jones, R.A. White, I.N. MacEwan, S.F. Hill, J.L. Sullivan (selector), R.A. Jarden.
Front row: T.C. Morrison (selector), I.J. Clarke, R.H. Duff (captain), L.V. Carmine (manager), A.R. Reid (vice-captain), M.J. Dixon, A.E. Marslin (selector).
In front: R.H. Brown, K.R. Davis.

Summary:
Played 4, won 3, lost 1
Points for 41, against 29

1958 v AUSTRALIA
First match 23 August, last match 20 September.

Backs: D.L. Ashby *(Southland)*₂. D.B. Clarke *(Waikato)*₁,₃. R.R. Cossey *(Counties)*₁. R.F. McMullen *(Auckland)*₁,₂,₃. P.T. Walsh *(Counties)*₁,₂,₃. J.R. Watt *(Wellington)*₂. R.H. Brown *(Taranaki)*₁. A.H. Clarke *(Auckland)*₁,₂,₃. T.R. Lineen *(Auckland)*₁,₂,₃. K. Davis *(Auckland)*₁,₂,₃.
Forwards: I.J. Clarke *(Waikato)*₁,₃. T.D. Coughlan *(South Canterbury)*₁. T.D. Gillespie *(Otago)*₃. D.J. Graham *(Canterbury)*₁,₂. S.F. Hill *(Canterbury)*₃. M.W. Irwin *(Otago)*₂. P.F.H. Jones *(North Auckland)*₁,₂,₃. I.N. MacEwan *(Wellington)*₁,₂,₃. C.E. Meads *(King Country)*₁,₂,₃. E.A.R. Pickering *(Waikato)*₂. W.J. Whineray *(Waikato)*₁,₂,₃. D. Young *(Canterbury)*₁,₂,₃.
Captain: W.J. Whineray

Record:

v Australia *at Wellington*	won	25-3
v Australia *at Christchurch*	lost	3-6
v Australia *at Auckland*	won	17-8

Summary:
Played 3, won 2, lost 1
Points for 45, against 17

1959 v BRITISH ISLES
First match 18 July, last match 19 September.

Backs: D.B. Clarke *(Waikato)*₁,₂,₃,₄. R.W. Caulton *(Wellington)*₂,₃,₄. E.S. Diack *(Otago)*₂. R.F. McMullen *(Auckland)*₁,₂,₃. B.E. McPhail *(Canterbury)*₁,₄. P.T. Walsh *(Counties)*₁. R.H. Brown *(Taranaki)*₁,₃. A.H. Clarke *(Auckland)*₄. T.R. Lineen *(Auckland)*₁,₂,₃,₄. J.F. McCullough *(Taranaki)*₂,₃,₄. K.C. Briscoe *(Taranaki)*₂. R.J. Urbahn *(Taranaki)*₁,₂,₃.
Forwards: I.J. Clarke *(Waikato)*₁,₂. R.J. Conway *(Otago)*₂,₃,₄. B.E.L. Finlay *(Manawatu)*₁. R.C. Hemi *(Waikato)*₁,₃,₄. S.F. Hill *(Canterbury)*₁,₂,₃,₄. M.W. Irwin *(Otago)*₃,₄. P.F.H. Jones *(North Auckland)*₁. I.N. MacEwan *(Wellington)*₁,₂,₃. C.E. Meads *(King Country)*₂,₃,₄. E.A.R. Pickering *(Waikato)*₁,₄. K.R. Tremain *(Canterbury)*₂,₃,₄. D.S. Webb *(North Auckland)*₂. W.J. Whineray *(Auckland)*₁,₂,₃,₄.
Captain: W.J. Whineray

Record:

v British Isles *at Dunedin*	won	18-17
v British Isles *at Wellington*	won	11-8
v British Isles *at Christchurch*	won	22-8
v British Isles *at Auckland*	lost	6-9

Summary:
Played 4, won 3, lost 1
Points for 57, against 42

1961 v FRANCE
First match 22 July, last match 19 August.

Backs: D.B. Clarke *(Waikato)*₁,₂,₃. R.W. Caulton *(Wellington)*₂. P.F. Little *(Auckland)*₂,₃. D.W. McKay *(Auckland)*₁,₂,₃. T.P.A. O'Sullivan *(Taranaki)*₁. J.R. Watt *(Wellington)*₁,₃. R.H. Brown *(Taranaki)*₁. J.R. Watt *(Wellington)*₁,₃. R.H. Brown *(Taranaki)*₁,₂,₃. T.N. Wolfe *(Wellington)*₁,₂,₃. D.M. Connor *(Auckland)*₁,₂,₃.
Forwards: I.J. Clarke *(Waikato)*₁,₂,₃. D.J. Graham *(Canterbury)*₁,₂,₃. I.N. MacEwan *(Wellington)*₁,₂,₃. C.E. Meads *(King Country)*₁. S.T. Meads *(King Country)*₁. K.R. Tremain *(Canterbury)*₂,₃. W.J. Whineray *(Auckland)*₁,₂,₃. V.M. Yates *(North Auckland)*₁,₂,₃. D. Young *(Canterbury)*₁,₂,₃.
Captain: W.J. Whineray

Record:

v France *at Auckland*	won	13-6
v France *at Wellington*	won	5-3
v France *at Christchurch*	won	32-3

Summary:
Played 3, won 3
Points for 50, against 12

1962 v AUSTRALIA
First match 25 August, last match 22 September.

Backs: D.B. Clarke *(Waikato)*₁,₂,₃. T.R. Heeps *(Wellington)*₁,₂,₃. P.F. Little *(Auckland)*₁,₃. P.J. Morrissey *(Canterbury)*₁,₂,₃. W.A. Davies *(Otago)*₂,₃. M.A. Herewini *(Auckland)*₃. R.C. Moreton *(Canterbury)*₁,₂. B.A. Watt *(Canterbury)*₂. T.N. Wolfe *(Wellington)*₁. D.M. Connor *(Auckland)*₁,₂,₃.
Forwards: I.J. Clarke *(Waikato)*₁. J.N. Creighton *(Canterbury)*₂. D.J. Graham *(Canterbury)*₁,₂,₃. J.M. Le Lievre *(Canterbury)*₂. I.N. MacEwan *(Wellington)*₁,₂. C.E. Meads *(King Country)*₁,₃. S.T. Meads *(King Country)*₂,₃. W.J. Nathan *(Auckland)*₁,₂,₃. K.A. Nelson *(Otago)*₂,₃. B.T. Thomas *(Auckland)*₃. K.R. Tremain *(Hawke's Bay)*₁. W.J. Whineray *(Auckland)*₁,₂,₃. D. Young *(Canterbury)*₁,₃.
Captain: W.J. Whineray

Record:

v Australia *at Wellington*	drew	9-9
v Australia *at Dunedin*	won	3-0
v Australia *at Auckland*	won	16-8

Summary;
Played 3, won 2, drew 1
Points for 28, against 17

1963 v ENGLAND
First match 25 May, second match 1 June.

Backs: D.B. Clarke *(Waikato)*₁,₂. R.W. Caulton *(Wellington)*₁,₂. D.W. McKay *(Auckland)*₁,₂. I.N. Uttley *(Wellington)*₁,₂. P.T. Walsh *(Counties)*₂. B.A. Watt *(Canterbury)*₁,₂. T.N. Wolfe *(Taranaki)*₁. D.M. Connor *(Auckland)*₁,₂.
Forwards: I.J. Clarke *(Waikato)*₁,₂. D.J. Graham *(Canterbury)*₁,₂. C.E. Meads *(King Country)*₁,₂. W.J. Nathan *(Auckland)*₁,₂. A.J. Stewart *(Canterbury)*₁,₂. K.R. Tremain *(Hawke's Bay)*₁,₂. W.J. Whineray *(Auckland)*₁,₂. D. Young *(Canterbury)*₁,₂.
Captain: W.J. Whineray

Record:

v England *at Auckland*	won	21-11
v England *at Christchurch*	won	9-6

Summary:
Played 2, won 2
Points for 30, against 17

1964 v AUSTRALIA
First match 15 August, last match 29 August.

Backs: D.B. Clarke *(Waikato)*₂,₃. M. Williment *(Wellington)*₁. R.W. Caulton *(Wellington)*₁,₂,₃. R.C. Moreton *(Canterbury)*₁,₂,₃. R.E. Rangi *(Auckland)*₂,₃. I.S.T. Smith *(Otago)*₁,₂,₃. J.L. Collins *(Poverty Bay)*₁. P.H. Murdoch *(Auckland)*₂,₃. B.A. Watt *(Canterbury)*₁. D.M. Connor *(Auckland)*₂,₃. C.R. Laidlaw *(Otago)*₁.
Forwards: D.W. Clark *(Otago)*₁,₂. D.J. Graham *(Canterbury)*₁,₂,₃. K.F. Gray *(Wellington)*₁,₂,₃. B.E. McLeod *(Counties)*₁,₂,₃. C.E. Meads *(King Country)*₁,₂,₃. S.T. Meads *(King Country)*₁,₂,₃. A.J. Stewart *(South Canterbury)*₃. B.T. Thomas *(Wellington)*₁,₂,₃. K.R. Tremain *(Hawke's Bay)*₁,₂,₃.
Captain: D.J. Graham

Record:

v Australia *at Dunedin*	won	14-9
v Australia *at Christchurch*	won	18-3
v Australia *at Wellington*	lost	5-20

Summary:
Played 3, won 2, lost 1
Points for 37, against 32

1965 v SOUTH AFRICA
First match 31 July, last match 18 September.

Backs: W.F. McCormick *(Canterbury)*₄. M. Williment *(Wellington)*₁,₂,₃. W.M. Birtwistle *(Canterbury)*₁,₂,₃,₄. M.J. Dick *(Auckland)*₃. R.E. Rangi *(Auckland)*₁,₂,₃,₄. I.S.T. Smith *(North Otago)*₁,₂,₄. J.L. Collins *(Poverty Bay)*₁,₄. M.A. Herewini *(Auckland)*₄. R.C. Moreton *(Canterbury)*₂,₃. P.H. Murdoch *(Auckland)*₁,₂,₃. C.R. Laidlaw *(Otago)*₁,₂,₃,₄.
Forwards: R.J. Conway *(Bay of Plenty)*₁,₂,₃,₄. K.F. Gray *(Wellington)*₁,₂,₃,₄. B.J. Lochore *(Wairarapa)*₁,₂,₃,₄. B.E. McLeod *(Counties)*₁,₂,₃,₄. C.E. Meads *(King Country)*₁,₂,₃,₄. S.T. Meads *(King Country)*₁,₂,₃,₄. K.R. Tremain *(Hawke's Bay)*₁,₂,₃,₄. W.J. Whineray *(Auckland)*₁,₂,₃,₄.
Captain: W.J. Whineray

Record:

v South Africa *at Wellington*	won	6-3
v South Africa *at Dunedin*	won	13-0
v South Africa *at Christchurch*	lost	16-19
v South Africa *at Auckland*	won	20-3

Summary:
Played 4, won 3, lost 1
Points for 55, against 25

1966 v BRITISH ISLES
First match 16 July, last match 10 September.

Backs: M. Williment *(Wellington)*; M.J. Dick *(Auckland)*₄, R.E. Rangi *(Auckland)*; I.S.T. Smith *(North Otago)*₁,₂,₃, A.G. Steel *(Canterbury)*; MA. Herewini *(Auckland)*; I.R. MacRae *(Hawke's Bay)*; C.R. Laidlaw *(Otago)*
Forwards: K.F. Gray *(Wellington)*; E.J. Hazlett *(Southland)*; B.J. Lochore *(Wairarapa)*; B.E. McLeod *(Counties)*; C.E. Meads *(King Country)*; S.T. Meads *(King Country)*; W.J. Nathan *(Auckland)*; K.R. Tremain *(Hawke's Bay)*
All played in the four tests except Dick and Smith.
Captain: B.J. Lochore

Record:

v British Isles *at Dunedin*	won	20-3
v British Isles *at Wellington*	won	16-12
v British Isles *at Christchurch*	won	19-6
v British Isles *at Auckland*	won	24-11

Summary:
Played 4, won 4
Points for 79, against 32

1967 v AUSTRALIA
19 August.

Backs: M. Williment *(Wellington)*, W.L. Davis *(Hawke's Bay)*, M.J. Dick *(Auckland)*, A.G. Steel *(Canterbury)*, M.A. Herewini *(Auckland)*, I.R. MacRae *(Hawke's Bay)*, S.M. Going *(North Auckland)*
Forwards: E.J. Hazlett *(Southland)*, B.J. Lochore *(Wairarapa)*, J. Major *(Taranaki)*, C.E. Meads *(King Country)*, B.L. Muller *(Taranaki)*, W.J. Nathan *(Auckland)*, S.C. Strahan *(Manawatu)*, K.R. Tremain *(Hawke's Bay)*
Captain: B.J. Lochore

Record:

v Australia *at Wellington*	won	29-9

1968 v FRANCE
First match 13 July, last match 10 August.

Backs: W.F. McCormick *(Canterbury)*₁,₂,₃, M.W. O'Callaghan *(Manawatu)*₁,₂,₃, W.L. Davis *(Hawke's Bay)*₁, G.S. Thorne *(Auckland)*₁,₂,₃, I.R. MacRae *(Hawke's Bay)*₁,₂, E.W. Kirton *(Otago)*₁,₂,₃, C.R. Laidlaw *(Otago)*₁,₂; W.D. Cottrell *(Canterbury)*₂,₃, O.G. Stephens *(Wellington)*₃, S.M. Going *(North Auckland)*₃
Forwards: B.J. Lochore *(Wairarapa)*₂,₃, I.A. Kirkpatrick *(Canterbury)*₁,₂,₃, K.R. Tremain *(Hawke's Bay)*₁,₂,₃, C.E. Meads *(King Country)*₁,₂,₃, S.C. Strahan *(Manawatu)*₁,₂,₃, T.N. Lister *(South Canterbury)*₁, A.E. Hopkinson *(Canterbury)*₁,₂,₃, B.E. McLeod *(Counties)*₁,₂,₃, B.L. Muller *(Taranaki)*₁, K.F. Gray *(Wellington)*₂,₃
Captains: K.R. Tremain ₁; B.J. Lochore ₂,₃

Record:

v France *at Christchurch*	won	12-9
v France *at Wellington*	won	9-3
v France *at Auckland*	won	19-12

Summary:
Played 3, won 3
Points for 40, against 24

1969 v WALES
First match 31 May, second match 14 June.

Backs: W.F. McCormick *(Canterbury)*₁,₂, W.L. Davis *(Hawke's Bay)*₁,₂,

M.J. Dick *(Auckland)*₁,₂, G.R. Skudder *(Waikato)*₂, G.S. Thorne *(Auckland)*₁, E.W. Kirton *(Otago)*₁,₂, I.R. MacRae *(Hawke's Bay)*₁,₂, S.M. Going *(North Auckland)*₁,₂
Forwards: K.F. Gray *(Wellington)*₁,₂, A.E. Hopkinson *(Canterbury)*₂, I.A. Kirkpatrick *(Canterbury)*₁,₂, T.N. Lister *(South Canterbury)*₁,₂, B.J. Lochore *(Wairarapa)*₁,₂, B.E. McLeod *(Counties)*₁,₂, C.E. Meads *(King Country)*₁,₂, B.L. Muller *(Taranaki)*₁, A.E. Smith *(Taranaki)*₁,₂
Captain: B.J. Lochore

Record:

v Wales *at Christchurch*	won	19-0
v Wales *at Auckland*	won	33-12

Summary:
Played 2, won 2
Points for 52, against 12

1971 v BRITISH ISLES
First match 26 June, last match 14 August.

Backs: L.W. Mains *(Otago)*₂,₃,₄, W.F. McCormick *(Canterbury)*₁, K.R. Carrington *(Auckland)*₁,₃,₄, M.G. Duncan *(Hawke's Bay)*₃(r),₄, B.A. Hunter *(Otago)*₁,₂,₃, H.T. Joseph *(Canterbury)*₂,₃, B.G. Williams *(Auckland)*₁,₂,₄, R.E. Burgess *(Manawatu)*₁,₂,₃, W.D. Cottrell *(Canterbury)*₁,₂,₃,₄, P.C. Gard *(North Otago)*₄, S.M. Going *(North Auckland)*₁,₂,₃,₄
Forwards: R.A. Guy *(North Auckland)*₁,₂,₃,₄, I.A. Kirkpatrick *(Poverty Bay)*₁,₂,₃,₄, T.N. Lister *(South Canterbury)*₄, B.J. Lochore *(Wairarapa-Bush)*₃, A.M. McNaughton *(Bay of Plenty)*₁,₂,₃, C.E. Meads *(King Country)*₁,₂,₃,₄, B.L. Muller *(Taranaki)*₁,₂,₃,₄, R.W. Norton *(Canterbury)*₁,₂,₃,₄, A.R. Sutherland *(Marlborough)*₁, P.J. Whiting *(Auckland)*₁,₂,₄, A.J. Wyllie *(Canterbury)*₂,₃,₄
Captain: C.E. Meads

Record:

v British Isles *at Dunedin*	lost	3-9
v British Isles *at Christchurch*	won	22-12
v British Isles *at Wellington*	lost	3-13
v British Isles *at Auckland*	drew	14-14

Summary:
Played 4, won 1, lost 2, drew 1
Points for 42, against 48

1972 v AUSTRALIA and INTERNAL TOUR
First match 13 May, last match 16 September.

Backs: T.J. Morris *(Nelson Bays)*₁,₂,₃, K.R. Carrington *(Auckland)*; D.A. Hales *(Canterbury)*₁,₂,₃, B.J. Robertson *(Counties)*₁,₃, G.S. Sims *(Otago)*₂, B.G. Williams *(Auckland)*₁,₂,₃, R.E. Burgess *(Manawatu)*₃, P. Dougan *(Wellington)*₁, P.C. Gard *(North Otago)*; J.L. Jaffray *(Otago)*₂, R.M. Parkinson *(Poverty Bay)*₁,₂,₃, G.L. Colling *(Otago)*; S.M. Going *(North Auckland)*₁,₂,₃
Forwards: I.M. Eliason *(Taranaki)*; R.A. Guy *(North Auckland)*; B. Holmes *(North Auckland)*; I.A. Kirkpatrick *(Poverty Bay)*₁,₂,₃, H.H. Macdonald *(Canterbury)*; J.D. Matheson *(Otago)*₁,₂,₃, K. Murdoch *(Otago)*₃, A.M. McNaughton *(Bay of Plenty)*; R.W. Norton *(Canterbury)*₁,₂,₃, A.I. Scown *(Taranaki)*₁,₂,₃, S.C. Strahan *(Manawatu)*₁,₂,₃, A.R. Sutherland *(Marlborough)*₁,₂,₃, R.A. Urlich *(Auckland)*; G.J. Whiting *(King Country)*₁,₂, P.J. Whiting *(Auckland)*₁,₂,₃
Captain: I.A. Kirkpatrick

Record:

v New Zealand Juniors *at Wellington*	won	25-9
v Marlborough *at Blenheim*	won	59-10
v Mid Canterbury *at Ashburton*	won	52-7
v Southland *at Invercargill*	won	30-9
v Wanganui *at Wanganui*	won	39-21
v Counties *at Pukekohe*	won	42-8
v North Auckland *at Whangarei*	won	33-15
v Wairarapa-Bush *at Masterton*	won	38-0
v Manawatu *at Palmerston North*	won	37-9
v Australia *at Wellington*	won	29-6
v Australia *at Christchurch*	won	30-17
v Australia *at Auckland*	won	38-3

Summary:
Played 12, won 12
Points for 452, against 114

1973 v ENGLAND and INTERNAL TOUR
First match 1 August, last match 15 September.

Backs: J.F. Karam *(Wellington)*, G.B. Batty *(Wellington)**, T.G. Morrison *(Otago)**(r), B.J. Robertson *(Counties)*, I.A. Hurst *(Canterbury)**, B.G. Williams *(Auckland)**, R.N. Lendrum *(Counties)**, R.M. Parkinson *(Manawatu)**, J.P. Dougan *(Wellington)**, G.L. Colling *(Otago)*, I.N. Stevens *(Wellington)*, S.M. Going *(North Auckland)**
Forwards: B. Holmes *(North Auckland)*, I.A. Kirkpatrick *(Poverty Bay)**, K.W. Stewart *(Southland)**, A.J. Wyllie *(Canterbury)**, S.C. Strahan *(Manawatu)**, A.M. Haden *(Auckland)*, H.H. Macdonald *(Canterbury)**, M.G. Jones *(North Auckland)**, K.K. Lambert *(Manawatu)**, G.J. Whiting *(King Country)*, A.L.R. McNicol *(Wanganui)*‡, R.W. Norton *(Canterbury)**, P.H. Sloane *(North Auckland)*, D.A. Pescini *(Otago)*‡
* Played in the test
‡ Added to team but did not play
Captain: I.A. Kirkpatrick

Record:

v New Zealand Juniors *at Dunedin*	lost	10-14
v President's XV *at Wellington*	lost	28-35
v New Zealand Maoris *at Rotorua*	won	18-8
v Invitation XV *at Auckland*	won	22-10
v England *at Auckland*	lost	10-16

Summary:
Played 5, won 2, lost 3
Points for 88, against 83

1975 v SCOTLAND
14 June.

Backs: J.F. Karam *(Horowhenua)*, B.G. Williams *(Auckland)*, W.M. Osborne *(Wanganui)*, G.B. Batty *(Wellington)*, J.L. Jaffray *(Otago)*, D.J. Robertson *(Otago)*, S.M. Going *(North Auckland)*
Forwards: A.R. Leslie *(Wellington)*, I.A. Kirkpatrick *(Poverty Bay)*, K.W. Stewart *(Southland)*, J.A. Callesen *(Manawatu)*, H.H. Macdonald *(North Auckland)*, W.K.Te P. Bush *(Canterbury)*, K.J. Tanner *(Canterbury)*, R.W. Norton *(Canterbury)*
Captain: A.R. Leslie

Record:

v Scotland *at Auckland*	won	24-0

1976 v IRELAND
5 June.

Backs: L.W. Mains *(Otago)*, N.A. Purvis *(Otago)*, B.J. Robertson *(Counties)*, B.G. Williams *(Auckland)*, J.L. Jaffray *(Otago)*, D.J. Robertson *(Otago)*, L.J. Davis *(Canterbury)*, S.M. Going *(North Auckland)*(r)
Forwards: A.R. Leslie *(Wellington)*, K.W. Stewart *(Southland)*, P.J. Whiting *(Auckland)*, H.H. Macdonald *(North Auckland)*, I.A. Kirkpatrick *(Poverty Bay)*, K.J. Tanner *(Canterbury)*, R.W. Norton *(Canterbury)*, W.K. Te P. Bush *(Canterbury)*
Captain: A.R. Leslie

Record:

v Ireland *at Wellington*	won	11-3

1977 v BRITISH ISLES
First match 18 June, last match 13 August.

Backs: C.P. Farrell *(Auckland)*1,2, B.W. Wilson *(Otago)*3,4, B.G. Williams *(Auckland)*1,2,3,4, G.B. Batty *(Bay of Plenty)*1, N.M. Taylor *(Bay of Plenty)*2,4(r), B.R. Ford *(Marlborough)*3,4, W.M. Osborne *(Wanganui)*1,2,3,4, B.J. Robertson *(Counties)*1,3,4, D.J. Robertson *(Otago)*1, O.D. Bruce *(Canterbury)*2,3,4, J.L. Jaffray *(Otago)*2, S.M. Going *(North Auckland)*1,2, L.J. Davis *(Canterbury)*3,4
Forwards: L.G. Knight *(Poverty Bay)*1,2,3,4, I.A. Kirkpatrick *(Poverty Bay)*1,2,3,4, K.A. Eveleigh *(Manawatu)*1,2, G.N.K. Mourie *(Taranaki)*3,4, A.M. Haden *(Auckland)*1,2,3,4, F.J. Oliver *(Southland)*1,2,3,4, B.R. Johnstone *(Auckland)*1,2, K.K. Lambert *(Manawatu)*1,4, W.K. Te P. Bush *(Canterbury)*2,3,4(r), J.T. McEldowney *(Taranaki)*3,4, R.W. Norton *(Canterbury)*1,2,3,4
Captain: R.W. Norton

Record:

v British Isles *at Wellington*	won	16-12
v British Isles *at Christchurch*	lost	9-13
v British Isles *at Dunedin*	won	19-7
v British Isles *at Auckland*	won	10-9

Summary:
Played 4, won 3, lost 1
Points for 54, against 41

1978 v AUSTRALIA
First match 19 August, last match 9 September.

Backs: B.W. Wilson *(Otago)*1,2,3, S.S. Wilson *(Wellington)*1,2,3, B.J. Robertson *(Counties)*1,2,3, B.G. Williams *(Auckland)*1,2,3, N.M Taylor *(Bay of Plenty)*1,2,3, O.D. Bruce *(Canterbury)*1,2, B.J. McKechnie *(Southland)*3, M.W. Donaldson *(Manawatu)*1,2,3
Forwards: G.A. Seear *(Otago)*1,2,3, B.G. Ashworth *(Auckland)*1,2, A.M. Haden *(Auckland)*1,2,3, F.J. Oliver *(Otago)*1,2,3, L.M. Rutledge *(Southland)*1,2,3, R.G. Myers *(Waikato)*3, J.C. Ashworth *(Canterbury)*1,2,3, A.G. Dalton *(Counties)*1,2,3, G.A. Knight *(Manawatu)*1,2,3
Captain: F.J. Oliver

Record:

v Australia *at Wellington*	won	13-12
v Australia *at Christchurch*	won	22-6
v Australia *at Auckland*	lost	16-30

Summary:
Played 3, won 2, lost 1
Points for 51, against 48

1979 v FRANCE
First match 7 July, second match 14 July.

Backs: B.W. Wilson *(Otago)*, M.G. Watts *(Taranaki)*, S.S. Wilson *(Wellington)*, B.J. Robertson *(Counties)*, J.L. Jaffray *(South Canterbury)*, M.B. Taylor *(Waikato)*, M.W. Donaldson *(Manawatu)*
Forwards: G.A. Seear *(Otago)*, G.N.K. Mourie *(Taranaki)*, L.M. Rutledge *(Southland)*, A.M. Haden *(Auckland)*, F.J. Oliver *(Otago)*, G.A. Knight *(Manawatu)*, B.R. Johnstone *(Auckland)*, A.G. Dalton *(Counties)*.
All players appeared in both tests.
Captain: G.N.K. Mourie

Record:

v France *at Christchurch*	won	23-9
v France *at Auckland*	lost	19-24

Summary:
Played 2, won 1, lost 1
Points for 42, against 33

1979 v ARGENTINA
First match 8 September, second match 15 September.

Backs: R.G. Wilson *(Canterbury)*, B.R. Ford *(Marlborough)*, B.G. Fraser *(Wellington)*, G.R. Cunningham *(Auckland)*, L.M. Cameron *(Manawatu)*, K.J. Keane *(Canterbury)*, E. Dunn *(North Auckland)*, D.S. Loveridge *(Taranaki)*
Forwards: M.G. Mexted *(Wellington)*, M.M. Burgoyne *(North Auckland)*, K.W. Stewart *(Southland)*, W.G. Graham *(Otago)*, J.K. Fleming *(Wellington)*, V.E. Stewart *(Canterbury)*, J.C. Ashworth *(Canterbury)*, P.H. Sloane *(North Auckland)*, B.A. Thompson *(Canterbury)*
Captain: D.S. Loveridge

Record:

v Argentina *at Dunedin*	won	18-9
v Argentina *at Wellington*	won	15-6

Summary:
Played 2, won 2
Points for 33, against 15

1980 v FIJI
13 September.

Backs: G.T. Valli *(Southland)*, F.A. Woodman *(North Auckland)*, J.L.B. Salmon *(Wellington)*, K.J. Taylor *(Hawke's Bay)*, W.M. Osborne *(Wanganui)*, M.W. Donaldson *(Manawatu)*, C.D. Wickes *(Manawatu)*(r)
Forwards: G.H. Old *(Manawatu)*, S.B. Conn *(Auckland)*, F.J. Oliver *(Manawatu)*, G. Higginson *(Canterbury)*, G.N.K. Mourie *(Taranaki)*, G.A.J. Burgess *(Auckland)*, A.G. Dalton *(Counties)*, R.C. Ketels *(Counties)*
Captain: G.N.K. Mourie

Record:

v Fiji *at Auckland* won 33-0

1981 v SCOTLAND
First match 13 June, second match 20 June.

Backs: A.R. Hewson *(Wellington)*, B.G. Fraser *(Wellington)*, S.S. Wilson *(Wellington)*, B.J. Robertson *(Counties)*, A.C.R. Jefferd *(East Coast)*, E.J. Dunn *(North Auckland)*₁, D.L. Rollerson *(Manawatu)*₂, D.S. Loveridge *(Taranaki)*
Forwards: M.G. Mexted *(Wellington)*, G.N.K. Mourie *(Taranaki)*, M.W. Shaw *(Manawatu)*, H. Rickit *(Waikato)*, G. Higginson *(Canterbury)*₁, A.M. Haden *(Auckland)*₂, G.A. Knight *(Manawatu)*, R.C. Ketels *(Counties)*, A.H. Dalton *(Counties)*
Captain: G.N.K. Mourie

Record:

v Scotland *at Dunedin* won 11-4
v Scotland *at Auckland* won 40-15

Summary:
Played 2, won 2
Points for 51, against 19

1981 v SOUTH AFRICA
First match 15 August, last match 12 September.

Backs: A.R. Hewson *(Southland)*₁,₂,₃, B.J. McKechnie *(Southland)*₁(r), B.G. Fraser *(Wellington)*₁,₂,₃, F.A. Woodman *(North Auckland)*₁,₂, S.S. Wilson *(Wellington)*₁,₂,₃, L.M. Cameron *(Manawatu)*₁(r),₂,₃, A.C.R. Jefferd *(East Coast)*₁, S.T. Pokere *(Southland)*₃, D.L. Rollerson *(Manawatu)*₁,₂,₃, D.S. Loveridge *(Taranaki)*₁,₂,₃, M.W. Donaldson *(Manawatu)*₃(r)
Forwards: M.G. Mexted *(Wellington)*₁,₂,₃, M.W. Shaw *(Manawatu)*₁,₂, K.W. Stewart *(Southland)*₁,₂, G.H. Old *(Manawatu)*₃, F.N.K. Shelford *(Bay of Plenty)*₃, A.M. Haden *(Auckland)*₁,₂,₃, G. Higginson *(Canterbury)*₁, F.J. Oliver *(Manawatu)*₂, G.W. Whetton *(Auckland)*₃, G.A. Knight *(Manawatu)*₁,₃, J.C. Ashworth *(Canterbury)*₁,₂,₃, G.A.J. Burgess *(Auckland)*₂, A.G. Dalton *(Counties)*₁,₂,₃
Captain: A.G. Dalton

Record:

v South Africa *at Christchurch* won 14-9
v South Africa *at Wellington* lost 12-24
v South Africa *at Auckland* won 25-22

Summary:
Played 3, won 2, lost 1
Points for 51, against 55

1982 v AUSTRALIA
First match 14 August, last match 11 September.

Backs: A.R. Hewson *(Wellington)*₁,₂,₃, S.S. Wilson *(Wellington)*₁,₂,₃, B.G. Fraser *(Wellington)*₁,₂,₃, S.T. Pokere *(Southland)*₁,₂,₃, W.M. Osborne *(Wanganui)*₁,₃, N.M. Taylor *(Hawke's Bay)*₂, W.R. Smith *(Canterbury)*₁,₂,₃, D.S. Loveridge *(Taranaki)*₁,₂,₃
Forwards: M.G. Mexted *(Wellington)*₁,₂,₃, G.N.K. Mourie *(Taranaki)*₁,₂,₃, M.W. Shaw *(Manawatu)*₁,₂,₃, A.M. Haden *(Auckland)*₁,₂,₃, G. Higginson *(Hawke's Bay)*₁,₂, G.W. Whetton *(Auckland)*₃, G.H. Old *(Manawatu)*₁(r), J.C. Ashworth *(Canterbury)*₁,₂, G.A. Knight *(Manawatu)*₁,₂,₃, T.T. Koteka *(Waikato)*₃, A.G. Dalton *(Counties)*₁,₂,₃
Captain: G.N.K. Mourie

Record:

v Australia *at Christchurch* won 23-16
v Australia *at Wellington* lost 16-19
v Australia *at Auckland* won 33-18

Summary:
Played 3, won 2, lost 1
Points for 72, against 53

1983 v BRITISH ISLES
First match 4 June, last match 16 July.

Backs: A.R. Hewson *(Wellington)*₁,₂,₃,₄, S.S. Wilson *(Wellington)*₁,₂,₃,₄, B.G. Fraser *(Wellington)*₁,₂,₃,₄, S.T. Pokere *(Southland)*₁,₂,₃,₄, A.M. Stone *(Waikato)*₃(r), W.T. Taylor *(Canterbury)*₁,₂,₃,₄, W.R. Smith *(Canterbury)*₂,₃, I.T.W. Dunn *(North Auckland)*₁,₄, D.S. Loveridge *(Taranaki)*₁,₂,₃,₄
Forwards: M.G. Mexted *(Wellington)*₁,₂,₃,₄, M.J.B. Hobbs *(Canterbury)*₁,₂,₃,₄,

A.M. Haden *(Auckland)*₁,₂,₃,₄, G.W. Whetton *(Auckland)*₁,₂,₃,₄, G.A. Knight *(Manawatu)*₁,₂,₃,₄, J.C. Ashworth *(Canterbury)*₁,₂,₃,₄, A.G. Dalton *(Counties)*₁,₂,₃,₄
Captain: A.G. Dalton

Record:

v British Isles *at Christchurch* won 16-12
v British Isles *at Wellington* won 9-0
v British Isles *at Dunedin* won 15-8
v British Isles *at Auckland* won 38-6

Summary:
Played 4, won 4
Points for 78, against 26

1984 v FRANCE
First match 16 June, last match 23 June.

Backs: A.R. Hewson *(Wellington)*, B.W. Smith *(Waikato)*, S.T. Pokere *(Auckland)*, J.J. Kirwan *(Auckland)*, W.T. Taylor *(Canterbury)*, W.R. Smith *(Canterbury)*, A.J. Donald *(Wanganui)*
Forwards: M.G. Mexted *(Wellington)*, M.J.B. Hobbs *(Canterbury)*, G.W. Whetton *(Auckland)*, A.M. Haden *(Auckland)*, M.W. Shaw *(Manawatu)*, G.A. Knight *(Manawatu)*, A.G. Dalton *(Counties)*, J.C. Ashworth *(Canterbury)*
All players appeared in both tests.
Captain: A.G. Dalton

Record:

v France *at Christchurch* won 10-9
v France *at Auckland* won 31-18

Summary:
Played 2, won 2
Points for 41, against 27

1985 v ENGLAND and AUSTRALIA
v England 1 June and 8 June; v Australia 29 June.

Backs: K.J. Crowley *(Taranaki)*, J.J. Kirwan *(Auckland)*, S.T. Pokere *(Auckland)*, C.I. Green *(Canterbury)*, W.T. Taylor *(Canterbury)*, W.R. Smith *(Canterbury)*, D.E. Kirk *(Auckland)*
Forwards: M.G. Mexted *(Wellington)*, M.J.B. Hobbs *(Canterbury)*, G.W. Whetton *(Auckland)*, M.J. Pierce *(Wellington)*, M.W. Shaw *(Manawatu)*, G.A. Knight *(Manawatu)*, A.G. Dalton *(Counties)*, J.C. Ashworth *(Hawke's Bay)*, A.J. Whetton *(Auckland)*(r)
All players with the exception of A.J. Whetton appeared in all three tests.
Captain: A.G. Dalton

Record:

v England *at Christchurch* won 18-13
v England *at Wellington* won 42-15
v Australia *at Auckland* won 10-9

Summary:
Played 3, won 3
Points for 70, against 37

1986 v FRANCE
28 June.

Backs: G.J.L. Cooper *(Auckland)*, J.J. Kirwan *(Auckland)*, J.T. Stanley *(Auckland)*, T.J. Wright *(Auckland)*, A.M. Stone *(Bay of Plenty)*, F.M. Botica *(North Harbour)*, D.E. Kirk *(Auckland)*
Forwards: M.R. Brewer *(Otago)*, M. Brooke-Cowden *(Auckland)*, G. Macpherson *(Otago)*, A.T. Earl *(Canterbury)*, B.A. Harvey *(Wairarapa-Bush)*, B. McGrattan *(Wellington)*, S.B.T. Fitzpatrick *(Auckland)*, K.G. Boroevich *(Wellington)*
Captain: D.E. Kirk

Record:

v France *at Christchurch* won 18-9

1986 v AUSTRALIA
First match 9 August, last match 6 September.

Backs: G.J.L. Cooper *(Auckland)*₁,₂, K.J. Crowley *(Taranaki)*₃, J.J. Kirwan *(Auckland)*₁,₂,₃, J.T. Stanley *(Auckland)*₁,₂,₃, T.J. Wright *(Auckland)*₁, C.I. Green *(Canterbury)*₂,₃, A.M. Stone *(Bay of Plenty)*₁,₃, W.T. Taylor *(Canterbury)*₂, F.M. Botica *(North Harbour)*₁,₂,₃, D.E. Kirk *(Auckland)*₁,₂,₃, M.J. Berry *(Wairarapa-Bush)*₃(r)

Forwards: M.R. Brewer *(Otago)*₁,₂,₃. M.Brooke-Cowden *(Auckland)*₁. A.T. Earl *(Canterbury)*₁. M.W. Speight *(North Auckland)*₁. B.A. Harvey *(Wairarapa-Bush)*₁. M.J.B. Hobbs *(Canterbury)*₂,₃. G.W. Whetton *(Auckland)*₂,₃. M.J. Pierce *(Wellington)*₂,₃. A.J. Whetton *(Auckland)*₂. M.W. Shaw *(Hawke's Bay)*₃. B. McGrattan *(Wellington)*₁. S.B.T. Fitzpatrick *(Auckland)*. K.G. Boroevich *(Wellington)*₁. G.A. Knight *(Manawatu)*₂,₃. H.R. Reid *(Bay of Plenty)*₂,₃. S.C. McDowell *(Auckland)*₂,₃
Captain: D.E. Kirk

Record:

v Australia *at Wellington*	lost	12-13
v Australia *at Dunedin*	won	13-12
v Australia *at Auckland*	lost	9-22

Summary:
Played 3, won 1, lost 2
Points for 34, against 47

1987 NEW ZEALAND WORLD CUP SQUAD
First match 22 May, last match 20 June.

Backs: J.A. Gallagher *(Wellington)*, K.J. Crowley *(Taranaki)*, J.J. Kirwan *(Auckland)*, C.I. Green *(Canterbury)*, T.J. Wright *(Auckland)*, J.T. Stanley *(Auckland)*, W.T. Taylor *(Canterbury)*, B.J. McCahill *(Auckland)*, G.J. Fox *(Auckland)*, F.M. Botica *(North Harbour)*, D.E. Kirk *(Auckland)*, I.B. Deans* *(Canterbury)*
Forwards: W.T. Shelford *(North Harbour)*, A.T. Earl *(Canterbury)*, A.J. Whetton *(Auckland)*, M.N. Jones *(Auckland)*, M. Brooke-Cowden *(Auckland)*, Z.V. Brooke *(Auckland)*, G.W. Whetton *(Auckland)*, M.J. Pierce *(Wellington)*, A. Anderson *(Canterbury)*, S.C. McDowell *(Auckland)*, J.A. Drake *(Auckland)*, R.W. Loe *(Waikato)*, A.G. Dalton *(Counties)*, S.B.T. Fitzpatrick *(Auckland)*
Captains: A.G. Dalton*, D.E, Kirk
Selectors: B.J. Lochore, A.J. Wyllie, J.B. Hart. **Manager:** R.A. Guy
*did not play

Record:

v Italy *at Auckland*	won	70-6
v Fiji *at Christchurch*	won	74-13
v Argentina *at Wellington*	won	46-15
v Scotland *at Christchurch*	won	30-3
v Wales *at Brisbane*	won	49-6
v France *at Auckland*	won	29-9

Summary:
Played 6, won 6
Points for 298, against 52

1988 v WALES
First match 25 May, second match 11 June.

Backs: J.A. Gallagher *(Wellington)*₁,₂. T.J. Wright *(Auckland)*₁,₂. J.T. Stanley *(Auckland)*₁,₂. J.J. Kirwan *(Auckland)*₁,₂. W.T. Taylor *(Canterbury)*₁,₂. G.J. Fox *(Auckland)*₁,₂. I.B. Deans *(Canterbury)*₁,₂
Forwards: W.T. Shelford *(North Harbour)*₁,₂. M.N. Jones *(Auckland)*₁,₂. A.J. Whetton *(Auckland)*₁,₂. M.J. Pierce *(Wellington)*₁,₂. G.W. Whetton *(Auckland)*₁,₂. R.W. Loe *(Waikato)*₁,₂. S.C. McDowell *(Auckland)*₁,₂. S.B.T. Fitzpatrick *(Auckland)*₁,₂
Captain: W.T. Shelford

Record:

v Wales *at Christchurch*	won	52-3
v Wales *at Auckland*	won	54-9

Summary:
Played 2, won 2
Points for 106, against 12

1989 v FRANCE, ARGENTINA and AUSTRALIA
First match 7 June, last match 5 August.

Backs: J.A. Gallagher *(Wellington)*, J.J. Kirwan *(Auckland)*, T.J. Wright *(Auckland)*, J.T. Stanley *(Auckland)*, B.J. McCahill *(Auckland)*₍ᵣ₎. N.J. Schuster *(Wellington)*, F.M. Botica *(North Harbour)*₍ᵣ₎. G.J. Fox *(Auckland)*, I.B. Deans *(Canterbury)*.
Forwards: W.T. Shelford *(North Harbour)*, M.N. Jones *(Auckland)*, Z.V. Brooke *(Auckland)*₍ᵣ₎. M.R. Brewer *(Otago)*, A.J. Whetton *(Auckland)*, G.W. Whetton *(Auckland)*, M.J. Pierce *(Wellington)*, R.W. Loe *(Waikato)*, S.C. McDowell *(Bay of Plenty, Auckland)*, S.B.T Fitzpatrick *(Auckland)*. The same team played in each match except for Brewer in place of Jones against Australia. McCahill (2), Botica and Brooke each went on as a replacement.

Captain: W.T. Shelford

Record:

v France *at Christchurch*	won	25-17
v France *at Auckland*	won	34-20
v Argentina *at Dunedin*	won	60-9
v Argentina *at Wellington*	won	49-12
v Australia *at Auckland*	won	24-12

Summary:
Played 5, won 5
Points for 192, against 70

1990 v SCOTLAND
First match 16 June, second match 23 June.

Backs: K.J. Crowley *(Taranaki)*, J.J. Kirwan *(Auckland)*, T.J. Wright *(Auckland)*, J.T. Stanley *(Auckland)*, W.K. Little *(North Harbour)*, G.J. Fox *(Auckland)*, G.T.M. Bachop *(Canterbury)*
Forwards: W.T. Shelford *(North Harbour)*, A.J. Whetton *(Auckland)*, M.R. Brewer *(Otago)*, G.W. Whetton *(Auckland)*, I.D. Jones *(North Auckland)*, R.W. Loe *(Waikato)*, S.C. McDowell *(Auckland)*, S.B.T. Fitzpatrick *(Auckland)*. The same team played in both tests
Captain: W.T. Shelford

Record:

v Scotland *at Dunedin*	won	31-16
v Scotland *at Auckland*	won	21-18

Summary:
Played 2, won 2
Points for 52, against 34

1990 v AUSTRALIA
First match 21 July, last match 18 August.

Backs: K.J. Crowley *(Taranaki)*, J.J. Kirwan *(Auckland)*, T.J. Wright *(Auckland)*, C.R. Innes *(Auckland)*, W.K. Little *(North Harbour)*, G.J. Fox *(Auckland)*, G.T.M. Bachop *(Canterbury)*
Forwards: Z.V. Brooke *(Auckland)*, A.J. Whetton *(Auckland)*, M.R. Brewer *(Otago)*, K.J. Schuler *(Manawatu)*₂₍ᵣ₎. G.W. Whetton *(Auckland)*, I.D. Jones *(North Auckland)*, R.W. Loe *(Waikato)*, S.C. McDowell *(Auckland)*, S.B.T. Fitzpatrick *(Auckland)*
Captain: G.W. Whetton

Record:

v Australia *at Christchurch*	won	21-6
v Australia *at Auckland*	won	27-17
v Australia *at Wellington*	lost	9-21

Summary:
Played 3, won 2, lost 1
Points for 57, against 44

1991 v AUSTRALIA
24 August.

Backs: T.J. Wright *(Auckland)*, J.J. Kirwan *(Auckland)*, J.K.R. Timu *(Otago)*, C.R. Innes *(Auckland)*, B.J. McCahill *(Auckland)*, G.J. Fox *(Auckland)*, G.T.M. Bachop *(Canterbury)*
Forwards: Z.V. Brooke *(Auckland)*, M.P. Carter *(Auckland)*, M.N. Jones *(Auckland)*, G.W. Whetton *(Auckland)*, I.D. Jones *(North Auckland)*, R.W. Loe *(Waikato)*, S.C. McDowell *(Auckland)*, S.B.T. Fitzpatrick *(Auckland)*
Captain: G.W. Whetton

Record:

v Australia *at Auckland*	won	6-3

1992 v WORLD XV
First match 18 April, last match 25 April.

Backs: G.J.L. Cooper *(Otago)*₁,₂,₃. F.E. Bunce *(North Harbour)*₁,₂,₃. M.C.G. Ellis* *(Otago)*, J.J. Kirwan *(Auckland)*₁,₂₍ᵣ₎,₃ J.K.R. Timu *(Otago)*₂. V.I. Tuigamala *(Auckland)*₁,₂,₃. E. Clarke *(Auckland)*₂,₃. G.J. Fox *(Auckland)*₁,₂,₃. W.K. Little *(North Harbour)*₁,₂,₃. G.T.M. Bachop *(Canterbury)*₁. A.D. Strachan *(Auckland)*₂,₃.
Forwards: R.S. Turner *(North Harbour)*₁,₂,₃. A.R.B. Pene *(Otago)*₁₍ᵣ₎,₂,₃. P.W. Henderson *(Southland)*₁,₂,₃. M.N. Jones *(Auckland)*₁,₃. J.W. Joseph *(Otago)*₂,₃₍ᵣ₎. D.J. Seymour* *(Canterbury)*, M.S.B. Cooksley *(Counties)*₁,₂. I.D. Jones *(North Auckland)*₁,₃. B.P. Larsen *(North Harbour)*₂,₃. G.L. Taylor* *(North Auckland)*, L.C. Hullena* *(Wellington)*, R.W. Loe

*(Waikato)*₁,₂,₃, S.C.McDowell *(Auckland)*₁,₂,₃, G.H. Purvis* *(Waikato)*,
G.W. Dowd* *(North Harbour)*, S.B.T. Fitzpatrick *(Auckland)*₁,₂,₃
Captain: S.B.T. Fitzpatrick
Coach: L.W. Mains
Manager: N.J. Gray
* indicates did not play

Record:
v World XV *at Christchurch*	lost	14-28
v World XV *at Wellington*	won	54-26
v World XV *at Auckland*	won	26-15

These matches marked the centenary of the NZRFU.

Summary:
Played 3, won 2, lost 1
Points for 94, against 69

1992 v IRELAND
First match 30 May, second match 6 June.

Backs: G.J.L. Cooper *(Otago)*₁, M.J.A. Cooper *(Waikato)*₂ J.J. Kirwan *(Auckland)*₁,₂, V.I. Tuigamala *(Auckland)*₁, J.K.R. Timu *(Otago)*₂, F.E. Bunce *(North Harbour)*₁,₂, E. Clarke *(Auckland)*₁,₂, W.K. Little *(North Harbour)*₁,₂, A.D. Strachan *(Auckland)*₁,₂
Forwards: A.R.B. Pene *(Otago)*₁,₂, J.W. Joseph *(Otago)*₁, P.W. Henderson *(Otago)*₁, M.N. Jones *(Auckland)*₂ I.D. Jones *(North Auckland)*₁,₂, B.P. Larsen *(North Harbour)*₁, R.M. Brooke *(Auckland)*₂, R.W. Loe *(Waikato)*₁, G.W. Dowd *(North Harbour)*₁(r), O.M. Brown *(Auckland)*₂, S.C. McDowell *(Auckland)*₁,₂, S.B.T. Fitzpatrick *(Auckland)*₁,₂
Captain: S.B.T. Fitzpatrick
Coach: L.W. Mains
Manager: N.J. Gray

Record:
v Ireland *at Dunedin*	won	24-21
v Ireland *at Wellington*	won	59-6

Summary:
Played 2, won 2.
Points for 83, against 27

1993 v BRITISH ISLES
First match 12 June, last match 3 July.

Backs: J.K.R. Timu *(Otago)*₁,₂,₃, M.J.A. Cooper *(Waikato)*₁(r),₃(r), V.I. Tuigamala *(Auckland)*₁,₂,₃, J.J. Kirwan *(Auckland)*₂,₃, E. Clarke *(Auckland)*₁,₂, F.E. Bunce *(North Harbour)*₁,₂,₃, W.K. Little *(North Harbour)*₁, L. Stensness *(Auckland)*₃, G.J. Fox *(Auckland)*₁,₂,₃, A.D. Strachan *(North Harbour)*₁, J.P. Preston *(Wellington)*₂,₃
Forwards: Z.V. Brooke *(Auckland)*₁,₂,₃(r), A.R.B. Pene *(Otago)*₃, M.N. Jones *(Auckland)*₁,₂,₃, J.W. Joseph *(Otago)*₁,₂,₃, R.M. Brooke *(Auckland)*₁,₂,₃, I.D. Jones *(North Auckland)*₁(r),₃, M.S.B. Cooksley *(Counties)*₂,₃(r), O.M. Brown *(Auckland)*₁,₂,₃, C.W. Dowd *(Auckland)*₁,₂,₃, S.B.T. Fitzpatrick *(Auckland)*₁,₂,₃
Captain: S.B.T. Fitzpatrick
Coach: L.W. Mains

Record:
v British Isles *at Christchurch*	won	20-18
v British Isles *at Wellington*	lost	7-20
v British Isles *at Auckland*	won	30-13

Summary:
Played 3, won 2, lost 1
Points for 57, against 51

1993 v AUSTRALIA and WESTERN SAMOA
First match 17 July, second match 31 July.

Backs: J.K.R. Timu *(Otago)*A,WS, M.J.A. Cooper *(Waikato)*WS(r), V.I. Tuigamala *(Auckland)*A,WS: J.J. Kirwan *(Auckland)*A,WS, F.E. Bunce *(North Harbour)*A,WS: W.K. Little *(North Harbour)*WS(r), L. Stensness *(Auckland)*A,WS: G.J. Fox *(Auckland)*A,WS, J.P. Preston *(Wellington)*A,WS
Forwards: Z.V. Brooke *(Auckland)*WS(r), A.R.B. Pene *(Otago)*A,WS: M.N. Jones *(Auckland)*A,WS. J.W. Joseph *(Otago)*A,WS, R.M. Brooke *(Auckland)*A,WS. I.D. Jones *(North Auckland)*WS, M.S.B. Cooksley *(Counties)*A, O.M. Brown *(Auckland)*A, C.W. Dowd *(Auckland)*A,WS, G.H. Purvis *(Waikato)*WS, M.R. Allen *(Taranaki)*WS(r), S.B.T. Fitzpatrick *(Auckland)*A,WS
Captain: S.B.T. Fitzpatrick
Coach: L.W. Mains

Record:
v Australia *at Dunedin*	won	25-10
v Western Samoa *at Auckland*	won	35-13

Summary:
Played 2, won 2
Points for 60, against 23

1994 v FRANCE and SOUTH AFRICA
First match 26 June, last match 17 August.

Backs: J.K.R. Timu *(Otago)*F1,2,SA1,2,3, S.P. Howarth *(Auckland)*SA1,2,3, J.J. Kirwan *(Auckland)*F1,2,SA1,2,3, J.T. Lomu *(Counties)*F1,2, F.E. Bunce *(North Harbour)*F1,2,SA1,2,3, W.K. Little *(North Harbour)*SA2(r), M.J.A. Cooper *(Waikato)*F1,2, A. Ieremia *(Wellington)*SA1,2,3, S.J. Mannix *(Wellington)*F1, S.J. Bachop *(Otago)*F2,SA1,2,3, S.T. Forster *(Otago)*F1,2, G.T.M. Bachop *(Canterbury)*SA1,2,3
Forwards: A.R.B. Pene *(Otago)*F1,2(r),SA1(r), Z..V. Brooke *(Auckland)*F2,SA1,2,3, J.W. Joseph *(Otago)*SA2(r), M.R. Brewer *(Canterbury)*F1,2,SA1,2,3, B.P. Larsen *(North Harbour)*F1,2,SA1,2,3, M.N. Jones *(Auckland)*SA3(r), M.S.B. Cooksley *(Waikato)*F1,2,SA1,2, I.D. Jones *(North Harbour)*F1,2, SA1,3, R.M. Brooke *(Auckland)*SA2,3, C.W. Dowd *(Auckland)*SA1(r), O.M. Brown *(Auckland)*F1,2,SA1,2, R.W. Loe *(Canterbury)*F1,2,SA1,2,3, S.B.T. Fitzpatrick *(Auckland)*F1,2,SA1,2,3
Captain: S.B.T. Fitzpatrick
Coach: L.W. Mains. **Assistant coach:** E.W. Kirton
Manager: C.E. Meads

Record:
v France *at Christchurch*	lost	8-22
v France *at Auckland*	lost	20-23
v South Africa *at Dunedin*	won	22-14
v South Africa *at Wellington*	won	13-9
v South Africa *at Auckland*	drew	18-18

Summary:
Played 5, won 2, lost 2, drew 1
Points for 81, against 86

1995 v CANADA
22 April.

Backs: G.M. Osborne *(North Harbour)*, M.C.G. Ellis *(Otago)*, J.W. Wilson *(Otago)*, F.E. Bunce *(North Harbour)*, W.K. Little *(North Harbour)*, A.P. Mehrtens *(Canterbury)*, G.T.M. Bachop *(Canterbury)*
Forwards: M.R. Brewer *(Canterbury)*, J.A. Kronfeld *(Otago)*, J.W. Joseph *(Otago)*, R.M. Brooke *(Auckland)*, I.D. Jones *(North Harbour)*, O.M. Brown *(Auckland)*, S.B.T. Fitzpatrick *(Auckland)*, C.W. Dowd *(Auckland)*
Captain: S.B.T. Fitzpatrick
Coach: L.W. Mains
Assistant Coach: E.W. Kirton
Manager: C.E. Meads

Record:
v Canada *at Auckland*	won	73-7

1995 v AUSTRALIA
21 July.

Backs: G.M. Osborne *(North Harbour)*, J.W. Wilson *(Otago)*, J.T. Lomu *(Counties)*, F.E. Bunce *(North Harbour)*, W.K. Little *(North Harbour)*, A.P. Mehrtens *(Canterbury)*, G.T.M. Bachop *(Canterbury)*
Forwards: Z.V. Brooke *(Auckland)*, M.N. Jones *(Auckland)*(r), J.A. Kronfeld *(Otago)*, M.R. Brewer *(Canterbury)*, R.M. Brooke *(Auckland)*, I.D. Jones *(North Harbour)*, O.M. Brown *(Auckland)*, S.B.T. Fitzpatrick *(Auckland)*, C.W. Dowd *(Auckland)*
Captain: S.B.T. Fitzpatrick
Coach: L.W. Mains
Assistant coach: E.W. Kirton
Manager: C.E. Meads

Record:
v Australia *at Auckland*	won	28-16

1996 v WESTERN SAMOA and SCOTLAND
First match 7 June, last match 22 June.

Backs: C.M. Cullen *(Manawatu)*WS,S1,2, J.W. Wilson *(Otago)*WS,S1,2. J.T. Lomu *(Counties-Manukau)*WS,S1,S2, E.J. Rush *(North Harbour)*S1(r),S2, A.R. Cashmore *(Auckland)*S2(r), F.E. Bunce *(North Harbour)*WS,S1,2, S.J.McLeod

*(Waikato)*ws,s1. W.K. Little *(North Harbour)*s2. A.P. Mehrtens *(Canterbury)*ws,s1,2. J.W. Marshall *(Canterbury)*ws,s1,2

Forwards: Z.V. Brooke *(Auckland)*ws,s1,2. J.A. Kronfeld *(Otago)*ws,s1,2. M.N. Jones *(Auckland)*ws,s1,2. B.P. Larsen *(North Harbour)*s2(r). R.M. Brooke *(Auckland)*ws,s1,2. I.D. Jones *(North Harbour)*ws,s1,2. O.M. Brown *(Auckland)*ws,s1,2. M.R. Allen *(Taranaki)*s2(r). S.B.T. Fitzpatrick *(Auckland)*ws,s1,2. C.W. Dowd *(Auckland)*ws,s1,2.

Captain: S.B.T. Fitzpatrick
Coach: J.B. Hart
Manager: M.C.F. Banks

Record:

v Western Samoa *at Napier*	won	51-10
v Scotland *at Dunedin*	won	62-31
v Scotland *at Auckland*	won	36-12

Summary:
Played 3, won 3
Points for 149, against 53

1996 v AUSTRALIA and SOUTH AFRICA (Tri-Nations)
First match 6 July, second match 20 July.

Backs: C.M. Cullen *(Manawatu)*A,SA. J.W. Wilson *(Otago)*A,SA. J.T. Lomu *(Counties-Manukau)*A,SA. E.J. Rush *(North Harbour)*A(r),SA(r). F.E. Bunce *(North Harbour)*A,SA. W.K. Little *(North Harbour)*A,SA. A.P. Mehrtens *(Canterbury)*A,SA. J.W. Marshall *(Canterbury)*A,SA

Forwards: Z.V. Brooke *(Auckland)*A,SA. J.A. Kronfeld *(Otago)*A,SA. M.N. Jones *(Auckland)*A,SA. R.M. Brooke *(Auckland)*A,SA. I.D. Jones *(North Harbour)*A,SA. O.M. Brown *(Auckland)*A,SA. S.B.T. Fitzpatrick *(Auckland)*A,SA. C.W. Dowd *(Auckland)*, N.J. Hewitt *(Southland)*A(r)

Captain: S.B.T. Fitzpatrick
Coach: J.B. Hart
Manager: M.C.F. Banks

Record:

v Australia *at Wellington*	won	43-6
v South Africa *at Christchurch*	won	15-11

Summary:
Played 2, won 2
Points for 58, against 17

1997 v AUSTRALIA and SOUTH AFRICA (Tri-Nations) and FIJI and ARGENTINA
First match 14 June, last match 16 August.

Backs: C.M. Cullen *(Manawatu)*F,A(r)1,2, A1,2,SA. J.W. Wilson *(Otago)*F,A(r)1,2, A1,2,SA. T.J.F. Umaga *(Wellington)*F,A(r)1,2,A1,2,SA. G.M. Osborne *(North Harbour)*A1,A2. F.E. Bunce *(North Harbour)*F,A1,2,A1,2,SA. L. Stensness *(Auckland)*F,A(r)1,2,A1,SA. S.J. McLeod *(Waikato)*F(r),A(r)2(r). A. Ieremia *(Wellington)*A1,A1,2,SA. J.W. Marshall *(Canterbury)*F,A1,2,A1,2,SA. O.F.J. Tonu'u *(Auckland)*F(r),A2(r).

Forwards: Z.V. Brooke *(Auckland)*A(r)1,2,A1,2,SA. T.C. Randell *(Otago)*F,A(r)1,2,A1,2,SA. J. Kronfeld *(Otago)*F,A(r)1,2,A1,2,SA. M.N. Jones *(Auckland)*F. M.P. Carter *(Auckland)*F(r), A1(r). C.C. Riechelmann *(Auckland)*F(r),A(r)1(r),A1(r). R.M. Brooke *(Auckland)*F,A(r)1,2,A1,2,SA. I.D. Jones *(North Harbour)*F,A(r)1,2,A1,2,SA. O.M. Brown *(Auckland)*F,A1,2,A1,2,SA. C.W. Dowd *(Auckland)*F,A(r)1,2. A1,2,SA. M.R. Allen *(Manawatu)*A(r)1,2,SA,A2. S.B.T. Fitzpatrick *(Auckland)*F,A(r)1,2,A1,2,SA. A.D. Oliver *(Otago)*F(r).

Captain: S.B.T. Fitzpatrick
Coach: J.B. Hart
Assistant coaches: G.R.R. Hunter, R.M. Cooper
Manager: M.C.F. Banks

Record:

v Fiji *at Albany*	won	71-5
v Argentina *at Wellington*	won	93-8
v Argentina *at Hamilton*	won	62-10
v Australia *at Christchurch*	won	30-13
v South Africa *at Auckland*	won	55-35
v Australia *at Dunedin*	won	36-24

Summary:
Played 6, won 6
Points for 347, against 95

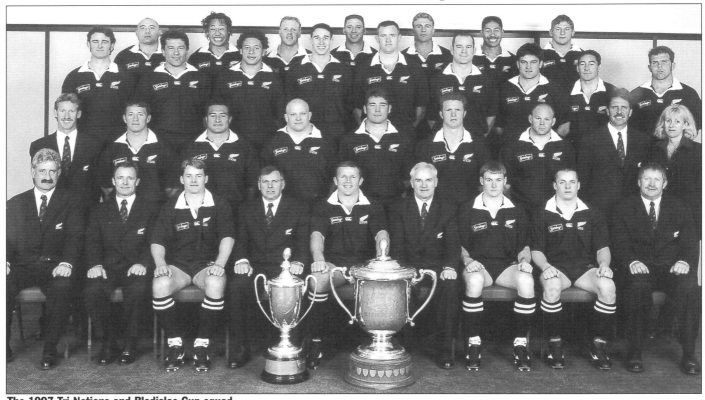

The 1997 Tri Nations and Bledisloe Cup squad

Back row: Norm Hewitt, Tana Umaga, Jeff Wilson, Glen Osborne, Justin Marshall, Alama Ieremia, Todd Blackadder.
Third row: Scott McLeod, Zinzan Brooke, Charles Riechelmann, Ian Jones, Mark Cooksley, Robin Brooke, Taine Randell, Frank Bunce, Anton Oliver.
Second row: Martin Toomey (fitness advisor), Carlos Spencer, Olo Brown, Mark Allen, Craig Dowd, Mark Carter, Josh Kronfeld, John Mayhew (doctor), Jane Dent (media liaison).
Front row: Gordon Hunter (assistant coach), David Abercrombie (physiotherapist), Jon Preston, John Hart (coach), Sean Fitzpatrick (captain), Mike Banks (manager), Andrew Mehrtens, Christian Cullen, Ross Cooper (assistant coach).

Visiting International Teams

This section lists the members and tour records of teams representative of their respective countries which have visited New Zealand. Several New South Wales sides and the 1896 Queensland team are included at the end of the chapter. Although matches between these sides and New Zealand are not internationals in the true sense, they were often referred to as 'tests' and the tours are certainly of historical interest.

Abbreviations used in the team listings are: New South Wales = NSW; Queensland = Q; Victoria = V; South Australia = SA; England = E; Ireland = I; Scotland = S; Wales = W.

An asterisk next to an individual's club in the various British teams indicates that the player had not represented one of the four Home Unions at the time of being selected for the team's tour of New Zealand.

1888 BRITISH TEAM
First match 28 April, last match 3 October.

Backs: J.T. Haslam (*Batley**), A.G. Paul (*Swinton**), J. Anderton (*Manchester Free Wanderers**), H. Brooks (*Edinburgh University**), H.C. Speakman (*Runcorn**), A.E. Stoddart (*Blackheath &E*), W. Bumby (*Swinton**), W. Burnett (*Hawick**), J. Nolan (*Rochdale Hornets**)
Forwards: T. Banks (*Swinton**), R. Burnett (*Hawick**), J.P. Clowes (*Halifax**), H. Eagles (*Swinton**), T. Kent (*Salford**), A.J. Laing (*Hawick**), C. Mathers (*Bramley**), A.P. Penketh (*Douglas**), R.L. Seddon (*Broughton Rangers & E*), D.J. Smith (*Edinburgh University**), A.J. Stuart (*Dewsbury**), W.H. Thomas (*Cambridge University & W*), S. Williams (*Salford**)
Captains: R.L. Seddon and A.E. Stoddart
Manager: A.E. Stoddart

Tour record:
v Otago at *Dunedin*	won	8-3
v Otago at *Dunedin*	won	4-3
v Canterbury at *Christchurch*	won	14-6
v Canterbury at *Christchurch*	won	4-0
v Wellington at *Wellington*	drew	3-3
v H. Roberts' XV at *Wellington*	won	4-1
v Taranaki Clubs at *New Plymouth*	lost	0-1
v Auckland at *Auckland*	won	6-3
v Auckland at *Auckland*	lost	0-4
v Auckland at *Auckland*	won	3-0
v Auckland at *Auckland*	drew	1-1
v Hawke's Bay at *Napier*	won	3-2
v Wairarapa at *Masterton*	won	5-1
v Canterbury at *Christchurch*	won	8-0
v Otago at *Dunedin*	drew	0-0
v South Island at *Dunedin*	won	5-3
v South Island at *Christchurch*	won	6-0
v Taranaki Clubs at *Hawera*	won	7-1
v Wanganui at *Wanganui*	drew	1-1

Summary:
Played 19, won 13, drew 4, lost 2
Points for 82, against 33

1904 GREAT BRITAIN
First match 6 August, last match 20 August.

Backs: C.F. Stanger-Leathes (*Northern**), J.L. Fisher (*Hull & East Riding**), R.T. Gabe (*Cardiff & W*), W.F. Jowett (*Swansea & W*), W.M. Llewellyn (*Newport & W*), E. Morgan (*Guy's Hospital & W*), P.F. McEvedy (*Guy's Hospital**), A.B. O'Brien (*Guy's Hospital**), P.F. Bush (*Cardiff**), F.C. Hulme (*Birkenhead Park & E*), T.H. Vile (*Newport**)
Forwards: D.R. Bedell-Sivright (*Cambridge University & S*), T.S. Bevan (*Swansea & W*), S.N. Crowther (*Lennox**), D.D. Dobson (*Newton Abbot & E*), R.W. Edwards (*Malone & I*), A.F. Harding (*London Welsh & W*), B.F. Massey (*Hull & East Riding**), C.D. Patterson (*Malone**), R.J. Rogers (*Bath**), S.M. Saunders (*Guy's Hospital**), J.T. Sharland (*Streatham**), B.I. Swannell (*Northampton**), D.H. Traill (*Guy's Hospital**)
Captain: D.R. Bedell-Sivright
Manager: A.B. O'Brien

Tour record:
v Canterbury-South Canterbury-West Coast at *Christchurch*	won	5-3
v Otago-Southland at *Dunedin*	won	14-8
v New Zealand at *Wellington*	lost	3-9
v Taranaki-Wanganui-Manawatu at *New Plymouth*	drew	0-0
v Auckland at *Auckland*	lost	0-13

Summary:
Played 5, won 2, drew 1, lost 2
Points for 22, against 33

1905 AUSTRALIA
First match 19 August, last match 16 September.

Backs: P. Carmichael (*Q*), D.J. McLean (*Q*), A.P. Penman (*NSW*), C.J. Russell (*NSW*), F.B. Smith (*NSW*), L.M. Smith (*NSW*), S.M. Wickham (*NSW*), E.A. Anlezark (*NSW*), M.J. Dore (*Q*), F. Wood (*NSW*)
Forwards: A. Burdon (*NSW*), P.H. Burge (*NSW*), J. Clarken (*NSW*), T. Colton (*Q*), W.A. Hirschberg (*NSW*), H.A. Judd (*NSW*), B.C. Lucas (*Q*), C.E. Murnin (*NSW*), F.V. Nicholson (*Q*), A. O'Brien (*Q*), A.M. Oxlade (*Q*), E.W. Richards (*Q*), B.I. Swannell (*NSW*)
Captain: S.M. Wickham
Manager: J.R. Henderson (*NSW*)

Tour record:
v Wellington-Wairarapa-Horowhenua at *Wellington*	lost	7-23
v Marlborough-Nelson-Buller-West Coast at *Nelson*	lost	3-12
v Canterbury-South Canterbury at *Christchurch*	lost	3-6
v New Zealand at *Dunedin*	lost	3-14
v Manawatu-Hawke's Bay-Bush at *Palmerston North*	won	7-5
v Wanganui-Taranaki at *Hawera*	won	18-13
v Auckland at *Auckland*	won	10-8

Summary:
Played 7, won 3, lost 4
Points for 51, against 81

1908 ANGLO-WELSH
First match 23 May, last match 25 July.

Backs: J.C.M. Dyke (*Penarth & W*), E.J. Jackett (*Falmouth & E*), F.E. Chapman (*Westoe**), R.A. Gibbs (*Cardiff & W*), R.B. Griffiths (*Newport**), J.P. 'Ponty' Jones (*Pontypool**), J.P. 'Tuan' Jones (*Guy's Hospital**), P.F. McEvedy (*Guy's Hospital**), H.H. Vassall (*Oxford University & E*), J.L. Williams (*Cardiff & W*), J. Davey (*Redruth & E*), H. Laxon (*Cambridge University**), W.L. Morgan (*London Welsh**), G.L. Williams (*Liverpool**)
Forwards: H.A. Archer (*Guy's Hospital**), R. Dibble (*Bridgwater Albion & E*), P.J. Down (*Bristol**), R.K. Green (*Neath**), A.F. Harding (*London Welsh & W*), G.R. Hind (*Guy's Hospital**), F.S. Jackson (*Leicester**), G.V. Kyrke (*Marlborough Nomads**), E. Morgan (*Swansea**), W.L. Oldham (*Coventry & E*), J.A.S. Ritson (*Northern**), T.W. Smith (*Leicester**), L.S. Thomas (*Penarth**), J.F. Williams (*London Welsh & W*)
Captain: A.F. Harding
Manager: G.H. Harnett (*E*)

Tour record:

v Wairarapa-Bush *at Masterton*	won	17-5
v Wellington *at Wellington*	lost	13-19
v Otago *at Dunedin*	lost	6-9
v Southland *at Invercargill*	won	14-8
v New Zealand *at Dunedin*	lost	5-32
v South Canterbury *at Timaru*	won	12-6
v Canterbury *at Christchurch*	lost	8-13
v West Coast-Buller *at Greymouth*	won	22-3
v Marlborough-Nelson *at Nelson*	won	12-0
v New Zealand *at Wellington*	drew	3-3
v Hawke's Bay *at Napier*	won	25-3
v Poverty Bay *at Gisborne*	won	26-0
v Manawatu-Horowhenua *at PalmerstonNorth*	won	12-3
v Wanganui *at Wanganui*	won	9-6
v Taranaki *at New Plymouth*	lost	0-5
v Auckland *at Auckland*	lost	0-11
v New Zealand *at Auckland*	lost	0-29

Summary:
Played 17, won 9, drew 1, lost 7
Points for 184, against 155

1913 AUSTRALIA
First match 27 August, last match 24 September.

Backs: L.J. Dwyer *(NSW)*, M.J. McMahon *(Q)*, E.T. Carr *(NSW)*, J.P. Flynn *(Q)*, H.A. Jones *(NSW)*, L.S. Meibusch *(Q)*, R.J. Simpson *(NSW)*, D.C. Suttor *(NSW)*, L.W. Wogan *(NSW)*, W.G. Tasker *(NSW)*, F. Wood *(NSW)*
Forwards: E.W. Cody *(NSW)*, E.J. Fahey *(NSW)*, H.W. George *(NSW)*, R.B. Hill *(NSW)*, A.D. Horodan *(Q)*, B.D. Hughes *(NSW)*, P.J. Murphy *(Q)*, C. O'Donnell *(NSW)*, R. Roberts *(NSW)*, F. Thompson *(NSW)*, W.T. Watson *(NSW)*, C. Wallach *(NSW)*, D. Williams *(Q)*
Captain: L.J. Dwyer
Manager: C.E. Morgan *(NSW)*

Tour record:

v Auckland *at Auckland*	lost	13-15
v Taranaki *at New Plymouth*	won	11-9
v Wanganui *at Wanganui*	lost	6-11
v New Zealand *at Wellington*	lost	5-30
v Southland *at Invercargill*	lost	8-13
v New Zealand *at Dunedin*	lost	13-25
v South Canterbury *at Timaru*	won	16-3
v New Zealand *at Christchurch*	won	16-5
v Marlborough *at Blenheim*	won	30-3

Summary:
Played 9, won 4, lost 5
Points for 118, against 114

1921 SOUTH AFRICA
First match 13 July, last match 17 September.

Backs: I.B. de Villiers *(Transvaal)*, P.G. Morkel *(Western Province)*, W.A. Clarkson *(Natal)*, C.duP. Meyer *(Western Province)*, H. Morkel *(Western Province)*, W.D. Sendin *(Griqualand West)*, S.S.F. Strauss *(Griqualand West)*, A.J. van Heerden *(Transvaal)*, J.J. Weepener *(Western Province)*, W.C. Zeller *(Natal)*, J.S. de Kock *(Western Province)*, J.P. Michau *(Western Province)*, J.C. Tindall *(Western Province)*, W.D. Townsend *(Natal)*
Forwards: N.J. du Plessis *(Western Transvaal)*, M. Ellis *(Transvaal)*, T.L. Kruger *(Transvaal)*, F.W. Mellish *(Western Province)*, J.M. Michau *(Transvaal)*, H. Morkel *(Western Province)*, R. Morkel *(Western Province)*, W.H. Morkel *(Transvaal)*, P.J. Mostert *(Western Province)*, J.S. Oliver *(Western Province)*, T.B. Pienaar *(Western Province)*, H. Scholtz *(Western Province)*, L.B. Siedle *(Natal)*, G.W. van Rooyen *(Transvaal)*, A.P. Walker *(Natal)*
Captain: T.B. Pienaar
Manager: H.C. Bennett *(Griqualand West)*

Tour record:

v Wanganui *at Wanganui*	won	11-6
v Taranaki *at New Plymouth*	drew	0-0
v Wairarapa-Bush *at Masterton*	won	18-3
v Wellington *at Wellington*	won	8-3
v West Coast-Buller *at Greymouth*	won	33-3
v Canterbury *at Christchurch*	lost	4-6
v South Canterbury *at Timaru*	won	34-3

v Southland *at Invercargill*	won	12-0
v Otago *at Dunedin*	won	11-3
v New Zealand *at Dunedin*	lost	5-13
v Manawatu-Horowhenua *at Palmerston North*	won	3-0
v Auckland-North Auckland *at Auckland*	won	24-8
v Bay of Plenty *at Rotorua*	won	17-9
v New Zealand *at Auckland*	won	9-5
v Waikato *at Hamilton*	won	6-0
v Hawke's Bay-Poverty Bay *at Napier*	won	14-8
v New Zealand Maori XV *at Napier*	won	9-8
v Nelson-Marlborough-Golden Bay-Motueka *at Nelson*	won	26-3
v New Zealand *at Wellington*	drew	0-0

Summary:
Played 19, won 15, drew 2, lost 2
Points for 244, against 81

1930 GREAT BRITAIN
First match 21 May, last match 12 August.

Backs: J. Bassett *(Penarth & W)*, W.G.M. Bonnor *(Bradford*)*, C.D. Aarvold *(Headingley & E)*, H.M. Bowcott *(Cardiff & W)*, R. Jennings *(Redruth*)*, T.E. Jones-Davies *(London Welsh & W)*, J.C. Morley *(Newport & W)*, P.F. Murray *(Wanderers & I)*, A.L. Novis *(Army & E)*, J.S.R. Reeve *(Harlequins & E)*, T.C. Knowles *(Birkenhead Park*)*, H. Poole *(Cardiff*)*, W.H. Sobey *(Old Millhillians & E)*, R.S. Spong *(Old Millhillians & E)*
Forwards: G.R. Beamish *(RAF & I)*, B.H. Black *(Blackheath & E)*, M.J. Dunne *(Lansdowne & I)*, J.L. Farrell *(Bective Rangers & I)*, J.M. Hodgson *(Northern*)*, H.C.S. Jones *(Manchester*)*, I. Jones *(Llanelly & W)*, D.A. Kendrew *(Woodford & E)*, S.A. Martindale *(Kendal & E)*, H.O'H. O'Neill *(Queen's University & I)*, D. Parker *(Swansea & W)*, F.D. Prentice *(Leicester & E)*, H. Rew *(Army & E)*, W.B. Welsh *(Hawick & S)*, H. Wilkinson *(Halifax & E)*
Captain: F.D. Prentice
Manager: J. Baxter *(E)*

Tour record:

v Wanganui *at Wanganui*	won	19-3
v Taranaki *at New Plymouth*	won	23-7
v Manawhenua *at Palmerston North*	won	34-8
v Wairarapa-Bush *at Masterton*	won	19-6
v Wellington *at Wellington*	lost	8-12
v Canterbury *at Christchurch*	lost	8-14
v West Coast-Buller *at Greymouth*	won	34-11
v Otago *at Dunedin*	won	33-9
v New Zealand *at Dunedin*	won	6-3
v Southland *at Invercargill*	won	9-3
v Ashburton County-South Canterbury-North Otago *at Timaru*	won	16-9
v New Zealand *at Christchurch*	lost	10-13
v NZ Maoris *at Wellington*	won	19-13
v Hawke's Bay *at Napier*	won	14-3
v Poverty Bay-Bay of Plenty-East Coast *at Gisborne*	won	25-11
v Auckland *at Auckland*	lost	6-19
v New Zealand *at Auckland*	lost	10-15
v North Auckland *at Whangarei*	won	38-5
v Waikato-King Country-Thames Valley *at Hamilton*	won	40-16
v New Zealand *at Wellington*	lost	8-22
v Nelson-Golden Bay-Motueka-Marlborough *at Blenheim*	won	41-3

Summary:
Played 21, won 15, lost 6
Points for 420, against 205

1931 AUSTRALIA
First match 22 August, last match 23 September.

Backs: A.W. Ross *(NSW)*, J.C. Steggal *(Q)*, D.L. Cowper *(V)*, W.H. Hemingway *(NSW)*, H.V. Herd *(NSW)*, G.T.B. Palmer *(NSW)*, H.A. Tolhurst *(NSW)*, C.H. Towers *(NSW)*, P.A. Clark *(Q)*, H.E. Primrose *(NSW)*, W.G. Bennett *(Q)*, S.J. Malcolm *(NSW)*
Forwards: M.R. Blair *(NSW)*, E.T. Bonis *(Q)*, O.L. Bridle *(V)*, W.H. Cerutti *(NSW)*, J.G. Clark *(Q)*, P.B. Judd *(NSW)*, E.W. Love *(NSW)*, J.R.L. Palfreyman *(NSW)*, T.D. Perrin *(NSW)*, J.F. Reville *(Q)*, W. Ritter *(Q)*, MC. White *(Q)*, F.J. Whyatt *(Q)*
Captain: S.J. Malcolm
Manager: T.C. Davis *(NSW)*

Tour record:

v Otago *at Dunedin*	drew	3-3
v Southland *at Invercargill*	lost	8-14
v Canterbury *at Christchurch*	lost	13-16
v Seddon Shield Districts *at Nelson*	lost	5-14
v Wellington *at Wellington*	lost	8-15
v NZ Maoris *at Palmerston North*	won	14-3
v New Zealand *at Auckland*	lost	13-20
v Hawke's Bay *at Napier*	won	27-11
v Taranaki *at New Plymouth*	lost	10-11
v Waikato-King Country *at Hamilton*	won	30-10

Summary:
Played 10, won 3, drew 1, lost 6
Points for 131, against 117

1936 AUSTRALIA
First match 22 August, last match 23 September.

Backs: K.P. Storey *(NSW)*, R.W. Dorr *(V)*, B.C. Egan *(NSW)*, E.S. Hayes *(Q)*, J.D. Kelaher *(NSW)*, R.E.M. McLaughlin *(NSW)*, A.D. McLean *(Q)*, R. Rankin *(NSW)*, J.D.C. Hammon *(V)*, L.S. Lewis *(Q)*, E.de C. Gibbons *(NSW)*, V.S. Richards *(NSW)*
Forwards: E.T. Bonis *(Q)*, O.L. Bridle *(V)*, W.H. Cerutti *(NSW)*, A.J. Hodgson *(NSW)*, F.E. Hutchinson *(NSW)*, R.L.F. Kelly *(NSW)*, J.H Malone *(NSW)*, T.P. Pauling *(NSW)*, K.M. Ramsay *(NSW)*, A.H. Stone *(NSW)*, R.J. Walden *(NSW)*, W.G.S. White *(NSW)*, K.S. Windon *(NSW)*
Captain: E.S. Hayes
Manager: E.G. Shaw *(NSW)*

Tour record:

v Auckland *at Auckland*	lost	5-8
v Wanganui *at Wanganui*	won	22-12
v Hawke's Bay *at Napier*	lost	14-20
v Wairarapa-Bush *at Carterton*	lost	13-19
v New Zealand *at Wellington*	lost	6-11
v North Otago *at Oamaru*	won	16-13
v New Zealand *at Dunedin*	lost	13-38
v Southland *at Invercargill*	lost	6-14
v Canterbury *at Christchurch*	lost	18-19
v NZ Maoris *at Palmerston North*	won	31-6

Summary:
Played 10, won 3, lost 7
Points for 144, against 160

1937 SOUTH AFRICA
First match 24 July, last match 29 September.

Backs: G.H. Brand *(Western Province)*, F.G. Turner *(Transvaal)*, L. Babrow *(Western Province)*, J. Bester *(Western Province)*, J.A. Broodryk *(Transvaal)*, S.R. Hofmeyr *(Western Province)*, A.D. Lawton *(Western Province)*, P.J. Lyster *(Natal)*, J. White *(Border)*, D.O. Williams *(Western Province)*, D.H. Craven *(Eastern Province)*, P.du P. de Villiers *(Western Province)*, T.A. Harris *(Transvaal)*, G.P. Lochner *(Eastern Province)*, D.F. van de Vyver *(Western Province)*
Forwards: W.E. Bastard *(Natal)*, W.F. Bergh *(Transvaal)*, B.A. du Toit *(Transvaal)*, C.B. Jennings *(Border)*, J.W. Lotz *(Transvaal)*, M.M. Louw *(Western Province)*, S.C. Louw *(Transvaal)*, H.J. Martin *(Transvaal)*, P.J. Nel *(Natal)*, A.R. Sheriff *(Transvaal)*, L.C. Strachan *(Transvaal)*, M.A. van den Berg *(Western Province)*, G.L. van Reenen *(Western Province)*, H.H. Watt *(Western Province)*
Captain: P.J. Nel
Managers: P.W. Day *(Western Province)* and A. de Villiers *(Western Province)*

Tour record:

v Auckland *at Auckland*	won	19-5
v King Country-Waikato-Thames Valley *at Hamilton*	won	6-3
v Taranaki *at New Plymouth*	won	17-3
v Manawatu *at Palmerston North*	won	39-3
v Wellington *at Wellington*	won	29-0
v New Zealand *at Wellington*	lost	7-13
v Nelson-Golden Bay-Motueka-Marlborough *at Blenheim*	won	22-0
v Canterbury *at Christchurch*	won	23-8
v West Coast-Buller *at Greymouth*	won	31-6
v South Canterbury *at Timaru*	won	43-6
v New Zealand *at Christchurch*	won	13-6

v Southland *at Invercargill*	won	30-17
v Otago *at Dunedin*	won	47-7
v Hawke's Bay *at Napier*	won	21-12
v Poverty Bay-Bay of Plenty-East Coast *at Gisborne*	won	33-3
v New Zealand *at Auckland*	won	17-6
v North Auckland *at Whangarei*	won	14-6

Summary:
Played 17, won 16, lost 1
Points for 411, against 104

1939 FIJI
First match 23 August, last match 16 September.

Backs: I. Korovulavula *(Defence)*, E. Bola *(Defence)*, V. Cavuilati *(Tovolea)*, I. Nagatalevu *(Toorak)*, S. Ralawa *(Lomaiviti)*, J.B. Voreqe *(Defence)*, G.K. Cakobau *(Tovolea)*, U. Radike *(Rewa)*, S. Serusavou *(Waimanu)*, A. Kororua *(Gaunavou)*, J. Wesele *(Gaunavou)*
Forwards: P. Ganilau *(Gaunavou)*, P. Lagilagi *(Tovolea)*, V. Loba *(Gaunavou)*, V. Nadaku *(Suva Police)*, O. Nalasse *(Rewa)*, S. Pita *(Gaunavou)*, S. Qurai *(Lomaiviti)*, A. Tuitavua *(Rewa)*, S. Vatudau *(Rewa)*, V. Vavaitamana *(Rewa)*, T. Vosaicake *(Lomaiviti)*, I.L. Vosailagi *(Otago University)*
Captain: G.K. Cakobau
Managers: J.B.K. Taylor and J.H.Wiley

Tour record:

v Bay of Plenty Maori XV *at Rotorua*	won	11-0
v North Auckland *at Whangarei*	won	12-11
v King Country *at Taumarunui*	won	14-9
v Auckland *at Auckland*	won	17-11
v Nelson-Golden Bay-Motueka *at Nelson*	drew	6-6
v Buller *at Westport*	won	9-4
v Ashburton County *at Ashburton*	won	10-4
v NZ Maoris *at Hamilton*	won	14-4

Summary:
Played 8, won 7, drew 1
Points for 93, against 49

1946 AUSTRALIA
First match 21 August, last match 28 September.

Backs: B.J.C. Piper *(NSW)*, C.C. Eastes *(NSW)*, J.R. McLean *(Q)*, J.M. Stone *(NSW)*, T. Allan *(NSW)*, M.L. Howell *(NSW)*, A.P. Johnson *(NSW)*, J.W.T. MacBride *(NSW)*, D.P. Bannon *(NSW)*, J.F. Cremin *(NSW)*, C.T. Burke *(NSW)*, B.G. Schulte *(Q)*
Forwards: A.J. Buchan *(NSW)*, G.M. Cooke *(Q)*, W.L. Dawson *(NSW)*, E. Freeman *(NSW)*, D.C. Furness *(NSW)*, G.A. Gourlay *(V)*, B.G. Hamilton *(NSW)*, P.A. Hardcastle *(NSW)*, K.J. Hodda *(Q)*, A.E. Livermore *(Q)*, W.M. McLean *(Q)*, R.E. McMaster *(Q)*, E. Tweedale *(NSW)*, C.J. Windon *(NSW)*, K.S. Windon *(NSW)*
Captain: W.M. McLean
Manager: W.H. Ward *(V)*
Assistant Manager: H. Crow *(NSW)*

Tour record:

v North Auckland *at Whangarei*	lost	19-32
v Taranaki-King Country *at New Plymouth*	won	9-8
v Wanganui-Manawatu *at Wanganui*	won	17-15
v Hawke's Bay-Poverty Bay *at Napier*	won	19-11
v Seddon Shield Districts *at Westport*	won	15-12
v Canterbury *at Christchurch*	lost	11-20
v Hanan Shield Districts *at Timaru*	lost	9-21
v New Zealand *at Dunedin*	lost	8-31
v Southland *at Invercargill*	lost	6-8
v Wellington *at Wellington*	won	16-15
v NZ Maoris *at Hamilton*	lost	0-20
v New Zealand *at Auckland*	lost	10-14

Summary:
Played 12, won 5, lost 7
Points for 139, against 207

1949 AUSTRALIA
First match 17 August, last match 24 September.

Backs: B.J.C. Piper *(NSW)*, C.C. Davis *(NSW)*, J.R. Fogarty *(Q)*, R.L. Garner *(NSW)*, A.H. Ware *(Q)*, T. Allan *(NSW)*, J. Blomley *(NSW)*, H.J. Solomon *(NSW)*, E.G. Broad *(Q)*, N.A. Emery *(NSW)*, C.T. Burke *(NSW)*, R.M. Cawsey *(NSW)*

Forwards: A.J. Baxter *(NSW)*, N.T. Betts *(Q)*, J.D. Brockhoff *(NSW)*, R.G.W. Cornforth *(NSW)*, N.V. Cottrell *(Q)*, K.A. Cross *(NSW)*, D.C. Furness *(NSW)*, K.M Gordon *(NSW)*, F.J.C. McCarthy *(Q)*, R.P. Mossop *(NSW)*, N.M. Shehadie *(NSW)*, C.J. Windon *(NSW)*, B.J. Wilson *(NSW)*
Captain: T. Allan
Manager: R.J. Walden *(NSW)*
Assistant Manager: W.H. Cerutti *(NSW)*

Tour record:

v King Country *at Taumarunui*	won	24-6
v Bay of Plenty *at Whakatane*	won	35-8
v Poverty Bay-East Coast *at Gisborne*	won	20-12
v Wairarapa-Bush *at Masterton*	won	21-14
v Manawatu-Horowhenua *at Palmerston North*	won	29-6
v New Zealand *at Wellington*	won	11-6
v Marlborough-Nelson-Golden Bay-Motueka *at Blenheim*	won	14-8
v West Coast-Buller *at Greymouth*	lost	15-17
v Hanan Shield Districts *at Oamaru*	won	12-0
v Southland *at Invercargill*	won	15-10
v Canterbury *at Christchurch*	won	16-12
v New Zealand *at Auckland*	won	16-9

Summary:
Played 12, won 11, lost 1
Points for 228, against 108

1950 BRITISH ISLES
First match 10 May, last match 2 August.

Backs: W.B. Cleaver *(Cardiff & W)*, G.W. Norton *(Bective Rangers & I)*, B.L. Jones *(Devonport Services & W)*, K.J. Jones *(Newport & W)*, M.F. Lane *(Cork University & I)*, D.W.C. Smith *(London Scottish & S)*, M.C. Thomas *(Devonport Services & W)*, N.J. Henderson *(Queen's University & I)*, R. Macdonald *(Edinburgh University & S)*, J. Matthews *(Cardiff & W)*, B.L. Williams *(Cardiff & W)*, J.W. Kyle *(North of Ireland Football Club & I)*, I. Preece *(Coventry & E)*, A.W. Black *(Edinburgh University & S)*, G. Rimmer *(Waterloo & E)*, W.R. Willis *(Cardiff & W)*
Forwards: G.M. Budge *(Edinburgh Wanderers & S)*, J.T. Clifford *(Young Munster & I)*, C. Davies *(Cardiff & W)*, D.M. Davies *(Somerset Police & W)*, R.T. Evans *(Newport & W)*, D.J. Hayward *(Newbridge & W)*, E.R. John *(Neath & W)*, P.W. Kininmonth *(Oxford University & S)*, J.S. McCarthy *(Dolphin & I)*, J.W. McKay *(Queen's University & I)*, K.D. Mullen *(Old Belvedere & I)*, J.E. Nelson *(Malone & I)*, V.G. Roberts *(Harlequins & E)*, J.D. Robins *(Birkenhead Park & W)*, J.R.G. Stephens *(Neath & W)*
Captain: K.D. Mullen
Manager: L.B. Osborne *(E)*

Tour record:

v Nelson-Marlborough-Golden Bay-Motueka *at Nelson*	won	24-3
v Buller *at Westport*	won	24-9
v West Coast *at Greymouth*	won	32-3
v Otago *at Dunedin*	lost	9-23
v Southland *at Invercargill*	lost	0-11
v New Zealand *at Dunedin*	drew	9-9
v South Canterbury *at Timaru*	won	27-8
v Canterbury *at Christchurch*	won	16-5
v Ashburton County-North Otago *at Ashburton*	won	29-6
v New Zealand *at Christchurch*	lost	0-8
v Wairarapa-Bush *at Masterton*	won	27-13
v Hawke's Bay *at Napier*	won	20-0
v Poverty Bay-East Coast-Bay of Plenty *at Gisborne*	won	27-3
v Wellington *at Wellington*	won	12-6
v New Zealand *at Wellington*	lost	3-6
v Wanganui *at Wanganui*	won	31-3
v Taranaki *at New Plymouth*	won	25-3
v Manawatu-Horowhenua *at Palmerston North*	won	13-8
v Waikato-King Country-Thames Valley *at Hamilton*	won	30-0
v North Auckland *at Whangarei*	won	8-6
v Auckland *at Auckland*	won	32-9
v New Zealand *at Auckland*	lost	8-11
v NZ Maoris *at Wellington*	won	14-9

Summary:
Played 23, won 17, drew 1, lost 5
Points for 420, against 162

1951 FIJI
First match 25 July, last match 12 September.

Backs: P. Lese *(Nadroga)*, I.R. Radrodro *(Suva)*, K. Cavuilati *(Suva)*, J.V. Levula *(Northern Districts)*, I.G. Sauleca *(Northern Districts)*, S. Domoni *(Rewa)*, S. Ganilau *(Suva)*, G. Cavalevu *(Northern Districts)*, W. Salabogi *(Rewa)*, P. Sauvaki *(Lomaiviti)*, J. Baba *(Suva)*, S. Vatubua *(Rewa)*
Forwards: S. Baleca *(Rewa)*, P. Kabu *(Vatukoula)*, W. Kunavula *(Northern Districts)*, S. Pe *(Suva)*, S. Ralagi *(Suva)*, M. Sauieca *(Northern Districts)*, F. Seru *(Northern Districts)*, J. Susu *(Suva)*, P. Tove *(Northern Districts)*, M. Tuvoli *(Suva)*, S. Valewai *(Suva)*, J. Vucago *(Rewa)*, R. Vuruya *(Suva)*
Captain: G. Cavalevu
Managers: L.R. Martin and P.T. Raddock

Tour record:

v Thames Valley *at Te Aroha*	lost	6-16
v Bay of Plenty *at Rotorua*	won	32-23
v Poverty Bay *at Gisborne*	won	14-11
v Hawke's Bay *at Napier*	won	23-14
v Marlborough *at Blenheim*	won	28-16
v Buller *at Westport*	won	6-3
v South Canterbury *at Timaru*	won	24-14
v Otago *at Dunedin*	lost	5-26
v Southland *at Invercargill*	drew	11-11
v Canterbury *at Christchurch*	lost	22-24
v Bush *at Pahiatua*	won	9-6
v Wanganui *at Wanganui*	lost	11-14
v NZ Maoris *at Wellington*	won	21-14
v Waikato *at Hamilton*	drew	11-11
v Auckland *at Auckland*	lost	16-29

Summary:
Played 15, won 8, drew 2, lost 5
Points for 239, against 232

1952 AUSTRALIA
First match 13 August, last match 13 September.

Backs: R. Colbert *(NSW)*, G.G. Jones *(Q)*, L. Johnson *(V)*, E.T. Stapleton *(NSW)*, H.S. Barker *(NSW)*, J.M. O'Neil *(Q)*, J.A. Phipps *(NSW)*, H.J. Solomon *(NSW)*, S.W. Brown *(NSW)*, M. Tate *(NSW)*, C.T. Burke *(NSW)*, B.P. Cox *(NSW)*
Forwards: A.J. Baxter *(NSW)*, A.S. Cameron *(NSW)*, J.C. Carroll *(NSW)*, N.V. Cottrell *(Q)*, K.A. Cross *(NSW)*, R.A.L. Davidson *(NSW)*, F.M. Elliott *(NSW)*, C.F. Forbes *(Q)*, B.B. Johnson *(NSW)*, A.R. Miller *(NSW)*, N.M. Shehadie *(NSW)*, J.J. Walsh *(NSW)*, C.J. Windon *(NSW)*
Captain: H.J. Solomon
Managers: J.G. Blackwood *(NSW)* and T.H. McCormack *(Q)*

Tour record:

v North Auckland *at Whangarei*	won	21-14
v Auckland *at Auckland*	won	17-16
v King Country *at Otorohanga*	won	16-6
v Taranaki *at New Plymouth*	won	13-9
v Manawatu *at Palmerston North*	won	16-6
v Otago *at Dunedin*	won	12-9
v Southland *at Invercargill*	lost	9-24
v New Zealand *at Christchurch*	won	14-9
v Nelson *at Nelson*	won	29-12
v New Zealand *at Wellington*	lost	8-15

Summary:
Played 10, won 8, lost 2
Points for 155, against 120

1954 FIJI
3 July.

Backs: T. Ranavue *(Suva)*, I. Vuivuda *(Northern Districts)*, O. Dawai *(Suva)*, S. Domoni *(Suva)*, J.V. Levula *(Suva)*, N.Taga *(Suva)*, T.M. Biumaiwai *(Suva)*, J. Baba *(Suva)*, A. Raratabu *(Suva)*, G. Cavalevu *(Northern Districts)*, P. Qau Qau *(Northern Districts)*, W. Salabogi *(Suva)*, L.R. Naitini *(Suva)*, S. Vatubua *(Suva)*
Forwards: S. Baleca *(Suva)*, A. Burogolevu *(Northern Districts)*, M. Labaibure *(Suva)*, G. Naborisi *(Suva)*, S. Naulago *(Northern Districts)*, A. Nawalu *(Suva)*, S. Pe *(Suva)*, S. Ralagi *(Suva)*, J. Saukuru *(Suva)*, S.G. Seruvatu *(Northern Districts)*, A. Sewale *(Northern Districts)*, J. Susu *(Suva)*, A. Tuitavua *(Suva)*, J. Vadugu *(Nadroga)*
Captain: A. Tuitavua
Managers: W.E. Goodsir and B. Watson

Tour record:

v Auckland *at Auckland*	lost	3-39

1955 AUSTRALIA

First match 6 August, last match 17 September.

Backs: R.M. Tooth *(NSW)*, G.G. Jones *(Q)*, R. Phelps *(NSW)*, E.T. Stapleton *(NSW)*, G.W.G. Davis *(NSW)*, J.A. Phipps *(NSW)*, P.J. Phipps *(NSW)*, B.T. Roberts *(NSW)*, B.A. Wright *(Q)*, H.J. Solomon *(NSW)*, C.T. Burke *(NSW)*, B.P. Cox *(NSW)*
Forwards: N.J. Adams *(NSW)*, A.S. Cameron *(NSW)*, J.R. Cross *(NSW)*, K.A. Cross *(NSW)*, D.M. Emanuel *(NSW)* N.M. Hughes *(NSW)*, B.B. Johnson *(NSW)*, A.R. Miller *(NSW)*, T.P. Mooney *(Q)*, J.J. Pashley *(NSW)*, N.M. Shehadie *(NSW)*, D.J. Strachan *(NSW)*, J.E. Thornett *(NSW)*
Captain: H.J. Solomon
Managers: J.W. Breckenridge *(NSW)* and W.H. Cerutti *(NSW)*

Tour record:

v Thames Valley-Bay of Plenty *at Te Aroha*	won	14-9
v Poverty Bay-East Coast *at Gisborne*	won	15-6
v Hawke's Bay *at Napier*	lost	11-14
v Bush-Wairarapa *at Pahiatua*	won	22-17
v New Zealand *at Wellington*	lost	8-16
v Nelson-Marlborough-Golden Bay-Motueka *at Motueka*	won	41-6
v West Coast-Buller *at Greymouth*	won	13-3
v South Canterbury-North Otago-Mid Canterbury *at Oamaru*	won	19-3
v New Zealand *at Dunedin*	lost	0-8
v Southland *at Invercargill*	won	11-5
v Canterbury *at Christchurch*	won	19-8
v Wanganui-King Country *at Wanganui*	won	38-8
v New Zealand *at Auckland*	won	8-3

Summary:
Played 13, won 10, lost 3
Points for 219, against 106

1956 SOUTH AFRICA

First match 9 June, last match 1 September.

Backs: J.U. Buchler *(Transvaal)*, S.S. Viviers *(Orange Free State)*, T.P.D. Briers *(Western Province)*, R.G. Dryburgh *(Natal)*, J.G.H. du Preez *(Western Province)*, P.G. Johnstone *(Transvaal)*, K.T. van Vollenhoven *(Northern Transvaal)*, A.I. Kirkpatrick *(Griqualand West)*, P.E. Montini *(Western Province)*, J.J. Nel *(Western Province)*, W. Rosenberg *(Transvaal)*, B.F. Howe *(Border)*, B.D. Pfaff *(Western Province)*, C.A. Ulyate *(Transvaal)*, T.A. Gentles *(Western Province)*, C.F. Strydom *(Orange Free State)*
Forwards: D.F. Retief *(Northern Transvaal)*, D.S.P. Ackermann *(Western Province)*, C.J. de Wilzem *(Orange Free State)*, G.P. Lochner *(Western Province)*, J.J. Starke *(Western Province)*, C.J. van Wyk *(Transvaal)*, J.T. Claassen *(Western Transvaal)*, C.J. de Nysschen *(Natal)*, J.A. du Rand *(Northern Transvaal)*, J.A.J. Pickard *(Western Province)*, H.P.J. Bekker *(Northern Transvaal)*, P.S. du Toit *(Western Province)*, A.C. Koch *(Boland)*, H.N. Walker *(Western Transvaal)*, M.v.d.S. Hanekom *(Boland)*, A.J. van der Merwe *(Boland)*
Captain: S.S. Viviers
Manager: D.H. Craven *(Western Province)*
Assistant Manager: D.J. de Villiers *(Transvaal)*

Tour record:

v Waikato *at Hamilton*	lost	10-14
v North Auckland *at Whangarei*	won	3-0
v Auckland *at Auckland*	won	6-3
v Manawatu-Horowhenua *at Palmerston North*	won	14-3
v Wellington *at Wellington*	won	8-6
v Poverty Bay-East Coast *at Gisborne*	won	22-0
v Hawke's Bay *at Napier*	won	20-8
v Nelson-Marlborough-Golden Bay-Motueka *at Nelson*	won	41-3
v Otago *at Dunedin*	won	14-9
v New Zealand *at Dunedin*	lost	6-10
v South Canterbury-Mid Canterbury-North Otago *at Timaru*	won	20-8
v Canterbury *at Christchurch*	lost	6-9
v West Coast-Buller *at Westport*	won	27-6
v Southland *at Invercargill*	won	23-12
v Wairarapa-Bush *at Masterton*	won	19-8
v New Zealand *at Wellington*	won	8-3
v Wanganui-King Country *at Wanganui*	won	36-16

v Taranaki *at New Plymouth*	drew	3-3
v New Zealand *at Christchurch*	lost	10-17
v NZ Universities *at Wellington*	lost	15-22
v NZ Maoris *at Auckland*	won	37-0
v Bay of Plenty-Thames Valley-Counties *at Rotorua*	won	17-6
v New Zealand *at Auckland*	lost	5-11

Summary:
Played 23, won 16, drew 1, lost 6
Points for 370, agains 177

1957 FIJI

First match 13 July, last match 31 August.

Backs: N. Uluiviti *(Suva)*, O. Dawai *(Suva)*, S. Domoni *(Suva)*, J.V. Levula *(Nadi)*, B. Tanivukavu *(Suva)*, K. Bose *(Suva)*, I. Burenivalu *(Lautoka)*, A. Kunawave *(Suva)*, T. Naidole *(Suva)*, A. Raratabu *(Taveuni)*, J. Mucunabitu *(Suva)*, S. Vatubua *(Rewa)*
Forwards: I. Cawa *(Suva)*, A. Kurisaqila *(Suva)*, T. Lisio *(Lautoka)*, N. Nabaro *(Batukoula)*, M. Naikovu *(Lautoka)*, P. Nayacakalao *(Suva)*, I.R. Radrodro *(Suva)*, J. Saukuru *(Suva)*, S. Sautu *(Lautoka)*, A. Secake *(Suva)*, J. Tabaiwalu *(Suva)*, R. Vunakece *(Navua)*, P. Wadali *(Suva)*, A. Waqanaceva *(Nadi)*
Captain: O. Dawai
Manager: J.W. Ackroyd
Co-Manager: A. Tuitavua
Tour Manager: P. Ganilau

Tour record:

v Poverty Bay *at Gisborne*	drew	14-14
v Bay of Plenty *at Tauranga*	won	22-3
v Auckland *at Auckland*	won	38-17
v North Auckland *at Whangarei*	won	6-3
v Taranaki *at New Plymouth*	drew	8-8
v King Country *at Taumarunui*	lost	14-26
v Manawatu *at Palmerston North*	won	30-12
v Wairarapa *at Masterton*	won	27-8
v NZ Maoris *at Wellington*	won	36-13
v Marlborough *at Blenheim*	won	39-9
v West Coast *at Greymouth*	won	23-17
v Southland *at Invercargill*	lost	8-13
v NZ Maoris *at Dunedin*	won	17-8
v Mid Canterbury *at Ashburton*	won	16-9
v Canterbury *at Christchurch*	lost	16-22

Summary:
Played 15, won 10, drew 2, lost 3
Points for 314, against 182

1958 AUSTRALIA

First match 9 August, last match 20 September.

Backs: T.G.P. Curley *(NSW)*, J.K. Lenehan *(NSW)*, A.R. Morton *(NSW)*, E.T. Stapleton *(NSW)*, T. Baxter *(Q)*, B.J. Ellwood *(NSW)*, R.A. Kay *(V)*, R. Phelps *(NSW)*, H.E. Roberts *(Q)*, A.J. Summons *(NSW)*, J.R. Cocks *(V)*, D.M. Connor *(Q)*
Forwards: J.K. Carroll *(NSW)*, P.K. Dunn *(NSW)*, K.J. Ellis *(NSW)*, L. Forbes *(Q)*, P.G. Johnson *(NSW)*, D.R. Lowth *(NSW)*, P.W. McLean *(Q)*, R.W. Meadows *(NSW)*, K.J. Ryan *(Q)*, J.E. Thornett *(NSW)*, M.M. Van Gelder *(SA)*, J.P. White *(NSW)*, C.R. Wilson *(Q)*
Captain: C.R. Wilson
Manager: C.W. Blunt *(NSW)*
Assistant Manager: R.E.M. McLaughlin *(NSW)*

Tour record:

v Hawke's Bay *at Napier*	lost	6-8
v Wanganui *at Wanganui*	won	11-9
v Taranaki *at New Plymouth*	won	12-0
v Nelson *at Nelson*	won	20-11
v New Zealand *at Wellington*	lost	3-25
v Southland *at Invercargill*	lost	8-26
v Otago *at Dunedin*	won	11-3
v South Canterbury *at Timaru*	won	26-17
v New Zealand *at Christchurch*	won	6-3
v Manawatu *at Palmerston North*	lost	6-12
v Waikato *at Hamilton*	drew	14-14
v North Auckland *at Whangarei*	lost	8-9
v New Zealand *at Auckland*	lost	8-17

Summary:
Played 13, won 6, drew 1, lost 6
Points for 139, against 154

1959 BRITISH ISLES
First match 20 June, last match 19 September.

Backs: T.J. Davies (*Llanelli & W*), K.J.F. Scotland (*Cambridge University & S*), N.H. Brophy (*Dublin University & I*), P.B. Jackson (*Coventry & E*), A.J.F. O'Reilly (*Old Belvedere & I*), J.R.C. Young (*Oxford University & E*), J. Butterfield (*Northampton & E*), D. Hewitt (*Queen's University & I*), W.M. Patterson (*Sale**), M.J. Price (*Pontypool & W*), M.C. Thomas (*Newport & W*), M.A.F. English (*Lansdowne & I*), A.B.W. Risman (*Manchester University & E*), G.H. Waddell (*London Scottish & S*), J.P. Horrocks-Taylor (*Leicester & E*), S. Coughtrie (*Edinburgh Academicals & S*), R.E.G. Jeeps (*Northampton & E*), A.A. Mulligan (*Wanderers & I*)
Forwards: A. Ashcroft (*Waterloo & E*), A.R. Dawson (*Wanderers & I*), W.R. Evans (*Cardiff & W*), J. Faull (*Swansea & W*), H.F. McLeod (*Hawick & S*), R.W.D. Marques (*Harlequins & E*), B.V. Meredith (*Newport & W*), S. Millar (*Ballymena & I*), H.J. Morgan (*Abertillery & W*), W.A. Mulcahy (*Dublin University & I*), T.R. Prosser (*Pontypool & W*), G.K. Smith (*Kelso & S*), R.H. Williams (*Llanelli & W*), B.G.M. Wood (*Garryowen & I*)
Captain: A.R. Dawson
Manager: A.W. Wilson (*S*)

Tour record:

v Hawke's Bay *at Napier*	won	52-12
v Poverty Bay-East Coast *at Gisborne*	won	23-14
v Auckland *at Auckland*	won	15-10
v NZ Universities *at Christchurch*	won	25-13
v Otago *at Dunedin*	lost	8-26
v South Canterbury-North Otago-Mid Canterbury *at Timaru*	won	21-11
v Southland *at Invercargill*	won	11-6
v New Zealand *at Dunedin*	lost	17-18
v West Coast-Buller *at Greymouth*	won	58-3
v Canterbury *at Christchurch*	lost	14-20
v Marlborough-Nelson-Golden Bay-Motueka *at Blenheim*	won	64-5
v Wellington *at Wellington*	won	21-6
v Wanganui *at Wanganui*	won	9-6
v Taranaki *at New Plymouth*	won	15-3
v Manawatu-Horowhenua *at Palmerston North*	won	26-6
v New Zealand *at Wellington*	lost	8-11
v King country-Counties *at Taumarunui*	won	25-5
v Waikato *at Hamilton*	won	14-0
v Wairarapa-Bush *at Masterton*	won	37-11
v New Zealand *at Christchurch*	lost	8-22
v NZ Juniors *at Wellington*	won	29-9
v NZ Maoris *at Auckland*	won	12-6
v Bay of Plenty-Thames Valley *at Rotorua*	won	26-24
v North Auckland *at Whangarei*	won	35-13
v New Zealand *at Auckland*	won	9-6

Summary:
Played 25, won 20, lost 5
Points for 582, against 266

1961 FRANCE
First match 8 July, last match 19 August.

Backs: J. Meynard (*Charentes-Poitou*), M. Vannier (*Bourgogne*), A. Boniface (*Cote-Basque*), G. Boniface (*Cote-Basque*), J. Bouquet (*Lyonnais*), G. Calvo (*Cote-Basque*), J. Dupuy (*Armagnac-Bigorre*), J. Pique (*Bearn*), S. Plantey (*Ile-de-France*), H. Rancoule (*Provence*), P. Albaladejo (*Cote-Basque*), G. Camberabero (*Alpes*), C. Lacaze (*Armagnac-Bigorre*), L. Camberabero (*Alpes*), P. Lacroix (*Perigord-Agenais*), J. Serin (*Pyrenees*)
Forwards: A. Bianco (*Armagnac-Bigorre*), G. Bouguyon (*Alpes*), M. Cassiede (*Cote-Basque*), P. Cazales (*Cote-Basque*), M. Celaya (*Cote-D'Argent*), M. Crauste (*Armagnac-Bigorre*), A. Domenech (*Limousin*), J. Laudouar (*Cote-Basque*), R. Lefevre (*Limousin*), S. Meyer (*Perigord-Agenais*), F. Moncla (*Bearn*), J. Rollet (*Cote-Basque*), J.P. Saux (*Bearn*), C. Vidal (*Pyrenees*)
Captain: F. Moncla
Manager: M. Laurent (*Pyrenees*)
Assistant Manager: G. Basquet (*Perigord-Agenais*)

Tour record:

v Nelson-Marlborough-Golden Bay-Motueka *at Nelson*	won	29-11
v Taranaki *at New Plymouth*	won	11-9
v Waikato *at Hamilton*	lost	3-22
v North Auckland *at Whangarei*	lost	6-8
v New Zealand *at Auckland*	lost	6-13
v Bay of Plenty *at Rotorua*	won	22-9
v NZ Maoris *at Napier*	lost	3-5
v Manawatu *at Palmerston North*	won	21-6
v New Zealand *at Wellington*	lost	3-5
v Southland *at Invercargill*	won	14-6
v Otago *at Dunedin*	won	15-6
v South Canterbury *at Timaru*	lost	14-17
v New Zealand *at Christchurch*	lost	3-32

Summary:
Played 13, won 6, lost 7
Points for 150, against 149

1962 AUSTRALIA
First match 11 August, last match 22 September.

Backs: J.K.M. Lenehan (*NSW*), J.S. Spence (*NSW*), J.S. Boyce (*NSW*), J.A. Douglas (*V*), B.J. Ellwood (*NSW*), B.J. Harland (*NSW*), R.J.P. Marks (*Q*), K.P. Walsham (*NSW*), P.F. Hawthorne (*NSW*), A.R. Town (*NSW*), K.W. Catchpole (*NSW*), K.V. McMullen (*NSW*)
Forwards: G.A. Chapman (*NSW*), C.P. Crittle (*NSW*), R.A.C. Evans (*Q*), J.E. Freedman (*NSW*), E.L.J. Heinrich (*NSW*), R.J. Heming (*NSW*), P.G. Johnson (*NSW*), A.A. Laurie (*NSW*), D.J. O'Neill (*Q*), R.B. Prosser (*NSW*), J.E. Thornett (*NSW*), R.N. Thornett (*NSW*), J.P.L. White (*NSW*)
Captain: J.E. Thornett
Manager: J.A. McLean (*NSW*)
Assistant Manager: A.S. Roper (*NSW*)

Tour record:

v Poverty Bay *at Gisborne*	won	31-6
v Counties *at Papakura*	won	20-14
v Wairarapa *at Masterton*	won	43-0
v Horowhenua *at Levin*	won	28-6
v New Zealand *at Wellington*	drew	9-9
v Buller-West Coast *at Westport*	won	9-0
v Canterbury *at Christchurch*	lost	3-5
v North Otago *at Oamaru*	lost	13-14
v New Zealand *at Dunedin*	lost	0-3
v Southland *at Invercargill*	lost	11-16
v Wanganui *at Wanganui*	won	29-6
v Thames Valley *at Te Aroha*	lost	14-16
v New Zealand *at Auckland*	lost	8-16

Summary:
Played 13, won 6, drew 1, lost 6
Points for 218, against 111

1963 ENGLAND
First match 18 May, last match 1 June.

Backs: R.W. Hosen (*Northampton*), J.M. Dee (*Hartlepool Rovers*), J.C. Gibson (*United Services*), M.S. Phillips (*Fylde*), J.M. Ranson (*Rosslyn Park*), F.D. Sykes (*Northampton*), M.P. Weston (*Durham City*), J.P. Horrocks-Taylor (*Leicester*), R.F. Reid (*Harlequins*), S.J.S. Clarke (*Cambridge University*), T.C. Wintle (*Northampton*)
Forwards: A.M. Davis (*Torquay Athletic*), H.O. Godwin (*Coventry*), J.E. Highton (*United Services*), C.R. Jacobs (*Northampton*), P.E. Judd (*Coventry*), V.R. Marriott (*Harlequins*), J.E. Owen (*Coventry*), T.A. Pargetter (*Coventry*), D.G. Perry (*Bedford*), D.P. Rogers (*Bedford*), J.D. Thorne (*Bristol*), B.J. Wightman (*Moseley*)
Captain: M.P. Weston
Manager: J.T.W. Berry (*Leicestershire*)
Assistant Manager: M.R. Steele-Bodger (*Central Districts*)

Tour record:

v Wellington *at Wellington*	won	14-9
v Otago *at Dunedin*	lost	9-14
v New Zealand *at Auckland*	lost	11-21
v Hawke's Bay *at Napier*	lost	5-20
v New Zealand *at Christchurch*	lost	6-9

Summary:
Played 5, won 1, lost 4
Points for 45, against 73

1964 AUSTRALIA
First match 5 August, last match 29 August.

Backs: T.V. Casey *(NSW)*, E.S. Boyce *(NSW)*, J.S. Boyce *(NSW)*, B.J. Ellwood *(NSW)*, D.N. Grimmond *(NSW)*, R.E. Honan *(Q)*, R.J.P. Marks *(Q)*, P.F. Hawthorne *(NSW)*, R.K. Trivett *(Q)*, K.W. Catchpole *(NSW)*, L. Lawrence *(Q)*
Forwards: L.R. Austin *(NSW)*, C.P. Crittle *(NSW)*, G.V. Davis *(NSW)*, J. Guerassimoff *(Q)*, E.L.J. Heinrich *(NSW)*, R.J. Heming *(NSW)*, P.G. Johnson *(NSW)*, A.A. Laurie *(NSW)*, D.J. O'Neill *(Q)*, D.J. Shepherd *(V)*, J.E. Thornett *(NSW)*, J.P.L. White *(NSW)*
Captain: J.E. Thornett
Manager: J.P. French *(Q)*
Assistant Manager: A.S. Roper *(NSW)*

Tour record:

v Wanganui *at Wanganui*		won	14-0
v Auckland *at Auckland*		lost	6-11
v East Coast *at Ruatoria*		won	28-3
v New Zealand *at Dunedin*		lost	9-14
v Mid Canterbury *at Ashburton*		lost	10-16
v New Zealand *at Christchurch*		lost	3-18
v Bush *at Pahiatua*		won	19-13
v New Zealand *at Wellington*		won	20-5

Summary:
Played 8, won 4, lost 4
Points for 109, against 80

1965 SOUTH AFRICA
First match 30 June, last match 18 September.

Backs: C.G. Mulder *(Eastern Transvaal)*, L.G. Wilson *(Western Province)*, G.S. Brynard *(Western Province)*, C.J.C. Cronje *(Eastern Transvaal)*, J.P. Engelbrecht *(Western Province)*, J.L. Gainsford *(Western Province)*, W.J. Mans *(Western Province)*, S.H. Nomis *(Transvaal)*, E. Olivier *(Western Province)*, F.duT. Roux *(Griqualand West)*, J.T. Truter *(Natal)*, J.H. Barnard *(Transvaal)*, K. Oxlee *(Natal)*, D.J. de Villiers *(Western Province)*, C.M. Smith *(Orange Free State)*
Forwards: T.P. Bedford *(Natal)*, P.H. Botha *(Transvaal)*, F.C.H. du Preez *(Northern Transvaal)*, J.H. Ellis *(South West Africa)*, C.P. Goosen *(Orange Free State)*, D.J. Hopwood *(Western Province)*, A. Janson *(Western Province)*, A.W. Macdonald *(Rhodesia)*, G.F. Malan *(Transvaal)*, J.F.K. Marais *(Eastern Province)*, J. Naude *(Western Province)*, J.A. Nel *(Western Transvaal)*, W.H. Parker *(Eastern Province)*, J. Schoeman *(Western Province)*, L.J. Slabber *(Orange Free State)*, C.G.P. van Zyl *(Orange Free State)*, D.C. Walton *(Natal)*
Captain: D.J. de Villiers
Manager: J.F. Louw *(Western Province)*
Assistant Manager: H.S.V. Muller *(Transvaal)*

Tour record:

v Poverty Bay-East Coast *at Gisborne*		won	32-3
v Wellington *at Wellington*		lost	6-23
v Manawatu-Horowhenua *at Palmerston North*		won	30-8
v Otago *at Dunedin*		won	8-6
v NZ Juniors *at Christchurch*		won	23-3

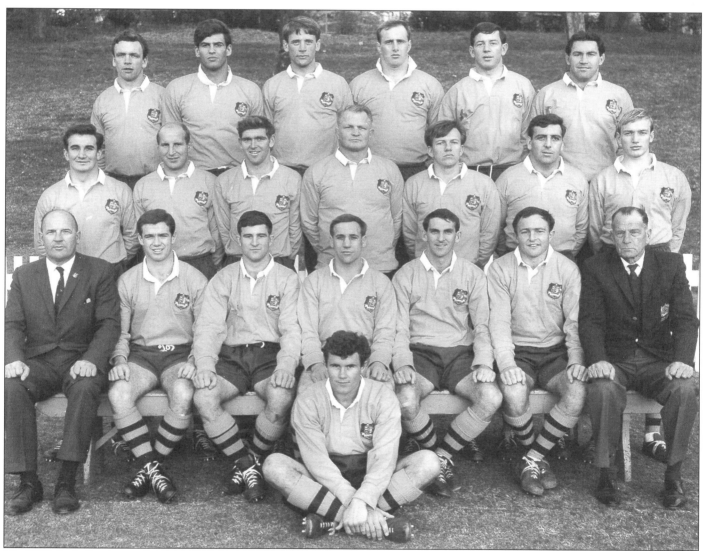

The 1967 Australian team
Back row: J.L. Sayle, A.M.F. Abrahams, D.A. Taylor, R.G. Teitzel, H.A. Rose, P.G. Johnson.
Second row: J.E. Brass, G.V. Davis, R.P. Batterham, A.R. Miller, R.C.S. Manning, R.B. Prosser, P. Smith.
Front row: G. Bebnam (manager), P.F. Hawthorne, J.N.B. Hipwell, K.W. Catchpole (captain), R.E. Honan, D.C. Crombie, B. Palmer (assistant manager).
In front: I.J. Proctor.

v Taranaki *at New Plymouth*	won	11-3
v Southland *at Invercargill*	won	19-6
v Canterbury *at Christchurch*	won	6-5
v West Coast-Buller *at Greymouth*	won	11-0
v New Zealand *at Wellington*	lost	3-6
v Wanganui-King Country *at Wanganui*	won	24-19
v Waikato *at Hamilton*	won	26-13
v North Auckland *at Whangarei*	won	14-11
v Auckland *at Auckland*	lost	14-15
v Marlborough-Nelson-Golden Bay-Motueka *at Blenheim*	won	45-6
v New Zealand *at Dunedin*	lost	0-13
v South Canterbury-Mid Canterbury-North Otago *at Timaru*	won	28-13
v NZ Maoris *at Wellington*	won	9-3
v Wairarapa-Bush *at Masterton*	won	36-0
v New Zealand *at Christchurch*	won	19-16
v NZ Universities *at Auckland*	won	55-11
v Hawke's Bay *at Napier*	won	30-12
v Bay of Plenty-Counties-Thames Valley *at Rotorua*	won	33-17
v New Zealand *at Auckland*	lost	3-20

Summary:
Played 24, won 19, lost 5
Points for 485, against 232

1966 BRITISH ISLES
First match 11 June, last match 10 September.

Backs: T.G. Price *(Llanelli & W)*, D. Rutherford *(Gloucester & E)*, S. Wilson *(London Scottish & S)*, D.I.E. Bebb *(Swansea & W)*, A.J.W. Hinshelwood *(London Scottish & S)*, K.F. Savage *(Northampton & E)*, S.J. Watkins *(Newport & W)*, F.P.K. Bresnihan *(Dublin University & I)*, D.K. Jones *(Cardiff & W)*, C.W. McFadyean *(Moseley & E)*, J.C. Walsh *(Cork University & I)*, M.P. Weston *(Durham City & E)*, C.M.H. Gibson *(Cambridge University & I)*, D. Watkins *(Newport & W)*, A.R. Lewis *(Abertillery & W)*, R.M. Young *(Queen's University & I)*
Forwards: M.J. Campbell-Lamerton *(London Scottish & S)*, D.Grant *(Hawick & S)*, K.W. Kennedy *(Church of Ireland Young Men's Society & I)*, F.A.L. Laidlaw *(Melrose & S)*, R.J. Lamont *(Instonians & I)*, W.J. McBride *(Ballymena & I)*, R.J. McLoughlin *(Gosforth & I)*, N.A.A. Murphy *(Cork Constitution & I)*, C.H. Norris *(Cardiff & W)*, A.E.I. Pask *(Abertillery & W)*, B. Price *(Newport & W)*, D.L. Powell *(Northampton & E)*, G.J. Prothero *(Bridgend & W)*, J.W. Telfer *(Melrose & S)*, W.D. Thomas *(Llanelli*)*, D. Williams *(Ebbw Vale & W)*
Captain: M.J. Campbell-Lamerton
Manager: D.J. O'Brien *(I)*
Assistant Manager: J.D. Robins *(W)*

Tour record:

v Southland *at Invercargill*	lost	8-14
v South Canterbury-Mid Canterbury-North Otago *at Timaru*	won	20-12
v Otago *at Dunedin*	lost	9-17
v NZ Universities *at Christchurch*	won	24-11
v Wellington *at Wellington*	lost	6-20
v Marlborough-Nelson-Golden Bay-Motueka *at Nelson*	won	22-14
v Taranaki *at New Plymouth*	won	12-9
v Bay of Plenty *at Rotorua*	drew	6-6
v North Auckland *at Whangarei*	won	6-3
v New Zealand *at Dunedin*	lost	3-20
v West Coast-Buller *at Westport*	won	25-6
v Canterbury *at Christchurch*	won	8-6
v Manawatu-Horowhenua *at PalmerstonNorth*	won	17-8
v Auckland *at Auckland*	won	12-6
v Wairarapa-Bush *at Masterton*	won	9-6
v New Zealand *at Wellington*	lost	12-16
v Wanganui-King Country *at Wanganui*	lost	6-12
v NZ Maoris *at Auckland*	won	16-14
v Poverty Bay-East Coast *at Gisborne*	won	9-6
v Hawke's Bay *at Napier*	drew	11-11
v New Zealand *at Christchurch*	lost	6-19
v NZ Juniors *at Wellington*	won	9-3
v Waikato *at Hamilton*	won	20-9
v Counties-Thames Valley *at Papakura*	won	13-9
v New Zealand *at Auckland*	lost	11-24

Summary:
Played 25, won 15, drew 2, lost 8
Points for 300, against 281

1967 AUSTRALIA
19 August.

Backs: R.C.S. Manning *(Q)*, R.P. Batterham *(NSW)*, J.E. Brass *(NSW)*, R.E. Honan *(Q)*, I.J. Proctor *(NSW)*, P. Smith *(NSW)*, P.F. Hawthorne *(NSW)*, K.W. Catchpole *(NSW)*, J.N.B. Hipwell *(NSW)*
Forwards: A.M.F. Abrahams *(NSW)*, D.C. Crombie *(Q)*, G.V. Davis *(NSW)*, P.G. Johnson *(NSW)*, A.R. Miller *(NSW)*, R.B. Prosser *(NSW)*, H.A. Rose *(NSW)*, J.L. Sayle *(NSW)*, D.A. Taylor *(Q)*, R.G. Teitzel *(Q)*
Captain: K.W. Catchpole
Manager: G. Bebnam *(Tasmania)*

Record:

v New Zealand *at Wellington*	lost	9-29

1968 FRANCE
First match 3 July, last match 10 August.

Backs: C. Lacaze *(Charentes-Poitou)*, P. Villepreux *(Pyrenees)*, P. Besson *(Limousin)*, J.M. Bonal *(Pyrenees)*, A. Campaes *(Armagnac-Bigorre)*, C. Dourthe *(Cote-Basque)*, J.P. Lux *(Cote-Basque)*, J. Maso *(Roussillon)*, A. Piazza *(Pyrenees)*, J. Trillo *(Cote-D'Argent)*, J. Andrieu *(Pyrenees)*, C. Boujet *(Alpes)*, J.L. Berot *(Pyrenees)*, M. Puget *(Limousin)*
Forwards: J.P. Baux *(Armagnac-Bigorre)*, M. Billiere *(Pyrenees)*, C. Carrere *(Provence)*, E. Cester *(Pyrenees)*, C. Chenevay *(Alpes)*, B. Dauga *(Cote-Basque)*, B. Dutin *(Cote-Basque)*, J.M. Esponda *(Roussillon)*, M. Greffe *(Alpes)*, J. Iracabal *(Cote-Basque)*, M. Lasserre *(Perigord-Agenais)*, J.C. Noble *(Alpes)*, A. Plantefol *(Perigord-Agenais)*, J.P. Salut *(Pyrenees)*, W. Spanghero *(Languedoc)*, M. Yachvili *(Limousin)*
Captain: C. Carrere
Managers: J.C. Bourrier *(Charentes-Poitou)*; A. Garrigue *(Pyrenees)*

Tour record:

v Marlborough *at Blenheim*	lost	19-24
v Otago *at Dunedin*	won	12-6
v Southland *at Invercargill*	won	8-6
v New Zealand *at Christchurch*	lost	9-12
v Taranaki *at New Plymouth*	won	21-6
v Hawke's Bay *at Napier*	won	16-12
v Manawatu *at Palmerston North*	won	8-3
v New Zealand *at Wellington*	lost	3-9
v King Country *at Taumarunui*	won	23-9
v North Auckland *at Whangarei*	won	10-6
v Waikato *at Hamilton*	won	13-8
v New Zealand *at Auckland*	lost	12-19

Summary:
Played 12, won 8, lost 4
Points for 154, against 120

1969 WALES
First match 27 May, last match 14 June.

Backs: J.P.R. Williams *(London Welsh)*, M.C.R. Richards *(Cardiff)*, A. Skirving *(Newport)*, S.J. Watkins *(Newport)*, T.G.R. Davies *(Cambridge University)* S.J. Dawes *(London Welsh)*, K.S. Jarrett *(Newport)*, P. Bennett *(Llanelli)*, B. John *(Cardiff)*, G.O. Edwards *(Cardiff)*, R. Hopkins *(Maesteg)*
Forwards: T.M. Davies *(London Welsh)*, N.R. Gale *(Llanelli)*, D. Hughes *(Newbridge)*, D.B. Llewellyn *(Newport)*, D.J. Lloyd *(Bridgend)*, W.D. Morris *(Neath)*, V Perrins *(Newport)*, B. Price *(Newport)*, J. Taylor *(London Welsh)*, B. Thomas *(Neath)*, W.D. Thomas *(Llanelli)*, D. Williams *(Ebbw Vale)*, J. Young *(Harrogate)*
Captain: B. Price
Manager: H.C. Rogers
Assistant Manager: D.C.T. Rowlands

Tour record:

v Taranaki *at New Plymouth*	drew	9-9
v New Zealand *at Christchurch*	lost	0-19
v Otago *at Dunedin*	won	27-9
v Wellington *at Wellington*	won	16-14
v New Zealand *at Auckland*	lost	12-33

Summary:
Played 5, won 2, lost 2, drew 1
Points for 62, against 76

1969 TONGA
First match 6 August, last match 10 September.

Backs: M. 'Alatini *(Hihifo)*, S. Sika *(Fasi)*, K. 'Iongi *(Police)*, T. Kavapalu *(Kolomotu'a)*, V. Vanisi *(Police)*, H. Veatupu *(Ma'ufanga)*, 'O. Eke *(Hihifo)*, P. Fakaua *(Mu'a)*, K. Hofoka *(Nukunuku)*, 'U. Tai *(Fasi)*, V. Fifita *(Fasi)*, F. Muller *(Nukunuku)*
Forwards: V. 'Alipate *(Fasi)*, M. Filimoehala *(Ma'ufanga)*, F. Fotu *(Mu'a)*, K. 'Inoke *(Kolofo'ou)*, 'I. Lupina *(Hihifo)*, S. Mafi *(Hihifo)*, F. Mailangi *(Ma'ufanga)*, F. Moala *(Nukunuku)*, S. Motu'apuaka *(Kolofo'ou)*, V. Pahulu *(Kolofo'ou)*, S. Selupe (i) *(Kolomotu'a)*, S. Selupe (ii) *(Police)*, S. Tavo *(Kolofo'ou)*
Captain: V. 'Alipate
Manager: D.W. Mullins
Assistant Manager: L. Finau

Tour record:

v Nelson Bays *at Nelson*	lost	21-22	
v South Canterbury *at Timaru*	won	25-14	
v Buller *at Westport*	won	40-8	
v NZ Maoris *at Christchurch*	won	26-19	
v Horowhenua *at Levin*	lost	10-22	
v NZ Juniors *at Wellington*	lost	3-43	
v East Coast *at Ruatoria*	won	28-19	
v North Auckland *at Whangarei*	lost	5-47	
v Thames Valley *at Te Aroha*	lost	10-12	
v NZ Maoris *at Auckland*	won	19-6	
v Bay of Plenty *at Rotorua*	drew	0-0	

Summary:
Played 11, won 5 drew 1, lost 5
Points for 187, against 212

1971 BRITISH ISLES
First match 22 May, last match 14 August.

Backs: R. Hiller *(Harlequins & E)*, J.P.R. Williams *(London Welsh & W)*, A.G. Biggar *(London Scottish & S)*, J.C. Bevan *(Cardiff College of Education & W)*, D.J. Duckham *(Coventry & E)*, T.G.R. Davies *(Cambridge University & W)*, S.J. Dawes *(London Welsh & W)*, A.J. Lewis *(Ebbw Vale & W)*, C.W.W. Rea *(West of Scotland & S)*, J.S. Spencer *(Headingley & E)*, C.M.H. Gibson *(North of Ireland & I)*, B. John *(Cardiff & W)*, G.O. Edwards *(Cardiff & W)*, R. Hopkins *(Maesteg & W)*
Forwards: R.J. Arneil *(Edinburgh Academicals & S)*, G.L. Brown *(West of Scotland & S)*, A.B. Carmichael *(West of Scotland & S)*, T.M. Davies *(London Welsh & W)*, P.J. Dixon *(Harlequins & E)*, T.G. Evans *(London Welsh & W)*, M.L. Hipwell *(Terenure College & I)*, F.A.L. Laidlaw *(Melrose & S)*, J.F. Lynch *(St Mary's College & I)*, W.J. McBride *(Ballymena & I)*, J. McLauchlan *(Jordanhill College & S)*, R.J. McLoughlin *(Blackrock College & I)*, J.V. Pullin *(Bristol & E)*, D.L. Quinnell *(Llanelli*)*, M.G. Roberts *(London Welsh & W)*, J.F. Slattery *(Dublin University & I)*, C.B. Stevens *(Harlequins & E)*, J. Taylor *(London Welsh & W)*, W.D. Thomas *(Llanelli & W)*
Captain: S.J. Dawes
Manager: D.W.C. Smith *(S)*
Assistant Manager: C.R. James *(W)*

Tour record:

v Counties-Thames Valley *at Pukekohe*	won	25-3	
v Wanganui-King Country *at Wanganui*	won	22-9	
v Waikato *at Hamilton*	won	35-14	
v NZ Maoris *at Auckland*	won	23-12	
v Wellington *at Wellington*	won	47-9	
v South Canterbury-Mid Canterbury-North Otago *at Timaru*	won	25-6	
v Otago *at Dunedin*	won	21-9	
v West Coast-Buller *at Greymouth*	won	39-6	
v Canterbury *at Christchurch*	won	14-3	
v Marlborough-Nelson Bays *at Blenheim*	won	31-12	
v New Zealand *at Dunedin*	won	9-3	
v Southland *at Invercargill*	won	25-3	
v Taranaki *at New Plymouth*	won	14-9	
v NZ Universities *at Wellington*	won	27-6	
v New Zealand *at Christchurch*	lost	12-22	
v Wairarapa-Bush *at Masterton*	won	27-6	

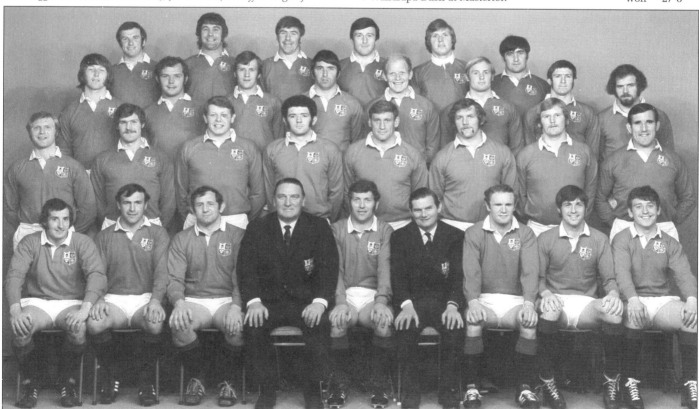

The 1971 Lions
Back row: C.W. Rea, A.J. Lewis, J.V. Pullen, A.B. Carmichael, J.F. Slattery, J. McLauchlan.
Third row: J.P.R. Williams, J.F. Lynch, A.G. Biggar, R. Hiller, M.L. Hipwell, D.J. Duckham, J.C. Bevan, J. Taylor.
Second row: J.S. Spencer, P.J. Dixon, G.L. Brown, T.M. Davies, W.J. McBride, M.G. Roberts, D.L. Quinnell, W.D. Thomas.
Front row: G.O. Edwards, F.A.L. Laidlaw, R.J. McLoughlin, D.W.C. Smith (manager), S.J. Dawes (captain), C.R. James (coach), C.M.H. Gibson, B. John, R. Hopkins.
Absent: T.G.R. Davies, B. Stevens, G. Evans, R. Arneil.

v Hawke's Bay *at Napier*	won	25-6
v Poverty Bay-East Coast *at Gisborne*	won	18-12
v Auckland *at Auckland*	won	19-12
v New Zealand *at Wellington*	won	13-3
v Manawatu-Horowhenua *at Palmerston North*	won	39-6
v North Auckland *at Whangarei*	won	11-5
v Bay of Plenty *at Tauranga*	won	20-14
v New Zealand *at Auckland*	drew	14-14

Summary:
Played 24, won 22, drew 1, lost 1
Points for 555, against 204

1972 AUSTRALIA
First match 5 August, last match 16 September.

Backs: A.N. McGill *(NSW)*, D.R. Burnett *(NSW)*, J.W. Cole *(NSW)*, R.D. L'Estrange *(Q)*, J.J. McLean *(Q)*, D.S. Rathie *(Q)*, J.I. Taylor *(NSW)*, R.L. Fairfax *(NSW)*, G.C. Richardson *(Q)*, P.G. Rowles *(NSW)*, J.R. Cornes *(Q)*, G.O. Grey *(NSW)*
Forwards: M.R. Cocks *(NSW)*, G.V. Davis *(NSW)*, B.R. Brown *(Q)*, G.Fay *(NSW)*, M.E. Freney *(Q)*, A.M. Gelling *(NSW)*, J.L. Howard *(NSW)*, R.B. Prosser *(NSW)*, R.A. Smith *(NSW)*, B.D. Stumbles *(NSW)*, P.D. Sullivan *(NSW)*, R.J. Thompson *(WA)*, R.N. Wood *(Q)*
Captain: G.V. Davis
Manager: J.P. French *(Q)*
Assistant Manager: R.I. Templeton *(Q)*

Tour record:

v Otago *at Dunedin*	lost	0-26
v West Coast-Buller *at Westport*	lost	10-15
v Taranaki *at New Plymouth*	won	20-15
v Bay of Plenty *at Tauranga*	drew	6-6
v New Zealand *at Wellington*	lost	6-29
v King Country *at Taumarunui*	won	13-6
v Hawke's Bay *at Napier*	lost	14-15
v Nelson Bays *at Nelson*	won	36-7
v New Zealand *at Christchurch*	lost	17-30
v North Otago *at Oamaru*	won	37-12
v Waikato *at Hamilton*	lost	24-26
v Poverty Bay-East Coast *at Gisborne*	won	22-19
v New Zealand *at Auckland*	lost	3-38

Summary:
Played 13, won 5, lost 7, drew 1
Points for 208, against 244

1973 ENGLAND
First match 1 September, last match 15 September.

Backs: A.M. Jorden *(Blackheath)*, P.A. Rossborough *(Coventry)*, D.J. Duckham *(Coventry)*, P.M. Knight *(Bristol)*, P.J. Squires *(Harrogate)*, G.W. Evans *(Coventry)*, J.P.A.G. Janion *(Richmond)*, P.S. Preece *(Coventry)*, A.G.B. Old *(Leicester)*, M.J. Cooper *(Moseley)*, S.J. Smith *(Sale)*, J.G. Webster *(Moseley)*
Forwards: A.J. Neary *(Broughton Park)*, J.A. Watkins *(Gloucester)*, P.J. Hendy *(St Ives)*, A.G. Ripley *(Rosslyn Park)*, R.M. Uttley *(Gosforth)*, R.M. Wilkinson *(Bedford)*, N.O. Martin *(Bedford)*, C.W. Ralston *(Richmond)*, M.A. Burton *(Gloucester)*, F.E. Cotton *(Coventry)*, C.B. Stevens *(Penzance)*, J.V. Pullin *(Briston)*, I. White *(Bristol)*
Captain: J.V. Pullin
Manager: D.L. Sanders
Assistant Manager: J. Elders

Tour record:

v Taranaki *at New Plymouth*	lost	3-6
v Wellington *at Wellington*	lost	16-25
v Canterbury *at Christchurch*	lost	12-19
v New Zealand *at Auckland*	won	16-10

Summary:
Played 4, won 1, lost 3
Points for 47, against 60

1974 JAPAN
First match 25 April, last match 26 May.

Backs: N. Ueyama, T. Ito, Y. Sakata, M. Fujiwara, M. Yoshida, S. Mori, A. Yokoi, I. Nakamura, M. Iguchi, H. Shukuzawa, R. Imazato
Forwards: Y. Murata, H. Akama, K. Masuda, T. Ishizuka, Y. Izawa,

K. Shibata, T. Terai, H. Ogasawara, S. Hara, T. Sato, T. Takata, T. Kurosaka, K. Ohigashi
Captain: A. Yokoi
Managers: S. Konno and T. Kobayashi
Coach: R. Saito
Assistant Coach: H. Yokoi

Tour record:

v Counties *at Papakura*	lost	23-42
v Taranaki *at New Plymouth*	won	19-15
v Poverty Bay *at Gisborne*	drew	13-13
v South Canterbury *at Timaru*	won	23-18
v NZ Universities *at Dunedin*	lost	31-40
v Southland *at Invercargill*	lost	20-39
v NZ Juniors *at Auckland*	lost	31-55
v NZ Universities *at Wellington*	won	24-21

Summary:
Played 8, won 3, lost 4, drew 1
Points for 184, against 223

1974 FIJI
First match 24 July, last match 2 September.

Backs: A. Naituyaga *(Nadroga)*, J. Visei *(Lautoka)*, R. Latilevu *(Nadroga)*, S.T. Cavuilati *(Suva)*, L. Namadila *(Suva)*, I. Batibasaga *(Nadroga)*, S. Nasave *(Nadroga)*, T. Rabuli *(Nadroga)*, W. Gavidi *(Nadroga)*, W. Nasola *(Lautoka)*, M. Masitabua *(Suva)*, T. Rauluni *(Rewa)*, I. Batibasaga *(Nadroga)*
Forwards: I. Cagilaba *(Ba)*, V. Modelutu *(Rewa)*, R. Samuels *(Suva)*, R. Qaraniquio *(Nadroga)*, J. Naucabalavu *(Suva)*, I. Tuisese *(Rewa)*, S. Naitau *(Nadroga)*, I. Taoba *(Nadroga)*, N. Ratudina *(Suva)*, I. Tasere *(Nadroga)*, J. Sovau *(Nadi)*, J. Rauto *(Buca Bay)*, A. Racika *(Suva)*
Captain: V. Mocelutu
Manager: D. Robinson
Assistant Manager: I. Tabualevu

Tour record:

v Buller *at Westport*	won	25-3
v Canterbury *at Christchurch*	lost	4-9
v North Otago *at Oamaru*	won	14-11
v Otago *at Dunedin*	won	9-7
v Marlborough *at Blenheim*	lost	13-21
v Waikato *at Hamilton*	lost	7-13
v King Country *at Taumarunui*	won	38-3
v NZ Maoris *at Auckland*	lost	9-24
v Hawke's Bay *at Napier*	won	28-21
v North Auckland *at Whangarei*	won	21-8
v Wanganui *at Wanganui*	won	28-9
v NZ Maoris *at Wellington*	lost	25-39
v Auckland Invitation XV *at Auckland*	won	31-20

Summary:
Played 13, won 8, lost 5
Points for 252, against 188

1975 ROMANIA
First match 6 August, last match 30 August.

Backs: R. Durbac *(Steaua Bucuresti)*, I. Simion *(Grivita Rosie Bucuresti)*, M. Bucos *(Farul Constanta)*, G. Nica *(Dinamo Bucuresti)*, M. Aldea *(Dinamo Bucuresti)*, P. Motrescu *(Farul Constanta)*, I. Constantin *(Dinamo Bucuresti)*, M. Nicolescu *(Sportul Studenesc Bucuresti)*, D. Alexandru *(Steaua Bucuresti)*, V. Irimescu *(Grivita Rosie Bucuresti)*, M. Paraschiv *(Dinamo Bucuresti)*, S. Bargaunas *(Brivita Rosie Bucuresti)*
Forwards: A. Pop *(Grivita Rosie Bucuresti)*, C. Fugigi *(Grivita Rosie Bucuresti)*, E. Stoica *(Stiinta Petrosani)*, G. Varga *(Farul Constanta)*, P. Bors *(Farul Constanta)*, G. Dumitru *(Universitatea Timisioara)*, C. Dinu *(Grivita Rosie Bucuresti)*, N. Baciu *(Dinamo Bucuresti)*, V. Turela *(Dinamo Bucuresti)*, D. Busat *(Farul Constanta)*, M. Munteanu *(Steaua Bucuresti)*, M. Ortelecan *(Siinta Petrosani)*
Captain: A. Pop
Manager: O. Marcu
Assistant Manager: P. Cosmonescu

Tour record:

v Poverty Bay *at Gisborne*	won	19-12
v Waikato *at Hamilton*	won	14-9
v Manawatu *at Palmerston North*	lost	9-28
v North Auckland *at Whangarei*	lost	0-3

v Marlborough *at Blenheim*	won	21-6
v Southland *at Invercargill*	won	12-9
v South Canterbury *at Timaru*	lost	4-12
v NZ Juniors *at Wellington*	drew	10-10

Summary:
Played 8, won 4, lost 3, drew 1
Points for 89, against 89

1975 SCOTLAND
First match 24 May, last match 14 June.

Backs: A.R. Irvine *(Heriot's FP)*, B.H. Hay *(Boroughmuir)*, W.C.C. Steele *(London Scottish)*, D.L. Bell *(Watsonians)*, L.G. Dick *(Jordanhill)*, G.A. Birkett *(Harlequins)*, J.N.M. Frame *(Gala)*, J.M. Renwick *(Hawick)*, I.R. McGeechan *(Headingley)*, C.M. Telfer *(Hawick)*, D.W. Morgan *(Stewarts Melville)*, A.J.M. Lawson *(London Scottish)*
Forwards: D.G. Leslie *(Dundee HSFP)* G.Y. Mackie *(Highland)*, M.A. Biggar *(London Scottish)*, W. Lauder *(Neath)*, W.S. Watson *(Boroughmuir)*, A.F. McHarg *(London Scottish)*, I.A. Barnes *(Hawick)*, A.J. Tomes *(Hawick)*, A.B. Carmichael *(West of Scotland)*, N.E.K. Pender *(Hawick)*, J. McLauchlan *(Jordanhill)*, D.F. Madsen *(Gosforth)*, C.D. Fisher *(Waterloo)*
Captain: J. McLauchlan
Manager: G. Burrell
Assistant Manager: W. Dickinson

Tour record:

v Nelson Bays *at Nelson*	won	51-6
v Otago *at Dunedin*	lost	15-19
v Canterbury *at Christchurch*	lost	9-20
v Hawke's Bay *at Napier*	won	30-0
v Wellington *at Wellington*	won	36-25
v Bay of Plenty *at Rotorua*	won	16-10
v New Zealand *at Auckland*	lost	0-24

Summary:
Played 7, won 4, lost 3
Points for 157, against 104

1975 TONGA
First match 25 June, last match 2 August.

Backs: V. Ma'ake *(Kolofo'ou)*, M. 'Alatini *(Polisi)*, T. Ngaluafe *(Longolongo)*, S. Matapule *(Polisi)*, H. Makaohi *(Polisi)*, S. Latu *(Polisi)*, S. Taniela *(Mu'a)*, S. Makalo *(Ha'apai)*, T. Kavapalu *(Longolongo)*, S. Petelo *(Sotia)*, H. Fonua *(Hihifo)*, P. Kaihau *(Longolongo)*, S. Tupou *(Polisi)*
Forwards: S. Mafi *(Hihifo)*, K. 'Inoke *(Kolofo'ou)*, F. Valu *(Hihifo)*, S. Vaea *(Hihifo)*, 'A. Vaihi *(Polisi)*, F. Tupi *(Nukunuku)*, P. Tu'ihalamaka *(Polisi)*, F. Kefu *(Longolongo)*, S. Fifita *(Polisi)*, V. Fakatulolo *(Kolofo'ou)*, S. Tapueluelu *(Kolofo'ou)*, M. Filimoehala *(Fasi)*, P. Tonga *(Kolofo'ou)*
Captain: S. Mafi
Manager: F.V. Sevele
Assistant Manager: S. Vunipola

Tour record:

v Wairarapa-Bush *at Masterton*	won	13-12
v West Coast *at Greymouth*	won	21-17
v North Otago *at Oamaru*	lost	18-30
v Canterbury *at Christchurch*	lost	20-31
v Mid Canterbury *at Ashburton*	won	22-19
v Wanganui *at Wanganui*	won	28-15
v East Coast *at Ruatoria*	won	47-6
v NZ Maoris *at New Plymouth*	lost	16-23
v King Country *at Taumarunui*	won	18-13
v Counties *at Pukekohe*	won	17-12
v Thames Valley *at Thames*	won	41-16
v NZ Maoris *at Auckland*	lost	7-37

Summary:
Played 12, won 8, lost 4
Points for 268, against 231

1976 IRELAND
First match 15 May, last match 5 June.

Backs: A.H. Ensor *(Lansdowne)*, L.A. Moloney *(Garryowen)*, T.O. Grace *(St Mary's)*, A.W. McMaster *(Ballymena)*, J.A. Brady *(Wanderers)*, C.M.H. Gibson *(North of Ireland)*, I.A. McIlraith *(Ballymena)*, B.J. McGann *(Cork Constitution)*, M.A. Quinn *(Lansdowne)*, D.M. Cannliffe *(Lansdowne)*, J.C. Robbie *(Trinity College)*, R. McGrath *(Wanderers)*
Forwards: W.P. Duggan *(Blackrock College)*, H.W. Steele *(Ballymena)*, S.A. McKinney *(Dungannon)*, S.M. Deering *(Garryowen)*, J.C. Davidson *(Dungannon)*, R.F. Hakin *(Church of Ireland Young Men's Society)*, M.I. Keane *(Lansdowne)*, B.O. Foley *(Shannon)*, E.J. O'Rafferty *(Wanderers)*, T.A.O. Feighery *(St Mary's)*, P. O'Callaghan *(Dolphin)*, P.A. Orr *(Old Wesley)*, R.J. Clegg *(Bangor)*, J.L. Cantrell *(Dublin University)*, P.C. Whelan *(Garryowen)*
Captain: T.O. Grace
Manager: K.J. Quilligan
Assistant Manager: T.W.R. Meates

Tour record:

v South Canterbury *at Timaru*	won	19-4
v North Auckland *at Whangarei*	won	12-3
v Auckland *at Auckland*	lost	10-13
v Manawatu *at Palmerston North*	won	22-16
v Canterbury *at Christchurch*	lost	4-18
v Southland *at Invercargill*	won	18-3
v New Zealand *at Wellington*	lost	3-11

Summary:
Played 7, won 4, lost 3
Points for 88, against 68

1976 WESTERN SAMOA
First match 30 June, last match 24 July.

Backs: S. Vasa *(Apia)*, P. Schuster *(Marist)*, P. Grey *(Marist)*, I. Leota *(Marist)*, I. Utuutu *(Vaiala)*, J. Atoa *(Vaiala)*, A. Palamo *(Alafua College)*, K. Avei *(Apia)*, A. Tanuvasa *(Faasaleleaga)*, M. Vili *(Taumasaga)*, F.Asi *(Vaiala)*, Tulitua *(Avele)*, F. Vito *(Marist)*
Forwards: S. Alesana *(Moataa)*, F. Soo Choon *(Marist)*, T. Kali *(Apia)*, I. Lagaaia *(Apia)*, P. Tuau *(Scopa)*, M. Muaitau *(Marist)*, F. Siu *(Vaiala)*, A. Simanu *(Alafua College)*, F. Taulefue *(Scopa)*, S. Tuataga *(Moataa)*, T. Iona *(Apia)*, S. Atii *(Moataa)*, E. Saaga *(Alafua College)*
Captain: F. Siu
Manager: T. McDonald
Coach: A. Grey

Tour record:

v Horowhenua *at Levin*	lost	6-17
v Buller *at Westport*	won	24-10
v Hawke's Bay *at Napier*	lost	0-38
v Poverty Bay *at Gisborne*	lost	3-28
v Counties *at Pukekohe*	lost	4-24
v NZ Maoris *at Rotorua*	lost	6-19
v Taranaki *at New Plymouth*	lost	0-16
v NZ Maoris *at Auckland*	lost	8-24

Summary:
Played 8, won 1, lost 7
Points for 51, against 176

1977 BRITISH ISLES
First match 18 May, last match 13 August.

Backs: B.H. Hay *(Boroughmuir & S)*, A.R. Irvine *(Heriot's FP & S)*, J.J. Williams *(Llanelli & W)*, H.E. Rees *(Neath & W)*, G.L. Evans *(Newport & W)*, P.J. Squires *(Harrowgate & E)*, S.P. Fenwick *(Bridgend & W)*, D.H. Burcher *(Newport & W)*, I.R. McGeechan *(Headingley & S)*, C.M.H. Gisbon *(North of Ireland & I)*, P. Bennett *(Llanelli & W)*, J.D. Bevan *(Aberavon & W)*, D.B. Williams *(Cardiff & W)*, D.W. Morgan *(Stewart's-Melville FP & S)*, A.D. Lewis *(Caerphilly & W)*
Forwards: W.P. Duggan *(Blackrock College & I)*, D.L. Quinnell *(Llanelli & W)*, A.J. Neary *(Broughton Park & E)*, T.P. Evans *(Swansea & W)*, T.J. Cobner *(Pontypool & W)*, J. Squire *(Newport & W)*, N.E. Horton *(Moseley & E)*, M.I. Keane *(Lansdowne & I)*, G.L. Brown *(West of Scotland & S)*, A.J. Martin *(Aberavon & W)*, W.B. Beaumont *(Fylde & E)*, F.E. Cotton *(Sale & E)*, G. Price *(Pontypool & W)*, C. Williams *(Aberavon & W)*, P.A. Orr *(Old Wesley & I)*, A.G. Faulkner *(Newport & W)*, R.W. Windsor *(Pontypool & W)*, P.J. Wheeler *(Leicester & E)*
Captain: P. Bennett
Manager: G. Burrell *(S)*
Assistant Manager: S.J. Dawes *(W)*

Tour record:

v Wairarapa Bush *at Masterton*	won	41-13
v Hawke's Bay *at Napier*	won	13-11

v Poverty Bay-East Coast *at Gisborne*	won	25-6
v Taranaki *at New Plymouth*	won	21-13
v King Country-Wanganui *at Taumarunui*	won	60-9
v Manawatu-Horowhenua *at Palmerston North*	won	18-12
v Otago *at Dunedin*	won	12-7
v Southland *at Invercargill*	won	20-12
v NZ Universities *at Christchurch*	lost	9-21
v New Zealand *at Wellington*	lost	12-16
v South Canterbury-Mid Canterbury-North Otago *at Timaru*	won	45-6
v Canterbury *at Christchurch*	won	14-13
v West Coast-Buller *at Westport*	won	45-0
v Wellington *at Wellington*	won	13-6
v Marlborough-Nelson Bays *at Blenheim*	won	40-23
v New Zealand *at Christchurch*	won	13-9
v NZ Maoris *at Auckland*	won	22-19
v Waikato *at Hamilton*	won	18-13
v NZ Juniors *at Wellington*	won	19-9
v Auckland *at Auckland*	won	34-15
v New Zealand *at Dunedin*	lost	9-19
v Counties-Thames Valley *at Pukekohe*	won	35-10
v North Auckland *at Whangarei*	won	18-7
v Bay of Plenty *at Rotorua*	won	23-16
v New Zealand *at Auckland*	lost	9-10

Summary: Played 25, won 21, lost 4
Points for 586, against 295

1978 AUSTRALIA
First match 29 July, last match 9 September.

Backs: R.G. Gould *(Q)*, L.E. Monaghan *(NSW)*, P.G. Batch *(Q)*, M. Knight *(NSW)*, P.E. McLean *(Q)*, K.J. Wright *(NSW)*, W.A. McKid *(NSW)*, A.G. Slack *(Q)*, B.J. Moon *(Q)*, S.F. Streeter *(NSW)*, P.J. Carson *(NSW)*, R.G. Hauser *(Q)*, G. Richards *(NSW)*, J.N.B. Hipwell *(NSW)*, T. C. Melrose *(NSW)*
Forwards: G. Cornelsen *(Q)*, K.S. Besomo *(NSW)*, M.E. Loane *(Q)*, A.A. Shaw *(Q)*, G. Fay *(NSW)*, S. Pilecki *(Q)*, P.W. McLean *(Q)*, P.A. Horton *(Q)*, W.S. Ross *(Q)*, C.B. Handy *(Q)*, G.K. Pearse *(NSW)*, R.L. Onus *(NSW)*, J.E.C. Meadows *(V)*, T.M. Barker *(Q)*
Captain: A.A. Shaw
Manager: R.V. Turnbull *(NSW)*
Assistant Manager: D.W. Haberecht *(NSW)*

Tour record:

v Nelson Bays *at Nelson*	won	16-9
v Southland *at Invercargill*	lost	7-10
v Otago *at Dunedin*	lost	8-10
v Hawke's Bay *at Napier*	won	16-6
v Manawatu *at Palmerston North*	lost	10-20
v Counties *at Pukekohe*	won	17-8
v New Zealand *at Wellington*	lost	12-13
v Mid Canterbury *at Ashburton*	won	19-12
v New Zealand *at Christchurch*	lost	6-22
v Wanganui *at Wanganui*	won	8-3
v Bay of Plenty *at Rotorua*	won	34-7
v North Auckland *at Whangarei*	won	16-11
v New Zealand *at Auckland*	won	30-16

Summary:
Played 13, won 8, lost 5
Points for 199, against 147

1979 FRANCE
First match 20 June, last match 14 July.

Backs: J.M. Aguirre *(Bagneres)*, S. Blanco *(Biarritz)*, J.L. Averous *(La Voulte)*, F. Costes *(Monteferrand)*, P. Mesney *(Racing Club of France)*, D. Cocorniou *(Narbonne)*, M. Duffranc *(Tyrose)*, A. Caussade *(Lourdes)*, L. Pardo *(Bayonne)*, G. Laporte *(Graulhet)*, Y. Laffarge *(Montferrand)*, J. Gallion *(Toulon)*
Forwards: J.P. Rives *(Toulouse)*, A. Maleig *(Oloron)*, J.L. Joinel *(Brive)*, J.F. Marchel *(Lourdes)*, P. Salas *(Narbonne)*, G. Colomine *(Narbonne)*, R. Paparemborde *(Pau)*, P. Dintrans *(Tarbes)*, J.F. Perche *(Bourg)*, D. Dubroca *(Agen)*, C. Beguerie *(Agen)*, F. Haget *(Biarritz)*, Y. Malquier *(Narbonne)*
Captain: J.P. Rives
Manager: M.Y. Noe
Assistant Manager: F. Cazenare
Coach: J. Desclaux

Tour record:

v Marlborough *at Blenheim*	won	35-15
v Waikato *at Hamilton*	lost	15-18
v North Auckland *at Whangarei*	won	16-3
v Wellington *at Wellington*	won	14-9
v Hawke's Bay *at Napier*	won	31-13
v New Zealand *at Christchurch*	lost	9-23
v Southland *at Invercargill*	lost	11-12
v New Zealand *at Auckland*	won	24-19

Summary:
Played 8, won 5, lost 3
Points for 155, against 112

1979 ARGENTINA
First match 22 August, last match 18 September.

Backs: M. Sansot *(Pueyrredon)*, R. Muniz *(Maristas)*, A. Cappelletti *(Banco Nacion)*, J. Gauweloose *(Buenos Aires University)*, R. Madero *(San Isidro)*, M.H. Loffreda *(San Isidro)*, M. Campo *(Old Georgian Guilmes)*, H. Porta *(Banco Nacion)*, J.P. Piccardo *(Hindu)*, R.T. Landajo *(Pueyrredon)*, A. Soares-Gache *(San Isidro)*
Forwards: R. Lucke *(San Isidro)*, H. Silva *(Los Tilos)*, T. Petersen *(San Isidro)*, E. Ure *(Buenos Aires University)*, R. Mastai *(Buenos Aires University)*, M. Iachetti *(Hindu)*, A. Iachetti *(Hindu)*, G. Travaglini *(San Isidro Athletic)*, A. Voltan *(Belgrano Athletic)*, E.E. Rodriguez *(El Tala)*, F. Morel *(San Isidro Athletic)*, H. Nicola *(Curupayti)*, A. Cubelli *(Belgrano Athletic)*, J. Perez-Cobo *(San Isidro)*
Captain: H. Porta
Manager: D. Bereciartua
Assistant Manager: L. Gradin

Tour record:

v Poverty Bay *at Gisborne*	won	26-3
v Auckland *at Auckland*	won	18-13
v Manawatu *at Palmerston North*	won	21-10
v Bay of Plenty *at Rotorua*	won	32-12
v Taranaki *at New Plymouth*	won	19-9
v New Zealand *at Dunedin*	lost	9-18
v South Canterbury *at Timaru*	won	23-13
v New Zealand *at Wellington*	lost	6-15
v Counties *at Pukekohe*	lost	11-18

Summary:
Played 9, won 6, lost 3
Points for 165, against 111

1980 ITALY
First match 21 June, last match 5 July.

Backs: C. Torresan *(Fracasso San Dona)*, F. Gaetaniello *(Jaffa Roma)*, L. Francescato *(Benetton Treviso)*, S. Ghizzoni *(L'Aquila)*, G. Limone *(Jaffa Roma)*, R. Francescato *(Bennetton Treviso)*, S. Bettarello *(Sanson Rovigo)*, F. Lorigiola *(Petrarca Padova)*, B. Franceschi *(A.S.R. Milano)*, M. Marchetto *(Bennetton Treviso)*, S. Bettarello *(Sanson Rovigo)*, F. Lorigiola *(Amatori Catania)*
Forwards: A. Angrisani *(Jaffa Roma)*, E. de Anna *(Sanson Rovigo)*, S. Annibal *(Metalcram Villoba)*, G. Artuso *(Petrarca Padova)*, F. Gargelli *(Frascati)*, J.L. Basei *(Benetton Treviso)*, A. Bona *(Montferrand)*, F. Di Carlo *(L'Aquila)*, G. Cucchiella *(L'Aquila)*, P. Mariani *(L'Aquila)*, G. Pivetta *(Fracasso San Dona)*, C. Robazza *(Benetton Treviso)*, F. Sintich *(Cus Genova)*, C. Tinari *(Cus Roma)*
Captain: A. Bona
Manager: M. Mondelli
Coach: J.P. Villepreux

Tour record:

v Nelson Bays *at Nelson*	lost	9-13
v Wairarapa Bush *at Masterton*	won	13-9
v Taranaki *at New Plymouth*	lost	9-30
v Horowhenua *at Levin*	won	21-12
v NZ Juniors *at Auckland*	lost	13-30

Summary:
Played 5, won 2, lost 3
Points for 65, against 94

1980 FIJI
First match 6 August, last match 13 September.

Backs: P. Nacuva *(Suva)*, S. Laulau *(Nadi)*, T. Makutu *(Nadroga)*, K.

Vosailagi *(Natroga)*, R. Nakiyoyo *(Nadroga)*, K. Nayacalevu *(Rewa)*, S.Cavuilati *(Nadi)*, W. Gavidi *(Nadroga)*, E. Labalaba *(Nadi)*, P. Waisake *(Rewa)*, S. Viriviri *(Nadi)*
Forwards: V. Ratudradra *(Suva)*, E. Ratudradra *(Lautoka)*, I. Kunagogo *(Korovou)*, K. Ratumuri *(Suva)*, I. Cerelala *(Natewai)*, V. Vatuwaliwali *(Nadi)*, J. Ravouvou *(Nadi)*, T. Tubananitu *(Suva)*, P. Kina *(Nadroga)*, S. Vavatu *(Nadroga)*, S. Seru *(Lautoka)*, P. Kean *(Suva)*
Captain: P. Nacuva
Manager: E. Tavai *(Suva)*
Assistant Manager: G. Pickering
Coach: V. Mocelutu *(Suva)*

Tour record:

v Wanganui *at Wanganui*	lost	11-16
v Wellington *at Wellington*	lost	8-24
v West Coast *at Greymouth*	won	28-12
v Canterbury *at Christchurch*	lost	4-10
v Southland *at Invercargill*	won	22-21
v Otago *at Dunedin*	lost	10-18
v Hawke's Bay *at Napier*	won	28-19
v King Country *at Taumarunui*	won	31-22
v Counties *at Pukekohe*	lost	10-35
v North Auckland *at Whangarei*	lost	4-38
v NZ Maoris *at Rotorua*	lost	9-22
v New Zealand *at Auckland*	lost	0-33

Summary:
Played 12, won 4, lost 8
Points for 165, against 270

1981 SCOTLAND
First match 27 May, last match 20 June.

Backs: A.R. Irvine *(Heriot's FP)*, P.W. Dods *(Gala)*, G.R.T. Baird *(Kelso)*, B.H. Hay *(Boroughmuir)*, S. Munro *(Ayr)*, R.W. Breakey *(Gosforth)*, A.G. Cranston *(Hawick)*, J.M. Renwick *(Hawick)*, J.Y. Rutherford *(Selkirk)*, R. Wilson *(London Scottish)*, I.G. Hunter *(Selkirk)*, R.J. Laidlaw *(Jedforest)*, A.J.M. Lawson *(London Scottish)*
Forwards: D.B. White *(Gala)*, I.A.M. Paxton *(Selkirk)*, P.M. Lillington *(Durham University)*, D.G. Leslie *(Gala)*, G. Dickson *(Gala)*, J.H. Calder *(Stewart's Melville FP)*, W. Cuthbertson *(Kilmarnock)*, T.J. Smith *(Gala)*, A.J. Tomes *(Hawick)*, I.G. Milne *(Heriot's FP)*, G.M. McGuiness *(West of Scotland)*, J. Aitken *(Gala)*, N.A. Rowan *(Boroughmuir)*, C.T. Deans *(Hawick)*, K. G. Lawrie *(Gala)*
Captain: A.R. Irvine
Manager: G.K. Smith
Assistant Manager: J.W. Telfer

Tour record:

v King Country *at Taumarunui*	won	39-13
v Wellington *at Wellington*	lost	15-19
v Wairarapa Bush *at Masterton*	won	32-9
v Canterbury *at Christchurch*	won	23-12
v Mid Canterbury *at Ashburton*	won	21-12
v New Zealand *at Dunedin*	lost	4-11
v Marlborough *at Blenheim*	won	38-9
v New Zealand *at Auckland*	lost	15-40

Summary:
Played 8, won 5, lost 3
Points for 187, against 125

1981 SOUTH AFRICA
First match 22 July, last match 12 September.

Backs: J.W. Heunis *(Northern Transvaal)*, Z.M.J. Pienaar *(Orange Free State)*, D.S. Botha *(Northern Transvaal)*, J.S. Germishuys *(Transvaal)*, E.F.W. Krantz *(Orange Free State)*, R.H. Mordt *(Transvaal)*, W. du Plessis *(Western Province)*, C.J. du Plessis *(Western Province)*, D.M. Gerber *(Eastern Province)*, E.G. Tobias *(S.A.R.F.F.)*, J.J. Beck *(Western Province)*, H.E. Botha *(Northern Transvaal)*, D.J. Serfontein *(Western Province)*, B.J. Wolmarans *(Orange Free State)*, G.P. Visagie *(Natal)*
Forwards: W. Claassen *(Natal)*, J.H. Marais *(Northern Transvaal)*, M.B. Burger *(Northern Transvaal)*, S.B. Geldenhuys *(Northern Transvaal)*, E. Jansen *(Orange Free State)*, R.J. Louw *(Western Province)*, H.J. Bekker *(Western Province)*, L.C. Moolman *(Northern Transvaal)*, M.T.S. Stofberg *(Northern Transvaal)*, J.D. Visser *(Western Province)*, R.J. Cockrell *(Western Province)*, W.J.H. Kahts *(Northern Transvaal)*, S.A. Povey *(Western Province)*, P.G. du Toit *(Western Province)*, O.W. Oosthuizen *(Northern Transvaal)*, H.J. van Aswegen *(Western Province)*, P.R. van der Merwe *(South Western Districts)*

Captain: W. Claassen
Manager: J.T. Claassen
Assistant Managers: C.M. Smith and A. Williams

Tour record:

v Poverty Bay *at Gisborne*	won	24-6
v Taranaki *at New Plymouth*	won	34-9
v Manawatu *at Palmerston North*	won	31-19
v Wanganui *at Wanganui*	won	45-9
v Southland *at Invercargill*	won	22-6
v Otago *at Dunedin*	won	17-13
v New Zealand *at Christchurch*	lost	9-14
v Nelson Bays *at Nelson*	won	83-0
v New Zealand Maoris *at Napier*	drew	12-12
v New Zealand *at Wellington*	won	24-12
v Bay of Plenty *at Rotorua*	won	29-24
v Auckland *at Auckland*	won	39-12
v North Auckland *at Whangarei*	won	19-10
v New Zealand *at Auckland*	lost	22-25

Summary:
Played 14, won 11, drew 1, lost 2
Points for 410, against 171

1982 AUSTRALIA
First match 28 July, last match 11 September.

Backs: R.G. Gould *(Q)*, G.J. Ella *(NSW)*, D.I. Campese *(Q)*, P.C. Grigg *(Q)*, M.C. Martin *(NSW)*, P.G. Southwell *(NSW)*, A.G. Slack *(Q)*, M.J. Hawker *(NSW)*, T.A. Lane *(Q)*, G.A. Ella *(NSW)*, R.G. Hanley *(Q)*, M.G. Ella *(NSW)*, D.V. Vaughan *(NSW)*, P.A. Cox *(NSW)*
Forwards: S.N. Tuynman *(NSW)*, P.W. Lucas *(NSW)*, D. Hall *(Q)*, S.A. Williams *(NSW)*, P. Clements *(NSW)*, S.N. Nightingale *(Q)*, S.A.G. Cutler *(NSW)*, R.J. Reynolds *(NSW)*, S.P. Poidevin *(NSW)*, C. Roche *(Q)*, J.E.C. Meadows *(Q)*, J.E. Coolican *(NSW)*, A.J. McIntyre *(Q)*, J.E. Griffiths *(NSW)*, S. Pilecki *(Q)*, B.P. Malouf *(NSW)*, L.R. Walker *(NSW)*
Captain: M.G. Ella
Manager: C.R. Wilson
Coach: R. Dwyer

Tour record:

v Taranaki *at New Plymouth*	won	16-15
v Manawatu *at Palmerston North*	won	26-10
v Hawke's Bay *at Napier*	won	13-12
v Southland *at Invercargill*	won	21-0
v South Canterbury *at Timaru*	won	29-21
v New Zealand *at Christchurch*	lost	16-23
v Buller *at Westport*	won	65-10
v Otago *at Dunedin*	won	29-12
v Waikato *at Hamilton*	won	23-3
v New Zealand *at Wellington*	won	19-16
v Bay of Plenty *at Rotorua*	lost	16-40
v Counties *at Pukekohe*	lost	9-15
v North Auckland *at Whangarei*	won	16-12
v New Zealand *at Auckland*	lost	18-33

Summary:
Played 14, won 10, lost 4
Points for 316, against 222

1983 BRITISH ISLES
First match 14 May, last match 16 July.

Backs: W.H. Hare *(Leicester & E)*, H.P. MacNeill *(Blackrock College & I)*, J. Carleton *(Orrell & E)*, T.M. Ringland *(Ballymena & I)*, G.R.T. Baird *(Kelso & S)*, G. Evans *(Maesteg & W)*, R.A. Ackerman *(London Welsh & W)*, D.G. Irwin *(Instonians & I)*, M.J. Kiernan *(Dolphin & I)*, C.R. Woodward *(Leicester & E)*, S.O. Campbell *(Old Belvedere & I)*, J.Y. Rutherford *(Selkirk & S)*, T.D. Holmes *(Cardiff & W)*, R.J. Laidlaw *(Jedforest & S)*, N.D. Melville *(Wasps)*, S.J. Smith *(Sale & E)*
Forwards: J.R. Beattie *(Glasgow Academicals & S)*, I.A.M. Paxton *(Selkirk & S)*, E.T. Butler *(Pontypool & W)*, J.H. Calder *(Stewart's Melville F.P. & S)*, P.J. Winterbottom *(Headingley & E)*, J.B. O'Driscoll *(Manchester & I)*, J. Squire *(Pontypool & W)*, N.C. Jeavons *(Moseley & E)*, S.B. Boyle *(Gloucester & E)*, M.J. Colclough *(Angouleme & E)*, S. Bainbridge *(Gosforth & E)*, R.L. Norster *(Cardiff & W)*, D.G. Lenihan *(Cork Constitution & I)*, S.T. Jones *(Pontypool & W)*, I. Stephens *(Bridgend & W)*, I.G. Milne *(Heriot's F.P. & S)*, G. Price *(Pontypool & W)*, G.A.J. McLoughlin *(Shannon & I)*, C.T. Deans *(Hawick & S)*, C.F. Fitzgerald *(St Mary's College & I)*

Captain: C.F. Fitzgerald
Manager: W.J. McBride *(I)*
Coach: J. Telfer *(S)*

Tour record:

v Wanganui *at Wanganui*	won	47-15
v Auckland *at Auckland*	lost	12-13
v Bay of Plenty *at Rotorua*	won	34-16
v Wellington *at Wellington*	won	27-19
v Manawatu *at Palmerston North*	won	25-18
v Mid Canterbury *at Ashburton*	won	26-6
v New Zealand *at Christchurch*	lost	12-16
v West Coast *at Greymouth*	won	52-16
v Southland *at Invercargill*	won	41-3
v Wairarapa-Bush *at Masterton*	won	57-10
v New Zealand *at Wellington*	lost	0-9
v North Auckland *at Whangarei*	won	21-12
v Canterbury *at Christchurch*	lost	20-22
v New Zealand *at Dunedin*	lost	8-15
v Hawke's Bay *at Napier*	won	25-19
v Counties *at Pukekohe*	won	25-16
v Waikato *at Hamilton*	won	40-13
v New Zealand *at Auckland*	lost	6-38

Summary:
Played 18, won 12, lost 6
Points for 478, against 276

1983 TONGA
First match 20 July, last match 13 August.

Backs: T. Halafihi, M. Taufateau, R. Fotu, P. Moala, L. 'Ofa, 'A. Liava'a, S.L. Fekau, T. Ma'afu, P. Ma'afu, K. Vunipola, T. Fifita, F. Moala
Forwards: T. Makisi, 'O. Pifeleti, P. Lolohea, F. Valu, P. Afeaki, T. Hafoka, V. Maka, T. Soane, T. Leha, P. Fifita, K. Ma'u, P. Taholo, H.T. Tupou, 'O. Blake, F. Moala
Captain: F. Valu
Manager: T. Simiki
Coach: K. Tupou
Assistant coach: F. Tuitarake

Tour record:

v Poverty Bay *at Gisborne*	won	11-9
v Taranaki *at New Plymouth*	lost	4-28
v North Otago *at Oamaru*	won	45-9
v South Canterbury *at Timaru*	lost	8-25
v Horowhenua *at Levin*	won	34-18
v New Zealand Maoris *at Rotorua*	lost	4-28
v King Country *at Taumarunui*	won	16-6
v New Zealand Maoris *at Auckland*	lost	4-52

Summary:
Played 8, won 4, lost 4
Points for 126, against 175

1984 FRANCE
First match 2 June, last match 26 June.

Backs: S. Blanco *(Biarritz)*, B. Vivies *(Agen)*, P. Esteve *(Narbonne)*, P. Lagisquet *(Bayonne)*, M. Andrieu *(Nimes)*, E. Bonneval *(Toulouse)*, D. Codorniou *(Narbonne)*, L. Pardo *(Monteferrand)*, P. Sella *(Agen)*, G. Laporte *(Graulhet)*, J.-P. Lescarboura *(Dax)*, P. Berbizier *(Lourdes)*, H. Sanz *(Graulhet)*
Forwards: J. Grattan *(Agen)*, J.-L. Joinel *(Brive)*, P. Lacans *(Beziers)*, L. Rodriguez *(Montois)*, J. Condom *(Boucau)*, F. Haget *(Biarritz)*, A. Lorieux *(Grenoble)*, J.C. Orso *(Nice)*, P.-E. Detrez *(Nimes)*, P. Dospital *(Bayonne)*, D. Dubroca *(Agen)*, J.-P. Garuet *(Lourdes)*, P. Dintrans *(Tarbes)*, B. Herrero *(Nice)*
Captain: P. Dintrans
Manager: Y. Noe
Assistant Manager: J. Fouroux

Tour record:

v Taranaki *at New Plymouth*	won	30-18
v Marlborough *at Blenheim*	won	36-9
v Wellington *at Wellington*	won	38-18
v Otago *at Dunedin*	won	20-10
v New Zealand *at Christchurch*	lost	9-10
v Hawke's Bay *at Napier*	won	40-18
v New Zealand *at Auckland*	lost	18-31
v Counties *at Pukekohe*	won	33-24

Summary:
Played 8, won 6, lost 2
Points for 224, against 138

1985 ENGLAND
First match 18 May, last match 8 June.

Backs: C.R. Martin *(Bath)*, I.R. Metcalfe *(Moseley)*, J.M. Goodwin *(Moseley)*, M.E. Harrison *(Wakefield)*, S.T. Smith *(Wasps)*, B. Barley *(Wakefield)*, P.W. Dodge *(Leicester)*, J.L.B. Salmon *(Harlequins)*, S.J. Barnes *(Bristol)*, G.H. Davies *(Wasps)*, R.J. Hill *(Bath)*, N.D. Melville *(Wasps)*
Forwards: R. Hesford *(Bristol)*, D.H. Cooke *(Harlequins)*, J.P. Hall *(Bath)*, G.W. Rees *(Nottingham)*, M.C. Teague *(Gloucester)*, S. Bainbridge *(Gosforth)*, W.A. Dooley *(Preston Grasshoppers)*, J. Orwin *(Gloucester)*, R.P. Huntsman *(Headingley)*, G.S. Pearce *(Northampton)*, M. Preedy *(Gloucester)*, A. Sheppard *(Bristol)*, S.E. Brain *(Coventry)*, A.W. Simpson *(Sale)*
Captain: P.W. Dodge
Manager: W.G.D. Morgan
Assistant Manager and Coach: M.J. Green

Tour record:

v North Auckland *at Whangarei*	won	27-14
v Poverty Bay *at Gisborne*	won	45-0
v Auckland *at Auckland*	lost	6-24
v Otago *at Dunedin*	won	25-16
v New Zealand *at Christchurch*	lost	13-18
v Southland *at Invercargill*	won	15-9
v New Zealand *at Wellington*	lost	15-42

Summary:
Played 7, won 4, lost 3
Points for 146, against 123

1985 AUSTRALIA
29 June.

Backs: R.G. Gould *(Q)*, P.C. Grigg *(Q)*, J.W. Black *(NSW)*, T.A. Lane *(Q)*, M.P. Burke *(NSW)*, M.P. Lynagh *(Q)*, N.C. Farr-Jones *(NSW)*
Forwards: S.N. Tuynman *(NSW)*, D. Codey *(Q)*, S.A.G. Cutler *(NSW)*, S.A. Williams *(NSW)*, S.P. Poidevin *(NSW)*, A.J. McIntyre *(Q)*, T.A. Lawton *(Q)*, E.E. Rodriguez *(NSW)*
Captain: S.A. Williams
Manager: C.R. Wilson
Assistant Manager: A.B. Jones

Tour record:

v New Zealand *at Auckland*	lost	9-10

1986 FRANCE
First match 24 June, last match 28 June.

Backs: J. Bianchi *(R.C. Toulon)*, S. Blanco *(Biarritz O)*, M. Andriew *(R.C. Nimes)*, P. Berot *(S.U. Agen)*, E. Bonneval *(Stade Toulouse)*, P. Chadebech *(C.A. Brive)*, D. Charvet *(Stade Toulouse)*, J.B. Lafond *(R.C.F.)*, P. Lagisquet *(Aviron Bayonne)*, P. Sella *(S.U. Agen)*, G. Laporte *(S.C Graulhet)*, J.P. Lescarboura *(U.S. Dax)*, P. Berbizier *(S.U. Agen)*
Forwards: M. Cecillon *(C.S. Bourgoin)*, E. Champ *(R.C. Toulon)*, D. Erbani *(S.U. Agen)*, J. Gratt *(S.U. Agen)*, J.L. Joinel *(C.A. Brive)*, L. Rodriguez *(Stade Montois)*, J. Condom *(Boucau Stade)*, F. Haget *(Biarritz O)*, J.C. Orso *(R.R.C. Nice)*, T. Picard *(A.S. Montferrand)*, P. Serriere *(R.C.F.)*, C. Portolan *(S.U. Agen)*, P.E. Detrez *(R.C. Nimes)*, J.P. Garuet *(F.C. Lourdes)*, P. Morocco *(A.S. Montferrand)*, D. Dubroca *(S.U. Agen)*, B. Herrero *(R.C. Toulon)*
Captain: D. Dubroca
Manager: Y. Noe
Assistant Manager: J. Fouroux

Tour record:

v North Auckland *at Whangarei*	won	30-9
v New Zealand *at Christchurch*	lost	9-18

1986 AUSTRALIA
First match 23 July, last match 6 September.

Backs: A. Leeds *(NSW)*, D.I. Campese *(ACT)*, P.C. Grigg *(Q)*, M.P. Burke *(NSW)*, I.M. Williams *(NSW)*, C.A. Morton *(ACT)*, A.G. Slack *(Q)*, B. Papworth *(NSW)*, M.T. Cook *(Q)*, G.J. Ella *(NSW)*, M.P. Lynagh *(Q)*, S.L. James *(NSW)*, N.C. Farr-Jones *(NSW)*, B. Smith *(Q)*

Forwards: R.J. Reynolds *(NSW)*, J.L. McInerney *(NSW)*, S.N. Tuynman *(NSW)*, J.S. Miller *(Q)*, S.P. Poidevin *(NSW)*, W.J. Calcraft *(NSW)*, J. Gardner *(Q)*, S.A.G. Cutler *(NSW)*, W.A. Campbell *(Q)*, D. Frawley *(Q)*, R.J. McCall *(Q)*, M.A. Murray *(NSW)*, E.E. Rodriguez *(NSW)*, M.N. Hartill *(NSW)*, G. Burrow *(NSW)*, T.A. Lawton *(Q)*, M.I. McBain *(Q)*
Captain: A.G. Slack
Manager: K.P. Grayling
Assistant Manager: A.B. Jones

Tour record:

v Waikato *at Hamilton*	drew	21-21	
v Manawatu *at Palmerston North*	won	9-6	
v Wairarapa-Bush *at Masterton*	won	18-6	
v Counties *at Pukekohe*	won	21-3	
v Wanganui *at Wanganui*	won	24-17	
v New Zealand *at Wellington*	won	13-12	
v Buller *at Westport*	won	62-0	
v Canterbury *at Christchurch*	lost	10-30	
v South Canterbury *at Timaru*	won	33-11	
v New Zealand *at Dunedin*	lost	12-13	
v Southland *at Invercargill*	won	55-0	
v Bay of Plenty *at Rotorua*	won	41-13	
v Thames Valley *at Thames*	won	31-7	
v New Zealand *at Auckland*	won	22-9	

Summary: Played 14, won 11, lost 2, drew 1
Points for 376, against 148

1988 WALES
First match 18 May, last match 11 June.

Backs: S. Bowling *(Llanelli)*, A. Clement *(Swansea)*, J. Mason *(Pontypridd)*, C. Davies *(Llanelli)*, I.C. Evans *(Llanelli)*, G.M.C. Webbe *(Bridgend)*, B. Bowen *(Southwest Police)*, J.A. Devereux *(Bridgend)*, M.G. Ring *(Pontypool)*, N. Davies *(Llanelli)*, J. Davies *(Llanelli)*, J. Griffiths *(Llanelli)*, R.N. Jones *(Swansea)*
Forwards: T. Fauvel *(Abervon)*, W.P. Moriarty *(Swansea)*, M. Jones *(Neath)*, D. Bryant *(Bridgend)*, R.G. Collins *(Southwest Police)*, R. Phillips *(Neath)*, G. Jones *(Llanelli)*, P.S. May *(Llanelli)*, K. Moseley *(Pontypool)*, R.L. Norster *(Cardiff)*, S. Sutton *(Southwest Police)*, A. Buchanan *(Llanelli)*, S.T. Jones *(Pontypool)*, J.D. Pugh *(Neath)*, D. Young *(Swansea)*, M. Pugh *(Southwest Police)*, K.H. Phillips *(Neath)*, I.J. Watkins *(Ebbw Vale)*
Captain: B. Bowen
Manager: W.R. Morgan
Coach: A. Gray
Assistant coach: D.L. Quinnell

Tour record:

v Waikato *at Hamilton*	lost	19-28	
v Wellington *at Wellington*	lost	22-38	
v Otago *at Dunedin*	won	15-13	
v New Zealand *at Christchurch*	lost	3-52	
v Hawke's Bay *at Napier*	won	45-18	
v Taranaki *at New Plymouth*	drew	13-13	
v North Auckland *at Whangarei*	lost	9-27	
v New Zealand *at Auckland*	lost	9-54	

Summary:
Played 8, won 2, lost 5, drew 1
Points for 135, against 243

1989 FRANCE
First match 7 June, last match 1 July.
Backs: S. Blanco *(Biarritz)*, J.-B. Lafond *(Racing Club)*, P. Berot *(Agen)*, P. Hontas *(Biarritz)*, P. Lagisquet *(Bayonne)*, S. Weller *(Grenoble)*, M. Andrieu *(Nimes)*, D. Charvet *(Toulouse)*, P. Sella *(Agen)*, J.-M. Lescure *(Narbonne)*, F. Mesnel *(Racing Club)*, P. Rouge-Thomas *(Toulouse)*, P. Berbizier *(Agen)*, H. Sanz *(Narbonne)*
Forwards: P. Benetton *(Agen)*, A. Carminati *(Beziers)*, M. Cecillon *(Bourgoin)*, L. Rodriguez *(Dax)*, J.-F. Tordo *(Toulon)*, D. Erbani *(Agen)*, P. Beraud *(Dax)*, J. Condom *(Biarritz)*, T. Devergie *(Nimes)*, O. Roumat *(Dax)*, H. Chabowski *(Bourgoin)*, P. Gallard *(Beziers)*, J.-P. Garuet *(Lourdes)*, P. Ondarts *(Biarritz)*, M. Pujolle *(Nice)*, D. Bouet *(Dax)*
Captain: P. Berbizier
Manager-coach: J. Fouroux
Assistant coach: D. Dubroca

Tour record:

v Counties *at Pukekohe*	won	24-21	
v Manawatu *at Palmerston North*	won	28-23	

v Southland *at Invercargill*	lost	7-12	
v New Zealand *at Christchurch*	lost	17-25	
v Seddon Shield Unions *at Blenheim*	won	39-13	
v Wellington *at Wellington*	lost	23-24	
v Bay of Plenty *at Rotorua*	won	22-18	
v New Zealand *at Auckland*	lost	20-34	

Summary:
Played 8, won 4, lost 4
Points for 180, against 170

1989 ARGENTINA
First match 2 July, last match 29 July.

Backs: S. Salvat *(Alumni)*, A. Scolni *(Alumni)*, J. Solar Valls *(Tucuman LT)*, D. Cuesta Silva *(San Isidro)*, C.I. Mendy *(Los Tilos)*, M.A. Righentini *(San Fernando)*, M. Allen *(CASI)*, P. Garzon *(Tala)*, M.H. Loffreda *(San Isidro)*, F.A. Turnes *(CA Banco de la Nacion)*, D. Dominguez *(La Tablada)*, R.M. Madero *(San Isidro)*, D.R. Baetti *(Atletico del Rosario)*, F.E. Gomez *(CA Banco de la Nacion)*, F.J.G. Silvestre *(Mendoza)*
Forwards: M. Baeck *(Teque)*, M. Bertranou *(Los Tordos)*, P. Di Nisio *(CA Banco de la Nacion)*, P.A. Garreton *(Universitario)*, P. Buabse *(Los Tarcos)*, A. Iachetti *(Hindo)*, G.E. Milano *(Jockey Club)*, J.E. Simes *(Tala)*, J.J. Uriarte *(Universitario)*, M.R. Valesani *(Atletico del Rosario)*, D.M. Cash *(San Isidro)*, S. Dengra *(San Martin)*, L.E. Molina *(Tucuman LT)*, A. Rocca *(BA Cricket and Rugby)*, J.J. Angelillo *(San Isidro)*, R. Le Fort *(Tucuman)*
Captain: M.H. Loffreda
Manager: H. Vidou
Coach: R. O'Reilly
Assistant coach: R. Sanz

Tour record:

v North Auckland *at Whangarei*	won	22-16	
v King Country *at Taupo*	won	9-4	
v Auckland *at Auckland*	lost	6-61	
v Wairarapa-Bush *at Masterton*	won	22-4	
v New Zealand *at Dunedin*	lost	9-60	
v Hanan Shield Districts *at Timaru*	won	17-6	
v Canterbury *at Christchurch*	lost	16-33	
v Waikato *at Hamilton*	lost	12-30	
v New Zealand *at Wellington*	lost	12-49	

Summary:
Played 9, won 4, lost 5
Points for 125, against 263

1989 AUSTRALIA
5 August.

Backs: G.J. Martin *(Qld)*, D.I. Campese *(NSW)*, L.F. Walker *(NSW)*, T.J. Horan *(Qld)*, I.M. Williams *(NSW)*, M.P. Lynagh *(Qld)*, N.C. Farr-Jones *(NSW)*
Forwards: S.N. Tuynman *(NSW)*, J.S. Miller *(Qld)*, S.P. Poidevin *(NSW)*, S.A.G. Cutler *(NSW)*, W.A. Campbell *(Qld)*, B. Girvan *(ACT)*, A.J. Daly *(NSW)*, P.N. Kearns *(NSW)*, A.J. McIntyre *(Qld)*
Captain: N.C. Farr-Jones
Coach: R.S.F. Dwyer

Tour record:

v New Zealand *at Auckland*	lost	12-24	

1990 WESTERN SAMOA
First match 21 March, last match 28 March.

Backs: T. Faamasino *(Vaimosa)*, A. Aiolupo *(Moataa)*, S. Tupuala *(Moataa)*, R.F. Siu *(Waitemata)*, K. Sio *(Scopa)*, T. Vaega *(Suburbs)*, T.D.L. Tagaloa *(Marist St Pat's)*, R. Filitona, J. Ah Kuoi *(Marist, Auckland)*, D. Schuster *(Marist)*, F. Saena *(Moataa)*, V. Fepulea'i *(Marist)*, M. Moke *(Vailele)*
Forwards: M. Iepeli *(Vaimoso)*, H. Schuster *(University, Wellington)*, D. Kaleopa *(Marist, Auckland)*, S. Lemamea *(Lefaga)*, P. Paulo *(Aana)*, V. Alaalato *(Manly)*, S. Vaifale *(Marist)*, F. Lameta *(Vaimoso)*, P. Fuatai *(Vaiala)*, P. Leavai *(Otahuhu)*, S. Po Ching *(Suburbs)*, A. Leu'u *(Otahuhu)*, T. Sio *(Marist)*, P. Fatialofa *(Ponsonby)*, V. Alalatoa *(Manly)*, S. To'omalatai *(Vaiala)*, P. Schmidt *(Marist)*
Captain: P. Fatialofa
Coach: P. Schuster
Technical advisor: J.D. Matheson
Manager: T. Simi

Tour record:

v NZ Divisional XV *at Taupo*	lost	9-57
v North Harbour *at Takapuna*	lost	8-24
v Counties *at Pukekohe*	won	34-20

Summary:
Played 3, won 1, lost 2
Points for 51, against 101

1990 SCOTLAND
First match 30 May, last match 23 June.

Backs: P.W. Dods *(Gala)*, A.G. Hastings *(London Scottish)*, A.G. Stanger *(Hawick)*, I. Tukalo *(Selkirk)*, A. Moore *(Edinburgh Academicals)*, S. Porter *(Melrose)*, S. Hastings *(Watsonians)*, C. Redpath *(Melrose)*, S.R.P. Lineen *(Boroughmuir)*, G. Shiel *(Melrose)*, C.M. Chalmers *(Melrose)*, D.S. Wylie *(Stewart's Melville FP)*
Forwards: D.B. White *(London Scottish)*, G.R. Marshall *(Selkirk)*, F. Calder *(Stewart's Melville FP)*, D.J. Turnbull *(Hawick)*, G.A.E. Buchanan-Smith *(Heriot's FP)*, J. Jeffrey *(Kelso)*, G. Weir *(Melrose)*, C.A. Gray *(Nottingham)*, D.F. Cronin *(Bath)*, J.F. Richardson *(Edinburgh Academicals)*, A.P. Burnell *(London Scottish)*, D.M.B. Sole *(Edinburgh Academical)*, I.G. Milne *(Heriot's FP)*, A.K. Brewster *(Stewart's Melville FP)*, K.S. Milne *(Heriot's FP)*, J. Allan *(Edinburgh Academicals)*
Captain: D.M.B. Sole
Manager: D.S. Paterson
Coach: I.R. McGeechan
Assistant coach: D. Grant

Tour record:

v Poverty Bay-East Coast *at Gisborne*	won	45-0
v Wellington *at Wellington*	drew	16-16
v Nelson Bays-Marlborough *at Nelson*	won	23-6
v Canterbury *at Christchurch*	won	21-12
v Southland *at Invercargill*	won	45-12
v New Zealand *at Dunedin*	lost	16-31
v Manawatu *at Palmerston North*	won	19-4
v New Zealand *at Auckland*	lost	18-21

Summary:
Played 8, won 5, drew 1, lost 2
Points for 203, against 102

1990 AUSTRALIA
First match 11 July, last match 18 August.

Backs: G.J. Martin *(Qld)*, D.I. Campese *(NSW)*, I.M. Williams *(NSW)*, P. Carozza *(Qld)*, J.A. Flett *(NSW)*, P.W. Cornish *(ACT)*, D.K. Junee *(NSW)*, A.G. Herbert *(Qld)*, T.J. Horan *(Qld)*, D. Maguire *(Qld)*, D.J. Knox *(NSW)*, M.P. Lynagh *(Qld)*, N.C. Farr-Jones *(NSW)*, P. Slattery *(Qld)*, A. Cairns *(NSW)*
Forwards: B.T. Gavin *(NSW)*, S.N. Tuynman *(NSW)*, S.J. Scott-Young *(Qld)*, B. Nasser *(Qld)*, J.R. Ross *(ACT)*, V. Ofahengaue *(NSW)*, T. Coker *(Qld)*, P. FitzSimons *(NSW)*, E.J.A. McKenzie *(NSW)*, M.J. Ryan *(Qld)*, P.N. Kearns *(NSW)*, M.I. McBain *(Qld)*
Captain: N.C. Farr-Jones
Manager: A.J. Conway
Coach: R.S.F. Dwyer
Assistant coach: R.I. Templeton

Tour record:

v Waikato *at Hamilton*	lost	10-21
v Auckland *at Auckland*	lost	10-16
v West Coast-Buller *at Greymouth*	won	62-0
v New Zealand *at Christchurch*	lost	6-21
v Hanan Shield Districts *at Timaru*	won	34-0
v Otago *at Dunedin*	won	24-20
v North Auckland *at Whangarei*	won	28-14
v New Zealand *at Auckland*	lost	17-27
v North Harbour *at Takapuna*	won	23-12
v Taranaki *at New Plymouth*	won	27-3
v Bay of Plenty *at Rotorua*	lost	4-12
v New Zealand *at Wellington*	won	21-9

Summary:
Played 12, won 7, lost 5
Points for 266, against 155

1991 WESTERN SAMOA
First match 16 April, last match 1 May.

Backs: T. Faamasino *(Wellington)*, P. Nee Nee *(Auckland)*, B. Lima *(Wellington)*, T. Vaega *(Auckland)*, M. Ta'ala, F.E. Bunce *(North Harbour)*, F. Tuilagi *(Marist St Joseph's)*, K. Sio *(Scope)*, S.J. Bachop *(Canterbury)*, M. Vaea *(Wellington)*, T. Nu'uali'itia *(Counties)*
Forwards: F. Lamarea, H. Schuster *(Wellington)*, S. Vaifale *(Marist)*, J. Paramore *(Counties)*, M. Iupeli *(Vaimoso)*, L. Falaniko *(Vaimoso)*, S. Lemamea *(Wellington)*, P. Fuatai, L. Po Ching *(Auckland)*, L. Siliga, P. Fatialofa *(Ponsonby)*, S. Fanolua *(Otago)*, A. Leu'u *(Auckland)*, S. To'omalatai *(NSW)*, P. Schmidt *(Marist)*
Captain: P. Fatialofa
Coach: P. Schuster

Tour record:

v Waikato *at Hamilton*	won	16-7
v Taranaki *at New Plymouth*	won	28-15
v Bay of Plenty *at Tauranga*	lost	21-22
v Auckland *at Auckland*	lost	3-42
v King Country *at Te Kuiti*	won	21-12

Summary:
Played 5, won 3, lost 2
Points for 89, against 98

1991 FIJI
First match 8 May, last match 15 May.

Backs: S. Koroduadua *(Police)*, M. Natuilagilagi *(QVSOB)*, N. Korovata *(Police)*, L. Erenavula *(Police)*, T. Vonolagi *(Army)*, N. Naisoro, T. Lovo, N. Nadruku, J. Waqabaca *(Army)*, T.M. Rabaca *(Mt St Mary's)*, K. Naisoro, P. Dau *(Top Line)*, P. Tabulutu *(Nabua)*
Forwards: M. Olsson *(St John-Marist)*, P. Naruma *(Police)*, P. Kubuwai *(QVSOB)*, I. Savai *(Regent)*, S. Domoni *(Waimanu)*, E. Naituivau *(Army)*, M. Taga *(QVSOB)*, N. Vuli *(PWD)*, S. Naivilawasa *(Police)*
Captain: M. Taga
Coach: S. Viriviri
Assistant coach: G. Simpkin
Manager: P. Hughes

Tour record:

v Bay of Plenty *at Rotorua*	won	42-31
v Auckland *at Auckland*	lost	6-36
v Canterbury *at Christchurch*	lost	24-47

Summary:
Played 3, won 1, lost 2
Points for 72, against 114

1991 ROMANIA
First match 15 May, last match 9 June.

Backs: V. Brici *(Farul)*, M. Dumitru *(Rapid)*, C. Sasu *(Farul)*, N. Racean *(University)*, S. Tofan *(Dynamo)*, C. Franciuc *(Dynamo)*, N. Fulina *(Farul)*, A. Lungu *(Dynamo)*, G. Sava *(Stiinta)*, G. Ignat *(Steaua)*, N. Nichitean *(Stiinta)*, D. Neaga *(Dynamo)*, T. Coman *(Steama)*
Forwards: T. Brinza *(Grivita)*, H. Dumitras *(Pau)*, T. Radu *(Dynamo)*, G. Dinu *(Grivita)*, I. Doja *(Dynamo)*, O. Sugar *(Stiinta)*, S. Ciorascu *(Angouleme)*, C. Cojocariu *(Dynamo)*, L. Constantin *(Mielan)*, T. Orian *(Steama)*, C. Constantin *(Farul)*, M. Dragomir *(Farul)*, G. Dumitrescu *(Pau)*, G. Leonte *(Mielan)*, C. Stan *(Contactoare)*, G. Ion *(Dynamo)*, V. Tufa *(Dynamo)*
Captain: H. Dumitras
Coach: P. Ianusievici
NZ-appointed coach: R.M. Cooper
Manager: V. Morariu

Tour record:

v Wanganui *at Wanganui*	won	26-18
v Horowhenua *at Levin*	won	48-12
v Wairarapa-Bush *at Masterton*	lost	25-32
v Hawke's Bay *at Napier*	lost	17-24
v King Country *at Taumarunui*	won	28-6
v Counties *at Pukekohe*	won	30-17
v Thames Valley *at Paeroa*	won	20-17
v New Zealand XV *at Auckland*	lost	30-60

Summary:
Played 8, won 5, lost 3
Points for 224, against 186

1991 SOVIET UNION
First match 25 May, last match 18 June

Backs: A. Zakarliuk *(Krasnyi Iar)*, V. Voropaev *(VVA)*, I. Kuperman *(Krasnyi Iar)*, I. Mironov *(VVA)*, V. Sorokin *(VVA)*, A. Kovalenko *(VVA)*, I. Tsyganov *(Zveda)*, A. Gamoskin *(Krasnyi Iar)*, S. Boldakov *(SKA)*, Y. Nikolaev *(Krasnyi Iar)*, A. Primachenko *(Politekhnik)*, A. Bychkov *(SKA)*
Forwards: V. Negodin *(Krasny Iar)*, A. Tikhonov *(VVA)*, A. Valialtchikov *(Slava)*, M. Uambaev *(SKA)*, A. Ogryzkov *(SKA)*, V. Zykov *(Krasnyi Iar)*, S. Ovsiannik *(Aviator)*, S. Sergeev *(Fili)*, E. Ganiakhin *(SKA)*, E. Kabylkin *(Krasnyi Iar)*, R. Bikbov *(Krasnyi Iar)*, S. Molchenov *(Slava)*, R. Malikov *(Edvi)*, V. Marchenko *(VVA)*
Coach: V. Grachev
NZ-appointed coach: D. Dysart
Manager: P. Etko

Tour record:

v Nelson Bays *at Nelson*		won	25-24
v Marlborough *at Blenheim*		won	23-16
v Canterbury *at Christchurch*		lost	15-73
v Mid Canterbury *at Ashburton*		won	33-10
v Otago *at Dunedin*		lost	11-37
Taranaki *at New Plymouth*		lost	16-39
v New Zealand XV *at Hamilton*		lost	6-56
v King Country *at Te Kuiti*		won	22-15

Summary:
Played 8, won 4, lost 4
Points for 151, against 270

1991 AUSTRALIA
First match 20 August, last match 24 August.

Backs: G.J. Martin *(Qld)*, M.C. Roebuck *(NSW)*, D.I. Campese *(NSW)*, P.V. Carozza *(Qld)*, R.H. Egerton *(NSW)*, J.A. Flett *(NSW)*, A.G. Herbert *(Qld)*, T.J. Horan *(Qld)*, J.S. Little *(Qld)*, R.G. Tombs *(NSW)*, D.J. Knox *(NSW)*, M.P. Lynagh *(Qld)*, N.C. Farr-Jones *(NSW)*, P.J. Slattery *(Qld)*
Forwards: T. Coker *(Qld)*, S.N. Tuynman *(NSW)*, B.P. Nasser *(Qld)*, V. Ofahengaue *(NSW)*, S.P. Poidevin *(NSW)*, S.J.N. Scott-Young *(Qld)*, J.A. Eales *(Qld)*, P. FitzSimons *(NSW)*, R.J. McCall *(Qld)*, G. Morgan *(Qld)*, D.J. Crowley *(Qld)*, A.J. Daly *(NSW)*, C.P. Lillicrap *(Qld)*, E.J.A. McKenzie *(NSW)*, P.N. Kearns *(NSW)*, D.V. Nucifora *(Qld)*
Captain: N.C. Farr-Jones
Coach: R.S.F. Dwyer
Assistant coach: R.I. Templeton
Manager: J.J. Breen

Tour record:

v Counties *at Pukekohe*		won	17-12
v New Zealand *at Auckland*		lost	3-6

Summary:
Played 2, won 1, lost 1
Points for 20, against 18

1992 WORLD XV
First match 18 April, last match 25 April.

Backs: A.G. Hastings *(Scotland)*, A.J. Joubert *(South Africa)*, P. Hendriks *(South Africa)*, M.J. Knoetze *(South Africa)*, Y. Yoshida *(Japan)*, J.P. Claassens *(South Africa)*, J.C. Guscott *(England)*, T.J. Horan *(Australia)*, J.S. Little *(Australia)*, H.E. Botha *(South Africa)*, D. Camberabera *(France)*, N.C. Farr-Jones *(Australia)*, A.D. Nicol *(Scotland)*
Forwards: D.B. White *(Scotland)*, V. Ofahengaue *(Australia)*, G.I. Mackinnon *(Canada)*, B.P. Nasser *(Australia)*, A. Perelini *(Western Samoa)*, M. Cecillon *(France)*, O. Roumat *(France)*, J.A. Eales *(Australia)*, P. FitzSimons *(Australia)*, G.W. Whetton *(New Zealand)*, T. Coker *(Australia)*, P. Fatialofa *(Western Samoa)*, F.E. Mendez *(Argentina)*, D.M.B. Sole *(Scotland)*, E.J.A. McKenzie *(Australia)*, P.N. Kearns *(Australia)*, U.L. Schmidt *(South Africa)*
Captain: N.C. Farr-Jones
Coach: I.R. McGeechan *(Scotland)*
Assistant coach: R.I. Templeton *(Australia)*
Manager: B.J. Lochore *(New Zealand)*

Tour record:

v New Zealand *at Christchurch*		won	28-14
v New Zealand *at Wellington*		lost	26-54
v New Zealand *at Auckland*		lost	15-26

Summary:
Played 3, won 2, lost 1
Points for 69, against 94

1992 IRELAND
First match 13 May, last match 6 June.

Backs: K.J. Murphy *(Cork Constitution)*, J.E. Staples *(London Irish)*, R.W. Carey *(Dungannon)*, J.D. Clarke *(Dolphin)*, J.N. Furlong *(Galway University)*, R. Wallace *(Garryowen)*, D.P. O'Brien *(Clontarf)*, V.J.G. Cunningham *(St Mary's College)*, P.P.A. Danaher *(Garryowen)*, M.C. McCall *(Bangor)*, M.P. Ridge *(Blackrock)*, D.R. McAleese *(Ballymore)*, P. Russell *(Instonians)*, L.F.P. Aherne *(Lansdowne)*, M.T. Bradley *(Cork Constitution)*
Forwards: M.J. Fitzgibbon *(Shannon)*, P.S.C. Johns *(Dungannon)*, K.T. Leahy *(Wanderers)*, W.D. McBride *(Malone)*, N.P. Mannion *(Lansdowne)*, B.F. Robinson *(Ballymena)*, P. Kenny *(Wanderers)*, R.A. Costello *(Garryowen)*, J.R. Etheridge *(Northampton)*, M.J. Galwey *(Shannon)*, B.J. Rigney *(Greystones)*, T.P.J. Clancy *(London Irish)*, G.F. Halpin *(London Irish)*, P. McCarthy *(Cork Constitution)*, N.J. Popplewell *(Greystones)*, T.J. Kingston *(Dolphin)*, S.J. Smith *(Ballymena)*
Captain: P.P.A. Danaher
Coach: C.F. Fitzgerald
Assistant coach: G. Murphy
Manager: N.A.A. Murphy

Tour record:

v South Canterbury *at Timaru*		won	21-16
v Canterbury *at Christchurch*		lost	13-38
v Bay of Plenty *at Rotorua*		won	39-23
v Auckland *at Auckland*		lost	7-62
v Poverty Bay-East Coast *at Gisborne*		won	22-7
v New Zealand *at Dunedin*		lost	21-24
v Manawatu *at Palmerston North*		lost	24-58
v New Zealand *at Wellington*		lost	6-59

Summary:
Played 8, won 3, lost 5
Points for 153, against 287

1992 WESTERN SAMOA
First match 1 June, last match 7 June.

Backs: A.A. Aioulupo *(Moataa)*, B. Lima *(Marist St Joseph's)*, K. Seinafo *(Linwood)*, T. Vaega *(Te Atatu)*, A. Ieremia *(Western Suburbs)*, K. Sio *(Scopa)*, F. Tuilagi *(Marist St Joseph's)*, F. Saena *(Moataa)*, M. Vaea *(Marist St Joseph's)*, O. Tonu'u *(Poneke)*
Forwards: D. Kaleopa *(Auckland Marist)*, A. Perelini *(Massey)*, J. Paramore *(Manurewa)*, S. Viafale *(Marist St Joseph's)*, E. Ioane *(Ponsonby)*, M.G. Keenan *(University, Auckland)*, M.L. Birtwistle *(Suburbs)*, S. Lemamea *(Lefaga)*, P. Fatialofa *(Ponsonby)*, V. Ala'alatoa *(Manly)*, T. Sio *(Northern Suburbs)*, S. Toomalatai *(Vaiala)*, P. Livomaiava *(Marist St Joseph's)*
Captain: P. Fatialofa
Coach: S.P. Schuster
Technical advisor: B.G. Williams
Manager: A.G. Meredith

Tour record:

v Waikato *at Hamilton*		lost	29-39
v Bay of Plenty *at Tauranga*		won	58-16
v Manawatu *at Palmerston North*		won	35-22

Summary:
Played 3, won 2, lost 1
Points for 122, against 77

TONGA 1992
First match 27 June, last match 12 July.

Backs: I. Tapueluelu *(Kolomotu'a)*, R. Masila *(Kolomotu'a)*, T. Tuineau *(Maufangal)*, M. Vea *(Ma'afu)*, L. Fotui *(Hihifo)*, B. Tasi, T. Vaenuku *(Police)*, C. Schaumkel *(Ponsonby)*, H. Nisa *(Haawini)*, T. Na'apuku *(Holonga)*, N. Tufui *(Kolomotu'a)*, M. Vunipola *(Ma'afu)*
Forwards: T. Latailakepa *(Ma'afu)*, S. Lolo *(Kolomotu'a)*, T. Tu'uta, P. Havili, P. Kaufusi *(Vaheloto)*, T. Kakato, K. Faletau *(Ma'afu)*, I. Fatani, P. Fisiiahi *(Auckland Marist)*, E. Talakai *(Suburbs)*, T. Lutuai *(Police)*, S. Latu, F. Masila *(Kolomotu'a)*, F. Vunipola *(Ma'afu)*, R. Kapeli *(Auckland Marist)*
Captain: T. Latailakepa

Tour record:

v Horowhenua *at Levin*	won	20-7
v King Country *at Taumarunui*	lost	8-30
v Taranaki *at New Plymouth*	lost	25-33
v Thames Valley *at Paeroa*	won	5-3
v North Harbour *at Takapuna*	lost	7-30

Summary:
Played 5, won 2, lost 3
Points for 65, against 103

ENGLAND B
First match 10 June, last match 5 July.

Backs: I. Hunter (*Northampton*), J. Steele (*Northampton*), S. Hackney (*Leicester*), A.T. Harriman (*Harlequins*), G.J. Thompson (*Harlequins*), H.S. Thorneycroft (*Northampton*), T. Underwood (*Leicester*), G.C. Childs (*Wasps*), P.R. de Glanville (*Bath*), D.P. Hopley (*Wasps*), S.J. Barnes (*Bath*), N. Matthews (*Gloucester*), A. Kardooni (*Leicester*), D. Scully (*Wakefield*)
Forwards: B.B. Clarke (*Bath*), S. Ojomoh (*Bath*), N.A. Back (*Leicester*), J. Cassell (*Saracens*), M. Greenwood (*Nottingham*), M. Russell (*Harlequins*), D.N. Baldwin (*Sale*), M.C. Bayfield (*Northampton*), M. Haag (*Bath*), D. Sims (*Gloucester*), G. Baldwin (*Northampton*), M.P. Hynes (*Orrell*), A.R. Mullins (*Harlequins*), V.E. Obugu (*Bath*), K.A. Dunn (*Gloucester*)
Captain: S.J. Barnes
Coach: J. Rowell
Assistant coach: M.A.C. Slemen
Manager: G.G. Smith

Tour record:

v North Otago *at Oamaru*	won	68-4
v Southland *at Invercargill*	won	31-16
v NZ Universities *at Wellington*	won	32-19
v Wairarapa-Bush *at Masterton*	won	40-6
v Wanganui *at Wanganui*	won	35-9
v New Zealand XV *at Hamilton*	lost	18-24
v North Auckland *at Whangarei*	won	31-27
v New Zealand XV *at Pukekohe*	lost	18-26

Summary:
Played 8, won 6, lost 2
Points for 273, against 131

1993 BRITISH ISLES
First match 23 May, last match 3 July.

Backs: A.G. Hastings (*Watsonians & S*), A. Clement (*Swansea & W*), I.C. Evans (*Llanelli & W*), I.G. Hunter (*Northampton & E*), R. Underwood (*Leicester & E*), T. Underwood (*Leicester & E*), R. Wallace (*Garryowen & I*), W.D.C. Carling (*Harlequins & E*), V.J.G. Cunningham (*St Mary's College & I*), I.S. Gibbs (*Swansea & W*), J.C. Guscott (*Bath & E*), S. Hastings (*Watsonians & S*), C.R. Andrew (*Wasps & E*), S. Barnes (*Bath & E*), C.D. Morris (*Orrell & E*), R.N. Jones (*Swansea & W*), A.D. Nicol (*Dundee HSFP & S*)
Forwards: D. Richards (*Leicester & E*), B.B. Clarke (*Bath & E*), M.J. Galwey (*Shannon & I*), M.C. Teague (*Mosley & E*), R.E. Webster (*Swansea & W*), P.J. Winterbottom (*Harlequins & E*), M.C. Bayfield (*Northampton & E*), D.F. Cronin (*London Scottish & S*), W.A. Dooley (*Preston & E*), M.O. Johnson (*Leicester & E*), A.I. Reed (*Bath & S*), A.P. Burnell (*London Scottish & S*), J. Leonard (*Harlequins & E*), N.J. Popplewell (*Greystones & I*), P.H. Wright (*Boroughmuir & S*), K.S. Milne (*Heriot's FP & S*), B.C. Moore (*Harlequins & E*)
Coach: I.R. McGeechan (*Scotland*)
Assistant coach: R. Best (*England*)
Manager: G.D. Cooke (*England*)

Tour record:

v North Auckland *at Whangarei*	won	30-17
v North Harbour *at Auckland*	won	29-13
v New Zealand Maoris *at Wellington*	won	24-20
v Canterbury *at Christchurch*	won	28-10
v Otago *at Dunedin*	lost	24-37
v Southland *at Invercargill*	won	34-16
v New Zealand *at Christchurch*	lost	18-20
v Taranaki *at New Plymouth*	won	49-25
v Auckland *at Auckland*	lost	18-23
v Hawke's Bay *at Napier*	lost	17-29

v New Zealand *at Wellington*	won	20-7
v Waikato *at Hamilton*	lost	10-38
v New Zealand *at Auckland*	lost	13-30

Summary:
Played 13, won 7, lost 6
Points for 314, against 285

1993 AUSTRALIA
17 July

Backs: T.P. Kelaher (*NSW*), P.V. Carozza (*Qld*), D.I. Campese (*NSW*), A.G. Herbert (*Qld*), J.S. Little (*Qld*), T.J. Horan (*Qld*), P.W. Howard (*Qld*), N.C. Farr-Jones (*NSW*)
Forwards: B.T. Gavin (*NSW*), T. Coker (*Qld*), D.J. Wilson (*Qld*), B.J. McCall (*Qld*), G. Morgan (*Qld*), E.J.A. McKenzie (*NSW*), A.J. Daly (*NSW*), P.N. Kearns (*NSW*)
Captain: P.N. Kearns
Coach: R.S. Dwyer

Tour record:

v New Zealand *at Dunedin*	lost	10-25

1993 WESTERN SAMOA
First game 4 July, last game 31 July.

Backs: A. Aiolupo (*Moata'a*), F. Saena (*Moata'a*), R. Koko (*Western Suburbs*), B. Lima (*Marist, St. Joseph's*), T. Meleisea (*Marist, St Joseph's*), M. Vaeono (*Police*), L. Langkilde (*Suburbs*), T.M. Vaega (*Te Atatu*), A.I. Ieremia (*Western Suburbs*), D.J. Kellett (*Ponsonby*), T. Samania (*Massey*), K. Sio (*Scopa*), T. Nu'uali'itia (*Te Atatu*), O.F.J. Tonu'u (*Ponsonby*), M. Vaea (*Marist, St Joseph's*)
Forwards: D. Kaleopa (*Marist*), H. Schuster (*Apia*), S. Tatupu (*Ponsonby*), A. Perelini (*Massey*), S.L. Vaifale (*Hawke's Bay*), M. Iupeli (*Marist, St Joseph's*), M.L. Birtwistle (*Suburbs*), L. Falaniko (*Marist, St Joseph's*), M.G. Keenan (*London Irish*), P. Leavase (*Apia*), V. Ala'alatoa (*Manly*), P. Fatialofa (*Manukau*), A. Leu'u (*Papakura*), P. Lilomaivao (*Marist, St Joseph's*), P. Solaese (*Vaiala*), T. Leiasamaivao (*Avalon*), S. To'omalatai (*Vaiala*)
Captain: P. Fatialofa
Coach: P. Schuster
Assistant coach: F. Selefuti
Technical advisor: B.G. Williams
Manager: T. Simi

Tour record:

v West Coast-Buller *at Westport*	won	72-0
v Marlborough *at Blenheim*	won	128-0
v New Zealand Universities *at Wellington*	won	48-10
v Wanganui *at Wanganui*	won	20-0
v New Zealand XV *at Rotorua*	lost	13-37
v Counties *at Pukekohe*	won	41-22
v King Country *at Te Kuiti*	won	57-21
v Poverty Bay *at Gisborne*	won	53-6
v New Zealand *at Auckland*	lost	13-35

Summary:
Played 9, won 7, lost 2
Points for 455, against 131

1994 WESTERN SAMOA
First match 16 April, last match 30 April.

Backs: A. Aiolupo, M.T. Umaga, R. Koko, B. Lima, T.M. Vaega, S. Fata, K. Sio, L. Langkilde, D.K. Kellett, T. Samania, T. Nu'uali'itia, R. Moors
Forwards: M. Iupeli, S.P. Kaleta, D. Kaleopa, A. Perelini, S.L. Vaifale, J. Paramore, M.L. Birtwistle, M.G. Keenan, L. Falaniko, P. Fatialofa, S. To'omalatai, H. Langkilde, G. Latu, T. Leiasamaivao, F. Lalomilo
Captain: P. Fatialofa
Coach: S.P. Schuster
Technical advisor: B.G. Williams
Manager: L.T. Simi

Tour record:

v Waikato (Super 10) *at Auckland*	won	32-16
v Taranaki *at New Plymouth*	won	32-16
v Auckland (Super 10) *at Auckland*	won	15-13
v Manawatu *at Palmerston North*	won	24-22
v Natal (Super 10) *at Auckland*	lost	26-48

Summary:
Played 5, won 4, lost 1
Points for 129, against 115

1994 TONGA
First match 7 May, last match 17 May.

Backs: S. Tu'ipulotu, L. Manako, A. Uasi, T. Va'enuku, S. Po'oi, P. Latu, F. Manukia, S. Alatini, E. Vunipola, N. Tufui, M. Vunipola
Forwards: T. Vikilani, I. Fatani, I. Fenukitau, T. Loto'ahea, S. Lolo, F. Mafi, V. Taumoepeau, P. Fisi'iahi, U. Fa, T. Lutua, P. Faletau, F. Vunipola, S. Tongia
Captain: F. Vunipola
Coach: S. Taumoepeau
Assistant coach: S. Vunipola
Manager: T. Fusimalohi

Tour record:
v Taranaki *at New Plymouth* — won 23-16
v Wanganui *at Wanganui* — won 42-13
v Manawatu *at Palmerston North* — won 19-9
v Hawke's Bay *at Napier* — drew 14-14

Summary:
Played 4, won 3, drew 1
Points for 98, against 52

1994 FIJI
First match 18 May, last match 4 June.

Backs: R. Bogisa, J. Damu *(Auckland)*, S. Aria *(Nadi)*, J. Thomas *(Auckland Marist)*, J. Toloi, P. Tuidraki, J. Vidiri *(Nadi)*, A. Elder, E. Nauga *(Nadroga)*, F. Rayasi, I. Saukuru *(Nadi)*, J. McLennan, S. Rabaka, N. Vitau
Forwards: M. Korovou, I. Kunaqio, S. Matalulu *(Nadi)*, A. Mocelutu, I. Tawake, I. Bassiyalo, J. Campbell, M. Kafoa, I. Savai *(Nadi)*, L. Rasala, S. Sadria *(Suva)*, J. Veitayaki *(King Country)*, E. Batimala *(Nadroga)*, G. Penjueli *(Auckland)*
Captain: I. Tawake
Coach: M. Kurisaru
Manager: S. Vuetaki

Tour record:
v Thames Valley *at Paeroa* — won 35-16
v East Coast *at Ruatoria* — won 62-6
v Bay of Plenty *at Rotorua* — lost 26-36
v NZ Universities *at Palmerston North* — lost 5-11
v Horowhenua *at Levin* — won 42-25
v NZ Maoris *at Christchurch* — lost 14-34

Summary:
Played 6, won 3, lost 3
Points for 183, against 128

1994 FRANCE
First match 9 June, last match 3 July.

Backs: J.-L. Sadourny *(Colomiers)*, S. Viars *(Brive)*, L. Leflamand *(Lyon)*, E. N'Tamack *(Toulouse)*, P. Saint-Andre *(Montferrand)*, W. Techoueyres *(Bordeaux)*, P. Carbonneau *(Toulouse)*, Y. Delaigue *(Toulon)*, T. Lacroix *(Dax)*, F. Mesnel* *(Racing, Paris)*, P. Sella *(Agen)*, B. Bellot *(Graulhet)*, C. Deylaud *(Toulouse)*, G. Accoceberry *(Begles)*, A. Macabiau *(Perpignan)*
Forwards: M. Cecillon *(Bourgoin)*, S. Dispagne *(Narbonne)*, P. Benetton *(Agen)*, X. Blond *(Racing)*, L. Cabannes *(Racing)*, L. Loppy *(Toulon)*, A. Benazzi *(Agen)*, O. Brouzet *(Grenoble)*, O. Merle *(Grenoble)*, O. Roumat *(Dax)*, L. Armary *(Lourdes)*, L. Benezech *(Racing)*, C. Califano *(Toulouse)*, L. Seigne *(Agen)*, J.-M Gonzalez *(Bayonne)*, J.-F. Tordo *(Nice)*
Captain: P. Saint-Andre
Coach: P. Berbizier
Assistant coach: C. Mombet
Manager: G. Laporte
* injured and did not play

Tour record:
v Northland *at Whangarei* — won 28-23
v North Harbour *at Auckland* — lost 23-27
v Wairarapa-Bush *at Masterton* — won 53-9
v New Zealand XV *at Wanganui* — won 33-25
v Nelson Bays *at Nelson* — won 46-18

v New Zealand *at Christchurch* — won 22-8
v Hawke's Bay *at Napier* — lost 25-30
v New Zealand *at Auckland* — won 23-20

Summary:
Played 8, won 6, lost
Points for 253, against 160

1994 SOUTH AFRICA
First match 23 June, last match 6 August.

Backs: G. Johnson *(Transvaal)*, A.J. Joubert *(Natal)*, J.T.J. van Rensburg *(Transvaal)*, C. Badenhorst *(Orange Free State)*, J.T. Small *(Natal)*, J.F. van der Westhuizen *(Natal)*, C.M. Williams *(Western Province)*, J.P. Claassens *(Northern Transvaal)*, F.A. Meiring *(Northern Transvaal)*, J. Mulder *(Transvaal)*, P.G. Muller *(Natal)*, B. Venter *(Orange Free State)*, H.P. le Roux *(Transvaal)*, L.R. Sherrell *(Northern Transvaal)*, J.P. Roux *(Transvaal)*, J.H. van der Westhuizen *(Northern Transvaal)*
Forwards: A.H. Richter *(Northern Transvaal)*, C.P. Strauss *(Western Province)*, W.J. Bartmann *(Natal)*, R.J. Kruger *(Northern Transvaal)*, J.F. Pienaar *(Transvaal)*, R.A.W. Straeuli *(Transvaal)*, F.J. van Heerden *(Western Province)*, M.G. Andrews *(Natal)*, S. Atherton *(Natal)*, A. Geldenhuys *(Eastern Province)*, K. Otto *(Northern Transvaal)*, G.N. Wegner *(Western Province)*, J.J. Wiese *(Transvaal)*, K.S. Andrews *(Western Province)*, G.R. Kebble *(Natal)*, A.H. le Roux *(Orange Free State)*, J.H.S. le Roux *(Transvaal)*, I.S. de V. Swart *(Transvaal)*
Captain: J.F. Pienaar
Coach: I.B. McIntosh
Assistant coach: Z.M.J. Pienaar
Manager: J.P. Engelbrecht

Tour record:
v King Country *at Taupo* — won 46-10
v Counties *at Pukekohe* — won 37-26
v Wellington *at Wellington* — won 36-26
v Southland *at Invercargill* — won 51-15
v Hanan Shield Districts *at Timaru* — won 67-19
v New Zealand *at Dunedin* — lost 14-22
v Taranaki *at New Plymouth* — won 16-12
v Waikato *at Hamilton* — won 38-17
v Manawatu *at Palmerston North* — won 47-21
v New Zealand *at Wellington* — lost 9-13
v Otago *at Dunedin* — lost 12-19
v Canterbury *at Christchurch* — won 21-11
v Bay of Plenty *at Rotoroua* — won 33-12
v New Zealand *at Auckland* — drew 18-18

Summary:
Played 14, won 10, drew 1, lost 3.
Points for 445, against 241.

1995 CANADA
First match 12 April, last match 22 April.

Backs: D.S. Stewart *(British Columbia)*, B.G. Ebl *(BC)*, D.C. Lougheed *(Ontario)*, S.T. Lytton *(BC)*, S.J. Mackinnon *(Ontario)*, C. Smith *(Western Province)*, G.L. Rees *(BC)*, R.P. Ross *(BC)*, J.D. Graf *(BC)*, A.P.C. Tynan *(BC)*
Forwards: G.D. Ennis *(BC)*, C.J. McKenzie *(BC)*, A.J. Charron *(Ontario)*, J.R. Hutchinson *(BC)*, G.I. MacKinnon *(BC)*, C.D. Michaluk *(BC)*, M.B. James *(BC)*, J.D. Knauer *(BC)*, G.D. Rowlands *(Saskatchewan)*, C.M. Whittaker *(BC)*, E.A. Evans *(BC)*, D.J. Jackart *(BC)*, P.G. Le Blanc *(BC)*, R.G.A. Snow *(Newfoundland)*, M.E. Cardinal *(BC)*, K.F. Svoboda *(Ontario)*
Captain: G.L. Rees
Coach: I. Birtwell
Assistant coach: R. Holloway
Manager: R. Skett

Tour record:
v South Island XV *at Timaru* — lost 18-19
v New Zealand XV *at Palmerston North* — lost 17-38
v North Island XV *at Rotorua* — won 40-35
v New Zealand *at Auckland* — lost 7-73

Summary:
Played 4, won 1, lost 3
Points for 82, against 165

The Encyclopedia of New Zealand Rugby

1995 COOK ISLANDS
First match 14 May, last match 26 May.

Backs: A. Henry *(Talauvaine)*, M. Hirovanaa *(Avatiu)*, H. Irepa, K. Maurangi *(Tupapa)*, David Munro *(Arorangi)*, D. Nekeare *(Western United)*, C. Petero, D. Piri *(Tupapa)*, W. Povaru *(Tupapa)*, S. Shepherd *(Ngatangiia)*, Tangiiau Tepai *(Arorangi)*, N. Tura *(Arorangi)*, A. Tyrell, D. Wichman *(Arorangi)*
Forwards: J.J. Atuahiva *(Tuakau)*, T. Bishop *(Avatu)*, S. Bracken *(Weymouth)*, H. Heather *(Arorangi)*, W. Heather *(Arorangi)*, O. John *(Manurewa)*, T. Joseph *(Titikaveka)*, M. Kiikore *(Talauvaine)*, A. Napa *(Arorangi)*, Tamaau Tepai *(Arorangi)*, Donald Munro *(Arorangi)*, M. Tini, T. Tini *(Tupapa)*, T. Tupou *(Aitutaki)*, S. Utia *(Arorangi)*
Captain: W. Heather
Coach: A. Heather
Assistant coach: A. Rangi
Manager: J. File

Tour record:
v Thames Valley *at Paeroa*	lost	15-45
v East Coast *at Ruatoria*	lost	17-20
v Poverty Bay *at Gisborne*	won	24-18
v Hawke's Bay *at Napier*	lost	0-99
v Horowhenua *at Levin*	won	22-14

Summary:
Played 5, won 2, lost 3
Points for 78, against 196

1995 WESTERN SAMOA
6 May.

Backs: T. Fa'amasino, G. Harder, T.M. Vaega, B.P. Lima, F. Tuilagi, M.T. Umaga, D.K. Kellett, T. Nu'uali'itia
Forwards: M. Iupeli, J. Paramore, P. Leavasa, D. Williams, P. Falaniko, S.L. Vaifale, S. Tatupu, M.A.N. Mika, B. Reidy, P. Fatialofa, G. Latu
Captain: P. Fatialofa
Coach: S.P. Schuster
Technical advisor: B.G. Williams

Tour record:
v Auckland *at Auckland*	lost	22-25

1995 AUSTRALIA
22 July.

Backs: M.C. Burke *(NSW)*, P.W. Howard *(Qld)*, J.W. Roff *(ACT)*, D.P. Smith *(Qld)*, J.S. Little *(Qld)*, T.J. Horan *(Qld)*, S. Bowen *(NSW)*, S. Merrick *(NSW)*
Forwards: B.T. Gavin *(NSW)*, T. Coker *(Qld)*, V. Ofahengaue *(NSW)*, D.T. Manu *(NSW)*, W.W. Waugh *(NSW)*, J.A. Eales *(Qld)*, D.J. Crowley *(Qld)*, P.N. Kearns *(NSW)*, M.N. Hartill *(NSW)*
Captain: P.N. Kearns
Coach: R.S.F. Dwyer

Tour record:
v New Zealand *at Auckland*	lost	16-28

1996 WESTERN SAMOA
First match 26 May, last match 14 June.

Backs: T. Faamasino *(Japan)*, V. Patu *(Vaiala)*, V. Fa'aofo *(Counties-Manukau)*, M.S. Fatialofa *(Wellington)*, G.E. Leaupepe *(Counties-Manukau)*, B.P. Lima *(Auckland)*, A.T. Telea *(Wellington)*, T.M. Vaega *(Southland)*, T. Fanolau *(Otahuhu)*, T. Samania *(Moataa)*, F. Tanoai *(Marist St Joseph's)*, K. Tuigamala *(Scopa)*, J.A. Filemu *(Wellington)*, T. Nu'uali'itia *(Auckland)*
Forwards: S.P. Kaleta *(Japan)*, M.A. Koloamatangi *(Auckland)*, P.R. Lam *(North Harbour)*, S.J. Smith *(North Harbour)*, S. Tiatia *(Moataa)*, S.L. Vaifale *(Japan)*, L. Falaniko *(Otago)*, P.L. Leavasa *(Hawke's Bay)*, S. Ta'ala *(Wellington)*, L. Tone *(Vaimoso)*, R. Ale *(Apia)*, P.M. Fatialofa *(Counties-Manukau)*, G. Latu *(Vaimoso)*, B.P. Reidy *(Wellington)*, T. Leiasamaivao *(Wellington)*, O. Matauiau *(Moataa)*
Captain: P.R. Lam
Coach: B.G. Williams
Assistant coach: T. Salesa
Manager: T. Simi

Tour record:
v Wellington *at Wellington*	lost	30-52
v Counties-Manukau *at Pukekohe*	won	31-19

v Taranaki *at New Plymouth*	won	26-18
v Wairarapa-Bush *at Masterton*	won	23-18
v New Zealand *at Napier*	lost	10-51
v King Country *at Taupo*	won	27-20
v NZ Maoris *at Auckland*	lost	15-28

Summary:
Played 7, won 4, lost 3
Points for 162, against 206

1996 FIJI
First match 15 June, last match 23 June.

Backs: J. Waqa *(Nadroga)*, W.T. Serevi *(Japan)*, A. Tuilevu *(Nadroga)*, A. Uluinayau, P. Rayasi *(King Country)*, S.C. Sorovaki *(Wellington)*, L.C. Little *(King Country)*, N.T. Little *(Waikato)*, P. Asalosi, J. McLennan *(Suva)*, S.D. Raulini *(Queensland)*
Forwards: D. Rouse *(Nadi)*, A. Naevo *(Counties-Manukau)*, T. Taminavalu *(Queensland)*, S. Tawake, I. Tawaki *(Nadroga)*, E.S. Katalau *(Poverty Bay)*, E. Naituivau *(Queensland)*, J. Veitayaki *(King Country)*, M. Taga, G.J. Smith *(Waikato)*, E. Batimala *(Nadroga)*
Captain: J. Veitayaki
Coach: B.R. Johnstone
Assistant coach: G.R. Cunningham
Manager: S. Vuetaki

Tour record:
v Northland *at Wangarei*	won	49-18
v Poverty Bay Selection *at Gisborne*	won	49-6
v Waikato *at Hamilton*	won	33-25

Summary:
Played 3, won 3
Points for 131, against 49

1996 SCOTLAND
First match 28 May, last match 22 June.

Backs: S.D. Lang *(Heriot's FP)*, R.J.S. Shepherd *(Melrose)*, C. Glasgow *(Heriot's FP)*, C.A. Joiner *(Melrose)*, K.M. Logan *(Stirling County)*, A.G. Stanger *(Hawick)*, D.A. Stark *(Melrose)*, B.R.S. Eriksson *(London Scottish)*, S. Hastings *(Watsonians)*, I.C. Jardine *(Stirling County)*, A.G. Shiel *(Melrose)*, C.M. Chalmers *(Melrose)*, G.P.J. Townsend *(Northampton)*, C. Armstrong *(Gosforth)*, A.D. Nicol *(Bath)*
Forwards: E.W. Peters *(Bath)*, B.L. Renwick *(Hawick)*, N.J.R. Broughton *(Melrose)*, I.R. Smith *(Gloucester)*, P. Walton *(Newcastle)*, R.I. Wainwright *(Watsonians)*, S.J. Campbell *(Dundee HSFP)*, D.F. Cronin *(Bourges)*, S. Murray *(Edinburgh Academicals)*, G.W. Weir *(Gosforth)*, D.I.W. Hilton *(Bath)*, T.J. Smith *(Watsonians)*, B.D. Stewart *(Edinburgh Academicals)*, P.H. Wright *(Boroughmuir)*, D.G. Ellis *(Currie)*, K.D. McKenzie *(Stirling County)*
Captain: R.I. Wainwright
Coach: J.R. Dixon
Assistant coach: D.I. Johnston
Manager: J.W. Telfer

Tour record:
v Wanganui *at Wanganui*	won	49-13
v Northland *at Whangarei*	lost	10-15
v Waikato *at Hamilton*	lost	35-39
v Southland *at Invercargill*	won	31-21
v South Island Divisional XV *at Blenheim*	won	63-21
v New Zealand *at Dunedin*	lost	31-62
v Bay of Plenty *at Rotorua*	won	35-31
v New Zealand *at Auckland*	lost	12-36

Summary:
Played 8, won 4, lost 4
Points for 266, against 238

1996 AUSTRALIA (Tri Nations Series)
6 July

Backs: M.C. Burke *(NSW)*, D.I. Campese *(NSW)*, B.N. Tune *(Qld)*, J.W. Roff *(Qld)*, T.J. Horan *(Qld)*, S. Bowen *(NSW)*, S.J. Payne *(NSW)*
Forwards: M.C. Brial *(NSW)*, D.J. Wilson *(Qld)*, O.D.A. Finegan *(ACT)*, G.J. Morgan *(Qld)*, J.A. Eales *(Qld)*, D.J. Crowley *(Qld)*, M.A. Foley *(Qld)*, R.L.L. Harry *(NSW)*
Captain: J.A. Eales
Coach: G. Smith

Tour record:

v New Zealand *at Wellington*	lost	6-43

Summary:
Played 5, won 1, lost 4
Points for 87, against 230

1996 SOUTH AFRICA (Tri Nations Series)
20 July.

Backs: A.J. Joubert *(Natal)*, J. Swart *(Western Province)*, J.T. Small *(Natal)*, P. Hendriks *(Transvaal)*, B. Venter *(Free State)*, J.C. Mulder *(Transvaal)*, J.S. Stransky *(Western Province)*, J.P. Roux *(Transvaal)*
Forwards: G.H. Teichmann *(Natal)*, R.J. Kruger *(Northern Transvaal)*, J.F. Pienaar *(Transvaal)*, J.N. Ackermann *(Northern Transvaal)*, M.G. Andrews *(Natal)*, M.H. Hurter *(Northern Transvaal)*, J. Allan *(Natal)*, J.P. du Randt *(Free State)*
Captain: J.F. Pienaar

Tour record:

v New Zealand *at Christchurch*	lost	11-15

1997 FIJI
First match 27 May, last match 14 June.

Backs: M. Bari *(Otago)*, L. Duvuduvukula *(Suva)*, F.T. Lasagavibau *(Nadroga)*, L.C. Little *(North Harbour)*, N.T. Little *(Waikato)*, S. Nasilasila *(Nadroga)*, M. Raulini *(Queensland)*, S.D. Raulini *(Queensland)*, F. Rayasi *(Japan)*, S.C. Sorovaki *(Japan)*, A. Tuilevu *(Waikato)*, A. Uluinayau *(Japan)*, J. Waqa *(Queensland)*
Forwards: E. Batimala *(Nadroga)*, V.B. Cavubati *(Wellington)*, E.S. Katalau *(Wales)*, M. Korovou *(Nadi)*, A. Mocelutu *(Japan)*, A.Naevo *(Counties-Manukau)*, E. Natuivau *(Queensland)*, A. Natuiyaga *(Nadroga)*, S. Niqara *(Nadroga)*, S. Raiwalui *(Queensland)*, D. Rouse *(Canterbury)*, G.J. Smith *(Waikato)*, M. Taga *(Suva)*, I. Tawake *(Nadroga)*, E. Tuvunivono *(NSW)*, J. Veitayaki *(King Country)*
Captain: G.J. Smith
Coach: B.R. Johnstone
Assistant coach: G.R. Cunningham
Manager: S. Vuetaki

Tour record:

v South Island Invitation XV *at Westport*	lost	24-31
v Mid-South Canterbury *at Timaru*	won	55-24
v Central Vikings *at Palmerston North*	won	19-10
v Wanganui *at Wanganui*	won	28-19
v Counties-Manukau Invitation XV *at Pukekohe*	lost	20-23
v New Zealand *at Albany*	lost	5-71

Summary:
Played 6, won 3, lost 3
Points for 151, against 178

1997 ARGENTINA
First match 14 June, last match 28 June.

Backs: D. Albanese *(San Isidro)*, L. Arbizu *(Belgrano)*, G. Aristide *(Gimnasia y Esgima)*, C. Barrea *(Cordoba)*, O. Bartolucci *(Rosario)*, J. Cilley *(San Isidro)*, N. Fernandez-Miranda *(Hindu)*, F. Garcia *(Association Alumni)*, E. Jurado *(Rosario Jockey)*, J. Legora *(La Tablada)*, G. Queseda *(Hindu)*, E. Simone *(Liceo Naval)*, T. Solari *(Hindu)*, F. Soler *(Tala)*
Forwards: P. Bouza *(Duendes)*, P. Camerlinckx *(Regalas de Bella Vista)*, C. Fernandez-Lobbe *(Liceo Naval)*, F. Grau *(Liceo de Mendoza)*, O.J. Hasan-Jalil *(Natacion y Gimnasia)*, M. Ledesma *(Curupayti)*, G. Llanes *(La Plata)*, R. Martin *(San Isidro)*, R. Perez, C. Promanzio *(Duendes)*, M. Reggiardo *(Castres)*, M. Ruiz *(Teque)*, J. Simes *(Tala)*, P. Sporleder *(Curupayti)*, R. Travalini *(San Isidro)*, G. Ugartemendia *(Los Matreros)*, C. Viel *(Newman)*, F. Werner *(CASI)*
Captain: L. Arbizu
Coach: J.L. Imhoff
Assistant coach: J.J. Fernandez
Technical adviser: A.J. Wyllie
Manager: J.M. Rolandi

Tour record:

v New Zealand Maoris *at Napier*	lost	17-39
v Nelson Bays-Marlborough *at Nelson*	won	42-10
v New Zealand *at Wellington*	lost	8-93
v Taranaki *at New Plymouth*	lost	10-26
v New Zealand *at Hamilton*	lost	10-62

1997 IRELAND A
First match 22 May, last match 10 June.

Backs: J. Bishop *(London Irish)*, C.P. Clarke *(Leinster)*, D. Coleman *(Leinster)*, M. Dillon *(Lansdowne)*, R. Governey *(Leinster)*, R. Henderson *(Exiles)*, D.G. Humphreys *(Ulster)*, M. Lynch *(Munster)*, A. McGrath *(Munster)*, S.McIvor *(Munster)*, K. Maggs *(Bristol)*, A. Matchett *(Ulster)*, B.O'Meara *(Munster)*, C.M.P. O'Shea *(Leinster)*, N.K.P.J. Woods *(Leinster)*
Forwards: S. Byrne *(Leinster)*, B. Cusack *(Leinster)*, K. Dawson *(Ulster)*, D. Erskine *(Ulster)*, J. Fitzpatrick *(Exiles)*, A.G. Foley *(Munster)*, G.M. Fulcher *(Munster)*, G.F. Halpin *(Exiles)*, E.O. Halvey *(Munster)*, D. Macartney *(Ulster)*, B. McConnell *(Briston)*, D. Molloy *(Wasps)*, M. O'Kelly *(Leinster)*, S. Ritchie *(Ulster)*, R. Sheriff *(Munster)*, D. Wallace *(Munster)*, G.L. Walsh *(Northampton)*
Captain: G.F. Halpin
Coach: B. Ashton
Assistant coach: D. Haslett
Manager: P.C. Whelan

Tour record:

v Northland *at Whangarei*	lost	16-69
v New Zealand Academy *at Albany*	lost	15-74
v Bay of Plenty *at Rotorua*	lost	39-52
v Thames Valley *at Paeroa*	won	38-12
v King Country *at Taupo*	lost	26-32
v New Zealand Maoris *at Palmerston North*	lost	10-41

Summary:
Played 6, won 1, lost 5
Points for 144, against 280

1997 AUSTRALIA (Tri Nations Series, Bledisloe Cup)
First match 5 July, second match 16 August.

Backs: S. Larkham *(ACT)*, J.W. Roff *(ACT)*, B.N. Tune *(Qld)*, P.W. Howard *(ACT)*, D.J. Herbert *(Qld)*, J.S. Little *(Qld)*, T.J. Horan *(Qld)*, D.J. Knox *(ACT)*, G.M. Gregan *(ACT)*, J. Holbeck *(ACT)*, M. Hardy *(ACT)*
Forwards: T. Coker *(ACT)*, D.J. Wilson *(Qld)*, B.J. Robinson *(ACT)*, M. Cockbain *(Qld)*, F.S. Finau *(NSW)*, O.D.A. Finegan *(ACT)*, J. Langford *(ACT)*, J.A. Eales *(Qld)*, R.L.L. Harry *(NSW)*, M. Caputo *(ACT)*, E.J.A. McKenzie *(ACT)*, D.T. Manu *(ACT)*, A. Blades *(NSW)*, M.A. Foley *(Qld)*
Captain: J.A. Eales
Coach: G. Smith

Tour record:

v New Zealand *at Christchurch*	lost	13-30
v New Zealand *at Dunedin*	lost	24-36

Summary:
Played 2, lost 2
Points for 37, against 66

1997 SOUTH AFRICA (Tri Nations Series)
9 August.

Backs: R. Bennett *(Border)*, J.T. Small *(Western Province)*, P. Montgomery *(Western Province)*, H.W. Honiball *(Natal)*, A.H. Snyman *(Northern Transvaal)*, J. de Beer *(Free State)*, J.H. van der Westhuizen *(Northern Transvaal)*, P.W.G. Rossouw *(Western Province)*
Forwards: G.H. Teichmann *(Natal)*, A.G. Venter *(Free State)*, M.G. Andrews *(Natal)*, K. Otto *(Northern Transvaal)*, R.J. Kruger *(Northern Transvaal)*, J.P. du Randt *(Free State)*, J. Dalton *(Gauteng)*, M.H. Hurter *(Northern Transvaal)*, F.J. van Heerden *(Western Province)*, D. Theron *(Griqualand West)*, A.E. Drotske *(Free State)*
Captain: G.H. Teichmann

Tour record:

v New Zealand *at Auckland*	lost	35-55

Australian State Teams

1882 NEW SOUTH WALES
First match 9 September, last match 3 October.

Backs: H.M. Baylis *(University of Sydney)*, G.W. Graham *(Wallaroo)*, M.H. Howard *(Balmain)*, G.W. Walker *(Redfern)*, H.G. Fligg *(Wallaroo)*, W. Flynn *(University of Sydney)*, W.J.G. Mann *(University of Sydney)*
Forwards: G.C. Addison *(University of Sydney)*, Z.C. Barry *(University of Sydney)*, C. Hawkins *(Balmain)*, R.B. Hill *(St Leonard's)*, C. Jennings *(Redfern)*, A.H. McClatchie *(Redfern)*, E.R. Raper *(University of Sydney)*, G.S. Richmond *(Wallaroo)*, R.W. Thallon *(Balmain)*
Captain and Manager: E.R. Raper

Tour record:

v Auckland Provincial Clubs *at Auckland*	lost	0-7
v Wellington *at Wellington*	won	14-2
v West Coast (North Island) *at Wellington*	won	9-2
v Canterbury *at Christchurch*	won	7-2
v Otago *at Mosgiel*	lost	0-9
v Wellington *at Wellington*	won	8-0
v Auckland Provincial Clubs *at Auckland*	lost	4-18

Summary:
Played 7, won 4, lost 3
Points for 42, against 40

1886 NEW SOUTH WALES
First match 28 August, last match 25 September.

Backs: G.W. Walker *(Redfern)*, R. Blaxland *(Maitland)*, G.W. McArthur *(Wallaroo)*, M. Shortus *(Oxford)*, F.E. Weaver *(Wallaroo)*, C.Y. Caird *(Wallaroo)*, P.B. Colquhuon *(University of Sydney)*
Forwards: P. Allen *(Newton)*, J. Austin *(Glebe)*, F. Belbridge *(University of Sydney)*, T.P. Carr *(Arfoma)*, J.de Lauret *(Wallaroo)*, A. Pearson *(Burwood)*, H. Read *(Bathurst)*, J.A.K. Shaw *(University of Sydney)*, P. Small *(Burwood)*, R.A. Warren *(Redfern)*, A.C. Wiseheart *(Newtown)*, H. Woolnough *(Balmain)*
Captain: J.A.K. Shaw
Manager: F.T. Cheeseman

Tour record:

v Auckland *at Auckland*	lost	0-6
v Nelson *at Nelson*	won	2-0
v Wellington *at Wellington*	lost	0-7
v Wairarapa *at Masterton*	won	6-5
v Canterbury *at Christchurch*	lost	0-6
v Otago *at Dunedin*	lost	0-23
v Otago 2nd XV *at Dunedin*	lost	0-9
v Canterbury *at Christchurch*	lost	0-17
v Wellington *at Wellington*	lost	0-18
v Hawke's Bay *at Napier*	lost	6-14
v Auckland *at Auckland*	lost	4-14
v Auckland *at Auckland*	lost	4-11

Summary:
Played 12, won 2, lost 10
Points for 22, against 130

1894 NEW SOUTH WALES
First match 25 August, last match 25 September.

Backs: W.G. Cobb *(Newcastle)*, J. McMahon *(Rosedale)*, J. Clayton *(Orange)*, R.C. Dibbs *(Wallaroo)*, G. Lusk *(Sydney Zealandia)*, H.P. Parish *(Randwick)*, O.N. Riley *(Randwick)*, F. Surman *(Randwick)*, J. Barry *(Orange)*, G. Bliss *(Armidale)*, W. Galloway *(Randwick)*
Forwards: T. Alcock *(Wallaroo)*, A. Braund *(Armidale)*, J. Carson *(Sydney Pirate)*, W. Cupples *(Sydney Pirate)*, W. Edwards *(Newcastle)*, E. Eyre *(Glebe)*, A. Hanna *(Paddington)*, F. Henlen *(Randwick)*, P.M. Lane *(Wallaroo)*, N. Lohan *(Orange)*, A. Rankin *(Bathurst)*, B. Sawyer *(University of Sydney)*, A. T. Scott *(Wallaroo)*, S. Walsh *(Sydney Pirate)*, C. Wiburd *(Bathurst)*
Captain: F. Surman
Manager: J. McMahon

Tour record:

v Auckland *at Auckland*	lost	11-14
v North Island *at Auckland*	lost	3-15
v Taranaki *at New Plymouth*	lost	6-21
v Wanganui-Manawatu *at Wanganui*	lost	0-13
v Hawke's Bay *at Napier*	lost	12-17
v Wellington *at Wellington*	lost	5-9
v South Canterbury *at Timaru*	won	23-0
v Canterbury *at Christchurch*	lost	3-11
v New Zealand *at Christchurch*	won	8-6
v West Coast *at Greymouth*	won	20-6
v Nelson *at Nelson*	won	13-4
v Wairarapa *at Masterton*	lost	3-21

Summary:
Played 12, won 4, lost 8
Points for 107, against 137

1896 QUEENSLAND
First match 8 August, last match 29 August.

Backs: R.H. McCowan *(Brisbane Past Grammars)*, J. Coghlan *(Brisbane City)*, W.T. Evans *(Brisbane City)*, J.J. O'Shea *(Brisbane Past Grammars)*, W.J.S. Rundle *(Warwick)*, W.H. Scarr *(Brisbane Past Grammars)*, W.C. Hawkins *(Brisbane Boomerang)*, D.J. Nelson *(Brisbane Past Grammars)*, E. Currie *(Brisbane City)*, A.S. Gralton *(Brisbane Boomerang)*
Forwards: J.S. Anderson *(Brisbane City)*, W.H. Austin *(Brisbane City)*, S.G. Cockroft *(Brisbane City)*, S. Daddow *(Charters Towers)*, T. Doyle *(Toowoomba)*, J.B. Higginson *(Brisbane Past Grammars)*, D. Milne *(Brisbane Boomerang)*, H. Nelson *(Brisbane Past Grammars)*, F.J. Pollard *(Warwick)*, W.H. Tanner *(Brisbane City)*, W.H. Tregear *(Charters Towers)*
Captain and Manager: S.G. Cockroft

Tour record:

v Auckland *at Auckland*	lost	6-15
v Wellington *at Wellington*	lost	7-49
v New Zealand *at Wellington*	lost	0-9
v Canterbury *at Christchurch*	lost	14-16
v Canterbury *at Christchurch*	lost	8-13
v Southland *at Invercargill*	lost	3-23

Summary:
Played 6, lost 6
Points for 38, against 125

1901 NEW SOUTH WALES
First match 17 August, last match 7 September.

Backs: J.W. Maund *(Eastern Suburbs)*, M.D. Barton *(Bathurst)*, A. Conlon *(Glebe)*, E.J. Hughes *(Bathurst)*, W. Lindsay *(Western Suburbs)*, E.J. McMahon *(Western Suburbs)*, S.M. Wickham *(Western Suburbs)*, F.G. Finley *(Armidale)*, H.V. Harris *(Glebe)*, W.A. Shortland *(Western Suburbs)*
Forwards: A. Avern *(Bathurst)*, A.E. Beaumont *(Eastern Suburbs)*, A. Burdon *(Sydney)*, T.B. Costello *(Glebe)*, L. Harrison *(Western Suburbs)*, A.S. Hennessey *(South Sydney)*, H.A. Judd *(Newtown)*, E.K. Lamb *(Armidale)*, D. Lutge *(North Sydney)*, S.See *(Clarence River)*, C.H. Shortland *(Western Suburbs)*, F.G. Underwood *(Eastern Suburbs)*
Captain: T.B. Costello
Manager: J.R. Henderson

Tour record:

v Wellington *at Wellington*	lost	16-17
v Southland *at Invercargill*	lost	0-17
v Otago *at Dunedin*	lost	0-5
v Canterbury *at Christchurch*	lost	5-11
v New Zealand *at Wellington*	lost	3-20
v Wanganui *at Wanganui*	won	9-8
v Auckland *at Auckland*	lost	9-24

Summary:
Played 7, won 1, lost 6
Points for 42, against 102

1921 NEW SOUTH WALES
First match 10 August, last match 7 September.

Backs: O.E. Nothling *(University of Sydney)*, E.W. Carr *(Eastern Suburbs)*, R. Chambers *(Manly)*, R.E. Lane *(Western Suburbs)*, J.F. Pym *(Manly)*, R.L. Raymond *(University of Sydney)*, J.L Shute *(Western Suburbs)*, R.G. Stanley *(University of Sydney)*, G.C. Walker *(Eastern Suburbs)*, A.C. Wallace *(University of Sydney)*, L.W. Wogan *(Western Suburbs)*, O.W. Humphreys *(North Sydney)*, N. Mingay *(Manly)*, A.S.B. Walker *(Eastern Suburbs)*

Forwards: J.H. Bond *(Glebe-Balmain)*, T.S.R. Davis *(Western Suburbs)*, V.A. Dunn *(Glebe-Balmain)*, R.E. Elliott *(Glebe-Balmain)*, D.G. Fowles *(University of Sydney)*, C.L. Fox *(North Sydney)*, J.H. Holdsworth *(Eastern Suburbs)*, D.B. Loudon *(North Sydney)*, G.R. McKay *(Newtown)*, T.S. Smith *(Manly)*, G.E. Steannes *(North Sydney)*, C.E. Thompson *(Eastern Suburbs)*, A.M. Thorn *(Manly)*
Captain: A.S.B. Walker
Manager: T.H. Bosward

Tour record:

v North Auckland *at Whangarei*	won	17-8
v Waikato *at Hamilton*	won	28-11
v Bay of Plenty *at Rotorua*	won	29-3
v Poverty Bay *at Gisborne*	won	26-8
v Wairarapa *at Masterton*	won	34-5
v Marlborough *at Blenheim*	won	19-11
v Buller *at Westport*	won	25-11
v West Coast *at Greymouth*	won	26-11
v New Zealand *at Christchurch*	won	17-0
v Wellington *at Wellington*	lost	8-16

Summary:
Played 10, won 9, lost 1
Points for 229, against 84

1923 NEW SOUTH WALES
First match 18 August, last match 19 September.

Backs: J.S. Crakanthorp *(University of Sydney)*, O.E. Nothling *(University of Sydney)*, A.J.A. Bowers *(Eastern Suburbs)*, H.M. Buntine *(Western Suburbs)*, D.J. Erasmus *(Glebe-Balmain)*, R.B. Loudon *(Sydney GPS Old Boys)*, W.B.J. Sheehan *(University of Sydney)*, N.C. Smith *(Manly)*, R.G. Stanley *(University of Sydney)*, H.B. Trousdale *(North Sydney)*, W.G. George *(Sydney YMCA)*, J. Duncan *(Sydney YMCA)*, F.W. Meagher *(Randwick)*, N. Mingay *(Manly)*
Forwards: A.R. Armstrong *(Eastern Suburbs)*, J.G. Blackwood *(Eastern Suburbs)*, T.S.R. Davis *(Western Suburbs)*, R.E. Elliott *(Glebe-Balmain)*, A.B. Erby *(University of Sydney)*, R.T. Ferguson *(Glebe-Balmain)*, D.G. Fowles *(University of Sydney)*, E.N. Greatorex *(Sydney YMCA)*, W.J. Marrott *(Eastern Suburbs)*, H. Pascoe-Pearce *(Manly)*, H.C. Taylor *(University of Sydney)*, C.E. Thompson *(Eastern Suburbs)*, E.J. Thorn *(Manly)*
Captain: W.B.J. Sheehan
Manager: T.H. Bosward

Tour record:

v Wellington-Manawatu *at Wellington*	lost	16-29
v South Canterbury *at Timaru*	won	23-16
v New Zealand *at Dunedin*	lost	9-19
v Southland *at Invercargill*	lost	9-31
v New Zealand *at Christchurch*	lost	6-34
v Hawke's Bay-Poverty Bay-East Coast *at Napier*	lost	15-32
v Auckland-North Auckland *at Auckland*	lost	11-27
v Waikato-Thames Valley-Bay of Plenty *at Hamilton*	won	11-5
v New Zealand *at Wellington*	lost	11-38
v Wairarapa-Bush *at Masterton*	lost	8-14

Summary:
Played 10, won 2, lost 8
Points for 119, against 245

1925 NEW SOUTH WALES
First match 22 August, last match 23 September.

Backs: A.E. Toby *(Sydney YMCA)*, A.J.A. Bowers *(Eastern Suburbs)*,

O.C. Crossman *(Randwick)*, R.H. Foote *(University of Sydney)*, S.C. King *(Western Suburbs)*, C.V. Morrissey *(Newcastle)*, P.J. Mulligan *(Randwick)*, D.C. Reid *(Western Suburbs)*, N.C. Smith *(Manly)*, F.G. Doran *(Glebe-Balmain)*, W.G. George *(Sydney YMCA)*, T. Lawton *(Western Suburbs)*, F.W. Meagher *(Randwick)*, H.W. Snell *(Newcastle)*
Forwards: J.G. Blackwood *(Eastern Suburbs)*, H. Bryant *(Western Suburbs)*, J.A. Ford *(Glebe-Balmain)*, E.N. Greatorex *(Sydney YMCA)*, P.B. Judd *(Western Suburbs)*, W.M.B. Laycock *(Walcha)*, L.A. Palmer *(Western Suburbs)*, W.A. Rigney *(Eastern Suburbs)*, E.V. Ritchie *(Glebe-Balmain)*, C. Shaw *(North Sydney)*, T.S. Smith *(Manly)*, K. Tarleton *(North Sydney)*, D.G. Telford *(Manly)*, E.J. Thorn *(Manly)*, H.F. Woods *(Sydney YMCA)*
Captain: E.J. Thorn
Manager: H.W. Baker

Tour record:

v Wellington-Manawatu-Horowhenua *at Palmerston North*		won	20-8
v West Coast-Buller *at Greymouth*		won	32-14
v Otago-Southland *at Dunedin*		won	22-17
v Canterbury-South Canterbury *at Christchurch*		lost	13-22
v Wanganui-Taranaki *at New Plymouth*		won	13-11
v Wairarapa-Bush *at Masterton*		won	28-8
v Poverty Bay-East Coast *at Gisborne*		won	11-3
v Rotorua and District *at Rotorua*		won	30-8
v Waikato-King Country *at Taumarunui*		won	19-16
v New Zealand *at Auckland*		lost	10-36
v North Auckland *at Whangarei*		won	32-6

Summary:
Played 11, won 9, lost 2
Points for 230, against 149

1928 NEW SOUTH WALES
First match 25 August, last match 26 September.

Backs: R. Westfield *(Randwick)*, D. Bull *(North-Western)*, R. Burge *(University of Sydney)*, B.C. Caldwell *(Randwick)*, B.H.D. Croft *(New England)*, W.H. Hemingway *(University of Sydney)*, A.M. Smairl *(Eastern Suburbs)*, C.H.T. Towers *(Randwick)*, W.J. White *(Randwick)*, H. Bartley *(Western Suburbs)*, W.G. George *(Sydney YMCA)*, S.J. Malcolm *(Newcastle)*, H.W. Snell *(Eastern Suburbs)*
Forwards: H.M. Abbott *(Manly)*, E.J. Bardsley *(Northern Suburbs)*, G.V. Bland *(Manly)*, W.H. Cerutti *(Sydney YMCA)*, I. Comrie-Thompson *(Eastern Suburbs)*, J.S. Lamb *(Eastern Suburbs)*, W.H. Lagenberg *(St George)*, R.B. Loudon *(Manly)*, A Munsie *(North-Western)*, J.A. O'Connor *(Randwick)*, J.B. O'Donnell *(Randwick)*, W.J. Phipps *(University of Sydney)*, M.E. Rosenblum *(University of Sydney)*.
Captain: S.J. Malcolm
Manager: C.E. Morgan

Tour record:

v Auckland *at Auckland*	won	19-8
v Wanganui *at Wanganui*	won	20-16
v Hawke's Bay *at Napier*	won	19-6
v New Zealand *at Wellington*	lost	12-15
v New Zealand *at Dunedin*	lost	14-16
v Southland *at Invercargill*	lost	26-31
v New Zealand *at Christchurch*	won	11-8
v Marlborough *at Blenheim*	won	27-15
v NZ Maoris *at Wellington*	lost	8-9
v Wairarapa *at Masterton*	lost	10-17

Summary:
Played 10, won 5, lost 5
Points for 166, against 141

Statistics
1884-31 December, 1997
Compiled by Clive Akers and Geoff Miller

LEADING POINTS-SCORERS IN ALL MATCHES FOR NEW ZEALAND

	Period	Matches	Points
G.J. Fox	1985-93	78	1067
D.B. Clarke	1956-64	89	781
W.F. McCormick	1965-71	44	453
B.G. Williams	1970-78	113	401
A.P. Mehrtens	1995-97	24	391
W.J. Wallace	1903-08	51	379
A.R. Hewson	1979-84	34	357
J.F. Karam	1972-75	42	345
K.J. Crowley	1983-91	35	316
J.J. Kirwan	1984-94	96	275
R.G. Wilson	1976-80	25	272
R.M. Deans	1983-85	19	252
J.A. Gallagher	1986-89	41	251
R.W.H. Scott	1946-54	52	242
C.J. Spencer	1995-97	17	239
M.J.A. Cooper	1987-96	26	224
R.A. Jarden	1951-56	37	213
T.J. Wright	1986-92	64	212
S.S. Wilson	1976-83	85	200

LEADING TRY-SCORERS IN ALL MATCHES FOR NEW ZEALAND

	Period	Matches	Tries
J.J. Kirwan	1984-94	96	67
B.G. Williams	1970-78	113	66[1]
I.A. Kirkpatrick	1967-77	113	50
S.S. Wilson	1976-83	85	50
J. Hunter	1905-08	36	49
T.J. Wright	1986-92	64	49[1]
B.G. Fraser	1979-84	55	46
G.B. Batty	1972-77	56	45
M.J. Dick	1963-70	55	42
Z.V. Brooke	1987-97	100	42
A.E. Cooke	1924-30	44	38
T.W. Lynch	1913-14	23	37
W.J. Wallace	1903-08	51	36
K.R. Tremain	1959-68	86	36
J. Steel	1920-24	38	35
R.A. Jarden	1951-56	37	35
G.S. Thorne	1967-70	39	35
J.A. Gallagher	1986-89	41	35
G.W. Smith	1897-1905	39	34
D. McGregor	1903-05	31	34
T.H.C. Caughey	1932-37	39	34
B.J. Robertson	1972-81	102	34
S.M. Going	1967-77	86	33
A.R. Sutherland	1968-76	64	32
R.W. Caulton	1959-64	50	31
J.W. Wilson	1993-97	45	30

[1]includes a penalty try.

Grant Fox . . . New Zealand's most prolific points-scorer.

MOST POINTS FOR NEW ZEALAND IN INTERNATIONALS

	Matches	Tries	Con	PG	DG	Mark	Total
G.J. Fox	46	1	118	128	7	-	645
A.P. Mehrtens	22	6	68	60	6	-	364
D.B. Clarke	31	2	33	38	5	2	207
A.R. Hewson	19	4	22	43	4	-	201
C.J. Spencer	8	5	31	20	-	-	147
J.J. Kirwan	63	35[1]	-	-	-	-	143
J.W. Wilson	35	24	1	3	-	-	131
W.F. McCormick	16	-	23	24	1	-	121
S.D. Culhane	6	1	32	15	-	-	114
C.M. Cullen	22	21	3	-	-	-	111
K.J. Crowley	19	5	5	23	2	-	105
F.E. Bunce	55	20[3]	-	-	-	-	96
Z.V. Brooke	58	17[6]	-	-	3	-	89
S.S. Wilson	34	19	-	-	-	-	76
T.J. Wright	30	19[2]	-	-	-	-	76
R.W.H. Scott	17	-	16	12	2	-	74
B.G. Williams	38	10[4]	2	9	1	-	71
J.T. Lomu	20	14	-	-	-	-	70
M. Williment	9	1	17	11	-	-	70
J.F. Karam	10	1	11	13	-	-	65
G.J.L. Cooper	7	2	14	7	2	-	63
I.A. Kirkpatrick	39	16[5]	-	-	-	-	57
M.N. Jones	51	13[8]	-	-	-	-	56
M.J.A. Cooper	8	2	10	9	-	-	55
M.C.G. Ellis	8	11	-	-	-	-	55
S.B.T. Fitzpatrick	92	12[7]	-	-	-	-	55
J.W. Marshall	23	11	-	-	-	-	55
B.W. Wilson	8	-	5	15	-	-	55
S.P. Howarth	4	1	2	15	-	-	54
W.J. Wallace	11	5	12	2	-	2	53
J.A. Gallagher	18	13	-	-	-	-	52
R.M. Deans	5	-	4	14	-	-	50

[1] includes three tries at five points.
[2] includes penalty try.
[3] includes four tries at four points.
[4] includes three tries at three points and one penalty try.
[5] includes seven tries at three points.
[6] includes six tries a four points.
[7] includes five tries at four points.
[8] includes four tries at five points.

MOST TRIES FOR NEW ZEALAND
IN INTERNATIONALS

	Internationals	Tries
J.J. Kirwan	63	35
J.W. Wilson	35	24
F.E. Bunce	55	20
C.M. Cullen	22	21
S.S. Wilson	34	19
T.J. Wright	30	19
Z.V. Brooke	58	17
I.A. Kirkpatrick	39	16
J.T. Lomu	20	14
J.A. Gallagher	18	13
M.N. Jones	51	13
S.B.T. Fitzpatrick	92	12
M.C.G. Ellis	8	11
C.I. Green	20	11
J.W. Marshall	23	11
S.M. Going	29	10
F.E. Mitchinson	11	10
A.J. Whetton	35	10

MOST APPEARANCES FOR NEW ZEALAND
IN INTERNATIONALS

	Period	Internationals
S.B.T. Fitzpatrick	1986-97	92[1]
I.D. Jones	1990-97	70[1]
J.J. Kirwan	1984-94	63
G.W. Whetton	1981-91	58
Z.V. Brooke	1987-97	58[4]
C.E. Meads	1957-71	55
F.E. Bunce	1992-97	55
M.N. Jones	1987-97	51[2]
O.M. Brown	1992-97	50
R.W. Loe	1987-95	49[3]
G.J. Fox	1985-93	46
S.C. McDowell	1985-92	46
W.K. Little	1990-97	46[2]
R.M. Brooke	1992-97	44
A.M. Haden	1977-85	41
C.W. Dowd	1993-97	40[1]
I.A. Kirkpatrick	1967-77	39[1]
K.R. Tremain	1959-68	38
B.G. Williams	1970-78	38[1]
G.A. Knight	1977-86	36
A.G. Dalton	1977-85	35
A.J. Whetton	1984-91	35[4]
J.W. Wilson	1993-97	35
M.G. Mexted	1979-85	34
B.J. Robertson	1972-81	34
S.S. Wilson	1977-83	34
M.R. Brewer	1986-95	32
W.J. Whineray	1957-65	32
D.B. Clarke	1956-64	31
G.T.M. Bachop	1989-95	31

[1] includes one appearance as a replacement.
[2] includes two appearances as a replacement.
[3] includes three appearances as a replacement.
[4] includes four appearances as a replacement.

MOST TRIES IN AN INTERNATIONAL

	Versus	Tries
M.C.G. Ellis	Japan, 1995	6
J.W. Wilson	Fiji, 1997	5
D. McGregor	England, 1905	4
C.I. Green	Fiji, 1987	4
J.A. Gallagher	Fiji, 1987	4
J.J. Kirwan	Wales, 1988	4
J.T. Lomu	England, 1995	4
C.M. Cullen	Scotland, 1996	4

MOST PENALTY GOALS IN AN INTERNATIONAL

	Versus	Penalty Goals
G.J. Fox	Western Samoa, 1993	7
D.B. Clarke	British Isles, 1959	6
K.J. Crowley	England, 1985	6
G.J. Fox	Argentina, 1987	6
G.J. Fox	Scotland, 1987	6
G.J. Fox	France, 1990	6
S.P. Howarth	South Africa, 1994	6
A.P. Mehrtens	Australia, 1996	6
A.P. Mehrtens	Ireland, 1997	6

Sean Fitzpatrick . . . 92 test matches.

MOST CONVERSIONS IN AN INTERNATIONAL

	Versus	Conversions
S.D. Culhane	Japan, 1995	20
G.J. Fox	Fiji, 1987	10
C.J. Spencer	Argentina, 1997	10
G.J. Fox	Italy, 1987	8
G.J. Fox	Wales, 1988	8
G.J. Fox	Wales, 1987	7
G.J. Fox	Argentina, 1989	7
A.P. Mehrtens	Canada, 1995	7
S.D. Culhane	Italy, 1995	7
A.P. Mehrtens	Scotland, 1996	7
A.R. Hewson	Scotland, 1981	6
G.J. Fox	Wales, 1988	6
G.J. Fox	Argentina, 1989	6
G.J.L. Cooper	World XV, 1992	6
M.J.A. Cooper	Ireland, 1992	6
A.P. Mehrtens	Scotland, 1995	6
A.P. Mehrtens	Fiji, 1997	6
C.J. Spencer	Argentina, 1997	6

HIGHEST POINTS-SCORERS IN AN INTERNATIONAL

	Opponent	Tries	Con	PG	DG	Total
S.D. Culhane	Japan, 1995[1]	1	20	-	-	45
C.J. Spencer	Argentina, 1997[1]	2	10	1	-	33
A.P. Mehrtens	Ireland, 1997	1	5	6	-	33
M.C.G. Ellis	Japan, 1995	6	-	-	-	30
A.P. Mehrtens	Canada, 1995[1]	1	7	3	-	28
A.R. Hewson	Australia, 1982	1	2	5	1	26
G.J. Fox	Fiji, 1987	-	10	2	-	26
G.J. Fox	Western Samoa, 1993	-	2	7	-	25
J.W. Wilson	Fiji, 1997	5	-	-	-	25
C.J. Spencer	South Africa, 1997	1	4	4	-	25
W.F. McCormick	Wales, 1969	-	3	5	1	24
M.J.A. Cooper	Ireland, 1992[1]	2	6	1	-	23
A.P. Mehrtens	Scotland, 1995	1	6	2	-	23
A.P. Mehrtens	Australia, 1995	-	1	5	2	23
G.J. Fox	Italy, 1987	-	8	2	-	22
G.J. Fox	Argentina, 1987	-	2	6	-	22
G.J. Fox	Scotland, 1987	-	2	6	-	22
G.J. Fox	Wales, 1988	-	8	2	-	22
G.J. Fox	France, 1990	-	2	6	-	22
A.P. Mehrtens	Scotland, 1996	1	7	1	-	22
A.P. Mehrtens	Australia, 1996	-	2	6	-	22
G.J.Fox	Argentina, 1989	-	6	3	-	21
A.P. Mehrtens	England, 1997	1	2	4	-	21
C.J. Spencer	Australia, 1997	-	3	5	-	21
A.R. Hewson	Scotland, 1981	2	6	-	-	20
G.J. Fox	Argentina, 1989	-	7	2	-	20
G.J.L. Cooper	World XV, 1992	2	6	-	-	20
J.T. Lomu	England, 1995	4	-	-	-	20
S.D. Culhane	Italy, 1995	-	7	2	-	20
C.M. Cullen	Scotland, 1996	4	-	-	-	20
C.J. Spencer	Argentina, 1997	1	6	1	-	20
C.J. Spencer	South Africa, 1997	1	3	3	-	20

[1] international debut

HIGHEST POINTS-SCORERS IN A MATCH

	Opponent	Tries	Con	PG	DG	Total
S.D. Culhane	Japan, 1995	1	20	-	-	45
R.M. Deans	South Australia, 1994	3[1]	14	1	-	43
J.F. Karam	South Australia, 1974	2[1]	15	1	-	41
R.A. Jarden	Central Coast, 1951	6[2]	10	-	-	38
G.F. Kember	North East Cape, 1970	-	14	2	-	34
S.P. Howarth	South of Scotland, 1993	2	9	2	-	34
C.J. Spencer	Argentina, 1997	2	10	1	-	33
A.P. Mehrtens	Ireland, 1997	1	5	6	-	33
D.B. Clarke	South West Zone, 1957	-	13	2	-	32
A.R. Hewson	Queensland Country, 1984	-	13	1	1	32
J.A. Gallagher	Japan, 1987	1[1]	10	2	-	30
G.J. Fox	Japan, 1987	-	15	-	-	30
M.C.G. Ellis	Japan, 1995	6	-	-	-	30

[1]Tries counted four points
[2]Tries counted three points

MOST TRIES IN A MATCH

	Versus	Tries
T.R. Heeps	Northern NSW, 1962	8
C.A. Rushbrook	Victoria, 1928	7
J.R. Watt	South West Zone, 1957	7
H.D. Thomson	British Columbia, 1906	6
R.A. Jarden	Central West, 1951	6
M.C.G. Ellis	Japan, 1995	6

HIGHEST SCORES BY NEW ZEALAND IN INTERNATIONALS

145	v Japan, 1995
93	v Argentina, 1997
74	v Fiji, 1987
73	v Canada, 1995
71	v Fiji, 1987
70	v Italy, 1987
70	v Italy, 1995
63	v Ireland, 1997
62	v Argentina, 1997
62	v Scotland, 1996
60	v Argentina, 1989
59	v Ireland, 1992
55	v South Africa, 1997
54	v Wales, 1988
54	v World XV, 1992
52	v Wales, 1988
51	v Scotland, 1993
51	v Western Samoa, 1996
51	v United States, 1913

HIGHEST SCORES BY NEW ZEALAND IN ALL MATCHES

145	v Japan at Bloemfontein, 1995
117	v South Australia at Adelaide, 1974
106	v Japan at Tokyo, 1987
103	v Northern New South Wales at Quirindi, 1962
99	v South Australia at Adelaide, 1984
96	v Asian Barbarians at Kyoto, 1987
94	v Japan B at Tokyo, 1987
93	v Argentina at Wellington, 1997

88	v Queensland Country at Surfers Paradise, 1984	
86	v South West Zone at Grenfell, 1957	
85	v North East Cape at Burgersdorp, 1970	
84	v South of Scotland at Galashiels, 1993	
84	v Victorian Invitation XV at Melbourne, 1988	
81	v Rosario at Rosario, 1991	
81	v Llanelli at Llanelli, 1997	
80	v Western Australia at Perth, 1992	
79	v Metropolitan Union at Sydney, 1920	
77	v South Australia at Adelaide, 1962	
75	v South Australia at Adelaide, 1980	
74	v Tasmania at Hobart, 1968	
74	v Fiji at Christchurch, 1987	
74	v Japan at Osaka, 1987	
73	v Tasmanian Invitation XV at Hobart, 1980	
73	v Canada at Auckland, 1995	
72	v Western Australia at Perth, 1984	
72	v Cordoba Selection at Cordoba, 1985	
71	v Fiji at Albany, 1997	
70	v Manning River Districts at Taree, 1920	
70	v Italy at Auckland, 1987	
70	v Italy at Bologna, 1995	

LARGEST WINNING MARGINS BY NEW ZEALAND IN ALL MATCHES

Margin	Score	Opponent
128	145-17	Japan, 1995
111	117-6	South Australia, 1974
103	103-0	Northern NSW, 1962
102	106-4	Japan, 1987
99	99-0	South Australia, 1984
94	94-0	Japan B, 1987
93	96-3	Asian Barbarians, 1987

LARGEST LOSING MARGINS IN ALL MATCHES

Margin	Score	Opponent
23	17-40	Sydney, 1992
22	3-25	New South Wales, 1893
17	0-17	New South Wales, 1921
17	0-17	South Africa, 1928
16	10-26	Australia, 1980
15	5-20	Australia, 1964

HIGHEST SCORES AGAINST NEW ZEALAND IN ALL MATCHES

40	by Sydney, 1992
36	by Wellington, 1932
35	by President's XV, 1973
35	by South Africa, 1997
32	by South Africa, 1996
32	by South Africa, 1997
31	by Quagga Barbarians, 1976
31	by Scotland, 1996
30	by Australia, 1978
30	by Scotland, 1995
29	by Northern Transvaal, 1976
29	by England, 1995
28	by World XV, 1992

MOST APPEARANCES IN ALL MATCHES FOR NEW ZEALAND

C.E. Meads	133
S.B.T. Fitzpatrick	128
A.M. Haden	117
I.A. Kirkpatrick	113
B.G. Williams	113
B.J. Robertson	102
G.W. Whetton	101
Z.V. Brooke	100
J.J. Kirwan	96
I.D. Jones	95
D.B. Clarke	89
S.M. Going	86
K.R. Tremain	86
S.S. Wilson	85
I.J. Clarke	83
S.C. McDowell	81
R.W. Loe	78
W.J. Whineray	77
G.J. Fox	76
M.G. Mexted	72
W.K. Little	71
M.N. Jones	70
M.W. Shaw	69
F.E. Bunce	69
B.J. Lochore	68
G.A. Knight	66
A.J. Whetton	65
A.R. Sutherland	64
T.J. Wright	64
K.L. Skinner	63
O.M. Brown	63
M.R. Brewer	61
M.J. Brownlie	61
G.N.K. Mourie	61
R.W. Norton	61
D. Young	61
A.R. Dalton	58
C.R. Laidlaw	57
G.B. Batty	56
P.J. Whiting	56
M.J. Dick	55
B.G. Fraser	55
K.W. Stewart	55
R.A. White	55
G.T.M. Bachop	54
D.S. Loveridge	54
M.J. Pierce	54
W.L. Davis	53
D.J. Graham	53
J.C. Ashworth	52
F. Roberts	52
I.N. MacEwan	52
R.W.H. Scott	52
M.F. Nicholls	51
W.J. Wallace	51
R.M. Brooke	50

MOST SUCCESSIVE INTERNATIONALS FOR NEW ZEALAND

S.B.T. Fitzpatrick	1986-95	63
G.W. Whetton	1986-91	40
I.A. Kirkpatrick	1968-77	38
S.C. McDowell	1987-92	38
M.G. Mexted*	1979-85	34
R.M. Brooke	1995-97	31
G.J. Fox	1987-91	31
O.M. Brown	1995-97	30
F.E. Bunce	1995-97	30
I.D. Jones	1995-97	30
C.W. Dowd	1995-97	28
I.D. Jones	1990-93	28
J.J. Kirwan	1985-89	28
W.J. Whineray	1957-64	28
R.W. Norton*	1971-77	27
J.T. Stanley*	1986-90	27
S.B.T. Fitzpatrick	1995-97	26
T.J. Wright	1988-91	26
F.E. Bunce	1992-95	25
B.G. Williams	1971-77	25
D.B. Clarke	1958-64	24
R.W. Loe	1988-91	24
J.W. Marshall*	1995-97	23
R.A. White	1949-56	23
C.M. Cullen*	1996-97	22
A.M. Haden	1977-80	22
J.A. Kronfeld	1996-97	22
D.S. Loveridge	1979-83	22
J.W. Wilson	1996-97	22
K.R. Tremain	1963-67	21
Z.V. Brooke	1995-96	19
S.S. Wilson	1980-83	19

*total appearances

NEW ZEALAND INTERNATIONAL CAPTAINS

S.B.T. Fitzpatrick	1992-97	51
W.J. Whineray	1958-65	30
G.N.K. Mourie	1977-82	19
B.J. Lochore	1966-70	18
A.G. Dalton	1981-85	17
G.W. Whetton	1990-91	15
W.T. Shelford	1988-90	14
D.E. Kirk	1986-87	11
A.R. Leslie	1974-76	10
I.A. Kirkpatrick	1972-73	9
C.G. Porter	1925-30	7
F.R. Allen	1946-49	6
R.R. Elvidge	1949-50	5
R.C. Stuart	1953-54	5
M.J. Brownlie	1928	4
D. Gallaher	1905-06	4
M.J.B. Hobbs	1985-86	4
J. Hunter	1907-08	4
P. Johnstone	1950-51	4
F.D. Kilby	1932-34	4
J.E. Manchester	1935-36	4
J.W. Marshall	1997	4
C.E. Meads	1971	4
R.W. Norton	1977	4

J.W. Stead	1904-08	4
I.J. Clarke	1955	3
R.R. King	1937	3
D.J. Graham	1964	3
D.S. Loveridge	1980	3
F.J. Oliver	1978	3
J. Richardson	1924	3
F. Roberts	1910	3
R.W. Roberts	1914	3
G.G. Aitken	1921	2
R.H. Duff	1956	2
J.L. Griffiths	1936	2
A. McDonald	1913	2
N.A. Mitchell	1938	2
M.J. O'Leary	1913	2
A.R. Reid	1957	2
K.L. Skinner	1952	2
J.B. Smith	1949	2
P.B. Vincent	1956	2
S.S. Wilson	1983	2
J. Duncan	1903	1
P.W. Henderson	1995	1
C.R. Laidlaw	1968	1
H.T. Lilburne	1929	1
R.M. McKenzie	1938	1
J.R. Page	1934	1
E.J. Roberts	1921	1
J.C. Spencer	1905	1
W.A. Strang	1931	1
K.R. Tremain	1968	1

FATHERS AND SONS WHO HAVE REPRESENTED NEW ZEALAND

E.F. Barry and K.E. Barry
K.E. Barry and L.J. Barry
H.W. Brown and R.H. Brown
R.A. Dalton and A.G. Dalton
J. Dick and M.J. Dick
B.B.J. Fitzpatrick and S.B.T. Fitzpatrick
W.R. Irvine and I.B. Irvine
L.A.G. Knight and L.G. Knight
T.W. Lynch and T.W. Lynch
A.G. McCormick and W.F. McCormick
G.G. Mexted and M.G. Mexted
F.J. Oliver and A.D. Oliver
E. Purdue and G.B. Purdue
H. Roberts and E.J. Roberts
J.T. Stanley and J.C. Stanley

BROTHERS WHO HAVE REPRESENTED NEW ZEALAND

G.T.M. Bachop and S.J. Bachop
C.E.O. Badeley and V.I.R. Badeley
A. Bayly and W. Bayly
R.M. Brooke and Z.V. Brooke
H.M. Brown and H.W. Brown
C.J. Brownlie, J.L. Brownlie and M.J. Brownlie
A.H. Clarke and P.H. Clarke
D.B. Clarke and I.J. Clarke
A.E. Cooke and R.J. Cooke
G.J.L. Cooper and M.J.A. Cooper

I.B. Deans and R.M. Deans
J.G. Donald and Q. Donald
E.J. Dunn and I.T.W. Dunn
A.H.N. Fanning and B.J. Fanning
J.W. Goddard and M.P. Goddard
K.T. Going and S.M. Going
A. Good and H.M. Good
S.B. Gordon and W.R. Gordon
S. Hadley and W.E. Hadley
J.S. Haig and L.S. Haig
J.L. Jaffray and M.W.R. Jaffray
A. Knight and L.A.G. Knight
A.F. McMinn and F.A. McMinn
C.E. Meads and S.T. Meads
K.F. Meates and W.A. Meates
E.B. Millton and W.V. Millton
H.E. Nicholls, H.G. Nicholls and M.F. Nicholls
C.A. Purdue and E. Purdue
E. Ryan and J. Ryan
J.D. Shearer and S.D. Shearer
J.B. Smith and P. Smith
D. Solomon and F. Solomon
G. Spencer and J.C. Spencer
K.C. Stuart and R.C. Stuart
M.B. Taylor and W.T. Taylor
F.J. Tilyard and J.T. Tilyard
A.J. Whetton and G.W. Whetton
F.A. Woodman and T.B.K. Woodman

MOST APPEARANCES IN EACH POSITION FOR NEW ZEALAND IN INTERNATIONALS

Position	Player	Years	Caps
Fullback	D.B. Clarke	1956-64	31
Wing	J.J. Kirwan	1984-94	63
Centre	F.E. Bunce	1992-97	54
Second five-eighth	W.K. Little	1990-97	41
First five-eighth	G.J. Fox	1985-93	46
Halfback	G.T.M. Bachop	1989-95	31
No 8	Z.V. Brooke	1990-97	52
Flanker	M.N. Jones	1987-97	49
Lock	I.D. Jones	1990-97	70
Prop	O.M. Brown	1992-97	50
Hooker	S.B.T. Fitzpatrick	1986-97	92

Michael Jones . . . most capped flanker.

Olo Brown . . . most capped prop.

OLDEST INTERNATIONAL PLAYERS

	Born	Played	Age
E. Hughes	26 April, 1881	v South Africa, 27 August, 1921	40 years 123 days
F.E. Bunce	4 February, 1962	v England, 6 December, 1997	35 years 305 days
J.C. Ashworth	15 September, 1949	v Australia, 29 June, 1985	35 years 287 days
R.W. Loe	6 April, 1960	v France, 18 November, 1995	35 years 226 days
R.W. Norton	30 March, 1942	v British Isles, 13 August, 1977	35 years 136 days
C.E. Meads	3 June, 1936	v British Isles, 14 August, 1971	35 years 72 days
W.T.C. Sonntag	3 June, 1894	v Australia, 27 July, 1929	35 years 54 days
A.M. Haden	26 September, 1950	v Argentina, 2 November, 1985	35 years 37 days
G.A. Knight	26 August, 1951	v Australia, 6 September, 1986	35 years 11 days
W.R. Heke (Rika)	3 September, 1894	v Australia, 27 July, 1929	34 years 327 days
S.B.T. Fitzpatrick	4 June, 1963	v Wales, 29 November, 1997	34 years 178 days
J.E. Spiers	4 August, 1947	v France, 21 November, 1981	34 years 109 days
J.E. Moffitt	3 June, 1887	v South Africa, 17 September, 1921	34 years 106 days
H.J. Mynott	4 June, 1876	v Australia, 2 July, 1910	34 years 28 days
W. Cunningham	8 July, 1874	v Anglo-Welsh, 25 July, 1908	34 years 17 days

YOUNGEST INTERNATIONAL PLAYERS

	Born	Played	Age
J.T. Lomu	12 May, 1975	v France, 26 June, 1994	19 years 45 days
E. Wrigley	15 June, 1886	v Australia, 2 September, 1905	19 years 79 days
P.T. Walsh	6 May, 1936	v Australia, 20 August, 1955	19 years 106 days
J.J. Kirwan	16 December, 1964	v France, 16 June, 1984	19 years 182 days
G. Nepia	25 April, 1905	v Ireland, 1 November, 1924	19 years 190 days
W.J. Mitchell	28 November, 1890	v Australia, 27 June, 1910	19 years 211 days
W.C. Francis	4 February, 1894	v Australia, 13 September, 1913	19 years 221 days
J.A.S. Baird	17 December, 1893	v Australia, 13 September, 1913	19 years 270 days
T.N. Wolfe	20 October, 1941	v France, 22 July, 1961	19 years 275 days
G.R. Hines	10 October, 1960	v Australia, 12 July, 1980	19 years 275 days
B.G. Williams	3 October, 1950	v South Africa, 25 July, 1970	19 years 295 days

Frank Bunce . . . second oldest test player.

PLAYING RECORD OF NEW ZEALAND TEAMS

		Played	Won	Lost	Drawn	Points for	Points against
1884	in New South Wales and New Zealand	9	9	–	–	176	17
1893	in New Zealand, New South Wales and Queensland	11	10	1	–	175	48
1894	New South Wales in New Zealand	1	–	1	–	6	8
1896	Queensland in New Zealand	1	1	–	–	9	0
1897	in New Zealand, New South Wales and Queensland	11	9	2	–	238	83
1901	New South Wales in New Zealand	2	2	–	–	44	8
1903	in Australia and New Zealand	11	10	1	–	281	27
1904	Great Britain in New Zealand	1	1	–	–	9	3
1905	in Australia and New Zealand	7	4	1	2	89	30
	Australia in New Zealand	1	1	–	–	14	3
1905/06	in the British Isles, France and North America	35	34	1	–	976	59
1907	in Australia	8	6	1	1	115	53
1908	Anglo-Welsh in New Zealand	3	2	–	1	64	8
1910	in Australia and New Zealand	8	7	1	–	138	78
1913	Australia in New Zealand	4	3	1	–	79	52
	in North America	16	16	–	–	610	6
1914	in Australia and New Zealand	11	10	1	–	260	69
1920	in Australia and New Zealand	10	9	–	1	352	91
1921	South Africa and New South Wales in New Zealand	4	1	2	1	18	31
1922	in Australia and New Zealand	8	6	2	–	198	102
1923	New South Wales in New Zealand	3	3	–	–	91	26
1924/25	in Australia, New Zealand, the British Isles, France and Canada	38	36	2	–	981	180
1925	in Australia and New Zealand	8	6	2	–	132	67
	New South Wales in New Zealand	1	1	–	–	36	10
1926	in Australia and New Zealand	8	6	2	–	187	109
1928	in South Africa and Australia	23	17	5	1	397	153
	New South Wales in New Zealand	4	3	1	–	79	40
1929	in Australia	10	6	3	1	186	80
1930	Great Britain in New Zealand	5	4	1	–	87	40
1931	Australia in New Zealand	1	1	–	–	20	13
1932	in Australia and New Zealand	11	9	2	–	331	135
1934	in Australia and New Zealand	9	7	1	1	201	107
1935/36	in the British Isles and Canada	30	26	3	1	490	183
1936	Australia in New Zealand	3	3	–	–	65	32
1937	South Africa in New Zealand	3	1	2	–	25	37
1938	in Australia	9	9	–	–	279	73
1946	Australia in New Zealand	2	2	–	–	45	18
1947	in Australia and New Zealand	10	8	2	–	263	113
1949	in South Africa	24	14	7	3	230	146
	Australia in New Zealand	2	–	2	–	15	27
1950	British Isles in New Zealand	4	3	–	1	34	20
1951	in Australia and New Zealand	13	13	–	–	375	86
1952	Australia in New Zealand	2	1	1	–	24	22
1953/54	in the British Isles, France and North America	36	30	4	2	598	152
1955	Australia in New Zealand	3	2	1	–	27	16
1956	South Africa in New Zealand	4	3	1	–	41	29
1957	in Australia and New Zealand	14	13	1	–	472	94
1958	Australia in New Zealand	3	2	1	–	45	17
1959	British Isles in New Zealand	4	3	1	–	57	42
1960	in Australia and South Africa	32	26	4	2	645	187
1961	France in New Zealand	3	3	–	–	50	12
1962	in Australia	10	9	1	–	426	49
	Australia in New Zealand	3	2	–	1	28	17
1963	England in New Zealand	2	2	–	–	30	17
1963/64	in the British Isles, France and Canada	36	34	1	1	613	159
1964	Australia in New Zealand	3	2	1	–	37	32
1965	South Africa in New Zealand	4	3	1	–	55	25
1966	British Isles in New Zealand	4	4	–	–	79	32
1967	Australia in New Zealand	1	1	–	–	29	9
	in the British Isles, France and Canada	17	16	–	1	370	135
1968	in Australia and Fiji	12	12	–	–	460	66
	France in New Zealand	3	3	–	–	40	24
1969	Wales in New Zealand	2	2	–	–	52	12
1970	in Australia and South Africa	26	23	3	–	789	234
1971	British Isles in New Zealand	4	1	2	1	42	48
1972	Internal Tour	9	9	–	–	355	88
	Australia in New Zealand	3	3	–	–	97	26
1972/73	in the British Isles, France and North America	32	25	5	2	640	266
1973	Internal Tour and England in New Zealand	5	2	3	–	88	83
1974	in Australia and Fiji	13	12	–	1	446	73
	in Ireland, Wales and England	8	7	–	1	127	50

		Played	Won	Lost	Drawn	Points for	Points against
1975	Scotland in New Zealand	1	1	–	–	24	–
1976	Ireland in New Zealand	1	1	–	–	11	3
	in South Africa	24	18	6	–	610	291
	in Argentina and Uruguay	9	9	–	–	321	72
1977	British Isles in New Zealand	4	3	1	–	54	41
	in France and Italy	9	8	1	–	216	86
1978	Australia in New Zealand	3	2	1	–	51	48
	in the British Isles	18	17	1	–	364	147
1979	France in New Zealand	2	1	1	–	42	33
	in Australia	2	1	1	–	41	15
	Argentina in New Zealand	2	2	–	–	33	15
1979	in England and Scotland	11	10	1	–	192	95
1980	in Australia and Fiji	16	12	3	1	507	126
	Fiji in New Zealand	1	1	–	–	33	–
	in North America and Wales	7	7	–	–	197	41
1981	Scotland in New Zealand	2	2	–	–	51	19
	South Africa in New Zealand	3	2	1	–	51	55
	in Romania and France	10	8	1	1	170	108
1982	Australia in New Zealand	3	2	1	–	72	53
1983	British Isles in New Zealand	4	4	–	–	78	26
	in Australia	1	1	–	–	18	8
	in Scotland and England	8	5	2	1	162	116
1984	France in New Zealand	2	2	–	–	41	27
	in Australia	14	13	1	–	600	117
	in Fiji	4	4	–	–	174	10
1985	England in New Zealand	2	2	–	–	60	28
	Australia in New Zealand	1	1	–	–	10	9
	in Argentina	7	6	–	1	263	87
1986	France in New Zealand	1	1	–	–	18	9
	Australia in New Zealand	3	1	2	–	34	47
	in France	8	7	1	–	220	87
1987	World Cup	6	6	–	–	298	52
	in Australia	1	1	–	–	30	16
	in Japan	5	5	–	–	408	16
1988	Wales in New Zealand	2	2	–	–	106	12
	in Australia	13	12	–	1	476	96
1989	France in New Zealand	2	2	–	–	59	37
	Argentina in New Zealand	2	2	–	–	109	21
	Australia in New Zealand	1	1	–	–	24	12
	in Canada, Wales and Ireland	14	14	–	–	454	122
1990	Scotland in New Zealand	2	2	–	–	52	34
	Australia in New Zealand	3	2	1	–	57	44
	in France	8	6	2	–	175	110
1991	in Argentina	9	9	–	–	358	80
	in Australia	1	–	1	–	12	21
	Australia in New Zealand	1	1	–	–	6	3
	World Cup	6	5	1	–	143	74
1992	Centenary matches in New Zealand	3	2	1	–	94	69
	Ireland in New Zealand	2	2	–	–	83	27
	in Australia and South Africa	16	13	3	–	567	252
1993	British Isles in New Zealand	3	2	1	–	57	51
	Australia in New Zealand	1	1	–	–	25	10
	Western Samoa in New Zealand	1	1	–	–	35	13
	in England and Scotland	13	12	1	–	386	156
1994	France in New Zealand	2	–	2	–	28	45
	South Africa in New Zealand	3	2	–	1	53	41
	in Australia	1	–	1	–	16	20
1995	Canada in New Zealand	1	1	–	–	73	7
	World Cup	6	5	1	–	327	119
	Australia in New Zealand	1	1	–	–	28	16
	in Australia	1	1	–	–	34	23
	in Italy and France	8	7	1	–	339	126
1996	Western Samoa in New Zealand	1	1	–	–	51	10
	Scotland in New Zealand	2	2	–	–	98	43
	Australia in New Zealand	1	1	–	–	43	6
	South Africa in New Zealand	1	1	–	–	15	11
	in Australia and South Africa	9	7	1	1	251	182
1997	Fiji in New Zealand	1	1	–	–	71	5
	Argentina in New Zealand	2	2	–	–	155	18
	Australia in New Zealand	2	2	–	–	66	37
	in South Africa and Australia	2	2	–	–	68	50
	South Africa in New Zealand	1	1	–	–	55	35
	in British Isles	9	8	–	1	395	119
	TOTALS	**1033**	**876**	**123**	**34**	**26,060**	**8547**

**NEW ZEALAND IN INTERNATIONAL
RUGBY, NATION BY NATION**

	Pl	W	L	D	For	Ag
Argentina	9	8	0	1	428	115
Australia	105	73	27	5	1873	1203
British Isles*	35	26	6	3	527	305
Canada	2	2	0	0	102	20
England	20	15	4	1	341	216
Fiji	2	2	0	0	145	18
France	32	24	8	0	601	352
Ireland	14	13	0	1	316	109
Italy	3	3	0	0	171	33
Japan	1	1	0	0	145	17
Romania	1	1	0	0	14	6
Scotland	20	18	0	2	491	217
South Africa	49	24	22	3	654	648
United States	2	2	0	0	97	9
Wales	17	14	3	0	426	121
Western Samoa	2	2	0	0	86	23
World XV	3	2	1	0	94	69
Summary	**317**	**230**	**71**	**16**	**6511**	**3481**

* Includes 1908 Anglo-Welsh team.

FIRST-CLASS RECORDS

1000 OR MORE FIRST-CLASS POINTS

	Period	Games	Tries	Con	PG	DG/Mark	Points
G.J. Fox	1982-95	303	29	901	683	47	4112
K.J. Crowley	1980-94	260	86	375	376	9	2261
G.J.L. Cooper	1984-96	188	60	385	388	14	2221
M.J.A. Cooper	1985-97	228	71	378	347	2	2124
R.M. Deans	1979-90	188	45	390	370	1	2073
W.F. McCormick	1958-78	310	57	457	314	9	2065
D.B. Clarke	1951-64	226	22	366	320	31	1851
W.B. Johnston	1986-97	175	24	333	309	4	1714
S.D. Culhane	1988-97	138	19	274	272	18	1507
J.B. Cunningham	1990-97	118	43	253	206	1	1338
A.R. Hewson	1973-88	154	19	247	229	17	1308
A.P. Mehrtens	1993-97	103	20	255	199	29	1294
M. Williment	1958-68	121	17	296	188	16	1255
L.W. Mains	1967-76	142	13	213	227	13	1193
E.J. Crossan	1987-96	91	29	189	220	-	1157
G.D. Rowlands	1969-82	179	41	198	186	15	1151
W.J. Burton	1990-96	93	10	215	204	5	1099
J.A. Gallagher	1984-90	139	67	196	144	1	1095
B.J. Fairbrother	1981-92	118	20	132	183	61	1076
A.R. Cashmore	1992-97	89	35	207	148	1	1036
R.B. Barrell	1963-79	147	20	125	225	10	1030
J.P. Preston	1987-97	149	18	204	177	-	1022

250 OR MORE FIRST-CLASS GAMES

361	C.E. Meads	1955-74
350	S.B.T. Fitzpatrick	1983-97
328	A.M. Haden	1971-86
322	R.W. Loe	1980-97
313	G.W. Whetton	1979-95
310	W.F. McCormick	1958-78
311	Z.V. Brooke	1985-97
303	G.J. Fox	1982-93
291	S.C. McDowell	1982-94
286	I.A. Kirkpatrick	1966-79
279	A.J. Wyllie	1964-80
275	A.M. Stone	1980-94
270	J.J. Kirwan	1983-94
268	B.G. Williams	1968-84
268	K.R. Tremain	1957-72
270	J.J. Kirwan	1983-94
260	K.J. Crowley	1980-94
259	I.A. Eliason	1964-82
256	G.A. Knight	1972-86
252	I.J. Clarke	1951-63
251	S.M. Going	1962-78
250	B.J. Robertson	1971-84

100 OR MORE FIRST-CLASS TRIES

J.J. Kirwan	204
T.J. Wright	177
B.G. Fraser	171
Z.V. Brooke	161
R.A. Jarden	145
B.G. Williams	137
K.R. Tremain	136
P.J. Cooke	133
M. Clamp	123
A.E. Cooke	119
I.A. Kirkpatrick	114
C.I. Green	111
G.B. Batty	109
B.R. Ford	109
J.K.R. Timu	108
T.W. Mitchell	106
S.S. Wilson	106
R.M. Smith	102
A.R. Sutherland	102
B.W. Smith	102
P. Bale	101